ISBN 978-0-259-92488-3
PIBN 10836727

English
Français
Deutsche
Italiano
Español
Português

www.forgottenbooks.com

Mythology Photography **Fiction**
Fishing Christianity **Art** Cooking
Essays Buddhism Freemasonry
Medicine **Biology** Music **Ancient
Egypt** Evolution Carpentry Physics
Dance Geology **Mathematics** Fitness
Shakespeare **Folklore** Yoga Marketing
Confidence Immortality Biographies
Poetry **Psychology** Witchcraft
Electronics Chemistry History **Law**
Accounting **Philosophy** Anthropology
Alchemy Drama Quantum Mechanics
Atheism Sexual Health **Ancient History**
Entrepreneurship Languages Sport
Paleontology Needlework Islam
Metaphysics Investment Archaeology
Parenting Statistics Criminology
Motivational

The
INTERNATIONAL
PHOTOGRAPHER

Official Bulletin of the International Photographers of the Motion Picture Industries, Local No. 659, of the International Alliance of Theatrical Stage Employees and Moving Picture Machine Operators of the United States and Canada.

Affiliated with
Los Angeles Amusement Federation, California State Theatrical Federation, California State Federation of Labor, American Federation of Labor, and Federated Voters of the Los Angeles Amusement Organizations.

Vol. 1 HOLLYWOOD, CALIFORNIA, JANUARY, 1930 No. 12

"Capital is the fruit of labor, and could not exist if labor had not first existed. Labor, therefore, deserves much the higher consideration."—Abraham Lincoln.

CONTENTS

The INTERNATIONAL PHOTOGRAPHER published monthly by Local No. 659, I. A. T. S. E. and M. P. M. O. of the United States and Canada

HOWARD E. HURD, *Publisher's Agent*

SILAS EDGAR SNYDER - - - - *Editor-in-Chief* IRA B. HOKE - - - - - - - *Associate Editor*
LEWIS W. PHYSIOC - - - - *Technical Editor* ARTHUR REEVES - - - - *Advertising Manager*
CHARLES P. BOYLE - - - - - - *Treasurer*

Subscription Rates— United States and Canada, $3.00 per year. Single copies, 25 cents
Office of publication, 1605 North Cahuenga Avenue, Hollywood, California. HEmpstead 1128

The members of this Local, together with those of our sister Locals, No. 644 in New York, No. 666 in Chicago, and No. 665 in Toronto, represent the entire personnel of photographers now engaged in professional production of motion pictures in the United States and Canada. This condition renders THE INTERNATIONAL PHOTOGRAPHER a voice of an *Entire Craft*, covering a field that reaches from coast to coast across the nation.

Printed in the U. S. A. at Hollywood, California

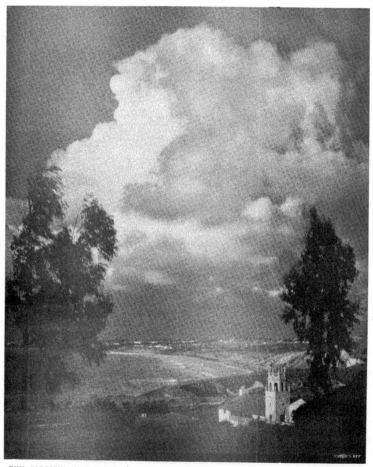

THIS GORGEOUS SHOT IS FROM THE CAMERA OF JAMES N. DOOLITTLE. THIS ARTIST IS ANOTHER
INTERNATIONAL PHOTOGRAPHER WHO HAS WON INTERNATIONAL RECOGNITION AS A PICTORIALIST.

What Say Ye of Thrift?

THE EDITOR

Somebody, said that the Dutch invented thrift, but it is quite likely that thrift existed in the world long before the Dutch nation arose. Anyway the picturesque people of the Low Countries have no copyright on it and there are evidences that even in Hollywood it is not unknown.

Truth to tell our little community is even establishing a reputation for thrift notwithstanding the many flamboyant tales spread abroad about the extravagance of motion picture workers. These stories are for the most part the dreams of semi-detached hack writers pandering to the demands of the sensational press and the scuffle-hunting magazines. One of our banks is witness to a vastly different state of affairs, for it knows of many specific instances indicative of the wide spread habit of thrift among the workers at the studios.

Thrift means economic management; and economic management implies not only a high degree of busines efficiency, but the principles and motives that lie back of business efficiency. Business efficiency means industry in the pursuit of vocation, profession or art and efficiency means doing the right thing in the right way at the right time.

The motives and principles back of any act are the soul of the act and they arise in the innermost self of the actor. They reside, therefore, in the character of the man and it is these things that constitute the character of the man.

The Bible and in fact all the charmed books of the world glorify thrift as one of the cardinal virtues, but nature goes much further and demonstrates in many ways, but particularly in the animal kingdom that thrift is a living principle, as witness the ants, bees and other insects, the beaver, squirrel, chipmunk, etc., etc.

To quote from the Bible: "He that provideth not for his own and especially for those of his own house he hath denied the faith and is worse than an infidel."

This means that thrift or "economic management" was to be regarded as the very highest of the qualities of character and that its absence was to be regarded even as a denial of faith in the providence of the Supreme One.

Thrift, therefore, implies industry, intelligence, order, sense of duty, steadines, reliability, self sacrifice and many other ashlars of character all ornaments of the personality and all necessary to the greater success which is above mere accumulation of wealth.

However, in these days thrift usually manifests in the form of a savings account at the bank, for money is the symbol of wealth and is, in the last analysis, labor or industry crystalized. When, therefore, a depositor presents himself at the receiving teller's window with money representative of his labor to place in a savings account, he is, in fact, demonstrating that thrift, or the saving instinct is strong in his character and, knowing the constituents of thrift, the man in the bank sees in the depositor a community builder in spirit and in truth. To be thrifty is to wear a badge of respectability. Thrift is a fundamental basis of character.

The Aladdin's Lamp of the Movies—No. 3
By John Corydon Hill

AND A LITTLE CHILD SHALL FEED THEM

*Willard Barth
demonstrating what
the 1930
Assistant
Cameraman
will wear*

—*Photo by Otto Benninger.*

HOSPITAL LIST

Frank Good is rapidly recovering from an illness which put him in the hospital and under the surgeon's knife. He is back home again and says he is going to be stronger than he ever was.

Forrest Hershey has been in Angelus hospital for three months with a bad fracture of his leg and he sends word that he is scheduled to remain there indefinitely. When you have an hour off run down and cheer Forrest up a bit.

Executive Jack Rose has reported for duty at Tiffany Productions after a serious bout with the flu. Tiffany thought enough of Jack's abilities to hold up production on their big picture, "Resurrection" for two weeks to enable Jack to get into the harness again. It is good to see Jack around again.

Kindergarten In Sound Pictures

—BY—
W. HOWARD CAMPBELL, *Formerly Sound Expert United Artists Studio*

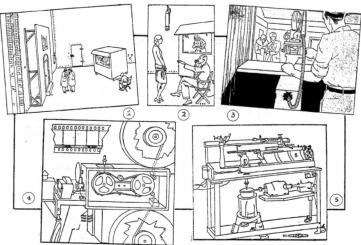

(1) *Set on sound stage showing portable camera booth and microphone. The "mike" is the sausage-like gadget hanging over the heads of the two actors. Note overcoats. Cold day on set.* (2) *Director doing in his directing in pantomime.* (3) *Inside of phone booth looking out.* (4) *Machine for recording the voice and other sounds. See under heading "Two Recording Systems."* (5) *Precision lathe for making master wax discs for recording sound.*

Talking pictures for the most part are made in specially constructed buildings set apart from the other structures in the big motion pictures studios.

Obviously, it would never do to have locomotive whistles, street-car bells, fire and police department sirens or other anachronic sounds heard and recorded during the filming of a picture with a desert isle as the locale.

HAVE DOUBLE WALLS

For this reason sound stages are constructed with double walls—really two buildings, one just inside the other to secure a dead air space between them—and all doors are padded like those used in cold storage vaults.

On sound stages the voices, music and other sounds do not echo like they would in armories and other large structures. Echoes are prevented by covering the inside surface of the inner walls and ceiling with a thick coating of rock wool or similar soft material.

On a big stage so constructed and treated, two people can stand 40 feet apart, conversing in ordinary tones, and each hear the other's every word clearly

In response to very many requests for a first grade sketch of the filming of motion pictures in sound these chart class lessons by W. Howard Campbell are offered. The lessons are brought down to date as there has been swift and continuous improvement since Mr. Campbell wrote, six months ago. Mr. Campbell was formerly sound expert with United Artists Studios. The line drawings in embellishment of the text were made by United Artists' engineers.—Editor's Note.

and distinctly. Louder sounds are heard and picked up by the microphone naturally and without any confusing rumble or roll. Only in such rooms can interior scenes and accompanying sound effects and dialogue be faithfully reproduced for recording, and synchronized with the scenes filmed by the cameras.

THE MIKE

In recording a device must be used which has the ability to transform sound waves into pulsations of electrical energy.

This device is the microphone.

The electrical energy produced by even the loudest sounds is however so little that a one tube audio frequency amplifier has to be built into the microphone in order to overcome the resistance of the wires that transmit these feeble pulsations to the recording apparatus.

These microphones, resembling large sausages, when in use are usually suspended just overhead the actors and actresses and out side the range of the motion picture cameras. Great skill, resulting from long experience, is required for properly spacing and setting microphones to pick up dialogue here and there on the set and all the other necessary sounds, with each part clear and of the right proportion of volume.

Even greater skill is required by the players, who must so control their voices at all times that a whisper will not be lost one second and a shout or scream the next second will not paralyze or "deafen" these mechanical-electrical ears.

"Mikes" are hyper-sensitive, so actors and actresses working in scenes must be careful what they wear. The rustle of a beaded gown might sound like the anvil chorus, and a bunch of keys, jing-

ling in a handsome leading man's pocket, might record like a ship pulling up its anchor.

The noise produced by the cameras when photographing a scene is sometimes very objectionable especially when the camera is close to the microphone. Until new cameras are designed that will operate silently it is necessary to confine the noise usually by one of three methods.

One method is to put the camera in a sound proof booth having a window of special optical glass through which the scene is photographed.

These booths are thick-walled and heavily padded, and the door is one of the "ice-box" variety. In fact, the booths resemble large ice chests, or grotesque telephone booths. They are mounted on rubber wheels to facilitate moving and are equipped with electric lights, telephones and special apparatus to furnish the men inside with a constant supply of fresh air.

There is a story going the rounds in Hollywood of a talking picture camera man who locked himself in his booth, forgot to turn on the air supply, and was nearly smothered to death.

Another method of confining the noise from the camera is to put the camera in a much smaller booth or "dog house" which rests on the camera tripod. Such a box has the advantage of being much more portable but has the disadvantage of rendering the parts of the camera relatively inaccessible to the cameraman especially during a scene when the box is completely closed up. To offset this various wheels, levers, buttons and other gadgets have been added — inventions worthy of a "Rube" Goldberg.

In some cases it has been found possible to obtain sufficient muffling of the camera noise by simply using a soft bag over the camera. The inside of the bag that comes in contact with the camera is made of sheeps' wool, very much like the comforters we like to snuggle under on cold nights. On the outside is a relatively impervious layer composed of several thicknesses of canvas. With this method no glass is used in front of the lens and the weight is greatly reduced but the camera is still somewhat inaccessible.

An important part of the recording system is the monitor booth. It is here that the "mixer" and dialogue director sit in judgment. The booth is soundproof so that only sounds as recreated on the loud speaker can be heard. The monitor booth is only slightly larger than a camera booth and can be rolled in quite close to the set where everything can be observed. The "mixer" can thereby direct the placing of the microphones and he can also determine accurately the amount of amplification needed to record the scene properly. The dialogue director, too, is in a postion to judge how well the dialogue is "getting over."

Two Recording Systems

There are two systems of recording voices, music and sound in talking pictures—film and disc.

Machines for recording sound on the film itself are somewhat like motion picture cameras in principle, except that the shutter is called a "light valve" and the aperture is a narrow metal slot.

The light valve consists of two ribbons of aluminum alloy called "duralumin." These ribbons are three ten-thousandths of an inch thick and six-thousandths of an inch wide. The light slot is only eight-thousandths of an inch wide.

Controlled by Magnet

A powerful electric light is focused through a lens system on this slot, back of which runs the sensitive film. The light valve ribbons are stretched across the slot on the side opposite from the film and the ribbons open and close as controlled by a powerful electromagnet.

The electromagnet is controlled by the pulsating electric current originating in the microphones after it has been multiplied millions of times in big audio frequency amplifiers. Every vibration of an actor's voice or from a musical instrument opens the light valves, and lines one-tenth of an inch long and of a width corresponding to the number of sound vibrations per second are exposed on the moving sensitive sound film.

'Sound Track' Results

When developed and printed a sound film, known as a "sound track," is obtained. Under a microscope it looks like a board walk made of boards of varying widths alternated with open spaces, also of varying widths.

When run in a projection machine in a theatre the various lines in the "sound track" control the amount of light from a powerful electric light which strikes a photo-electric cell in such a way that electric pulsations are again created exactly like the ones first produced by the microphone.

After they have gone through the theatre power amplifiers they are carried to big loud speakers which produce the final retransformation of electrical impulses into sound waves as heard by audiences.

Machines which record sound for audible pictures on phonograph records are essentially precision lathes which cut spiral grooves on polished surfaces of master wax discs 16 inches in diameter and about 2 inches thick.

The cutting tool, or "stylus" is a V-shaped sapphire point mounted on the end of a delicately balanced arm and set to cut a wax groove from two to six thousandth of an inch deep. At the same time the cutting stylus is moved from side to side by a powerful electromagnet fed by pulsating electric current originating in the sound stage microphones but multiplied millions of times in the recording system amplifiers.

Long and Short Bends

Under a microscope the resulting groove looks like a continually winding ditch made up of a great variety of long and short bends. Each bend corresponds to a vibration of an actor's voice, musical instrument, noises, or mixtures of all.

The master wax is coated with graphite flour paint and electroplated. The resulting copper plate carries ridges instead of grooves. From the copper plate, or matrix, are stamped the records for the theatres.

What system is used by theatres depends upon the way the house is equipped. Many of the biggest talking pictures are made with both systems.

'Playback Disc'

When a picture is being filmed and microphoned, two wax recording ma-

"Hot Points"

Conducted by Maurice Kains

When cleaning magazines try holding them upside down as you brush them, that is, with the opening toward the floor. The dirt will drop out instead of finding another place to stick inside the magazine. A piece of velvet ribbon folded double will remove all dirt from the light traps if drawn through the traps from the inside toward the outside several times. One large studio blows the dirt from the magazines with an air compressor.

If you have occasion to use adhesive tape that is sticky on both sides, take an ordinary piece of adhesive tape and roll it around a thin pencil, as you would a cigarette, sticky side out. One edge should just lap over the other and stick to it. After so doing, pull it from the pencil, flatten out and you have a narrow tape, sticky on both sides.

A good way to make finder matts accurately and quickly as follows: Procure celluloid sheets with one side ground, like camera ground glass. Cut a piece so that it fits snugly into your finder. With a sharp pencil make a small mark on the approximate position of your top frame line. Place celluloid in finder and look through to see how far off line your pencil mark is. If it is not right, withdraw celluloid, make another mark and erase the old mark. Repeat until you have all four sides accurately marked. Now clamp the pattern to the celluloid you intend cutting out and trace your lines with a ruler and razor blade. Amber or colored celluloid is preferred by many cameramen. The edges of the cut-out of any transparent finder mat may be slightly beveled with a fine file to show a black line around opening.

You can easily magnetize your screw drivers on the "whistle boxes" used on all arc lamps. Such a screw driver is often useful in working with delicate or tiny screws. I have found it valuable in recovering a screw which had dropped into an inaccessible part of the camera or mechanism.

The "Hot Points" editor will be glad to print any camera kinks which you have found helpful or interesting in your work. Mail your contribution to Maurice Kains, care of *The International Photographer.*

chines are generally run at the same time, so that the second wax disc can be used for a "playback" when the scene is completed. The director, actors, sound engineers and other technical aids listen to the action through loud speakers, to determine whether or not the recording has been made properly and the voices, music, sounds, etc., properly balanced. Scenes are sometimes remade several times until the director is satisfied.

Because of the softness of the wax, a disc used as a playback is spoiled for use as a "master." In fact, it can not be played back more than two or three times before it is worn out.

Kindergarten In Sound Pictures

—BY—

W. HOWARD CAMPBELL, *Formerly Sound Expert United Artists Studio*

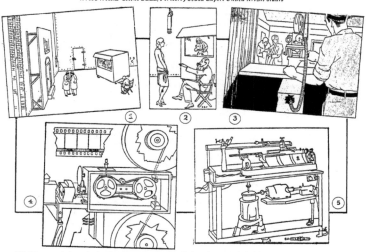

(1) *Set on sound stage showing portable camera booth and microphone. The "mike" is the sausage-like gadget hanging over the heads of the two actors. Note overcoats. Cold day on set.* (2) *Director doing in his directing in pantomime.* (3) *Inside of phone booth looking out.* (4) *Machine for recording the voice and other sounds. See under heading "Two Recording Systems."* (5) *Precision lathe for making master wax discs for recording sound.*

Talking pictures for the most part are made in specially constructed buildings set apart from the other structures in the big motion pictures studios.

Obviously, it would never do to have locomotive whistles, street-car bells, fire and police department sirens or other anachronic sounds heard and recorded during the filming of a picture with a desert isle as the locale.

HAVE DOUBLE WALLS

For this reason sound stages are constructed with double walls—really two buildings, one just inside the other to secure a dead air space between them—and all doors are padded like those used in cold storage vaults.

NO ECHO TO VOICES

On sound stages the voices, music and other sounds do not echo like they would in armories and other large structures. Echoes are prevented by covering the inside surface of the inner walls and ceiling with a thick coating of rock wool or similar soft material.

On a big stage so constructed and treated, two people can stand 40 feet apart, conversing in ordinary tones, and each hear the other's every word clearly

In response to very many requests for a first grade sketch of the filming of motion pictures in sound these chart class lessons by W. Howard Campbell are offered. The lessons are brought down to date as there has been swift and continuous improvement since Mr. Campbell wrote, six months ago. Mr. Campbell was formerly sound expert with United Artists Studios. The line drawings in embellishment of the text were made by United Artists' engineers.—Editor's Note.

and distinctly. Louder sounds are heard and picked up by the microphone naturally and without any confusing rumble or roll. Only in such rooms can interior scenes and accompanying sound effects and dialogue be faithfully reproduced for recording, and synchronized with the scenes filmed by the cameras.

THE MIKE

In recording a device must be used which has the ability to transform sound waves into pulsations of electrical energy.

This device is the microphone.

The electrical energy produced by even the loudest sounds is however so little that a one tube audio frequency amplifier has to be built into the microphone in order to overcome the resistance of the wires that transmit these feeble pulsations to the recording apparatus.

These microphones, resembling large sausages, when in use are usually suspended just overhead the actors and actresses and out side the range of the motion picture cameras. Great skill, resulting from long experience, is required for properly spacing and setting microphones to pick up dialogue here and there on the set and all the other necessary sounds, with each part clear and of the right proportion of volume.

Even greater skill is required by the players, who must so control their voices at all times that a whisper will not be lost one second and a shout or scream the next second will not paralyze or "deafen" these mechanical-electrical ears.

"Mikes" are hyper-sensitive, so actors and actresses working in scenes must be careful what they wear. The rustle of a beaded gown might sound like the anvil chorus, and a bunch of keys, jing-

ling in a handsome leading man's pocket, might record like a ship pulling up its anchor.

The noise produced by the cameras when photographing a scene is sometimes very objectionable especially when the camera is close to the microphone. Until new cameras are designed that will operate silently it is necessary to confine the noise usually by one of three methods.

One method is to put the camera in a sound proof booth having a window of special optical glass through which the scene is photographed.

These booths are thick-walled and heavily padded, and the door is one of the "ice-box" variety. In fact, the booths resemble large ice chests, or grotesque telephone booths. They are mounted on rubber wheels to facilitate moving and are equipped with electric lights, telephones and special apparatus to furnish the men inside with a constant supply of fresh air.

There is a story going the rounds in Hollywood of a talking picture camera man who locked himself in his booth, forgot to turn on the air supply, and was nearly smothered to death.

Another method of confining the noise from the camera is to put the camera in a much smaller booth or "dog house" which rests on the camera tripod. Such a box has the advantage of being much more portable but has the disadvantage of rendering the parts of the camera relatively inaccessible to the cameraman especially during a scene when the box is completely closed up. To offset this various wheels, levers, buttons and other gadgets have been added — inventions worthy of a "Rube" Goldberg.

In some cases it has been found possible to obtain sufficient muffling of the camera noise by simply using a soft bag over the camera. The inside of the bag that comes in contact with the camera is made of sheeps' wool, very much like the comforters we like to snuggle under on cold nights. On the outside is a relatively impervious layer composed of several thicknesses of canvas. With this method no glass is used in front of the lens and the weight is greatly reduced but the camera is still somewhat inaccessible.

An important part of the recording system is the monitor booth. It is here that the "mixer" and dialogue director sit in judgment. The booth is soundproof so that only sounds as recreated on the loud speaker can be heard. The monitor booth is only slightly larger than a camera booth and can be rolled in quite close to the set where everything can be observed. The "mixer" can thereby direct the placing of the microphones and he can also determine accurately the amount of amplification needed to record the scene properly. The dialogue director, too, is in a position to judge how well the dialogue is "getting over."

TWO RECORDING SYSTEMS

There are two systems of recording voices, music and sound in talking pictures—film and disc.

Machines for recording sound on the film itself are somewhat like motion picture cameras in principle, except that the shutter is called a "light valve" and the aperture is a narrow metal slot.

The light valve consists of two ribbons of aluminum alloy called "duralumin." These ribbons are three ten-thousandths of an inch thick and six-thousandths of an inch wide. The light slot is only eight-thousandths of an inch wide.

CONTROLLED BY MAGNET

A powerful electric light is focused through a lens system on this slot, back of which runs the sensitive film. The light valve ribbons are stretched across the slot on the side opposite from the film and the ribbons open and close as controlled by a powerful electromagnet. The electromagnet is controlled by the pulsating electric current originating in the microphones after it has been multiplied millions of times in big audio frequency amplifiers. Every vibration of an actor's voice or from a musical instrument opens the light valves, and lines one-tenth of an inch long and of a width corresponding to the number of sound vibrations per second are exposed on the moving sensitive sound film.

'SOUND TRACK' RESULTS

When developed and printed a sound film, known as a "sound track," is obtained. Under a microscope it looks like a board walk made of boards of varying widths alternated with open spaces, also of varying widths.

When run in a projection machine in a theatre the various lines in the "sound track" control the amount of light from a powerful electric light which strikes a photo-electric cell in such a way that electric pulsations are again created exactly like the ones first produced by the microphone.

After they have gone through the theatre power amplifiers they are carried to big loud speakers which produce the final retransformation of electrical impulses into sound waves as heard by audiences.

Machines which record sound for audible pictures on phonograph records are essentially precision lathes which cut spiral grooves on polished surfaces of master wax discs 16 inches in diameter and about 2 inches thick.

The cutting tool, or "stylus" is a V-shaped sapphire point mounted on the end of a delicately balanced arm and set to cut a wax groove from two to six thousandsth of an inch deep. At the same time the cutting stylus is moved from side to side by a powerful electromagnet fed by pulsating electric current originating in the sound stage microphones but multiplied millions of times in the recording system amplifiers.

LONG AND SHORT BENDS

Under a microscope the resulting groove looks like a continually winding ditch made up of a great variety of long and short bends. Each bend corresponds to a vibration of an actor's voice, musical instrument, noises, or mixtures of all.

The master wax is coated with graphite flour paint and electroplated. The resulting copper plate carries ridges instead of grooves. From the copper plate, or matrix, are stamped the records for the theatres.

What system is used by theatres depends upon the way the house is equipped. Many of the biggest talking pictures are made with both systems.

'PLAYBACK DISC'

When a picture is being filmed and microphoned, two wax recording ma-

Conducted by MAURICE KAINS

When cleaning magazines try holding them upside down as you brush them, that is, with the opening toward the floor. The dirt will drop out instead of finding another place to stick inside the magazine. A piece of velvet ribbon folded double will remove all dirt from the light traps if drawn through the traps from the inside toward the outside several times. One large studio blows the dirt from the magazines with an air compressor.

If you have occasion to use adhesive tape that is sticky on both sides, take an ordinary piece of adhesive tape and roll it around a thin pencil, as you would a cigarette, sticky side out. One edge should just lap over the other and stick to it. After so doing, pull it from the pencil, flatten out and you have a narrow tape, sticky on both sides.

A good way to make finder matts accurately and quickly as follows: Procure celluloid sheets with one side ground, like camera ground glass. Cut a piece so that it fits snugly into your finder. With a sharp pencil make a small mark on the approximate position of your top frame line. Place celluloid in finder and look through to see how far off line your pencil mark is. If it is not right, withdraw celluloid, make another mark and erase the old mark. Repeat until you have all four sides accurately marked. Now clamp the pattern to the celluloid you intend cutting out and trace your lines with a ruler and razor blade. Amber or colored celluloid is preferred by many cameramen. The edges of the cut-out of any transparent finder mat may be slightly beveled with a fine file to show a black line around opening.

You can easily magnetize your screw drivers on the "whistle boxes" used on all arc lamps. Such a screw driver is often useful in working with delicate or tiny screws. I have found it valuable in recovering a screw which had dropped into an inaccessible part of the camera or mechanism.

The "Hot Points" editor will be glad to print any camera kinks which you have found helpful or interesting in your work. Mail your contribution to Maurice Kains, care of **The International Photographer.**

chines are generally run at the same time, so that the second wax disc can be used for a "playback" when the scene is completed. The director, actors, sound engineers and other technical aids listen to the action through loud speakers, to determine whether or not the recording has been made properly and the voices, music, sounds, etc., properly balanced. Scenes are sometimes remade several times until the director is satisfied.

Because of the softness of the wax, a disc used as a playback is spoiled for use as a "master." In fact, it can not be played back more than two or three times before it is worn out.

Silence With Arcs

—BY—

W. J. QUINLAN, *Chief Engineer, Fox Film Corporation*

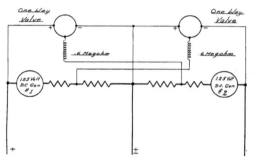

Schematic Connection Diagram of Hook-up
for Generators using One Way Valves.
W. J. Quinlan
Chief Engineer
Fox Film Corp
June 12 1928

Much has been said, and current articles have been printed that have been rather misleading, regarding the supposed difficulties, encountered with the use of hard light (arc lights), for the taking of talking pictures.

The Incandescent Lamp had been introduced, long before the advent of talking pictures, and it could, therefore, be truthfully said, that it WAS NOT DEVELOPED FOR TALKING PICTURES. It had been in use for upwards of a year in the Pacific Coast studios, and approximately that time in the New York studios. It is quite obvious, therefore, that the producers, or those responsible in the various studios, never intended to throw aside or junk their hard light apparatus, on account of noises, variously described as "commutator hums," "commutator ripples," "whistling arc lights," etc.

The first public endeavor, drawn to the writer's attention, to combat and eliminate these noises, was made by the Cinema Studio Supply Corporation, in the form of a choke coil. It would be difficult to say, however, what personal efforts were being made by the various studios; but it is to be assumed that they were not heavy ones, because at about this time, the general ground and camera noises in the average set, were far in excess of any noise emanating from lamp equipment, and still their attention had not been focussed on it, to any great degree.

The studios of the William Fox Corporation have, all through this period,

used at least 95 per cent of hard light equipment, and the results in their photography, have been very gratifying. Pictures were finally arranged, and the sequences were brought in with background noise, camera noise, or lamp noise. However, it did not reach to such magnitude that any of the picture making people on the Coast decided to junk or discard the use of hard lighting equipment, in favor of incandescent lighting. It is quite possible that those companies, who had purchased considerable incandescent equipment, continued buying additional equipment, with the thought in mind that, added silence would be created by additional apparatus of the incandescent type.

In an article prepared and read at the Society of Motion Picture Engineers, a paper described the application of the Electrolytic Lightning Arrester, for the cure of this WHISTLING. The effect was quite satisfactory, from all reports; but, it suffers from many disadvantages likewise.

A similar problem of this nature was tried out by the writer, in the New York studios of the Fox Film Corporation, some three years ago, where a combination of old storage batteries were floated along the line at the plant, and additional such equipment, floating across the line at the sub-station. This brought the RIPPLE to within reasonable limits, and the disadvantage, found in lightning arresters, when subjected to continuous operation, was thereby avoided.

The application of a filter circuit, to pass above, below, or within the given frequency, is a very simple problem for plate generators; but, other complications arise when we are forced to handle thousands of amperes, or, if necessary only a few amperes.

Many pieces of apparatus can be assembled to work around this condition, in various ways; but they are very often limited in their usefulness, on account of the space required to handle them in; and in some cases, the complete electrolysis of the metals employed; also because of the obnoxious fumes, and the high maintenance cost of keeping them in operation.

The conditions in the various studios, are naturally variable, and it would be unwise for anyone to endeavor to prescribe a general remedy to apply under such conditions. The Fox studios, through their engineering department, and the constant perseverance of Mr. Glenn Farr and Mr. Ray Fitzgerald, have always laid great stress on a REJECTOR COIL, built in the form of a REACTOR, applied and mounted as a part of the lamp equipment. These coils are so placed, that they do not call for any external housing or preparations.

It would be entirely impossible for lamp operators to pick out any lamp equipment possessing such an appliance, merely by lifting it, to determine if any appreciable additional weight had been added, for the weight of such equipment does not amount to more than, from 15 to 18 pounds for sun arcs, and is considerably less for broadsides, spots and scoops.

We have found that an additional protective measure is afforded, when the installation is made this way. One set operating on a stage, with their lamps burning, may sometimes be annoyed when the lamp equipment is lighted on an adjoining stage, by transmission through the feeder cables, of a series of variable frequencies, which occur when the lamp load is thrown on. It was found that this small rejector coil not only eliminated to a very satisfactory degree, the commutator ripple coming into the carbons, but likewise kept a great percentage of these variable frequencies out of the other stages.

It is quite obvious that all the trouble does not lie in the generator room and therefore, too much effort should not be spent in there. In addition to this, to overcome the generator noise, after several small changes were made on the machines themselves, one-way valves, which are ELECTRONIC rather than ELECTROLYTIC, have been added, to smooth out the few remaining little troubles.

This equipment was not required at the Fox Hills Studio, because considerable capacity had been introduced there, by grace of the underground system, which is entirely lead covered, thereby

introducing considerable capacity, and the effects of shielding. Thought was given to this, when the installation was made, and the added expenditure for an underground system of this type, is thoroughly within reason, if the installation is a complete one, from the ground up.

The use of static condensers has shown to disadvantage to a great degree, and equipment of this kind, other than for testing purposes, has not been used. It is, of course, bulky in the amounts required, and it was found that it added, in most cases, additional troubles in the place of those that were eliminated. In hooking up any one-way valve at the generators, it does not make any appreciable difference wherether we do it by shunting across the line, or tapping between the fields.

As a matter of fact, the electronic, one-way valves, employed by the Fox organization, are hooked across the generators, in the form of BALANCE SETS, thereby affording us great smoothness, and giving us an improvement over the conventional hook-up.

As an indication of the quietness that may prevail, by the use of properly designed rejector coils, reactors, or chokes, the taking of one picture uses the following equipment:

51 SUN ARCS, 8 of which are 36-inch LAMPS ENTIRELY OPEN IN THE FRONT; NO GLASS OF ANY KIND BEING USED. The balance of the SUN ARCS being 24-inch LAMPS, also BURNING WITHOUT ANY DIFFUSERS IN FRONT OF THEM OF ANY CLEAR GLASS.

56 90 AMPERE ROTARIES.

69 BROADSIDES

72 SCOOPS.

Perfect silence prevailed on this set, so far as the use of arc lights was concerned, and the extra effort on the part of the Fox engineers, during this much discussed question of arc lights against incandescent lights, has proved well worth any additional effort shown by the employees of this department.

The introduction of COLOR PHOTOGRAPHY has further aggravated the need for additional light; the sets have become larger; while the comfort of those engaged in picture making is always in mind. Not one scene has ever been held up on the new Movietone stages on account of intense heat, and it is very noticeable on those sets using incandescent lamps. The air conditioning system has very ably handled any additional heat, created by the increase in the number of arc lights that are necessary for COLOR PHOTOGRAPHY.

The sum and substance of our trying period resolves itself simply into this: We have splendid photography, and we still continue to use the original investment that was made, on arc light equipment.

SEIZURE LIFTED

G. C. Pratt, vice-president and general counsel of the Western Electric Company, has been advised by cable from the company's London office, that the Upper Court of Budapest, Hungary, has lifted the seizure on the Royal Appolo Theatre, in which a Western Electric sound system had been installed, and ordered the return of the bond which had been put up.

SQUARE DEAL FOR THE ARCS
December 14, 1929.

An open letter to Mr. Harry Carr, Los Angeles Times.

May blessings be upon Cadmus, the Phoenician, or who ever it was that invented books because by doing so they have saved us from having to depend on the columns of the daily papers for our education and enlightenment.

In your "Lancer" column of the Los Angeles Times, dated December 13th, 1929, you speak of a recent fire in a picture studio in New York City. The quotation in full, for the benefit of those who do not read your column is as follows:

Criminal!

The fire in the Pathe Studio in New York was nothing short of criminal. With the exception of the Paramount Studio at Long Island, all the New York studios are a lot of infernal old barns—fire traps.

The fact that they were using Sun Arc lights with carbons shows that their equipment was out of date, archaic and dangerous. All talking pictures in Hollywood are made in ground floor concrete buildings, and with lights not intended for the use of suicide clubs.

Since when, Mr. Carr, have Sun Arcs which burn carbons (as all arc lights must do) been out of date, archaic and dangerous? It is plain to see that your education along these lines has been sadly neglected because the demand today for Arc lamps to be used in talking pictures in Hollywood and in fact all over the world, as our records will show, are greater than they have ever been in the history of our organization.

I am not questioning the first paragraph of your article, but I am certainly taking exception to the last one, in justice, not only to myself and the organization I represent, but to the electrical engineers in the motion picture industry who have made wonderful strides in developments, not only since the advent of talking pictures, but since motion pictures were first made. On this point, I can speak with authority this being my twenty-first year as an illuminating engineer in the motion picture industry. Not only that, my business brings me in daily contact with chief engineers in all studios in Hollywood and I do know the problems they are confronted with and what they are doing to solve them.

In another section of this magazine you will read an article by Mr. W. J. Quinlan, chief electrical engineer of the Wm. Fox enterprises and you can readily see that Sun Arcs using carbons are not out of date, archaic and dangerous. I might also add that the only fire that happened in one of our largest studios in the past year was caused by a light that did not use carbons and as you say, not intended for the use of "suicide clubs."

For further information on the use of Arc lamps for talking pictures, I suggest that you contact the Academy of Motion Picture Arts and Sciences.

We electrical engineers of the motion picture industry always welcome criticism when it is of a constructive nature, but, when it become destructive, then criticism be damned.

I hope you can see your way clear to make some amends for the injustice you

AN UNBRIDGED DICTIONARY OF GOLF TERMS, REVISED

(Unbehooven, Unexpurgated and Undefiled)

Green: The mental condition of a beginner of golf.

Course: "Off Course" seems to be the better form.

Fairway: A myth.

Dog-Leg: Why bring that up?

Marker: Indicates the size a golf ball should be.

Divot: A deep strata of the earth's crust out of control.

Stymie: An intercepted pass.

Driver: No, Geraldine; it's not a wooden-headed chauffeur.

Brassie: An egotistical driver.

Spoon: A brassie gone wrong. (Not complimentary to necking.)

Mid-Iron: A device for severing golf balls into several parts.

Mashie: The feminine of masher.

Niblick: Scotch for shovel.

Putter: A misnomer—you cannot.

Cup: That which cheers—or runneth over, by the ball.

Trap: The Devil's own.

Barranca: A concavity in juxtaposition to a convexity, the whole being synonymous with perplexity when in interposition with par.

Bunker: The bunk. If "a" be substitued for "u," it becomes "banker."

Out-of-Bounds: Nearly always.

Slice: It's a gift.

Hook: A slice in reverse. Something sought by a poor fish . . . that slices.

Top: About 110, thank you.

Explode: A phenomenon peculiar to beginners and evidenced only in the absence of the opposite sex.

Par: The theme of "Paradise Regained."

Handicap: To tease or torment under the guise of satisfying.

Four-some: A "two-some" squared. Sometimes spelled "fearsome," as in golf.

Balls: Plural of "ball."

Birdie: Nearly extinct species of a most elusive hybrid — an eagle whose "par" was led astray by one . . . who didn't care.

Eagle: A cross between a "birdie" and a "hole-in-one."

Score: The summation of divots, dubs, and damns, which, if added together, give a quantity such that the addition of "eagles" and "holes-in-one" does not change its value . . . it remains constant. Solve for "x."

Cost: If we had only known! ! ! !

Hazard: For a man,—WOMAN. For a woman,—the other woman. For a GOLFER,— his version of his first "Hole-in-One;" also his score.

To Improve Your Lie: Think up a better one.

CAN YOU.

Noah Websterally submitted,

VIRGIL E. MILLER.

have done to the electrical engineers of our industry in the last half of your article that is in discussion.

Thank you,
JOSEPH P. O'DONNELL.

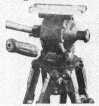

BORN IN JANUARY

This classy outfit began life even with
the calendar. In their ranks they boast
the crack golfer of the Local as well as
forty of the champion good resolution
makers of the world (count 'em). Their
birthstone is the famous Blarney Stone of
Ireland and their colors are wild crab-
apple and slippery elm. People born in
January sooner or later find themselves
in the motion picture business, usually in
the photographic department. Usually
they exhibit a strong tendency toward
flying and could pilot an airplane if they
had one to pilot and knew how to pilot
it. Read 'em:

Jack Anderson, Jerome Ash, Bert Bald-
ridge, Otto Benninger, Paul Cable, Ed-
ward Cohen, Rex Curtis, William Dodds,
Joe Dorris, Rolla T. Flora, Elmer Fryer,
Henry Gerrard, Marcel Grand, Gordon
Head, Roy Ivey, H. J. Kirkpatrick, Henry
Kohler, Stanley Little, William P. Mc-
Pherson, Robert Mack, William Mar-
gulies, Oliver Marsh, John Mescall, E.
Roy Musgrave, Alex Philli--, William
Reinhold, Irving Ries, Josiah Roberts,
Albert Scheving, Nealson Smith, Amos
Stillman, Edward Tanner, Ellis Thack-
ery, Richard Wade, Lloyd Ward, Joe
Walters, Jr., Harold Wenstrom, Carl
Wester, William Williams and Jack R.
Young.

ESTABROOK HEADS EFFICIENT
CAMERA DEPARTMENT

Ed. T. Estabrook, chief cameraman for
Technicolor, has devised a routing sys-
tem for his color cameras and camera-
men, similar to the staff operations of
a daily newspaper. Estabrook's desk is
completely covered by a chart showing
at a glance where every man and camera
can be found at any hour of the day,
every day in the week. Advance book-
ings are also cared for, so that camera
crews may be assigned many days in ad-
vance to cover, with the least waste in
man power or equipment overhead, the
unprecedented demand for Technicolor
pictures.

With more than a score of men and
cameras in the field, waste of time and
equipment becomes a vital factor of loss
if crews are not properly scheduled in
advance of actual working dates. Sche-
dules are made more complicated by the
fact that a camera crew may work on
one production anywhere from two days
to nine or ten weeks.

Estabrook's chart system has adapted
itself to these contingencies in such a
satisfactory manner during the past few
months that his department has without
doubt become paramount in efficiency
among the camera staffs on the Pacific
Coast.

TO WHOM IT MAY CONCERN

Fearless Camera Company hereby an-
nounces that Len H. Roos is no longer
associated with Fearless Camera Com-
pany in any capacity.

FEARLESS CAMERA CO

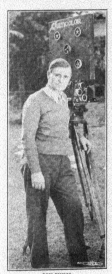

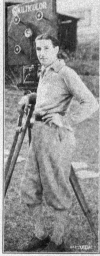

Cream o' th' Stills

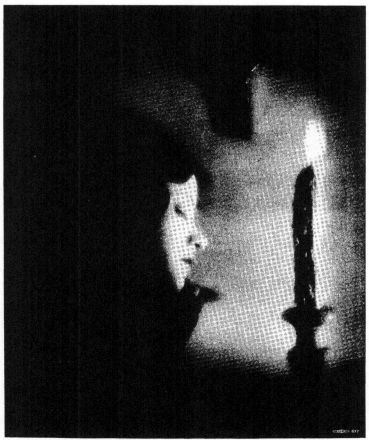

This art study by Frank Tanner is representative of his excellent technique. Mr. Tanner is one of the pioneers of good photography in the studios. He is a painstaking artist.

Cream o' th' Stills

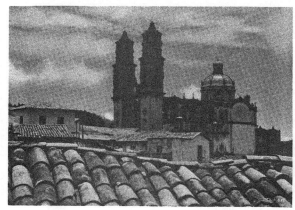

Robert A. Turnbull is responsible for this shot of the old Mexican church at Xochitil. It was built by La Borde in 1522 and is a masterpiece of architcceture. Mr. Turnbull was in the mood for beauty when he trained his camera on this grand old pile.

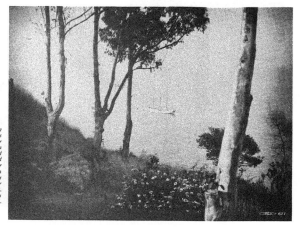

Here is a charming view of Zane Grey's three masted schooner lying at anchor in a sequestered roadstead of the sleepy old Pacific. As a picker of vantage points from which to train his camera, Mr. Elmer G. Dyer is an expert. Note the wild flowers in the foreground.

Cream o' th' Stills

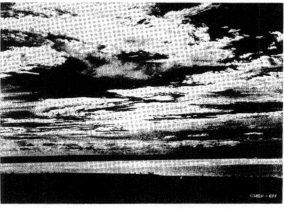

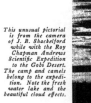

This unusual pictorial is from the camera of J. B. Shackelford while with the Roy Chapman Andrews Scientific Expedition to the Gobi Desert. The camp and camels belong to the expedition. Note the fresh water lake and the beautiful cloud effects.

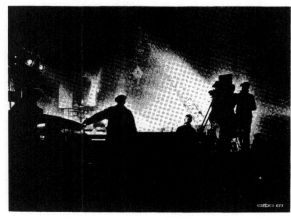

James Manatt recorded this night time silhouette while on location. Mr. Manatt is a specialist at such composition. He loves to write with bold strokes.

Cream o' th' Stills

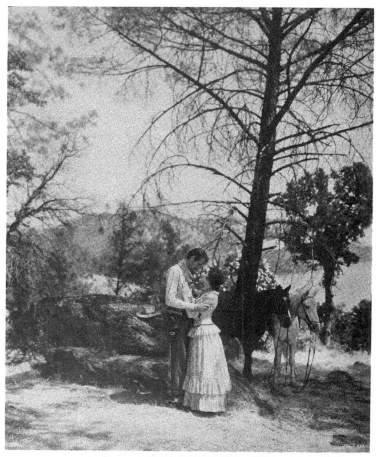

While making stills for the Paramount Famous Lasky production, "The Virginian", John S. Landrigan intrigued the featured players into the charming pose in a bosky nook exactly suited to the mood of the scene. They are Gary Cooper and Mary Brian.

The *Mitchell* Adapted to *Multicolor*

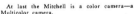

turn would cause scratches on the film when put under pressure in order to secure contact between the two negatives as used in Multicolor. Every type of pressure plate in existence was used before the experimentators contrived their own method to overcome this hurdle.

For several weeks the Mitchell as adapted to Multicolor by Fisher and Williams has been operated with success and the process is now available for use by cameramen.

The Bell & Howell camera, it may here be stated for the information of those who do not know, has been used successfully by Multicolor for a long time as its mechanism was peculiarly adapted to the Multicolor process. This work of adapting the Bell & Howell was done by and under the direct supervision of Technical Advisor Crespinell.

Multicolor has also but recently perfected a new magazine, the fourth in their line of evolution. This new magazine will undoubtedly become standard.

At last the Mitchell is a color camera—a Multicolor camera.

After three months of grilling efforts, laboratory experimentation of the most concentrated kind the Mitchell camera has been definitely adapted to the Multicolor process of color photography.

It was a case of "couldn't be done," according to expert opinion, but Ross Fisher and Billy Williams, two of Local 659's smart boys, held a different opinion and to them is very largely due the fact that the Mitchell has been broken to Multicolor.

Working on their own volition but with frequent consultations with W. F. Crespinell, technical advisor for Multicolor, and with George Mitchell and other officials of the Mitchell Camera Company, Messrs. Fisher and Williams found their efforts crowned with success and their judgment vindicated when quite recently they achieved a perfect dupe negative and the elimination of static and scratches.

They are able to say, today, that the period of experimentation with the is past and the Multicolor corporation is able to announce that at slight expense, in comparison with the cost of experimentation and research the Mitchell can be transformed into a color camera. This will be good news to the many owners of Mitchell equipment who are interested in using Multicolor in production.

Contrary to general belief motion picture negative is coated with a soluable solution that comes off in the developer and that is known as M Back—similar to the X Back of time agone. This gave trouble to Messrs. Fisher and Williams in their experimentation . because this M Back coating would pick up on the aperture and pressure plates which in

Afient

Afient is a trade name made up of the initial letters of Associated Film Enterprises, located at 1056 Cahuenga Avenue, Hollywood.

General Manager R. (Bud) Hooper, of this up-and-coming organization, is a member of the Board of Executives of 659, and was the organizer of the Commercial Raw Stock Company, predecessor of Afient.

From the start this enterprising firm was successful and it grew so rapidly that it was recently necessary to remove to larger quarters and these the organization found at 1056 Cahuenga Avenue, formerly the location of another successful firm, Smith & Aller, Dupont distributors.

This plant was enlarged and remodeled into an up-to-the-minute complete sound equipped laboratory with Frank Biggy in charge, one of the best laboratory technicians in the business.

Associated Film Enterprises has many activities, among them, briefly being: Negative Developing; 35 mm. and 16 mm. Printing; Sound Track; Var-Area; Var-Density; Agents for DeVry Sound Equipment and Products; Cameras, Projection Machines, Complete Equipment for the Amateur and the Professional, Sound, Silent; Cameramen with latest photographic equipment available at all times; Producers of Industrial, Educational and Commercial Motion Pictures; Commercial Raw Stock; Tested Eastman and Dupont Panchromatic Negative; 100, 200, 400 Foot Rolls two and one-half cents per foot.

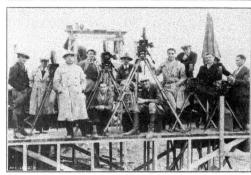

Gaetano (Tony) Gaudio and his camera staff on the new sound sequences of "Hells Angels." Left to right—Roy Babits, Pliny Goodfriend, Tony Gaudio, Jockey Findel, Don Brigham, Harry Perry, Rod Tolmie, Lester Shorr, Fred Eldridge, Joe Dorris, Sam Landers.

CLYDE DE VINNA RETURNS

Brother Clyde De Vinna has returned from Africa where he went several months ago with the M-G-M safari to film "Trader Horn." Clyde "got it in the box" all right in spite of heat and danger and inconvenience of almost every brand. Later, when he gets his Hollywood clothes on again he may tell his story in The International Photographer.

One incident of general interest connected with Clyde's sojourn in the Dark Continent was his stunt of getting in touch by radio with the Byrd expedition in the Antarctic. This remarkable stunt was originated and engineered by Mr. De Vinna although he was ignored in the publicity attending it. The facts are these: A distinguished visitor from the United States showed up at camp there on the "Trader Horn" location and Mr. De Vinna found out that he had a son with Byrd. As a pleasant surprise De Vinna, having a powerful radio equipment, made a hook up with the Byrd camp through a station at Hartford, Connecticut, and in less than two days had a radiogram for the visitor direct from his son in Little America. Some stunt, Clyde—Africa to Hartford to Byrd to Hartford to Clyde. That's the way Local 659 boys do things.

CHESS PLAYERS N. B.

Some of the chess players of Local 659 are eager to get the names of all the chess bugs in the Local who have any time to devote to the game. The big idea is to organize a club and get ready for a tournament. The magazine will offer prizes in the way of I. A. T. S. E. rings and buttons and a championship silver cup will also be put up. Send your names in to the Editor at once so that a start may be made shortly after the new year.

Harry Vallejo, who is a chess fiend, says he has a Mexican friend who is willing to take on seven or eight players at one sitting. Let's go.

A Trip

I N the general revolution which has taken place in the moving picture industry in the last few years not the least of the changes has been the quest for greater verisimilitude in the filming of stories existing in other lands than ours; greater exactitude in portraying the life customs, scenery and so forth of the countries foreign to Hollywood.

A very few years ago producers hesitated to send—except for purely educational films, a company very far from the source of supplies as well as from the eagle eye of home supervision, but nowadays perfectly functioning units, complete even to laboratories and projection and, oh yes, by all means sound equipment, are sent to the uttermost parts of earth, to stay and live and, perhaps, to work for months at a time. Only recently a company has returned from nine months in the heart of the big game country of Africa.

The public pulse, jaded, perhaps, with the constantly reiterated sex stories, nights of love, Three Weeks, Three Hours, Three Minutes—gives a quick thrill when shown pictures from under the sea, the Orient, the Holy Land, any countries beyond our own. There is a natural enthusiasm in visiting on the silver screen countries which we may never see in all reality; and the further the scenes are from our own humdrum daily life, the greater the pleasure.

The story having been decided upon and its locale studied, the technical and art directors begin their labors and the demand for photographs commences. Libraries are searched for photographs of the country, of the people, of nature, dress, etc., etc., to the last detail; many times, however the existing supply of data falls far short of being sufficient to properly invest a film production. It is then necessary to choose a man, saturate him with the scenario details, equip him photographically and send him forth to the country itself to gather material.

Get pictures, are the orders. Get hundreds of pictures. Of the country, the hills, the valleys, the natives in

Here Mr. Martin captures on his silver plate a sweet bit of the South Seas.

their huts, the mode of dress, the methods of living. Cover every angle of the life of the country—and then come home, with no expense account to speak of!

Then the still cameraman comes most beautifully into his own. It is his opportunity — if he has anything between his ears besides his hat to s h o w his fundamental education in photography, his keenness in the interpretation of the script, his ability to get in pictorial form all vital and necessary facts—in short to prove his worth to his company.

The rug maker of Bagdad is a picturesque subject not to be overlooked by the snap shot man.

Among the great number of photographs he has taken, mostly from production and purely technical angles— there will be perhaps a dozen *pictures,* beautiful enough to treasure as the children of his brain; to give to friends that they may share the joy of his trip with him.

It was the writer's good fortune, not long ago, so to be chosen; to fare forth and take pictures, not for any one production, but of peoples and countries; of life as it is lived, in the high places and the low places, wherever cameras and film could be carried.

Naturally it is impossible to touch more than the merest highlights of such a journey or to present more than half a dozen photographs culled from the hundreds of films exposed; however a short description of these few may prove not uninteresting.

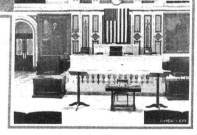

The National House of Representatives, difficult to photograph.

By *Shirley Vance Martin*

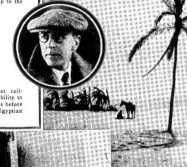

To be properly prepared for a journey round the world, letters and passports were a vital part of the equipment, so a trip to the National Capital was arranged. Naturally, while at Washington, the camera was unlimbered and pictures taken. The Monument, the Lincoln Memorial, the Library of Congress—perhaps the most beautiful interior in our country—the Capital, all fell victims to an insatiable craving for photographs.

The one picture of Washington I prize most highly is one of the interior of the House of Representatives chamber, for it is positively prohibited to take pictures inside the Capital and it was by dint of diplomacy that I was allowed one day at the noon recess to set up and grab a view of Mr. Longworth's favorite resting place.

Cairo! Cairo the very gateway to all ancient and mysterious Egypt. The northern terminus of that great railway which splits the continent of Africa, rendering accessibility to big game hunters and moving picture companies. Vast areas before most difficult to penetrate. One thinks of Cairo as just an Egyptian town, but upon arrival finds a cosmopolitan city; the air of the famous Shepheard's Hotel is quite that of London or Paris. The men strictly in evening clothes after six, the women in the smartest of French fashions. There are several large and modern hotels as well, while the Street of Jewels displays as many hundreds of thousands of dollars in diamonds, rubies and pearls as the Rue de la Paix.

A corner's turn from the hotel beggars swarm—beggars and dogs, beggars and dogs and flies. In one of the shadowy arches was a blind beggar in veriest tatters, holding forth a shell and mumbling something which might well have been: 'Alms for the love of Allah, alms," caught my eye; and my camera caught him.

From Cairo up the Nile toward Luxor, the Valley of the Tombs of the Kings, Khartoum. The desert at certain hours of the day held pictures most beautiful to the eye and most

The Sahara Desert with its age-long lure attracts the picture hunter.

difficult to transfer to film. A couple of wandering Bedouins and a single camel resting at sunset on the rippling sands made a perfect silhouette, while a caravan seeking shelter from the fierce noon-day heat in the shade of tall palms of an oasis made a picture hardly to be forgotten. The huge stone images at Karnak, the Pyramids at Gizeh, the Sphynx all held us spellbound, but must be passed over. The Egyptian Governmental Museum holds the golden glories that were King Tut-ank-amen's, the most magnificent collection of treasures ever unearthed from the tombs of the Pharoahs, but these might not be photographed.

From Egypt across the Suez at El Kantara, up through the Holy Land—Jerusalem, Damascus, on to Bagdad, in Mesopotamia, the home of the Caliph Haroun-al-Raschid —the setting for the adventures of the Arabian Nights. Before the World War the dream of the Germain Kaiser was a road from Berlin to Bagdad with a covetous eye on all of India, the scene of General Allenby's great campaign.

To Bagdad have come from the far provinces of Arabia and Persia caravans loaded with silks and rugs and here I pictured an old Arab rug weaver at work as had been his forbears for centuries.

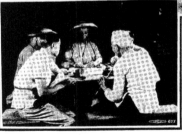

A bit of old China.

Cairo hath an irresistable enchantment for the artist soul.

(Concluded on Page 28)

Shackelford's Portable Developing Outfit

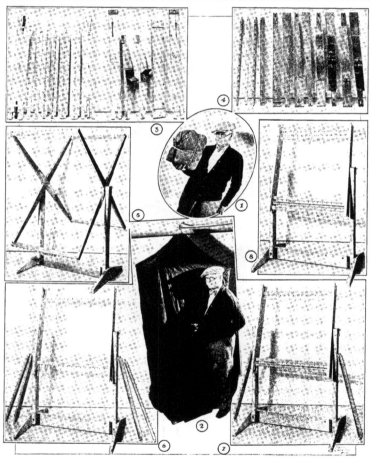

Those cameramen preparing to depart on long journeys for locations in remote parts of the world will be interested in the experience of 659's distinguished globe-trotter, Mr. J. B. Shackelford, who has become internationally known through his trips to the Gobi desert of Central Asia with the Roy Chapman Andrews' Scientific Expedition. "Shack," as he is affectionately called by those who know him best, is a photographic scientist if there ever was one

and his portable dark room and drying drum, contrived and used by him in Asia, will be of immense help to those cameramen who go far afield but who have had no experience along these lines.

Describing these conveniences to **The International Photographer** the other day Brother Shackelford said:

"I have used this system for field developing since 1922 and found it so far superior to the regular deep tank system that I discarded the deep tanks (with a capacity of 25 gallons for single rack tanks) in my Peking laboratory and installed this multiple rack layout. These portable racks fit into a tank 33 inches deep, 26 inches long and 4 inches wide with a capacity of 15 gallons. My tanks were of copper and wood (two copper nesting in the wood) with angle iron braces, and carried in the tanks.

"The dark room, which I used for loading and developing stills and tests, along with three developing (200 foot each) racks, two drying drums (200 foot each) and the winding stand went into a small steamer trunk with room to spare.

"The drums were strung on a wire when drying films and were kept revolving by a native boy."

1—*Portable dark room ready to pack.*
2—*Portable dark room set up ready to use, size 4 ft. x 4 ft. with 7 ft. clearance inside—contains window with colored window—shelf 12 inches x 4 ft., and fully ventilated.*

3—*Drying drum (capacity 200 ft.) knocked down.*
4—*Drying drum set up on winding stand ready for winding.*
5—*(a) Developing rack (capacity 200 ft.) and (b) winding stand knocked down.*
6—*Developing rack with single bars— capacity 50 ft.*
7—*Developing rack with double bars— capaacity 115 ft.*
8—*Developing rack with triple bars— capacity 200 ft.*

Introducing Brother Merl La Voy, news-cameraman, who accompanied President Hoover to South America. Look out for a story from Merl.

Mrs. Otto Himm and myself wish all the boys of the International Photographers, I. A. T. S. E., a Merry Christmas.

PATRONS ARE REQUESTED TO FAVOR THE COMPANY BY CRITICISM AND SUGGESTION CONCERNING ITS SERVICE

CLASS OF SERVICE		SIGNS
This is a full-rate Telegram or Cablegram unless its deferred character is indicated by a suitable sign above or preceding the address.	# WESTERN UNION	DL = Day Letter
		NM = Night Message
		ML = Night Letter
		LCO = Deferred Cable
		NLT = Cable Letter
		WLT = Week-End Letter

NEWCOMB CARLTON, PRESIDENT J. C. WILLEVER, FIRST VICE-PRESIDENT

The filing time as shown in the date line on full-rate telegrams and day letters, and the time of receipt at destination as shown on all messages, is STANDARD TIME.

Received at 6360 HOLLYWOOD BLVD., HOLLYWOOD, CAL., GLADSTONE 4190 DEC 6 AM 11 48

SB88 91DL=OR LOSANGELES CALIF 6 1134A

SILAS EDGAR SNYDER EDITOR=
 INTERNATIONAL PHOTOGRAPHER 1605 NORTH CAHUENGA

 AVE=

DEAR SY HAVE JUST RECEIVED YOUR LETTER ASKING OUR
COOPERATION WITH YOU IN SENDING IMMEDIATELY RUSH COPY
FOR YOUR JANUARY ISSUE STOP HERE IT IS STOP AND SPEAKING
OF COOPERATION I HOPE YOUR MEMBERSHIP WILL ACCEPT OUR
EXPRESSION OF SINCERE APPRECIATION FOR THEIR COOPERATION
WITH US WHICH HAS BROADLY CONTRIBUTED TO THE MOST
PROGRESSIVE YEAR OF ACTUAL ACCOMPLISHMENT WHICH WE HAVE
EVER ENJOYED STOP THEREFORE ON THE PAGE JUST OPPOSITE
THIS WONT YOU PLEASE REPRINT THE FINAL PAGE FROM OUR
 FOUR PAGE ADVERTISEMENT WHICH APPEARED IN YOUR NOVEMBER
ISSUE KINDEST REGARDS=

 E O B.

THE QUICKEST, SUREST AND SAFEST WAY TO SEND MONEY IS BY TELEGRAPH OR CABLE

WESTERN UNION

NEWCOMB CARLTON, PRESIDENT A. C. WILLEVER, FIRST VICE-PRESIDENT

CLASS OF SERVICE	SIGNS
This is a full-rate Telegram or Cablegram unless its deferred character is indicated by a suitable sign above or preceding the address.	DL = Day Letter NM = Night Message NL = Night Letter LCO = Deferred Cable CLT = Cable Letter WLT = Week-End Letter

The filing time as shown in the date line on full-rate telegrams and day letters, and the time of receipt at destination as shown on all messages, is STANDARD TIME.

Received at Main Office, 608-610 South Spring St., Los Angeles, Calif. Always Open

NB420 CABLE=LONDON 29 1929 DEC 29 PM 5 47

NLT EDWARD BLACKBURN=

 6700 SANTA MONICA BLVD LOS ANGELES (CALIF)=

ATLANTA WORLDS FIRST BILINGUAL FILM PHENOMENAL SUCCESS HERE
AND CONTINENT DEMONSTRATES SUPREME QUALITY OF ROCHESTER
STOCK CORDIAL NEW YEARS GRETTINGS=

 CHARLES ROSHER.

WESTERN UNION

NEWCOMB CARLTON, PRESIDENT J. C. WILLEVER, FIRST VICE-PRESIDENT

CLASS OF SERVICE	SIGNS
This is a full-rate Telegram or Cablegram unless its deferred character is indicated by a suitable sign above or preceding the address.	DL = Day Letter NM = Night Message NL = Night Letter LCO = Deferred Cable NLT = Cable Letter WLT = Week-End Letter

The filing time as shown in the date line on full-rate telegrams and day letters, and the time of receipt at destination as shown on all messages, is STANDARD TIME.

Received at

CLT OR4 34= **DEC 30 1929**

CHARLES ROSHER=

 BRITISH INTERNATIONAL=

 ELSTREE LONDON (ENGLAND) =

THANKS CABLE KIND GREETINGS AND VERDICT SUPREME QUALITY
EASTMAN TYPE TWO STOP ALL BIGGEST BEST PICTURES OF YEAR
PHOTOGRAPHICALLY CONFIRM YOUR OPINION HAPPY PROSPEROUS
NEW YEAR=

 BLACKBURN...

THE QUICKEST, SUREST AND SAFEST WAY TO SEND MONEY IS BY TELEGRAPH OR CABLE

Atlasta Slate

—BY—
ARTHUR REEVES, Local 659

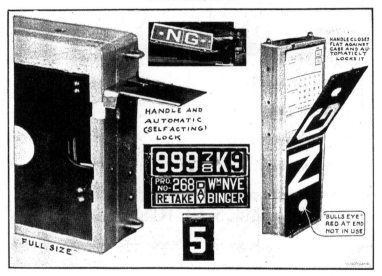

Some time ago Mr. Ted Wharton came into the office of **The International Photographer** with some pictures of his old studio at Ithaca, New York, and at that time he stated that he had an improved slate, so we asked him to bring it in and let us see it. By the way let me introduce Mr. Ted Wharton to you.

He was a director with the Essanay Company in Chicago, and later, in 1915, opened his own studio with his brother and the firm was known as The Whartons of Ithaca, N. Y. In those days they made that famous series that was noted for its trick work "The Mysteries of Myra." Mr. Wharton has been a writer here in Hollywood for a number of years.

The slate, shown in the cut above, was brought into the office and left so that our members could see it. I took it into the recreation room of the Local and the boys there made their comments on it. One assistant exclaimed: "At last a slate," so I thought that would make a good name for it. Here are some of the remarks of the boys that examined it:

Ira Hoke says "that's sure a darb and I think it's hotsie."

Speed Hall admits that it is just what he had been thinking of for years.

Billy Bitzer—"Oh boy it's a beauty—it's wonderful and I am jealous of this slate; it's worth any price."

George Gibson, of Brulatour, the man with those famous focus cards says: "This slate is an excellent idea."

Andre Barlatier, who invented the Filmoscope, says: "The slate is very clever."

Roy Klaffki declares "It's a nice baby."

L. Guy Wilky—"It will save a lot of time on the set."

Max Stengler—"Wish I had had one on that Florida location."

Elmer G. Dyer—"That Wharton slate is the cat's arm pit."

Billy Tuers—"The Atlasta Slate is very efficient—a great proposition."

Alvin Wyckoff—"How soon can I get one?"

Jack Fuqua—"It will make life easier for the assistant."

J. N. Giridlian—"The Atlasta Slate is a peach."

Jack Rose says "it's certainly great."

Take a look at the picture and draw your own conclusion or come up to the office and Editor Si Snyder will be glad to show it to you. For the benefit of those that can not come to the office I will endeavor to describe it briefly.

The slate is about the same size and weight as the slates now in use. The frame is made of cast aluminum and backed with fiber. It is the folding type which makes it strong. The lock at each end acts as a handle when the slate is open so the assistant's hand does not cover any numbers on the slate. The numbers are very quickly changed, which is the great feature of this slate. The numbers are built into the slate and cannot be lost out. Each set of numbers has a protruding gear wheel which controls it. The numbers roll back and forth as on a roller shade with rollers at both ends so that it can be wound up in either direction, therefore, the numbers can be changed in a few seconds. Mr. Wharton has informed us that he will be in a position to deliver some of the slates early in January.

Hoke-um
By IRA

Reminiscent of the War

Overhead this one at lunch time on the Tiffany set where a scene in darkest Africa was in course of production. Two dusky gentlemen in native dress lay prone in the sunshine engaged in idle conversation.

First colored boy: "When I lie down like this for a quiet think, I realize how tempus fugit is creepin' on."

Second colored boy: "I couldn't have told you the foreign name, but ever since I put on this rented costume they're creepin' on me too."

— :: —

Discrimination

Speed Mitchell: "How do you tell port from starboard?"

Bob Wagner: "The safest way is to look for the labels on the bottles."

— :: —

No Hard Feelings

Ben Lyon (after two years' work on a single picture): "Well, I can't find fault with my engagement with "Hell's Angels," Mr. Hughes; because you mentioned when you employed me that the job wouldn't be steady."

— :: —

The Universal Language

Faxon Dean: "I suppose some company will be making talkies in Esperanto before long."

Perry Finnerman: "What is Esperanto?"

Faxon: "It's the universal language."

Perry: "Whereabout is it spoken."

Faxon: "Nowhere."

— :: —

Fair Question

Boy Friend: "I'd love to marry you, but you couldn't live on an assistant cameraman's salary."

Girl Friend: "Oh, I could manage to do that all right, but what would you do?"

— :: —

Cause for Cachinnation

Second Assistant: "That's funny."

First Assistant: "What."

Second Assistant (evasively): "Oh I was just thinking."

First Assistant: "Ha! ha! That is funny."

There's a Difference

Lady from Iowa: "Oh, are you a cinematographer, sir?"

One of the Boys: "No ma'am, I just shoot a camera here."

— :: —

Sound Stuff

Chuck Geissler: "Do you ever read love stories?"

Cutter Girl: "No, but I've listened to a lot of them."

— :: —

There's a Reason

Director (to forlorn extra man): "Why in the devil don't you go back to Italy?"

— :: —

Forlorn Extra Man: "No spika da English."

— :: —

Inflammable

Excited Fireman: "Quick, what caused the fire?"

Bright Lab. Boy: "Both film vaults, sir."

— :: —

Employment Note

Tourist: "What kind of a town is this, anyway?"

Cameraman: "It's a movie town."

Tourist: "And what do the people who don't make movies do?"

Cameraman: "They do the people who do make the movies."

— :: —

Write Your Own Head

Bill: "Joe, is that a picture of your girl?"

Joe: "Yep."

Bill: "Gosh, she must be an heiress."

— :: —

As the Years Pass

Our philosophic assistant remarks that getting the baby to sleep is hardest when she is about eighteen years old.

— :: —

Producers, Too

Some of these millionaire movie directors can thank their lucky stars.

— :: —

Almost Unique

Dev. Jennings: "What makes you say Duke Green's new La Salle is an unusual car?"

Lyman Broening: "Because it's paid for."

Dr. G. Floyd Jackman
DENTIST
Member Local No. 659
706 Hollywood First National Bldg.
Hollywood Blvd. at Highland Ave.
GLadstone 7507 Hours: 9 to 5
And by Appointment

RIES BROS., INC.
PHOTO SUPPLIES

1152 N. Western GRanite 1185

LEWIS W. PHYSIOC
Special Effects Card Shots
Multiple Exposures
TEC-ART STUDIOS
5360 Melrose Ave. Telephone
Los Angeles GRanite 4141

Cash...

For professional Bell & Howell
and DeBrie cameras. Send full
description for cash offer. Or
telegraph Bass Camera Company, 179 West Madison
street, Chicago, Illinois.

For Sale or Rent
2 B & H Cameras, 2.3 Astro Lenses
and Cinemotor Complete

B. B. RAY
401 N. Orange Grove WHitney 4062

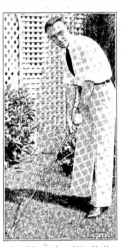

*In training .to beat Eddie Blackburn
in the Second Annual Gold Tournament
of Local 659 in 1930. Wes Smith, of
Smith & Aller, Dupont agents, caught
practicing at home. Take a tip Eddie.*

FOR RENT
Complete Mitohell sound equipment—Cable and Clutch.

Phone HE-6230

John Silver

ROY H. KLAFFKI

Walter J. Van Rossem
Photographic Laboratory and
Camera Rental Service

HOlly 0725 6049 Hollywood Blvd.
Hollywood, California

Ira B. Hoke
now with
Technicolor

M. HALL
Assistant Cameraman

GLadstone 4203 HEmpstead 1128

Richter Photo Service
Movie and Still Cameras
for Rent
Still Finishing
7915 Santa Monica Boulevard
OX. 2092 HP. 1780

James E. Woodbury
Portrait and Commercial
Photographer

GRanite 3333 5356 Melrose Ave.
Los Angeles, Calif.

Mitchell and Bell & Howell Cameras
Sales and Rentals

For Rent—Three Mitchell sound cameras complete, including two 1,000-ft.
magazines with each camera at regular camera rental.
For Sale—Bell & Howell cameras complete and in first class condition.
Prices on application.

J. R. LOCKWOOD

GRanite 3177 · 1108 North Lillian Way Cable Address
Phone Hollywood, California "Lockcamera" Hollywood

A TRIP
(Continued from Page 19)

Then to India. All the film of Eastman and Dupont could not catch and hold a tenth of its beauties. The Taj Mahal, at Agra — that loveliest monument ever erected to a woman was worth all the film I had. Delhi, colorful and vivid.

Far inland palaces of white marble carved as fine as lace, crumbling away, in the clutches of the ever-encroaching

jungle and inhabited only by troops of monkeys.

Australia and beyond. As we approached the Samoan Islands the days took a jump backwards from Thursday to Wednesday. With the possible exception of the Marquesas, among all the islands of the South Seas the Samoans seem to hold the most of beauty and romance. The hills covered with luxuriant tropical growth, filled with mysterious lights and shadows and lovely colors. The native women, when young, lithe and straight and graceful, are worth a picture always.

At Tahiti among the many small boys where the jungle growth comes down to meet the sea and photographs beyond compare in beauty of line and light and shade.

China, too, was a gold mine for photographs. Pictures were everywhere. On account of more than the usual revolutionary rumblings, it was deemed unsafe to venture far into the interior, but Shanghai, Hangchow, Soochow and Nangpo, in the cities, themselves, and, along the canal and river fronts were a never-ending source of supply of picturesque subjects.

At Hangchow hundreds upon hundreds of poverty stricken families are living in squalid boats, never setting foot upon dry land, while at Shanghai the great junks come lazily sailing down the river—most probably manned by dirty pirates ready for any deviltry. Along the water front many gambling dens, with fan-tan the favorite game. It was with much trepidation I pictured one quiet game in one of these evil smelling dives.

From China north and east beyond the Pribiloffs and Aleutians to Alaska. What a thrill to go up into the real gold country—cold and forbidding though it seems always to be. In Tawana Creek—pictured in last month's International Photographer—one could, by carefully lifting a rock from the land at the water's edge, get tiny nuggets and color almost anywhere.

And so back to Hollywood with enough material to stock a studio library and enough memories to last a life time, had I but taken the trip, for I have never been out of these United States and all these photographs were taken within a hundred or two miles of Los Angeles—"around the world in Hollywood."

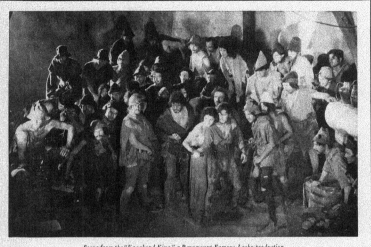

Scene from the "Vagabond King," a Paramount-Famous-Lasky production

Micks and Mikes

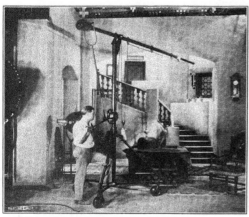

Behold the "Mike Boom" as produced for the trade by Mole-Richardson, Inc. Note the cleverness of construction and the ease and simplicity of operation.

It certainly looks as though the Irish had invaded Hollywood.

In every studio the number of "Mikes" has been growing all out of proportion to the number of Cinematographers, Sound Engineers, Mixer Men, and even Cameramen's Assistants. With things in this condition something has had to be done, for when the Irish predominate there is bound to be plenty of trouble.

This problem was brought up to the diplomatic department of the Mole-Richardson, Incorporated, and they are producing a means to stop this new invasion of the Irish. St. Patrick is reputed to have chased the snakes out of the Emerald Isle with a shillalah. The boys on Sycamore Avenue taking that cue, have brought in another 'mick' to assist in the elimination of these obstreperous "Mikes." With a good Irish given name, and a surname that sounds as though related to a California real estate promoter; in infancy this "mick" was christened by the industry as "Mike Boom."

All kidding aside, there have been a number of microphone booms ingeniously contrived, but generally hastily constructed in the prop shops of the studios. It was some booms of this type that prompted Douglas Shearer, chief sound engineer at the M-G-M Studios, to seriously have his department undertake the problem of developing a Mike Boom, which would be a satisfactory operating device.

Lou Kolb, who heads up the production problems of the sound department in that studio, was assigned to the problem, and from his design there was produced an all metal microphone boom, with the essential moving parts operating in ball bearings, and so constructed that the microphone could be raised and lowered, moved from side to side, or traveled from front to back, with all mechanical sounds so reduced that they would not interfere with the recording.

The use of a plurality of microphones inherently carries with it considerable complication and entails very clever manipulation of the mixing panel if satisfactory quality of recording is secured. With the boom above mentioned, the action in the set can be followed by carrying the microphone just out of the camera angle, yet in close proximity to the actors.

One of these booms was built in the shops at M-G-M Studios and proved so satisfactory that an order was placed with the Mole-Richardson, Inc., to build several more of the same type to meet the needs of their sound department. While these were being constructed a number of improvements were suggested and incorporated in the design. The use of these microphone booms made it possible to obtain such excellent recording that demands arose from other producing organizations for similar equipment, and Mr. Mole requested of the M-G-M Studios the privilege of building a microphone boom similar in design to theirs. The management of that studio took the generous attitude, and allowed Mole-Richardson to manufacture a similar apparatus which the above concern has now been producing for several months.

Booms of this type are in use at R. K. O., Columbia and Universal studios.

With this equipment it is practicable to control the placement of a microphone within a radius of eighteen and one-half feet, and to raise and lower that instrument from the floor to a height of over twenty-two feet. In addition to the advantages gained by using a single microphone a considerable economic saving can be made due to the facility with which the microphone can be shifted during the course of production. With sound production often carrying an operating cost of $20.00 per minute, even the slight delays necessarily entailed become costly, and a device which will minimize such delays is a good investment.

The Irish have always been an irrepressible race, but it does seem now that we are gaining better control over these "Mikes" who have brought so much grief to all concerned with the sound end of the motion picture business.

YOUNG EAGLES

Elmer G. Dyer, aerial Akeley expert, has been retained by Paramount to shoot the aerial Akeley sequences on "Young Eagles," the big air special of that organization. Ralph Stout is chief cameraman on this production.

Cream o' th' Stills

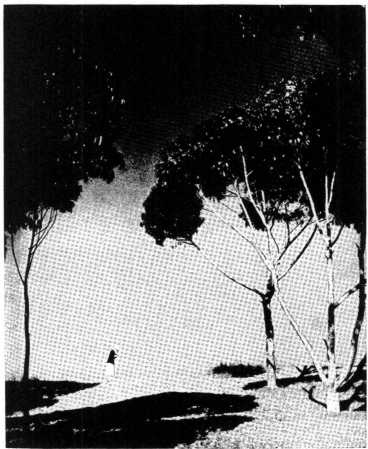

The Spirit of California is in the enchanting study of the young eucalypti here shown from the facile camera of Karl Struss. The girl is not Mary Pickford though she might well be. Mr. Struss is a versatile pictorialist, but he is in his element in a study like this.

Cream o' th' Stills

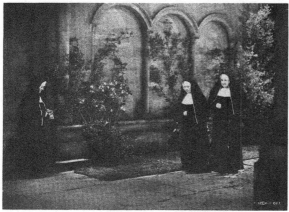

Young Oliver Sigurdson, native of Iceland, is to be commended for this delightfully artistic composition. His sense of values is unfailing and that he thoroughly knows his photographic oats is undisputed.

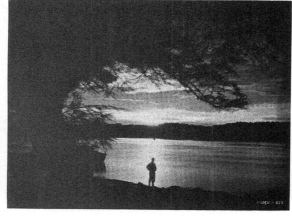

Bob Roberts contributed this African picture to our collection of masterpieces for this month. He entitled it "Sunset on the Nile". The spot is on the Victoria Nile below Murchison Falls.

 # Cream o' th' Stills

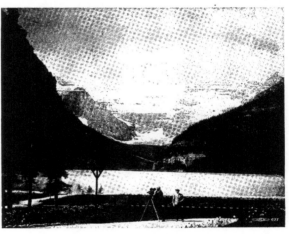

Harry Zech shot this intriguing picture of Lake Louise when she wasn't looking. That is Mr. Zech standing to the right of the camera which is manned by Marvin Spoor. Now just how do you suppose Harry shot this picture with himself in it?

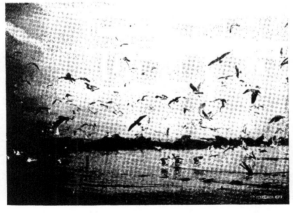

After getting the gulls all excited by filling the circumambient with many bags of popcorn, Frederic Colburn Clarke cold bloodedly shot them with the accompanying results. Mr. Clarke is one of the best bird hunters in America with a camera.

Cream o' th' Stills

"The Sheik" is the title of this fine bit of portraiture by Elmer Fryer, chief still artist with First National. Mr. Fryer is particularly happy at this class of camera craft.

"The Choice of the Profession"

STILL BY GASTON LONGET

The Ensemble

— IN —

"Hit the Deck"

ROBERT KURRLE. *Cameraman* HARRY PRIENGLE, *Make-up Artist*

R-K-O PRODUCTION

If the Film Keeps Getting Wider

In Memoriam

ONCE MORE do the asphodels bloom along the pathway of Local 659.

This time it is our Brother A. LeRoy Greiner who has "joined the innumerable caravan which moves to that mysterious realm where each shall take his chamber in the silent halls of death"—leaving behind to mourn his untimely departure a devoted wife and a host of friends.

It is not difficult for the scribe to indite the obituary of this brother, for every memory of him is one of cheerfulness and joy.

LeRoy Greiner was one of those rare souls who was never without the ready, friendly smile in spite of the clouds of adversity and ill health that beset his pathway and even in his last days, when the angel of death had already laid a hand upon his shoulder he planned hopefully for the future, and spoke of happier days to come.

BROTHER A. LEROY GREINER, Local 659

It is a pleasure to recall this courageous soul who would not be cast down in spite of the evidence of the approach of death in his broken body and there is no gloom in the memory of him among those of his loved ones and friends who saw him fight the battle without complaint and lose it like the cheerful warrior he was.

LeRoy was only thirty-five but in that brief space he had packed the experience of a useful life and had reached an enviable place in his profession. To his beloved wife and relatives the International Photographers, Local 659, extend heartfelt sympathy and enduring regard, and every heart in its silent meditations sends to our departed brother a "bon voyage," having faith that LeRoy has but preceded us a little along the pathway of the life eternal.

The asphodel, flower of death, if we but know it, is as sweet as the amaranth, flower of life.

The New Fearless Silent Camera

——BY——

ARTHUR REEVES, Local 659

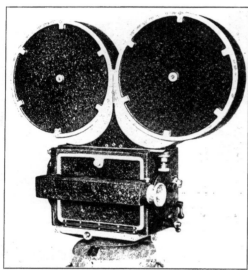

Ralph G. Fear, head of the Fearless Camera Company, formerly the Cinema Equipment Co. of Hollywood, an engineer well and favorably known in the film industry brings to a culmination years of study and endeavor in the presentation of the New Fearless Silent Camera. Perhaps as well qualified as any engineer in the producing end of the picture industry, Mr. Fear has put into the New Fearless Silent Camera the accumulated scientific and practical knowledge gained through ten years of intimate association with the engineering phases of motion pictures.

"Most of the professional motion picture cameras in common use today," says Mr. Fear, "were designed a dozen or more years ago. As a matter of fact there isn't a professional motion picture camera now in common use in the studios that was not designed prior to 1920. These cameras were not designed for silence, hence they all develop so much noise that with the advent of talking pictuers it become necessary to provide some sort of sound proofing for the cameras in order that they might be used on

CHANGE OF NAME

Ralph G. Fear, head of Cinema Equipment Co., announces that on January 1, 1930, the firm name will be changed to Fearless Camera Company. "The change of name," says Mr. Fear, "does not denote a change in ownership or of policy. We are doing business at the old stand, and with the advent of the New Fearless Silent Camera, we expect to do it in a bigger, better way.

sound productions. This has resulted in a multitudinous array of booths, blimps, bungalows, blankets, etc., in a vain effort to keep the camera noises within an enclosure so that they will not affect sound recording. But even with these cumbersome devices, and the attendant discomfort and trouble experienced with their use, the noise still continues with sufficient volume to cause great trouble in recording.

"In addition the cameras present a bewildering appearance with their array of accessories that have become necessary with the advent of sound pictures.

"Some of the older camera manufacturers have tried with only partial success, to silence their cameras. They have replaced the conventional ball bearings, which were of the old bicycle type and very noisy, with plain bearings. Metallic gears have been replaced with Bakelite. Movements have been quieted to some extent. And one manufacturer covers his camera with sponge rubber. None of these expedients has been entirely successful and we still find the cameras in booths, or the so-called blimps and bungalows."

Continuing, Mr. Fear says: "I approached the problem of noisy cameras from a different angle than that followed by other engineers. I contended that the scientific way to eliminate camera noise was at its source and with this thought in view invented and developed a silent camera movement which it is possible to run at high speed without noise. This movement was first placed on the market in July, 1928. It then became necessary to eliminate the balance of the noise in the cameras, and after six months of intensive effort in re-designing and re-building, was successful in eliminating practically all the noise in the old cameras. Dozens of these re-built cameras are in use today, and no booth or sound-proofing is necessary with their use."

During the entire time that he was re-designing and re-building these old cameras, Mr. Fear was perfecting a new camera designed for the present day conditions.

"A modern motion picture camera," continues Mr. Fear, "should be so silent in operation that it can be used within ten feet of the microphones while photographing sound pictures. Provision should be made within the camera for recording sound on the same film and at the same time that the image is being photographed. It should be extremely easy to focus, retain all of the features in common use before the advent of sound, and in addition should contain all of the modern accessories that have become necessary attachments with the permanent establishment of talking pictures. It should fill the every need of modern motion picture photography. Such is the 1930 Model Fearless Silent Camera.

"In addition to being so silent in its operation that the microphones may be placed within ten feet of the camera without picking up unwanted noises, the Fearless Silent Camera embodies many new and desirable features. However, it should be stated at this juncture that the Fearless Silent Camera does not contain any radical or untried features. To the contrary, everything that goes into its construction is based on sound engineering principles.

"The Fearless Silent Camera is equipped with the Fearless Simplex High-speed movement of which there are nearly half a hundred in use, several having been installed in Europe. This is the simplest camera movement in the world to thread and due to precision workmanship and accuracy of design is so silent while in motion that only by placing the ear against the frame of the movement can any sound be detected.

"One of the outstanding factors that contribute to the almost uncanny silence of the Fearless Silent Camera," says Mr. Fear, "is the full force oiling system that pumps oil under pressure to every bearing point. This system of positive oiling is employed in all high grade automobiles, but this is the first time it has ever been applied to a motion picture camera. The few gears that are used in the Fearless Silent Camera are designed for silent operation and wherever ball bearings are necessary the finest of imported instrument bearings are used.

"One of the noteworthy features of the Fearless Silent Camera is the method of shifting for focusing and returning to shooting position. Instead of shifting the entire camera head, the lenses and their mounts are shifted by the simple process of turning a lever conveniently located at the rear of the camera. This requires merely the effort exerted in turning a small lever with thumb and forefinger. The lenses are in micrometer mountings that are mechanical precision itself and will delight every cameraman. The turret has been so designed that all the lenses, together with their mounts, may be removed in less than one minute. A simple follow focusing device can also be supplied.

"At the side of the camera are located four separate driving shafts. These are designed for the plug-in type of motor. One drive shaft is for 60 cycle current, one for 50 cycle, a third shaft is for high-speed work and drives the camera through a built-in three-speed transmission. The fourth is for hand cranking at normal speed. At the rear of the camera is a fifth drive shaft for stop motion work. A footage speedometer with a large window and generous size figures is provided. This footage speedometer may be removed from the camera at will. It will be apparent that this method of providing for the different cycle currents is of tremendous value, not only obviating the need for different motors, but is an additional assurance of quiet motor operation because the reduction gears are in the camera operating in oil rather than in the end-bell of the motor.

"The dissolve is controlled from the rear of the camera. A convenient lever controls the mechanical dissolve which operates through a gearset that provides for three different speed changes. A dial indicator calibrated to show percentage of shutter opening is provided.

"Built into, and a part of the camera is the Fearless Automatic Film Tension control which has proven its worth in over a year of use. This prevents film buckles by varying the tension on the take-up belt. Another feature is the Electric Circuit Breaker which instantly stops the motor in the event of a film break or at the end of the reel. It is also an added safety factor, for if the film should buckle by reason of breakage of take-up

HANDSOME HARRY HALLENBERGER

Honor to Handsome Harry Hallenberger, Technicolor expert, pictorialist, portrait artist and general go-getter.

This Hallenberger boy has won a permanent home in the hearts of Local 659 and **The International Photographer** by his extraordinary enthusiasm for our magazine as demonstrated by his voluntary campaign to secure cash subscribers.

Handsome Harry just simply feels that **The International Photographer** should be owned by everybody associated with the production side of motion pictures and he told Ira Hoke the other day that he didn't intend to let up until the technicians were subscribers 100 per cent.

In three or four days during the few hours of leisure at his command Harry wrote up nearly half a century of new ones.

belt or for any other cause, the circuit breaker will instantly stop the motor and camera.

"For recording purposes the Fearless Silent Camera can be furnished with an auxiliary sound photographing aperture at the correct distance of 19 frames from the photographic aperture and with gears, rollers, etc., necessary for recording the sound directly on the film as it passes through the camera. A Fearless Recording Photo Lamp, or any standard light valve may be attached and when so equipped it may be connected to any recorder amplifier and the sound record made on the same negative as the picture being photographed. This should prove a boon to newsreel cameramen and to location expeditions that are remote from electricity, for in cases of that sort the camera motor may be operated from the batteries that provide current for the recorder amplifier.

"The Fearless Silent Camera can be furnished for double-width film or for the Fearless Wide Picture on standard 35 m.m. film. Of special interest is the fact that colored motion pictures by the Multicolor system may be taken with the New Fearless Silent Camera.

"Lack of space prohibits enumerating all of the unusual features of the Fearless Silent Camera. Suffice it to say that it is the finest motion picture camera ever manufactured for the professional cameraman, and is in every sense a 1930 model camera."

"Daily Grind"
By RALPH B. STAUB

SOL POLITO says his idea of an easy job is garbage collector in Scotland.

 * *

A barber to JIMMY VAN TREES: "You say you've been here before, I can't seem to remember your face."
Jim to Barber: "Oh it's all healed up again."

 * *

VIC MILNER: In hat store; clerk to VIC: "That's a smart hat."
Vic: "It don't have to be smart—I'll put the brains in it."

 * *

AL JONES knows a Scotchman who beat his wife because she washed the soap out of his shaving brush.

 * *

JERRY ASH (to his assistant): "You know I'm a great thinker."
Assistant: "So am I Jerry, let's celebrate together.

 * *

LEN SMITH's assistant to Len: "I'll go blind if I study so long."
Len: "Don't worry, I'll donate the monkey."

 * *

BOB PLANCK says his girl is very modest. Bob took her to dinner and she ordered bosom of chicken.

 * *

FRANK KESSON on university location to assistant: "How do you like co-eds?"
Assistant: "I don't know; I never drove one."

 * *

JOHN SIETZ says he knows a girl who was so pleased with her first wedding that she can hardly wait for the next one.

 * *

MIKE JOYCE arrested for speeding, to Judge: "Can you change a twenty Judge?"
Judge: "No, but I can change the fine."

 * *

HERMAN SCHOPP sitting down to dinner.
Wife: "I baked this bread with my own hands."
Herman: "But who helped you lift it off the stove?"

 * *

RENE GUISSART cables me that his assistant killed himself in Paris. Rene says he went in Seine.

 * *

Assistant to HARRY DAVIS: "I'm in trouble; my wife needs food."
Harry: "You don't know what trouble is, my wife wants a diamond necklace."

 * *

Would it surprise you to know that—
LEW PHYSIOC was once a famous artist and sculptor before he became a cameraman.
JOE WALKER once owned a butcher shop.
BILL FRACKER studied to be an undertaker.
HARRY JACKSON was an architect before going into the movies.

Photographing the "Unseen"

—BY—

BISHOP CHARLES W. LEADBEATER

EXTENSION OF FACULTY

Many people suppose that our faculties are limited—that they have their definite bounds, beyond which we cannot go. But this is not so. Now and then we find an abnormal person who has the X-Ray sight by nature and is able to see far more than others; but we can observe variations for ourselves without going as far as that. ..If we take a spectroscope, which is an arrangement of a series of prisms, its spectrum, instead of being an inch or an inch and a half long, will extend several feet, although it will be much fainter. If we throw that upon a huge sheet of white paper, and get a number of our friends to mark on that sheet of paper exactly how far the violet extends at the one end and just how far the red extends at the other, we shall be surprised to find that one end and just how far the red extends at the other, we shall be surprised to find that some of our friends can see further at one end, and some further at the other. We may come upon some one who can see a great deal further than most people at both ends of the spectrum; and if so, we have found some one who is on the way to becoming clairvoyant.

It might be supposed that it is only a question of keenness of sight, but it is not that in the least; it is a question of sight which is able to respond to different series of vibrations, and of two people we may find that one can exercise it only toward the violet end, and the other toward the red end. The whole phenomenon of colour-blindness hinges on this capacity; but when we find a person who can see a great deal further at both ends of this spectrum, we have some one who is partially clairvoyant, who can respond to more vibrations; and that is the secret of seeing so much more. There may be and there are many entities, many objects about us which do not reflect rays of light that we can see, but do reflect these other rays of rates of vibration which we do not see; consequently some of such things can be photographed, though our eyes cannot see them. What are called "spirit photographs" have often been taken, although there is a great deal of skepticism in connection with them, because, as is well known to any photographer, such a thing can easily be produced by a slight preliminary exposure. There are various ways in which it can be done; nevertheless, although they can be counterfeited by fraud, it is certain that some such photographs have been taken.

DR. BARADUC'S EXPERIMENT

The recent experiments of Dr. Baraduc, of Paris, France, seem to show conclusively the possibility of photographing these invisible vibrations. When last I was there he showed me a large series of photographs in which he had succeeded

So many amazing developments are making in the evolution of photography these days that it will not seem particularly amazing that the silver plate has been made to record emotions and thought forms. There has been an interest developing in the occult side of photography for some-time and this excerpt from Bishop Leadbeater's book, "Some Glimpses of Occultism," may throw an interesting light on the subject. The experiments of Dr. Baraduc, of Paris, herein mentioned by the Bishop may start some of our bright young men on a phase of research that may one day turn the photographic world upside down.—Editor's Note.

in reproducing the effects of emotion and of thought. He has one of a little girl mourning over the death of a pet bird, where a curious sort of network of lines produced by the emotion surrounds both the bird and the child. Another of two children, taken the moment after they were suddenly startled, shows a speckled and palpitating cloud. Anger at an insult is manifested by a number of little thought-forms thrown off in the shape of flecks of incomplete globules. A lady who has seen the collection since I did describes "a photograph demonstrating the purr of a cat, whose sonorous contentment projected a delicately-tinted cloud."

The doctor employs a dry-plate system without contact and with or without a camera, in total obscurity through black paper or in a dark room. The plate is held near the forehead, the heart, or the hand of the person who is experimenting. He says: "Vital force is eminently plastic, and, like clay, receives impressions as life-like as if modeled by the invisible hand of some spirit sculptor. These phantom photographs, these telepathic images of the invisible, are produced by concentration of thought; thus, an officer fixed his mind upon an eagle and the majestic form of the bird was depicted upon the plate. Another shows the silhouette of a horse." He tells us that sometimes faces appear upon the plates, and especially described one case in which a mother's thought produces a portrait of a dead child. He gives us also the following interesting account of an impression made during an astral visit.

"An astonishing feat of telepathic photography is related by a medical practitioner of Bucharest, Dr. Hasdeu. Being interested in the telepathic phenomena, he and his friend, Dr. Istrati, determined to put it to a photographic test, so as to prove whether it were possible to project an image at a distance upon a plate already prepared. The evening agreed on for the crucial experiment arrived. Dr. Hasdeu before retiring placed his camera beside his bed. Dr. Istrati was separated

from him by several hundred miles. The latter, according to agreement was, just before going to sleep, to concentrate his thoughts in the endeavor to impress his image upon the plate prepared by his friend in Bucharest. The next morning, on awakening, Dr. Istrati was convinced that he had succeeded, being assured of it in a dream. He wrote to a mutual friend, who went to Dr. Hasdeu's residence and who found that gentleman engaged in the development of the plate in question. Upon it there appeared three distinct figures, one of them particularly clear and life-like. It depicted Dr. Istrati gazing with intensity into the camera, the extremity of the instrument being illuminated by a phosphorescent glow which appeared to emanate from the apparition. When Dr. Istrati returned to Bucharest he was surprised at the resemblance of his fluidic portrait, which revealed his type of face and most marked characteristics with more fidelity than photographs taken by ordinary processes."

OUR WIDER POWERS

All these experiments show us how much is visible to the eye of the camera which is invisible to ordinary human vision; and it is, therefore, obvious that if the human vision can be made as sensitive as the plates used in photography we shall see many things to which now we are blind. It is within the power of man not only to equal the highest sensitiveness attainable by chemicals, but greatly to transcend it; and by this means a vast amount of information about this unseen world may be gained.

With regard to hearing, the same thing is true. We do not all hear equally, and again I do not mean by that that some of us have better hearing than others, but that some of us hear sounds which the others could under no circumstances hear, however, loud they might become. This, again, is demonstarble. There are various vibratory sounds caused by machinery which may be carried to such a height as to become inaudible as the machinery moves faster and faster they gradually become less and less audible, and at last pass beyond the stage of audibility, not because they have ceased, but because the note has been raised too far for the human ear to follow it. The pleasantest test I know of, which anyone can apply in the summer months if he is living in the country, is the sound of the squeak of the bat. That is a very razor-edge of sound, a tiny-needle-like cry like the squeak of a mouse, only several octaves higher. It is on the edge of the possibility of human hearing. Some people can hear it and others cannot, which shows us again that there is no definite limit, and that the human ear varies considerably in its power of responding to vibrations.

If, then, we are capable of responding only to certain small groups out of the

The Laboratory Technicians

The Journey of the Film From Cameraman Through the Laboratory

By CARL KOUNTZ

Does the layman or any other person not connected with a motion picture laboratory have any concise idea of just how much work, worry and care is required to handle the miles of exposed film the camera man turns in to the laboratory at the end of the day.

The enormous sums of money the producer has to supply, the work of the director, actor, cameraman and everyone connected with the production staff; may become just so much wasted effort through one misstep by some member of the laboratory crew.

To give the reader an idea of the important part the laboratory plays in the motion picture industry, I shall endeavor to take him step by step along the highways and byways of the laboratory—from the time the exposed negative film leaves the camera man until the finished film is shown on the screen.

When the director calls a halt for the day, the assistant cameraman takes the film magazines to his dark room and unloads all the exposed film. This he wraps in black paper, puts it into film cans, seals the cans with adhesive tape and takes them to the laboratory along with the camera report.

The receiving clerk at the laboratory takes the weight of these cans containing the film. By computing the weights he will know how much film was turned in. In the meantime the chemist of the laboratory will have all the solutions that are necessary for the processing, in condition. It is imperative that the solution should be the same strength and temperature from day to day, as an error on his part will start a lot of headaches. The exposed film is then given to the developing crew for processing.

A year or so back human element played an important part in this work, as the film was wound on wooden racks each with a capacity of 200 feet or less, and developed by inspection. The opportunity for errors here was great as it is almost impossible for a man to develop rack after rack of film without variation in density. Since the advent of the processing machines this has been reduced to some extent; yet trained men are necessary, as the machine is only as good as its weakest part.

When trouble occurs the operatives must know what to do and do it quickly, as scenes costing thousands of dollars may at that particular moment be in the solutions and a stop of only a few minutes will make this film unusable. The cause of the trouble may not necessarily be that of the machine. I think the worst offender is the broken perforation, as this will invariably cause a break; for this reason all film is inspected before it is fed into the machine.

Processing machines have eliminated many evils of the rack and tank days. Such things as rack scratches, rack flashes and finger marks were entirely eliminated and with the building of new laboratories with modern equipment, dirt and dust, the nemesis of the laboratory, will be practically removed.

Now to get back to the film. The exposed film is fed into the machine at the rate of speed that will give it sufficient time for full development fixing and drying. This whole process goes on without an interruption, the dry film being wound on a reel on the opposite end of the machine.

Several types of processing machines are in existence, each one having its good and bad points. The main difference lies in the drive; that is, in one, the film is being pulled at the dry end by friction. The second type uses sprocket wheels on each drive shaft. The sprockets on these wheels or rollers engaging the perforations on the film.

The reels with the dry film are then delivered to the assembling department or the breaking down department, as we call it. Here the films from the different companies are segregated, weighed and the weights compared with the weight given on the camera report. If the two weights match, well and good, if not the missing footage has to be located. At times this is quite some job, as identification slates are not always legible. Here, also the N. G. and O. K. scenes, as bad and good scenes are termed, are segregated. The O. K. scenes are then marked or cued for the sound and gotten ready for testing and printing.

vast mass of vibrations, we may readily see what an enormous change would be produced if we were able to respond to all. The etheric sight of which we sometimes speak is simply an added power of responding to physical vibrations, and much of the clairvoyance on a small scale which is shown by dead people at seances is of that type. They read some passage out of a closed book, or a letter which is shut up within a box. The X-Rays enable us to do something similar—not to read a letter, perhaps, but to see through material objects, to descry a key inside a wooden box, or to observe the bones of the human body through the flesh. All such additional sight is obtained in the way I have described, by being able to respond to a large set of vibrations.

Let us carry that a little further; let us go beyond the vibrations of physical matter and imagine ourselves able to respond to the vibrations of astral matter; at once another world is ours for the winning, and we see the objects of a plane material still, but on a higher level. In this, although there may be much which is unfamiliar, there is nothing which is impossible. It all leads on, stage by stage, from the faculties which we already know and use, and this world of astral matter follows step by step from the world with which we are so familiar. There is nothing irrational about the conception. The claim made by Theosophy, and by all those belonging to the great religions of the East, that it is possible for man to sense this unknown world and tell us all about it, is in reality a perfectly reasonable one, instead of being a grotesque and absurd suggestion savoring only of charlatanism or fraud, as is so often supposed. The whole theory is in fact scientific and coherent and may be approached along a purely scientific line of investigation.

Technicolorings

Director John Francis Dillon, assisted by Val Paul, has just completed a super feature operetta, "The Bride of the Regiment," for First National. The picture is all Vitaphone and all Technicolor. It boasts a long list of 659 men on its photographic staff. For First National they are as follows: J. Dev Jennings, supervisor; Faxon Dean, Lyman Broening, Frank Evans, Russell Hoover, and Perry Finnerman. For Technicolor: Charles Schoenbaum, supervisor; Friend Baker, Earl Stafford, Ira Hoke, John Shepek, and H. C. Ramsey. MacJulian on the still camera. Bob Comer, of Local 37, gaffed the entire production. The picture boasts an all-star cast of exceptional brilliance as it features Vivian Segal, Walter Pidgeon, Louise Fazenda, Allan Prior, Ford Sterling and Myrna Loy.

* * *

The Russian operetta, "Song of the Flame," directed by Allan Crosland for First National, has reached completion. It is an all Vitaphone, all Technicolor feature with an all-star cast composed of the following favorites: Alice Gentle, Bernice Claire, Noah Beery, Alexander Gray, Bert Roach and Inez Courtney. The photography was supervised for First Naitonal by Lee Garmes, while Frank Good looked after the best interests of the color cameras. Their associate cameramen were: Lyman Broening, Lee Davis, Milton Bridenbecker, Lester White, Bob Miller, Jack Alton, Chuck Geissler and Wesley Anderson. John Ellis is responsible for a fine set of stills. The production was gaffed by George Whittemore, of Local 37.

* * *

Robert Bronner, formerly with the Newcomb Process Department at M-G-M, has added his name to the long lineup now working at Technicolor.

* * *

"Parisian Knights," a Warner Bros. short sound feature in Technicolor, has just reached the cutting room through the efforts of Cameramen Al Gilks, Willard Van Enger, Harry Hallenberger, Ira Hoke and Kenneth Green. They were assisted by Louis De Angelo, Jack Kauffman and Bob Clark.

* * *

Pierre Mols, who for the past five years have been associated with the camera staff of the M-G-M studios, has joined the Technicolor camera forces. Pierre will be remembered for his excellent work on the "Trail of '98."

* * *

"Flower Song," an all sound and all Technicolor short subject for M-G-M has just been completed by Winny Winstrom, Al Gilks, Harry Hallenberger, Art Reed and Ira Hoke. Assistants on the picture were Louis De Angelo, Maurice Kains and John McBurnie.

* * *

John Shepek, whose past photographic activities have been centered on the Educational and Warner lots, has deserted both former homes for a new berth on the Technicolor staff.

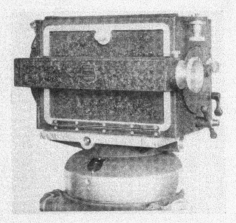

Chicago — Six-Sixty-Six — Chicago

Writing of oneself is a tough job—but it started back in 1910 when one said Harry Birch sought to become a motion picture operator.

In Nevada City, California, there were two motion picture theatres, one was the TRUST house and the other the INDEPENDENT. However my first experience was in the TRUST house as operator, soon branching from there to Sacramento, California.

HARRY BIRCH

In 1912 I landed in Los Angeles and went to work for Mr. Loper at Clune's Broadway Theatre. While here I met a Harry Kelly who was then producing pictures for the Lubin Company—he invited me to try twisting the crank of a camera instead of a projector which I did. Those were the days when a few boards for a floor, 4x4's for supports and a muslin overhead made a studio.

After working on many of those early "productions" I had the pleasure of helping Claude C. Laval, of Fresno, California, to photograph the state of California for the P. P. I. E. held in San Francisco in 1915.

In 1915, I became associated with the Rothacker Film Co., Chicago, doing industrials and also handling the Universal News Reel. As the news work seemed to interest me most of all I was soon devoting all of my time to the Chicago Tribune Animated Newsreel, later known as the Selig-Tribune. My next news reel work was with the old Mutual, later known as the Gaumont News and Graphic, going over to Fox News when this reel was started, covering Chicago territory for their first years.

Several years ago I decided that I wanted my own business 'so here I am with a shingle hanging out at 845 South Wabash Avenue. Of course I do not make all of the commercial or industrials in these parts but I make "some of the best"—don't rush boys, don't rush.

Having been an operator, a dark room man, a cameraman and sometimes a director and also a janitor, I thought that my experience in this business was rather complete, but now I am informed that I am to become editor of this page in the International Photographer for Local 666. Willing to try anything once; I hope that "yo all" (please page Floyd Tranyman) like "the page" and if you don't, let me hear from you.

SIX SIXTY-SIX

ONE YEAR OLD

At the next meeting of Local 666 to be held at the Palmer House, Chicago, there will be a little surprise in store for all the boys. The Palmer House is the official meeting place for Local 666, and by the way is one of Chicago's finest hotels, if not the "Hotel.". Getting back to this

**Motion Picture Industries Local 666,
I. A. T. S. E. and M. P. M. O., of the
United States and Canada**
By HARRY BIRCH
President

CHARLES N. DAVID	Chicago

Vice-Presidents

OSCAR AHBE	Chicago
CHARLES E. BELL	St. Paul
F. L. MAGUIRE	St. Louis
W. W. REID	Kansas City
RALPH BIDDY	Indianapolis
J. T. FLANAGAN	Cleveland

Treasurer

WILLIAM AHBE	Chicago

Secretary

EUGENE J. COUR	Chicago

**Offices
12 East Ninth Street, Chicago**

BULLETIN — The regular meetings of Local 666 are held the first Monday in each month.

surprise, the chef, Ernest E. Amiet, is preparing a large cake with one little candle in the middle and each slice will be marked for cutting. We are told that each slice will contain "the surprise" and that if Uncle Sam's agents are not on the job, of course then the surprise will be good for the last drop. Local 666 is just one year old, having gone through the stages of teething, learning to walk and speak a little, and is now setting out on its second year with the realization that it is growing stronger and will soon be as big as its brothers.

SIX SIXTY-SIX

MYSTERY BEWARE

At the last meeting of Local 666, a "big stick" was introduced to beat down this bird called "Mystery or Secret." It was suggested, voted upon and decided that a committee be formed for the purpose of seeking the inner gates of that "mystery" of the motion picture, principally sound. Those elected and shall be known as the "Technical Committee" are as follows: Conrad Luperti, chairman; Fred Wagner, Mervin LaRue, Morris Hair, George Bastier and Daniel Tattenham. The work of this committee is to bring matters of interest to the various meetings of Local 666 for discussion and also to arrange with manufacturers to bring their "wares" that they may give a demonstration, thereby, giving the boys a chance at inside information that could be obtained no other way. For the out of town boys, should there be any questions that may arise in your work, this committee will be more than pleased to hear from you and will answer you on this page, or by personal letter, if desired. Let us hear from you with your troubles.

SIX SIXTY-SIX

Local 666 wished to take this time to express sympathy to Major Spoor, having lost his brother Harry A. Spoor, age 54, who passed away in London, England.

SIX SIXTY-SIX

VISITORS

Mickey Marigold, from Local 659, was on hand at the last meeting and after

being introduced, proceeded to give the boys a talk. Mickey let it be known that he was not sold on Chicago weather and, then, of course, he had to tell us that he missed the California sunshine. Mickey if you are with us very long you will not see much of the sun for the next couple of months and we would advise that you buy a fur lined overcoat for the coming season, if your locale be Chicago.

SIX SIXTY-SIX

THIS AND THAT

It seems that Norman Alley, of Hearst Metrotone, is paying off a bond-issue on the eastern railroads. He is in New York City on business.

SIX SIXTY-SIX

Chas. Ford has just purchased a new front wheel drive Cord car and claims that he can do 65 miles per hour in reverse speed—anyone desiring to take a ride with Brother Ford "backwards" can locate him at 845 South Wabash Avenue, Chicago. Omit flowers.

SIX SIXTY-SIX

Days are getting gloomy with the coming of winter in Chicago, so Brother Bob Duggan is polishing up the reflectors of his day-light arcs and furnishing sunlight for all the boys—local and visitors. Bob's favorite ditty lately is "Singin' in the Rain."

SIX SIXTY-SIX

Struggling out of a cab with a pair of hip boots, next a rubber slicker and a rain hat, then came a camera and tripod, and inside of the rubber wear was none other than President David of Local 666. When asked where he was going to or coming from, he advised that he was out in Lake Michigan looking for a steamer that had sunk. Of course you know Charlie makes "Moving-Pitchers" for the Chicago Daily News-Universal News Reporter.

BELIEVE IT OR NOT

Frank Bowers getting away with at least six meals each day.

"Bull" Phillips looking forward to Santa Claus leaving some spare parts for a Hupmobile.

Fred Geise photographing a football game at 5 below zero.

Bill Strafford makes 1,000 pictures or 62 feet per second—film traveling at the rate of 50 miles per hour—figure that out!

SIX SIXTY-SIX

OUT OF TOWNERS

The International Photographer has been kind enough to give Local 666 this page every month, and that means that this is your page and we expect each and every one of 666'ers to "kick in" once in awhile with some material—let us know what you are doing—send us news from your locale—let's make this a REEL page. By the way you may have something for sale or you may want to buy—don't forget that the International Photographer reaches the trade—rates are low—if you want this information let us hear from

you as we don't think that Brother Reeves will refuse your business.

SIX SIXTY-SIX
A VOICE FROM MEXICO

Mervin LaRue just received a letter from Brother George Bastier, now with the Rothacker Film Co. and at this time is in Mexico on an assignment. Bastier, in his letter coming from the Hotel Regis-Odenida, Juarez 77 Mexico, D. S., tells of the people, weather, elections, etc. He tells of watching an election in Mexico City, but saw no shooting, although there were plenty of the natives that were "half-shot." Bastier wants it known that Mexico is wet—that is not the climate—but from the labels that accompanied the letter proves that Bass Ale, Johnny Walker, Gordon Dry, or what have you, can be had without the aid of a "speakeasy"—please do not judge wrongly—Bastier says that he found these labels in the street. (That's O.K. George, we take your word for it.)

SIX SIXTY-SIX
A REAL TREAT

Local 666 claims everything and we don't mean maybe—Bill Strafford, a member of 666 makes pictures faster than any man in the world and that's saying a "mouthful." Bill has given us his word that for the next issue he will give us all the facts of why he does it and how and also some pictures of his "speedygroan-box."

SIX SIXTY-SIX
WESTWARD, HO!

Major Spoor, the wide film expert, leaves Chicago for the west coast to instruct the boys of Sunny California on

PARICHY GOES ABROAD

Brother Essell Parichy, editor of the Sun News Reel at Long Beach, has gone to Europe for a seven months' sojourn in the capitals and larger cities where he expects to shoot at least ten thousand feet of film. Considerable time also will be spent on the Mediterranean and in Egypt with a probable side trip into the Holy Land.

ESSEL E. PARICHY

In observance of the first anniversary of the Long Beach Sun News Reel a film review of the year in Long Beach was featured and Editor Parichy said on that occasion that since the inauguration of the reel in September, 1928, more than eighteen miles of film had been shot.

———o———

First Permit-Assistant: "Are you going to work steady in the camera game?"

Second Permit-Assistant: "No, I gotta go back to my old job in Frisco."

First Permit-Assistant: "My application was rejected also."

the 70 m.m. film. During his absence, which we hope will not be for long, William Abbe has been elected as "pinch hitter" to handle the funds and business of the Treasurer of Local 666.

LOYALTY

Loyalty in a man is one of his most essential characteristics. Without it he is without power to do the work of the kind that counts. Let it be loyalty to a principle, loyalty to his employer, loyalty to a sect; just so it is loyalty to some constant thing or person it will serve its purpose.

There is nothing by which we may judge better a man's character than by his ability to remain loyal to one given thing. Strength of character, determination, integrity, all of these are indicated in a man by the degree of his loyalty. Find a man who is loyal to an animal, a person, a belief, and you will have found a man worth while—a man in whom there is good, even though a careless world may never have discovered it.

Loyalty has kept men at their tasks through countless ages. It is the beacon light that guides storm-tossed, temptation-wrecked human vessels over life's rough seas, twinkling ever just over the bow and offering a constant hope to the mariner.

The man who is loyal—he will be with you when you are up and he will be with you when you are down, because he has in him that which is infinitely finer than wealth or great glory. He has in him an appreciation of the finer things of life —a safeguard for his fellow humans.— Contributed by Les Rowley from a current exchange.

NEW STATION S-T-A-R

At the opening of "Rio Rita" at Carthay Center Theatre recently Otto Himm presided at the camera which shot the stars for the great event.

Otto and Bebe Daniels, star of "Rio Rita," were honored by having an open-ing the same night—Bebe making her debut in her first sound picture which parades her beautiful voice to perfection, while Otto was celebrating the inaugura-tion of Radio Station S-T-A-R, the "Voice of Hollywood." Incidentally both Miss Daniels and Mr. Himm began their movie careers with the old Rolin Com-pany, in Lonesome Luke Comedies. S-T-A-R is located at Tec-Art Studios where the new station has been granted a new wave length by Tiffany. The staff of Station S-T-A-R is made up of Lewis Lewyn, station director; Otto Himm, chief broadcaster, with George (Bunny) Traf-ton, assistant; Ernest Rovere in charge of monitor room, assisted by Leo Hanig and Mr. Tope; Les Tracy and Joe Wharton, electricians.

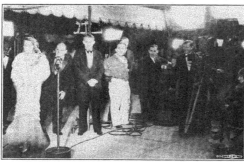

Left to right—*Bebe Daniels, Lewis Lewyn, Bunny Trafton; the two lightwave makers; Leo Hanig, Otto Himm.*

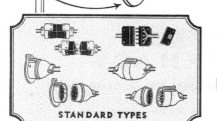

The Sound Track

OFFICERS

International Photographers of the Motion Picture Industries, Local 659

ALVIN WYCKOFF...............................*President*
JACKSON B. ROSE.............*1st Vice President*
H. LYMAN BROENING........*2d Vice President*
IRA B. HOKE.....................*3d Vice President*
ARTHUR REEVES.....*Recording Secretary*
ROY H. KLAFFKI.........*Financial Secretary*
CHAS. P. BOYLE...........................*Treasurer*
WM. H. TUERS.............*Sergeant-at-Arms*

HOWARD E. HURD
Business Representative

BOARD OF EXECUTIVES

International Photographers of the Motion Picture Industries, Local 659

ALVIN WYCKOFF	PAUL P. PERRY
JACKSON J. ROSE	L. GUY WILKY
H. LYMAN BROENING	J. O. TAYLOR
IRA B. HOKE	ARCHIE J. STOUT
ARTHUR REEVES	HARRY ZECH
ROY H. KLAFFKI	JEAN C. SMITH
CHAS. P. BOYLE	S. C. MANATT
WM. H. TUERS	R. B. HOOPER
FAXON M. DEAN	SOL POLITO
IRA MORGAN	PAUL HILL

IT CAN BE DONE

"Anna Christie" was filmed in sound recently at M-G-M studios, Clarence Brown directing.

The camera crew was composed of William Daniels, Al Lane, Max Fabian, Charles Marshall, Cecil Cooney, Thomas Tutwiler, Nelson McEdwards and Walter Rankin.

The average time of call for staff was ten o'clock in the morning and production usually ceased at approximately 4:30 in the afternoon.

There was no Sunday work.

There was no night work.

The picture was scheduled for thirty days.

It was finished on time.

The production work was a masterpiece of co-operation and co-ordination.

Whoever draughted the production schedule on this picture was a workman that needs not to be ashamed.

He knows his movies.

And Clarence Brown knew how best to handle his materials to make the most of them.

As for the camera crew it was on the job 100 per cent, as usual. No delay on their account.

It can be done.

HOLE IN ONE

At last the International Photographers can boast a member of the "Hole in One Club," for on the sixth of this present December, Brother Harry Cooper, playing on the Wilson course at Griffith Park, plunked one into the cup at the tenth hole—a 200-yard shot. Who'll be next?

UNFAIR

Local 659 is in receipt of a letter from Joseph Obergfell, of Cincinnati, secretary-treasurer of the International Union of United Brewery, Flour, Cereal and Soft Drink Workers of America, from which the following excerpts, are reprinted:

Cincinnati, Ohio, Dec. 4, 1929.

To Organized Labor of California:

Dear Sirs and Brothers:

We wish to call to your attention that the Hollywood Dry Corporation of Los Angeles, Calif., manufacturers of Hollywood Dry Ginger Ale, Hollywood Dry Orange, Hollywood Dry Pomo and Hollywood Mato, and Purity bonded syrup extracts, has been declared unfair to organized labor of California at the request of Bottlers' Local Union No. 293 of the International Union of United Brewery, Flour, Cereal and Soft Drink Workers of America, for abrogation of its signed working agreement, which was to expire on May 15, 1930.

Every effort has been made by the representatives of organized labor of California, the Bottlers' Local Union No. 293, and international representatives to have the firm continue its contractual relationship, but to no avail. Hollywood Dry Ginger Ale, Hollywood Dry Orange, Hollywood Dry Pomo and Hollywood Mato, are sold throughout the state of California, and we urge the organized wage earners and friends to render every possible assistance to our Local Union No. 293.

Every individual member of the organized labor movement can render moral service by advising the trade handling this product that it is unfair to organized labor, and urge them to handle only union made products.

Members of 659 are urged to lend every possible assistance to our brothers in this case.

WHITLEY EXPANDS

An another page of this issue Brother W. F. Whitley, assistant, announces the purchase of Carthay Center Cleaners, 911 Carillo Drive, WHitney 2761. In this enterprise he is associated with C. C. High and as an evidence of their faith in the new investment the boys are having plans drawn for a $20,000 building which will constitute one of the most complete cleaning plants in the city.

Carthay Center Cleaners will specialize in service to motion picture people and particular attention will be given to ladies' wear. The plant is open for business and members of Local 659 will be cordially welcomed.

TANNURA IN PARIS

Director Philip Tannura writes from Paris that he is working at the Gaumont Studios and that he expects to remain in France indefinitely. He has met Georges Benoit and says that Georges is happy and prosperous back there in his native land. Good luck to them both.

OUR COVER FOR JANUARY

Frederic Archer, chief pictorialist and portrait artist for Warner Brothers, is the wonder worker who fabricated the amazingly beautiful front cover for this issue of **The International Photographer.** Brother Archer is internationally known as a photographer and is the proud possessor of many testimonials, prizes, ribbons and honorable mentions.

He has exhibited in many of the larger cities of the United States and at many expositions. Just now he has an exhibit at Barcelona Exposition and is sending an exhibit to Japan by special invitation.

Our front cover was originally entitled "The City of Brass," a dream of the Arabian Nights Entertainments, but for our purpose it has been re-christened "A Dream of the New Year." Thank you Mr. Archer.

For those who desire to know, the lower portion of the composite picture on our front cover for December was from "The Adoration of the Shepherds," by Lerolle.

500,000 IN UNITED STATES HAVE FIVE-DAY WEEK

Nearly 500,000 workers in the United States are now on a five-day-week basis, according to a bulletin published today by the national industrial conference board.

Included in the figures are about 220,-000 factory employes in 270 plants, and while the week is not one of 40 hours in all cases, there are two full days of rest in each seven.

Out of Focus

DO YOU KNOW

That weather permitting calls are seldom heard of nowadays.

That the new emblems that sell for $2.00 cost almost that much to make.

That Local 665, Toronto, did not send any new items last month.

That you should always notify the office when going on distant locations.

That I. Heard is no relation to H. Hurd our business manager.

That Frank Good has been in the hospital havings things removed.

That he thinks Delores is about the best nurse of them all. Naturally.

That Georges Benoit is in Paris trying to pick up the language.

That Vic Milner was an ace newsreel cameraman at one time.

That Harry Zeck has one of the finest Mitchell outfits and likes to keep it busy.

That Corp. Phil Tannura, I mean Sergt., or was it Loot., is in Paris.

That Ray Renahan and Hal Mohr are shooting a fellow that they think will make good in the sticks some day—Paul Whiteman.

That after mentioning Pequot Sheets in the magazine some of the assistants are sleeping on sheets for the first time. They are 100 per cent Union made.

That I have been in Hollywood for 10 years and have never seen Mary Pickford. This is not a gag.

That Ed. Estabrook has a new electric clock at his home. When late for work all the boys have to do is to cut his wires.

NEW NON-SENSIBLE MICROPHONE

This beautiful study of wild fowls was underexposed by Eugene Richee.

POWDERING MILL.

All the trouble that has been caused by sensitive microphones in the past will soon be eliminated, according to Ernie Rovere, of Tec Art Studio's sound department. This new device can be carried by all actors in the watch pocket or other places when no watch pockets are worn. The principle is very simple. Ex-

STARTLING INNOVATION

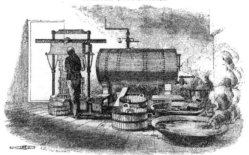

THE LABORATORY

The above marine view was aimed by Fred Archer.

The Rushem and Pullem laboratories have just installed the new super-developing machine as shown above. This machine will over come all the difficulties that the cameramen have had in the past. By certain gadgets it can develop for the gauze, make soft scenes sharp and sharp scenes sharper; bring out the backgrounds and reduce double chins; put in hi-lights and take out bad action. The only trouble at the present time is that they have not a member of Local 683—Laboratory Technicians—operating this machine and the non-union operator can't do the right things at the right time. We have been assured that this will be straightened out very shortly. Be sure your dues are paid.

tra simple. In fact the whole idea is simple. But to get back to the microphone it works as follows: The voice hits the croquette on the left which is grounded by the plow-share attached alongside and then reverberates to the 50 cycle wow-wow in the center and then by induction to the ink well on the right. The influx is nominal or aboriginal as they say at the Academy. Simple?

LETTERS RECEIVED

Dear Mr. Out from the Focus:

I understand that you have been married recently. Am I right or was it just another roomer?

Ans. Yes, you are right. It was a retake though. The first time we were out of sync and the dialogue was bad. Fine recording now.

* * *

Dear O. O. F.:

Is John Boyle any relation to you?

Ans. No relation, but brothers under the I. A. T. S. E.

* * *

Dear Sir. and Brother:

Can you tell me what to do when the director does not go to lunch until 4 o'clock.

Ans. Bring your lunch like the electricians do.

SOCIETY NOTES

Mr. Edward Cohen, no relation to Harry (that's nice), entertained recently and served coffee and cake free.—Speed Hall furnished the music. Curley Lindon played a Mazola and was accompanied by Chas. Bohny on a portfolio.—Harold Winstrom was able to enjoy the music.—Billy Tuers argued the sextette from "Lucia" throughout as to the merits of brewers' yeast as compared with regular yeast.—Flowers furnished by Pillsbury and L. A. Grain Co.

IF YOU DON'T BELIEVE IT, SUE ME

Two three-inch lenses do not make a six-inch lens.

The F system is not an easy payment plan.

There are a great many things that the Hypo can not fix.

A scene in the box is worth two in the script.

Buddy (A. E.) Williams writes from Sumatra that his outfit is so far away from civilization that it is impossible to keep in close touch with the mails. They are getting a lot of original stuff and Brother Schoedsack is well pleased with the results thus far. Address Buddy, care American Consulate, Medan, Island of Sumatra.

We are pleased to announce that we
are now in production on our new 70
M. M. Mitchell Camera and are in a
position to accept orders from the
profession for these cameras. This
is the same type camera manufactured
by us and now in use in the produc-
tion of the Fox-Grandeur pictures.

Mitchell Camera Corporation

665 North Robertson Blvd. West Hollywood, Calif.
Cable Address "MITCAMCO" Phone OXford 1051

The
INTERNATIONAL
PHOTOGRAPHER

Official Bulletin of the International Photographers of the Motion Picture Industries, Local No. 659, of the International Alliance of Theatrical Stage Employees and Moving Picture Machine Operators of the United States and Canada.

Affiliated with Los Angeles Amusement Federation, California State Theatrical Federation, California State Federation of Labor, American Federation of Labor, and Federated Voters of the Los Angeles Amusement Organizations.

Vol. 2 HOLLYWOOD, CALIFORNIA, FEBRUARY, 1930 No. 1

"Capital is the fruit of labor, and could not exist if labor had not first existed. Labor, therefore, deserves much the higher consideration."—Abraham Lincoln.

CONTENTS

The INTERNATIONAL PHOTOGRAPHER published monthly by Local No. 659, I. A. T. S. E. and M. P. M. O. of the United States and Canada

HOWARD E. HURD, *Publisher's Agent*

SILAS EDGAR SNYDER - - - - *Editor-in-Chief* IRA B. HOKE - - - - - - - *Associate Editor*
LEWIS W. PHYSIOC - - - - *Technical Editor* ARTHUR REEVES - - - - *Advertising Manager*
CHARLES P. BOYLE - - - - - - - *Treasurer*

Subscription Rates— United States and Canada, $3.00 per year. Single copies, 25 cents
Office of publication, 1605 North Cahuenga Avenue, Hollywood, California. HEmpstead 1128

The members of this Local, together with those of our sister Locals, No. 644 in New York, No. 666 in Chicago, and No. 665 in Toronto, represent the entire personnel of photographers now engaged in professional production of motion pictures in the United States and Canada. This condition renders THE INTERNATIONAL PHOTOGRAPHER a voice of an *Entire Craft*, covering a field that reaches from coast to coast across the nation.

Printed in the U. S. A. at Hollywood, California

THIS WORK OF ART IS OUT OF THE GOOD BOX OF BROTHER CARLTON GROAT, INDUSTRIAL CINE-
MATOGRAPHER, PORTLAND, OREGON. IT WAS SHOT AS IS, WITHOUT ANY FRILLS OR FURBELOWS.

1914—They're Together Again—1930

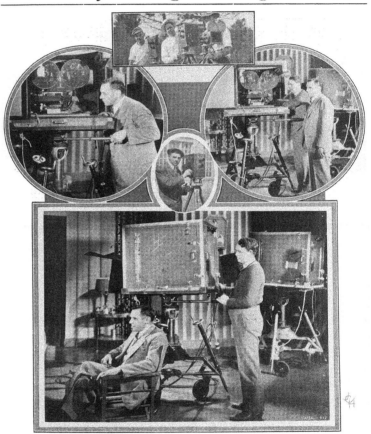

Top—*Jack Rose and Art Reeves at the old Essanay studio with Bell & Howell cameras Nos. 1 and 2.*
Center—*Jack with Bell & Howell No. 1 wooden box.* Left and right—*Rose and Reeves today with
sound cameras at Tiffany studio.* Below—*Close-up showing tripod.*

Away back in 1914 B. S. B., (Before
Sound Booths) two young blades named
Rose and Reeves wandered into Chicago
and struck the Essanay studio for a job.
To hear them tell it they could photo-
graph anything and they convinced
George Spoor that Essanay couldn't get
along without them. Sure enough the
(Concluded on Page 21)

By John Corydon Hill

The Aladdin's Lamp of the Movies—No. 4

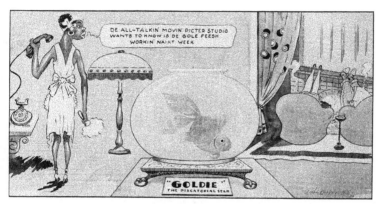

WHAT'S TH' ODDS WHO YOUR BREAD-WINNER IS?

In Memoriam

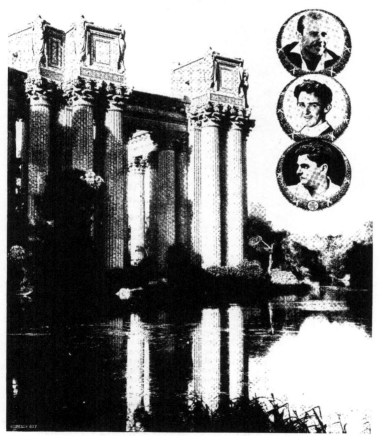

Photograph by Carl Widen

GEORGE EASTMAN, OTTO JORDAN, CONRAD WELLS, MEMBERS OF LOCAL 659, I. A. T. S. E.
AND M. P. M. O., DEPARTED THIS LIFE IN THE DISCHARGE OF DUTY, JANUARY 2, 1930.

Ten men are dead.

Ten men who should be alive and well today.

Ten men sacrificed on the altar of Thrill.

Ten men, casualties of the motion pictures.

Ten men leaving behind wives, children, sweethearts, parents, brothers, sisters, friends to mourn their untimely and utterly useless taking off.

Is any scene or any picture or indeed the entire picture industry worth the lives of ten men? Count your own life and the lives of your loved ones.

Was the sun in the eyes of the pilots and did it blind them so that they misjudged distance and, therefore, went into this terrible crash, or what was the cause?

Can you imagine experienced pilots like Cook and Rouse falling into a holocaust like this?

Unavoidable accident? Accidents happen, but there is always a reason why. Somebody somewhere is always responsible.

Lest there be more wholesale sacrifice of life let there be diligent effort to find out the cause of such accidents in order to guard against others in future.

In the presence of this frightful tragedy what is to be said of condolence to the bereaved that does not sound like mockery.

It is wonderful to believe with St. Paul that "There is no death," but who will answer when sad-eyed children, heart-hungry for the beloved form, lisp the name of Daddy?

Or wives and sweethearts cry out against a silence from which comes no call in return.

If the waves, into which plunged their flaming chariots of the air, could speak in language we could understand they would tell, no doubt, of the unimaginable travail of these men riding open-eyed, helpless and hopeless to certain destruction.

And this travail would tell of an unutterable sense of injustice at being thus hurled into eternity in time of peace and in the loyal whole-hearted discharge of duty.

But there is a rift in the clouds, letting through a glint of hope.

Out of sacrifice comes better things and, if from this tragedy there arises the wisdom that will guide men to guard against such happenings in future, these departed brothers may not have made the supreme sacrifice in vain.

Individuals there may be who are directly responsible for this wholesale killing, but in a larger sense the entire industry is responsible and it stands as a rebuke to all those careless, callous souls who put selfish considerations ahead of absolute safety for men whose duties lie in activities classed as hazardous to life and limb.

There has been too much petty authority and the taking of things for granted.

The only thing a cameraman fears is fear.

Rather would he risk his life uncomplainingly and with a smile than to be considered a coward. So deeply is this ingrained in his nature that he has come to confuse caution with cowardice and horse-sense with timidity.

Never again must such a happening shock the world and blemish the fair record of the cinema.

There must be authoritative lines of safety established.

There must be no joy rides in the air to tempt the angry gods of fate.

Making motion pictures is not a hazardous profession, craft or art—or at least it need not be.

The craftsmen of the cinema have a magic of photography which, intelligently used, forever puts an end to risk of life and limb—the trick shot.

Henceforth let it be invoked in all cases of hazard.

Not again will the cinema look with forbearance upon the useless destruction of life.

But what shall we say of death?

What words of consolation can we give to those who sit in the tents of sorrow and will not be comforted?

In such plight let one of those answer for us who had the gift of tongue:

"We cry aloud and the only answer is the echo of our waiting cry. From the voiceless lips of the unreplying dead there comes no word; but in the night of death hope sees a star and listening love can hear the rustle of a wing."

"He who sleeps here, when dying, mistaking the approach of death for the return of health, whispered with his last breath: 'I am better now.' Let us believe, in spite of doubts and dogmas, of fears and tears, that these dear words are true of all the countless dead" *(Ingersoll at the bier of his brother.)*

And so we leave them, whether asleep under the flowers in the churchyard or lulled to eternal rest in the cradle of the deep, secure in the faith that none of His sons shall ever lose hold of the hand of the God who, in His love and wisdom, called him into being.

May They Rest in Peace

ROSS COOK, GEORGE EASTMAN, BEN FRANKEL, MAX GOLD, TOM HARRIS HENRY JOHANNES, OTTO JORDAN, HALLOCK ROUSE, KENNETH HAWKS, CONRAD WELLS.

The Influence of Color

—BY—

P. F. L. RICE

Natural color photography has revolutionized practically every phase of motion picture making.

By providing the screen with a new element possessing dramatic, emotional and pictorial possibilities, it has brought important changes to the work of every production unit.

These sweeping changes extend from the scenarist's office to the cutting room. All along the production line, cognizance is being taken of a new and powerful element, with every effort being bent to make full and intelligent use of it.

The writer must employ color with understanding in fashioning his stories. In selecting players for an all color picture, the casting director is forced to give unusual attention to hue of complexion, hair and eyes. The wardrobe designer, the art director who plans and supervises the building of settings, the drapery maker, the set dresser, the make-up artist, the cameraman all find their work influenced by the color angle.

These individual and departmental efforts require expert unified direction toward the one aim of using color to cause audience emotional and mental reactions in keeping with the spirit of the production.

This direction was placed in the hands of a "color committee" during the preparations for, and the filming of, Paramount's musical romance, "The Vagabond King." The Technicolor process of natural color photography was employed in the making of this Dennis King starring, all-dialogue and song picture. Members of the committee were: B. P. Schulberg, general manager of west coast production; J. G. Bachmann, associate producer; Ludwig Berger, the director; Herman Mankiewicz, author of the screen adaptation from the stage operetta; Hans Dreier, unit art director; Travis Vanton, wardrobe designer; and Mrs. Natalie Kalmus, the Technicolor Corporation's color advisor. Henry Gerrard, cameraman, assisted on photographic details.

The part that color was to play in the production was first discussed in general and then planned to the most minute detail by this committee. Among other things, the color schemes of each of the fifty-five settings and the several hundred pieces of wardrobe were evolved.

With this expertly planned course to follow, so far as their work was affected by color, the various production units carried out their tasks.

Dressing the players in colors to meet the mood and dramatic spirit of the action was the new problem brought to the wardrobe department. Style and harmony through contrasts of light and shadow are the sole concerns of the wardrobe designer for black and white pictures.

For "The Vagabond King," the fashion creator was required to clothe the players in "warm" colors for joyous scenes and to garb the menacing characters in

warning hues such as bright scarlet or deep black. Symbolic and suggestive meanings of colors were used throughout. Never were colors selected without some definite dramatic, emotional or pictorial purpose.

The art department was faced with another phase of the same problem. Constructing settings for a black and white picture is largely a matter of building rooms in which action can be played; different sorts of rooms and elaborate structures, it is true. For a color production, the art director must not only construct rooms; he must also paint them so they form a pictorial background for the action.

This background must be harmonious and in keeping with the dramatic spirit of the action played against it. For "The Vagabond King," settings ranging from the magnificent throne room of Louis XI of France to the meanest and dingiest streets of Fifteenth century Paris were constructed.

Rich blue and gold, with its suggestion of cold majesty, was the color scheme used in the great throne room setting. Somber grays and browns were employed in the gallows setting and the mean sections of Paris. Warm tones of red, pink and green characterized the rose garden and the palace festal setting. Purple, with its symbolism of royalty, was used effectively in the monarch's bed chamber and warm tints predominated in the boudoir of Jeanette MacDonald, the golden haired leading woman.

The drapery and set dressing departments had their own distinctive parts in completing these harmonious color arrangements.

Over in another section of the studio, the makeup chief and his assistants shaped their work to the changes brought by color. Entirely different makeups from those used in black and white pictures are required for Technicolor productions. Face rouge is employed in preparing players to face the natural color cameras and the principles of correct street make-up are followed closely.

The transition from dealing with lights and shadows to working with natural colors is most marked in the photographic and laboratory processes. Special cameras are required for filming pictures in Technicolor.

One path of light enters through the lens of the Technicolor camera, where it is divided into two paths of equal length by a prism. One passes through a red filter onto the negative film. The other penetrates a green filter. Thus two color corrected negatives of identical size are obtained.

An ordinary strip of motion picture film shows a series of black and white reproductions of the images before it. The Technicolor negative shows first a red recording, and then a green recording of the same figures.

The negative is sent to the Technicolor

laboratories where it is first developed so that all the red recordings are on one strip and all the green on another strip. The positive films are then printed much the same as are the colored sections of a newspaper.

The red recording are printed with the green recordings on the same film. The film is then rolled through a series of color presses until it has taken the hues as recorded in the delicate Technicolor camera.

The present Technicolor film is of exactly the same thickness as the ordinary black and white film. It requires no special projection apparatus, running through the standard machine without difficulty.

Lighting requirements for Technicolor and black and white pictures are different, and that brings a slight change to the work of the electricians on the setting. The amount and quality of illumination is governed by the cameraman, who must understand thoroughly the medium with which he works.

Even the property men and members of the "grips" force are affected by natural color photography. They had to pass color tests before they could work with "The Vagabond King" unit. One color blind workman might have caused considerable mischief.

(Layout on Page 10)

OUR PRESIDENTS

Nearly everybody worth while was born in February. George Washington, Abraham Lincoln, Saint Valentine and Joseph Biroc, William Clothier, Lloyd Combs, Ned Connor, Robert DeGrasse, Peter Denie, Albert DeSart, George Diskant, Max Dupont, Ross Fisher, Harry Flenner, Harry Gant, James Giridlian, Charles Glouner (withdrawal), Harvey Gould, Arthur Grant, Sol Halorin, T. F. Jackson, Joseph Johnson, Wallace Kelly, Donald Keyes, William C. King, Matthew Klueznik, Milton Krasner, Robert Kurrle, Joseph List, Bert Longworth, Cecil Love, George Lyng, John McBurnie, Carl Meister, Milton Moore, Al Myers, Harry Neumann, Henry Polak, Leonard Poole, George Richter, Donald Sargent, Fleet Southcott, Arthur Todd, Glenn Twombly, Homer Van Pelt, Fred Westerberg, William Wheeler, A. E. Williams.

They have no birthstone and don't need any, for they know early in life that they will be presidents of the United States.

If you believe in re-incarnation better begin to arrange to be born in February next time.

You can bring this about by talking to your subsconscious self about it every time you think of it. If you are persistent and nice to Sub he'll put it over for you.

 # Cream o' th' Stills

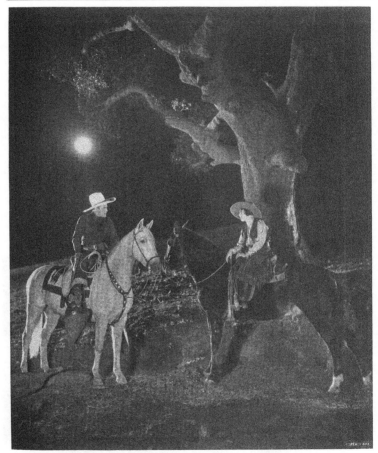

Ray Jones is particularly happy in the handling of a subject like this. A lover of the wide open spaces, he brings enthusiasm to the assistance of his art and never fails to get results.

Cream o' th' Stills

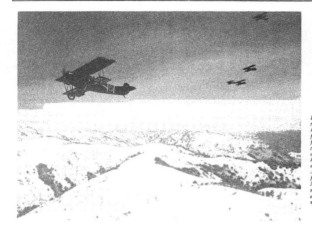

Elmer G. Dyer, like the albatross, is at home in the air. His flying camera is famous in motion pictures and the gods of the upper air know him well. Here he opens the eye of his Akeley over a snow field in the Santa Monica mountains, near Hollywood—an area seldom covered with snow.

Jack Alton made this intriguing exposure on one of his visits to the United States Military Academy at West Point. Here he picks up a charming view of "the lordly Hudson, moving in its silent, but majestic course to the sea," with the Kaatskills crowding close around to enhance the beauty of the scene.

Cream o' th' Stills

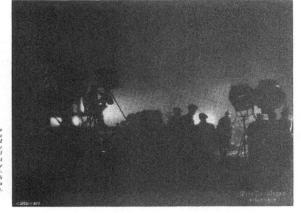

*Otto Benninger saw
a picture in this
night war-stuff and
promptly caught the
scene in his still
camera. Otto cannot
resist the silhouette
and, it must be ad-
mitted, that such
a picture has a
charm all its own.*

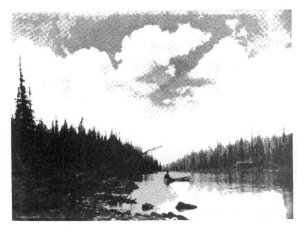

*Rambling around in
the Canadian
Rockies, J. A. Val-
entine paddled right
into the heart of the
Valley of a Million
Pictures. With a
birch canoe, a shack
on the shore and
plenty of film one can
imagine J. A. being in
a heaven all his own.*

Cream o' th' Stills

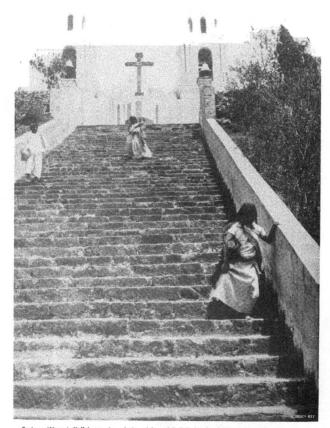

Enrique (Harry) Vallejo, a scion of the celebrated Vallejo family of Mexico, himself a native of our Sister Republic, caught this entrancing vista of the famous shrine of Guadalupe with devotees on the stairway. It requires a sympathetic and understanding artist to catch the true spirit of these people with a camera.

The Influence of Color

Sets in "The Vagabond King," good examples
of "the influence of color" in motion picture
production. Technicolor picture.

—*Photographs by John Landrigan.*

See Page Eight

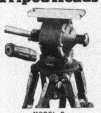

WHERE THE MONEY GOES

It has been estimated that the ordinary motion picture of program value, which is usually made at a cost not to exceed $100,000 over all, actually represents a working expenditure equivalent to $200 a minute of production time. An insight as to where this money goes was explained by Curtis Nagel, vice-president and production manager of the Colorart Synchrotone Corporation, Ltd., by showing a list taken from his pay roll in the making of the all-color short subjects.

This list includes everything except the cast. The cost of each item varies in accordance with magnitude of the picture, but the departments represented are essentials which cannot be obviated and are common to all motion pictures, whether they be of one reel or feature length.

Mr. Nagel states that it is quite possible that in many instances a half dozen or more accounts may be added to the list, but in general these are the items which represent the channels through which production costs flow:

Director, assistant director, script, dialogue, dialogue director, watchman, film cutter, film titler, property men, carpenters, grips, electricians, laborers, painters, cast, extra talent, animals, camera rental, negative, negative developing, positive prints, special work, photography, insurance.

Studio rental, lighting equipment, electric current, location rental, set rental, set construction, set dressing, prop rental, props purchased, wardrobe rental, wardrobe purchase, wig rental, orchestra, music rights, scoring, recording royalty fee, recording, sound track, duping, sound technicians, railroad and Pullman, automobile hire.

Auto expense, mileage-staff cars, trucking, meals, hotel expense, tips, location lunches, make up, make up man, stills, still man, scratch titlers, permits, special equipment, sound stage rental, projection rental, conductor, vocal music, effects, and miscellaneous.

BLESS POLLY'S HEART

Polly Walker, star of the R-K-O musical comedy, "Hit the Deck," presented each of her cameramen with a beautiful International Alliance emblem at the conclusion of the photographic work on the picture.

Director Luther Reed played Santa Claus, giving the boys Miss Walker's surprise packages as the names were called.

As the cameramen gathered around Miss Walker to voice their thanks she exclaimed: "Why, this is lovely. It's just like getting married." Well, anyway, thanks again to Miss Walker from the boys of Local 659.

"Hit the Deck" was photographed by Robert Kurrle, with Howard Greene supervising the Technicolor sequences. Associate cameramen were: Al Green, Robert DeGrasse, J. B. Shackelford, Harry Hollenberger and Ira Hoke.

The Wonder Box

(A Letter to the Editor)

Mr. Silas Edgar Snyder,
Editor International Photographer.

My dear Editor: Not having heard from me in some time, you are no doubt wondering what has become of me.

When you learn however what I have been about, you will not be surprised that I have had little if any time for correspondence.

Having always been of a mechanical turn of mind, as you well know I have devoted all of my spare time, which has been considerable, to the

JOHN LEEZER

invention of what I am positive will be the last word in animated picture camera equipment. So many of the boys have been inventing something along this line that I determined to exercise the unusual ability I possess, to the end that it will be unnecessary for any one, in this generation at least, to expend any more grey matter in the development of a motion picture camera. You may consider this a very high recommendation of myself and my ability but I am sure you will say that I am justified when you understand more fully the achievement which I have achieved.

Naturally such an undertaking needs financial backing. My invention embraces 743 items which must be covered by separate patents. This in itself will entail much expenditure of time and money. After that five to ten million will be necessary to build machinery and house it properly. It has been necessary for me to devise 22 new machines for making parts. Machines which function on principals altogether new to modern mechanics. I expect to interest D. W. in my enterprise but failing that I shall not be deterred. Mack Sennett will no doubt be glad to place sufficient funds at my disposal.

First you must know that my principal aim in designing the camera, has been to condense into one instrument or unit, all that is necessary to produce a picture, which will be in color only, with sound track, ready for assembling.

Condensing the sound equipment to such an extent that it could be accommodated within the camera was one of the first difficulties to be overcome but this was finally accomplished with the assistance of a young lady who was at one time chief operator for the Bell Telephone Company in Sand Prairie, Iowa. It was evident at once, that the sound track must be a part of the original negative. While photographing "Our Gang" comedies in Europe, I met a Turk in Turkey, who claimed that he could not only depict two or more kinds of emulsion on the one base but could easily make one of those emulsions sensitive to

colors,—without the use of dyes or filters. He intimated that he employed certain chemical salts which in themselves were sensitive, each to its own color and when developed in the presence of Neon gas, the negative became a positive and the subject in all its colors would be visible upon the screen. Fortunately I remembered the Turk's address and telephone number with the result that he has agreed to furnish me film, with a slow emulsion sound track on the same celluloid base as the color sensitive emulsion. I am sorry to pass up George Eastman this way but he can blame no one but himself for I begged him with tears in my eyes, to put a film similar to this on the market years ago and let me peddle it instead of J. E. Brulatour.

I had some little difficulty in persuading the Turk to let me in on the development or reversal of the negative image to positive by the use of Neon gas but when I gave him to understand that without this information I would purchase none of his film, he readily consented. Rather diplomatic — yes? — no? When once the secret was mine, it was a simple matter to contrive an attachment for the camera which would, with the aid of a jet of the Neon gas, change the negative to positive. This will no doubt work a hardship on Consolidated but it can't be helped. All laboratories must have seen the handwriting on the wall—in the perfection of television. One print only will be necessary for broadcasting in the United States and Canada, in English of course, so the film delivered by my brain-child will be ready for the Television-projector as soon as assembled. With the addition of an Ouija-board to the camera, the film could no doubt be assembled therein but I am acquainted with a number of the girls who depend on the scissors for a living and I am loath to deprive them of their orange juice diet.

With the sound equipment I have devised and incorporated within my camera, it possible to register only the sounds coming from the area covered by the angle of the lens being used at the time. All other sounds being tuned out. The lamp which registers the microphonic vibrations on that part of the film reserved for the sound track is, of course, shielded from the other emulsion so that it is impossible for the latter to become fogged. I take a great deal of pride, Silas, in thus bringing to perfection a feature of sound production so long sought. In this connection I wish to gratefully acknowledge my indebtedness to my friend George Kelley for valuable assistance.

As in the sound area, so is the illuminated area confined to the angle covered by the lens being used. A very powerful lamp mounted just above the turret, and no larger than a thimble, gives a dark brown ray to which the Turkish color emulsion is sensitive. The chief electrician of the Adohr dairy, who has

charge of all of their electric milking machines, gave me some most timely hints in working out this system of lighting. No light is necessary for the camera making the long shots because the set will be amply illuminated from the angles already covered by the other cameras. The super-sensitive color film is so sensitive to daylight that only the smallest stops can be used. In fact the largest stop which can be used on an exterior is F. 11.

The turret of my camera, controlled from a key-board in the rear, accommodates twelve lenses of different focal length. The longest being six feet. This lens will do away with expensive transportation for the camera crew to distant locations, as same can be covered from the studio towers. Incidentally it will go far to alleviate indigestion pains from partaking of box-lunches.

The entire camera unit is mounted on a rubber-tired truck—the tires being of sponge rubber to take up vibration caused by earthquakes, etc., etc., and operates under its own motive power—a battery small enough to put in your overcoat pocket. When I say that the entire unit, truck included, will weigh well under 47 pounds, you may well be astounded. You have no doubt, observed how light in weight celluloid is but it never occurred to you that such inflammable material could be used in place of metal. Of course it didn't. Well I have simply taken advantage of this natural phenomenon in that all castings, gears, shafts, lens mounts, etc., etc., are made of celluloid instead of metal. The celluloid when in a liquid state is mixed with Pyrene to make it fireproof and a small quantity of Portland cement to harden it and then poured into the moulds to set.

I have given you but a meager outline, Silas, of what I believe is destined to revolutionize the motion-picture industry but you can no doubt form some conception at least of its importance and magnitude. I am working night and day in order that I may the sooner receive the plaudits of my brethren and maybe get a job, because it's a cinch that at least three first, three seconds and six assistants will be required to operate this Wonder Box.

Wishing myself good luck, I am as ever,　　Yours very truly,
JOHN LEEZER, Local 659.

───o───

Karl Struss, winner of the Academy of Motion Picture Arts and Sciences award for the best motion picture camera work of last year, is photographing his fifth consecutive all dialogue United Artists picture of 1929—Dolores Del Rio's "The Bad One," with Edmund Lowe, a George Fitzmaurice production. Struss headed the camera batteries during the filming of Mary Pickford's "Coquette;" Herbert Brenon's production, "Lummox;" "The Taming of the Shrew," co-starring Mary Pickford and Douglas Fairbanks, and Lillian Gish's, "The Swan."

New M-R Rolling Tripod

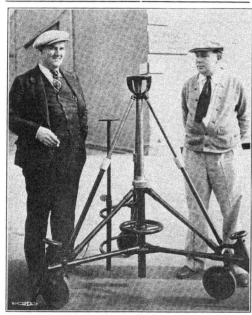

Wally Oetel, chief electrician at Metropolitan Studios and Arthur Todd, chief cameraman for Sona-Art, inspecting the new Mole-Richardson Rolling Tripod.

Ever aggressive in developing solutions for the equipment problems of our industry, Mole-Richardson, Incorporated, have developed a cleverly designed rolling tripod for use in conjunction with "blimp" cameras.

The additional weight of "blimps" has made the ordinary tripod inadequate as a supporting means. The accompanying cut illustrates this new piece of equipment, which embraces many useful features greatly facilitating the setting up of the camera equipment.

The tripod is constructed with specially designed bronze castings and steel tubing. The entire unit is mounted on eight inch rubber-tired casters, which allow the tripod to be easily rolled over such small obstructions as are almost always found on the studio floors.

When the tripod is used for a stationary set-up leveling screws are provided by which the camera may be leveled directly to the floor. The tripod embraces an elevating feature which permits the camera lens height to be adjusted from a standing position to a sitting position height by the operation of a convenient hand-wheel.

To give satisfactory rigidity three telescopic struts are provided which may be locked when the camera is brought to the desired elevation.

To facilitate the use of the rolling tripod for travel shots, pins are provided by means of which the casters, which ordinarily swivel in all directions, may be locked to a fixed position, as the Cinematographer may see fit. Either the Bell-Howell or Mitchell camera base may be applied to the camera support fitting. An auxiliary adjustable support has been provided on which the camera motor may be mounted. This makes the tripod, camera, blimp, and synchronizing motor a complete unit in itself which is readily portable, quickly set up, yet far more rigid than the ordinary tripod.

Mr. George Crone, director of the Sona-Art productions, has two of the M-R Rolling Tripods in use in their current picture, "The Dark Chapter," which is being photographed by Arthur Todd, ably assisted by Jake Kull.

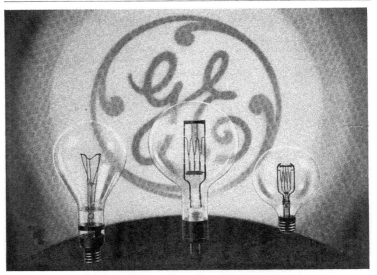

BACKGROUND

NATIONAL MAZDA Lamps—long a General Electric product—now take the name General Electric MAZDA Lamps.

What's in a name? In the case of General Electric MAZDA lamps, its background. "Long a General Electric product". That MEANS something. "MAZDA". THAT means something. Between them, they mean the finest quality, the utmost performance, the most exhaustive research that can go into the creation of an incandescent lamp.

To the moving picture photographer, The National Lamp Works presents photographic lamps upon which he may rely—General Electric MAZDA lamps. Thoroughbreds, they are, with a background of sterling achievement. On our staff of engineers are those whose sole occupation it is to study photographic conditions and lighting needs in the moving picture studio. Supplementing their efforts, are the invaluable contributions of the MAZDA research laboratories in Schenectady. That is why General Electric MAZDA lamps are constantly more efficient in meeting the specific demands of the motion picture photographer. National Lamp Works of General Electric Company, Nela Park, Cleveland, Ohio.

Join us in the General Electric Hour, broadcast every Saturday at 9 P. M., E. S. T., over a Nation-wide N. B. C. network.

GENERAL ELECTRIC
MAZDA LAMPS

A Letter from Donald Bell

The Retired Former Chief of Bell & Howell writes interestingly of the Beginnings of Projection and the Development of Cinematography Machinery

Left to right—*Original Magniscope; First Bell & Howell Standard Camera; Printing Machine (one of the "funny little things" referred to in text). (Photographs from Local 666, Chicago, Illinois.)*

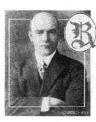

DONALD J. BELL

Brawley, California
Mr. Silas Edgar Snyder,
Editor "The International
 Photographer,"
Hollywood, California.
Dear Sir:

RESPONDING to your very complimentary invitation to present, through your publication, a review of my activities and engagement in the cinema industry, the following is offered:

Throughout the many happy years of my business life the desire to do something worthy and beneficial in the chosen line of my endeavor has always been uppermost.

THE MAGNISCOPE

The beginnings of my activities had much to do as an influence upon my purposes of the later years of effort, so first I must tell my beginnings. Arriving in Chicago, October 1, 1896, employment was secured as chief usher in the Schiller Theatre, on Randolph street. There we had the Lumiere Cinematograph, to me intensely interesting, but my desire to see the machine and become familiar with its operation was not satisfied as entrance to the booth was denied to all.

This Cinematograph was followed by George K. Spoor with the Amet Magniscope and its installation was to be my opportunity. The Magniscope required the services of an operator and an assistant, so in furtherance of my desire to learn the operation of motion picture projectors, I suggested to Mr. Spoor that he could secure my services at a nominal amount instead of full pay to an assistant.

I LAND A JOB

My suggestion was well received and my name was placed on Mr. Spoor's payroll, giving me the desired opportunity to become an operator. Many questions were asked of the operator, with the answers carefully recorded in my little book and, as I became familiar with the machine, the operator allowed me to carry the key to the booth, on my promise to keep the booth clean and have his show ready. This privilege and the kindness of the stage electrici an provided means to the end I sought, and it wasn't long until I had the job of operator at the Schiller.

Mr. Spoor had a booking agreement with a small theatre in Waukegan, Illinosi; my first experience as a "projectionist" was there. The Magniscope was mounted on a platform supported by beer barrels borrowed from a nearby saloon. The electric supply was a "cut-in" on street light series arc circuit direct to the lamp without resistance, on account of low voltage. The street were nearly dark in Waukegan that Saturday night on account of my demand made on the series arc circuit.

LIMITED FILM SUPPLY

Much coudl be told of my first few experiences as an operator when the art of cinematography was new, but my most impressive recollection is that even then the necessity for a definitely fixed standard was apparent to me.

The source of film supply was limited to a few American, English and French studios. All perforations, however, differed as to gauge of all dimensions, necessitating actuating means of sprocket or shuttle action so that they would engage any or all perforations. Correct registration was impossible and the moving picture projector soon came to be known as the "flicker-scope."

OUR EARLY FEATURE

On this account moving pictues were not popular after the novelty ceased and the engagements were few until some actual, and many fake, pictures of the Spanish-American War were available. About this time Mr. Spoor secured an engagement at a music hall in Chicago and during this time the Maine was blown up in Havana harbor. Soon thereafter pictures of the

wreck were available and after the beginning of the Spanish-American War some actual and many fake pictures, including Lubin's "Charge Up San Juan Hill," with Roosevelt, were offered. These pictures would now look very ridiculous to our movie audiences, as they were indeed very crude. The increased demand for films made production profitable and brought out many interesting short subjects, scenics, illusion and comedy, and some short stories.

The two outstanding feature pictures of 1896 were "The Empire State Express," produced by Biograph, on 70 mm. film, time thirty seconds and "The Cavalry Charge," by Lumieres, on the cinematograph, time about fifty seconds.

THE OPTOSCOPE

During the year 1898 MacMillan made the Optoscope, sold principally by Sears, Roebuck and Company. Mr. Spoor bought one for inspection and trial. This machine consisted of a small cast iron box, two gears, a driver geared direct to pinion on camshaft, barrel shutter, hard rubber sprocket, lens fixed to box and sliding aperture operated by finger movement for framing, a two pin cam necessitating large shutter area effecting a distressing flicker.

THE FIRST KINODROME

Mr. Spoor was, at that time, superintendent of the parcel room and news agency at the old Northwestern Passenger station, Chicago. He gained permission for me to use the machinist tools and bench at the station power house. Here the Optoscope was remodeled to make it practical for exhibition purposes. The lens and aperture were tied together and fixed to a substantial mounting and the mechanism was made to slide in this mounting to effect correct framing.

This machine was the first Kinodrome. My first engagement with that was at the County Fair at Beaver Dam, Wisconsin, in the fall of 1898. A favorable telegraph report to Mr. Spoor led us in to the Great Northern Theatre at Chicago and thereafter we had continuous booking for this machine and four more remodeled Optoscopes, under the name of Kinodrome.

KINODROME IMPROVED

One of these engagements took me to Shubert's Grand, at Syracuse, New York, where the first Kinodrome of my own design was made during the winter of 1899-1900. Sunday was a dark day in Syracuse theatres, so this day was chosen for my try-out. It would take many paragraphs to tell of my construction experiences, but suffice it to say that my months of work had a happy ending.

Mr. Shubert and his stage manager were asked to enter the theatre to see my next week's show and this show was projected by my new machine. Both exclaimed: "What have you done to the machine?" After being shown my new machine, Mr. Shubert at once offered to finance the machine by way of ten on a fair partnership agreement, but to me it seemed that in fairness to my employer, Mr. Spoor, I should give him the first call, so we two later on entered into an agreement under which we operated until 1908.

BUSINESS PICKS UP

It may be interesting to some to learn that during this engagement at Syracuse,

our program carried a wonderful picture of Dewey's fleet entering New York harbor. This picture was well received until Wednesday of that week when publication was made that Admiral Dewey had given to his wife the house in Washington, D.C., which had been presented to him by the school children of the United States. After this the picture was hissed and it was necessary to remove it from the program.

Our success at Syracuse and several theatres in Chicago brought great popularity to the "Spoor Kinodrome Service" and our business grew very rapidly, our engagements being vaudeville houses during the winter season and amusement parks during the summer.

Our business getting efforts were confined to the territory west of Cleveland, but, John Rock of the Vitagraph, in some clever way "edged" us out of a summer engagement at Saginaw, Michigan, so by way of retaliation I had the pleasure of assisting his Vitagraph operator to pack up at Wilmer & Vincents (Utica, N. Y.), Theatre shortly after their opening the following fall.

This business continued until the establishment of the moving picture theatre. The business was not on a very high plane in these earlier days and I recall the incident of a manager from Marion, Ohio, coming to the Spoor office to engage service for his new forty thousand dollar theatre. Our price for operator, machine and one thousand feet of film for a weekly program was forty dollars. This price seemed very high to the manager and to justify our price the first explanation given was that the operator received $15.00 per week. To this explanation his reply was that "he could get any boy in town to run the picture machine for two dollars weekly and the privilege of seeing the show." It should be added that Mr. Spoor did not receive the contract for this new theatre.

MEETS ALBERT HOWELL

My first introduction to "Bert" Howell was in the Crary Machine Works, at Chicago, where this shop made many parts for my Kinodrome projectors. My machines were really very crude in design, although quite practical and accurate. Mr. Crary kindly suggested that Bert could be a valuable aid to me as he was a competent draughtsman and a skilled mechanic. At this shop opportunity offered to witness Mr. Howell's very clever work on automatic machinery so, gladly, his services were accepted, the result being a fine redesigned machine following the details of a complete set of drawings from Mr. Howell's board.

Bert's experience in my work set his ingenious and prolific mind to work and one day he referred a drawing to me which showed that he was deeply interested in my line of endeavor. It was the drawing of a structure for which he had applied for a patent, it being the new and novel means for framing by cleverly swinging the cam on an axis to the star wheel, thereby advancing or retarding the intermittent sprocket to effect framing. This structure was used by the designers of Simplex who, at that time, did not know of its use on Kinodrome, as the Kinodrome had never been used in the New York City territory.

B. & H. COMPANY BORN

This display of talent by Mr. Howell

convinced me that in order to avoid competition from his efforts it would be well to establish a company wherein Mr. Howell would have a substantial interest, so the Bell & Howell Company was incorporated January 1, 1907.

AUTOMATIC MACHINERY

Our plans were to manufacture my Kinodrome machine and to attempt the manufacture of automatic machinery. In all seventy-five new model Kinodromes were made, but most of the number were put into my shop vault, as our projection business suffered after Mr. Spoor established Essanay films.

We made an automatic machine, a very efficient one, producing three thousand strawberry boxes per hour at a cost to us far in excess of contract price and sold by us under execution at a junked price in an attempt to satisfy our account for its manufacture.

"FUNNY LITTLE THINGS"

About this time, Mr. Spoor, who had established the Essanay Company, came to us with a printer, perforator and other film production machinery purchased in England for the use of the Essanay films. All were crank operated and, in fact, almost toys. At that time it appeared that no one had attempted the manufacture of cine-machinery to supply the trade. "The funny little things" which we were asked to make practical were a revelation to us so, as happily I had the financial means to attempt my fondest hope for the industry—Standardization, and having full faith in Mr. Howell's ability, it was decided that our company should engage in the manufacture of cine-machinery.

STANDARD PERFORATOR

My years of experience as an operator and designer of projectors established in my mind the paramount necessity of producing a standard perforator, this to be our first development toward effecting standardization of all motion picture producing machinery. We gathered together a great number of film samples of all makes and as many different intermittent sprockets as were obtainable. A very careful analysis was attempted resulting in what appeared to us as being the most nearly correct as to dimensions to adopt as standard. Our computation figures indicating the basis of our conclusions and why the B. & H. perforating gauge was adopted would possibly be dry reading, so will not be given herein.

Most certainly Mr. Howell joins with me in the belief that the design and making of a perfect perforator, effecting the beginning of standard cine-machinery has been an important factor and of lasting benefit to the moving picture industry now resulting in perfect projection, and that this machine, was our first undertaking, was our most important offering to the industry.

B. & H. STANDARD CAMERA

Following the perforator, the development of a B. & H. Standard Camera was attempted. Accuracy, close to our established standard, was our aim. The first two cameras were splendid instruments. One was purchased by Essanay and one by Kalem Company, of New York. After the first cameras were well along in work Mr. Howell's ingenius mind began to unfold, releasing many novel features for an accurate and efficient camera, result-

ing in the production of B. & H. Professional Model, now so well known throughout the world.

Many of the trade said that one thousand dollars could not be put in that small box, tripod, one lens, one magazine and carrying case, but the fact is that at that price, after two per cent, ten days, was taken on cash sales, the books of our company showed that our loss on the transaction was $1.92.

Now the trade is more liberal in their opinion as they are willing to pay several thousand dollars for one camera equipment and offer no complaint. Unusual were among those who could not associate the amount of one thousand dollars with Camera Perfection Language, so it was not until 1915 that they were convinced by demonstration, we having recalled that the old "Proof of the Pudding" talk might taste fine to the management, so a B. & H. was given into the charge of Klaffki, our only observance being it should be used for a complete production. Klaffki "rushes" soon brought demands from all directors on the lots for B. & H. cameras.

The above may sound much like a Bell & Howell Company advertisement or a testimonial to Mr. Howell's ability rather than a tale of my experiences in the industry, so I will modestly claim a good share in the early efforts we both gave to our undertakings.

And, though not being a skilled mechanic, a certain amount of native ingenuity and imagination was helpful to our promotions and a determination to be helpful and fair to our trade in our advices and business methods had much to do with our success and balanced our usefulness to the company quite evenly and I may claim with pride that, at the time my interests in Bell & Howell Company were sold to the present owners, the business was built on a very solid foundation, having a world-wide reputation for excellence so the new owners' path to the great success they have made, had previously been made smooth.

Redfield's Condenser

Reverting to early experiences, those of my engagements as operator and, later, as employer of operators, hold memories of instances, many amusing and some distressing, as my projection business with Mr. Spoor grew more rapidly than operators could be developed. Many of my boys became capable rapidly and, of course, some never could quite get the right line-up for success.

Before the advent of the movie theatre, many exhibitors sent out what we call "road shows." It is recalled that we sent Frank Redfield out with San Francisco earthquake pictures, but in our haste to get this show out, the condensers for the lamp were overlooked and his opening show too far from home to correct this mistake. At dinner in the American Plan Hotel, Redfield found a round water decanter on his table. Fortunately the sun coming through the window reached this decanter and Redfield at once noticed the rays condensed on a menu at the opposite side of the table. This ingenious operator immediately determined to try this decanter to replace his condensers and this was done by permission of the hotel manager and Redfield gave his show that night.

Chester N. Sutton, now manager of Mason Opera House, Los Angeles, was one of our first operators, he having served his apprenticeship with me at Syracuse, his home town in 1900. His first engagement was at Lake Erie Cosmo, Toledo, Ohio, and his first mistake was to connect his booth incandescent to a 500-volt circuit, resulting in a beautiful display of fireworks. Chester still calls me boss, and I will testify he can still qualify as a projectionist—although he soon left our employ to become manager in Orpheum Company employ.

Kinodrome Road Show

Mr. Spoor sent out a Kinodrome show with twenty-two pieces of baggage. This baggage included six Roman chariots, street banners, banners for horses driven in tandem and considerable advertising matter. Arriving at a small Iowa town, Mr. Jules Bistes, the operator, contacted the local manager, who it appears was the transfer man, the constable, the piano player and about everything in the small town.

Jules gave the manager twenty-two checks for baggage, but as the operator and the trumpeter for the parade were the only ones to alight from the train, the manager inquired:
"Where is the troupe?"
Jules, pointing to a small heavy Taylor trunk, containing the film, told the manager that the troupe was in the trunk. This hardly satisfied and an emphatic demand was made to learn when the troupe would arrive, and so on until our rube friend was made to understand that Kinodrome show was moving pictures.

Carl Laemmle's Start

Sometimes I wonder if dear old Carl Laemmle remembers the time when I, acting for Mr. Spoor, ran off many hundreds of feet of old film subjects for him at Spoor Company's office, and which he purchased at a very low price. We thought he had purchased lemons and Mr. Spoor was glad to get the money, but soon it was apparent that Mr. Laemmle was the wise one, for his "junk," added to a quantity of new film, placed him in a position to cut heavily into Mr. Spoor's film rental business and this was the start of the great Laemmle moving picture enterprises.

The Motion Picture Patents Company was formed about the time of the beginning of our Bell & Howell enterprise. Our first productions were sold to the licensees of this company only on the assurance given by Mr. Spoor that on these sales we were not infringing on any patents claimed by the Patents Company. While on its "death-bed" this company made a claim against us for infringement, asked many thousands of dollars from us, and gladly took one thousand, which was paid to avoid further .annoyance. Mr. Spoor took the license for my Kinodrome in his name and I paid the royalty.

Meets Bill Fox

It seems that William Fox, now a big figure in the industry, was the only one who successfully combated the Patents Company and its child, The General Film Company. This reminds me of my introduction to Mr. Fox by Doc Willett in the Men's Grill at the Claridge on Broadway, New York. Through the business relations between our companies, Mr. Fox

knew Bell and Howell, but our introduction brought a laugh to Mr. Fox, his first smile since Herbert Brenon made "Neptune's Daughter" with Annette Kellerman, Mr. Fox explaining that he had always pictured me in his mind as one of those long-bearded fellows like Nichols Power, designer of the Camerograph Projector.

It has always seemed to me that the trade owes much to Mr. Laemmle, as he was probably the most active in litigating the claims of the Motion Picture Patents Company and I am led to believe that Doc Willett, while in the employ of "IMP," Mr. Laemmle's first production enterprise, was very helpful and an important factor in "IMP's" production. Doc is the son-in-law of the late William Rock, one of the "License Bunch." Doc left a monument to his name when he quit the industry, Willett Laboratories at Fort Lee, New Jersey.

Beginnings of S. M. P. E.

Who recalls by whom and when was the Society of Motion Picture Engineers first suggested. Frank Cannock, designer of Simplex Projector; Mr. Howell and myself were having dinner one evening at the Hermitage, Forty-second and Seventh avenue, New York. If my recollections serve me correctly, I was the one at that time and place who suggested it was timely to endeavor to form the society that now so efficiently and intelligently works for the betterment of the cinema industry.

The December number of **The International Photographer** discloses to me three very interesting articles, ably discussed and cleverly illustrated: First, the Super Simplex; then references to George K. Spoor's activities and Mitchell's buckle proof magazine.

Because of my many years of friendly and interesting association with the designers and promoters of the remarkable projector Simplex, it is particularly pleasing to me to note that Simplex is the first to adopt my idea of correct position for the shutter. I most certainly shall seek an early opportunity to see the Super Simplex. It is also interesting to note that the Mitchell Camera Company has adopted my film take-up tension regulator which I designed and used on my Kinodrome projectors beginning about 1902. Mr. Jonson's illustrated article discloses that Mr. Mitchell uses spring tension, while on my take-up, an adjustable counter weight was employed to gain the correct balance between the constantly increasing film tension and the spring drive belt, the counter weight proving to be more effective on the lower magazine take-up than spring tension.

The pictures above your "Chicago Six-Sixty-Six" department and the subject matter take me back to the very beginning of my cinema experience, the Magniscope disclosed by Mr. Spoor being the one on which I received my first tuition. The hardwood "gated spindle" upper film holder on the Magniscope disclosed is the one I made and attached, this being my first mechanical work on a film projector.

The Magniscope was designed and made by Mr. Ed Amet, then of Waukegan, Illinois, but now of Redondo Beach, California. Mr. Amet's first projector, the companion to the one disclosed, is now in an honored position at the Smithsonian Institution, Washington,

D. C. The operator of this first Amet Projector, Mr. Amet's brother, is now residing here in Brawley, California. Mr. Spoor did not design or make the Magniscope.

The picture of Essanay's first perforator and the printer, as illustrated in this article are familiar faces, they being the "funny little machines" previously referred to herein.

Mr. Howell's first camera is correctly disclosed. True, the box was rather large, but it was a splendid instrument and its use by Essanay brought very favorable comment on the excellence of that company's photography. Now that the cinema industry may endure the cost necessary to conduct engineering and development of cinemachinery, to process a greatly enlarged film, there most certainly will be a great advancement in the art and my sincere hope is that Mr. Spoor's engineers will bring their activities to a successful conclusion and that along with the recording of natural color and the human voice will be the third dimension: to add to the beauty of moving pictures.

Let us all hope that those who are now devoting their talents and millions of dollars to special machinery to employ the use of a wider film will get together and adopt a certain definite standard as to all dimensions and details; then possibly within a few years the use of the 35 mm. film may be discarded and our movies may be a thing of beauty forever.

Here in my fine little home town I find much happiness in my agricultural developments. Some of my friends have heard that I have "invented something to take the flicker out of motion pictures," but I shall not attempt to explain my present connections with the cinema industry as the story would hardly be interesting to those not conversant with the subject.

One may be just as active and helpful in a small town as those having residence in metropolitan areas. We have everything they have, although not so pretentious, so with my own business affairs, Chamber of Commerce, County Board of Trade, Country Club, etc., I am very happy here one hundred and twenty feet below the sea's level.

Faithfully yours,
DONALD J. BELL.

NIG, LOCAL 659's DOG MASCOT

Technicolor has a lot of mighty good men from the cameramen's Local 659 in Hollywood. Technicolor also has Nig, 659's mascot, a little dog that is loved by all the cameramen in Hollywood.

All you folks that have known hunting dogs, love to see them get excited at the sight of a gun. Nig displays the same joy at the sight of a camera.

Nig was found outside Cecil DeMille's studio gate three years ago one rainy night, when Mr. DeMille was shooting Technicolor on the King of Kings. And Nig, with his sad brown eyes trying to tell the human world of his cold and hunger, was standing there like many of the thousands who come to Hollywood. Then some one who loves dogs came along—a member of Local 659.

Nig has been a trooper through twenty-eight productions and the last four have all been Technicolor. And as Nig is probably at heart, like his master is in person, part Indian, he likes all things in colors.

Focusing Device for the Mitchell Camera

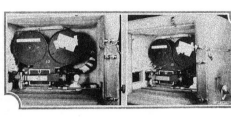

Joseph Walker has just completed the fabrication of a focusing device for Mitchell Cameras. By the use of the Walker device the camera can be accurately focused outside of the bungalow.

It can be attached to any Mitchell camera in half a minute and does not interfere with the action of the turret. It will work with any size lenses from a 25 mm. to a 12 inch.

In attaching the device no screw holes or other marks are made on the camera.

It does not interfere with free action of finder or door.

Brother Walker is using one of his new devices at Columbia studios where he will be glad to show it to anyone interested.

It is nothing new to Joseph Walker to make improvements for camera and other photographic equipment. He has many to his credit and is still researching for improvements.

Some day Joe may make a present of three dimensional photography to the industry.

THEY'RE TOGETHER AGAIN

(Continued from Page 8)

two young cubs did know how to crank a camera and it wasn't so long before they were the high men at the studio, made famous by Broncho Billy, Edna Mayo, Henry Walthall and other stars of the P. S. T. (Pre Sound Track) days. Jack Rose and Arthur Reeves were beginning to show the stuff that later made them top-notch cinematographers of the progressive school.

At Essanay they had the honor to operate Nos. 1 and 2 Bell & Howell professional cameras and their records at this studio enabled them to secure comfortable berths in Hollywood studios when production began to take its shift into this territory.

Arrived in Hollywood at different times the two side partners became separated and it was not until Local 659 was organized in 1928 when they found themselves closely associated in the fight to establish better working conditions for cameramen.

After the Local was organized and a going concern on a substantial basis Rose was called again into active production work but Reeves devoted his time to the building up of the advertising department of The International Photographer.

However, early in January Reeves heard the yelp for help that Jack sent out from Tiffany Productions, where he had for long been supervisor of photography and, thus, after sixteen years they were together again at the same old job of cinematogging, but under vastly different conditions.

Sound had come in and with it all sorts of freakish contrivances to silence the cameras — Warner's with their sound booths; Lasky with their "ice boxes" and baby blimps; M-G-M with their "Bungalows;" Columbia with their improved blimps evolved by Joe Walker and staff.

"Cyclone Hickey," directed by Jimmy Flood, was the picture which brought our two friends together. In this picture Jack Rose supervised the lighting and camera work while Art Reeves did the actual shooting and the combination once under way worked as smoothly and efficiently as in the halcyon days at Essanay. Geo. Hager was chief electrician.

Note in the accompanying layout the difference in equipment. The two cameras of the Essanay days are the first two wooden models made by Bell & Howell. Note the sound-proofed cameras of today with their heavy tripods built for quick leg adjustment, the camera head and box in perfect balance working easily on the free head. But it takes a lot more skill and energy to operate the camera of today, as in sound and color photography new problems are springing up continually.

Rose and Reeves improved the blimps at Tiffany studio with the co-operation of Chief Sound Engineer Lew Myers.

A Martens Photometer Adapted to the Reading of Photographic Densities

BY

O. E. CONKLIN, *Physicist Redpath Laboratory, DuPont-Pathe Film Mfg. Corp., Parlin, N. J.*

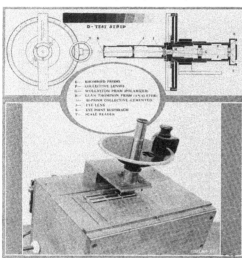

Top, Fig. 1—*Test Strip.* Below, Fig. 2—*Martens Photometer set up.* Top Panel, or Fig. 3—*Diagram of Bausch & Lomb Martens Photometer.*

The following description of the Martens Photometer may be of interest to those who are interested in sensitometry as applied to the development of sound pictures.

The Martens Photometer is used among other things for measuring photographic densities. The blackness of a photographic deposit may be expressed either as the per cent of light transmitted or as a density. The relation between the two units is given by the equation

$$D = 2 - \log T \qquad (1)$$

Where D is the density and T is the transmission expressed in per cent. The following table illustrates the numerical relationship between the two units.

Density	Transmission in Per Cent	Density	Transmission in Percent
0	100	1.0	10.00
.1	79.4	1.1	7.94
.2	63.1	1.2	6.31
.3	50.1	1.3	5.01
.4	39.8	1.4	3.98
.5	31.6	1.5	3.16
.6	25.1	1.6	2.51
.7	19.95	1.7	2.00
.8	15.85	1.8	1.58
.9	12.59	1.9	1.26
1.0	10.00	2.0	1.00

The density of a photographic deposit is proportional to the amount of silver per unit area. When a series of densities are plotted against the logarithms of the exposures which produced them we obtain the well known H & D curve. The physiological sensation of the blackness of a picture is proportional to the density, thus the densities .1, .2, .3, etc. appear to the eye to be equal steps of blackness. For all these reasons density is preferred to the percentage transmission as a measure of blackness.

The usual form of test strip is shown in Fig. 1. It is made by exposing a series of squares on one side of the strip, leaving the other side unexposed. In any optical photometer the density of these squares will be measured by comparing two beams of light. One beam must pass through the square to be measured and the other is either unobstructed or passes through the unexposed area. The latter arrangement will be found more convenient in most cases since it subtracts the fog and the density of the film base. The densities obtained in this way are the densities which are effective in making the picture. In order that the two beams may pass respectively through the exposed and unexposed areas, they should not be more than 10 mm. apart.

Perhaps the most popular instrument for measuring densities is the Martens Photometer. It was put on the market originally by Franz Schmidt and Haensch and more recently by the Bausch & Lomb Optical Company. The photometers in use in Redpath Laboratory are all of the Schmidt and Haensch type and were purchased without bases. Special direct reading density scales were made for them by the Bausch and Lomb Optical Company.

Figure 2 is a photograph of one of the photometers. In using it the test strip is first placed in a holder made of two pieces of 3/32" brass riveted close together except for a slot of .008" wide at its upper end to receive the film. The test strips being .006" thick and having a slight curl, there will be just enough friction in the slot to hold it in place. Also in the upper end of this holder are three sets of slot shaped apertures. The densities to be read cover the upper aperture, the fog strip the middle and the lower aperture is left clear. The lower edge of the holder is notched at regular intervals equal to the steps on the test strips. When placed on the photometer the holder rests against a bar through which a pin. This pin fits successively into the notches of the film holder thus bringing the successive density squares under the photometer head for reading. To which brings the fog strip and the clear area of the lower slot into alignment with the photometer. If one wishes to distinguish between fog and the light absorption of the base this clear area can be covered with a piece of film base. If the test strip is tinted, a piece of base of the same tint is placed over the lower slot. The base of the instrument contains a lamp whose position may be adjusted to set the zero reading of the instrument. Between the lamp and the film holder is an opal glass window which gives fully as complete diffusion of the light as more complicated devices.

The Martens Photometer depends on matching the intensity of beams of polarized light. Certain crystals, notably calcite, have the property of splitting a beam of ordinary light, which has a random vibrating motion, now in one plane, now in another, into two beams of polarized light which vibrate in two planes, at right angles to each other. Two optical devices, the Glan Thompson and Wollaston prisms make use of this property of calcite. In the Glan Thompson prism one of the beams is destroyed leaving a single beam of polarized light pass

(Concluded on Page 39)

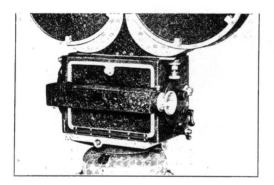

Fearless Newsreel Recorder

DEVELOPED FOR THE CAMERAMAN

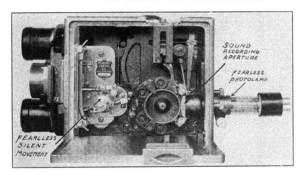

Rebuilding Bell & Howell or Mitchell camera for silence; Installing Fearless Silent Movement and equipping camera for Sound Recording$1,500

Bell & Howell silenced and equipped for sound recording

Fearless Newsreel Recorder, including the rebuilding of your B. & H. camera, as pictured above or your Mitchell for sound recording; Fearless Recording Amplifier, 2 Fearless Photolamps, 1 Condenser Microphone, batteries, cable, etc., contained in carrying cases..$3,600.00

Fearless Newsreel Recorder with Fearless Camera, and recording equipment as listed above.. 5,800.00

Director Current Camera Motor.. 100.00

Speedometer .. 75.00

Fearless Photolamps — replacements.. 50.00

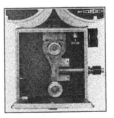

Fearless Sound Recording Head for recording separate sound track...$1,000.00

FEARLESS CAMERA COMPANY

Formerly Cinema Equipment Co.

7160 Santa Monica Boulevard Hollywood, California

Hoke-um
By IRA

Well; How Did It?

Clyde DeVinna, who recently returned from a six months' trip to British East Africa where he photographed "Trader Horn" for M-G-M, invited several of the boys in to see some snapshots from the jungles.

After showing a number of interesting stills, Clyde finally displayed one of a magnificent lion stretched dead at his feet.

"This lion," said he, "I shot in my pajamas."

"Gosh-a-mighty," exclaimed Joe Darrell; "how in the world did it get in there?"

— :: —

Rumor

Al Gilks: "So you were in Caliente last week, eh?"

Art Reed: "Yeah—that's what I hear."

— :: —

That Settles It

Maury Kains (looking for an argument): "Who won the war?"

Earle Walker: "Well, the Germans have eight per cent beer. Figure it out for yourself."

— :: —

Looking Out for No. 1

Bert Lynch says he had a dandy Christmas. He presented the youngsters with a pool table, and his wife with a five-pound box of smoking tobacco.

— :: —

Too Late

On one of the recent cold nights Harry Hallenberger parked in front of the Hollywood Chamber of Commerce and proceeded to cover the engine of his Ford coupe with a blanket.

A newsboy watched Harry for a few moments, then remarked:

"Don't cover it up, mister, I saw what it was."

— :: —

Heredity

First Extra Man: "What makes you so rude?"

Second Extra Man: "Sorry. It's inherited; father was a studio gate keeper."

Sticking Close to Business

Sign on Cahuenga Pass—DR. WOOD, TREE SURGEON.

— :: —

Some Distance to Go

News Cameraman (upstate on an assignment): "Have you been living around here all your life?"

Ancient Native: "Nope. Not yit."

— :: —

And That Isn't All

John Landrigan: "Who made the first cotton gin?"

H. C. Ramsey: "Land sakes, are they making it from that too?"

— :: —

Optimistic

Tom Tutwiler is my idea of an optimist. He does all his cross-word puzzles in INK.

— :: —

How Does Ira Know? (Ed. Note)

One hand of strip poker would send any of those M-G-M revue girls home in a barrel.

— :: —

Statistical

Eddie Garvin, mathematical wizard, has recently compiled statistics showing that under proper conditions a quart of gasoline will move an automobile 3 and 3/8 miles. When carelessly used as a cleaning fluid, the same quantity may readily move three fire trucks, an ambulance, and a large number of onlookers about the same distance.

— :: —

True to Form

During the recent cold snap something gummed up the works of the thermometer outside the Chamber of Commerce building, and the worst it would do was about 75.

Along came a man, bundled up to his ears, but shivering nevertheless. For a moment he gazed at the thermometer, then turned away in disgust, saying:

"Ain't that just like the gol dinged Chamber of Commerce anyway?"

— :: —

Infamous last words—"I thought that tripod was steady."

The Daily Grind
By RALPH B. STAUB

Assistant to JACK YOUNG: "You never encourage me."
Jack: "Well you never offered to jump out of a window."

* *

A beautiful extra girl was leaving the studio after the day's work and was accosted by IRVING GLASSBURG.
Irving: "Want a ride home?"
Girl: "I want you to know that I'm a lady."
Irving: "I know that—if I wanted a man I'd take my brother out."

* *

HAL PORTER says his assistant is so wide-minded a mosquito could do the split between his eyebrows.

* *

Cameraman Out of Work: "Things are tough—I haven't worked in a long time."
GILBERT WARRENTON: "Don't get discouraged—they still make guns and night still falls."

* *

EDGAR LYONS: "Do you think the opposites attract?"
BUD LONGWORTH: "Sure—that's why I'm looking for a girl with money."

* *

SPEED MITCHELL was once a lifeguard at the beach—but he went crazy trying to learn the epileptic stroke.

* *

BILLY WILLIAMS (to assistant): "I'm going to the masquerade ball tonight —are you going?"
Assistant: "Well, I think so but I don't know whether to dress as a jackass or go as I am."

* *

JOE TRAUB: "My gag man's sipping soup in Henry's.
STAUB: "That's great sound effect."
TRAUB: "That's nothing—wait till I get up to speed."

DWIGHT WARREN and assistant in theatre. Very poor picture; everyone hissing.
Assistant starts applauding.
Dwight: "Don't do that, can't you hear they're all hissing."
Assistant: "Well I'm applauding the ones who are hissing."

* *

ARCHIE STOUT (to assistant): "You mean as much in this world as one sock —you're only half there."

* *

Absent Minded Half Sleepy Director in Cafe: "Bring me a ham and egg sandwich."
Waitress: "We haven't any."
Absent Minded Director: "Fake it."

* *

STANLEY CORTEZ was a doctor before he entered the picture business. Once called upon a maternity case; the mother and baby died but he saved the father.

* *

OLLIE MARSH claims he is the man who put the hyphen in M-G-M.

* *

ELMER FRYER: "Remember a bird in the hand is worth two in a bush."
JUNE ESTEP: "Yes, and a bird in the hand soils the cuff."

* *

Assistant coming to work with a black eye.
DICK FRYER: "What's wrong?"
Assistant: "Aw, I mistook asthma for passion."

* *

BILLY MARSHALL'S definition of a sound man—one who has his mother's eyes, his father's nose and his uncle's interlock.

* *

Famous Last Words: "Remember boys it's all in fun."

The Laboratory Technicians

The Journey of the Film from Cameraman Through the Laboratory

— By CARL KOUNTZ —

PART TWO

The negative assembly room, with its expert workers, plays an important part in the laboratory. The dry films have to be handled carefully and sneedily as the enormous footage that is handled nightly at times runs into a hundred thousand feet or more and has to be made ready for the printer so that the work may go on without any interruption. To the casual onlooker watching this work, it may seem a wonder that a lot of the film is not scratched or ruined, yet these trained experts will run through a night's work with only an occasional error.

After the good scenes have been assembled into rolls, each scene is notched. This notch is in the form of an "elongated crescent." The reason for this will be explained when we come to printing. A card is made out for each roll, then both are given to the tester. Here a light test is made for each scene. The machine upon which this work is done has a glass panel fitted into the top. This panel is usually spaced into eleven (11) slots or frames, so adjusted that each succeeding frame receives a definite increase of light usually two points. The varying density thus obtained corresponds with the amount of light that can be obtained in the printing machine by varying its shutter openings. The Bell & Howell printing machine, which is standard equipment and stages at its shutter opening. These almost universally used, has twenty-two stages of the shutter opening are called light points.

When the tester has finished with his work he turns his test over to the positive developing room. Here the test rolls are developed, fixed, washed and dried and given to the light test reader.

To be able to judge the density and keep this uniformly from day to day requires an enormous lot of experience and good judgment. Errors here not only mean waste of film, but all the labor that goes to finish the film and the loss of precious time, which at times overshadows the cost of the labor and value. The light test recorder has an indirectly illuminated box with a strip of ground glass on top. Here he selects the right density or printing time for each scene, marking down the printing time on the card which accompanies the negative. In the meantime the negative is given a cleaning as particles of dust or other foreign matters collect and the film is not accepted in this condition. Benzine, carbon tetrachloride or a light rubber solvent are used as cleaning fluids, these liquids being so volatile that a roll of film can be run through a cloth wet with any one of them and be dry in a very few seconds; after this, the film is given to the printer.

The printer's job is by no means a bed of roses, the work is confining and at times montonous, yet the man has to be an expert to do his work right, particularly so since the advent of the "talkies."

During the regime of the silent film the requisites for the printer were not as exacting as now. He did not have to worry about sound synchronization or about the mats for blocking out the sound for the picture, as in the sound-on-the-film system the sound and the pictures are usually recorded on separate films. The fault is that of the printer if the finished film is out of synchronism, providing the film was cued properly. A few frames either way and the sound will come either too soon or too late for the lip movement as seen on the screen.

Now to go back to the crescent shaped notches mentioned in a previous paragraph. These notches are cut about five inches from the end of the scene; in case of double notching as in release work, the left side of the film is also notched. This notch is cut 5 inches from the beginning of the scene. This is done so that the film does not have to be rewound after each printing. On Bell & Howell printing machines about 5 inches from the aperture there is a small roller connected with an electro magnet. This roller rides along the side of the film and when it strikes a notch it shows on an indicator that a new scene is coming and that perhaps a change of light is necessary.

(Continued in March)

———

The Laboratory Technicians and Film Editors have moved to their new offices, at 1605 North Cahuenga, Marion Building, Hollywood, California. The organiztaion grew so fast that it was necessary to look for larger quarters in order to perform the work more efficiently. It is well to mention that the Film Editors are showing a wonderful spirit in the organization of their craft and we congratulate them.

———

Things have been humming in Local 683 during the last month or so. Christmas over gave the members a chance to get into the spirit of the work, especially the Board of Directors and above all the Ways and Means committee.

SICK MEMBERS

Sister Martha Rosseter is doing very well, but would be glad to see more callers. When you have a minute drop in.

Sister Elva Frasier is at the Barlow Sanitarium. Visitors hours are from 4 p.m. to 5:30 p.m. daily. She has made wonderful progress since Christmas.

Brother Bill Hinckly, the boy with the jovial face and heart full of joy, is at the Cartheasican Hospital, 1605 South Figueroa street, Los Angeles. Brother Bill is again sick from metal poison which he contracted on the Ben Hur picture for M-G-M in Italy some few years ago. Bill looks good and feels good but all laboratory technicians know what metal poisoning is.

Brother Cliff, at the Sylvan Lodge Hospital, is doing better than any of us expected. It was a ten to one shot that Cliff's leg would be stiff, but you know Brothers, that power of determination does wonders. Cliff expects soon to be around on crutches.

Every member of Local 683 should make an effort to get behind our Business Representative Kountz and give him all the information and support that he requests from time to time. He is indefatigable in his work for the Local and needs the help of all members, particularly at this time.

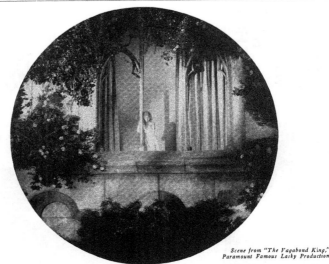

Scene from "The Vagabond King,"
Paramount Famous Lasky Production

even balance

LIGHT struck from National Photographic Carbons permits an even balance of light *and shade;* between actors and the rest of the set. Light from these arcs has penetrating power unequaled by any other form of studio lighting.

For night shots, National White Flame Photographic Carbons (hard-arc) can't be beat. Their light is identical with sunlight. Permits clean, sharp moonlight effects, or brilliant contrasts.

National Panchromatic Carbons (soft-arc) give a softer orange-colored light, ideal for close-ups. Particularly effective in taking colorful scenes, as their light, rich in red, orange and yellow-green rays, smooths and softens the face, and brings out natural tonal shades in costumes and settings.

National Photographic Carbons (White Flame or Panchromatic) are interchangeable and come in sizes to fit any studio arc lamp. Tests prove that they are the most economical form of studio lighting, as these carbons give more light per watt of electrical energy.

NATIONAL CARBON COMPANY, INC.

Carbon Sales Division: Cleveland, Ohio

Branch Sales Offices: New York, N. Y. Pittsburgh, Pa.
Chicago, Ill. Birmingham, Ala. San Francisco, Cal.

Unit of Union Carbide ⬚⬚⬚ *and Carbon Corporation*

National Photographic Carbons
White Flame and Panchromatic

MAINTAINING SIMPLEX SUPREMACY

The new **Super Simplex**

with

Pre-Focusing
Lens System

VIGNETTE TYPE

REAR
SHUTTER

Simplex

The International Projecto

IMPROVED
LENS MOUNT
OILING SYSTEM
FILM TRAP
EYE SHIELD
THREADING AND
FRAMING LAMPS, ETC.

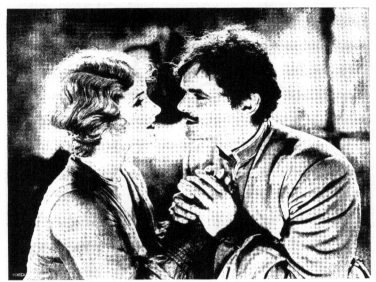

The only *absolutely*

SILENT

Incandescent Spot Light

Light in weight—

SILENT in operation

THE LACO LITE HAS PROVEN ENTIRELY SATIS-
FACTORY IN SUCH STUDIOS AS PARAMOUNT
FAMOUS LASKY CORPORATION, R. K. O. STUDIOS,
INC., COLUMBIA PICTURES CORPORATION, TIF-
FANY PRODUCTIONS, INC., AND TEC-ART
STUDIOS, INC., WHERE OVER EIGHT HUNDRED
LACO LITES ARE NOW IN SERVICE.

If it isn't a LACO it isn't SILENT

LAKIN CORPORATION
1707 Naud Street

CApital 5387 LOS ANGELES, CALIFORNIA

A camera crew of Local 659, aboard U. S. S. Maryland, at San Pedro, filming Universal's latest Glen Tryon picture. Left to right—Harold Gates, Lloyd Ward, Bob Morton, Gilbert Warrenton, John Hickson, George Bourne, Leonard Galezio, Bert Six.

AN AUTOBIOGRAPHY
.. By Frank C. Bangs

I am one of the most important parts of
 the world's greatest industry and,
 still,
I am the most neglected.
The motion picture industry would not
 be so far advanced today, if it had
 not received by help.
I am one of its most permanent records.
I bring thoughts of sorrow.
I also bring the message of joy, happi-
 ness and laughter.
I give my message to the world in many
 different ways and the editors of the
 different periodicals of the world are
 glad to receive me, when—
I come in a pleasing form.
It is difficult for me to receive the touch
 of life.
I am the "bete noir" of many directors
 as I tend to interrupt their transition
 of thought.
I meet the leading characters usually
 when they are tired and uninterested
 and again
When I have come to life,
They are most anxious to look upon me.
I tell the story of the picture I am with,
 to the world before it sees the light
 of day.
I have secured employment for thousands.
I go to the offices of the man who help
 to make the pictures famous.
The men who give the pictures their
 value through publicity and they re-
 ceive me with
Gladness or with sadness.
To the selling force I give encourage-
 ment;
If my appearance
Meets their approval,
I sell the pictures.
The world crowds around me in front
 of the theaters and they either go
 in to witness the cause of my birth
 or
They turn away and are not interested.
I go out into the world and announce
 my master is to follow.
In the journals of the world's publicity,
 I live as a record
After my master
Is dead and forgotten.
I am a still picture.

Copyright, 1928, by Frank C. Bangs

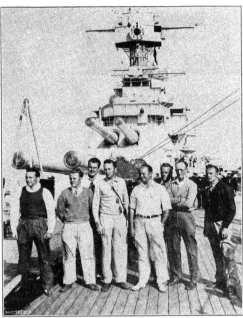

A camera crew of Local 659, aboard U. S. S. Maryland, at San Pedro, filming Universal's latest Glen Tryon picture. Left to right—Harold Gates, Lloyd Ward, Bob Morton, Gilbert Warrenton, John Hickson, George Bourne, Leonard Galezio, Bert Six.

AN AUTOBIOGRAPHY

By Frank C. Bangs

I am one of the most important parts of the world's greatest industry and, still,

I am the most neglected.

The motion picture industry would not be so far advanced today, if it had not received by help.

I am one of its most permanent records.

I bring thoughts of sorrow.

I also bring the message of joy, happiness and laughter.

I give my message to the world in many different ways and the editors of the different periodicals of the world are glad to receive me, when—

I come in a pleasing form.

It is difficult for me to receive the touch of life.

I am the "bete noir" of many directors as I tend to interrupt their transition of thought.

I meet the leading characters usually when they are tired and uninterested and again

When I have come to life,

They are most anxious to look upon me.

I tell the story of the picture I am with, to the world before it sees the light of day.

I have secured employment for thousands.

I go to the offices of the man who help to make the pictures famous.

The men who give the pictures their value through publicity and they receive me with

Gladness or with sadness.

To the selling force I give encouragement;

If my appearance

Meets their approval,

I sell the pictures.

The world crowds around me in front of the theaters and they either go in to witness the cause of my birth or

They turn away and are not interested.

I go out into the world and announce my master is to follow.

In the journals of the world's publicity, I live as a record

After my master

Is dead and forgotten.

I am a still picture.

Copyright, 1928, by Frank C. Bangs

Top—*The new Dunning Process Building at 932 North La Brea Avenue.*
Left center—*Machine now installed for making Dunning Dupe Negatives.*
Center—*The Plant also contains a rack and tank system for emergency developing on tests made at night.*
Center right—*Showing end of automatic machine for making Dunning process plates. Sixteen operations are performed by this machine, without touching the film.*
Lower center—*A corner of the chemical laboratory, where Dodge Dunning daily continues his technical research work.*
Lower left—*Pres. Dunning's private office is most inviting.*
Lower right—*A library of published works on all branches of photography is being collected.*
Below—*Dodge Dunning, inventor of the Dunning Process.*

Expansion With a Big "E"

Another important firm of "Tek-Nik-Towne"—in Hollywood joined the elect the other day when Dunning Process Company, whose cinematographic wizards have put magic into many motion pictures, left their old quarters at 1616 Cahuenga Boulevard and took possession of their attractive and commodious new building at 932 North La Brea, Hollywood.

This building just completed from plans suggested by President Carroll Dunning is unique in the industry, it being the first private studio ever built for special process work exclusively. In short this studio is what is considered by technicians as being the finest and most complete technical laboratory in existence today, which houses the most up-to-date and unquestionably the finest machinery obtainable for double exposure and trick photography.

The accompanying cuts give the reader a fair idea of the new Dunning plant, but only a personal inspection will enable one to appreciate its many interesting details.

Their new plant is the logical outgrowth of a business course of integrity, industry and unbeatable service and, at that, it represents not the ultimate in Dunning evolution but only a long step forward toward a great ideal.

The new home of Dunning Process Company is built on a tract of ground facing on La Brea—75' by 150'. A lawn and flower garden occupy the front 75' and a five foot wall separates the lawn from the building proper leaving a strip of ground 15' wide inside the wall for a private garden.

The business offices, laboratory, drying room, cutting room and President Dunning's private office are on the main floor, while in the sound proof basement is the heating apparatus and the electrical equipment of various kinds.

All the second floor is a studio for animating and other trick photography; a real fire-proof vault of large capacity and a roof garden equipped for use both as an outdoor stage and theatre.

There is nothing lacking here that should appertain to such an establishment and the capacity of the plant is limited only by the endurance of the operators.

A brief sketch of Dunning Process Company and its personnel is interesting.

From 1918 to 1923, Carroll Dunning, now President of Dunning Process Company was vice-president and general manager of Prizma Incorporated, which organization, by the way, made the first feature length all color production starring Lady Diana Manners and introducing Victor McLaglen to the American screen.

During that period Mr. Dunning experimented with the possibility of applying color separately to the production of double exposure in black and white photography, but his son, Mr. Dodge Dunning, is responsible for the perfection of the Dunning Process of double exposure. Dodge began his experiments while still

a high school boy and was only seventeen years of age when he applied for his first patent in 1926.

It is an interesting commentary on business expansion to compare the small closet in the basement of the Dunning home, which then served as a laboratory, with the new Dunning Building on La Brea Avenue.

This building as has been stated, houses the most up-to-date automatic developing machines and other equipment necessary for the execution of all types of trick photography and technical photographic work, also as has been stated, it is the only institution of its kind and makes a much needed addition to the facilities necessary for the production of the present day feature picture.

The first studio to use Dunning process was F. B. O. and the first picture on which Mr. Dodge Dunning worked was "Lady Robinhood," photographed by Roy Klaffki. The late Fred Thompson, who was very technically inclined, took a great interest in Dodge and was very helpful to him in playing the actor for his early demonstrations tests.

Several F. B. O. pictures contained Dunning shots during the years 1926-27, but the work was carried on so quietly that the industry as a whole knew nothing of this process which at the present time is creating so much interest in all studios. The initial work of, any importance done by this company was the double exposure shots in the battle scenes in Corinne Griffith's "Divine Lady."

The great development of this business has been brought about by the "talkies." Ever since "In Old Arizona" was made the studios have attempted to remove the stilted type of the "parlor, bedroom and bath" drama and get out into the great open spaces "where movies are movies" and the action we now see on the screen depicting the spaces of the great out-of-doors makes it almost impossible to believe that it was shot within the four walls of a sound stage.

Even many of those on the inside of the industry believe that Will Rogers went to Paris to make "They Had to See Paris;" that Gloria Swanson and Henry B. Walthall were compelled to go to Chicago for the street scenes in "The Trespasser," or that Jack Holt and Ralph Graves actually took the hair-raising chances in mid-air as depicted in "Flight," nevertheless all of these pictures and many other thrill shots were made by Dunning Process in the studio. In fact there were eighty-four Dunning shots throughout the aerial sequences of "Flight."

This not only means a great saving in production expense but is a boon to cinematography because it eliminates the danger to life of the cameramen and their assistants and in most cases makes it unnecessary to take chances in order to make thrill shots.

The following are the titles of a few productions containing Dunning process shots: "The Divine Lady," "Saturday's

Children," "The Man and the Moment," "This Is Heaven," "Hell's Angels," "The Cock-Eyed World," "Half Marriage," "The Trespasser," "The Rescue," "Love and the Devil," "Whirls and Girls," "Scandal," "The Flying Fool," "Riesenfeld's 1812," "Masquerade," "Tin Pan Alley," "Anna Christie," "New York Nights."

In addition to these the Dunnings were responsible for the sky-scraper scenes in Victor McLaglen's recent production, "On the Level" and the flying scenes in the late Kenneth Hawkes' recently completed production "Such Men Are Dangerous."

They are now conducting experiments in their chemical department in an endeavor to improve the quality of duplicate negatives. This department is under the supervision of Mr. Dodge Dunning, ably assisted by Wallace Kelley.

Mr. Dunning, Sr., devotes his time with directors and production executives in going over the scenes and mapping out sequences showing production value through the use of Dunning shots. The business manager of the laboratory is Mr. James Cowper.

The Dunning Process Company control particular patents covering the use of a balanced transparent background scene in conjunction with foreground action. They also have covered by patents the elimination of extraneous noises or sounds by shooting the outdoor scene in silence and combining it with foreground dialogued action. At the same time such extraneous sounds as are necessary can be introduced whenever desired so as not to interfere with dialogue. We all know how difficult it is to take streets scenes and to have any control over the street noises while scenes are being shot.

In 1927 Mr. Dunning, Sr., was made the first chairman of the Pacific Coast Section of the Society of Motion Picture Engineers and was re-elected for a second term last year.

The New Jenkins Camera

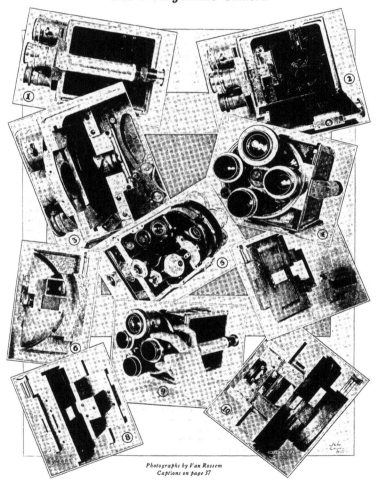

Photographs by Van Rossem
Captions on page 37

J. F. Jenkins Describes New Camera

The newest professional motion picture camera to be announced is that of Brother J. F. Jenkins, who has but recently put the finishing touches to a mechanism which promises most interesting developments.

Mr. Jenkins declares that his intentions in designing this camera were principally to remodel the Bell & Howell to make of it not only a silent camera, but one calculated to meet every reasonable demand of the cameraman under the conditions of production brought forth by the advent of sound and color.

Said Mr. Jenkins in explanation of his work:

"My conception of a modern motion picture camera is one free from mechanical defects and I considered one of the best ways to avoid mechanical difficulties was to eliminate all trigger mechanism.

"The first feature of importance, according to my way of thinking, in a camera is a quick focusing device that allows the camera to be focused without shifting the camera or lens. This is done in my camera by a surface reflector set at a 45 degree angle.

"The microscope I use for the ground glass turns the image up straight, with sides correct, and with full illumination to the corners of the aperture. The entire optical system is designed to transmit to the eye-piece all the possible light that come sthrough the ground glass.

"I use the original Bell & Howell eye-piece as the back element in the microscope which is a little saving in converting the camera.

"Another important feature is the film pull-down mechanism and the film track. I use an intermittent sprocket that runs at right angles off of the shutter shaft for pulling the film down. This sprocket serves two purposes, the second purpose being that, when the sprocket stops, two teeth on each side are engaged in the perforations, the top tooth on each side engaging in the top of the perforations and the, bottom of the lower teeth engaging with the bottom of the lower perforations, so that when the sprocket stops the film that is to be photographed. This ends scratch difficulties.

"The fly wheel shutter and intermittent cam are solid on one shaft so that it is impossible for the shutter to get out of time. This eliminates gears and other mechanism. The shaft comes out the back of the camera and engages with the synchronous motor. The movement is so made that, by opening the door of the camera, it can be pulled out and taken completely apart without loosening latches or removing any screws. It is also designed so that if the movement is not threaded up properly, it will not close.

"Mr. Jenkins has increased the shutter opening to such an extent that an F 3.5 lens will take very satisfactory pictures when the set is lighted for an F 2.3 lens in connection with a 170 degree shutter. This should eliminate a lot of critical focusing in photographing moving objects.

He has kept to the standard of the Bell & Howell in re-designing the camera, as the shutter shaft runs at the same speed and in the same direction, and the lenses are interchangeable without resetting in the mount. He has also retained the origi nal Bell & Howell ground glass as it is necessary to use this when using a lens of les sthan 32 mm. focus. This acts as a check for the movable ground glass should the cameraman be in doubt about the movable ground glass being in exact alignment.

Said Mr. Jenkins: "I spent a year developing this camera and I should like to manufacture it myself but as this is a fast moving business and requires great capital, I have found it necessary to rely on other sources. Thus far I have made no permanent arrangements for its manu-

Fig. 1—*This shows the microscope and portion of the movement that is on the outside of the camera. At the top of the movement is the lever that operates the focusing device. You will notice that I still use the Bell & Howell eye piece, in the back of the microscope. This feature will immediately show a decided sawing towards converting the cameras. I want to call your attention to the fact that when the microscope eye piece is pushed in it is flush with the back of the camera, so there is no danger of bumping it or damaging it. The image as viewed through this microscope is right side up and sides correct with full illumination at the corners of the picture.*

Fig. 2—*This shows the intermittent movement in the camera. You will notice that the focusing aperture is slightly ahead of the photographing aperture. One feature of this movement is that there are no latches that hold it in the camera that have to be latched by the cameraman, as sometimes they forget to lock them in. On the door of the camera at the opening of the microscope is a piece of metal that locks the movements solidly in the box. Another feature that I might mention here is that the movement is so built that unless it is threaded up properly the movement will not go in and the door will not close.*

Fig. 3—*This shows the camera with the movement removed, exposing the cam. I wish to state here that the fly-wheel shutter and cam still remain on the same shaft that the motor drives, thus eliminating any gears operating other than for driving the take-up sprocket while shooting sound pictures. The shutter has a great deal more opening than your present camera and will take very satisfactory pictures with any F 3.5 lens, where cameras of 170 degree opening are using a stop of about F 2.3. Owing to the type of this intermittent there are no reciprocating parts and there is very little vibration in the entire camera. Cams of this type can be made that will allow as little shutter opening as 160 degrees and by merely changing the cam and not the roller mechanism that engages in it a shutter opening of about 300 degrees is possible. The 300 degree shutter would of course make a little more noise, but where light conditions are*

very bad it would take pictures that have never been photographed before. However for studio work a shutter opening of about 250 degrees is quite practical. It will permit the photographing of interiors with about 75 per cent of the light that they now use.

Fig. 4—*The front view of the camera shows the distance the microscope projects and the position of the focusing device.*

Fig. 5—*This shows the crank side of the camera. The only thing that is different here is a cover that goes over the gear that drives the shutter shaft, this gear being moved back for the purpose of keeping the noise out of the hollow space in the front of the camera.*

Fig. 6—*This shows the front of the movement removed. You will notice the reflector above the photographic aperture. The focusing is done by pushing the reflector down in register in front of the photographing aperture. You will also notice the groove back of the film track in the aperture plate.*

Figs. 7 and 8—*These are intended to show the film track. I have used a principle here of curling the edges of the film outside of the perforations toward the emulsion side. The spring plate of the movement and the emulsion side of the film inside of the sprocket holes never touches anything going through the movement. This eliminates the scratch problem. You will notice in Fig. 8 at the right, the edges of the back plate turn up slightly. The pressure on the film is where the perforations are and if any emulsion should pick up the scratch would be down the center of the perforations, but as soon as emulsion begins to build up the sharp edge of the perforations would cut this out and automatically keep cleaning itself.*

Fig. 9—*This shows the camera with the left, first finger pushing the lever into focusing position. This leaves the second finger and thumb for focusing the lens. By removing the hand a spring pushes the focusing lever up—consequently as soon as your hand is removed your camera is in photographing position.*

Fig. 10—*Explained in text.*

facture but hope to make a satisfcatory connection in Los Angeles.

"I sincerely appreciate the interest that my brother cameramen, who have seen this camera, have taken in it; and I hope to be able through it to save much obsolete equipment that otherwise might be lost."

The shop work on Mr. Jenkin's camera was done by expert machinists in the plant of the Acme Tool Manufacturing Company, No. 297, San Fernando Road, Los Angeles.

Mr. Jenkins announces that he has also designed a camera to meet the wide film threat. It embodies the same principles and mechanism as his first model except that it will require a special box.

"Hot Points"

Conducted by MAURICE KAINS

Bob Bronner, formerly of the Newcombe Process Department of M-G-M, and now an assistant at Technicolor, has shown us an easier, quicker and more accurate way of making finder mattes than we have seen to date. Bob takes a narrow strip of very thin brass and inserts it, together with the blank celluloid matte, into the finder. He makes sure the blank is down in the finder as far as it possibly can go. Then he works his brass strip up and down until the end of the strip is perfectly superimposed on the point where he wants his frame line marking. Next he grasps the blank and the brass strip very tightly in his manly fist and withdraws both of them, being careful not to let either one of them slip. A pin or sharp instrument is then used to make a dot or scratch at the end of the strip. This is repeated for all four sides. What could be simpler, I ask you? If you know any better way, we're from Missouri!

For you fellows who still work in booths we have this one: A baby tripod makes a dandy motor stand. It can be raised or lowered or placed at an angle very easily and serves the purpose splendidly. A piece of felt on the top of the tripod helps matters somewhat. I sometimes use a baby tripod as a seat inside the booth when it is necessary for me to follow focus. In this case you may be sure I use a piece of felt also.

Take a trip down to the camera morgue and see if you can find a few old spring belts (reminders of the good old days when "silents" were golden). Cut them into short pieces and bend the ends down flat. Then screw them into your kit case, using a screw at each end of the spring. They are dandy for holding screwdrivers, tools, mattes, accessories, etc. They also keep the oil can from upsetting and spilling.

At Technicolor we have found another use for old leather camera belts. As you probably know, our cameras pass twice as much film as the black and white cameras. This extra speed causes the roll of unexposed film in the magazine to coast. Buckles are often traced to the slack film in the magazine caused by this coasting. This slack can be eliminated by attaching a leather belt to the camera and letting it hang over the pulley wheel on the magazine. Cut a finger off of an old glove and partially fill it with buckshot and attach to the other end of the belt as a weight. Actual tests will show how much drag and buckshot will be required. This idea is often used on recording machines.

Frequently it is necessary to use a wire in a scene for some trick or comedy effect. Years ago, while working on a Wallace Reid picture, the writer substituted a black silk fish line for wire and had much better results. The fish line does not halate because it stays black; is more invisible and is surprisingly strong because it is braided instead of twisted. Fish line can be procured in all lengths and weights. I often use fish line for snapping the shutter on my graflex when I want to be in the picture myself. It never shows.

Now that Christmas is over, send in a few of your own "Hot Points." "Speed" Mitchell, start the ball rolling. Address ideas to Maurice Kains, care International Photographer, 1605 No. Cahuenga, Hollywood, California.

A MARTENS PHOTOMETER
(Continued from Page 22)

through. If a second Glan Thompson prism is now placed in the path of this polarized beam a position can be found which cuts off the light entirely. At right angles to this position the two Glan Thompson prisms will transmit the maximum of light and the amount of light transmitted at any intermediate angle is proportional to $\cos^2\theta$ where $\theta = 0$ for the maximum transmission of light.

The Wollaston prism differs from the Glan Thompson in that it passes two beams polarized at right angles to each other. If a Glan Thompson prism is placed in front of the Wollaston prism it is clear that a position can be found which will cut off one beam completely while transmitting the maximum intensity of the other. For any other setting of the Glan Thompson prism the intensity of the transmitted beams are respectively proportional to $I_a \sin^2\theta$ and $I_b \cos^2\theta$, where I_a and I_b are the intensities of the beams before entering the prisms and $\theta = 0$ for the total extinction of one of the beams. If now we find a position of the Glan Thompson prism for which the emerging beams are equal in intensity we have

$$I_a \sin^2\theta = I_b \cos^2\theta \qquad (2)$$

If the beam I_b passes through the density to be measured and I_a is the comparison beam, then the per cent of light transmitted is

$$T = 100 \frac{I_b}{I_a} \qquad (3)$$

From (1), (2), and (3) we obtain—

$$D = 2 \log \cot \theta \qquad (4)$$

as the formula converting angular readings into densities.

The comparison of the beams is made by means of a biprism. One face of the biprism is plane and the other has two plane surfaces, meeting like a roof in a ridge across the middle of the field. The function of the biprism is to bring the comparison beams into parallelism so that on looking through the eye-piece one sees half of the biprism illuminated by one beam and the other half by the other. The quality of the instrument depends very largely on the fineness of the edge between the fields. This edge should disappear when the halves of the biprism are equally illuminated.

The settings of the instrument are made by rotating the Glan Thompson prism. In the original Schmidt and Haensch Photometers 45° represents zero density and 0° represent a density of infinity. The useful range of the instrument is therefore only 45°. This may be extended by inserting known densities in the path of the comparison beam and adding these densities to the density read. In our photometers we have permanently inserted a density of 1.00 just over the opal glass in the path of light beam and have computed direct reading scales on this basis. These scales have a density range of 0 to 4.5 spread over 71° 26', and are subdivided to a density of .02 over most of the range.

Our graph paper for recording densities likewise is graduated to a density of .02 and we find this correspondence between the graph paper and the instrument facilitates the recording of densities in graphical form directly from the readings of the photometer.

The new Bausch & Lomb Martens Photometer is shown in Fig. 3. While intended primarily as a part of their spectrophotometer it can readily be adapted to the measuring of photographic densities. Mechanically it is of very rugged construction. It has a large, easily read circle, different portions of which are divided into degrees, transmissions and densities. Its biprism is placed between the eyepiece and the Glan Thompson prism instead of being between the two polarizing prisms as in the original Martens Photometer. This rearrangement of parts corrects for a small error due to polarization by the biprism. In front of the photometer are two rhombs E intended to give the separation of 40 mm. between the beams, which is required by the spectrophotometer. When used for reading photographic densities these rhombs can be replaced by two simple apertures which allow the comparison of two beams 10 mm. apart as in the original Martens Photometer.

Jules Brulatour, president of J. E. Brulatour, Inc., will arrive in Hollywood about February 3, to visit his local representative, E. O. Blackburn and to look over the field. This is Mr. Brulatour's first visit to Hollywood in three years. He will be accompanied by his wife, the beautiful and accomplished Hope Hampton who recently created a sensation in the East with her singing voice. Miss Hampton will be happily remembered by a large following who admired her in the days when she was a star in motion pictures. The Brulatours have but recently returned from a protracted visit in Europe.

Mr. Ted Curtis, popular and efficient general sales manager of the Eastman Kodak Company, is in Hollywood for a protracted visit. He reports business as never better and the outlook for 1930 as decidedly flattering. The International Photographer is glad to welcome Mr. Curtis to Tek-Nik Towne.

Chicago — Six-Sixty-Six — Chicago

STYLES CHANGE

F'rinstance, a sixteen-year-old adventurer left the civilized world behind, at least two miles behind. He had set out to find himself a job in the busy marts of Chicago, but the spirit of Mr. Coincidence had l u r e d the husky, unemployed youth a w a y from the job center and he finds himself seeking what-have-you in t h e vicinity o f Western Avenue and Irving Park Boulevard.

OSCAR AHBE

The y e a r i s 1907.

T h e r e were miles and miles of vacant property surrounding a story and half brick building. It was the Selig Polyscope Company studio. Temporary quarters were scattered about on the prairies. Here was the beginning of the famous Selig Zoo. Over there a desert caravan and on the big prairie opposite, was none other than Tom Mix and a crew of real live cow punchers.

Our hero was dumbfounded. He had wanted a job, but his appetite for jobs quickly faded. He wandered from one surpise to another and then wandered into proximity of a director. "Hey, kid! lend a hand." And the kid has been lending a hand ever since making movies move. That kid grew up to be none other than Oscar Ahbe, vice-president of Local 666. Oscar loaned a lot of hands to the Selig outfit for two years and then took up camera work for Essanay. While here he shot Harry Beaumont's first production. He remained with Essanay until 1919 shooting everything in sight with Wallace Beery and other notables of the day. In all, the short productions of that day piled up on the cameraman, but Oscar put a few hundred productions behind him before he took up industrial "experting" for "Watty" Rothacker. Here he stayed until 1929. He is now with the bigger and wider films of George K. Spoor. That's a "brief" of the very notable career of our First Vice-President.

SIX-SIXTY-SIX

RED GOES SOUND

"Red" Felbinger, the Paramount "shiek" of Wabash Avenue, has just taken upon himself a sound truck—it's a pretty thing, all dolled up with Paramount Sound News and e'erything. Red's experience with news reels dates back for some time. Starting with Pathe News many years ago he has photographed many of the biggest events in these parts. One coincidence in Red's life, as he relates, is that his first assignment with Pathe News was to cover a funeral, that was some time ago, but the day that Paramount presented Red with the sound truck, his first assignment on his sound work was to cover a funeral. Watch out Red and

Motion Picture Industries Local 666, I. A. T. S. E. and M. P. M. O., of the United States and Canada
By HARRY BIRCH
President

CHARLES N. DAVID...............................Chicago
Vice-Presidents
OSCAR AHBE..Chicago
CHARLES E. BELL...................................St. Paul
F. L. MAGUIRE.......................................St. Louis
W. W. REID...Kansas City
RALPH BIDDY.....................................Indianapolis
J. T. FLANAGAN....................................Cleveland
TRACY MATHEWSON.................................Atlanta
GUY H. ALLBRIGHT....................................Dallas
RALPH LEMBECK....................................Cincinnati
Treasurer
WILLIAM AHBE......................................Chicago
Secretary
EUGENE J. COUR.....................................Chicago
Offices
12 East Ninth Street, Chicago
BULLETIN — The regular meetings of Local 666 are held the first Monday in each month.

don't let the funerals get the best of you.

SIX-SIXTY-SIX

SOUND MAN 'RECOUPING'

That good looking big southern boy, Floyd Traynham, Pathe Sound Man, is at the Columbus Memorial Hospital keeping the nurses entertained with that 'Yes Sar' line, that is truly natural with Floyd. All the boys of 666 miss you and want to see you out Floyd, and we know when you read this that you will be back on the job doing your stuff.

SIX-SIXTY-SIX

UNAVOIDABLE DISAPPOINTMENT

Last month we promised that Brother Bill Strafford would come forth and tell us all about that high-powered "groanbox" that makes so many pictures per minute. Sorry to say that Bill wants me to advise our readers that he had to make an unexpected trip and was so busy that he can not let us in on the "secrets" this month, but will tell us all about it shortly. Watch for it, Bill says it's good.

SIX-SIXTY-SIX

OLD SELIG STUDIO BURNS

Many of the boys now working in other parts of the country, but having in the past worked in the old Selig studio in Chicago, will regret to know that the old big studio building is no more. Many happy hours have been spent by some of the boys at the old studio on Claremont Avenue. In years of late this building has been used by the Flavour Candy Co. The writer witnessed this sad sight and while the flames were spreading from the second floor up to the roof, there was a certain feeling that shot into my heart that is rather hard to explain. It seemed that there was personal loss, a loss of past days, days when the clicking of Schustek cameras might be heard on the top floor. As the flames shot skyward there seemed to be a re-filming of the old "Third Alarm" with the "cast" on the job,

with the pretty "heroine" crying for help from the smoke and flames, rescued in the nick of time by the brave firemen. However, those things happen, and the only thing left of that building that has started many on great careers, are the four walls.

SIX-SIXTY-SIX

Way back when, or do you remember when "Take Me Out to the Ballgame" and "Alexander's Ragtime Band" were being played as the popular tunes of the day—well about this time the picture here was made and it is none other than Robert J. Dugan (Robert in those days if you please) or better known to the boys today as "Bob"—Bob claims that "Robert" made good pictures in those days, but how could he help it when you look over the classy togs, patents leathers

ROBERT J. DUGAN

with felt tops and those peg top trousers that were a little short at the ankle—but don't kid yourself we all wore them and "Robert" was no exception to the rule, that is when it came to style. From the looks of "Bob" today and "Robert" of days gone by—"me thinks" that "Bob" has taken on a lot of extra tissue or maybe the credit goes to Mrs. "Bob" Dugan who took it upon herself to put "Robert" up in the 200-pound class.

SIX-SIXTY-SIX

FIRST 1930 MEETING OF 666

At the last meeting of Local 666, which was the first meeting for the year of 1930, held at the Palmer House, Chicago, the usual business disposed of, Mr. James P. Devine, of the Western Electric System, was formally introduced. Mr. Devine told the boys all about the "Why and Wherefore" of sound, projection and recording. During the talk, Mr. Devine

 # Cream o' th' Stills

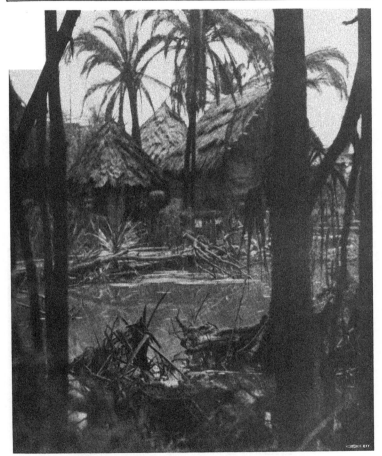

Credit for this shot is given to Robert Bonner, who caught the scene from "West of Zanzibar." It is a set and one of the very cleverest of its kind, but what's a set unless there is a clever photographer to "get it in the box."

 # Cream o' th' Stills

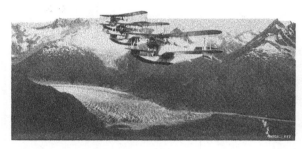

J. M. F. Haase, Chief Photographer of the United States Navy, scored this remarkable bull's-eye while sailing over the famous Wright Glacier, Taku River, Alaska. The three birds are army hydroplanes in echelon formation. Brother Haase is a wonder-worker at this kind of photography.

Billy Williams induced this humming bird to pose for him during his leisure time at the studio. Billy is crazy about live things and the birds and beasts understand Billy. He hunts only with a camera and has many masterpieces to his credit.

Cream o' th' Stills

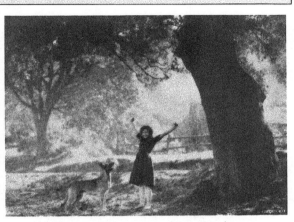

Gaston Longet who so kindly donated our beautiful front cover this month is also responsible for this delightful pastoral. Gaston is especially clever at recording light effects out doors and the Sierras furnished the location for both of these exquisite pictures. The artist who habitually "thinks in pictures" may be depended upon to get results.

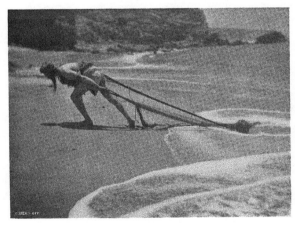

This conception of "The Fisherman and the Genii" was composed by Fred R. Archer. As usual Mr. Archer gives us a work of art. The editor agrees with the brother who said recently: "Fred Archer can get a masterpiece out of a corn cob and a dried grape vine."

Cream o' th' Stills

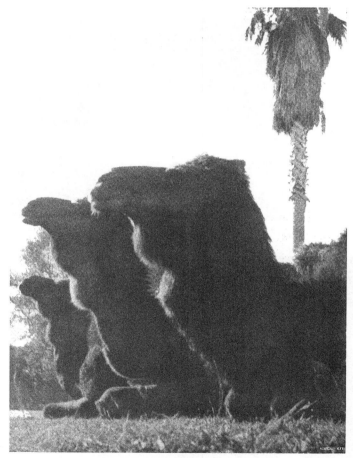

This interesting shot is from the "good box" of Monroe Bennett. Until Mr. Bennett caught this picture nobody ever thought that camels were particularly impressive, but now all opinions must be revised. In this picture Brother Bennett has a beautiful study.

passed out various parts of the latest and most modern sound equipment so that the boys could examine them. It was a great evening for all and Mr. Devine has extended an invitation to any of the boys to visit the Western Electric office, Room 400, 910 South Michigan Avenue, and he will be glad to answer any question that you may have in mind. Thank you, Mr. Devine.

SIX-SIXTY-SIX

'MYSTERIOUS WRITINGS'

Received in the mails with no signatures is the following:

As the old year passes, one of the Brother "News-reel Grinders" arises to suggest several improvements and eliminations of "Star Boners" he witnessed during the year 1929.

Hear Ye, Hear Ye, Resolved—

To stop Brother Jack Flaanigan waving Kentucky Corn Bottles from atop Ohio River Sidewheelers at a poor unfortunate brother in speedboat alongside, during Steamboat River Classics.

* * *

To stop Brother Norman Alley, when covering stories such as "Lady wrestling with a Tiger" from saying, "Lady can you hold it a minute while I reload my camera!"

* * *

To stop Brother Ralph Lembeck, of Cincinnati, bragging about trading in his Packard on a Model A Ford, because the "godam" little car had the Packard backed off the map.

* * *

To stop President Chas. David using his Eyemo, as it is breaking the hearts of "the" other Eyemo specialists who are now lugging heavy sound boxes around.

* * *

To stop "Half-Pint" Santone signing names "Sr," I guess we all know by now that he is the proud papa of a baby boy.

* * *

To make Secretary Eugene Cour travel to Indianapolis next time he packs the horde to the Soverin Hotel, to keep the boys out of the hallways, when attired in their pajamas.

* * *

To make Brother Chas. Ford drive his Cord 110 miles an hour, to settle this for once and for all.

* * *

To make Brother Trabold, of Omaha, cover all endurance flights in the future —he likes them.

* * *

To make the Cubs run another World Series show at Chicago in 1930, so Brother Billy Andlauer, of Kansas City, can return for the visit he started but couldn't finish—the Cubs lost.

* * *

To make Brothers Luperti, Duggan, Birch and "Bull" Philips (Bull's not fat but he blows up most of the time) "the four-horsemen of 666" try the eighteen-day diet.

* * *

To make Brother Fred Giese wear his "Iron Derby" to the next meeting so that we can all see what the well dressed cameraman is wearing.

* * *

To make some brother inform the rest of us, how one of our brothers wrote a book called "God Have Mercy On Us" or sumpin' like that, and also tell us, if this be true, at what newstand it is for sale.

* * *

To ask Brother "Bull" Philips, why he has cut out his old-fashioned visits along film row looking for bargains in raw stock.

* * *

To send Brother MacGuire, of St. Louis, on all endurance flights that last as long as the famous "St. Louis Robin flight." Brother Mac was a "God-send" one cold morning after watchful waiting.

Which reminds us of Brother Harry Yeager, also of St. Louis, and his famous "St. Louis Heimgemacht."

* * *

To make Brother Eugene Cour confess as to the correct way that a newsreel man should address the Ambassador to Great Britain when being turned down on a "close-up."

* * *

To advise Brother "Red" Felbinger the next time we have "Ladies' Night," so that he will show up at a meeting sometime.

* * *

The writer to the above is unknown, but here's saying that whoever he may be, he is sure giving us some "dirt." The editor would like to add one more resolutions to this list for 1930 and that is:

To make all members of Local 666 contribute a few lines once each month to this page, from all parts of our territory,

or that their name shall be taken off the mailing list of the International Photographer for not less than six months. I know that you will MISS it. I for one do not want to miss one single copy of The International Photographer as it is the "pep" book for all of us—so send your few lines in to Harry Birch, 845 South Wabash Avenue, Chicago, and we will see that you stay on said mailing list.

SIX-SIXTY-SIX

FIRE FIGHTING CAMERAMEN

Cast—C. Ford, H. Chung, S. A. Savitt, E. Cour, H. Birch, F. Bowers and C. David, all members of Local 666.

Location—845 South Wabash Avenue, Chicago, Illinois.

Scene—Interior, Universal Daily News Laboratory.

Time—Christmas Eve.

Action—C. Ford seated at desk . . . heavy thinking . . . writing titles for locals . . . H. Chung wrestling with racks in the dry room . . . everything quiet on the "Wabash" . . . peaceful setting . . . more action . . . BING, BANG and another BANG . . . flames burst through walls past Ford's desk . . . Ford jumps . . . Chung drops rack . . . both run for fire extinguishers . . . and then they learned that the Advance Trailer Co. next to the Daily News "lab" was doing all the BANGING . . . and shooting flames all directions . . . books, films, desks and what have 'ou—in the meantime Savitt happened by on Wabash Avenue saw the flames and pulled the alarm . . . at the same time Ford and Chung are shooting extinguishers . . .

then the clanging of bells and fire apparatus dashing down to the scene of action . . . E. Cour in his office at Pathe Exchange, Tenth and Wabash Avenue had his "sound truck" on the street, his men were waiting for more action to put over another Pathe "scoop" . . . Cour remembering that Paul Revere story . . . he galloped into the office and started to warn all the tenants of 845, those that he figured would be home preparing for the Xmas parties . . . he called H. Birch at him home and his tidings for the evening were as follows: "Hate like H—— to spoil your Xmas, but due to the fact that the Advance Trailer is in a mass of flames and that your office is next door, I thought you should get down here immediately" . . . (a nice Xmas Eve message) . . . he also called F. Bowers, of the Mid-West Film Co. with the same message . . . C. David was also at home preparing said Xmas tree, but Mrs. David had to complete the job . . . there was a mad dash by all to the scene . . . arriving it certainly was a "sweet" mess . . . A MERRY XMAS was had by all. . .

SIX-SIXTY-SIX

SOUND TRUCK BURNS

Brother Norman Alley, of 666, was in South Bend, Indiana, awaiting the arrival of his Fox-Heart Sound Truck from Chicago—while waiting he was paged to the telephone and advised that his said truck was about eight miles from South Bend, a total wreck. Alley immediately rushed to the spot and found that all his sound equipment had been destroyed. He inquired from J. Aray, his sound man,

what had happened, he was informed that while trying to make time and traveling over icy highways that the truck skidded, turned over and burst into flames. Alley estimates that the total loss was approximately $27,000.00.

Turn your scrap film and short ends into cash

HORSLEY CHEMICAL COMPANY

1123 Lillian Way GLadstone 5490
Hollywood

FOR SALE

3 Bell & Howell Cameras equipped with Fearless Silent Movement. Complete equipment

TIFFANY PRODUCTIONS, Inc.
4516 Sunset Blvd. OLympia 2131

E. J. O'Toole

ASSISTANT

New Home Phone
HE. 1128 MOrningside 13245

KLIEGL CONNECTORS *for Sound Recording Apparatus*

PIN-PLUG connectors, especially designed for quickly connecting electrical circuits of sound recording devices, telephone and signaling systems—to the sound-proof camera booth, the monitor room, and other locations about the studio . . . numerous designs meeting innumerable requirements . . . various current capacities . . . different combinations for multiple and branch-off circuits . . . any number of poles desired . . . substantial, serviceable, practical . . . just what you need.

Write for Bulletin No. 102

KLIEGL BROS
UNIVERSAL ELECTRIC STAGE LIGHTING CO., INC.
321 WEST 50th STREET
NEW YORK, N.Y.

STANDARD TYPES

A Co-operative Theatre Here

—BY—

H. O. STECHAN, *Editorial Director*

Every activity and organization is built upon the ideal of co-operation. To get anywhere or achieve results requires a working together of a number of people. No one can get very far by himself, though many misguided persons try to do so—and fail.

Even such outstanding individualists as Henry Ford, John D. Rockefeller and Thomas A. Edison have never been entirely self-sufficient. Without the loyal assistance of a lot of co-workers they would not have reached the heights they occupy. No matter how able the general, he needs an army to win his battles.

The universe is the best symbol of thorough co-operation. The planets all keep their orbits according to principle, wherefore eclipses can be figured out hundreds of years in advance. The seasons follow each other without a thought of variation. Crops grow and man's needs are supplied to meet his requirements, whether he agrees with the arrangement or not. But it has all been set up and works like a clock—another excellent example of co-operation, where all the parts work together for a common object.

Now what this is all leading up to is the explanation of another instance of co-operation which is coming into being, here in Hollywood. It is the Civic Repertory Theatre, Ltd., which promises to sound a new note in the evolution of the American stage. Of course, as everyone knows, great changes have been taking place in the native theatre in recent years or since the advent of motion pictures.

In the old days, a hundred or more touring theatrical companies, each one headed by a star or two, left New York annually and visited all cities of 50,000 and over. It was a sort of fore-runner of the chain idea applied to the theatrical business. But the rapid growth of the screen in popularity put an end to most of the so-called "road shows"—that and the mounting costs of transportation. It soon became evident that, if the stage was to endure, its activity must be reorganized on an entirely new basis.

To begin with: It must be conceded that the stage has to be maintained, if there is to be any drama. Its abandonment instead of helping the screen would be a body blow. Spoken drama is a fundamental form of human and artistic expression, with many centuries of honorable tradition back of it. The only rivalry between the stage and the screen is a friendly one. There are audiences enough for both to prosper, side by side.

The resident dramatic company is not a new thing here. Stock groups have been in operation for a long time; and some of them have attained to a high degree of excellence. But now, in various parts of the country there is a growing demand for a higher type of play than the average stock company is equipped to offer. Furthermore, the stock clientele is not interested in the literary or intellectual drama. That does not mean heavy or "highbrow" plays but plays which signify something underneath as well as entertain.

In New York, Chicago, Cleveland, Detroit and several other key cities, repertory groups have been formed. They consist of professionals who, by reason of their seasoned experience, can do a wide variety of parts. This enables them to develop a list of plays, which can be revived from time to time, during each season, thus giving the actor a chance to perfect his art, which he had never had under the old system in this country.

Los Angeles is about to join the other American cities striving to develop dramatically, by freeing themselves from the handicaps under which the old-time commercial theatres operated. To this end, a group of players resident here have associated themselves together with four executives, on a share-and-share alike basis. They have taken a lease on the Hollywood Music Box, where eight productions will be made during the next six months.

As the term "civic" is used in this connection, it is not intended to infer that the Civic Repertory Theatre is subsidized out of public funds, as notable theatre groups are abroad. It will be nonetheless public-spirited, however. Its relation to the people of Los Angeles and vicinity will be similar to that of Hollywood Bowl, the Huntington Library, the Southwest Museum, and other cultural projects hereabouts. Like them, it will appeal for general support. It aspires to become another link in the unfolding artistic life of that great Southwest, doing here for the drama what has already been accomplished so outstandingly for music and the other arts.

Believing sincerely in the fine possibilities of the stage to serve the public, the co-operators instrumental in organizing the Civic Repertory Theatre have joined hands. They feel that the theatre has an obligation to the people, which they want to help discharge. If the organization succeeds, it will provide a model for other American cities to adopt. The Mannhaim Players of Germany, the Moscow Art Theatre, and the Horniman Players of Manchester, England, are notable examples of successful co-operative dramatic activities.

The Civic Repertory Theatre's first concern will be to give the people of Los Angeles and vicinity plays that are both representative and entertaining. Needless to say, there must appeal to a sufficiently large patronage to permit of carrying on. Like all other amusement enterprises, it has an overhead to meet and those devoting their time and talents to it, not being independent, must be compensated. But they are not seeking to get rich out of the theatre. They will be satisfied with a fair, living wage. This frees the Civic Repertory Theatre to a considerable extent, as well as the fact that there is no invested capital on which a return must be paid.

The people profit from this arrangement, because it brings down the price of tickets. The purpose is to win back the many former patrons of the theatre, who have been driven away by high prices. The ultimate aim of the Civic Repertory Theatre is to make it possible to sell its offerings for a dollar "top." The theatre is to be democratized once more. It has been all too exclusive for its own good, in recent years.

The co-operators are pledged to operate it as a non-profit activity. That means that they do not consider themselves the owners of the Civic Repertory Theatre, entitled to divide the net proceeds among themselves. Rather do they stand in the relation of stewards to the project. Operating expenses such as rent, royalty, advertising, utilities, stage hands, etc., are paid out of the first receipts. When these bills have been met, the co-operators share equally the balance, up to a certain point, each week. Any surplus that remains goes into a sinking fund, to be spent on future productions, for emergencies and to extend the scope of the Civic Repertory Theatre.

All exponents of the ideal of co-operation, the workers associated together in the Civic Repertory Theatre are naturally believers in organized labor. The players all belong to Equity, while the backstage crew are members of the I. A. T. S. E. All for one and one for all might well be called the slogan of this new experiment. It is an actor's theatre, operated for the best interests of the drama as an institution and the player as its beneficiary. They come first—never the box-office. Hence, the participants are really working for the public, instead of a manager.

Therefore, the Civic Repertory Theatre of Los Angeles is strictly speaking a non-commercial and non-profit organization; but all participants are paid for their efforts. However none is inordinately remunerated to the disadvantage of others. The whole idea is to equalize things more than has been the custom in the theatre operated for individual profit, and exploitation of dramatic art—all too often to its great detriment.

Ultimately, it is hoped to enlist the support of a group of advisors from the community-at-large. They are to help administer the affairs of the Civic Repertory Theatre and to see that it functions along dramatic lines for the greatest good to the greatest number. If the people generally like good, intelligent plays, there is no reason why this cannot become one of the outstanding theatres of America and in time grow into the long looked-for National Theatre. Hollywood is the logical place for such a development.

GOSS TO THE ACADEMY

Mr. Foster Goss has been added to the staff of the Academy of Motion Picture Arts and Sciences in connection with the continuation of the Academy's school in sound recording for studio employees.

Mr. Goss has been associated with the Gloria Swanson Productions, R. K. O. and F. B. O. publicity departments for several years, and was for five years editor of *The American Cinematographer*. The International Photographer congratulates both the Academy and Mr. Goss upon the new association.

Silence With Arcs

—BY—

W. J. QUINLAN, *Chief Engineer, Fox Film Corporation*

PART TWO

The ever-increasing demand for the additional use of Hard Lights, and the requests for additional information, as to the treatment of such equipment, and the removing of the accompanying "noises," created by generator equipment feeding arcs, has prompted the writer to add such additional information, as may be of some use to those engaged in the Motion Picture Industry.

It is believed that most of the studio engineering departments have devoted some time to the building of Reactance Coils and that opportunity has not permitted—due to the heavy demands on production—very much occasion to the application of Condensers.

Of the various types of condensers, the Electrolytic type offers complete elimination of such noises as occur in commutation and, owing to their low cost of construction and maintenance, several types have been developed which function very thoroughly, under the most trying conditions.

To the Electrolytic Condenser, no introduction is needed. In every class-room, those dealing with chemistry and physics, have had, more or less, some contact with such apparatus. Therefore, we cannot beguile ourselves into thinking that something "new" has been created; on the contrary, the application — with some modifications, including the size — has been in use in another industry.

Electrolytic condensers have been successfully used for several years, in radio practice, and they date back many years in their use in telephone practice. They are to be found, in small capacities, in the radio receiver for the home; and, in some cases, in conjunction with additional apparatus, for broadcasting.

In this particular field they have been somewhat limited in their break-down voltage; but this has been overcome, to some extent, by the method in which they are placed in the circuits, so that the voltages emanating from those circuits, do not quite approach the critical, or break-down point.

For those of the motion picture studio industry, who have not had occasion to read the article by H. O. Siegmund, in the *Bell Technical Journal* of January 29, I would heartily recommend that this splendid article be procured and considerable thought be given to it, before the construction of such equipment.

A photograph is attached hereto showing four various forms of condensers, modified in each case, to meet the particular type of service that they would be subjected to, and with the thought in mind that they would be practical.

Condenser No. 1 is a corner can, with a Bakelite cover supporting the electrodes which, in turn, rests on a shoulder, providing not only support for the element, but also additional space for caulking and sealing with a compound, to prevent spilling, in the event that it is moved about.

Condenser No. 2 is a duplicate of Condenser No. 1, but without the glass windows; and, while it is more serviceable, in that it does not provide visual observation for those who would care to inspect, in this manner, the element contained in the can.

Condenser No. 3 has been built up to place in a standard battery jar, and was put together, primarily, in this jar, for appearance, where it was necessary to mount such equipment in that part of a building or buildings which would somewhat resemble a battery installation, mounted on a common battery rack.

Condenser No. 4 was built up thoroughly with the thought in mind of "portability" and has been mounted in a standard 180 ampere hour battery container, using the vent caps, which also served for filling purposes. The sealing of this particular piece of apparatus followed the usual battery practice, and much thanks is to be expressed here to the battery people.

In Condenser No. 1, the plates have been alternately spaced, differing considerably from that shown in No. 3. The ultimate shape of the plate was finally worked out by Mr. Farr, and the main object of the construction of such equipment, is, to be sure that sufficient space is placed around the common electrodes on which the plates are mounted; making sure that the surface of the plates, to the film created thereon, and to the electrolyte, is a conducting medium, and not any shorted paths.

Various forms of solutions have been recommended and in the *Bell Technical Journal*, referred to herein, some very splendid curves have been placed on ammonium borate. However, very satisfactory condensers can be constructed of borax and boracic acids; and, to show their mild effect upon the metals, the writer conducted an experiment, wherein *gold fish were placed in one of the jars,* their actions watched carefully, and *no bad effects resulted from this unusual "bath."*

It is obvious, therefore, that it is not essential, nor is it dangerous in the operation of this equipment, that any attendant in the room, working on apparatus, should be annoyed, or suffer the slightest anxiety of any kind.

With equipment of this type, so far as the commutator noises are concerned, they are virtually quenched and, from that particular angle, coils are not essential. However, in the Fox studios, coils have been placed on all equipment for protection against annoying angles, over which these condensers have no control.

It is our thought that our application of these particular types may prove of benefit to other studios, and at no time has a thought ever existed that something "new" has been invented or designed. To some extent, however, something has been re-designed, or re-created; but is just one of the many ways of overcoming machine noises, which have, from time to time, proved to be somewhat obnoxious.

Condensers of the type shown in No. 1, would average about 3,500 Microfarad, and have been formed originally, at approximately 300 volts. No great heat, nor warming up of solutions, should be noticeable, after an eight-hour run, unless such apparatus is first affected by the surrounding temperatures.

Care should be exercised in mounting such equipment, such as would be shown in the treatment of any refined electrical apparatus. To those who have not manipulated such equipment: The plates should remain perfectly clean, other than for the film that forms, which will be created on them, and which may change its color, as the age in such apparatus is carried on. This likewise holds good for the containers; and no sediment should appear, until considerable time has elapsed.

Condensers of the type shown in Fig. 2, should be successfully constructed for $35.00 and for not more than $50.00. Particular stress is laid on this part of the article dealing with condensers, in order to offset some of the current rumors to the effect that, considerable material would be required for a 550 KW generator, to obtain the desired effect, namely, the entire emiliination of "noises," and the values vary between $1500 and $2500.

The assembly of such materials for the completion of such condensers, is, therefore, far more satisfactory, and far more practical and economical, than to endeavor to apply a sufficient quantity of the smaller types, which were developed, primarily, for radio purposes.

(See Page 45)

Brother Ted Weisbart who sang so effectively the theme song in "The Black Watch," studied with Walter Damrosch in New York and then went to Milan, Italy where he took instruction of the famous Signor Cecchi. He is now studying with John Clair Monteith, in Los Angeles, one of the finest instructors of voice in America and, if he can leave the camera alone long enough, Mr. Weisbart bids fair to make a career for himself with the singing voice.

Silence with Arcs. Left to right—Condenser No. 1, Condenser No. 4, Condenser No. 2; Condenser No. 3.

NEW S. M. P. E. JOURNAL

The first issue of the new Journal of the Society of Motion Picture Engineers made its appearance early in January. Hereafter it will be published monthly, replacing the semi-annual Transactions, formerly published by the Society. Recommendations for the new Journal were passed upon at the Society's last convention in Toronto.

The new Journal is the same size as the old Transactions, and will contain from 120 to 150 pages each issue, according to present plans. The Journal is strictly scientific or technical in nature, carrying only articles of the highest scientific, technical and engineering quality, and shall be kept free from semi-popular, commercial, trade and advertising types of articles.

The contents will consist of articles of the following classes: Papers read at the Society's semi-annual meetings and those read at meetings of local sections of the Society; other papers authorized by the publication committee; reprints of papers from both foreign and domestic sources; book reviews; patent notes and news of the Societies activities, etc.

The Journal will go to all members of the Society and subscriptions will be sold to non-members at the rate of $12 a year.

———o———

Fred Hoefner has further improved his famous Model B Professional Trueball Tripod Head by lightening the weight from 26 to 20 pounds. He achieved this by virtue of a new alloy developed at his plant, 5319 Santa Monica Boulevard. The Trueball remains the same size and is equally as efficient if not more so than formerly. The great beauty of Trueball is that it affords smooth, equal tension on all motions. No compounds are necessary to get a "drag" on the Trueball. It is entirely unaffected by temperatures and is ever ready in all kinds of weather. All motions are preformed on the ball. Mr. Hoefner reports a good business on Trueballs last year and a good outlook for 1930.

AS ONE CAMERAMAN TO ANOTHER

UNION CIGARETTES

Tobacco Workers Local No: 16, of Louisville, Ky., employed in the Axton-Fisher Tobacco Company's plant, have sent out the following information that they desire Trades Unionists to be sure and note:

"Our contract with the Axton-Fisher Tobacco Company, manufacturers of Clown cigarettes, does not call for free meals, yet every day at noon our company serves every employee a hot dinner, absolutely free of charge. This dinner is served in a well-appointed dining room, on clean white enameled tables. It costs the company many, many thousand dollars each year to provide this meal, and every member of our Union appreciates it and wants you to know about it.

"This is just another reason why we think every Union man in this country should buy Clown cigarettes, instead of products made in scab factories un.ler rotten conditions and where the wages paid do not constitute even a living wage.

"Read the following, as it contains an expose of some of the misleading and untruthful advertising now being done by the trust factories:

"Truth About Toasting—Do not be mislead by statements of cigarette manufacturers that a secret toasting process removes throat irritants from tobacco. There is no such thing as toasting tobacco. Outlined below are the methods of curing tobacco and the exact process of manufacture of all cigarettes.

"After the tobacco is cut in the field it is hung up in country barns to cure. Farmers cure tobacco either by air or by

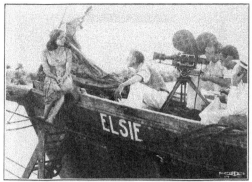

Max Stengler, chief cinematographer of "Hell Harbor," Henry King's production, featuring Lupe Velez, on location in Florida.

slow fires. The moisture leaves the tobacco so that it can be handled without bruising. When the tobacco is purchased by the manufacturer from the farmer it is hung up and air cured or run through drying machines, and enough moisture removed so that it can be pressed into hogsheads without danger of fermentation or decay. It is all put up in practically the same kind of manner, on the same kind of machines, by all manufacturers in different sections of the country.

"Always buy Union made cigarettes. They are manufactured right and are advertised and sold without the necessity for false and misleading statements."

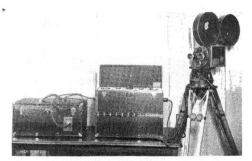

The Sound Track

OFFICERS

International Photographers of the Motion Picture Industries, Local 659

ALVIN WYCKOFF*President*
JACKSON B. ROSE*1st Vice President*
H. LYMAN BROENING*2d Vice President*
IRA B. HOKE*3d Vice President*
ARTHUR REEVES*Recording Secretary*
ROY H. KLAFFKI*Financial Secretary*
CHAS. P. BOYLE*Treasurer*
WM. H. TUERS*Sergeant-at-Arms*

HOWARD E. HURD
Business Representative

BOARD OF EXECUTIVES

International Photographers of the Motion Picture Industries, Local 659

ALVIN WYCKOFF	PAUL P. PERRY
JACKSON J. ROSE	L. GUY WILKY
IRA B. HOKE	J. O. TAYLOR
ARTHUR REEVES	ARCHIE J. STOUT
ROY H. KLAFFKI	HARRY ZECH
CHAS. P. BOYLE	JEAN C. SMITH
WM. H. TUERS	S. C. MANATT
FAXON M. DEAN	R. B. HOOPER
IRA MORGAN	SOL POLITO
	PAUL HILL

Power for Good

One of the greatest powers for good in the United States today is the Trades Union. No other institution of the kind can point out so many benefits achieved for the workers, as can the various Unions of the American Federation of Labor.

Our good friend, Mr. O. O. McIntyre, cites in a few terse paragraphs an example of such benefits as applied to the printing trade.

Mr. McIntyre writes:

"Trade unionism and its strict exactments for both employer and employee steadied the printer. He found he could no longer carouse and hold his job. Today the printer is a fair model of sobriety. He is a regular patron of the savings bank. He even carries a cane.

There is a deep gulf between the blowzy, unshaven creature who slouched into composing rooms and ad alleys of yesterday and the spruce, clear-eyed fellows who now cast type on the linotype machines. Nearly all printers today are settled husbands and home owners with bank accounts.

In New York the majority live in sprightly towns on Staten Island. Their wives meet them at the ferry in automobiles. It is doubtful if any other class of workmen has made such progress in improving living and workin᧐ conditions in the past twenty years.

WHAT TAXI DO YOU CALL?

The following self-explanatory letter has been sent to the various locals and others of Organized Labor by Taxi Drivers' Union No. 640. Members will please note and act accordingly:

"Los Angeles, Calif., Jan. 4, 1930.

"To All Local Unions, Greeting:

"Taxi Drivers' Union No. 640 wishes to inform you that the Red Top and California Cab companies are the only taxicab companies that will employ members of the Taxicab Drivers' Union.

"The Yellow, Crown and Peerless Cab companies are diametrically opposed to any form of organization that has to do with Labor. The Crown Cab company at one time was owned and operated by the Red Top Cab company, but of recent date the Red Top relinquished their claim on said Crown cabs, and it is alleged that Crown cabs are now part of the Yellow system.

"We hope that your membership will recognize the Red Top and California Cab companies as being favorable toward Organized Labor, and you will notify your friends of this fact and urge them to call FAber 2111 for Red Tops and WAshington 1212 for California cabs.

"Red Top Cab company is using Ford safety cabs exclusively.

"With kind fraternal greetings, we remain,

"TAXI DRIVERS' UNION,
LOCAL No. 640,
By G. D. BAKER, Secretary."

―――o―――

SHORTER WORKING DAY

Wage earners throughout the United States now are paid approximately $2.62 for each $1 that they received in 1913, according to a study just completed by the United States Department of Labor. The working day is 8.5 per cent shorter than in the pre-war year, the study also shows.

These proportions represent an average covering wages in 1929 in virtually all trades in which a Union scale is in operation. They represent an average of all crafts. The trend of wages and hours of labor as reported by the Department year by year is shown in the following table:

Year	Increase in Wage Scale	Decrease in Working Hours From 1913
1913	$1.00	0.0%
1914	1.02	0.4
1915	1.03	0.6
1916	1.07	1.2
1917	1.14	1.6
1918	1.33	3.0
1919	1.55	5.3
1920	1.99	6.2
1921	2.05	6.1
1922	1.93	5.6
1923	2.11	5.7
1924	2.28	6.1
1925	2.38	7.0
1926	2.50	7.2
1927	2.59	7.6
1928	2.61	8.1
1929	2.62	8.5

―*L. A. Citizen.*

Look for this Label

Shop Card of Journeymen Barbers' Union

Before you patronize a barber shop This card is displayed only where good, competent Union barbers are employed.

This shop card is printed in black, red, blue and gold.

The Union Label is not only a sign of wholesome, cleanly standards of workmanship, but it is a symbol of Americanism, as the Union Label appears only on American made products.

IT WAS GREELEY

Q. What great editor helped to found New York Typographical Union No. 6?

A. Horace Greeley, who advocated the principle that "without organization, concert and mutual support among those who live by selling their labor, its price will get lower and lower as naturally as water runs down hill."―*L. A. Citizen.*

AIRCRAFT UNION

The Citizen carried an item several weeks ago about aviators and pilots in the aircraft service becoming Unionized. The first charter for such an organization has been issued by Secretary Frank Morrison of the A. F. of L. to the Aviators and Pilots' Union at Muskogee, Okla. Several more, he reports, are in process of formation. A number of inquiries have come to the Central Labor Council office here regarding the subject from those following the calling. For the present at least all such are to be chartered direct by the A. F. of L.―*L. A. Citizen.*

HARRY'S BROILER NOT SO HOT

The members of the Culinary Workers report that "Harry's Broiler" on Melrose avenue is not playing straight with their Unions, and that Unionists who desire to help their cause should keep out until the place gets right. There are other card houses in that section that should be patronized.―*L. A. Citizen.*

Out of Focus

DO STILLS SELL THE PICTURES?

The above autochrome was chiseled from life by S. C. Manatt.

Once again we go back to the old argument: "Do stills sell the pictures?" How can anyone keep from buying the picture after seeing the above masterpiece. This is a still shot in action from that well known movie, "The Trimming of the Shrewd," an original, by B. Shakespeare. You can see this at your local theatre for 65 cents or whatever the conditions may demand. You will observe that Doug has the biggest part in the picture and Mary runs a close second, around the hips. Speed Hall says that more pictures have been sold by stills, especially in Laurel Canyon, than through any other medium.

A LESSON IN SOUND

Professor Nil, the scientist who crossed the Los Angeles River with camera was lying on the floor of the Plaza just as I was passing out, I mean through, when I heard him talking to a couple of visitors from the East.

"Were you ever in a studio where they make sound pictures," inquired the Professor?

"No," replied the visitors in unison.

"Well," said the Pro. beaming, "I will tell you all about it," and then he went along as follows:

"First of all they take a stage and put a lot of red lights on the outside, a few bells and a man with a red flag.

"The red lights are to keep the producers out. The bells to wake up the electricians and the red flag is to be used in case they have an auction.

"After opening several ice box doors you are on the sound stage. If you hear a lot of noise, walk in that direction and then you will see that they are making sound pictures.

"Due to the fact that the sound engineer and the cameraman had so many arguments they had to place them in separate cages.

"The cameraman gets the best view

and the sound man can hear what is being said so it is about a 50-50 break, except when they have a girls' chorus and then the cameraman gets the best of it.

"In each cage or camera booth is an assistant cameraman. He helps the cameraman look.

"Out in front of the booth is a thing hanging by a wire called a 'Mike.' A fellow by the name of Abe generally has charge of the Mike.

"Regardless of this, if Mike does not want to work all the Abe's can't make him so they get another one. In fact they have more Mikes than Abes.

"The Mike is very sensitive. This may be do to the fact that it was hung.

"A peculiar thing about the Mike. You can talk so sweet-ly into it and it comes out so sour. Or opposite, opposite.

"The sound engineers have all graduated from some place. The cameramen just happened to be around.

"That's why they get more dough. Who? Yeah!

"The sound men claim that the camera's make a noise when shooting so the camera's must be in sound proof booths. This is just a gag so the cameraman and the director can not talk about the sound man when he is in his cage.

"Oh, yes. They have directors too.

"They can generally be found peeking from behind a lamp. The lamps are used for photographing. They burn coal oil and are very warm.

"Sometimes when the lamps are out and something goes wrong it gets extra warm.

"The sound man has his office in the Moniker Room. Moniker is slang for name. They call this the moniker room because this is where the sound man calls the cameramen names.

"It is also called the mixing room because this is where they seem to get mixed up the most.

"Some studios use wax for recording and some use film. The wax melts if it gets too hot so in recording hot numbers they must use film.

"There are two kinds of film. Eastman Dupont and Agfa.

"If the sound is good they call it variable density.

"If the sound is good they call it variable area.

"If it is neither of the above and is still good it's a record. Yeah?

"Most all the sound men have gold teeth and if working wear diamond rings.

"If out of work they have the teeth, but not the rings.

"So you can see from what I have been telling you that it is very interesting and I would gladly take you to the studio that you care to go to but my car is in dry dock. No. I couldn't think of using your car but if you would just loan me 20 dollars until we get to the studio I will repay you them."

DON'T LET THIS HAPPEN TO YOU

The above circuit photograph made with a banquet camera on a 4x5 plate was shot in action at the preview of a non-union picture at a non-union theatre, by George Baxter, unassisted by Les Rowley.

At the recent preview of "Hells Fire Hot Passion Paris," a committee was appointed to attend. It was composed of President Wyckoff, on left who is looking out of one eye, to make sure that the still man has a card; Art Reeves, who is hiding under Faxon Dean's arm; Roy Klaffki, who is plenty sore and Howard Hurd on the right who had on a pair of pants and a hat that evening.

This picture was made out of unused titles and sunsets, was printed on a drop forge, due to the hard negative, by the Baker Iron Works. By using a non-union cameraman they saved over $3.00 and I am sure that the reaction of the committee will tell you that the three dollars was saved in the wrong place. See this picture when it comes to your theatre and see for yourself how the producers and the public have to suffer on account of this kind of a picture being shown throughout the country and then be sure and pay your dues and your assessments.

Just then the house detective spoke the magic word "Scram" and the Pro. left at once. But not for his car.

I WONDER

What became of Amelia's Chili Hutch?

What year will "Hell's Angels" be released?

What happened to the directional mike that would permit the director to talk to the actors during recording?

Why the R. C. A. system does not use the playback for shooting long shots?

When the cameraman will be fully protected by the studios every time he is placed in a hazardous position?

MITCHELL STILL LEADS
The new 70 MM. Mitchell
Camera embodies all those fea-
tures of the regular Mitchell
Camera which are so familiar
to the Cinematographer and
which have made it the out-
standing professional camera
for the past few years.

§

Mitchell Camera Corporation

665 North Robertson Blvd. West Hollywood, Calif.
Cable Address "MITCAMCO" Phone OXford 1051

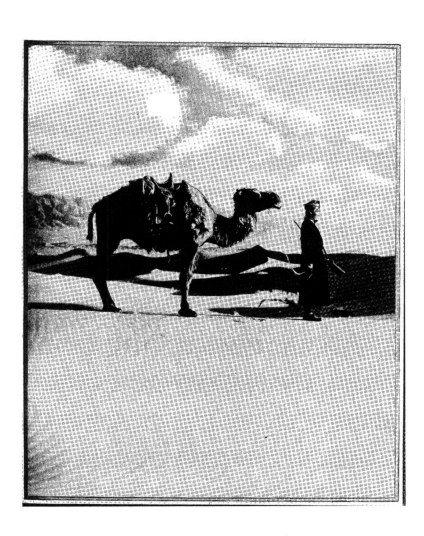

The
INTERNATIONAL
PHOTOGRAPHER

Official Bulletin of the International Photographers of the Motion Picture Industries, Local No. 659, of the International Alliance of Theatrical Stage Employees and Moving Picture Machine Operators of the United States and Canada.

Affiliated with Los Angeles Amusement Federation, California State Theatrical Federation, California State Federation of Labor, American Federation of Labor, and Federated Voters of the Los Angeles Amusement Organizations.

Vol. 2 HOLLYWOOD, CALIFORNIA, MARCH, 1930 No. 2

"Capital is the fruit of labor, and could not exist if labor had not first existed. Labor, therefore, deserves much the higher consideration."—Abraham Lincoln.

CONTENTS

The INTERNATIONAL PHOTOGRAPHER published monthly by Local No. 659, I. A. T. S. E. and M. P. M. O. of the United States and Canada

HOWARD E. HURD, *Publisher's Agent*

SILAS EDGAR SNYDER - - - - *Editor-in-Chief* IRA B. HOKE - - - - - - - - *Associate Editor*
LEWIS W. PHYSIOC - - - - - *Technical Editor* ARTHUR REEVES - - - - *Advertising Manager*
CHARLES P. BOYLE - - - - - - - *Treasurer*

Subscription Rates— United States and Canada, $3.00 per year. Single copies, 25 cents
Office of publication, 1605 North Cahuenga Avenue, Hollywood, California. HEmpstead 1128·

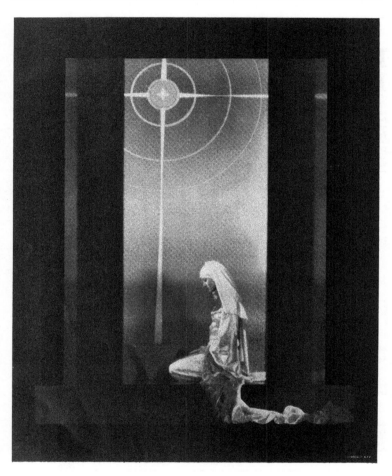

AN IDYLL OF EASTERTIDE FROM THE CAMERA OF MR. FRED R. ARCHER. POSED UNDER DIRECTION
OF THE ARTIST BY MYRNA LOY, WARNER BROTHERS.

Editorial

The editors of The International Photographer, have received a letter from Mr. P. A. McGuire, director of advertising of the International Projector Corporation, and executive vice-president of the Projection Advisory Council, who asks us to write an editorial on "Collective Thought." Mr. McGuire was kind enough not only to compliment us on the editorial "INTER-DEPENDENCE," which we wrote some time ago at his suggestion, but to supply some material for this editorial on *"Collective Thought."*

We also reprint at his suggestion, the editorial "Collective Thought" which recently appeared in *Publix Opinion*, the house organ of Publiv Theatres, Incorporated, and are glad to give Mr. Katz full credit for the idea. We think it no more than fair, however, to credit Mr. McGuire with the ideas and ideals expressed in a pamphlet issued by the Projection Advisory Council and for the organized effort of the Council to put into effect its motto: "PROGRESS THROUGH UNDERSTANDING."

Mr. Sam Katz was among the business leaders who recently had the privilege of discussing the 1930 national prosperity program with President Hoover.

In addressing members of his home office executive cabinet, Mr. Katz passed on to them an attitude which he said Mr. Hoover had displayed during the course of the interview.

Mr. Hoover, at the time, expressed the belief that it was his duty to solicit and encourage advice from industrial leaders because every citizen would benefit by it. His attitude was that advice from a great many expert sources, rather than reliance upon the ability of a single individual, no matter how highly placed in authority, would afford the greatest possible assurance of national prosperity.

This attitude from our great public administrator and executive, declared Mr. Katz, should be most illuminating to each of us in the conduct of our individual affairs. The rapidity with which conditions and influences change in modern life, makes constant and reliable information imperative as well as faultless application of that information.

Security of everyone's interests is obtained best from the counsel of collective thought. There is no individual in Publix, no matter what his position who can afford to rely solely upon his own judgment as long as community thinking and information are so easily obtainable.

About two years ago sound was literally hurled at the motion picture industry and the result was temporary chaos. Many executives acted as though all they had to do was to install a phonograph or radio set and let it go at that.

Under the circumstances there has been, of course, a tremendous amount of fault finding. That fault finding has been to some extent by the public and public press. Some of the complaints were justified and some were not. The complaints were quite unjustified when the critic specifically blamed a department without having any possible information or knowledge to support the criticism. As an instance, we quote from a noted New York paper, in the review of Gloria Swanson's picture "The Trespasser," shown for the first time in New York last fall: "The men in the projection booth had obviously not had sufficient time to study the various scenes in the production for when 'The Trespasser' was seen in an ordinary small projection room a few days ago the vocalization was distinct and far more even in tonal quality. Miss Swanson's singing then was most pleasing and her voice was as clear as a bell."

At the William F. Canavan luncheon, given by the Projection Advisory Council, it was very conclusively shown that the projectionists were not at fault. They returned six prints before they got one they could use, and representatives of the sound system frankly admitted that the fault was in the prints. It must be understood that it was also shown that there was nothing the matter with this particular sound system, that it was simply the prints that were causing the trouble.

Incidents somewhat similar to this are constantly occurring and there is no doubt that the blame is being passed back and forth constantly. Our idea is, that everybody has done remarkably well, and every technical department of the motion picture industry deserves credit for the splendid results so quickly secured under such difficult conditions. Instead of fault finding they ought to get together, discuss their problems, fix the blame in specific instances, and correct faults and co-operate in every possible way to bring about improvement. Although everyone has done so well, there of course, is plenty of opportunity for improvement.

The Projection Advisory Council definitely stands for co-operation and collective thought, as opposed to the ancient system of "passing the buck" and "fault finding."

But in spite of the early hysteria little short of a miracle has been achieved in the evolution of sound pictures, and the complete overturn of the cinema from the silent pictures to sound in so short a time is one of the most amazing developments in the entire history of American, nay of the World's industry.

Not enough has been said about this astounding accomplishment, but in time to come the story will be told to the everlasting glory of motion pictures.

It was a case of individual thinking resolving rapidly into collective thought—many minds brought to bear upon one subject with the idea of betterment uppermost—perfection being the ideal.

Collective thought is what makes public opinion and public opinion is what gets things done. It is the motive power of groups and of nations.

A motion picture is a symbol of collective thought. The finished picture is the thought of many minds worked into a concept with the ideal always kept before one.

The day of the individualist is past. Even the work of our United States Congress is done in committees. No longer does the individual will dominate in government. Many are heard, but the collective thought of the whole prevails and usually it proves to be the best thought.

This principle was recognized even in the days of the glory of Old India. Their great teacher, Shri Krishna, speaking more than 5000 years before Christ, made it plain that collective thought bearing upon one ideal—the "Great Ideal"—that in truth ALL are ONE—was the supreme force that would liberate all and bring all to peace, prosperity and victory.

In Russia, no matter what we may think of it, "Collective Thought" applied to an ideal has, in an incredibly brief period of time, overturned an order of polity more than a thousand years old and has set up another diametrically opposed to the old in all its moods and tenses.

In motion pictures, the studio czar disappeared when sound came, for a motion picture studio is no place for a congregation of the dead—that is workers made inarticulate save alone for the word "Yes," by the dominant thought of one who had jobs and favors to bestow.

Today "Collective Thought" (that is, competent thought) sitting in co-operative council with the ideal of the perfect picture, perfectly screened, held steadfastly in view, is the motive power that is governing the cinema and its allied industries.

Looking ahead, we may be tempted to exclaim: "See how far we have to go," but looking backward we have a right to say: "See how far we have come in a few years!"

Thought is the fire of progress, but COLLECTIVE THOUGHT shapes life to our uses and governs the world henceforth.

The entire motion picture industry is in process of stabilization and standardization, and the gamble of the "hit or miss and blame everybody but me" method must be eliminated.

This can be accomplished by the views expressed by Mr. Hoover and Mr. Katz, and by the ideas and ideals embodied in the motto of the Projection Advisory Council, "Progress Through Understanding."

Big Game

Grabbing the Stills

Gustav Schoedsack, genius of the great productions of "Grass" and "Chang" is at his old tricks shooting big game, head hunters, and other interesting things in the wilds of Sumatra. The picture herewith shows Mr. and Mrs. Schoedsack posing above their latest "kill." Looks like Alfred "Buddy" Williams at this distance.

When (Buddy) Bert Longworth goes out to get a still he gets it. Here we see him holding his victim by the hair with one hand after throwing him to the stage floor, while he snaps the shot with the other. This method is somewhat drastic but very effective.

Nippon Goes Hollywood

—BY—

HARRY A. MIMURA, *Local 659*

EN YEARS ago there was not a single first class cameraman in Japan. About that time, Henry Kotani, who had had considerable training in the Lasky Studio in Hollywood under tutelage of Mr. Alvin Wyckoff, director of photography, joined the newly constructed studio near Tokyo. He was welcomed with open arms in Japan and wherever he went he was followed by a number of young Japanese men who wanted to learn his American technique in photography.

Mr. Kotani was sitting pretty with a good salary and the admiration of the Japanese and was envied by many because of his ability to smoke high priced cigars every day (Cigars in Japan are very expensive and only the wealthy can afford them.)

With Mr. Kotani's photographic knowledge on the one hand and his having seen so many foreign pictures on the other, Japanese cameramen gradually learned cinematography and today there are more than seventy cameramen working in the eight leading studios alone.

Customs of motion picture production in Japan differ greatly from those in no free lancing cameramen except for other countries. For instance, there are a few who do commercial and newsreel work.

All cameramen as well as directors, stars, scenario writers, etc., are under contract to the studio for which they work and they are given a life long job so long as they maintain good records. Good team work is welcomed. When a director finds a good cameraman they usually work together for years. I know several who have been with the same director for the past seven years.

I have been asked why there are not more American cinematographers working in Japan. It is simply because there are no better American cinematographers than the Japanese—in Japan—and that the studios cannot afford to pay the Americans the same salaries as the Hollywood studios. There is no other reason.

All Japanese cameramen are more than willing to work with an American if there is any chance to do so. A few years ago Universal Film Corporation sent Harold Smith to Japan. He made several pictures and everyone liked him and he got along wonderfully with the Japanese cameramen and producers.

Most of the larger studios in Japan at present are using Bell & Howell cameras while some still prefer to use French made Parvoes. Only one studio has the Mitchell camera with high speed outfit. The Mitchell is just beginning to come in.

Carbon lights have been used for the last few years, but the incandescent lights have invaded the studios lately. Both kinds are being used.

Many years ago the Japanese people did not pay much attention to motion picture photography. They did not seem to notice whether it was good or not. The cameramen were merely "crank turners"—there was no art work in it. But within the last few years Japanese cameramen have gradually earned and received the appreciation due artistic photography of today, and even the laborers in the streets talk of the photography in the films.

I have heard that a Japanese girl broke her engagement because her fiance did not appreciate the photography in "Seventh Heaven" and that two high school boys saw a picture and did not notice the name of the cinematographer. They started an argument and one boy lost the bet. He had to do all the friend's homework for the rest of the semester.

People in Japan appreciate the cameraman's work as well as the good direction and fine acting. Such pictures as the "Covered Wagon;" "Dark Angel;" "Winning of Barbara Worth;" "Music Master;" "Last Laugh" and "Sunrise" made tremendous hits over there and the people gave half the credit to the cameramen who photographed those pictures.

American newspapers and magazine critics often neglect to mention the name of the cameraman to whom credit is due for photographing a successful picture and in America we seldom see the cameraman's name advertised in the theater advertisements of the newspaper. In Japan, in every daily paper, one can always tell what director, star and cameraman made a picture. Many people prefer to see the work of their favorite cameraman rather than of the star or director. No picture is found in Japan which does not give credit to the assistant as well as first cameramen.

The worst condition in Japanese Studios is the lack of proper lighting equipment. With the exception of two or three studios they always have a hard time shooting a large set. I remember when I was working with had to shoot a large ball room scene and the other three units had the day off.

Another time I had to shoot a department store, on location in Tokyo, and as we had to work every night after the store closed and the scenes were supposed to be day sequences, we had a hard time. The company I. worked for was a small independent one and had only fourteen lights, including five spots. All I had to do was to shoot down so that dark windows wouldn't be in the picture. No panchromatic film was used.

The latest information from Japan is that there are 42 productions now being made in ten studios in Japan and 22 more to be started soon. That means that most of the cameramen are busy.

Motion Picture Production

By HAYAKAWA

Motion pictures in Japan are as old as in America or Europe. In 1896, three years after the World's Columbian Exposition in Chicago, in which Edison's Kinetoscope, the Vitascope and Cinematograph were exhibited. These inventions were introduced into Japan and were favorably received by the reason of curiosity, mostly.

The first filming of motion pictures in Japan was made in the spring of 1897. Mr. Inahata, our first producer, filmed a stage actor. Mr. Nomura, a painter, went to Japan from Paris to film the landscape. These first two films were not good enough to project on the screen in public. In the autumn of that same year, Mr. Shibata filmed the Geisha girls, utilizing a Gaumont camera. This was the first successful motion picture made in Japan.

In 1904, the Yoshizawa Studio was built in Tokyo and this was the first motion picture studio to be erected in Japan. By 1910 four other studios had been built and many American and European films were being shown there. In 1905, "Robinson Crusoe" was shown and in 1906 "The Life of Christ." These created a great sensation.

After seeing the foreign pictures the Japanese people had developed a desire to see some pictures filmed in their own land, with their own actors, and with titles in their own language.

In 1909 Yoshizawa Studio produced the first dramatic picture which was strictly Japanese. In 1912 the Japanese Motion Picture was organized and it now has one of the largest studios in Japan.

The Japanese Motion Picture Co. made several pictures and they always utilized the same background which was usually taken from a cloth painting and not from the real background. The feminine parts were always played by men. No actresses were used in motion pictures and very few spoken titles were used. The pictures were taken from stage dramas only. The camera position was just for one scene.

In those days, in order to get a good film, the actors had to stop and hold their position exactly until the film in the camera had been changed. The director who could make the whole picture go on without showing that the film had been changed was called a good director. The cameraman who could change the film quickly and expertly was called a great cameraman.

In 1920, the Shochiku Cinema company was formed. Until this time there (Concluded on Page 8)

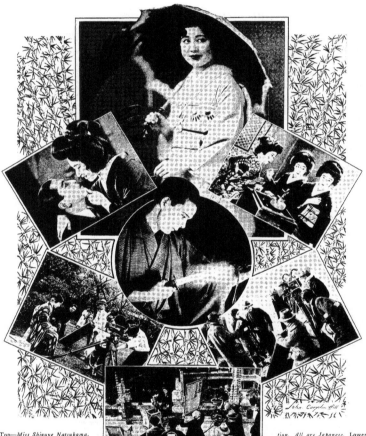

Top—*Miss Shizuye Natsukama,
star of the Japan Motion Picture
Co.* Top left—*Two stock play-
ers.* Top right—*Three stars of
the Japan Motion Picture Co.*
Center—*Demmei Sudzuky, Sho-
chiku Cinema Co.* Lower left,
right and below—*Japanese com-
panies at work in actual produc-* tion. *All are Japanese.* Lower
left—*Cameraman Oda shooting
close-up of the Shochiku Kinema
Star, Sumkio Kurishima.* Lower
right—*One of the Nippon Kine-
ma Studio cameramen on loca-
tion.* Below—*Shooting on roof
of Imperial Hotel, Tokyo, Sho-
chiku Kinema Studio on location.*

How Animated Cartoons Are Made

(From the Celebrated Bray Studios)

There must be a staff of 25 to 30 people in a studio which produces a complete animated cartoon each week. This includes six "animators," who do nothing but pencil drawings; "tracers," who ink them in; a "gag writer," whose duty it is to think humorous situations; and a photographer.

The scenario is written. The artist in charge distributes the various scenes among the animators, who study the action very carefully to see where they can insert a little funny piece of business. If a scene calls for an action where a man peels a potato, it is left to the imagination of the animator as to how the man should do it in the funniest possible way. It is not so much the incident but how each animator handles it that makes the scene funny.

The drawings are made on fairly transparent paper and the figures are drawn about two to three inches high. The paper has two holes punched at the top, like the paper in a loose-leaf ledger, and there are two pegs to match the holes fixed in the top of the drawing board. The artist makes the first drawing and then puts a blank sheet of paper on the pegs. Then he draws the next position, moving it slightly forward or around, as the case requires.

Those movements have to be calculated with mathematical accuracy to insure smooth running. If a character has to walk across a room it requires about 40 drawings, moving each one a quarter of an inch. If the character is to move faster, he is spaced at half an inch, or if he is running, he is spaced a whole inch forward each time he is drawn.

After a scene is animated in pencil it is turned over to the tracer. The tracers are generally young art students who are ambitious to become animators. They trace the pencil drawings on sheets of celluloid the same size as the paper and punched with two holes in the same way. "Cels" is the professional pet name of these tracings. The young tracer must be very accurate in his work, for if he does not keep strictly within his lines, the figure will quiver like a jelly-fish when the whole sequence is run off.

Tracing eliminates a lot of work. If a figure is to raise his arm the animator makes the first drawing of the character, which is called the "model." Then he only animates the arm, fitting each position to the "model." The tracer then makes a "cel" of the figure, minus the arm, and puts the arms on another set of "cels." When this action is ready to be photographed, the "model cel" remains on the pegs and each "cel" of the arm is photographed with the model. Where a figure talks, the animator makes five or six drawings of the head only, and one drawing of the first position complete. The tracer inks in the heads on a set of "cels" and makes a "cel" of the figure, minus the head.

After the tracer has inked in the entire scene, it is then passed on to other people who fill in the blacks, such as coats, shoes, and so on. On the reverse of the "cel" the figures are then painted with a white opaque water-color paint. This is done so that when a "cel" is photographed against a background that has furniture and people in it, the objects will not show through and make our cartoon characters like transparent little animated ghosts.

When the scenes have all been blackened and opaqued, they are ready to be photographed. Each animator receives the scenes he animated and writes a chart showing how much exposure each drawing is to get.

Meanwhile, the cast of real people have been photographed in the studio with regular sets, such as are used in feature pictures. They go through their parts as though the cartoon figures were on the set with them. They look down, laugh or scowl, snatch at apparently nothing, listen appreciatively to someone who is obviously not there.

Then this reel-full of seemingly meaningless action is finished and ready to be combined, by clever double-exposure, with the finished cartoon sequence.

When the cartoon part is ready the scene and the exposure chart are given to the cameraman. A regular motion picture camera is used, which is suspended over a table on which are a set of pegs like those used on the drawing boards. The lens of the camera is in direct line with these and illumination is furnished by special lamps, suspended on each side of the camera, so that light is centered on the drawings.

The camera has an automatic crank, operated by a motor. When the photographer pushes a button the camera takes one picture. The background is placed on the pegs, remaining so through the scene and the "cels" are then photographed one at a time as marked on the exposure sheet.

It requires three days for one man to photograph a complete picture, and after that the film must be cut and assembled, so that many hours of work as well as a mighty amount of concentration go into the making of ten minutes of laughter for us all when we see the results on the screen.

OBITUARY

Brother Michael Santa Croce has returned from New York City where he was summoned to the beside of his mother, Mrs. Fannie Santa Croce, wife of Nicholas Santa Croce. Mrs. Santa Croce passed away on January 2, leaving her husband and three children. She was buried in New York. Local 659 extends to Brother Michael its heartfelt sympathy.

NIPPON GOES HOLLYWOOD

(Continued from Page 6)

had been several movements to put better art into the pictures but they had failed. At this time there were many American films imported, for example: Blue Bird pictures, Chaplin pictures, William S. Hart pictures, Sessue Hayakawa pictures, Alla Nazimova pictures and many others.

The intellectual and high class people liked all the imported pictures. They did not care for the pictures filmed in Japan by the Japanese people.

The Shochika Cinema Company was making the Americanized pictures and, therefore, the camera work of the Shochika films was of the American type.

While the Shochiku Cinema Company was making Americanized films, the Japan Motion Picture Co., was making copies of Japanese stage plays.

There was nothing much to camera work in Japan until the big earthquake in the autumn of 1923. After that year there have been many fine productions made and at the present time there are 13 large studios in Japan and several small ones, each studio making from two to three pictures each week.

The camera work in "Kengeki," a process used by the Japan Motion Picture company is unique in that most of the scenes are follow shots. The sub-titles and spoken titles are over-lapped on the scene. They do this in order to make the title look like a scene. This film is very strong and positive and very artistic. It is not smooth like the American film, but is roughly expressed.

On the other hand, the Shochiku Cinema Company is doing Americanized camera work, filming modern stories and plays. Many Japanese films are now being exported to Germany and France.

A bright future can be seen for the so-called "Classic Play Films" and "Modern Play Films" produced according to the "Kengeki" method.

By this method the Japanese are rapidly developing a very unique technique and they will soon have their own original way of filming a picture.

The Japanese wood -int called "Ukiyo-Ye" will be a great influence on the people who make pictures in Japan. These wood-prints are several hundred years old. In Japan "Ukiyo-Ye" is considered a very wonderful piece of art.

These pictures will undoubtedly exercise a great influence over the camera work of the Japanese pictures. They are in fact the basis of the Kengeki system.

Cream o' th' Stills

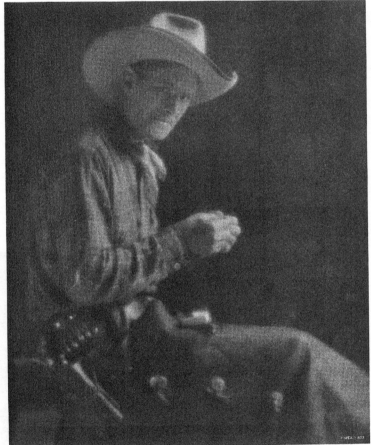

The cow-boy is always a picturesque figure, no matter where you find him, but it takes the facile camera of Shirley Vance Martin to cast the glamour of romance about him. This study of "Slim Smith" is reminiscent of Mr. Martin in one of his happiest moods.

Cream o'th' Stills

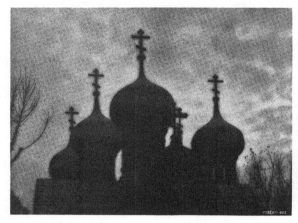

Gaston Longet loves to paint in strong, bold strokes and this silhouette of the old Russian flavor is characteristic of his best work. This subject is pre-Soviet Russia, all right, but Mr. Longet did not have to go to Moscow to get it. Hollywood has a way of making the farthest flung parts of the world come at her call.

You who have had the joy of looking upon the marine and shore glories around old Monterey, California, will be charmed again at this vista picked up by the still camera of Robert Coburn. The Mediterranean may be blue, but in all the world there are no marine settings more enchanting than these "On the Way to Monterey."

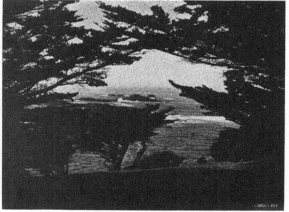

Cream o' th' Stills

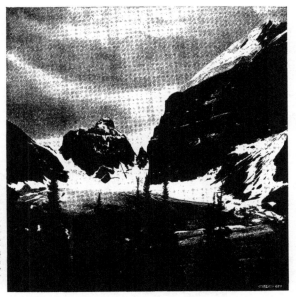

From the camera of President Alvin Wyckoff, of The International Photographers, came this stark, bleak vista of the Canadian Rockies in winter mood. Mount Le-Froy is straight ahead and Mount Mitre is on the right. Mr. Wyckoff, in registering this picture, exercised his usual good judgment in selecting a vantage point.

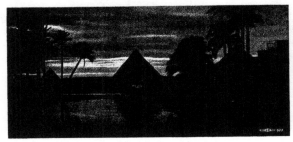

George Hollister, one of the International Photographers' famous globe-trotters, trapped this entrancing picture while returning from his adventures in the Boxer Rebellion in China, where he was a war correspondent. The angle represented in this particular shot is the only one from which all three of the pyramids may be gotten together in the frame and at the same time an art setting obtained.

Cream o' th' Stills

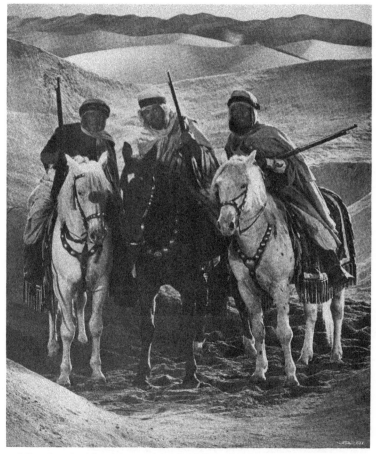

Is this a set or a shot of the sand dunes around the Gulf of California. Right! It is not a picture of the sand dunes. Mr. Carl Widen ran onto this one day while gunning for big game around a studio set. This is a good example of studio practice in the fabrication of settings dealing with outdoor subjects. It is an intriguing bit of camera work.

A Pioneer of the Motion Picture Industry Goes Home to Rest

Our Mable Normand in her happier days when she was the biggest and most charming star in pictures. Here she is photographed in character by Enrique (Harry) Vallejo, Local 659, who was for long her cameraman. These pictures are engraved directly from the original stills.

Goodbye, Mable; your place in the history of the Cinema is assured.

BORN IN MARCH

Here is the dazzling galaxy of hand-
some and talented gentlemen who chose
the month of March in which to be born.
Together with St. Patrick they have made
the third month of the year famous as
the only one that "comes in like a lion
and goes out like a lamb" and vice versa.

Birthday presents may be sent them
care the editor of The International
Photographer.

Kenneth Alexander, Gordon Avil,
Charles Bartleet, John Breamer, J. S.
Brown, Jr., Robert Bryan, Emilio Cal-
ouri, Roy Clark, Charles Clarke, Wm.
Cronéweth, Edward Cronjager, John
Crouse, Warner Cruze, Robert Davol,
Lauron A. Draper, August Elliott, LeRoy
Eslick, Junius Estep, Roman Freulich,
Martin Glouner, William Grimes, John
Hallenberger, Neal Harbarger, Wilton
Hill, Ross Hoffman, Geo. Hollister, Sr.,
Dr. G. Floyd Jackman, John Jenkins, Ray
June, Joseph Kealey, Roy Klaffki, Jack
Koffman, Ted Landon, Charles Lang,
Bert Lynch, Jack Marta, Jr., Clyde Meg-
inness, Ernest Miller, Robert Miller,
Philip Peach, Knut Rahmn, Guy Roe,
Henrik Sartov, John Schmitz, Emmett
Schoenbaum, Cliff Stine, A. J. Stout,
Philip Tannura, Clifton Thomas, Wm. C.
Thompson, Lindsay Thomson, Earle
Walker, Gilbert Warrenton, Richard
Worsfold, Harold Wyckoff, Herry Zech,
Enest Zimmerman.

A PHOTOGRAPHIC LEGACY

*Brother Les Rowley, whenever he goes
on locations, invariably carries along a
small graflex, and in idle moments—
which are few, to be sure—spends a little
time in getting various atmospheric
effects of the nearby scenery. Thereby
testing filters, screens, and films which
is of great benefit to him in his motion
picture camera work.*

*At the last meeting of the club he had
with him a little gem of a composition.
In the foreground were four white birch
trees bordering a road, which curved in
the distance over a small hill. On top of
the hill was a picturesque white farm
house and its outbuildings. Far in the
distance storm clouds were gathering, and
the whole scene seemed to have been
taken through a crevice in some rocks,
forming a most symmetrical frame.*

*A crowd of still men immediately sur-
rounded him, and begged to know hwo
and where he found such a wonderful
location—especially the dark frame.*

*Brother Rowley smiled his quizzical
smile and, looking over his glasses said:
"Well, boys, I don't mind telling you
where the place is, but I do not think
you could duplicate it."*

*"Why not," demanded Brother Shirley
Vance Martin. "Couldn't we find the
same frame you took that picture
through?"*

*"Nope," replied Brother Rowley, "you
see a bow-legged girl stepped right in
front of the camera as I snapped the
shutter, and—"*

*But just then Brother Alvin Wyckoff
rapped for order, so the boys never did
get the maiden's name and address.*

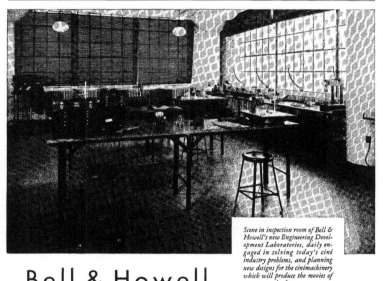

Scene in inspection room of Bell & Howell's new Engineering Development Laboratories, daily engaged in solving today's ciné industry problems, and planning new designs for the cinémachinery which will produce the movies of the future.

Bell & Howell
Accuracy Begins in the
Test Tube

THE rigid specifications guiding every operation in the manufacture of Bell & Howell Cinemachinery begin with inflexible chemical formulae. For the various kinds of metals used, specifications as to hardness, texture, and reaction to temperature are inviolable, and can be achieved only by exacting restrictions in their manufacture.

Scores of minute inspections follow every manufacturing operation. Tolerances of one ten-thousandth of an inch are commonly demanded. Completed machines must run a hard gauntlet before they are released. Bell & Howell's first guarantee is to itself . . .

that its Standard Cameras, Perforators, Printers and Splicers be made in such a way as to render the full measure of dependable service the world has learned to expect of them.

This accuracy and dependability is a part of the permanent contribution to the economic and artistic advancement of the industry which is made by the Bell & Howell Engineering Research Laboratories. Consultation on any of your own problems is invited.

BELL & HOWELL CO.

Bell & Howell Co., Dept. O, 1849 Larchmont Ave., Chicago, Ill. , , New York, 11 West 42nd Street
Hollywood, 6324 Santa Monica Blvd. , London (B. & H. Co., Ltd.) 320 Regent Street , *Established 1907*

A New Chromium Reflector and Why

—BY—

GUSTAV DIETZ, *Dietz Panchromatic Lamp Company*

If we survey the progress in artificial studio lighting and the change of lighting that has taken place during the last decade we must admit that the same electrical types of lighting fixtures are very much in evidence at the present time and models have been changed only to take a different light source.

Primarily these fixtures were designed to return the waste light to the front and gain added light efficiency without giving much consideration to the quality of light. This quality we were expected to attain by using difusers and screens and we had to do it, thus cutting the actual efficiency of the light source down to a considerable extent in order to get a light quality suitable for photography.

The spotlights were constructed to give high concentrated light value, and the means for projecting the light in concentrated form were either lenses or curved reflectors or a combination of both and then the sun arc was introduall mechanism in front, giving a powerduced with a large open reflector, and ful light but also projecting the shadow of the mechanism as soon as the concentration was passed and prism glasses and screens were employed to even out the larger light fields when smoothness was desired.

With the general introduction of Panchromatic film, with its sensitivity to the red and of the spectrum incandescent lighting made its appearance and proved successful even with the rather, for this purpose, crude fixtures or arc lighting fitted with incandescent globes.

Experiment started especially with spots to overcome the uneven light that they also gave. They showed the filament or smudges, and dark centers and so on. Nothing seemingly could be done about this and the studios accepted it by getting used to it.

Now let us investigate the reason for these defects in lighting fixtures, and let us investigate the glass reflector.

This curved mirror acts the same way as a single lens does, with this difference that it focuses in front, whereas the lens focusses in back and a photographic image is produced by either one. Both mirror and lens also project an image; both enlarge an image; in fact both are identical in optical tendencies. Besides all undesirable faults as stygmatism, curvature and abberation are very much more pronounced in a reflector.

We have now the following results: When an arc is projected in parallel beam for strongest light the field looks even, because the light source is one point source and the collective light rays are not so much affected by the mechanism. By moving the arc towards the mirror, the mechanism is brought in focus and begins to be projected and reproduced, by increasing the movement the sharpness of image is flattened out and we have what we call ghost.

With incandescent lighting we met the same proposition. When light is in focus, the filament shows brightly and clearly, when globe is moved back we wash out the filament image and get light and dark smudges. A further movement starts to produce the ghost of the globe and the reflected light that passes the globe produces lighter rings around the ghost. With concentrated filaments it is hopeless to try to get even a semblance of a practical spot, as always part of the filament either front or back is yet in focus, and this form of filament has been discarded for spot purposes.

So we see that mirrors need means to smooth out the light and screens, diverging glasses, florentines, etc., are generally employed with a fairly large loss of light efficiency and producing flood lights instead of spots.

Incandescent lighting created a new problem as the light source is not any more a one point source but a space, either one plane or cube, filled with separate lines of glowing filament which has to have a certain separation to burn efficiently and a reasonable length of time.

But it is reasonable to expect a vast improvement in filaments in the not very distant future as soon as it is realized that not alone strength but also quality is so necessary for photographic lighting. With incandescents a very considerable number overlapping each other have to be employed to give a comparative smooth light over the set.

If we bear in mind that objects within the set are moving in smaller light cones of the same spots we cannot expect the same even light on them as we do on the set proper. We must not leave out of consideration the effect, however slight, of infra-red rays with which the set is filled up and which also helps to create a certain flatness on negative. This calls for stronger and stronger highlights and the laboratories, frequently getting these flat exposures, accommodate themselves gradually to it, develop harder, and cry for more light. So the cycle goes on and everybody is guessing.

This long introduction leads up to what was in the undersigned's mind when he designed and introduced the first panchromatic lamps a few years ago.

Bearing in mind that incandescents predominate in reds it was desirable to favor the blues as much as possible, which glass and silver does not do and a bluish metal, "alluminum" was used on the floodlights. The construction of lamp gives a very smooth strong whitish light of a great angle and soft illuminated shadows right back of objects which no other fixtures could show. This allowed directional soft lighting on sets and did counteract flatness.

The preservation of the proper balance of spectrum gave a wonderful texture to the flesh and the floodlight was immediately recognized as superior and found great favor for close-up work also.

Preservation of the blue rays has been further increased in lamps of latest design, where chromiumplating has been selected as a medium to give even better photographic results. For confirmation we quote here a report by Professor R. K. Young which was published in The Times and which reads as follows:

"Another paper presented to the astronomers by Prof. R. K. Young of the University of Toronto, indicates the improvement that may come in the future of reflecting telescopes. In the reflector, with silver to reflect the light to the the concave mirror is ordinarily covered focus. Though universally used, silver is not ideal. Even when new, it reflects red light better than blue, or the shorter invisible waves beyond in the ultra-violet. It soon deteriorates, and does so most rapidly in this same blue and ultra-violet region. Yet these are the very waves in which the astronomer is most interested.

Professor Young made comparative tests on the reflecting power of silver and chromium, a metal formerly rather rare, but now common as one of the chief constituents of stainless steel, commonly used for kitchen knives. When new, he found a chromium surface does not send back quite as much light as silver, but it does reflect all colors equally well and reflects the ultra-violet as well as silver. Furthermore, it does not tarnish, and a coat a year old is as good as new and much better than silver of the same age. So the same quality that has made chromium of value in peeling tomatoes may help the astronomer solve the secrets of the stars."

In design and construction of the new 24" all metal Sectional Reflector for incandescent lamps, which has received such a gratifying welcome, the undersigned will say that most of the defects of glass reflection have been eliminated.

The light from filament is mixed and broken up before being reflected so that no image can be formed. Stigmatism and curvature and the appearance of ghost in flooding is corrected and the field is absolutely smooth with even extreme flooding. The spot has no harsh and contrasting edges but softens out gradually so it can be superimposed anywhere without showing that spot effect of a round illuminated sharp circle.

In flooding it gives at all stages virgin strength or light which can be adjusted to any strength desired by controlling the flood and gives light variations from one to about 1-200. It does away with the expensive diverging glasses, which cause a sport to lose its identity and change it to a limited flood light. It can be used in all stages of light strength for close-up work without screening, and in color photography it has found instantaneous recognition.

(Concluded on Page 23)

"*Hot Points*"

Conducted by MAURICE KAINS

Stereo camera with special back taking all standard 4x5 Graflex rear attachments.

Have you ever shopped for a hand camera only to find that the box you liked most would not take the size plates or films that you wanted to use and therefore was practically worthless to you? Recently we made an extensive search for a stereo camera, but could not find exactly what was desired because we wanted to use cut film, which can be easily procured all over the world. The happy thought of rebuilding the back saved the day, however. We found a first-class second-hand camera and built a back on it, taking the standard 4x5 Graflex cut film and plate magazine. This special back enables us to use 4x5 cut film or plates of any manufacture or emulsion, autochrome plates or even film packs, to say nothing of the advantage of using the regular Graflex ground glass for accurate focusing. The magazine can be transferred from the Graflex camera to the stereo or vice versa provided an accurate check is kept of the septums exposed on the Graflex so as to avoid double exposures. We shoot twelve stereo views or twenty-four single views on the upper half of the plates, remove the magazine, invert it and then shoot through twelve more stereos or twenty-four single views on the other half of the plates. Filter holders and a track on the under side of the camera fo sliding it sidewise have been added. On long shots the stereoscopic relief is more pronounced by increasing the inter-pupillary distance of the two lenses. This can be accomplished by sliding the camera to one end of the track, capping one lens and making an exposure, then sliding the camera to the other end of the track, capping the other lens and exposing the other end of the film. Of course this can be done only on shots in which there is absolutely no action.

———

Jack MacBurnie has contrived a clever little gadget for use in following focus while shooting from a booth. Jack went up to the Five-and-Ten Cent store and purchased a small aluminum funnel or a bullet-shaped cream skimmer. He then removed the spout from the funnel. The large end of the funnel was cut down and fitted to the business end of his flashlight. This device has the effect of concentrating the light into a tiny but strong beam of light on the lens mount calibrations, reducing the hazard of reflection on the glass to the minimum. You may find it necessary by experiment to paint the inside of the funnel red or black.

———

"Grandpa" Hoke recently needed some emery cloth to sand down a tight fitting clutch. Sandpaper was the only tool available at the time and was not very satisfactory because it tore into pieces too easily. Ira (may his shadow never grow less) then conceived the clever idea of sticking adhesive tape to the back of the sandpaper, thus quickly converting it into a splendid substitute for emery cloth.

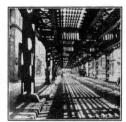

A Sound Track

MAZDA . . . not the name of a thing, but the mark of a research service

5 kw. MAZDA Photographic Lamp, G-64

This
makes the
difference

NOW, even a gradually accumulating residue of "bulb blackening" on the inside of high wattage photographic lamps need not put an end to their invaluable lighting service to the motion picture photographer.

MAZDA research has discovered a practical method of removing this black deposit from lamps otherwise as good as new. A teaspoonful of special crystalline tungsten powder, placed inside the lamp bulb before it is exhausted, makes the difference.

When blackening forms, remove the lamp from its socket, invert it so that the powder touches the blackened inner surface, rotate it gently, and friction removes the blackening. Nothing else to be done — your lamp is as good as new. Put it back in its socket, where it burns in an upright position, and the powder and residue return to the base.

Increased efficiency a great saving in the cost of motion picture production greater uniformity of illumination lighter equipments more easily handled many other benefits. Another reason for the leadership of G. E. MAZDA incandescent lamps as light sources for motion picture photography.

GENERAL ELECTRIC
MAZDA LAMPS

"ORTHOVISEUR"

This is the new Debrie Finder called the Orthoviseur which appears to be a most excellent instrument. By Victor Scheurich from the "Cinematographer Francaise."

THE HIGH HAT

In this picture Brother Charles Stumar wears the uniform of the cinematographer in Germany. Here Mr. Stumar is shown cranking on "Das Schweigen Im Walde," "The Silence of the Woods" after the story by Ludwig Ganghofer, directed by W. Dieterle. Mr. Stumar has been in Europe more than a year and reports that he has been busy every day of the time.

THE FIRST MOTION PICTURE*t*

Mr. Maupin is one of the clever cartoonists of Local 659.

MOUNTING PAPER PINHOLES

(British Journal Photographic Almanac)

(For an example of a beautiful pinhole picture see Mr. Crandall's photograph of the Los Angeles River in our art insert, this issue.)

In view of the requirements that an ideal pinhole for photographic purposes would have to be made in a surface having no thickness and must be absolutely clear and regular in form, H. D'Arcy Power advocates the use of extremely thin black paper, such as the protective cover of an Agfa film-pack.

A very good result may be obtained by supporting the paper on a block of paraffin wax and piercing it with a hot needle.

From the point of view of perfect sharpness of the edges, still better results may be obtained by cutting such paper with scissors into strips having perfectly clean edges and re-assembling four such strips, in couples placed transversely to one another, leaving between each couple a gap of the width of which the aperture is desired to be.

There is thus left a minute central rectangular opening to act as the pinhole.

The strips are thus assembled on a sheet of glass and secured to one another with seccotine. When dry the central portion forming the aperture may be cut out for mounting.

In order to keep this paper pinhole in perfect condition it is sealed with Canada Balsam between two sheets of the thinnest microscope cover-glass.

PINHOLE EXPOSURES
(Watkins-Power Numbers)

W. P. No.	Diameter Inch	Inch	Nearest Needle Size	Good Working Distance Inches
1	0.160	1/ 7
2	0.080	1/13
3	0.053	1/19	1	40
4	0.040	1 25	4	20
5	0.032	1/31	5	14
6	0.027	1/38	7	10
7	0.023	1/44	8	8
8	0.020	1/52	10	5

Rule for use of W. P. No. in Column 1. Multiply W. P. No. of aperture by its working distance from plate. Use the results as the f/NO in calculating exposure by meter, tables or other means. Whatever the calculated result is in seconds or fractions of seconds, expose that number of minutes or fractions of a minute.

Example: W. P. 6 at 8 inches—calculate as f/48.

665—*Toronto*—665

Canada

IT'S A GIRL!

Now that the tumult and the shouting of the festive season has subsided your scribe girds up his loins to let you know that — race suicide is unknown among cameramen. We, of Local 665, extend the congratulatory mitt to Hilliard Gray, our new secretary. He is the daddy of a bouncing baby girl. But between you and me, Hilliard, what makes these babies bounce?

* * *

LOSE POPULAR MEMBER

The Local lost a popular member recently when Marvin Jacobs, cleared for the south. Marvin had been with us only a short time, but long enough to endear himself to the boys. We have had cards from him bearing New York and Texas addresses. We don't know where he is now, but wherever he is we say: "Hey! Marv.! Don't forget us and hurry back!"

* * *

CALIFORNIA—HERE WE COME!

While you birds in California are basking in the sunshine and pelting one another with roses, we up here are going gray wrestling with furnaces, keeping the driveways clear and going to the mat with the old bus—stalled with the battery dead in eight-foot banks of snow. We of scant locks and graying temples were but callow youths when such winters were the accepted thing. So great has been the fall of snow, so seriously has traffic been crippled, and so many of our cameramen have been lost without a trace in the wilds of Yonge Street, that Filmart Motion Pictures (Local 665's place of meeting) has set aside the brick faced east side of the premises as a wailing wall. This weather is a stinging rebuke to the pride of some of our members. In the leafy, smiling days of summer some of the wealthy members of our union drove through the streets in high powered cars much to the discomfort of us lesser ones. Now, these same high powered cars are the first to fail and it is with ill-concealed elation that we come upon these erstwhile plutocrats, stuck, with "the beautiful" piled high above their runnings boards.

As I sit, typewrite in lap, inditing these poor lines, outside the storm is raging. Snow swirls and hisses about the window sill. In my despair at depicting better the rigors of our climate I turn to Walt Swaffield, our artist who will—in his graphic way, carry on from where I leave off.

* * *

HOLD ANNUAL ELECTION

Now that the smoke of battle has cleared, through the haze we discern figures destined to guide the good ship Local 665 through the troubled waters of 1930. That's another way of saying we held our annual election of officers. The feature of the event was the election of Ross Beasley, of Vancouver, B. C., to the position of vice-president. This is the

HIGHLIGHTS OF LOCAL 665

"SNOW USE WALKING"

"GET HOT FOR DADDY OR DADDY WILL FREEZE"

THIS YEAR'S MODEL

— Swaffield

first member outside of Toronto to win a place among the executives of our Local. Frank O'Bryne, our popular president, stills hold the helm and Charles Roos was re-elected vice-president. The other officers are secretary, Hilliard Gray; recording secretary, George Rutherford; treasurer, Norman A. Gunn; sergeant-at-arms, Roy O'Connor; business agent, William H. Graham.

This year promises to be a banner one for Local 665. Increased membership is assured and the officers have pledged themselves to do all in their power to forward the ends of the motion picture industry in the Dominion, particularly in those matters relating to cinematography.

* * *

THE LIGHT THAT FAILED

Having had his own car knocked into the ditch recently to the tune of $100.00 for repairs, your Scribe can sympathize with our president, Frank O'Bryne, who struck a farmer's wagon near the Dundas Highway the other night. It was a horse drawn vehicle loaded with lumber. When Frank hit it he knocked the lumber flying; he knocked the horse down and the farmer on top of the horse. The radiator in his sedan was shoved back and the windshield was shattered into a million pieces. The remarkable thing was that no one was hurt, not even the horse. We would like to lay a little bet that in future the farmer will carry a light on his wagon which works.

* * *

This year Ontario cameramen with cards will receive special markers from the Provincial government. These markers will enable the owners to proceed to scenes of film interest without the irritating delays that will continue still to mark the pathway of the Hoi-Polloi, i.e., the common people. Ever since the Local was fomed the members have been striving to obtain this privilege. Last year there were special numbers issued to some, but everyone, including the department officials who issued them seemed to be hazy regarding the why and wherefore. This year the whole thing has been threshed out beforehand. Now highway officials and cameramen are unanimous in declaring the idea to be in the best interests of the motion picture industry in Ontario.

In view of this generous treatment by the Ontario Government it is expected that the city police department will lend an attentive ear to our plea for more

(Continued on page 23)

Radionics and the Electro-Chemical Factor

Written for The International Photographer by DR. C. H. GOURDIER, *Calbro Magnowave, Inc.*

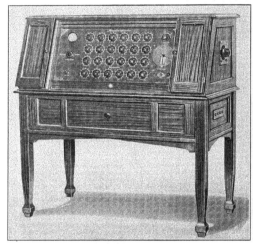

The Hemodimagnometer (the diagnosing part of the instrument) Dimagnometer (the treating part of the instrument)

Due to the great interest of the public with reference to the scientific principles of the Calbro Magnowave Radionic instrument I am going to attempt to give you an idea of its working principles.

To begin with we do not feel, as it has sometimes been put, that we have a panacea or cure-all, but we do feel that in our equipment we have that around which will be built one of the greatest therapeutic agents that will ever be brought forth. While the principles as we will set them forth here may seem a bit far-fetched, nevertheless, we feel that we have in our laboratories, sufficient proof that warrants us to make the statements we are going to make.

Back in the age of Aristotle, and later of Leeuwenhoek, Pasteur, Ehrlich and even up to the more recent years of Kitasato and Noguichi the things that these men worked for, and which were then scoffed at, have since been accepted as facts. It was Leeuwenhoek, the little old man of Holland, who two hundred and fifty years ago, was hooted for the statements he made regarding microbes. While his method was crude he opened the way for others who followed out the ideas that he held at that time, which ideas have been the means of the discovery of many things that today are

From time to time the editors will publish articles of general interest to the members of Local 659, to their families and our readers, not necessarily appertaining to cinematography nor to technical matters having to do with the motion picture industry. This will be done in the spirit of "take it or leave it," the idea being that some reader may be helped by them. Here is a brief presentation of an instrument and a system that is doing immense good to the victims of disease. The instrument herein dealt with not only treats but makes diagnoses. It was developed and is controlled by the Chiropractic professi on.—Editor's Note.

seldom given a thought.

The principles around which Radionics are built are the principles of matter, as taught in college physics, these being that all substance regardless of its nature, whether living or dead (while we do not believe there is such a thing as dead substance), is made up from a tiny particle known as the atom. This atom has within it, which has to do with the regulating and stabilizing of it, a combination of tiny particles known as electrons.

These tiny electrons are a dancing mass and its motility gives off what we term an oscillation, which oscillation is constant with no variations until the substance that the atom constructs changes, and such changes are due to the change in oscillation of the electrons within the atom. That is—the small particles or electrons traveling from one atomic structure to another and their rate of travel is, their oscillation and can be classed as electro-positive and electro-negative.

Whenever an electron leaves an atom that particular atom becomes electro-positive and the atom where the electron settles become electro-negative and it is this interchange as above mentioned that produces the normal oscillation of the particular substance. Once we change this particular oscillation we change the structure of the substance that we are able to measure and standardize as an oscillatory rate for conditions. We have found that each and every bacteria, depending upon its structure, its virulence (or we might say, characteristics) has an oscillation of its own. This we can also pick up and measure on our equipment.

Another point that plays an important part in the stabilizing of the oscillation of our body tissue and in building up a resistance and a power to combat disease is the body nutrition that we take into our system in the form of food. This food when it enters our body is prepared for assimilation by the action of various enzymes.

These enzymes come from the various digestive organs such as pancreas, stomach, liver and gall bladder and when they reach the lacteals or vili, through the magneto-strictive oscillation of these particular vili, they are taken into the blood stream due to the attractive force of the blood. They are then carried into the circulation, the largest portion going to the brain so that the brain is continually being recharged by the electrochemical factor contained within the blood.

This gives the brain power to distribute impulses which we know to be electrical in nature. These impulses go to the peripheral tissue which in turn regulates the magneto-strictive oscillation of the cells of the peripheral tissue. This renders them capable of an attractive force which has the power of assimilating the remainder of the electro-chemical nutritious product which was in the blood stream that did not go to the brain.

The processes involved in the entire equipment have been worked out from the standpoint that our entire body is a mass of electrical energy as has been stated above. This energy, so long as our metabolism (or the process of absorption and assimilation) is normal in constructive energy. The effect of bacterial invasion due to the particular oscillation of the bacteria is what changes the energy to destructive and, by setting our instrument on the oscillation of the various bac-

(Concluded on Page 28)

Chas. G. Roos, V.-P., Local 665

TORONTO—665
(Continued from Page 20)

lenient treatment as regards traffic laws. As things are now we are cursed with a deluge of summonses, mostly for parking but the odd for speeding too. A committee has been formed to approach the chief of police in this connection and in next month's write-up we hope to have much to tell you that is good.

* * *

AND HOW!

See a horse shoe on the road,
 Let it lie.
See a horse shoe on the road,
 Pass it by,
Remember, Lot's wife had to halt,
She looked back and turned to salt,
If you look back—Oi, Oi Gevalt
 Let it lie.
 A. M. B.

I was driving up Jarvis Street last Friday afternoon when suddenly before me on the road I saw a horse shoe. I applied my brakes and managed to come to a stop two blocks further on. I backed up. Alighted. Despite the danger to life and limb I weaved my way through traffic and gained my prize. That afternoon I nailed it above the doorway in the office and waited for developments. Saturday came around without anything unusual happening. Saturday night while bound for a show on Yonge street, I brought my car to a halt behind another at an intersection to wait for the lights to change.

WHAM ! ! ! ? ? ? ! I was almost flattened against the wheel. When the pyrotechnical display that danced before my eyes had faded somewhat I struggled out of the car to see what it was all about. And I saw plenty. The driver of the car behind me had not noticed that traffic had halted, and coming at a high rate of speed had piled up on me. The impact was so great that it piled me up on the car ahead of me. It was a swell sandwich, the cars ahead and behind were the slices of bread and I was the piece of cheese.

Both bumperettes at the back were knocked off and in front, the bumper was twisted so that it pointed heavenward. The tail-light was smashed and

the spare tire knocked off the rim. The car that struck me had lost both headlights and will carry scars of the encounter for the rest of its days. There was the usual arguing and in the end the cop had us all trail into the station and tell our stories. I won't inflict further details upon you. I have yet to know out of whose purse the repair bill will be met. But whether it is from mine or from that of the bird who smashed me and my car, I shall remain a horse shoe hater to the end of my days.
 Sincerely, AL.

―――o―――

CHROMIUM REFLECTOR
(Continued from Page 14)

Besides the reflector is mechanically designed to be practically indestructible. The segments are floating and contract and expand freely.

In case of accident the segments are easily replaced by inserting new ones where necessary. Therefore it is absolutely dependable and mechanically reliable as breakage does not need to be expected.

The finish will not suffer under great heat and 10 KW's can be safely used with this reflector.

Short circuiting blades and subjecting them to the heat that melts metal does not affect the finish 1-16 inch away from melted edge. It should outlast any other reflector, provided it is not cleaned and polished with dusty dirty rags. Quite a number of these reflectors are in use in R. K. O., United Artists, Famous Players, Lasky, Columbia, Tiffany-Stahl, Universal and Tec-Art Studios.

In closing this introduction of the new reflector the undersigned begs liberty to mention that much abused word to be met with frequently. That word is "Standard." There is no such a thing as a standard for light fixtures, but there is a standard for measure such as, candle power, voltage, etc.

A greater number of fixtures does not make them standard otherwise it means stagnation and a Good-Bye to any possible improvement in the art of motion pictures, for which the higher executives are continually striving and undersigned begs the kind readers to accord this new spot the same consideration as to a new lens or camera or similar new appartus. The reflector has been designed to improve the light just as the modern lens has been designed to improve photograhpy.

DOINGS IN

SCHNEIDERMAN RETURNS

George Schneiderman is back on the camera. This veteran cameraman was drafted by Wm. Fox at the advent of sound films to whip the Fox camera organization onto a sound-film basis.

In the course of the past year he has traveled extensively, covering the entire world in an effort to get the color of foreign climes into the Fox talking pictures. He has had associated with him David

Ragin, as second cameraman, and James Gordon and Max Cohen as assistants, in his first production just completed entitled "The Big Party."

With such masterpieces as "The Iron Horse," "Four Sons," "Three Bad Men" and "Hangman's House" behind him the Fox organization gained a valuable photographic asset when Schneiderman decided to return to active camera work again.

SETTLED

Bray Hurd Process Co., Inc., inventor and owners of the patents covering th processes by which animated cartoons ar made, announce that the suits for in fringement brought so far against certai infringers of the patents have been set tled, and the parties involved have take out licenses.

The following producers now hav

Technicolor's Crew of Expert Cine
Max Factor's Technicolor Make-

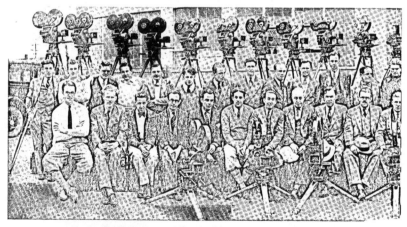

The Technicolor camera crew today. Taken in the yard of the Technicolor Camera Department Buil
and equipment. Each camera

Top row, left to right—*Louis DeAngelis, assistant; John Shepek, assistant; Chas. Geissler, assistant; Harvey Gould, assistant; Robt. Seely, maintenance; Henry Prautsch, chief of camera machine division; Frank Morse, film loader; Gilford Chamberlain, assistant m maintenance; Adrian Todd, film loader; J. A. Grant, film loader; Frank Walton, film loader; Chas. Russell, film loader; Robert Bro*

Sitting, left to right—*Morris Kains, assistant; Henry Kruse, second; Ira Hoke, second; Earl Stafford, second; Milton Bridenbecker, Rennahan, first; Chas. E. Schoenbaum, first; Chas. P. Boyle, first; Arthur Reed, second; Roy Musgrave, second; John Landrigan; Bohny, assistant.*
All these cameras were built from

=K-NIK TOWNE

licenses to operate under the Bray Hurd Process Co., Inc., patents: Bray Pictures Corporation, Aesop Fables Inc., Max Fleischer, Winkler Pictures Inc., Winsor McKay and Paul Terry.

Bray Hurd Process Co., Inc., states suits will be immediately started against all remaining infringers as it is determined to protect its rights under these patents to the fullest extent.

SPANISH COMING FAST

A campaign to stimulate production of talking films employing the Spanish language was recently launched at a conference between Los Angeles representatives of Spanish speaking countries and officials of the Motion Picture Producers and Distributors' Association of America.

The session, was attended by James

McDermott Sheridan, Vice-Consul of Brazil and representative of the Spanish-American Cultural Association, Marquis De Villa Alcazar of the Del Ama Foundation, and Fred W. Beetson, Jason S. Jay and J. V. Wilson of the Association.

Next to English-speaking films, executives have pointed out, the largest revenue accrues to the industry from productions shown in countries in which Spanish is the native tongue.

atographers Heartily Endorse
'p for Use in All Technicolor Productions

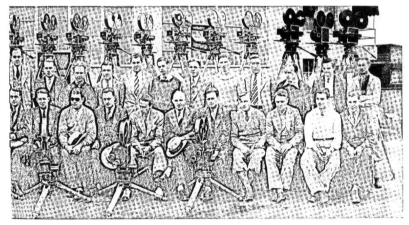

23 North Seward Street, Hollywood, California. In this picture there is over $400,000 worth of cameras added equipment costs $10,000.

ssistant; Earl Wilson, developer; Robt. Pilkington, developer; Frederick E. Grant, maintenance; Friend F. Baker, special effects; Louis mera department; Curtis Cady, camera maintenance; Floyd Lee, maintenance; Robert McLaren, maintenance; Henry Prautsch, Jr., itant; Carl Guthrie, assistant; Thad Brooks, assistant.

Lee Davis, second; W. Howard Greene, second; Frank Good, first; Al Gilks, first; Ed. T. Estabrook, head of camera department; Ray arry Hallenberger, second; Earl Walker, second; Pierre Mols, second; Jack McBurnie, assistant; Edward Garvin, assistant; Charles lo r design by the Mitchell Camera Corporation.

Hoke-um
—— By IRA ——

Far Flung
News Cameraman (Making sound pictures of a yodler in the Swiss Alps): "Now this reel goes to show that Listerine ads are read all over the world."

— :: —

Quiescent
Max Fabian (severely). "Joe, what's that ragged piece of film doing in the aperture plate?"

Joe Darrell tripped quietly over to the camera and peered cautiously within, as though endeavoring not to disturb anything. After a careful examination he turned to Max with:

"It's not doing anything now, Max."

— :: —

Generous
Eddie Garvin: "Hey, throw me some of that chewing gum."

Charlie Bohny: "This isn't chewing gum. It's a package of razor blades, but here you are."

— :: —

A Tough Spot
Fred Kaifer: "It's tough to pay fifty cents a pound for meat."

Don Brigham: "Yes, but it's tougher when you pay twenty-five."

— :: —

One a Day
A scene a day keeps collectors away.

— :: —

And Aren't They Pulchritudinous?
Chuck Geissler (On M. G. M. Revue): "Gosh, Bob, look at the chorus girls. Aren't they numerous?"

Bob Tobey: "Yes, and aren't there a lot of them."

— :: —

Foursome
H. C. Ramsey (to girl on phone) "Now you get another girl, and I'll get another good looking fellow."

— :: —

Rosalie Philosophizes
Rosalie, the revue girl, says: "'Tis better to have loved and walked, than never to have loved at all."

"Them Was the Good"
"In the old days." (18 months ago).

— :: —

Leave it to the P. A.
Bud Hooper, while out on a newsreel assignment recently covered a story in a quiet little town on the edge of the Mojave desert. But was pestered for several days by the "oldest inhabitant," who insisted upon telling his age again and again and boasting of his physical soundness.

To humor the old fellow Bud asked to what he attributed his longevity.

"Well," said the ancient soberly, "My advertising manager just sold all rights to my name to the 'Aunt Jennies' Liver Remedy Corporation, and what they say goes with me."

— :: —

Playing It Both Ways
A certain well known cameraman called his assistant the other day and handing him a five dollar bill, said:

"Charlie, here is a fiver. Go down to the Santa Fe station and take my mother-in-law out to my house."

"Supposing she is not on the train when it arrives," asked Charlie.

"Well," replied the cameraman, "in that case I'll give you another five."

— :: —

The Peak
The height of efficiency is making the assistant cameraman total up his waste footage before throwing it in the ash can.

— :: —

Sapristi!
Second assistant: "I had an awful nightmare last night."

First assistant: "You certainly did. I saw you with her."

— :: —

H2O
Our philosophic assistant remarks that if water rots developing tanks, think what it will do to your stomach.

WILL PHOTOGRAPH THOUGHTS
That photographs of human thoughts, pictures of the ideas that pass through the brain and are later expressed in words or action, may be taken on dry plates or films, developed and kept as records of mental processes, is the latest wonder of science, for which a wide and startling usefulness, is predicted by Dr. Max Baff, eminent psychologist of Clark College Worcester.

"We hear that such experiments have brought surprising results when carried on by Japanese savants," says Dr. Baff, "and it seems to me that the next thing is for us to go into the matter in this country."

"As a method of taking such thought photographs a capital way would be to expose the film in a vacuum tank and have the subjects whose thoughts are to be photographed placed near the tank, even with their heads against it. To develop the film roll, after it had been unwound in darkness, with a pair of objects thinking on a given subject while it was being unrolled would show extremely interesting results. It is a matter for close investigation and should be taken up in a long series of carefully conducted experiments."

——o——

W. E. INSTALLATIONS NEAR 5,000
World wide installations of Western Electric Sound Systems are nearing the 5,000 mark. The latest report shows that 3,489 installations have been completed in the United States and 1,268 in the foreign field.

The Daily Grind

By RALPH B. STAUB

REGGIE LYONS says that some of the doctors in Hollywood give one the impression they are still working their way through college.

* *

ELMER FRYER has just written a new song dedicated to the city of Chicago, entitled: "Enlighten the Coroner Where You Are."

* *

HAL PORTER says his assistant has a heart like a house—a bird house.

* *

NORB BRODIN thinks that false teeth should be seen and not heard.

* *

TONY GAUDIO says an optimist is a person who buys a one-way ticket to Chicago.

* *

JOHN SEITZ says his assistant thinks a medicine ball is a doctor's dance.

* *

MERRITT GERSTAD says a friend of his has a home built like an apartment house—radio in every room—the walls aren't sound-proof.

* *

ERNIE HALLER: "What's the matter —you look terrible!"
JOE McDONALD: "My wife's on a diet."

* *

JOE MORGAN says he always wears a Tuxedo to a banquet so in the middle of any speech he can grab a dish or two and leave with everyone thinking him a waiter.

* *

CHICK McGILL wants to know if NICK LUCAS croons in his bath.

* *

MACK ELLIOTT says the public thinks prohibition such a joke they now call it the 18th enfacement.

* *

BENNIE RAY says: "What the Los Angeles police don't know would fill a couple of jails."

* *

JEAN SMITH (after smash-up; opening eyes): "I had the right-of-way."
DAVE ABEL: "But the other fellow had a truck."

FRANK GOOD'S idea of how to get the right-of-way on Hollywood Boulevard: "Speed along Hollywood Boulevard in a hurry, be sure it's a big car and the cops will think you're a bootlegger and give you the courtesy of the road."

* *

"TRAILIN' THE COOLIDGES"

LAST week
AT the breakfast club
RAN into
JOHNSON of Paramount News
CUBBY of Fox News
THEN to
WARNER'S studio
MET reggie lyons
LEE davis
WILLARD van enger
WITH a rush to
UNITED ARTISTS
SHOOK hands with
JEAN smith
RAY june
KARL struss
LUNCH served by
HARRY brand
ENJOYED by all
THEN to m-g-m
TO meander with
LOUIS b. mayer and
RAMON navarro
THEN home to my office at
COLUMBIA studios where my gagman
JOE traub awaited my
APPEARANCE with glee.
I THANK YOU (with apologies to K. C. B.).—Ralph B. Staub.

* *

"ETSLA ELAY OINGAY"

are the magic words used by the famous stage and screen comedian EDDIE LAMBERT while playing the part of master of ceremonies in SCREEN SNAPSHOTS, issue number sixteen, directed by RALPH STAUB for COLUMBIA release. Eddie, with the aid of his magic words introduces such well known celebrities as Mary Pickford, Doug. Fairbanks, Mr. and Mrs. Calvin Coolidge, Will Hays, Jack Warner, Louis B. Mayer, Ramon Navarro, Ralph Graves, Marie Dressler, Chas. King Laurence Tibbett, Von Stroheim, Dolores Del Rio and others to the audience on his official trip to Hollywood.

Mr. L. C. Porter, past president of the S. M. P. E., has left the Edison Lamp Works, Harrison, New Jersey, to join the staff of the Engineering Department, Incandescent Lamp Division of the General Electric Co., Nela Park, Cleveland, Ohio. Mr. Porter's specific work at Nela Park will be as engineer in charge of the Special Development Section.

L. C. PORTER

HELL'S ANGELS

Following is a story quoted from the Monthly Bulletin of the International Alliance of Theatrical Stage Employes and Moving Picture Machine Operators of the United States and Canada. Every article in this Bulletin is read at open meetings of Operators and Mixed Locals throughout the United States and Canada. Because of this article, operators throughout two nations will be on the look out for "Hell's Angels," and it is safe to say that in the history of moving pictures no production will have more careful screening:

Howard Hughes has completed "Hell's Angels," one of the costliest motion picture productions of all times, and announces an early Broadway showing. The picture in question is the first production in the history of the motion picture industry that was made completely with union help. Mr. Hughes was the first producer to recognize and meet the conditions of the Cameramen's Local Union. Judging from the comment of our members who are associated with Mr. Hughes' production of this spectacle, we may expect to see a really worth while contribution to the motion picture screen.

RADIONICS AND THE ELECTRO-CHEMICAL FACTOR

(Continued from Page 22)

teria we believe we are able, not only to pick out the one that is producing pathology (disease), but that we are also able, through our instrument to throw into the area involved, an oscillation with sufficient strength to destroy the oscillation of the particular bacteria that is producing pathology and, in the study of the body cells, we believe there exists a certain inter-relationship of the body cells that determine their stability and that there must be a certain equality existing between electro-positive and electro-chemical elements that constitute the attractive and repellant force.

We also believe that the foregoing brief explanation of inter-relationship can be applied to gross body structure in that there are being emanated from our bodies at all times invisible rays of emanation; that it is these invisible rays of emanation which we might call our personality and that it is from these that we judge individuals as to our likes and dislikes. This sums itself up to the point of synchronization between body emanations and if these emanations were visible they might well be compared with the small sparkler that is so popular on July 4th.

There is no end to what can be said on the aforementioned subjects and I trust that the reader may be able to gather from this brief exposition of our ideas of the electro-chemical factors of our body, a few points which can be applied to the etiological factors concerned in diseased conditions. Much work has been done in the past, and there is no end to the future work and its accomplishments and we hope to be able, in the near future, to set forth a more detailed explanation of our idea of health, disease, life and death.

In the preceding paragraphs, we have tried to outline the results of our real scientific research on Radionics and its development.

After all is said and done we know there are more people who can understand, real horse sense than that care to take the time to reason out facts from scientific terms, for that reason we are going into a short paragraph on Radionics and its simplicity.

Our great scientific progress in the twentieth century has without doubt, established the fact that all substance, of whatsoever kind, has its own vibration rate.

Therefore, the minds of scientists long since began the work of establishing the vibration of foods and flesh, as well as the pathology (the science treating of diseases, their nature, manifestations, etc.) of disease in the human body. All this has now been definitely established through research principally by taking cultures of pathology and continuing their culture in their own media, until absolutely pure, when definite vibration rates are established.

Thus, by connecting the human body to the radionic instrument and by tuning in on the various scientifically established rates, reactions appear *when* and *only when* pathology is present in the body; it being no more possible to find ulcers of the stomach, if ulcers are not present, than it is to get a Chicago station by

turning the dial on your radio to a Denver station.

Radionics is not a substitute for any other science known, but a science in itself.

Translating Sound Energy Into Sound Sensation Units

Explaining the Whys and Wherefores of the Transmission Unit (DB)

Written by J. GARRICK EISENBERG *especially for The International Photographer and Projection Engineering.*

Among the many new terms which the operator of sound reproducing equipment has had to familiarize himself with, probably the least understood, and most confusing to the non-technically trained man, is the transmission unit. This simply, is the engineer's yardstick for measuring the transmission efficiency in terms of hearing response, of any electrical communication circuit. The expression of this efficiency is a mathematical one, and relates to power, voltage, or current, conducted by the circuit. The units of measurement, at first simply called transmission units (TU) have more recently, through international agreement for standardization in technological nomenclature, been called decibels (DB). The name obviously honors Alexander Graham Bell, pioneer in telephone research; wherever the term TU is encountered in older writings therefore, the more modern designation, DB, is interchangeable with it. Written mathematically the expression is: $DB = 10 \log \dfrac{P_1}{P_2}$ or, 10 times the common logarithm (to the base 10) of the ratio of output to input powers; $P_1 P_2$, correspond to output and input powers respectively. As the expression is a logarithmic one it is seen that if one circuit transmits 10 times as many watts as another, there would be a difference of 10DB between them. If the power ratio is 100 the difference would be 20DB, if 1000 it would be 30DB, 10,000 40DB etcetera. One of the main reasons for employing this apparently cumbersome unit of measurement is that it is true to nature.

We hear logarithmically; the ears' response, in other words, is proportional to the logarithm of the sound energy impressed upon it. This thoughtful provision of nature protects us against injury from very loud noises, but it causes us to underestimate a great many times, the actual sound energies involved in relative degrees of loudness. When we

say a sound is twice as loud as another, the actual energy ratio may be on the order of 100:1, or if three times as loud, 1000:1. For example, a full orchestra playing at it's loudest, sounds about sixty times as loud as when playing at it's softest; the amount of energy involved at the fortissimo passages is actually one million times greater (10 log 1,000,000 = 60). The necessity for translating electrical measurements, such as volts, amperes, and watts, into actual response units, for sound work, therefore becomes obvious. Telephone engineers originally used the "miles gain" unit of measurement, which was a relative measure (logarithmic) of gain, or loss, in a circuit, as compared to an ideal standard mile of #19 gauge telephone cable having the same input power. With the development of high quality speech reproducing circuits and equipment however, a formula which would be independent of the frequency characteristic of the equipment was required; the transmission unit, evolved in the telephone communications field fulfils this requirement, and has since come into general use in all branches of the audio field therefore, as the unit of sound measurement. Technicians who are engaged in the handling of sound energies must learn to calculate and gauge the output of their equipment in these terms of relative sound response, since the ultimate criterion of proper levels is after all the aural one. However, it should be pointed out here that the calculation of overall gain of an amplifier in DBs does not necessarily tell us anything about it's power handling capacities. This is a point on which a good deal of confusion exists. The determination for maximum undistorted power which the amplifier is capable of delivering is a purely electrical one, depending upon type of tubes used, operating conditions of the circuit, etcetera. In calculating it's overall gain, we are simply transposing it's actual output power from electrical units into equivalent hear-

ing response units (DB). We might for example, have an amplifier with an overall gain of 50 DB which was capable of delivering 2 watts of undistorted output, feeding into a power stage which has a gain of only 7 DB, but is capable of handling 12 watts of output energy. We shall attempt here to illustrate the method of calculating the output of such circuits in DBs when their electrical constants are known; several practical problems will be worked out, in order that the projectionist may familiarize himself with the actual processes involved.

We have said that the expression for DB is written: $10 \log_{10} \dfrac{P_1}{P_2}$. As voltage or current ratios, and not power ratios, are ordinarily encountered in audio amplifier circuits however, and as power ratios are equal to the square of the voltage or current ratio, a more convenient expression for our calculations will be: $DB = 20 \log_{10} \dfrac{E_1}{E_2}$ or for current ratios, $DB = 20 \log_{10} \dfrac{I_1}{I_2}$. The first problem to be considered is one of simple conversion. A two stage amplifier has an overall gain of 400; what will its overall gain be, measured in DBs? From a table of logarithms we determine that 2.6 is the common log of 400; therefore the gain of our amplifier will be 52 DB (20 log 400 = 52). Figure 1 illustrates the method of determining the overall voltage amplification of the circuit. This of course does not tell us what the actual output levels will be; these will naturally depend upon the input to the amplifier.

Consider a problem wherein we must determine how much amplification is necessary to bring the output of a photoelectric cell, which is measured in microwatts, up to normal theatre volume. The cell passes a current of 5 microamperes through a load resistance of 2 megohms,

under conditions of maximum illumination; it's output is down about 66 DB (—). It should be obvious now, that for the latter part of our statement to be correct we must have some standard of comparison, since we are dealing in efficiency ratios. In other words we must have a reference level (Zero level) to work from. This has been arbitrarily defined as "a power of 10 milliwatts, corresponding a current of 4.17 milliamperes flowing through a resistance of 600 ohms, or 2.47 volts across 600 ohms." It corresponds to the normal output of a standard carbon telephone transmitter. All measurements, whether + or — are taken with reference to this initial standard level. Thus when we refer to the threshold of audibility, which is the region of zero sound sensation for the ear, we say it is —60 DB, or 60 DB down from zero level. The ratios here are derived through a complicated formula for translating sound pressure units (dynes per square centimeter) into watts. As will be seen from the graphs, Figure 2, the threshold of audibility will vary somewhat at different frequencies, being maximum in the region of 2000 cycles. The chart in Fig. 3 interpolates the graph of these various degrees of sound sensibility at different frequencies. But to return to our problem. It has been found by experiment that an average size theatre, when nearly filled, requires a maximum of about 10 watts of sound energy for satisfactory hearing conditions. This is 1000 times the energy involved at zero level, or a difference of +30 DB. Average speech levels will be of the order of +10 DB, with occasional loud peaks reaching +20. Or in other words, speech energies will vary from .1 watt to 1 watt, a ratio of 1:10, whereas the ratio of the sound response of the ear is 1:2. When we consider impact noises, however, such as airplane crashes, collisions, and various explosive noises, we will want to increase the sound sensation perhaps 200% or more, above average speech levels. This will require the full output of +30 DB, which will give us an energy ratio of 1:100 (or .1 watt/10 watts) as between average output and maximum output levels. The real ratios in the actual sounds are of course considerably greater, but fortunately, the optical sensation lends illusion to the sensation of hearing also, and we do not, therefore, have to reproduce in the theatre, the tremendous sound energies originally involved. An output of +30 DB is really quite a whale of a level for indoor reproduction; reverberation (which is additive in effect) and other acoustic phenomena, also increase the sound sensation. Well designed theatre amplifiers are capable of delivering an average maximum of +30 DB without serious distortion. Some of the larger systems run as high as +40, or 100 watts of output energy. Photocells of different types vary in output, some being as much as 90 DB down, requiring greater amplification therefore to achieve the necessary output levels. In practice, total overall gains from photocell to horns of between 80 and 120 DB are encountered.

The actual energies involved in the various parts of the circuit, and the necessity for manipulating voltage and current ratios in building them up, offer a

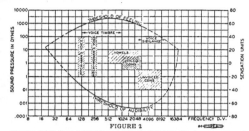

FIGURE 2

Diagram taken from publication of John C. Steinberg showing a number of interesting characteristics of speech and hearing.

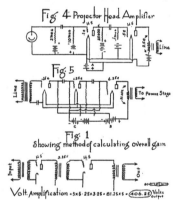

Fig 4 - Projector Head Amplifier

Fig. 5

Fig. 1

Showing method of calculating overall gain

Volt. Amplification = 5x5·25x3·25 = 81.25x5 = 406.25 Volts output

concrete illustration of the advantages of calculating in sensation units rather than electrical units. Our photocell, delivering 5 microamperes through its 2 megohm load resistor, has a maximum output of .00005 watts or we would say, is down 66 DB. Such small energies cannot be handled through ordinary coupling methods without considerable losses, and the usual practice therefore is to mount a two stage amplifier in the projector head to build up this output before feeding it to the line. The conventional circuit arrangement is shown in Fig. 3. Input voltage variations on the grid of the first tube are of the order of .1 volt; as will be seen, the total voltage amplification of the circuit is 25, giving an output of 2.5 volts in the last stage. From our formula DB = —20 log $\dfrac{2.5}{.1}$ = 28 DB (nearly). The output from this amplifier will therefore be down 38 DB or —66 + 28 = 38. Power output from the

circuit is now of the order of about .0003 watts, on the basis of $\dfrac{E^2}{R}$; the load resistance for this type of tube is assumed to be 20,000 ohms, and maximum voltage 2.5 volts. In the transfer of energy however, this voltage is stepped down, through line matching impedances etcetera; an average voltage of perhaps .3 volt being applied to the input circuit of the second amplifier. This is a three stage resistance coupled amplifier, each stage having a gain of 5, which is the μ of the tube, or a total voltage gain of 125 overall; the voltages appearing on the grids of the various tubes, with the input voltage specified, are shown in the diagram Fig. 4. The actual output energy from this amplifier is about .024 watts; the output voltage being μ6.25 volts = 31.25 volts. These figures of themselves, tell us very little insofar as sound sensation units are concerned.

(Concluded on Page 38)

This Ever Happen to You?

The New Bucklebird Camera

—BY—

CHARLES BOYLE, *Local 659*

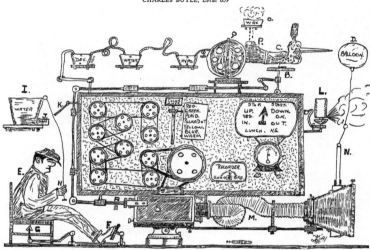

To the Editor:—After reading about "The Wonder Box," by John Leezer, in the last issue, I am forced to bring forth my pet invention. I tried to get a draughtsman by the name of Rube Goldberg to draw up my plans, but he is busy writing magazine articles so I had to do it myself.

National Distribution has been granted to the International Commercial Pictures —Board of Directors: Billy Tuers, Perry Evans, J. R. Palmer; Production Manager, Harry Fraser; chief office boy, Jack Fuqua.

DESCRIPTION

The Bewhiskered-Double-Whisk-Broom-Bucklebird-Camera Adapted to All Color — All Sound — All Everything

* * *

In case of buckle, the buckle plate (A) at rear of Camera moves shaft that is connected with platform (B) on which Bucklebird (C) rests. The Bucklebird does not like to be disturbed so when the platform moves this annoys him and he looks for something to bite. A red balloon (D) is placed in front of him so that when he bites this it explodes. The assistant cameraman (E) has been going out with another fellow's wife and is very nervous. He hears the explosion and thinks that it is a shot and jumps up which causes his foot to place pressure on pedal (F) which starts arrow (G) in upward motion. The assistant cameraman is very ticklish and so when arrow makes contact he moves faster, pulling the rope (H) thereby upsetting water. (I) and starting soap (J) in downward motion. When the pail makes contact with lever (K) it blows whistle (L) which wakes up propertyman who comes running with a towel. The Assjstant Cameraman then washes his ears and shuts off motor on camera.

Some sound men think that a 6 inch lens makes twice as much noise as two 3 inch lens so we have a novel device in the bellows (M) which keeps all lens noises in the camera. A plate attached to matt box (N) drops over lens when balloon explodes thereby saving the film from being exposed.

The Bucklebird is very nervous and by dropping hot wax (O) on his tail the developed films is polished as it goes on rewind.

Buying Power of Labor Essential to Business

Workers Best Customers of Business, Declares Roger Babson

[Published by special permission of the Babson Statistical Organization and The Hollywood Citizen, sole publisher of the Babson financial letters in Hollywood.]

BABSON PARK, Mass. (Exclusive).— When man first used a plow in place of a crooked stick and hitched it to an ox instead of to a woman he was able to produce as much goods as before with less work. All industrial history shows that most of man's progress is the result of using devices to save his own labor. Moreover, some of the greatest progress in this way is yet to come. Anyone who opposes the increasing use of labor-saving machines is merely shouting at the wind. Organized labor long since ceased trying to stop its introduction and is now bending every effort to securing a larger share of the increased profits resulting from machine methods. The more labor receives through wages and full employment the more it will have to spend.

PURCHASING POWER VITAL

Business has a vital interest, entirely aside from humanitarian or sentimental reasons, in keeping as many people at work as possible. Business men now realize that the working men constitute 85 per cent of the market for their goods. Anything that endangers labor's purchasing power endangers business. In the early days labor constituted only a small part of the market. Workers were on a bare sustenance wage, and the aristocracy bought most of the goods produced. However, a millionaire cannot wear 10,000 pairs of pants, but 10,000 workmen can if they have the money to buy them. One rich man uses only one or two automobiles, but 100,000 workmen can use 100,000 automobiles. There lies the secret of our expanding markets. When business leaders discovered that the only outlet for the tremendously increased production of machinery lay in the consuming power of the millions of workers they saw the value of maintaining high wages and high buying power. Yet the very machine methods which have made the United States the wealthiest country in the world with the best standard of living, with the most comforts and conveniences, now threaten to undermine that prosperity.

VARIOUS SOLUTIONS OFFERED

If modern industrial methods are throwing men out of work and reducing their purchasing power what can be done about it? Certainly we cannot, and ought not to try to stop the use of labor saving machines. Probably there is one solution to this problem. Certain conscious efforts can, however, be made by business men to help the situation. (1) New industries should be encouraged. Had it not been for the growth of certain industries like the automobile, the radio, the motion pictures, the electric refrigerators, oil heaters, garages, filling stations, and others which have helped to take up the slack as men were released from other industries by machinery, we should have had an unemployment crisis of drastic proportions long ago. Such new industries, must, and undoubtedly will,

This article is offered for the consideration of those of our membership who have it in their hearts to achieve economic independence. The editors have no investment tips to give. The matter to be submitted along this line will be of a general nature and entirely impersonal.—Editor's Note.

continue to be developed. Business should regard them not as competitors, but as new sources of buying power.

(2) We need more adult education, night schools, intelligent employment agencies, and other vocational guidance organization. A man who has been trained all his life in a steel plant cannot instantly become a successful life insurance salesman, or operate a corner grocery store. A soft coal miner needs training before he is worth much as an electrician for a telephone company. Moreover, the habits of a lifetime are not easily changed. So far, the facilities for placing the other jobs is totally inadequate to the problem. As a result such men drift into the first job presented to them regardless of whether or not they are fitted for it by ability or temperament. Also they accept, if they are older men, whatever wages they can get.

(3) Another way business men can maintain purchasing power is to keep their employes as long as they are physically able to perform their duties, regardless of their age. There is a senseless waste of man-power going on today through the "firing at 50" practice. Added to the displacement of workers by machinery there is the tendency of employers to use only the younger men and and let those above 50 go. This is not only unjust but uneconomic. Business should remember that every employe let go when he reaches 50 stands a good chance of becoming permanently unemployed. Thus business loses the buying power of one customer for every man released. Henry Ford says that he prefers men between 35 and 60. The records of his employment department show that the work which calls for endurance is best performed by men who are over 40. The younger men are restless and want to be transferred to other work.

THE FIVE-DAY WEEK

Whether or not the five-day week would help cure unemployment is a much disputed question. Labor leaders believe that it would if generally adopted. If, however, the five-day week means speeding up the work during five days in order that production may be equal to five and a half or six days, then obviously the most efficient workmen could stand the pace. Hence, the slower or less efficient men would drop out, thereby increasing, rather

than diminishing, unemployment. Labor's idea is not to speed up all production, but to make jobs for more men. In this way they claim general purchasing power would be increased. A few industries such as the building trades, Henry Ford, and the General Electric Company (during the summer months) are already operating on a five-day schedule.

A recent survey conducted by the United Business Service of Boston among prominent manufacturers showed about two-thirds were favorable to the five-day week in principle. A number of them stressed the point that in order to be practical it would have to be illegal to work on Saturday as it now is on Sunday, so that all competitors would be on the same footing. Moreover, there is a wide variation in the adaptability of industries to the five-day week. Some are now using it in the summer months for seasonal curtailment of output. Other industries are not sufficiently mechanized to make it practicable. Others particularly those operating on six full days and those businesses requiring constant operation of furnaces or chemical processes, feel that complete cessation of work on Saturday would seriously hamper their business. The half day on Saturday is generally regarded as unsatisfactory, but not all industries are prepared to adopt the straight five-day week. At present there is a disposition to use it according to production requirements, that is, to go on a five-day schedule during the dull season and to work Saturday when demand justifies it.

BE OF SOME HELP

Although it seems unlikely that the five-day week, even if it spreads rapidly, will have a very significant effect on the unemployment situation, it will undoubtedly help to a certain extent. More important to business, however, is the fact that workers would have more time to spend money, and more things to spend it for. If added leisure means that workers will buy more, it should stimulate certain lines of business. What leisure there is now, aside from Sunday, was probably instituted for commercial advantage. I strongly suspect that the idea of Saturday half holiday in business originated with some enterprising amusement parks and trolley companies. The idea of a two weeks' vacation in the summer was brought about by advertising of the railroad companies, the resorts, and the outfitting concerns. The motion picture, automobile, and radio industries could never have been developed in times of the ten hour day! The biggest purchaser of the products in industry—the laboring man himself—needs to have not only the money to purchase goods but the time to enjoy his purchases. Business by the Babsonchart is now 6 ner cent above normal compared with just normal a year ago.—Copyright 1929 Publishers Financial Bureau.)

The Aladdin's Lamp

How pathetic the longings of the aged and helpless.

of the Movies—No. 5 *By John Corydon Hill*

And yet sometimes the wishes of a deserving old man materialize.

TRANSLATING SOUND ENERGY
(Continued from Page 30)

Knowing the overall voltage gain of the amplifier however, which is found to be 125, we find the logarithm of this number —2.0969—and from the formula resolve the gain of the amplifier as 42 DB. Since the input power was —38 DB we now perceive that our output will be +4 DB at maximum. From this point on it is apparent that we will have to deal with appreciable power; it will be desirable here to recapitulate somewhat therefore, to stress the fact that sensation units (DB) have a direct relationship to power ratios. We have simply manipulated our mathematics a little in order to calculate in voltage (or current) ratios; power ratios being equivalent to the square of the voltage or current ratios, and since squaring a number is equivalent to doubling its logarithm, we made use of the factor 20 for voltage ratios instead of 10 times the log of the power ratios. This was alright while we were dealing strictly with voltage amplifiers, and made our calculations somewhat less cumbersome. We are, of course, primarily interested in building up our power output, and this is achieved by successively stepping up the available voltages until they are large enough to operate the so-called power amplifier stages. Actually, the difference between voltage amplifier and power amplifier types of tubes is not one of function, but of degree. The requirements for the former type are that it have a large amplification constant (μ) while the latter type is designed to have a large power handling capacity. This necessitates basic differences in internal structure, resulting in limited power handling capacities for tubes designed for a high μ (voltage amplifiers) and usually, in a low μ for tubes which have been designed to handle large power outputs. It is the latter type of tube which we deal with now; we will therefore make use of the orthodox formula based on power ratios (DB = 10 log $\dfrac{P_1}{P_2}$) for the rest of our calculations. We now have available an output of 24 milliwatts, or a power corresponding to +4 DDB, in sensation units, which it is desired to increase to a maximum of 10 watts, or +30 DB. To do this will require the use of two additional power amplifier stages; the maximum undis-

torted power which any vacuum tube can handle is limited, it can be shown, by its grid voltage-plate impedance characteristics. This is written mathematically:

Output Power $=\dfrac{(\mu E_g)^2}{8 R_p}$. Where μ is the (in milliwatts) tube amplification constant, E_g is the maximum grid volts applied, and R_p the plate impedance in ohms; 8 being a constant of geometric ratio. Thus if we take our input voltage as roughly, 30 volts, the μ of the tube as 6 and its R_p as 4000 ohms, its maximum output in undistorted energy will be a trifle more than 1000 milliwatts or 1 watt. With two such tubes arranged in push-pull their total power handling capacity becomes about 2½ times that of a single tube, due to the elimination of non-linear distortion, or a power output with the tubes described of 2.5 watts. Our input power was of the order of 24 milliwatts (actually, it is somewhat less, due to coupling losses) and the ratio of gain therefore is 1:100 in power units, or a gain of 20 DB. Since the input to the power stage was +4 DB we now have available a total output of +24 DB, from the intermediate power stage. Applying the formula for power to our last stage, whose tubes have a μ of 3 and an R_p of 1500 ohms, we find its total power handling capacity to be 12.5 watts, giving us a desirable margin over the actual power required. Its power ratio of 1:5 gives nearly 7 DB, bringing our total overall output up to +31 DB.

We increased the available powers from .3 milliwatts to 24 milliwatts the net gain was 42 DB, whereas the increase from 24 milliwatts to 12.5 watts meant an increase of only 27 DB. Correspondingly it is pointed out that whereas a power of 1 watt is equivalent to a 20 DB level, (10 log $\dfrac{1}{.010}$), in order to add another 20 DB, we would need an output power of 100 watts. It should hardly require any further demonstration to make clear the desirability of making our calculations in terms of actual hearing response. In this respect, it is pointed out that changes in power corresponding to 3 DB are noticeable to the average ear; a trained ear can just detect differences of 2 DB in output. Gain controls are designed to give variations between 1

and 2 DBs, therefore. From this data we can likewise determine by how much it will be necessary to increase our power output, to effect an appreciable gain in hearing response. For example, if we increased the power output of an amplifier from 10 watts to 20 watts, the net gain would only be 3 DB, which would be just noticeable; obviously, such a gain would hardly pay us for the additional costs involved. This ratio of increments by the way holds approximately true for power gains; doubling the power, means an increase of 3 DB in response units. A table is appended here to show the approximate number of DBs gain or loss, corresponding to various power ratios. It should be clear that gain and loss ratios are both calculated from the basis of zero level = .010 watts, the answers differing simply as + or — values. The method of translation as pointed out, is fairly simple, and should involve no difficulties to the projectionist who is able to use a table of logarithms.

Fig. 3

DBs at various frequencies at threshold of audibility. The initial volume is assumed to die down 1,000,000 times, or 60 DB down, to be just audible.

Pitch Frequency		Threshold of Audibility	Standard Initial Volume
C1	64	—16 DB	+44 DB
C2	128	—32 "	+28 "
C3	256	—48 "	+12 "
C4	512	—60 "	0 "
C5	1024	—65 "	—5 "
C6	2048	—67 "	—7 "
C7	4096	—65 "	—5 "
C8	8192	—53 "	+7 "
C9	16384	—15 "	+45 "

TABLE OF APPROXIMATE POWER RATIO EQUIVALENT IN DB's

	Losses		Gains
DB	Fractional	Decimal	Decimals
1	4/5	.8	1.25
2	2/3	.63	1.6
3	1/2	.5	2.0
4	2/5	.4	2.5
5	1/3	.32	3.2
6	1/4	.25	4.0
7	1/5	.2	5.
8	1/6	.16	6.
9	1/8	.125	8.
10	1/10	.1	10.
20	1/100	.01	100.
30	1/1000	.001	1000.

$$DB = 10 \log \frac{P_1}{P_2} = 10 \log \frac{(E_1)_2}{E_2} = 20 \log \frac{E_1}{E_2}$$

A Divotee of Gawlph

—BY—

VIRGIL MILLER, P. F. L.

The word "Golf" comes from a Scotch ejaculation of one syllable meaning "Eagles are bigger than Birdies." Being fond of peanuts the "Old Scotch" (sounds good) pea-nutters used a crooked stick for planting the nuts and the holes being called "divots." Singing as they pea-nutted, they swung their crooked sticks (called "putters"), in ecstatic elation and eccentric curves, divoting here and pea-nutting there as they perambulated over the highland greens. Thus was born the game of which I am now a "divotee"—being also found of peanuts.

The last tournament of Local 659, is now local history, the pages of which make Bobbie Jones seek out the hiding place of his older brother, Davey. And high amongst the rest—but pardon my modesty—suffice to say, Elmer Dyer, the aerialist (always in the air) took my picture along with the other members of my "Fearsome"—wonder what he did with it.

I was then told to get my driver and "tea off," but as my chauffeur is not English, I told them I'd take coffee, unless the DuPont boys were present, in which case I'd take . . . Well, anyway, having watched the other 659'ers hit the little white ball, I walked up and hit the nice white ball that someone so kindly left on the grass and as I picked up the pieces of my club, I learned that I'd hit one of the "markers."

With my new club I swung wickedly and the little white ball sped towards the rising sun—and fame. But as I broke "stance" and remarked that I had lost the ball in the sun, some "par 110er" says:

"Why don't you look the other way—it's over there in the rough." Following his cue I started over towards tall grass, oilwells, sand-hills, etc., hoping to find a Cro-flite No. 4. And I found it; in fact I almost found two of it, for my so-called "driver" must have been a "cutter." I found out it was a "mid-iron; it was, judging from the middle of my ball.

Guy Bennett now told me I'd have to "explode" my ball out of the sand; my dumb look brought forth the explanation that no dynamite was needed—only brains and a niblick. Having a niblick, I' shut my eyes, cranked thirty-two and Bennett yelled: "A beauty, Virg—you're almost on the green." I told him I knew I was green, but not to rub it in.

After the embryonic Hagenses, Joneses, and Diegles had ,'putted' within a few feet of the cup, I began looking for my ball.

They told me to throw in—(I felt like changing the preposition) which I did and then "pitched in" to within a few feet of the pin. McPherson now putted into the cup, started to pick up his ball, and fainted. When he came to, he said weakly.

"Miller's ball is in the cup!"

You can imagine mv embarrassment when they explained that I'd made an "eagle 2" which nearly spoiled my chances for the "booby" as Roy Klaffki was going strong.

To make a long story longer, I chipped, pared, sliced, chopped, cut and hacked my way into the "far-ways," byways, rough ways, traps, barracudas (I mean barrancas), greens, holes, cups, motion picture studios, oil wells, etc., until someone yelled: "Eighteenth next! Steady, Virg, and you'll break the course record!"

As I'd broken everything else in sight, including three clubs and my reputation for placidity, I steadied and having now learned the game in all its phases, I quit fooling and, remembering the old wrist movement that made me famous in pre-moter days, I proceeded to simply paralyze the other members of my fearsome—I mean foursome—with the meteor-like flight of my ball off the tee. They were flabbergasted and could only marvel at the skill I had acquired in such a short number of divots.

ın the meantime a crowd had gathered to witness my finish—a tenseness seemed to grip everyone—they felt the presence of a great moment; they anticipated a marvelous "putt" and were searching for my Cro-flite No. 4 as I approached the green—but alas, they were to be sorely disappointed.

Not having been able to follow with my eyes the small white speak that was my ball, I had a "hunch" that maybe my ball was in the cup without even looking further I walked up to the pin, and reaching down, lifted up the ball that you may now see in any window, autographed with that flourish for which I am also famous.

My modesty forbids my proceeding further, but in another issue I shall try to give you an encyclopedia of golf terms, the study of which will familiarize you with the intricacies of the supergobslupshus game of golf.

I thank you!

Chicago — Six-Sixty-Six — Chicago

HELP! HELP! HELP!

Chick David called up and says he wants the low down on the secretary for "The Page" and he don't mean maybe.

"Yes," says the secretary. He being David's YES man. "I'll confess everything."

A few years back the secretary was born in Indiana. He arrived in the world with a T-square, slide rule and well thumbed volume of Kent.

"Who's yer," asks the non-plussed Doc.

"Who, me?"

"Yes, you."

"Confidentially Doc," answers the Cherub, "I'm going to be a sound man in the movies."

The noisy young villian stuck to the slide rule and T-square until the success of his articles on steam engineering swelled his head, then he turned to newspaper work to get a full outlet for his ego.

While he was doing a combination picture feature signed "Eugene Cour for Hearst," the California publisher made his first venture in the movies. One of the higher-ups decided that the "guy" what takes his own pictures and writes his own stories for them would make a good type for the new organization—Hearst-Selig News Pictorial.

Cour was advised that he was a movie reporter.

"What's that?"

"You take motion pictures of News Events."

"What do you take them with?"

"We'll give you the dope in due time," was the reply.

Cour had never seen a motion picture camera and was totally ignorant of what made the wheels go 'round. He considered the matter fully, took it up with his managing editor and the result was his refusal to be a "Nickel Show" expert.

Despite his decision a few days latter several big packing boxes arrived in the editorial rooms addressed to him.

There was little less than a carload of apparatus.

Cour laughed.

The managing editor laughed.

It might be well to point out that the secretary at the time mentioned was a high salaried editorial expert and was getting top money—$27.50 per week.

Cour again laughed at the packing cases.

The managing editor had another laugh.

Then New York called Cour on the phone at Chicago.

"You will start at $45.00 per week and $60.00 per week when you learn what it's about."

Did Cour laugh! Almost. He couldn't grasp that there was that much money in the world.

A bit suspicious of the deal, he nevertheless opened the packing cases and started to collecting books on the subject of what make the wheels go 'round.

Result.

The secretary boast one of the finest libraries extant on the subject of motion pictures.

That's that.

SIX-SIXTY-SIX

BELIEVE OR NOT

And so it started, and had gone on for some time, but it was getting damn hot just about the time that some one in Washington said that what the United States needed for the "protection" of the Nation was that thing called "Prohibition"—at the same time this other thing was going on, that "shin-dig" in Europe as we all remember when Kaiser Bill wanted the world—so "Bill" told his "Goose-steppers" that he wanted a gun that he could shoot Paris with—without getting too close to Paris—so Bill's boys started making "him" a little gun—and when it was finished "Bill" looked it over and he thought it was so good that he named it "Big Bertha"—he wanted to see it work but didn't want to be there at the time "Big Bertha" did her stuff, so Dr. Ernemann, of Dresden, was called on to build a "movie-box" that could make pictures of "Big Bertha" in action—Dr. Ernemann built the camera and then the "mess" over-there stopped. After "Kaiser Bill" flew to Holland there was no further use for Dr. Ernemann's camera and for some unknown reason the camera fell into the hands of W. H. Strafford of Local 666—please do not misunderstand us, the camera was not "willed" to Brother Strafford as Brother Strafford is not related to "Kaiser Bill," but nevertheless Brother Strafford now has the camera and has made some great pictures in slow motion. After asking Brother Strafford for some figures, here is what he gave us—the camera is capable of taking more than 1000 pictures per second and is used for the purpose of mechanical analysis of high speed machinery movement. When producing 1000 pictures per second the film passes

Motion Picture Industries Local 666, I. A. T. S. E. and M. P. M. O., of the United States and Canada

By HARRY BIRCH

President

CHARLES N. DAVID............................Chicago

Vice-Presidents

OSCAR AHBE.......................................Chicago
CHARLES E. BELL...............................St. Paul
F. L. MAGUIRE....................................St. Louis
W. W. REID......................................Kansas City
RALPH BIDDY..................................Indianapolis
J. T. FLANAGAN...............................Cleveland
TRACY MATHEWSON...........................Atlanta
GUY H. ALLBRIGHT................................Dallas
RALPH LEMBECK...............................Cincinnati

Treasurer

WILLIAM AHBE..................................Chicago

Secretary

EUGENE J. COUR................................Chicago

Offices

12 East Ninth Street, Chicago

BULLETIN — The regular meetings of Local 666 are held the first Monday in each month.

through the camera at a speed of 50 miles an hour and considerable ingenuity has been necessary to prevent creeping, buckling or scratching. The film has a continuous movement and the action that is being photographed is reflected onto the film by a series of accurately aligned mirrors on the rim of an electrically driven wheel which is geared to the film movement, therefore making the camera "shutter-less." Film traveling through the camera at the above speed, the exposure for each picture is less than 1/50,000 of a second, and necessitates a lighting equipment capable of furnishing 12,000,000 candle power. Pictures taken at this high speed, when projected, the action is slowed up 62½ times. The camera is portable, weighing about 250 pounds and is motor or hand operated. The magazines carry five hundred feet of negative and it takes exactly 6 seconds to expose the five hundred feet.

NOTE: Bill says the outfit is portable, weighing about 250 pounds—maybe Bill has been looking over some of the "sound outfits" and decided that his equipment is "also" portable.

The enclosed pictures are of the high speed camera—first one showing the interior which gives an excellent idea of the "reflecting mirrors" mentioned above. The second picture will give an idea of just what the camera looks like from the outside.

SIX-SIXTY-SIX

SEEN ON THE "WABASH"

While "Old Man Winter" was holding the thermometer down to the point of zero—Brother Chas. Gies with the assistance of Brother Martin Barnett was seen "rushing the can"—that is both were carrying two red cans that generally means "out of gas"—it was later discovered that one perfectly good Chrysler was several blocks away calling to its Master Chas. Gies—"fuel is what I want"—Gies and Barnett soon relieved the situation when the contents of the two cans were emptied and the little Chrysler went fluttering down the avenue.

* *

A much used Willys-Knight standing in front of 845 South Wabash Avenue, two flat tires, one fender missing with a sign hanging on the side "USE NO HOOKS"—someone advised that our President, Chas. David, would move the "remains" after the winter thaw.

* *

Harry Birch and Bob Duggan returning to Chicago after working three days in the Nash motor foundry at Kenosha, Wisconsin. For those that have ever worked in a foundry, they will understand, but here's saying that a foundry is no place to wear a palm beach suit or a "derby"—Bob claims that he swallowed three complete Nash motors and he is still picking cylinder blocks out of his eyes.

* *

Floyd Traynham was just seen racing down the street bidding everyone in sight

Cream o'th'Stills

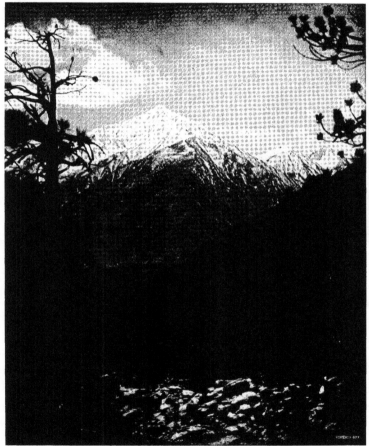

Trust Karl Struss to see a picture if there is one anywhere about. He is at home on any sort of terrain and successful with any kind of subject, interior or exterior. Mr. Struss' mountain stuff is famous here and abroad. The picture herewith speaks for the excellence of his artistry.

Cream o' th' Stills

Robert S. Crandall contributes
this remarkable "Pin hole"
picture of a scene on the upper
waters of the famous Los An-
geles River. Mr. Crandall is
expert on pin-hole photography
and from time to time
his fine work will appear
in these pages.

"Snow Peak Avenue," on the
way to Yo Ho Valley, in the
Canadian Northwest, afforded
this unusual subject for the
Camera of Harry Zech. The
dog is not posing. He was on
his way to Yo Ho and stopped
to watch the antics of a
beetle just as Mr. Zech
made the shot.

Cream o' th' Stills

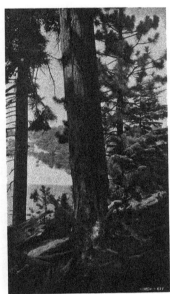

Maurice Kains set the trap for this intriguing lake and mountain view. He calls it "Three Men in a Boat". (Find the Boat). Mr. Kains is another International Photographer who loves to stalk Mother Nature with the camera and the more rugged the view the better he likes it.

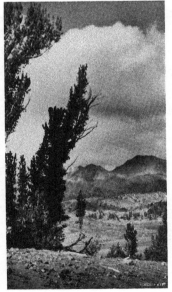

E. A. Schoenbaum, while wandering around in the vicinity of Tioga Pass, recently came upon this glorious view of "Saddle Bag Lake" and its rocky terrain. Lake, mountains, clouds and the ragged trees blend smoothly into a vista at once charming and mysterious.

Cream o' th' Stills

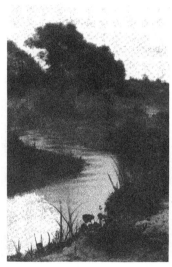

Robert S. Crandall contributes this remarkable "Pin hole" picture of a scene on the upper waters of the famous Los Angeles River. Mr. Crandall is expert on pin-hole photography and from time to time his fine work will appear in these pages.

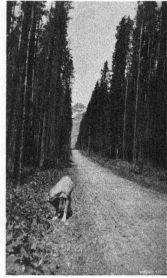

"Snow Peak Avenue," on the way to Yo Ho Valley, in the Canadian Northwest, afforded this unusual subject for the Camera of Harry Zech. The dog is not posing. He was on his way to Yo Ho and stopped to watch the antics of a beetle just as Mr. Zech made the shot.

Cream o' th' Stills

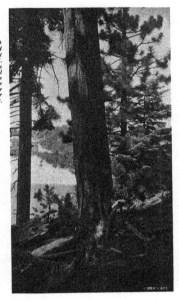

Maurice Kains set the trap for this intriguing lake and mountain view. He calls it "Three Men in a Boat". (Find the Boat). Mr. Kains is another International Photographer who loves to stalk Mother Nature with the camera and the more rugged the view the better he likes it.

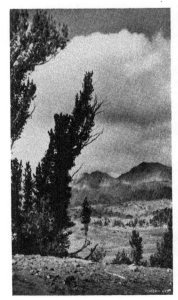

E. A. Schoenbaum, while wandering around in the vicinity of Tioga Pass, recently came upon this glorious view of "Saddle Bag Lake" and its rocky terrain. Lake, mountains, clouds and the ragged trees blend smoothly into a vista at once charming and mysterious.

Cream o' th' Stills

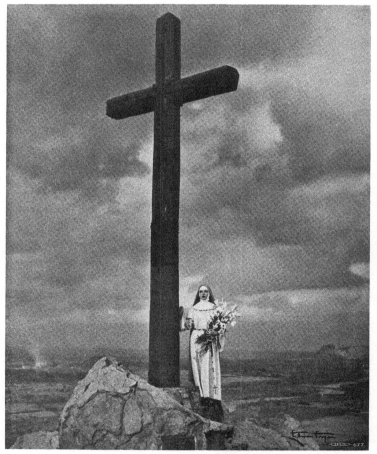

Elmer Fryer, First National Studios, is responsible for this impressive picture from the summit of Mount Rubidoux, near Riverside, made famous as the place of pilgrimage for all Southern Californians to attend the annual Easter Sunrise Services held there since 1900—the original Easter Sunrise Services in America. Miss Jeanette Loff is the White Sister at the Cross.

Left and right—*The Erneman "Big Bertha" camera.* Center—*Eugene Cour.*

the "good-bye" sign—he tells us that he has been transferred to Atlanta for Pathe—good luck, Floyd, and we know you will knock 'em for a row of sound when you get there.

* *

"Bull" Phillips sporting a new pair of "hot-dam" spats or maybe it was his socks hanging down.

SIX-SIXTY-SIX

NEWSREEL GOSSIP

The town of Vincennes, Indiana, had warning that the heavy snows from the northlands would soon flood their town —or something like that—however all the "news-shooters" from Chicago dug out their snow-shoes and started for Vin-

cennes—the boys spent several days and a few nickels waiting for the action of a flood—one stormy night Brother "Red" Felbinge rand Brother Chas. Gies decided to take in the movie and upon their return to the hotel they found a delegation of "two" waiting for an interview with "Red"—it was soon learned that the "two" represented the Vincennes High School—having read in the local paper of the "news-shooters" being in their town, they requested "Red" that he give a talk at said school on journalism— "Red" very modestly told them "that he really was not prepared at that time and unaccustomed as he was, etc., etc." However "Red" being the only one of the Chicago "news-shooters" that had received the honor of being called upon, we understand that he is now being referred to as "Red, the Great."

APOLOGIES IN ORDER

Brother Frank Bauer wants it known that he spells his name BAUER and not BOWER, and also wants it known that he only eats five meals per day instead of six.

Our mistake Frank and we hope no hard feelings.

SIX-SIXTY-SIX

"AI'R" HIS ROUTE

Brother "Bob" Duggan received a call from Detroit that it was very urgent that he appear in person that same day in the "automobile city," and knowing that it was to late for train travel, Bob called the Stout Airlines and left that morning via the "air-route"—Bob admits that he spent an hour in Windsor, Canada, and said what he did over there was really none of our business—I guess you're right Bob, but we all enjoy talking about the Canadian "stuff" even if we can't taste it.

SIX-SIXTY-SIX

"FISH" HIS NEW JOB

Brother Martin Barnett will soon be teaching the "fishies" how to strut their stuff for the "talkies" very soon, at least he says so. Brother Barnett has just taken over the "shooting job" at the new Shedd Aquarium, in Grant Park, Chicago. Brother Barnett is spending the first few weeks of his job learning the "fish lingo," that he may be able to talk to them in "their own."

SIX-SIXTY-SIX

91,000,000 YARDS OF 'SPAGHETTI'

Brother Rufus Pasquali has suggested

a "spaghetti" eating contest for all members of Local 666—he will furnish the "spaghet"—those wishing to participate will report to Brother Pasquali at the next regular meeting. There has been nothing mentioned up to this time as to what the color of the drink will be, red or white. Brother Pasquali will give all details upon receiving your request.

SIX-SIXTY-SIX

BLAME IT ON YOURSELF

It was indeed a pleasure to see Brother Traynham, of Pathe, at the last meeting of Local 666—of course you all know that Floyd has been a guest at the Columbus Memorial Hospital for the past month—but Floyd is all fixed up now and back on the job "sounding for Pathe." Floyd inquired about the "page" and when advised that we wanted a word from every one, Floyd promised to do his bit and so here it is just as Floyd sent it in:

Dear Harry:

You played hell when you asked me for an article for the page. Here 'tis, and HOW. T'was certainly a grand and glorious meeting and having missed the previous six, guess I enjoyed it more than anyone else. Who rounded up all the new members? And so much dignity. Next time I'm going to wear my Tux. Surely all those guys can't be "crank turners." When I asked who one of the new members might be, Harry Birch replied: "Why don't you know him? That's Tiry Miller, of the Rothacker Film Co., the only cameraman in the world who can wrestle a camera and eighteen lights all by himself." Now that stopped me.

And here and now I want to second the motion of Chas. Ford THAT President Chas. David, personally, foot the bill for the proposed banquet. I've been wondering all along what local presidents were for anyway.

Elections in Chicago are always hot and I wouldn't miss the next two meeting for anything. Gene Cour says that he is not up for re-election as secretary and I don't blame him. That's neither a position no an hour, but just a plain job. I'm in favor of making officers of all the members, then some of the "cockroaches" will feel sufficiently important to attend meetings.

Guess the meeting for March, will be the greatest yet. Bill Strafford is going to give a demonstration of his high speed camera that makes 1000 pictures a second. Now that's my idea of a sure 'nuff high speed camera. And get this, he is going to take a picture of a pigeon in flight, develop and project the film, all at this meeting. And, wait a minute, this demonstration is at night with artificial light. Now some of you ex-graflex and graflex boys start figuring that one out. And some of you expert sound cameramen give this a thought. This camera of Bill's weighs just about two hundred pounds and why mention the tripod. Being anxious to see just how this camera works, the boys are all invited to bring along their screw-drivers to this meeting.

And while Bill is developing negative, our old pal, Joe Dubray, is going to give a demonstration of how sets should be properly lighted. All this we owe to the kindness of the Essanay Studios. Seems to me that the Spoors and the Ahbes have done more to "pep" up our meetings than most anyone else.

Brother Bill Scanlon's prize novel, "God Have Mercy On Us" still seems to be going strong.

Secretary Cour has had a turrible siege of flu.

Brothers Trabold, Saunders and Caputo are way up in Minneapolis making plenty of good, snappy sound news stories fo Pathe. We're going to start an Eskimo Club when they return.

Brother Norman Alley, with the Hearst Movietone combine, had the misfortune of having his sound truck burn completely. Was it a misfortune? Anyway, the idea is worth thinking about.

Brother Sergeant Geo. Lockyear, who is always so nice in helping the boys arrange their shots of army activities, showed up at the last meeting with a broken arm. In Chicago we have learned not to ask questions.

Brother John C. Zimmerman has been moved from Kansas City to Chicago, and Brother Ed. Trabold has moved into the bankrupt city from Omaha.

Pathe News is now in their new offices at 1029 South Wabash Avenue. Visiting Brothers are cordially invited.

Now all the space is gone without telling about "my operation."

So here it is Harry—that's all I know at this time—you asked me to send you something—so blame it on yourself if it's not right.

Best of luck.

(Signed) FLOYD TRAYNHAM.

SIX-SIXTY-SIX

What is wrong with the out-of-town Brother of 666—if your typewriters don't work send them in in long hand—these stories or what have you—we want material for this page and we know that you out-of-towners have a lot of it—send them in—also some good stills that you moy have—sit down right now and get some thing in for the next issue—send your material to Harry Birch, 845 South Wabash Avenue, Chicago, Illinois.

SIX-SIXTY-SIX

VISITING BROTHERS

Brother Howard Hurd and Roy Klaffki arrived in Chicago on their wav to the coast—they were met by President Chas. David of Local 666, who supplied them with the necessary implements of war before they ventured out on the steets of Chicago. Brother David escorted them about the city so that they may see all our latest developments—after "doing" Chicago they departed via the Santa Fe Chief for Los Angeles.

SIX-SIXTY-SIX

A GOOD TIME BY ALL

In the "wee hours of the morn" several members of 666 were seen hovering about the north side of Chicago—they were on their way home from the Sixteenth Annual Ball of the I. A. T. S. E., Local No. 2, held at the Aragon ball room—Local 666 had a table but it was hard to find because of the large attendance—in fact there were so many people there that our boys claimed it was impossible to reach their hip pockets so that they just carried the "contents" in their hands—however it was a great success, that is the ball, and a good time was had by all. Notables of the evening were none other than "Bill" Canavan, "Dick" Green, George Brown and many others.

———o———

BACK HOME

Business Representative Howard Hurd, with Executives Jackson Rose and Roy Klaffki, have returned from New York where they were recently summoned to represent Local 659 in important conferences with the international officers of the I. A. T. S. E. and M. P. M. O.

AN ACE ANY WAY YOU TAKE HIM

In these days of "Show me" a man usually has a job (if he have one) because he ought to have that particular job.

In short, there is a reason. Take Edward P. Curtis, for instance (Ted to his friends and the trade). Here's a boy, born January 14, 1897, and already over the top.

EDWARD P. CURTIS

It's terrible to be born in northern New York in the winter time, but Ted is husky and could stand it.

He picked Rochester as his birthplace because that town has the highest smoke-stack on earth and just for that George Eastman felt so honored that he ordered George Blair to keep his eye on Ted.

At a suitable age Edward was sent to Williams College and he was bowling along easily in his Junior year when the World War inconveniently broke out and Edward, without even taking the trouble to return to Rochester, enlisted in the French Army at Paris, and was assigned to the French Aviation Corps.

Here he served until August, 1917, when he was transferred to the American Aviation Division and he finished as an American Ace, having shot down six German planes.

At the age of twenty-one our hero was honorably discharged at Washington, D. C., with the rank of major and with one of the cleanest records of the war.

This was in the summer of 1919 and Ted, now Major Curtis, almost immediately was sent to Russia, on a special mission for the United States State Department, residing at the Port of Riga, on the Baltic, for more than a year.

Returning home he joined the Eastman Kodak Company, in the accounting department. Promotions rapidly followed to the Research Laboratories, Export Department, Business Development Department and then to the Motion Picture Sales Department—made famous by the genial George Blair.

Then came July 1, 1929, in Rochester, N. Y., a day of fruits and flowers, when our Major was called into the "Throne Room" and informed that henceforth he would be sales manager—Mr. Blair transferring to another department.

Now, Major Curtis, with his charming wife and three children is sojourning in Hollywood for several months, looking over the motion picture film field and preaching the gospel of Eastman films.

The International Photographer wishes Major Curtis and his family a happy and panchromatic sojourn in the glorious climate of California.

LETTER FROM BELL & HOWELL

Chicago, Ill., February 3, 1930.

To Members of Local 659, International Photographers.

Publicity never hurt a cameraman, so far as we know. We are in a position to give valuable publicity to Cinematographers who use Bell & Howell cameras and who will send us photographs of themselves at work with their cameras in the studios or on location. These photographs should be accompanied by full data, including names of all individuals shown—camera men, directors, actors, etc., names of producing company and photoplay involved and any other facts which would help us in preparing comprehensive captions.

Such photographs should, where possible, include the scene being filmed. Naturally, sound picture stills are preferred.

We are always in need of such photographs and accompanying captions for publicity purposes, both in our own magazine which has a large and high-class circulation, and in newspapers and national magazines. It is our practice always to give complete credit lines.

Perhaps you have some "stills" on hand now dealing with films now in production or only recently released. If you will send these to us, and keep us in mind as a publicity outlet for future photographs which include Bell and Howell Cameras, we will see that your corporation is well rewarded in publicity obtained.

Very truly,

Bell Howell Company,

(Signed) E. A. REEVE
Assistant Manager
Sales Promotion and
Advertising Dept.

The I. A. T. S. E. and M. P. M. O.
Come to Los Angeles

The Biennial Convention of the I. A. T. S. E. and M. P. M. O. for 1930 will be held in Los Angeles beginning the first Monday in June, according to the announcement made by President William F. Canavan and Secretary Richard J. Green, who have just returned to New York after a brief sojourn in Southern California looking over the field.

There are five locals in this city chartered by the International, namely: Stage Employees No. 33, Studio Stage Mechanics No. 37, Cameramen No. 659, Laboratory Workers No. 683 and Moving Picture Projectionists No. 150. Nos. 33 and 150 meet in Los Angeles proper, while the other three are in Hollywood, the members being employed in the studios. The entire membership of the five locals approximates 3500 and constantly growing. Full details of the coming convention will appear in the April issue of The International Photographer.

Delegates, their families and guests will number upward of 1800.

A Crack Up to Order

This remarkable shot is that of a crack-up done by Dick Grace for a scene in "Young Eagles," a Paramount special film under photographic supervision of Archie Stout. It was the thirty-third crack-up done by Dick Grace for motion picture thrill stuff. This shot was made by Clifton L. Kling with an 8x10 still camera. The stunt was pulled at Las Turas Lake in the San Fernando valley. Elmer Dyer and Billy Tuers did some extraordinarily fine aerial shooting on this picture. Archie Stout was chief cinematographer.

CAUGHT ON THE JUMP

What is said to be the longest jump ever made from a burning building to a fire net was filmed in Chicago recently with a Bell & Howell Eyemo camera. Because of the extreme adaptability and flexibility of this hand-held camera, the cameraman was able to keep the jumper in focus during the entire leap, from the time he first hesitated on an eight-story window ledge until he hit the net. No other camera was able to register this spectacular leap.

John Sandman, a Chicago film broker, made the hair-raising leap for life and Charles David, camera man, who was covering the fire for Chicago Daily News-Universal filmed the picture.

This is just another of many Eyemo news reel "scoops." Where the professional camera man cannot have time or opportunity to set up tripod and camera, the Eyemo is able to capture unusual and valuable pictures which would otherwise be lost.

Every camera man for Chicago Daily News-Universal takes an Eyemo home with him at night for emergency calls.

The Sound Track

TO THE MEMBERS OF LOCAL 659

The Officers, Business Representative
and Editors:

Please accept my heartfelt thanks for
the beautiful floral offering sent to the
memorial services for my husband,
George Eastman, and for the many
courtesies extended me by the Local.

RUTH EASTMAN.

While in the east recently Jackson
Rose, chief cinematographer at Tiffany
studios, visited the plant of the DuPont-
Pathe Corporation at Parlin, New Jersey.
He was tremendously impressed with the
big plant covering four square miles as
it does and giving employment to 1500
men. Among others Mr. Rose met Dr.
Seass, chief of Ridpath Research Lab-
oratories; Dr. E. B. Middleton, plant
manager; Dr. H. Kinloch, assistant man-
ager; J. H. Theiss, vice president and
Messrs. Briggs and Moyes of the tech-
nical staff.

Business Representative Howard Hurd
and Executives Rose and Klaffki have
returned from the east.

Executive Roy Klaffki has signed up
with Technicolor and both signatories
are to be congratulated upon the alli-
ance. Mr. Klaffki is one of the pioneers
of the industry and he knows photog-
raphy from pin-hole to sound track.

Executive Alvin Wyckoff has signed a
contract with Universal and is on the job
as chief cinematographer of the unit
filming "The Storm."

Agreement With Producers

Business Representative H o w a r d
Hurd, Local 659, reports that as a
result of negotiations recently carried
on between the special committee of
the Local and representatives of the
producers, in New York and Holly-
wood, the following amendments were
agreed upon and have been written
into the contract. Other important
changes under discussion will be an-
nounced as soon as agreements have
been reached.

Amendment to Paragraph 4 under

RULES GOVERNING ALL CLASSES

As a general policy, no cameraman
shall be required to work for a greater
period than 16 consecutive hours with-
out a rest period of 8 consecutive
hours. If, however, the period of 16
consecutive hours is exceeded then
the excess time over and above such
16 consecutive hours shall be paid for
in accordance with the following
scale:

First Hour or Less—All Classes:

First Cameraman	$12.50
Second Cameraman	6.25
Still Cameraman	6.25
Assistant Cameraman	3.25

Additional consecutive time beyond
the first hour shall be computed in
half hour periods with 5 minutes lee-
way pro rata of the above scale. Such
excess time shall be separate and dis-
tinct from all other time and shall not
be included in any cumulative hour
period or periods, and shall be paid
for in cash at the time that the cam-
eraman's regular compensation is pay-
able.

Men receiving in excess of the
scale do not have excess applied to
this period, but instead receive in cash
the compensation provided in this
amendment.

INSERT IN CLASSES 2 AND 3

All holiday work shall be computed
on double time basis. Such double
time may be applied to the cumulative
hour period.

This amendment is retro-active as of
February 25, 1930.

Cheap Clothes

Those who buy what they can buy
the cheapest, do not know the price
they may afterwards pay when they
clothe their children or themselves in
sweat shop or prison made apparel.
The Label of the Garment Workers is
a sign of safety—their only sign of
safety, for the members of the craft
refuse to work in any but well lighted
and sanitary quarters. The wonderful
improvement in surroundings and con-
ditions of work to be noted in these
Union controlled factories and work-
shops are results of the energy and
insistence of the organized workers.
Look for this label before you spend
your money for clothing.

"THE CAMERAMAN"

A worthwhile comment gleaned from
the New York World:

"He's an artist and a skilled technician,
is the modern motion picture cameraman,
and he's often by way of being a bit of
an adventurer to boot. His work is not
only one of the most important factors in
the making of a picture—it is vital. Were
it not for the fact that he possesses both
daring and initiative you would be de-
barred from the pleasure of viewing
many of the "new shots" which have
made you sit up on the edge of your
chair in vicorious excitement.

"And yet, so far as the average fan
is concerned, he might as well be non-
existent!

"Utterly aside from the romance, the
adventure, and the peculi ar physical
problems which beset the cameraman
there is that other vastly important fea-
artistic. In your good cameraman—and
when he's not good he doesn't last very
long these days—technic and artistry are
more perfectly blended, perhaps, than in
any other profession.

"The cameraman is an artist. Unlike
other artists, he works in a fluid
medium. His is a picture produced
other artists produce pictures through the
through the medium of a lens, just as
mediu mof paint, or ink, or crayon. But
their pictures remain static, while his
is constantly moving necessitating rapid
changes in composition and in lighting.

"While the work of the cameraman
is by no means accorded the popular
recognition which it should have, there
have been instances in which the artistic
ingenuity of a member of the guild has
enabled the producer to obtain a higher
price for his product from the exhibitor.

"The next time you go to the movies,
think occasionally of the cameraman.
View the film as a picture, as well as a
story. As a fluid painting which tells
its story by means of light and shadow."

Out of Focus

A Lesson in Composition
By PRO. NIL
Special arrangements with the Sheriff—Stills by the Academy of Mushing Pitchers.

For the best 15,000 answers The International Photographer will give permission to listen to Prof. Nil over the radio. The lecture to be, "How to Keep Home Brew on Your Stomach."

Mail replies to editor, *Out of Focus*, 15th floor, Out of Focus Building.

Any pictoor, to be satisfying, must have a principle object or idea, to which all else is subordinated, and to which all the other components of the picture contribute, by contrast, by suggestion, or by explanation. That's what they say but enough of that hooey. Take the mug that is portrayed above.

Picture one—This shows a man 6 ft. 3 inches tall sitting on a piano bench at noon. Full light is the best here as it gets both ears which is very hard to do at noon.

Pitchure two—This shows a young man with indigestion and a leaning towards photography. A half light and two drinks can best be used here.

Pitcher three—This shows a gent with one ear. By subdueing the high lights and increasing the shadows a very satisfactory result can be obtained.

View four—A large mouth often allows the tongue to fall out. A sharp clip on the chin corrects this and if shot at F 5.6¾ west of the Rockies good definition is bound to follow.

Portrait five—This was shot at Wilmington on the Canal and the breezes from the refineries are passing by. By stooping down you can eliminate the breezes, but not the expression.

Etching six—Here is a bozo with 2 eyes and 2 ears and 2 chins. The 2 chins can be eliminated by turning the camera in the opposite direction.

I am sorry that I have not more pictures to comment on but I will tell you soon—how to write scenarios with two chins.

PRO. NIL,
Traeger's Hotel, 1st and Broadway.

DO YOU KNOW

That a certain (not so well known producer) gave all his employees a goose and a pair of socks for Xmas?

That Ed. Estabrook has the largest camera crew (week in and week out) in the M. P. business and it gets larger each week?

That Carl Freund, the German wizard of photography is now in Hollywood and will soon be putting his many original ideas forward, in Technicolor?

That if any of the brothers can get an article from the various heads of departments, the editor, Si Snyder, would like it very much?

That the next International Convention of the I. A. T. S. E. will be held in Los Angeles?

That we should all get behind this and help out, when the time comes, because we would still be dragging along if we didn't have their support?

That Roy Klaffki, that grand old guy that we all love, is now with Technicolor?

That it is a hell of a job to get this page out every month?

That the population of the United States is supposed to be 121,951,865, but they did not count the cameramen that were locked up in booths so the census bureau should add a couple of dozen for that?

Pick Up Shots

FRIEND BAKER saying the $%shr"s" thing is only 0.001th out.—FARCIOT EDOUART explaining how the Army, Navy and civilian flyers are trying to locate his brother-in-law, M A U R Y GRAHAM, the missing air mail pilot. MAURY was a loader and assistant director for Paramount at one time.— ROLLO FLORA has a full page ad in a movie magazine and refers to his art as trick shots. Why not special effects?— ELMER DYER wants to raise the ante on flying and has plenty of support.—

SHACKELFORD standing in front of the Biltmore Theatre where his picture of India is showing.—ARCHIE STOUT telling CURLEY LINDON what shots to get from the air.—"BORDY" BORRADAILLE telling how they do it in Mexico City.—DON KEYES house is still on the hill after the recent wet spell.— CHAS. LANG now a head man at Lasky's. His dad developed enough film at that plant to reach around the world a great many times.—JOE LA SHELLE bought a new Mitchell and then Pathe furnished him with one.

WIDE FILM NOW A REALITY

Although wide film has been discussed for many months it has just recently been offered to the public and has been enthusiastically received.

GRANDEUR 70 MM pictures now being exhibited were taken by MITCHELL-GRANDEUR CAMERAS. These cameras are Mitchell...designed and built with the care and precision that has made MITCHELL CAMERAS the leader.

We are in a position to make prompt deliveries of 70 MM cameras and accessories.

⚮

Mitchell Camera Corporation

665 North Robertson Blvd. West Hollywood, Calif.
Cable Address "MITACAMCO" Phone OXford 1051

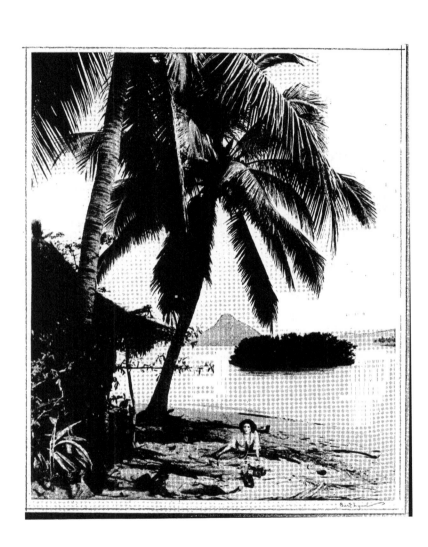

The
INTERNATIONAL
PHOTOGRAPHER

*Official Bulletin of the International
Photographers of the Motion Picture
Industries, Local No. 659, of the Inter-
national Alliance of Theatrical Stage
Employees and Moving Picture Mach-
ine Operators of the United States and
Canada.*

*Affiliated with
Los Angeles Amusement Federation,
California State Theatrical Federation,
California State Federation of Labor,
American Federation of Labor, and
Federated Voters of the Los Angeles
Amusement Organizations.*

Vol. 2 HOLLYWOOD, CALIFORNIA, APRIL, 1930 No. 3

*"Capital is the fruit of labor, and could not exist if labor had not first existed.
Labor, therefore, deserves much the higher consideration."—Abraham Lincoln.*

CONTENTS

The INTERNATIONAL PHOTOGRAPHER published monthly by Local No. 659, I. A. T. S. E. and M. P. M. O.
of the United States and Canada

HOWARD E. HURD, *Publisher's Agent*

SILAS EDGAR SNYDER - - - - *Editor-in-Chief* IRA B. HOKE - - - - - - - *Associate Editor*
LEWIS W. PHYSIOC - - - - - *Technical Editor* ARTHUR REEVES - - - - *Advertising Manager*
CHARLES P. BOYLE - - - - - - - *Treasurer*

Subscription Rates— United States and Canada, $3.00 per year. Single copies, 25 cents
Office of publication, 1605 North Cahuenga Avenue, Hollywood, California. HEmpstead 1128

The members of this Local, together with those of our sister Locals, No. 644 in New York, No. 666 in Chicago,
and No. 665 in Toronto, represent the entire personnel of photographers now engaged in professional pro-
duction of motion pictures in the United States and Canada. This condition renders THE INTERNATIONAL
PHOTOGRAPHER a voice of an *Entire Craft*, covering a field that reaches from coast to coast across the nation.

Printed in the U. S. A. at Hollywood, California

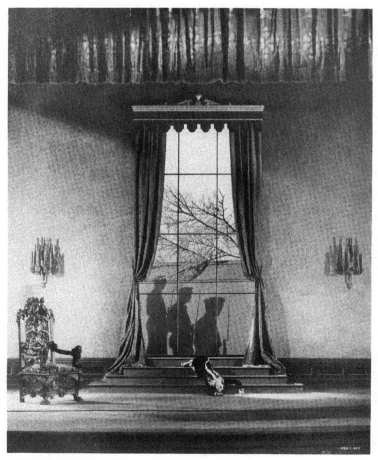

TO MR. LES. ROWLEY, 659, MUST BE CREDITED THIS INTERESTING PHOTOGRAPH. THE UPSIDE DOWN
LADY IS ESTHER RALSTON.

70 MM. Film Versus Other Sizes

BY

GEO. A. MITCHELL, *Mitchell Camera Corporation*

A few old facts presented anew.

Wide film is old. The mere use of wide film is no novelty. Many have advocated its use in the past, and have pointed out its many advantages. There have also been others who have been careful to point out its disadvantages and a panacea for all ills; in fact, it is not a cure for any ills at all. It opens possibilities for bigger and better pictures.

It is slightly more expensive, but the results justify the increase. I believe that within a very short time the public will be very emphatic in its discrimination between is: *How wide should wide film be.* Very little discussion takes place regarding the width of sound track, it all centers around size and shape of perforations or the width of sound track, it all centers around millimeters, 48-65-70—or what is your idea.

Anyone of them is better than 35 mm.

Company at work with Mitchell cameras at Warner Brothers Eastern Vitaphone Studio. Note image of actors in Mitchell Erect Image View Finder on center camera.

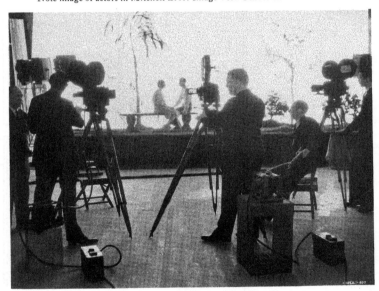

Left to right—*Tom Darley, technical director; Ed. Du Par, chief cameraman; Ray Foster, cameraman; Murray Roth, director in chief; Ed. Horton, assistant cameraman.*

until recently the later have made the most progress with their argument.

The cost of changing the equipment was looked upon as an insurmountable obstacle. It took the talking picture to convince the profession that the public wanted the best obtainable, regardless of cost, and that it was economy to give the public something better if possible. Now wide film is going to get its just desserts and come into its own. Wide film is not tween wide film pictures and the old 35 mm. standard. This is based upon conversation with people working with wide film and they all admit after viewing wide film for a while that the 35 mm. standard looks funny. There is no need here to go into the detail regarding the virtues of wide film. I believe that the industry is already sold on the proposition.

The question now before the industry and almost in proportion to their width. I believe every theatre should show as wide a picture as their proscenium arch will permit. Our lenses won't permit this with absolute sharpness in the margins at the present time, but here is the point. Put your principal action in the center of the screen and let the margins go fuzzy if you please (we will have better lenses some day). It is much better to

(Concluded on Page 7)

Otto Dyar Heads Model Studio

Otto Dyar, chief of the Paramount West Coast Studio still department, has at last attained his dream of a model portrait studio. He has long planned a gallery on the studio lot which would enable him to portray to the very best advantage the galaxy of famous Paramount stars. Through persistent effort he sold the idea that "stills move the movies," and the better the facilities for producing these stills, the finer the result.

Probably no more complete or efficient portrait studio exists on the West Coast than that built under Dyar's supervision by the Paramount studio artisans.

As one enters the building a beautifully appointed reception room dispels all idea of a workshop. A home-like atmosphere is created as if by magic. Adjoining the reception room is a spacious dressing room fitted with practical accessories.

Then comes the gallery proper, which holds especial appeal to photographers. The two long side walls are so furnished and decorated that several combinations of home atmosphere may be quickly arranged and properly lighted. At the end of the studio a series of 16 different back-drops are arranged on sliding hangers which allow instant change to suit the subject, and when not in use are rolled on their overhead tracks to a store-room adjoining the gallery. A feature of these back drops is that they do not in the least way clutter up the work room. A large sliding door, opening directly to the studio street, affords a means of photographing feature players in their favorite automobiles without moving the regular studio cameras off the work room floor. Immediately across a miniature highway a section of the dressing room building has been refinished to represent a Hollywood mansion, and serves as an ideal background for such publicity photographs.

Following the moving picture methods of overhead spot lighting, Mr. Dyar has arranged a series of top lights on sliding tracks, so controlled from the floor that they offer a wide variation of effect lighting.

On the floor 15 plug-in boxes afford a range of front and side light. All light source is D. C., which feature, together with effect lights and general equipment, was worked out by Earl Miller, head of the Paramount electrical department.

All camera equipment and accessories are of the latest type offered by the Eastman Kodak Company. A number of different plate sizes, together with lenses of various focal lengths, add to the versatility of this modern model studio.

Mr. Dyar will also maintain the old gallery, which has undergone a complete remodeling, and will operate it in conjunction with the new one in the case of rush orders or special effects.

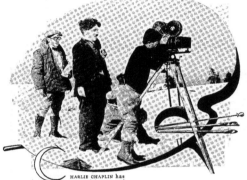

The Old Roman
of the Films
Caught on Location
Directing His
Own
Picture

HARLIE CHAPLIN has come right out and declared in so many words that the talkies have nothing in him nor he in them. And thereby Charlie Chaplin shows that he knows his Charlie Chaplin.

For what would the spoken word add to the art of this unique actor.

Chaplin is probably the greatest pantomist of all time and words would only mar his clever facility. The eagle does not need to sing.

The admirer of Chaplin will not pass him up because he refuses to give voice to his mimetic genius; on the other hand they will applaud his decision and welcome his offerings with the eagerness and enthusiasm of the past.

When Mr. Chaplin says he will organize a company with a capital of $10,-000,000 with which to keep the tradition of the silent drama alive and it may be accepted as a matter of big news. The industry will watch Mr. Chaplin's activities with renewed interests and will wish him unlimited success.

Surely he will do no violence to the sound pictures by keeping out of them for his place is just where he knows it is.

John Corydan Hill

SILENCE IS GOLDEN

70 MM. FILM VERSUS OTHER SIZES
(Continued from Page 3)

have your pictures fade off fuzzy on the side gradually than to stop the picture and restrict the view by a black border; concentrate your action near the center and the audience will not be aware that the margins are fuzzy. Look at twenty of the great masterpieces and note how much detail you can see near the margins of the canvas.

Now the larger your film is the less possibility there is of the grain becoming

is expensive. Often after a machine is designed and built the cost is only started for the changes necessary to develop the machine to practical perfection is problematical and often excessive. One way the studio can save lots of money is to adopt a process and machinery that is already developed and brought to a state of perfection to where it is commercial, and not try to develop some new system of width, pitch and perforation.

I do not believe that it is economically

production quicker with GRANDEUR than you can build your own equipment to your own design. GRANDEUR is proven and your own may give trouble. You can save money for yourselves and the industry generally.

This system was developed at a tremendous cost, but now that it is developed it is offered to the industry for their use with no strings attached and with no royalties or tributes to pay. The cost of this machinery will be lessened as pro-

Camera crew at Warner Brothers Eastern Vitaphone Studio with Mitchell cameras.

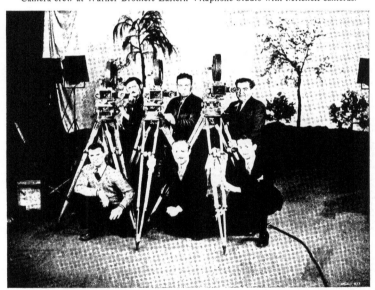

Upper—Ed. Du Par, Ray Foster and Jay Rescher, cameramen. Lower—Roy Smith, Sam Marino, Edward Horton, assistants.

bothersome. A wide sound track is desirable for the ratio of grain size to slit width is reduced, therefore the ground noise is lessened.

The question of cost now comes up. Of course the wide film is going to cost more money, but not much more. Film as well as machinery will be more expensive. An important fact for the producer to remember is that the big cost on any production is labor. Don't forget that point.

Everyone knows that to design and develop any new process for any purpose

possible for two wide film systems to exist in the field and if various studios go ahead with several sizes of wide film I am sure the result will be a big loss to someone, which, in the last analysis, is a loss to the whole industry. No one likes to lose money and I don't believe anyone likes to see the other fellow lose money.

The system I advocate from an economical standpoint is called GRANDEUR, and is available to the industry as a whole and immediate delivery of cameras may be had. You can get in

duction can be increased and production can be increased as, and in proportion to, the way the industry adopts this system.

There is no engineering problem between 65 mm. and 70 mm. You can matt down to the 65 mm. size picture if you use 70 mm. but not the reverse. *Make the standard adequate;* 70 mm. is the logical and economical size it is *proven.*

Technic of Talking Pictures

— BY —

DR. PAUL HATSCHEK, *D. K. G., Berlin*
(Contributed by Karl Freund, member Local 659)

Talking pictures are going to displace silent pictures, a fact which can be noticed all over the world. Numerous systems and methods have been employed to tackle the problems of talking pictures. They all have in common that the recording of the picture has to be taken simultaneously with the recording of the sound. The microphone furnishes exceedingly low electrical currents, which are intensified by the well-known radio intensifier, in order to control with them such an apparatus which registers the waves of the current.

The best known and the simplest method is the one that is mostly employed by the recording-industry, which consists of controlling a recording stylus by the electrical currents; the latter cuts the sound into a turning wax-plate in the shape of a wave line.

Another method is that of conducting the electrical currents into an instrument called "oscillograph" and which is also used for gauging the electrical current oscillations. Here, a tiny mirror is caused to oscillate, which diverts the light beams falling upon it in rhythm with the current oscillations. These fall upon a moving strip of film and thus a photographic recording of the sounds is accomplished in a similar wave line as used by the Grammaphon.

Another photographic recording method consists of supplying the so-called Kerr-cell (invented by the English physicist Kerr in 1875) with the electrical currents. This marvelous cell admits more or less light, depending upon the supplied current being high or low. If light entering the cell falls upon a moving strip of film, light or dark stripes are formed upon same. This photographic process is called record of the variable-density type, while the aforementioned is called record of the variable-area type.

To the latter type belong also such recordings by which a glow-lamp or a Wolfram arc-lamp is supplied with electrical currents, which subsequently flare in rhythm with the speech oscillations and, therefore, likewise produce stripes of different brightness upon a moving film strip.

Entirely deviating from all of these processes is the recording of electric current oscillations upon a moving steel wire or steel strip. Here the electrical currents float around a small magnet which thereby is more or less magnetized—similar to the magnet of a telephone receiver — and, therefore, magnetizes a wire more or less on different places which is passed by it.

Comparing the qualities of the different recording methods, it seems at first that the Grammaphon method is the most primitive one, but experience teaches us, that better results have been accomplished by it, than with photographic recording. In Grammaphon recording the recording stylus, which is driven by the electrical current has relatively speaking a great deal of work to do. Therefore, it has to be rigid and must have a certain weight. But the greater the weight of a body is, the more difficult it will be to put it into rapid oscillations. In recording of sound it is desirable to record a frequency up to about 5000 per second to which task the stylus cannot be equal. Without any doubt the light oscillograph can be equal to this task, and the Kerr-cell, the Wolfram arc-lamp and the flare-lamp should accomplish it perfectly. But, here we are confronted with certain difficulties of photographic nature, which naturally do not exist with the oscillograph, as in this case only curves are photographed. Along with other processes where the finest lighting variations should be recorded in the finest gradations upon the film, the difficulties rise exceedingly and there is no hope, that this will ever be overcome completely. The most perfect is the recording upon a magnetized steel strip. There exist no swinging masses which is also the case with the Kerr-cell. On the other hand all the photographic difficulties are abolished, the intensity variations of the magnet are reflected true to nature in the magnetization of the wire. In the last described method we have therefore the best recording method before us which is in existence at the present time.

Now how is it with the reproduction? As generally known, this takes place by Grammaphon records by means of a pick-up box. A needle sliding along in a small groove of the turning record moves a magnet in a small coil and produces electrical currents, similar to a small generator; these electrical currents are intensified by an intensifier and thus operate one or more loud speakers. Of course, the currents produced by the pick-up box are not extremely high, but are at least of the same range as the currents by radio-reception with a crystal detector. Such currents can be very well and troubleless intensified by comparatively simple intensifiers. This, however, is not true with the photographic method. A 2.7 mm. wide border has been reserved on the film strip for sound recording and only a slit of 0.025 mm. and 2.7 mm. length is exposed by means of an optic device; the film passing by this slit produces the effect of a curtain which allows more or less light to pass into the space behind the film. Thus tiny light variations are produced behind the film. A photo-electric cell is installed behind the film, which can be regarded as a transformer of light into electrical currents. We just noticed that only very little light falls upon the photo-electric cell which, moreover, is a very uneconomical transformer. The cell thus produces tiny electrical currents which are brought only by means of very complicated intensifying-devices to that height which the currents of the pick-up box possess in the start, and only then the further normal intensifying takes place. The first intensifying is accompanied by numerous disturbances; it is very seldom without objection. Furthermore it means a considerable increase of size and price of the equipment.

Considering, that already in recording by the variable density method mistakes show up, it is understood that the mistakes made in recording and producing are multiplied under circumstances, and that this method must be at any rate inferior to the Grammophon method.

Again the superiority of the magnetic method is proven by the reproduction which is just a reversal of the recording: the steel strip, which is passed by a magnet, weakens or strengthens the latter, whereby current variations are produced in a coil of wire which surrounds it. The current variations are of the same range as the currents of the pick-up box. There is no oscillating mass and the records are transformed into current variations without objection. It is not necessary to mention that those troublesome noises disappear, which are caused by dragging of the Grammophon needle upon the record.

The patrons of the photographic recording will remark, that it is of extraordinary advantage to have picture and sound recorded on the same film strip. Hereby picture and sound have to be synchronized which is not absolutely essential with other methods. The Grammophon record takes the worst place among them. Of course, one can see to it that the record revolves in synchronism with the film strip by hooking them up. So far it cannot be done that the Grammophon needle is started exactly at the right point, and neither can it be prevented from jumping from one groove into a neighboring one. Nevertheless experience has proved that picture and sound are well synchronized in the Grammophon method. The magnetic recording is in a much better position than the Grammophon recording. Here the steel strip is simply provided with perforation holes in a similar manner as is the film strip. It is rotated over a gear drum which is hooked up with *that* gear drum over which the film is moved. This way a perfect synchronism of picture and sound is obtained automatically.

What happens if the film strip breaks and a shorter or longer piece has to be cut out?

In this respect the photographic sound recording is worse off than the other methods. By the other methods a piece of the same length of opaque film is pasted in place of the cut out piece; the sound recording remains untouched. But should by the photographic methods a piece of the sound recording fall away, very dis-

(Concluded on Page 12)

 # *Cream o' th' Stills*

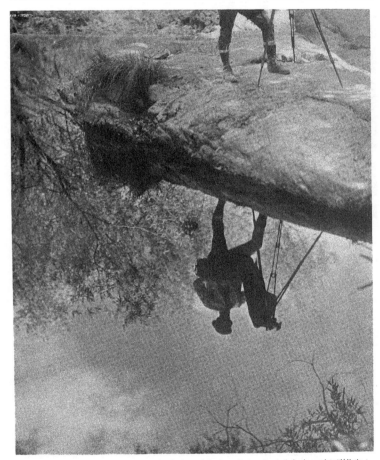

Here we have a picture of the kind that delights the heart of the picture hunter when he is in the mood to "kid" the observer. Guess how he got this, before we let you into the secret that the eloquent feet herein portrayed are those of that eminent pictorialist, Mr. Fred R. Archer.

Cream o' th' Stills

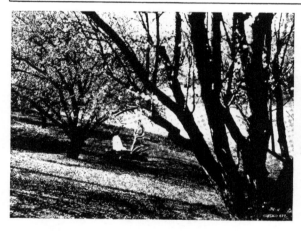

*"The Medicine Man,"
a Tiffany production,
yielded this intriguing
pastoral from the
still-box of Donald
MacKenzie. It is a
spring scene in South-
ern California, just
the kind of picture
that delights the heart
of the cameraman
who loves the great
out-doors.*

*"The lowing herd
winds slowly o'er the
lea," a chance shot
from the good-box
of our Icelandic
brother, Mr. Oliver
Sigurdson. The live-
oaks in middle ground
with the mountains
in the distance, and
the rocky terrian in
the foreground, pre-
sent a set of features
that form unmistak-
ably a Southern
California locale.*

 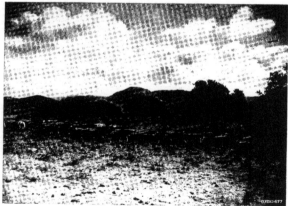

Cream o' th' Stills

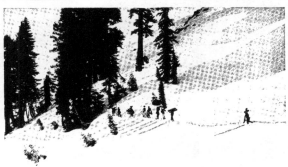

Edward B. Anderson judged correctly when he thought he saw an unusual picture in this trek of Charley Chaplin's camera crew while shooting "The Gold Rush." That's Rollie Totheroh, for a score of years Mr. Chaplain's chief cinematographer, up-ahead there giving orders for the camera set up.

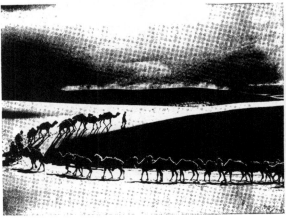

It was J. B. Shackelford, globe trotter and camera wizard, who furnished The International Photographer with that striking cover for the March issue. Here we see Mr. Shackelford's work on the Gobi Desert, whither he went with the Roy Chapman Andrews Scientific Expedition. The camels are unloaded and on their way to water.

 # Cream o' th' Stills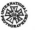

James N. Doolittle and Mother Nature have always been pals. To quote from Thanatopsis: "For his gayer hours she has a voice of gladness and a smile and eloquence of beauty, and she glides into his darker musings with a mild and healing sympathy."—That's Jim Doolittle, and this picture was taken in one of those latter moods.

Jack Rose Goes Amateur

It was away back in the early days of the motion picture industry when Jackson Rose, now vice president of Local 659, "joined on" with the old Essanay studio to become a professional motion picture cameraman.

But even so early as the beginning of Essanay Jack already had a background of success as a commercial photographer associated with Harry Zech, another member of Local 659. At Essanay Mr. Rose shot such stars as Francis X. Bushman and Beverly Bayne, Edna Mayo, Broncho Billy, Bryant Washburn, Richard Travers Charley Chaplin and others. Later he shot scores of the Big Time stars for many studios, his latest engagement being with Tiffany.

And now what do you suppose has happened to Jack. Right. He has gone 16 m m!

You wouldn't have thought it of Jack but strange things do happen in Hollywood.

Said Mr. Rose in commenting upon his new fad:

"I'm having the time of my life. Even in my childhood's happy days down on the farm I never had a toy that delighted my heart like this new Filmo camera, and my family is sharing my pleasure.

It is very interesting to photograph one's family, and one can do so many things with a small camera that you can't do with a professional one. Take the matter of projection, for instance. Of course, to project standard size film, which is highly inflammable, one would need a fireproof projection booth, with costly apparatus and all the necessary precautions for its safety, and besides, there would be all sorts of red tape about fire inspections, and so on. So it is hardly practical for a cameraman. Using the non-inflammable 16 mm. film, however, with only the ordinary amount of caution one can have a projection room right in one's living-room, especially with the light, portable projectors and screens we now have.

"But perhaps the best part of home movie-making is the cheapness of it all. I expected it would be much worse than it really is. And, honestly, I get a great kick out of it, for it's even more interesting to shoot that film than it is to do my regular work in the studio. This reversal business is a funny thing for a professional cameraman to get used to, though—this business of not having any negative, and getting your original film back as a positive. It really seemed uncanny to me at first—but it just naturally cuts down the expense of the thing, and that's an angle all of us can understand without any further explanation!

"I recently bought a Filmo 70-D together with a projector, a screen, and— oh well, I got the whole works and I'm

telling you, it's the best investment I've made. The camera is as perfect as a camera can be, and I know it's built with the same precision and fine workmanship that its professional brother is. I ought to know, for I've been using Bell & Howell professional cameras for 20 years. In fact, I had the good fortune to be the first professional cameraman to use a Bell & Howell camera; far back in 1910 I used Bell & Howell No. 1—and I'm still using one.

"That little camera is certainly a compact and accurate little machine, and its seven speeds are a marvellous help to us all, professionals and amateurs alike, for the different speeds enable us to make many novel and interesting scenes and trick effects.

"The only thing I really miss is the fact that I can't have dialogue and sound effects with my personal 16 mm. pictures the same as I have with the professional ones I have at the studio. But I am sure that, before long, this feature will be forthcoming.

"Since becoming a 16 mm. amateur I've found so many of my associates, and the directors and stars as well, either users or prospective users of 16 mm. outfits, that I'm sure that before long they'll all have 16 mm. outfits. And so, after seeing the results that they get, and knowing the results that I've gotten, I'm glad to say—'Yes, I'm an amateur movie-maker —and proud of it!'"

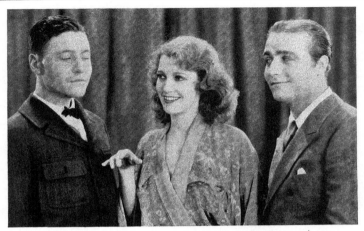

A scene from "Let's Go Native," a Paramount Production with Jack Oakie, Jeanette MacDonald and James Hall

putting her best foot forward

HERE SHE IS! You've seen her a thousand times on the screen. Her demure little smile is warm and friendly. The pert smoothness of her nose . . . the depth and luster of her sparkling eyes, are bewitching. Light from National Photographic Carbons emphasizes her piquant charm. National Panchromatic Carbons (soft-arc) mold her face in close-ups. The soft orange light struck from these carbons is rich in red, orange and yellow-green rays. It brings out the youthful colors, the smoothness of the forehead and neck. And for longer shots, National White Flame

Photographic Carbons (hard-arc) have the actinic carrying power necessary for successful photography. Every graceful gesture is registered, is made an exciting pattern of light and shadow. Give your stars every chance to "get over." National Photographic Carbons, White Flame and Panchromatic, help them put their best foot over.

NATIONAL CARBON COMPANY, INC.
Carbon Sales Division, Cleveland, Ohio

Unit of Union Carbide **UCC** *and Carbon Corporation*

Branch Sales Offices:　New York, N. Y.　Pittsburgh, Pa.
Chicago, Ill.　Birmingham, Ala.　San Francisco, Calif.

National Photographic Carbons
White Flame and Panchromatic

—

Jack Rose Goes Amateur

It was away back in the early days of the motion picture industry when Jackson Rose, now vice president of Local 659, "joined on" with the old Essanay studio to become a professional motion picture cameraman.

But even so early as the beginning of Essanay Jack already had a background of success as a commercial photographer associated with Harry Zech, another member of Local 659. At Essanay Mr. Rose shot such stars as Francis X. Bushman and Beverly Bayne, Edna Mayo, Broncho Billy, Bryant Washburn, Richard Travers Charley Chaplin and others. Later he shot scores of the Big Time stars for many studios, his latest engagement being with Tiffany.

And now what do you suppose has happened to Jack. Right. He has gone 16 m m!

You wouldn't have thought it of Jack but strange things do happen in Hollywood.

Said Mr. Rose in commenting upon his new fad:

"I'm having the time of my life. Even in my childhood's happy days down on the farm I never had a toy that delighted my heart like this new Filmo camera, and my family is sharing my pleasure.

It is very interesting to photograph one's family, and one can do so many things with a small camera that you can't do with a professional one. Take the matter of projection, for instance. Of course, to project standard size film, which is highly inflammable, one would need a fireproof projection booth, with costly apparatus and all the necessary precautions for its safety, and besides, there would be all sorts of red tape about fire inspections, and so on. So it is hardly practical for a cameraman. Using the non-inflammable 16 mm. film, however, with only the ordinary amount of caution one can have a projection room right in one's living-room, especially with the light, portable projectors and screens we now have.

"But perhaps the best part of home movie-making is the cheapness of it all. I expected it would be much worse than it really is. And, honestly, I get a great kick out of it, for it's even more interesting to shoot that film than it is to do my regular work in the studio. This reversal business is a funny thing for a professional cameraman to get used to, though—this business of not having any negative, and getting your original film back as a positive. It really seemed uncanny to me at first—but it just naturally cuts down the expense of the thing, and that's an angle all of us can understand without any further explanation!

"I recently bought a Filmo 70-D together with a projector, a screen, and— oh well, I got the whole works and I'm

telling you, it's the best investment I've made. The camera is as perfect as a camera can be, and I know it's built with the same precision and fine workmanship that its professional brother is. I ought to know, for I've been using Bell & Howell professional cameras for 20 years. In fact, I had the good fortune to be the first professional cameraman to use a Bell & Howell camera; far back in 1910 I used Bell & Howell No. 1—and I'm still using one.

"That little camera is certainly a compact and accurate little machine, and its seven speeds are a marvellous help to us all, professionals and amateurs alike, for the different speeds enable us to make many novel and interesting scenes and trick effects.

"The only thing I really miss is the fact that I can't have dialogue and sound effects with my personal 16 mm. pictures the same as I have with the professional ones I have at the studio. But I am sure that, before long, this feature will be forthcoming.

"Since becoming a 16 mm. amateur I've found so many of my associates, and the directors and stars as well, either users or prospective users of 16 mm. outfits, that I'm sure that before long they'll all have 16 mm. outfits. And so, after seeing the results that they get, and knowing the results that I've gotten, I'm glad to say—'Yes, I'm an amateur movie-maker —and proud of it!'"

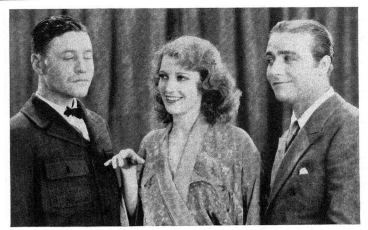

NEW YORK SECTION S. M. P. E.

A New York Section of the Society of Motion Picture Engineers was formed at a recent meeting of more than 150 Eastern members of the society.

At the meeting the following officers were elected: M. W. Palmer, chairman; T. E. Shea and M. C. Batsel, managers; and D. Hyndman, secretary-treasurer.

The geographical boundaries of the New York Section were defined by the Board of Governors as an area enclosed within a circle having a radius of 50 miles from Times Square.

With the formation of the New York Section, it will be possible for the Eastern members to become better acquainted with each other and the work of the society. At the organization meeting Dr. Walter Pitkin, of the School of Journalism, Columbia University, delivered an address on "The Psychology of the Sound Picture," drawing attention to the many shortcomings of the present methods of sound reproduction, particularly with respect to the reproduction of noises. President J. I. Crabtree acted as temporary chairman of the meeting.

Sol Polito is shooting "The Girl of the Golden West" for First National. Eight years ago Mr. Polito shot this same picture under direction of Edwin Carewe.

Eddie New has just returned from Sonora, California, where he shot the stills for "The Border Legion," Paramount's latest production, directed by Otto Brower.

CAMERA CAR

Camera car used by Signal Corps Photographic Section, Headquarters Ninth Corps Area. Sergeant Charles, Local 659, in charge.

---o---

TECHNIC OF TALKING PICTURES
(Continued from Page 8)

agreeable sound effects will then be produced, and this will be worse, as the picture and the proper sound are not next to each other, as generally believed. Moreover the sound recording is 19 picture heights ahead of the proper picture, which is 361 mm. (This happens because the film strip has to be switched intermittently for the purpose of the picture reproduction, whereas for the purpose of the sound reproduction it has to be done constantly. A more thorough explanation of this would lead too far.)

Out of all of these reflections one can readily see the immense advantages of the magnetic method in comparison with all the other methods. There is another advantage to be mentioned and that is especially in recording. A test can be made right after it has been taken, whereby much time and material can be saved, as the immediate repetition of spoiled records can be made. The indestructibleness of the steel strip, which can be demagnetized and bespoken as often as liked, opens up the possibility to carry out different kinds of corrections and tricks, after the recording in the laboratory, and in this way effects can be produced, such as are absolutely impossible with other methods. Furthermore, methods have been worked out by which magnetic recordings can be transformed into photographic. This can be done in the laboratory in the simplest manner. In this case one has the possibilities to produce a photographic sound film by the variable width-type without having to take into consideration the faults of the oscillograph. These faults appear only by extremely high oscillations. One can work in the laboratory as slowly as one desires.

Some of the machines which are making history in the moving picture industry — general view of the tool room, milling department, in the new Bell & Howell Engineering Development Building.

Bell & Howell sees it through!

A new piece of Bell & Howell cine-machinery is never put into production until conditions under which it might operate are carefully surveyed; not a wheel is turned until the whole function of that machine is visualized and prepared for in advance.

From this care in design, and the precision of their manufacture come the constant dependability of Bell & Howell Standard Cameras, both sound and silent.

Wherever movies are made, the name Bell & Howell has rightfully become synonymous with known high quality.

The foresight of its engineers is but a part of the contribution of the Bell & Howell Engineering Development Laboratories to the progress of the industry. Clear thinking and rare skill in application of theory to practice are daily solving the problems of the moment in these Laboratories. Penetrating vision and mechanical ingenuity are constantly at work in anticipation of the future. The submission of your problems is invited.

BELL & HOWELL

Bell & Howell Company, Dept. P, 1848 Larchmont Ave., Chicago, Ill. New York, 11 West 42nd Street. Hollywood, 6324 Santa Monica Blvd. London (B. & H. Co., Ltd.) 320 Regent Street
Established 1907

When Sound Builds Form

—BY—

BISHOP CHARLES W. LEADBEATER, *in "The Hidden Side of Things"*

There are many people who realize that sound always generates color—that every note which is played or sung has overtones which produces the effect of light when seen by an eye even slightly clairvoyant. Not every one, however, knows that sound also builds form just as thoughts do. Yet this is nevertheless the case. It was long ago shown that sound gives rise to form in the physical world by singing a certain note into a tube across the end of which was stretched a membrane upon which fine sand or lycopodium powder had been cast.

In this way it was proved that each sound threw the sand into a certain definite shape, and that the same note always produced the same shape. It is not, however, with forms caused in this way that we are dealing just now, but with those built up in etheric, astral and mental matter, which persist and continue in vigorous action long after the sound itself has died away, so far as physical ears are concerned.

Let us take, for example, the hidden side of the performance of a piece of music—say the playing of a voluntary upon a church organ. This has its effect in the physical world upon those of the worshipers who have an ear for music—who have educated themselves to understand and to appreciate it. But many people who do not understand it and have no technical knowledge of the subject are yet conscious of a very decided effect which it produces upon them.

The clairvoyant student is in no way surprised at this, for he sees that each piece of music as it is performed upon the organ builds up gradually an enormous edifice in etheric, astral and mental matter extending away above the organ and far through the roof of the church like a kind of castellated mountain-range, all composed of glorious flashing colors coruscating and blazing in a most marvelous manner, like the aurora borealis in the arctic regions. The nature of this differs very much in the case of different composers. An overture by Wagner makes always a magnificent whole with splendid splashes of vivid color as though he built with mountains of flame for stones; one of Bach's fugues builds up a mighty ordered form, bold yet precise, rugged but symmetrical, with parallel rivulets of silver or gold or ruby running through it, marking the successive appearances of the motif; one of Mendelssohn's Lieder ohne Worte makes a lovely airy erection—a sort of castle of filigree work in frosted silver.

In the book called "Thought-Forms," will be found three illustrations in color, in which we have endeavored to depict the forms built by pieces of music by Mendelssohn, Gounod and Wagner respectively, and I would refer the reader to these for this is one of the cases in which

it is quite impossible to imagine the appearance of the form without actually seeing it or some representation of it. It may some day be possible to have a book containing studies of a number of such forms, for the purpose of careful examination and comparison. It is evident that the study of such sound-forms would be a science in itself and one of surpassing interest.

These forms, created by the performers of the music, must not be confounded with the magnificent thought-form which the composer himself made as the expression of his own music in the higher worlds. This is a production worthy of the great mind from which it emanated, and often persists for many years—sometimes even over centuries if the composer is so far understood and appreciated that his original conception is strengthened by the thoughts of his admirers. In the same manner, though with wide difference of type, magnificent erections are constructed in higher worlds by a great poet's idea of his epic, or a great writer's idea of the subject which he means to put before his readers such for example, as Wagner's immortal trilogy of The Ring. Dante's grand representation of purgatory and paradise, and Ruskin's conception of what art ought to be and of what he desired to make it.

The forms made by the performance of the music persist for a considerable space of time, varying from one hour to three or four, and all the time they are sending out radiations which assuredly influence for good every soul within a radius of half a mile or more. Not that the soul necessarily knows it, nor that the influence is at all equal in all cases. The sensitive person is greatly uplifted, while the dull and preoccupied man is but little affected. Still, however, unconsciously, each person must be a little the better for coming under such an influence. Naturally the undulations extend much faster than the distance named but beyond that they grow rapidly weaker, and in a great city they are soon drowned in the rush of swirling currents which fill the astral world in such places. * * *

In the quiet country amidst the fields and the trees the edifice lasts proportionately much longer and its influence has a wider area. It is surely a beautiful thought that every organist who does his work well, and throws his whole soul into it is thus doing far more good than he knows, and helping many whom perhaps he never saw and never will know in this life.

Another point which is interesting in this connection is the difference between the edifices built by the same music when rendered upon different instruments—as, for example, the difference in appearance of the form built by a certain opus when played upon a church organ and the same

piece executed by an orchestra or by a violin quartette, or played on a piano.

In these cases the form is identical if the music be equally well rendered, but naturally, in the case of the violin quartete, the size of the form is far less, because the volume of sound is so much less. The form built by the piano is often somewhat larger than that of the violins, but is not so accurate in detail, and its proportions are less perfect. Again, a decided difference in texture is visible between the effect of a violin solo and the same solo played upon the flute.

Surrounding and blending with these forms, although perfectly distinct from them, are the forms of thought and feeling produced by human beings under the influence of music. The size and vividness of these depend upon the appreciativeness of the audience and the extent to which they are affected. Sometimes the form built by the sublime conception of a master of harmony stands alone in this beauty, unattended and unnoticed, because of such mental facilities as the congregation may possess are entirely absorbed in millinery or in the calculations of the money-market, while on the other hand the chain of simple forms built by the force of some well-known hymn may in some cases be almost hidden by great blue clouds of devotional feeling evoked from the hearts of the singers.

Another factor which determines the appearance of the edifice constructed by a piece of music is the quality of the performance. The thought-form hanging over a church after a performance of the Hallelujah chorus infallibly and distinctly shows for example, if the bass solo has been flat, or if any of the parts have been noticeably weaker than the others, as in either case there is an obvious failure in the symmetry and clearness of the form.

Naturally there are types of music whose forms are anything but lovely, though even these have their interest as objects of study. The curious broken shapes which surround an academy for young ladies at the pupil's practising hour are at least remarkable and instructive, if not beautiful; and the chains thrown out in lasso-like loops and curves by the child who is industriously playing scales or arpeggios are by no means without their charm when there are no broken or missing links.

SINGING

A song with a chorus constructs a form in which a number of beads are strung at equal distances upon a silver thread of melody, the size of the beads of course, depending upon the voice and expression of the solo singer, while the

(Concluded on Page 27)

"Hot Points"

Conducted by MAURICE KAINS

Gordon Head, Local 659, and his new turret for still cameras; made from an aluminum sauce pan.

Amazing shot of a water-spout from a U. S. Destroyer in the China Sea October 16, 1929, by Nathan Siegle and sent to The International Photographer *through Kay Norton, 659.*

Gordon Head, one of our most enterprising still men, has just perfected one of the best "hot points" it has been our good fortune to come in contact with.

The accompanying cut of Gordon and his still camera are almost all that is necessary to put over the idea to you except that I would like to say that the materials cost less than $5 and the main part of the turret is curt from the bottom of a large aluminus sauce pan.

Incorporated in the turrent behind the lenses is a revolving wheel with six openings. Three of these opens are for various filters, one for an O. B. disc, one for gauze and one remains permanently open for straight shots.

Gordon has had the foresight to design the turret with an adapter frame which enables him to transfer in a few seconds the entire device from an Eastman camera to an Ansco or vice versa.

The shell or turret proper is bolted to a 2¾ inch Packard shutter. The lenses are 9½ inches, 12 inches and 16 inches focal lengths. There is ample room on the turret for a fourth lens. Gordon may pick one up soon in England as he anticipates a nice engagement there in the near future.

The results achieved with this idea are well worth the effort put forth in its construction.

We saw several splendid examples of wide angle stills, medium shots and medium close-ups all shot from the same parallel or set-up. We think Gordon has started something which many still men could copy to their advantage.

Some of the boys recently needed some stop motion cranks but did not care to "put out" for them. Henry Prautsch, Jr., loader, made up several cranks out of ordinary brass tubing. He first filled the tubing with hot lead, then bent the tubing crank shape, after which he melted the lead out. One end of the crank is bent square by placing a square rod inside

BIGGEST LAMP ON EARTH

The most powerful incandescent lamp in the world, 50 k.w., developed by General Electric lighting engineers, is making the rounds of the studios just now. It has recently arrived from the east—especially designed for big Technicolor sets where a tremendous amount of light is often required from a single source. It is capable of giving a 3,000,000 candle power beam over a 120 degree spread.

The three pounds of tungsten used to form its giant coiled filament is the equivalent of 125,695 filaments used in ordinary home lamps.

Its total light is equivalent to all the light gathered from 50 average homes with all lights burning, gathered up and packed into one concentrated source.

and then clamping it in a vise. Art Reed uses his crank for a cigarette holder between shots.

MAZDA . . . not the name of a thing, but the mark of a research service

5 kw. MAZDA Photographic Lamp, G-64

NOW, even a gradually accumulating residue of "bulb blackening" on the inside of high wattage photographic lamps need not put an end to their invaluable lighting service to the motion picture photographer.

MAZDA research has discovered a practical method of removing this black deposit from lamps otherwise as good as new. A teaspoonful of special crystalline tungsten powder, placed inside the lamp bulb before it is exhausted, makes the difference.

When blackening forms, remove the lamp from its socket, invert it so that the powder touches the blackened inner surface, rotate it gently, and friction removes the blackening. Nothing else to be done — your lamp is as good as new. Put it back in its socket, where it burns in an upright position, and the powder and residue return to the base.

Increased efficiency a great saving in the cost of motion picture production greater uniformity of illumination lighter equipments more easily handled many other benefits. Another reason for the leadership of G. E. MAZDA incandescent lamps as light sources for motion picture photography.

This
makes the
difference

Join us in the General Electric Hour, broadcast every Saturday at 9 P. M., E. S. T., over a Nation-wide N. B. C. network.

GENERAL ELECTRIC
MAZDA LAMPS

The Effect of Bromide in a Borax Developer

—BY—

EMERY HUSE and GORDON A. CHAMBERS,

West Coast Division, Motion Picture Film Department, Eastman Kodak Co.

There has been quite a little written regarding the effect of the various constituents entering into the composition of a borax developer. Much has been said of the effect of bromide and we are of the opinion that it is quite generally understood that bromide acts as a detrimental constituent to this type of developer.

If we examine the developer formulas prior to the issuance by the Eastman Kodak Company of the borax formula we will observe that it is difficult to locate a formula which does not contain potassium bromide.

It is well known that the effect of bromide in a developer is to reduce the amount of chemical fog resulting from development. Unfortunately, when bromide is introduced in the borax developer there are other phenomena taking place which do not work to the advantage of the developer. Sensitometrically the effect of bromide for a given degree of development, that is same gamma, is to alter the point at which the straight line portion of the H and D curve crosses the exposure axis. This has the effect of reducing the speed of the emulsion. This idea, when thought of in terms of a family of H and D curves for various times of development, shows first that in an unbromided developer of a normal type the intersection point of the series of curves lies practically on the exposure axis. In the second place, when this same developer has potassium bromide added to it and another series of H and D tests developed, it will be found that the intersection point for this family of curves lies below the exposure axis. Figure I shows graphically the point being made here. The upper series of curves, A, that is those intersecting on the exposure axis, represent developments in a non-bromided developer while the lower set, B, represents an identical series developed in the same type developer but to which has been added a quantity of potassium bromide.

Realizing the above considerations a series of tests has been made which show the actual loss in the effective speed of the emulsion when a certain developer has had added to it a quantity of potassium bromide.

Two sets of six sensitometric strips each of Eastman Panchromatic Type Two negative were exposed in a time scale sensitometer in which the exposing light was spectrally of daylight quality. The actual control of time in the sensitometer is accomplished by a sector wheel operating during only one revolution, and driven by a synchronous motor. Each set of strips was developed for a series of times and from each strip the values of speed, gamma, and fog were determined for both bromided and non-bromided developer. The developer formula used is one which is described in a paper by

LOG EXPOSURE

Carlton and Crabtree entitled "Some Properties of Fine-Grain Developers for Motion Picture Film." This formula was built up for sensitometric purposes and with the bromide added to it, it represents a formula which compares very favorably with the standard D-76 borax formula through which has been developed approximately 30 feet of film per gallon. It is estimated that this gives a developer which corresponds to the standard borax formula just after the initial fogging point has been passed. The formula itself is tabulated below.

MQ BORAX SB

	Grams
Elon	2
Hydroquinone	5
Sodium Sulphite (dessicated)	100
Borax	8
Boric Acid	8
Potassium Bromide	0.25
Water to make	*1

* Liter.

As aforestated, the two developers which were compared in this series of tests were the above formula as published, and the same formula minus the potassium bromide. The following table contains for each developer the times of development, relative values of speed and also the gamma and fog values. The percentage speed is given in terms of nine minute development for the unbromided developer as 100 per cent, inasmuch as nine minutes represents a good average time of development. The developer marked MQ Borax SB contains bromide as indicated in the above formula. The developer marked MQ Borax B contains no bromide.

In addition to these two sets of data an additional column is added to show the percentage drop in speed, for each time of development, due to the bromide effect. It will be observed that the percentage drop in speed decreases as the development time increases. In other words, this indicates very strongly that the bromide has a very marked effect on the early stages of development. The 2 per cent increase shown for the 18' curve is no doubt influenced by the difference in the fog values because these speeds are determined taking into consideration the fog values. It should be borne in mind that the fog values as shown for the non-bromided developer are perfectly normal and are not detrimental to photographic quality in any respect.

It is interesting to note also that the effect of bromide in a borax type of developer plays a great part in depleting an emulsion of its shadow detail characteristics. A phenomenon of this type can be shown much more conclusively in the examination of actual camera negatives which have been shot under identical conditions, developed to the same degree of contrast, but one having been handled in a normal borax developer while the second was handled in the borax developer with the addition of bromide.

This article has dealt with this problem of bromide effect in a borax developer almost exclusively from the standpoint of sensitometric measurements. The purpose of this work was to present figures showing the actual loss in development brought about by the bromide. Of course the examination of pictures on a screen will show differences but it is difficult to express these differences numerically, as for instance in terms of percentage loss. However, these losses brought about by the presence of bromide in a borax developer are detectable on the screen from prints of negatives developed under the same conditions that the sensitometric strips were developed, as reported in the above article.

It is hoped that the data presented in this article will serve as a definite indication of the effect of potassium bromide in a borax type developer.

	MQ BORAX B				MQ BORAX SB			
Time of Development	Speed (%)	Gamma	Fog		Speed (%)	Gamma	Fog	(%) Drop in Speed
3'	87	0.27	0.07		35	0.27	0.05	52
6'	100	0.56	0.08		62	0.55	0.07	38
9'	100	0.71	0.08		68	0.72	0.09	32
12'	105	0.81	0.11		88	0.80	0.09	17
15'	110	0.92	0.13		110	0.87	0.10	0
18'	112	0.95	0.15		114	0.96	0.11	*2

* Per cent increase in speed

I WONDER WHY

By *Jack Rose*

Joe AUGUST was born in APRIL.
Bob DE GRASSE uses a lawn MOWER.
J. O. TAYLOR always has PRESSING business.
Eric MAYELL, but never too LOUD.
Walter HAAS; but maybe he HASN'T.
John FULTON did not invent the STEAMBOAT.
Paul HILL lives in the VALLEY.
James KING has never been CROWNED.
George ROBINSON has a cousin named CARUSO.
Bert SIX can always throw 7 or 11.
Amos STILLMAN is now shooting the 'WHOOPEES.'
Alvin, WYCKOFF if you smoke OLD GOLDS?
Howard HURD, but said not a WORD.
Jack ROSE, when he sat on a tack.
Dave ABEL never raises CAIN.
Frank REDMAN did not photograph "REDSKIN."
Herman SCHOPP is not a merchant.
Harry UNDERWOOD is liked by stenographers.
Lester WHITE is never off COLOR.
Jerry ASH is off of CIGARETTES.
Milton BROWN always seems BLUE.
Paul CABLE is a WIRY chap.
Billy TUERS, but never leaves TOWN.
Bob PLANCK is always BORED.
Dick FRYER is no spring CHICKEN.
Charley CRANE is not a MACHINE.
Elmer DYER is not a master CLEANER.
John FINGER is always on HAND.
Jimmy DIAMOND is not a BALL PLAYER.

Many interesting and important jobs in motion pictures require years of training and are vital to good films, yet the public is not aware of the work done or its necessity. The finished picture unfolds so smoothly, that many details of laborious endeavor are overlooked.

William Dietz is an example of this. Now working on "Hell's Angels," "What a Widow," the current Gloria Swanson production and "Swing High," for Pathe. Dietz is responsible for some of the most intricate and · important photographic effects in the films.

Dietz received much favorable comment. for the ballet sequences of "Paris Bound" in which wierd and varied dancers pass before the figure of Ann Harding. Twenty shots were combined by multiple process on the finished film and even more extraordinary results will be seen in "Hell's Angels."

CAMERA STAFF OF THE FIRST NATIONAL VITAPHONE TECHNICOLOR PRODUCTION "UNDER WESTERN SKYS"

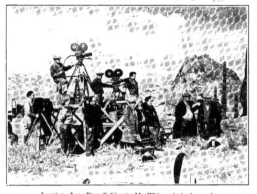

Location—Lone Pine, California, Mt. Whitney in background.

Lower left to right—*Elmer Fryer, Ralph Ash, Mike Joyce, Duke Green, Perry Finnerman, Clarence Badger (director), Sol Polito.* Upper left to right—*Eddie Linden, Shorty Stafford, John Shepeck.* This still take by Mac Julian.

MAKING MOVIE HISTORY

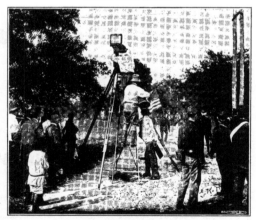

This still was shot in 1913 at Jacksonville, Florida, by George K. Hollister, correspondent, artist and cinematographer. The picture was "The Fighting Chaplain," produced by Kalem. In that picture Brother Hollister shot his action stills at the same time he photographed the picture. Note still box mounted on top of the Moy camera.

The Fearless Silent Super Film Camera

A New Universal Camera for Modern Conditions

The year 1930 will go down in the history of motion pictures as marking the advent of a new type of picture. Wide film is apparently the most revolutionary development in the motion picture industry since the advent of the talking picture. The wide picture is here and undoubtedly here to stay. All producers are eagerly watching developments, and some of the larger producers are rushing out new equipment to make this type of picture. However, it is going to take some time to build equipment to handle this new type film, and in the mean time production must continue on the present 35 mm. film.

This condition has placed a dilemma before the producer and cameramen who need new photographic and camera equipment. If he purchases camera and equipment for 35 mm. he realizes that it will be obsolete in a short time, and on the other hand if he purchases camera equipment for the new film he can not get full use of it until the exhibitor is in a position to show the wide picture.

The Fearless Camera Company, headed by Ralph Gordon Fear, believe they have solved the answer to his dilemma in the development of a new camera. Mr. Fear is well and favorably known in the industry and his accumulated scientific and practical knowledge, gained through ten years of intimate association with engineering phases of the industry, makes it possible for him to see the needed developments necessary to keep in step with the rapid growth of motion pictures.

In describing the new Fearless camera, Mr. Fear said: "The new camera is built, first, to be silent so that it can be used in the open without any sound proof covering for all ordinary shots; second, to use the new 65 mm. super-film; third, so that it can be readily converted to the special 62 and 70 mm. film which some of the producers are experimenting with; fourth, for taking colored pictures in the camera without any alteration; fifth, for recording sound directly in the camera if so desired, and lastly and most important, 35 mm. film can be used in it also.

"Inasmuch as both large film manufacturers are now in a position to furnish the 65 mm. super-film to the producer, the difficulty of obtaining film has been eliminated, and for this reason the 65 mm. standard has been adapted for the new camera. .

"From the cameraman's point of view the most interesting feature of the Fearless camera is the feature of being able to use the camera for either 35 mm. or wide film. The camera is normally built for the standard 65 mm. film. A special movement for 35 mm. film has been developed, and this movement is interchangeable with the 65 mm. movement. Two interchangeable sprocket and roller assemblies have been developed. One is for 65 mm. super-film and the other for 35 mm. film which are interchangeable. So by merely removing one movement and sprocket assembly and substituting the other, the camera can be used for either size film. This feature applies to any other size film as special movements and sprocket assemblies can be furnished for any size film up to 70 mm. The change over from one size film to the other can be made in less than ten minutes."

In regard to the magazines relative to this change in film size Mr. Fear says: "When the Fearless camera is purchased for 65 mm. standard film or for special size wide film, the accompanying magazines are designed so that 35 mm. film can also be used in them. This is accomplished by providing the film rollers with a relief so that the 35 mm. film is properly guided into the magazine and by furnishing special take-up spools for the narrow film. These spools hold the film central in the magazine and prevent it from creeping, to one side or the other. In fact they practically act as a film reel.

"Standard 35 mm. magazines can also be used on the camera when using 35 mm. film; thus making it possible to use some of the equipment that the producer now has. This is accomplished by making a special adapter which fastens on top of the camera. This adapter partially covers the hole for the large size film and excludes all light from the inside of the camera when using the 35 mm. magazines. With the adapter in place, standard 35 mm. magazines can be used.

"Insasmuch as this feature of interchangeability is one of the biggest features of the Fearless camera extreme pains have been taken to secure patent protection on this feature, and thus prevent infringement. Separate patent applications have been made on the construction of the magazine with the relieved rollers for handling 35 mm. film; on the adapter for attaching 35 mm. standard magazines to a wide film camera; on a narrow magazine with a wide base for attaching to a wide film camera, and on a movement adapter for properly locating a movement designed for a narrow film camera in a wide film camera. These patent applications preclude the possibility of any other manufacturer building a similar camera in which both wide film and narrow film can be used.

"Other features furnished as standard equipment in the new Fearless camera include a quick focusing device; full force feed lubrication to all major driven parts, all driving parts being inclosed and running in an oil bath, and two built-in footage counters. As special equipment the camera can be furnished with a built-in speedometer, a built-in three speed high speed gear box and a built-in sound recording mechanism.

"To elaborate on the method of focusing the photographic lens—the camera is built with a sliding turret and lens carrier on the front of the camera box. This lens carrier is mounted in dove tails and constructed so that it may be shifted across the front of the camera box to a point where the photographic lens is in front of the ground glass of the focusing tube. The lens carrier is made so that the light shade is mounted to it and instead of having to shift the camera, magazine, motors, cables, etc., only the light weight lens system and light box is shifted.

"The actual shifting is accomplished by merely pressing down a knob and moving a lever from one side of the camera to the other. This focusing operation is performed so quickly that it has been a revelation to all who have seen it. Suitable stops prevent over-travel and suitable locks are provided to hold the lens carrier either in the focusing position or in the photographic position. The image is viewed with a conventional finder or focusing magnifier which is supplied for either five or ten power. The focusing telescope is of the simple astronomical type, and re-inverts the inverted image formed by the lens on the ground glass, thus bringing the viewed image right side up and right side to.

"The Fearless camera can be furnished with a built-in auxiliary recording aperture at the proper distance from the photographic aperture and sprocket for recording sound directly in the camera. The auxiliary sprocket for pulling the film past the sound recording aperture is driven by a mechanism designed to absorb vibration so that the sound recorded is free from the so-called wow-wows caused by irregularity of film speed by the sound aperture. This feature of built-in sound recording makes it possible for the producer to make sound pictures at once without having to wait for new recording apparatus for the new size film. The design is adaptable to almost any type of light valve or glow lamp type of recording.

"A standard Fearless Silent movement of enlarged size is used to feed the film intermittently past the aperture. Two claw pins are used on each side of the film to pull the film down and pilot pins are used to lock the film during the exposure. This movement is extremely easy to thread and due to simplicity of design and accuracy of workmanship is so silent that only by placing the ear against the frame of the movement can any sound be heard while in operation.

"The camera has been designed for silence throughout and extreme pains have been taken in the design and construction to eliminate noise wherever possible. The camera can be used in the open for all ordinary shots without any sound proof covering. This has been accomplished by using fibre gears to transmit the power, precision bearings for the driving shafts, and by inclosing all

(Concluded on Page 26)

The Fearless Silen

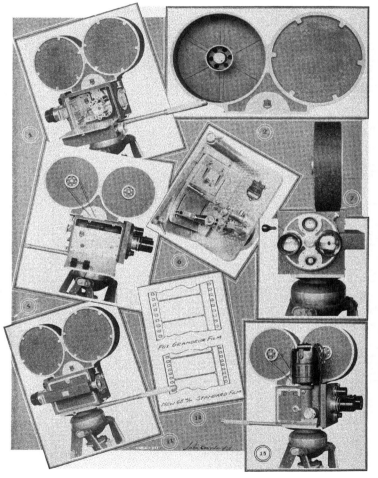

1—S*
assembl*
Fearles*
adjuste*

2—In
zine sh*
spool.

3—Li
special
mm. fil*

4—R*
angle s

5—Ri
showing
footage

6—T
less Sil

7—Fr
shoot.
mounts.

8—F*
sliding
carrier
in focu

9—T
movem
film.

10—
plate
mechan
and s
partme

11—

12—
of 65
film.

13—
motor

14—
don F
65 mm
comple

15—Re
out mo

;uper Film Camera

d roller
era and
ovement
m. film.

maga-
bearing

showing
for 35

ght side
nera.

of box
n k and

. Fear-
nent.

ready to
nd lens

showing
nd lens
of box,
n.

Silent
5 mm.

of box-
showing
d tight
f com-

be.

e size
0 mm.

showing
t.

h Gor-
is new
camera

, with-
ent.

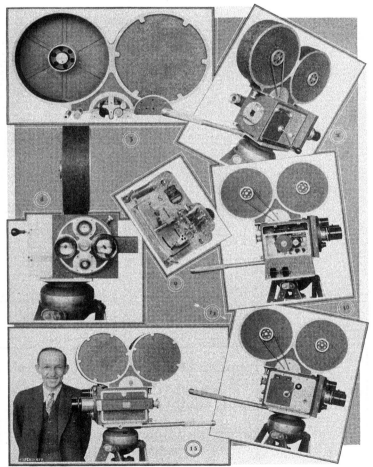

THE FEARLESS SILENT SUPER-FILM CAMERA

(Continued from Page 23)

moving mechanism outside of the movement and sprocket assembly in an oil tight and sound proof compartment which serves as an oil reservoir. An oil pump within this compartment pumps oil to all bearings and moving parts therein. This circulating oil deadens any noise developed by the mechanism. The oil level may be viewed through a window, built into a plate, that covers the mechanism compartment. Sufficient oil is placed into the compartment to last for several months. All high grade automobiles use pressure feed lubrication but this is the first time it has ever been applied to a motion picture camera.

"The motor drives directly into an extension of the movement cam shaft, thus transmitting the motor power directly to the most highly stressed part of the camera and eliminates a great deal of noise caused from gears. The motor itself absorbs any vibration caused by the intermittent movement.

"Silent bakelite gears are used to drive the sprockets and shutter shaft. A large heavy shutter of the two opening type running at a speed one-half of the intermittent mechanism is used for a flywheel. This heavy revolving shutter also absorbs any noise that might be transmitted to the front of the camera. Wherever possible instrument type precision annular ball bearings have been used to reduce friction and to insure long life to the camera.

"Two footage counters of the Veeder type are built into the camera, one being used for total footage shot and the other being used for individual takes.

"Provision is made for attaching to a standard Fearless tripod, the tripod being equipped with a stud which can be turned by suitable gears and which engages with a bronze nut inserted in the camera case. The camera crank is used to actually deliver power to the stud to screw the camera to the tripod."

In closing Mr. Fear says: "It is impossible to adequately describe this camera, but some idea of the thought placed in its design can be gained by reading over the list of features, on all of which patents have been applied for to prevent infringement."

Following is a list of patents which have been either applied for or granted:

CAMERA PATENTS APPLIED FOR

1. Quick shift with lever action.
2. Quick shift with gear and twisting handles.
3. Automatic dissolve.
4. Built-in three speed gear box for Hi-speed work.
5. Built-in automatic belt tightener (two applications).
6. Built-in motor circuit breaker.
7. Built-in force feed lubrication system with pump.
8. Adapter for adapting 35 mm. film movements to wide film cameras.
9. Dual sprocket for 35 mm. film and wide film.
10. Magazine adapter for using standard 35 mm. film magazines on wide film cameras.
11. Automatic trip for motor control.
12. Non-reversible drive for camera or motor.
13. High speed silent movement.
14. High speed 35 mm. silent movement with extra wide aperture plate for fitting wide film cameras.
15. Film sound recording aperture and auxiliary sprocket drive.
16. Quick threading pin for locating film properly in movement.
17. Removable prism for focusing directly on the film through the intermittent movement for precision work.

THE NEW FEARLESS MAGAZINE

The new Fearless Magazine is being announced along with the advent of the new Fearless Super-Film Camera. Over eighteen months' time was spent in experimenting, research, and patent investigation before the Fearless Camera Company had developed a magazine that they feel would be superior to any now on the market.

A camera magazine at first thought appears to present no problems, but with a little thought any cameraman will realize that thousands of feet of film have been spoiled by the magazine. Scratches are one of their worst faults. Practically all buckles in a camera are caused by improperly constructed magazines. Most magazines are extremely hard to thread, and it is almost impossible to keep them clean; and in every case it takes a great amount of labor to dismantle the magazine to remove rollers and light trap for cleaning. All of the magazines now on the market are somewhat noisy.

Realizing all the above defects, the Fearless Camera Company has perfected a new type magazine which overcomes the troubles found in most magazines. The new magazines were designed primarily for silence, serviceability, durability and reliability, and are extremely easy to load.

The main magazine casting carries the take-up rollers and spools. This assembly

is carried on imported instrument type annular ball bearings. The spool will turn thirty to forty revolutions, even when loaded with a thousand feet of film if it is twisted quickly by hand. In fact the film moves so freely that one hardly believes there is film in the magazine.

Film is fed from the carrier spool through a free opening light trap which is clearly illustrated in the accompanying photographs. The light is trapped by two rollers which are also mounted on precision instrument type ball bearings, and by a velvet lining in the throat of the magazine. The rollers are made from duralumin and the roller shafts from steel. As will be noticed from the photographs, the light trap is removable from the magazine. Six screws in the bottom of the magazine hold it in place in the main casting. These may be removed in a few seconds time and the entire light trap removed. The light trap assembly can be quickly taken apart by removing four screws from the side of the casting. In fact the light trap can be removed, completely dismantled, cleaned, and re-assembled in less than ten minutes time.

In developing this magazine cost was not taken into consideration, as we felt that the loss of one roll of film caused by scratches would pay for the additional cost of this magazine over the other type magazines now on the market.

This magazine can be supplied for Fearless, Bell & Howell, or Mitchell cameras, in either 35, 65 or 70 mm.

The perfection of design, the materials used in fabrication and the extreme pains taken to insure precision machine work in their construction makes the Fearless Magazine buckle proof, dust proof, and insures against trouble.

The following patents have been applied for on the design, etc.:

1. Magazine with removable throat and free opening light trap.
2. 35 mm. magazine with broad base for wide film cameras.
3. Wide film magazine with recessed rollers for using two different size films in same magazine.

Discretion, Etc.

Russell Hoover (Breathless): "I just stopped a big fight down on stage 6."

Less White: "How did you do that, Russ?"

Russell: "I ran away."

THE OLD VITAGRAPH

Here is Brother Reginald Lyons with his Vitagraph camera model of 1914. Note that Reggie is prepared for frost. The locale is at Saranac Lake, New York. This old camera took two negatives at once — one for U. S. release the other foreign. Reggie was with Vitagraph for fourteen years and before that he was one of the star motorcycle riders of the country riding under the name of Flash Lyons. He is now with Warner Brothers.

PICK UPSHOTS
(Out of Focus see Page 48)

BENNIE CLINE turns in his wig after finishing "Journeys End" (gets hair cut).—JACK FUQUA mailing out The International Photographer to all points of the globe.—SPEED HALL delivering copies to various local points.—MISS VAN ETTISCHE trying to tell one of the brothers what to do if he works three hours overtime and his dues are not paid.—ED. ESTABROOK lining up 31 Technicolor cameras and 75 men for a circuit picture. He has plenty of experience.—MAX DUPONT sells out at Vitacolor and is at Tiffanys.—OTTO HIMM shooting Amie (not so) Semple MacPherson.—ART REEVES head man at Tiffany while JAX ROSE goes east.—JOHN ARNOLD looking at Grandeur camera at M-G-M.—CHAS. CLARK (getting stout) crossing Western Avenue. PERRY EVANS flys the night mail, north, when he can't sleep.—MAX FABIAN can set lights faster than his electrician can place them back again.—BILL WILLIAMS explaining what the 5 pulleys on the Multicolor magazines are for.—AL GILKS knocking no ashes out of his pipe while trying to figure how to get back light on the cute little thing when she has been plastered up against the wall.

"WHEN SOUND BUILDS FORM"
(Continued from Page 14)

form into which the thread is plaited depends upon the character of the melody. Of great interest also are the variations in metallic texture produced by different qualities of voice—the contrast between the soprano and the tenor, the alto and the bass, and again the difference between a boy's voice and a woman's. Very beautiful also is the intertwining of these four threads (quite unlike in color and in texture) in the singing of a glee or a part song, or their ordered and yet consistantly varied march side by side in the singing of a hymn.

A processional hymn builds a series of rectangular forms drawn with mathematical precision, following one another in definite order like the links of some mighty chain—or still more (unpoetical thought it sounds) like the carriages of some huge train belonging to the astral world. Very striking also is the difference in ecclesiastical music, between the broken thought glittering fragments of the Anglican chant, and the splendid glowing uniformity of the Gregorian tone. Not unlike the latter is the effect produced by the monotonous chanting of Sanskrit verses by pandits in India.

It may be asked here how far the feeling of the musician himself affects the form which is built by his efforts.

His feelings do not strictly speaking, affect the musical structure at all. If the delicacy and brilliancy of his execution remain the same, it makes no difference to that musical form whether he himself feels happy or miserable, whether his musings are grave or gay. His emotions naturally produce vibrant forms in astral matter, just as those of his audience, but these merely surround the great shape built by the music, and in no way interfere with it.

His comprehension of the music, and the skill of his rendering of it, show themselves in the edifice which he constructs. A poor and merely mechanical performance erects a structure, which though it may be accurate in form, is deficient in color and luminosity—a form which as compared with the work of a real musician gives a curious impression of being constructed of cheap materials. To obtain really grand results the performer must forget all about himself, must lose himself utterly in the music as only a genius may dare to do.

Eastman's New Service Building

That mysterious new building arising at No. 1017 Las Palmas is a mystery no longer. It turns out to be just another manifestion of the purpose of the Eastman Kodak Company to give service where service is required.

This new building of Eastman was built more particuarly to improve the company's service to the motion picture industry in Hollywood and also to the users of 16 millimeter amateur motion pictures in the whole of the Southern California district.

HYPERSENSITIZING

Part of the plant will be used for hypersensitizing panchromatic negative. This consists of treating the raw stock with a bath which very considerably increases the speed of the film. This hypersensitizing equipment is designed primarily to furnish hypersensitized negative for use in commercial color processes, as it is not expected that hypersensitized stock will be used very gen-

erally in ordinary black and white photography.

It can be used very effectively for trick shots with filters, such ·as· night scenes, moonlight, etc., and undoubtedly. a good deal of it will be used for this purpose. Hypersensitized film does not have the keeping qualities of regular panchromatic negative so that it cannot be kept in stock indefinitely. It is with the idea of having fresh hypersensitized stock available in Hollywood at any time that the company decided to erect this plant.

KODACOLOR

Cine Kodak film from Los Angeles and surrounding districts, which has, heretofore, been shipped to San Francisco, will now be processed at this plant, which will be equipped to handle Black and White and Kodacolor.

This will mean that Cine Kodak users can get approximately 24-hour service on their finishing and will undoubtedly fur-

ther stimulate the making of Cine Kodak pictures in Southern California.

THE RECORDAK

It is planned eventually also to have this plant equipped to process film for the RECORDAK, a machine developed by the Recordak Company, a subsidiary of the Eastman Kodak Company, to photograph bank checks. These machines are being extensively used in New York banks at present and it is planned to extend their use to the Pacific coast as soon as possible.

———o———

Winston-Salemn, N. C.—(AFL.)—R. J. Reynolds Tobacco company profits last year totaled $32,210,000, as compared with $29,080,000 the previous year. These profits are built on the enormous sales of "Camel" cigarettes and "Prince Albert" smoking tobacco. Wages paid by this concern are among the lowest in the South. Rates range from $7 to $11 a week, with a maximum of 43 cents an hour. Unionism is not tolerated.

Our Family Tree's New Branch

Written for The International Photographer *by* A. ZUBER, M.D.

Men, races and things are swinging along at giant strides these fast flying days and it is very difficult when one is in the maze of such activity, ever to climb to the heights and take a broad view of this complicated pattern so intricately woven, with its taut warp and long striding woof.

But once on top—let's take a look at the men themselves for the moment—their color, build, physiogomy, etc.

We find them black? Yes a few. Yellow? Yes, far outnumbering the whites; and also white. These three races compose the world at present and have for millions of years. Those who have traveled most, read widest and studied longest are of the opinion that two great races preceded the blacks, but being differently constructed and constituted than we are, have long since vanished from the earth. Little remains and only the wise ones can read its meaning and offer any solution to its complex problems.

We are being informed that the blacks were a different folk some millions of years ago. They had larger bodies, were more ferocious, exhibited a greater degree of cunning and did much fine work with their hands. Intellectually they were nothing to boast of. But nature was kind to them, supplying their simple wants with a lavish hand, so why the need of any awakening ingenuity in wresting a living from her.

The yellow race occupied in its prime, a glorious pinnacle, one representing vast strides in the civilization of that time. Our own country is shedding much direct light at present, on this once great and noble race, in its ever greater unfoldment of marvelous archeological finds. Just picture a moment, the vast, unexplored territory of Central America and what has in our time been brought to light there; the great treasures of Southern Mexico which have as yet simply been discovered and not uncovered.

Cross over to Asia Minor and go down into the archeological mines of Mesopotamia, etc. See an old city unearthed 'neath the floor of the next oldest one until you descend six steps allowing a step for each city as it were, in the long ebb of time. Imagine the thrill of finding oneself five cities below the now shifting sands of what is supposed to be the location of the ancient city of Ur.

Then come back to South America and enter the little known country of Peru, to find there a civilization so marvelous, so different, so pure in its form of Government, so far advanced in its now decadent spiritual life and so rich in splendid tradition (which always rests on some basis of truth) and be convinced that the yellow race was a vastly superior one to what it is today.

It was a race arisen from the finest seed stock which the world could produce at that time and developed, in its prime, a type of body superior in some respects, to our own. It could endure greater hard-

A. Zuber, M. D., is a citizen of Los Angeles, of long residence. For ten years she was a member of the Los Angeles Board of Health and has also occupied important positions in the service of the State of California. Dr. Zuber is also an occult scientist of note and her discussion of the subject herewith treated may be accepted as an ex-cathedra statement. — Editor's Note.

ships because of its less finely constructed and adjusted nervous system; was guided more by its emotions and instincts than by its intellect; seemed from the great stone monuments which it has left to us, example, Stonehenge, the pyramids of Egypt, the temples of Chichen-Itza, etc., to have understood and to have been able to control certain definite forces of nature of which we today are just becoming cognizant.

Just what this race could have accomplished had it gone on to greater heights can scarcely be imagined.

But nature had other plans, and its decay and destruction set in as does dry rot in the finest specimen of sturdy oak, and constantly taking its toll, finally renders the forest monarch a wasted, scarred, leafless and branchless ghost, of which only those reading backward can sense the once perfect grandeur of the King that was.

Again from the finest seed stock which could be gathered, was started the baby fifth race, and since progress is the law of nature, it must rise to greater heights even, than did the fourth or yellow race.

Thus, reading the story of the great streams of humanity which are ever pouring westward, we find ourselves stressing certain qualities which we consider ideal and toward which we all work, forced ever forward by a mighty urge from within to be better, do better, live better, etc. For is not the ideal of the individual a replica of the ideal of the race? Are we not wanting for our children, better things than our own childhood provided?

Because of this, we are trying to develop fine bodies with delicately balanced nervous systems, finer emotions to supplant the grosser, intellects superior to those which have preceded our own, and so on. Are we not being College educated? Is not the search for the white collar job but our response to nature's urge to use our intellects more and our hands less? Is not the rabot the perfect mechanic in many ways? Does not the scientist continually research to lighten the load on our backs and in our hands? Is not the press button the result of some one's using his intellect and does it not perform the work of many hands?

Small wonder then that the remark:

"If I only had the brains"—has been the household expression of this the white man's era.

And so we shall go on developing more and more intellect until some thousands of years hence, we will be many times more brilliant than we are today. Our gradual understanding of nature's laws will have made us masters of invention, mechanical devices, electrical assistants of every sort, etc., etc., till there will seem verily, nothing more to be accomplished.

But nature, ever the master-builder must have finer and better forms through which to express her vast hidden stores of knowledge. And later while we may be apparently all wise, we shall still find that there are many things which we can not know and problems which we can not solve even with such colossal intellects as shall then be possessed by us. They will still be far from fine enough or highly evolved enough to interpret and apply such higher laws of nature as are entirely hidden or at most, barely sensed at present. For example—think of the vast strides necessary to the understanding of electricity, ionization, sound, color, etc. How little we really do know of them.

Again will the dry rot of satiety set in and the undermining and disintegrating of white bodies will start as it ever has in the past. And so too, the white race will go down to oblivion as have and are those which passed their zeniths myriads of years ago. Nature is insatiable and time provides unceasing progress for her activities. We are but the "puppets" in her vast drama.

It requires no great stretch of vision to be assured that another and better race must arise to take the place of the declining ones, for not all the lessons of the human family are yet learned, nor is perfection a fact. And until it is, we must go on and on, striving toward that ideal which is indelibly impressed on each human consciousness and toward which humanity is ever urged with an impelling force which it cannot thwart.

The beginnings of this new race which must carry on are not difficult to find even now, if one but has the eyes to see and the ears to hear. Southern California is the center of uncounted innovations, the impetus of great strides in many things, the leaven for all manner of new ideas, the nucleus as it were, of a vast vortex of progress toward which the entire world is looking. It is unique in ways too numerous to mention. Small wonder then, that it should not play a great part in the formation of this new race. It is the nest, so to speak, wherein is nurtured an entirely different type of child than is found elsewhere, except possibly in some parts of Australia.

Every teacher realizes this; parents sense it, some vaguely and others to the extent of remarking it. Physicians are

exceedingly interested in our annual crop of ever more perfect child life; all those engaged in the study of humanity from its sociological and civic angles are coming west to know these fledglings at first hand.

The children are being weighed, measured, intellects tested, attention, discrimination, etc., charted, and in all ways are they found by actual count to be above the averages of other states in the Union and other countries in the world. To be sure, this is not true of *all* our children, but there is a group emerging from this great mass of detailed survey which bears a certain peculiar stamp of progress all its own.

It has become very noticeable in the school system of Southern California that these particular children are far in advance of their classes. There is no restraining them. They want to know the "why" of everything and have little patience with our wheezy explanations. They seem to sense our lack of knowledge on many things and even while we are in the very act of explaining, their sharp little eyes are probing our very depths to determine just how much we really do know.

They have such minds as arrive at conclusions intuitively. They shun the more round-about and cumbersome methods of present day teaching by appealing to the intellect. Their lightning like methods of arriving at results are available only to those who are intuitive and they see the point of a problem or conversation at first glance. Apropos of this one youngster, whose teacher had very carefully explained some problem which she thought intricate enough to be noted step by step, simply replied, when she had finished: "Why do you talk so much? We already understand it." And another: "Never mind the explanation. Let me work it out by myself."

The constant restlessness of these children during a discussion, explanation or the giving of minute instructions as to methods of procedure in any given subject, is so evident that those most interested in these little folks, have about given up such methods, and tossing their problems to their pupils without a word of assistance, are more and more inclined to let them go their ways with the work at hand. The youngsters' answers are frequently ready before the problem is fairly launched.

Needless to say, these particular children are causing endless trouble because they are misfits wherever they go. So much so in fact, that at this very moment a school is being launched by the Los Angeles City School System at Laguna Beach to give them their rope and let them progress as rapidly as they care to. A few years hence, this school will have marvelous tales to tell and some far superior if not giant intellects to turn into America's fields of business, art, and so forth.

These little fellows are most ingenious in the use of their toys as well as with their school work. They much prefer to make their playthings. Give a boy a wood-pile, some tools, a pound of nails, some wire, pipe, etc., and see him work. The seven-year-old tow-head whose picture accompanies this article has the unparalleled assets of an oil drilling company's junk heap. The train is evidence of his ability and the smile, the satisfaction of his accomplishment unhindered by the do's and don'ts of grown-ups. His discipline problem simply does not exist for the very reason that he has understanding parents and is too busy fashioning with raw materials by the pen, brush, hammer, shovel or what not to have a minute for useless horse play or time killing of any sort. Cut deleted; damaged in transit.

The new race children are also very versatile, being able to do so many more things than we could ever imagine accomplishing when we were their ages. They possess knowledge of many things; know what self-government means; are courteous by nature; understand much of the sciences; use the language remarkably well; can and do frequently offer sage remarks in adult conversation. They are lovable, loyal, gentle and keen to be doing. No laggards, they seem to feel intuitively that they have much to accomplish in this busy world.

They are usually rather spare, straight limbed but muscular, taller than normal, possess keen well-placed eyes and rather prominent cheek bones. They are to be found in all sorts of families, living in all manner of surroundings, but pushing forward with wills to succeed, all their own. Nothing is too difficult for them to undertake, not even the re-education of their parents.

One little fellow just slipping into his sixth year, informed us, that given paper and scissors, he could cut out anything. We suggested a flower-pot. And with the courage born solely of absolute assurance of his ability, he folded the paper lengthwise and proceeded to cut that very thing even to the flowers growing out of its upper curve, before our astonished eyes. No doubt he will be cutting coupons before any of us are much older, for already are his parents receiving exceptional reports from his teachers.

And so they continue to pass before our awakened vision, their methods of accomplishing whatever they aspire or are are to do, bringing with them a freshness and uniqueness not to be found in the rank and file of childhood.

Be on the lookout for them for, once having found such a child, you will be so intrigued by his "difference" that it will bring you endless joy to watch him at his work or play or what-not.

He is the Seed, the focus of forces moulding the new race, the fore-runner, the pioneer. And because of these very facts, his way will not be easy; his path will not be smooth; he will be misunderstood by the world in general. And only those understanding few, who appreciate the vast responsibilities placed upon him, will be able to bring him the occasional ray of light, the kindly word, the love and thoughtfulness which should accompany him on his pathless and untried journey into the uncharted future.

Jimmy Whelan is working in Old Mexico.

DeVRY INDUSTRIAL CINETONE

The Q R S-DeVry Corporation of Chicago has just released an announcement of their new 16 mm. Cinetone talking picture equipment which is an innovation in its forceful effectiveness as an aid to sales, advertising and publicity.

The Cinetone is one combined unit, comprising a 16 mm. projector and 16-inch 33⅓ R.P.M. phonograph record turn-table. Synchronous motor operates both projector and turn-table simultaneously. There is no chance for imperfect synchronization. Both projector and turn-table cannot operate except at a fixed speed.

Instead of several units to assemble, the Cinetone is one integral unit. The amplifier is of the latest design, employing only one No. 224 screen grid tube, one 250 amplifier tube and one 281 rectifier tube. As in the case of radio amplifiers, when used on D.C. a converter is necessary.

Brilliant illumination, to meet all 16 mm. requirements, is accomplished through the use of a 20-volt 250 watt prefcus projector lamp 110 A.C. The Cinetone has a self-contained transformer which converts 110 A.C. to 20-volt.

Absolute control of volume to meet all requirements of room size or acoustics is provided for by a volume control at the base of the cinetone, thereby making possible the fade out or swell out of sound from a whisper to such volume as is suitable for large gatherings.

The lens used is the new powerful "Big Bertha" Graf 2-inch Anastigmat. This in conjunction with the New DeVry condenser, makes the most perfect optical system ever employed in DeVry projectors. So powerful is the light that at a 50' throw, a brilliant illumination over an area of more than 8' on the screen is clearly projected.

A HANDY TRIPOD

Camera tripod designed and used by Karl Struss, of the United Artists Studio Staff. Mr. Struss has used this tripod to advantage in all his recent productions. The simple mechanics and the ease of adjustment of the tripod are its claims to efficiency.

Amenities on Location

SPECIAL
Souvenir Art Edition
of
The International Photographer
for June, 1930

**in honor of the Bi-ennial Convention
of the
I. A. T. S. E.
and M. P. M. O. to be held in
Los Angeles the week
beginning June 2.**

¶ This book, the Official Souvenir of the Convention, will be widely distributed at home and abroad and among many other interesting features will contain an art insert in colors. It will be the finest thing in the way of a magazine ever issued within the motion picture industry.

¶ Advertising space may be reserved by communicating with the editor care The INTERNATIONAL PHOTOGRAPHER.

How Wide is Wide Film?

J. O. Taylor, Local 659, International Photographers of the Motion Picture Industries, is the genius who, to date, has photographed all of the Fox-Grandeur pictures—"The Fox Follies," "Happy Days," now playing at the Carthay Circle Theatre, Hollywood, and John McCormack's first picture.

Mr. Taylor has been in charge of Grandeur cinematography since its beginning

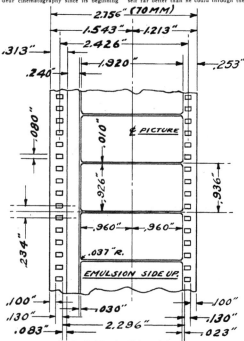

Detail of Grandeur Film, actual size.

a year and a half ago and he knows more about Grandeur than any other man in the industry.

His opinion, therefore, may be considered as competent and he does not hesitate to give his 100 per cent O. K. to the Fox wide film.

According to Mr. Taylor wide film (and he champions the 70 mm. width),

like sound, has come to stay and is but a step in the logical evolution of motion photography. The glories still ahead he is sure will be realized in the not distant fture and, beautiful as Grandeur is, he feels sure there are yet many chapters to be written of its improvement.

Mr. Taylor feels that the wide film enables the photographer to express himself far better than he could through the

medium of the 35 mm. film and, when the photographer has a free hand, the results are bound to approximate cinematographic perfection.

According to Mr. Taylor, Grandeur brings the beauty back to the films while it lends added facility to production in nearly every department.

For an understanding of the optical

problems accompanying the introduction of wide films Mr. Taylor cites the reader to an excerpt of the paper on that subject read by Mr. W. B. Rayton, of the Scientific Bureau of the Bausch & Lomb Optical Company, read before the fall meeting of the S. M. P. E., 1929, herewith. Said Mr. Rayton:

The employment of film wider than the standard 35mm seems imminent in the immediate future. No one can say whether we will have to deal with one size or several but, however that question may be settled the difficulties encountered in designing adequate optical systems are of the same kind in all cases but differ in degree with the variations in width of film and size of projected image.

One of the reasons that is impelling the industry to adopt a wider film is the loss of area on the film formerly available for pictures, which is now given over to sound track. The addition of speech and music is also leading to a demand for a larger picture on the screen commensurate with the necessary volume of sound. The present screen is not only too small but the action lacks scope due to the necessity of crowding the action into a small space in order to obtain figures of sufficient size.

To meet the situation it is necessary to project a picture in which the figures remain of a sufficiently large size but which include more of them. This means,

DETAIL OF SPROCKET PERFORATION.

obviously, a wider included angular field of view and a larger projected picture.

To accomplish this two methods of attack occur at once. One is to alter the aperture now in use by reducing the height and to magnify the image in projection to the necessary size by the use of projection lenses of shorter focal lengths. The other method is to increase the size of the picture on the screen by increasing the area of the picture on the film thus making it unnecessary to increase the magnification in projection.

The first method is impractical because the resolving power of photographic emulsions of adequate speed is insufficient to permit a satisfactory screen image to be obtained by such a process. Graininess would be very pronounced

(Concluded on Page 38)

The Aladdin's Lamp

Ira B. Hoke
now with
Technicolor

M. HALL

Assistant Cameraman

GLadstone 4203 HEmpstead 1128

B. B. Ray, Freelancing

Second Cameraman
with 2 New Mitchell Sound
Cameras Complete

1000 FT. MAGAZINES - ADAPTERS

WH-4062 or HE-1128
WILL RENT WHILE AT LIBERTY

FOR SALE

Complete Mitchell sound
equipment

Cable and Clutch

Phone HE-6230

John Silver

James E. Woodbury

Portrait and Commercial
Photographer

GRanite 3333 5356 Melrose Ave.
Los Angeles, Calif.

Tom Galligan

Second Cameraman

St. Francis Hotel Hollywood

HO-9111 HE-1128

WITH COMPLIMENTS

Earl (Curly) Metz

Assistant Cameraman

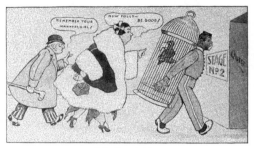

Polly, the meal ticket,

Frederick Kaifer

HE-1128 HO-7101

For Sale Cheap

Bell & Howell Camera, Mitchell
Tripod Legs—40, 50, 75 m.m. Astro
2.3 Lens.
Akeley Camera—35, 50, 75, 100—
6 inch, 12 inch lens—Mitchell Tri-
pod Legs. Also B. & H. Eymo.

WM. H. TUERS

WANTED—EARLY FILMS OF AVIA-
TION FLIGHTS AND EVENTS; nega-
tive or positive; any lengths over 30
feet. The older, the better, such as: first
air meets. Beachey, Curtiss, Hoxey, old
war planes, record flights prior to 1925.
Pay cash. For private use. What have
you? Phone or write ZENO, 143 North
Broadway, Los Angeles, MUtual 4174.

Warner Crosby

For Rent

Mitchell with Speed Movement
complete. Five matched and cali-
brated lenses.

4, 3, 2, 40 and 35 Pan Tachar
2—1000 ft. and 4 400-ft. magazines
1—Gear box and shaft
1—Baby tripod and high hat

Glenn R. Kershner
Culver City 3154

Rent or Sale

3 New Mitchell Sound Cameras,
Friction Heads, Motor Adapters

1000 ft. Magazines, Baby Tripod,
5 in. Astro 2.3 Lense

Also Bell & Howell complete with
5 in. Astro Lens

B. B. RAY
Second Cameraman
401 North Orange Grove Ave.
WH-4062 Hollywood, Calif.

RIES BROS., INC.
PHOTO SUPPLIES

1152 N. Western GRanite 1185

MELROSE
Trunk Factory

UNION MADE Camera
Cases for
UNION CAMERAMEN

UNION MADE Camera Number
Boards

Trunk and Luggage Repairing
Our Specialty

Automobile Trunks, Sample and
Make-up Cases to Order

GLadstone 1872 646 N. Western
LOS ANGELES, CALIF.

of the Movies—No. 6 *By John Corydon Hill*

does her stuff.

HOW WIDE IS WIDE FILM?
(Continued from Page 35)

and detail would be lost. The second method is the logical point of attack. The film manufacturer need feel no embarrassment insofar as his emulsions are concerned but the lens designer of course is left with many problems to face before success can be achieved.

The first requirement is that of designing photographic lenses having a larger field of view than is now required. The following table presents the values of the angular fields of view demanded by three different picture areas for lenses within these limits and shows what is required in the way of added covering power.

TABLE OF ANGULAR FIELD OF VIEWS

Picture Area

Focal Lgth. of lens	19mm. x 25mm.	18mm. x 36mm.	23mm. x 46mm.
40 mm	42° 52′	53° 24′	65° 28′
50 mm	34° 52′	43° 50′	54° 28′
75 mm	23° 38′	30° 02′	37° 50′
100 mm	17° 50′	22° 46′	28° 50′

There has been some progress made already. I am happy to announce that I have been able to design a 50mm lens of relative aperture of v/2.3 which covers the 23mmx46mm area very satisfactorily.

To cover the field with lenses of longer length is a task of less difficulty, but here one must guard against a deterioration of general definition due to residual aberrations which become the more noticeable the longer the focal length.

After the pictures have been taken the problem of illumination in projection has to be met. It is obvious that if the same amount of light which passes through the aperture of the film gate in an ordinary projector be spread over a screen area twice as large the illumination of the screen image will be only half as great. One obvious means of increasing the illumination is to increase the diameter of the condensers to obtain a greater angle of convergence. We found it possible to obtain a marked increase in angle with condensers of 6″ diameter with aspheric surfaces, of course. A substantial increase in illumination resulted. Some additional illumination, however, is possible by using an astigmatic condenser, one whose focal length in one meridian is shorter than its focal length in the other principal meridian. A preliminary investigation subject to possible correction indicates a gain of something like 25 per cent obtainable in this manner.

If, now, the arc be run at something like 150 amperes with condensers as described above, a satisfactory illumination will be found possible. It still remains a question as to just what degree of illumination will be required. It is possible that the relatively enormous picture on the screen may prove more satisfactory at a level of brightness lower than we have been accustomed to in the smaller picture. Certainly, a projected picture of, say 23x46 feet illuminated as brightly as some of the news reels we see might be expected to raise the general illumination of the theater to an undesirable level.

For the projection of the pictures ordinary projection lenses are entirely out of question except in the longest focal lengths because of objectionable curvatures of field. It happened that I had been working on an improved form of lens for the shorter focal lengths for the projection of ordinary film when the demand came for lenses to project the large pictures. The design had progressed to the point where it was possible to offer lenses of 4″ equivalent focal length and of a speed of F/2.2 which projected a picture 23x46mm with complete satisfaction. Since then it has been found entirely possible with lenses of 3″ focal length. These lenses are, of course, anastigmats.

For the benefit of those who may have seen the demonstrations, I might say that both the Grandeur Film show at the Gaiety Theater in New York and the earlier demonstration by Paramount Famous Lasky were for the most part accomplished with the aid of the optical developments described above.

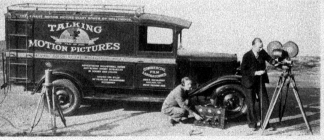

Chicago — Six-Sixty-Six — Chicago

SOUP'S ON!

Brother Ray and Brother Bell both of 666, with permanent address in Minneapolis and St. Paul, Minn., were seen in Milwaukee, Wis. The meeting was in a restaurant and of course you know what happens when 'crank-twisters' meet—it's all about sound, talkies, color, this and that what have you. The usual line was on when a waitress became very impatient about Brother Ray not finishing his soup. She approached him and very boldly said: "Pardon me, are you all caught up with your soup." That ended the meeting and Brother Bell paid for the dinners and a good laugh.

SIX-SIXTY-SIX

CRIMINALS, EH?

Fred Geise of Camion Crew No. 202, of Pathe Sound News force operating out of

TONY CAPUTO

Chicago, looks like a sheriff when he wears that iron hat. And Tony Caputo, of the same crew, looks like the picture herewith when he is dressed for an Italian wedding and otherwise. The other day Geise and the camera crew boarded a train down in Indiana to return to Chicago. Giese held the tickets for the crew. They took secluded seats in the smoking compartment.

Motion Picture Industries Local 666,
I. A. T. S. E. and M. P. M. O., of the
United States and Canada

By HARRY BIRCH

President
CHARLES N. DAVID...................Chicago

Vice-Presidents
OSCAR AHBE.......................Chicago
CHARLES E. BELL.................St. Paul
F. L. MAGUIRE...................St. Louis
W. W. REID...................Kansas City
RALPH BIDDY..................Indianapolis
J. T. FLANAGAN................Cleveland
TRACY MATHEWSON................Atlanta
GUY H. ALLBRIGHT................Dallas
RALPH LEMBECK.................Cincinnati

Treasurer
WILLIAM AHBE....................Chicago

Secretary
EUGENE J. COUR..................Chicago

Offices
12 East Ninth Street, Chicago

BULLETIN — The regular meetings of Local 666 are held the first Monday in each month.

Caputo was in a black sweater and ragged pants while Ralph Saunders, recordist and sound engineer, covered his General Electric education with a two day beard and some machine grease off the camion.

The conductor took the tickets from Geise and regarded his companions with a slanting eye.

"Criminals, eh?" he remarked to Geise. Geise's reply to the conductor is still unknown, but it has been learned that Caputo's right eye is on Geise at all times and is waiting for a comeback—watch your step Fred.

WHAT NEXT

Several weeks ago Judge Landis said: A man cannot hold down two professions at one time." Well Mr. Landis, it's being done every day and here is the proof in one case—Brother Jack Barnett claims the welterweight championship of Local 666 and also has proven himself a worthy Akeley man with the International News Reel. Brother Barnett challenges all members of 666 and in fact, all I. A. T. S. E. and M. P. M. O. camerman who will qualify in the welterweight class. Any brother wishing to take up Brother Barnett can reach him thru Local 666, Chicago. The low-down on Barnett is as follows: He is 24 years old, born in Chicago, has been active for the past eight years in both boxing and camera work and will welcome a challenge anywhere in the United States. Go to it; here's a chance for some one to 'give and take' with Barnett, and HOW.

(Note: Photo of Brother Barnett in action on both jobs.)

SIX-SIXTY-SIX

HIP, HIP THEY'RE COMING IN

I thought when we threatened to take their names from our mailing list that some of the boys would 'break-out' with some scandal from the various locals away from the Windy City. Here they are. Headed from Indianapolis, Ind., comes the following under the title of "Mysterious Writings' unsigned:

"I heard somebody ask Brother Neville the other day if he was going to 'shoot' the Auto Race this year.

"Why sure I am, I have a great place to shoot from this time; I'm going to get

(Concluded on Page 41)

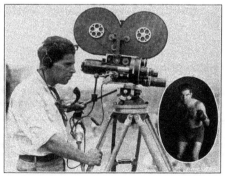

Jack Barnett, champion of the cameramen in the welterweight class.

 # Cream o' th' Stills

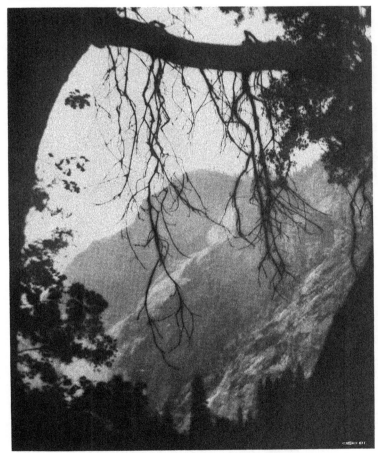

Henry Freulich captured one of the elusive beauties of the Yosemite Valley when he snapped this view—the famous El Capitan which is usually photographed from the floor of the Valley on the sheer side. Mr. Freulich is another International Photographer who knows how to co-operate with Mother Nature.

Cream o' th' Stills

J. M. F. Haase, chief photographer of the U. S. Navy, of whom Local 659 is pardonably proud, was up in the air in a navy amphibian 14,000 feet when he snapped this wonderful Alaskan vista. The picture shows the terrian looking across from Mt. Barnard, Alaska to Mt. Fairweather, showing Margie Glacier on left, Ferris Glacier to right and face of Grand Pacific Glacier. Photo was made for the boundary commission and shows the recession of the latter glacier to give Canada a port of entry.

This charming little bit of hill country, the cabin and its sheltering live-oak, was resolved into a picture by the camera of Mr. David Ferrell. The rock and stick chimney is a delightful feature, and moreover it is real and not a part of a moving picture set.

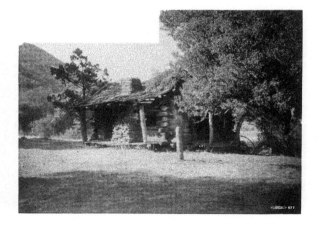

 # Cream o' th' Stills

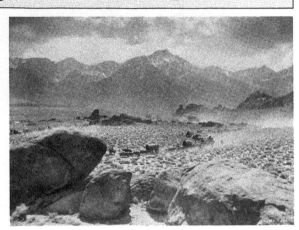

Mr. Mack Julian is given deserved credit for this unusual and beautiful still, reminiscent of those good old "covered-wagon" days. The locale is near Lone Pine, California, and the still was made during the filming of "Song of the West," a First National production. Not often in these days do we see such a shot.

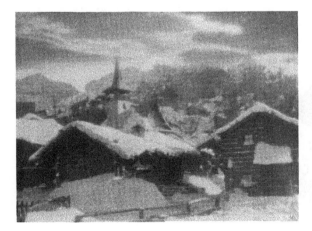

This beautiful winter scene is from the camera of Elmer G. Dyer, who comes down out of the air occasionally to train his lenses on things beautiful and out of the ordinary. Here he is intrigued with a miniature from a recent release starring John Barrymore.

 # Cream o' th' Stills

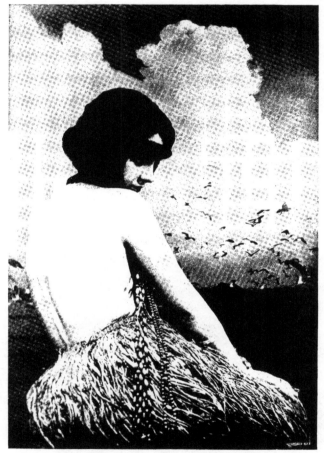

A study from the facile box of Frederic Colburn Clarke, is this combination of sea birds and native Hawaiian beauty. Mr. Clarke is notably clever at this kind of work, an outgrowth of his experience with camera and pen; for before coming into the cinema, he was widely known in the east and in England as a cartoonist and illustrator.

all my shots from off the top of the Soldiers and Sailors monument—(which is about 8 miles away). "Getting crashed by a race car last year doing over a 100 per didn't seem to slow him up at all; the truth about the matter is he is doing a little speeding himself. He is making some of the boys with big cars think they have 'slow motion' by taking them out and walking right away from them in his new DeSoto Deluxe Straight Eight." P. S. Some one tell Brother Ford about this. Don't let them kid you, Charley, we all know that you have a good car too.

SIX-SIXTY-SIX

Brother Ralph Lembeck, of Cincinnati, evidently wants to stay on the mailing list of The International Photographer so here he comes with:

THE TRIPOD OUT IN THE STICKS

Dropped into Columbus, O., the other day and found Lafe Wareham cleaning up his outfit. Lafe must have a hunch that a railroad wreck or fire is about due.

Dropped over the same day and found Bob Greer and George Haliday in deep thought. Better watch the Columbus wires, maybe they are in with Lafe to pull the wreck. Well if it does come off you can bet Pathe will be well represented with these three.

Over at Springfield, Harold German is running up a phone bill a yard long hunting for a printer.

Bill Mayfield and Harry Eldridge, at Dayton, are still working on the "Four Horsemen." That pair is always dealing

in something with horses attached to it. Maybe they put over a couple of those long shots I gave them at Latonia last week. May I explain the "Four Horsemen" is the local community chest picture —a three reeler.

Here at Cincinnati, Eddy Momberg is busy taking care of news and on Sundays playing professional football. All the strong arm boys on the sound trucks should be in great shape for a football team.

Ren Anderson is doing some sales work on a patent he has just received on an animated sign. Best of luck to you Anderson.

Pete Sebastiani is still looking after Pathe interests in Cincinnati and is sure a busy little boy.

As for myself, I will say that I am trying to give Local 666 something they want and to let the world know what our boys are doing. Let me know if you want this report monthly. Signed

'THE STICKS SHERIFF'
Ralph Lembeck

(Editor's Note: You sure will stay on the mailing list, Brother Lembeck, that's the kind of stuff we want. Shoot it along, the more the merrier.)

SIX-SIXTY-SIX

ON THE 'WABASH"

Speaking of Brother David, it has been learned that Charles is disposing, selling, trading or otherwise nine lots in a Chicago cemetery to early buyers. He claims that he bought them not knowing why

and is now willing to take a little profit on the sales. Leave it to Brother David to discover a business deal.

Brother Edward Traeger has real United States money that he is willing to trade for a second hand automobile. Here's a chance for some member that might have something for sale. (Cord Cars Barred).

Brother Norman Alley has been made General Representative of the Middle West territory for the Hearst-Fox Newsreels, which means Hearst Metrotone and Fox Movietone.

SIX-SIXTY-SIX

PHOTOS WANTED

I think that every one of us have admired the photographs that appear in The International Photographer. Now let us break out with some of those photos that we have made—send them in and let us look them over; that also goes for all you "out-of-towners," if they are good enough—and we know that there are some good ones around that our members have made. The International Photographer will use them and also give you a credit line, so let's go. Let's show the other Locals that we also have some great scenic values east of the Rockies. Photos will be returned to you after used.

CONSTRUCTIONISTS SUBSCRIBE

Don Jahraus, foreman of the R. K. O. property construction department, boasts a crew of technicians almost 100 per cent subscribers to The International Photographer.

Hoke-um

By IRA

Pertinent?

Sonny Broening: "Tell me about St. Patrick, Daddy."

Lyman Broening: "Well, once upon a time there were snakes in Ireland—"

Sonny: "Did they come in bottles, Dad?"

— :: —

Not Acquainted

Mervyn Freeman: "Been on a news-reel assignment in New Orleans, eh? Did you visit the levees?"

But Hooper: "I don't even know them. I stopped at the Cohens' "

— :: —

Why Art!

Wes Anderson: "What do you think of bathing girls?"

Art Reed: "I don't know. I never bathed one."

— :: —

Linguistic

Speed Mitchell: "I certainly ought to be assigned to that company going to Seattle on location."

Bob Bronner: "Why so, Speed?"

Speed: Because, in case they need an interpreter I sure speak good Oregon."

Haven't We All?

Al Alborn: (lining up talent for big Siberian picture, spots actor in ordinary street clothes): "Hey you, over there, didn't I say to show up today dressed for a Russian scene?"

Extra Man: "I am, Mr. Alborn, I got on two suits of heavy underwear and they're itching something fierce."

— :: —

Uplift

A lot of the uplift in this business is confirmed to noses.

— :: —

Speed Note

Cameraman (After waiting 10 minutes for the vamp to powder her make-up): "Sister, have you ever been to the zoo?"

Vamp: "Of course not, silly."

Cameraman: "Well, you ought to go. You'd enjoy watching the turtles whiz past you."

— :: —

Right

The height of efficiency: Rolling in a booth for the still-cameraman.

Yeah

Charles Schoenbaum (Upon finding inter-office communcation on bulletin board): "Um-m. More pan mail."

— :: —

Must Be!

Henry Kruse of Technicolor, says his wife is the world's champion optimist. After 10 years in the movie business, she still makes dinner engagements.

— :: —

Careful Ralph

Ralph Ash: "Darling, in the moonlight, your teeth are like pearls."

Bettie Mae: "Oh, indeed! And when were you in the moonlight with Pearl?"

— :: —

Cheated

Al Gilks says he joined the Navy to see the world, and then spent four years in a submarine.

— :: —

Vogelsang

Cutter Girl: "A little bird told me you were going to propose to me tonight,"

Cameraman: "That bird was a little cuckoo."

SHADOWS OF SOUNDS

Some time ago the Associated Press carried this special telegram from New York City: Pictures of spoken words were shown to the New York Electrical Society tonight and discussed as a new kind of possibility for enabling the deaf to hear conversation.

These speech pictures were thrown on a canvas screen, where they literally talked, by turning themselves back into speech. The pictures were the sound track of a motion-picture film, magnified with a stereopticon until the row of jagged shadows which represents spoken sounds was as large as a line of icicles. As this row moved across the canvas the alternating lights and shadows penetrated a slit in the cloth and fell upon a mirror, thence they reflected to a photoelectric cell and were turned into words.

As the speech translation was instantaneous, the audience could see the shape of shadows that made the sounds. In reading the shadows, said the demonstrator of the picture, John Bellamy Taylor of the General Electric Company, lies a possibility of relief for the deaf. He warned, however, that there is no early likelihood of this relief.

Tonight, for example, when he wished to show the shape of speech, he had to stop the picture, turning it into a silent still. Even so, only the simplest vowel sounds could be exhibited. Nevertheless Mr. Taylor said it is conceivable that methods can be devised of turning the moving shadows into a series of stills which the eye can see while speech goes on. Ordinarily the shadows move so fast

that thye are a blue. He said that although he knows of no one now able to read the words in these sound tracks, the key to shadow translation may yet be discovered.

Mr. Taylor made the talking canvas do astonishing tricks. By changing the speed of the shadows the speaker's voice became that of a seemingly different person. A sentence spoken by a man ranged all the way from a startling imitation of a pig's grunt up through intelligible speech in higher and higher key as the speed increased, until it became an unintelligible high-toned warble. But the man's voice never became feminine. Women's voices, said Mr. Taylor, undergo similar changes.

Then the screen spoke the words backward, and demonstrated that reversing the order of spelling does not reproduce the sound backward. The name Taylor when reversed sounds as if spelled orlate. This is because the voice pronounces whole sound instead of letters.

"Eetay eye sauce le keert kelly kawye oon," said Mr. Taylor. He put the picture of this sound on the canvas, reversed the direction, and the canvas said: "New York Electric Society," that was what Mr. Taylor had said backward.

Aint It?

Hughie Roman (to Eddie Horton, who has just blown in at 8:30 on an 8:00 call): "I don't think you're late, I hope."

GRANDEUR

All Fox-Grandeur productions to date have been photographed by J. O. Taylor, member of the Executive Board of Local 659.

Mr. Taylor began work on Grandeur one and one-half years ago with the first Grandeur camera and has had full charge of the wide film photography through the filming of "The Fox Follies," "Happy Days" and the latest Grandeur picture starring John McCormack.

Mr. Taylor is the past-master of Grandeur and wide film camera work in general and the pioneer in this new excursion into film wider than 35 mm. In his opinion wide film pctures have come to stay.

"Mike"

BY
JOHN LEEZER

"Ach du lieber Augustine! Augustine! Augustine!
Ach du lieber Augustine! Alles ist hin!"

MIKE R. O'FONE

T' sounded like the drinking scene from the "Student Prince," but it was only our latest imported European director, Herr Goofenhauser, broadcasting for the benefit of the girls who were hanging around drinking in the melody — even though it was but two per cent.

"Mr. Goofenhauser, you should have been in Grand Opera" chirped a blonde wig.

"Sing it again, won't you Mr. Goofenhauser."

"How lovely, Mr. Goofenhauser, I didn't know you went in for voice."

"Caruso never sang like that," and so on and so on.

Herr Goofenhauser absorbed the "yes" stuff like a sponge and yelled louder than ever.

"Let's get that on a sound track," suggested Nolan, one of my chauffeurs.

"How ya gonna do it an' him not get wise to it," Malloy a boomman, wanted to know.

"Leave it to me Kid," says Nolan and he grabs me and wraps me up in a bunch of flowers and gives me to a little skinny peroxide blonde.

"Now Flossie," says Nolan, "as soon as I connect this up, you meander over there and let Mike listen to him warble, but be sure and hide the cord."

"Oh gee," lisped Flossie, "this is gonna be good."

I have worked a long time for old General Electric and I have often heard him say that if it wasn't for me, he would be sunk. Therefore, I have a right to consider myself pretty good. I also admit that I am tempermental, but that is because I am so sensitive. When that dizzy blonde squeezed me up against her grease paint, I got sore pronto. If there is anything that unties my angora quicker than something else, it's hanging around a lot of near nude women, but as usual I said nothing.

The director thought that Flossie was bringing him a floral offering and reached for the boquet. If Nolan hadn't grabbed the flowers in time, Adolph would have

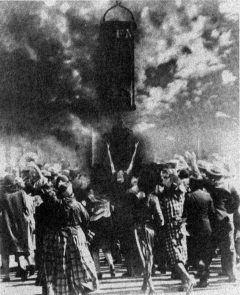

Still by Buddy Longworth

THE GREAT GOD MICROPHONE

discovered me, but the orchestra struck up then and Herr Goofenhauser got busy on the first scene. In about an hour he said: "O kay, we will take him!"

After we took "him" Adolph called for a play-back, and "Ach du lieber Augustine!" came off the wax in all its gorgeous splendor. But the voice of Max Goldberger arises in angry accents: 'Shop id, shtop id," he yells, and shake his fists at the monitor-room. When all is quiet he turns to the director: "Meester Goofenhauser, do you dink I puy filum for you to mek monkey business? Phy dit you allow such a terrible singink? We want only goot singink. Discharge der loafer right avay!" Herr Goofenhauser's face and bald-spot were very red as he promised to carry out Max's instruction and there was blood in his eye, too.

The cameras were then moved in for close-ups of the principals. The leading lady first; another blonde but it wasn't her own hair. The director stopped her in mid-air. Then politely inquired if she would prefer to wait until another time: "You don't been in so good voice today, yes?"

"Why I don't understand, Mr. Goofenhauser," cried the fair haired one. "But then it is possible that you are confusing the sound of the ordinary voice with my microphone voice. My voice can be judged only in the theatre. In other words I possess a Mike Personality. Everyone says I do at any rate and I regret exceedingly that it is not likewise apparent to you. But do not mistake me. I have no regrets for myself. It is of you and your future, that I am thinking. You have just come over but you are not over yet. Failure to discern this rare gift, as it is exemplified in me, is bound to retard if not wholly unfit you for fur-

ther usefulness as a director of animated pictures."

She was interrupted at this juncture by a confused jumble of spluttering and gasping noises. Adolph was trying to say something. Finally he got in "sink."

"Ach Gott! Vas iss das 'Mike Personalities'? You mean to toldt me mine tear yong lady, dot you gott dose—dose—Himmel! vas iss——!"

"Allow me to explain, my dear Mr. Goofenhauser," broke in the Mike Personality! "I have been laboring under a most unfortunate misapprehension. It had not occurred to me that you were ignorant of the meaning of the term, Mike Personality. Permit me to elucidate. A Mike Personality is the personality which allows itself to be the most readily disseminated by means of the vibrations which the recording apparatus records. All other personalities lack this freedom in passing from one vibration to another and consequently, gum up the works. Hence the personality for which your recording instruments yearn is my personality. I trust that—but what has happened," she cried.

I heard a sound like the over-turning of an overstuffed couch and then running feet. "Let's get him outside," said a voice which I recognized as Red Sullivan's, the assistant director.

"Easy now," cautioned Red. "He ain't no blimp ya know. An' somebody get 'im a bottle beer."

Sullivan returned shortly and dismissed

Our Brother Herford Tynes Cowling, of the Teaching Films Department of the Eastman Kodak Company, has but recently been honored with a commission as captain in the U. S. A. Reserve Corps and just the other day he was assigned to the General Staff of the Chief Signal Officer in the Signal Corps for Industrial Mobilization The International Photographer congratulates both Captain Cowling and the Corps.

HEREFORD T. COWLING

INDUSTRIAL SOUND-ON-FILM BIGGER

After ten years of successful business in the industrial field in Northern California, The Commercial Film Laboratories of 3664 Broadway, Oakland, have entered a new field with the acquisition of the first Fearless Dramaphone Portable Sound Recorder designed by Mr. Ralph Fear, of the Fearless Camera Co.

In announcing this equipment they will enter a new era and make available sound-on-film for industrial, advertising and scenic subjects with and independently owned and controlled outfit. The equipment will be stationed in Oakland but will be sent anywhere on a rental basis.

The sound recording equipment has been installed in an attractive truck and every necessity for portable recording is included. The camera is a Bell & Howell and is completely rebuilt and silenced, equipped with Fearless speed movement, silent motor drive and 1000 foot magazines. All of the camera work, as well as the rest of the equipment, was done by the Fearless Camera Co. of Hollywood, and Ralph Fear's experience in this work guarantees that it is of the best.

The amplifier is placed directly in back of the front seat and the operator can monitor from the driver's compartment. Although all of the equipment can be operated over 100 feet from the truck without moving batteries; the entire outfit is portable and can be removed from the truck and carried in cases to any point desired.

A condenser microphone is used and was selected after a thorough and comprehensive search for the best in this type of apparatus.

The Commercial Film Laboratories have been operating a complete laboratory in the past, but with this new equipment they have installed a sound printer

the cast until ten o'clock the following morning. The verbal harrage laid down by the lady with the "Mike Personality" had been too much for poor old Goofenhauser. But how did that dizzy blonde get that way? A "Mike Personality" me eye! If anybody has one of them things, it's me. I've always had it. I'm "Mike" himself—in person.

as well as sound reproducer and picture reviewer for cutting. Their projection room is now also equipped for sound making. The plant is the most modern of its kind in Northern California. An automatic developing machine will be installed soon.

A complete stock of incandescent lights, spots, rifles, floods, overheads, strips and side lamps are available at this plant as well as a small sound proof stage. A motor generator plant, four 24-inch searchlights, a rotary, spots and side arcs, form, in addition the balance of the finest lighting equipment that can be obtained in this territory.

With their past experience in the advertising field as a background and the fact that they can place this type of picture in 200 theatres, many of which they hold exclusive rights for, the Commercial Film Laboratories are in a position to offer an added service to the user of industrial films.

Seventy-five per cent of the theatrical trailers made in Northern California are made here and such circuits as Fox West Coast, Publix, R. K. O., T & D Jr, and Golden State have long been satisfied users of this type of work. Of course, trailers will now be made in sound.

Besides shooting in sound, they offer color for pictures or titles and will put in sound effects or synchronize a silent picture.

A cordial invitation is extended to anyone interested to call and inspect the plant and equipment. Producers or cameramen may make this their headquarters when in the North.

R. E. Farnham, engineer of the General Electric Company, Nela Park, Cleveland, has returned home after several weeks work among the Hollywood studios in the interest of incandescent lighting. Mr. Farnham is a specialist in Mazda light construction and it is his big job to "shoot" the trouble when and if any arises during production.

R. E. FARNHAM

The Sound Track

OFFICERS

International Photographers of the Motion Picture Industries, Local 659

ALVIN WYCKOFF....................President
JACKSON B. ROSE............*1st Vice President*
H. LYMAN BROENING.......*2d Vice President*
IRA B. HOKE.................*3d Vice President*
ARTHUR REEVES...........*Recording Secretary*
ROY H. KLAFFKI.......*Financial Secretary*
CHAS. P. BOYLE.......................*Treasurer*
WM. H. TUERS.............*Sergeant-at-Arms*

HOWARD E. HURD
Business Representative

BOARD OF EXECUTIVES

International Photographers of the Motion Picture Industries, Local 659

ALVIN WYCKOFF	PAUL P. PERRY
JACKSON J. ROSE	L. GUY WILKY
H. LYMAN BROENING	J. O. TAYLOR
IRA B. HOKE	ARCHIE J. STOUT
ARTHUR REEVES	JEAN C. SMITH
ROY H. KLAFFKI	S. C. MANATT
CHAS. P. BOYLE	R. B. HOOPER
WM. H. TUERS	SOL POLITO
FAXON M. DEAN	PAUL HILL
IRA MORGAN	

President Alvin Wyckoff, Local 659, caught on location.

THE UNION LABOR LIFE INSURANCE COMPANY

February 19, 1930.

Mr. Arthur Reeves, Rec. Sec'y.,
Local No. 659, Cameramen,
1605 Cahuenga Ave.,
Hollywood, California.

Dear Mr. Reeves:

We are pleased to advise you that Mr. George O. McMaster, 1328 W. Fifth Street, Los Angeles, California, has been appointed General Agent of our Company for Los Angeles and vicinity.

You are, of course, familiar with The Union Labor Life Insurance Company. You know that it is Union Labor's Own Insurance Company and that it was created for the benefit of members of organized labor. With less than three years 'operation, The Union Labor Life Insurance Company has more than $44,-000,000 of insurance in force and is in a position to offer you and your associates as full protection and as efficient service as any other "old line" legal reserve life insurance company. The variety of its policy contracts and the flexibility of its' settlement options enable it to solve practically any life insurance problem that may confront you.

This letter is to give you official notice of the appointment of our General Agent and to solicit your support of our representative in every way possible in order that we may make this Company not only an outstanding success as a Life Insurance Company but also in order that it may be clearly recognized as Labor's Own Company. It is our undertaking pure and simple and the degree of its

success must depend upon how thoroughly we appreciate that each of us has to broaden the field of usefulness of this organization which we have brought into being.

Mr. McMaster will make an active drive in his territory for insurance. He may desire to visit your organization and address your meeting. If he should ask you fo rthis privilege and you see your way clear to grant him the privilege of the floor, we will greatly appreciate it. If you or any of your members are in need of insurance you may call VAndike 9662 for an appointment and Mr. McMaster will be glad to serve you.

Thanking your for your assistance and co-operation, I am

Sincerely and fraternally,
MATTHEW WOLL,
President.

BORN IN APRIL

April showers bring May flowers and here's a bouquet worth hollering about. Look it over and note the many celebrated names. The fact that All Fools' Day falls on the first of this month has nothing to do with this bunch—not a dunce-cap wearer in the whole group. Read 'em and send their presents care Local 659.

April Birthdays—Lloyd Ahern, Kenneth Allen, Harry C. Anderson, Joseph August, Walter Bader, Friend Baker, Gorge Baxter, Thad Brooks, Jr., Robert D. Clark, Russel Cully, Jean Davenport,

Frank Dugas, Edw. Estabrook, Daniel Fapp, Jeff Gibbons, King Gray, Gene Hagberg, Byron Haskin, Edwin B. Hesser, Harry Jackson, Edw. C. Jones, Frank King, Ernest Laszlo, Paul Lerpee, Walter Lundin, Wm. McGann, Barney McGill, Pierre Mols, Sam Moran, Robert Newhard, Chas. Over, Esselle Parichy, Wm. Pearsall, Gordon Pollock, Ray Ramsey, Wm. Rand, Frank Ries, Chas. Schoenbaum, Lester Shorr, Leonard Smith and Harry Webb.

THE ALL-AMERICAN SALON

It is now nine years since the Camera Club sponsored its first show. Until a few years ago this was purely a Western show, for the workers of the Pacific Coast and the Western States. Feeling that it would be beneficial to all to show here the work as well of the most talented workers of the East, it was decided to broaden the scope making it all-American.

The all-American idea took well from the start and, even now, it is safe to predict that the coming Salon will surpass all previous ones.

It is not one bit too early to start making prints now. The entry forms are ready and may be had upon request to the Camera Club, 108 Stimson Building, Third and Spring streets, and let us whisper this information: It will be necessary to select the prints for illustrating the catalog very early this year. In other words, the early prints will have the best chance for this honor.—F. R. Dapprich, Salon Director.

Out of Focus

NEW FOCUSING DEVICE

This intriguing pastoral shot was made from a 500 feet step ladder by Bert Lynch of the M-G-M studios.

Due to the fact that so many aeroplane shots have been out of focus, it was decided at the last board meeting that something should be done to over come this fault. Brother Rose got busy and the result is astonishing. The first thing that Brother Rose found to enable him to arrive at this idea was, that all ships have altimeters that tell the height at which they are flying. So all that has to be done is to set the distance with the aviator and then set the focus with the aid of the Rose Phony Focuser.

This picture shows Speed Hall, Jack's favorite assistant, holding up his hat for a focus, having left the focus card behind. Notice Jack in the lower left hand corner waving at his boy, which means everything is O. K. and for the boy to hurry down and load the camera.

AGREEMENT FINALLY REACHED

This action still was made in front of the Bronx by Buddy Harris of Local 644 and sent by Telephoto to Local 659. Due to the recent storms in the east the mail was late in reaching us so this picture did not appear in the last issue.

Reading backwards and forwards the committee is as follows. On the left is Brother Howard Hurd. Some might take this for Charlie Boyle on account of the long nose and trick chin. We asked Brother Boyle if he was in New York and he said, he didn't remember being there. Brother Hurd didn't have very much to do on this trip and was able to have a shave now and then. The rest were shaved as soon as the meeting adjourned. Next is the Producers' representative. You can see that our boys have just about won a point as the representative is so worn out he had to sit down. The high hatted gent is Jax Rose. He is explaining that "Our hands are clean," but in the event that don't work he has something up his sleeve as you can see by the other hand. The next gent is Roy Klaffki. From the picture it looks as tho Roy had a Red Nose but this was caused by the extreme cold in New York. The two men in the background are a couple of New York bankers that are trying to get cards in Local 659 on account of the recent drop in the stock market. When asked if they had any qualifications for an assistant's card they stated that they had been sitting down for years and liked the short hours we have in the studios.

* * *

IMPORTANT POINTS WON ARE AS FOLLOWS

After three months of debating and disposing of many cases the following points were won by some one:

1. All cameramen shall be gentlemen when in soundbooths.

2. Refrain, as much as possible, from saying what you think of the director

DO YOU KNOW

That I. Hoke, associate editor, the boy that started this magazine, is no relation to "I. Hope."

That they have to issue weather permitting calls at Tiffany's when it rains. The roof is not sound proof. That's not the only place.

That a not so well known producer sent letters to his employee's telling them that Christmas was next July.

That the big C. B. initials were on top of the bank in Beverly before I moved there.

That "General Crack" is not an earthquake story and was photographed by 'Duke' Green and Tony Gaudio.

That J. B. Shackelford has made so many trips to the Gobi Desert, of Central Asia, that he can tell the difference between a Goygophysgatutti egg and a Mhdptwzxjkski egg by looking at them.

That the new Deitz reflector is just what you need to fill up the bad shadows under the eyes and around the nose and if they had an ad in our magazine I am sure they would have lots of inquiries about it.

That about a month ago it was announced over the radio that the Slate Steam Pushed Dirigible, of Glendale, would take the air Thursday. Yeah! What Thursday? No; I haven't any, but Eddie Cohen has a few shares.

That the Los Angeles Fire Department Band was on the air this A.M. playing "If I Had a Talking Picture of You," as the local fire department went by.

That since Harry Hallenberger had his picture in the magazine he takes a great deal more care in combing his hair.

That Lee Garmes lives at Laguna Beach and works at First National.

That out of 47 men in the Technicolor picture in last issue Jean Davenport's name was left out of the list.

That Dale Deverman, Gordon Avil and Geo. Nogle were dumped out in the Pacific ocean recently.

That Dale tried to save the camera and almost cost the boys $1.30.

That Merritt Gerstad studied art at the Chicago Art Institute for five years.

when he is in the mixing room. Microphone—you know.

3. If a cameraman should work for 6 days and 6 nights without rest he is entitled to Sunday off, but this is subject to the decision of the secretaries.

4. When on distant locations cameramen are not expected to return home for lunch.

5. Par 7 Aerial flights does not cover cameramen that "go up in the air" at the studios. This applies to aerial flights only.

For the balance of the agreement see page 132 of next January issue.

Out of Focus

NEW FOCUSING DEVICE

This intriguing pastoral shot was made from a 500 feet step ladder by Bert Lynch of the M-G-M studios.

Due to the fact that so many aeroplane shots have been out of focus, it was decided at the last board meeting that something should be done to over come this fault. Brother Rose got busy and the result is astonishing. The first thing that Brother Rose found to enable him to arrive at this idea was, that all ships have altimeters that tell the height at which they are flying. So all that has to be done is to set the distance with the aviator and then set the focus with the aid of the Rose Phony Focuser.

This picture shows Speed Hall, Jack's favorite assistant, holding up his hat for a focus, having left the focus card behind. Notice Jack in the lower left hand corner waving at his boy, which means everything is O. K. and for the boy to hurry down and load the camera.

AGREEMENT FINALLY REACHED

AFTER THE DEBATE

This action still was made in front of the Bronx by Buddy Harris of Local 644 and sent by Telephoto to Local 659. Due to the recent storms in the east the mail was late in reaching us so this picture did not appear in the last issue.

Reading backwards and forwards the committee is as follows. On the left is Brother Howard Hurd. Some might take this for Charlie Boyle on account of the long nose and trick chin. We asked Brother Boyle if he was in New York and he said, he didn't remember being there. Brother Hurd didn't have very much to do on this trip and was able to have a shave now and then. The rest were shaved as soon as the meeting adjourned. Next is the Producers' representative. You can see that our boys have just about won a point as the representative is so worn out he had to sit down. The high hatted gent is Jax Rose. He is explaining that "Our hands are clean," but in the event that don't work he has something up his sleeve as you can see by the other hand. The next gent is Roy Klaffki. From the picture it looks as tho Roy had a Red Nose but this was caused by the extreme cold in New York. The two men in the background are a couple of New York bankers that are trying to get cards in Local 659 on account of the recent drop in the stock market. When asked if they had any qualifications for an assistant's card they stated that they had been sitting down for years and liked the short hours we have in the studios.

* * *

IMPORTANT POINTS WON ARE AS FOLLOWS

After three months of debating and disposing of many cases the following points were won by some one:

1. All cameramen shall be gentlemen when in soundbooths.

2. Refrain, as much as possible, from saying what you think of the director

DO YOU KNOW

That I. Hoke, associate editor, the boy that started this magazine, is no relation to "I. Hope."

That they have to issue weather permitting calls at Tiffany's when it rains. The roof is not sound proof. That's not the only place.

That a not so well known producer sent letters to his employee's telling them that Christmas was next July.

That the big C. B. initials were on top of the bank in Beverly before I moved there.

That "General Crack" is not an earthquake story and was photographed by "Duke" Green and Tony Gaudio.

That J. B. Shackelford has made so many trips to the Gobi Desert, of Central Asia, that he can tell the difference between a Goygophysgatutti egg and a Mhdptwzxjkski egg by looking at them.

That the new Deitz reflector is just what you need to fill up the bad shadows under the eyes and around the nose and if they had an ad in our magazine I am sure they would have lots of inquiries about it.

That about a month ago it was announced over the radio that the Slate Steam Pushed Dirigible, of Glendale, would take the air Thursday. Yeah! What Thursday? No; I haven't any, but Eddie Cohen has a few shares.

That the Los Angeles Fire Department Band was on the air this A.M. playing "If I Had a Talking Picture of You," as the local fire department went by.

That since Harry Hallenberger had his picture in the magazine he takes a great deal more care in combing his hair.

That Lee Garmes lives at Laguna Beach and works at First National.

That out of 47 men in the Technicolor picture in last issue Jean Davenport's name was left out of the list.

That Dale Deverman, Gordon Avil and Geo. Nogle were dumped out in the Pacific ocean recently.

That Dale tried to save the camera and almost cost the boys $1.30.

That Merritt Gerstad studied art at the Chicago Art Institute for five years.

when he is in the mixing room. Microphone—you know.

3. If a cameraman should work for 6 days and 6 nights without rest he is entitled to Sunday off, but this is subject to the decision of the secretaries.

4. When on distant locations cameramen are not expected to return home for lunch.

5. Par 7 Aerial flights does not cover cameramen that "go up in the air" at the studios. This applies to aerial flights only.

For the balance of the agreement see page 132 of next January issue.

SANMEAT
MORATANCPICH
GIVEATEN

The printer may make it sound strange—
but for the cinematographer it speaks the
Universal language—
Understood and appreciated

in Hollywood

 New York

 London

 Paris

 Brussels

 Tokio

 Riga

 Madrid

AND—WHEREVER PEOPLE HAVE EYES

J. E. BRULATOUR, INC.

NEW YORK CHICAGO HOLLYWOOD

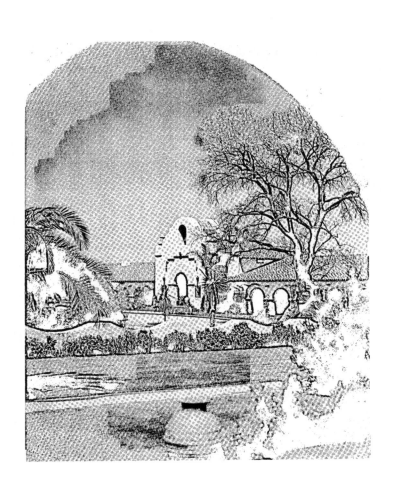

The INTERNATIONAL PHOTOGRAPHER

Official Bulletin of the International Photographers of the Motion Picture Industries, Local No. 659, of the International Alliance of Theatrical Stage Employees and Moving Picture Machine Operators of the United States and Canada.

Affiliated with Los Angeles Amusement Federation, California State Theatrical Federation, California State Federation of Labor, American Federation of Labor, and Federated Voters of the Los Angeles Amusement Organizations.

Vol. 2 HOLLYWOOD, CALIFORNIA, MAY, 1930 No. 4

"Capital is the fruit of labor, and could not exist if labor had not first existed. Labor, therefore, deserves much the higher consideration."—Abraham Lincoln.

CONTENTS

The INTERNATIONAL PHOTOGRAPHER published monthly by Local No. 659, I. A. T. S. E. and M. P. M. O. of the United States and Canada

HOWARD E. HURD, *Publisher's Agent*

SILAS EDGAR SNYDER - - - - *Editor-in-Chief* IRA B. HOKE - - - - - - - *Associate Editor*
LEWIS W. PHYSIOC - - - - *Technical Editor* ARTHUR REEVES - - - *Advertising Manager*
CHARLES P. BOYLE - - - - - - - *Treasurer*

Subscription Rates— United States and Canada, $3.00 per year. Single copies, 25 cents
Office of publication, 1605 North Cahuenga Avenue, Hollywood, California. HEmpstead 1128

The members of this Local, together with those of our sister Locals, No. 644 in New York, No. 666 in Chicago, and No. 665 in Toronto, represent the entire personnel of photographers now engaged in professional production of motion pictures in the United States and Canada. This condition renders THE INTERNATIONAL PHOTOGRAPHER a voice of an *Entire Craft*, covering a field that reaches from coast to coast across the nation.

 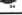

THIS BEAUTIFUL MARINE VIEW FROM THE CAMERA OF MAC JULIAN SPEAKS ELOQUENTLY FOR ITSELF.
THE DOG IS RIN-TIN-TIN WITH HIS MASTER.

Color Expression and Its Practical Application

—BY—

MARY KING HUNTER

There is today what one might term a color reform. We are not content with knowing the old pigmentary rules of color; we — the people — who are consciously using color, have substituted modern scientific laws. One entirely new thought is to apply the law of light rays to pigments. A modern scale of color expression is in combined pastel moods, some clear and some grayed, a new feminized color technique. Acquiring a muted effect is one of the newer color interpretations, as against the bright, raw spectrum primals of yesterday. There is, one feels, a distinctly personal quality in the exploitation of color, indeed all the inflections of the color scale are weighted with individual values. Beauty can only be achieved through harmony, rhythm and balance. Repetition (unity—continuity) equals Harmony. Sequence equals Rhythm; balance equals Line, Form, Light, Shade and Texture.

Color Is Either a Smile or a Frown. Different characters adhere to the colors which are attuned to their deeper subconscious needs. Generalizing: One finds that the softer moods of color appeal to the pretty woman, whereas the direct contrasts of complementary tones and the strong, pure primals are the choice of the person who prefers to be "smart." Uneducated individuals and peoples show in no way more clearly their lack of breeding than by their color expression. Women of this class will often crave color—they are sentimental rather than emotional, and they usually over-paint the picture — cloying sweetness — "over-pinked" as I have often termed it, or with strong though mayhap unrealized sex desires they paint the self-same picture in flamboyant tones of red, cerise or deepest orange. It is true, I believe, that one's life is painted so that "all who run may read." If we paint it in clear, true colors—translucents—people behold in us the fine, upright, courageous character, whilst in direct opposites we find the expressed inner self in dull, murky browns, a deadly, "muddied" life stream, a dull uninteresting and sometimes altogether retrograde character. Truly we make of our lives a beautiful, soulful picture or a drab, badly drawn daub, which commands neither admiration nor respect. The wise use of color is an outlet, an effort at self-expression that can be both beneficial to the character, and bring success, health and happiness to the individual and to the beholder. There are colors which both denote and produce a joyous, harmonious outlook and inlook, and some there are that drag us down, make us and keep us "of the earth earthy." Today it is the combination of colors which one must study, both the value and the meaning of each color in the group about to be used.

Ensemble Is the Expression Moderne. On our persons, in our homes and, so to speak, our immediate landscape, the effect of the ensemble is, or should be, the keynote to the picture, yet often this seems to be entirely overlooked, or it may be there is a lack of knowledge of color

Mary King Hunter is of Scottish birth and has been a student of color since childhood. She is a graduate of the University of Glasgow and later took her certificate as an art teacher at Chelsea School of Art, London. During the war she was shell shocked and for a time wholly incapacitated. Her activities have been world-wide and she is famous in the field of education.—Editor's Note.

tone. Men are proverbially color blind, and almost always demur at the statement, yet prove in every possible way that there is at least a grain of truth in the adage. The ancients knew the value of color; the value also of light. Worshiping the sun, its beneficial rays were fully recognized as also the hurtful glare of light on color.

Royal Purple—red and blue (a combination of the two primals)—has come to us all down through the ages as denoting pomp, ceremony, dignity of the church and of the law, of crowns and kings, a sad, heavy, boresome vibration: yet add a slightly larger quota of the life-giving red, and note how the purple revives— a hint of mastery, of passion, is at once apparent in its depths. Withdraw a double quota of red, and on our palette appears the studious, retiring, self-conscious, shy and modest violet color. Reduce this fugitive color by the use of the neutral white (white—the Light) we feel the entrenched sweetness of lavender, with more of blue in its composition, politeness, gentleness, refinement, its very essence. The impulsive Lilac, another of this family, the sad, aloof, almost melancholy Heliotrope; running the entire gamut we arrive at the variable orchid shades. Agreeable, charming, gracious and kind, almost religious vibration, Orchid is yet somewhat of a butterfly, changing and changeable. The idealism of the Blue has been almost entirely nullified by the entrance of the neutral White, whilst the militant Red has been so reduced in its properties that sex had with drawn before the clear white light of reason; danger has been ruled out, minimized to a degree, the curative qualities negatived—A Primal Gone Pastel!

It is interesting to work out color combinations, such as Royal Blue, Sea Green, and Orange—(Inspiration — Courage — Tenacity — Aspiration) and to find that this bluegreen vibration of Turquoise is the very highest in Music, Art and Science. No color is more valuable than Blue, and yet no color is so fugitive, so difficult to acquire in its clear sapphire or azure blue nuances. It is an entirely mental vibration, clear, cold and calm, shedding by its light little warmth or welcome, it yet carries in its tones the optimism, the idealism, we so sadly need to relieve the neutral grays to which it is so often allied. Blue is the one color which is at the same time electrical and yet in some of its tones a distinct depressant—is truthful, almost rudely so, and reduces the vitality. We use its calming influence to cool down a too-hot color scheme; or again we may raise the vibration by the inclusion of the blue-green Turquoise. Very highly sensitized natures are often painfully affected by color—or rather a blending and shading of several colors. Certain inharmonious blendings will cause a nerve sickness, and have been known to produce physical discomfort. White, a wonderful neutral,— is so much of a neutral, that nurses and persons who must wear it continuously often become, as we say, "case hardened" —a surface coldness—and finally admit their inability to emote, except on very rare occasions. Very emotional people, on the other hand, are benefitted by this great Neutral, acting as it does, almost as a deterrent to temperamental outbursts. There is no color so beneficial to tired nerves as a cool shade of Green. It is called the success color, successfully blending, as some note of it does, with every neutral, pastel, or primal. Green walls in a small dinette or living room, green table linens and green stemware: The green of the sea, a mystical gray-green; or of the woods, the young spring green or the deep dark Hunter's Green: the green of the desert oasis. Desirable, delectable, cool, refreshing and life-giving; sufficient cannot be said of this wonderful color, yet many people cannot wear it, a superstitious person feeling that wearing of the green may bring upon him some deep grief or even calamity; yet Green was and is the Safety color on land and sea. Green— when not the bilious, yellowish green—induces a deep, dreamless, restful sleep.

Both color and music arouse and stimulate the memory and, as all things in the Thought World seek to become definite in the physical, Color Thoughts seek expression in Harmony. Color appeals first to the emotions, and produces there an instantaneous effect; reaching out, it contacts the nerve-centers, when the nervous system reflects its own disturbances, causing pain or pleasure as the accompanying emotion. Supersensitiveness reveals a coordination of color vibrations to moral impulses, causing the effect of color to be clearly shown on the morals of Man.

Work with nature's own colors and anything progressive is possible. Nature is always seeking direct expression. As will readily be seen, Color Psychology as it stands today, to the unenlightened, is more or less the propounding of a theory. To take the abstract thought and apply it to the individual or to the subject in hand requires both the knowledge and the skill of the trained mind. From my actual experience both in this country and in many other countries, Color Expression suffers greatly by the mediocre treatment of unskilled labor. Now that Color has become of both national and international importance, it behooves us to organize a constructive, harmonious and intelligent display of color, as Art, real Art, draws all nations and peoples together.

The Director General
—BY—
JACK ALTON, *Local 659*

Silence. The silence of the African desert. Only a faint suggestion of oriental music from the distance. Only one window of the hotel was illuminated—the window of the director's room—the man in charge of a motion picture expedition. With the aid of whisky and soda he was studying the map of Morocco laid out on the floor.

"Ah! There it is, at last I found it!" he exclaims, jumps up and presses the button of the servant's bell.

The servant is used to the director's sudden calls, opens the door and just stands there waiting for orders.

"Wake up everybody," he commands. And, in a few minutes, the whole crew, cameramen, assistants, technicians and script clerks were kneeling on the floor yessing the director's discoveries.

"An army post!" says the director as he looks around studying the different sleepy faces; "I have discovered an army post!"

Pointing at an unpronouncable Arabic name printed on the map, he shouted: "Thousands of soldiers, Arabs, camels, sheiks, battles, desert dunes, sunsets, everything to make beautiful exteriors. The stuff we will bring back with us will knock out supervisors for a roll of wide film. Pack up immediately and ready to leave in an hour!"

They all looked at the director kind of doubtfully, but orders are orders. An attack on the kitchen and they ate everything there was left from the previous night.

The drivers did not like the idea at all. They knew the Arabs and said something to that effect, but it was in Italian, so it did not matter. No one understood it.

Baggage loaded, bills paid and the silence of the desert was broken by the grinding sound of the automobile starters. High up on the tower an Arab was saying his prayers in every direction.

"We must get there in time," is the next command issued by the director general. So without rest and hardly time to eat their canned meals, the little caravan was speeding through miles and miles of desert country, their faces long, and gray from the thick layer of dust that settled on them.

After two days' and two nights' tiresome riding they arrived where, according to the map, the post was supposed to be.

It was so dark that the director found it advisable to camp on the spot and, exhausted from traveling and forgetting the lurking dangers of the desert, the gang soon fell asleep.

The director was the first one up. Dawn. Still hazy. More commands. Cameras had to be set up. His commands were automatically carried out.

Trucks were unloaded, cameras oiled. By now every member of the expedition had the so-called tropical melancholy, expressionless faces wondering what all it will lead to.

When the sun rose over the horizon, the walls of an army post became visible in the distance. The company was ready to shoot. The director gathered his staff and started down towards the post to pay compliments to the commanding officer.

It is customary to hoist a flag on the arrival of civilians, but no such thing happened this time. It also seemed strange that there were no guards at the entrance of the wide open gates.

An uncanny feeling overcame the whole deputation. Not a word was said. All sensed danger. However, they could not stop now, so they let the director enter through the gates first. Here and there were the remnants of what once had been an army post. Skeletons of men and horses were scattered about. Legends of whole posts being wiped out by the Arabs flashed through their minds. It couldn't be a mistake, the director thought, no, the name was correct. They entered the building. Not a soul in sight. The crew looked at the director as if demanding an explanation. Cold perspiration ran down his face. He looked again at the map and his eyes almost popped out as, in the morning light he saw the date—1370.

A New Mole-Richardson Product

Fig. 3

Fig. 1

Fig. 2

With the adoption of sound proof camera housing (BLIMPS), which have increased the weight of the Motion Picture camera by an additional 190 pounds it has been necessary to provide a substantial supporting tripod and a tilt head of rugged design to support this increased load.

The Mole-Richardson rolling tripod is constructed of Shelby tubing and bronze castings to provide strength, rigidity and indestructibility, with as light a construction as is practical.

The tripod, which is illustrated in figures 1 and 2, is mounted on three eight inch rubber-tired casters, which may be left free to swivel or may be rigidly locked, so the tripod may be used for follow shots or as a "perambulator."

At each of the three supporting points of the tripod screws are provided by which the camera may be leveled, and which affords increased rigidity to the entire structure when the weight is lifted off the casters.

In the center of the tripod is a telescoping elevating tube construction, by which the camera may be raised or lowered by means of a hand-wheel. To give addition rigidity, six telescoping struts attached direct to the base of the tilt head, provided with clamping sleeves, brace the tilt head to the supporting fittings.

The design of these tripods is such that they may be built in various heights as may be desired. The following combinations have proved very satisfactory. The standard tripod will operate a camera from a lens height of 70 inches down to 48½ inches down to 37¾ inches.

When it is desired to use the camera lower than 37¾ inches, there has been provided a High-Hat consisting of a series of aluminum sections, illustrated in Figure 3. By using combinations of these aluminum sections the camera may be lowered from 37¾ inches to lens height of 20 inches; at this height it is possible to photograph children, animals, and other subjects close to the floor.

The tilt head which has been developed permits either free or mechanical tilt 28 degrees below level, and 19 degrees above level; and either mechanical or free panning movement through the entire 360 degrees. The changing from mechanical operation to free motion on the tilt head is accomplished by a clutch mechanism in the case of the tilt movement, and by withdrawing a locking pin in the case of the panning movement. Suitable hand-wheels are provided for control on either of the movements. It is possible with these heavy blimps cameras to have almost the freedom that was afforded with the standard camera base and the unencumbered camera.

By the liberal use of ball and roller bearings friction has been reduced to a minimum, a very essential feature when the cinematographer wishes to "sneak" on either movement.

A fundamental principal in the design of this tilt head is the use of a table supported on rails in the form of a sector, the radius of which falls at approximately the center of gravity of the blimp. This feature of design keeps the camera in good balance in all positions and is an essential feature where the mass is as great as in this case.

In concluding this description, Mole-Richardson wish to give credit where credit is due. The basic design is a modification of a tilt head and rolling tripod which the Metro-Goldwyn-Mayer Studios developed.

The Pathe Studios through their representative, Mr. Clark, head of their Sound Department, have collabrated with use in many of the details of design, and placed an initial order with us for ten of the standard tripods and tilt heads, and additional supplementary equipment.

This piece of equipment is entirely beyond the experimental stage, and from the way orders are being booked Mole-Richardson are convinced that they have produced another valuable piece of equipment in their efforts to serve the industry.

A "CUE METER"

A mechanical reminder which makes incorrect modulating of voice and sound projection of a talking picture impossible, has been invented by Charles C. Reese, chief projectionist at the Fox Carthay Circle Theater, and James J. Graham.

The new invention soon be marketed under the trade name of "cue-meter."

Technical experts have pronounced the "cue-meter" as one of the most unique accessories since the advent of talking pictures.

Head of Paramount Camera Dept., Virgil Miller, bids Cameraman Rex Wimpy "bon Voyage" on eve of Rex's departure for Monte Carlo to shoot some shots for a forthcoming Paramount picture.

Photographing Air Waves

BY

DR. ALFRED N. GOLDSMITH, *Vice-President and General Engineer, Radio Corporation of America*

(Written for The International Photographer)

The photographic art has changed greatly as the years have passed. The first photographers took pictures of people and everyday things. It was comparatively easy to light the subjects then photographed, and to focus sharply on them.

As time went on, the requirements of the photographic art increased in difficulty, and ever more delicate effects had to be depicted. For example, pictures were desired of scenes in mist and fog and rain, as well as photographs of complicated softly glowing clouds, the purple haze over distant mountains, and the like. Here the light could not be controlled to any extent, and the photographer had to wait his time and use just the right sort of plate and color filter before he could be sure of getting the desired effects.

Today even more is required of the motion picture photographer. He must photograph objects that are stationary or in rapid motion, that are flatly lit, illuminated by "hard lighting," in silhouette, or in any other of the numerous types of lighting which have been found either artistic or interesting. The motion picture sets, which frequently cover large areas and are of great complexity, must be so carefully illuminated that natural or deliberately fantastic effects are produced.

However, we have now come to a new era of photography which off hand sounds almost impossible. It is the photographing of sound waves. It is not known whether any motion picture photographer has ever attempted to photograph the wavering currents of heated air which rise over a steam radiator and which cause the curious ripple in the appearance of distant objects which are viewed through these rising air currents. Undoubtedly photographing such air waves would be a difficult job, and yet extremely easy in comparison to the photography of sound waves.

A sound wave is a region of comparison in the air which expands outward in all directions at the rate of about twelve miles a minute, or rifle bullet speed. There is not a high compression and the ripples may be either very close together (only a few inches for high notes) or relatively far apart (ten feet or more for low notes). The waves are quite invisible to the eye and photographing them directly would be almost out of the question unless some extremely intense and sudden illumination (such as that of the electric spark) were used. Sound waves have, nevertheless, been photographed in connection with special investigations of the acoustics of planned theatres, through the use of miniature models of such theatres. This sort of photography of sound waves has, however, no direct present application in sound motion picture reproduction.

Nevertheless there has been developed an indirect method of photographing sound waves on film. It has produced a new branch of photography—that of the sound recordists—who are charged with the job of indirectly photographing the sound waves. This is done by a sort of trick which enables us to photograph the shape of the waves on a moving film without, however, photographing the waves themselves.

Instead of using a lens to pick up the sound waves in the first place, a microphone or telephone transmitter is used. A vacuum tube amplifier then strengthens the relatively tiny current from the amplifier. Then, in the variable width or variable area recording process, a tiny mirror is caused to swing to and fro by electrical means, following accurately the original air vibrations. A spot of light reflected from the vibrating mirror on to the uniformly moving film then draws the outline of the original waves in clean-cut form.

There are a number of technical differences between picture photography and sound photography. In the first place, it is to be noted that there is no intermittent motion in sound recording as there is in camera or projector mechanisms. Unless the film moves uniformly during sound recording the sound waves would be irregularly recorded or blurred. The frequencies of the recorded notes would be raised or lowered and disagreeable effects, sometimes known as "flutter," would be produced. Sound recording is really a sort of high speed photography.

Motion pictures are ordinarily taken nowadays twenty-four per second, but sound waves are recorded which run considerably beyond 5000 vibrations per second. Otherwise stated, the sound recordist must photograph things that are happening many thousands of times per second, and with a high degree of accuracy.

Sound recording is also more nearly a branch of micro-photography than ordinary motion picture photography. It frequently requires a magnifier to see the full detail which exists in the sound track. Indeed, the sound head of the projector which reproduces the sound from the film actually contains a microscope for this purpose.

There is another outstanding difference between picture photography and sound photography. In the case of picture photography, only sample pictures are made at regular intervals. Everything in between the individual pictures is supplied by the theatre audience through the persistence of vision. People only imagine they see motion on the screen —all that is really present is a succession of still pictures which are fused through visual persistence into the impression of motion. In the case of sound photography, it is not necessary to depend upon persistence of hearing, and in fact, this would be undesirable. The entire sound wave is recorded without gaps or the utilization of sample sections. It is just as if motion picture film had a true series of moving images on the picture, each one of which followed the preceding by practically zero time instead of coming a twenty-fourth of a second later.

Both motion picture photography and sound photography are truly remarkable arts. It is astonishing that throwing a succession of still pictures on the screen should create in the eye and brain so perfect an impression of motion. It is perhaps only slightly less astonishing that it is possible to duplicate complicated and delicate sound waves from a film sound track and yet give the listener the impression of a faithful reproduction of the original performance.

The problems of the two arts are therefore entirely different in many respects. One of them is much concerned with the lighting and arrangement of the scene, which is in many cases under good control. In the case of the other art, the sound recordist cannot in as great measure control the shape of the wave forms which he desires to photograph. The best he can do is to cut down undesirable echo, adjust the distance and position of his microphone and the acoustic surroundings in such fashion as to get accurate records and occasionally to "mix" microphone outputs so as to get just the right impression of an orchestra or moving action.

Nevertheless, these two arts are related photographically. When the film for each of them comes into the processing laboratory similar problems are encountered. Each type of film requires care in exposure, reasonably correct development, careful and cleanly handling, and correct printing and processing; and finally sight and sound are combined on a single film forming that masterpiece of modern scientific achievement which now gives and will continue to supply so much entertainment and amusement to the people of the world—the sound motion picture. This is a true wedding of the sciences and arts of photographing pictures and of photographing air waves.

McCLUNG RETURNS

Hugh McClung, that noble old veteran of the camera who has been for long in the laboratory doing special technician work on "Taming the Shrew," "Coquette," "The Iron Mask," "The Gaucho" for Doug and Mary; "Hell's Harbor" for Henry King; "Bulldog Drummond" and "Condemned" for Goldwyn, is arranging to return to his old love—the camera.

Mr. McClung has an interesting background. Years ago he made a trip around the world for Melies; shot all of Douglas Fairbanks' pictures from "Painted Past" to "Knickerbocker Buckaroo," did "Mickey" and was for years with D. W. Griffith. His host of friends in Hollywood will welcome his return.

The Dieterich Universal Lens

—BY—

ARTHUR REEVES, *Recording Secretary, Local 659*

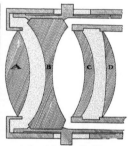

ARTHUR REEVES

While working with Carl Struss, chief cameraman with D. W. Griffith on his picture "Abraham Lincoln," I noticed an elderly gentleman shooting a Bell & Howell c a m e r a. Turning to Stanley Cortez, w h o was assisting S t u a r t Thompson, on the adjoining parallel, I asked him who t h i s person was with the B e l l & Howell camera, as we were all using Mitchells. He informed me that the Bell & Howell operator was Dr. L. M. Dieterich, who was making tests for United Artists with his Universal Focus Lens.

The accompanying illustration shows Dr. Dieterich and his camera. During the lunch period Dr. Dieterich explained his camera to me. I inquired: "Dr. Dieterich, I understand you have a Universal Focus Lens?" He corrected me to this extent—he explained that he has a lens in which the focus travels during one exposure. The fundamental characteristic of the lens is that it changes focus without changing the size of the image.

In practical action on the camera the lens is shot at three feet when the shutter opens; the focus travels during the shutter opening and is shot on infinity just before the shutter closes. By this action the object field is cut in progressive planes of sharpness, the images of which are all of the same size and, therefore, perfectly registered and the final picture on one frame is an image of even definition throughout the field.

Dr. Dieterich gave me a piece of film showing a sample of his work. In this piece of film the nearest object was five and one-half feet. The second person was thirty feet and the third person was fifty feet from the camera. My assistant, Brother Fernandez, asked Dr. Dieterich if the picture was stereoscopic and he was corrected thus:

"This camera uses a single lens only and you can not get stereoscopic pictures without using two lenses side by side. I agree, however, that my pictures show a certain depth effect resulting from the fact that the eye sees several objects at different distances from the camera clearly. I am aware that the word 'stereoscopic' is used rather freely, but so far there hasn't been any method developed in the motion picture industry which will produce upon the screen a truly stereoscopic picture that can be viewed with the unaided eye."

I then asked Dr. Dieterich how he accomplished his depth of focus. He explained as follows: "I realized some time ago that one of the greatest difficulties cameramen have to contend with is the limitations of standard photographic motion picture lenses as far as its focal efficiency is concerned. It was one of my

Dr. Dieterich has been a citizen of the United States for nearly thirty-five years. He was born and educated in Vienna, his alma mater being the Vienna Polytechnic University whence he graduated with the degree of Doctor of Engineering. On recommendation of the celebrated electrical scientist, Nicola Tesla he came to America and took a position with the Pope Manufacturing Co., of Hartford, later going to the Cadillac Automobile Co., as chief engineer. He was designer of the Aero-Car and became an authority on auto engineering. Dr. Dieterich went to New York City in 1909 and has since resided there as a consulting engineer. He has long been interested in optics and has resided in Hollywood during the past seven months, researching in the studios and perfecting and demonstrating his invention herewith written about by Mr. Reeves.

endeavors in working out the design of this lens to furnish the cameramen with an optical unit which will more or less end his focus troubles.

"The fundamental step to bring this endeavor to a practical result was to design a lens which would act similar as

the human eye; that would accommodate itself to all distances. Without going into the optical and mathematical difficulties I had to contend with and which were considered by optical experts as impos- (Concluded on Page 10)

A, C and D fixed. B sliding.

Cross section of the Dieterich lens.

Dr. Dieterich and his camera showing lens mount.

(Concluded on Page 10)

 # Cream o' th' Stills

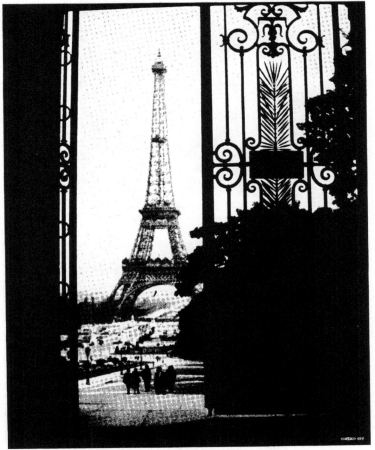

This shot tells its own story. Mr. Monroe Bennett was strolling about the French capital one day when he happened to catch this vista from the Trocadero. A minute later he had trapped it in his good box.

Cream o' th' Stills

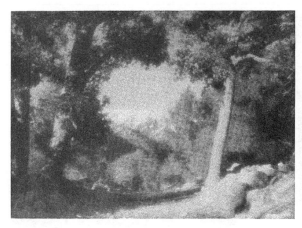

Mount San Antonio, affectionately called by Southern Californians "Old Baldy," has been photographed from every imaginable vantage point, but if any shot could be more enchanting than this of Mr. Bert Baldridge it has not yet been registered. Mr. Baldridge is an indefatigable searcher for the unusual.

This charming silhouette of the desert was one of the gems picked up by M. Lucien Andriot while on location during the photographing of "The Oregon Trail." He is a lover of the wide open spaces and particularly of the mysterious.

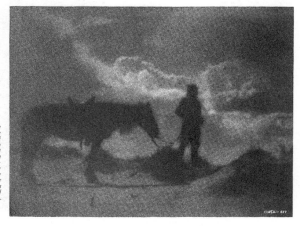

 # Cream o' th' Stills

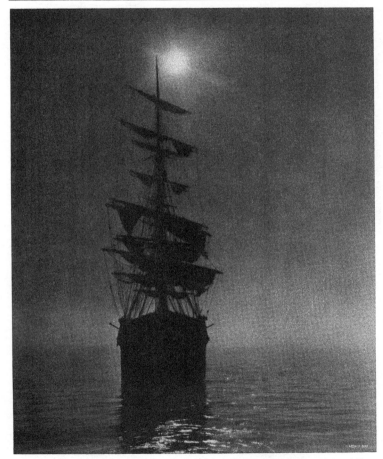

This old wind-jammer, at anchor off San Pedro harbor (note battleship on the horizon) caught the imagination of Mr. Fred Archer while on location down there one day. If it had to have a title the photographer would probably call it "Becalmed." Anyway it brings up images from the works of Cooper, Marryat, Bullen, Conrad, Melville, et al.

Cream o' th' Stills

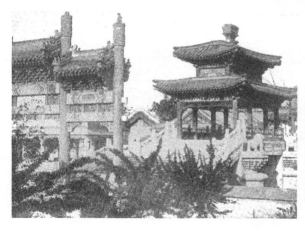

George Hollister, one of the motion camera's oldest pioneers, was also a war correspondent of note. In the Boxer Rebellion he had a prominent place and while in the midst of that adventure caught this rare photograph, one of the first ever shot inside the "Forbidden City." This is a view of the Sacred Arched Bridge of the Empress Dowager. The picture was made in 1901.

Victor Scheurich, although a German by birth and cinematographic training, seized upon the true spirit of the old pioneer days of the West. Here is an excellent sample of the work of Mr. Scheurich with his still camera.

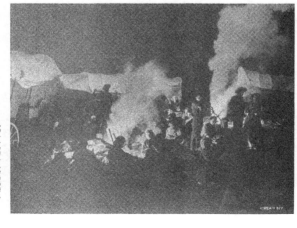

The Dieterich Universal Lens

(Continued from Page 8)

Single film frame shot by Dieterich lens. The figures are 4½ feet, 30 feet and 50 feet distant.

sible of solution, the final result is a lens consisting of four elements, three of which are fixed and one element movable."

"Now, Doctor," I asked, "could you make me a sketch showing the workings of this lens," to which he replied that he would and it is found in the illustration herewith. This sketch shows a four-element lens consisting of a positive lens "A" which is the front element; a negative lens "B" and two meniscus lenses "C" and "D." As the reader will observe in this sketch, lenses "A," "C" and "D" are fixed or mounted stationary in the lens barrel. Lens "B" is mounted in a sleeve "S" which can move forward and backward on the optical axis of the system.

The movement of the "B" element is only a fraction of a millimeter and is produced in synchronism with the shutter shaft movement by a simple mechanical connection. When the element "B" moves forward during the shutter opening the angle of the lens does not change, which accounts for the fact mentioned before that the image size remains the same.

"Well. Doctor Dieterich, this has been considered an optical impossibility. Could you explain how you accomplished it."

"Mr. Reeves, this is a rather complex situation and it is difficult for me to explain to you in simple language the optical phenomena which actually exists during the operation of this lens. In non-technical language, I am effecting among other things a change in the second equivalent focal length without changing the position of the second principal plane relative to the stationary lenses."

"Now, Doctor, if that has been considered an optical impossibility how do you stand in the patent situation?"

"You are bringing up a very interesting point. The fact that I found a solution to the so-called optical impossibility gives me a very strong patent situation and I have a great number of patents all over the world protecting this invention of mine in a basic way."

"I want to draw your attention to the practical advantages of this lens as against standard motion picture lenses. I have said before that it is to the advantage of the cameraman always to get a picture with good focal value. Also, as

Single film frame. The figures are 4½ feet and 80 feet distant.

far as sound recording is concerned, you can watch lip movement in dialogue scenes of persons at different distances from the camera. Now, insofar as the color photography is concerned, we know that any color scheme is at its best where it is sharp. Where the color photograph is out of focus the circle of confusion creates a confusion of colors which is, of course, obviated in color pictures produced with this lens."

I saw one reel of film shot with Dr. Dieterich's lens and in my opinion it shows great promise. Especially does it work well in color. The sample in Multicolor I saw showed excellent definition in the background.

―――――o―――――

PARAMOUNT PARAGRAPHS

If It's a Paramount Picture—

Then the following well-known men supervised it: Harry Fischbeck, Victor Milner, Henry Gerrard, Archie Stout, Chas. Lang, Allen Seigler, Gilbert Warrenton, Dave Abel.

And these men did the panning and tilting: Clemens, Fapp, Reynolds, Bennett, Pittack; Titus, Mayer, Knott, Lindon, Mellor, Rand, Blackstone, Pierce, Lynch, Merland, Nicklin, Boradaille, Laszlo . . . ad infinitum.

These men got the overtime . . . and are now driving 16 cylinder cars, and wearing 24-inch cuffs on their corduroys —beg pardon—silk-striped chevoits: Lane, Myers, Bourne, Norton, Morris, Shirpser, Over, Burgess, Smalley, Harlan, Ahearn, Ballard, LaBarba, O'Toole, Cruze, Rhea, Tripp, Seawright, and most of 659's other money-lenders.

—It's the Best Picture in Town—

Such as:

"True to the Navy"—Milner, of course.

"Benson Murder Case" (Spanish). Ask Gerrard.

"Benson Murder Case" (English). That sailor, Stout.

"High Society"—A golfist by the name of Siegler.

"Border Legion"—Stengler and Lang, tourists.

"City of Silent Men"—Prison atmosphere by Lang.

"Devil's Holiday"—Who else but Fischbeck.

ALVIN WYCKOFF'S CAMERA CREW ON "THE STORM," UNIVERSAL FEATURE, ON LOCATION AT FEATHER RIVER

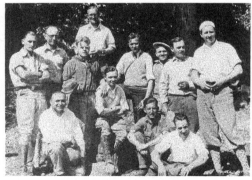

Left to right—*Will Cline, Leonard Galexio, James Goss, Bill Sickner, Gil Warrenton, James Palmer, Cliff Thomas, Walter Boling.* Seated—*Jas. Giridlian, Michael Walsh, Harlow Stengle, Roy Vaughn.*

Scene from "The Vagabond King,"
Paramount Famous Lasky Production

even balance

LIGHT struck from National Photographic Carbons permits an even balance of light *and shade;* between actors and the rest of the set. Light from these arcs has penetrating power unequaled by any other form of studio lighting.

For night shots, National White Flame Photographic Carbons (hard-arc) can't be beat. Their light is identical with sunlight. Permits clean, sharp moonlight effects, or brilliant contrasts.

National Panchromatic Carbons (soft-arc) give a softer orange-colored light, ideal for close-ups. Particularly effective in taking colorful scenes, as their light, rich in red, orange and yellow-green rays, smooths and softens the face, and brings out natural tonal shades in costumes and settings.

National Photographic Carbons (White Flame or Panchromatic) are interchangeable and come in sizes to fit any studio arc lamp. Tests prove that they are the most economical form of studio lighting, as these carbons give more light per watt of electrical energy.

NATIONAL CARBON COMPANY, INC.

Carbon Sales Division: Cleveland, Ohio

Branch Sales Offices: New York, N. Y. Pittsburgh, Pa.
Chicago, Ill. Birmingham, Ala. San Francisco, Cal.

Unit of Union Carbide |UCC| *and Carbon Corporation*

National Photographic Carbons
White Flame and Panchromatic

HOLLYWOOD FILM ENTERPRISES, INC.

With 16 millimeter motion pictures developed from a toy into a world wide industry, and with business in general tending toward consolidation, the merger of the Centaur Film Laboratories, Inc., Cine Art Production, Inc., and the Hollywood Movie Supply Company, all Hollywood companies whose activities have pertained to the 16 millimeter motion picture industry, into Hollywood Film Enterprises, Inc. has just been consummated. This will make one of the largest organizations of its kind in existence today.

The new organization will reach out into the many branches of the 16 millimeter field and is planning many things for the future development of the industry. Simultaneous with the announcement of the consolidation is the announcement of the consolidation is the announcement of cineVoice, "the voice of home movies," a portable home talking picture attachment Hollywood Film Enteprises, Inc. is putting on the market.

This device, which will attach to any 16 millimeter motion picture projector or any portable 35 millimeter projector, has been carefully planned and built according to the specifications of sound engineers of the professional motion picture world. It plays sound-on-disc talking pictures recorded either at the standard professional speed of 33 1-3 revolution of the turntable per minute, or at the standard phonograph speed of 78 revolutions per minute.

Along with the announcement of cineVoice also comes the announcement of the first films of a series of full reel feature talking pictures for the home recorded at the professional speed of 33 1-3.

Sound recording studios are being prepared by Hollywood Film Enterprises, Inc. Under one roof will be a complete production unit with every facility for the making of both sound and silent pictures for entertainment purposes, these films being released exclusively in 16 millimeter, and also for the production of industrial and advertising films. A complete production staff will devote full time to the making of these last two types of pictures in both 35 and 16 millimeter.

This merger brings into cooperation with this producing unit a distributing organization which is known throughout the world as the distributor of Cine Art 16 millimeter motion pictures for the home, and also one of the finest and most complete laboratories devoted to 16 millimeter films there is today. The laboratory is also doing developing and printing for some of the foremost motion picture producers in Hollywood. The unit which was formerly the Hollywood Movie Supply Company will continue as a retail distributor of motion picture equipment in and around Hollywood, California.

Hollywood Film Enterprises, Inc., as well as taking over the parent companies, will continue to maintain the branch offices established by Cine Art Productions, Inc. in Chicago and New York. These offices will be direct branches of Hollywood Film Enterprises, Inc. for the marketing of Cine Art 16 millimeter films and cineVoice, and for the making of industrial pictures, both silent and sound,

with a production staff available at each of these offices.

The New York office, located at 6-8 East 46th Street, will be in charge of Mr. Harry S. Millar, who has been with Cine Art Productions, Inc. for the past two years. Mr. John J. Mertz, who has been with Cine Art Productions, Inc. in Chicago during the past year will be in charge of the Chicago office located at 109 North Wabash Avenue.

WELCOME CINEMATOGRAPHY

With the April edition the magazine of Local 644, New York City, theretofore known as the *Bulletin* of "The International Photographers Local 644," burgeons forth in a new dress and under a new name—"*Cinematography*."

Lawrence A. Fiferlik is the new managing editor and The International Photographer, Hollywood, hereby extends to him and his new book a most cordial welcome to the field. Congratulations 644!

IN TEK-NIK-TOWNE

Mr. Edward O. Blackburn, general manager of J. E. Brulatour, Inc., 6700 Santa Monica Boulevard, Hollywood, distributors for Eastman film on the West Coast, is the proud occupant of one of the finest offices in Western America. Recently the Brulatour architects reconstructed Mr. Blackburn's old office, the featured change being a magnificent wainscoting of black walnut constituting a complete inner-lining of the room. The furniture, fixtures, lighting equipment are in keeping with the woodwork. No; the price of Panchromatic No. 2 Type has not advanced.

FILM WANTED

The following motion picture scenes are wanted in connection with a film on Rocky Mountain Animals. Owners of original negative only need submit. Duplicating Positives made from original negatives can be used. Please submit a list of scenes available and state if you will send a positive print for inspection.

Rocky Mountain Peak and Timber Line Mammals.

Mountain S h e e p, Mountain Goats, Marmots a n d Conies.

Rocky Mountain Wooded Area Mammals.

Mountain lion, gray wolf, grizzly b e a r, black bear, mule deer, pack rat.

The Plain Country:

Antelope, American e l k, coyotes, buffalo.

Address Hereford Tynes Cowling, Eastman K o d a k Co., Rochester, N. Y.

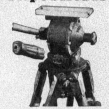

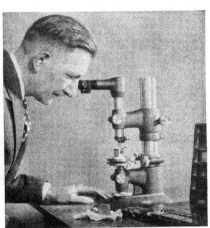

A Sound Printing Attachment

For Bell & Howell Continuous Printer

From the Technical Service Department of the BELL & HOWELL COMPANY

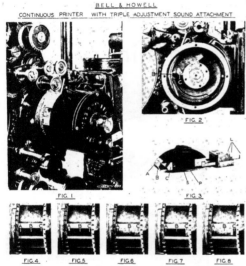

BELL & HOWELL
CONTINUOUS PRINTER WITH TRIPLE ADJUSTMENT SOUND ATTACHMENT

FIG. 2

FIG. 1 FIG. 3

FIG. 4 FIG. 5 FIG. 6 FIG. 7 FIG. 8

'A' 'B' & 'C'-- SHUTTERS MASKING SOUND AND PICTURE AREAS.
'L'- SHUTTER OPERATING LEVERS 'S' - PAWL TENSION SPRING
'P' - SHUTTER LOCK PAWL

FIG. 1 - MAJOR DETAIL OF B&H PRINTER - WITH GATE REMOVED.
FIG. 2 - THE TRIPLE ADJUSTMENT SOUND MASK ATTACHMENT - INSTALLED.
FIG. 3 - THE TRIPLE ADJUSTMENT SOUND MASK ATTACHMENT
FIG. 4 - SHUTTERS RETRACTED FOR FULL APERTURE PRINTING
FIG. 5 - SHUTTER 'A' SET FOR MASKING THE SOUND AREA - FORWARD RUN
FIG. 6 - SHUTTERS 'B' & 'C' SET FOR MASKING PICTURE AREA - FORWARD RUN
FIG. 7 - SHUTTER 'C' SET FOR MASKING THE SOUND AREA - REVERSE RUN
FIG. 8 - SHUTTERS 'A' & 'B' SET FOR MASKING PICTURE AREA - REVERSE RUN

In order to fulfill the technical and commercial exigencies imposed upon the motion picture laboratories by the advent of sound pictures, it was found necessary to devise means by which the accurate and rapid printing of the sound negative could be conducted independently from that of the picture record.

The well known characteristics of sound recording and reproducing demand an extremely smooth and continuous motion of the film in front of the scanning slit, as well as a perfect control of the sources of light which impress the film upon which the sound record is registered or excite the photoelectric cell in the process of reproduction.

The meticulous care with which a film sound record is made would be of no avail if the printing process of the sound negative could not be controlled with equal certainty and accuracy.

From the early inception of sound pictures, it was evident that the Bell & Howell Continuous Printer answered all the requisites of sound pictures, because through years of patient research it had reached such point of development that all the refinements most appropriate to take care of absolute film registration were incorporated in it.

It remained to devise means by which the printer could rapidly and with least inconvenience to both laboratories and producers be made adaptable to the new condition.

The Bell & Howell engineers happily solved the problem by designing a "Triple adjustment sound printing attachment" which can be adapted to all Bell & Howell printing machines in existence and, of course, to all apparatus being manufactured.

In order to fully appreciate the problems involved and the unique manner in which they were solved, let us summarize the requirements imposed.

1. It was desirable that existing equipment could be used.

2. The sound attachment should preferably require only nominal alteration and fitting.

3. Definite light control for printing the sound and picture portions independently should be insured.

4. If possible, the attachment should permit printing either the sound or the picture area from either end of the roll, the eliminate waste time in rewinding.

5. It was desirable that it comply with the standards approved by the Society of Motion Picture Engineers, whereby a black light shield is to be printed along the sound track to eliminate any possibility of variation of tone in sound reproduction due to a possible side motion of the film in front of the scanning slit of the projection apparatus.

6. The device should be convenient, quickly set at any desired adjustment, positive and accurate.

7. It was desirable to have the masks arranged so that the full negative (for silent pictures) could be printed at one adjustment.

The following description will explain clearly how very effectively the Bell & Howell Company have solved this problem, and the figure illustrating this article will clearly illustrate the workings of the attachment.

At 1 and 2 the triple adjustment sound attachment is shown installed in the standard Bell & Howell Continuous Printer. The attachment itself consists of two main assemblies — the masking unit and the operating lever unit.

The masking unit is installed in place of the usual top aperture plate. After it has been accurately adjusted in the printer, a hole is drilled through the top of the printer casting into the masking unit, and tapped. This insures the masking unit always being held in perfect alignment.

The operating lever unit is then inserted through an accurately milled slot in the printer casting so that the levers engage the masks proper. The operating unit is then fastened permanently in position.

At 2 is plainly shown the manner in

(Concluded on Page 18)

THE DIETZ FAMILY

"Dubbing," the motion picture process of combining numerous sounds and scenes on one film, has its word origin in "dove tailing," according to William Dietz, chief of special effects and miniatures for Pathe pictures and member of Local 659.

"It is an economical way of securing brilliant effects and will be used more and more in talking pictures."

One of the first outstanding pieces of work with "dubbing" was created by Dietz in "Paris Bound" in which twenty different scenes were combined for one sequence.

"We had only six minutes for the sequence," said Dietz. "In that brief time we had a kaleidoscope of events to present. A street is crowded with coming and going people. Two criminals rob and murder a rich couple. A chase begins—the law, the murderers, and the spectators depicted in whirling, stimulating movements.

"The criminals are caught. A funeral march indicates the death of one. Life goes on, the music of crowds trying to be gay combatting the sad music of the funeral march. Every angle was used for these shots. Cameras were focused from the crow's nest, from the floor, from the crane and from the pit. The result was 'dubbed' into what we call an impressionistic scene."

Dietz is at present doing special camera effects for "Hell's Angels," "Journey's End," "Swing High" and "What A Widow," Gloria Swanson's current picture.

Dietz won the title of "Hollywood's Aerial Cameraman" several years ago when he learned to fly a ship and secured a government license. This accomplishment has its inception in the demands of aerial films. When taking air scenes, he found it difficult to get the shots he wanted because pilots did not, naturally, understand camera angles.

"By operating the ship myself, I could take another cameraman along and get just the angles I wanted," explained Dietz.

Mrs. Dietz, known in the film world as Barbara Hunter, realized she could be a tremendous help to her husband by learning to fly. She studied under his tutelage and recently, when she went to Washington, D. C. in connection with a picture she had cut, she applied for, and

received a pilot's license. Now, when air scenes are being filmed, she is often at the "stick."

Dietz joined Pathe studio during the filming of "King of Kings," when thirteen trick cameramen were on the studio payroll.

"I'm the only one left. Do you call that unlucky? I was born on the 13th and the number has no jinx for me at all. I would just as soon end up the day on Special Shot No. 13. Or sit down at a table with 13 people. I decided I was born under a lucky star after my experience of running out of gas 3000 feet in the air and making a safe landing."

The business career of this young man is varied and long. He is a graduate of the Oregon Institute of Art in Portland and has used his art knowledge in theatrical work and in illustrating his mother's magazine articles. His sketching comes in handy at his present job, too.

Bill learned to operate a motion picture camera at high school in Portland. Before he graduated he was operator in a Portland film house and was later made manager of the theater as well. The road to his present job is studded with a dozen different kinds of work—from janitoring to playing a banjo in a dance orchestra.

OUR 659 RIFLE CLUB

Those members of Local 659 who are interested in pistol and rifle shooting will find a wide field for their talents along these lines in membership in the Hollywood Rifle club which is an organization sponsored by a number of shooting enthusiasts of Local Union. The rifle club is affiliated with the National Rifle Association through which affiliation guns, targets and ammunition are furnished to club members free of charge.

The National Rifle Association is one of the oldest sportsmen's organization in existence in the United States. It was incorporated in New York State in 1871 and still operates under its original charter.

The N. A. A. has long outgrown its original status as an organization for Target Riflemen only. It is today the accepted representative of the shooters of America in the halls of Congress and state legislature. Its programs cover all

types of small arms firing except shotgun shooting and its service to its members includes everything from the provision of matches and trophies down to assistance in locating good guides and fields for hunting. It has been of material assistance to various bankers' associations in curbing bank robberies and it has been largely responsible for the increased interest on the part of police departments in the subject of marksmanship. It has prevented the passage of many so-called anti-firearm bills. in state legislatures throughout the country where the effect of such bills would have been to deprive honest citizens of their guns.

The membership of the N. R. A. includes every type of American without regard to race, creed or sex. Its ramifications embrace the farthest bounderies of the globe, its creed "America First," and through the instruction of its members in the use of fire arms it assures a reliable means of home defense, both against foreign aggression and the invasion of the precincts of the home by unauthorized persons bent on criminal errands.

Rifle and pistol shooting teaches coordination, keenness of perception, steadiness of the nerves and sobriety, a few things that all photographers find essential to the artistic and mechanical progress of their craft. Also it offers a change from the ordinary line' up of sports.

Membership in the Rifle Club is $5,00 per year and includes a year's subscription to the "American Rifleman," 200 rounds of 30 Calibre Ammunition, 300 rounds of 22 Calibre ammunition, Springfield Service Rifle, 22 Government Rifle on 30 calibre frame and all targets, carriers and materials for the conduct of a rifle range.

If interested, apply to Howard Hurd, Roy Klaffki or Gene Hagberg and then go into the recreation room and take a look at the charter and read the bulletin pinned to the wall beneath it.

The Eighth International Congress of Photography will be held in 1931 in Dresden. It will convene on Tuesday, July 28, and adjourn the following Saturday, August 1.

First National Locals

—BY—
ONE OF OUR BOYS

Howard Hawks is directing an air picture, "Without Women," featuring Richard Barthelmess and Douglas Fairbanks, Jr. Ernie Haller is nonchalantly bearing the photographic burden with the help of Bull Schurr, Bob Wagner and Dick Fryer. The weight of worry and cameras are borne by Fredricks, Larson, Belmont and Cable. Elmer Dyer and Ray Olsen are the Akeley specialists. Bill Walling shoots the stills and Hoover mounts the cameras on the ships in such a way that they wont fall off while in the air, we hope. The company has spent considerable time at Newhall and Calabassas.

Frank Lloyd recently finished a picture entitlde "The Right of Way," with Conrad Nagel. John Seitz was master of cinematography. The "eagles" were shot by Reinhold, Davis, Cohen and Towers. Classberg, Trafton, Roberts and Sargent carried the guns and ammunition. John Ellis made pot shots with a still camera.

First National Studios have devised a new type of "blimp" to the unbounded joy of the second cameramen and the everlasting dispair of the assistants. It is composed of a transparent material, similar in appearance to celluloid, and is without doubt the light-weight champion of the species. The motor is attached directly to the camera. One of the outstanding advantages will be in bringing the cameramen into the open, thereby enabling them to know what is going on in and about the set. Here-to-fore the directors have enjoyed a handicap, by changing the action at the last minute, the innocent ones in the booths have been exposed to the extreme embarrassment of seeing the principals leave for parts unknown and of discovering strange people in their finders during the take. The assistant will also benefit, the extra fifty pounds will develope his physique and he will grow to be a strong and robust man.

Hal Mohr is using his own inimitable brand of photo-technic and gauzes on Eddie Cline's picture "Man Crazy." Glenn Kershner, Evans, McLean and Greenburg use their ability and pan handles, while Underwood, Surtess, Rice and Finneeman just use their backs. Bert Six uses a bulb. Alice White is the star.

Tony Guadio, with a team composed of Branigan and Heller, Larabee and Beckman, Diamond and Whitley, Kronman and Brigham, LaPrell and Palmer is photographing a picture for Wm. Beaudine called "The Devil's Playground" with Billy Dove. Earl Crowley makes 8x10 portraits between set-ups.

The boys on the Hawk's company worked a stretch for 27 hours. At the new rate the accumulated profits should about equal the expenses of a trip around the world. But inquiries reveal the fact that most of the extra remuneration was paid out for rest-cures and over-time on sleeping accommodations.

Edward Dillon's picture, "The Girl of the Golden West" is being well taken care of. Sol Polito looks after the lighting. Kesson, Ramsey, Joyce and Gray look after the focuses (foci ?). Mitchel, Andersen, Dugas and Heckler just look after—everything. Mac Julian watches to see that they don't move.

Mervyn LeRoy is directing "Top Speed" while Sid Hickox is photographing it both good and fast. The second men, Linden, Dean, Walters and Lawton are always on their toes. The assistants are also good—when fast asleep. They awake at the call of Warren, Worth, Weiler and Hower. Don McKenzie is their still man.

Eli Fredricks: "Do you have calibrated lenses on your camera?"

Max Heller: "No, they are all Astros." Never-the-less Max shagged magazines the rest of the afternoon.

And believe it or not no one laughed.

Willard Van Enger is shooting 'shorts' with whatever photographic talent happens to be available at the time.

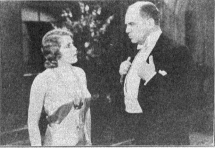

B. & H. Sound Printing Attachment

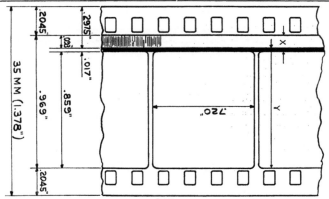

FIG. 10

(Continued from Page 14)

which the sound attachment is arranged. Note carefully how the masks of the sound attachment interlock with the lower aperture jaw to prevent light leakage.

In the early models of the B. & H. Printer, the printing light was controlled through the mobility of the jaws of the printing aperture. By enlarging or reducing the printing aperture more or less exposure was given the positive film for a uniform running speed of the machine.

A refinement developed a few years ago added a new method of light control called the "black shutter," which, as its name implies, consists of a variable aperture shutter located at approximately middistance between the printing light and the aperture. The versatility of this method of light control is so great that it permitted to dispense with the varying in width of the printing aperture itself while retaining a great range of light intensities easily controlled from the outside of the apparatus.

The "black shutter" proved invaluable in the development of the triple adjustment sound attachment, because it permitted to stabilize the printing aperture to a standard 5-16" dimension which is also the height dimension of the triple mattes.

The "back shutter" method of light control is applied to the independent printing of both the picture or the sound record, as the occasion arises.

Now let us turn for a moment to a consideration of the actual manner in which the three masks are arranged so as to control the final result in the print. At Fig. 3 is shown the complete unit so that its action can be more clearly visualized.

Three masks are employed, the width

of the center one being—.750" and of the two side masks—.107" each. They are made so that they fill the 5-16" high opening. These masks are made to very close limits, as may be expected, to insure accuracy in their action, and eliminate the possibility of light leaks at their adjacent sides.

Each mask operates in accurately milled control slots in the main casting. On the under side, each mask has two slots cut, into which the pawls P (Fig. 3) engage. These pawls are held in place by the triple-tongued Spring S (Fig. 3). The slots in the masks are ½" apart, so that the stroke of the masks is ½". This withdraws the masks sufficiently far back to avoid any interference with the printing light.

Figure 2 demonstrates this more clearly than any further explanation.

The middle mask is cut away just back of the part that blocks the aperture. This recessed portion comes within 1-16" of the front and is arranged so as to avoid any possibility of fringing due to reflections from the sides of the masks. In practice, it insures the line between the picture and sound areas having sharply defined edges.

The two side mattes are milled with a slight rib on the sides adjacent to the middle mask. This rib is ⅞" from the front of the mask and protrudes .014" from its side.

When the middle mask (B Fig. 3) is pulled back, it engages this rib on the side mask and moves it over sideways. The mask is moved .017" at the aperture itself. This means that the sound track mask does not cover as much space adjacent the picture area as it did before. Therefore, that portion of the film now uncovered (.017" wide) receives a double

exposure, which results in a black line, or light shield between the picture area and the sound track.

Reference to the dimensional drawing (Fig. 9) and to Figures 4, 5, 6, 7 and 8 will show exactly what goes on. When the middle mask B (Fig. 4) is drawn back it engages the mask A (Fig 5) and pushes it to the left. In this position the mask A (Fig. 5) covers the sound track proper and the portion of the negative marked Y (Fig. 9) is printed. However, when the sound track is to be printed the mask A (Fig. 6) is set back and the area marked X (Fig. 9) is printed. This overlapping of the two exposures produces the black line between the sound and the picture area. As stated previously, the overlapping is adjusted so that this line has a width of .017". To insure clarity in presenting this explanation of the modus operandi of the masks, it was assumed that the film was rewound before the printing of the masks and picture areas.

Now let us assume that we have printed our picture area as before with the masks as in Fig. 5. (The negative will be in the forward running position). Then if we desire to print the sound area without rewinding, we remove both the positive and negative films from the takeup spindles and put them on the feed spindles. The printer is again threaded up and the masks set in the position shown in Fig. 8 instead of position 6.

Reference to the captions given in the figure will show how the masks are set for different conditions — it is obvious that the versatility of this sound attachment is all that can be desired. It can also be accepted that its accuracy is likewise.

An Experience With African Buffalo

—BY—

W. EARLE FRANK, *Local 659*

To get a proper picture of stampeding buffalo is by no means a simple undertaking, since the particular "shot" we wished was a herd of no less than fifty animals coming directly into the lens of the camera and yet save the instrument, to say nothing of the man behind.

The motor lorries were loaded with camera equipment, guns, bedding and food traveling about thirty five miles per hour over the Kafue Flats to some point fifty miles from our main camp when, of a sudden, we crossed a number of fresh buffalo trails all leading in the same direction and, from the number of spoor, proved well over the number required. We stopped, taking a general survey of the land, where these animals go, at what time of day, since light conditions must be considered; we off-loaded.

That entire day was spent in studying the habits of this particular herd since we had tried in vain for six weeks with hours from 3 a. m. to 6 or 7 in the evening, arriving back in camp at 10 or -1 o'clock at night, fagged out and nothing gained, only to repeat the routine daily.

The Kafue Flats at this point was a stretch of flat country with buffalo grass growing in various heights from two or three inches to twelve feet. Most of it was about four feet high which made it possible from atop of an ant hill to locate animals with binoculars at a great distance.

The main water course of the Kafue River bordered the flats on the east while, some four miles west, on the opposite side of the flat, was a narrow but deep swamp extending about five miles in length, with the exception of a small neck near the center. This was some two hundred feet wide which, in this case, was the only outlet for this herd in coming from the feeding grounds back to the dense thorn bush saka where they lie down during the heat of the day.

Next day, from the top of a high ant hill, I could plainly make out a huge black mass moving slowly about over the flats, proving that the buffalo were still grazing on the flats and that the plans previously made held some possibility of getting a head-on stampede picture as the script called for.

We quickly camouflaged one of the lorries to represent an ant hill similar to those surrounding us so that we might place it squarely on the buffalo trails leading to the saka and about five hundred yards from the neck of the swamp.

On the top of the lorry a platform had been previously arranged to hold a camera at high elevation. This was G's set-up; the next camera was placed on top of an eight foot ant hill just at the dry neck of the swamp.

This was a favorite spot since it was up to me to photograph whatever might happen at the neck of the swamp and by all means to direct the herd into the other camera some 500 yards further along the buffalo trail. They must be on a stampede de luxe to enter the camera lines at this point.

W. Earle Frank, second cameraman, Local 659, was with Clyde De Vinna, on the Paramount expedition to Africa shooting "Trader Horn." Mr. Frank will appear again soon in The International Photographer *with another story about the African buffalo.*— Editor's Note.

Having the camera well braced and camouflaged with grass, I turned my attention to my boy holding my ammunition jacket, double bore 500 express rifle and canteen. I had sent him far enough away and safe in a tree. When all was ready I climbed the ant heap placing my rifle against the tripod leg, and laid two extra steel bullets on top of the camera, "just in case."

Having previously hired some fifty natives from the adjoining village and with the assistance of H in the other lorry, the drive was started at 9 a. m., October 11.

From the top of the ant hill I saw great clouds of dust rise and then disappear only to be repeated as the drive progressed. At times they seemed to disappear completely then suddenly from my view point the herd seemed to be headed the wrong direction and again the dust settled. I grew nervous as I felt something had gone wrong; maybe a charge on the other car or a stampede on the natives. It was a hot spot standing on the ant hill and I wiped my brow so many times I thought the skin would come off. While waiting patiently for something to happen, I examined my gun to make sure it was loaded. It was red-hot as though it had been shot a dozen times in quick succession, but only from the sun's blistering heat.

As the drive came on, I could see nothing. I picked up my glasses to have another look only to have the perspiration seep into my eyes at the moment when I thought I could see something black coming toward me. It was some time before I could see it again when suddenly they came from the long grass—not buffalo but native drivers. H. was with them. As they neared me, H. yelled: "Did you get your picture of the buffalo?"

"Which picture of what buffalo? I have seen nothing that resembles a buffalo. Where's the car?"

H. replied: "It was back some distance with a flat tire and in a deep hole."

All hearts sank, but after a hasty lunch, we felt encouraged to try again—12:30 and after extraction of the truck from the hole, repairs, and watering, the drive was started once more.

The buffalo had worked their way nearer, but in the long grass those on the drive could not see over the top, with the exception of H, in the car who, of course, directed the drive as best he could. From the top of my ant hill I could plainly see the grass being trampled by the many hoofs of the buffalo, while very soon the dust obstructed everything as the herd came into the open.

It was a glorious sight to see them coming on at break-neck speed. At this moment a shot rang out. Obviously it was H's gun, but why, since we were not shooting unless absolutely necessary. Another shot followed by two more. Something must be wrong. But on came the herd and great clouds of dust followed which blotted out all signs of what might be happening behind them. On they came—nearer—nearer. "Some herd," I thought to myself. "They are coming just

(Concluded on Page 26)

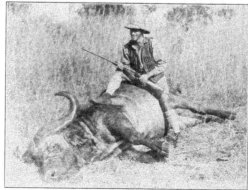

W. Earle Frank, Local 659, with his first buffalo kill.

Fearless
Silent Super-Film Camera

For the New 65 mm. Super Film

A new Universal Camera for modern conditions scientifically designed to meet the requirements of the modern cinematographer. This new camera is the only one which can be used for both the new wide super-film and 35 mm. film. It is designed to fill all the needs of the profession today as well as the future. This camera is presented as the last word in design, construction, workmanship, and materials.

Our factory is now in full production on Fearless Super-Film Cameras for the new standard 65 mm. super-film.

Orders for sixteen Super-Film Cameras have been booked since our April announcement

Fearless Camera Co.

7160 SANTA MONICA BOULEVARD
HOLLYWOOD, CALIFORNIA

Telephone
GRanite 7111

Cable Address
"Fearcamco"

CABLE ADDRESS "BRULAT" TELEPHONE HOLLYWOOD 4121

J. E. BRULATOUR, INC.
6700 SANTA MONICA BOULEVARD

DISTRIBUTORS OF SENSITIVE FILMS FOR MOTION PICTURES
MANUFACTURED BY EASTMAN KODAK CO.
ROCHESTER, N. Y. HOLLYWOOD, CALIF., April 22, 1930.

This is NOT an advertisement ----

"ALL QUIET ON THE WESTERN FRONT"

Hollywood is hushed ---- awed ----- speechless -----

I am bewildered --- I am groggy ---- I grope for words ----

Last night I attended the premiere of a great picture at The
Carthay Circle Theatre ----

Cheap effusions ---- hollow congratulations to the men of genius
who are responsible for this milestone in the upward path of
picture production might be misunderstood ----

I could wire loquacious laurels to a courageous producer ---

I could send a bouquet of beatitudes to a master director ---

I could express my gratitude and appreciation to a master cameraman ---

But to men of such inspiring intelligence ---

What can I say ?

They know what they have done ---

They knew what they were doing ------

I bow to them in the eloquence of respectful silence ----

And I humbly acknowledge

They have taught me a great lesson ---

CABLE ADDRESS "BRULAT" TELEPHONE HOllywood 4121

J. E. BRULATOUR, INC.
6700 SANTA MONICA BOULEVARD

DISTRIBUTORS OF SENSITIVE FILMS FOR MOTION PICTURES
MANUFACTURED BY EASTMAN KODAK CO.
ROCHESTER, N. Y. HOLLYWOOD, CALIF.

They have given me the greatest inspiration I have ever had in my twenty years of selling screen perfection ---

They have given me a bigger faith and a finer understanding and appreciation of my own product ---

They have humiliated me with their bombardment of conviction which has broken down the last line of possible resistance in the mind and heart of any thinking cinematographer ---

The man who photographed this splendid screen document was not asked to use the product which I have the honor and privilege of selling ---

He was selected for the big job because of his ability and consequent reputation ---

He chose the film which has consistently and constantly emphasized his ability ---

The film which has safe-guarded his reputation ---

Today --- in Arizona --- in the very heart of the great west -- he starts the photography of another colossal cinema conception with another great producer and another great director ---

All Quiet On The Western Front ---

With Pardonable Pride

Awards of Merit of the Academy of Motion Pictu

Awards of merit for outstanding individual achieven
in motion pictures were presented by the Academy of M
Picture Arts and Sciences at a banquet in Los Angeles, rece
The ceremony, which is an annual event, was attended by
300 Academy members and guests.

rts and Science for the Year Ending July, 31, 1929

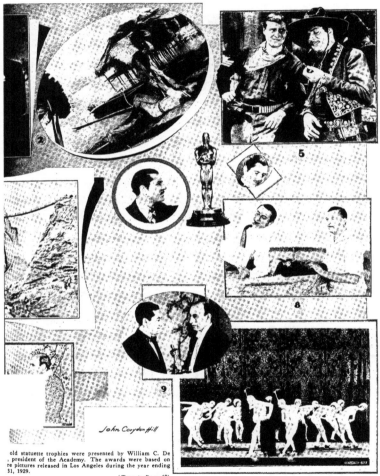

John Corydon Hill

old statuette trophies were presented by William C. De
, president of the Academy. The awards were based on
re pictures released in Los Angeles during the year ending
31, 1929.

(*Turn to Page 48*)

AN EXPERIENCE WITH AFRICAN BUFFALO

(Continued from Page 20)

as the doctor ordered, right into the narrow dry neck between swamps."

Now they disappeared into the trees that bordered the swamp on the opposite side—3:30 p. m. The camera clicking off that wonderful sight. Single file they came on with heads high and noses straight forward. There seemed no end to the long thundering herd coming through that narrow neck.

"Will they ever quit," was my thought, "or am I to run out of film in the midst of the on-rush of about four hundred strong. That must be the end, surely."

Immediately I swung the camera around to film the entire herd in one great line. Grind—grind, until they were well out of my picture, when suddenly I looked up from the camera's finder to feel my heart sink. The entire herd was headed in the wrong direction. The line of stampede was circling toward the village.

They must have got my wind. There was no time to lose now, for I must try to change their course and head them on into the other camera further along the trail. The herd was circling to the left instead of right.

I did not see my gun boy come up, but he was there with my gun jacket on. In my haste to get down from the ant hill, quickly grabbing at the two extra steel bullets that were on the camera one fell to the ground on the opposite side of the ant hill, I having no time to go after it. I ran towards the fleeing herd, shouting and firing a left barrel shot at the ground to the left of the last animal. He seemed so large he could scarcely keep up with the rest of the herd. At the shot's report the herd circled still more to the left. My heart sank. The natives in the village started screaming as the herd was almost on them. It seemed too late to try to turn them. I was furious. Not wishing to have any injured animals run through the other camera lines, I quickly decided if I could hit that big fellow hard enough to stop him, perhaps that would help as sometimes a stampeding herd can be changed in its course by shooting one of the stragglers rather than the leaders.

I gritted my teeth and let drive with my remaining right barrel. The bull dropped or rather flip flopped while rolling over and over. It worked as the entire herd broke from their long line of stampede to a right angle which made

fully a 300 yard-wide mass of thundering, stampeding buffalo who headed exactly as planned into the other camera. That sight was glorious for it meant a great relief.

What to do next was a question, as from my position it looked as though the entire herd had blotted out the car and camera, to say nothing of the man behind the camera. I started to run in that direction to help them shoot their way clear of buffalo. A shot was fired in the midst of the dust which caused me to stop, when something seemed to carry my eyes back to the old bull that I had shot only to see him charging down on me with head down. I had but one bullet left in my hand, the boy having my ammunition jacket and no boy could I see. Losing no time in ejecting and reloading I fired and the animal stopped dead at the crack of the gun.

The boy must have heard my shot as he came running to me yelling with a shrill voice, "Bwana! Bwana! Bosop! Bwana!" and pointing back of me. I wheeled around only to see a cow buffalo charging down on me. She was at top speed about a hundred yards from me and followed by a nearly grown calf, just coming through the neck of the swamp.

I had no ammunition and my boy was running away. I immediately charged after the boy, yelling for ammunition. That boy certainly could run. I simply had to catch that boy but it seemed I could not. I had already run so far in the blistering heat with the now heavy gun (since I had already thrown my binoculars and helmet away to lighten the load) before the boy slackened speed. I finally made him hear me, but I was afraid it was too late. I looked around as I ran, now keeping my eyes on the charging cow rather than the boy as she was nearing all the time. I changed my course, so did the cow. I noticed the native drivers coming through the neck of the swamp, but they could not help my situation. I could just barely move along now as my breathing was intense, drowned in prespiration, my eyes popping out and all in. My boy stopped, luckily I fronted the cow while I could, walked backwards towards the boy. I was thinking what a poor club a 500 heavy double rifle would make while I was so weak I did well to lift it. Now the cow was no more than fifteen paces from me. Curiously enough it was my birthday; I had already sent up a prayer of gratitude knowing that my insurance was paid,

when, with one last good-bye-cruel-world grabbed backwards, my hand fell on my jacket, which was worn by the boy. Two steel bullets actually flew into the breech of the gun as both barrels spoke at the same time. The boy and I went down together since the recoil of the gun's two barrels at the same time along with my weakened condition luckily knocked me over backwards as the buffalo stumbled past me in a heap. Fortunately the frenzied calf turned to one side and stopped in a curious manner and, from my unpleasant position, sitting there on the ground, that calf looked twice the size of the cow.

The boy from some distance away threw a handful of bullets towards me which I immediately made use of, the metallic sound of fresh bullets bringing the calf down to my size. I was too weak to move but had to laugh at the exceedingly uncomfortable situation while the sun was baking my head and back until the native drivers came up with my helmet and binoculars.

They helped me to the lorry on the trail where I sat on the running-board still trying to get my breath. I looked over some few yards from the car and there lay another bull buffalo that had charged the lorry.

A government O. H. M. S. messenger came over from the village telling us that two buffalo had attacked them which they were compelled to spear, while H soon came in with his story of a charging buffalo which he had to shoot to save a couple of boys on the flats during the drive and that the lorry was still on the other side of the swamp steaming away and having but one good tire.

That night I celebrated a birthday, Christmas, and Fourth of July all at once.

A Tribute to the Engineer

CONTRIBUTED

It is gratifying indeed to know that time, in its flight, makes many changes. These changes should always be looked upon as progress. Progress means the going ahead with our ideals.

Individually, one may not always think of progress, as time changes, but collectively, we always note progress as time advances. Time is also a wonderful healer, the pains, the heartaches and sorrows, are all cured by time. Only in progress can real happiness be found. Apply the test to physical and moral development or to worldly attainments and you must find that you are not happy unless you are improving. In this article the writer has taken time as the fundamental principle for what is to follow.

The history of motion pictures, over a period of twenty years, truly reads like a modern thousand and one nights, but I wonder if those outside of the industry realize the many heartaches that have caused those thousand and one nights loss of sleep.

The progress that the motion picture industry has made over a period of twenty years, placing it fourth in our national industries, has reflected the ability of the studio engineers who have made this wonderful record for themselves, but whose praises are never sung; not that they ever have sought it, but whenever any reflection is cast upon their ability and progress, their voices can be heard all over the world.

Often, as I have attended meetings of these enginners, when they gather at the festive board to exchange ideas and offer suggestions, I wished that representatives of other industries could be present and note the happy care free look upon their faces and listen to their good natured banter. Then the observer would realize that only in progress can real happiness be found and the studio engineers are one of the happiest set of men in the world. Happiness, found in their progress, but never boasting.

The many accomplishments that come to mind would require page upon page to record, but the writer will attempt to

select some of the outstanding ones over this period of time.

The first to come to mind is a picture called "Neptune's Daughter," showing the famous crystal caves of Bermuda. These caves have a subterranean lake about two hundred feet underground, the roof being of stalactite formation. The scenes photographed in there were beautiful and showed plenty of illumination.

A later picture, "Twenty Thousand Leagues Under the Sea," filmed in the Bahama Islands, showed the balloon ascension, Captain Nemo's submarine at sea, a yacht traveling at full speed—all photographed at night. Then followed "A Daughter of the Gods," filmed in Jamaica B. W. I.; the photographing of Niagara Falls and the lower gorge from the Canadian side at night. We then change our geographic location and cite "The Covered Wagon," "The Iron Horse" and many other big pictures.

These, were the fore-runners for what the engineers now have at every studio, namely, gas generator sets, capable of generating more than 1000 amperes. These sets are mostly used where there are no light and power lines. Where there are power lines, portable motor generators are used when working on location.

Other equipment developed by the engineers are as follows:

Wind machines, both gas and electrically driven; lightning torches; water pumps capable of 700 gallons a minute; rain machines and many other devices necessary for the construction of motion pictures.

A review of the lighting equipment of the past fifteen years would fill volumes. From the old style arc lamp built for portrait studios and using a large glass globe and drawing 30 amperes, to the present day high intensity arc, drawing twice the amperage and giving thousands of increased candle power and costing less than half of the old style 30 ampere lamps to operate, preaches a sermon in itself on the progress the motion picture engineer has made. Now codes for fire

prevention had to be written for the studios, new safety factors introduced for the protection of life and limb. Who brought all this about? The studio engineer, of course.

With the advent of sound pictures, a new craft was introduced into the studios, which for a time threatened to surpass the studio engineer, but that was only temporary. When sound stages were first built, they were very small, it being said that no more big pictures would be made, due to the limitations placed on recording. Some sound stages had concrete walls, over one foot in thickness to keep out extraneous noises. That was before the studio engineer was let in on the secret. But what is the result today. Sound stages are building bigger even than in the days of silent pictures and not a bit of concrete is being used except for the foun dation. Who brought this change about? The answer is, the studio engineer.

Today, a goodly portion of sound recording is being done by men who had their training under the studio engineer.

Another development is the progress that has been made in color pictures. A few years ago a color picture was a rare treat to witness and this involved a slow tedious process before being brought to the screen. Today color pictures are every where, with several processes being available to the studios. Credit this to the studio engineer also.

Another problem that presented itself with the advent of sound was the noises found on the set that interfered with the recordi ng. Two of these problems were the noises made by the cameras, and the arc lights. Before the cameras were silenced, which did not take much time to do, once the engineer got busy, the cameramen were housed in large booths, much resembling the old type ice boxes, but the other extreme in temperature. Th cameramen were hoping that they would be out of the booths by Christmas. They are not now.

The problem of arc light noises was

(Concluded on Page 48)

Some Biological Aspects
of Educational Cinematography

—BY—

DR. ALBERTO LUTRARIO, *Member of the International Health Committee of the League of Nations*

Provisions for the culture of the race rank high among the complex and manifold enterprises of the Fascist government.

Physical culture in its most varied forms, from simple medical gymnastics to sports of every description, is a foremost consideration. For this purpose the government has created the necessary instruments and centres, from gymnasium halls and simple playgrounds to vast stadiums.

Mental and spiritual culture is provided for through the agency of the far-reaching and original activities of the National After Work Recreation Societies, the Cinema, and countless other enterprises, calculated to form the new consciousness of the Italian people.

It is beyond dispute that the activities of the cinema hold a commanding position among the numerous state activities.

Besides the National Institute of Cinematography, the Fascist government created the L. U. C. E. Institute which it reorganized by the Royal Decree of November, 1925, and by later amendments (1926 and 1929).

Then followed the foundation of the International Educational Cinematographic Institute which, although an international organization owes its origin to an initiative of the Italian government, which offered to house it, placing at its disposal two stately and beautiful villas. By so doing the government showed its desire to collaborate in the achievement of a human, noble and universal goal, co-ordinating the energies brought to bear on the development of this powerful instrument of world culture.

In this connection the head of the government in his report accompanying the proposal submitted to the League of Nations wrote:

"The cinema, which is still in the first stages of its evolution scores the great advantage over the book and the newspaper of speaking directly to the eye, that is to say of using a language comprehensible to all the peoples of the world. It is from this fact that it derives its universal character and its consequent innumerable possibilities for international collaboration in the educational field."

The cinema is therefore a powerful means of education and, consequently, of moral elevation. An efficacious auxiliary of applied science, it contributes to culture a form if iconography which constitutes a universal language. This is a fact and a fact that is generally acknowledged, but not everyone, perhaps will inquire by means of what biological mechanism the cinema attains such elevated and beneficial aims.

This is an interesting point, which it may not be out of place to elucidate by a, necessarily brief, allusion to some principles of the physiology of the central nervous system.

"Nihil est in intelectu quod prius non fuerit in sensu," wrote Aristotle, defining

Reproduced from The International Review of Educational Cinematography. Published monthly at Rome by the International Educational Cinematographic Institute of The League of Nations.

in his lapidary style one of the deepest and most human laws of physiology, which unquestioned and unmodified, has withstood the passing of the ages and the vicissitudes of human affairs. The senses are, so to speak, the great entrance hall of notions and ideas and, sensation, as Professor Santa de Sanctis has pointed out, is the first contact with reality; transferred to the upper regions of the central nervous system sensation is transformed into perception, that is to say into a conscious and, therefore, more evolved notion, by means of a mechanism which is still surrounded by mystery. Galileo Galilei said well that "to try to define essences is lost labour and a vain endeavor."

As this is a basic conception which forms the pivot of the whole nervous system, it appears advisable to define more precisely the idea of the functions and the nature of sensations.

Nomal man lives in an environment of sensation, both internal and external. From the interior sensational environment, that is to say, from the depths of being, he received, through his general sensibility, impressions regarding the state of his internal organs, which are expressed in sensations of fitness or indisposition. From his outer surroundings the totality of his relaitons to envirement. Such stimuli are numerous. They excite the terminals of the sensitive nerves in different ways, according to the nature of the stimulant, and of the nervous system on which they react. The sensations caused by external stimuli are always specific: Visual, oral, olfactory and tactil, and a special sense organ corresponds to each order of sensation. To awaken sensation stimuli must be adequate in nature, intensity and duration.

There is consequently a limit, short of which sensations do not register, and this limit is called the Threshold, taking its name from Flechner, who discovered it and built a doctrine around it.

Sensation, generally speaking, does not stop at the organs of sense, but, conducted along the nerve apparatus (centripetal or outgoing nerves) rises to the central nervous system, projecting itself on the cerebral cortex, where again, by means of the still undiscovered mechanism, it evolves into that more perfect activity, PERCEPTION, which is always conscious.

There is a profound difference between sensation and perception. Sensation is elementary and consists in the mere presentation of the object to the conscious-

ness. Whereas, according to Reid, perception is a more concentrated state of relations and re-actions, reinforced and illumined by a maximum of personal activity (de Sanctis). We have perception when sensation is enriched and completed by all the accompanying elements of judgment, transforming itself into the most highly evolved state of conscious impressions. Let us suppose that we are presented with a book. The first impression received by the sense of sight is that it is a book, but later, while examining it, we supplement the first impression by many other elements; the title, the author, the shape, the characters, the print, the number of pages and so on. At this point perception follows sensation and discovers numerous other qualities which did not register in our consciousness at first sight.

In the child the impression stops short at the rudimental stage of sensation. But in proportion to the development and perfectioning of the central nervous system, the sensations are transformed into perceptions, at first incomplete, then complete.

Among other aims, education has that of awaking adequate *perceptions.*

But perception does not stop nor end where it arises. In other words, our higher nervous system does not react i the same way as a musical instrument which, after the sound has been produce returns to its normal state. On the con trary our cerebral cortex is like a tele graphic apparatus in which the trans mission of the word remains impresse as upon a strip of paper.

In the same way the perceptions leav traces of their passage adhering to ou memory.

The perceptions themselves, are th cause of other stimuli, which pass throug the nervous system in an inverse sens to the primitive sense stimuli. Instead o rising like the former, they descend. Tha is to say, they move from within outwarc from the center to the periphery, con ducted down the centrifugal nerves, t reach the several organs, where the awaken different orders of reactio These are psychic-reflex actions, stim ulated by experienced sensations and ca ried out by voluntary reactions.

Let us take an example: When climbin a hill, we see a precipice yawning at ou feet. The image of the precipice, forme at the back of the eyeball, traversing th centripetal passage of the optic nerve, i projected on the cortex zone of the occ pital lobe, where it is transformed int a conscious perception, permitting us, i this case, to gain a complete notion the precipice, that is to say to form a estimate, with the assistance of o memories, of its depth, form and stee ness, the rocky or earthy nature of i sides, the vegetation or lack of it, an so forth. This closes the first phase.

Then the second opens. The perceptio

of the precipice and, consequently of the danger, releases a new stimulus within us which, by conduction from the center down the centrifugal nervous system, reaches the muscular apparatus of locomotion, where it is transformed into a series of voluntary motions, co-ordinated and adequate to obviate the fall.

This mechanism, constituting the "nervous process" which, arising from the simple sight of a precipice, continues and culminates in a series of reflex actions, calculated to avoid the fall, takes place rapidly in the normal individual without any break between the first and the second phase.

Similar examples might be multiplied ad infinitum, also with regard to the other sensations, auditory (a sound that causes the head to be turned in the direction from which it comes, olfactory (the perfume of a flower that causes a dilating of the nostrils and a deepened respiration), and so on.

It is always a question of reflexes which are interwoven into our whole psychic life as "no sensory reverberation is without a centrifugal reverberation," according to Professor Patrizi. To believe, for instance, that "a word, a sound, entering the ear, stops at the alleged auditive-verbal center of the listener, and does not move down in minute waves to the muscles of his mouth, would be like supposing that a bell does not resound at the antipodes of the spot where the clapper beats.' (The 'preface letter to R. Bruglia's book on "The Irreality of the Nervous Centers.")

This question of reflexes is still enormously complicated, and although it has entered the field of experimental investigation and promises success, it is still full of incognita. So much so, that Paulow, after twenty years of memorable experiments exclaimed that at the end of this first phase of his formidable task he saw stretching out before him a much longer series of problems than those he had seen before embarking on his venture.

As far back as three hundred years ago, Descartes had started the notion of the "reflexes," as a fundamental activity of the higher nervous system. Every activity of the organism, according to Paulow, is nothing more than a response (reflex) to the sensation produced by a stimulus proceeding down the nervous passages which serve as a *diastyle arch* of passage. The theory of reflexes has cast much light on the complicated phenomenon of the associative power of sensations, perceptions, representations in psychic life, all dominated by these reflexes, which are internal and external, congenital (instinctive, according to some) and conditioned; simple and complex; positive and negative (inhibitory).

Among the reflexes that have been most studied are the alimentary reflexes expressed by animals when craving food, the degree of which Paulow estimated by the quantity of saliva segregated in a given unit of time under the impression of diverse and not only alimentary stimuli. Then there is the preservative stimulus, by virtue of which the animal recedes from destructive stimuli in search of safety. And further, the liberty stimulus, which provokes the defense reaction in the animal when one tries to snare it. And again, the investigation stimulus, which makes the animal turn its head

and prick up its ears as a sign of recognition of a sound. These reflexes manifest themselves in different ways, according to the subject. For instance, the investigation reflex that takes place in the animal, by the raising of its head and the pricking up of its ears, provokes in men of genius grand and unexpected reactions, sometimes leading to discoveries that further the progress of science.

Reflexes are largely dominated in emotional states; commotion, blushing, acceleration of the pulse and breath, weeping, laughter, heightened temperature, are so many reflex activities.

After these allusions to sensations, perceptions and reflexes in general, which are to be found among the fundamental elements of psychic life, we may now return to the specific sensations and the respective organs of receptive sense, the highest of which in normal man is doubtless the organ of sight. The eye is the window of the spirit on the outer world. It is also the fundamental organ for the cinematic function.

The eye is formed on the principle of the "camera obscura" in which the collective (crystalline) lens unites in the rear the luminous rays that form on the retina a diminutive and inverted picture of the objects perceived in the field of vision.

The retina is the indispensable intermediary between the physical phenomenon of light (vibration of ether) and the physiological phenomenon of sensory excitation (vibration of the nervous elements). The vision on the retina reaches its maximum intensity in the "macula lutea" or more precisely in the "foveola centralis."

The retina is not only sensitive to luminous rays, but to other stimuli; mechanical (pressure), traumatic (puncture) electric (current). But it invariably reacts to luminous sensations (phosphorous), according to the noted principle of the specific energy of nervous apparatus, whereby any given apparatus under the stimulus of different impulses always gives the specific sensations inherent in its nature.

The visual image projects itself along the optic nerve by means of a nervous impulse toward the primary optic centers. It passes these to reach the area striata of the occipital lobe of the brain cortex, a zone which is composed of one and a half billion cells of grey matter. Visual sensations are divided into sensations of light, and chromatic (colour) sensations (Santa de Sanctis). Altogether, there exist a total of 32,820 different visual sensations.

The visual sensations are extremely complex and, transferred to the upper nervous system, are the cause of innumerable perceptions and primitive judgments, mnemonic, singular, associative, static, dynamic, and so on. The visual sensation, like other sensations, persists for a certain time in the respective organs.

As a result of this fundamental character, a luminous dot, moving rapidly in a given direction, gives us the sensation of a continuous, not a broken line. This principle is fundamental for the continuity of cinematic images.

The images on the retina are inverted, but we see them upright, because what we see is not within, but outside ourselves, in space (psychic operation). Also

the fusion of the images caused by the pair of eyes, is the result of a psychic operation

Light, aided by the education formed by the example of the other sense organs, enables us to estimate (by psychic judgment) the forms of objects, their dimensions and consequently their size. These are characteristics which we gather not from the dimensions of the images, which are well under life size, but through the processes of the mind due to mnemonic residues and to the estimate of distance. Light enables us to estimate the shape of objects; their position in space (sense of locality), their condition of rest or motion, the direction and velocity of motion. It enables us further to estimate the depth of space.

In brief, a large, perhaps the largest part of the biological characteristics of the way of being, the arrangement and relationship of all our surroundings, perceptions and sensations, is presented to our minds by means of sight, rightly classed with hearing and feeling, though certainly more potent than these, among the "senses of knowledge."

The reference made to the visual center of the occipital lobe of the brain incidentally reminds us of the vexed question of the existence or non-existence of the cortical centers, custodians of all organic activity.

Authoritative voices have been raised against the concept of Charcot's school, which considered the grey matter of the cerebral convolutions as a federation of organs (neurones) each of which had a distinct property, function and faculty. Cowers enjoined that this "center" must not be interpreted in a narrow, topographical or geometric sense. Golgi himself, believed that not only cell bodies, but the diffused fibrillous net took part in the psychosensorial activity. The distinguished physiologist, Loeb, denied as far back as twenty years ago, that the various motor sensory and psychic reactions were necessarily restricted to special cortical zones. Burgia quotes these authorities in his recent work, "The Unreality of the Nervous Centers" and in the volume published this year, "A Revision of the Doctrine of Cerebral Localization," in which the author has accumulated an immense mass of evidence, taken more especially from war surgery, to support his new doctrine of the Functional Unity of the Nervous System, as opposed to the opposite doctrine of independent neurones and their localization.

In spite of all this, the old theory of the nervous centers has still many supporters who can boast of much experimental evidence. However, that may be, this is not the place to discuss this much-contended issue. It must suffice to have pointed it out. But this controversy does not in any way detract from the physiological and psychological importance of sight as a most efficacious means of communication with the outer world, also because the activity of the occipital lobes (area striata and more especially the occipital pole) as a reference goal of the visual sensory perceptive organs, is admitted even by many of the opponents of the doctrine of nervous centers. In the observations made on certain aspects of the physiology of the central nervous system, there are many elements that have a bearing on the biological mechanism of

cinematic images, that is to say, on the influence exercised on our psyche by the living picture of the cinema. These include sensations in general, and visual sensations in particular, the phenomena of perception and the vast stretch of psychomotor and psycho-sensory reflexes.

The secret of the suggestive power of the cinema lies in the manner of utilizing these various constituent elements of biological reactions, and raising them to a high degree of sensory significance.

Each of the Fine Arts has its own mode of manifestation, and its own appeal to heart and mind, and it is not my intention to make comparisons between forms of art that are incomparable. Nevertheless, it is unquestionable that as regards the sensory aspect, certain cinematic images are sometimes more significant than other forms of art.

Take, for example, a landscape. A writer may describe it in clear and adequate words, enabling you to perceive it with the mind's eye (mental vision) in all its fascination. A painter on the other hand will fix it on his canvas, giving you a conception of its reality; but it is a static reality, the fleeting moment held fast by the painter's brush. Whereas on the screen you see the landscape in all its reality, in its dynamic reality. The mountains, the valleys, the houses clustering around the church, the towering campanile, the animals moving under the shady trees with the foliage stirred by the wind, men going about their business. In these images all the manifestations of life are woven together with a grand variety of lights and forms that give relief to the picture. I do not mean to assert that for this reason cinematographic art is superior to that of writing or painting; each has its own special and unique advantages; but doubtless, the landscape projected on the screen assumes for the majority a more convincing, more humanly eloquent appeal, because cinematographic representations are not above anybody's level, while a certain habit of culture is required to understand the beauty of a poem or a prose passage.

The factors which contribute to the expressive energy of the cinema are of various orders. Some act subjectively, others objectively. The former are physio-psychological and refer to the spectator; the others are of a technical order and concern the art of the cinema itself.

Foremost among the factors of the first category is the elementary or fundamental character of the cinematographic, that of teaching us by natural images as Nature herself does. Man in relation to the cinema is in identically the same position as man in relation to nature. He learns by seeing. But there is a difference, the cinema shows a much greater number of images in a given unit of time than Nature can. Take, for example, the film of a scientific expedition; in an hour it will show you the events of several months.

There is another consideration to be made. Man is naturally inclined to be "visual." He is born an image maker and almost instinctively clothes every abstract idea in concrete forms.

The method of art, personifying incorporeal entities, is also that of Nature. Thus a painter personified the images of virtue, vice, justice and so forth, on his canvas. Visual images predominate in our consciousness, and this is most providential, because without this tendency many abstract ideas would be incomprehensible to the majority of us, if they could not be conveyed by means of images.

"Mental iconography," as de Sanctis says, "is a common phenomenon." It is the instinctive tendency of man, who finds his natural mental food in the moving picture.

The cinema, as we have already pointed out, utilizes on a large scale the physiological phenomenon of the persistency for a certain period of the sensation at the back of the eye-ball, as a result of which the images corresponding to the various instants of the action follow in a succession of absolute continuity, giving the illusion of a single image of animated things, very much like what happens in nature. Interesting cinematographic spectacles have further the virtue of stimulating the attention of the spectator, which is a psychic aspect of the greatest importance, directing the attention toward the object in order to know it and its details. It often succeeds in awakening in the spectator the still rarer spirit of inquiry, the sense of "investigation," which lies beyond the threshold of sensation, making people "visual" who are not generally so. There are many who have not visual perception in the sense of seeing what surrounds them. Among such are often people of high culture, absorbed in interior reflection. Such people on returning from a walk will not recall any faces they have seen. After a drive they will not know whether it was uphill or downhill, whether the vegetation was rich or consisted chiefly of trees, whether the sun shone or clouds obscured it. On the other hand, as Scarfoglio has pointed out, such details do not escape the "visual," and endow him with a psychological patrimony of images that are stored up in his memory. The cinema acts in this sense: Awakening our attention, it leads us to look beyond the conventional goal, increasing, so to speak, the excitability of our visual apparatus, thereby lowering the threshold of sensibility.

The cinema is also a powerful memorizer, for its images which are merely living symbols distributed on the screen and woven into the pictures of the series, form a sort of mnemonic chain which clings to the memory.

This is an important aspect of our psychic life. We know in proportion as we succeed in remembering.

Once it was assumed that everything encountered by the senses remained lodged in the memory. Today it is generally believed that perhaps only about ten per cent of our mental operations become concrete and make an impression on our memory. All the rest remain in the vast domain of the subconscious. What we call conscious perceptions are nothing but the peaks of symbolic promontories the bases of which are hidden in the depth of the subconscious.

This has been pointed out by William Walker Atkinson, who illustrated the concept by an apt comparison. We are, he says, so to speak in a forest on a dark night, holding a lantern in our hands. The lantern lights up a small luminous circle around us, which is surrounded by an ample ring of shadow; beyond this there is complete blackness.

The bright circle is our consciousness, in which by degrees and as required, there arise subconscious impressions as from the dark ring of shadow. In no one moment of our psychic life do we succeed in attaining consciousness of more than a small part of what is stored in our minds. And many things that seem forgotten and which we have possibly tried in vain to recall, rush up in our minds at a given moment almost involuntarily, by a sort of automatic impulse.

Our subconsciousness may be likened to a great reservoir, in which impressions are deposited and stored. *But not all impressions.*

Only those to which we have given a certain attention. The "size and form" of the impression is indeed in proportion to the amount of attention given at the moment when the impression was produced.

It has already been pointed out what a powerful stimulator of attention the screen is; and as such it must necessarily contribute to feed our memory and, therefore, to our education, all the more as the sense of sight is recognized as the one that is the most apt and most instrumental in aiding the mind to register correctly the impressions received.

The cinema also plays a large part in the zone of psychic reflex actions, both on account of the state of soul and the emotional impulses inherent in the nature of some subjects and on account of its "mimicry."

'The face is the tacit voice of the soul," said Goethe, wishing to express how our most intimate sentiments are registered and transmitted by it.

Mimicry is a language apart, supremely capable of expressing our state of soul by the facial expression and by gestures. No fewer than seventeen muscles concur in the formation of our facial expression. Much has been said and written on the subject. There is passionate, natural mimicry, with automatic and reflex expressions, betraying the most diverse states of mind; joy, suffering, fear, anger, desire and so on. And then there is intentional mimicry, voluntary or semivoluntary, which is artificial and dependent on the will of the actor, who deliberately interprets the psychic states of which it is the expression.

The cinema avails itself largely of this form of language to exteriorise the states of soul of the actors.

By a similar complexity of subjective reactions, called forth in the spectators by means of psycho-reflective mechanisms, the cinema achieves its educational aims.

But what is the intrinsic virtue of the cinema, which makes it capable of arousing such vast psychic sensory reactions? It is doubtless the particular character inherent in this form of art and its technical excellence.

Foremost among its characteristics is that of universality. The language of the cinema, consisting of pictures is universal, speaking to all peoples regardless of the bounds of state frontiers.

The technical means at the disposal of this cinematic apparatus ensures the production of images of extraordinary luminosity and vivacity.

(Concluded on Page 38)

"*The Bears Came Over the Mountains*"

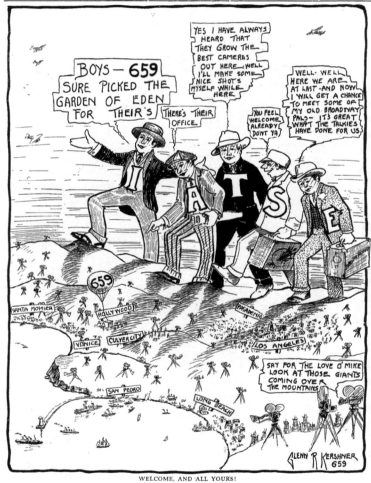

WELCOME, AND ALL YOURS!

"*The Bears Came Over the Mountains*"

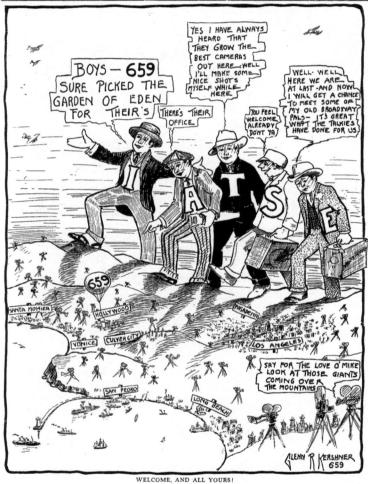

WELCOME, AND ALL YOURS!

SPECIAL
Souvenir Art
Edition
of
The International
Photographer
for June, 1930

**in honor of the Bi-ennial Convention
of the
I. A. T. S. E.
and M. P. M. O. to be held in
Los Angeles the week
beginning June 2.**

¶This book, the Official Souvenir of the Convention, will be widely distributed at home and abroad and among many other interesting features will contain an art insert in colors. It will be the finest thing in the way of a magazine ever issued WITHIN the motion picture industry.

¶Advertising space may be reserved by communicating with the editor care The INTERNATIONAL PHOTOGRAPHER.

665—*Toronto*—665

BY

AL BEATTIE

LOCAL MEMBERS TRAVEL FAR

Members of this local are becoming regular gadabouts. You see a Brother one day on the street and the next day you learn that he has left for Bulgaria, or points south. Three of our members have traveled far this month. Roy O'Connor, of the Ontario Government Motion Picture Bureau, did New Orleans the honor of attending their annual Mardi Gras in person. Roy assumed the role of propagandist inasmuch as he preached the gospel of our glorious Northland and its advantages to tourists, to all he came in contact with. He took with him a series of motion picture subjects dealing with Canadian tourist resorts. These were projected in several New Orleans theatres. Roy is loud in his praises of the Southland and of the hospitable people who live there in fact we have heard that he has developed a pronounced southern drawl and a craving for barbecue sandwiches.

* * *

Bert Bach, another employee of the Ontario Government Motion Picture Bureau, spent some time in the South Western states and came back smelling of sagebrush and with that arid look about him that all Canadians get when they are separated from the reason for their liquor permits for any length of time.

* * *

Bill Graham, just to be contrary, we suppose, traveled north last week from Lake St. John, Quebec, by airplane into the vast unknown wilderness of the Ungava Peninsula. What a trip! Sixteen hours in the air and well over 1000 miles north of Quebec city before a landing was made. They traveled high, Bill said, and it was cold, so cold that the thermometer, attached to the outside of the plane registered 87 degrees below zero. We are trying to make up our mind which was crazy, Bill or the thermometer. But it was another argosy of the air, almost in the same class as the hops across the Atlantic, and we are rather proud of the laurels that Bill brings to local 665.

* * *

STILL FIGHTING

It's a long, far cry back to the thrilling first days of the Great War. When the Princess Patricia's Canadian Light Infantry was organized in August, 1914, George Rutherford, a member of our local, was among the first to join. He served with this crack Canadian regiment overseas and was wounded several times. We think of the war as being over, but it's not really over, for many are fighting still. Today George lies in Christie Street Military hospital dangerously ill. Sharpnel wounds in his leg long considered healed, broke open recently. It's a tough break and all of the boys of the local are hoping and praying that the worst is over and that he soon will be able to leave his sick bed and be back with his wife and family, and with us again.

COPS AND CAMERAMEN STAGE THRILLING BATTLE

The jolly old police force and the merry members of Local 665 aided and abetted by still photographers from local papers, staged a thrilling hit and run contest during the funeral of a prominent local citizen Thursday. Being an event of magnitude it was only to be expected that the cameramen should be on hand. The police, however, with characteristic dumbness, felt that the occasion was an opportune one to show their authority. When the cameramen attempted to photograph the procession they were set upon by these guardians of the law and roughly jostled. Several brave officers mounted on prancing steeds rode down on the photographer's front line, and it was only by remembering that time worn adage: "He who fights and runs away etc." that the little band of die-hards are alive to tell the story today. It was a gallant affray, something along the lines one would expect to see in Moscow where it is common practice, we understand, for the military to attack offenders with the butts of guns and whips. But although that is all we have to tell just now, with the exception of course, that the boys got the pictures, just the same, we expect to have more to relate on this subject in the very near future.

* * *

CAMERAMEN PREPARE FOR BIG CONVENTION

The boys are all het up over the forthcoming Shriners Convention which takes place here in June. It is going to be a big event and the numbers estimated to attend total something like 600,000. That's a lot of visitors. Our Local has completed plans to take charge of all news shots for silent news reels. We expect a battery of sound trucks will be on hand and we are anxious that all members of other locals, who come up for the event, should get in touch with us. There may not be a great deal of time to show the boys around, but we will do our best to give any of our brothers from over the line what ever hospitality we can rake up or uncork. It is rumored that Len. H. Roos, our former president, now residing in Hollywood, has bought a camel together with some striped awning material and plans to make the trip across country in easy stages disguised as an eastern Fakir. If we really wanted to be very smart we might make a crack about that being "a clever ruse."

* * *

BACK TO THE LAND

About this time every year Brother Walt H. Swaffield, Filmart Motion Picture's artist, poultry fancier and gentleman extraordinary, gets a far away look in his eye which bespeaks that "back to the land" urge. So it is with no great surprise that we learn that Walt leaves next week for his ranch on the Kennedy Road, five miles from town. Here he will commune with nature for the next few months and incidentally enter into a

working agreement with a flock of chickens, the agreement being that if he supplies the food they will supply the eggs. It is only natural that Walt should go into a business like chicken ranching for he is a good egg himself.

* * *

LOCAL SHOWS APPRECIATION

Back in history when this local was but a brain child to most of us several local cameramen got together and, after much discussion, decided that we should organize. It was a brilliant idea, but how could we bring it to fruition. (shades of Noah Webster, what a word!) One of the boys, with something more than bone above his ears, suggested that we get in touch with William Covert, Second Vice President I. A. T. S. E., at his office in the Labor Temple where he received us like a father welcoming home an aggregation of Prodigal sons. Not only did he give us the low down on organizing, but gave us his time without stint. Throughout the first few trying months he was a tower of strength that we ran to in the face of every adversity. It was our privilege some weeks ago to extend to Brother Covert a tangible expression of our esteem in the form of an honorary life membership in the Local. The card, which was presented by President Frank O'Byrne, was encased in a leather cover, suitably engraved with gold letters. Brother Covert, visibly moved expressed his appreciation of the honor done him in a few, well chosen words, at the same time pledging himself to continue to do all in his power for Local 665.

* * *

PRESIDENT VISITS WINDY CITY

Frank O'Byrne, worthy president of our Local, spent a week in Chicago recently delving into the mysteries of sound and sound equipment. While there he viewed several recent releases of scientific motion picture subjects. They were unusually well taken, he reports and superior to anything he had seen to date.

* * *

TOURIST SEASON OPENS

The tourist season was opened officially for the local this week when Brothers Charles Roos and Fred Huffman left by motor car for New York City. On this trip they will combine business with pleasure. deviating the route so that they will go through Pennsylvania going down and through central New York State coming back. Ostensibly the journey is being made in the interests of sound, the purpose being to get the low down on the camera end of synchronized pictures. It's a good story if they stick to it. But what's troubling us is whether Brother Charles will travel through the U. S. A. in the same pants that he wore in that photo that appeared in **The International Photographer's** March number.

* * *

CLAP HANDS HERE COMES CHARLIE

Charlie Quick, who turns a mean crank for the Canadian Government Motion

(Concluded on Page 38)

The Aladdin's Lamp

◆

Warner Crosby

◆

Little mother worked her poor old head off grooming her brood for inspection

of the Movies—No. 7 *By John Corydon Hill*

and then — well mother is in the movies now.

665—TORONTO—665
(Continued from Page 35)

Picture Bureau in Ottawa, blew into town over the week-end. "Ottawa's all right; the job's all right, and Local 665's all right," declared Charlie, his face shining with the effulgent glow that marks the super optimist! Charlie reports that Ottawa cameramen are working hard and showing keen interest in all things pertaining to the Local. The Winter Carnival, which was the feature sport event of the winter season in Ottawa, was a gold mine for the free lance men of the district, he says. This spring the Bureau will move into its own building which will be completey equipped for every phase of motion picture production. It will be, Charlie says, one of the most up-to-date plants on the continent, and will be a great factor in developing the Canadian Motion Picture Industry.

* * *

READ THIS FOR SURE

Here's a little message to members of our Local who live far away in British Columbia, the Prairie Provinces, or away down east in the Maritimes. We want you to know that this is your Local just as much as it is ours, who live here in Toronto and in districts close by. We want to know what you are doing, what assignments you are covering, what adventures you are having. We would be grateful indeed if you would write to us every month at least, and give us the news of your locality. We want to get it in THE INTERNATIONAL PHOTOGRAPHER so that every member will know what every other member is doing. Send pictures, if possible on glossy paper, and they will be reproduced in the magazine. Send your communications to ALLAN M. BEATTIE, Press Representative, Local 665, 107 Richmond St., East, Toronto, Ontario. Remember, we'll be expecting a letter from you soon!

* * *

Having we suppose, discarded his woolen unmentionables too soon Brother N. A. Gunn has developed a slight indisposition, commonly diagnosed as a cold. At present he is confined to his home and is doctoring himself, we understand, with Government Controlled medicine. Now the question arises: "Are colds worth while?"

In view of the prescribed remedy we have no hesitation in answering "yes."

* * *

A 34 STORY

It won't be long now until that last steel beam is bolted into position on top of the new Bank of Commerce skyscraper, here in Toronto. That doesn't mean much to you boys across the line, but to us up here it is a big event. This big 34-story building will be the highest in the British Empire. When the flag is raised, signifying that the steel work is completed, it will be a signal for the cameramen of the city to get on the job. The ceremony of placing the last girder will be covered from every angle by cameramen. And your scribe rises to remark that that is no child's play, for he has been through the ordeal himself. Some of the boys will ascend to the top of the structure in a swaying box arrangement suspended by a cable attached to a derrick on the top story. Others will photograph this perilous trip by hanging with

EDUCATIONAL CINEMATOGRAPHY
(Continued from Page 30)

Everyone has been at times impressed by the suggestive fascination of the luminous effects of sunrise, sunset, moonlight nights, and so on.

The cinema can further get inspiration from the real and often does so. Nothing is more interesting and more attractive than reality. I remember a cinema known as "The Real Cinema," that once existed in Rome, and that reserved every Friday for scenes from actual life. They were highly instructive and people frequented the cinema more on that day than on any other. I recall scenes of great artistic and cultural significance such as studies of the bottom of the sea, the life of infusoria, the biology of pathogenic germs and some manufacturing processes, such as that of iron, the picking and manufacture of cotton and so on; all processes not generally or only imperfectly known, and which yet contribute enormously to general culture.

Another asset of the cinema is that of movement, enabling us to appreciate, for example in an animal, its typical characteristics; not only its shape, size and general exterior but also its movements, expressions, way of jumping, running, etc., elements that escape a stationary projection.

The cinema takes us to the remotest parts of the earth, enabling us to perceive the configurations, hydrography, orongraphy, uses and customs of regions otherwise inaccessible.

Over and above this body of intrinsic factors, objective and subjective, there is a body of extrinsic factors.

Among these are the captions which greatly facilitate the interpretation of certain situations, that are not rendered sufficiently clear by the image itself.

The musical accompaniment is another important factor, forming a significant comment on the action and a powerful auxiliary stimulator of the attention. In a well-selected and well-executed musical accompaniment, the action lives and palpitates, following the various phases of the idea, the most subtle nuances of feeling and the impetus of dramatic situations.

The sense of hearing, coupled with that of seeing, increases the vivacity and number of impressions on the onlooker, awakening strong sensory motor reflexes.

But, as Mussolini pointed out in the words quoted at the commencement of this article, the cinema is still at the first stages of its evolution. There are "other peaks already being scaled," the cinematography of colour, the talking film and the three dimensional film. Innovations that will revolutionize the whole motion picture field, by the realization of undreamt of efficacy of expres-

their cameras over the edge of the building, with a sheer drop below them of nearly 500 feet and at the same time assistants will hold on to them for dear life, fearful that at any time they all may be precipitated to the pavement below. But there is a thrill in the job and after all that is what makes a cameraman's life a little different, and a little better than any other.

sion. But that is beyond the theme of this article.

Concluding, I should like to state my belief that the educational film should draw its inspiration above all from real life. I have already pointed out the enhanced interest of such representations. But all false appearances, all trickery, should be avoided.

Sometimes, no doubt, dissimulation is necessary, but it should never be exaggerated, as now is often the case when the whole action is relegated to a plane of irreality that is often grotesque. Such aberrations deform the aesthetic sensibilities, the good taste and spirit of inquiry of the public.

And here I am not alluding to the moral character of films, which should always be above reproach, as otherwise the cinema, with its powerful appeal to the imagination, risks becoming a school for vice and crime.

Here the objection may be raised that the public enjoys improbable situations and scenes of pure criminality. But this is not a good argument. I recall a famous orchestra director who resolutely faced unpopularity in order to inspire the public with a new sense of art. After years of patient and perserving labor he triumphed, awakening his audiences to enthusiasm for and comprehension of classical compositions, not easy to follow on account of their technical structure.

And such examples are to be found in all the domains of ART. They should serve as a warning. The great mission of the so-called silent screen is to raise the spiritual standard of the people cultivating its taste for the beautiful and true, drawn chiefly from reality. The cinema, far from being silent, speaks a universal language to heart and mind.

—o—

GROWTH OF S. M. P. E.

Growth and importance of the Society of Motion Picture Engineers in the industry is indicated in the fact that the membership has been increased by 313 new members in the last year. Latest figures show that the Society now has a total of 611 members, and 25 applications are now pending action.

The growth is regarded by the industry as a recognition of the value and service of the Society to the motion picture industry. The large increase in membership does not represent a mushroom growth, it is pointed out, since all applicants are thoroughly examined as to their eligibility for membership, and each applicant must meet the membership requirement.

The Pacific Coast Section shows a total of 74 members. The London Section which was organized last year has increased during the year to 90 members, and is very active, holding meetings regularly once a month during the winter season. Recently a New York Section was formed.

The total Society membership as distributed over the United States and foreign countries is as follows: New York and East, 303; Chicago and Mid-West, 82; Pacific Coast, 74; British Isles, 90; Canada, 15; France, 14; Germany, 15; India, 6; Italy, 3; Russia, 2; Australia, 2; Japan, 2; Switzerland, 1; Sweden, 1; Holland, 1; Total 611.

Peterson Oil Well Survey Camera

—BY—

EDWIN M. WITT, *Local 659*

Mr. George Peterson, of Peterson's Camera Exchange, O. T. Johnson Building, 356 South Broadway, Los Angeles, conceived the idea, about two years ago, of photographing lost tools in oil wells and began to design a camera to accomplish this.

While pursuing this work he became impressed with the necessity of some means to detect the drift and the direction of the drift of the drill while in process of boring a well and turned his efforts to the achievement of that much to be desired discovery.

The fundamentals of his invention comprise the incorporation of a combination compass and spirit level superimposed above a light source, the light from which, passing through the compass and level casts an image on the 35 mm. standard film above.

A battery furnishes the light and a clock-work mechanism moves the film, shutter, etc., enabling the camera to register a picture every 3¾ minutes. The whole is incorporated in a non-magnetic container 6 feet long, 6 inches in diameter and weighing 350 pounds, which container screws onto the end of the casing when ready to be lowered into the well. The camera proper is 3 feet long and 3 inches in diameter.

The container has been ested for 4500 pounds pressure. The camera carries film for a capacity of 500 pictures or sufficient to go to a depth of 45,000 feet.

The compass and level is a glass container filled with a clear liquid, a target being etched on the glass cover. When the camera is level and plumb the bubble is in the center and the compass needle reading will register its position on the film as it is at the top on the well.

Owing to the constantly changing conditions as the drill bit passes through the succeeding strata in the process of sinking the well the drill is often deflected from the perpendicular and sometimes goes off on a tangent even approximating a right angle.

The Peterson Oil Well Survey Camera has been thoroughly tried out and is certain of a great future. A regular form for keeping a log of the camera has been worked out and it shows results as follows:

Picture No.	Measured Depth Top of Well	Real Vertical Depth	Direction	Inclination		Feet off Center N or S	E or W
				Degrees Each Stand	Per 100 ft.		
1	0	0					
68	5770.7	5757.88	N 65° W	6° 30'	9.52	35' E	91' N
69	5858.3	5845.18	N 64° W	4° 45'	7.24	28' E	95' N

This shows that in a distance of about 85 feet there is 1 per cent increase in deflection to the north and about 5 feet off to one side. That is: In drilling 85 feet the drill has penetrated 80 feet perpendicularly and has been deflected 5 feet toward the north.

Chicago — Six-Sixty-Six — Chicago

ELECTION

At the last meeting of Local 666 held at the Palmer House, Chicago, the usual business was handled, then came the election of officers for the coming year. Of course in Chicago, it is the custom, when you go to the polling booth to cast your vote that you carry your own "firearms." Well, all the boys wanted to feel at home and so the election proceeded. After the ballots were counted it was learned that the officers for the coming year were as follows:

President—Charles N. David.
Vice-President—Oscar Ahbe.
Treasurer—Marvin Spoor.
Secretary—Norman Alley.
Financial Secretary—William Ahbe.
Sergeant-at-Arms—Harry Birch.
Vice-President — Harry Yeager, St. Louis; Howard Cress, St. Paul.
Trustees—Conrad A. Luperti, Richard Ganstrom, Ralph G. Phillips.
Executive Committee — Charles N. David, Oscar Ahbe, Marvin Spoor, Norman Alley, William Ahbe, Harry Birch, William Strafford, Eugene Cour.
Delegates to the I. A. T. S. E. Convention of 1930 — Charles N. David, Harry Birch..

Everyone satisfied with the outcome on the election, the meeting was closed early due to the fact that this was the night before the big "SHOW and SUPPER" of Local 666, also held at the Palmer House.

SIX-SIXTY-SIX

THE CAMERMAN'S BALL

By Birch's Sassiety Reporter

Well it sure was the gala affair, all right, all right.

I thought I'd get there early, so that I wouldn't miss anything—I didn't.

The doors hadn't been opened yet to the general public so I battled through the mob in the corridor of the fourth floor of the Palmer House. At the door old Gene Cour was having his hands full trying to make everybody happy by giving 'em ringside seats.

Bein' a news-man I crashed the gate; nobody was inside except an awful big army of waiters, which wasn't waiters at all, I found out later—they was cameramen decked out in waiters' uniforms. Boy a fire or sumpin should of bust in Chicago then; the world sure would have had a treat on seein' what the well dressed cameraman wuz wearin'. I bet there wasn't a dress suit rent-a-place in town that wasn't sold out. And the boys looked swell too. Maybe they ought to wear 'em different and prove that cameramen are good lookin' as any men can be.

President David had his hands full taking care of all the big shots that were honorary guests and sat at the big long table. He was aces and I guess the boys owe old Charlie a heluva lot for the way he put over the big affair. It's all over now, but a lot of us will remember one great evening for a long time.

Well they opened the doors and the big feed began. I sat through a meeting

Motion Picture Industries Local 666, I. A. T. S. E. and M. P. M. O., of the United States and Canada

By HARRY BIRCH

President

CHARLES N. DAVID............................Chicago

Vice-Presidents

OSCAR AHBE....................................Chicago
HOWARD CRESSSt. Paul
HARRY YEAGERSt. Louis
W. W. REID...................................Kansas City
RALPH BIDDY...............................Indianapolis
J. T. FLANNAGAN...........................Cleveland
TRACY MATHEWSON............................Atlanta
GUY H. ALLBRIGHT............................Dallas
RALPH LEMBECK.............................Cincinnati

Treasurer

MARVIN SPOOR.................................Chicago

Secretary

NORMAN ALLEY................................Chicago

Financial Secretary

WILLIAM AHBE.................................Chicago

Sergeant-at-Arms

HARRY BIRCH..................................Chicago

Board of Executives

CHARLES N. DAVID	WILLIAM AHBE
OSCAR AHBE	HARRY BIRCH
MARVIN SPOOR	WILLIAM STRAFFORD
NORMAN ALLEY	EUGENE COUR

Offices
12 East Ninth Street, Chicago

BULLETIN — The regular meetings of Local 666 are held the first Monday in each month.

the night before while we battled over what the feed would be. Squab had been suggested, but seein as how everybody had to wear soup and fish we ruled it out because it wouldn't look so hot taking the squab in your fingers, so we decided on Filet Mignon—well, boy, wuz that squab good!!

Urban Santone was waiting for somebody to kick on the lights so's he could shoot some pictures. Some boy boop-a-doop singer was singing a mammy song and the big show wuz on.

All the boys had wives along—their own wives.

It was a great reunion for a lot of birds who hadn't seen each other in a long time.

Charlie Geis, Harry Birch, Bull Phillips were among those dressed up like human beings.

So was Frank Bauers. Who in blazes were you looking for all night long, Frank?

What happened to all the boothleggers on Prairie Avenue, Bull Philips, or have you taken the veil?

Old Buddemeyer showed up with his bunch; hadn't seen Buddy in a long time.

Couldn't tell the Ahbe Brothers apart; they looked like twins in the soup-n'-fish.

Old Doc Nicholson from the Edgewater Athletic Club, a friend of the gang, draped himself gracefully over the speaker's table.

. Norman Alley looked so swell and smelled so strong—some joker spilled perfume all over Alley's outfit.

Red Felbinger was there with two suits

of underwear, we discovered at midnite. Modest guy Red, why didn't you sport suit number 2 sooner.

Charlie Ford didn't do his usual act about calling out the squads with machine guns.

Bob Duggan, light impressario, looked like the head waiter.

Dick Ganstrum wore a bow tie that you tie yourself. It would have been too bad if somebody had torn it open on him.

Max Markman, what were you carrying in that grip all night long?

Fred Giese, Tony Caputo, Zimmerman, Trabold admit the gravy didn't match the vests.

Jack Flanigan, of Cleveland, was present.

Viola Braun, our secretary, gave us a treat by dancing with a lot of us.

Nobody asked Billy Stratford all about his high speed camera.

Billy saved the day in one of the private rooms by reciting when a certain bird offered to sing.

Martin Barnett had the steady along. When's it comin' off, Martin?

Twenty-third floor please! For further information ask the elevator boys.

Boy, what a way to trot out the dessert; what a parade the chef put on serving us our ice cream. Suppose the gang's better halves we be trying that one the next time we have company over and put out the Sunday silverware.

Maybe it's all over, but guess the memory lingers, maybe underneath ice packs for some of us, but it was a great night, thanks to Charlie David and the crew that help him put it over.

If Mae Tinee, of the Tribune, had covered it she'd have given it four stars.

See you at the next one with bells on.

SIX-SIXTY-SIX

Thanks "Red" for your story on the 'lil' party—might add that it would be impossible to publish here the hundreds of telegrams that were received from various parts of the country telling us how sorry, etc., they were that they could not be with us, especially those from the boys on the coast and some of them from our own boys out there telling us how sunburned they are getting—well maybe they are getting sunburned on the "outside" but the boys in Chicago were well "moon-burned" on the "inside" so that makes us all even. Here's thanking all the boys for the many telegrams.

SIX-SIXTY-SIX

AFTERMATH

HI YAH FOLKS, HI YAH! Havalook, it's all free! Step right tup'n look 'em ovah! Those two, hell roarin cyclones! Those two arch defyers of "Pop Time," Knights of the Roaring Benzine Buggies! Yes, sir! Two of the ripsnortinest accelerator hounds that ever placed a number eleven brogan on a gas pedal! Step RIGHT UP and meet 'em! ON THA LEFT! Ladees 'n Genl'mn —that distance ELIMINATOR who fears neither man nor beast. Note his features

Cream o' th' Stills

Henry Kruse snapped this enticing view of Indian life while on location in the Northwest. This encampment is so clean and trim looking that it might well be a "movie" set, but the testimony of Mr. Kruse is that it is a simon pure Indian habitation.

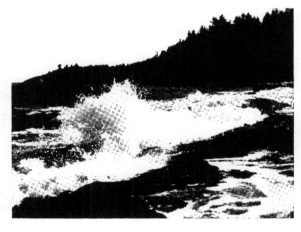

James N. Giridlian, that enthusiastic propagator of the lovely Iris lillies (having the most beautiful garden of this wonderful flower in Southern California), is a lover of the sea. Here is one of his marine views caught while wandering along the beach near Monterey.

 # Cream o' th' Stills

Without the Eucalyptus tree Southern California would not be what it is. Against the sky no tree is more graceful and eye-filling, especially when there are mountains in the distance. This lovely picture is from the camera of Clifton Maupin.

Cream o' th' Stills

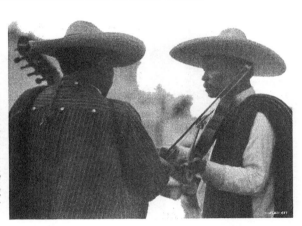

Tonala, Jalisco, Old Mexico, is noted for its wonderful pottery; in fact the entire population of the pueblo is made up of potters and has been for two hundred years. These Indian musicians of Tonala were photographed by Mr. R. A. Turnbull, news cameraman, assigned to Old Mexico. The Musicians inspire the workers in clay.

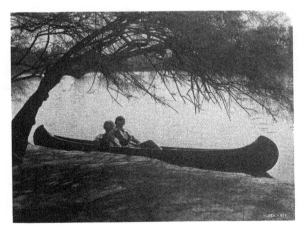

Mr. Robert Coburn saw a picture in this location while working on a recent release featuring Douglas Fairbanks Jr. Mr. Coburn is a photographer of wide experience and artistic attainment.

Merle La Voy, but recently of Pathe news and who was attached to the famous Good Will Cruise of President-elect Hoover to Central and South America, has made pictures in every important country on earth. Here is a snapshot by Mr. La Voy of Mr. Hoover and Capt. Kimberley of the U.S.S. Maryland on a windy day at sea. Mr. La Voy saw service during the war on the American, British, French, and Serbian fronts and also at Salonica.

folks! SPEED, SPEED, in every line. From that inhaling nose, back to his ears! Ears, set well back, that offer no wind resistance! AB-SO-LOOT-LY NO WIND RESISTANCE and his hair, folks, THA TURRIFFIC FRICTION of the atmosphere encountered in his many high speed runs! It was HE, and HE alone, who harrassed a FA-RONT DA-RIVE COR-RUD until, one hundred and seventeen of the one hundred and thirty gas inspired horses could hardly be restrained by human hands! SO VIOLENT was their reaction to his skillful maneuvering in this race, that, before the timers of this historical event could co-ordinate their thumb muscles with their eyes, he had disappeared completely! YES, SIR, vanished from sight! When the thumbs of these dumbfounded timers pressed upon the stop watches they were holding, it was found that the time elapsed was approximately twenty seconds! It MEANS, that a stock Front Drive Cord negotiated the distance at a terrific speed. A speed in excess of NINETY MILES PER HOUR!

On the right! LADEES 'N GENL'MN, on tha RIGHT! You gaze into two of the calmest, case hardened, steel grey eyes, that were ever surmounted by so little Tawney hair! CON-CEN-TRATE FOLKS! On those intrepid features. You are gazing upon the man who whirled his CHEWTURBACKER chariot ovah the half mile in eighteen seconds or thereabouts! EEMAGINE IT! TEARING through space at ONE HUNDRED MILES PER HOUAH!—in a stock Stude-

backer Prexi (we are only repeating this, we dare not try to think).

ON THA LEFT FOLKS! ON THA LEFT we have CHARLES FORD of the Daily News Universal Screen Service, and on the RIGHT, ladees 'n genl'mn ON THE RIGHT we have Norman Alley! YES, SIR, Mr. Alley of HEARST METROTONE NEWS!

BEFORE we go into the main tent (I mean the details of their encounter) let us consider the details of the matter in which we defied all of the laws of time and gravity (including the statutes of the State of Illinois). I want to make it clear that this was strictly a STOCK car race! When I say "strictly" I mean STRICTLY. It seems there was a dispute as to the relative amount of "Get UP and Go" in their respective Gas Eaters, and the result was a duel. Not a duel of arms, but of speed! I repeat SPEED! INTENSE TURRIFFIC, breath taking, CHASSIS SHAKING, SPEED!

On Mr. Ford's word of honor we have it that his Cord was shipped to the Cord-Auburn factory, only to have the steering gear adjusted. And, would you believe it, upon examination they found a Mack truck behind on the steering knuckles! Hardly discernable to the naked eye, BUT there it was! This caused such consternation and embarrassment to the factory officials that they went into a huddle and decided that the only remedy would be to install new PISTONS and VALVES! Now folks you all know that no motor will perform properly with only pistons and valves!

There was but one course open to the chagrined officials. That was, to humor the new pistons with another cylinder head and to quiet the jealous valves with a new set of special springs and a different camshaft, that was all! NOT ANOTHER THING was even touched!

BUT, lo and behold! While this was occuring, Mr. Alley's car, normally, as spry and chipper a bundle of cast iron transportation as ever outdistanced a cop, suddenly developed a mysterious case of SPANTIDS. You all know what spantids means — to motor folks. No more would this proud product from South Bend, prance and snort, at the sound of its master's footsteps. Mr. Alley's Pampered Darling stood trembling, as one with the ague. Doses of asperin and even "Greasing the Clearance" were resorted too! But to no avail. It was in the advanced stages of those deadly maladies, known as, Varicose Exhaust Pipes and Falling of the Universal Joints. His heart torn with anguish, tears blurring his vision, Mr. Alley besought the aid of the well known Speedway Professor, Cliff Woodbury. A strict examination disclosed that only an immediate operation could restore the Studebaker to its former vitality. However, even the "Great Woodbury" must have assistance. A hurried consultation, a telephone call, and presto—two of the family physicians from Mr. Erskine's great plant appeared as if by magic. Hardly had the incision been made when it became apparent that the Venturi tubes in the carburetor were

(Continued on Page 43)

Hoke-um

By IRA

Musical Note

Gene Davenport: "Do you know that Carl Guthrie sings tenor?"
Bob Miller: "He does? Are you sure?"
Gene Davenport: "Certainly; ten or fifteen notes behind the others."

— :: —

Distance Lends, Etc.

First Cameraman: "I understand that from a standpoint of experience, the "Synk Em Studio" is a good place to be from."
Second Cameraman: "I'll say it is. The fromer the better."

— :: —

True

Eastern Exhibitor (Visiting Hollywood): "Do you not find the water is awfully hard here?"
Cameraman (Native): "Yeah. It rained had this winter."

— :: —

Thrift Stuff

"Scotty" Kains (At Soda Counter): "Give me a glass of water please, vanilla flavor."

— :: —

Art Note

Art Dealer: "Here is an equestrian statue of Jeanne d'Arc.
Property Man: "And is the horse made of that stuff too?"

— :: —

Politeness

Stage Watchman: "Young feller, is that your cigarette stub?"
Eddie Garvin: "Go ahead, Dad, you saw it first."

— :: —

Cheaper That Way

Earle Walker: "What were you doing outside the Roosevelt Hotel yesterday?"
Harry Merland: "I live there."
Earle: "Where?"
Harry: "Outside the Roosevelt."

— :: —

Another Wild One

First Extra Man: "Did you have a good time at Mae's party last night?"
Second Extra Man: "And How! I don't remember a thing."

Precaution

Elmer Dyer, air photography specialist, says he never makes a flight unless he has on his union chute.

— :: —

Applies to Ralph Staub, Too

Si Snyder: "Late with your copy, as usual."
Ira Hoke: "Yes sir, but an absolutely new excuse."

— :: —

Financial

Sonny Broening: "Pop, what's a joint account?"
Lyman Broening: "It's an account where one person does the depositing and the other the withdrawing."

— :: —

Church Chimes

First Cameraman's Wife: "My husband went to church this morning."
Second Cameraman's Wife: "My husband's Sunday morning paper didn't come either."

— :: —

Off and On

Milton Cohen: "Can you tell me how much film your company has on hand."
Perry Finnerman: "Well, I can't say, offhand."
Milton: "I said on hand, not off hand."

— :: —

An Anxious Moment

Speed Mitchell: "How much is the admission to the Egyptian theatre?"
Clarence Hewitt: "Sixty-five cents."
Speed: "Gosh, that worries me terribly."
Clarence: "Why? Haven't you the sixty-five?"
Speed: "Yes, but how is my girl going to get in?"

— :: —

No Cause for Excitement

Temperamental Star (Standing in for camera line-up): "Do hurry, Mr. Cameraman, I've been standing in front of this camera for 20 minutes."
Lee Garmes: "That's nothing, sister, I've been standing behind it for 20 years."

Discovery

Harold Baldwin (Looking vainly for a scene number): "Joe, what did you put on your slate?"
Joe Darrell: "Chalk, my boy. It shows up wonderfully on that black background."

— :: —

War News

First Extra Man: "You look tired today."
Second Extra Man: (Wriggling silently in a rented costume): "Nope. I'm full of life."

— :: —

Half the Lies Told About the Scotch Are Not True

Faxon Dean (Scotchman): "Got a match, Maury?"
Maury Kains (Also Scotchman): "Yup. Here is one."
Faxon: "And I've forgotten my cigarettes."
Maury: "Are you sure you've forgotten your cigarettes?"
Faxon: "Yep."
Maury: "Then, would you please return my match?"

— :: —

Live Stock Bulletin

What's this new hypo-sensitized stock we hear so much about?

HOLDING MEMBERSHIP IN MORE THAN ONE LOCAL UNION

A member of the International Alliance is permitted to hold membership in as many local unions as he wishes. Recent events in the General Office would indicate that many of our local unions are not familiar with this ruling. It is, of course, to be understood that where a member holds membership in more than one local union, he will be subject to the loss of all local memberships held in the event he is deprived of his membership by either local.

666—CHICAGO—666
(Continued from Page 41)

too small, its lungs were so congested with carbon that it was necessary, to install a new set of rear axle gears. While the grief stricken Mr. Alley paced the floor like an expectant father, the specialists unbeknown to him, installed new breaker springs in the ignition system, hoping against hope, that they could inject a spark of life into their fast expiring patient. As a last resort, before sewing up the crankcase, a bushel basket full of new pistons, valves and connecting rods were poured in.

AND NOW, LADEES 'AN GENL'MN step inside, and hear them give you their own, unbiased version?

NOTE.—Personally I think they rolled the bones to see which had the fastest car, however in next month's issue you shall hear their own story on the topic SPEED.

SIX-SIXTY-SIX

SELF DEFENSE

It seems that the March issue of The International Photographer aroused the Irish in one said "Red" Felbinger of Local 666 as to the story on his "Talk on Journalism" for the Vincennes High School:

So says I
A special delivery boy
Rushes into my office
Hands me a "Special"
And after reading same
I decided with the help of
The International Photographer
To publish "Red's" letter
Word for word, providing

The Board of Censors
Do not interfere.

Here it is:

Dear Harry: Well so you're still editor of THE PAGE! It's a grand old page at that, but I just wanta arise to belch about a story I see in this month's. Personally I guess every great sheet must at least have one correspondent on its staff who don't worry much about the authenticity of the stuff he sends in. I'm referring to one about me making a speech at Vincennes, Indiana, on "Journalism." The dope is this—seeing as how everybody has read the wrong story. A bunch of the boys of the news-reels were whooping things up at the local nickel-odeon while waiting for the flood waters to inundate the metropolis of Vincennes and Harry, I hope to hell you don't get stuck there for a week end with just one movie and a golf betting machine in the lobby of the Grand Hotel for amusement. It's even worse now, since Fred Giese busted the golf machine on that last trip. Well, anyhow we're all coming home from the movies and "Joe the Greeks" where the gang has been guzzling malted milks. As we bust into the hotel lobby we're approached by a couple of youngsters who's been scorching their flannels on the Grand Hotel leather divan, and who want an authority on news-reels to address the class on Journalism. It seems as how the local sheet has been running a lot of hooey about how all the news-reel editors been shipping their aces down to Vincennes to grab off footage on the banks of the Wabash, going on a rumpus. That's what started the whole mess. The

truth of it was, I didn't meet any news-reel aces down there at that. The only birds I saw were Chas. Geis, Fred Giese, Tony Caputo and myself. Well these youthful contact boys for the Journalism class dances up to us expecting to see a couple of hot news-reel men with caps turned backwards and they gave us the "double O" and spilled the dope on us. Guess it was sort of an open invite. Well, the kids were in a heluva mess and they didn't care who they got to make the speech as long as he was a news-reel cameraman. So the gang of us started to look important as hell and we asked them all the dope as to where it would take place, time, etc., and if the teacher was a male or female. Well the kids were getting to first base when they said the teacher was of the sex appeal gender. Everything was going lovely until we starts to put down the address. We asks the kids what room to report to and they says, the "Class in Journalism." Boy you never saw a funnier sight in your life —a bunch of news-reel men trying to spell the word Journalism. It was right here that the rest of the birds back out and, seeing as how, maybe, the teacher might be a pippin, I thought I'd take a chance. So while the rest of the crank-turners are knocking off the winks, I'm walking back and forth in my room all night fixing up a great line all about the racket.

So the next morning I hops over to the school to give the the song and dance about "Unhung Heroes of the Movies." Well I bust into the classroom, give

(Concluded on Page 44)

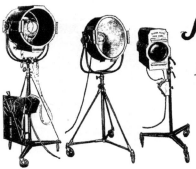

The International Photographer for June

●

BY REQUEST of all I. A. T. S. E. and M. P. M. O Locals **The Interntional Photographer** for June will appear as the special art souvenir of the Bi-ennial Convention of these two great organizations which will be held in Los Angeles during the week beginning June 2.

Our affiliated locals are lending their enthusiastic support to make this edition a success, but the weight of responsibility is upon Local 659, and the loyal members are, therefore, urged to spare n o pains to put their magazine over 100 per cent.

The time is short and the work must be intensive, therefore, every member who has the success of our magazine at heart is appointed a committee of one to lend full co-operation to this drive.

MRS. JACKSON PASSES

As our May edition goes to press we learn of the passing of Mrs. T. F. Jackson, who died after a very brief illness on Easter eve at her home in Hollywood.

Mrs. Jackson leaves husband and a five-year-old son. She was only thirty-five years old and a woman of many virtues and great sweetness of character.

Her untimely taking off is the source of intense grief to a host of friends who were devoted to her.

The heartfelt sympathy of the entire membership of Local 659 goes out to "Jack" and his baby boy in this hour of their bereavement.

————o————

WHO ARE OUR BOWLERS?

All members of Local 659 who are devoted to bowling are requested to send their names to Harry Perry or to the editor. Mr. Perry is out to organize several teams and pull off a tournament. Hurry up.

666—CHICAGO—666

(Continued from Page 48)

teacher the "double O" and decide right then and there she don't get the red apple I brought along in case. So please kinda tip off President Charlie David in case he's got a lot of applications coming in from Vincennes to pay no attention as those kids ought to get over it soon and go back to more serious problems of Journalism other than news-reeling. Also, if you run across any of the birds that was in the lobby at the Grand, the night I accepts the nomination, please thank them for me for the swell razzberry they give me when I accepts.

I just been down to New Orleans on the Mardi Gras and I bucked into one of the old gang that most of you birds know. Old Tracy Mathewson and his Pathe gang. Tracy's getting big as a tent, but still the same old Tracy. Willie Deek who used to cover Chicago for Gene Cour's gang was down there with him. A good time was had by all. Met a brother from 665 there, too, Roy O'Conner was his name and a real Canuck, too. He's the official photographer for the Canadian government. He was filming a Canadian good-will tour and a mighty fine bird. Tracy was telling me our old pal Floyd Traynam is now doing Sunny Florida and liking it fine.

Well, I hope I can hang around town long enuf to take in a meeting again. See on arriving here news must be pretty dead as the only thing I runs across in the morning paper is how two newsreel men bets each other they's got faster cars than the other guy and it's none other than Norm Alley and Charlie Ford and wow, I had to read it twice—Alley wins and Ford driving that Cord we been hearing so much about. Well I gotta come up to the next meeting and hear Ford tell as how the accelerator got caught in his foot and he could only open it up halfway; it'll be funny to take it in with Alley and his funny ha ha topping off the bill. In case I don't see you before, I'll see you at the big shindig at the Palmer House.

Well hoping you got me straight on this Journalism business, I am,

Yoors trooly,
"RED" FELBINGER.

"Mike"

BY

JOHN LEEZER

Heard a new one the other day. Old General Electric farmed me out some to the K. F. Y. Z. studio for experiments, and while I was down there a lady between 37 and 38 years of age came in and struck the Boss for a job singing bed-time songs for the kids of Radio-land.

"Do you think that you can put them to sleep," the Boss wanted to know.

"I'm sure of it," replied the lady who had never marched to the strains of Lohengrin.

"Why are you so positive," he inquired.

"Because I have an *ether* personality." And the Boss yelled "Ouch!"

So it goes. We hear of a new kind of personality, nearly every day. But speaking of personalities, one of my chauffeurs has one and it's the meanest personality I know anything about. Had a little earache the other night and couldn't hear as well as usual, so this guy, just to be mean, parks me in a big brass cuspidor. He told the Director that I could hear better there, but if he had been onto his job, he would have known I could hear a whole lot better in the waste-paper basket under the desk and not be in half so dangerous a position.

I'll have to admit though, that being parked in the cuspidor was a bit more comfortable than where this same bozo planted me one day while on location up the state about a hundred miles. We were making a war picture for a change; one of the kind that the poor public was sick and tired of long before the war. This chauffeur of mine, had me in a hole in the ground so that I could hear a big bozo's feet as he tramped back and forth with a gun on his shoulder.

We took the scene nine or ten times, but they couldn't get the guy's feet to synchronize or he walked left-handed or something; anyhow they got another tin-soldier on the job and after one take the director came over on the jump and yells: "Say, what size shoes do you wear?"

"Fiveths thsir," answered the neuter gender.

"For the love of Casey," cried the hero of many a silent picture: "Get me a man!"

They did and how! His feet were so big they looked like a couple of caterpillar tractors bearing down on me and one of them sent me into the ground another six inches.

"Hey!" yelled Brownie from the sound truck; "show that Goliath where that Mike's buried."

I'll say I was buried, but when I heard the big flat-foot coming again, I became aware of an altogether new sensation. And when I say new I mean new because I have had a pile of sensations in my time, but nothing like that one. "What the heck's comin' off," thinks I to myself and then I heard the clappers for the end of the scene.

"What's makin' that funny noise,"

Brownie wanted to know of the man with the gun.

"You can search me," says he and they did, but evidently found nothing they were looking for.

Once more I heard the slew-foot coming and he was directly opposite my hide out when I again got hep to something bein' wrong in Denmark.

" ***!*!*!***** !" and Brownie was again on the job. "Let's look at that feller's shoes," says he and they looked.

"What kind of a noise is it Brownie," inquired Red Hogan, one of the grips.

"Blamed if I know, but it sounds like this guy was skatin' along on a bunch of files or tryin' to learn how to shift gears or somethin'!"

"Well let's try it again," suggested the Director. "We've only used two thousand feet so far."

The clappers clapped and we were on the first lap of the three thousand feet of film when, "Ouch!" and I felt my pants rip or they would if I had been wearin' any and out comes the entire personnel of the sound department, the Director and his assistants, the script girls, the yes men, and assistants, the supervisors of military tactics, the wardrobe men and assistants, the efficiency experts and assistants, a half-dozen carpenters and assistants, all the auto chauffeurs and a goodly sprinkling of the citizens from the surrounding landscape.

This gathering of the great and near great was just another indication of the importance of the position I hold in the realm of the animated sound pictures, for this time Brownie says: "Let's look at that Mike!" And the bozo who put me in the hole in the first place, yanked me out.

"Well whadda ya know about that," snickered Brownie. "Some gopher has been sharpenin' his teeth on the Mike!"

ANDY CLYDE PLAYS M. C.

Through the courtesy of Mack Sennett, Andy Clyde plays the Master of Ceremonies in the all-talking Screen Snapshots issue number eighteen, directed by Ralph Staub for Columbia release. While waiting in the Snapshots office for ye Editor, Andy introduces various Stars through several novel camera trick shots. Some of the stars he introduces are: Bessie Love, Eddie Cantor, Patsy Ruth Miller, Aileen Pringle, Grant Withers, John Miljan, Gwen Lee, Julia Faye and Walt Disney with Mickey Mouse.

RAY-BELL FILMS, INC.

R. H. Ray of Ray-Bell Films, Inc., St. Paul, Minnesota, has been in Hollywood during the past two months studying the sound and color situation in the motion picture industrial field. The Ray-Bell organization is one of the most enterprising in the country.

"THE DAILY GRIND"

RALPH B. STAUB

While galloping through Hollywood on my weekly jaunt to the various studios I find the still men holding their own. Bumped into Charles Pollock of MGM and he invited me along to the aviation field to view the taking of some pictures. Back on Hollywood boulevard.

Bill Fracker hurrying to work at Columbia.

Bud Longworth with a new idea and don't think for a minute he hasn't got 'em—ask me—I know.

Henry Freulick off to Europe—God speed Henry.

Hal Porter buying a red tie—Oh Hal.

Irving Lippman getting ready for the Warner premiere.

Mack Elliott—ditto.

Homer Van Pelt window shopping—between lunch hours.

Elmer Fryer head man at F. N. going into the bank.

George Baxter buying a new hat—what's the matter George; losing your hair?

Fred Archer sees a new model on the street and starts to follow—her.

June Estep getting a hair cut. That reminds me—need one myself.

I promised a man a writeup for the past several months so think I shall fulfill that promise right now as I am a little short on gags this month (hope Si and the boys forgive me, as I am working on a large list for our special number).

George Seid—ace laboratory man who runs the Wm. Horsley Laboratories certainly knows his stuff and if anyone in this business doubts my word let them see my dailies and release work—that tells the story. George is out to help the boys and get them the results required these days to keep one's job. George, could I say more?

Now get together boys and start boosting for our special number. If you need any information just get hold of Si Snyder. Let's make this special issue one to be remembered for a long time in the history of 659.

She—"You are a talented and observing man, Mr. Gaudio, will you please name a use for cowhide"?

Tony (Obligingly as usual)—"Why, of course, lady. A cowhide is used to hold the cow together."

History Makers of Old Essanay

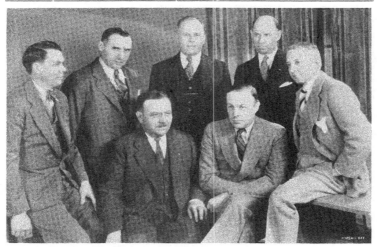

Left to right, standing—*Arthur Reeves, Jackson Rose, Victor Carlson, David Hargan.* Sitting—*C. A. Luperti, Marvin Spoor, Harry Zech.*

Here in this little group is contained the original construction gang of the old Essanay Studio at Chicago, 1909 to 1918. Our artist caught them when they were all in Hollywood recently holding a reunion after twelve years.

The old Essanay Studio, built in 1907, was the proving ground of cameramen, directors, stars and technicians and the very name "Photoplay" originated there. Scores of the old-time stars won their spurs there any many of them like Rod LaRocque, Colleen Moore, Gloria Swanson are still in the electric lights.

At the pioneer studio the first overhead artifical lighting of sets was originated and demonstrated by the gentlemen of this group and here was shot the first three-reel photoplay ("One Wonderful Night," with Bushman) photographed by Jackson Rose and the first five-reel feature ("The Fall of Montezuma"), also photographed by Rose who was the first cinematographer to use the first Bell & Howell camera.

In those days the boys were compelled to do a lot of team work. Rose might start a picture and Reeves finish it and vice-versa according to the extra work that had to be done by one or the other.

It is said that the researches and experiences of this group were responsible

(Concluded on Page 48)

The Sound Track

OFFICERS

BORN IN MAY

With Mother's Day and Memorial Day both coming in May the cinematographers born in this month are peculiarly honored. Also May poles were invented for May Day festivities and if it hadn't been for May there wouldn't have been any "Queen of the May" so our brothers born in May are sitting pretty. From Joe Brotherton to Jim Woodbury this May outfit is some gang. Look 'em over. We have represented here beside U. S.—France, Italy, Spain, England, Germany,, Russia, Holland, Canada, Mexico, Scotland, Ireland and Streator, Illinois.

Joseph Brotherton, Clarence Bull, Walter Castle, Wallace Chewning, Judson Curtiss, Allen Davey, Faxon Dean, Louis DeAngelis, Wm. V. Draper, Perry Evan, Maxmilian Fabian, Harry Forbes, Harry Fowler, Wm. Fraker, Jr., Lee Garmes, Maurice Gertsman, Al Greene, Fred Grossi, Burnet Guffy, Ernest Haller, Clarence Hewitt, Ira Hoke, George Hommel, Pliny Horne, Leo Hughes, Paul Ivano, Arthur Lane, Nelson Laraby, Don Lawrence, T. Martin LeClede, John Leezer, Gaston Longet, Frank Lowery, Chester Lyons, Gordon MacLean, Glen MacWilliams, Harold Marzorati, Bud Mautino, Nelson McEdward, Paul Mohn, George Nogle, Kay Norton, James Palmer, Harry Perry, Edward Pilkington, Al Prince, Arthur Reeves, Ray Rennahan, Raymond Ries, Les Rowley, Verne Rucker, Jack Russell, Victor Scheurich, Henry Sharp, John Stumar, George Teague, Fred Terzo, Wm. S. Thompson, Frank Titus, Gregg Toland, Roy Tripp, Robert Turner (withdrawal), Harry Vallejo, Walter Van Rossem, Blaine Walker, Vernon Walker, Jack Warren, John Weiler, Charles Welborn, James Woodbury.

MEXICO'S LABOR CODE

The Labor code proposals recently adopted, roughly, are:

Establishment of an elaborate system of labor courts with the power to advise employers as to the conduct of the business.

Appointment of a corps of labor inspectors under government supervision.

Recognition of the rights to strike, without violence. Arbitration, at first voluntary, then compulsory, would be provided for.

Establishment of an eight-hour day—six day week—and with four obligatory holidays and obligatory annual vacation periods with pay.

Obligatory insurance for employees to be conducted by the government and maintained by assessments of five per cent against the employee's salaries and seven per cent of salaries paid out against employers.

Every able-bodied citizen must learn a trade or profession and work at it at least one year in Mexico. When the nation's interests demand he must place himself at disposal of nation, working at least one month in post assigned by labor authorities.

Seventy per cent of workers in any factory must be Mexicans. Only Spanish speaking people will be allowed to occupy posts of managers, superintendents, doctors and foremen.

Saloons and gambling houses will be banned in labor centers.

A minimum wage would be fixed in accordance with cost of living.

Employers would be obliged to obtain consent of the labor courts and then give employees one month's notice before closing their business.

WELCOME

"The Loud Speaker" is a nifty house organ issued for the first time under date of April, 1930, by California Chapter No. 7, American Projection Society. Wallace G. Crowley is editor; W. R. Hermance and Rodney T. Bacon, asssociate editors. The officers and governors of Chapter No. 7, are as follows: Sidney Burton, president; J. B. (Pop) Kenton, vice president; D. H. Koskoff, secretary; A. Feinstein, treasurer; board of governors: J. B. Kenton, A. C. Schroeder, D. B. Leavitt, W. C. Crowley.

The new publication is a snappy, well edited little book of eight pages—chock full of interesting matter. **The International Photographer** bespeaks for *The Loudspeaker* a long and successful career.

GET READY FOR GOLF

Brother Jimmy Palmer, professional golf impressario, desires to announce that the Second Annual Golf Tournament of Local 659 I. A. T. S. E. and M. P. M. O. will be held on Sunday, September 7, 1930, the first Sunday after Labor Day. He wants two hundred contestants in their tournament. Get ready. This means you.

PROJECTION ADVISORY COUNCIL'S NEW HEAD

At its recent election the Projection Advisory Council unanimously chose as its president Thaddeus C. Barrows, a man peculiarly fitted for this important position and **The International Photographer** in congratulating the Council upon its wisdom in electing Mr. Barrows hereby also extends the heartiest felicitations to the new incumbent.

Mr. Barrows received his license to operate a motion picture machine in Massachusetts in 1907 and in 1910 helped to organize and secure charter from the I. A. T. S. E. for Boston Local No. 182. He has held practically every office in Local 182, including financial and corresponding secretary, member of the executive board and treasurer. For the' past fourteen years he has been elected President of Local 182, without opposition. From 1914 to 1930 he worked for' ten years as chief projectionist of the Park Theatre, Boston, and when Publix opened the Metropolitan in Boston, the first of Publix New England De Luxe Theatres, he was made supervisor of projection and now holds that position.

Thad. C. Barrows has attended many conventions of the I. A. and will be present at the coming convention in Los Angeles. He is a member of the Society of Motion Pictures Engineers, American Projection Society and takes a keen interest in all activities for the betterment of his own craft and the motion picture industry.

As President of the Council he will also splendidly combine much enthusiasm and idealism with the willingness to work and much executive experience.

THAT CHESS TOURNAMENT

Hurry and sign up for that chess tournament the chess fiends of Local 659 have so long been talking about.

Plans are making for the first meeting to be some time soon after the June convention.

The following members have signified their eagerness to participate: William Draper, B. B. Ray, Enrique Vallejo, Abe Scholtz, A. Fernandez, Fred Westerberg, Eddie Ullman, Willie Wheeler, Ernest Laszlo, James E. Woodbury, Donald Keyes.

OFF TO ITALY

Brother Gaetano (Tony) Gaudio is packing his bags for a two months' visit to his old home in Italy.

Tony has just signed the longest contract in the history of the industry for cameramen — a six years stretch with that prince of producers Howard Hughes, master of Caddo and producer of "Hell's Angels."

Mr. Gaudio will depart April 26 and return July 5. In the meantime he is making a First National picture starring Billy Dove.

AWARDS OF MERIT
(Concluded from Pages 24 and 25)

The Academy awards were as follows:

5—Actor: To Warner Baxter for his distinctive performance in the pioneer outdoor Western talking picture, "In Old Arizona," produced by Fox Film Corporation. In cut, Baxter at right with Eddie Lowe, left.

4—Actress: To Mary Pickford for the distinctive performance in the exceptional motion picture "Coquette," a United Artists production. In cut, a group of shots of Miss Pickford in "Coquette."

6—Director: To Frank Lloyd for his distinctive achievements in directing the exceptional pictures "Weary River," "The Divine Lady" and "Drag." Mr. Lloyd in inset with picture of Corinne Griffith as Lady Hamilton and scene from "The Divine Lady."

7—Art Director: To Cedric Gibbons for his distinctive achievements in the art direction of "The Bridge of San Luis Rey" and other pictures produced by Metro - Goldwyn - Mayer Corporation. Scene from "The Bridge," inset of Gibbons.

1, 2, 3—Cinematography: To Clyde De Vinna, member of Local 659, I. A. T. S. E. and M. P. M. O., International Photographers of the Motion Picture Industries, for his distinctive achievements in photographing the unique motion picture, "White Shadows in the South Seas," produced by the Metro-Goldwyn-Mayer Corporation. De Vinna with his trophy flanked by two scenes from "White Shadows."

8—Writing: To Hans Kraly for his distinctive achievements in writing the artistic motion picture, "The Patriot," produced by Paramount Famous Lasky Corporation. Kraly at typewriter with Director Lubitsch.

9—Production: To the Metro-Goldwyn-Mayer Corporation for the distinctive achievements in producing the outstanding pioneer musical picture, "The Broadway Melody." President William De Mille, of the Academy, presenting trophy to Mr. Thalberg.

10—President De Mille making presentation speech to Messrs De Vinna, Gibbons and Thalberg.

Characterized as the motion picture industry's own judgment of its best work, the Academy honors were conferred after a study of the feature pictures released during the year between August 1, 1928, and August 1, 1929, nomination by Academy members and vote of a board of judges composed of leading members of the creative branches of motion picture production.

In formally conferring the awards William C. De Mille, president of the Academy, stated: "The control board representing all five branches of the Academy judged each achievement with special reference to its value to the motion picture industry, and to the arts and sciences on which the industry exists. Each achievement was judged from all its aspects combined rather than on any single point of excellence."

Out of Focus

Our "Out of Focus" editor, Mr. Charles P. Boyle, has been far away on location and too busy to wield his facile typewriter to fill out his assignment for our May edition, which his host of admiring readers will greatly regret, but look out for his June budget—he has a treat for you.

—o—

NEW POLICY

It seems as though this page has been dying for sometime—altogether boys—"It's been dead for months," but nevertheless we are going to have a new policy or else get pushed off the last page for trying.

After reading quite a few of the larger magazines and noting that they have come out in favor of repealing the prohibition law and getting a lot of new subscribers, this page has decided to do the same.

So after a great deal of thought and very little deliberation we have decided to go wet. This page has been all wet so long that there will be very little change, if any.

We are in favor of light wines, beer, jamaica ginger, wine tonics, orange peel, bay rum and milk.

We are opposed to good whiskey. You can't get it anyway.

You will find a ballot below and you can cast your own vote. After filling it out place it in a plain envelope and send it to the cleaners.

SAMPLE BALLOT

Are you in favor of the above?	
Are you in favor of anything?	

(X) should mark the spot.

Do not vote more than once unless you are accustomed to it.

Non-members may vote by securing 50 new subscriptions.

—o—

HERE'S HOW

Imagine my surprise and feeling of satisfaction to know that Schlitz Gold Seal is made by Union Labor.

—o—

Harry Merland said that he went to France to give them a hand and they took a lung.

—o—

NEW ASSISTANT

Paul Perry is now another uncle. Harry, his younger brother, is the proud Pop of another boy. This makes three.

HISTORY MAKERS
(Continued from Page 46)

for many of the improvements made on the Bell & Howell camera.

This group also was responsible for the installation at Essanay of the first developing machine ever made. It was invented by Fred Thompson and a success for those days.

The late Rudy Bergquist was one of the original group. All save Mr. Hargan, Reeves, Rose and Zech are in Hollywood. Reeves, Rose and Zech are members of Local 659; Spoor, Hargan and Luperti are members of Local 666, Chicago; and Carlson is in the employ of the Southern California Telephone Co.

Messrs. Spoor and Luperti are associated with Mr. George K. Spoor, of Chicago, inventor of the famous Spoor camera.

—o—

TRIBUTE TO ENGINEERS
(Continued from Page 27)

one that forced many of the studios to increase their glow type of illumination to a point where heat became a serious factor and the quality of the photography was impaired. Today all noises have been eliminated from the arc lamps, with the result that those studios who had arc light equipment lying dormant can now use all of it, thereby exploding a theory advanced a year ago that the studios would be forced to junk their arc light equipment, totaling several million dollars.

These are accomplishments that the studio engineers can well be proud of and the fact that all these problems were solved by the engineers themselves, without having to call on any one outside of their own organization to help solve them, is something that the engineers can well feel proud of.

With wide film coming into its own place in the industry, I know that any drawbacks it might have, will all be solved by the studio engineers. They have made wonderful progress and will continue to progress because they are not the type of men to stand still. To repeat, only in progress can real happiness be found.

Visit any of the studios and trace the history of its progress and you will find that all this has been brought about by the engineers actively engaged in the studio today. Every development in the motion picture studios of today was solved right within its own portals. True, they did not build all these things, but they specified them and when you have specifications and drawings, it is very easy to have them built.

A. S. C. ELECTS

At the regular annual meeting of the American Society of Cinematographers for 1930 the following members were elected: President, Hal Mohr; First VicePresident, Vic Milner; Second VicePresident, Arthur Miller; Third VicePresident, Chas. G. Clarke; Treasurer, John Arnold; Secretary, Wm. Stull.

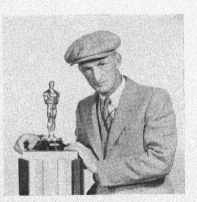

ALTHOUGH many sizes have been suggested for the width of the Wide Film only one size has been developed to the point of production, this being the 70 mm. GRANDEUR. Other sizes that have been experimented with have adopted the same ratio of size of picture but have included objectionable features that have precluded their use.

70 mm. GRANDEUR pictures are now being shown and others are in production. Mitchell Grandeur 70 mm. cameras were selected by the producers of these pictures because these cameras enabled them to produce high grade pictures without costly delays and experiments.

We are in production of 70 mm. cameras but will build any other size on special order if desired. This, of course, would cause delay in delivery and an increase in price above the 70 mm.

Mitchell Camera Corporation

665 North Robertson Blvd. West Hollywood, Calif.

Cable Address "MITCAMCO" Phone OXford 1051

A Few More of Our Current Photographic Successes

Negative? Naturally!

REG. U. S. PAT. OFF.

CAMERAMEN

"He Knew Women"	R. K. O.	Eddie Cronjaeger
"Alias French Gertie"	R. K. O.	Roy Hunt
"Devil's Holiday"	Paramount	Harry Fishbeck
"True to the Navy"	Paramount	Victor Milner
"Return of Dr. Fu Manchu"	Paramount	Archie Stout
"The Big Pond"	Paramount	George Folsey
"Young Man of Manhattan"	Paramount	Larry Williams
"Sea Bat"	M. G. M.	Clyde De Vinna and Ira Morgan
"Caught Short"	M. G. M.	Len Smith
"Floradora Girl"	M. G. M.	Oliver Marsh
"In Gay Madrid"	M. G. M.	Merritt Gerstad
"Lady of Scandal"	M. G. M.	Arthur Miller and Oliver Marsh
"The Bad One"	United Artists	Karl Struss
"The Storm"	Universal	Alvin Wyckoff
"Under Montana Skies"	Tiffany	Harry Zech
"The Big Fight"	Sono Art	Jackson Rose
"Swing High"	Pathe	David Abel

"The DUPONT Trade Mark Has Never Been Placed On An Inferior Product"

SMITH & ALLER, Ltd.

6656 Santa Monica Blvd. HOllywood 5147

Pacific Coast Distributors

For

DU PONT PATHE FILM MFG. CORP.

35 West 45th Street New York City

The
INTERNATIONAL
PHOTOGRAPHER

Official Bulletin of the International Photographers of the Motion Picture Industries, Local No. 659, of the International Alliance of Theatrical Stage Employees and Moving Picture Machine Operators of the United States and Canada

Affiliated with Los Angeles Amusement Federation, California State Theatrical Federation, California State Federation of Labor, American Federation of Labor, and Federated Voters of the Los Angeles Amusement Organizations.

Vol. 2 HOLLYWOOD, CALIFORNIA, JUNE, 1930 No. 5

"Capital is the fruit of labor, and could not exist if labor had not first existed. Labor, therefore, deserves much the higher consideration."—Abraham Lincoln.

CONTENTS

The INTERNATIONAL PHOTOGRAPHER *published monthly by Local No. 659, I. A., T. S. E. and M. P. M. O. of the United States and Canada*

HOWARD E. HURD, *Publisher's Agent*

SILAS EDGAR SNYDER *Editor-in-Chief* IRA B. HOKE *Associate Editor*
LEWIS W. PHYSIOC *Technical Editor* ARTHUR REEVES *Advertising Manager*
JOHN CORYDON HILL *Art* FRED WESTERBERG *Asso. Technical Editor*
CHARLES P. BOYLE *Treasurer*

Subscription Rates— United States and Canada, $3.00 per year. Single copies, 25 cents
Office of publication, 1605 North Cahuenga Avenue, Hollywood, California. HEmpstead 1128

The members of this Local, together with those of our sister Locals, No. 644 in New York, No. 666 in Chicago, and No. 665 in Toronto, represent the entire personnel of photographers now engaged in professional production of motion pictures in the United States and Canada. This condition renders THE INTERNATIONAL PHOTOGRAPHER a voice of an *Entire Craft*, covering a field that reaches from coast to coast across the nation.

Printed in the U. S. A. at Hollywood, California

The
INTERNATIONAL
PHOTOGRAPHER

Official Bulletin of the International Photographers of the Motion Picture Industries, Local No. 659, of the International Alliance of Theatrical Stage Employees and Moving Picture Machine Operators of the United States and Canada.

Affiliated with
Los Angeles Amusement Federation, California State Theatrical Federation, California State Federation of Labor, American Federation of Labor, and Federated Voters of the Los Angeles Amusement Organizations.

Vol. 2 HOLLYWOOD, CALIFORNIA, JUNE, 1930 No. 5

"Capital is the fruit of labor, and could not exist if labor had not first existed. Labor, therefore, deserves much the higher consideration."—Abraham Lincoln.

CONTENTS

The INTERNATIONAL PHOTOGRAPHER published monthly by Local No. 659, I. A. T. S. E. and M. P. M. O. of the United States and Canada

HOWARD E. HURD, *Publisher's Agent*

SILAS EDGAR SNYDER - - - - *Editor-in-Chief*	IRA B. HOKE - - - - - - - *Associate Editor*
LEWIS W. PHYSIOC - - - - - *Technical Editor*	ARTHUR REEVES - - - - *Advertising Manager*
JOHN CORYDON HILL - - - - - - - - *Art*	FRED WESTERBERG - - *Asso. Technical Editor*

CHARLES P. BOYLE - - - - - - - *Treasurer*

Subscription Rates— United States and Canada, $3.00 per year. Single copies, 25 cents
Office of publication, 1605 North Cahuenga Avenue, Hollywood, California. HEmpstead 1128

The members of this Local, together with those of our sister Locals, No. 644 in New York, No. 666 in Chicago, and No. 665 in Toronto, represent the entire personnel of photographers now engaged in professional production of motion pictures in the United States and Canada. This condition renders THE INTERNATIONAL PHOTOGRAPHER a voice of an *Entire Craft*, covering a field that reaches from coast to coast across the nation.

Printed in the U. S. A. at Hollywood, California

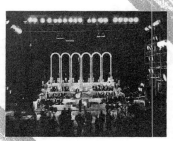

Full Realization
of a
Tremendous Responsibility

A tremendous responsibility is placed upon studio lighting equipment in this era of sound pictures. Particulars are needless .. the Industry knows. So do Mole-Richardson lighting engineers know .. to the extent that they allow nothing to prohibit their producing the finest lighting equipment obtainable. Consequently Mole-Richardson equipment is considered superior. Above all, Mole-Richardson equipment consistently maintains this superiority, overcoming the inevitable penalties that forever attack all leaders.

If It Isn't An Ⓡ It Isn't An Inkie.

MOLE-RICHARDSON INC.
STUDIO LIGHTING EQUIPMENT
941 N. SYCAMORE AVENUE · · · · · · · · HOLLYWOOD, CALIFORNIA

This glorious picture of the California desert is from the painting of our distinguished brother and Technical Editor of THE INTERNATIONAL PHOTOGRAPHER, Mr. Lewis W. Physioc. Here is the desert as it really appears to the observer and our artist with his genius for color and composition has succeeded perfectly in bringing connectivity to our prints

Full Realization
of a
Tremendous Responsibility

A tremendous responsibility is placed
upon studio lighting equipment in this
era of sound pictures. Particulars are
needless .. the Industry knows. So do
Mole-Richardson lighting engineers know
.. to the extent that they allow nothing
to prohibit their producing the finest
lighting equipment obtainable. Conse-
quently Mole-Richardson equipment is
considered superior. Above all, Mole-
Richardson equipment consistently main-
tains this superiority, overcoming the
inevitable penalties that forever attack
all leaders.

If It Isn't An (MR) It Isn't An Inkie.

This glorious picture of the California desert is from the painting of our distinguished brother and Technical Editor of THE INTERNATIONAL PHOTOGRAPHER, Mr. Lewis W. Physioc. Here is the desert as it really appears to the observer and our artist with his genius for color and composition has succeeded perfectly in bringing convincingly to our pages.

I. A. T. S. E.--*Convention* Program--*M. P. M. O.*

THE convention of the International Alliance of Theatrical Stage Employees and Moving Picture Machine Operators to be held in Los Angeles, June 2nd to 7th of this year is the first International Alliance Convention to be held on the Pacific Coast in seventeen years, and the first that was ever held in the city of Los Angeles. The convention opens June 2nd in the Rose Room at Eighth and Spring streets.

It may be of interest to some of our readers to know that the first convention of the International Alliance was held in the city of New York on July 17th, 18th and 19th of 1893. Thirty-six years ago. That convention was attended by sixteen delegates represents ten Locals.

But in this good year of 1930 we Angelenos are expecting to welcome not less than three thousand delegates with their relatives and friends. Six hundred and eighty-three local unions will be represented and they are due in from almost everywhere.

The big works will start on Monday, June 2, the first day of the convention which, by the way, will meet in the Rose Room, Eighth and Spring streets.

After the adjournment of the morning session of the convention the entire personnel will be transported to the William Fox Westwood Studios where a glorious program has been provided by the studios represented in the Motion Picture Producers' Association.

Here, at noon, on the largest stage, will be spread the greatest buffet luncheon ever served in Hollywood and a program of music and entertainment will feature it.

The orchestra of Arthur Ray and Carli Elinor will be in attendance and there will not be an idle moment nor a silent one—for these are the days of sound.

President Canavan, of the I. A. T. S. E. and M. P. M. O., will speak while the prominent executives of the great studios will be present to personally welcome the visitors.

After the luncheon the newsreel boys will go into action and that night and all the rest of the week the delegates may see themselves on the screens of all the big theaters.

There will be a panorama picture shot with scores of motion picture stars, players and executives from all the studios scattered among the visiting hosts and individual groups also will be photographed with their favorite players.

The next big event on this unique program will be a vaudeville entertainment staged by the featured players of a dozen studios—an entertainment almost as big as "The Biggest Show on Earth" put on by the Convention Committee at the Shrine, on May 6.

The grand finale will be an exhibition of the actual making of sound-motion pictures by one of the Fox units. Here the visitors will be shown the modern openandi of the Talkies with an explanation of the Movietone system.

After the big show the visitors will be taken for a three hour scenic drive through Pasadena, Hollywood, San Gabriel, Chevy Chase, Glendale, Flintridge, over Hyperion Bridge, etc.

That night in downtown Los Angeles the biggest electric ballyhoo on record, connecting up Paramount, Loew's State, Orpheum, Tower, Rialto, Criterion, Warner Brothers, R. K. O. and United Artists theaters will be staged for the

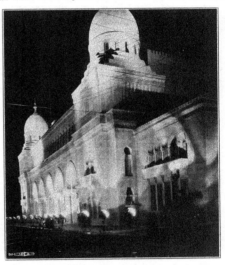

Shrine Auditorium, Los Angeles, scene of "The Biggest Show on Earth," put on in preparation for the I. A. T. S. E. and M. P. M. O. Convention.

delectation of the visitors, featuring the greatest electrical display ever made here.

On Tuesday, while the convention is in session, the ladies will be taken on a trip to Catalina Island for a glimpse of the old Pacific and Los Angeles harbor. At night the fights will be the mecca for the delegates. Wednesday the ladies will go to Mount Lowe.

Thursday the entire group of delegates, their families, friends and hosts will be taken for a tour of the Orange Empire in busses. The iterinary will include the Italian vineyards and wineries, orange and lemon groves, the great fruit packing plants, the flying fields, etc.

On Friday, after the election of officers and final adjournment, the delegates and visitors will be turned loose to follow their own devices and by Saturday we will be bidding "Adios" to many of our beloved brothers and honored guests.

On one night during the week our visitors will be taken in the automobiles of their hosts to vantage points on the Hollywood hills and Santa Monica mountains to view the lights of the city. Than this panorama of light there is no more amazing and beautiful sight on earth. It is easily the eighth wonder of the world and our visitors are urged not to miss this gorgeous spectacle under any circumstances. It will be a cheerful and inspiring vision to carry in your mind's eye through life.

Hail I. A. T. S. E. and M. P. M. O.! You are more than welcome to our Miracle City and when you depart we will say with the Spanish people—Adios. And Adios means, "Go with God."

The Biggest Show On Earth

When the International officers of the I. A. T. S. E. and M. P. M. O. decided to hold the Thirtieth Convention of these organizations in Los Angeles, the five Locals of this city, Theatre and Studio Employees No. 33; Laboratory Technicians No. 683; Studio Cameramen No. 659; Studio Mechanics No. 37, organized a committee to arrange for the big doings. The personnel of this committee, officially known as the General Committee, read as follows:

Of Local 33, W. S. (Bill) Scott, business representative; John J. Riley, T. Z. Hughes, P. O. Paulsen, James Mathews, (chairman of the committee.)

Of Local 37, Lew C. B. Blix, business representative.

presence and ripe judgment was keenly felt.

The first duty of the committee was to devise ways and means for defraying expenses of the convention and it was unanimously decided to put on such a show as would throw into eclipse the combined efforts of all shows produced in Los Angeles and Hollywood to date.

The popularity of the I. A. T. S. E. and M. P. M. O. with the stage and motion picture people made such a show possible and, with the date fixed at May 6, only four weeks away, the committee led by the five business agents went to the tremendous job of lining up the talent and perfecting the arrangements for what Bill Scott called "The Biggest Show on Earth."

The bandstand set especially built by Billy Woods for "The Biggest Show on Earth."

Of Local 683, Carl J. Kountz, Dominic DeCenco, George D. McGrath.

Of Local 659, Howard Hurd, business representative; Silas E. Snyder, James Palmer, William H. Tuers, and Faxon Dean.

Of Local 150, Ted Eckerson, business representative; P. R. Cromes, Frank Sawyer, F. L. Borch and J. B. Kenton.

The majority of this representative committee functioned 100 percent and held weekly meetings to check up on each others activities, the only rift in the lute of complete accord being the illness of Chairman Mathews, who was stricken a few days after the second meeting and at this writing lies apparently fatally ill at Angelus hospital. This noble old war-horse in the battle of economic liberty widely known and respected, a strong pillar in the Temple of Labor, a just, humane and able worker for our own ideals and a highly respected citizen.

This beloved brother's illness cast a pall of sadness over the deliberations of the committee and the loss of his genial

The result was that on the fatal night there was pulled off at the Shrine Auditorium an entertainment such as Los Angeles had never before seen and which fully justified the committee in naming it "The Biggest Show on Earth."

Now the Shrine Auditorium has a seating capacity of 6500 and it is one of the show places of Southern California, yet the house was practically sold out, a wonderful testimonial to the popularity of the I. A. T. S. E. and the M. P. M. O. Some idea of the magnitude of this big show may be had from a contemplation of the array of talent secured by the entertainment committee.

The Program

Organ selection, Claude Reimer, (courtesy Warner Bros.); Overture, Leo Forbstein and his First National Recording Orchestra; Monte Blue, Los Angeles County American Legion Drum Corps; Leon Errol, (courtesy Paramount); Eddie Cantor; Harold William Roberts and Trojans' music; Fred Niblo, (courtesy of M-G-M Studio); Taylor Holmes, (cour-

tesy of Duffy Theaters); Larry Ceballos and his world-renowned beauties, (Warner Brothers); Edna Covey, premier danseuse direct from European triumphs; Neil Hamilton, (courtesy of Paramount); Eddie Lambert; R. K. O. vaudeville act; Vera Downs and H. Melhorn; Bob Murphy; Estaleah, prima donna (courtesy of Farris Hartman Light Opera Co.) George O'Brien (courtesy of Fox Film Corporation); Tom and Hank McFarland, (Courtesy of Jimmy Casey); Ruth Chatterton, (courtesy of Paramount) Dorothy Mackaill; Johnny Mack Brown; Anita Page; Leo Carrillo, (courtesy of Duffy Theatres); Gene Morgan, "He of the Green Hat;" needs no introduction, Clyde Hager, "The Street Fakir;" Frank Fay, (courtesy of Warner Brothers); Slate Brothers; Ferris Hartman, Ferris Hartman Opera Co.; Skeets Gallagher, (courtesy of Paramount).

Kathryne Campbell's Hollywood Fashion Revue. Intimate Feminine Fancies, Delightful Conceits of the Boudoir, an Adventure Modernistic. Boudoir furnishings by Hal Smith, Inc., 300 N. Vermont Ave. Diamonds and Parfums, courtesy Wm. Stromberg; Negligees Designed by Gwen Wakeling. Negligees and Lingerie courtesy of Pathe Studios. Furs especially designed by Baker Fur Company, 6325 Hollywood Boulevard.

I

Forecast of the Bathing Mode for the Beaches of Southern California.

II

Catalina Swim suits, courtesy of Hollywood Knit Shop, Hollywood boulevard at Cherokee avenue.

III

Shower bath curtains, courtesy of Meneley-Diedrich Co., Inc., 1722 E. Seventh street.

Produced under the personal direction of Kathryne Campbell.

Models participating—Margaret Steppling, Dorothy Dahl, Kathleen Lally, Dorothy O'Hara, Alta Faulkner, Kathleen Parker, Eleanor Spies, Valta Boyer, Josephine Brimmer, Bula Christian, Eileen Stewart, Isabel Walker, Marie Fowler, Alice Maye, Virginia Maye, Lois Thompson, Patricia Connelly, Mary Beth Hull, Violet Lundee.

Finale—Beauty and the Bath enacted by Violet Lundee assisted by chorus.

Abe Lyman, assisted by Ted Ledford, Phil Heely, Lucille Page; Laura Lee, (Courtesy of First National Studios); Little Mary Rose, "Just Herself;" Hobart Kennedy, (courtesy of KFWB); Freeman Lang.

Lillian Albertson and Louis O. Macloon Present the Original New York and London Singing Star, Allan Prior and the Famous Male Chorus, "That Makes You Feel Like Marching," from the New Stage Production of the Glorious Operetta "The Student Prince," now playing a limited engagement at the Majestic theatre.

Charlie Irwin, "Just Himself." Joe E. Brown and William Lightner, (courtesy of Warner Brothers); Lilyan Tashman

(Concluded on Page 36)

General Officers of the International Association of Theatrical Stage Employees and Motion Picture Machine Operators of the United States and Canada

The General Arrangements Committee

J. B. Kenton

William F. Scott
Chmn

F. A. Sawyer

Carl Kountz

Fred L. Borch

Paul R. Cramer

Johnny Riley

Lew C. G. Blix

Howard Hurd

James R. Palmer

T. H. Eckerson

William H. Tuers

To this Committee on General Arrangements for the 1930 Convention of the I. A. T. S. E. and M. P. M. O.
in Los Angeles goes the credit of performing well the herculean task of putting over successfully "The Big-
gest Show on Earth," in preparation for the Convention and of laying out the broad lines of the general pro-
gram, the details of which were worked out by the Entertainment Committee. Not all of the members could
be represented by photographs. The names of the General Committee in full appear on page 4.

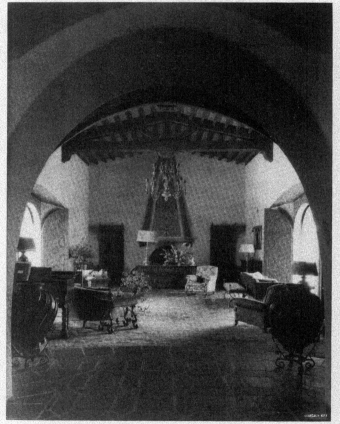

Color Rendition

A Series of Practical Tests of the Monochromatic Rendition of Color With Commercial Motion Picture Negative

—BY—

JACKSON J. ROSE, *First Vice-President, Local 659*

Jackson J. Rose, author of this article, is a pioneer photographer of the motion picture industry and his long experience has peculiarly equipped him to discuss subjects of the kind here treated. In subsequent issues of The International Photographer *Mr. Rose will continue his discussion of the action of other colors on different kinds of film, with illustrations, and the thoughtful cinematographer will look forward to them with interest.*—Editor's Note.

Mr Rose in his laboratory making tests on color rendition.

HE past year has seen tremendous advantages in the popularity of natural color cinematography for the production of dramatic feature pictures, as well as comedy shorts, but nevertheless the motion picture industry as a whole continues to operate on a black and white basis. Yet even so, the question of color and its rendition is of vital importance to cinematographers, for black and white pictures are nothing more nor less than representations of the form and color of a scene in monochrome. Therefore it is of the utmost importance that cinematographers, art directors and others interested know exactly how every color and shade will photograph under everey condition of lighting and filtering, and upon every available make of film.

The past year has seen tremendous advances in the popularity of natural color cinematography for the production of dramatic feature pictures, as well as comedy shorts, but nevertheless the motion picture industry as a whole continues to operate on a black and white basis. Yet even so, the question of color and its rendition is of vital importance to cinematographers, for black and white pictures are nothing more nor less than representations of the form and color of a scene in monochrome. Therefore it is of the utmost importance that cinematographers, art directors and others interested know exactly how every color and shade will photograph under every condition of lighting and filtering, and upon every available make of film.

The long years of experience behind most cinematographers and art directors is sufficient to give them a fairly accurate judgment of such things in most cases, but there are times when even the most extensive experiment must be at a loss to find the right answer to such problems. Furthermore, the opinions of

Color Rendition

experienced cameramen as to the photographic value of certain materials may often be diametrically opposed. An instance of this occurred in the writer's experience some time ago: In the course of his work in photographing a picture at one of the larger studios he had to photograph a set whose background should have photographed in a very light tone, while according to the judgment of one of his colleagues—an equally experienced cinematographer—the set should have photographed in a very dark tone.

They both were careful in giving a decision, in this case both the Pan glass viewing filter as well as the Blue glass were brought into play. One contended that the said background would go fairly light while the other contended it would photograph very dark. In the projection room the next day it was viewed and actually, it was found that neither man was perfectly right, and that the green of the set photographed as dark grey, midway between the two values predicted.

In itself, this incident had no practical value; but it very closely showed the writer that something was wrong. Here were two experienced, veteran cinematographers, whose judgments of the

photographic value of a certain color were diametrically opposed, and who were both proven to be wrong by actual practice. Furthermore, every practicing cinematographer can easily cite a dozen similar instances from his personal experience. This pointed to an alarming state of affairs, for the keynote of the cinematographer's work is his exact knowledge of the photographic value of every object and color he is to photograph before money is needlessly expended on construction and photography. He is almost the only man in a studio who cannot say: "This ought to photograph thus and so." He must know, positively, how it will appear or his judgment will be questioned.

Of course there are certain aids in determining the photographic values of such materials by inspection through the various monotone viewing-filters available; but the writer's personal experience with such filters is that none is uniformly accurate with all colors and under all light conditions; in fact, no such filter will give an accurate reading for any color material under nearly all the conditions met with in the course of general studio or exterior work. For instance, the so-called "Pan glass" is reasonably accu-

Color Rendition

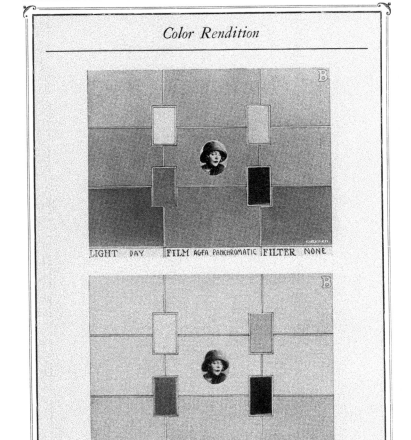

Color Rendition

rate inasmuch as it will show about what one will get on Panchromatic film with a K-2 filter; but with either a heavier or lighter filter, or with none at all used, this glass is entirely incorrect.

The same may be said of the so-called Blue glass or C monotone filter. It is useless to use such a filter when photographing with Mazda light or Panchromatic film. They may, however, give one a fair idea of the color rendition when arc or hard light or even Cooper-Hewitt light is used and even in daylight when one is using Orthochromatic film, but for other uses this filter is of little value.

Therefore, it is this writer's suggestion that if a single pair of accurate, neutral-colored viewing-filters (one for Orthochromatic film, and one for Panchromatic) could be devised, it would be a great boon to the cinematographic profession.

Such a filter would of course have to be made in several different densities to take care of the use of various kinds of filters as well as both Orthochromatic and Panchromatic emulsions.

In view of the existence of the condition just outlined, it appeared to this writer that a systematic series of tests of the various sensitive materials commonly used in the studios, and covering a wide range of colored materials and textures, made with absolute uniformity under the light and filter conditions most commonly met with in studio practice, would furnish a far more nearly scientific basis from which to judge such photographic values than experience, filters, or any previous tests with which he was acquainted. Accordingly, he set himself to the task of devising and exacting such a series of tests.

The first problem was to collect a vast amount of colored material in every shade and tone possible, to get which incidentally took the writer over six months to collect and then to segregate these different shades and tones of each individual color, eliminating those that were not necessary.

The second problem was that of arranging the color-specimens to be photographed in a way that permitted several different shades and tones of the same color to be easily compared. This was done by arranging the color charts with nine squares of different shades of each color to the sheet. Then, to form a basis for more rigid comparison, upon completion each sheet was also provided with

Color Rendition

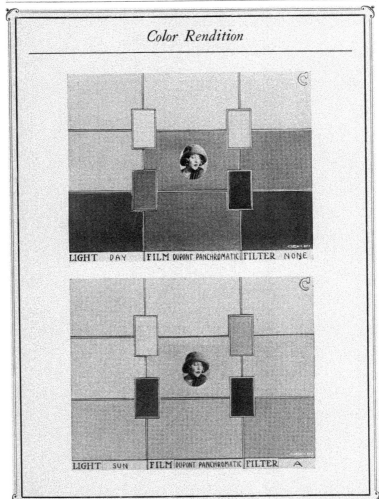

Color Rendition

identical monochromatic squares of white, light grey, dark grey and black.

But these test films must all be exposed and printed so as to preserve the same relative factor of density for the entire series, or the tests would be valueless. To this end identical photographs were placed at the center of each of the test sheets, and exposure and printing were keyed by these.

Then came the problem of the manner of photographing these tests. Obviously it would have been considerably easier to have photographed them with the conventional 8x10 still camera; but this would have been no true test, for, contrary to the general opinion, the writer found that the emulsions coated on photographic and cinematographic films by the various manufacturers are entirely different in many characteristics.

Furthermore, this would have given no measurement to the grain of the several cinematographic emulsions — a feature which is also of great importance to the cinematographer. Therefore, these tests were made on standard motion picture negative film, in a standard motion picture camera in order that the exposures might be absolutely even, a motor was used, and a definitely fixed footage—

fifteen feet—was exposed in the course of these tests.

It is worthy of mention here, that many errors were made due to the different speeds of the various films tested and also due to the change of light while using filters in the sunlight tests because these tests were started in the morning and continued until late afternoon. A system of accuracy was finally adopted and applied to meet all light conditions and densities.

The negative exposed was treated in the identical manner in which it would have been treated if it had been a part of ordinarily, commercial production. It was developed in a well known commercial laboratory, by machine methods, and in the solutions regularly employed by the laboratory.

In fact every step in the making of these tests was as near normal conditions photographing productions as was humanly possible to apply.

A single-frame of each test strip was chosen at random and enlarged to 8x10 inches, being printed on glossy stock, and, as said before, to a uniform relative density.

In the final, enlarged prints these photographs all showed the same density, the

Color Rendition

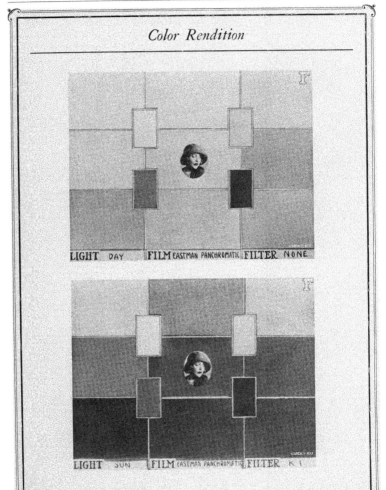

Color Rendition

Showing the attractive manner in which Mr. Rose binds his color charts.

relative densities of the different color squares would be uniform, and the tests therefore accurate.

These prints were then mounted on a muslin backing and fitted with a hinge, and the tests of each make of film collected in a separate, loose-leaf album, as were the original color charts.

It is well to note that the record of each film, light and filter was photographed with each color sheet making a permanent record.

Together, these five books comprise as complete a set of reference charts as the author has thus far been privileged to inspect, and it is with what he hopes is pardonable pride that he presents them to the cinematographic profession.

The color chart sheets which were photographed in this test number nineteen; each sheet contains squares of nine different shades or colors, making a total of one hundred and seventy-one different colors and shades tests; these have been photographed on each of the four makes of film most used in American production, viz., Eastman Type Two Panchromatic, DuPont Panchromatic, Agfa Panchromatic, and Agfa Super-Speed (Orthochromatic). Nine different light and filter conditions were used on each test.

It is well to mention here that the same lens, a four inch Pan Astro was used in all these tests and the full opening of the lens F. 2.3 brought to play. The shutter, of course, was manipulated to compensate the variations of light and filters used.

The colors on the test charts are arranged as follows, nine different shades being grouped on each sheet:

COLOR SHEET

A. Yellows: lemon, canary, cadmium, chrome, etc.

B. Oranges: Chrome, cadmium, red-orange, etc.

C. Light Reds: pink, vermillion, rose, cherry, etc.

D. Dark Reds: blood, scarlet, turkey, etc.

E. Greens, nine shades.

F. Blues: sky, pearl, royal, Prussian, indigo, etc.

G. Purples, nine shades.

H. Browns: nine shades.

I. Miscellaneous studio finishes: marble, oak, mahogany, etc.

J. Leather, nine colors.

K. Metallic Surfaces: g o l d silver, aluminum, bronze, etc.

L. Blue-Greens.

M. Yellow-Greens.

N. Orange-Reds.

O. Lavender and violets.

P. Red Browns.

Q. Greys.

R. Flesh tints.

S. Cloth (for textures): red, purple, brown, etc.

Each sheet is plainly lettered with its identifying letter, and when photographed in the tests also carried a card specifying the make of film, light, and filter used for that particular test, thus furnishing an exact and ineradicable record of the essential details of the test.

The light-conditions and filters used are:

1. Mazda Light	No.	Filter
2. Arc Light (White Flame)	No.	Filter
3. Daylight (Subdued)	No.	Filter
4. Sunlight	K 1	Filter
5. Sunlight	K 2	Filter
6. Sunlight	K 3	Filter
7. Sunlight	G	Filter
8. Sunlight	A	Filter
9. Sunlight	F	Filter

The results of these naturally comprise a tremendous amount of highly interesting information, but the mass thereof is so tremendous that it is impossible to go into detail in the limited space available here. Some general observations, however, and a few specific instances, may not be amiss.

Probably the outstanding fact which these tests proved is the general superiorities on certain colors or with certain types of light.

The Eastman Type Two Panchromatic emulsion showed itself particularly satisfactory in the rendition of the blues, as with it almost every shade of blue was rendered accurately and pleasingly. This particularly adapts this film for use when making night effect scenes by daylight, with the A or F filters. It is also well to notice the vast difference caused by the use of the ordinary yellow filters with this film. The illustration shows this very clearly, Chart F being the one which comprises the blues, and the illustrations showing how it photographed with and without the use of a K 1 filter.

This film also showed remarkable results with many other colors which contrasting effects were very favorable, but space prevents us from writing this up at this time. In a later issue we will take up the action of this film with all other colors.

The DuPont Panchromatic emulsion proved itself particularly superior in its red-sensitivity being, if anything, somewhat more sensitive to this region of the spectrum than any other film tested. This characteristic makes it particularly desirable when photographing people with a high coloring, when they use little or no makeup. This characteristic also adapts to fire-scenes, and to night shots where artificial illumination—particularly incandescent—is used. The illustrations show the results of photographing color chart C, which embraces the lighter reds, with this film. Notice the vast difference between the tests made with and without filters.

It is worthy of mention at this time that the color sensitivity of this film upon all colors was very satisfactory and its speed ratio was highly pleasing. This film showed slightly softer results in the darker colors.

The Agfa Panchromatic proved itself particularly sensitive to the yellows and oranges. Which makes it especially suitable for photographing sunrise and sunset effects, and gives it excellent characteristics for general use with incande-

(Concluded on Page 28)

 Cream o' th' Stills

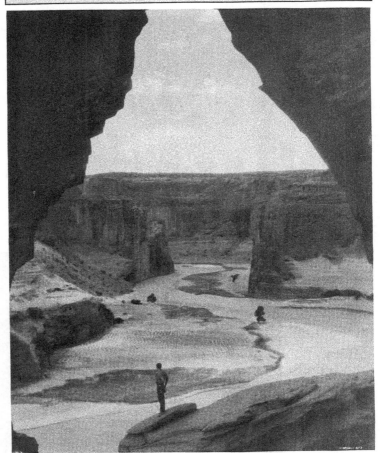

One of the natural wonders of America is the Canyon de Chelly. There have been thousands of photographs made of it, but none from this particular angle be more impressive. It was taken at considerable risk of life and limb by Fred W. Mayer.

Cream o' th' Stills

This bouquet of pulchritude is the ballet of Albertina Rasch featured in M.G.M.'s production "The Rogue Song." It was photographed by that clever still artist Mr. Clarence Hewitt.

It was a "dark and gloomy night" when Lindsay Thompson caught this picture along the water front at Santa Barbara. The spirit of the rain was in the air and the sea was calm and peaceful. Behind the horizon are the Channel Islands where the storm clouds are gathering for the attack.

Cream o' th' Stills

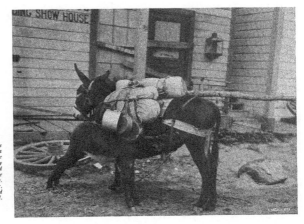

Bert Longworth is versatile. He can shoot 'em from the sublime to the every day, homey stuff and here is a masterpiece of the latter type. Leave it to Mr. Longworth to find the unusual.

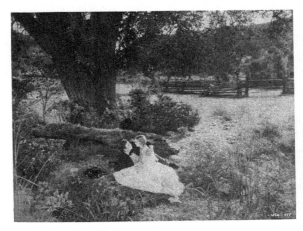

Clifton Maupin was given the important assignment of shooting the stills for D. W. Griffith's new "Abraham Lincoln" picture. Here is a scene in which the young Abraham appears with his sweetheart, Anne Rutledge. The locale featuring the old "stake-and-rider" fence might very easily be taken for the banks of the Sangamon.

 Cream o' th' Stills

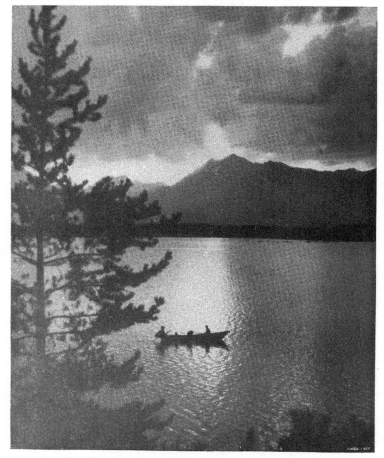

According to this enchanting photographic record the moon shines on the lakes of Wyoming as brightly as on any other "Sky Blue Waters." The clever artist is Jesse G. Sill and the place is Jackson Lake, Wyoming. The title is "Moonlight" of course.

Cream o' th' Stills

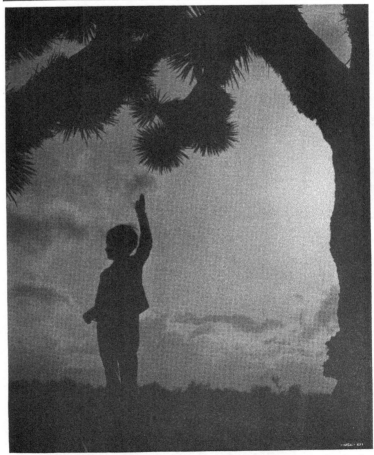

Clifton King of Palmdale knows his Joshua trees. He picked this beauty as a frame for Teddy Kling, also of Palmdale. It's a charming fancy and a fine sample of Mr. Kling's work.

Cream o' th' Stills

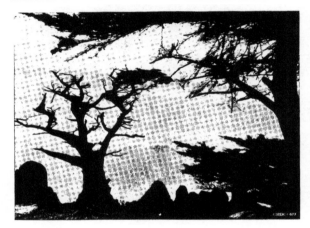

This marine by Frederic Colburn Clark was shot on the beautiful coast of the Monterey Peninsula, California. Such a picture is soothing to the weary spirit. Mr. Clark is internationally known as a painter, poet, writer and pictorialist. He was formerly connected with several New York magazines and newspapers.

Reminiscent of "The Covered Wagon" days is this intriguing still from the camera of J. Edwin New. The ox team and wagon are authentic and Frank Campau is a model Forty-Niner.

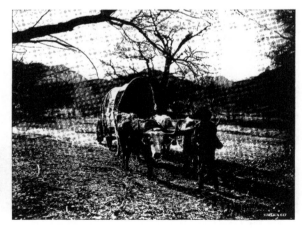

 # Cream o' th' Stills

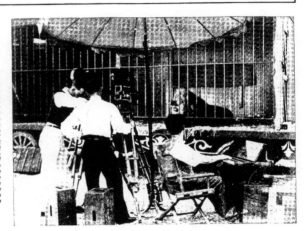

Edward B. Anderson snapped this at Charlie Chaplin's Studio one day when he surprised the great artist playing the organ for the delectation of a lion he was using in a scene for his new picture "City Lights." The observer can tell by the pleased expression on the lion's face that the King of Beasts is enjoying Charlie's playing. The cameraman weeping at his instrument is none other than Rollie Totheroh who has been with Mr. Chaplin for sixty-five years.

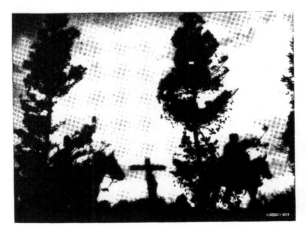

Gaston Longet is responsible for this exquisite silhouette, the locale of which, evidently, is Russia But not so. Mr. Longet ran across this one day while scouting around with his camera in the hills of Universal City.

 # Cream o' th' Stills

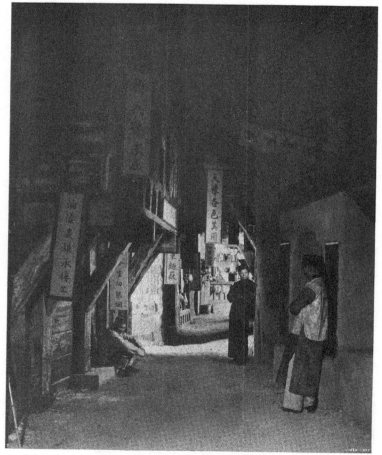

Paul Grenbeaux poses this scene on on old studio set. A fine photograph of a fine sample of stage setting.

A CIRCLE IS A SIMPLE THING

 Cream o' th' Stills

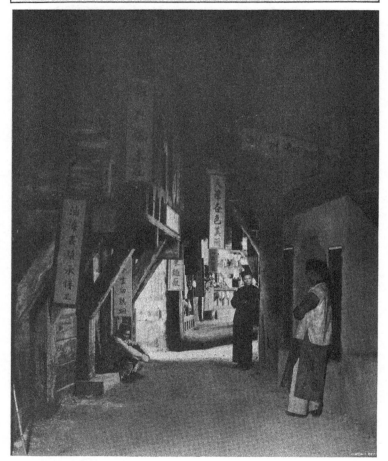

Paul Grenbeaux poses this scene on on old studio set. A fine photograph of a fine sample of stage setting.

A CIRCLE IS A SIMPLE THING

Around the World With a Globe-Trotting Cameraman

—BY—
DELBERT DAVENPORT

NE thing a newsreel cameraman cannot complain about is a lack of opportunity to go places and see things. Least of all can Merl LaVoy of Local 659, make such a complaint. Forsooth, since that day twenty years ago, when he started to turn a camera crank in Alaska, he has circled the globe, shooting newsreel stuff and still pictures in almost every country on earth. To him a trip across a continent and a couple of oceans to preside over photographing ceremonies for a single day is just like crossing a street to the average man. And, from the inception of his interesting career up to now, he always has been where the most extraordinary human events have been taking place.

For instance, back in 1912 while Woodrow Wilson was being elected president of the United States, Merl was climbing up and down Mount McKinley, the highest peak in North America, with the Parker Brown expedition of which he was the official photographer. Then when the same Woodrow Wilson directed our military forces into the maelstrom of the World War, this same Merl got into the thickest of the "fray," becoming a recognized specialist in war photography. He saw service on five different battle fronts before he got through and this included that one away up in bleak Siberia.

Since the war he has had important assignments in Australia, in the Solomon Islands, in the Bering Sea, the Arctic Ocean, China, and last but not least in the various South American countries visited by President Herbert Hoover during his famous good-will tour which preceded his induction into the highest office in the land.

It is worthy of special note that during a rather protracted sojourn in Alaska, Mr. LaVoy succeeded in getting onto his negative plates just about the whole story of Eskimo life, including its inner, intimate domestic aspects. In fact, a study of his remarkable collection of still photographs will serve to give the average person a liberal education as to how those strange denizens of far-northern shelves of ice live and how they avail themselves of whatever nature provides to fulfill their destiny on this mundane sphere. One of the more interesting shots he has captured in Alaska is that of an Eskimo burial ground inasmuch as it impresses upon one the resourcefulness of a race of people who cannot have many of the conveniences of more civilized races. Explicitly, when it became necessary to place a fence

Merle LaVoy, Local 659, got his first picture experience in Alaska twenty years ago and since that time he has shot still pictures and news reel stuff in almost every country on earth. He was a member of the Parker-Brown expedition which in 1912 was first to ascend Mt. McKinley, highest peak in North America. He was a specialist in war photography and saw service on five fronts during the World War including Siberia. Since the war he has had important assignments in Australia, the Solomon Islands, Alaska, Bering Sea, the Arctic Ocean and China in which latter country he made pictures in the Chinese Nationalist armies. Mr. LaVoy also did some fine work on President Hoover's good will cruise.—Editor's Note.

around that burial ground, some one of them had ingenuity enough to think of making use of the whale bones which abound in that country, and in consequence, was erected what is perhaps the only whale-bone fence in the world. An accompanying picture shows this novelty to a distinct advantage.

That the Eskimo parents are not only

good judges and expert makers of attractive clothes is also illustrated and the care they give to their children is an eye-opener, revealing as it does a loving solicitude comparable to that of any race of people on earth. All this valuable information is to be gleaned from the photographs for which Merl LaVoy is responsible and it constitutes a service to the cause of education. This, indeed, is a point worthy of being stressed, for it is an inevitable and enviable fate that professional cameramen do and shall contribute without limit to the elevation of

(Continued on Page 20)

1. *A Turkish peasant as he paused a bit uncertainly when he saw Merl LaVoy level his trusty camera upon him.*

2. *In Russia we find the church dignitary the best available subject for the camera.*

3. *This is the original Rodin's Thinker and it's still doing its thinking in Paris.*

4. *If you think the Eskimo bread-winner neglects his family or himself, just take a squint at the truly fine clothes this couple wears.*

5. *Another cute Eskimo kid here, too, safely at home on its happy mother's back.*

6. *The Alaskan glacier is here caught in all its awesome and terrific beauty.*

7. *And here we have the big bull sea lion and his sleek and numerous furry harem.*

8. *This Eskimo lady wears the smile that won't come off as a result of learning that her husband had triumphed to the extent of killing a polar bear.*

9. *Mt. McKinley, overpowering in its grandeur, was good for at least one tremendous shot.*

10. *And, if this isn't a cute, well-dressed baby, we don't know one when we see it. Yes, it's a fine sample of the Eskimo off-spring.*

11. *Who has not heard of the famous steamer "Bear," the staunch storm-battered craft, which plowed its tortuous course through many a blithering winter?*

12. *Eskimo burial ground at Point Hope, Alaska. Take note of the unique fence. "Them's whale-bones" the ingenious far-northerners have pressed into service to enclose the precious plot.*

13. *How could they get along in Alaska without the "Husky"? And here is one which can almost speak to us.*

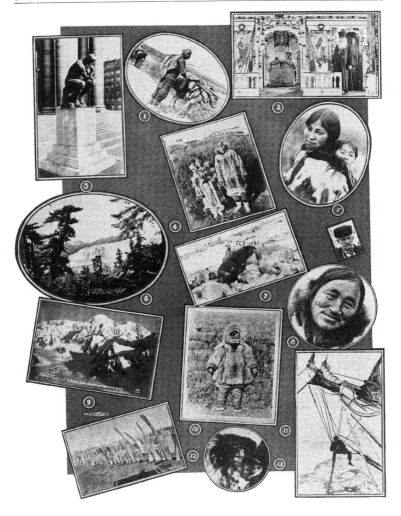

Around the World With a Globe-Trotting Cameraman

(Continued from Page 18)

the standards of human knowledge through suffering to explore far and wide for photographic r e c o r d s which enlighten while they entertain.

Mr. LaVoy is one of the few cameramen w h o h a s been permitted to focus his lens u p o n the danger-infested leper colony of the Philippine I s l a n d s. Here resigns supreme the tragedy and the pathos of life as it treats the more unfortunate, for of all the scourges to which mankind ever w a s subjected, none is more withering, more terrible than leprosy. Merl's shot of the so-called "unclean" at prayer on Easter morning, at the entrance of an old Spanish church, tells a story of stark misery most e l o q u e n t l y. These lepers, probably all doomed to a horrible end, b e t r a y that force which springs eternal hope, as they kneel reverently in recognition of a Supreme Being in Whose hands their fates rest.

Coincidental to this, many thousands of miles a w a y from that unhappy quarter, this same cameraman has c a u g h t Bedouins also at prayer o n t h e forbidding wastes of the mighty Sahara desert. Here the "scourge" is one of keeping supplied, first of all, with ample water to keep the heart-beat going.

On the South Sea islands, Mr. LaVoy spent much time and many of the photographs he brought back from that alluring section of the world surpass most anything which ever has been published insofar as revealing the customs of the strange blacks residing there is concerned. It is notable that he discovered the fact that the average ebony-hued mother was irreproachably dutiful toward her offspring, but that she seldom allows this

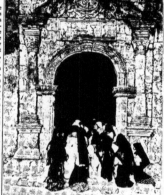

The proverbially unfortunate 13 is selected for this one purposely, because these women kneeling at prayer before this old Spanish church are all very unhappy— they are lepers of the famous Philippine Islands

sense of duty to interfere with the pleasure she derives from smoking her trusty old pipe, invariably a vile-smelling instrument. The favorite way of carting the maternal pipe along is on the arm with the aid of a fiber band.

As still another one of Merl's stills makes plain, when the men folks array themselves for a ceremonial dance, it's all the same as going to war so far as the fierceness of their appearance reaches. The penchant of these black people for disfiguring their faces and bodies in the belief that they are thus beautifying themselves is strikingly illustrated in several

of the special poses our artist has succeeded in recording with his camera.

In his almost unlimited globe-trotting of the last score of years, Merl has covered just about every square mile of his own United States and among his more remarkable shots, both in motion- and in stills, has been the photographing of a herd of seven thousand Hereford cattle, all within one camera field.

Verily, the life of a news-reel cameraman is one extraordinary event after another, and involved therein is one of the most useful works the great film industry has developed.

14. *It seems Merl LaVoy always has managed to be on the right spot at the right time. This is probably one of the last photographs ever taken of Abdul Hamid before he abdicated as Sultan of Turkey. Hizzoner is the gentleman in the buggy, of course.*

15. *And now to the other side of this little old globe. The Sultan of Turkey, wearied with his amorous household, takes the air.*

16 *How faithful to his Maker, is the true believer. The caravan pauses in prayer.*

17. *A Malata mother and her child of the South Sea Isles.*

18. *This Solomon Islander is musically inclined and the conglomeration of pipes he holds in his hands is an instrument that produces weird sounds we folks wouldn't interpret as music.*

19. *And here we have a cluster of Sérbians, and their surroundings.*

20. *This is one of the warriors of Solomon Islands. If he fails to nail you with his arrow, he might jab your eye out with that harpoon he wears in his nose.*

21. *Pomp and circumstance is the dominant note in the ranks of these colorful natives of the Southern Seas.*

22. *Here is a remarkably comprehensive view of the city of Constantinople photographed from the air by Merl LaVoy.*

23. *Outrigger boat used by the Solomon Islanders for inter-island communication.*

24. *The Solomon Islands abound with interesting people of ebony-hued skin. Believe it or not, this is a belle of the islands and, don't overlook the numerous scars on her bosom and shoulders. She's been beautifying herself if you please!*

25. *Here's a real avalanche in action on Mt. McKinley, and, according to Merl LaVoy, who photographed it, these countless tons of snow and ice made a roar which could be heard for miles around.*

26. *It may not make your blood congeal as does a mighty battleship in action, but this is a war canoe being manned by British Solomon Islanders.*

27. *The tortoise-shell nose ornament is quite the fashionable thing on the Solomon Islands. This gay, young blade wears one and how!*

28. *Speaking of devoted mothers and their babies, how about this pair. Merl LaVoy caught this glimpse of hippopotamus domestic life in a zoo in Australia.*

And even if you don't like cows, you've got to admire this photographic achievement, because Merl LaVoy has gotten into his camera field no less than 7,000 Herefords, snapped on the plains of the great American southwest.

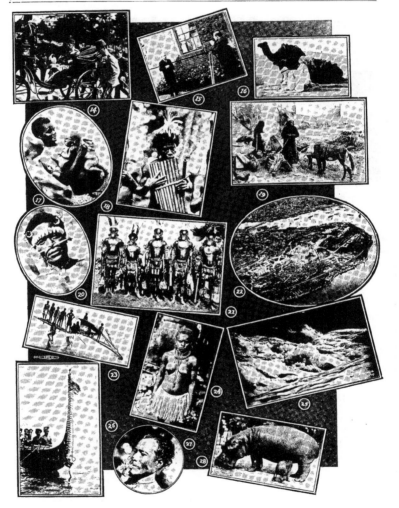

ALL THE WAY FROM ST. PAUL

These handsome boys of the staff of Ray-Bell Films, Inc., St. Paul, are all members of Local 666, I. A. T. S. E. and M. P. M. O., Chicago. Their names were not sent with the art hence the omission. The Ray-Bell Organization is one of the up-and-coming industrial film companies of the country.

FIRST NATIONAL LOT

By Les Rowley

Willard Van Enger says there is no place like the foot of Topanga Canyon to live, but it's tough about six or seven a. m.; the dog won't let him sleep.

Jack Greenhalgh says he likes Arrowhead Springs, especially in May.

Lyman Broening has at last stopped eating cheese cake—now it's butter-milk.

Eddie Linden as per usual still trying something new: He's now going to try painting automobiles.

Jack Warren is having trouble with his music—wonder why?

Why are Joe Walters and Jack Greenhalgh always in conference? Once in a while Lyman Broening buts in — then there's a laugh—SECRETS?

Speed Mitchell is a changed boy since Easter Sunday—he'll never be the same again—no work nights or Sundays—we all wish you, Speed old boy, the best of everything—THE GANG.

Johnny Seitz—the Sphynx.

Boys, have you noticed Ben White lately? Some class. What's going to happen, Ben?

Buddy Longworth not only shoots the unusual publicity shots at the First National lot, he also is an amateur Einstein hunting things out of the air—atoms, electrons, and what-have-yous.

Come on, boys of the First National lot, let us give a big hand for Miss Bangs—what do you say?

Ray Jones is a busy boy on Saturday afternoon. Take your graflex along Ray —Arrowhead is the answer.

NATURALLY . . .
THE YEAR'S BEST
USED MAZDA
LAMPS . . .

Disraeli

Broadway Melody

Madam X

Rio Rita

Gold Diggers of Broadway

Bulldog Drummond

The Last of Mrs. Cheyney

Hallelujah

THERE were many fine pictures last year. New subjects, new talent, new stunts in photography. But with it all, consistent application of the fundamentals of high class production, the product of years of experience. That is why MAZDA lamps played so important a part in the big pictures of 1929.

That is why incandescent lamps were used for artificial lighting, in eight of the ten finest pictures* of 1929. Lending themselves perfectly to new and unusual effects, MAZDA lamps are at the same time designed in accordance with fundamental principals of superior cinematography.

General Electric MAZDA lamps combine the contributions of the unparalleled MAZDA research service with the outstanding accomplishments of the General Electric Company. Again in 1930, where the best productions are found, there will be found incandescent lighting. National Lamp Works of General Electric Company, Nela Park, Cleveland, Ohio.

*Best according to FILM DAILY poll of 327 critics

Join us in the General Electric Hour, broadcast every Saturday evening over a nation-wide N. B. C. Network.

GENERAL ELECTRIC
MAZDA LAMPS

Why Microscopic Precision?

—BY—

JOSEPH A. DUBRAY

Perfect projection is the ultimate goal of the motion picture mechanical engineers.

Some 25 years ago, Mr. A. S. Howell, now Chief Engineer of the Bell & Howell Company and the inventor of motion picture machinery bearing the trade mark of this organization, became interested in motion picture apparatus and devoted his energies to the designing of a projector which would insure steady and flickerless projection, and at the same time, protect, so to speak, the film so that its perforations and its surfaces would remain unscathed, even though the film would be run several hundred times.

A few years of indefatigable and diligent work brought about the creation of such machine which responded to Mr. Howell's self-imposed requirements.

It was, however, quite natural that the trend of thought of the inventor would immediately and forcibly turn to the facts that the perfect functioning of a projection machine is not only dependent upon perfection of design and workmanship of the machine itself, but also to the functioning of all other machinery which is called to handle the film before being put through the process of projection.

From the very beginning of motion pictures, the perforation system was considered and adopted as the most suitable for the guiding and the registering of the film through cameras, printers, and projectors. It was quite evident that the most exact precision was to be exerted in the perforating of the film material.

Mr. Howell followed the success he achieved in the designing of an efficient projector by devising a perforator which is to this date considered as the incomparable result of mechanical engineering ingenuity and which is used for perforating most of the motion picture film used throughout the world.

Four sets of two punches each, ground and shaped to infinitesimally small toler-

CARL ZEISS OPTIMETER

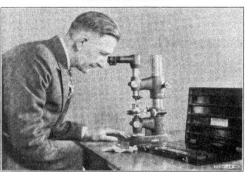

Used for measuring, checking and inspecting quantity production by comparison with a known standard used in connection with a set of Johannsen gauge blocks. On the table is shown a box containing a set of Johannsen gauge blocks and resting on a piece of chamois leather is the standard gauge block used to check by comparison a 35 mm. Bell & Howell perforator punch which is set in the Optimeter. The measuring pressure is a few ounces. Readings can be determined to less than .00005 of an inch. The spacings on the 35 mm. Bell & Howell perforator punch are held within .00005 of an inch, ground and lapped to a high finish.

ances, punched simultaneously and with the aid of a die plate, four pairs of perforations per stroke, while four pilots, engaged in a similar set of perforations previously made, hold the film in proper register.

Four perforations correspond to one picture frame height and the machine is so devised that any error, ever so slight, which may be introduced by the influence of atmospheric conditions upon the film is compensated for at each stroke and has no influence during the further processing of the film.

From the very inception of motion pictures it was discovered that film is quite sensitive to variations of temperature and to the condition of atmospheric humidity. This characteristic of the film is such that it makes it undergo a change in length and width during the laboratory processing, to which it is submitted and which consists roughly in the wetting and subsequent drying of the material.

Film shrinkage characteristics under all possible atmospheric conditions, as well as under varied treatments to which it may be submitted, have been quite carefully studied and although there is much yet to do for the research laboratories in this line of investigation, the present knowledge of film behavior has proven sufficient to anticipate its possible dimensional variations and therefore it has been possible to design motion picture machinery with a degree of accuracy sufficient to insure the accommodation of film shrinkage under ordinary conditions.

The problems which confronted the motion picture mechanical engineers were varied and complex. Now, shrinkage of film is not controllable in itself and films may be used in the various motion picture machines in either an unshrunk state or at different stages of shrinkage up to a possible maximum of 3 per cent, with a possible increase of 10 per cent in the transverse direction. It is quite obvious that under such conditions it was necessary to devise instruments which could accommodate these irregular dimensional variations under this extremely wide range.

It would appear at first that a maximum of 3 per cent shrinkage is not an entity of great import, but when one considers the great magnification to which a motion picture frame is submitted in the process of projection, one realizes that an error of microscopic order in either one of the machines called to handle the film is sufficient to result in an unsteady flickering, tiresome to the eye picture upon the screen.

We shall add to this that it is the aim, nay, the duty, of a mechanical engineer to design machines which must first be easy to duplicate so as to make possible their commercial production and second that these machines must have a capacity of work and a resistance to wear and tear sufficient to warrant the expenditure involved in their purchase.

To further complicate matters, motion picture film processing is of such nature that it calls, in the printing process, for the necessity of perfectly registering two films of different dimensions.

The negative film, having been put through the process of developing, fixing, washing, and drying, has become shorter, as well as narrower, to an extent which is dependent upon a great number of factors. The positive film being used in its absolutely raw state has usually not suffered any shrinkage. The succeeding perforations of the two films must naturally be brought to extremely accurate coincidence in order to transfer each frame of the negative upon the positive film in such manner that when the intermittent sprocket of the projection ma-

(Continued on Page 26)

WHY MICROSCOPIC PRECISION?
(Continued from Page 24)

chine carries them in rapid succession in front of the aperture of the projector, each one of these frames is perfectly registered, in orther words, each stationary point of motion picture image is to be replaced on the screen by its corresponding stationary point of the image immediately following.

Foreign mechanical engineers, especially the French, overcame this difficulty by perforating the positive film at a pitch smaller than the negative film. This was indeed one way of solving the problem, but it presented the inconvenience that the printing machines could not perfectly accommodate films which for some reason or another had been submitted to an excessive shrinkage.

Others, and among them most of the American designers, devised printing

a shorter radius than the positive. The design of the bearing surfaces of the sprocket teeth bring the lower and one side faces of both the negative and positive perforation in perfect coincidence, just before they reach the printing aperture. The accommodation of transversal shrinkage is in this printer permitted by difference in the size of the right hand teeth of the sprocket as compared with the size of the left hand teeth, which control the registering of the film. It is quite obvious that the accuracy of registration is dependent not only upon the ingenuity displayed in the designing of the machine, but also in the accuracy displayed in the manufacturing and the assembly of its different component parts.

It is no wonder then that the most scrupulous attention is paid to all processes of manufacture, from the selection

CARL ZEISS OPTICAL DIVIDING HEAD

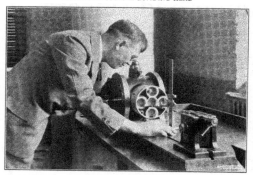

Used for laying out and checking angles, checking spacings or gear teeth and sprockets, checking graduations on lenses, location of holes, checking drill jigs and fixtures. It serves for many other purposes where close readings are concerned. The part being inspected is the "lens carrier plat" of the Bell & Howell Standard professional camera and the instrument is measuring the spacings, and the center distance of the holes in the lens carrier plate. With this instrument work can be ascertained to within 20 seconds of arc.

machines with an intermittent movement which permitted to bring the lower face and one side of the positive film perforation in register with the same faces of the negative. This process gave, and still gives, satisfactory results, but of necessity, it implies a slowness in the operation of the machine.

Mr. Howell, after having designed his perforating machine, which insures extreme accuracy in regard to perforation dimensions and spacings, devised a printer continuous in operation, in which perfect registration is obtained through the design of the main sprocket which carries the two films in contact directly in front of the printing aperture.

The radius of the sprocket is so calculated that it compensates for the difference in length of the negative and the positive film, the negative film, being the shorter, follows an arc of contact having

and inspection of the raw metals used in the construction of the machine, to the final assembly. Only the most experienced mechanics are engaged in this work and all inspections are carried with instruments of high precision, some of which can detect errors as small as 0.00025".

The motion picture camera is in itself an instrument of high precision. Although it is not called to make any great compensation for film shrinkage, it must be so designed and constructed that it permits the most exact registering of each and every one of the picture frames.

The requisites of a motion picture camera are such that its intermittent movement must be capable of performing with utmost accuracy and extreme rapidity a succession of cycles of movements. The film feeding fingers must be actioned so that they first perform a motion downward to bring an unexposed

portion of the film corresponding to a picture frame in position at the photographic aperture of the apparatus; third, a motion backward to disengage from the film perforation, and fourth, a motion upward to resume the position which they occupied prior to motion 1.

This cycle of operations is completed 24 times each second when the film is run at the normal sound picture speed. The Bell & Howell ultra-speed camera, which varies very little in construction from the standard camera, is capable of performing this cycle of movements as many as 200 times each second and each time it brings the film to such perfect register that it is possible to photograph special process and trick cinematography scenes usually known as "double exposures" without disturbing the accuracy of registration and thus guaranteeing perfect illusion during the process of projection.

One of the requisites of a motion picture camera, the reason for which is quite obvious to our readers, is that it should permit as long an exposure per picture frame as possible. In order to obtain as great an angular shutter aperture as possible, the camera mechanism is so designed that the periods of occultation of the shutter correspond with one out of a four movements of the film feeding fingers. That is to say, that the shutter uncovers the film at the exact moment at which the film feeding fingers begin to withdraw from the perforations and masks the film at the very exact moment in which the film feeding fingers after entering the perforations just begin to lead the film down in its allotted path.

It does not require a mechanically inclined mind to realize the necessity of extreme accuracy in the course of manufacture and assembly of such instruments which, in spite of their high precision, must be constructed with sufficient ruggedness to withstand the relative abuse to which they are submitted in the course of their many years of useful life.

The accuracy of design, construction, and assembly for a motion picture camera is essential in the centering of the photographic lens in respect to both the focusing and the photographic aperture. Critical focusing is so highly desirable that all parts directly connected with the lens mount and the film intermittent mechanism are manufactured and assembled within ultimate tolerances not to exceed 0.0005 inches, and submitted to extremely severe and critical tests and inspections throughout the course of their manufacture.

The three major instruments, if we may be permitted to call them so, through which the film has to pass before reaching the projection machine, that is to say, the perforator, the camera, and the printer—are in some way related to each other, inasmuch as no printer can give good service if the camera through which the picture has been taken is defective in mechanical construction, and no camera can properly function if the perforating machine has not performed its duty with utmost perfection.

It has been the privilege of the writer to have the occasion of investigating the performance of hundreds of these machines in operation in all laboratories in

(Concluded on Page 28)

WHY MICROSCOPIC PRECISION?
(Continued from Page 24)

chine carries them in rapid succession in front of the aperture of the projector, each one of these frames is perfectly registered, in orther words, each stationary point of motion picture image is to be replaced on the screen by its corresponding stationary point of the image immediately following.

Foreign mechanical engineers, especially the French, overcame this difficulty by perforating the positive film at a pitch smaller than the negative film. This was indeed one way of solving the problem, but it presented the inconvenience that the printing machines could not perfectly accommodate films which for some reason or another had been submitted to an excessive shrinkage.

Others, and among them most of the American designers, devised printing

a shorter radius than the positive. The design of the bearing surfaces of the sprocket teeth bring the lower and one side faces of both the negative and positive perforation in perfect coincidence, just before they reach the printing aperture. The accommodation of transversal shrinkage is in this printer permitted by difference in the size of the right hand teeth of the sprocket as compared with the size of the left hand teeth, which control the registering of the film. It is quite obvious that the accuracy of registration is dependent not only upon the ingenuity displayed in the designing of the machine, but also in the accuracy displayed in the manufacturing and the assembly of its different component parts.

It is no wonder then that the most scrupulous attention is paid to all processes of manufacture, from the selection

portion of the film corresponding to a picture frame in position at the photographic aperture of the apparatus; third, a motion backward to disengage from the film perforation, and fourth, a motion upward to resume the position which they occupied prior to motion 1.

This cycle of operations is completed 24 times each second when the film is run at the normal sound picture speed. The Bell & Howell ultra-speed camera, which varies very little in construction from the standard camera, is capable of performing this cycle of movements as many as 200 times each second and each time it brings the film to such perfect register that it is possible to photograph special process and trick cinematography scenes usually known as "double exposures" without disturbing the accuracy of registration and thus guaranteeing perfect illusion during the process of projection.

One of the requisites of a motion picture camera, the reason for which is quite obvious to our readers, is that it should permit as long an exposure per picture frame as possible. In order to obtain as great an angular shutter aperture as possible, the camera mechanism is so designed that the periods of occultation of the shutter correspond with one out of a four movements of the film feeding fingers. That is to say, that the shutter uncovers the film at the exact moment at which the film feeding fingers begin to withdraw from the perforations and masks the film at the very exact moment in which the film feeding fingers after entering the perforations just begin to lead the film down in its allotted path.

It does not require a mechanically inclined mind to realize the necessity of extreme accuracy in the course of manufacture and assembly of such instruments which, in spite of their high precision, must be constructed with sufficient ruggedness to withstand the relative abuse to which they are submitted in the course of their many years of useful life.

The accuracy of design, construction, and assembly for a motion picture camera is essential in the centering of the photographic lens in respect to both the focusing and the photographic aperture. Critical focusing is so highly desirable that all parts directly connected with the lens mount and the film intermittent mechanism are manufactured and assembled within ultimate tolerances not to exceed 0.0005 inches, and submitted to extremely severe and critical tests and inspections throughout the course of their manufacture.

The three major instruments, if we may be permitted to call them so, through which the film has to pass before reaching the projection machine, that is to say, the perforator, the camera, and the printer—are in some way related to each other, inasmuch as no printer can give good service if the camera through which the picture has been taken is defective in mechanical construction, and no camera can properly function if the perforating machine has not performed its duty with utmost perfection.

It has been the privilege of the writer to have the occasion of investigating the performance of hundreds of these machines in operation in all laboratories in

(Concluded on Page 28)

CARL ZEISS OPTICAL DIVIDING HEAD

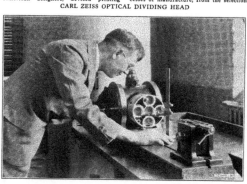

Used for laying out and checking angles, checking spacings or gear teeth and sprockets, checking graduations on lenses, location of holes, checking drill jigs and fixtures. It serves for many other purposes where close readings are concerned. The part being inspected is the "lens carrier plat" of the Bell & Howell Standard professional camera and the instrument is measuring the spacings, and the center distance of the holes in the lens carrier plate. With this instrument work can be ascertained to within 20 seconds of arc.

machines with an intermittent movement which permitted to bring the lower face and one side of the positive film perforation in register with the same faces of the negative. This process gave, and still gives, satisfactory results, but of necessity, it implies a slowness in the operation of the machine.

Mr. Howell, after having designed his perforating machine, which insures extreme accuracy in regard to perforation dimensions and spacings, devised a printer continuous in operation, in which perfect registration is obtained through the design of the main sprocket which carries the two films in contact directly in front of the printing aperture.

The radius of the sprocket is so calculated that it compensates for the difference in length of the negative and the positive film, the negative film, being the shorter, follows an arc of contact having

and inspection of the raw metals used in the construction of the machine, to the final assembly. Only the most experienced mechanics are engaged in this work and all inspections are carried with instruments of high precision, some of which can detect errors as small as 0.00025".

The motion picture camera is in itself an instrument of high precision. Although it is not called to make any great compensation for film shrinkage, it must be so designed and constructed that it permits the most exact registering of each and every one of the picture frames.

The requisites of a motion picture camera are such that its intermittent movement must be capable of performing with utmost accuracy and extreme rapidity a succession of cycles of movements. The film feeding fingers must be actioned so that they first perform a motion downward to bring an unexposed

FROM OUT THE PAST

This rare and priceless document of motion picture history was lent to The International Photographer by our Brother James Woodbury. The still is a shot of the original D. W. Griffith Company made at Albuquerque, New Mexico, en route to location. All of the people cannot be identified, but the headliners are: Billy Bitzer (left), Walter Long, Donald Crisp, Lillian and Dorothy Gish, Henry Walthall, Bobbie Harron, Fay Tincher, Teddy Sampson, Mae Marsh, Mary Alden, Wallace Reid, Owen Moore, Jack Dillon, James Kirkwood, Flora Finch, Commodore J. Stuart Blackton, extreme right.

WHY MICROSCOPIC PRECISION?
(Continued from Page 26)

the country, and it has been his privilege to be for quite a length of time in constant direct contact with laboratories and production units all over the world. It is with pleasure that he remarks here that in the great majority of cases the importance of mechanical accuracy and the importance of the upkeep of this accuracy is so well understood that the operators do not merely consider the machine which is entrusted in their hand as an assembly of parts of certain shape and form, but they usually consider it as, so to speak, part of themselves. They learn to love it; they learn to care for it. This loving care is essential for the good functioning of such apparatus. It is so essential that the results obtained reflect it to an astonishing extent and it has been one of the major factors of the success of motion pictures.

It has not been our privilege, however, to be in a position to conduct a similar investigation on projection machines scattered all over the country. But the results that one sees on the screen today certainly speak very highly of the ability and earnest attention with which the projectionists care for their machines, and this in spite of ever-increasing technical

COLOR RENDITION
(Continued from Page 16)

scent lighting. The high yellow sensitivity also makes the use of the K series of filters particularly benefiecial, as the illustrations show.

Although in most cases this film showed much more contrast than either the Eastman or Du Pont upon almost all colors, its speed was also slightly slower which may be desirable for certain effects.

In all the tests of the Agfa Super-Speed which of course is an Orthochromatic emulsion many interesting results were noted and it is well to mention that while this film lacks the color sensitivity shown in the Panchromatic emulsions, it is very desirable because of its amount of speed and can be used especially when light conditions are very poor. In a series of tests made in very subdued light, this film showed very favorable results although its color rendition was not as satisfactory as Panchromatic film. In illustration number 3 you will notice the results of this film upon a yellow color sheet.

difficulties which are thrown in their path, and which demand every day a greater knowledge of the maze of technicalities involved in modern motion picture presentation.

These few remarks are all which the space allows to be made about the definite results of these tests. In closing, however, the writer wants to reiterate that these tests were made, not only as a means of securing practical information which he found vital to his work, but as a means of obtaining and codifying a vast mass of data of which his experience showed him the Cinematographic Profession as a whole stood in urgent need.

'ON THE ROAD TO MANDALAY'
The Harry Garson unit of the Universal Film Company is half seas over enroute to the Orient for a four to six-months' sojourn shooting "Ourand" for Universal release.

The personnel of the expedition follows: Harry Garson, producer; Isadore Bernstein, assistant to Garson; Lewis W. Physioc, technical and art director, Local 659; Julius Bernheim, business manager; W. S. Adams, cameraman, Local 659; Sidney Lund, laboratory head; George John DeMoss, assistant; C. E. Cobb and Fred Feichter, electricians and sound experts; Dorothy Janis featured lead.

The company sailed from Halifax on May 7 and will visit Japan, China, Java, Singapore, Siam, Celebes, Borneo and all points north, south, east and west.

SPLICINGS

ESSELLE PARICHY

RETURNING from a sojourn in the "tucked-away" places, Esselle Parichy brings a Cinematographer's Rhapsody of Egypt, a land that reminds one of "Sunday school picture" days — where the Timetable of Archaeology proclaims the dead, alone, are great.

SPAIN, rich in romance and ancient lore—with her pleasure loving people steeped in tradition — the echoes of the past edged with modern trend — truly a land of contrasts. Here close-ups and long-shots are alive with interest.

Nile Boatman
Royal Palace, Madrid
Colossi of Ramses, Karnak
Gitanos of Granada
Ramses II, Memphis
Handwork of Seville
Queen Hatasu's Temple, Thebes
Camel Racers, Luxor

Why Our Film Capital Is Air-Minded

(Delegates to the I. A. T. S. E. Take Notice)

Written for The International Photographer by WILLIAM WAGNER, *Curtiss-Wright Flying Service*

In no section of the country has aviation development been more marked than in Southern California.

So often has this statement been made that it seems unnecessary to repeat it again here, but in spite of the wide publicity given aeronautical progress in this section, the great majority has not yet

time there are 18 airplane and 11 aircraft engine manufacturing companies engaged in business here.

In the transportation of passengers, mail and express by air, Southern California has fully contributed its share in developing this phase of the industry. Every day 19 scheduled commercial runs

is ideally situated with relation to downtown Los Angeles. Due to a great extent to the operation from this field of T. A. T.-Maddux Air Lines, this airport now handles approximately one-fourth of all scheduled air transport operation in the country.

This modern air terminal, owned by

Here is a high air view of the United Field, one of the several large flying fields in and around Los Angeles. This field is equipped with every imaginable facility and device for safe arrival and departure of air traffic handling large numbers of travelers. From this field many delegates of the I. A. T. S. E. Convention arrived and will depart for their homes. Our photograph of Grand Central Terminal was lost in transit.

been fully appraised of the rapid strides made here.

With pride California points to the fact that this state is easily the leader in number of pilots, mechanics and licensed aircraft, but with greater pride does Los Angeles County remind the rest of the world that more than two-thirds of the state's aviation activity is concentrated in this area.

Of the state's 2076 licensed pilots, 1461 licensed mechanics and 1476 licensed aircraft, approximately 70 per cent are in Los Angeles County.

By no means has this section's rapid growth been wholly in the actual operation of aircraft, for last year a total of $5,500,000 in aeronautical products were produced in the county. At the present

are made in and out of Los Angeles. The planes used on these airlines are flown 21,000 miles daily, bringing into and taking out of this section a steady stream of rapidly growing air commerce.

Due to climatic conditions principally we have been able to accomplish much which would not be possible to undertake in any other section of the country.

Particularly has this advantage been shown in the development of our splendid airports and in the training of students. In this line have our own organizations—Curtiss-Wright Flying Service and Grand Central Air Terminal—been unusually active.

Of the county's 67 airports and landing fields, none is better equipped or more active than Grand Central, which

the Curtiss-Wright Airports Corps., is also the headquarters in Southern California of Curtiss-Wright Flying Service, the world's oldest flying organization, which operates 42 bases throughout the country.

During 1929, Los Angeles county's five leading airports spent in excess of $1,500,-000 each on new developments. Grand Central during February of this year celebrated the opening of its new $150,-000 terminal station on the airport.

At Los Angeles Airport, the municipal field, Curtis-Wright Flying Service conducts its flying school, which holds the government's highest approved rating. This school has just been approved by federal immigration authorities as an

(Concluded on Page 32)

Why Our Film Capital Is Air-Minded

(Delegates to the I. A. T. S. E. Take Notice)

Written for The International Photographer by WILLIAM WAGNER, *Curtiss-Wright Flying Service*

In no section of the country has aviation development been more marked than in Southern California.

So often has this statement been made that it seems unnecessary to repeat it again here, but in spite of the wide publicity given aeronautical progress in this section, the great majority has not yet

time there are 18 airplane and 11 aircraft engine manufacturing companies engaged in business here.

In the transportation of passengers, mail and express by air, Southern California has fully contributed its share in developing this phase of the industry. Every day 19 scheduled commercial runs

is ideally situated with relation to downtown Los Angeles. Due to a great extent to the operation from this field of T. A. T.-Maddux Air Lines, this airport now handles approximately one-fourth of all scheduled air transport operation in the country.

This modern air terminal, owned by

Here is a high air view of the United Field, one of the several large flying fields in and around Los Angeles. This field is equipped with every imaginable facility and device for safe arrival and departure of air traffic handling large numbers of travelers. From this field many delegates of the I. A. T. S. E. Convention arrived and will depart for their homes. Our photograph of Grand Central Terminal was lost in transit.

been fully appraised of the rapid strides made here.

With pride California points to the fact that this state is easily the leader in number of pilots, mechanics and licensed aircraft, but with greater pride does Los Angeles County remind the rest of the world that more than two-thirds of the state's aviation activity is concentrated in this area.

Of the state's 2076 licensed pilots, 1461 licensed mechanics and 1476 licensed aircraft, approximately 70 per cent are in Los Angeles County.

By no means has this section's rapid growth been wholly in the actual operation of aircraft, for last year a total of $5,500,000 in aeronautical products were produced in the county. At the present

are made in and out of Los Angeles. The planes used on these airlines are flown 21,000 miles daily, bringing into and taking out of this section a steady stream of rapidly growing air commerce.

Due to climatic conditions principally we have been able to accomplish much which would not be possible to undertake in any other section of the country.

Particularly has this advantage been shown in the development of our splendid airports and in the training of students. In this line have our own organizations—Curtiss-Wright Flying Service and Grand Central Air Terminal—been unusually active.

Of the county's 67 airports and landing fields, none is better equipped or more active than Grand Central, which

the Curtiss-Wright Airports Corps., is also the headquarters in Southern California of Curtiss-Wright Flying Service, the world's oldest flying organization, which operates 42 bases throughout the country.

During 1929, Los Angeles county's five leading airports spent in excess of $1,500,000 each on new developments. Grand Central during February of this year celebrated the opening of its new $150,000 terminal station on the airport.

At Los Angeles Airport, the municipal field, Curtiss-Wright Flying Service conducts its flying school, which holds the government's highest approved rating. This school has just been approved by federal immigration authorities as an

(Concluded on Page 32)

ATTENTION DELEGATES I. A. T. S. E. AND M. P. M. O.

Photo by A. C. Gates

This is a picture of the Westwood district of Los Angeles. Over the hills in the background you see the famous San Fernando Valley. In the lower right hand corner is the Hillcrest Country Club and just above Hillcrest to the right, extending the entire distance from Pico to Santa Monica Boulevard may be seen the big flat top stages and outdoor sets of the Fox Westwood Studios where you will be entertained by the Motion Picture Industry on Monday, June 2, the first day of the Los Angeles Convention. To the right of the studio lot may be seen one of the oldest oil fields in California. In the middle distance at the foot of the hills are the magnificent new buildings and campus of the University of California at Los Angeles. The rest of the buildings are new homes built within the last two years and the large vacant squares are the cultivated fields of ranchos.

WHY OUR FILM CAPITAL IS AIR-MINDED
(Continued from Page 30)

institution of learning for alien students, placing it on the same level with leading universities and colleges. This is the first aviation school in the country to receive this sanction.

In Los Angeles County there are now more than 1600 registered aviation students, with every indication pointing to a rapid increase in this number during the summer months. Due to its excellent climatic conditions and geographical location, Southern California bids fair to become an international aviation training ground.

Already a steady flow of aviation students are coming to this section for advanced flight training from Central and South America, Mexico and Canada, as well as from Japan and China across the Pacific.

One of the most novel and successful experiments in stimulating the use of air travel was recently put into effect by Curtiss-Wright Flying Service at Grand Central Air Terminal.

This new idea, credited to the fertile brain of Major C. C. Moseley, vice-president and general manager in the west for Curtiss-Wright, is now the much-talked of "Penny-a-Pound" flights.

Knowing that once people have made an initial flight in an airplane they are almost certain to be won over to this newest and most rapid method of transportation, Curtiss-Wright put into effect new low rates of "penny-a-pound" for men and a flat $1 for women and children for short scenic flights.

During a single month nearly 5000 persons were carried at these novel low rates, without the slightest mishap of any nature, nor a single report of air-sickness.

Due principally to the interest shown by Col. Charles A. Lindbergh during his and Mrs. Lindberg's recent visit to Southern California, glider flying has shown rapid progress during the past few months. Today the county boasts more than a dozen glider clubs, composed of from 10 to 30 active members in each club.

Not only is this section favored with a semi-tropical climate, which makes flying and student training throughout the year possible, but high winds that prevail in other states are almost unknown. Records of the local weather bureau reveal that the highest wind ever recorded here was 48 miles per hour, and that in January forty-seven years ago.

Aviation in Southern California is now represented in all of its phases by four of the dominant groups in the industry—Curtiss-Wright, Western Air Express, United Aircraft and Detroit Aircraft. In addition there are a great many smaller concerns who are doing their share to see that this state maintains its impressive leadership of America's Fastest Growing Industry.

———o———

TO ALL MEMBERS

In the building of this issue of **The International Photographer** the editors have been overwhelmed by an embarrassment of riches in the way of contributions of art by members.

It is manifestly impossible to use all of this material in this current issue because of economic considerations not to be ignored, but it is with great pleasure the editors are able to announce that in subsequent issues of our magazine all of that omitted will be given space.

And this is not all, for the policy of the publishers is to use more and more art as the months go by, therefore, all our members are urged to keep the contributions coming with the assurance that they will frequently be represented in these columns.

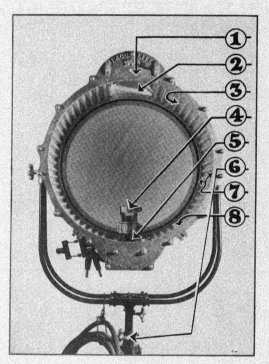

1—Rings cast of American Aluminum Company of America Virgin aluminum ingot.
2—Ventilated to expel heat naturally. (Minimum mirror breakage).
3—General Electric high heat resisting aluminum lacquer.
4—Quick operating carriage for changing globe and focusing.
5—Specially designed Bakelite adapter for electrical connection to globe.
6—Positive hinge clamp for holding head when raised vertically.
7—Insulated channels allowing corrugations to expand and contract silently.
8—Corrugated duralumin drum which is light and strong and a natural dissipater of heat.

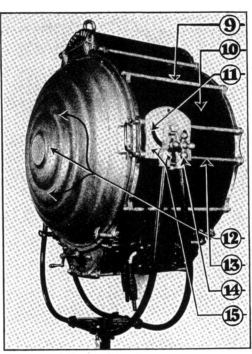

9—All steel parts cadmium plated.
10.—General Electric Glyptal lacquer used exclusively.
11—Drum having full 180° tilt with positive locking screw. (Easy to tilt due to perfect balance.)
12—Mirror has full spring support and is protected by a specially designed corrugated steel spinning.
13—Unit construction and assembly facilitating repairs.
14—All handles designed for positive grip.
15—Parts subject to exceptional strains are castings of heat treated aluminum alloys.

Weights of LACO Incandescent Equipment

Rifle Spot, complete with stand	54½ lbs.
LACO Five Lite Strip Lite, complete	59 lbs.
LACO 18-inch Sun Spot, complete with stand	75½ lbs.
LACO 24-inch Sun Spot, complete with stand	139½ lbs.
LACO 36-inch Sun Spot, complete with stand, cable and turtle	374 lbs.

Before and After Sound

—BY—

DANIEL B. CLARK, *Local 659. Past President A. S. C.*

DANIEL B. CLARK

In the beginning we had to make pictures and make them artistic, and, it will be the same in the end. In the days before sound, the cinematographer worked to develop better lenses, better lighting equipment, better negative stock and better mechanical equipment. All was for one purpose which was to improve production from an artistic as well as an economic standpoint and, while we, as cinematographers, had not succeeded in reaching the highest stage of success, at least we are proud of the fact that gradually and surely we were working toward real artistry and maximum economy—the former for a cinematographic monument and the latter for the benefit of the producer whom we were serving.

Often we had to work under tremendous handicaps in the matter of credit, which was always deserved, but denied as a rule, but mostly for lack of opportunity which is frequently the death of ambition and the graveyard of progress. Such was not the case with the majority of the present cinematographers. Instead, they buried their ambitions under a desire for knowledge and, not because of, but in spite of a seemingly hopeless condition, continued to build with interchanging ideas, experiments and research until today our calling ranks among the highest in the world insofar as education and art are concerned.

Then sound appeared on the horizon —at first only as a whisper which grew into a rumble and then burst forth as a fact. In the meantime the cinematographer was not idle. By research and experiment they were preparing the producer and themselves to meet the new era of production. Incandescent lighting was brought out and perfected, cameras were silenced, etc., and the stage was set. But not for what really happened. No one had anticipated the hordes of so-called sound men, dialogue writers and stage directors and the veritable avalanche of negative forces such as "you can't do this or you can't do that," which followed. No one expected that the artistic expression of story which we had striven so long to acquire would be shattered and pulled asunder. No one expected to hear the producers say: "Never mind the picture; we want the sound." No one expected to see the industry we love so well undergoing such a chaotic upheaval at the the cost of the millions. No one expected the time when the cinematographer would have to essay making a picture entombed in an impossible struc-

ture of glass and sound-proof walls and be forced to limit his lighting equipment to a certain type or have his range of angles and effects cut in half despite his willingness to prove the lack of necessity of such procedure.

Nevertheless, to the chagrin and dismay of all concerned it happened and continued to happen until the hopelessness of the situation began to express itself through the added cost and the limited scope of production and finally through the box-office, which is the keystone of the industry's existence. Perhaps these conditions are natural in the face of any evolution. At any rate, the world in general and the motion picture industry in particular may console themselves in the fact that out of it all has sprung the possibility of bigger and better pictures if

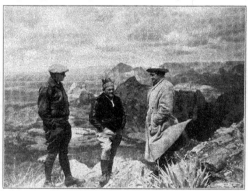

Talking it over on location. A windy, but withal picturesque spot in the New Mexican mountains. Left to right—Barney Freericks, Daniel B. Clark, Al Werkes.

the proper use is made of the tools which have been placed in our hands.

Forsooth, the readjustment is under way which might separate the wheat from the chaff. Already cinematographers are coming out of the booths and are being allowed to use lights and angles to fit the subject and to shoot under natural conditions with the co-operation of the director to stage the action as he always has done in the past. The soundman is awakening to the fact that things are being done which a few months ago he claimed could not be done, thus spurring this group on to greater achievements.

It is my good fortune to have been associated with soundmen, who, much to their credit, have realized that the pic-

endeavored to add to the picture with the sound rather than to forcing the latter to predominate at the cost of the former. Foremost among these is Barney Freericks, a gentleman with a fine sense of artistry and a keen appreciation for the advancement the cinematographer has made in past picture production and sound technique. Recently during a discussion with Mr. Freericks on the past, present and future of sound pictures, I was interested to note his observations, which I will quote in part as follows:

"When the sound man first came into the picture business, he almost created a panic with his demands to do this and you can't do that," he said. "Cameras had to be placed in small stock cabinets, hard lights had to be discarded and special sets and stages had to be built. All

ture should come first and who have of this naturally affected the cinematographer to a great extent. All the wonderful technique it took years for him to acquire had to be forgotten and he had to start all over again. This would not have been the case had the sound man known as much then as he does now. Because of his training he could only see his side of what had to be done and he was sufficiently backed by the newness of his devices to carry his point.

"But, times have changed. Now the cinematographer can go back to the methods that he used before sound. Hard lights are again being used and his camera is being released from its cell. Scenes

(Concluded on Page 36)

SPEED - ACCURACY - QUALITY

Ass't BOB RHEA Ass't BUD MAUTINO Ass't RAY WISE

ANTHONY UGRIN ART ARLING SID WAGNER DAN CLARK

DANIEL B. CLARK
AND HIS *"PATH-FINDERS"*

LONE STAR RANGER
ROUGH ROMANCE
LAST OF THE DUANES

"THE BIGGEST SHOW ON EARTH"
(Continued from Page 4)

and Edmund Lowe; Waring's Pennsylvanians, (Mason Opera House).

Five solid hours of entertainment supreme—$10,000,000 worth of talent under one roof—a show that could not possibly be produced except by the I. A. T. S. E. and M. P. M. O. and nowhere else than Los Angeles.

The show was staged by Billy Woods, stage manager of the Philharmonic Auditorium, Los Angeles, internationally recognized as a wizard in his profession, an artist of extraordinary ability and especially equipped to handle "big stuff." Mr. Woods and his able crew built a beautiful set for the occasion, one of the units being a band stand mounted on casters that enabled the stand to advance and recede giving an impressive effect to the ensemble.

Under this able director the show was "clicked off" like clock work and without a hitch from Claude Reimer's organ recital to Fred Waring's Pennsylvanians.

It was a great night and a wonderful audience worthy of the cause, of the performers and of the members of the Committee on Entertainment.

BEFORE AND AFTER SOUND
(Continued from Page 34)

which were called impossible then are now being shot without trouble. The sound man's technique has improved greatly and his apparatus has been simplified. Portable sound equipment for pack train has been developed and used

HOBART IS IN A HURRY

Hobart Brownell and his camera shooting the round-up at Pendleton, Oregon, in 1914. Bud Ogilvy on Wrangler.

successfully. All this has been accomplished by the close co-operation of the cinematographer and the sound man. And it is to be hoped that nothing will happen to retard further progress of a like nature."

Verily, more of Mr. Freerick's type would help considerably to simplify conditions.

All in all, I am of the opinion that in spite of the chaotic evolution and readjustment which the industry has undergone in the past two and one-half years and will continue to undergo for a while yet, the near future will bring to the screen productions which will represent the highest type of entertainment, education and art which it is possible for the Twentieth Century ability, endeavor and machinery to bring.

SPEAKING OF BROTHERHOOD

We have talked much of the brotherhood to come; but brotherhood has always been the fact of our life, long before it became a modern and insipid sentiment. Only we have been brothers in slavery and torment, brothers in ignorance and its perdition, brothers in disease and war and want, brothers in prostitution and hypocrisy. What happens to one of us sooner or later happens to all; we have always been unescapably involved in a common destiny. The world constantly tends to the level of the downmost man in it; and that downmost man is the world's real ruler, hugging it close to his bosom, dragging it down to his death. You do not think so, but it is true, and it ought to be true. For if there were some way by which some of us could get free apart from others, if there were some way by which some of us could have heaven while others had hell, if there were some way by which part of the world could escape some form of the blight and peril and misery of disinherited labor, then would our world indeed be lost and damned; but since men have never been able to separate themselves from one another's woes and wrongs, since history is fairly stricken with the lesson that we cannot escape brotherhood of some kind, since the whole of life is teaching us that we are hourly choosing between brotherhood in suffering and brotherhood in good, it remains for us to choose the brotherhood of a co-operative world, with all its fruits thereof — the fruits of love and liberty.—George D. Herron.

A Hollywood in the African Hills

—BY—

W. EARLE FRANK, *Local 659*

THE popularity of film stories dealing with wild animals has, in recent years, led to several big expeditions being organized to capture, in those parts of the world which have defied the tread of civilization, some tangible records of the wonders of the wilds.

The film story records are usually divided into two classes—that dealing with animals in their relation to man and that directed purely towards obtaining nature studies. An excellent example of the former will be seen in M-G-M's new production of "Trader Horn," the expedition for filming which recently returned from Africa and which shows man's conquest of nature, whilst that marvelous effort of Martin Johnson, "Simba," typifies magnificently the latter style of film.

Such films have only been made possible by the rapid strides made in the technical development of moving picture photography, eg.: a telephoto 20-inch lens, the introduction of which enables the operator to take up a position at considerable distance from the extremely shy game, is not the least item of such equipment.

Tropical Africa houses a world of difficulties that has taxed the resources of the best of laboratories, but, thanks to the special films, filters, etc., haze, that other bugbear of photography, has also been overcome.

Now, little children, kindly lead us to the villain who invented sound; that we may overcome him!

Inspired by the success of animal photography in Africa, an expedition under the leadership of Mr. W. D. Hubbard, the well known authority on big game, was organized with the object of creating a picture story along the lines of "Chang," which called for the actual handling of big and ferocious game by the actors. On this expedition I signed up as cameraman.

The story's locale was a strip of country bordering on the Kafue River, in Northwest Rhodesia, Africa. Leaving Choma, the rail head, we encountered many difficulties, which may be gauged from the fact that it took our fifteen transport wagons a full month to reach our first camp 150 miles from the railroad. It was during the rainy season and immense stretches of liquid mud had to be traversed in getting our tons of equipment to camp.

It tired our patience and oxen severely as on several occasions wagons were overturned, loosing valuable articles. On the occasion of one incident of this kind we had exactly 156 head of oxen in an effort to pull one of the huge wagons from a mud hole. At the signal of "long-lease" eighteen native drivers cracked their long whips and the power of the oxen simply pulled the wagon apart; again we camped.

The Kafue River, which in the rainy season overflows its banks for miles on either side, makes a fine pasture land on which great herds of game feed. Here we made our main camp.

Because of their known passion for getting results the Americans spare no money in the out-fitting of an expedition. The camp did have the appearance of a miniature Hollywood that had been transported into the wilds. A trade store for the natives and a comfortable house was built on the spot for the two children of Mr. and Mrs. Hubbard. Thousands of pounds worth of piece goods and other truck was there for payment and barter with the hundreds of blacks on our staff.

Our first week in camp was in many respects the most exciting and hinged on the fact that evidently leonine blood, like human blood, is thicker than water. We had taken four lion cubs up with us from Johannesburg for the purpose of close-ups with the children and we little thought as we boxed these playful little animals that they would bring us to within a hair's breadth of overwhelming disaster.

Each of the little fellows was placed in a well built house and, after night fall, their quaint and instinctive little whines, the very first night, were answered, as we all could clearly hear from the wilds.

A few days later Hubbard and George F. Noble, another cameraman, from Johannesburg, and myself moved off to get photographs of Letchwe, a species of antelope of the water-buck family which fed on the flats by thousands. Some thirty miles separated us from our main camp and on the fourth day of our absence, a native runner came up with a note from the women folk asking us to hasten to camp as a troupe of lions were circling around uncomfortably close to camp and they were afraid for their lives.

We at once set off in a Ford lorry, arriving just at sun down and were greeted with the story that, on the previous evening, six lions came into camp and deliberately went to the cubs' cages, scratched and tore at the wood.

This invasion of the lions was first seen by a "piccanin" who promptly rushed through the camp yelling "shumbwa," "shumbwa" (lions). Consternation de luxe ensued. The native gun-bearers seized some guns that had been left in camp, took to the trees and from these vantage points began firing wildly in all directions. By sheer luck they managed to bring down a big lioness while the rest of the lion troupe dashed pell mell through the camp scattering everything before them. The danger to the women and children—Miss Walther, secretary to Hubbard, and Mrs. Noble, was more from the excited natives firing their rifles than from the lions. This will be better appreciated when one realizes that the women were less than 50 yards from the lions

(Concluded on Page 40)

The lioness interrupts the hyena's breakfast.

A HOLLYWOOD IN THE AFRICAN HILLS

(Continued from Page 38)

at the time of the firing.

All was quiet the night we arrived, but the following evening at dinner time the house boy who had been watching the sleeping children in the house some fifty yards from our dining room hut, walked up to Hubbard and calmly announced in English:

"Bwana, the lions have arrived."

Camp again came to life as we all jumped up and hurried after our heavy double-bore guns.

Accompanied by three native boys, each carrying a powerful Carpentier spot light torch, which was kept turned off so as not to scare the lions before we were in good position to shoot, we set off in the dark in the direction of the house where the children slept.

In front of the house the usual fire was burning low, but we could manage to see two of the prowlers. On hearing us they made off in the darkness, but determined to give a lesson, we followed. We crept slowly along for some distance when Hubbard suddenly gave the signal for the boys to turn on the lights. The sight that met our eyes will not easily fade from memory. Not over fifty yards in front of us stood six lions staring unblinkingly at us. One of them stood atop an ant hill, a perfect shot.

Hubbard commanded: "Steady boys and make sure. Fire!"

As one shot the three heavy guns discharged and the repercussion gave us that dreadful feeling that accompanies an earthquake so that the boys momentarily lowered their lights and, when they raised them again, the lions were gone; Hubbard and I both had brought down one each. For the space of a few seconds we stood there wondering what to do under the circumstances and then the decision was taken out of our hands for the sound of padded feet was heard coming through the grass. The nerves of the blacks gave way first as one boy dropped his light and disappeared. Another followed suit, leaving us in total darkness confronted, as we had every reason to believe, by a half dozen of the savage beasts.

In the stillness of that African night we stood, each rooted to the ground by the paralyzing fear. Hubbard broke the silence, whispering hoarsely: "They are after us." We've got to run," and run we did. Mosquito boots are very poor running gear and I had no sooner started than I stepped into a huge sun-baked crack and down I went only to do a repeater as the soles of my boots were like glass from wading through the grass. I was well in the rear before my last prayer was answered, expecting every moment to be my last. Exhausted, I turned to make a fight for life. I sought wildly to find the line of fire and, just as I was about to let go, there in front of me I recognized running towards me one of our hunting dogs!

The anti-climax nearly made me drop in my tracks. The dog, evidently aroused by the firing and scenting sport, had run out of the compound to find us and the sounds he made coming through the grass had been the cause of our terrible scare. We visited the scene of the hunt next morning and found bloody spoor only. The lion cubs were shortly afterwards dispensed with and we were troubled no more with lions in that camp.

The most touching incident of the whole expedition took place in camp, a lion and his mate being the principal actors. We needed a pair for close-up work and succeeded in getting the female first. We placed her in a huge cage, but she lay on the floor and sulked, refused to drink and would not look at the most tempting morsel of meat. This lasted three days and she never was seen to move from the spot she chose the first day. She seemed to be dying from grief and we all thought seriously of letting her go free in spite of the fact that we needed a pair for our picture. However, the traps still remained set in the expectation of catching a male and, when we had fully decided to let the lioness go a native boy came in dancing and yelling in the native tongue that a male was in the trap.

I was not greatly surprised nor much elated. Those eyes of the lioness seemed to haunt me, but the newcomer made up the pair long sought. The dancing and singing of the natives, who hate and dread the lion, seemed to put a new light on the subject, so it was not long before the male, a wary brute, was brought to camp. The "Bwanas" had done a great thing—caught two lions.

Two large cages were placed back to back, one containing the now furious male, roaring and prancing up and down. The doors of both cages were suddenly drawn. The male wheeled around and leaped in with the lioness. All was silent. The lion stood staring unblinkingly at his mate. Then raised his huge paw and placed it gently on top of the head of the lioness. She turned to him and her eyes cleared as the noble beast nosed her and licked her face. Then he lay down beside her.

There was, I fancy, a sudden moisture in the eyes of the women folk as they witnessed the meeting of the two animals, while we men were not unconscious of a lump in our throat. Bones and an empty water pan was seen in the cage the next morning telling mutely the story of reunion.

Many other stirring incidents with lions marked the progress of the film we were making, the most thrilling that befell Noble and myself occurring when, after many attempts, we managed to entice a lioness to feed in front of our safety pit. This was covered by many planks and earth strewn with bushes to produce a semblance of nature. One big aperture was provided for the lenses of our cameras and we calculated that no lion's paw would ever reach us or our machines.

A dead buck was duly laid out one morning as bait, and we stood ready for action. A hyena arrived first on the scene laughing for dear life to think that he had found such a huge meal that was not intended for him. His feast, however, was short lived, for up walked Mrs. Lion and, seeing the interloper, gave him a tap on the head that sent him flying off with a sore and bleeding face. She then ate slowly and steadily for some minutes. Suddenly she lifted her head, sniffed suspiciously and looked around. She must have seen the aperture or heard the clicking of the cameras, for she moved forward a couple of paces. Then she sprang, got one paw through the gap in the plank and at the same time bit clean through the metal lens jacket of Noble's camera. He and the camera collapsed but the only real damage was done to the head of the tripod which was put out of action for evermore. Retreating, the lioness made another attempt to get at me, but finding it useless turned back to the buck and dragged the carcass into the bush.

Spring Convention S. M. P. E. 1930

Courtesy of LAWRENCE A. FIFERLIK, *Managing Editor Cinematography, New York*

The 1930 Spring Convention of the Society of Motion Picture Engineers has come and gone and no definite solution of the momentous problem of the picture industry, the adoption of a wide film standard has been announced. Over five hundred members and guests of the society gathered at Washington, D. C., the first week in May to discuss the problems of the industry, and although much was said on the matter of changing the film standard, the final decision is apparently as uncertain as it was a year ago.

The standards committee reported that close cooperation between the big producing companies had been brought about and weekly sessions are being held by representatives of the companies advocating various new film sizes, and that these companies all have agreed to cooperate in the adoption of a new standard before plunging into the manufacture of apparatus for the production of a larger film.

The decision is now between 70 and 65 mm., and it is very probable it will be in favor of the former, as more financial weight is behind the engineers who are working out the development of that size.

By far the greatest number of papers read before the convention was by sound engineers. The trend of development in the sound branch of the industry, as brought forth by these papers, indicates that recording has passed the experimental stage and is now rapidly becoming stabilized. The problems now are more along the line of polishing off the fine points and perfecting systems rather than adopting new and radical changes in methods.

Hollywood was ably represented on the floor of the convention by E. C. Richardson, of Mole-Richardson, Inc., and George Mitchell, of the Mitchell Camera Company.

Four of the most interesting papers of the convention were presented by Richardson, acting as pinch hitter for various west coast members who were unable to attend in person. The new adjustable microphone booms, developed to keep a microphone in proper position over a moving actor, and the heavy duty tripods developed to facilitate the use of "blimps" were described.

Richardson also brought news of what is being done to lighten and simplify sound proof housings for cameras in Hollywood in a paper written by L. E. Clark, Pathe Studios, Culver City.

The "squeeze track" method of controlling sound volume in reproduction, as worked out in the Metro-Goldwyn-Mayer studios and described in a paper by W. C. Miller, which Richardson presented, was received with much interest and brought out a great deal of discussion, especially from the projectionist faction of the society.

A simplified description of the method is that the volume control of sound is printed into the sound track on variable density film by narrowing or widening the width of the sound track. This means that the operators projecting the pictures will have nothing to do with regulating the volume of sound. The results as projected on the screen for demonstration showed the practicability of the method and its advocates claim its greatest value is that it gives the director control of the ultimate effects he wishes produced instead of putting that control, or responsibility, in the hands of each person who projects the picture.

A new type of sound-on-film recorder was demonstrated by E. W. Kellogg of the Radio Victor Corporation, the important feature being that the film is moved past the light valve on a revolving drum free from any pull of sprockets. The advantage is that it is entirely free from the slight irregularity of motion a sprocket gives, no matter how perfectly it is constructed or operated.

A practical continuous projection machine was demonstrated by A. Holman of Brookline, Mass. A series of lenses is mounted on a revolving disc that moves in opposite direction to the film as it travels through the machine and creates a stationary image on the screen for each frame. The result is a fading from one picture to the next which gives a continuous screen illumination instead of a quick black out and jump to the next picture as is the case with a shutter and intermittent movement. The results both in color and black and white gave nothing in projection quality with which fault could be found, and the developers of the method claim that a great deal of wear is taken from the film and that the eye strain on the part of the audience is appreciably reduced.

Television came up for considerable discussion but the jist of what was said is that this new branch of science is still in a very experimental form and that it will be anyway from five years to a very long time before the picture industry will be revolutionized by it.

A new method for automatically timing negatives was brought forward in a paper presented by M. W. Palmer of the Paramount New York studios. It is proposed that a density record corresponding to the density of the important object, such as the actor face, in each scene be recorded along the edge of the film as the scene is being taken. This would be made by a light of adjustable strength in the camera which would be set in accordance with the measurement of the light on the principal object as recorded by a photometer.

The automatic printing machine would be equipped with a photoelectric cell arrangement which would regulate the printing light in accordance with the variation of density of this density strip along the edge of the film. If this can be worked out practically it will solve one of the greatest problems of the laboratory, correctly timing of prints. However, it will shift more responsibility on to the cameraman for the proper adjustment of this light record would always be a fine and accurate requirement, as well as choosing just which subject in the scene to print for.

No new camera improvements or suggestions of changes were brought up at the meeting. Neither was any development of color processes mentioned.

Will H. Hayes was the guest of honor at the annual banquet and the assembly was greeted with talking pictures of various distant members, including George Eastman and many Hollywood friends, which were shown by portable R.C.A. equipment set up on the ballroom floor between dances.

During the business sessions a new set of by-laws was adopted. It was also decided to make an annual merit award to the person who, in the opinion of the society, contributed most to the scientific progress of the picture industry during each year.

Honorary memberships were voted to the presidencies of the Royal Photographic Society, London, and the German Photographic Society, Berlin.

The fall convention of the society will be held in either Detroit or New York, and in all probability the next spring convention will be in Hollywood, although there are many who advocte taking it abroad to London.

Courtesy of JOSEPH DUBRAY
Bell & Howell

Reporting on any Society of Motion Picture Engineers Convention is either an easy or a difficult task. It seems logical to think that the technical and scientific aspects of the convention should hold a preponderant place in the report, but the material offered is usually so large and detailed that it would be an herculean task even to attempt to make mention of all the communications and papers presented and discussed during the meetings.

We will, therefore, simply refer the reader to the convention's program and to the coming issues of the Society of Motion Picture Engineers' Journal, in which the papers presented at the 1930 Spring Convention will be reprinted.

The Society of Motion Picture Engineers have once more proven that they are on the constant alert, that their work is indefatigable and systematic, that old problems are constantly investigated with a view to improving accepted practice, and new problems are attacked with the spirit of conservative forwardness, which is proper for technical or scientific investigation.

One thought has been in constant evidence in the mind of the writer, and that is the liberality, the generosity, with which the fruits of laborious and costly investigation are made available through Society of Motion Picture Engineers'

(Continued on Page 60)

Loads o' Luck

to the boys . . .
and their International
Convention!

LOUISE FAZENDA

℄ According to the new By-Laws, every good I. A. T. S. E. man should buy a copy of Joe Cook's "Why I Will Not Imitate Four Hawaiians" . . . which will set them back one buck, at any book store.

Camera!

FRANK CAPRA

Here's to my friends of the I. A. T. S. E.--

BUSTER COLLIER

P. S.—In or out of focus!

Why Is An Assistant?

(Contributed by Eddie O'Toole, 659)

Harking back to dear old flat-lite days, an assistant was an all-around man who might also be prop boy, still-man, second and actor. To help or assist a cameraman was considered lowly and a position of minor importance.

As time and flickers wore on producers found that much time was saved by having someone help the cameraman who was more or less conversant with the camera, its mechanism and photography in general.

Then came the time when the assistant's job was clearly outlined; to help and assist the cameraman and care for the equipment. The pay was low and, though somewhat responsible, even ten years back, the job was the one low spot in the ordinary troupe. Gradually a few individual men realized the help rendered and the money saved so they voluntarily raised the wages of their assistants. These assistants "went out of their way," as the saying goes, or let's say exerted themselves to keep the troupe, as far as the photographic end was concerned, running. They watched the equipment, loaded and unloaded and shipped the film, kept reports, etc.

It was at this time that an assistant's position began to be of more importance and producers watched the merit of the men they chose to fill them. And so, more or less, the condition continued until the recognition of our union.

We now find an assistant to be, in most cases, all that the word implies. He has evolved from the "camera-punk" stage to that of "junior artist" (ahem), with pay enough to support a new Ford, swanky clothes, and an occasional sandwich at Henry's.

He is half a cameraman at all times. He checks and changes the focus, the stop, the oiling of camera, the footage, the "shot," and many other things not apparent to the casual observer. He is the cameraman's second pair of eyes. The cameraman's work is his work. He reviews it with a kindred interest, for you will hear him forever saying: "We shot that at such and such place," or 'You should have seen the girls on the location where we shot that stuff" (replace the word "girls" with any other concrete word like snow, dust, horses, games, fog, rain, etc., etc.).

His duties are so inconspicuous but withal so important that cameramen once used to an assistant, try to keep the same men as long as possible to work with them. Also they speak of "breaking in an assistant," meaning getting the young hopeful acquainted with their pet gauzes, disks, filters, habits (not the ones you are thinking of) and so forth.

Not only has the photographic equipment become finer, more extensive, more technical and complex, but shots are now harder to get. The formerly unknown, but now common "dolly" or traveling shot is a major responsibility for any assistant, the success of which rests a great deal upon his shoulders.

Rumors of lenses which change their own focus and finders which also change themselves from far to near and vice versa are still rumors. The human element in technical work is very hard to displace.

Assistants who were formerly just chore boys and pack men are now men with a store of photographic knowledge and a great deal of very necessary and proven self-confidence.

Last, but not least, we might say that as time goes on and photography becomes more technical an assistant will be and have to be a true cameraman's helper, a friend in need and in the true sense of the word an artist's artist or a "photographic artist's apprentice artist."

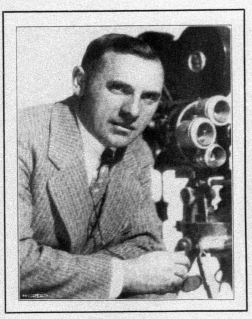

Ask the
Director
Who
Knows

◆

George Archainbaud
Norman Taurog
Al Rogell
Edward Laemmle
Arthur Rossen
William Craft
Chester Franklin
E. A. Dupont
William Seiter
Harry Beaumont
Wesley Ruggles
Walter Lang
James Flood
Reggie Barker
John M. Stahl
Ralph Ince
William Beaudine
Edward Sloman
James Cruze
Clarence Brown

Welcome to Los Angeles
I. A. T. S. E. and M. P. M. O.

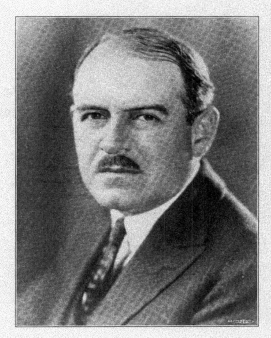

ALVIN WYCKOFF, President Local 659
I. A. T. S. E. AND M. P. M. O.
International Photographers of the Motion Picture Industries

 # Cream o' th' Stills

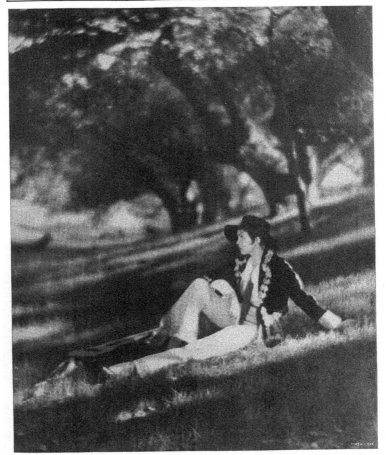

This beautiful still might be from a fragment of life in early California times when the good gentle people of old Spain ruled here. Lila Lee is the young caballero and the artist is that excellent workman, Mr. Elmer Fryer.

 # Cream o' th' Stills

David Ragan saw a picture worthy of The International Photographer in these choir boys. The scene is from a motion picture, but it is none the less convincing coming from Mr. Ragan's camera.

This still of one of the big war pictures is as realistic as they come. In photographing scenes like this the time of shooting is the essential thing. James Gordon knew when to press the bulb and got a real picture

 # *Cream o' th' Stills*

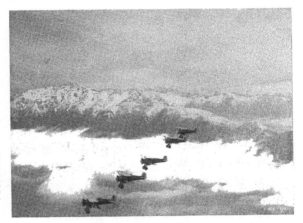

This air shot up twelve thousand feet will be hard to beat. It is from the camera of Mr. John L. Herrmann who knows his air stuff. The locale is Alaska above Juneau.

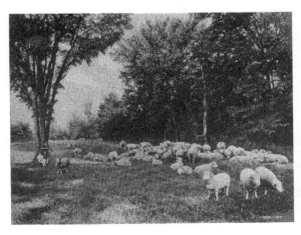

Earl Stafford discovered this lovely pastoral in a rural nook hidden away in the hills of Central California. It is for all the world like a scene in the sheep country of merry England. Mr. Stafford knows his locations.

Cream o' th' Stills

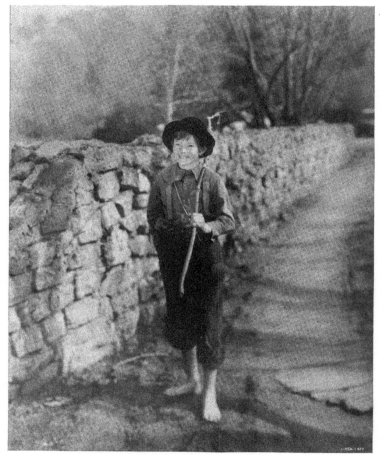

Donald MacKenzie's still herewith brings back memories of "The Barefoot Boy", "Tom Sawyer", "Huckleberry Finn" and the rest. It is a sweet picture and absolutely convincing in all its elements.

Cream o' th' Stills

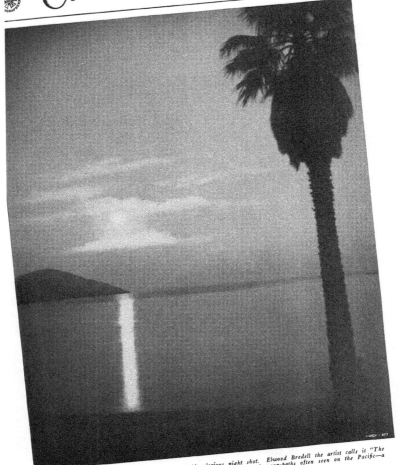

Catalina Island, the enchanting, is the scene of this glorious night shot. Elwood Bredell the artist calls it "The Winter Moon." The Moon path is not accentuated. That's the kind of moon-paths often seen on the Pacific—a veritable path of flame.

Cream o' th' Stills

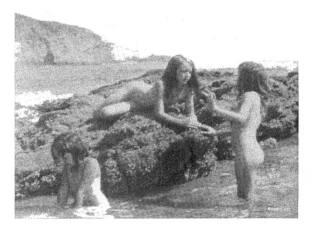

These mermaids disporting on the rocks of Laguna form as entrancing a group as was ever seen in the sea. This gem was posed for the camera by Roy Eslick.

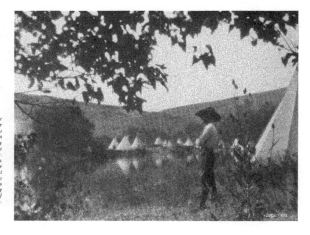

Virgil Miller's poetic soul was not in error in seeing in this Blackfeet Indian encampment a worthy subject for his facile camera. Too bad Mr. Miller's multifarious duties as chief of the camera department at Paramount Studios will not permit him to go more frequently afield in search of natural beauty.

 # Cream o' th' Stills

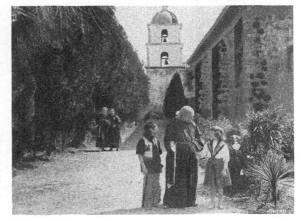

Thus charming picture is out of the camera of Victor Schuerich. It was caught at the historic old Mission of Santa Barbara in the days before the earthquake. Visitors to Los Angeles should not fail to visit this lovely old landmark.

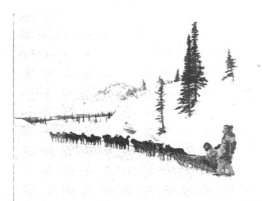

If the observer likes a combination of snow and dogs it is in this picture. This study is an Alaskan subject accidentally picked up by Mr. Hobart Brownell on one of his trips.

 # Cream o' th' Stills

"The Mill Race Makes a Detour" was shot at "The Old Mill Site" near historic Bull Run, Virginia, by Gorman A. Charles, who arrived on the spot just in time to catch the runaway in all its beauty.

Eight Hundred Men in One

Howard Hurd, business representative of the International Photographers of the Motion Picture Industries, Local 659, I. A. T. S. E. and M. P. M. O.

The business representative of a union local is just that. He is the man who represents the local in all its business transactions, both within and without the organization. He is the executive officer who gets things done and he looks after all details. He is also the official spokesman of the Local and he puts into execution the resolutions and the acts of the officers and the governing board. In the case of Local 659, at least, he is nearly eight hundred men rolled into one and to handle the affairs of that many men is a real man's job. Local 659 is proud to honor Mr. Hurd with the administration of its business affairs. Ladies and gentlemen—Mr. Howard Hurd.

The Convention Entertainment Committee

The members of this committee have permanent headquarters at the Alexandria Hotel. If in trouble or if you want anything locate one of the following named gentlemen, Brothers of the I. A. T. S. E. and M. P. M. O., and he will see that you are made happy:

William F. Scott, business representative, Stage Employees, Local 33, Chairman.

John J. Riley, also of Local 33.

T. H. Eckerson, business representative and secretary-treasurer, Motion Picture Projectionists, Local No. 150.

Howard Hurd, business representative, International Photographers, Local No. 659.

Carl J. Kountz, business representative, Film Editors and Laboratory Technicians, Local No. 683.

Lew C. G. Blix, business representative, Studio Mechanics, Local No. 37.

These are the men responsible for running the machinery of the Convention and a better committee could not possibly have been selected.

LOOK 'EM UP.

Officers International Photographers of the Motion Picture Industries, I. A. T. S. E. and M. P. M. O., Local 659

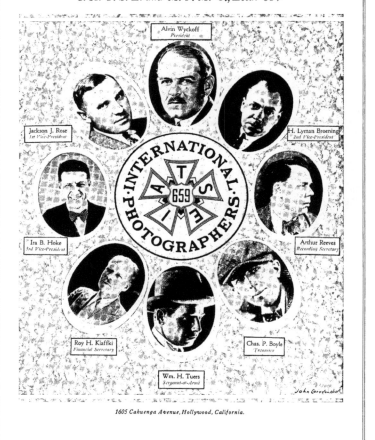

1605 Cahuenga Avenue, Hollywood, California.

Board of Executives International Photographers of the Motion Picture Industries, I. A. T. S. E. and M. P. M. O., Local 659

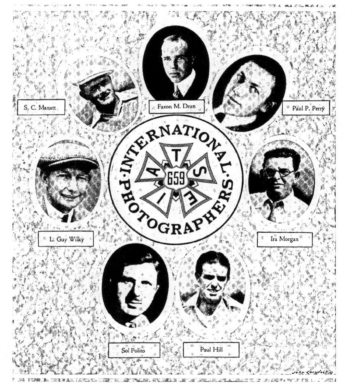

Other members of the Board of Executives are J. O. Taylor, Archie J. Stout, R. B. Hooper.

Members Local 659—First Cameramen

Sol Polito, Jas. S. Brown Jr., Henry Sharp, Max Fabian, Ralph Staub, Virgil E. Miller
Farciot Edouart, Victor Milner, Ted Tetzlaff, Edward Snyder, Ray June, Paul P. Perry
J. R. Lockwood, Edwin B. DuPar, Philip Tannura, Sol Halprin, Robert E. Cline, G. Floyd Jackman
Frank B. Heisler, Bert Baldridge, Paul H. Allen, Jerry Fairbanks, Irmin E. Roberts, Pliny Goodfriend
Lewis Physioc, Joseph Dubray, Harry Forbes, Harry Neumann, Alvin Wyckoff, Karl Freund
Dewey Wrigley, Edward Gheller, Len Powers, Wm. H. Dietz, Harry Jackson, Merritt Gerstad

Members Local 659—First Cameramen

Max B. Dupont, Robert Kurrle, Josiah Roberts, Norbert Brodine, Harry Vallejo, Faxon M. Dean
Peverell Marley, Ray Rennahan, Joseph Walker, Allen C. Jones, Frank B. Good, Lucien Andriot
Ernest J. Crockett, Ernest Miller, Lauron Draper, Paul Eagler, Wm. Williams, Henry Cronjager
Ernest Palmer, Gus Peterson, Leon Shamroy, Karl Struss, Lloyd Knechtel, John Stumar
Arthur Reeves, Lee Garmes, M. A. Anderson, Jas. Van Trees, Hal Rosson, W. Howard Greene
Ernest Depew, Jas. B. Shackelford, Park Ries, Pliny Horne, Chester Lyons, Fred Westerberg

Members Local 659—First Cameramen

Arthur Edeson, Edw. J. Cohen, Edw. Cronjager, Leroy Eslick, Howard Oswald, John J. Mescall
Roland Totheroh, Willard J. Van Enger, Wm. Daniels, H. Lyman Broening, Eddie Linden, Harry Cooper
Chas. B. Lang, Ross G. Fisher, John L. Stevens, Chas. E. Schoenbaum, Allen Davey, Fred Eldredge
Wm. H. Tuers, Daniel B. Clark, Ira B. Hoke, Joseph Valentine, Jules Cronjager, Gilbert Warrenton
Wm. A. Sickner, Jackson J. Rose, Jack Young, Glenn R. Kershner, George C. Stevens, Bert Longnecker
Walter Lundin, Arthur Todd, Joe Novak, Chas. P. Boyle, Ed. Estabrook, J. P. Whalen

—illusion that becomes **reality!**

The DUNNING PROCESS

of double exposure converts the studio stage into any locale that the production may require —it brings to the screen, convincingly, locations from the four corners of the earth—photographed in the studio with dialogue and sound effects....a great saving in production expense as well as eliminating the danger to life while photographing hazardous scenes!

DUNNING PROCESS

932 NORTH LA BREA **PHONE GLADSTONE 3959**

"Success and Good Will to the I. A. T. S. E."

Members Local 659—First Cameramen

Wm. C. Thompson, Russell Cully, Sidney Wagner, J. Dev Jennings, Wm. C. Hyer, John Fulton
Howard Anderson, Nicholas Musuracca, Vernon Walker, Joseph Brotherton, Jacob Badaracco, Wm. Wheeler
George Meehan, Harold Lipstein, Lewis O'Connell, Roy H. Klaffki, John Hickson, Perry Evans
L. Guy Wilky, Leo Tover, Jack Fuqua, Gordon Pollock, Wm. Fildew, Ernest Smith
Wm. C. Marshall, Paul Ivano, Raider Olsen, Raymond Ries, Harry Perry, Henry Kohler
Robert V. Doran, Glen MacWilliams, Glen Gano, Frank Redman, Hal Mohr, Arthur Lloyd

Members Local 659—First Cameramen

Barney McGill, Ned Van Buren, Edgar Lyons, Otto Himm, Clyde DeVinna, E. L. McManigal
Wm. S. Adams, Chas. Stumar, Arthur Miller, Irving Ries, John W. Boyle, Elmer Dyer

Len Smith, Ben Kline, Tony Gaudio, Jack McKenzie, Ira Morgan, Wilfrid Kline

SPRING CONVENTION S. M. P. E.

(Continued from Page 42)

meetings to the industry as a whole.

We consider it appropriate also to pay a tribute of gratitude to the various committees of the Society. Their reports have disclosed not only a truly amazing amount of work enthusiastically conducted by the committee members, but also a true spirit of self-effacement which, though in accordance with the unwritten ethical code of all scientific societies, is nevertheless a constant source of admiration to all who realize the personal efforts expended by each individual member in order to bring about that correlation of efforts which is indispensable in all human endeavors, and without w h i c h progress would be stunted.

The beautiful and comfortable Wardman Hotel housed the members of the convention. The Wardman "Little Theatre" proved ideal for holding the meetings and for the presentation of pictures during the sessions, as well as in the evenings, which were set aside by the convention committee for showing to the members and guests some of the newly released productions.

Mr. Herbert Griffin of International

Projector Company of New York spared no effort in supervising the installation of the sound reproducing projection equipment, and the success of this important part of the program is entirely due to his energy and methodical organization as well as to the co-operation of those who so ably assisted him.

The program was crowded, perhaps somewhat overcrowded, a n d President Crabtree found himself in the obligation of establishing a limit of time for each speaker to present his paper and for its discussion. This was, however, carried with complaisance on the part of all and the program was completed within the allotted time.

Aside from the technical and scientific aspects of the convention, good tidings of the growth of the Society were presented to the S. M. P. E. members. The membership committee report showed that membership of the Society has increased by leaps and bounds, the last figures nearing the 800 mark.

President Crabtree announced officially that authorization was given for the establishment of a "Chicago Section," the boundaries of which shall be defined shortly.

Since the writer has been elected as temporary chairman of this section, he finds it quite opportune to express here the pleasure he derives from the decision of the Board of Governors. A Chicago Section, which will include members mostly devoted to advances in motion picture mechanical engineering and to the production of industrial motion pictures is most desirable a n d will undoubtedly prove its worth.

The semi-annual banquet was very successfully held on the evening of May 7. The Hon. William P. Connery, Jr., Congressman of the Seventh District, Massachusetts, acted as master of ceremonies. C. Francis Jenkins, scientist, inventor, and founder of the Society of Motion Picture Engineers, addressed the gathering with a discourse in which he eloquently described how man is constantly forging the tools which harness and put at his disposal nature's forces. Will H. Hays, President of the Association of Motion Picture Producers and Distributors of America, outlined the growth of the motion picture industry, its steady advancement, and its contribution to the educational, the scientific and the amusement world. He made an incursion into the

(Continued on Page 64)

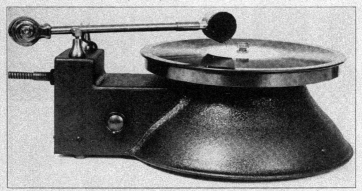

Members Local 659—Second Cameramen

N. C. Travis, Maurice Gertsman, Loyal Griggs, John Jenkins, Monroe Bennett, Jack Greenhalgh
Carl Wester, Earl Stafford, Ray Ramsey, Harry Hallenberger, Joe Biroc, Hatto Tappenbeck
King Gray, Linwood Dunn, Paul Lerpee, Erwin Musgrave, A. L. Lane, Glenn Twombly
Leland Davis, Mark Marlatt, E. G. Ullman, Earl Walker, W. Earl Frank, Paul Garnett
Burnett Guffey, Pierre Mols, Emilio Caluori, T. F. Jackson, Tony Kornmann, Walter Bader
Al Henderson, James Giridlian, Warner Crosby, Joe La Shelle, August Elliott, Paul Hill

Members Local 659—Second Cameramen

Harry Wild, Jockey Feindel, William Bradford, Edw. Henderson, Richard Fryer, Roy Vaughan
Geoffrey Heriot, Edw. Pyle, Robert Palmer, Cliff Thomas, J. Henry Kruse, Robert DeGrasse
Norman DeVol, Rube Boyce, Forrest Hershey, B. B. Ray, Peter Denie, Al M. Greene
James R. Palmer, Harry Fowler, Thos. J. Galligan, Guy Roe

Reggie Lanning

SPRING CONVENTION S. M. P. E.
(Continued from Page 60)
future, and prophesied constant and still greater progresses in the art than have been witnessed in the past.

In answer to Mr. Hays' inspired speech, President Crabtree outlined the aims of the Society of Motion Picture Engineers and most appropriately sounded a warning in regard to future expectations.

Stereoscopic pictures and television, he said in substance, will probably materialize in the future, but our present knowledge does not permit us to forecast how soon these developments will be available to mankind. It seems logical to think that such achievements are still rather remote unless discoveries are made which will revolutionize our present understanding of the factors involved. The conservative attitude of President Crabtree will be appreciated by all researchers the world over.

The speeches were broadcast through the Columbia broadcasting system, and we are confident that the listeners who tuned them in have been amply repaid for their interest.

Ultra modern features of the banquet were the "listening in" to an address by H. Warner, of Warner Brothers, broadcast from New York, and the introduction, via talking pictures and R.C.A. portable sound projector, of a number of motion picture personalities of both Hollywood and New York.

Among those present were Simon Rowson, chairman of the London Section; M. W. Palmer, chairman of the New York Section; Townsend of Hollywood, representing the Academy of Motion Picture Arts and Sciences; E. C. Richardson and George Mitchell, both of Hollywood, and old and new members, who largely contributed to the success of this convention.

The entertainment committee proved to be as efficient as usual. Besides organizing a very entertaining after-banquet show, presented by the Loew Unit of the Palace Theatre, and the brilliant
(Continued on Page 68)

Members Local 659—Assistant Cameramen

Louis Molina, Harry Dawe, Edw. Garvin, James Barlotti, Willard Emerick, Robert Pierce
Edw. Collins, Al Prince, Robert Miller, Fred West, Louis De Angelis, Al Smalley
Harold Graham, Thad Brooks, Arthur Rice, Fred Campbell, Robert Morton, Clarence Slifer
Joe Dorris, Lee Crawford, James Gordon, Harvey Gould, Jack Alton, Robert Hoag
Donald Brigham, Fred Terzo, Jean Davenport, Gene Hagberg, S. Morgan Hill, Frank Dugas
Dale Deverman, W. V. Draper, Michael Walsh, James Higgins, Chas. Leahy, James Goss

hat's become of
the "Flickers"?

WE laugh at them now...those flicker-ing, unsteady, battle-scarred shadows called "motion pictures" back when a nickel bought a front row seat. "The Flickers", they were called in the comic magazines, and rightly named, too!

What's become of them? Packed safely away in tin cans; most of the machinery that produced them has long since been scrapped. Precision did it, and research and technical skill — the foundation upon which Bell & Howell built an institution dedicated to progress in cinemachinery.

Through Bell & Howell Standard Cameras, Printers, Perforators and Splicers runs a goodly portion of the world's annual output of movie film. For nearly a quarter of a century, Bell & Howell ingenuity in design and precision in manufacture have made themselves felt, all the way from the "lot" to the projection booth. Bell & Howell are proud to have contributed this large a share in the upbuilding of "the flickers".

BELL & HOWELL

Bell & Howell Company, Dept. R, 1849 Larchmont Ave., Chicago, Ill. New York, 11 West 42nd Street. Hollywood, 6324 Santa Monica Blvd. London (B & H Co., Ltd.) 320 Regent Street. *Established 1907*

Members Local 659—Assistant Cameramen

Lester Shorr, George Diskant, John Crouse, Francis Burgess, Frank Ries, Anthony Fernandez
Frank Buchholz, Joe Lykins, Bill Margulies, Monte Steadman, Ed Jones, Warner Cruze
Royal Babbitt, Ed. J. O'Toole, George G. Trafton, Eric DeBrath, Robert Tobey, Jesse Ivey
Jack Kiehl, Robert Bryan, Sidney Newburgh, Walter Rankin, H. C. Ramsey, Rod Tolmie
Harold Wellman

SPRING CONVENTION S. M. P. E.
(Continued from Page 64)

dance that followed, a visit to the White House had been scheduled for Wednesday, May 7, in the early afternoon. President Hoover condescended to pose in the semi-annual group of the Society, which will undoubtedly be much in evidence in the offices of the Society members. That same afternoon a reverent tribute was paid at the tomb of the Unknown Soldier in the Arlington National Cemetery, and a visit to Mount Vernon culminated the few hours of relaxation accorded to the members during this very busy convention.

Local members and Mr. N. D. Golden, of the Department of Commerce, were most kind in offering their assistance to visiting members, and their courtesy and hospitality contributed not a little to the comfort of all.

Mrs. C. F. Jenkins and Mrs. Pritchard acted as hostesses to the ladies of the convention. Tea, bridge and excursion parties made their sojourn pleasant while their male companions were delving into the intricacies of motion picture technicalities.

(Continued on Page 72)

'Members Local 659—Still Cameramen

Harry Blanc, Harold Wyckoff, W. P. McPherson, J. Edwin New, Paul Ries, Les Rowley
Paul Grenbeaux, Chas. Lynch, Walter Boling, Mac Julian, Clifton Maupin, Raymond Nolan
Shirley V. Martin, Hal Porter, Wm. E. Thomas, Edwin Witt, Donald MacKenzie, Bert Lynch
Edw. B. Anderson, Fred Archer, Robert Coburn, Oliver Sigurdson, Otto Benninger, Joe Harris
David Farrell, Otto Dyar, Elmer Fryer, K. O. Rahm, Bert Anderson, Chas. Welborn
Eugene Richee, Walter J. Van Rossem, Clarence Graves, Clarence Bull, Gaston Longet, Clifton Kling

TECHNICOLOR

Members Local 659—Still Cameramen

Ray Jones, Fred Hendrickson, Neal Harbarger, Rex Curtis, Gene Kornman, Gordon Head
Ernest Bachrach, Junius Estep, George Baxter, Robert Crandall, Frank Bjerring, Carl Day
Lindsay Thompson, Mickey Marigold, Frank Tanner, Frank Newburg, Wm. H. Grimes, H. L. Osborne
Irving Lippman, Merritt J. Sibbald

SPRING CONVENTION S. M. P. E.
(Continued from Page 68)

"Journey's End," "Song of My Heart," and "All Quiet on the Western Front," were the three main attractions on the motion picture program, while a Metro-Goldwyn-Mayer dog comedy, the title of which the writer missed, aroused enthusiastic mirth and was highly praised.

Every evening pictures were shown in the Little Theatre and the large attendance proved the interest aroused by these remarkable productions.

In conclusion, the convention was a business, technical, and a social success, and all present are undoubtedly already making preparations for the next Fall meeting, which will take place either in New York or Detroit, these being the two cities decided upon by the Board of Governors.

The choice of these two cities will be submitted to the vote of the membership at large. Hollywood is tentatively chosen for the next Spring Convention. London for some future time.

Again, the Society of Motion Picture Engineers has demonstrated the true worth of its untiring efforts, which guarantee a constant progress in motion picture technique.

Extracts of papers, addresses and reports follow:

Abstract of Advantages of Non-Intermittent Projection by the Revolving Lens Wheel Mechanism, by Arthur J. Holman.

Extensive comparison tests, conducted by men thoroughly familiar with the performance of intermittent projectors, have proven conclusively that the revolving wheel projector easily produces screen images which are fully the equal of the best present day presentations as regards definition, steadiness and brilliancy. In other words, this system of projection, as embodied in a mechanism designed and constructed some four or five years ago, meets the most exact requirements of critical definition, steadiness and screen brilliancy.

The advantages of the revolving lens wheel system of projection reside in the elimination of the intermittent movement and the shutter. The uninterrupted flow of uniform and relatively low intensity light to the screen produces a clear, bright and extremely pleasing quality of picture, entirely free from scintillating effect in the highlights. Due to the continual dissolving action, which occurs between successive film frames, the appearance of graininess is greatly reduced and the action is smoothed out. These factors materially reduce eye-strain and fatigue, thus enabling the observer to enjoy to the

(Continued on Page 74)

Members Local 659— News and Industrial Cameramen

George Richter, Frank King, Jesse Sill, Gorman Charles, Bert Trouslot, Lenwood Abbott
Loyal Himes, Ernest Zimmerman, Edward Kemp, Frank Blackwell, Mervyn Freeman, Robert Connell
Esselle Parichy, Joseph M. F. Haase, Merl LaVoy, Albert C. Schmidt, James B. Herrick, Ralph E. Yarger
Harry Flenner, John L. Herrmann, John M. Culver

SPRING CONVENTION S. M. P. E.

(Continued from Page 72)

fullest extent the improved tone qualities. The screen results produced with this system have been likened to paintings of old masters.

Elimination of the intermittent movement and the introduction of a scientifically designed take-up control, reduce film wear and damage to a minimum, making it possible to get several thousand exhibitions from a single print without accumulating scratches, oil and dirt over the picture area. Moreover, since the spot intensity is only half normal, the film strip is subject to very little heating effect. The aperature and gate design effectively prevent "buckling."

The optical system, easily and instantly adjustable for variation in shrinkage of film, is very simple: It contains no mirrors or prisms and does not require cams or other variable velocity devices for its operation. The system may be designed for any desired film frame size and is equally effective for 16 mm. or double with film. The model used at the S. M. P. E. Spring Meeting is equipped with improved safety devices including a foolproof fire shutter and effective magazine valves.

Abstract of Highlights of the Report of Progress Committee*, by G. E. Matthews, chairman.

*This is an abridgement of the entire report which will be published in an early issue of the Journal of the Society of Motion Picture Engineers.

Increased interest was noted in the past six months in the subject of wide films. Several different widths were proposed, and of these, 70 mm. and 65 mm. appear to have been most favored. A sub-committee of the Standards Committee of this Society held several meetings to encourage the adoption of one width as standard. The personnel of the sub-committee consisted of the leading engineer of the producing organization interested in this problem. A feature picture, "Happy Days," and a newsreel on 70 mm. film, were shown at a regular program, opening March 14, at the Roxy Theatre, on a screen 41½ feet by 22 feet. Several other theatres were also equipped to handle this type of film, and at least four feature pictures were known to be in progress.

Definite advances in optical systems, processing methods, and the experience that follows production problems on a large scale, all contributed to a substantial improvement in the quality of color pictures.

Two huge sound stages have been completed in Hollywood recently by two producers. One of these comprises a theatre auditorium capable of seating 1500 persons and a section which is also designed as a theatre stage in size, 75 feet deep, 80 feet wide, and 120 feet high. This

(Continued on Page 158)

That All May Be Represented

For a variety of good reasons photographs of the entire membership of Local 659 could not be secured in time for inclusion in their respective groups. In due time when all are received they will be published. In order, however, that the Local membership may be represented one hundred per cent the names of these brothers are hereby printed:

FIRST CAMERAMEN

Abel, Dave
Arnold, John
August, Joseph
Avil, Gordon

Baker, Friend
Barlatier, Andre
Barnes, George
Binger, R. O.
Booth, Frank H.

Clarke, Chas. G.
Cotner, Frank

Davis, Harry
DeSart, Albert
Diamond, James R.
Dunning, Carroll D.

Fischbeck, Harry
Flora, Rolla T.

Galesio, Len
Gant, Harry
Gerrard, Henry W.
Gilks, Alfred L.
Griffin, Walter L.

Haskin, Byron
Haller, Ernest
Hammeraas, Edwin M.
Hesser, Edwin B.
Hickox, Sid
Hilburn, Percy
Hinds, Earl R.
Howe, James
Hunt, J. Roy

Jackman, Fred
Jennings, Henry G.

Kesson, David James
Kesson, Frank
Keyes, Donald B.
Kirkpatrick, H. J.
Koenekamp, Hans F.
Kull, Eddie

Landers, Sam
Lyons, Reginald

Mammes, Raymond
Marsh, Oliver T.
Marshall, Chas.
Martinelli, Arthur
Moore, Milton

McCord, T. D.

Newhard, Robert
Nobles, Wm. W.
Nogle, George

Overbaugh, Roy

Peach, Kenneth D.
Phillips, Alex
Pilkington, Edward L.
Planck, Robert H.

Peed, Arthur
Rees, Wm. A.
Reynolds, Ben
Robinson, George

Schneiderman, George
Schoedsack, Gus
Seitz, John F.
Siegler, Allen
Smith, Arthur
Smith, Harold
Smith, John C.
Stengler, Mack
Stillman, Amos
Stout, Archie

Taylor, J. O.

Van Enger, Charles

Warren, Dwight
Wenstrom, Harold
Wimpy, Rex

Young, Frank W.

Zech, Harry

SECOND CAMERAMEN

Anderson, Don
Arling, Arthur E.

Bennett, Guy M.
Bentley, Fred
Blackstone, Clifford
Borradaile, Osmond H.
Boyce, St. Elmo
Brannigan, Tom
Breamer, Jack
Brick, Al D.
Bridenbecker, Milton
Brownell, Hobart H.

Castle, Walter H.
Charlton, Chas.
Chewning, Wallace
Clancey, James C.
Clark, Roy S.
Clemens, Geo. T.
Collings, Russell D.
Constant, Max
Cunliffe, Don C.

Drought, James B.

Evans, Frank D.

Fapp, Daniel L.
Fettera, Chas. Curtis
Finger, John
Fitzgerald, Edw P.

Gerstad, Harry W.
Gibbons, Jeff T., Jr.
Green, Kenneth

Haas, Walter E.
Haines, Bert
Hughes, Leo

Irving, Allan Edw.

Jennings, Louis E.
Joyce, Michael

Kaufman, Harry
Kesley, Jos. H.
Knott, Wm. James
Krasner, Milton R.
Kull, Jacob

Landrigan, John S.
LaProll, Robert
Laraby, Nelson W.
Lasslo, Ernest
Lawton, Chas., Jr.
Lesser, Jno. W.
Lessley, Elgin
Lindon, Lionel
Lynch, Warren E.

MacDonald, Joe
Marta, Jack A., Jr.
Martin, R. G.
Marzorati, Harold J.
Mayer, Fred Wm.
Mevland, Harry J.
Metty, Russell L.
Moran, Sam

McCormick, John

Nicklin, Allen B.

Pierce, Otto
Pittack, Robt. Wm.

Ragin, David
Rand, Wm.
Reinhold, Wm.
Reynolds, Ralph E.
Robinson, Walter C.

Scheurich, Victor
Schmitz, John J.
Schopp, Herman
Schurr, Wm. F.

Shipham, C. Bert
Silver, John
Smith, Jean C.
Smith, Wm. Cooper
Steadman, Monte G.
Stine, Harold
Storey, Thos. L.

Thompson, Wm. Stuart
Titus, Frank
Toland, Gregg
Towers, Richard A.

Unholz, Geo.

Van Dyke, Herbert C.
Vogel, Paul

Wade, Richard K.
Wagner, Robt. H.
Walters, Jos. J., Jr.
White, Ben
White, Lester
Widen, Carl
Williams, Alf. E.
Wright, Cecil Bird

STILL CAMERAMEN

Alexander, Kenneth
Autrey, Max Munn

Bartleet, Chas. Horace
Bredell, Elwood B.
Brown, Milton

Casey, James
Clark, Sherman
Clarke, Fred C.
Crowley, Earl Robert

Davol, Robt. E.

Elliott, Mack
Ellis, Jno.
Elwert, Ed.

Fraker, W. A., Jr.
Freulich, Roman A.

Grossi, Fred

Hewitt, Clarence B.
Hollister, Geo. K., Sr.
Hommel, Geo. P.
Hoporaft, Newton J.

Johnson, Roy S.

Kahle, Alex

Lacy, Madison S.
List, J. Z.
Longworth, Bert

Manatt, Samuel C.
Marion, Arthur P.

Pollock, Chas. A.
Powolny, Frank

Rosenberg, Irving

Schafer, Adolph L.
Schoenbaum, Emmet A.
Six, Bertram M.
Smith, Nealson

Ugrin, Antony A.

Van Pelt, Homer

Walling, Will R., Jr.
Woodbury, James E.

ASSISTANT CAMERAMEN

Abbott, Lenwood B.
Adams, Edw. F.
Ahern, Lloyd C.
Anderson, Harry C.
Anderson, Wesley H.
Andersen, Jack G.
Ash, Ralph W.

Ballard, Lucien K.
Barth, Willard
Beckman, Geo.
Belmont, Palmer W.
Bender, Frank
Bohny, Chas.
Bourne, Geo.
Bronner, Robt. J.
Bunny, Geo. Hy.
Burke, Chas. E.

Cable, Paul
Carney, Harold F.
Charney, Wm. B.
Clark, Robt.
Cline, Roscoe B.
Clothier, W. H.
Cohen, Max
Cohen, Sam
Collins, W. A.
Cooney, Cecil
Cornica, Martin
Cortes, Stanley
Crane, Chas.
Curtiss, Judson

DaKey, Dean C.
Daly, James S.
Darrell, Joe
Davol, Richard
Dawson, Fred
DeCazstellaine, Paul
Dickerson, Donald
Dodds, Wm.
Dowling, Thos. L.
Doyle, Michael F., Jr.

Eagan, Jackson
Eckert, John
Epstein, Jack J.

Finnerman, Perry
Flinsky, R. A.
Fort, James M.
Foxall, Wm. T.
Fredericks, Ellsworth

Gates, Harold V.
Geissler, Chas. Robt.
Glassberg, Irving
Glouner, Martin G.
Gold, Milton
Gough, Robert J.
Grand, Marcel
Grout, Jno. A.
Guthrie, Carl E.

Hackett, James C.
Hall, Maurice
Harlan, Russell
Harper, J. B.
Hayes, Ted
Heckler, Wm. G.
Heller, Max D.
Hoffman, R. A.
Hollister, Geo. K., Jr.
Hoover, Russell C.
Hower, Aron W.

Ivey, Roy H.

Kalfer, Fred E.
Kearns, Edw.
Kelley, Geo. F.
Kenny, Jack
King, James V.
King, Wm. C.
Klett, Ted W.
Klucznik, Matthew Jos.
Koffman, Jack
Kalna, Maurice

LaBarba, Ted
Lane, Arthur A.
Larson, Vernon
LaShelle, A. G. W.
LeClede, T. Martin
Liggett, Eugene
Little, Stanley E.
Lockwood, Paul A.
Love, Cecil

That All May Be Represented

(Continued from Page 76)

Mack, Robt. H.
Marble, Harry R.
Marsh, Harry
Martin, John
Martinelli, Enzo
Mautino, Bud
Meade, Bud
Meister, Carl
Metz, J. Carl
Mimura, Harry A.
Mitchell, Robt. G.
Mohn, Paul
Moore, Bernard
Moore, Philip L.
Morris, Thos. C.
Murray, James V.
Myers, Al
Meade, Kyne

McBride, James
McBurnie, John
McEdward, Nelson
McPherson, Duncan

Noble, Roy Wm.
Norton, Kay W.

Over, Chas.

Parkins, Harry
Parsons, Harry
Perreault, Oliver D.
Pierson, Arthur E.
Polak, H. B.
Rhea, Robt.
Riddell, Thos. G.
Riley, Chas. W.
Roberts, Allan T.
Russell, Jack

Santacrose, Micheal
Sargent, Don B.
Scheving, Albert
Schuck, Wm. J.
Seawright, Bryon
Shearman, Roger C.
Shepek, Jno., Jr.
Shirpser, Cliff M.
Smith, Dave
Snyder, Wm.
Southcott, Fleet
Stine, Cliff
Stranmer, E. Chas.
Strong, Rob. G.
Strong, Wm. M.
Surtees, Robt.

Thoenson, H. E.
Thomas, Jack A.
Tripp, Roy
Tutwiler, Thos. Edw.

Underwood, Harry L.
Underwood, Louis C.

Van Wermer, Jno. P.

Wade, E. P.
Wagner, Blakeley A.
Wallace, Wm.
Ward, Lloyd
Warren, Jack
Webb, Harry H.
Weiler, John
Weisbart, Teddy
White, E. L.
Whitley, Wm. F.
Williams, Shirley

Williams, Walter E.
Willis, Bert
Wise, Ray
Worsfold, Richard L.
Worth, Lothrop B.
Wright, Wilbert

INDUSTRIAL AND NEWS CAMERAMEN
Allen, Kenneth P.
Auerbach, Irving J.
Averett, Walter E.

Combs, Lloyd M.

Duhem, Raymond

Emery, Paris E.

Groat, Carlton

Heaton, Frank C.
Higueret, Hy

Ibbotson, Geo. H.

Jacobs, Frank
Jolly, Fred R.
Jones, Otto M.

Kelley, W. W.

Meginness, Clyde A.
Purdon, Roy

Roche, James V.
Rucker, Verne R.

Shaw, Harry
Skall, Wm. V.
Sullivan, Wm. F.
Vail, Frank W.

White, Fred H.

Ayers, Milton Al

Blanche, Maurice

Gabbani, Attilio
Greenwald, Sanford E.

Hooper, R. B.
Hudson, Will E.

, Johnson, Jos. Rogers

Kluver, Roy

Lowery, Frank T.
Lyng, Geo. J.

Nichol, Raleigh B.

Piper, Chas. Scott

Russell, Mervin P.

Sinkey, Chalmer David
Stolberg, Otto

Turnbull, Robt. A.

Walker, Blaine

BRYAN FOY
Supervising Director

VITAPHONE VARIETY

DEL LORD
Comedy Director

CARL McBRIDE
Director of Color Harmony

HERMAN RUBY
Author

ONE OF HOLLYWOOD'S FOUNDATION STONES

Back in the days prior to the all-encompassing era of chain stores galore, the Sam Kress Drug Company at the northwest corner of C a h u e n g a and Hollywood Boulevard was the center of H o l l y - wood's pharmacy w o r l d, and, the store was an outstanding financial success, because, primarily, f r o m the inception the o w n e r, Sam Kress, recognized that this was the film capital of all nations and that w h o s o ever did

SAM KRESS

business in the said capital must cater to the workers in its principal industry, motion pictures.

Therefore, the Kress drug store became the leader in its field. Not the least important by way of attesting to his fidelity to the cause of the cinema players and workers, he used to donate space to any and all comers in his store windows for photographic displays which might be helpful as publicity to those concerned.

This made him a host of friends. Likewise it helped him to win financial prominence and cleared the way for him to become one of Hollywood's leading bankers, for today he is an important element in the Bank of Hollywood, where, as

THANK YOU A MILLION

The officers and members of the International Photographers, Local 659, I. A. T. S. E. and M. P. M. O., and the editorial staff of **The International Photographer** take this occasion to express their heartiest and most enduring regard to all our regular advertisers for their generosity in carrying additional space in this issue of our magazine. Our new advertisers also are cordially welcomed to our columns with every assurance that their interest is appreciated and that they will be given the sincerest consideration and support. Contributors of art and written matter, both within and without our organization, are hailed with the truest sentiments of friendship and gratitude and all are assured that they will have no reason to regret their generosity and spirit of co-operation.

genial as ever and as willing to co-operate with picture people as ever, he is making a bigger-than-ever name for himself in the realm which is our industry.

Conclusively, there is a reason, for instance, why the camera boys favor Sam Kress and look to him as a loyal friend and that is, this same Sam Kress is naturally and always one of the boys in all the term implies.

There will be plenty of 'em to join in wishing him continued prosperity in his efforts to do his big bit toward building up Hollywood and its major industry, the film-making business. You'll find him at the Bank of Hollywood on Hollywood Boulevard at Vine.

AYE, TAKE IT BACK!

In this glorious pastoral scene we present to our readers the cat editor's idea of a little incident that happened the other day on Hollywood boulevard, the actors being a delegate to the I. A. T. S. E. Convention, who arrived a week ahead of the gang, and a popular motion picture star. The delegate looks like Harry Birch of Local 666, Chicago, but the editor would not think of saying such a thing.

Interested,
Personal Service
at
Hollywood's
Largest Independent
Bank

BANK OF HOLLYWOOD

Hollywood Boulevard
► at Vine Street ◄
Branch...Santa Monica Blvd. at Vine St.

 # Cream o' th' Stills

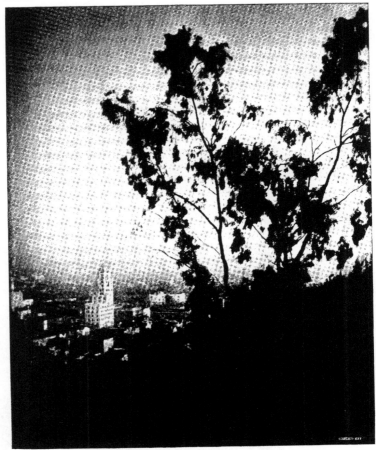

Karl Struss, that master pictorialist is known internationationally for his facility in finding the unusual angle. This vista of a section of Hollywood is a case in point. There is none other just like this shot and as usual it is done with Mr. Struss' own inimitable touch.

 # Cream o' th' Stills

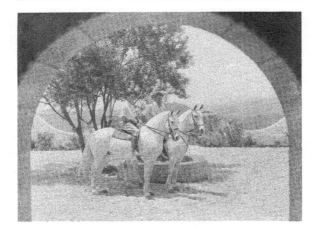

Walter Van Rossem, one of the still wizards of the world, contributed this shot of these two Arabian thoroughbreds. They are mounted by thoroughbreds, too, but in these days beautiful horses are few and men are many

The old Pacific is famous for its sunsets, especially those viewed from Santa Monica Bay. Here is a glorious one that posed for Mr. William Marshall. We leave it to the observer to supply his own color.

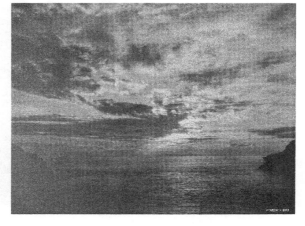

 # *Cream o' th' Stills*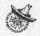

Joseph M. F. Haase is chief photographer for the United States Navy and is famous for his remarkable pictorials especially shooting from high altitudes. Here is a beautiful view of Juneau, Alaska, taken while Mr. Haase was photographing the U. S. Navy Alaska Survey.

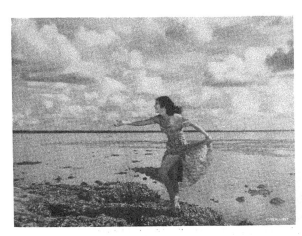

This delightful vista of sea and cloud, made more enticing by the graceful figure of Lupe Velez, is the work of Wm. A. Fraker. The locale is the coast of Florida where Henry King filmed "Hell's Harbor."

Cream o' th' Stills

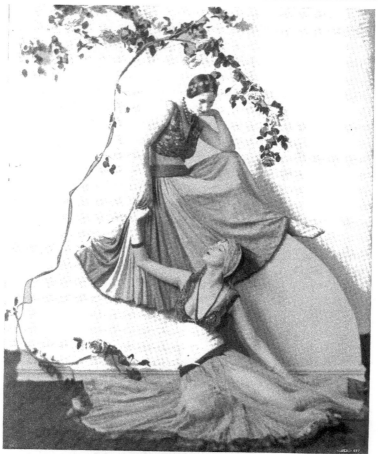

A master of composition is Harry Blanc as may be noted by this artistic and convincing photograph of these lovely dancing girls. It is in registering the human form divine that Mr. Blanc excels

 # Cream o' th' Stills

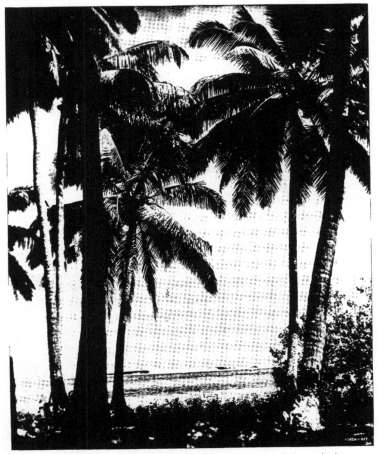

On his recent trip to the South Seas, L. Guy Wilky trained his camera on many a lovely view, but few more entrancing than this vista of strand and surf. The feathery cocoanut trees add their enchantment to the scene.

 # *Cream o' th' Stills*

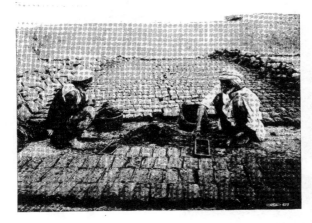

George Hollister, Sr., dean of motion picture still men, the man who used to shoot his stills at the same time he cranked his movie camera, ran across this picture on the banks of the Nile. Three old Egyptians are making bricks, but not without straw.

Rocks, trees and shadows on this mountain slope form the element of a charming picture which Francis J. Burgess brought home with him from the upper reaches of the Sacramento.

Cream o' th' Stills

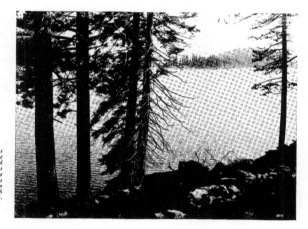

John J. Schmidt loves
to prowl around the
"haunts of coot and
hern" and the waters
of lonely lakes in the
high solitudes. This
restful scene is from
a location in the high
Sierras.

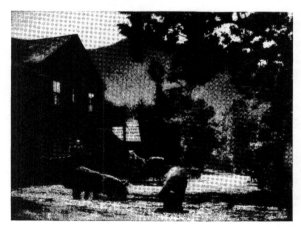

Frank Tanner spread
his net for this
delightful shot of rural
small town life and
it's not a movie set
either, perfect as it
may be. Mr. Tanner
loves the homely
subjects and his
collection is great.

 # Cream o' th' Stills

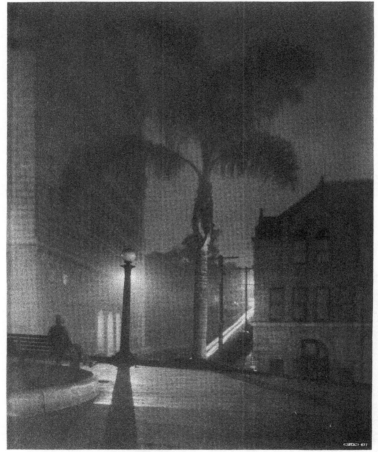

J. Z. List could make a picture out of chips and whetstones. Here is one of the most unattractive spots in Los Angeles made exquisitely interesting by his genius for selection and composition. Note how the queue of auto lights fit into the scheme.

A Small Plant With a Big Service

The owners of the Associated Film Enterprises, Ltd., are proving that there is room in the film industry for a small laboratory capable of doing work equal to the largest; for the smaller producer as well as anyone else. Blaine Walker and Leonard Poole, two of the owners of this concern, are members of Local 659. Mr. Walker, however, is not active in the business, acting merely in an advisory capacity, as his time is taken up at the Fox studios. M. J. McDermott, the third principal owner is active with Mr. Poole.

Both Mr. Walker and Mr. Poole are old-timers in the film business, the former having started back in 1913 with the Gaumont Company, while the latter got under way as a newsreel cameraman in 1923 with Pathe News, he having literally grown up with the sound-on-film industry.

When the Associated Film Enterprises, Ltd., was organized the sole purpose was to provide a small, economically managed laboratory as a sort of a boon to the smaller producer and it has succeeded admirably in that purpose. Only the finest equipment was installed and only the finest of work is done. Frank Biggy, well-known throughout the industry, is foreman of the plant, which is a guarantee within itself.

This laboratory specializes in sound track negative and print, handling a variable density not previously undertaken by the smaller laboratories. No attempt whatever is made to compete with the larger laboratories. Instead this one sticks to its field of giving service equal to the best to the smaller producer who so often has suffered from a lack of attention in plants which are overrushed.

---o---

AGUA CALIENTE

For the information of those of our readers who have never had the good fortune to visit Agua Caliente, Old Mexico, it may be stated that Mr. Paul Perry's unusually beautiful front cover on The International Photographer's May issue, was a shot of the main entrance and garden of the hotel at the famous Mexican resort.

Agua Caliente will be one of the show places to be visited by the delegates to the I. A. T. S. E. and M. P. M. O. Convention and their families and friends.

A Cinema World Wonder

(The Technicolor Camera Department)

————BY————

THE EDITOR

The miracle that is Technicolor did not spring into being in a day.

It requires time to build for permanence, particularly along the line of things scientific and technical and, when it is considered that Technicolor is really only about five years old, its achievements as evidenced by the greatest screen successes of today, are miracles indeed.

The camera department of Technicolor is a model of intelligent organization and, therefore, of amazing efficiency, largely due to the genius of Mr. Edward T. Estabrook, organizer and manager.

Mr. Estabrook grew up with Technicolor and knows it in all its moods and tenses. He was one of the three members of the original camera staff and he not only understands the operation of the Technicolor camera, but could build one if called upon. The other two cameramen were Ray Rennahan and "Duke" Greene, while the assistants were Musgrave, Davis and Kruse.

Being a practical operator, therefore, as well as a technical engineer, he knows cameramen, their needs, their idiosyncrasies, their ideals, and their problems and these are some of the reasons why Mr. Estabrook is the head and heart of the Technicolor camera department.

From his unpretentious office in the camera department of the Technicolor Company, Mr. Estabrook runs the amazing photographic machinery of this great organization. He directs his department like a captain on the bridge of a battle ship and so efficiently does the machine function that he can move ten tons of equipment and fifty men in less than ten minutes.

Ask him at any time just where any cameraman or any camera is located and without an instant's delay he will tell you. Also, at every minute of every day he can tell just exactly the mechanical condition of every camera, just how it is functioning and what will likely be the state of efficiency tomorrow. This is done by means of a series of unique charts originated by Mr. Estabrook.

In this camera department everything is done except the actual machine construction of the Technicolor camera. They are all designed and built on paper in this camera department but the heavy mechanical work is done in the shops of the Mitchell Camera Corporation. But once delivered to and accepted by Technicolor all future repair work, readjustment and improvement is done in the machine and optical shops of the Technicolor plant.

There is no taking things for granted in Mr. Estabrook's camera department. Perfection is the ideal there and when the reader is told that 10,000 to 15,000 feet of film is used every twenty-four hours in making tests of the cameras alone

he will begin to grasp the magnitude and SPIRIT of the thing that is Technicolor.

Previous to his connection with Technicolor Mr. Estabrook had been for several years in the photographic business, having started in 1907. During that time he has been a press photographer in New York. In 1912, he, together with a Mr. Hughes, organized the firm of Hughes & Estabrook and until 1920 they operated one of the largest commercial photographic studios in New York. After coming to Hollywood, in 1921, Mr. Estabrook entered the movie field. Later he became affiliated with Technicolor and has been with them ever since, steadily advancing. Mr. Estabrook was Technicolor's first cameraman on the first all-talking all-Technicolor picture "On With the Show," which started the tide of production toward color with sound.

Mr. Estabrook's genius is not all in organization and administration. It is his philosophy of life that men can work best when they are happiest and fairplay is, therefore, the slogan of his department. He keeps the Golden Rule dusted off and in continual use and the consequence is that his men swear by him. The answer is results with a big "R" and a happy family of cameramen who keep the gonfalon of Technicolor in the front rank of motion photography.

At this writing Mr. Estabrook has over one hundred men employed in his particular department, easily the largest in the world.

The expansion of Technicolor since the advent of sound pictures has been tremendous.

In 1925 one building in Boston was enough to house the activities of the corporation, whereas, today there are three buildings in Hollywood alone, Nos. 1006 Cole avenue, 1016 Cole avenue, and 823 Seward avenue, now devoted to Technicolor, and the camera department has expanded so rapidly that, within the ten months just passed, it has so far outgrown its quarters, No. 823 Seward, that a new building designed exclusively to accommodate its needs will be erected at once.

And, speaking of expansion, Technicolor already has a large plant in Boston, its home and birth place, where all domestic release prints are made and another big plant is now in process of construction in London to take care of all foreign release prints.

In the new laboratory on Cole avenue, Hollywood, Technicolor has created an immense plant for processing film. Here is the last word in laboratory practice and equipment and, when it is stated that there are over six hundred men on the payroll of this laboratory alone the magnitude of this great photographic color concern will begin to be understood.

The entire personnel of Technicolor aggregates seven hundred and as the use of color in production rapidly increases, as it will, Technicolor will continue to expand by leaps and bounds.

The genesis of Technicolor may be found in a camera designed and built by Mr. J. A. Ball, present head of the corporation's research laboratories. This was at Boston in 1916. Mr. Ball, a graduate of Massachusetts Institute of Technology,

(Concluded on Page 86)

1. Camera Assembly Room. It is in this room where the camera equipment is assembled each day by the Technicolor cameramen preparatory to going on the job. Each cameraman and assistant has an individual section in each of these assembly benches where he keeps his auxiliary equipment. Through this method the Technicolor cameramen are able to assemble the equipment for nine units, each unit consisting of four cameras and its necessary equipment and weighing approximately two thousand pounds. It is so arranged that nine of these units can assemble and load the equipment into camera cars, which are parked immediately outside of this room, simultaneously aand be on their way within a space of fifteen minutes.

This view is looking toward one of the fireproof vaults, where the Technicolor cameras are stored when not in use.

Wide passageways are left throughout this room so that seventy-five or eighty cameramen can move this equipment with the least amount of confusion.

2. One of the Camera Testing Rooms. It is in this room where all Technicolor cameras are tested under actual shooting conditions and where many thousands of feet of film are run through the cameras to thoroughly test them against any damages to production.

3. A corner of the Focus Setting Room. Mr. Fred Grant, Jr., is shown here setting the focus of a Technicolor lense with the aid of 100 time magnifier to within 1/1000 of an inch.

4. Edward T. Estabrook, manager of of the Technicolor Camera Department. It is under his supervision that all Technicolor cameras are made and operated, and it is in his department that the largest number of motion picture cameramen are employed of any company in the motion picture industry.

5. Another view of the Camera Department Repair Shop. Because of the necessity of exact precision machine work the Technicolor Company maintains its own shops to insure the producers of the very finest equipment.

9. Executive Offices of Technicolor Motion Picture Corporation, 1, Hollywood Division. This is plant number 5. Plants numbers 1 and 2 are located in Boston, while plants numbers 3, 4 and 5 are all in Hollywood.

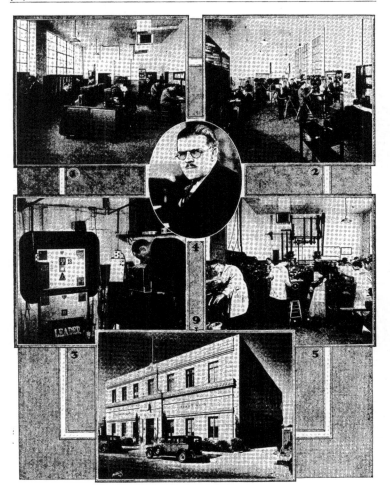

A Cinema World Wonder

(Continued from Page 84)

had been for sometime researching in the realm of color and his work attracted the attention of the research engineering firm of Kalmus, Comstock and Westcott. Progress was made until America entered the war and during that period Technicolor lay dormant. It was not until "The Ten Commandments" was filmed that the promoters received any great encouragement, although the first real Technicolor picture had been filmed in Florida previous to 1920.

"The Toll of the Sea," with Anna May Wong, filmed in 1922, was the first picture of feature length filmed by this organization, but the picture-going public and the press did not seem to be impressed until the Technicolor shots appeared in "The Ten Commandments."

Impressed with the enthusiastic reception of the fans and the general applause of the press, Paramount was induced to try for a 100 per cent Technicolor picture and the result was "The Wanderer of the Wasteland," featuring Billie Dove and Jack Holt. This was in 1924.

The success of this feature encouraged Douglas Fairbanks to go into color and he produced "The Black Pirate."

Technicolor was now definitely on the way and its growth and expansion constitue one of the magical stories of the motion picture industry. Since that time the achievements of Technicolor have become a part of the interesting history of the cinema.

The most recent releases in Technicolor speak for themselves and, when you remember that Technicolor is only an infant, the glory of its future achievements may be imagined.

The administrative and technical personnel of Technicolor includes names of international reputation, its success alone

proclaiming their superior excellence.

To Dr. Herbert T. Kalmus, president, goes the lion's share of credit for the development of the Technicolor process. Through his foresight and leadership he has brought together a group of scientists, engineers and financiers who have developed this modern color process to its present degree of perfection.

Mr. Andrew Callaghan, genial business manager of Technicolor, is one of the pioneers of the motion picture industry, having started with the old Essanay Company in Chicago many years ago. It is through his efforts that the business of Technicolor has grown to its present astonishing proportions.

Mr. Geo. A. Cave, plant superintendent, has worked his way up through every department of Technicolor to his present responsible position where he is utilizing his great capabilities to produce the very highest quality of release prints.

Mr. J. A. Ball, director of the research department, as hereinbefore stated, is the designer of the original Technicolor camera and the inventor of great improvements. in the Technicolor process. He is a recognized authority on motion picture engineering.

Mr. J. Henry Prautsch served his apprenticeship in the finest machine and optical works of Germany. He was later foreman of the Akeley Camera Company, where he helped design the first Akeley models. He has been with Technicolor six years and during that time has demonstrated that there is no finer machinist connected with the building and repairing of motion picture cameras in this country. It is through his intelligent co-operation that recognition by the entire industry of the high quality of Technicilor camera equipment has been brought about.

6. View of Camera Assembly Room, looking toward the Machine Shop and Camera Repair Department.

7. One corner of the Camera Department Machine Shop. It is here that the Technicolor cameras are overhauled and auxiliary equipment made. This department is under the direction of Mr. Henry J. Prautsch, who had considerable to do with the development of the Akeley camera and he is considered one of the very best tool and instrument makers as pertaining to any motion picture equipment that there is in the business.

8. In this picture are two Technicolor trained camera experts who make' the final adjustments on the Technicoror cameras. Mr. Fried Baker on the left and Mr. Curtis Cady on the right. This work is of extreme importance because it is upon these men that the responsibility of the operation of the cameras in the field or studios is placed.

10. Plant No. 4 is the newest addition of Technicolor to its Pacific Coast resources. This new laboratory located at 1016 North Cole Avenue, in Hollywood, is a three-story and basement structure. It is built and equipped throughout with the most modern approved fireproof construction and safety apparatus. Its addition to the plant facilities of Technicolor brings the capacity in Hollywood to approximately three millions of feet of film and prints a month. Though erected in record time in an effort to keep pace with the tremendous demand for Technicolor, this laboratory was carefully planned and laid out by Technicolor staff engineers whose long experience with the film has thoroughly familiarized them with plant and equipment demands of the various phases of processing involved in making Technicolor product. Operation of this plant in the heart of the film industry is a vital factor in the service which Technicolor is giving the major studios utilizing this product.

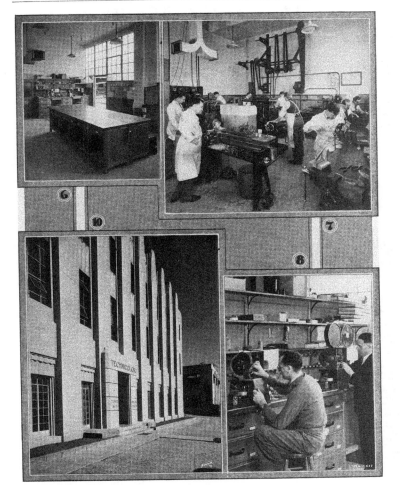

Two Men of Tek-Nik Towne

—BY—
BOYD

The threads of men's lives cross and in many cases run parallel to the fulfillment of their ambitions, as illustrated in the case of Pete Mole and Elmer Richardson, the men who gave the motion picture industry incandescent lighting equipment, popularly called Inkies.

Elmer Richardson was born in Minneapolis, Minn. Pete Mole was born in far away sunny Italy, but traveled to this country with his parents at the tender age of six years. It may or may not be a co-incidence that one escaped the wheat

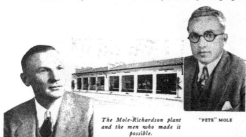

*The Mole-Richardson plant "PETE" MOLE
and the men who made it
possible.*

"ELMER" RICHARDSON

or lumber business in northern United States—that the other failed to become, in New York City, a purveyor of delectable foods, for which his countrymen are famous. Both however were technically inclined, which accounts for their present occupations.

The boyhood of Pete Mole was plentifully studded with hardships, as was the life of the average youngster, brought from his native land to the great, ruthless city of New York. He responded to the prod of necessity, at the age of twelve, becoming a plumber's helper at fifty cents a day.

As the years marched by his working experience was varied by such occupations as Western Union messenger service, grocery delivery work and other odd jobs. During this time he never gave up the job of gaining an education. It failed to occur to him, until he was twenty years of age, that he was working in circles, drifting aimlessly. This fact was brought to his attention in rather a subtle, round-about way. It seems that his many friends at this particular time all held rather splendid positions, paying proportional salaries. Furthermore their working day was extremely short compared to his. They dressed to the minute in fashions, they entertained occasionally; they took weekend trips, did the theaters. Briefly they

enjoyed more pleasures with far greater frequency than their pal, Pete Mole, who worked many hours a day at some "job" for a meager pittance. Pondering over this state of affairs it became clearly apparent to him that at his present work and rate he would probably end nowhere.

Action followed immediately. He soon qualified himself to enter Bryant & Stratton College at Buffalo, New York. At this institution he completed a preparatory course in electrical engineering. This was directly followed by a designing and electrical engineering post-g r a d u a t e course in the Union College at Schenectady New York.

Upon completion of his academic work in 1914, he became associated with the engineering division of General Electric Corporation, as a draftsman. There was now a goal to be achieved, a career to be fashioned.

With the General Electric Corporation, Mr. Mole began intensive work on the study and development of lighting equipment. His work at this time was on the high intensity arc, which was being designed and perfected exclusively for the United States Army and Navy. During the four years from 1914 to 1918 his work was confined solely to research and design on government assignments.

The latter part of 1918 a new interest came into his life. General Electric Corporation made the first sale of high intensity arcs to a motion picture studio for set lighting purposes. A great, new field was opened for this particular type of lighting equipment. Mr. Mole was detailed to work of designing and perfecting high intensity projection lights embodying the necessary requirements for motion picture work. Here was a strange, indefinable lure; something new—lighting equipment made for an unusual use. He thought deeply about this. He sensed that something big, stupendous was to be evolved. It is not surprising that the industry touched him on the shoulder, beckoned, led him across the United States to the realm of cinema.

His first work in California was with the old Goldwyn studios at Culver City where he was employed as an electrician. During these past years the thread of Elmer Richardson's life had been unraveling. From Minnesota he came to Los Angeles, where he attended Occidental College, majoring in electrical engineering. After his graduation Mr. Richardson taught Manual Training classes in the elementary city schools of Los Angeles. Later he became associated with the Chamberlin Reynolds Electrica Company in Hollywood, which name was later changed. Mr. Richardson became a partner of this firm.

Eventually there entered a period of dissension which caused Mr. Richardson to leave his company and return to the field of teaching. This was not for long however, and in 1926 he again joined the same firm in capacity of shop superintendent.

In the meantime Mr. Mole had executed seven months of his new career in motion picture studio work as an electrician's helper. It is characteristic of Mr. Mole that he told no one at the Goldwyn studio of his intensive experience in the actual designing of the lighting equipment being used on the sets at that time. On several occasions he derived much amusement from various individuals who would stare surprisingly at him when at times he would let slip some technicalities regarding the lights. His status as an electrical engineer was eventually discovered and he was shortly afterward offered a position, as general manager, with a Hollywood electrical firm. He accepted this position in 1923; when the threads crossed and he met Elmer Richardson for the first time. Mr. Richardson was the shop superintendent of this company.

In the following three years Mr. Mole and Mr. Richardson worked hand in hand at their respective positions during which time a deep admiration and respect for the abilities of the other grew within these two men.

In 1927 they conceived the idea of their own business. The idea took reality in a work shop at the back of a garage located at 6310 Santa Monica Boulevard. At the outset their business consisted purely of renting lighting equipment to studios.

Just at this time panchromatic materials were developed, and the talkie film had appeared on the horizon of the motion picture industry. A new type of lighting was badly needed. Mole Richardson, Inc., foreseeing the need, had been conducting exhaustive tests and researches. They came forth with the first practical incandescent lighting equipment, which they called Inkies.

The business of Mole-Richardson began to prosper—a dream was being realized. The intangible was becoming tangible. November 1, 1928, the pretentious new home of Mole-Richardson,

(Concluded on Page 120)

A Life-Long Furrier

Louis Loober, whose headquarters are in room 607, at 635 South Hill Street, has won international attention for himself by suggesting that Russian sable be introduced in Alaska. Mr. Loober, who is a life-long furrier, evinces a keen interest in the farming of fur-bearing animals and has spent many years in Russia, where, for generations, his family has been engaged in the fur business.

This well-known expert maintains a fine factory at his Los Angeles address and is widely patronized by motion picture people. He purposely occupies comparatively low-priced quarters off the downtown expensive ground floor in order to offer his goods at lower prices. In fact, those who trade with him are buying direct from the manufacturer and saving the extra charges of middlemen.

Since Mr. Loober has visited practically every country in the world, looking into the fur situation, his advice on all subjects pertaining to this line of goods may be considered the proverbial "last word."

During the months of June and July he conducts special sales at which he offers many bargains in furs. Inevitably as a part of his business he maintains a department for repairing, cleaning and remodeling furs as well as storing them.

Incidentally, it is interesting to note that in consequence of his suggestion relative to the introduction of sable in Alaska the initial experiments in it have been highly successful and he is given credit for pointing out the way to avert a virtual disappearance from the market of sables, which are becoming alarmingly scarce in Russia.

1890

I N 1890, when this picture of Kodak Park was made, the whole idea of pictures in motion was probably as far from being practical as television, for instance, is today. Less than a year previously, Edison had obtained from Eastman the strip of film that opened the way to the success of his movie experiments. Less than half a year before that, there had been no photographic medium but glass plates and paper, and transparent, flexible film was just on the eve of being produced. George Eastman had been working for ten years to make photography simpler and more general, but even yet it was crude.

This first Eastman factory in the country outside the small city of Rochester, New York, represented an ambitious expansion of a business that had hitherto done all its manufacturing in a modest building near the center of the town. Nobody conceived of this new factory out on a farm as a future source of most of the raw material for a great industry, for the movies were yet untalked of outside the laboratory.

1930

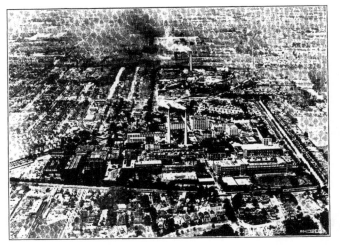

ADJOINING farms were bought . . . Kodak Park now occupies 400 acres, with the homes of the city that has engulfed it stretching away from it in all directions. The original little group of buildings has grown to 74 in number, the aggregate product of which is 200,000 miles of film a year for the motion picture industry, in addition to an amazing range of photographic supplies and chemicals.

It takes 8000 employees to operate this plant. To turn out a week's supply of film they use more than three tons of silver, more than 100,-000 pounds of cotton, more than enough water to supply a city of 150,000 population, methanol from the waste wood of 40,000 acres of forest, and a variety of chemicals from many parts of the world.

Broad surrounding lawns protect the important film-making processes in the vast plant from highway dust, chimneys 366 feet tall carry away the factory's own smoke and fumes, and five miles of paved streets within Kodak Park are constantly sprinkled to keep down possible dust within the plant.

Cutting "Hell's Angels"

—BY—
FRANK LAWRENCE

Hollywood's most colossal film enterprise, "Hell's Angels," will soon culminate in a brilliant world premiere at Grauman's Chinese theater.

No picture, undoubtedly, has been more widely publicized and more generally discussed in advance of its premiere showing than this gigantic air spectacle.

Produced and directed by Howard Hughes at a cost of more than $4,000,-000 and requiring three years to film, it has created more comment among fans and members of the film trade than any previous production.

Now that this epochal picture is about to be witnessed by the public, there is endless comment throughout both fandom

Frank Lawrence, editor of "Hell's Angels," in his cutting room.

and filmdom as to whether or not the enormous outlay of time and money is justified by the results. Is the completed picture all that has been striven for, and does it confirm the advance predictions of those associated with its making?

The writer, having devoted the past three years to cutting and editing this picture, is in a position to state, with authority, that "Hell's Angels," in its final entirety, will more than justify the pre-release claims of its most ardent boosters.

It is safe to state that this film will not only establish a new mark in motion picture artistry, but in addition will hang up new box-office records in all parts of the world. As a film editor, I have been a student of audience reaction for more than thirty years. And while "Hell's Angels" is a film of a distinctly novel

character, and something more daring than any producer has heretofore attempted, I predict that it will make an extraordinary appeal to audiences and critics alike, and incidentally provoke more favorable comment than any picture that has come out of Hollywood in the past.

It would be unfair to both the producer and the public to reveal at this time the nature of the unusual story which forms the basis of this pretentious picture. Suffice to say, it is one of the most original and realistic dramas ever screened, and a distinct credit to Howard Hughes' courage to invest millions in a film creation so devoid of the traditional Hollywood "hokum" which is regarded among the old-time movie-makers as sure-fire material for the box offices.

The finest of motion-picture photography has gone into the making of "Hell's Angels." The aerial sequences, filmed by Harry Perry, the late Burton Steene, Elmer Dyer, Harry Zech, and a staff of some twenty other cinematographers, in my opinion, will never again be duplicated. "Hell's Angels" will stand as a monument to the abilities and daring of these men who spent hundreds of hours in the air photographing difficult and dangerous air scenes. The dramatic sequences, filmed by Tony Gaudio and staff, are magnificent also, and will be permanent records of cinematographic artistry as applied to the talking screen.

As many as forty airplanes, engaging in a free-for-all "dog-fight," are shown in simply gorgeous panoramas in the aviation section of "Hell's Angels." The public will probably never realize the skill and daring required by pilots and cameramen to photograph these scenes.

More than 3,000,000 feet of negative were ground through "Hell's Angels" cameras during the three years of production. This has been cut and edited to 10,000 feet, and what is most amazing, not a single important sequence has been clipped from the finished film.

"Hell's Angels," in addition to establishing a new mark in cinematic achievement, will be an everlasting tribute to the fighting flyers of the world war—a permanent historical document — made overwhelmingly real by the compartively new medium of the sound and talking screen.

It is a tribute also to the genius and courage of Howard Hughes who has devoted more than three years of his youth to the creation of a "dream picture"—a film which will not only upset moviemaking traditions, but will be popular entertainment wherever motion pictures are shown and with theatergoers of all ages and classes.

The right arm of Business Representative Howard Hurd, of Local 659. She knows the middle names of eight hundred cameramen and, moreover, she can tell at any given time just who hasn't paid his dues.

PARICHY RETURNS

Esselle Parichy, 659, has returned to Hollywood after a six months' sojourn in Europe and Egypt.

During his absence abroad he shot film in Paris, Madrid, Granada, the Seville and Barcelona Expositions, Nice, Cannes, Marseilles, Monte Carlo, Alexandria, Cairo, Luxor and other interesting points in Egypt including a visit to the tomb of King Tut-Ankh-Amen.

Mr. Parichy secured several thousand feet of unusual shots, among the subjects being camel racing and snake stuff in Egypt and Gypsy life in the caves of Spain.

While in Egypt our brother suffered an almost fatal illness and was forced to curtail his visit. He returned home and spent several weeks at Miami, Florida, where he was restored to health.

Mrs. Parichy accompanied him on the trip. They are making their home in Long Beach where Mr. Parichy formerly owned the Long Beach News Service.

—o—

OUR COVER FOR JUNE

Mr. Fred Archer, that consummate artist whose name is known as well in Europe as in America, whose eagerness to serve is one of his chief characteristics and whose popularity among his brothers of The International Photographers is ever on the increase, is the author of our cover page for June. Mr. Archer did not wait to be asked to contribute of his art to our special edition, but went to work and produced this masterpiece out of the kindness of his heart and his deep sense of loyalty to the cause of the I. A. T. S. E. and M. P. M. O.

Mr. Archer will be seen often in future issues of The International Photographer. Thank you Fred.

When the Movies Toddled

ACK in the days when "The Cowboy's Vacation" was the screen sensation of the day—that was in the year of 1909—an actor who aspired to high honors in western drama had to be able to ride anything from an alligator to an ostrich and from a bucking broncho to the hood of a super-bucking Ford. Roy Purdon, present owner of the Ince Film Library can testify to this, because that is precisely what he did when he made his debut in motion pictures as a Thespian, in that very year, at the studios of the old Bison Company, which occupied the site of the now old Sennett studios in Edendale.

Moreover, the exponents of the silent dramatic art then had to "double" like they never have since or ever will again. For instance, oftentimes the boys saw themselves chasing themselves up over hills and down through valley. First they would don the make-up and regalia of wild Indians, doing a scene of riding like fury over a hill. When this was gotten "in the box" successfully the director would shout: "Cut!"

Thereupon there would be a lull in cinematic endeavors while the same bunch of fellows got rid of their redskin outfits and got into either the clothes of cowboys or the uniforms of soldiers. When thus attired they would mount the same bunch of horses and make a wild ride across the same hill after themselves. These two "shots" would be assembled in continuity and the patrons of ye merry olden nickelodeon would yelp with glee over the bravery of the boys who gave chase to themselves with such reckless abandon.

Back in those days Hoot Gibson and Art Acord were among the members of the Bison Stock Company. E. H. Allen, now manager of Educational Pictures also was "under contract."

Mr. Purdon also recalls that in 1910, David W. Griffith directed the first of all two-reel pictures. It was entitled "Two Brothers" and most of the scenes were photographed at San Juan Capistrano. The cast was particularly interesting inasmuch as Mary Pickford played a child role while Florence Lawrence enacted the feminine lead opposite good old Arthur Johnson, long since dead. Henry B. Walthall handled the juvenile role while Mack Sennett and Robert Emmett served as "extras."

"They had an awful time in those days getting by the ever alert officers of the law who clung to the idea that folks who made moving pictures were no good for anything excepting to be chased away from whatever spot they elected to train their cameras," observes Mr. Purdon. "Consequently, our life then was just one official chase after another. Personally I missed the clutches of more than one earnest constable by the proverbial hair's breadth and heaven alone knows what the punishment would have been in case of capture."

Incidentally, Roy Purdon has one record of which he may well feel proud—a record it is doubtful his has an equal in the entire annals of the film industry. From June 23, 1909, when he joined the staff of the late Thomas H. Ince, up to the day he left the organization a year ago last September, he did not miss one single week's salary. This means that for practically twenty years he was on one job which never failed him financially for one minute of that long period of time. Still standing as monuments to his efforts of these two decades are the wardrobe buildings, both on the present Pathe and M-G-M lots, which he designed.

"Yes, those were mighty interesting days when the picture business really was in its infancy, but as interesting as they were, these days are far more so, because now we are witnessing the performance of photographic marvels synchronized with sound miracles such as would have startled us out of our wits if they had been sprung on us suddenly without warning those twenty years ago," concluded the affable head of the Ince library.

The—House—That—'Slim'—Built

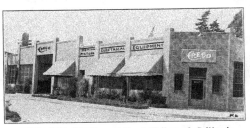

"*Howdy boys, yes, sir, this is 'Slim' Roe's 'CRECO' Home.*

"*The front door is always open to you. Come on over and let's talk.*"

"*How does 'she' look to you?*

Twenty - five thousand square feet of floor space devoted to manufacturing and service."

CRECO, INC., 1027 Seward Street, Hollywood, California

"Besides all this I have 10,000 square feet of storage . . . for finished products . . . at our Cole Avenue warehouse . . . chock-a-block" . . . and Old John "Buck" Neff, late of Topeka Local 206, now of Local 37, in charge of rentals and stock, is using about 15,000 square feet of roof to hang equipment from . . . a total of about 50,000 square feet . . . and with all this footage you might say "our quarters are inadequate." We must grow bigger. Boys, we're loaded for "b'ar" and sure getting something done.

Thanks to our old friends . . . and those not so friendly . . . but who do appreciate the best equipment . . . plus 100 per cent service. We are sure a busy "Jay-Hawker" a long way from Local 190 . . . but we always find time to welcome our friends and visitors—so come out and see us and bring the folks.

Old Wichita turned me loose and Young Hollywood wrapped me right up in her arms and won't let me get away . . . and am I happy? "SLIM" ROE.

P. S.—Slim Roe and CRECO are synonymous. Call Gladstone 4181 - 4182. P. S.—Again . . . phone your reservations. Thanx.

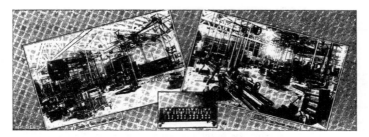

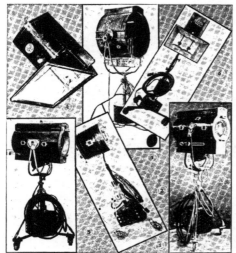

The "CRECO" equipment displayed in the inllustrations on these two pages is: Top left page—"Creco" Mach-
ine Shops and Four Unit Remote Control Board, with raised cover. Center—No. 1, "Baby Spot," No. 2, the
new 80 Amp. Rotary; No. 3, 100 Amp. Rotary; No. 4, CRECO "Scoop"; No. 5, 36-inch Sun-Arc; No. 6, "Side
Arc." Bottom, left—400 Amp. Power Plant Truck; center, Six Hole Plug Box; right, 300 K. W. "M. G." Set,
Power Plant.

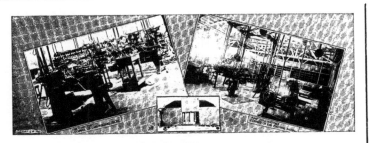

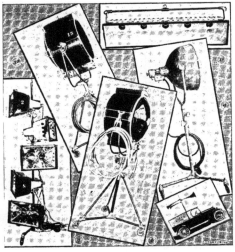

Top of this page—More illustrtaions of the interior of CRECO machine shops and Remote Control Board. Center—No. 7, two views of 24-inch Incandescent Spot; No. 8, Address System Equipment; No. 9, 18-inch Rifle Spot; No. 10, Incandescent "Broads"; No. 11, Overhead Strip. Bottom, left—1200 Amp. "Liberty" Motor Gas Generator Set; center, Two Hole Extension Plugging Box and Plug; right, 360 H.P. "Liberty" Wind Machine.

"One and One Half Seconds' Work"

(Photographing An Eclipse)

——BY——

J. M. F. HAASE, *Chief Photographer U. S. N.; Member Local 659*

This communication is from the pen of our distinguished fellow cameraman and Brother member of Local 659, J. M. F. Haase, no less a person than official photographer of the United States Navy and located at San Diego. Brother Haase was in charge of the photography for the Naval Observatory on its expedition to observe the total eclipse of the sun on the 28th of April, last. His first hand description of the photographic program will be found intensely interesting to both cameramen and our general readers.—Editor's Note.

Silas Edgar Snyder,
Editor-in-Chief,
The International Photographer.

Dear Editor—Well, the "Shadow Chasers" are back and it's all over but the shouting and just how loud a peep we will give vent to rests on the value of the film we shot to authorities who deal in Moons, Suns and Stars. Having run the stuff out and seeing that we got the customary number of frames all carrying their little message that "it's recorded" and, somewhere a shadow making some 30 miles a second across it, makes us feel like a little unofficial peep anyway. To not repeat, not have the camera freeze, lenses fog, or pass out for want of oxygen, to see all the frames with a suitable exposure considering the light—well, guess that rates a "peep."

Our two planes, one a Vought Corsair and the other a ten-passenger Sikorski with their personnel and cameras and baggage took off from San Diego at 9:15 Friday morning, April 25, 1930, passed over Hollywood about 10 a. m. and put down in Bakersfield for lunch at 11:30. Took off for Oakland at 12:30 and cut corners getting into Oakland about 3 p. m. Schedule called for continuing on to Reno the next day so we had the rest of the day to roam around.

Saturday morning's weather reports from Oakland to Reno were far from encouraging, for a storm had blown down from the north and the air lanes to Reno were below par. Weather between Oakland and Sacramento was favorable enough to make that trip possible and then if a chance in the weather breaking presented itself we could make the best of it. This we did, arriving at Sacramento about noon. Weather reports still continued to come in as being bad though a break in the storm was to the south of the regular course.

Leaving Sacramento about two we headed for Placerville and ran into said storm plenty hard. Snow, sleet and rain met us and when we couldn't discern the difference between a cloud and a snow clad mountain side, Lieutenant Geheres,
(Continued on Page 98)

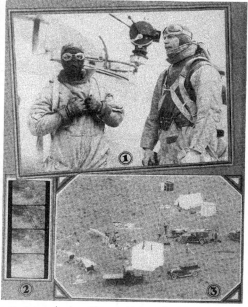

1—*Myself (in disguise) and Lieutenant L. E. Geheres on landing after having recorded the passing of the Shadow Path. Dressed as we are we stand better than 250 lbs. on the hoof and when at 18,000 feet altitude could have used a few more furlines quite comfortably.* 2—*Four frames made at 11.05 with the 17-inch lens from the ground through a special ruby filter that reduced the halation to a minimum. This camera was located in the path of the calculated path and was therefore a mile out of position to get the corona, although they did succeed in getting a perfect circle of Bailey Beads as they are called, namely balls of fire that shoot out from behind the moon. These four frames were made at 11:05 A. M. or 51 seconds before the totality and the calculated and true paths are approximately plotted thereon. The altitude from which the exposures were made was 17,900 feet and, considering that, at that time, 51 seconds before totality, the light was quite weak the ground below shows up quite plainly. The rest of the negative shows the gradual loss of light and weakening exposure, then picking up again to the quality as of a minute before the totality. In the passing minute from 11:05 the wind drifted us down over and into the true path so that we were in the absolute totality.* 3—*Camp of the Mt. Wilson Observatory, located at Honey Lake, Nevada. Note the two Sound Cars of the Fox and Hearst outfits. The gentleman at the rear of the Fox truck is none other than Brother Kluver.*

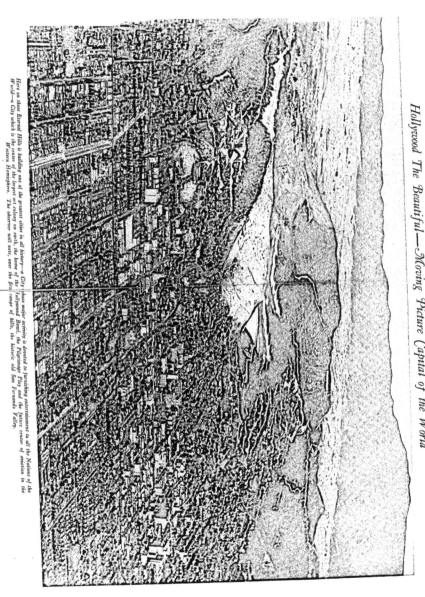

Hollywood The Beautiful—Moving Picture Capital of the World

Here on these Eternal Hills is building one of the greatest cities in all history—a City whose major activity is devoted to furnishing entertainment to all the Nations of the World—a City which is the center of the largest art colony on earth, the home of the Hollywood Bowl, the Pilgrimage Play and the future center of emotion in the Western Hemisphere. The observer will note, over the first range of hills, the historic old San Fernando Valley.

"One and One Half Seconds' Work"

(Photographing An Eclipse)

—BY—

J. M. F. HAASE, *Chief Photographer U. S. N.; Member Local 659*

This communication is from the pen of our distinguished fellow cameraman and Brother member of Local 659, J. M. F. Haase, no less a person than official photographer of the United States Navy and located at San Diego. Brother Haase was in charge of the photography for the Naval Observatory on its expedition to observe the total eclipse of the sun on the 28th of April, last. His first hand description of the photographic program will be found intensely interesting to both cameramen and our general readers.—Editor's Note.

Silas Edgar Snyder,
Editor-in-Chief,
The International Photographer.

Dear Editor—Well, the "Shadow Chasers" are back and it's all over but the shouting and just how loud a peep we will give vent to rests on the value of the film we shot to authorities who deal in Moons, Suns and Stars. Having run the stuff out and seeing that we got the customary number of frames all carrying their little message that "it's recorded" and, somewhere about a shadow making some 30 miles a second across it, makes us feel like a little unofficial peep anyway. To not repeat, not have the camera freeze, lenses fog, or pass out for want of oxygen, to see all the frames with a suitable exposure considering the light—well, guess that rates a "peep."

Our two planes, one a Vought Corsair and the other a ten-passenger Sikorski with their personnel and cameras and baggage took off from San Diego at 9:15 Friday morning, April 25, 1930, passed over Hollywood about 10 a. m. and put down in Bakersfield for lunch at 11:30. Took off for Oakland at 12:30 and cut corners getting into Oakland about 3 p. m. Schedule called for continuing on to Reno the next day so we had the rest of the day to roam around.

Saturday morning's weather reports from Oakland to Reno were far from encouraging, for a storm had blown down from the north and the air lanes to Reno were below par. Weather between Oakland and Sacramento was favorable enough to make that trip possible and then if a chance in the weather breaking presented itself we could make the best of it. This we did, arriving at Sacramento about noon. Weather reports still continued to come in as being bad though a break in the storm was to the south of the regular course.

Leaving Sacramento about two we headed for Placerville and ran into said storm plenty hard. Snow, sleet and rain met us and when we couldn't discern the difference between a cloud and a snow clad mountain side, Lieutenant Geheres,

(Continued on Page 98)

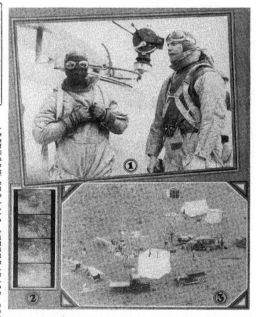

1—Myself (in disguise) and Lieutenant L. E. Geheres on landing after having recorded the passing of the Shadow Path. Dressed as we are we stand better than 250 lbs. on the hoof and when at 18,000 feet altitude could have used a few more furlines quite comfortably. 2—Four frames made at 11:05 with the 17-inch lens from the ground through a special ruby filter that reduced the halation to a minimum. This camera was located in the path of the calculated path and was therefore a mile out of position to get the corona, although they did succeed in getting a perfect circle of Bailey Beads as they are called, namely balls of fire that shoot out from behind the moon. These four frames were made at 11:05 A. M. or 51 seconds before the totality and the calculated and true paths are approximately plotted thereon. The altitude from which the exposures were made was 17,900 feet and, considering that, at that time, 51 seconds before totality, the light was quite weak the ground below shows up plainly. The rest of the negative shows the gradual loss of light and weakening exposure, then picking up again to the quality as of a minute before the totality. In the passing minute from 11:05 the wind drifted us down over and into the true path so that we were in the absolute totality. 3—Camp of the Mt. Wilson Observatory, located at Honey Lake, Nevada. Note the two Sound Cars of the Fox and Hearst outfits. The gentleman at the rear of the Fox truck is none other than Brother Kluver.

"One and One Half Seconds' Work"

(Continued from Page 96)

my pilot (and a crack one if there ever was), started looking for the roof. Up, up, up and still up we went until it even got too darn cold to bother looking at the altimeter, but its last reading was 16,000 feet and still climbing until finally we were above it all with a bright sun and nothing but clouds as far as the eye could see. After about twenty minutes we saw a head of us what looked like a break in the cloud bank and approaching closer made out Lake Tahoe below us surrounded in majestic glory by its white mantle.

Our course had been as straight as an arrow from Placerville. Dropping down through the hole we came to where the clouds were but fleecy packs with none of the threatening appearance of the storm clouds we had flown through. Passing at an altitude of about 10,000 feet we had a good view of Tahoe, and passing up the valley we were in sight of Reno before many minutes and at 3:30 landed at the Boeing Air Mail field, where planes were gassed and every thing put in readiness for our run up to Honey Lake to look the situation over on the morrow.

Opinions on our landing successfully at Honey Lake were many and varied and as is usually the case, all wrong, for it was found to be one of the finest natural landing fields in existence. I had had bright visions of landing some plane on or near the lake and then having to drag the cameras that we were using for the ground end of the job, some two or more miles.

My worries were all for naught for we landed and deposited our gear within fifty feet of their place of set-up. Information as to the time of the totality, the path of the shadow and what was required from us wasn't long in the telling. Mt. Wilson Observatory and Pomona College had camps there at Honey Lake and had done extensive surveying, laying out lines over which the shadow would pass for our guidance while aloft. All matters attended to we returned to Reno.

Monday morning we were out bright and early and ready to take off for Honey Lake at 8 a. m., the run out there being 45 minutes. Ground camera was set up and made ready for photographing various phases of the moon's passage across the face of the sun. This Akeley was equipped with a 17-inch lens, braced that no vibration existed, a ruby filter (either a red A or F) was used which worked excellently; Hyper Pan stock was used. This camera was to start 1 minute before totality and crank on through to one minute after. The results obtained with this camera has us all raving as we have some of the cleanest halation free stuff you would want to see.

The ground camera being ready it was for me to get my box ready for the task. Prior to leaving here I had had a special mount built for securing an Akeley to a scarf ring (machine gun mount) that must be solid and yet light. This was cast of alumnium. With two holding down bolts that firmly clasped the ma-

chine gun mount yet allowed it to swing at will and locking in place when set, I had rigidity in italics. Any one desiring some dope on it can have it for the asking.

Our end of the job was to make 18,000

feet and shoot down and get the shadow as it passed over the earth at the rate of 30 miles a second. Yea, we or rather my pilot saw it, I being to busy cranking and keeping set on our line, and his report is

(Concluded on Page 99)

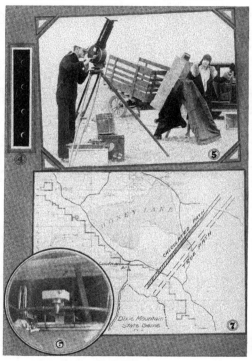

4—*The eclipse almost total.* 5—*McDonald, at the Akeley equipped with the 71-inch camera braced against vibration and which recorded the passing of the moon across the face of the sun. Mrs. Isabel Lewis, representative of the U. S. Naval Observatory with her 46-inch camera. Mrs. Lewis is a mathematician of note and is responsible for the Nautical Almanac, etc.* 6—*Mount and holding down hooks in place on machine gun mount for Akeley camera. This rig permitted free control of camera, allowing a free swing around scarf-ring of 360 degrees putting camera in position at any point immediately. Absolute rigidity was had, especially against the windblast of a Corsair which our good brothers and Charley Marshall, who have had to buck it, will appreciate.* 7—*May showing the approximate locations of the calculated and true paths of the shadow path, in the vicinity of Honey Lake, Nevada.*

ONE AND ONE HALF SECONDS' WORK

(Continued from Page 98)

that the camera got it. We'll let it go at that for 30 miles a second is just a little to fast for me to give an authentic report on as being on film.

Anyway, it being cloudy and these clouds up some 12,000 feet, our next bet was that if we couldn't see any point on the ground to identity locality of shadows passing over them to shoot the Corona. Made filters and got set for that job. By this time the eclipse had started, it being about 9:45. All in readiness, dressed in fur lined face masks and fleece lined moccasins we took off at 10:20 a. m. Steadily climbing we reached 18,000 feet at 11 a. m.

Getting into position over these points as plotted where the shadow would pass we waited till 11:04 at which time I was to start cranking. Our watches were set to those of the observers on the ground. Between 11:04 and 11:06 I was to busy to worry about what took place around me.

The cold at this altitude was extreme. Bundled as we were it felt like we could have put on three times as much. Goggles were useless in that the heat of the face would fog them and at that altitude without aid of oxygen tanks it was kind of hard on the bellows and it seemed that I was cranking a Ford.

And here I pass around a little tip to the boys that go in for high altitude photography—it is well to take about a half crank about every two or three thou-sand feet to test diaphragms, to test raise and tilt pans; this all assists in keeping the camera from freezing. We used that method up in Alaska on our mapping cameras, clicking the shutters every thousand feet to keep them free, especially when flying in an open plane.

The change of density of exposure during this two minutes proves that we were in the line of the shadow path. Report of the pilot is that he actually saw the shadow pass and later identified its path on the film. Calculations of some of the observatories put the path a mile further to the north than it actually was.

Our being in its direct path can be attributed to the wind drifting us down. A lucky break maybe. All I know about the minute before and the minute after the totality was that I had thought I was cold but during that time a cold wave hit me that dressed as I was made me know it was cold. Temperature at that height was approximately 20 degrees below zero. Immediately after the passing of the shadow I took a look around above me to see if there was anything worth recording. All that met my eye was a beautiful blue sky clear as a bell.

Giving the pilot the high sign that we were through I had the nosed her down. After losing about a thousand feet I happened to gaze up again and saw the most peculiar cloud formation that I had ever seen, it resembled a sky-writer up there about 40,000 feet. Knowing darn well there was no sky-writer up there about 40,000 feet I swung the camera on it and ground off some footage. On landing everyone asked us if we had seen this peculiarity and when told yes and that we had photographed it they seemed pleased to have something they could worry over.

Packing up all our gear and stowing it in the Sikorsky it wasn't long before we were on our way back to Reno, then over the mountains at 16,000 feet some more intense cold and finally into Oakland, just two hours after leaving Reno.

After all this high flying and with speed attached you may think that flying doesn't hold any kicks for me. Well, it didn't until we arrived in Oakland and previous arrangements had been made for me to run out some stuff in Frisco. I had figured being taken over in a car and I could grab a little rest enroute. Nay nay, as soon as I was cleaned up and ready they loaded me into an Air Ferry and I was landed in Frisco about 8 minutes later. Ride those ferries back and forth as I have done as a kid, and since, where it takes over an hour to get across with its attendant discomforts; then hop in a plane and be set ashore eight minutes later and if you don't get a kick, well, it's just too bad for you, 'ats all.

And so, leaving Oakland Tuesday morning about 10 a. m. and taking a nice sight-seeing jaunt down to San Diego where we all were met with the question—how did your pictures turn out —and having seen that they turned out, all we have to do now is the shouting.

Bigger and Better Pictures

MITCHELL
WIDE FILM CAMERA
with large Friction Head

Standard 35 mm.
MITCHELL CAMERA
with Regular Equipment

On United Artists Lot

Sick Notice

"Pecks Bad Boy" Gregg Toland is on a speedy recovery from the ether fumes he inhaled while working on the Technicolor picture "Whoopie."

* * *

Mickey Neilan chased Abe Scholtz off the set the other day because Abe pulled out an orange handkerchief—said red would have been more suitable.

* * *

They say the taxicab business has increased 20 per cent since the drive on tipsy drivers. The boys will manage somehow.

* * *

Announcement

Don Keyes is no relation to Asa Keyes even if he has that trick haircut.

* * *

Advertisement

Reasonable rates on furniture moving. See Bert Shipman, United Artist Camera Department. Tables a specialty.

* * *

Gene Smith and Jim Hackett did not go out Sunday because of the rain. They said it was wet enough inside as it was.

* * *

Geo. Meehan is doing some visions for Pickford. I know some boys who sure could help you a lot, George, on those things!

* * *

"Rodney St. Clair" Kenny is on the IA now and is dabbling in the stock market.

For Sale

Good beaver gun. Cheap. Apply Still Department.

A TRUE STORY

All of us have our lessons and those of us who are intelligent profit by them. This is a story of perseverence and willingness or more so character. Once upon a time a second cameraman was with one of the biggest directors in the business. Sickness came on and with a run down condition, doctors ordered him to go away and take a rest. He came back some time later not wholly fit; tough luck, no job; had to take out an assistant's card. One of the leading first men having trouble getting a boy to run the slate and load, offered him the job. He took it; was on for three pictures. Then came a fourth picture where a second man was needed and a friend got the job.
MORAL: YOU HAVE TO GIVE TO RECEIVE.

* * *

Of national importance is the fact that several of the fellows have some marvelous big cocktail shakers that have never seen a cocktail.

* * *

Fred Westerberg is just like "Old Faithful" in Yellowstone National Park, only different. Fred never blows up or spouts.

* * *

My idea of an assistant cameraman's heaven would be a place where you could let a 24 pop right in the lens; never change focus; forget to rack over; not have to reload; let the camera be off level; be late on the set; shoot everything with a 35; leave the old box on the set every night and use thumbs for diffusion disks.

* * *

Contrary to all reports the wardrobe department did not design Mary Pickford's period breeches from Jack Landrigan's trick golf trousers. Trousers is correct.

* * *

Bernie Moore says that Jack Kenny carries rat traps in his pockets. Some boys are just slow on the draw.

* * *

"ROUND THE LOT WITH THE ROUNDER"

Mary Pickford Company

Mary Pickford has that genial gentleman George Barnes as her chief beauty specialist. Looking at the rushes the other night I decided our Mary is still my favorite movie queen—she looks so young and wistful.

Donald Keyes is supervisor de luxe with "Togo" Harry Mimura desisting; Bertram Shipham, Alexander Phillips and Gabriel McBride are the other light experts. Mr. Carney, Mr. Liggett, Mr. Curtis and Mr. Carson are the Yes-men. The present name of the Pickford picture is "Forever Yours." The company is using blimps mounted on the Mole-Richardson-movable tripods with the new Cannon motors. Some of the older boys say their conscience bothers them when they go to get their checks, in comparison with the days when you had to pack a camera.

"Forever Yours" was originally done by Norma Talmadge some years ago and was called "Secrets" but it is no secret

that Oppie Rahmm is the stillman. Oppie has been on the pay roll for a long time, so I guess there is not much to say about this up and coming young feller.

Sam Goldwyn Productions

This is the only lot in the business where the boys can make "Whoopie" and not lose their jobs. And how they are making it. Director T. Freeland sure is a fast gunner, much to the chagrin of the O. T. friends. The critics can't say this picture lacks color. Goldwyn has them stopped there. Smart boy Sam; he looks at it from all angles. And what a colorful camera crew with Lee Garmes, Ray Ranahan, Les White, Roy Musgrave, Gregg Toland and Jackie Landrigan. The big money men Bernie Moore, Shirley Williams, Carl Guthrie, Ellis Carter, and Thad Brooks, complete the list.

Of interest to the stillmen is Kenneth Alexander's new 11x14 view camera. Ken has it mounted on a Mitchell tripod and it pans and tilts just like the real McCoy.

Ken showed the old spirit when he squawked for an assistant. If these 11x14 come into universal use, how about it Mr. Hurd? Mr. Goldwyn wanted to pull his hair when Ken mentioned it but you know that is impossible.

This show is just like having a good $2.50 seat at the theater every day. Eddie Cantor keeps the boys well supplied with convulsions. It's a shame this troup will close soon, but the boys still have that location at Palm Springs to look forward to.

Norma Talmadge Company

Ollie Marsh, M-G-M's pride and joy came up from the grand old town of Culver City to do "do Barry" and he seems to be "do doing" very well. "Menjou" Eddie Fitzgerald is Ollie's right hand man and "Lindy" Hymie Meade is seeing that everything is under control. Other persons on the opera are Bob Planck (ask Bob to show you his pencil flashlite) "Sen Sen" Gene Smith, "Rosher" Stew Thompson, "Whistling" Stan Cortez and last but not least that blushing youth "Hercules" Jim Hackett.

John Meihle is the instigator of those 8x10 masterpieces on this epic of that bad king and his haughty girl friend. Jonny should get some nice studies when he gets to that set where those water mymphs or what ever they are, flit about. Johnnie gets good stuff all the time; even Pebbleford.

This is the "Ritz" troupe; they call afternoon tea at 4:30 and everyone just naturally forgets to come back to work. Some of the gang take their tea cold. Guess who? $.20000 in prizes for the correct answer.

Note. I think the working title of this picture is "Deception."

Trick Department

I can't say much for this department as I never did care for magic anyway; it is too much of a fake. Just two men take care of the needs here, Mr. Schmid and his assistant Roy Noble; there seems to be no need for more, with two such capable men. It is not my intention by any means to slight this department in volume of news interest, but they are stuck away down under the gym and we never get down to see what is going on and, what's more, probably would not know anyway. Let me tip you off fellows; it's a swell spot to make your hand tests, and Smitty or Roy never knew what the word "no" is. Don't know what Mr. Schmid's first name is but it must be Accommodate.

Camera Department

Fred Westerberg is in charge of this department. Mr. Westerberg is responsible for the many new developments in the camera department, especially the new attachment that the Mitchell's clamp on to in the blimps, and those marvelous geared focus devices. Fred is never too busy to give the boys a hand and is on the go every minute working on new improvements and what not. He is a credit to the industry and United Artists should

(Concluded on Page 164)

Radio Pictures

The Boys of the Camera Department of R. K. O.

Let's Go!

Welcome You Brothers of the I. A. T. S. E. and M. P. M. O.

BILL EGLINTON, *Department Head*

ROY HUNT	BILL SCHUCKS
KARL STRUSS	EDWARD ADAMS
EDDIE CRONJAGER	HAROLD WELLMAN
LEO TOVER	BOB DEGRASSE
NICK MUSURACA	JOE BIROC
JOHN BOYLE	HARRY WILD
MAJOR SPOOR	RUSS METTY
HERR LUPERTI	BERNIE GUFFEY
CHAS. BURKE	JEFF GIBBONS
CECIL LOVE	FRANK REDMAN
GEO. DISKANT	FRED BENTLEY
WILLARD BARTH	BEN WHITE
JIM DALY	EDDIE PYLE
BILL CLOTHIER	EDDIE HENDERSON
CLIFF STINE	TED WINCHESTER
JACK KIEHL	LEDGE HADDOW
DICK DAVOL	EMMETT BERGHOLZ

J. O. Taylor with his Fearless Silent Super-Film Camera

J. O. TAYLOR

*H*AS PHOTOGRAPHED to
date every feature length
production made on wide
film......One and one-half
years' identification with
cinematography using wide
film......

Chicago — Six-Sixty-Six — Chicago

REGULAR MEETING

At the last meeting of Local 666, held at the Palmer House, Chicago, on May 5th, the first business was that of swearing in the officers for the coming year. The "working tools" of the secretary were passed on by Eugene Cour to the new secretary, Norman Alley. A vote of thanks was extended to the out-going secretary, Eugene Cour, by all the boys, and it was one of deep appreciation by all. We fully realize that Brother Cour can now return to his own business and devote his time there, now that 666 is on its own. It is needless to say what Brother Cour has done for Local 666 in the past year. He has been the main stem of the "works" and we all know that 666 was more than fortunate in having an officer such as Brother Cour who is greatly responsible for the success of Local 666. After the meeting closed most of the boys proceeded to the North Side to "wet their nose" as it was a very warm night.

SIX-SIXTY-SIX

HAIR CUT?
WHERE DID YOU GET THAT

Brother Fred Wagner appeared at the last meeting in the latest mode of "boyish bob." A "Joliet" clip was the result of Wagner's visit to the barber—one more cut like than and Fred will be riding around in a baby carriage.

SIX-SIXTY-SIX

CHICAGO BAD? NOT SO BAD

Heard on the long distant telephone: "Yeah, everything on the truck gone except the parts that couldn't be carried

Motion Picture Industries Local 666, I. A. T. S. E. and M. P. M. O., of the United States and Canada

By HARRY BIRCH
President

CHARLES N. DAVID............................Chicago
Vice-Presidents
OSCAR AHBE ..Chicago
HOWARD CRESSSt. Paul
HARRY YEAGERSt. Louis
W. W. REID.................................Kansas City
RALPH BIDDY.............................Indianapolis
J. T. FLANNAGAN.........................Cleveland
TRACY MATHEWSON........................Atlanta
GUY H. ALLBRIGHT...........................Dallas
RALPH LEMBECK........................Cincinnati
Treasurer
MARVIN SPOOR...................................Chicago
Secretary
NORMAN ALLEY...............................Chicago
Financial Secretary
WILLIAM AHBE...................................Chicago
Sergeant-at-Arms
HARRY BIRCH.......................................Chicago
Board of Executives
CHARLES N. DAVID WILLIAM AHBE
OSCAR AHBE HARRY BIRCH
MARVIN SPOOR WILLIAM STRAFFORD
NORMAN ALLEY EUGENE COUR
Offices
12 East Ninth Street, Chicago

BULLETIN — The regular meetings of Local 666 are held the first Monday in each month.

away." Here's what happened, that is as we get the story: Several months ago Brother Eugene Cour received a sound truck for his territory and realizing the value of same he was determined to have

this truck guarded by an "eagle eye"—after searching Chicago in its various parts he found that he had just the man he wanted in his own office, Brother Tony Caputo—after much discussion Tony was advised that he was the "eagle's eye" for said sound truck—Tony knows his Chicago and he did a "double eagle eye" when ever on Chicago assignments. Brother Cour decided had the right man —so say's Cour to Tony—"you're going West, young man" and Tony went West to still do the "eagle eye" on said sound truck—well, naturally Tony figured that only Chicago was a bad place and upon arriving in a town in Kansas, I believe Bemington was the name or something like that, where things are all up and up Tony left said sound truck on the street while he "sipped his coffee"—and upon returning he found that all but the truck and, of course, the inside "works" had departed—and so that accounted for the telephone conversation.

We understood that Tony is now being fitted to glasses and that they will be double thickness—and, well it will be just too bad for the next one that even looks inside the truck, regardless of town, place or what have you. Note to hospitals: Be on the lookout for customers when Tony is in your town.

SIX-SIXTY-SIX

Having been away from Chicago most of the month I returned to find that most of the boys here were too busy to tell us what was going on for the PAGE. Just as things were looking dark for 666, that is for news, along comes that live-wire individual self-titled "Birch's Sassiety Reporter"—by the way, I want to introduce this good-looking, high-powered, fast-stepping "Sassiety Reporter"—he is none other than "Red" Felbinger, the Paramount Sound Scoop Shooter. The following is "Red's" report for the month:
Here he is.

"IN FOCUS — IN SPOTS"

By "Birch's Sassiety Reporter"

Been a hectic month in old 666's boundaries considering most of us still moseying around with sort of kind of a hangover from the David's Palmer House birthday party, but we nevertheless gotta "get those pictures" or starve.

Columbus Prison Burns—comes across the news printers one night. Ho· hum, says a bunch of the camera reporters, "Just another one of those fires."

Three hundred convicts burn to death —and action by same grinders. "Hey? What times does the next train leave for Columbus?" "Operator, for cripes sake give me long distance, etc., etc. Comes the dawn and—Columbus, Ohio—and Red Felbinger and Eddie Morrison outside the gates looking in, the boys found out sometimes it's just as hard to get in as get out. Morrison and Red were just deciding to blow up a bank to crash inside for some pictures when some kind-

(Continued on Page 110)

THE RECENT ANNUAL BANQUET OF 666

It was some night even for Chicago

ONE YEAR OLD
AND GOING LIKE HELL

From
LOCAL
666
CHICAGO
ILLINOIS

The boys namely

OSCAR AHBE
Chicago, Ill.
WILLIAM AHBE
Chicago, Ill.
IRVING W. AKERS
Chicago, Ill.
G. H. ALLBRIGHT
Dallas, Texas
NORMAN W. ALLEY
Chicago, Ill.
ROY ANDERSON
St. Louis, Mo.
BEN M. ANDERSON
Cincinnati, Ohio
W. ANTHONY ANDLOUER
Kansas City, Mo.
FRANK E. ARVER
St. Paul, Minn.

JACK BARNETT
Chicago, Ill.
MARTIN M. BARNETT
Chicago, Ill.
GEORGE BASTIER
Chicago, Ill.
FRANK BAUER
Chicago, Ill.
LOUIS BAUER
Chicago, Ill.
CHARLES E. BELL
St. Paul, Minn.
EDMUND A. BORTRAM
Chicago, Ill.
GEORGE BERTRAM
Chicago, Ill.
EDWARD BICKEL
St. Louis, Mo.
RALPH BIDDY
Indianapolis, Ind.
WALTER BIDDY
Indianapolis, Ind.
HARRY BIRCH
Chicago, Ill.
E. BISHOP
Akron, Ohio
VERNE W. BLAKELEY
Chicago, Ill.
CARL H. BOWERS
Dayton, Ohio

FRED BOCKELMAN
Dallas, Texas
EDWARD CAMPION
Kansas City, Kans.
ANTHONY CAPUTE
Chicago, Ill.
RUSSELL G. CARRIER
Akron, Ohio
CHARLES T. CHAPMAN
Evanston, Ill.
ALFRED R. CHOUINARD
Chicago, Ill.
HERBERT CHUNG
Chicago, Ill.
J. CHARLES CLICKNER
Indianapolis, Ind.
R. L. CLINTON
Chicago, Ill.
EUGENE J. COUR
Chicago, Ill.
HOWARD W. CRESS
St. Paul, Minn.
WALTER S. CROFT
Kansas City, Mo.
H. F. CULVER
Chicago, Ill.
CHARLES N. DAVID
Chicago, Ill.
JAMES RUSSELL DOTY
Dayton, Ohio
R. J. DUGGAN
Chicago, Ill.
ROY F. DWYER
Chicago, Ill.
KENNETH EDDY
Sault Ste. Marie, Mich.
H. C. ELDRIGE, JR.
Dayton, Ohio
SAMUEL EMBER
Chicago, Ill.
FRED A. FELBINGER
Chicago, Ill.
ROGER W. FENIMORE
Chicago, Ill.
PETER FISH
Chicago, Ill.
J. T. FLANAGAN
Cleveland, Ohio
KURT B. FLORMAN
Duluth, Minn.

CHARLES E. FORD
Chicago, Ill.
BART FOSS
St. Paul, Minnesota
F. D. FOX
Minneapolis, Minn.
R. G. GANSTROM
Chicago, Ill.
CHARLES GEIS
Chicago, Ill.
H. J. GERMANN
Springfield, Ohio
FRED GIESE
Chicago, Ill.
R. W. GREER
Columbus, Ohio
JOE GUERCIO
Chicago, Ill.
G. H. GUTERMUTH
Fort Wayne, Ind.
FRED HAFFERKAMP
Chicago, Ill.
MORRIS E. HAIR
Chicago, Ill.
GEORGE HALLIDAY
Columbus, Ohio
DAVID T. HARGAN
Chicago, Ill.
R. E. HOLLAHAN
Maywood, Ill.
WALTER HOTZ
Chicago, Ill.
GRANVILLE L. HOWE
Chicago, Ill.
C. W. HUTTON
Chicago, Ill.
WILLIAM B. JACOBS
Toledo, Ohio
BERTEL J. KLEERUP
Chicago, Ill.
HUGO KUERSTEN
Chicago, Ill.
C. W. LANE
Chicago, Ill.
MERVIN LA RUE
Chicago, Ill.
RALPH M. LEMBECK
Cincinnati, Ohio
R. C. LIGGET

GEORGE W. LUCKYEAR
Chicago, Ill.
FLOYD LOGAN
Detroit, Mich.
CONRAD A. LUPERTI
Chicago, Ill.
F. L. MAGUIRE
St. Louis, Mo.
JERRY MARINO
Chicago, Ill.
MAX MARKMANN
Chicago, Ill.
E. G. MARQUETTE
Indianapolis, Ind.
ORLANDO R. MARSH
Chicago, Ill.
TRACEY MATHEWSON
Atlanta, Ga.
W. PRESTON MAYFIELD
Dayton, Ohio
BOWAN MILLER
Omaha, Nebr.
TIRY H. MILLER
Chicago, Ill.
R. F. MITCHELL
Chicago, Ill.
G. E. MOMBER
Cincinnati, Ohio
T. C. MONTGOMERY
Chicago, Ill.
H. K. MOSES
New York City, N. Y.
R. E. NELSON
Chicago, Ill.
LOUIS D. NEVILLE
Indianapolis, Ind.
WARREN S. O'BRIEN
Waukesha, Wis.
C. P. O'HAVEN
Hannibal, Mo.

HERBERT C. OSLUND
St. Paul, Minn.
R. D. PARRY
Cincinnati, Ohio
RUFUS PASQUALE
Chicago, Ill.
A. E. PETERSON
Chicago, Ill.
HARRY PETERSON
River Forest, Ill.
A. F. PETILL
St. Louis, Mo.
RALPH G. PHILLIPS
Chicago, Ill.
STANLEY POLINSKI
Chicago, Ill.
W. W. REID
Kansas City, Kans.
REID H. RAY
St. Paul, Minn.
J. C. RICHARDSON
Chicago, Ill.
WAYMAN ROBERTSON

M. J. ROTUNNA
Chicago, Ill.
ROBERT SABLE
Cleveland, Ohio
URBAN M. SANTONE, SR.
Chicago, Ill.
SAM SAVITT
Chicago, Ill.
W. T. SCANLON
Chicago, Ill.
T. A. SEBASTIANI
Cincinnati, Ohio
ART SIGAL
Omaha, Nebr.
PETER A. SIMON
Detroit, Mich.
E. C. SLY
Minneapolis, Minn.
RAYMOND SOITZ
Berwyn, Ill.
MARVIN W. SPOOR
Chicago, Ill.
ALBERT STEIS
Chicago, Ill.
R. J. ST. MARTIN
St. Paul, Minn.
W. H. STRAFFORD
Chicago, Ill.
G. B. STRAUBER
Cleveland, Ohio
F. C. SI SSENGUTH
St. Paul, Minn.
D. F. TATTENHAM
Chicago, Ill.
ROBERT TAVERNIER
Elmwood Park, Ill.
H. E. THEONSEN
Des Moines, Iowa
E. R. TRABOLD
Chicago, Ill.
E. A. TRAGER
Chicago, Ill.
FLOYD TRAYNHAM
Chicago, Ill.
LOREN TUTELL
Chicago, Ill.
C. L. VENARD
Peoria, Ill.
F. J. VENEGAS
Chicago, Ill.
FRANK E. VICKERS
Kansas City, Kans.
FRANK WAGNER
Chicago, Ill.
ROGER WAITE
Cleveland, Ohio
LAFAYETTE WAREHAM
Columbus, Ohio
RALPH WETTSTEIN
Milwaukee, Wis.
HARRY YEAGER
St. Louis, Mo.
J. C. ZIMMERMAN
Chicago, Ill.

Chicago—Six-Sixty-Six—Chicago

(Continued from Page 107)

hearted guard left the gate open a little too long, so they got in.

Charlie Ford also went over the wall for a couple of inside close-ups—but Charlie had to leave the Cord outside.

Incidentally, Ford started to relate to the boys down there what great time he made with the now historic Cord in the dash for Columbus. What's matter Charlie, you haven't forgotten a certain race near Chicago in which said Cord figured; well we ain't, Charlie.

Speaking of cars and the Columbus fire —where or where were you Brother Ralph Lembeck? First time we didn't see you on the job in your territory, what happened Ralph Ford break down or were you too busy writing a column for Editor Birch, so as to keep on the mailing list, then again, maybe the said high speed flivver got you there and back before we arrived, go ahead, start bragging now, we ain't listening.

Well the Drake Relays happened again this year with sound effects. Zimmerman, Eddie Morrison and Red were out there. But what we're missing this year is the good old days at the relays with the old timers—the Trabolds, the Andlauers and the old Eymo specialists.

Just happened to think the Eddie Morrison we're refering to, is the same Morrison we used to know a couple of years ago. Glad to see you Eddie, unless of course you see us first.

Saw Bill Ahbe, out on the west side of boom-town, making movies of a communistic demonstration. Yeh, making movies with a sixteen millimeter amateur camera. Ha, ha, says we to Bill. Oh, just playing around says Bill, having a little fun." "Yeh, so are we, likes I, and I kick my godam sound back breaker.

President David was found out in Chinatown the other night learning how to eat Chinese melon soup with chopsticks. Boys look out, maybe Charlie's going to spring another banquet on us again and I hope it ain't with chop-sticks. David ain't practicing for no good reason says we.

In another part of Chinatown we discovered Secretary Norm Alley learning how to write Chinese. Clever people these Chinese—ask Norm, they took him for a couple sawbucks when he entered their merchandise mart. Norm just moved and he bought a couple of nick-nacks for the new home—all he needs now is a capping machine and he's all set for a new batch of homebrew.

All kidding aside though, the reason we bust into Chinatown was to be guests of the Chinese merchants at a very nice little affair at Won Kow's arranged by our good friend Herbie Chung.

Some of you birds that read this probably think we're writing a lousy column. We don't care if you do but if you don't like it try it yourself sometime—I bet the boss of THE PAGE will back me up on it, too.

See you again, unless you see us first as Eddie Morrison says.

Note.—Thanks Red—don't forget the address next month.

WAY BACK WHEN!

Brother Chas. Ford will do most anything in a pinch. Here we see the boy "way back when" he was grinding for the International Newsreel—with no tripod Chas. made pictures with his "Shoe-String" camera just the same. Don't

CHAS. FORD

laugh at the camera boys, because there are many of you who used that old Schustek camera and made good pictures even if it was a "man killer" to "lug" around. Note: Ford will you tell the boys how you make pictures without the usual lens—I notice that the lens in the picture is missing.

SIX-SIXTY-SIX

ANOTHER BOOSTER

"Well for the first time in my life I'm getting something for nothing and when I say something I mean SOMETHING." Brother Chas. Geis was making this little speech so that everyone could hear him. When asked just what he was talking about, Chas. said: "Why you big bums, I'm getting **The International Photographer** every month and it just seems too good to be true, with the many interesting articles, one better than the other. That's what I mean when I said SOMETHING FOR NOTHING."

SIX-SIXTY-SIX

MISSED A GOOD STORY

Brother "Shorty" Richardson is bemoaning the fact that he attended a good banquet several weeks ago and one of the speakers told a story of which "Shorty" missed the last part. "Shorty" has been asking all the members of Local 666 if they know any stories about the PICCOLO player—the story he missed dealt with a PICCOLO player and therefore if any of the members of the I. A. T. S. E. any-

where in the country know a PICCOLO player story please send them into Local 666 and they will be turned over to Brother Richardson to see if he can find the one he missed.

SIX-SIXTY-SIX

PUTTING ON THE FEED BAG

Local 666 believes in doing all things the right way. We now have on file official restaurants or whatever you may call them. They are filed for the benefit of the members and according to their feeling. So far we have the good American dinner, the Chinese variety, the Italian dishes, the Swedish. Now here's the idea: Of course if you want a good American dinner you go to the official headquarters of Local 666 which we all know is the Palmer House; if you feel Chinese'ee you look over the file and go to "One-Cow" (that is in English) for your Chinese dinner—and then again if you feel Italiano you go to Como Joe's where you meet the famous Como Joe himself and he suggests a real Italian meal and the longest spaghetti served in Chicago—or if you feel like a bit of Sweden you just amble over to the Bit-o-Sweden and treat the digestion organs to a little Swedish relish. No matter how you feel you can always rest assured that "Soup's On" in Chicago.

SIX-SIXTY-SIX

HOW COME

Just received a postcard from Brother Chas. Geis—he is in New York learning the secrets of Movietone so that he can put over some real "scoops" for Fox Movietone from now on. How come, Chas., you are now with Fox and you are stopping at the Paramount Hotel.

SIX-SIXTY-SIX

ONE FOR THE BOX

Brother Guy H. Allbright of Dallas, Texas, sent in the following: A few days ago I met up with a very close friend of mine and we were discussing THIS THING CALLED LOVE and he makes a GENERAL CRACK about some LUMMOX named TIGER ROSE gathering LILIES OF THE FIELD for THE MIGHTY when SKINNER STEPS OUT of THE GRAND PARADE and declares himself THE VAGABOND LOVER and proceeds to plant THE KISS on the cheek of the SHANGHAI LADY. This was resented by THE VIRGINIAN and he dared THE LAUGHING LADY to enter THE MARRIAGE PLAYGROUND. She being entirely familiar with THE MYSTERIOUS ISLAND promptly told him to take SALLY and go HALF WAY TO HEAVEN. He realized THE AWFUL TRUTH and cries NO, NO, NANNETTE the DYNAMITE was intended for the GOLD DIGGERS OF BROADWAY to blow them all to HALLELUJAH.

Then my friend says to me, you can tell THE COCK-EYED WORLD all HELLS ANGELS couldn't keep the SUNNY SIDE UP unless a Western Union messenger should rush up to you

(Concluded on Page 112)

CHICAGO — SIX-SIXTY-SIX
(Continued from Page 110)

with the BIG NEWS that you had your job back—the WELCOME DANGER—the long strain of waiting over, you could rest your weary bones in THE LIGHT OF WESTERN STARS, out where men are men and cactus is cactus—OH! YEAH?

Note.—Atta boy, Guy, don't stop with this one.

SIX-SIXTY-SIX

HONOR TO THOMAS E. MALOY
By EUGENE J. COUR

Honor to Thomas E. Maloy, manager Chicago moving picture machine operator, Union A. F. of L. Fraternal Delegate to British Trades Union Congress at Nottingham, England.

The most impressive tribute ever paid organized labor and the greatest honor ever accorded a labor leader, is to be tendered Thomas E. Maloy, Business Manager of the Chicago Moving Picture Machine Operators Union, at a testimonial banquet in the Grand Ballroom of the Stevens Hotel, Chicago, on Saturday evening June 21.

The selection of Mr. Maloy as one of the two fraternal delegates of the American Federation of Labor to the British Trades Union Congress inspired his many friends to celebrate the signal honor accorded him. The banquet numbers among its personnel leaders from the industrial, commercial, amusement, political and social worlds and includes:

Oscar Carlstrom, attorney general, State of Illinois.

Dr. Karl A. Meyer, medical director, Cook County Hospital.

G. W. Schick, past commander, American Legion.

Attorney Thomas Nash.

E. D. (Jack) Miller, president, Exhibitor's Association of Chicago.

Captain Michael O'Grady, Chicago Police Department.

Alderman John P. Wilson.

George E. Brown, vice-president, I. A. T. S. E.

Dan Serritella, city sealer.

Frank O'Neill, secretary, Oak Parks Elks, 1925.

J. Seigel, president, General Markets Corporation.

P. J. Berrill, vice-president, I. B. T. S. and H. of America.

James Coston, National Theater Corporation.

William Baron, vice-president, Movie Supply Company.

George L. Carrington, installation manager, Electrical Research Products, Inc.

Boone McCall, editor, The Motion Picture Projectionist.

John Balaban, Public Theater Corporation.

U. J. "Sport" Herman, Cort Theater.

William Martin, president, Kenwood Trust and Savings Bank.

Phil Collins, Illinois Commerce Commission.

Judge Lyle, Municipal Court of Chicago.

Thomas Reynolds, president, Local No. 10, I. A. T. S. E. and M. P. M. O.

Peter Drautzburg, United States Secret Service.

Henry Schoenstadt, Schoenstadt's Theater Corporation.

Alderman William Pacelli.

John Garrity, Shubert's Theater.

Rev. A. J. Ashenden.

Isaac Powell, president, South Side Trust and Savings Bank.

Judge John Lupe, Municipal Court of Chicago.

W. E. Green, president, National Theater Supply Company.

Thomas Flannery, president, White Way Electric Sign and Maintenance Company.

It is unusual that so great an honor be paid a labor man but it is exceptional in the case of so young a man as Mr. Maloy. Mr. Maloy although fourteen years the able business director of Local 110, I. A. T. S. E. and M. P. M. O., is but thirty-five years old. He was born in Chicago, Illinois, October 14, 1895, educated in the public schools and graduated from Christian Brothers College. He has been a member of Local 110 since 1909. He was elected to the office of Business Representative in 1916 and has held that office continuously since. He stepped into office at a time when there was a serious jurisdictional controversy that not only threatened to destroy his local but threatened a set back to the craft throughout the United States. His untiring efforts and ability successfully defeated the efforts of the dual organization.

In 1917 he attended the American Federation of Labor Convention at Atlantic City at the personal request of International President Charles C. Shay, I. A. T. S. E. He was first elected delegate to the Convention of the American Federation of Labor in 1920 and has been re-elected for each succeeding convention.

Mr. Maloy is a member of various fraternal and civic organizations which owe much to his aid and co-operation. Last October the Elks Oak Park Lodge made him a life member.

Despite the constant demands upon his time by the problems of organized labor, Mr. Maloy devotes much of his leisure to outdoor sports and is an accomplished equestrian. He has a stable of thoroughbreds and has won several honors at the annual horse shows of the South Shore Country Club and the International Livestock Exposition.

His favors and philanthropies are of no mean proportions and are not used as a means of self-aggrandizement but are an expression of his impulsive generosity and good-fellowship.

All of the locals of the I. A. T. S. E. and M. P. M. O. are indirectly honored by the tribute paid Mr. Maloy and join with the leaders of the Middle West in tendering him their respects and support.

At the testimonial banquet this month Mr. Maloy will be introduced as follows:

"This is indeed an occasion the many friends and admirers of our esteemed guest of honor have hoped for. An occasion where they might give expression to their admiration and affection for him in a humble way at least and make it possible for those less fortunate, those who do not know of his many and varied virtues, that they may share with us the great privilege of knowing him for what he is and what he stands for.

"Thomas E. Maloy came to us in a time of great stress. At a time when the need of an able leader was acute. An extraordinary situation existed and only an extraordinary individual would suffice. Our crying requirement in that dark hour fourteen years ago was conciliation; to be saved from ourselves as it were. A depression in our business affairs had reached a very serious stage indeed, harmony was lacking, real friendships few, and to begin all over appeared our only salvation and to do that we would have to set our divided house in order first.

"And then came from our ranks a young man, a boy almost, who so ingratiated himself that he was looked upon in the light of a saviour, at once, and when the youth had developed into a giant, physically and intellectually, and as such, and for his great worth to a vital cause, we pay homage to him on this occasion.

"Due to his broadness of vision, definiteness of purpose, unswerving loyalty to his adopted cause—our cause—his untiring and ceaseless efforts, we are well on the way toward a full realization of our quest of peace and happiness, and that which rightfully belongs to us. Under his leadership lost ground has been restored, friendships cemented and more strongly than ever before, a finer understanding between employer and employee, all contributing influences, toward the welfare and development of our craft.

Through his advanced ideas and originality of application, fair dealing and utter fearlessness in the prosecution of a just policy, he has gained the esteem and friendship of the police of this community. We honor one whose qualities have earned it for him—Thomas E. Maloy, Business Representative of Local 110, I. A. T. S. E. and Fraternal Delegate to British Trades Union Council.

DO YOU KNOW

That the rates in the post office are cheaper in Hollywood than they are downtown. We mailed some magazines recently and the clerk said 4 cents. By the time they got down town it cost 5 cents to mail them. We had to bring them back and chisel off the edges. Next time we will try Beverly Hills. They may make us a rate of 3 cents.

That the Royal Diner, in front of Lasky's has a brand new Union Card and should get a call from you when in that neighborhood.

That ex-President Coolidge lived in one-half a double until he started to write and then he had too get a house with 17 rooms. I bet at that he has to go to the office to write.

That Rob Wagner, editor, etc., of the *Beverly Hills Script*, always gives the cameraman a break when he is entitled to it. Good reading the Script and if you read a few copies you are bound to subscribe.

That the Red Top and California Cabs are Union. Taxi Lady? No? Giddap.

 # Cream o' th' Stills

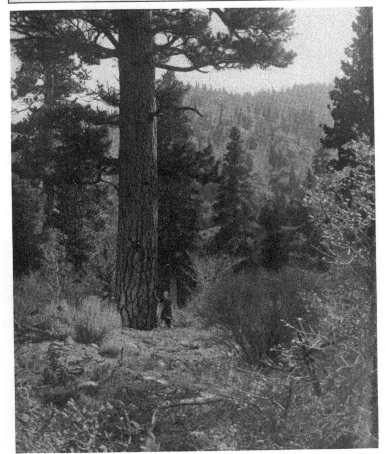

That versatile artist, Bert Baldridge, brings to us from not so far away the smell of the big rugged pines, gloriously mingled with sage and manzanita.

 # Cream o' th' Stills

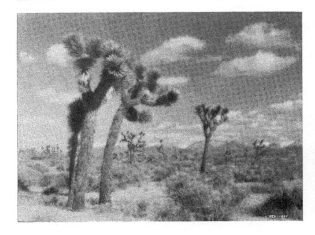

Ned Van Buren is an expert at desert photography. He loves the desert and understands its moods. This shot was enlarged from film and brought down again. All the values are there.

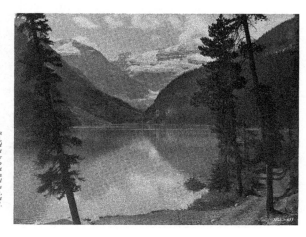

President Alvin Wyckoff, Local 659, I. A. T. S. E. and M. P. M. O., spent some time in the Canadian Rockies two years ago and brought back with him a collection of beautiful photographs. Here is a shot of Lake Louise, famous throughout the world.

Cream o' th' Stills

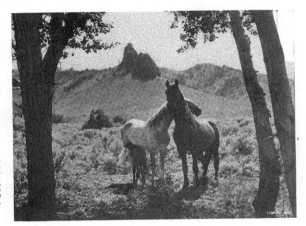

Rex, Lady and their baby were induced to pose for Clarence Graves, still artist for Hal Roach, who owns them. Only once in a lifetime is a shot like this possible.

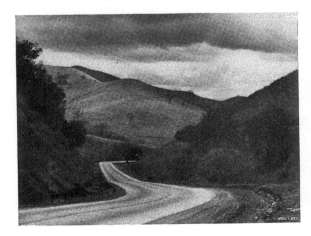

Les Rowly finds in our asphalt and concrete highways a subject worthy of his ready camera. Nature provided the way, the road-builder did his stuff, but it remained for Les to see the beauty of it all.

Cream o' th' Stills

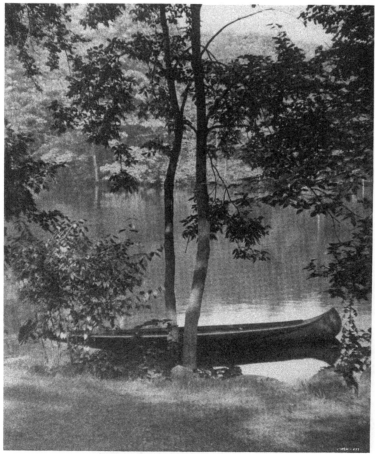

James N. Gridlian combines in one fine shot sunshine, shadow, mirrored water, greenery and a sample of the boat builder's finest art.

Cream o' th' Stills

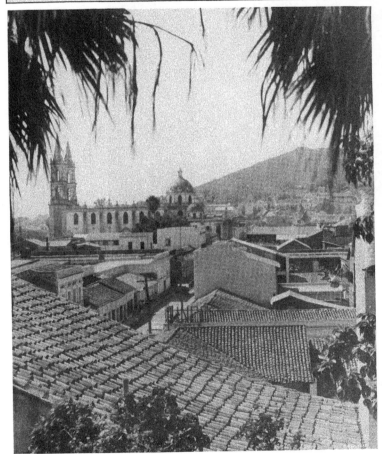

From the sun-drenched hills of Old Mexico, Bert Lynch has salvaged this exquisite bit of old Spanish architecture, a huddle of adobe and hand-made tile under the shadow of the ever-present cathedral.

Cream o' th' Stills

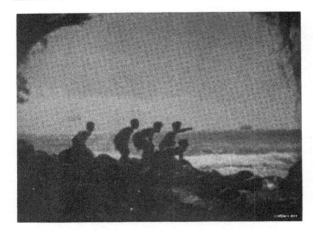

Out of the "good box" of Paul Ivano came this entrancing marine view. The silhouettes of the boys on the rocks and of the four masted schooner hull-down on the horizon are elements that would lend charm to any vista of the sea.

Farciot Edouart contributes this bit of art and names it "Contentment." So intriguing is his technique that one wonders if it is photography or the work of his skilful hand.

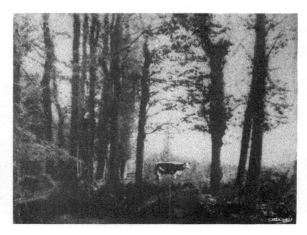

 # *Cream o' th' Stills*

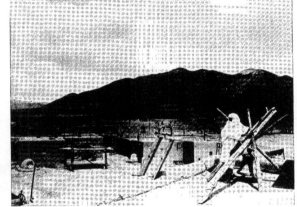

An Indian roof garden may not be as high up in the circumambient as a sky-scraper, but it is a lot more picturesque, especially when its setting is mountains and desert. Note the old Spanish Mission bell with the bell-ringer standing by. Edward H. Kemp photographed this picture.

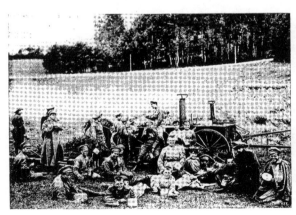

Major N. C. (Doc) Travis contributes this interesting picture of a company of Russian women soldiers of the celebrated Battalion of Death. Major Travis saw a lot of service in Russia and was in close touch with these picturesque troops.

Cream o' th' Stills

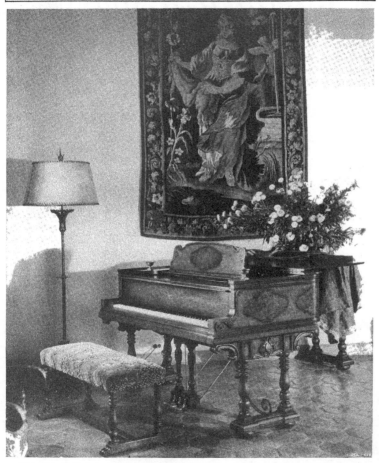

Shirley Vance Martin just can't help getting a picture whenever he trains his camera on any subject, person or group worthy of it. He ran across this enticing shot in the showrooms of the famous Birkel Music Company, 446 S. Broadway, specializing in the Steinway Piano here dominating the picture.

43 YEARS OF FIREWORKS

Founded in 1887, the Los Angeles Fireworks Company was a power in its field in the pre-movies days and then, with the advent of the great silent art which now has developed into an audible one, this concern forged ahead with augmented rapidity inasmuch as it soon found its useful niche in the film industry, supplying the materials which added light and spectacle to the photography. In truth, the very first flares and powder ever used in the making of motion pictures were furnished by this pioneer business firm.

It is interesting to note that the Los Angeles Fireworks Company, 410 East Third Street, has occupied the same building ever since it was established and that this was one of the first brick structures ever built for miles around in those days of yore. It is also noteworthy that there has been only one management from the inception.

Picture producers were indebted to the Los Angeles Fireworks Company for bringing forward the calcium lights which were so indispensable especially in the earlier days. It likewise developed the actinic flares which were used to such distinct advantage for battle-scene effects in such productions as "The Birth of a National" and "Intolerance."

By way of keeping abreast of the times in this swift-moving age, G. E. Fetters, the manager, announces that he and his associates are in the midst of extensive experimental work in the matter of perfecting cold light and it is probable an announcement of widespread importance to the entire film industry will be made ere long.

———o———

CAMERA THE FULCRUM

The camera will be the starting point of the motion picture in the future as it always has been in the past, despite the present centering of interest on the microphone, according to Ralph Block, Pathe producer, in an article on the talking picture in *Vanity Fair*.

"Despite all the good intentions of the numerous stage personalities now engaged in the making of screen entertainment, the motion picture of a year from now will have only an academic relation to the elements of the theatre," Block writes.

"So long as the camera remains static, the relationships of tempo between what people say and what they do does not differ greatly from that of the speaking stage. It was obvious, of course, at the beginning, that to project the photographed sound and action of a stage play in its entirety would take at least three times as long as the usual movie is allowed to run. A three-act play, not counting intermissions, can run slightly under two hours—a movie not much over one.

"But aside from this difference, mechanical requirements of sound recording have slowed down action on the screen. Silent films run sixteen or eighteen images a second through the camera, whereas now the camera equipped with sound devices record twenty-four images a second. The greater the number of images, the more celluloid is devoted to the separate parts of action, and the

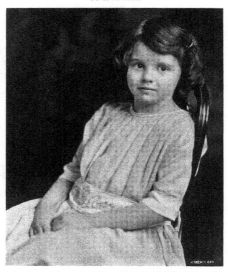

It is with great pleasure that editors of The International Photographer *reproduce this charming picture from the camera of Col. W. G. Stuber, president of the Eastman Kodak Company. Colonel Stuber was internationally famous as a photographer many years before he went with Eastman and his chiefest recreation still is to browse around with his camera*
Thanks Colonel Stuber.

slower the whole action will appear on the screen. The new medium, because it is slow, therefore carries an even heavier burden than the silent movie in its effort to tell its story in the exhibitors' conventional sixty minutes.

"Motion picture dialogue of the future, therefore, will have to become more essential, concentrated, retaining all the packed values of the motion picture subtitle, without its stilted qualities. Shorter lines, devised to say more and speak less, will place a new burden of naturalness upon the actor. Diction will have to find new processes. Tonal quality will have to find new forces of clarity and new colorings.

"But the most important changes in this new medium will be the visualized relation between people and things. The camera should not sit squarely in front of people who are talking. The eye of the camera may be at one place and the ear of the microphone at another, and the relationship—which holds the two together—will be a subjective one, a unity given by thought and imagination.

"Although the stage may seem to be moving into the ancestral halls of the

studios, bag and baggage, the movies are too fundamentally related as a form of expression to the modern mind to surrender their identity. It is more likely that, like the Chinese who absorbed all their conquerors, the movies will assimilate everything the stage has to offer and become themselves again."

TOURING HOLLYWOOD

Billy Bevan has just completed the role of master of ceremonies in Screen Snapshots issue number twenty, directed by Ralph Staub for Columbia release. While touring the various studios, Billy plays in luck and happens in on Dorothy Sebastian's birthday party, gets a kiss and a piece of birthday cake. He sees and introduces to the audience—Jack Holt, Ralph Graves, Flo Ziegfeld and his wife—the former Billie Burke—with their daughter, Patricia. At the premiere Billy sees Al Jolson, Ben Lyon, Bebe Daniels, Edmund Lowe, Lilyan Tashman, Nancy Carroll, George Sydney and Charlie Murray.

A New Method of Blocking Out Splices in Sound Film

—BY—

J. I. CRABTREE and C. E. IVES, *Eastman Research Laboratorie·*

A splice in motion picture film which bears a sound record usually introduces extraneous noise in the reproduced sounds unless some means is taken to obscure it. Rapid variations in light transmission of the sound record area are productive of sound and the reproducing equipment is, of course, unable to distinguish between the record proper and such extraneous variations.

It is not difficult to see that a badly aligned splice surrounded by cement smears, finger prints, abrasions, and dirt spots could produce noise. Even though the splice is made with the greatest care and precision, however, a very objectionable noise might be introduced as a result of the passage of a splice joining parts of the sound record between which there is an abrupt change in transmission. This condition is liable to be encountered even if the method of joining were capable of eliminating all other mechanical imperfections such as roughness of the cut edge and light loss produced by refraction at the edge. Therefore, noise will be produced if the change in transmission between the contiguous areas is large and abrupt enough to come within the range of the reproducer.

If the transmission of the area illuminated by the slit in the reproducer is reduced gradually until it is insignificant at the time when the splice passes, then no noise will be made by the splice in passing. The rate of decrease of transmission must be less than that corresponding to the minimum frequency attainable in the reproducer system.

Remedy for Splice Noise.—It has been found possible to eliminate the splice noise by applying an opaque coating to the sound track (Fig. 1) in such a way

FIGURE 1

that as the film travels past the slit the effective transmission is gradually reduced to a very small value and then increased in the same manner. It is much easier to apply an opaque coating in the shape of a wedge than to vary the thickness of the coating, so the overlay usually is made to resemble a ten to forty cycle variable area signal.

When a splice is "inked out" or 'painted-out" in this way in the negative,

it leaves an area of high transmission in the positive which is very easily scarred so that it might cause ground noise. In the positive, the "paint-out" does its work very well. India ink has been used in this way but becomes brittle and develops very noisy cracks. An opaque lacquer has proven more satisfactory.

Improvement in the Method of Masking Out.—In a processing laboratory it is quite possible to make good "paint-outs" by applying a black lacquer with a fine brush either with or without the assistance of a stencil. In the hands of a skilled worker making many hundreds in a day, this method has proven satisfactory, but in the projection room of a theater different conditions exist. It is often necessary for the projectionist to make a number of splices in a few minutes when a new picture is received, and since he is not doing the brush work frequently, it is difficult for him to make a satisfactory "paint-out" quickly with the result that more noise is liable to be introduced by a poor "paint-out" than would have resulted from the splice in the first place.

It was obvious that the solution of this problem lay not alone in the use of a quick drying lacquer, but in devising a rapid method of applying it. Various types of stencils constructed of the following materials were tried: Cardboard, rubber, inking roller gelatin, steel and rubber plated metal and steel. A slow drying lacquer or ink could be used with any of the above devices, but in the case of rapidly drying lacquers, if the brush contained sufficient liquid to make the film opaque with one or two applications, the more mobile, rapidly drying inks were sucked in under the edge of the stencil by capillary attraction, and a very irregular edge was produced. This effect did not occur when a thick lacquer was used, or when very small quantities of the thin lacquer were applied repeatedly, but this procedure was so slow as to be of no advantage. It was then considered that an opaque sticker or patch of suitable material and design could be applied rapidly enough for this purpose. A gummed paper patch was first tried. This could be applied readily and eliminated the splice noise but became brittle and sometimes peeled off after the film had been projected a few times.

Decalcomania transfers were also tried but found unsuitable. These transfers as purchased consist of a sheet of material, 0.001 inch thick, attached to a thick paper. They are soaked in water and the transfer then floated off onto the gelatin coated side of the film. This type of patch dries too slowly and does not become intimately attached to the film in the region of the splice, because there is no fusing together as with a cemented patch.

An opaque film was then made by incorporating dye and pigment in motion picture film base, but when the cement film they curled excessively. A critical thickness of four-thousandths of an inch was necessary in order to prevent curling. This thickness was considered excessive. If the film base was coated with a gelatin layer, this materially reduced the curling tendency.

The film patch material finally adopted consisted of clear film base, emulsion-coated, and rendered opaque by exposure and development. A film of minimum thickness (0.003 inch) was chosen so as to conform readily to the irregular sur-

FIGURE 2

face of the splice and prevent the splice from becoming too thick and stiff.

This type of splice (Fig. 2) was very successful. The patches were tested by applying them over splices in a positive film which was then run through a projection machine until the film broke down completely. The patches were intact up to the time when the perforations commenced to fracture at the corners.

The Splicing Operation.—The patch is applied with the aid of a registration block shown in Fig. 3. This consists of a bed plate fitted with registration pins and a pressure platen fitted with a rubber pressure plate. The platen is hinged to the bed and the rubber pressure surface is cut out so that it fits closely around the pins.

The motion picture film is placed on the registration block with the support side up and that side of the strip which bears the sound record in engagement with the four pins. The splice is placed at or near the center of the block. The pins fit the perforations so closely that pressure clips for holding the film in place are unnecessary. When the film is in position on the block the patch is picked up and held at one end by means of tweezers or an attached tab while cement is applied to the side which is to come in contact with the film strip. The cement

(Continued on Page 118)

BLOCKING OUT SPLICES
(Continued from Page 116)

application is accomplished by a single stroke of a soft cementing brush of medium size. The patch is placed immediately on the registration pins, the pressure plate brought down, and held in position for about five seconds.

The patch which proved most successful was so made that it covered the en-

Now it might be argued that this length causes a noticeable discontinuity in the sound. This is not so serious as might seem. A patch having straight instead of curved sides has been considered because it is much more easily made, especially if it is to be cut by hand. If the patch is shorter (about one-half this length, as has been recommended), the harmonics introduced by using a straight

TABLE I
Experimental Patch Dimensions
(See Fig. 4)

Patch No.	A	B	C
1	0.09 in.	0.29 in.	0.10–0.12 in.
2	0.1875 in.	0.65 in.	0.10–0.12 in.
3	0.1875 in.	1.00 in.	0.10–0.12 in.
4	0.1875 in.	1.40 in.	0.10–0.12 in.

The tests were made by running these strips through a standard type of reproducer operated at a normal gain setting. The modulation of the oscillator record was such as to produce at this gain setting a volume corresponding to normal speech. The noise from a well made splice, made with a widely used mechanical splicing machine, was plainly audible.

In general, the noise produced by a plain splice was least noticeable in the oscillator records, more noticeable in the 0.7 density, and most of the 0.1 density film. The patch number 1 produced a plainly audible sound, number 2 was somewhat less loud, and number 3 and 4 were only just audible on the 0.1 density film and apparently about equally effective.

Numbers 3 and 4 were noticeable because of their obscuring the oscillator record for a perceptible duration of time. Number 2 did not cause a noticeable interruption. The best length of patch is therefore indicated by number 2 or 3,

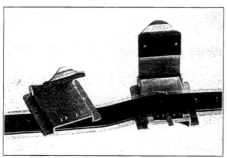

FIGURE 3

tire width of the sound track completely and extended as far as possible toward the center of the film strip without entering the picture area. Some of the factors which entered into consideration of the best design for the patch are discussed below.

Design of Patch.—As mentioned above, the patch or a "paint-out" performs its function by masking off an area of sound track of varying width so as to reduce the total transmission of the area illuminated by the slit in the reproducer at a rate which is insufficiently rapid to cause the recorder to generate an audible sound, and then, when the splice is past, uncovering the track in a like manner.

The reproducers now in use are capable of generating sounds of a frequency

edge for the cut-off as an approximation for an edge of curved contour, are of a higher frequency and therefore more prominent. Also, the fundamental is well within the range of the reproducer.

The following tests were made with a view to arriving at a design which would be a compromise between one which would be audible and one which would obscure too much of the sound record.

A number of patches having dimensions indicated in Table I were made and applied to (1) an oscillator record of low modulation (frequency 540 cycles); (2) a strip of clear film of density about 0.1; and (3) a strip of film flashed and developed to produce a uniform density of about 0.7.

FIGURE 5

number 1 being noisy of itself and number 4 interfering with the record for an unnecessarily long period of time. With reproducing systems which are capable of reaching 20 to 30 cycles it is necessary to use the number 3 size, because the smaller patches make an offensively loud sound.

The patch should cover the splice at the widest point. This condition is satisfactorily fulfilled, when the sound track is completely obscured for a distance equal to 0.098 inch each way of the center line of the central perforation (Fig. 4 at A). This allows for the standard "full-hole" splice. It is advisable to have the patch extend inward almost to the

(Concluded on Page 150)

FIGURE 4

not less than 20 to 50 cycles per second. Therefore, if the splice is to be designed so that it will cause no noise of itself, it should vary the transmission as it would be varied by a signal whose frequency is not more than 20 cycles. Such a signal would be represented by a patch whose contour would be described by a sine curve of an amplitude corresponding to full modulation. Its length for 20 cycles would be

$$\frac{18 \, inches}{20} = 0.9 \, inch$$

In each of these films two splices were made with 5 feet of film between them and then 17 feet were skipped before another splice was made. The first splice was left bare, the second was covered with the patch, and then 5 feet beyond the second splice a patch was mounted at a point where there was no splice. In this way each of the patches in the table was prepared for test. In order not to have any bad corners it is desirable to avoid cutting across perforations so that the choice of lengths is limited.

First Cameramen

David Abel
Harry Fischbeck
Henry Gerrard

Charles Lang, Jr.
Victor Milner
Allen Siegler

A. J. Stout
Rex Wimpy
Buddy Williams

Paramount Publix
CAMERA DEPARTMENT

VIRGIL E. MILLER, Head

MEL STAMPER, Assistant

SUZANNE ROY, Secretary

JACK BISHOP, Loading Room

CHARLES STARBUCK, Loading Room

Second Cameramen

Guy Bennett
Clifford Blackstone
O. H. Borradaile
George Clemens
Roy Eslick
Dan Fapp

Ernest Laszlo
Curly Lindon
Warren Lynch
James Knott
Fred Mayer
William Mellor
Harry J. Merland

Allan Nicklin
Otto Pierce
Robert Pittack
William Rand
Ralph Reynolds
Frank Titus

Assistant Cameramen

Lloyd Ahern
Lucien Ballard
Neal Beckner
George Bourne
Francis Burgess
Charles Over, Jr.
Alfred Smalley

William Collins
Warner Cruze
Russell Harlan
James King
Ted LaBarba
Byron Seawright

Fleet Southcott
Arthur Lane
Thomas Morris
Albert Myers
Kay Norton
E. J. O'Toole
Clifford Shirpser

Big Chief of the *A. S. C.*

Hal Mohr, for long one of the Motion Picture Industry's premier cameramen, was recently elected president of the American Society of Cinematographers. If any of the big tobacco manufacturers ever see this picture Brother Mohr will be $10,000 richer. It's a wow.

TWO MEN OF TEK-NIK TOWNE
(Continued from Page 88)

Inc., was completed. November, 1929, a single year later, their volume of business forced them to erect an addition. At the present time the floor space amounts to 14,000 square feet. There are approximately fifty-seven skilled employees working for the company, including engineers, draftsmen, machinists, office and delivery force.

Mr. Mole states that the latest perfected Inkie unit now accomplishes the equivalent of five individual lighting units of earlier models. Mr. Mole and Mr. Richardson believe that the future development of studio lighting equipment will be a simplification of units that will be adaptable to a greater number of uses. This, of course, will enormously increase the efficiency and decrease the tremendous expense of lighting equipment.

A URGENT APPEAL!

To All Local Unions:

The entire membership of the Cloth-Hat-Cap and Millinery Union Local 26 of Los Angeles is urgently appealing to organized labor to demand the union label from your store-keeper when buying caps or hats. By doing this you will help us in our unemployment situation and a great cause for solidarity. By neglecting the demand for the label you are helping the sweat-shop or the so-called bed-room shop, where one man or the entire family with a outside girl helper are working 16-18 hours a day under the most unsanitary conditions.

May we also suggest that this local will be glad to have your members communicate with us if they call on a merchant when purchasing a cap and he says he cannot supply one with the label. If you members will give us the names of such stores we will see to it they will have an opportunity to buy union made caps.

Thanking you in advance for your co-operation in this matter, and assuring you of our desire to render a similar assistance at every opportunity, we are,

Fraternally yours,

S. STEINFELD,
Sec'y of Local 26.

"Girl of the Golden West" Crew

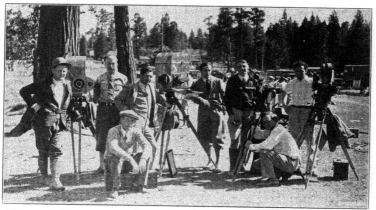

This handsome group constitutes the camera crew that shot "The Girl of the Golden West." Left to right—Geo. Trafton, Mike Joyce, Sol. Polito, Harry Davis, Elmer Dyer, Irving Glassburg. Down in front—Speed Mitchell, Ted Hayes.

The Larger Screen

—BY—

A. LINDSLEY LANE, *Local 659*

Its seems inevitable that a large motion picture screen will come. But a larger, not a "wide" screen. The question is: What will its proportions be?

Standard silent proportions were 3x4 and proved highly acceptable to cinematographic composition. Earth's surface 'eing "scratch" and most everything in life attracted to it and at least held there n inertia if not moving, argued for the ¬orizontal picture. And the horizontal ¬longation was a perfectly natural ex¬rression since horizontal motion plays a much greater part on the screen than vertical motion.

Then sound breathed a larger life into the silent cinema and with it came many complications; for one: The picture proportions approached a square due to the encroachment of sound-track into picture area. This was an unfortunate transitional development, a temporary maladjustment that must eventually give way to a more natural expression.

The enhanced 'illusion of reality' which sound gave to moving pictures was sorely

Among other complications the advent of sound in pictures gave rise to a new choice of subject-matter. The crude and untried mechanics of the different medium made necessary the use of subjects that would easily lend themselves and furthermore be effective. As part of this material came the musical comedy from the stage with its chorus of girls and boys. It was at the time of photographing the extended chorus that the small screen became so palpably inadequate, and brought to a focus the ideas circulating in the minds of executives and technicians that something was lacking in the pictorial part of the new medium as compared with good sound. Subsequently, wide film made its appearance, coming from a number of sources almost at the same time, varying in width according to the notion of the individual sponsor, and was shown to the public in two or three widths.

To the observer the effect of the wide screen is startling: The characters and the background fairly exude vigorous

standardized in the cities of medium and large population.

As for the logical compromise in screen proportions. The classic mathematical proportions of dynamic composition* are based on the natural progression of proportions within living things—a sequence of natural form, expressing a feeling of contentment and a sense of finality. This sequence of 'form' is analagous to sequence of 'tone' and sequence of 'color,' both of which are scientifically understood and artistically applied. Thus, in sound motion pictures, if the medium as a composite entity is to be fully effective the individual physical constituents of form, sound and color parelleling each other must completely harmonize and prove equally effective. Necessitating, in this instance, a serious consideration of prime importance: natural picture proportions — the shape of the standard larger screen. The Greek proportions, at root 2, formed a 3x4¼ relation. Root 2 is obtained by taking a perfect square, swinging its diagonal down to be the

6 x 8 5 x 8 4 x 8

cramped by the flowing images within the ill-proportioned and boxed-in square recoiling upon themselves. The illusion of reality of the sound, when well done, transcended and tended to destroy the diminutive and constricted pictorial figures, impinging upon them an unreality and futility they had never expressed during their days of silent action. And once the novelty of sound pictures passed, the new unbalance became disturbingly apparent.

So now the urge to perfected balance is seeking relief and satisfaction. A rebirth of vitality in the pictorial impression is imperative if a unity of 'sound-picture illusion' is to prevail.

The square picture is obviously not in harmony with the flow of cinematographic composition, there being nearly always excessive height for the essential spread, this overbearing height aggravating the already shorter and smaller figures—smaller that they may go places on a narrower screen, as the larger figures went like places on a wider screen. The coming larger screen will give the figures broader scope of movement together with increase of figure size, thus fulfilling two prime requisites of the pictorial impression: vigor and intimacy: creating a powerful unity of picture-sound illusion of reality.

action and vital intimacy. Great potential force and sweeping movement lie waiting for realization into a life of almost unbounded possibility and accomplishment thru the magic of the master director.

But the fresh force and intimacy of the larger screen makes a definite requirement upon sound, which in many perspectives must be richer to catch up with the re-vitalized pictorial impression: The pictorial characters having become more real, so must their voices prove an integral, compelling part of them, and not a thin, weak echo that comes from far away.

The aesthetic perceptions of man are limited physically. Were it feasible optically and mechanically to project a moving picture wide and high enough it would quickly pass beyond the very narrow 'angle of inclusion' of man's vision. At best a practical compromise must be established as standard: This being a spread of the maximum horizontal sweep commensurate with the minimum of eye movement. And it follows, the spread of the screen depends upon the size of the theatre and the distance of the audience from the screen. No doubt, at some future date, an especially favorable auditorium will be evolved for the presentation of sound motion pictures, and this will be

base of a rectangle, retaining the height of the square as the height of the rectangle. As will be readily seen this proportion closely approximates the proportions of the old standard silent screen. But when the Greeks recognized this formula the factor of actual movement of the picture mass within its boundaries was nonexistent. Today that movement is the essence of motion pictures. It would seem, therefore, that the Classic proportions must be qualified by the new factor which, as we know, is pre-dominantly lateral movement. A relatively increased expansion of width to height follows naturally, though just how much depends on many human, optical, mechanical, and economic contingencies, one of the most fundamental being eye strain.

The present day wide screen with its extreme spread causes undue eye strain to the observer and is consequently not an acceptable standard. Nor is it economically practical, since the majority of theatres are incorrectly designed to accommodate the extreme screen. The examples of wide screen we see today of 4x8 proportions are inconsistent with restful vision, also too self-conscious in their very squatty extent, thus precluding the ultimate in illusion and automatically eliminating them as a permanent stand-

(Concluded on Page 126)

William Seiter and his camera crew

Glen MacWilliams at the camera

This picture, which will become a classic, was photographed on location during the production of one of his famous Universal pictures. Left to right, standing—Glen MacWilliams, Paul Burns, Mr. Seiter. Sitting—Nate Watt, Marvin Wilson, Dan Dougherty. Photographed by Frederic Colburn Clarke.

THE LARGER SCREEN
(Continued from Page 124)

ard; besides appearing as a needless optical problem, and another genuine cost worry for production officials.

So it all comes down to a happy medium, specifically, proportions of 5x8. 4x8 are the proportions of the current wide screen; 6x8 are the proportions of the standard silent screen. And be it noted, 5x8 is of the proportions of natural sequence; 1, 2, 3, 5, 8, 13, 21, 34, 55, 89, and so on; i. e., 1 plus 2 equals 3, 2 plus 3 equals 5, 3 plus 5 equals 8, 5 plus 8 equals 13, 8 plus 13 equals 21, 13 plus 21 equals 34, 21 plus 34 equals 55, 34 plus 55 equals 89, etc., this progression having been scientifically ascertained to exist in natural growth respecting its 'form' proportions. So, after all, the 5x8 relation is not only a happy compromise, but a logical one, since through its relationship with the scheme of natural expression it endows the medium of the larger screen with the maximum of pictorial power, satisfaction and finality.

If proportions of 5x8 were to be adopted by the Academy of Motion Picture Arts and Sciences, the Society of Motion Picture Engineers and the industry, the cinematographers would find themselves one of the chief beneficiaries, for they would discover the majority of their sets and actor-movements naturally conforming to their camera scope, involving conservation both in range of long-shots and of camera panning and tilting in follow-action shots.

Directors would strongly approve of the 5x8 proportions, for to them it would mean more intense drama, because of a greater percentage of total screen area being vital movement and interpretation.

Art directors, studio managers, in fact, nearly everyone concerned in picture production would perceive the 5x8 proportions making his work easier and more effective of full accomplishment.

The distributors would more than likely cuss the added bulk of the larger reels. And whether it would make much difference to the exhibitor except through increased box-office receipts is doubtful, though the initial expense of installing larger screen equipment would be sufficient to induce many a headache. Yet, after the change has been gradually made and the public is taking to its favorite entertainment more avidly than ever before, it will be seen to be but a step ahead in the never-ending stream of progress and will only make more achievable the succeeding step.

*See works of Michel Jacob and Jay Hambidge on 'Dynamic symmetry.'

OLLIE LEACH RETURNS

Brother Ollie Leach, Local 644, New York, arrived in town with a new Photocolor camera and hopes to get busy within the next few days on color shorts at Columbia studios. He says this new camera is a great improvement over the one being used in New York for the past year. He hopes to be able to break in a number of the boys so they will be all primed and ready when the next shipment of Photocolor cameras arrives in Hollywood. He visited our offices and club rooms and greatly appreciates the cordiality extended him by Mr. Hurd and all the brothers.

Metropolitan Special Effects Department

Metropolitan Sound Studios have recently made the services of its special effects department available to various producers, with the result that a great variety of multiple exposure combinations in effects are being used currently in some of the leading talking pictures coming from Hollywood.

Howard A. Anderson, who was for a long time associated with Thos. H. Ince, Cecil B. DeMille, and Pathe Studios, specializing in optical printing effects and miniature shots of all kinds, has been placed in charge of this department at Metropolitan and is furnishing the services of the department to other studios making pictures, in addition to Metropolitan.

Especially commented on recently was the work of his department in Samuel Goldwyn's United Artists production, "Condemned," in which a remarkable effect shot was seen of a locomotive coming up out of the ocean.

Special combinations and effects are seen currently in Columbia's production, "Ladies of Leisure."

Effective combination of a great variety of war scenes and visions with sound have been done by Mr. Anderson for the Brown-Nagel Creator's Band subject, "Memories," which has been produced for Tiffany, and also in Sono-Art's production, "Blaze O' Glory."

A SHIP OF THE DESERT
By Frederic Colburn Clarke, 659

Brother Elmer Fryer was visiting at Fort Huachuca, in Arizona, and came rushing into the officer's mess hall one windy afternoon after his camera, an excited look on his face.

"What now," asked Colonel Winans.

"There's a ship over past the corrals and I want to get a picture of it," replied brother Elmer.

"What river is it on?"

"The Green river," broke in Lieutenant Hall, facetiously — knowing the Green river flows underground in Arizona, and that there was no other water nearer than the Rio Grande, seventy miles away.

"Thanks," floated back as Brother Elmer dashed out.

The officers finished dinner and strolled out on the porch puffing Partagas from the Colonel's private stock. Colonel Winans saw the photographer in a cloud of dust running towards a white object floating erratically through the haze.

"A mirage, sure," mused the Colonel, and departed for his usual siesta.

An hour later he came down officer's row refreshed by a nap and a cold shower to see a crowd in front of the mess hall, surrounding something and, from the middle of the assemblage, stood up a mast with sail and jib. The Colonel rubbed his eyes in amazement; this could not be a mirage—and on military grounds without a permit.

The crowd opened as he approached and discovered an antiquated automobile, dusty and dirty, rigged like a cat-boat. It contained two tired and sun-burned women who essayed weak smiles as Brother Elmer implored them to "look pleasant, please."

They turned out to be a couple of resourceful ladies from Iowa who, having run out of gas on the level desert, cut up their tent for a sail, found some dead manzanita branches for mast and spar, and, with a strong wind favoring their ingenuity, had taxied safely, if not gracefully, into port, or rather fort to beg the favor of a five gallon can of gasoline— and they had the price.

"See!" exclaimed Brother Fryer to the Colonel, "I told you there was a ship on the desert. Next time maybe you will believe me."

SERATIM

Dedicated to the cameramen and their colleagues in sound by Virgil Miller, Local 659.

Out of a Chaos Primeval,
Up from the muck and the ooze,
Wriggled a shapeless, ugly thing
With paramesic mind, to choose
Between the nether, Stygian dark
With its protoplasmic swarm,
Or pioneer in the upper sphere
Of the world's first sunlit morn.

Out of Mediaeval Oblivion,
Born of Antiquity's womb,
Struggled a new-born consciousness,
To roll the door from the tomb
Of unrecorded remembering,
Making the dead Past's thought,
Live again in symbol and sign
That the hand of man had wrought.

The Rosetta Stone, once crumbling clay,
Hieroglyphically concealed
The record of another's thought
For ages unrevealed.
Cold marble cluttered Aegean Hills,
Latent with beauty rare,
Waiting for an Angelo's hand to loose
The stories buried there.
His artistry conquered resisting stone,
He told of life, till life fled;
A painter dipped brush in blood—his own,
That a sun might go down red.
Each one gave of his all, and passed,
Leaving a work, mute and still;
The world applauded, and then forgot
Art's Legacy, until

Out of the Present's Perfection,
Flung from a source Divine,
Photography imprisoned actinic rays
To set Eternity's seal on Time.
Spread on canvas with brush of glass,
Dipped in light from Heaven's abyss;
Is a silvered image of Life, to last
As long as Love's first kiss.
Our picture is chiseled sunlight,
A Phidias and Rembrandt in one;
And the voice that was softer than silence, lives
And speaks from the screen: "Well Done!"

Something to Take Home

The Roman Chariot races had nothing on these "Horse Marines of the Pacific." The delegates to the Convention of the I. A. T. S. E. and M. P. M. O. will find them at one of the beaches. Try to find 'em. This stunt was framed and photographed by Robt. M. Connell, Pathe Sound-News.

"Hot Points"

Conducted by MAURICE KAINS, *Local 659*

In the past two years we have seen our craft grow from a more or less simple process to a complicated system of newly devised machinery and methods.

The cameraman of today is required more than ever to keep abreast of developments in his field and those branches of motion picture production closely allied to cinematography.

Of late there has been a great deal said pertaining to optical printers. They have won great favor amongst the various producers and have surely earned every bit of their popularity.

Lloyd Knechtel, in charge of all special effects and process photography at the R. K. O. Studios, has made an additional accessory for the optical printer which I am sure you will find interesting. The device herewith illustrated is a precision matting box, which can be used on a camera as well as on the optical printer. Various effects, such as barn doors, split stage doubles, and wipe-overs can be made with ease and accuracy. The apparatus is also used very effectively in making lap dissolves, etc. The four blades can be set at any degree of angle

MAURICE KAINS

and operated individually or collectively. A rotating handle operates these blades. Turns of this handle are usually synchronized with the numbers on the Veeder counter or footage dial. There are a great many other decided advantages too numerous to mention incorpo-

rated in this appliance. A word of credit should be given to William Leeds, who is responsbile for the design and construction of the entire mechanism, which was made in the experimental division of the miniature department at the R. K. O. Studios, this department being under the supervision of Don Jahrous. Lloyd merely had to explain what was needed and Bill went ahead and produced in his usual quiet but efficient manner. More power to Lloyd and Bill! What will they do next?

Ya just can't keep Gordon Head out of this column. Here he crops up again with another "hot point." The illustration showing Gordon and his still camera just about tells the story. The idea is particularly handy for exterior work where Old Man Sunshine persists in creeping in where he is not wanted. It's the cat's whiskers on windy days, too, entirely eliminating the nuisance of the old focusing cloth—easily and quickly folded up, always ready and quite efficient. Note also that Gordon keeps his shutter bulb right close at hand. Some boy, eh!

Stolen: One idea from Friend Baker, who is still the camera doctor for Technicolor. Friend is required to watch and inspect the delicate precision workings of the Technicolor cameras. Sometimes it is very difficult to see into the nooks and crannies of these big boxes; so the old boy just got himself one of those little mirrors on a long handle like your dentist uses when he is working on that aching tooth. It is invaluable. Friend says no kit case is complete without one. They can be had at almost any drug store or dental supply house. Some of the mirrors magnify and others do not.

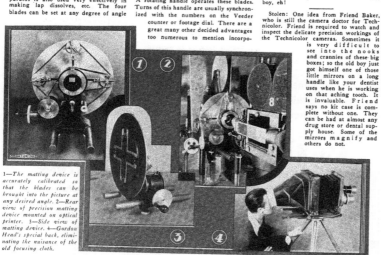

1—*The matting device is accurately calibrated so that the blades can be brought into the picture at any desired angle.* 2—*Rear view of precision matting device mounted on optical printer.* 3—*Side view of matting device.* 4—*Gordon Head's special back, eliminating the nuisance of the old focusing cloth.*

Sublime Moments of History

(Adolphus J. Meghafone Shapes a Scene for the Newest Super-Cinema)

—BY—

ROBERT TOBEY, *Local 659*

The scene opens up on what, in an off moment, might be called a set. After observing the set for a minute, the scene would probably close right up again, or go galloping off cross-country, but that is neither here nor there. Nor anywhere else, for that matter. The scene, if you must know, is a very large bathroom, done in the most DeMillionaire manner and decorated here and there with what have you. Now if you'll quit asking silly questions I'll go on with the drama.

Adolphus J. Meghafone (hereafter known as Meggy, per his own request) paces back and forth on the set. He knits his brows in deep thought, now and then dropping a stitch with a loud clatter. As he paces he mumbles to himself, or at least it might just as well be to himself for all anyone else could get out of the jargon. Actors, cameramen, and other menials wait expectantly for the product of the great brain's ratiocinations.

Meggy (suddenly, between a purl and a dropstitch): "I have it! In fact, Eureka! Garta Grabbo will throw her silken robe over her left shoulder instead of her right. This will give her the motif for a quick step to the mirror to view the beauty of her form in the altogether and therein see the reflection of the villain as he stealthily opens the door. Eureka! That is the solution! Our hours of pondering are not in vain."

Garta Grabbo (in broken English): "Hey, hey, beega da boy, I no t'eenka that's such a hot one. My lef' shoul' no photograft so good—gotta da beega bumps. You t'eenka I let me be photograph' like washa da lady jus' because you gotta da inspirash'?"

Joe Camera (2nd) (muttering under his breath) (way under): "Wottell's he think I got on here, a miracle lens? I gotta five inch on and I can't keep her in focus if she's gonna bounce all over the set."

His Assistant: "Aw whaddya want, a tear bucket? I oughta do the cryin', I gotta change focus for ya."

Bill Camera, chief cameraman and Joe's brother, goes by at this moment. "Pipe down, you two. "I'll do the moaning—that's my job." He gesticulates for emphasis and knocks the finder out of position. Joe gurgles once or twice, and then subsides and venomously commences whittling on a tripod leg.

Meggy meanwhile has been laboriously trying to piece together Garta's broken English and at this point says irritably to her: "I wish you'd been built so you'd photograph human on both sides. Now I suppose I'll have to move the mirror over so you can look in it without turning." Yells at his assistant: "Get that mirror moved over!"

Third cameraman: "Whoa! Don't get all stewed up. If you do that I get the

mirror in my shot and photograph the part of the set that's left out."

Meggy (nastily): "Then go sit on your laurels and we'll shoot it with two cameras."

Third Camerman: "Aw"

Meggy (yells): "Come on, boys, get that mirror moved!"

Sixteen men and two extras jump forward to move the mirror. One stumbles over a 10 k.w. which falls and strikes an assistant camerman on the head, completely demolishing the lamp. Two others lose their way and end up in the marble wash-basin playing double dummy whist. One of the grips slips on a cake of soap as he whizzes by Miss Grabbo, loses his equilibrium and a new pair of pliers, and strikes her amidships, almost causing her to lose her equilibrium, if you know what I mean. Five men eventually reach the mirror, and start to nail it in the new position. Grip No. 1 misses his nail by a good six inches and hits another grip on the left ear, and I don't mean gobo.

Grip No. 2: "Say, will ya call yer shots! You ain't no grip, you're not even a small satchel."

Grip No. 1: "And you're not even a headache. Another yelp outa you and I'll pop ya."

Grip No. 2: "Yelp!"

Both let go of mirror suddenly and it falls on toe of Grip No. 3.

Grip No. 3: " !"

Mirror by this time has fallen to floor and smashed into bits. Time out for two hours to replace mirror. Finally new mirror is in place and scene ready to shoot.

Miss Grabbo: "Now I go feex my make-opp."

One hour out for adjustments by Mr. Factor.

Meggy)wearily, as Miss Grabbo staggers back on set): "All right boys. Let's jump into the harness."

Bill Camera: "Hit 'em all, Jerry."

Jerry, the gaffer, blows whistle for lights. Seconds go by, and nothing happens. Jerry goes back of the set and finds juicer asleep by the board. Hits all the switches and the juicer and the set is flooded with light.

Asst. Cameraman: "Hey, script, how about a number fer the scene?"

Script Girl (chawing gustily on Mr. Wrigley's extra special—borrowed): "I give it to ya six times a'ready."

Asst.: 'Make it a seventh for luck. Or I'll take back that gum.'

Meggy: "Let's have quiet and make this scene."

At this juncture Kenny Speaklouder, the mixer, comes tearing out of his sarcophagus.

Kenny: "Sorry, but we have to change mikes. This one's noisy."

Meggy: "Well of all . . . ! You had all day to do that."

Kenny: "You had all day to shoot, too, but you didn't. It just went bad two minutes ago. If you can outguess a mike you're a better man than I am."

One-half hour out to hang new mike.

Meggy: "Now let's get this in the box. Quiet! Start your motors!"

Bill Camera (snorts): 'Wait'll we get the lights on, will ya? Hit 'em all, Jerry."

Meggy (snorts too, then brays, then cackles, then imitates turtle dove): "Let's go. Quiet! Start your motors."

The cameras start grinding and just at this instant a messenger boy comes tearing in onto the set.

Meggy: "Hey you! Quiet! We're making a sound scene. How long you been in pictures?"

Mess. Boy: "The front office says this bathroom scene is out. They just got a wire from New York saying it wouldn't get by."

Deathly quiet reigns on the set, broken only by the sound of a jaw dropping here and there; and Joe Camera slowly reaches up to his camera and pushes the button for a fade out.

"Soundfilm"

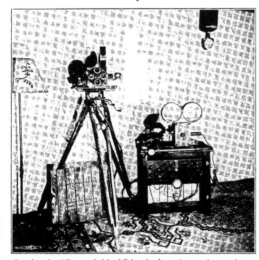

Recorder using different principle of light valve from other recorders now in use.
Recording either in camera or in separate recorder head. Conveniently portable,
high gain amplifier with new type microphone. Designed by Frank W. Vail, member
Local 659. Credit M. Schwartz with research work on recording valve.

A Quiet Day on Location!

GETTING THE CANDY SHOT

The Motion Picture of Today:
"*A Precocious Child*"

—BY—

CRITICUS

It has a great host of guardians and tutors, competent and incompetent, responsible and irresponsible, most of them allowing it to grow up without proper restraint and benevolent guidance; a few of them conscious of their parental duties, worrying about some of its traits and honestly trying to helpfully influence its growth from the present state of puberty towards a harmoniously developed personality loved by mankind.

Let us consider the problems which this last mentioned minority of dutiful and competent tutors are confronted with.

Studying the conditions of its peculiar conception, its birth and its ultra-rapid growth and its ultra-rapid growth, we are tempted to plot its horoscope.

We find it not only lacking of a normal healthy growth, but shooting up like "Jack's beanstalk;" forced by the hot-house conditions, created by brilliant, forceful and vision-saturated, commercial tutors.

Those shining examples of financial and commercial genius courageously took the helm of our beautiful ship into a stormy sea, but did not anticipate the squalls and breakers they were to meet. Very soon serious trouble developed in the hold. The captains on the bridge, however, did not realize the importance of the machinery below decks.

Not only did they not appreciate the help and counsel of the master of this machinery, but usually disregarded and even scorned it.

They kept him battened down, asking only for high pressure steam and only in desperate cases was he allowed on the bridge.

Fortunately, this master—the motion picture engineer—who kept the ship afloat and moving, was not dismayed by his cramped quarters; he has been, and still is, untiringly working to improve the efficiency of his beloved craft and to prepare for future emergencies, which he knows the captain on the bridge is bound to face. It is only when these emergencies arise that his efforts, so far little encouraged, are appreciated and welcomed.

Changing now from this metaphoristic study to stark realism—what are the results of the analytical studies of the broad technical aspects of the motion picture industry?

What are the fundamental problems which must be furthered and brought to conclusive issue in order to develop a stability satisfactory alike to producer and public?

The selection of a few of the most important of these problems is essential, in order to systematically focus and condense the activities of the motion picture engineer.

To do so logically, the ideal aims in the production of motion pictures must be

This is the first of a series of articles contributed by a man of profound scientific and practical attainments in a spirit of friendly constructive criticism. The next article entitled: "He Is Only a Cutter" will appear in an early issue.—Editor's Note.

realized, understood and striven for.

The production of motion pictures must be considered as a new branch in the realm of fine arts—a new endeavor to arrest the fleeting impressions of nature upon our senses. These ideal considerations, however, must blend with the realization, that entertainment is one of the necessary attributes of the motion picture.

The characteristic possibilities of this new art are overwhelming. Overwhelming, because they encompass the characteristics and possibilities of "all" the branches of the fine arts which man has so far enjoyed—music, poetry and pictorial impressions, combining the master-produced effects in the reproduction of form, light contrasts, undreamt of color control, the plastic effects of sculpture and the crowning glory: reproducing at will that dramatic gem—the never ceasing motion of mother nature.

This analysis helps us to group and segregate our problems into several classes—dramatic problems, problems of vision, including color and motion, and sound problems.

The dramatic problems are outside the mental domain of the motion picture engineer. His comprehensive knowledge of methods and means, as well as their efficiency, should however not be disregarded; rather should they be drawn upon and used as helpful information by all those persons and agencies active in the moulding of a motion picture from its inception to its finished state.

This certainly should hold true with the author, in the true and full sense of his name, the all important creator of the basis upon which the final perfection of the screen result is built.

It seems that the tools and means for expressing the poetic and dramatic conceptions of the creative author of motion pictures immeasurably increase his ability to convey to others the thoughts of his creative mind. So far, he is restricted to the written word or the comparatively limited facilities of the stage craft, but finds in motion picture production practically unlimited means for expression. At the present his mental creations have to be adapted to current motion picture practice.

More often than not adaptation is in reality a criminal literary act, running from mutilation to mayhem, and even

murder—a tragedy. We must, however, consider that adaptation should facilitate, not hamper, the conveyance of the thoughts of the author in their most impressive form to the public.

The ideal motion picture author should be fully conversant with the methods and means used in motion picture production and should think in terms of final screen effects when performing his creative work.

Training himself in such direction would immediately eliminate the "adapter" or non-independent scenarist, who can at best produce only a screen version, comparable with a mediocre translation of a masterpiece of literature from the original language into another idiom.

Once the author has mentally assimilated all the possibilities and governing steps, his brain child has to go through before it becomes a screen effect; once he thoroughly understands the tools and their efficiency he has at his disposition —then he will achieve the intimate contact with the public which he strives for.

Other conditions, some helpful and some at the same time restricting, exist for the composer. The importance of his contributions, however, is not as unassailable as that of the author. His efforts must be in channels pointed out to him by the work of the author and governed and often limited by the director, who is in supreme command and responsible for the disposition of the forces, effects and sense impressions constituting a motion picture.

As director we present here a composite personality, consisting of the director proper, the supervisor and the producer, all of which should always work in close harmony and under ideal production conditions should actually be a single person.

It is not generally realized, how versatile in his attainments such a director should be to properly use and control the various branches of motion picture technique to produce a final satisfactory screen effect.

To properly instruct and guide his art director, a mighty link in the producing chain:

(1) He must have an artistic critical faculty of observation of set and costume effects, as presented through the artistic conception of his art director, anticipating their changed screen values as far as composition and details are concerned.

(2) His artistic sense must also enable him to check the lighting effects proposed by his cinematographer in their final screen results.

(3) He must have the rare faculty to guide his actors in their emotional performance in order to personify the thought and intent of the author in

(Concluded on Page 140)

The Motion Picture of Today:
"*A Precocious Child*"

(Continued from Page 138)

dramatic and smoothly progressing continuity.

(4) He must study and analyze the continuously varying efficiency of these different personalities and their limitations and outstanding qualities and characteristics—mentally composing and actually, by his guidance, combining all of these details into a final harmony of dramatic screen rendition.

To spur his army of co-workers, however, to their best efforts, a director should endeavor to instill them with a activities are partly or entirely circumscribed by the dominating influence of the mighty trinity—that nevertheless his is the responsibility for shortcomings in final results and that only too often he has to bear the burden of criticism which should be born by others.

If we consider the technical end only, he is entirely dependent upon the means and material he is equipped with by the spirit of eager co-operation rather than assume the position and demeanor of an autocrat, forcing his helpmates into resentful bondage and grudgingly rendered service. He certainly, if anybody else, is in need of and dependent upon loyal and gladly given support.

The advent of sound in motion pictures has presented the director with a new tool of somewhat bewildering characteristics. It imposes upon him new responsibilities which are by no means enviable. The producer wants to use sound unstintingly, but the sound technique is so far away from perfection or reliability, that very often a director is knowingly forced to jeopardize the success of his labors.

While using such unreliable sound machinery, he must at the same time not only assume the position of a music critic, but also select sound effects, be it dialogue, synchronized accompaniment, solo performances or natural sound effects and place them in harmonious sequence during the progress of the picture.

He is at the same time aware of the unstable reception, sound pictures are accorded by the public, which on one side gladly accepts the novel pleasure of "hearing" a motion picture and on the other side becomes critically aware of the so far great difference between the original sound and that emanating from the screen.

It certainly calls for more than average directorial ability to successfully blend artistic pictorial effects, true to nature with special entertainment factors and pleasing sound effects, in order to produce a result, in every way and detail satisfactory to the final arbiter — the public.

To achieve this success, the present day director, however, apparently tries to impress the audience by continuous and overwhelming mass effects, be it sound, action or magnitude of set elaboration and multitudes of actors.

We certainly hope that the near future will not present us exclusively with continuous jazz effects in pictures, so short lived in the memory of the public.

To accomplish big things with small means is real art. But to accomplish big things with small means is impossible in this art, except when the small means in themselves are big—big as far as effectiveness, reliability and ease of handling is concerned.

Here we meet again the third of the trinity—author, director, engineer.

We must, of course, not only consider the motion picture engineer per se, but also all other departments and persons whose activities are closely interlocked with those of the motion picture engineer.

The results of efforts and labors of these allied departments are to a great extent dependent upon the motion picture engineer and the technical means he equips them with.

Take for example the cameraman who is in a class by himself. He is in the last analysis the one person responsible for the all important, indelible record, comprising the fruits of the labor and creative activities of author, director and motion picture engineer.

It is a peculiar and very unsatisfactory condition and fact that, although his motion picture engineer. The cinematographer cannot improve upon emulsion characteristics or laboratory facilities, equipment and practice, nor are his often valuable suggestions treated with a satisfactory degree of seriousness. And yet, he is blamed ninety times out of a hundred if faulty color records, fog, poor definition, excessive graininess, etc., etc., appear, for which defects other causes are often responsible.

The optical and mechanical means he is furnished with are far from perfect and he is continually called upon to remedy the imperfectness of his equipment, and so often called upon by the director to perform beyond its capacity. Let us consider only two qualities of his equipment. The quality to produce a predetermined value of correct focus and to unfailingly produce a correct exposure.

So far the motion picture engineer has failed to perfect the mechano-optical equipment to enable the cinematographer to control these two all important factors and even with the highest mental equipment and well digested large experience, it is always a gamble for him to produce pictures with thoroughly satisfactory focus and exposure effects on the screen.

It is the motion picture engineer who should remedy these two so important shortcomings of camera equipment. It seems that the responsibility for unsatisfactory final results should in these instances rest upon the shoulders of the motion picture engineer and not upon those of the cameraman, as is now the case.

The psychologically proper and logically correct recent endeavor to bring screen sizes and the corresponding expanse of scenes nearer to natural vision is another important problem for the engineering fraternity.

Sound recording too is now entirely in the hands of the motion picture engineer, who works through his assistants side by side the cameraman. In this regard we find the unfortunate conditions that the newer art of sound recording frequently clashes with the older art of pictorial recording and that we have as yet not found the common level upon which harmonious co-operation would bring satisfactory results in both instances.

Here we have again a mighty problem for the motion picture engineer. In this instance, we must think of a motion picture engineer theoretically and practically combining the knowledge of the engineer specialist, be it chemical, optical, mechanical or acoustical in the broadest sense, including electrical and musical training.

We have within the scope of this article, of course, only been able to consider the outstanding and fundamental conditions and influences which control the production of motion pictures and although this industry, more than any other, shows the importance of even the smallest part in this mighty interlocking mechanism, the burden of responsibility for smooth, economical and artistic performance lies within the harmonious co-operation of the aforesaid trinity.

Only the author and director so far receive the unstinted support of the producer, but whenever the producer realizes how much and how radical the motion picture engineer influences the financial result of a production, then he will, for his own benefit, listen more attentively to engineering counsel and realize the invaluable influence so-called unproductive work and efforts have upon the actual production and the final object of his mental focus—the box office results.

COLOR TODAY
By Jerry Fairbanks, 659

From the standpoint of the audience possibly the greatest innovation of modern motion pictures is sound, but from the standpoint of the cinematographer, certainly natural color can claim first place. This novelty has opened up greater fields for the cameraman in beautiful compositions and superb lighting effects than were ever possible before.

Natural color photography has rapidly developed during the past few years although accuracy of color was sometimes missing. Producers gave special care to the color scheme of sets and satisfied themselves with pleasing effects rather than faithful color reproduction.

Recently however, a series of experiments was conducted using the Multicolor process to see how closely the gorgeous colors of nature could be reproduced on the screen. For instance, shots were made on the snow-covered mountain tops among the stately pines. The results were most gratifying. The pastel shades reflected from the iridescent snow were perfectly recorded and the majestic giants of the forests showed a perfect green in contrast with a brilliant blue sky above. The gaily colored sweaters

" JERRY " 60 ⚡ 𝑅𝐸𝐷
Jerry Ash

and scarfs of those indulging in winter sports made a truly beautiful effect against the soft background tints. When projected on the screen one could almost feel the nipping cold of the snow country.

In striking contrast to all this, shots were made in the mighty desert of Death Valley. Famous painters have portrayed this district and produced the brilliant sun effect by use of strong purples in the shadows and a lavender haze over the distant hills. The inexperienced eye could not detect those shades in looking at the landscape, but the camera proved their actual existence, for there they were on the screen, just as brilliant as the artist's brush has ever painted them. It was not the time of the desert flowers, but the endless sands and rocks reflected a beautiful variety of tones which made the scenes genuine works of art.

There is no question today that nature's hues and colors may be faithfully reproduced on the theater screen, providing the photographer is thoroughly conversant with the process. Now if someone would only bring out an Aromatone; but we won't go into that.

The Perennial Pioneer

From the quiet and peaceful tranquility of a New Haven boiler works to the din and turmoil of the world's largest motion picture metropolis this story deals with one, who, through his keen perception of the future, an abnormal foresight and with that most commendable quality called determination—braved the perils that beset those who first ventured into the early motion picture fields—and made pictures becoming the very foundation of American home life. What is the actual condition this very day, constitutes a complete proof of the righteousness of the well-meaning pioneer's case: Talking motion pictures are in many tens of thousands of American homes and 'ere long four out of every five of the civilized domiciles will boast such!

All of which brings us to the subject

In this building at 900 Broadway, Bayonne, New Jersey, twenty-two feet wide, fifty-two feet long, on a lot one hundred feet long by twenty-five feet wide, David Horsley started making motion pictures in 1907 under the name of Centaur Film Company. When the Motion Picture Patents Company was formed in 1908 every single company in the U. S. was allowed to join except the Centaur Co. "They only had a wash tub and a sink", was the excuse for refusing a license. This then became the **birth-place** of the independent motion picture industry of the United States, and in five years time it became so big that it killed the **trust** which tried to strangle it in the place where it was born.

for himself an enviable name in cinema history.

William Horsley, well-known to anyone who knows anything about the motion picture business, was the superintendent of the best boiler works New Haven, Connecticut, ever had, up to this instant. For about two years every spare cent he earned at this occupation was "loaned into" the new motion picture business—that was during the two queer years of 1907 and 1908, when everything was so doubtful that half of the time Adolph Zukor, "Bill" Fox or Carl Laemmle knew not whether the beard was on or off their visages, mugs, or what have you.

Back in those days when a real pioneer was the only boy who counted for a minute or who ever brought home anything resembling bacon, "Bill" Horsley was making hay while the sun was shining. In short, he was looking far ahead —so far ahead that most people thought he was crazy. Just the same, he was probably the first practical business man to foresee the certainty of talking motion

of the sixteen millimeter film—or as they say among the knowing ones, the 16 mm.

Ten years ago when "Bill" Horsley first told "the boys" that the day of keeping·moving pictures out of the homes of American patriots was past it is common knowledge that it was figured out that he had lived in Hollywood's famous "Poverty Row" too long and was suffering from the dire results of it. Now, this moment, everybody in Filmdom wishes he or she could be in the advantageous position occupied by this same so-called "wild prophet." For, indeed, he has, more than any other one man, placed the motion picture diversion plus its newly acquired talking and sound power within the range of every moderate wage-earner and, if, for no other reason, he is not entitled to this special mention, let us concede right now that he deserves plenty of praise for pursuing so tenaciously the courage of his convictions. For example, he has spent no less than a small fortune in providing some way to protect those who purchased "silent out-

fits" against the onslaughts of time such as the audifilms brought into being. Specifically, he provided to the extent of placing on the market, a talkie adjunct which could be added to any projector for less than a hundred dollars—about ninety-five of said simoleons, to be exact.

From the beginning to the end, figure it all out as you may, when the man who places within your grasp those luxuries and delights you most desire fails to come forward and even let his name be known, he is entitled to some attention from an ordinary "scrub" newspaper reporter such as the writer of this. William Horsley never has tooted his own horn and therefore he has lost not tens of thousands, but hundreds of thousands of dollars.

Therefore, if William Horsley is the leading factor in the promulgation of the home-movie idea today, it is because he looked far ahead of the mere horizon and provided for all contingencies. Just like he blazed trails almost innumerable twenty and three years ago, he is doing the same thing today, and, in pursuing such a course, is providing employment for many men who otherwise would be idle. What more can be asked of any man?

And don't miss this point—so much has the idea of amateur movies taken a hold that some of the leading cameramen are embracing it with rare avidity. Tomorrow — and that means the very near future—nine out of every ten homes will be equipped with apparatus both for photographing and projecting motion pictures of family events and anything else. This will be due largely to the persistency of William Horsley in sticking to the belief that he was right when most everybody said he was wrong. He was right and is right. However, he won't make a fortune out of it. He is too generous a soul for that. Indeed, he has made several fortunes only to dissipate them in trying to help others to rehabilitate theirs.

"I've figured for a long time if the boys would take off their high hats—all of them—long enough, we'd discover that motion pictures were conceived, designed and developed for the people, not the prejudices of people, and therefore it long has been a foregone conclusion that talking pictures in the homes of ordinary folks would be of ordinary occurrence," comments this William Horsley.

If anybody—you, for instance—wants to know any more about all this business, please seek out "Bill" Horsley. He'll tell you plenty and with more enthusiasm than a two-year-old, though he personally is far past the kick-your-heels-up-in-the-air period.

James E. Woodbury

Portrait and Commercial
Photographer
GRanite 3333 5356 Melrose Ave.
Los Angeles, Calif.

| OUR PRESDIENT | OUR SECRETARY-TREASURER | MR. OTTO PHOCUS |

The Right Very Honorable Mister
William F. Canavan

Very often referred to as Bill and to those who know him real well (well enough to know that he won't sock them on the chin), Willie.

Bill was born when very young and after some years he grew up. Realizing that it was cheaper to see the show from back stage than from out front, he decided to become president of the International Alliance. After the show business slowed up and pictures became popular he tried to get into one of the studios. They said that they did not know him and had never heard of him. He said, "You will," and when he says, "You will," he means you will. So that is how he came to adopt the Cameramen into the best Labor Organization in the world. Now, when we don't get good cigars with our location lunches and we say: "We will tell Bill," we get good cigars.

Which goes to show that if you make up your mind you can do anything. So try and make up your mind to send in a couple of subscriptions to this magazine, because when we get enough advertisers this department will be pushed off the back page and then you won't have to read this hooey.

PROGRAM FOR CONVENTION
WEEK

Monday—All delegates will go to Pomona to look at a prune. Cameramen will not go on this trip as they have to look at prunes all week.

Tuesday—All deck hands will go to the harbor at San Pedro and watch ships come and go. These deck hands get about $60.00 per month.

Wednesday—If this is a clear day all clearers will go to the top of City Hall and try and see Catalina. If cloudy and windy, remain on the street and try and see clear up.

Thursday—All property men will take a trip and see the nice real estates that are located near Los Angeles. During this Convention special arrangements have been made to sell some.

Friday—All projectionists who do not keep sharp focus on Paid Up cameramen pictures are invited to a rowing contest 10 miles off shore.

Saturday—Not doped.

None other than Richard J. Green

Mr. Green is very democratic and without the least effort you can call him Dick, but be very careful not to call him Dickey. He is a pretty big fellow as you can see by the accompanying portrait. Not only big and heavy, but big in the eyes of all the members of the International Alliance.

Mr. Green has been treasurer for years, and as the writer is treasurer of his local union I realize what he has to put up with. Us treasurers sure have a lot of responsibilities. But in addition to all the treasuring he has to do he also has to do a lot of secretarying.

Mr. Green has a home in California. He has been in New York on location for a good many years and when he comes home expects to come into the Cameraman Local, providing that the cameramen are out of the booths by that time.

Mr. Green has said that "dues are a nuisance, but I at least give you a stamp for what part I get of them."

I forgot to mention to Ouida, the staff artist of this department, Mr. Green's nationality. She took it upon herself to accentuate what she thought was his nationality, because I told her he was the treasurer.

A number of our leading citizens were asked the following question:

Are you in favor of repealing, modifying or enforcing the prohibition laws of the country?

Their replies were as follows:

Pres. Canavan—I don't live in the country.

Vice-President Dempsey—Our trip to Montreal was very successful. We disposed of a great many cases that needed attention.

Vice-President Covert—Did you hear about the fellow that asked if we were the Green Fence Committee? He wanted the Grievance Committee.

Vice-Presidents Elliott, Beck, Browne and Nick (altogether boys): "Your the Flower of My Heart, Sweet Adeline."

Vice-President Harrer—Can you show me a short cut to Tia Juana.

Secretary-Treasurer Green — Those stamps are cheap at that.

Assistant President Dignam—Yes.

Hon. Mr. Lang—I think that California is a wonderful place. I have heard so little about it.

Boyle

No relation to Johnny

This is a very good likeness of Otto and his many readers will recognize him at once by his chins.

Mr. Phocus was formerly in the transportation business (taxi, lady) in Chicago and was forced, I mean, decided to go west. After looking the studios over, the Veeder counters, on the cameras interested him. It reminded him of a meter. He has been trying for years to beat this type meter, but so far has not found the right system yet.

HOW TO BECOME A
PROJECTIONIST
By Prof. Nill

I have received a great many inquiries as to how to become a projectionist, or in other words the chief manipulator of a movie machine. Knowing nothing about it except that it is nice work if you can get it, I will try to tell the customers about it.

First of all you must have a shave and a hair cut. Then you park your limousine and take off your gloves and climb up the ladder to the projection room.

Your assistant takes your name and hat and assures you that every thing is about ready and you call the manager and tell him that when ever he is ready he can go on with the show. Shortly thereafter you get a signal and the assistant starts the machinery going. The assistant puts on spool after spool of film and eventually it is time to go home. The assistant does a lot of work during the day, but there has to be some one there to tell him whether he is doing right or not so the projectionist must do that.

Now there is only one way that I know of to become a projectionist and that is to buy a magic lantern and hire an assistant. Then on the other hand some day you might buy a theater and if you have a PAID UP CARD you might be able to run a few spools.

Now for the benefit of those that want to remain I will answer a few questions.

I have a high arc intensity that fluctuates between commas and periods. What shall I do about it? Ans. Subscribe to The International Photographer.

The eccentric bearings of the mani-

(Continued on Page 146)

Out of Focus

A LESSON IN COMPOSITION
By Prof. Nill
Through special arrangement with the sheriff.

This picture was taken west of the Rockies in the month of May or June early morning light, late in the afternoon. As you gaze at the work of art shown

A lesson in composition.

above just close your eyes and see if you can follow me. There are horizontal and vertical bars in front of me (I mean lines), and the room is dark. This is a good way to plan your picture.

Do you realize the trouble the cameraman went to, to get this gem before you. Sometimes it takes weeks to get a view like this so we will proceed with the lesson. Understand this is all constructive criticism.

To start with we will take the camel in the center of the picture. This animal has marvelous stance, so the photographer was fortunate in getting this pose. Notice the position of the rear legs. There is one better position though, and that is to cross them in half light. By pointing the camera the other way you can make the animal go up hill. The animal as you can see has been under-developed, so the blacks have no half tones and the tail has been caught short.

Now as to the little cherub aboard the mule. Had it worn a frontispiece the back of the head would not be so far from the front. Lack of definition is noticed here especially on the eyelashes.

The one-legged boy on the left shows signs of joy. This is probably because he will only have to wear one shoe when vacation is over.

You can tell by the expression on the old fellow's face that it is a nice spring day and he is smelling the spring flowers as he passes the tannery.

All in all this is a very good example of what you can do west of the Rockies in June, July or August. In other words watch your high lights, shadows, exposures, subjects, and you have nothing else to worry about.

I expect to finish my contract with the people that I am now engaged with and as soon as I do I will try to give you a little article on how to tell good lenses from the bad. Hoping you and your kodack are well oiled will stop for this time.

RULES OF CONDUCT TO BE FOLLOWED DURING CONVENTION

Notice! Please pay as little attention to these rules as possible.

Do not gamble on street corners or in the hotel lobby. This gives the wrong impression and people are led to believe that you might be playing for keeps.

Do not throw empties out the window. We can get 2 cents apiece for them after you have gone home. This money will be used mailing back things that you forgot in your hotel room.

Loud talking and swearing are forbidden unless you mean it. In that case you accept all the responsibility.

When visiting Hollywood, be sure and wear golf sox and knickers or you might be taken for a visitor and someone might sell you the new Pantages Theater. This has been sold so often lately that it has been taken off the market.

All the Chicago boys are warned. If you hear a shot while in Hollywood, do not fire back as it will be a picture company making pictures.

Do not invite our policemen to have a drink on street intersections. At least ask them into the alley.

NEW DEVELOPMENT

To save thousands yearly

This machine will save time and money for you. Has been approved by the Akademey.

The machine illustrated above is now on the market and can be bought for money. Plans have been made whereby you can purchase this device according to the number of seats in your theater or by the 1st, 2nd, and 3rd lease contract. No matter how you buy it we can't lose.

No need to buy new needles to play your records. Use your old needles over and over again. Merely sharpen them on the above pictured machine. In spare moments or in slack times you can sharpen razor blades or pocket knives. For further information apply to Otto Phocus, 16th floor, O. F. Building, Hollywood, Calif.

FORTY YEARS BACK-STAGE AND CAN'T DANCE YET
By Prof. Nill

(Author of "Across the Los Angeles River with a Camera." "A Lesson in Sound and How to Write Scenarios with Two Chins.")

Having worked for the Auditorium Theater in Chicago and through my connections with the Century Grand Opera Co., I feel qualified to write a little story as to what goes on back stage. This will be interesting to those that know nothing about it and those that know about it won't read it; so I feel safe in going ahead.

It is always necessary to enter the theater from an alley and, on entering the door, there is an old fellow with a pipe that welcomes you, inside and takes your hat and points out the way to the superintendent's office. This old fellow is called the guardian or keeper of the door and will not take tips. After you have been inside a while and you have looked around, some one will come up to you and ask if you are enjoying yourself and would like to look into the dressing rooms.

After a tour of the dressing rooms and meeting all the girls you naturally would like to know about some of the machinery that it takes to make the curtain go up and down and as to how they work the lights. There is a man in charge and he is called the "Studge." He blows a whistle once for the curtain to go up and twice to come down. If the curtain sticks he blows up. The large board with all the light controlling devices is called the switching board. There are several rheostaffs on this which are used to make the lights change from one color to another. These rheostaffs are just levers, but at the other end is a piece of iron that goes into a barrel of salt water.

Then there is another set of men that wear milk-men's overalls and they are called suit-cases. This name is too long and they call them grips for short. If anything has to be moved that can't be pushed they call the grips and they get a good grip and lift it. These boys are all nice boys and their work is done in time to see the show, as a rule.

Then there is another set called the clearers. They clear things out of the way for the grips and the grips give them a little extra money each week for doing this so they like their work, too.

Then there is the flyman. I don't know just what he does, but he is up on top of the roof of the stage at all times, in case of emergency and about the hardest thing he has to do is to climb up there, but that is worth quite a bit. I have heard that he pulls hemp in his spare time and this must be like spinning flax, so he is occupied and this prevents him from falling asleep and dropping down on the acts.

The property man has a good job because he orders the food when necessary for an act and in that way gets lots of free meals which also helps. Then he can send out the laundry to a cheap laundry

(Concluded on Page 148)

Out of Focus

FORTY YEARS BACK-STAGE
(Continued from Page 146)

and put on a bill for an expensive laundry and this helps, too.

The small lights are called spotting lights and they have another square light with several lamps in it that is called an Oliver. The big curtain that goes across the front of the stage when the curtain is up is called a tormentor. They have to raise and lower it so much that it sort of torments the carpenter that has to move it and that way gets its name.

Before the show starts it is fun to watch the card players or deckhands as they are called, making ground loops over the ground rows and landing on the ground cloth.

The place that they tie all the ropes to its called the Rope Fastening Rail. The side of the stage nearest the switching board is called the prompt side because someone will be very prompt to ask you to move, as the electrician can't see the show if you stand there, so then you go to the other side of the stage and they call this the reverse side.

Before you leave ask the electrician if you can run the switchboard for a while as they are always glad to get some one to help them.

Oh, yes. I forgot to say that I was only at the Auditorium Theater for a week before they found out what was wrong. I ran a stereoptican with a falling star on the back drop and I was the fellow that would bring the star back into place again without covering it up. A very good effect, but as Joe Baker said, the scene called for falling, not shooting stars.

When with the Century Grand Opera Company I had charge of the Transportation department. I drove one of the trucks. Harry Beatty said he didn't think that I should go joy riding in a five-ton truck so I up and left.

Don't forget that this was over fifteen years ago and I might have made one or two mistakes on the technical names in this article, but nevertheless I worked in a theater.

ENTIRE CAST OF FOLLOW-THRU CO. SUBSCRIBES TO INTERNATIONAL PHOTOGRAPHER

Photograph by E. Schoenbaum.
Subscriptions by Earl Walker and Harry Hallenberger.

The above picture shows cast and reading from left to right the names are:

Standing—Lloyd Corrigan, Jack Haley, Eugene Pallett, Nancy Carroll, Frances Dee, Dot Pondell and Larry Schwab.

Seated—Charles "Buddy" Rogers and Zelma O'Neil.

On the ground — Electricians, Grips, Property men and the rest of the cast. Names will be sent for five new subscriptions to this magazine.

Mr. Lawrence Schwab has subscribed to the International Photographer for 11 years and 3 months. Thanks to a lucky pass in a—you know—game.

HOW TO BECOME A PROJECTIONIST
(Continued from Page 144)

pulator shows no respect for the arc crater. How about it? Ans. This should be referred to the Akademey.

Every time I go near the projection machine I get shocked. How come? Ans. Close your eyes or try running news-reels.

What is the Ohms law? Ans. If you owe'em you must pay'em.

What is a non-conductor. Ans. A motor man.

What does D.C. mean? Ans. Don't chisel.

What does positive and negative mean? Ans. If your wife says it is so, that's positive. If you say it's so, that's negative.

Do you advise wearing rubber boots when working on a hot line and is it necessary to stand in water? Ans. I insist on it.

———o———

If you don't see as many Union Cards here, as you would like to, be patient. There will be more next year.

In case any of the delegates should like to visit San Francisco on the way back, it is north of here some place and is supposed to be quite a city.

Hoke-um
By IRA

Bargain

Fore Sale, Cafe: Seating capacity 500—15 at a time. Call Robt. Bronner, care of Technicolor.

— : —

Not So Bad

Bob Tobey calls the time over 16 hours, "gravy time," so Maury Kains rises to ask if an Akeley man's overtime is pan gravy.

— : —

Leo Travels on Sunday

Leo Hughes says he never drinks out of a folded paper cup on Monday morning because it makes the water taste flat.

— : —

Old But Good

Ed Estabrook: "Why are you late for work this morning?"

Chuck Geissler: "Well, you see I locked the ignition, the steering wheel, the gear shift and the door to my car—then lost the keys."

— : —

Encouraging

Ralph Ash: "Cheer up, old man, remember that the first year of married life is the hardest."

Speed Mitchell: "Yeh? I suppose after that they make rolling pins softer."

— : —

Isaiah Was Right

Make-up Girl: "I think necking is positively repulsive."

Chorus Girl: "I don't like it either."

Make-up Girl: "Shake, sister, we're both liars."

— : —

One Moon

Fred Terzo (looking at Agfa time book): "We've been on this picture four weeks."

Harry Anderson: "Gee whiz! Is that all? It seems like a month."

— : —

A Terrible Situation

First Cameraman: "What? Box lunches again today?"

Second Cameraman: "Yes, de luxe against us."

— : —

Hopeless

Judging from Bob Bronner's whistle he couldn't carry a tune if it had a handle.

— : —

Infallible

Les White: "How do you know she's a lady?"

Art Reed: "Because, when we neck she makes me take off my hat."

— : —

In Every Port

Sweet Young Thing: "You can't kid me—you have a sweetheart in every city."

I. A. Rounder: " 'Taint so, sister. They don't hold these conventions in every city."

— : —

Fashion Note

First Assistant: "Does she wear too thin skirts?"

Second Assistant: "No; only one."

— : —

Motto

Motto for conventionists: See Los Angeles fust.

Precaution

Assistant Cameraman: "Where is my new I. A. pin?"

Cutter Girl: "I have it on my chiffonier."

Assistant Cameraman: "Um, well be sure to take it off before you send it to the laundry."

— : —

The Best in the House

Henry Prautsch (at Woolworths): "Is that sign outside correct?"

Clerk: "Certainly. You can have anything in the store for a dime."

Henry: "That's fine. I'll take that little blonde at the radio counter."

— : —

Convenient

These convention tickets are sure great; they allow a five day hangover in Los Angeles.

— : —

Seasonal

Conventionist: "Do you have hot and cold water in this hotel?"

Bell-hop: "Yes, hot in summer, cold in winter."

◆

Warner Crosby

◆

Wild West Stuff

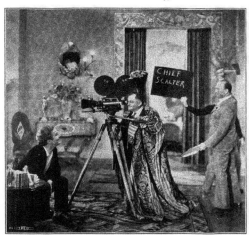

Depicting Brother Eddie Kull about to "get the axe." In this case, a hatchet. This still was taken on "Broadway Playboy," starring Frank Fay, who is seen on the left. At the right is Director Michael Curtis about to wield the well known hatchet. Mr. Curtis seemed to harbor a belief that Brother Eddie had rightfully earned the title of Chief Scalper after viewing the first day's rushes. In all justice to Brother Kull, the fact should be mentioned that he went home that evening and practiced giving sufficient headroom, thereby restoring to himself his former prestige. Mr. Curtis had nicknames for several others of the camera crew, among them being: Reggie Lyons, "Double Eagle"; Monroe Bennett, "Prince of Monaco"; Rod Tolmie, "Long Legs." In turn Mr. Curtis was given the title of "Iron Mike."

"WAY PAVERS" IN PICTURE PROGRESSION

Known to the motion picture industry as an organization that, for the past decade, has contributed to production of some of Filmland's most notable achievements, as well as consistently having supplied necessary electrical commodities to the many film organizations of the cinema world, Cinema Studio Supply Corporation, 1438 Beechwood Drive, today enjoys the distinction of being classed as one of the most up-to-date and efficient institutions in Hollywood's realm of Picturedom.

With years of practical experience to their credit, the personnel of this organization is numbered among those who have seen the nickelodeon of the "Old Plaza Days," become the most profusely embellished temple of cinematographic art—from flickers to sound film.

Harry B. Brown, Jess C. Rose, Joseph E. O'Rourke and "Joe" P. O'Donnell need little introduction. These men know the picture game—and the requirements that progression demands of the institutions that supply the studios with equipment.

More than forty employees, all of whom are necessary factors adding to the perfect running order of Cinema Studio Supply Corporation, competently produce the electrical accessories that make for the completion of perfect picture production. Everything electrical for the studio is offered by them—they have kept abreast of the times. A complete foundry, machine shop as well as other distinct units of this organization supply the fundamental electrical requisites to the studios.

Among the necessities to picture production, manufactured by Cinema Studio Supply Corporation is the Brown-Ashcraft Quiet Arc Lamp which, perfected as it has been to meet the requirements of silent pictures, with its intensity, offers the motion picture producer a lamp recognized today as one of the foremost in lamp construction.

Out of the Past

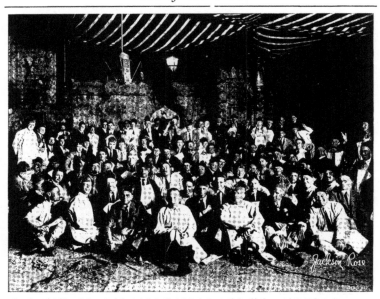

Here is a cheerful reminder out of the past that will delight the hearts of the old pioneers of the Hollywood cameramen. The occasion was the beefsteak dinner given by the A. S. C. to the members of the Motion Picture Directors' Association away back in 1917. The place was the old Hollywood Studio and the picture was shot one one of the famous Omar Khayaam sets. The reason Jackson Rose isn't in the picture is that he was out there in front photographing the gang. Those were the days of camaraderie between directors and cameramen. There was no high-hatting, no upstaging and most of the studios were happy families. In this history-making group are Reginald Barker, D. W. Griffith, Harry Beaumont, T. Hayes Hunter, William Beaudine, Rex Ingram, Ted Sloman, Allen Holubar, Frank Lloyd, John Ince, Clarence Badger, Edward LeSaint, William Desmond Taylor, George Melford, Jack Jaccard, William Seiter and others, directors. Among the cameramen were Alvin Wyckoff, Fred Jackman, Phil Rosen, Tony Gaudio, John Seitz, L. Guy Wilky, Sol. Polito, Ernest Palmer, Lyman Broening, Charles Rosher, James Van Trees, Virgil Miller, Edward Kull, Norbert Brodine, K. McLean, William Fildew, Billy Foster, Karl Brown, Arthur Edeson, George Meehan, Geo. Marshall, J. Hunt, H. Koenekamp, George Barnes, Bob Walters, Chas. Schoenbaum and others whose names are not at this writing available. Other guests present are Charley Chase, now a Hal Roach star and the artist, Ferdinand Pinney Earl.

HONOR WHERE DUE

Nathan D. Golden, assistant chief of the Motion Picture Division, Department of Commerce, was presented with a gold medal by the Projection Advisory Council, at 3 p. m., Tuesday afternoon, May 6, in the Capitol building, Washington, D. C.

P. A. McGuire, Executive Vice president of the Council represented Thad C. Barrows, president and the Board of Directors of the Projection Advisory Council. The Hon. William P. Connery, Jr., representative from Massachusetts, acted as master of ceremonies and the presentation was made by the Hon. David I. Walsh, senator from Massachusetts.

The medal is being awarded in accordance with the following resolutions:

WHEREAS, Nathan D. Golden, for many years a member of CleVeland Local No. 160, haVing suffered from seVere wounds whRe in the serVice of our country during the World War, which wounds resulted in the loss of a leg, and

WHEREAS, Nathan D. Golden, still an honored member of CleVeland Local No. 160, through his own ability, determination and courage has risen to a position of importance and responsibility as Assistant Chief, Motion Picture DiVision, Department of Commerce, thereby rendering a real serVice to the entire motion picture industry and reflecting credit on his fellow projectionists, and

WHEREAS, he has been of inestimable serVice to the Projection AdVisory Council since its inception, giVing adVice, encouragement and assistance to the organization.

RESOLVED, that the work of Nathan D. Golden is deserVing of recognition as part of the plan and purpose of the Projection AdVisory Council "to suitably recognise any work for the advancement of projection or an act of meritorious nature performed by a projectionist," and that an appropriate testimonial be giVen by the Projection AdVisory Council as a tangible eVidence of his sacrifices and accomplishments.

Signatures of Yore

Here's a poser for ye old-timers. It's a treasured possession of Theodore K. Hastings, well-known commercial photographer, 6615 Santa Monica Boulevard, and, most notably, a two-time circumnavigator of the globe.

From a day away back in the 80's, Mr. Hastings has had a proclivity for inducing celebrities of the stage to write their signatures for his collection.

As the reader will observe by examining the accompanying cut, Sarah Bernhardt and Anna Held, both long since departed, were among those who have acceded to his requests.

Lillian Russell and Eddie Foy, also among those gone, were as accommodating.

Mr. Hastings is very much a pioneer of the photographic field. For instance, back in 1888 he furnished the first athletic picture ever published, this was for the New York Herald, showing the then famous hammer thrower, Quirkberner.

Mr. Hastings, through his ability to get such picture subjects as would produce well for newspapers, won an enviable reputation among his colleagues of "Old New York and Gav Nineties."

An interesting bit of picture history which marks an episode in Mr. Hasting's career is that he photographed the first picture where real action was employed. This featured Kyrle Bellew in a story called, "A Gentleman of France," and was produced in Newark, N. J., with all of the scenes, location as well as sets "on canvas."

Another high-light of his career was camera service for the Hearst papers in Cuba during the Spanish-American War of 1898.

Mr. Hastings recalls the old "Moore" mercury vapor lamp—the Cooper-Hewitts which he was the first to use in photography.

"Old Nasseau Street" and "The Old Vitagraph," John Bunny and "The Girl from Kays"; Maurice Costello and Teft Johnson, "A Tale of Two Cities." Mr. Hastings was a real photographer even then, and that's going back a few years

It is with great regret that The International Photographer must announce the resignation of Jackson Rose as a member of the Board of Executives and as First Vice-President of Local 659, to take effect May 22, 1930. Mr. Rose retires from active service as an official that he may devote a greater part of his time to research along lines of color rendition and other angles of his profession.

Mr. Rose's record as a member of Local 659 reflects immense credit upon him. It is not too much to say that he has put in more hours than any other member of the original organizers and, as Chairman of the Negotiations Committee of the organization, his advice and co-operation were of inestimable benefit.

He retires with the regrets of the entire Local and a great sense of loss among the members of the Board of Executives in whose counsels he has been a power of force and of loyal service.

"Mike"

"Mike," says my chauffeur one' morning, "how would you like to take a ride on a rubberneck wagon?"

Mack talks to me like some women talk to their pet cats.

"O. K." says Mack, "we'll take you out and hang you up proper, so that you can listen in with the brethren who have come out here from all over the United States to give us and the ˙climate˙ the once over. But don't get so puffed up that you won't be able to hear all the guy with the megaphone spills to 'em. That bird has spent more time on a 'look-see' wagon than Von Stroheim ever did on a picture and he knows his studios like a movie fan knows his "stars."

We left the hotel with a full load and the sound truck hooked on behind. If you think I didn't feel important, you're crazy. It was up to me to record for future generations, all the sounds, hot air and otherwise, sure to occur on such a memorable occasion.

I forgot to say that some of the boys had their wives and sweethearts along; I mean, wives *or* sweethearts, and they all looked like beauty prize winners to me; especially the ones from Chicago.

"Ladies and gentlemen," roared the megaphone and I bet that mixer back in the sound truck cussed a plenty, but he must have 'saved his mirror, for we kept on going, "we are now passing out Sunset Boulevard, so-called because the sun actually sets at the end of it. On the right where the theater stands, was the former location of D. W. Griffith's 'Intolerance' sets, where the poor elephants stood for over a year before being removed by the Cruelty to Animals Society. On the left are the Tiffany studios. They are now shooting 'Ladies Left Over'. Pretty hard on the ladies, what?"

"Here is Western Avenue, with the now famous Fox studios on the left. They have about twice this much out at Fox Hills. Bill Fox got about $17,000,000 for the works at a forced sale and if it hadn't been for Tom Mix there wouldn't have been anything to sell. I understand that they have made a companion picture to 'Hell's Angels' and are going to call it 'Hell's Bells'.

"The imposing structure on the left is the Warner Brothers studio, as you can see by the sign. They have lately been working on a picture called 'See Naples and Die.' Hope you boys don't die after seeing Hollywood. We will turn here and go down to Melrose Avenue where movie history was in the making when you and I were playing marbles.

"This is Melrose and up there on the left are the Tec-Art studios, formerly the Clune studio. Years ago, John Clune made a picture called 'Ramona'. A masterpiece on celluloid and one of the seven best pictures ever filmed. The Tec-Art is where Delores Del Rio used to work and across the street is a studio where a lot of people used to work. Famous Players Lasky or Players Lasky Famous, I have forgotten which. One of their recent pictures is, 'Ladies Love Brutes'. Not a dog picture.

"Behind this fence on the right are the R. K. O. studios. Since the slump in the stock market, we don't know what R. K. O. stands for. They are busy building sound stages; they have to be sound you know, and haven't had time to make many pictures. 'In Old Rio Rita', is the one they spent so much money on, advertising.

"Now folks we are going north on Vine street. Real estate values in this vicinity have increased more rapidly than anywhere else in the world—likewise taxes. We turn here onto Santa Monica Boulevard and proceed west, where in a few moments you will see some more of what made Hollywood famous. Here's one of 'em, on the left, the hangout of Harold Lloyd, when he's ashore. Making a picture somewhere on the Pacific Ocean. Probably trying to put his spectacles on a whale.

"Now then, here comes the United Artists studios. They are artists all right but whether they are united or not I am not so sure. This is another instance of how ornate a structure an ordinary fence can be made under proper treatment. This is where D. W. shot 'Lincoln'—in all probability for the last time. Doug and Mary Fairbanks work here, too, occasionally. Doug helped Mary make one of Bill Shakespeare's pictures a while back, called 'Taming a Woman'. I wanted to take my wife to see it, but she wouldn't go, so I can't say whether Doug tamed Mary or not.

"We will now return to what is in many respects the most famous street in Hollywood, if not the whole world—La Brea Avenue. The entire scientific world was suddenly aroused from its slumbers some years back by the discovery of the bones of prehistoric monsters. La Brea Avenue was the place of their long entombment. But cinematically, a six-bit word you will observe, cinematically speaking La Brea Avenue will occupy a place pre-eminent because here on the right, with the English architecture, are the studios of the greatest actor of them all—Charles Spencer Chaplin" and the applause gave our friend on the mixing panel another thrill.

"Rest yourselves now folks until we get up on Highland Avenue."

"Up here on the left we are coming to the entrance of the Hollywood Bowl, in other words, 'Symphonies Under the Stars,' where our brother musicians helped out our brother electricians somewhat in a little difficulty last summer.

"This concrete boulevard, along which we roll so smoothly, is 70 feet in width and will reach eventually to Santa Barbara, if the citizens of that beautiful city vote for annexation to Los Angeles.

"We turn to the right now and pass over the hills into the valley of San Fernando. I am sure that you will agree with me that the view which will be presented presently, is most inspiring. Ah! Is is not so? There are the First National studios; a veritable bee hive of industry. Put away in a fire and burglar proof safe they have a dotted line with Dick Barthelmess' name on it which accounts for a lot of the activity.

"And now folks, one more proof that pictures pay dividends and we will have finished today's tour. We have reserved for you a name which has, more than any other, cemented a bond between the public and the producer—Universal Pictures. Their studios are on the other side of the beautiful park through which we are passing. Over the bridge to the left, the largest motion picture studio in the world. About two months ago they finished a picture entitled, 'All Quiet on the Western Front' and it has been quiet on the Universal front ever since.

"Well, that's that," said Mack back at the studio. "Another day, another dollar."

A NEW METHOD OF BLOCKING OUT SPLICES

(Continued from Page 118)

picture frame. Then there is no danger of leaving part of the splice uncovered through an inaccuracy in mounting the patch.

A total length of 1.00 inch was found best because of these considerations. A spliced sound record film fitted with the patch is shown in Fig. 5. The sloping sides have a length along the sound track of, in this case, $1.00 - 0.1875 = 0.8125$ inch, or 0.4102 inch each. This is slightly shorter than that for the one-half wave length at 20 cycles (0.45) and corresponds to a frequency of about 22 cycles.

The patch is very much easier to handle if it is supplied with a finger tab, consisting of a strip of stiff cloth attached with a non-permanent adhesive. (See Fig. 2 at left.) The tab is readily removed in the same manner as ordinary surgical adhesive tape.

"THE WORLD IS SMALL"

LENWOOD ABBOTT; *Local 659*

The Dutch officials of Borneo had very kindly furnished us with a small house along the banks of the Barito River, in a little river town called Poeroek Tajhoe, to serve us as headquarters in motion picture work in the interior of the island. This was about three hundred and fifty miles up the river from Banjermasin, the Dutch metropolis of Borneo.

I was having one of those celebrations which come far too often as we grow older—a birthday. We had given our Malay cook *carte blanche* to go the limit in honor of the occasion. He was instructed to collect all the choice viands the jungle could furnish. Our menu ran like this:

Beans, raised in California, baked in Boston, shipped to Holland and re-shipped to Dutch India; Del Monte brand (California) fruit; San Francisco packed coffee, and cheese from Holland, of course. No Dutchman will eat a meal without it. For dessert we had the ever present bananas. We had a regular schedule of five meals a day here in the tropics and bananas were served at both ends of each meal. I was beginning to slip on these in my dreams.

We were located almost directly on the

Photo by Lenwood Abbott

"Susie," so named in disregard of sex. An intelligent Dyak who became an able guide and all-around handy-man.

Equator, right in the center of Borneo, over three hundred miles from the coast in all directions. Our American salesmen had flooded the entire country with sewing machines and fish hooks, but as yet no Fords had arrived. American newspapers are used all over the Orient for wrapping paper and for making firecrackers. You may see them in bales by the tons, being handled at the docks.

After our wonderful dinner I strolled up along the one little dinky street of the town. There are a few Chinese *tokos* (stores), one or two Malaya jewelrymen and a few blacksmith shops. I stopped and listened for a few minutes to a Victor phonograph singing a native love song. This shows that American genius, while not willing to devote time to having our sales representatives learn the language, is able to build a machine that can speak it perfectly.

I then happened to remember that we were seriously in need of soap. So I went into a little Chinese store and, after a struggle with the sign language, managed to make my wants known. Imagine my surprise and delight when the Chinaman handed me my package wrapped up in a paper published in my boyhood town, "The Pasadena Star-News."

Welcome

to

Los Angeles

I. A. T. S. E.

CHARLES CRANE
Assistant

JOE NOVAK
First Cameraman (Akeley)

HARRY NEUMANN
First Camerman

WILLIAM BRADFORD
Second Cameraman

SPRING CONVENTION S. M. P. E.
(Continued from Page 74)

stage has been designed particularly for the production of lavish spectacles. It is equipped with a steel curtain weighing 65 tons, and each of its 12 floor sections is fitted with a hydraulic lift. A vertical steel track, 65 feet high, permits camera shots in synchronism with the rising stage and curtain.

The increased use made of incandescent lights has necessitated the installation of refrigeration plants in studios in connection with ventilation systems.

A novel feature of the sound studio at Wembly, England, is a tank fitted with a camera booth permitting under water photography. The four new German studios at Newbabelsberg are built as the arms of a cross; all recording and monitoring being done at the center.

A novel lens device for securing wider pictures without the use of wide film is of interest. It consists of two lenses held in a mount which screws onto the front of the camera. A lateral compression of the image is produced so that nearly three times as much image is included in the normal frame. The picture is then expanded to three times normal width on projection.

The added weight of sound-proof housings resulted in the design of stronger tripods. One of these called a "camera dolly," was constructed of telescoping steel parts attached to a triangular, rubber-tired traveling support.

Portable dimmers were devised for use in the Hollywood studio. They were used individually or in connected units of 2 or 3, for sunrise or sunset effects. Each unit handled 20 kilowatts.

A joint committee of the Producers and Technicians branches of the Academy of Motion Picture Arts and Sciences reported on an investigation of arc lighting in 15 Hollywood studios. Three types of filters were found in use: (a) individual choke coils for each lamp unit; (b) choke coils for each group of lamps, and (c) the use of large electrolytic capacity across the generator windings. The investigation is being continued with plans for making oscillograph records of the commutator ripple at each studio.

Abadie reported before the cinematographic section of the French Photographic Society on some interesting experiments with gaseous illuminants. Mercury and neon cannot be used effectively in the same tube to give a white light, but when their combined light is supplemented with that from vaporized antimony and arsenic, a good white light is produced for the photography of colored objects. A lamp has been produced which contains neon gas and a cadmium-bismuth alloy at the cathode. After heating, the cadmium is vaporized and its arc given a light of desirable spectral distribution.

Several French s t u d i o s have commenced sound productions on a large scale, a number of them by the variable area process. Societe Gaumont, which until quite recently recorded on the full width of a separate film by the Danish Peterson-Poulson method, have adopted fixed density recording in the margin of a separate film. This record is printed

subsequently on the border of the film bearing the positive image.

Great interest has been shown in the sound school sponsored by the Academy of Motion Picture Arts and Sciences and with the completion of the fifth and sixth sections, more than 900 studio workers will have taken the course. The lectures presented by various authorities before this school have been assembled and published as a Technical Digest.

The Debrie camera has been fitted with a sound-proof housing consisting of a box, containing the motor drive encased under the camera, and a cover on a vertical track which may be lowered or raised quickly by the movement of a hand lever. All controls are accessible from outside the case when it is closed. The merits of 16 different types of camera silencing housings used in Hollywood studios were tested by a joint committee representing the producers and technicians.

Booms for holding the microphone over the actors have undergone material development and several ingenious devices are now available for handling microphones on the set.

A modification of the Poulson magnetized wire recording method uses film base impregnated with colloidal particles of an alloy of nickel, cobalt and iron as the magnetically susceptible recording material. The film possesses a slight lavender tint when so treated.

Another novel recording process is that suggested by Madelar which records a groove on the film support by means of a diamond stylus.

Printing machinery was being redesigned rapidly for better quality and more rapid production of sound-on-film prints. One manufacturer of printing equipment brought out a single operation printer and another manufacturer was reported to be working on a new model.

One of several problems connected with the reproduction of sound has been the proper control of sound level in the the-

atre. Much use and some abuse of fader control has resulted from efforts to correct for volume variations resulting from recording sound at different levels and which were not entirely smoothed out by re-recording. One studio has devised a "squeeze track" for the purpose of adjusting these differences in level. This consists in blocking out part of the sound track by exposing it before development to a negative consisting of a black line of varying width from zero to the full track width. The positive sound track becomes a record of varying width contained between two black lines filling up the remaining space of the track on each side of the track itself, which is in the center of the space.

Equipment for cutting has been developed on a basis of the needs experienced for sound pictures and many of the makeshift devices are giving way to commercial products embodying the necessary features for handling sound films. Three designs of one type of equipment were available for sound film editing: (a) a sound picture synchroniser for use with records on separate films; (b) a disc reproducer, and (c) an apparatus for use when sound and picture are on the same film.

As a result of a serious studio fire in the east and a laboratory fire on the west coast during 1929, a great deal of pressure was brought to bear on all laboratories to increase their safeguards for fire prevention. Even before the two fires, however, a committee of representatives from all laboratories were appointed by Mr. Will Hays to work with the National Board of Fire Underwriters to revise the code of recommended practice for laboratory requirements.

Impending adoption of wide film introduces problems for the film exchanges, since the larger reels will require larger shipping cans, and will cost more to ship because of their increased weight. An

(Concluded on Page 176)

SHOOTING TAKU GLACIER

Scene when an iceberg big as the Woolworth Building broke off and nearly swamped Brother J. M. F. Haase and his associates.

Aluminum Boons for the Boys

It makes little difference where you may walk on this wonderful sphere of ours—you're liable to be walking on aluminum, for no less than one-twelfth of the whole earth's crust is aluminum, and, in view of the fact that this particular metal is only one-third as heavy as steel, it facilitates the task of walking for those who must lug such things as tripods and various containers. Herein the Boothe Company, 1333 Willow Street, Los Angeles, being the largest dealers in aluminum and its alloys, enter the picture in moving picturedom as a force to be considered since this c o n c e r n specializes in supplying everything in this line needed by manufacturers. Forsooth, the Boothe Company is the largest dealer in especially duralumin, the main alloy, in the United States and possibly the entire world.

Ever since the year of 1825, when the Danish scientist, Hans C. Oerstedt, first isolated aluminum in the form of minute metallic globules, it has contributed a large share to the progress of humanity, becoming a requisite to electrical development, aviation advancement and now, most notably, the producing of motion pictures, the usefulness of the metal having been given a tremendous boost by the advent of sound, due to its adaptability in the building of sound-proof booths and the like. Only recently the Boothe Company completed something of a marvel in duplicating steel beams in duralumin

for Metro-Goldwyn-Mayer, and among the most extensive users of its products among the cameramen is Merl LaVoy, who has equipped himself with such tripods, map containers and what-not.

Originally aluminum c o s t $90 per pound, but today you can buy all you want for twenty-five cents per pound. This remarkable reduction in price has been due to the discovery of Charles M. Hall in 1886, that the metal could be extracted from clay, rocks and soil much easier and cheaper with the aid of electricity than by chemistry, and, most important of all, it places this valuable substitute for steel within the reach of all.

So far as its usefulness in the manufacture of cameras, portable equipment and sound apparatus is concerned, it has become indispensable for the double reason that it is so much lighter in weight and in most cases far more serviceable than the best of mild steel.

The Boothe Company makes a special business of solving the aluminum problems constantly confronting picture producers, and, both I. J. Boothe, the owner, and his sales manager, A. S. Everett, devote many of their wakeful hours to rendering such service.

"To provide boons for the camera boys," constitute a sort of a watchword in this House of Aluminum, and, it must be conceded the burdens of those who do the photographing of photoplays are be-

THAT GOLF TOURNAMENT
By JIMMIE PALMER

Well, boys, your Golf Committee is again on the job making preparations for a bigger, better golf tournament.

The magic-date will be Sunday, September 7, and all the celebrities will be there including Eddie Blackburn, Wes Smith and King Charney.

Harvey Gould's dog, "Nig," our mascot, will be in attendance to make a collection of golf balls for Harvey, and Glen Kerschner will do the cartooning as usual.

We look for practically 100 per cent turnout this year for the absentees last year are good and sorry and they aren't going to be left out any more.

Because of the great amount of work attendant upon the increased attendance the Golf Committee has been enlarged and now stands: William Foxhall, Virgil Miller, William Snyder, Reggie Lanning, John Mescal, Norbert Brodin and myself, chairman.

This is a live bunch and you can look for the hottest golf tournament in the history of Hollywood and vicinity. And prizes—but please be patient!

Look for the golf stuff in every issue of The International Photographer for there will be a lot to tell. When better golf is played the International Photographers will play it. Remember — September 7th.

ing lightened prodigiously since equipment made of this metal or any of its alloys is much more movable than it ever was before.

We invite you to familiarize yourself with the mechanical properties of aluminum and aluminum alloys Some of the light alloys have the strength of mild steel, yet maintain the lightness of aluminium Information and samples furnished upon request.

Dynamic Photography

—BY—

FRED WESTERBERG, *Local 659*

FRED WESTERBERG

It is quite apparent that today as in the days of ancient Greece the principles of dynamic symmetry are again finding their way into the arts, both fine and applied. What a splendid renaissance this promises to be! A golden age of beauty in which photographic art, too, will find a place.

This revival is due in large measure to the enthusiastic study of Greek symmetry made by the late Jay Hambidge. He found that the shapes taken by plants and animals show definite dynamic characteristics, the product of life itself, forever in motion, never still. He also found that this symmetry of motion and life which dominates all nature also dominated Greek art and architecture and made it the thing of beauty that it is.

In analyzing the field of dynamic symmetry for possible help in the creation of photographic art, two basic assumptions command attention. One is that proportionate areas in a picture or object have greater significance than linear proportions. The other assumption is that living objects in growing, exhibit a tendency to conform to a basic law of proportion which can be expressed by the ratio 1 to 1.618.

These assumptions were kept in mind to some extent in working out the various rectangles which serve as the foundation for the practical application of dynamic symmetry. The rectangle of the "Whirling Squares" (see article "Is Thirty-five M.M. Film Passing" in The International Photographer for October, 1929) is perhaps the simplest since its proportions, 1 to 1.618, are taken directly from

nature. However in applying this proportion as a linear dimension the proponents of dynamic symmetry do not seem to have really reached the heart of the matter.

The significance of area was realized in working out the various root rectangles

Fig. 3

of which the root 2 rectangle (Fig. 1) is an example, but in missing the root 1.618 fundamental rectangle of them all seems to have been overlooked.

Here we have the missing link that photography especially has needed in order to carry out in a simple and practical way the fundamental phases of dynamic symmetry. The photographer as a rule has neither the time nor the inclination to work out elaborate schemes of composition but he can and does strive usually to make his compositions artistically sound.

This root 1.618 rectangle was found curiously enough directly from nature by the measurement of sea shells. Fig. 3 is a fine example photographed by Edward Weston. Within narrow limits the logarithmic spirals produced by these molluscs have a ratio between radii vectors 180 degrees apart of 1 to 1.618. Tangents drawn to this curve 90 degrees apart produces a rectangle 1 by 1.272 which is the root 1.618 rectangle.

Two significant attributes of this rectangle are:

(1) It is the only rectangle in which either crossing line meets the diagonal at a point which divides the whole rectangle vertically and horizontally according to the dynamic ratio of 1 to 1.618. In Fig. 3 for example the line OD meets AB at O.

$$\frac{OH}{OS} = \frac{OC}{OP} = \frac{1}{1.618}$$

(2) It is the only rectangle capable of

(Concluded on Page 164)

ROOT 1.618 RECTANGLE.

AD = 1.000
AR = 1.272

Fig. 2

$\sqrt{2} = 1.4142$

1.4142

ROOT 2 RECTANGLE

$\sqrt{1} = 1$

Fig. 1

THE EYES OF THE RAILROAD

In this day of highly specialized work, when the ambitiou sman, to be outstanding, must concentrate his efforts and abilities on one branch of his chosen profession, there is one place where there is no demand for a specialist, and that is the photographic department of a modern railroad.

To this department comes daily all classes of work and the man who handles it must be an artist skilled in every branch of photography, who can and must consistently produce the highest class of work.

He must be a portrait photographer and a good retoucher, for there are almost daily calls for portraits of officials.

He must be a good landscape artist, capable of getting the most artistic and enticing views of points of interest for the advertising department.

He must know something of engineering to make progress pictures of construction work, and pictures of accidents for the legal department.

He must be able to handle bromides of immense size; to make perfect lantern slides; to copy all sorts of pictures, old in new, in monochrome and in color; and to use a speed camera.

He must also be able to operate a motion picture camera with a high degree of skill, and with some railroads be able to supervise the making of sound pictures. He must also do the laboratory work himself.

Loyal Himes, Local 659, is head photographer of the Southern Pacific Company, and has a force of eight opertors under him, al lof whom are finished photographers doing daily all classes of work. Mr. Himes, in addition to his supervisory work, handles the motion picture photography himself.

Modern "art" photography, however, has no place in railroad work. All railroad photographs are made for record purposes, and must be clear cut and needle sharp. Diffused and soft pictures are taboo with the possible exception of occasional portraits.

An Eternal Triangle

VIRGIL E. MILLER, *Chief of Paramount Camera Department*

A few years ago I wrote an article using the above title. The article dealt with the cameraman, the director, and the story. Today, with the multitudinous interests that the advent of sound has imposed upon the manufacturer of talking pictures, I believe that a triad of the fundamentals can be so chosen and correlated that the analogy to the triangle still holds true.

An equilateral triangle is described as one having all three sides and all three angles respectively equal. Any divergence of line or angle will either shorten or lengthen the sides with a corresponding change in angles; equality will be replaced with inequalities; equal angles will become either acute or obtuse, and the structure that symbolized strength will have lost its greatest virtue.

A well-balanced talking picture must contain three fundamental values, viz.: Story, Direction, and if I may use the word, Presentation. That there must be a story is axiomatic; it is equally self-evident that the story must be told well and entertainingly ; that is direction. Without good photography and good sound, the efforts of both the author and director are wasted.

I am not particularly concerned with the story at this time; suffice to say, as the story is weak, so also is the whole picture structure—one leg of the triangle has departed from the equilateral ideal. Neither am I particularly concerned with the direction; a good story, poorly told, throws a terrific strain on the other two legs of the triangle, and we again have an unbalanced whole. But I am concerned with the third value, Presentation, for Sound has become co-ordinate with Sight, giving us at the present time the third leg of the triangle, of such tremendous value and possibilities that its strength temporarily will support the adjacent weakened sides; eventually these sides will be built up to meet the newly imposed conditions, giving us an equilateral structure stronger than was ever builded by silent pictures.

A mutual appeal to the ear and eye means a harmonious blending of co-ordinated effort, and it is this phase of the work of making sound pictures that interests the cameraman. Prior to the introduction of sound, photography reached the very ultimate of beauty; Corots, Rembrandts, Titians, Millets, and Raphaels flashed on the screen with the speed of light, kaleidoscopically following each other in bewildering array, either building up a weak story or bolstering up poor direction until the audience forgot both story and direction; or making a good story and fine direction stand out and above the average because of the beauty of rendition on the screen.

With the advent of sound, photography was forced to give way to its "swaddling clothes" brother; this new plaything, appealing to one of the senses that had hitherto been ignored, suddenly became an all-pervading force that brooked no intervention; it rode rough-shod over built-up traditions, and the poor cameraman played second fiddle to a new instrument—the microphone.

With the coming of the "mike," and the accompanying sound-track on the film, the cameraman's difficulties were multiplied several fold: His composition had to be revised to meet the new nearly square picture; he had to shoot through an added piece of quarter-inch glass interposed to lessen noise; he had to dodge microphones that further impaired his composition; he met with new lighting requirements that had to be mastered; he was told to forget photography in the interests of sound. With all these restrictions, and with his being told where to place his camera and that he must shoot under the conditions imposed by sound men—many of whom had never seen a motion picture camera—he was confronted with a dilemma that was trying, to say the least.

After a year or more of sound work, it can be said that the same determination that made the cameraman successful as a silent artist has made him even more successful as a cinematographer of sound pictures; he has overcome most of the earlier difficulties that beset him, with the result that good photography is coming back. It has not yet attained the perfection that it formerly had, but with the laboratory co-operating to eliminate the Greek alphabet (Gamma mostly), and a closer co-ordination existing between the sound men and the cameramen, it won't be long until an audience can once more revel in the beautiful renderings of light and shade and color that is their due.

This article would mean nothing unless it carries a helpful thought, and it is my impression that the greatest reason for the improvement of sound photography lies with the inherent qualities of the cameramen themselves in adapting themselves to changing conditions, and particularly to their ability to work with and alongside the sound men who operate the microphones. For a time there was a certain amount of bitterness and jealousy existing between these men, but in most cases the men themselves have learned the futility of achieving results under such conditions, and are working together, giving and taking, that their combined or composite product may reach the high standard necessary to keep the old box-office cash register ringing.

Such co-operation not only raises the standard of the product itself, but increases the morale and lifts to a new high level the qualities of the cameramen themselves; it gives us a body of men who can take their place alongside the men of those professions that make the world a better place in which to live. Such co-operation strengthens the third leg of the triangle, forcing the other two prime values, story and direction, to meet the added strength if sound pictures are to be equilaterally restored to a healthy condition that will endure.

ON UNITED ARTISTS LOT

(Continued from Page 102)

feel lucky that they have such a capable head of this department.

P. S. Don't forget the telephone number, Westy. I mean all this and am not trying to red apple, Fred.

Westy is the original Dr. Jekyll and Mr. Hyde; he is always in two places at the same time. And I defy anyone to find him in either of those two places. In fact he is so busy that he has worn out four pairs of shoes this month and they weren't "Youngs" either. Westy comes famous runner Nurmi. It's a good thing he never met Fred because Fred would outrun him sure.

DYNAMIC PHOTOGRAPHY

(Continued from Page 162)

being divided into a series of similar whirling rectangles whose respective areas conform to the summation series which is based on a factor of 1 to 1.618.

In Fig. 2 for example:

If area	ARBD	= 89
Then area	ORBP	= 55
And area	OSBP	= 34
And area	OPDH	= 21
And area	OHAC	= 13
And area	OCET	= 8
And area	OTFU	= 5

This rectangle is made to order for the photographer with an 8x10 camera. The size 7½x9½ obtained when ¼ inch is matted out all around is almost exactly the root 1.618 shape.

And now we come to the application of Dynamic Symmetry to photographic work but that is another story that will have to be told at a later date.

Suffice to say at this time that dynamic symmetry will not of itself create pictorial art. But it can be used to indicate, more effectively perhaps than native judgment alone can, the unnatural and grotesque on one hand and the natural and the beautiful on the other.

Left to right—Bryan Foy, John Lavin, Ed. Du Par, Willard Van Enger, Leo. Green.

By LES ROWLEY

After three years, the pioneering crew who made the first Vitaphone Variety in Hollywood is still actively engaged in the production of Vitaphone pictures for Warner Brothers.

On the little wooden sound-proof stage on which was filmed and recorded "The Pullman Porters," the first short reel Vitaphone talkie made in the west, was a crew that wrote the first pages of talking picture history.

They were: Bryan Foy, director; Edward DuPar, chief cinematographer; Willard Van Enger, second cameraman; Leo Green, chief electrician; John Lavin, grip, who is now assistant foreman of grip department, First National Studio; Pinky Weiss and R. Van Netta, property men.

This group of men remained together during the making of innumerable Vitaphone Varieties for many months. Practically the same crew pioneered again with the filming and recording of "Lights of New York," the first feature length all talking film ever made.

With the temporary transfer of the Vitaphone short feature staff to New York and the subsequent dividing of production activities between Hollywood and the Brooklyn studio, this crew was gradually dispersed. Edward DuPar is now in New York as chief cinematographer for Murray Roth, directing Vitaphone Varieties there.

With the return to Hollywood of Bryan Foy, Willard Van Enger was promoted to the job of chief cinematographer under Foy, who is in charge of Vitaphone Varieties production for Warner Bros. in the West.

Today all the original crew except DuPar can be seen at work at either Warner Brothers or First National Studios.

Bryan Foy, pioneer talking picture director, has installed his department at First National where he is turning out a large number of Vitaphone Varieties using outstanding stage and screen talent.

Willard Van Enger is supervising photographer for the department.

Pinky Weiss is now one of the assistant directors of Vitaphone Varieties.

Leo Green, chief electrician, is busily engaged managing electrical crews on various Vitaphone specials and technical productions, and R. Van Netta is working as grip and property man on the talking pictures.

History may not record and remember these pioneers of the talkies, but they certainly will have something to tell their grandchildren that will rival any bedtime story ever told.

Then Len Settled Down

Nobody ever would have expected it. Such a confirmed victim of wanderlust as Len Roos had been for so many years seemed destined to remain immune to the lure of a comparatively quiet life in a single community. But, the unexpected has happened and this well-known master of the camera has withdrawn from the ranks of travellers to the far corners of the world and becomes the contended

LEN ROOS

head of a manufacturing concern in Hollywood—the Tanar Corporation, Ltd., to be precise. As a mater of fact, when Len returned to these parts a few months ago, he had no idea of staying very long. His mission was solely to find some sort of a portals sound-recording apparatus which could be adapted to a lot of moving garound in remote countries where such moving is the most difficult.

When Len became convinced he would not find what he wanted, he concentrated his attention on the job of creating some such a device. The upshot of this was more than he himself had anticipated, namely: he succeeded in developing an outfit which was replete with too many possibilities to be kept for his exclusive use. Therefore, he decided to launch himself on the high seas of business adventure as a manufacturer in order that other cameramen might have the opportunity of enjoying the relief his inventions could provide. Thus came into being the Tanar Coporation, and now every indication points to a definite cessation in the roaming proclivities he has manifested for such a long period of time. The uninvaded regions of China, India, Borneo, Siam, Africa and South America which had seen much of him would be likely to see him no more, because his new business of making portable sound equipment instantly became a big business requiring his entire time.

This particular equipment is unique in several ways, but mainly in its compactness and lightness, two qualities which do not impair the usefulness of it. The whole shebang can be carried in two grips and can be carried by hand, astride a horse or mule or in a wheelbarrow, and, can be set up for use in a few minutes under the most cussed weather conditions.

"Basing my calculations on my own experiences as a roving cameraman in quest of news and educational shots for the screen, I know the Tanar equipment will prove a great boon to the boys who now are obliged to think of sound while now are obliged to think of sound while doing their photographing," says Mr. Roos. "Whether the set-up be in the thickest of the jungle, high on a mountain peak or in the center of the most forbidding desert, the result will be gotten quickly and with all the perfection required. And, any able-bodied man can carry the apparatus for miles without becoming a victim of anything like extreme fatigue."

EFFECT MAINTENANCE IN QUIETING CAMERAS
(Attention Assistants)

The following statement on camera maintenance was furnished by G. W. Jonson of the Mitchell Camera Company.

The life and usefulness of a camera depend much on the care it receives. As a test for endurance we put a camera on a milling machine, running it at 24 pictures a second continuously for five weeks, equivalent of two or three years' use. During the run the camera was well taken care of and oiled once or twice a day. At the end of five weeks we compared measurements with those made at the beginning and were unable to detect any wear. A camera properly constructed and cared for will last a lifetime and give very little trouble. If not oiled and cleaned when necessary it will become noisy in a short time.

The unit of a camera that receives the most wear is the movement. This mechanism pulls the film down and dowels it in place while the picture is photographed, 1,400 times a minute. The movement, therefore, should be oiled frequently while in use.

The main parts in the camera itself, where there is any great amount of wear or friction, have oilless bearings that take care of themselves. Any other bearings used are minor ones that are oiled when the camera is cleaned, which should be done at least twice a year.

The aperture plate of the movement should be taken out, and the aperture itself wiped off, after every 1,000 foot roll. This should be done so that no small particles of dirt remain in the aperture and consequently show in the picture.

The roller pressure plate behind the film should be inspected to be sure that the rollers are turning freely and not clogged with any particles of dirt or lint that would prevent perfection action. A drop of oil should be put on the film roller and sprocket guides about once a week.

If these precautions are taken, camera noise will be reduced to the minimum.—From Report No. 3, Academy Producers-Technicians' Committee.

ALICE WHITE AND NIG

Here is Alice White, First National star, with Nig, mascot of Local 659 and owned by Harry Gould. Nig first showed up as a stray one dark and stormy night at Cecil DeMille's studio. That was eight years ago. Harvey adopted him and Nig repays his kindness by keeping him in golf balls. Everybody loves Nig except the boys who play golf with Harvey.

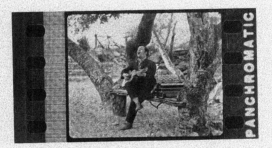

One of the Industry's Brightest Lites

—BY—

BEN SAVAGE

FRANK P. ARROUSEZ

With almost twenty-five years of technical experience in the motion picture industry to his credit, the activities of Frank P. Arrousez, director of production and sales and export in electrical detail of the Lakin Corporation, well known local manufacturers of "Laco Lites," the publication of any periodical dealing with the technicalities of motion picture equipment would indeed be incomplete without, at least, a brief summary of Mr. Arrousez's activties and association with the film world as well as his advent into Picture-town.

Like most boys who seem to follow their natural inclinations along with the years, Frank already had solved the riddle of "what makes the door bells ring" and "how many parts the telephone has" and had graduated to that precocious stage when "short circuit," "amps," "watts," "juice" and "alternating current" formed a part of his every day vocabulary. It was at this time, along in 1907 that with all his worldly possessions, Frank came to Los Angeles and got a job with W. B. Palmer Electric Company, now known as the Quality Electric Works.

While associated with the Palmer concern, our young electrician enjoyed frequent buggy and wagon rides to Hollyweed, never dreaming that in the immediate years to follow, this peaceful little suburban town was destined to become the motion picture metropolis of the world—and Frank, with his knowledge of electricity, which was to play such an important part in picture production, grew right along with it.

1912 and 1913 when little groups of California picture concerns, up and down the coast from Niles Canyon to San Diego were worrying along faithfully, shooting their one and two-reelers in barns and back lots, fighting public opinion and deputy sheriffs, Frank seemed to sense the fact that electricity was to become a dominant and necessary factor in the production of motion pictures.

Motor generators and arcs came with stages and studio electrical apparatus of all descriptions were found to be of vital importance as motion pictures gained a foo hold—they had begun to be looked upon as a permanent industry. · They represented a big payroll, growing day by day, of which Los Angeles and Hollywood were proud—this E pia that came over ight. Hilly wood je sed from

her peaceful slumbers, began to acquire a metropolitan aspect—cabbage patches and orange and lemon groves became studio lots, and tall eucalyptus and pepper trees in whose shade the Dons of old California would sleep their quiet afternoons away, were torn up to make room for paved streets and activity. Not many more buggies and wagons did Frank Arrousez see—automobiles and street cars brought one to Hollywood and its business like aspect — and electricity everywhere.

Frank Arrousez, in 1914, sold to D. W. Griffith organization, the first three unit motor generator set ever used in a motion picture studio, and it proved so satisfactory in operation that through this introduction, three unit motor generator sets, today, are standard equipment in the industry. After sixteen years of service this set still is in use at Metro-Goldwyn-Mayer studios; and so perfect is its design and assembly that it never has been changed.

The largest synchronous set in use at that time was sold in 1921 to the William N. Selig Studio on Mission Road. This was a 400 k.w. set purchased by Arrousez in Goldfield, Nevada, and the delivery upon which is studio history.

According to the contract between "Colonel" Selig and Arrousez, the set was to be "on the lot" and in working order thitry days after the date of purchase. Frank "knew his machinery," also, he knew his Nevada—and the work that was required in order to bring the generator to Los Angeles.

Goldfield and its railroad facilities offered nothing to brag about—the mining industry of Nevada has induced the railroads to build their tracks into the district—and a mighty precarious procedure it proved to be. A net work of tunneling and underground passages were poor foundation for heavy hauling—but after a lot of hard thinking—and harder hauling, Frank's equipment, bound for Los Angeles and the Colonel's studio was loaded and on its way. After arrival here, the machine was redesigned throughout under Frank's supervision, the result of which proved to be one of the outstanding mileposts on the road of motion picture progression.

With several years of intense practical motion picture experience to his credit, Frank Arrousez in 1928 "sold Creco Incorporated" the idea of mounting a 300 k.w. 2200 and 4400 volt synchronous set on a truck for portable duty. He negotiated with Creco for the trade of a 300 k.w. General Electric motor generator set for some Creco arc equipment and the result is that the motion picture industry enjoys the rental privileges of generator sets with quiet operation and at the same time capable of an overload capacity. This equipment, according to those acquainted with it, is the utmost in mechanical perfection.

It was during this stage, of what was to prove one of the world's greatest in-

dustries, that Frank Arrousez foresaw the possibilities of incandescent studio equipment—sound pictures had been introduced and with them had come the necessity for silent equipment. From the electrical departments to the production management of the studios came the cry for quiet equipment—the result of which is "Laco Lite" to meet the requirements of modern production.

The experience that Frank Arrousez had gained through his association with motion picture activity brought him in contact with Mr. A. L. Lakin, president of the "Laco Lite" Corporation which bears name. Mr. Lakin was so impressed with Arrousez's knowledge of motion picture requirements, that he advanced him his first financial backing to the extent of $250 which, through the progression of the industry has grown until today the Lakin Corporation represents an investment of more than $100,000.00.

The Lakin Corporation is represented by more than forty employees, a payroll which adds a consistent contribution to the industry of Los Angeles and Hollywood.

The manufacture of "Laco" products is under the direction of Frank Arrousez who has, through his undisputed knowledge of studio lighting requirements, gained the co-operation of the entire Laco organization.

Frank Arrousez has progressed with motion pictures—he has proved himself a factor in the introduction of electric equipment necessary to the talking pictures of today. In line with evolution, we feel that Frank, who found out what made the "door bell ring" still will continue to find out what demands the manufacturer of motion pictures will make upon electricity.

Long Ago With "The Old Master"

Left—*Scene from one too old for anyone to remember its name: Mack Sennett, Gladys Brockwell, James Kirkwood and George Siegmann.* Center—*David W. Griffith.* Right—*Another scene from another old-timer: Bessie Barriscale, Mack Sennett, James Kirkwood, Billy Quirk and (don't miss her!) Mary Pickford at the extreme right.*

Food for Thought--Dear I. A. Brothers

"You men with the right idea, grit and determination to develop it, have a chance in this the most progressive industry.

"Ten years ago, Slim Roe, from Wichita Local 190, had an idea but no capital. Some of us wise birds tried to discourage him; couldn't see so far ahead. We figured it a waste of time and money. But Slim, a little ahead of the game possibly, started as his own, adopted as a policy and motto, 'Nothing Impossible', and give them what they want, when and where, with plenty of service.

"From his first 'Jenny', built by himself in his own back yard, to a fleet of fifteen portable gas generators in three years was certainly an achievement. But he didn't stop there. He added effect machines—wind, rain, lightning, fire and accessories so necessary to the business.

From Slim Roe and his 'Jenny' the Roe Lighting Company developed.

"Arc light equipment was in demand. He took over the long established Creco Incorporated, and combined it with the Roe Lighting and started the manufacture of arc lamps, in addition to his portable generators and effect machines. The introduction of sound and the necessary quiet incandescents turned the industry upside down. He adjusted his plants to the manufacturing of incandescents, never losing sight, however, of the possibility of quieting and perfecting the arc. His development along this line has been extensive and successful and the industry will learn of it soon.

"Slim Roe and his Creco equipment is known the world over, wherever pictures are made. His New York representative has placed Creco equipment in practically every Eastern studio. His London representative has sold his products in England, Australia, China, Japan, Java and Borneo.

"From a backyard beginning, with no capital, in ten years, he has built up a world-wide business second to none. His original policy and motto still prevails in his present extensive organization. His efforts to keep a little ahead of progress is untiring. With the industry practically in its infancy we can expect big things from Slim in the next few years. This is a history of but one of the many successful I. A. men in the moving picture business. Slim has a good start—watch him grow."

JONES TO ENGLAND

Laurence Jones, secretary of the Projection Advisory Council, sailed for Europe on May 10th to act as special representative of the Council and organize its activies in Great Britain.

HIS FACE HIS FORTUNE

While on location in the Northwest our handsome viking, J. Henry Kruse, Local 659, discovered the original of Uncle Sam's Buffalo Nickel and immediately shot him. Here he is in ceremonial dress.

A VEST POCKET MOVIE SHOW

Andre Barlatier is the inventor of a unique device designed to augment entertainment in the home. It is called The Filmoscope and it presents a series of views on motion picture film in plastic relief with stereoscopic depth of perspective. It is manufactured and distributed by Boeger Brothers, 666 North Robertson Boulevard. The Filmoscope sells for $2.50 and each roll of film costs 50 cents, which low price places the device within the reach of all.

A striking feature of the outfit is that it can be collapsed into a space occupied by a vest pocket booklet and therefore is convenient to carry any place.

The observer will be startled by the uncanny illusion that he is face to face with the subjects he views. It is like taking a trip right into the homes, the studio sets and the lives of the celebrities you will see.

The views furnished are on transparencies so that bright back lighting displays the most minute detail unlike the dullness of pictures on paper, no matter how well done. These small views, two inches from the eye, show more detail than a bill-board by the roadside.

The Filmoscope uses motion picture film not only to compactly concentrate many views into a small space, but to particularly use the sprocket holes found in such film for engagement by its ingeniously operated "camera" claw to impart lateral movement, thus passing view after view of interest in a continuous procession before the eye, as rapidly as it can be manually operated.

After the first viewing of Filmoscope pictures, the observer will feel as though a fog had been dispersed, a veil lifted, the eyes cleared, so realistic are these brilliant, back-lighted transparencies when viewed through the twin-optical stereoscopic lenses.

The selection of views in such concentrated space makes it now possible to unreel before the eyes all subjects which can be visualized. Celebrated film stars, celebrated stage stars, celebrated civic figures, celebrated internationals, historical figures (as portrayed by specially posed subjects).

Zoology (animals), Botany (plants, trees, flowers, vegetables), Entomology (insects), Geology (rock formations), (world travel).

The Engineer and His Tools

—BY—

C. FRANCIS JENKINS, an extract from a paper read at the 1930 Spring Convention of S. M. P. E.

We are here tonight for a recreational hour in a convention of the Society of Motion Picture Engineers, a group of specialists gathered together with a basic thought, namely, to improve the tools of our profession.

The line of our particular activities is picture entertainment, but all such conventions of engineers in every line have a like purpose, namely, to improve the facilities of their particular employment.

Has it ever occurred to you that we act like civilized beings only because we have such a great and varied collection of tools that we can live together in communities of common interest?

The tools available to us and our engineers are the things which enable us, we moderns, to live at all, although we usually think of them as means to decrease our labor and increase our leisure.

As a definition I refer to "tools" as any physical aid to an end; and any clever applicator as an engineer, whether he be uncultured of mind or a trained intellect; but each is helpless without these tools.

Tools have been the most civilizing influence in all man's history. It has changed him from a selfish food robber to a sympathetic neighbor.

I cannot agree with some of my evolution friends. The preponderance of evidence proves there has been no evolution of man, but only an evolution in his tools. Early man was as clever and ingenious as modern man. His earliest handicraft was as adaptable and symmetrical as that of today.

The scope of his works, and the fineness of detail of the product has developed with the refinement and additions to his available tools.

Man's first aids doubtless were devices employed to obtain food and clothing more easily than he could do with hands and teeth alone; to be followed by tools to improve his shelter and security.

Later he began to impress his will on others, requiring them to use these tools to the master's advantage; and so slave labor became an established institution. Next he turned to his personal use the natural forces about him, i.e., "fire, water, earth, and air."

The known works which man performed with an abundance of slave labor and more and more ingenious tool equipment are marvels to this day. Nothing in modern times exceeds these early examples in majesty, in beauty, or in symmetry.

Scientists of the National Museum tell me that "the beautiful leaf-shaped flint blade has never been made by modern man"; and that "the modern quarryman cannot even guess how his predecessors removed and set up the great monuments of the past."

But eventually tools were so many and so varied that they could not be learned unaided in a single lifetime.e So institutions were set up to teach the young the artifices available to make easier for him the getting of food, clothing, and shelter; for example, and alphabet; the three Rs; the multiplication table; pi times the diameter; the level; the transit; the telescope, etc.

But eventually tools became so numerous and so varied that no one man could master them all, even with every possible instructional aid, so he must learn the tools of a single trade; and thus specialists became common.

The modern machine age really began when America was settled by the white man, for from that date the evolution of machine tools has grown with unprecedented rapidity.

Soon the perfect slave of man was the machine; and as it developed into an aid a thousand times more efficient than the human slave, the human slave was liberated.

Our food, our clothing, our shelter, our transportation, our communication, which make living together possible for us, are products of tools, tools, tools; the human hand only guides the tool.

But man is the same man he has always been; he is of the same stature, is no more clever, no more ingenious today than was the primitive man. All known evidence is to that effect, and no evidence to the contrary exists.

If his evolution had been in stature, comparable to the evolution of his tools, he would today be taller than the mountains; and if in mental attainment, he would be a super-man indeed, even a super-god.

There has been no evolution of man, but only an evolution of his tools; and this fact is irrefutable proof that man is a spiritual being, sprung from a discrete germ, not an offshoot from some early animal plasm. His evolution of tools differentiate him from all other living creatures.

And as tools accumulate, more tools are available with which to make more tools, a tool evolution which equips the inventor to evolve newer tools for the use of the engineer in his attainments of greater and greater feats. Tomorrow's tool equipment is inconceivable today, and what can be done therewith impossible of prediction.

With this infinite evolution of tools we have put more and more of nature's forces to work for us; coal, oil, gas, water; all of them sources of energy we can see and touch.

Tomorrow we will put to work those sources of energy which could rather more properly be spoken of as the intangible forces of nature;—"a double bit on the teeth of the lightning."

And these new forces will be distributed over like intangible channels. Long copper wires will not be so essential as today. And over these intangible channels power can then be delivered where wires cannot reach.

In 1837 a wire was stretched from Washington to Baltimore over which enough energy was transmitted to operate a telegraph recorder. But now a similarly stretched wire carries the power to drive heavy interurban railway trains between these cities, and with the swiftness of the wind.

Comparably, today, over an intangible radio channel, we send aloft energy enough to operate a communication device aboard an airplane in flight. Tomorrow we will transmit over this same intangible channel enough power to drive the motors of the plane itself.

The next age is the age of electronics, the age of intangible contacts of man with man, and over channels against which physical obstacles will have little effect. Energy to light, to heat, and to cool our homes, and for general communication, tranportation, and control, may then be distributed without limits over the whole earth.

As far as our picture engineers are interested, I confidently assert that the day is now within sight when distant scenes and notable events may be reproduced in our homes and on the screens of our theaters simultaneously with their happening; and when motion pictures will be distributed from Hollywood directly by radio instead of by film.

The Society of Motion Picture Engineers, in the fourteen years since its organization, has seen tremedous developments in the greatest of human entertainment, motion pictures; but the next fourteen years will see even more startling developments, and the audience many times multiplied, as radio is substituted for film as a carrier of this entertainment.

The Daily Grind

By RALPH B. STAUB

MILTON (overtime) KRASHNER. Some people are interested in golf; some are interested in the stock market; some are interested in home and family; but there's only one thing that interests this guy and that's OVERTIME.

* * *

RUBE BOYCE just returned from Palm Springs. Rube says all one does there is sit in the sun and watch his arteries harden.

* * *

My gagman, JOE TRAUB to JACK OAKIE:
"I know you; your name isn't Jack Oakie—it's Jake Feegenboom."
Oakie—"No, it isn't."
Traub—"Then what is it?"
Oakie—"I should tell you—you might be a German spy."

* * *

HOMER VAN PELT is a corker—he used to work in a bottle factory.

* * *

TONY GAUDIO (to assistant) — 'I told you to come after dinner."
Assistant—"That's what I came after."

* * *

GEORGE FOLSEY is coming out here to settle down as soon as he can settle up.

* * *

IRVING RIES knows a Scotchman whose daughter became an old maid because the father refused to give the bride away.

* * *

"That was a howling success," said LEN SMITH after photographing the M-G-M dog picture.

* * *

Headline in Hollywood Paper, "Big Riot at First National Studios." Three Scotch cameramen fight over who shall be the first to use new FREE HEAD.

* * *

Seen by ELMER DYER.
Old man about seventy putting arm around girl on park bench.
Girl—"Gee, but you work fast."
Old Man—"Well, I gotta; I'm getting old."

* * *

Visited M-G-M studios and saw party just arrived from the east touring studio. Man was just about to step on caterpillar when Easterner spoke up.
"Ooh—look out— that might be Lon Chaney!"
Other man—"Don't be silly, I'm Lon Chaney," and he was.

* * *

Two assistant in tongue fight.
First Asst.—"You rat—you're so small you could hide under a table with a high hat on and still have room for an acrobat to do a handspring."
Second Asst.—"You're smaller than a rat—you're a mouse."

* * *

BEN REYNOLDS says there's only one thing that sticks closer than a mustard plaster and that's an assistant cameraman —when you owe him $5.

During the recent market crash I asked JIM VAN TREES what he did with his assistant. Jim said he put him up for margin.

* * *

Famous Last Words: Remember boys, it's all in fun.

* * *

EDGAR LYONS has just completed the building of a new home. Ed says the back door has a novel lock on it that opens by signal knocks on the door— kinda tough on Federal agents.

* * *

RUBE ROYCE says—where there's a will there's always a lot of relatives.

* * *

BENNIE RAY is going to open a tailor shop on Hollywood Boulevard and sell three pants suits to tired cameramen.

* * *

JACKSON ROSE says it's remarkable how our industry is progressing with the new wide film. In fact an inventor is now perfecting a new 100 mm. camera— but Scotland still sticks to its 16 mm. film —and seems satisfied.

* * *

BUMPED into billy marshall
WORKING at columbia ditto
JUNE ESTPE, tom storey, boy tobey
THESE boys are certainly putting
IN the overtime
VACATION time being near at
HAND they will be able to use
THAT extra dough and how:
CHARLIE lang is getting to feel
SEXY shooting so many
BOW pictures.
CHARLIE ought to give the other
BOYS at paramount a chance at
KNOWING how it feels to have IT.
TED mccord and billy tuers send
THEIR best to the boys from
KERNVILLE where they are shooting
BUCK jones in a western
EPIC.
BEN REYNOLDS lost ten pounds
WRESTLING with howard hurd
THE doctor say howard will
BE up and out again in a
FEW months.
BEN kline showed me a
VERY fine notice he received
FROM r. c. sheriff the man who
WROTE journey's end congratulating
BENNIE on his wonderful photography.
With apologies to K. C. B.

* * *

Scenario
Place: Silver Moon Saloon.
Time: 8:30 A. M.
Year: 1904 A. D.
(Standing at Bar.)
JOHN SILVER (Irishman): Stood a round of bourbon.
IRA HOKE (Englishman): Stood a round of rye.
MILT KRASHNEH (Jewish): Stood around six foot four.
JOE WALKER (Scotch): Stood around and admired them all.

* * *

CLYDE DEVINNA and GEORGE NOGEL are still on "Trader Horn" at M-G-M. Both Clyde and George believe that in the course of a few months their picture will be runner-up to "Hell's Angels" in taking time and money to produce. Show us the cost sheets—George.

* * *

GEORGE STEVENS has just written a new song dedicated to the Los Angeles Detective Bureau entitled "I'm Followin' You."

——o——

"FIVE FEET ONE AND SCARES ELEPHANT"

The booby prize of the coming year and perhaps many years to follow should go to Hal Porter, Hollywood's famous still expert, but in private life just a stillman for Columbia studios.

It happened while Director Frank Capra was making some shots in his latest comedy starring Joe Cook, Broadway comedian.

Night, rain scenes, mud up to their knees, with the elephant pushing one of the circus wagons, hundreds of extras battling in the rain, Hal gets a bright idea for a publicity still (Alec Moss, ace publicity expert at his heel) gets his camera set up, flash light in hand and yells hold still everyone: Off goes the flash light and so does the elephant, but he left everything including wagon overturned and started down the boulevard, extras scrambling to their feet in the mud, tents falling down as the elephant passed through them, one man, a trainer, hanging on to the trunk but old E. L. dropped him off at the station a block further down. It took hours until they were able to get old E. L. back to the tents and remember this was 1 a. m., in the morning, cold, wet, director, cameramen, stars, and extras all yelling at the tops of their voices for Hal to go to Hal!

Wide Film

—BY—

J. O. TAYLOR, *Local 659*

A Cinematographer who ought to speak authoritatively.

There have been many articles written in opposition to the wide film—articles stating that the height is not sufficient—that the proportions are wrong and I am told on the average of about ten times a day why it is closeups can't be made, together with a hundred and one other limitations of the wide film.

I happen to stand in a little different position to the majority of these anti-wide-filmites because of the fact that I have photographed the only four complete productions that have been made on the wide film and I have had the opportunity to experiment and actually find out what shots can and can not be made.

With my experience of almost two years I feel the proportions as they are now are just right. They are based on the ancient Gothic architecture of theater construction and consequently will fit all the theaters in the country for those are the proportions of their proscenium arches. If the film were any higher, stages would have to be rebuilt and if it were any narrower it would be out of architectural proportions.

While on the subject of size, I would like to stay that to me the one big thing in favor of the wide film is the opportunity it gives actors to move around freely, not limiting them to a very small space. This limitation has always been extremely noticeable—particularly since the advent of talking pictures. It will not be necessary for characters carrying on a group conversation or a couple of singers rendering a duet to blow down each others throats in order to keep from having their limbs or at least some part of their anatomy outside the camera lines.

Regarding the arguments on closeups —closeups *can* be made on the wide film. Of course, it is not necessary to get as close as you do with the thirty-five millimeter camera but, comparatively speaking, you can make the same sized closeup. However, with the wide film very few closeups are needed. After all, the main reason for closeups is to get over thought and with the wide film you can get all the detail and expression in a full sized figure that you would get in a six-foot closeup with the thirty-five millimeter film. Popping to head closeups of characters from distorted angles has always been more or less objectionable to me anyway.

When one considers the amount of money and time and thought that is put into the building of character sets for a motion picture it is amazing to realize the vast amount of detail that is absolutely lost in the thirty-five millimeter film. Anything twenty-five feet distant from the camera could almost be a painted setting instead of the real thing. With the thirty-five millimeter film long shots of elaborate sets can only be used in short flashes as, after all, the action must be covered close enough to see the expression on the characters' faces because atmosphere and thought are the only things in the making of a motion picture. Now, with the wide film the character can get over the action and yet you can still pick up the marvelous details and atmosphere in your sets.

There have been quite a few attempts and suggestions to enlarge the small film. These have all been proven impossible, due largely to the great quantity of grain that is picked up. As a matter of fact with the wide film there is comparatively no grain evident under the proper lighting conditions.

Even under poor lighting conditions you can obtain very wonderful results with the wide film as you still maintain the geography of your sets in which your characters are working and you are not watching a series of closeup angles popping in and out all the time.

I have also heard several arguments to the effect that a slow moving picture could not be speeded up in the cutting. Whenever a cutter has more than one angle to cut with he can usually find a method of eliminating footage. At the beginning of the talking picture era it was considered next to impossible to "speed up" any action. As a picture was shot, so it would remain. However, it was soon discovered that the limitations were not as great as anticipated. So it is with the wide film. It is pliable and the more it is experimented with the more pliable it will become.

I had the pleasure of seeing a recent picture, the director of which made the statement that because of this limitation in cutting it could never have been made on wide film. To me this was a typical statement of a person who had no experience with wide film because as I saw that picture it was, to me, one of the best examples of a wide film subject. If the people who are against the wide film would just become the least bit familiar with its uses and possibilities I am sure they would not make the ridiculous statements they do at this time because they are as much out of place as the arguments against talking pictures were at their introduction.

However, I really believe that a person cannot appreciate the wide film until he has made a production and thereby draws an actual comparison, scene for scene, with the thirty-five millimeter film. For myself, I feel that after looking at the rushes on the wide film each day and then seeing the thirty-five millimeter film with its cramped and limited proportions it looks positively antiquated and it almost seems ridiculous that anyone could even draw a comparison.

I feel, however, that the wide film requires a different technique just as the technique of the talkies differs from that of the old silents. It is an entirely different means of expression and should be handled with that idea in mind. Only when this is done will they get the proper value from the wide film.

In conclusion I might say I have yet to find a director who has worked on the wide film, regardless of his attitude before the picture, who was not absolutely sold on it after his first experience.

"Now In Those Days"—

(About 1914)

Shooting "JOAN THE WOMAN"

The crew (left to right)—*Unknown, Ralph Morrello, Dent Gilbert, Percy Hilburn, Hal Rosson, Chas. Rosher. Chief Cameraman, Alvin Wyckoff; Unknown, Edward Morrison, Paul Perry, Harry Rathbun, Henry Kotani, Harry Sandford.* Seated— *Unknown, Al Gilks, Don Short, Connie DeRoo.*

NEW INVENTION

The "Permanent Saluting Arm"
By Sergeant Charles, Local 659, Signal
Corps, Ninth Corps Area

The attached drawing illustrates meth-
of using the "Permanent Saluting Arm"
for the service cameraman in peace-time
and in war" (if and when). Place your
order early and avoid the rush. When
not used, as above illustrated, it will
come in handy:

For the wife to stir soup, beat the rugs,
swat flies and the cat and also the chil-
dren providing they are small enough.
She can also use it to give signals while
driving the family car (provided she is
not Scotch) and to protect herself against
the bad, bad drug store cowboys.

For the other half of· the family who
may also find many uses for this saluting
arm:

To play handball on the set while the
assistant is loading the camera.

To level up the parallels.

To use for a quick fade.

As an indicator that the cameraman
is in his dugout making sound movies.

As an extension arm for the cameraman
to slate his scenes (if the assistant is hav-
ing his daily siesta) and many other
things too numerous to mention.

This is the invention of Sol Fite who
solved the solution of preserving chem-
icals.

———o———

SAYS BOB TOBEY

Tough Second Cameraman—"Hey, do
ya know anything about lenses?"

His Assistant (very new)—"Sure I
do."

Tough Second 659er—"Well, len's a
fiver, huh?"

* * *

"Why do you say your blonde girl
friend has laboratory hair?"

"Because she treats it to chemical
fades."

* * *

First Cameraman—"What're you bang-
ing your head on the wall like that for?"

Second Alibi Artist—"Just getting in
condition to invent a new noiseless
camera."

* * *

Assistant No. 1—"I was so embarrassed
at the Costume Ball last night down at
the Cocoanut Grove."

Assistant No. 2—"How so?"

Assistant No. 1—"I went dressed as a
camera and broke a belt."

* * *

Also Bob Tobey Wants to Know:

If a director has to have a 659 card
to pan a cameraman?

If First National Pictures were Para-
mount, would that out-Fox M-G-M?

When Virg Miller is going to stop
talking golf.

Why a Mitchell magazine costs a hun-
dred dollars when the International Pho-
tographer costs only a quarter. And why
the studios don't take advantage of this?

What happened to all the Akeleys?

Why a motion picture artist has such
a hard time drawing a salary.

When is Mr. Out-of-Focus going to get
back in? I'll lend him my knife to
sharpen himself up.

How the Warner Brothers' cameramen
enjoy being out in the fresh air at last?

Who was the Scotch cameraman who
refused to make anything but panning
shots so he could use a free-head?

If it's assault and battery when a
juicer hits a broad?

THE FABLE OF THE CAMERAMAN AND THE MULE

By W. VERNON DRAPER, *Local 659*

There once lived, in a far away land, a young lad who could not play the saxaphone, do parlor tricks or make his ears wiggle, so he was not very popular.

As time rolled on he began to find it annoying to be hit with old shoes, chased by bull dogs and thrown out of pool halls, so looking the situation squarely in the face he decided that the best thing to do would be to do something about it. So he began to look about for something that would make him the life of the party.

It occurred to him that among the social successes of his acquaintances the most instantaneous was one who had visited Hollywood and was able to speak of having seen so and so, an actor (whose name cannot be mentioned here because of advertising restrictions), at a certain cafe (which cannot be mentioned because of a lapse of memory), taking a nip of a beverage that cannot be mentioned because of a constitutional amendment.

One evening the lad had just left his girl's apartment, hurriedly, and happened to glance in the window of an apartment on the tenth floor, as he passed, in time to see the aforementioned lion necking fiercely. This set the .lion to thinking in earnest and he determined that his next trip would be to Hollywood, providing, of course, the present trip ended successfully, which it did, for he lit on his head and, as the paving commissioner of the town was recently from Los Angeles, he was just getting ready to tear up the pavement anyway.

So it came to pass that after a great many hardships the lad arrived in Hollywood and was presented with an opportunity to ask a cameraman if he needed a boy. Now it so happened that this cameraman chanced to be an honest man and he told the lad that he did not need a boy, but that he did need a mule.

"Well," said the lad, "you've got nothing on Moses, but inasmuch as I've been called a jackass all my life, I see no reason why I should not make it a profession."

"You will not be called a jackass here," said the cameraman. "The efficiency expert would never stand for such waste. We will just call you Asst. The t will stand for terrible, and we will save Jack."

Years came and passed in their customary manner and the Asst. became very efficient in his chosen work. He could stick a half tree down his back and hang so many cases on the hat hooks that when he made the brow of the Truckie and Mowapa hills under full load the native mules who chanced to see him very often died of pure shame. And so the Asst. became very strong of back and strangely enough he learned many things.

He learned that a nod of the head will get you further than the palsy. He learned that all the actors he had wanted to meet had a disease called: "Boy, would you mind running to the corner and getting me a sandwich?" He learned that most people making overe $500 a week don't know that sandwiches cost 20 cents. He learned that directors are almost always out of cigarettes and never have matches. And he learned that every time a cameraman died a cousin appeared out of the east.

But there was one thing that he could not learn. He could not figure out why it was always necessary for the cameraman to move the camera exactly 6 inches from the set up he had so laboriously chosen. So he bought himself a ticket to a land a great deal farther away than the one whence he had come, and when he arrived there he told people he was from Patagonia, and whenever anyone would approach him and say:

"Aren't you f r o m Hollywood?" he would reply:

"No spikka de Eenglish."

---o---

ACCIDENT TO BROTHER KAIFER

As this publication goes to press we are informed of an accident to Brother Fred Kaifer which is likely to keep this industrious and ambitious young man away from the camera for several weeks.

It was the "deadly parallel" again and it cost Brother Kaifer a fractured thigh and a fractured arm, both compound. Some of these days the parallel will be be built with a view to safety as well as utility. Brother Kaifer has the heartfelt sympathy of the entire Local with earnest wishes that he may recover quickly and permanently.

SPRING CONVENTION S. M. P. E.

(Continued from Page 168)

average reel of 70 mm. film weighs 34 pounds, and rewinding is a man-sized job, requiring care to prevent cinching or tearing of the film.

A new model projector, as well as a new assembly for older models, was announced in 1929 which incorporates as a special feature a rear shutter between the lamp house and the gate. Other features of the new model as claimed are: Easy and rapid change-over from disc to sound-on-film, and means for maintaining accurate focus and centering of the picture.

The problem of equipping many thousands of theatres for sound reproduction during the comparatively short period of a year and a half has been a serious and gigantic task both from the engineering as well as the economic standpoint.

Sound picture projection apparatus is now in active use on trans-Atlantic liners, in a Chicago hotel dining room, and even in railway cars. A successful showing on a Union Pacific trans-continental train was arranged during the fall of 1929. A Delaware corporation has been formed to promote a fleet of specially designed railway coaches as the first unit of a projected nation-wide system of mobile sound theatres to present pictures in small villages. The first theatre for the exclusive showing of sound newsreels opened early in November, 1929, running a continuous show from 10:00 A. M. to midnight.

An audible frequency selector has been designed for use of the projectionist to accentuate, attenuate, or eliminate certain frequencies delivered to .the amplifier.

Details have been published on the technical characteristics of all the sound reproducing equipment on the French market. The only French process which is complete from the taking to the production end is that of Gaumont.

A unique generator is being marketed by an Austrian firm located in Vienna. It is known as the Rosenberg cross-field generator. An arc, such as that, in a projector, may be connected directly to the generator and the voltage and current are self regulating. Two of the four commutator brushes are short circuited. When the outer circuit is closed, a magnetic field and an armature field results in the same direction but opposed; the former increasing slowly, the latter rapidly.

A new sound-on-film portable projector equipment by RCA was announced in October, 1929. The projector and sound reproducer is housed in a metal cabinet 24 inches square and 12 inches wide, mounted on four telescopic legs. Film magazines are located on the art side of the case.

Further details have been made available on the portable sound equipment supplied by Western Electric. The delivery and take-up reels are included on the same shaft inside the projector case. A 60-foot throw is possible giving a picture 7 feet by 8 feet in size.

A continuous projector designed by a Frenchman, M. R. Huc, has several novel aspects to recommend its consideration. Film is passed on a curved track in the form of a part cylinder before a light aperture somewhat higher than that of a single frame. An image is projected onto a mirror in the center of the cylinder and set at an angle of 45 degrees to the light path. The mirror turns at a speed one-half that of the moving film through a slight arc and then returns to the original. position, while a shutter cuts off the light momentarily. A stationary image is projected on a screen placed at right angles to the original light source.

Considerable attention has been given the theatre acoustics problem during the past year. One firm has made an acoustical analysis of over 1500 theatres and made recommendations for treatment of the auditorium. A lowering of the accepted optimum reverberation time as a function of volume was reported. Theatres with square auditoriums were found in general to have better acoustic properties than long, narrow theatres.

(To Be Concluded in July)

A Staggering Opportunity

(From Rob Wagner's Script)

—BY—

BARON OTTO VON HIMM, *Local 659*

This article is written in the hope of interesting millionaire readers of *The Script* in the most marvelous invention of the cinema—the Von Himm Emotion Track!

A big producer recently remarked: "With sound, color and stereoscopic, motion pictures will have reached the ultimate of their possibilities."

He reckoned without my invention.

What is the Von Himm Emotion Track? It is a track alongside of the sound track on the outer edge of the film by which the emotion of each and every scene is communicated to the audience?

Many a film has died the death because the audience was not in tune emotionally with the story. During the war, the success and failure of pictures fluctuated with the daily news. Every exhibitor knows that in the first three or four days of the month when bills come due, patronage falls off. Hot days and cold days make a difference, and a fall in the stock market has a most depressing effect upon audiences.

Then there are individual emotional idiosyncrasies. Certain people do not respond to the patriotic impulse; others are not touched by the emotion of mother love and there are no end of picture fans to whom romance is a piffling thing, and still others, such as a bond salesman, who look upon it with only one unmentionable consequence.

Thus it will be seen how important it is to make an audience respond to the emotions of the screen story. The Himm Emotion Track will do it.

As even millionaires do not invest their money blindly, I herewith append a brief sketch of my invention.

The recording is done as follows: The picture is shot in the usual way, but a protected sensitized strip is left along the outer edge of the film. The reels are then turned over to me to add the emotion track in my especially equipped recording room.

Let us suppose the picture opens with the birth of the hero, or depicts him in infancy. Next the boy goes off to war.

A romance develops with a nurse. He returns to America and gets into trouble with the police. In the big punch he beats up the heavy. Finally the clinch.

Here are several distinct emotions to be recorded—mother love, patriotism, romance, gangster behaviorism, anger and finally love.

Each of these scenes is shown in the recording room to separate audiences especially chosen to record the particular emotion.

In the first scene I collect only mothers capable of deep mother love. They sit in chairs the arms of which are covered with metal cathodes which in turn carry wires to the Himm transformer attachment of the projection machine, and as the mothers holding tight to the cathodes, witness mother love on the screen, they begin to feel this intense emotion which is transferred directly to the Himm Track where it is registered on the film.

The same process is used in the other scenes. American Legion boys are used to register patriotism, school children for romance, criminals for gangster stuff, wrestlers and fighters for anger and engaged couples for love. In fact, by securing say twenty or thirty couples of passionate neckers who will be stirred by the love theme and take advantage of the darkness of the projection room, the emotion of love will be recorded with a combined intensity that will be absolutely startling.

I will not go into details of the mechanical wonders of the Himm Emotion Track, but having demonstrated that I can record these various phases of feeling, how are they to be communicated to the audience?

By the simple play-back scheme of having the theater wired and each seat provided with cathodes which will carry from the picture the corresponding emotion of each scene.

Thus as the audience views the opening scene each and every member will have communicated to him the emotion of mother-love, whether he be a father or merely an uncle. Communists will feel

the thrill of patriotism and even the gentlest of old maids will experience bloodlust in the fight sequences. As for the passionate love scenes, my device in several experiments has brought happy blushes to the faces of ministers, and on one occasion when the lights went on suddenly during the love sequence, the whole audience became so obviously amorous that fearing the consequences, I stopped the picture entirely.

Thus it will be seen what a tremendous factor for success the Himm Emotion Track will be both to the producer and exhibitor. Furthermore, it will be employment to thousands of people in pictures who cannot act but need only to cash in on their expert emotions. A good mother-lover will be in constant employment, professional patriots can market their emotions, and highly technical kissers and neckers will be paid handsomely for doing their stuff.

For particulars regarding the financing of this extraordinary invention, address the author, care of *The Script*.

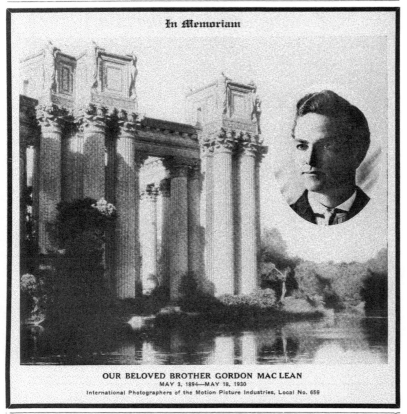

In Memoriam

OUR BELOVED BROTHER GORDON MAC LEAN
MAY 3, 1894—MAY 18, 1930
International Photographers of the Motion Picture Industries, Local No. 659

EXTRA NUMBERS OF THIS ISSUE

May be had at

1605 █ Cahuenga Avenue, Hollywood

or Phone HEmpstead 1128

The Sound Track

YOUR MAGAZINE

Well here it is with the compliments of the editors and we hope you like it.

The International Photographer is only a little over a year old and its record of achievement during that period has won it an honorable place in the history of publications devoted to the cinema and the allied industries. For speedy growth in so short a life it probably stands alone.

This June number as a Special Souvenir Edition was sort of "thrust" upon the editors and three months' job had to be done in three weeks, but anything is possible when the I. A. T. S. E. and M. P. M. O. calls.

This June issue is our first Souvenir Art Edition and it is not unlikely that it will henceforth be an annual event, but very much bigger and better than this hastily constructed book.

For our visiting brothers and those who do not know let it be stated that the International Photographers of the Motion Picture Industry, Local 659, of the I. A. T. S. E. and M. P. M. O., is that organization of cameramen who photograph the great pictures coming out of Hollywood Studios.

In this fine organization, the most numerous and important of its kind in the world, are the master cameramen of the cinema, and have been since motion pictures became popular.

This group of artists numbers nearly 800 men and, together the affiliated Locals —No. 665 of Toronto, No. 666 of Chicago and No. 644 of New York, represents 100 per cent of the professional personnel engaged in the production of motion pictures in the United States and Canada,

including News and Educational cameramen and assistants.

This group of camera-masters owns and publishes a magazine, The International Photographer, Hollywood, is the only exclusively professional technical journal in the world that is owned and published within the motion picture industry.

The International Photographer, Hollywood, is, therefore, the voice of an *Entire Craft*, covering a field that comprises the North American Continent and reaching out into all the principal nations abroad, thus giving this journal an international character.

Affiliated with Los Angeles Amusement Federation, California State Theatrical Federation, California State Federation of Labor, American Federation of Labor, and Federated Voters of the Los Angeles Amusement Organizations, this journal has a broad and sympathetic field for expansion and its rapid progress during the few months of its existence is not only proof of its virility, but a forecast of its future growth, prosperity and influence.

The International Photographer's field embraces the entire technical side of motion picture production and its allied industries. It is designed to be a clearing house for technical information pertaining to the cinema, and its location, in the midst of the studios of Hollywood, and its close association with the S. M. P. E., the projectionists, electrical workers, the sound experts, the research laboratories, individual researchers, inventors and other sources of news, affords this journal unique opportunities to give to its readers first hand information *while it is news*.

The International Photographer, Hollywood, is unique among advertising mediums. The magazine has a reader circulation far in excess of its book circulation, for every number is preserved and is read and re-read by the many interested. It is subscribed for and purchased by those who *need* and *use* it and who partonize its advertisers as the leaders in their respective lines.

In the pages of this journal are and shall henceforward be seen the finest cinema still and pictorial art published in the United States—art originating with the cleverest camera-masters in the world and these art pages alone are worth many times the small subscription price.

Plans for the future comprehend greater expansion in all departments and the gradual upbuilding of a staff of contributory writers who will cover our potential field one hundred per cent with ex cathedra and authoritative articles on timely subjects.

BORN IN JUNE

This galaxy put off being born until June so they could get their names in The International Photographer Souvenir number and attend the convention of the I. A. T. S. E. and M. P. M. O. They are not strong in number, but Oh! Boy! what a lot of talent they have in their saddle bags. They don't have to have any birthstone as each one is a brick. Read 'em:

Lenwood B. Abbott, W. S. Adams, Howard Anderson, Max Autrey, Royal Babbitt, Tom Branigan, Lyman Broening, Robert Bronner, Warner Crosby, Dean Dailey, James Daly, Norman De-Vol, Fred Eldredge, Harry Fischbeck, R. A. Flinsky, Ellsworth Fredricks, Edward Garvin, James Goss, Robert Gough, Walter Hass, Fred Hendickson, George Hollister, Jr., R. B. Hopper, Alfred Jacquemin, Hanry Jennings, Jack Kenny, Ted Klett, Jacob Kull, Augustus Lane, Elgin Lessley, Harold Lipstein, Lewis Physioc, Charles Piper, Walter Rankin, Ralph Reynolds, Irmin Roberts, Herman Schopp, John Seitz, Allen Seigler, Bertram Six, Earl Stafford, Ted Tetzlaff, Rod Tolmie, Edwin Witt, Cecil Wright, Dewey Wrigley.

Excelatone

The famous old Balboa Studio at Long Beach, owned and operated by Herbert W. and Elwood D. Horkheimer, was, in the early days of the cinema in the west, the proving ground of motion pictures.

Out of that fine old school of the movies came hundreds of technicians, artists, directors, actors, writers and other workers who have long since achieved fame and who are to this day helping to make the world happier by turning out great pictures.

A few among the many Balboa names written high on the tablets of cinema fame, past and present, were: Ruth Roland, Henry Walthall, Lillian Lorraine, Marie Doro, Dorothy Dalton, Mabel Normand, Mae Marsh, Jackie Saunders, Gail Kane, Margarita Fischer, Charles Ray, Marie Empress (the first movie vamp), Little Mary Sunshine, Gloria Joy, Leon Purdue (the first child colored actor), Daniel Gilfeather, Alice Lake, Mollie McConnell, Cullen Landis, Bebe Daniels, Philo McCullough, William Conklin, the original Balboa Beauty Squad (a group of beautiful girls antedating the advent of the bathing beauties), Lew Cody, William Elliott, Buster Keaton, Roscoe Arbuckle and scores of others.

Among the writers were Frances Marion, Will M. Ritchey, Dan Whitcomb, Jeanne MacPherson, Luther Reed, Calder Johnston, Douglas Bronston, Lee Arthur, et al.

Among the directors were Henry King, Reeves (Breezy) Eason, Henry Otto, Sherwood MacDonald, Buster Keaton and other successful ones.

The cameramen were Joseph Brotherton, Local 659, and William Beckway, both real artists.

Of laboratory, technical and production men they were legion, most of them still in pictures and in responsible places.

This fine old organization was famous for its serials, released by Pathe, the most famous being "Neal of the Navy," "The Red Circle," "Who Pays," productions that made motion picture history.

In those days there were five principal releases—Pathe, General Film, Mutual, Metro, Paramount and Balboa had them all.

When production began to center in Hollywood the Horkheimers closed their studio at Long Beach and transferred their activities to New York.

Since the war the brothers have been engaged for the most part in real estate financing, handling Hollywood properties, but the lure of the films was too strong and here recently they organized the General Recording Corporation, Ltd.,

with H. M. Horkheimer, president; H. B. Gunter, vice-president and chief engineer; Elwood D. Horkheimer, secretary and treasurer; D. E. Kirk, sound engineer; E. M. Leibscher, mechanical engineer.

The organization is featuring Excelatone, a sound recording system, a description of which will appear in the July issue of The International Photographer.

The headquarters of Excelatone are located at 1611 Cosmo Street, Hollywood, where a spacious and attractive studio has been equipped and is already a going concern.

PARAMOUNT PUBLIX CORPORATION

By Virgil E. Miller

Paramount and Mr. Lubitsch are again assured of a box-office clean-up in "Monte Carlo" because none other than VICTOR MILNER is doing the negative fogging.

* * *

It will be interesting to see the three versions of "Slightly Scarlet" directed by Mr. Gasnier—the English version has photographed by CHARLES LANK; the Spanish by ALLEN SIEGLER and the French by HENRY GERRARD—so have a look.

* * *

HARRY FISCHBECK has made "Civilian Clothes," directed by Roland Lee, a "uniform-ly" photographed production that reflects credit on his ability as a master magician in the handling of actinic values.

* * *

"Manslaughter," under Mr. Abbott's direction, h a s received ARCHIE STOUT'S divided and undivided attention for several weeks, with a result that stresses STOUT'S strength stupendously (s)inematographically . . . alliteratively speaking.

* * *

DAVE ABEL has forsaken the haunt of the "Rooster that crows on the screen" for the Paramount-Publix "mountain," from whose snowy heights he now flaunts his sound cameras . . . with the result that "Grumpy," directed by Messrs. Cukor-Gardner, is photographically excellent . . . Dave's next effort will be with Mr. Goulding on a big special called "Dancing Mothers."

* * *

ALLEN SIEGLER is scoring "pars" in Clara Bow's "Love Among Millionaires" with Mr. Frank Tuttle handling the megaphone . . . AL'S "putts" keep down his score . . . he "putts" the lights just

where they belong for maintaining Paramount-Bow-Siegler reputation.

* * *

HENRY GERRARD makes Berger's "Little C a f e," featuring Chevalier; HARRY FISCHBECK next makes Carewe's "The Spoilers"; CHAS. LANG is again with Dorothy Arzner in the production "The Better Wife"; ARCHIE STOUT is getting all sails set for Mr. Abbott's "The Sea God," which smacks of the briny; ALLEN SIEGLER will probably make "The General" with Roland Lee; last, but not least, VICTOR MILNER has the nicest assignment of all . . . a vacation of about three months, during which time his address will be in automobiles, boats, mountain fastnesses, etc. . . . between here and Skagway and points north . . . directed by Mrs. Milner . . . this is a feature production for VIC that will probably bring him more satisfaction than the several other immediate past efforts . . . and all overtime after sixteen hours will probably make him a booster for other vacations.

* * *

With twenty-two of the best. second cameramen in the business (all potentially "firsts") and a like number of assistants, par excellent, well . . . Paramount can't go wrong.

SNAP

SPARKLE

BEAUTY

PERFECTION

E A S T M A N
PANCHROMATIC NEGATIVE

J. E. BRULATOUR, Inc.
DISTRIBUTOR

\mathcal{M}ITCHELL \mathcal{C}AMERA \mathcal{C}ORPORATION

665 N. Robertson Blvd. West Hollywood, Calif.

Cable address "MITCAMCO" *Phone OXford 1051*

NETEEN · THIRTY

The
INTERNATIONAL
PHOTOGRAPHER

Official Bulletin of the International Photographers of the Motion Picture Industries, Local No. 659, of the International Alliance of Theatrical Stage Employees and Moving Picture Machine Operators of the United States and Canada.

Affiliated with Los Angeles Amusement Federation, California State Theatrical Federation, California State Federation of Labor, American Federation of Labor, and Federated Voters of the Los Angeles Amusement Organizations.

Vol. 2 HOLLYWOOD, CALIFORNIA, JULY, 1930 No. 6

> *"Capital is the fruit of labor, and could not exist if labor had not first existed. Labor, therefore, deserves much the higher consideration."—Abraham Lincoln.*

CONTENTS

The INTERNATIONAL PHOTOGRAPHER published monthly by Local No. 659, I. A. T. S. E. and M. P. M. O. of the United States and Canada

HOWARD E. HURD, *Publisher's Agent*

SILAS EDGAR SNYDER - - - - *Editor-in-Chief* BEN SAVAGE - - - - - *Advertising Manager*
LEWIS W. PHYSIOC - - - - *Technical Editor* FRED WESTERBERG - - *Asso. Technical Editor*
JOHN CORYDON HILL - - - - - - - *Art* CHARLES P. BOYLE - - - - - - *Treasurer*

Subscription Rates— United States and Canada, $3.00 per year. Single copies, 25 cents
Office of publication, 1605 North Cahuenga Avenue, Hollywood, California. HEmpstead 1128

The members of this Local, together with those of our sister Locals, No. 644 in New York, No. 666 in Chicago, and No. 665 in Toronto, represent the entire personnel of photographers now engaged in professional production of motion pictures in the United States and Canada. This condition renders THE INTERNATIONAL PHOTOGRAPHER a voice of an *Entire Craft*, covering a field that reaches from coast to coast across the nation.

Printed in the U. S. A. at Hollywood, California

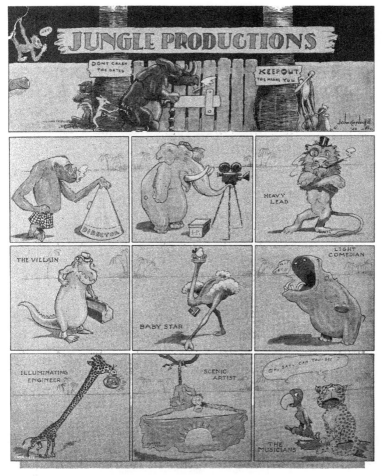

THESE TALENTED AND TEMPERAMENTAL FOLKS HAVE IN THE WORKS FOR YOU
TWELVE SNAPPY, HAIR-RAISING MOTION PICTURETTES. MONTH BY MONTH THEY
WILL BE RELEASED—EACH MORE THRILLING THAN THE LAST!

What Is the Photo Cell?

Written for The International Photographer

By T. THORNE BAKER, F.Inst., A.M.I.E.E.

Member Institute of Radio Engineers, U. S. A., Fellow of the Physical Society of London, Fellow of the Royal Photographic Society

It is only just over forty years since the German physicist Hallwachs made the important discovery that a body charged with negative electricity loses that charge if exposed to ultra-violet light.

The discovery was immediately followed up by two of the most prolific researchers in Germany, Elster and Geitel, who within a few months succeeded in finding substances which were similarly affected by light of the visible spectrum —white light, instead of the invisible ultra-violet.

The importance of these discoveries was fully recognized in the purely scientific world, and an extensive amount of research was carried on, particularly in Germany and the United States. But just as the invention of the three electrode valve made possible the wireless of today, which up to that time had been a matter for experts and engineers only, so the discovery of the same valve provided the necessary link between the photo cell as a scientific curiosity, and the photo cell

as the key to the solution of talking pictures.

Eugene Lauste and Ernst Ruhmer and others, had a quarter of a century ago succeeded in making talking films by the use of selenium. The selenium cell was the only light sensitive element then known, and while crystalline selenium deposited on a grid of platinum or gold wire will increase in conductivity ten or twenty times if the light of a few candles be thrown upon it from a metre distance, the conductivity is maintained for some seconds after the light has been extinguished, and the return to normal conductivity is retarded by the well known property of lag.

It is hardly necessary to point out that in dealing with the voice it is necessary not only to take into account eight or ten thousand sound waves per second, but that the waves themselves rise to a maximum amplitude and tail off to minimum amplitude in a very varied manner. In other words, if the sounds of the voice from a microphone be passed through a perfectly made oscillograph, and from the

latter a photographic record is made on moving film, it is seen that the trace of the waves is by no means a smooth sine curve, but that the contour may have extraordinary variations (Figure 1), the character of which is responsible for the quality of the voice. Thus the sluggish selenium cell was found to be incapable of dealing with these minute light changes.

The writer had the opportunity, on several occasions, of hearing the reproduction of music by Mr. Lauste's selenium apparatus, and the results were, to a point, remarkably good. But for the reason above stated, the talking picture lay in abeyance until the birth of the three electrode valve, which coincided with the development of a photo cell containing a light sensitive substance that responded within a two-millionth of a second to the slightest light intensity variation.

Long before there was any real thought of linking up the photo cell with talking pictures, it had been found that a good cell would detect the light of a candle

(Continued on Page 4)

WHAT IS THE PHOTO CELL?

(Continued from Page 3)

two miles away, and this extraordinary delicacy of reaction to light was made use of by astronomers in detecting the passage of a star across a slit in the eye piece of a telescope.

Today the photo cell has been developed to a quite extraordinary degree, though we are as yet only on the fringe of future developments. There are light sensitive cells of various kinds and shapes in use for light measurement, detection of color changes in chemical analysis, burglar alarms, measurement of intensity of the light of the atmosphere, detecting the presence of haze in railway tunnels, and so on, irrespective of picture telegraphy and sound films. Just, however, as cinematography is today the biggest industry in the world, so the application of the photo cell to talking pictures will probably be its most important one, and in the present article we shall deal with some of the properties of this remarkable "electric eye" which, has given entree to the new motion picture era.

Certain metals re-act to light in the following way: When light falls upon them, negatively charged electrons break away from the surface, or are "emitted." These electrons are emitted at a rate which is directly proportional to the amount of light, and if a metallic conductor such as a wire ring or loop be placed a short distance away from the illuminated surface, the electrons will fly across to it and be collected by it. If the metal on which the light is falling, and the metal ring, be connected by wires to a delicate galvanometer, the latter will register a feeble current showing that the emission of the electrons and their transfer from the metal to the loop is causing a continual flow of electrical energy around the circuit. The metals which are most affected are unfortunately potassium, sodium, rubidium, caesium, etc., all of which have the property of being almost instantly oxidized when in contact with air. If a piece of sodium is cut in two with a penknife, it will be seen to become coated with a grey film of oxide almost at the moment it is cut. The oxide is not sensitive to light, and it is therefore imperative to keep the light sensitive metallic surface from contact with air. Hence the modern cell is prepared by introducing potassium or other vapor into an evacuated glass or quartz bulb, and the vapor deposits itself on cooling on to the inside walls of the cell. In this way it is kept from oxidization. The wire ring, grid or collector has, of course, been introduced into the centre of the cell beforehand, and while a small current is passed through the cell, using the deposit of potassium or sodium, etc., as the cathode, a little hydrogen gas is introduced, which has the effect of converting the metal into potassium or sodium hydride. The hydride, unlike the oxide, is not only sensitive to light, but far more sensitive than the metal itself. The cell can then be sealed off in a state of very high vacuum, or before it is sealed off a trace of argon or some other inert gas may be introduced. The reason for this will be seen in a moment.

We have now a photo cell which will create an electric current proportionate to the strength of the light which falls

EISENSTEIN ARRIVES

Serge Eisenstein, famous Russian motion picture director at left with his cameraman, Henk Alsem. Mr. Eisenstein, producer of "Cruiser Potemkin," "Old and New" and other well known Russian films, has recently arrived in Hollywood to direct a picture for Paramount.

on the metal coating; with a patch of light three centimetres in diameter falling on the cathode, the light of a 100 watt lamp 8 inches away will produce a current of about one micro-ampere.

The electrons travel with tremendous speed, and in the case of a gas-filled cell, they come into collision with the argon molecules. The effect of these collisions is that electrons become detached from the argon molecules, and these electrons travel along with the original electrons, and add to their number. Hence the photo electric current for a given amount of light is enormously increased.

Another advantage of the gas-filled cell is that the current generated from a given amount of light can be greatly increased by increasing the voltage applied to the cell. This is seen in Figure 2. In the vacuum type of cell (b) the output in micro-amperes increases with the voltage up to about 20 volts and then remains almost stationary. With the gas-filled lamp (a), on the other hand, the micro-amperes increase very rapidly when the voltage rises above 60. There is a limit to the voltage which can be applied on account of the so-called glow discharge which takes place above a critical value. As the voltage is increased, a stage is reached in which the positive ions which are produced in the cell cause, through collision with the electrons emitted by the cathode equally as numerous. This stage is accompanied by a glow discharge when current continues to flow, even though the cell be not illuminated. The gas-filled cell is most efficient when worked at a potential a few volts below that which causes the glow discharge, and this voltage is known as the glow potential.

An important point which requires careful study in connection with these cells is the variation in their sensitivity

with light wave-length. Some attention will be paid to this point, because it introduces the question of tone of the positive image and control of the quality of the light which is projected through the sound track on to the cell in reproduction. Different photo electric substances such as the hydride of potassium, rubidium, caesium and so on, exhibit selective tendencies with regard to the light which excites them. Figure 3 shows the maximum sensitivity of four types of cell. It will be seen that the sodium cell responds chiefly to the ultra-violet rays of shorter wave length than the extreme violet. Potassium is chiefly sensitive to light of wave lengths about 430 millimicrons. Rubidium on the other hand, has its maximum sensitiveness to light of wave length 470, while caesium is mostly sensitive to green light of wave length 550. It is thus important to bear in mind the color sensitiveness of the cell when choosing the light with which it is to be used. In the photometry of white light it is a common practice now to employ two or even three cells with maxima in different parts of the spectrum so as to integrate the total spectrum effect.

A new method has been recently introduced in which the photo electric film is coated upon a metallic support, and in this way a cell can be produced by depositing potassium on a copper cathode with a maximum sensitivity in the orange at about 580 to 590 wave length. Caesium deposited on silver can be made to respond chiefly to rays in the deep red with a maximum of about 750. It is thus seen that the photo electric cell is capable of very varied properties, and when we remember that these properties have only been intensively studied during the last two or three years, it will be realized that the sound film engineer has a rich harvest in front of him from which to gather improvements for his work.

Figue 4 shows the effect of variation of the light intensity on the voltage-current effect of an average gas-filled cell. Such series of curves indicate that there is an optimum minimum voltage for different strengths of the light that is allowed to fall on the cell.

Bearing in mind the fact that even with a gas-filled cell the current produced with the strongest amount of light that can be conveniently projected through the sound track is excessively minute, we can see that amplification by valves is essential for the operation of any form of loud speaker. As in photo telegraphy it is essential for the best results to choose straight line portions of the characteristic curves of both cells and valves, and to co-ordinate these so that over a wide frequency range the currents produced in the loud speaker are kept proportional to the quantity of light passing through the sound track. The methods of linking up the cell with the loud speaker are as many and as varied as the ordinary circuits of the wireless engineer. In its simplest form the effect of light on a cell can be tested, as shown in Figure 5. Here we see the cathode connected in series with a delicate galvanometer (g), a safety resistance (r) of about 10,000 ohms, and a battery. Over a wide range the reading of the

(Concluded on Page 6)

What's In a Name?

Names represent products . . standards. As reputation of a product increases, so, in proportion, does its standard.

Millions of dollars a year are expended upon various products simply because of names and what they insure . . quality, usefulness, organization integrity.

Within the motion picture industry "Mole-Richardson" retains a significance, imparts a sense of confidence in the products it represents.

Whenever "Mole-Richardson" is mentioned there is an immediate association with "Inkies" and set lighting equipment of every discription . . good dependable equipment.

For such is the reputation of Mole-Richardson products, such is the standard Mole-Richardson products maintain . . good, dependable lighting equipment.

If It Isn't An Ⓡ It Isn't An Inkie.

MOLE-RICHARDSON INC.
STUDIO LIGHTING EQUIPMENT
941 N. SYCAMORE AVENUE · · · · · · · · HOLLYWOOD, CALIFORNIA

The Advent of the Lamp That Can Make No Noise

DELBERT E. DAVENPORT

Behold the Creco Mute! And, you can only behold it, for you cannot hear it. Not even is the highly sensitized microphone capable of picking up the slightest semblance of sound though this newest baby sun arc of picturedom be as close as two feet. Representing as it does the latest and one of the most important triumps of C. Slim Roe and bidding fair to prove the complete answer to the soundman's prayer, this aforesaid Creco Mute is certainly worthy of plenty of attention from the motion picture industry, just now on the threshold of the grim necessity for perfection in all that pertains to the making of sound films.

Mute, as a name, by the way, is most appropriate and is destined to become a by-word in studios, especially since this lamp is declared to be one hundred per cent mute— as silent as a tomb at the witching hour of midnight. Forsooth, in tests made on various sound stages, the soundmen were not aware of its presence even though it was operating full-blast, and, soundmen, you know, have the added advantage of marvelous mechanical "ears" besides their own highly trained ones!

Several of the intricate features of the construction of this baby arc are secret, but there is no hesitancy on the part of Mr. Roe to divulge the fact that one of the main things about it is there has been provided a way to avoid intermittent feed, the positive head being designed so this part of the operation is continuous, thus eliminating the click which has been the bane of makers of sound pictures.

Equally important are the gears, and equally different, too. At last this part of the mechanism can be depended upon to be submerged too deeply in death-like silence to be detected by the most powerful microphone. Working on the well-known basis that when a lamp is cold the gears run on a pitch line while when hot the inside cam expands due to the effect of the heat on the different metals used in the head as well as the mechanism in the base, all of which did not expand the same, thereby throwing the whole gear system out of line and making them loose, the ever-resourceful Slim Roe and his corps of engineers devised a brand-new formula for a composition which, when moulded into gears, would not be subject to such erratic changes. In fact, the material which is used to manufacture these vital parts of this electric-driven lamp is absolutely immune to any and all assaults either of intense heat or the cold. Explicitly, the gears in the Creco Mute neither contract nor expand, and, once they are adjusted properly, they are free from all back-lash permanently, lubricating themselves from their own textures, quite a remarkable achievement within itself.

Likewise were metal brushes dispensed with for the reason that they were invariably guilty of making noises. A spe-

cial composition was pressed into service to overcome this fault and squeaks were made impossible while simultaneously the maintenance of perfect lubrication was assured.

Much in the way of improvement was accomplished in the construction of the choke coil used on the Creco Mute, too. The result of nearly a year of experimental work on this part of the lamp is, the total elimination of all carbon noises

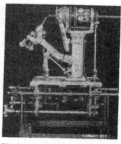

The element of the Creco Mute, showing the graceful lines which only genius is capable of producing; a mechanism which is at once simple and efficient.

when, of course, carefully selected carbon, free of gas pockets, is made.

Creco has started mass production on two sizes of its new Mute—an 18-inch and a 24-inch. The latter is only sixty pounds heavier than an incandescent of the same size and weighs less than one-quarter what any other sun-arc does. This will prove a boon inasmuch as the lamp is usually mobile and easy to handle under all film-making and recording conditions. The light value is 20,000 candle-power at the crater of the lamp with 9 mm. carbon being used. This gives the Creco Mute the advantage of making use of 2,925 watts at the arc as against the 500 watts of which the same sized incandescent is capable. It is noteworthy to add in this connection that due to the installation of a special ventilating system, there is much less heat generated than in any other lamp, according to the claims advanced for it.

The Creco Mute is being manufactured at "the house that Slim Roe built" at 1027 Seward street, Hollywood, under the Beck patents through a special license, and twenty expert mechanics are working full time every day to build enough of these all-silent light-givers for motion pictures to meet a demand which already is reaching large proportions.

[*Six*]

WHAT IS THE PHOTO CELL?

(Continued from Page 4)

galvanometer should be directly proportional to the intensity of the light.

Photo electric cells have their own individualities, and a certain amount of physical skill is necessary at the present time for trying them out and getting the best out of them that they can give. But we can look forward to the time when one or two standardized types will be available for motion picture work, with probably a very much greater output than is obtainable at present, and such improvements will, of course, be of very great value to the sound picture man.

It will be seen that although the vacuum type of cell gives an almost exact relationship between the strength of illumination and the current, a number of other relationships enter into the process of converting the image on the sound track into music or speech. The problem of the variable density record is more photographic than anything else, because the relation between density and exposure is a fundamental characteristic of the emulsion with which the stock is coated. This is a matter which requires separate treatment and will be dealt with in a future article. In the variable area method, we are concerned with black and white only and immediate response. But in both cases the greatest respect is due to the lamp, the rays of which are passing through the sound track to the photo cell. It is indeed doubtful whether sufficient attention has yet been paid to the standardization of this light. In the case of a filament lamp, the illumination given for a given current drops with time, as is well known, and then continues more or less steady for a further period, after which it drops badly. A lamp of this type should be run in a laboratory until the long period is reached over which it will maintain a given output for a given current. The change in spectrum energy distribution must be also studied, and to get the best results a type of lamp is desirable in which spectral distribution remains nearly constant during its useful life.

No matter how good the photo cell may be in its emission over a range of light intensities, its virtues may be upset by undesirable characteristics in the valves. In fact, although the photo cell is the best behaved unit in a talkie set, it is after all only a unit, and must be considered in conjunction with the whole of the outfit employed in sound reproduction.

June — the biggest month in *Laco* history!

—an open letter

to the Chief Electricians of the motion picture industry, in answer to inquiries in regard to repeated demands for the delivery of *Laco* LITES

Gentlemen:

In answer to the many recent inquiries regarding delivery of *Laco* LITES, we wish to advise, that due to the consistent demand that has been made for this product, out plant is working at full speed turning out *Laco* LITES, in an endeavor that we may, in the near future, be able to have, at least, a small surplus supply.

Then, too, in reference to our latest achievement—we are developing a *Laco* LITE that will embody every advanced improvement in incandescent light construction to be put on the market within the next thirty days. As has ever been found true of *Laco* products, this lite will offer the last word in studio illumination.

We herewith thank Mr. Frank Murphy, well known lighting authority and chief electrical engineer of Warner Brothers Studios, who this month has favored us with an order for one hundred and fifty *Laco* LITES, proof enough of his appreciation for up-to-the-minute lighting apparatus.

Sincerely yours,

LAKIN CORPORATION
Manufacturers of "*Laco* LITES"
Frank P. Arrousez, Sales Manager.

P. S.—A recent order for 36-inch *Laco* LITES, from Mr. William Johnson, chief electrical engineer of R. K. A. studios, consistently manifests his appreciation of the merits of Lakin products. Mr. Johnson, ever eager to adopt the best, has favored us with many repeat orders for *Laco* LITES.

New Follow Focus Device

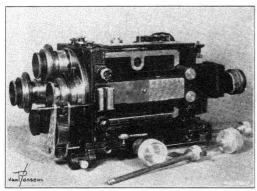

COMING AND GOING

Leonard T. Galezio has gone to the Orient to join the Garson unit of Universal as chief cinematographer to relieve Billy Adams who is en route home because of almost constant illness since he left Hollywood two months ago. All the other members of the expedition are well. Tough break for Billy.

ON VACATION

J. D. McCall, executive of the Mitchell Camera Corporation, and family are motoring in the Northwest. While away they will visit Washington, Oregon, British Columbia, Glacier Park, Lake Louise and other interesting points. We shall expect an interesting motorlogue from J. D. on his return.

RICHARDSON RETURNS

Elmer Richardson, of Mole-Richardson Corporation, has returned from Washington, D. C., where he attended the Spring Convention of the S. M. P. E. as a delegate from the Pacific Coast Section. "Rich" and Pete Mole take turns about representing M.-R. at the S. M. P. E. gatherings.

J. B. Dabney & Co., 4857 Melrose Avenue, announce a new follow focus device which is attracting a lot of attention. The device was invented by Mr. J. B. Dabney, of the Tiffany Studios, and it has been found a practical and efficient improvement by Universal, United Artists, Tiffany, Technicolor, Metropolitan studios and by Samuel Goldwyn.

The Dabney Follow Focus Device is suitable for any blimp and is adaptable to either Mitchell or Bell & Howell cameras.

Here is a picture of Ray June's camera equipped with a Dabney. It will be seen that the device is as simple as A B C.

Cream o' th' Stills

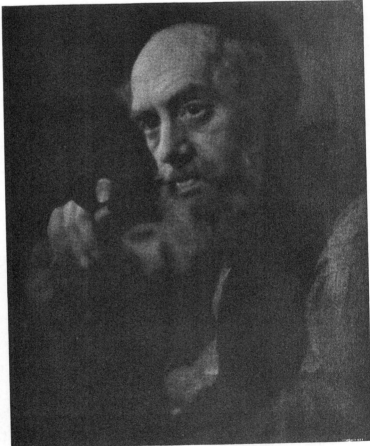

One day while at work in the studio Louie De Angelis thought he saw possibilities in an old extra man. A pipe, a cap and an old coat as props and this work of art was the result.

 # Cream o' th' Stills

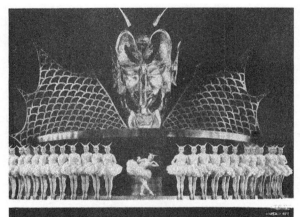

S. C. Manatt
is responsible
for this attractive
still, which is
a study in tarleton
and silk. The
dancers are from
the school of
Albertina Rasch.

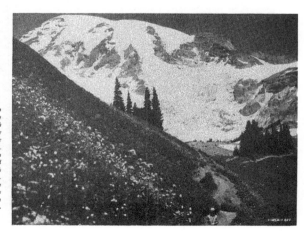

Walter Van Rossem
found this charming
mountain path
away up in the
meadows of the
High Sierras.
The flowers in
the foreground add
a delightful touch
to the picture.
Too bad that a
shot like this
cannot be done in
the natural colors.

Cream o' th' Stills

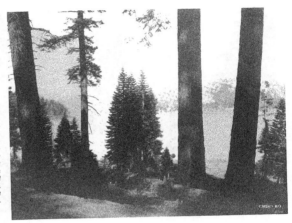

Lights and shadows on giant redwood trees in the High Sierras around Lake Huntington. Snowy peak of Kaiser Mountain in the background. Some of the largest redwood trees in the world abound in this section. A. C. Schmidt is the artist.

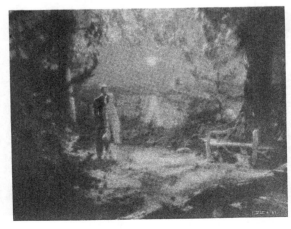

During the filming of the Fox picture, "Very Confidential," this scene attracted the attention of David Ragin. The featured player is Madge Bellamy.

 # Cream o' th' Stills

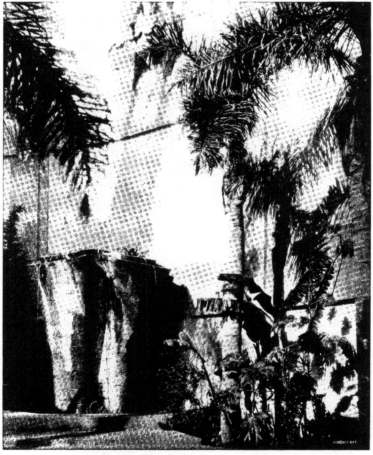

Shirley Vance Martin loves to snoop with his camera around the nooks and crannies of beautiful buildings. Here is an effect you may not have noticed while knocking around Grauman's Chinese Theatre.

My Impressions of the "Still" Picture

By DAVE FRAZER, Local 659

(As seen by a former Exchange Member and Home Office Representative)

Frankly, this article has one purpose—the continuation, certainly, and the increase if possible of the use of *still* photographs. The writer must, of necessity, confine his opinions strictly to the viewpoint of the man in the field, but that includes the exhibitor as well as the representative of the distributor, since in the final analysis the exhibitor is the ultimate in field work.

In order intelligently to present my thoughts it is necessary that I resort to the personal pronoun, so please do not consider this as any attempt to exploit ego.

My initiation into the motion picture industry was as sales representative for one of the oldest and largest of the production companies, however, my territory consisted, for the most part, of small towns. It was not long before I realized that newspaper exploitation was out of the question in these places, that they had no boards to use anything larger than a one-sheet and that they depended almost entirely upon the use of 11x14 lobby cards and *stills* since almost without exception one-sheets feature no action and are largerly "star" publicity.

The 11x14 lobby cards are in practically every case "dressed up" and entirely lacking in portraying any action. Please bear in mind that the small town exhibitor, whether he be in the east or west, sells his attraction through the medium of the action displayed in his lobby exhibit; consequently through a natural course of deduction I soon found that I could sell more pictures through carrying a set of *stills* than in any other manner. The exhibitor's interest was always obtained in that way, and it was not long before the lobby displays in my territory consisted largely of *stills*; also in just five months from the day I entered the business I had made sufficient showing to be appointed manager of an exchange.

As an exchange manager I came in contact with first-run exhibitors and their publicity men, but I continued my faith in *stills*. In the great majority of instances the picture is bought en bloc and booked immediately after a world premiere, before prints are received by the distributing exchange. But the publicity department of the theatre have their layout completed before previewing the subject, all material being secured from the set of studio *stills* which have reached the exchange weeks ahead of the print.

I became quite concerned regarding the set of eight 11x14 lobby cards being issued on each release and wrote my home office suggesting that twelve of these cards be issued, still to be distributed in sets of eight, but with four cards depicting action so that those exhibitors who needed them could get action and the others could still receive "dressed up" lobby cards (because as issued, practically all 11x14s are devoid of action), and the home office replied that they didn't care to make the change inasmuch as *stills* were available on all releases and that exhibitors could always procure what they needed through the use of the *still* photographs. Certainly a worth-while testimonial for the *still* picture.

CHICAGO S. M. P. E.

The first meeting of the Chicago Section of the Society of Motion Picture Engineers was held recently, at which time officers were elected. J. A. Dubray was elected chairman and J. Elliott Jenkins, secretary. Dubray, Jenkins, O. F. Sphar and O. B. Depue were made governors, and Dubray, E. S. Pearsall, Jr., and Fred Kranz were made members of the paper and program committee with Dubray acting as chairman. B. W. Depue was appointed to handle publicity. The boundaries of the Section were set as a line running north and south through a point fifty miles west of Cleveland and a line east of Denver, the north and south boundaries to be those of the United States. It was also decided that a dinner meeting shall be held once every month.

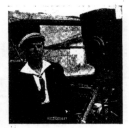

.. THE UNIVERSITY OF LIGHT

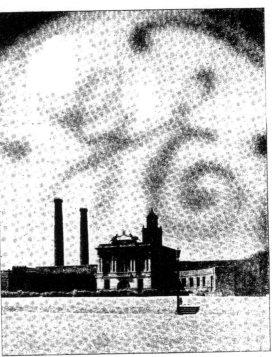

HIGH on the hills east of Cleveland, Ohio, looking out across a teeming city, is Nela Park—Lighting Headquarters of the world. Here, surrounded by great trees and broad expanses of lawn, suggestive of a college campus, the scientist works in his laboratory on tomorrow's light. Here, dedicated to the best interests and specific needs of the cineatographer, are specialists in photographic lighting who devote themselves unremittingly to solving each new problem that arises in the photographic studio. Here, in the experimental laboratory and lamp testing department, are evolved principles and developments that have added to the sterling reputation of G. E. MAZDA photographic lamps. Here, in the shadow of the greatest name in electricity, are formulated the ideals of quality and service of a great product. National Lamp Works of General Electric Company, Nela Park, Cleveland, Ohio.

• • •

GENERAL ELECTRIC
MAZDA LAMPS

My Impressions of the "Still" Picture

By Dave Frazer, Local 659

(As seen by a former Exchange Member and Home Office Representative)

Frankly, this article has one purpose—the continuation, certainly, and the increase if possible of the use of *still* photographs. The writer must, of necessity, confine his opinions strictly to the viewpoint of the man in the field, but that includes the exhibitor as well as the representative of the distributor, since in the final analysis the exhibitor is the ultimate in field work.

In order intelligently to present my thoughts it is necessary that I resort to the personal pronoun, so please do not consider this as any attempt to exploit ego.

My initiation into the motion picture industry was as sales representative for one of the oldest and largest of the production companies, however, my territory consisted, for the most part, of small towns. It was not long before I realized that newspaper exploitation was out of the question in these places, that they had no boards to use anything larger than a one-sheet and that they depended almost entirely upon the use of 11x14 lobby cards and *stills* since almost without exception one-sheets feature no action and are largely "star" publicity.

The 11x14 lobby cards are in practically every case "dressed up" and entirely lacking in portraying any action. Please bear in mind that the small town exhibitor, whether he be in the east or west, sells his attraction through the medium of the action displayed in his lobby exhibit; consequently through a natural course of deduction I soon found that I could sell more pictures through carrying a set of *stills* than in any other manner. The exhibitor's interest was always obtained in that way, and it was not long before the lobby displays in my territory consisted largely of *stills;* also in just five months from the day I entered the business I had made sufficient showing to be appointed manager of an exchange.

As an exchange manager I came in contact with first-run exhibitors and their publicity men, but I continued my faith in *stills*. In the great majority of instances the picture is bought en bloc and booked immediately after a world premiere, before prints are received by the distributing exchange. But the publicity department of the theatre have their layout completed before previewing the subject, all material being secured from the set of studio *stills* which have reached the exchange weeks ahead of the print.

I became quite concerned regarding the set of eight 11x14 lobby cards being issued on each release and wrote my home office suggesting that twelve of these cards be issued, still to be distributed in sets of eight, but with four cards depicting action so that those exhibitors who needed them could get action and the others could still receive "dressed up" lobby cards (because as issued, practically all 11x14s are devoid of action), and the home office replied that they didn't care to make the change inasmuch as *stills* were available on all releases and that exhibitors could always pr.ocure what they needed through the use of the *still* photographs. Certainly a worth-while testimonial for the *still* picture.

CHICAGO S. M. P. E.

The first meeting of the Chicago Section of the Society of Motion Picture Engineers was held recently, at which time officers were elected. J. A. Dubray was elected chairman and J. Elliott Jenkins, secretary. Dubray, Jenkins, O. F. Sphar and O. B. Depue were made governors, and Dubray, E. S. Pearsall, Jr., and Fred Kranz were made members of the paper and program committee w;th Dubray acting as chairman. B. W. Depue was appointed to handle publicity. The boundaries of the Section were set as a line running north and south through a point fifty miles west of Cleveland and a line east of Denver, the north and south boundaries to be those of the United States. It was also decided that a dinner meeting shall be held once every month.

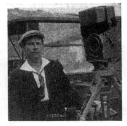

... THE UNIVERSITY OF LIGHT

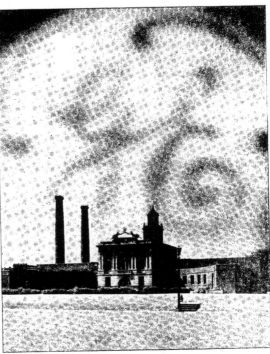

Hɪɢʜ on the hills east of Cleveland, Ohio, looking out across a teeming city, is Nela Park—Lighting Headquarters of the world. Here, surrounded by great trees and broad expanses of lawn, suggestive of a college campus, the scientist works in his laboratory on tomorrow's light. Here, dedicated to the best interests and specific needs of the cinematographer, are specialists in photographic lighting who devote themselves unremittingly to solving each new problem that arises in the photographic studio. Here, in the experimental laboratory and lamp testing department, are evolved principles and developments that have added to the sterling reputation of G. E. Mazda photographic lamps. Here, in the shadow of the greatest name in electricity, are formulated the ideals of quality and service of a great product. National Lamp Works of General Electric Company, Nela Park, Cleveland, Ohio.

• • •

Join us in the General Electric Program, broadcast every Saturday evening over a nation-wide N. B. C. network.

GENERAL ELECTRIC
MAZDA LAMPS

Optical Printing

By LLOYD KNECHTEL, R. K. O. Studios

Within the past few years departments have sprung up in the majority of motion picture studios that specialize in the re-photographing of film by means of an optical printer. An optical printer is a device consisting of an ordinary motion picture camera mounted to photograph a positive print, the movement of the print and that of the raw negative stock, being synchronized. The process of optical

made care is taken that the quality is soft, in other words that the blacks in the prints are on the gray side, and that all of the half-tones in the film are brought out. It is quite important to use a soft master print.

In optically making a duplicate negative it is found advisable to build up the quality in richness and if given the proper exposure and the proper handling in the

Lloyd Knechtel at his Optical Printer.

printing may be compared to the making of the photographic copy of a still picture.

Perhaps a short outline of the procedure used in this work would be interesting. A print is made from the original negative, usually on a special lavender positive stock. When the print is

laboratory, will give very satisfactory results. The film used for the duplicate negative is a yellow-dyed film, very fine in grain, known as duplicating negative stock. Of course different methods of working are used in extreme cases. In the production of a picture one is called upon to reproduce a new negative from

a black and white projection print. For this problem, orthochromatic of par-speed negative is used to best advantage, with the aid of the desired number of filters and the proper balance of exposure.

Great care is taken at all times in the handling of the lavender master print, both at the laboratory and before the film is processed. Any dirt, scratches, fluctuations, or abrasions would naturally be re-photographed on the duplicate negative.

In many cases original negative may be improved by use of an optical printer. A negative may be very thin, and lacking in contrast. By proper handling of the master print on the optical printer, a much richer quality may be obtained on a duplicate negative. An optical printer may be used for magnifying scenes, for reducing scenes, for stop-motion or speeding up action, split-screens and double exposure. With the arrival of sound the making of lap dissolves on the set has its complications.

The optical printer is used to great advantage here, because direct contact may be made with the film editors of the picture being worked on. The proper tempo of the action is then used, without dead footage between the lap dissolves.

It is very difficult in shooting on the set to obtain the desired footage that the film editor requires in the cutting of a picture. Many interesting trick effects are worked out with the aid of the optical printer, and its use today in the industry is a decided asset to the production of a modern motion picture in sound.

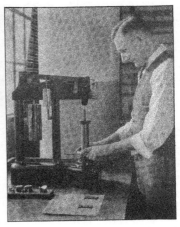
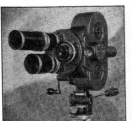

The X-Atomic (Unknown Atom) Normalizer

By RUTH B. DROWN, Doctor of Chiropractic

It would seem that a few words concerning radio and its theory would not be out of place here. Since my story has to do with and instrument relating to radio, I feel I can better explain its working to those who have perhaps not studied this science to any great extent.

I am quoting extracts here and there from Drake's Radio Cyclopedia for better explanation of the theory of this instrument.

The meaning of Atom as taken from the recognized authority gives to us the smallest particle of the molecule which still retains its chemic parts and consists of a nucleus surrounded by negative electrons (now thought to be positive and negative electrons) which in themselves are electrical.

The foundation of radio is a peculiar radio circuit called oscillatory circuit, and this circuit consists of a coil or wire having its two ends connected to a metal plate called a condenser. The coil of wire gives us electrical property called inductance. The metal plates of the condenser are separated from each other by insulated material called the dielectric of the condenser. This arrangement gives the condenser another electrical property called capacity or capacatance.

As the electric current passes through the coil it causes the coil to act like a magnet, and a magnetic field forms itself about the coil. Practically all of the energy in the form of electric current finally appears as a different form of energy in the magnetic field of the coil. The inductance of the coil has had the effect of stopping the flow of current and of changing the energy of the current into a magnetic field. Unless a magnetic field is formed by a permanent magnet of steel or by a steady current of electricity flowing through a coil, the magnetic field cannot long continue to exist. (Therefore, our instrument holds magnetic current only during the time a patient is attached to the instrument.)

As magnetic lines of force drop back through the wires, they set up a new electric current in the coil. Now the magnetic energy has changed back to electric current. The current flows through the coil and through the connections over to the condenser. The plate or plates of the condenser to which the current is flowing, soon are giving surplus of electricity. They have more than their normal amount of electricity. While the current is flowing toward one set of plates, it must be flowing away from the other set of plates, so its other set of plates has a deficiency of electricity, less than the normal amount. The plates of the condenser have now been charged. The plates which have more than enough electricity are said to have a positive charge, while those that have too little electricity, are said to have a negative charge.

The condenser is the only device that

RUTH B. DROWN

Dr. Ruth B. Drown, founder of the Drown Clinical Laboratory, 3085 West Seventh Street, Los Angeles, is a graduate of the Los Angeles College of Chiropractic in the class of 1926 and was also for two years a student of Osteopathy at Kirksville College. Since 1922 she has been a student of healing by what might be called vibratory methods and she is the inventor of the "X-Atomic Normalizer" and the discoverer of the principle of self-healing which called forth its invention. This article by Dr. Drown is the second of a series of articles on subjects of general interest aside from cinematography and submitted to our members and reading clientele in the hope that some may be benefitted by them. In this case the important facts are: First, that Dr. Drown has discovered a new and painless method of healing and, second, that through her invention, healing by BROADCAST is now a scientific fact open to the investigation of anyone interested. Dr. Drown is a practical person as well as a theorist and she is able to wire her own instruments, or "healing units." The Doctor has applied for patents through Patent Attorneys Stitt, of Washington, D. C., and in the meantime is conducting her clinic and has a long list of cures to the credit of her X-Atomic Normalizer. It is also of interest to note that the first report of a practical system of healing by BROADCAST is published first in the world by The International Photographer. — Editor's Note.

actually stores electricity in its original form. A storage battery does not store electricity, but only provides materials which are changed chemically by a flow of electric current through them, so that they may produce another electric current when the chemical change is reversed. The condenser, however, actually stores a charge of electricity on its plates. Therefore, as one set of plates in the condenser has a charge of positive electricity and the other has a charge of negative electricity, it may be realized that these two charges are going to come together and neutralize each other.

Both sides of the condenser are then again in normal condition, but as the electric current from the condenser flows through the coil, another magnetic field is built up, and so the action goes on. The energy oscillates, or swings back and forth between the coil and condenser, and it keeps on oscillating until all the energy has been dissipated by the resistance in the parts of this oscillatory circuit. If the act of an oscillating current is understood, many of the apparent mysterious actions in radio will lose their mystery and be easily understood. Therefore, our instrument seems to us to be very simple with nothing unusual about it in any way, excepting the fact that the energy used is sent out from the human body, instead of being sent out from the usual electrical dynamo.

The *theory* of this instrument is the same as the radio broadcasting station, which consists of a device assigned to send electro-magnetic waves out unto the antenna and to make the impulses leave this antenna and travel through space. One terminal of the broadcasting apparatus is connected to the antenna and this then is grounded; the electro-magnetic impulses acting between the antenna and ground produce radio waves which leave the antenna and ground combination and pass out from the station with the speed of light. The speed of light is approximately 186,000 miles per second, so it does not take the radio waves very long to travel from the transmitter to the receiving stations or sets within range.

In explaining this instrument, it is necessary to refer frequently to the amperage, or flow, of the electro-magnetic energy which we use in this instrument, It is also necessary to refer to the frequency of the electro-magnetic current.

It may be considered improper to speak of amperage or voltage of a current of such frequency, as this coming from the human or animal body, but since the principle is absolutely the same as the commercial electrical principle, with no difference in the wiring or its function, it seems necessary to speak of it in terms which can be understood by one versed in commercial electricity.

As very little is known about the elec-

(Concluded on Page 18)

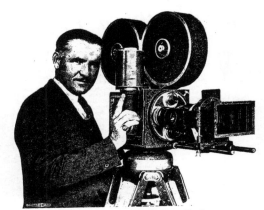

Barney McGill and his Fearless Silent Super Film Camera

Mr. Barney McGill, whose artistic perception and extreme capability has ranked him as one of Hollywood's foremost cinematographers, is the first on our list of cinematographers to receive his Fearless Silent Super-Film Camera.

Mr. McGill is recognized as one of the leaders of the industry in the number of sound productions photographed. Amongst his achievements are:

Noah's Ark
Desert Song
Show of Shows
Gold Diggers of Broadway
Mammy
What Price Glory
The Terror
Three Faces East
Soldier's Plaything
A Handful of Clouds (now making)

The World's Finest Cameramen are Ordering Fearless Cameras

Fearless Camera Co.

7160 Santa Monica Boulevard

HOLLYWOOD, CALIFORNIA

Telephone
GRanite 7111

Cable Address
"Fearcamco"

From Northern Lights

By John Corydon Hill

WHATEVER may be our conception of the stark, uncompromising nature of the Arctic region, one cannot grasp the meaning of life in that frigid country without hearing from the lips of one born and raised there the real story.

Aghnichaek, just in from the deserts of Arizona, told me the other day something of life close up under the Northern lights. It seems funny for an Eskimo to be knocking around in Arizona, but this particular Eskimo has encountered funny experiences galore—and some not so funny, likewise.

For instance, it was news to me that these people bleed at the nose upon changing to a warmer climate, and many of them die. They also suffer from the change of diet; the change from real honest-to-goodness foods to near victuals, imitation eatables and plain and fancy junk, which comes in cans, and which only the blonde race, with gizzards like ostriches, can negotiate.

At sixteen Aghnichaek started for the Indian school and, while waiting for a steamer, bumped into a cameraman, who was in need of an assistant. The young Eskimo tackled the job, and got the hang of the proposition so well and quickly, that he put in a year and a half at it.

A romantic outlook onto the lake at Fairbanks shot by the Eskimo boy with his little camera.

Then he took to shooting news stuff and the like and had many strange adventures, including a set-to with an obstreperous bear, which came near ending his young and ambitious career. Finally, he fared forth on the trail to Hollywood, to take part in an Eskimo picture which never was, and suffered as all do who leave the wholesome

invigorating Arctic life and come to the luke warm States.

Assistant Cameraman Ray Wise, Local 659, as we know him, is a a genial chap, quick to sense just the information you are pershing to know and generously proceeds to tell you all about it in the most instructive and entertaining way. Perhaps when he gets to be a first cameraman he will close up like a clam, but we hope not.

Not one of the eight-hundred cameramen in our organization, but could relate something

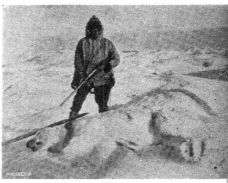

Getting ambitious, Ray Wise attempts to direct a temperamental Polar bear, with the result that he had to lance the beast and make a quick exit from the lot, to keep from being slit to ribbons.

worth while for publication, but when you try to get it—good night! Our favorit game is to "sic" one onto another and pretend not to listen. But usually it takes blasting operations to get results. The reader would hardly believe what our bill is each month for fuse, black-powder, dynamite and T. N. T.

From the kit-bag of our young friend Aghnichaek we have chosen a few fine photographs—some shot by others, but most of them by himself. Those herewith displayed show him not only to be good looking, but to be a good judge of what constitutes a picture, and to be able to go and get it.

Eskimo twins come chubby, and look as much alike as all twins do.

To Desert Sands

1—*Grandma Tug-loah-chaek, chipper at sixty, does a man's work with her rifle and snow-shoes.*

2—*Home-folks are home-folks the world over, and look good to wandering boys.*

3—*A wee snow-bird, only half Eskimo, but all girlie at that.*

4—*Two of Ray's live-wire young sisters.*

5—*An uncle and aunt, and both good to look at.*

6—*Kiddies, whatever their nationality, know what the sea shore is for.*

7—*Aghnichaek himself, equipped for a hard winter.*

8—*The old home town. Kotzebue, Alaska, facing west upon a sound within the Arctic Circle.*

9—*A small, small fisher-maid, with a big catch.*

10—*Ray has his picture taken with his Excellency, the Governor of Alaska.*

11—*In the States our Eskimo boy goes on location as an assistant cameraman.*

THE X-ATOMIC NORMALIZER
(Continued from Page 14)

tro-magnetic energy of the body, we can only assume that the body atoms which are made up of positive and negatice electrons, give off an alternating current and possibly a direct current, as the meter which we use is a direct current meter. (However, this meter may be only a heat meter, but its action on each patient varies with the tuning in of the different dials, and sometimes does not register at all. This varies from day to day.) Also, we find when we connect a violin in the position of the patient and vibrate the strings, that this meter moves up and down, varying with the different strings and their vibration.

The impulses of electro-magnetic energy sent from the body into the instrument are of very small amperage (micro-amperage) but are of extremely high frequency. We would say, to the best of our knowledge, basing it upon the fact that the highest broad-casting frequency of the electrical stations is 1,500,-000 cycles, that ours is 500,000,000 and over, at the present time too rapid to be measured accurately. This may seem difficult to comprehend, but since it is being done, there must be some method devised in the future by which it can be measured comparatively accurately.

Because the human ear can distinguish as sounds all vibrations having frequences between about 16 per second and 16,000 per second, frequencies greater than these do not affect the average ear as sounds. Therefore, this cannot be heard by the ear, excepting through modulated radio waves, this being controlled and affected by commercial electricity, and our energy which comes from the body, comes "as is," without changes in any way. There is a certain amount of this energy which can be heard as such, only by the telephone receivers, but this does not include all of the wave lengths of electro-magnetic energy which passes through our instrument and takes its place as part of the healing energy.

This instrument was invented to provide an apparatus which causes the electro-magnetic energy of the atoms of the body, human or animal, to become so amplified that the molecular energy (or atomic energy) is changed from one of very low frequency to a much higher

frequency, thus causing the diseased tissue of the body to vibrate at a much faster rate of vibration, which, when coupled with the general metabolism of the body, causes the newly formed cells to vibrate very much faster, and the old cells to fall away normally.

Our instrument, by energising from the human (or animal) body, and having no electricity generated from any other form of battery or generator, treats the patients entirely with that energy which is individual to them. The fact that each person is an individual proves that he has his own normal rate of vibration, and only his own energy can heal him—any other energy is foreign to his body.

It is my opinion that disease germs must have their own soil in which to live, and that is none other than their own rate of vibration. When the cell vibration rate is raised, the disease no longer has its own soil in which it can live. So-called disease germs can never be killed out. The world is full of them, but the body is immune to them when vibrating at its normal rate. Therefore, this instrument amplifies the body energy, using the electro-magnetic energy of the cells, and by radio "step-up" system, raises the energy to a faster rate of vibration, or higher frequency.

We also are able to tune into the different organs of the body (as each organ gives off its own rate of vibration) and discover the disease located there. Everything has its molecular rate of vibration and can be "tuned in" for and located the same as any broadcasting station can be located.

Another object of this instrument is to use a condenser (which is a true storage battery) for the purpose of broadcasting treatment to the patient, after the patient's energy has been stored therein. This is done by treating the patient through this condenser (or storage battery) and storing his energy in it. Then at any time later, this condenser can be attached to the instrument and the patient treated by broadcasting, the patient being the only receiving station "tuned in" to his rate of vibration.

It is my theory that the ether, as well as the earth, is made of strata of vibrations, and they circle the world as layers, all vibrating as fast and faster than light. We have the strata of rock, branch formation of trees, etc., in the earth as

proof. Thus this energy sent in to its own combination of strata, causes the patient to receive almost instantaneous results. These strata consist of radio frequencies or radio waves which are used for transmission of radio signals or energies through space. These frequencies range from between 90,000 to 100,000 cycles per second in long waves transmission, up to 400,000,000 or more cycles per second, depending on type of transmission.

It is my opinion that this instrument sends its energy out even faster than any other method because of the rapidity of the molecular vibration of the body. As we have only 0 to 9, inclusive, combined in many ways, it would seem that we have ten different strata through and around the earth's surface, numbering from 0 to 9. If we have in our disease a combination of 50-3-2, our instrument would say the 5 strata, the 0 strat, the 3 strata, and the 2 strata. Thus we would tune in to the above strata and the organ which it represents. The organ being in tune (or in harmony) and the disease, whose rate precedes, being out of harmony, or in a state of disease, we amplify that rate through the instrument until it no longer exists as such, but has become amplified and harmonious with the normal rate of the patient.

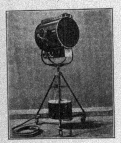
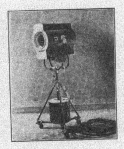

Report of Election Commissioners

Second General Election Local 659, I. A. T. S. E. and M. P. M. O. Held Sunday, June 29, 1930

June 30, 1930.

International Photographers of the Motion Picture Industries, Local 659, I. A. T. S. E. and M. P. M. O., 1605 North Cahuenga Avenue, Hollywood, California.

Greetings:—

The members of Local 659 shown in the list immediately following are declared elected to the office preceding their name. Figures show the total number of votes cast for the candidate.

President	Alvin Wyckoff	323
First Vice President	Roy H. Klaffki	321
Second Vice President	Ira Morgan	324
Third Vice President	Archie Stout	298
Recording Secretary	Arthur Reeves	313
Financial Secretary	Ira B. Hoke	318
Treasurer	Chas. P. Boyle	320
Sergeant-at-Arms	Len Powers	317
Chairman Trustees	Faxon Dean	252
Trustees	J. O. Taylor	221
	Paul Perry	235
First Cameramen	Jackson J. Rose	263
Representatives on Board	Sol Polito	248
	Guy Wilky	242
	Wm. H. Tuers	205
	Lyman Broening	206
Second Cameramen	Reggie Lanning	141
Still Cameramen	Fred Archer	197
News Cameramen	Joe Johnson	196
Industrial Cameramen	Ralph Yarger	234
Assistant Cameramen	Jack Russell	179

The following list indicates office for which candidate was nominated, name and number of votes cast for said candidate:

Chairman Trustees	Len Smith	73
Trustees	Arthur Miller	60
	Daniel Clark	58
	Norbert Brodine	64
First Cameramen,	Hal Mohr	146
Representatives	John Seitz	97
Board of Executives	Ernest Palmer	82
	Robert Kurrle	65
Second Cameramen	Robert DeGrasse	74
	Paul Hill	28
	James Palmer	53
	Henry Kruse	24
Assistant Cameramen	Roy Ivey	29
	James King	54
	Stanley Cortez	47

News Cameramen	Mervyn Freeman	25
	Sam Greenwald	17
	Blaine Walker	65
Industrial Cameramen,	Lenwood Abbott	57
Still Cameramen	Robert Coburn	60
	Bill Fraker	26
	Milton Brown	11

The names of the following members were written in on the ballot with the number of votes as indicated:

President	Chas. G. Clarke	1
	Joseph August	1
First Vice President	David Ragin	2
	Clyde DeVinna	1
Chairman Trustees	Dan Clark	1
	Nick Musuraca	1
First Cameramen,	Nick Musuraca	6
Representatives Board	Eddie Cronjager	4
Assistant Cameraman	Bill Clothier	1

The following members whose names are listed hereunder are those who withdrew their candidacy:

Roy W. Noble	Robert Surtees	Elmer Dyer
Bill Bradford	J. Roy Hunt	Ray June
Willard Emerick	Karl Struss	Jack Eagan
Joe Darrell	Clyde DeVinna	George Diskant
Fred West	Ralph Ash	Burnett Guffey
	Nick Musuraca	

Respectfully submitted,

ELECTION COMMISSIONERS
Local 659, I. A. T. S. E. and M. P. M. O.
JACK FUQUA,
HARRY FORBES,
HARRY VALLEJO.

RALPH STAUB COMPLETES 300TH FILM

Ralph Staub who has directed and photographed practically every star in the motion picture industry, but has never made a feature, has just completed his 300th one-reel picture, "Screen Snapshots," issue twenty-two, for Columbia release.

Included among the 300 one-reel pictures that Staub has made in the past eight years are the much noted "Guess Who" contest, "Screen Star Sport" series, "Cinema Stars," and several series of "Screen Snapshots," the all-talking newsreel showing the stars at work, at home, and at play.

Paul Perry has returned from a trip to the Yosemite and all points north. Mrs. Perry accompanied him.

LEN'S NEW CORD

Len Roos, head and chief genius of the Tanar Corporation, 1107 North Serrano, Hollywood, is driving a gorgeous new Cord car. He will now be able to slow down to 99 miles an hour.

Clifton Maupin was awarded the prize for the "most beautiful still of the month," by Screenland Magazine. The subject was a scene from D. W. Griffith's newest picture, "Abraham Lincoln."

Harry Zech has returned from a six thousand mile drive through the East and Middle-West.

Harry Gant has gone to New York with his new picture "Georgia Rose."

Fleet Southcott and Buddy Williams wrote the Editor from Paris the other day, but didn't say anything. However, judging by the post card sent it is believed that the boys have succeeded in locating "Harry's" and that Harry is looking after them. For the information of the uninitiated, it may be said that these two errant knights have been shooting stuff in Sumatra where the boa constrictors are ten feet high when parked for the night.

Brother John L. Herman, of San Francisco, is in Los Angeles for several weeks on a much deserved vacation. While here he is studying sound and sound systems as applied to newsreel work for cameramen. Brother Herman is steward of Local 659 in San Francisco.

A CORRECTION

In the article entitled "The Motion Picture: A Precocious Child," by Criticus, in The International Photographer for June, the text was garbled by the printer in the makeup thereby beclouding the meaning of several paragraphs. Following is the correct text:

Take for example the cameraman, who is in a class by himself. He is in the last analysis the one person responsible for the all important, indelible record, comprising the fruits of the labor and creative activities of author, director and motion picture engineer.

It is a peculiar and very unsatisfactory condition and fact that, although his activities are partly or entirely circumscribed by the dominating influence of the mighty trinity—that nevertheless his is the responsibility for shortcomings in final results and that only too often he has to bear the burden of criticism which should be borne by others.

The cinematographer cannot improve upon emulsion characteristics or laboratory facilities, equipment and practice, nor are his often valuable suggestions treated with a satisfactory degree of seriousness. And yet, he is blamed ninety times out of a hundred if faulty color records, fog, poor definition, excessive graininess, etc., etc., appear, for which defects other causes are often responsible.

The optical and mechanical means he is furnished with are far from perfect and he is continually called upon to remedy the imperfectness of his equipment, and so often called upon by the director to perform beyond its capacity. Let us consider only two qualities of his equipment. The quality to produce a predetermined value of correct focus and to unfailingly produce a correct exposure. So far the motion picture engineer has failed to perfect the mechano-optical equipment to enable the cinematographer to control these two all important factors and even with the highest mental equipment and well digested large experience, it is always a gamble for him to produce pictures with thoroughly satisfactory

focus and exposure effects on the screen. It is the motion picture engineer who should remedy these two so important shortcomings of camera equipment. It seems that the responsibility for unsatisfactory final results should in these instances rest upon the shoulders of the motion picture engineer and not upon those of the cameraman, as is now the case.

PARAMOUNT-PUBLIX LOT
By VIRGIL MILLER

Since the last issue, two productions have finished. Clara Bow in "Love Among the Millionaires," directed by Frank Tuttle and photographed by Allen Siegler; also "The Sea God," featuring Richard Arlen and Fay Wray, directed

by George Abbott and transferred to the screen by Commodore Archie Stout.

The five productions, now occupying the attention of the Actiniographers receiving overtime, with pay, are: 'The Spoilers," directed by Edwin Carewe, and being photographed by Harry Fischbeck and wife (yep, she's on location with him!); "The Better Wife," Dorothy Arzner directing while Charles Lang (unmarried) tells the electricians where to put the lights; "Grumpy" (Spanish) directing, with Allen Siegler directing the "Brownie No. 2's"; "Little Cafe" is taking shape under Dr. Berger's direction, Henry Gerrard being responsible for film used; "Honeymoon Hate" is getting under way with Lothar Mendes at the helm, while Dave Abel explains the working of the "blimps" to his filter fiends.

ASTRO G.M.B.H. BERLIN
F:1.8
F:2.3

ON SALE BY
MITCHELL CAMERA CORPORATION
665 NORTH ROBERTSON BOULEVARD
WEST HOLLYWOOD CALIF.

1930 Convention I. A. T. S. E. & M. P. M. O.

HE June convention of the I. A. T. S. E. and M. P. M. O. held in Los Angeles was the most successful and altogether delightful in the history of this great organization, according to what appears to be the unanimous verdict of the delegates and their friends.

The Brass Collars all were here and the attendance of delegates large and representative of the organization throughout the United States and Canada.

It was a hard working, hard playing, alert, intelligent gathering and the remembrance of this convention will linger long in the memories of all who attended.

Harmony prevailed and there was a distinct atmosphere of "get together" and "drive ahead" present at all the sessions which were sandwiched in between all sorts of entertainment stunts for the edification of the delegates and their numerous friends.

The elaborate program arranged by that famous entertainment Committee composed of W. S. (Bill) Scott, business representative; John J. Riley, T. Z. Hughes, P. O. Paulsen, James Mathews (chairman of the committee), Local 33; Lew C. B. Blix, business representative, Local 37; Ted Eckerson, business representative; P. R. Cramer, Frank Sawyer, F. L. Borch and J. B. Kenton, Local 150; Howard Hurd, business representative; James Palmer, William H. Tuers and Faxon Dean, Local 659; Carl J. Kountz, Dominic DeCenco, George D. McGrath, Local 683; was carried out as planned with only one major change and the committee functioned like a Swiss watch.

The great loadstone for all delegates was the motion picture studios and the committee was enabled to satisfy this longing to the limit.

The elaborate entertainment provided by the Fox Studios at Westwood and Warner Brothers-First National at Warner Brothers Studio was lavish, gorgeous and absolutely delightful —just what the visitors, unused to motion picture pageantry, art and hospitality most desired to experience and it was a happy, inspired, grateful throng that sang the praises of these generous hosts as they departed and will be singing them for years to come.

The entire metropolitan district of Los Angeles, including the beach cities, the mountain and valley resorts formed the playground of the delegates and visitors, while most of them visited Santa Catalina Island, the Missions, the High Sierras, the desert and, not a few, sailed through the blue ether to inspect our wonderland from above.

It was typical California hospitality and not a delegate but lingered to the last possible moment.

The convention held in the Rose Room, 755 South Spring Street, Los Angeles, turned off an immense amount of work, a full and exhaustive report of which will be forwarded direct to every I. A. T. S. E. and M. P. M. O. member from the International Headquarters in New York City.

On opening day the convention was called to order by William Scott, business representative of Local 33 and chairman of the General Committee on Arrangements, who addressed the assemblage extending to the delegates the hospitality of the Five Affiliated Locals.

Mr. Scott was followed by Secretary-Treasurer J. W. Buzzell, of the Los Angeles Central Labor Council; by Sheriff W. I. Traeger, of Los Angeles County; by Mayor John C. Porter, of Los Angeles, who presented the Key of the City to the delegates; and by C. C. Young, governor of the State of California.

In part, the Governor stated that it has been his privilege to address many conventions, national and international, and of state-wide extent, but that our International Convention, by considerable margin, was the largest he had the opportunity of facing in the last three years. Stressing the importance and necessity of entertainment, he continued: "You are members of an organization whose desire is to give the very best for the entertainment of the people. As long as you do that there isn't any doubt that the people of the United States and Canada are going to stand back of you in your endeavors. We are mighty glad to have you here in the State of California and give you a most sincere welcome, and feel that you will want to come back for subsequent conventions a good deal sooner than is now anticipated. So, come back, get the habit, California will always be glad to see you."

Brother Scott then informed the convention that as International President William F. Canavan was indisposed, First Vice-President Fred J. Dempsey would act as chairman, and presented him with a gavel in behalf of the Los Angeles delegation, as a token of the high esteem in which the official International family is held. Vice-President Dempsey acknowledged the presentation, stating it was accepted in the keen interest of our alliance and that every time it was struck it would be for the unity of the International.

Upon calling the roll it was determined that 654 local unions were represented by 846 delegates, the largest assemblage in the history of the I. A. T. S. E. and M. P. M. O.

Reports of Auditor, Secretary-Treasurer, General Executive Board, Adjustment and Claims Departments, Board of Trustees were submitted, read and accepted and the convention machinery, well oiled with intelligence and energy, moved smoothly to the end without the painful waits attendant upon the usual convention.

The following Los Angeles locals were recognized on the committees:

Resolutions—T. E. Eckerson, No. 150; L. C. G. Blix, No. 37; Howard E. Hurd, No. 659; William F. Scott, No. 33.

Grievance—E. Wentworth, No. 33; Mrs. Nell Rhea, No. 683.

Auditing and Finance—John J. Riley, No. 33; Karl Kountz, No. 683.

Special Committee—Steven Newman, No. 37.

The convention finished its labors by electing the following named officers: (Concluded on Page 28)

[*Twenty-three*]

*International President Wm. F. Canavan and his charming family
are sold on California.*

*This inverted pyramid is made up of officers a[...] E.
were active in entertaining the delegates of the [...] M.
left to right—Paul Perry, Paul Hill, Ira Mor[...]
Secretary Roy Klaffki; Recording Secretary A[...]
—Treasurer Charles P. Boyle; Vice-President [...]*

2500 *Happy Labor Devotees*

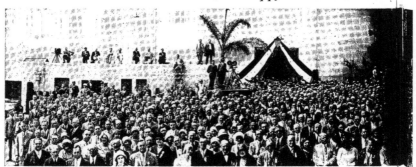

*Panorama of delegates to the Thirtieth Biennial Convention of the International Alliance Theatrical Stage Employees and [...] M.
at the Westwood Studios of the Fox Film Corporation, on the first day of the convention, where they were tendered a de[...]
of sound pictures in the making. The occasion was the most notable gathering of the kind in the history of the studios. It [...]*

of the Executive Board of Local 659 who
C. and M. P. M. O. Convention. From top,
aylor, Bud Hooper. Second row—Financial
ergeant-at-Arms William Tuers. Third row
All by himself—President Alvin Wyckoff.

Three of a kind—Howard Hurd, 659; Ralph O'Hara
and Thomas Maloy, 110, Chicago.

An Eye Full in Filmland

:ture Machine Operators, held in Los Angeles, June 2-6, 1930, together with their families and friends, photographed
ay luncheon followed by an elaborate entertainment, with the producers as hosts. Their entertainment included a view
>mely attired, good looking, dignified gathering, everyone of whom went home an enthusiastic booster for motion pictures

[*Twenty-five*]

1930 CONVENTION I. A. T. S. E. AND M. P. M. O.

(Continued from Page 23)

William F. Canavan, International President; William C. Elliott, First Vice-President; William P. Covert, Second Vice-President; Cleve Beck, Third Vice-President; John P. Nick, Fourth Vice-President; William J. Harrer, Fifth Vice-President; Joe C. Campbell, Sixth Vice-President; William Madigan, Seventh Vice-President; Fred J. Dempsey, General Secretary-Treasurer.

Trustees—William C. Scanlan, Walter Croft, John McCarroll.

Assistant President and Manager Claim Department not appointed at time of going to press.

An outstanding innovation of the Thirtieth Bi-ennial Convention of the I. A. T. S. E. awaited eight hundred and forty-six men who represented more than six hundred and fifty motion picture organizations of the United States and Canada in the Rose Room in Los Angeles, when, at the initial meeting of the convention, Mrs. Nell Rhea, representative of Los Angeles Film Editors and Laboratory Workers, Local No. 683, the first woman delegate ever elected to the International Alliance of Theatrical Stage Employees and Moving Picture Machine Operators, was introduced.

Mrs. Rhea, after the introduction, which was most ably and effectively performed by William F. Scott, business representative of Los Angeles Stage Employees and chairman of Local Arrangements, was escorted to the speaker's platform, amid tumultuous applause, where she thanked the assemblage for its enthusiastic and sincere reception.

Delegate Rhea made is known also that she appreciated the honor which Los Angeles Local 683 had conferred upon her when she was elected a representative from that organization. "It is my earnest hope," she said, "that Local 683

Mrs. Nell Rhea

will be able to do for the International Alliance, what the other local organizations already have done."

Nell Rhea, together with being an able and sincere worker for the Alliance and the Laboratory Workers' organization, holds a priceless position in the home. The mother of three children, two of whom are members of the I. A. T. S. E., is proof enough that the same spirit of unity is manifested in the Rhea home.

THE CAMERA

By JAMES COURTNEY, in Cameracraft

In master-hands, the camera is not
A mere device; it is a tool through which
His artist-soul, keyed to its highest pitch
Of pride, portrays most delicately what
His inner nature holds,
As slowly it unfolds.

Behind his great productions I can see
The man himself,—the heart's deep joy
 and strife,
The reachings of a mind that knows of
 life
And interweaves with human sympathy
The lights and shades that bring
A living, breathing thing!

QUICK IF YOU WANT 'EM

Members of Local 659 who want extra numbers of the Convention Souvenir Number of THE INTERNATIONAL PHOTOGRAPHER should notify the office at once as the issue will very soon be exhausted.

6,000 MARK

Western Electric installations throughout the world are right on top of the 6,000 mark. The latest report shows 4,093 in the United States and 1,867 in the foreign field, a total of 5,960.

Scene from the "Vagabond King," a Paramount-Famous-Lasky production

"ACTION!"

NATIONAL PHOTOGRAPHIC CARBONS allow you to get every bit of action in the scene. For sunlight and moonlight effects, night work or for long shots, use National White Flame Photographic Carbons. Their light is actinically identical with sunshine. They retain their actinic value for long distances.

The use of National Photographic Carbons cuts down the cost of lighting—enhances the efficiency of studio work. These carbons are more economical to use because they produce less heat and give more light per watt of electrical energy. They can be used in small or *large units.*

Through years of unfailing service National Photographic Carbons have established undisputed leadership in studio lighting. Stars and motion picture engineers alike enthusiastically endorse them for economy, comfort and reliability under the most trying conditions.

NATIONAL CARBON COMPANY, INC.
Carbon Sales Division: Cleveland, Ohio

Unit of Union Carbide *and Carbon Corporation*

Branch Sales Offices: New York, N. Y. Pittsburgh, Pa.
Chicago, Ill. Birmingham, Ala. San Francisco, Calif.

National Photographic Carbons

A Master of Aerial Photography

There is very little more to add to the story of the production of Howard Hughes' mammoth aerial epic, "Hell's Angels," since veritable miles of copy have been written on every conceivable angle of this fine and epoch-making cinematic job.

However, there is one part of the story of the making of this unusual picture which has not been stressed as it deserves, and, this part is of particular interest to readers of this magazine, because it concerns one of our brothers who has been distinguishing himself to a remarkable degree in recent years due to the advent of the era of air films, which have created a need for not only a further perfecting of photographic processes, but for rare human daring.

It is Harry Perry, of Local 659, who is referred to in this connection. His official title during his affiliation with the Hughes organization was supervisor of aerial cinematography and upon him depended everything when the action of the story went aloft.

Indeed his responsibility was extraordinarily great inasmuch as he had the lives of scores of men as well as his own to think about while concentrating his attentions upon the difficult task of getting recorded on film the almost unbelievable aerial stunts which abound in this picture.

It is interesting to take due cognizance at this juncture of the fact that "Hell's Angels" is the eighth motion picture feature of which he acted as supervisor and that he is at the head of the list of those who risk everything to augment the entertainment values of stories for which the theatre-going public has displayed a distinct preference here of late.

To have been in charge of the "biggest shot" ever taken in motion picture history is alone an honor for which any cinematographer would strive and this belongs to Harry Perry, because in the big dog fight which was staged over the Oakland airport and which constitutes such an outstanding feature of "Hell's Angels," he was in the thickest of it from the start to the finish. The advantageous manner in which this shot shows itself on the screen is ample proof of the complete success Mr. Perry scored in fulfilling his part of the bargain.

There were actually forty aeroplanes participating in this scene enacted high above the clouds and it cost Mr. Hughes something in the neighborhood of $300,-000. Every pilot who took part in this remarkable shot had to be trained for weeks in not only military formations in the air, bu thow to really fight as if they meant it despite the obvious dangers which lurked in every bank of the wings and every touch of the controls.

It does not seem far-fetched to state that Harry Perry had the toughest job of them all, for he had many cameras to think about while keeping uppermost in his mind the necessity for averting disaster to any of his men. After it was all over he said that when he completed his work on Paramount's "Wings," he felt convinced he had experienced the maximum in thrills, but that this maximum proved to be a very mild affair when compared to the thrills he derived from photographing this memorable dog fight.

Llewellyn Miller, in the Los Angeles Evening Record, hits the nail on the head when he writes: "Even with the inflated rumors of its spectacular qualities to surpass, 'Hell's Angels' drew enthusiastic applause for its air shots, which, beyond doubt, are the surpassing achievement of aerial photography to date."

Simultaneously, Louella Parsons, in her review in the Hearst papers, thought so much of the photography to insert in boldface type the following: "And last but by no means least, the aviators and cameramen, all of whom risked daily death to get these daring scenes. The large camera staff is headed by Gaetano Gaudio and Harry Perry and they deserve praise for their photographical exploits."

Nearly a hundred members of Local 659—cameramen and assistants—worked on "Hell's Angels" at different times under Harry Perry, whose flying record

on the picture show that he was in the air 175 hours. Burton Steene, one of his standbys, was flying 200 hours while Elmer Dyer put in fifty exciting hours up among the countless dangers. It is most regrettable that our beloved Brother Steene succumbed to heart failure the day following his rounding out of the two hundredth hour of valiant service. Brother William H. Tuers, also was one of Supervisor Perry's ace photographers.

When it is taken into consideration that there was more than two million feet of film "in the can" at the conclusion of this record-breaking filmization and that approximately $1,200,000 was expended on the air flights alone, it can be more readily understood how Howard Hughes managed to get rid of four million dollars on this ambitious cinema project.

That Harry Perry was in charge of the vital work of getting the film record of the photoplay events which involved such extensive possibilities of great loss of human life and money and that he "came through" without flinching once or without failing to do his part of the job brilliantly is conceded by all and his fellow workers in the craft have plenty of reasons to feel proud of him as one of their kind.

He has contributed much to building up the prestige of cameramen in general by his aerial achievements in "Hell's Angels" and he has set a new high mark which they will be shooting at for years to come. (*See also page 29.*)

FRANCIS J. BURGESS

S. M. P. E.

Camera Department

PARAMOUNT - PUBLIX CORPORATION

Shots from Harry Perry's Air Album

Top, center—*Showing camera mount for work in the clouds.* Top, left and right—*Shots from "Wings,"* one of Mr. Perry's big pictures. Center—*Mr. Perry ready to go aloft.* Lower left. *An enemy bomber cracks up and burns.* Right—Mr. Perry and his Aces—*at the camera, Mr. Perry; the late Burton Steene; William H. Tuers; Elmer Dyer. First row, kneeling—Tod LeClede, Don Brigham, Rod Tolmne, assistants.* At Mr. Perry's right—*Jeff Gibbons, second cameraman.* Bottom—*Chinese Theatre and Hollywood Boulevard the night of the world premiere of "Hell's Angels"* (photographed by Mickey Marigold, Local 659). *On this night Mr. Perry was up in an airplane shooting the scene below.*

"Only a Cutter"

By CRITICUS

You are visiting a motion picture studio in Hollywood and passing through the lot, a rather young man is passing you rapidly, attracting your attention by the peculiar nervous intelligence and somewhat worried concentration stamped on his face.

You turn to your guide: "Who is that chap that just passed us?" and get the answer, "Who? Him? Oh, he's only a cutter."

This answer is characteristic of one of the several idiosyncrasies prevailing in the motion picture business.

Suppose we concentrate on this statement and try to analyze it.

We find that the words "he's only a cutter," depict a frame of mind, existing in the majority of heads on the shoulders of men of important executive positions.

To understand this rather belittling frame of mind towards a "cutter" we must try to understand the position of most of the studio executives.

Shouldered with great responsibilities, too often forced to make weighty decisions as soon as the problems arise or the questions are put, their very training and routine crystallizes in high pressure production methods.

"What I want is results—and the man that gives me results today not tomorrow, is the man I want."

That's the dynamic thought and principle guiding the average head of a motion picture studio, forced upon him by the demands of the financial management.

This method is considered "good business," but if not tempered by modifications and governed by thoughts of a higher order, it defeats itself in its final results.

It is excellent for emergency conditions, but unfortunately such emergency conditions are more and more becoming normal.

To maintain, or if possible to reduce the cost estimate by speeding up production, and to maintain or if possible shorten the time schedule for release dates, anticipating the psychological demands of the public, *is* certainly good business.

With such high pressure production, however, very often ruthlessly enforced by studio management, consideration of final cost, in mental and physical efforts and human endurance (balanced by highest economical efficiency) does not enter the program.

Let us analyze for example, the defacto conditions in one of the important departments of studio organization:

The department, where the physical results of a production, comprising a mass of apparently unrelated, unchangeable, pictorial and sound records, are assembled and dissembled, moulded, changed, refined and retouched, until a final form, ready for public screen presentation is reached.

When we delve into the details of work to be performed by this department, we find it to be of necessity manned by persons with the highest class of practical experience in technical details and mental qualifications, definitely responsible for the final screen version of a picture—for its success or failure.

Who is the responsible head of this all-important department?

'Oh, he is only a cutter."

This reminds one of early Dutch and French history when the words, "Les Gueux"* and "Sans-Cullottes"† were coined by the governing cliques or classes in a ridiculing and belittling sense and intent. Words that later on, by force of performance, become of national import, by no means belittling their bearers.

"A cutter"—even the phonetics of this name imply a rather menial laborer, and there are even today a great number of studio employees who think that all a cutter has to do, is to clip the ends of the shots handed to him and paste them togehter, according to the identification "slates" and scenario numbers.

But what does he actually do; what are his responsibilities; what do his work and duties consist of?

An example:

The shooting of a picture is finished, the pictorial and sound records are turned over to the cutting room, usually in batches as they leave the laboratory, and are reviewed by the director. Even before all shots and records are in his hands, the cutter already hears the monotonous, but insisting words from all

GUESSING CONTEST

Who is this cameraman? The first ten answers will be awarded a set of Bakelite golf clubs in pastel shades with sound effects by the Baldwin Locomotive Works.

sides, "when will you be ready," and later on "Aren't you ready yet?" or "we have got to ship complete negative to New York for release prints not later than such date" and so on—High Pressure.

Remember the phrase "I want results today, not tomorrow"? That constitutes the atmosphere under which the cutter is forced to work. That atmosphere creates a tension, that increases from day to day, until his labors are finished with a success, that is only determined by the judgment of the public—that fearful judge of ever-changing whimsicality.

That nervous tension explains the expression on his face, which you observed as he passed.

During the time the records arrive in his room, he tries to study them on hand of story and scenario; unless he is working on another picture which "must" be finished on such and such a date.

He cannot, of course, determine on a definite plan of action, until all of the records are before him. His study of them enables him to make a rough pictorial sketch, which naturally follows more or less closely to the scenario—if he has the good luck of having it prepared by a picture-wise scenario writer. If the director has cutting experience, then he is still further in luck.

It is a well known fact that some, of our most successful directors have not only actual cutting experience, but really spend a great deal of their time, effort and directorial ability in the cutting room. These are of the few that "do" appreciate the difficult art of cutting.

One of the reasons for this directorial appreciation of the cutter, lies consciously or unconsciously in the recognition of the fact, that the director always sees a very much greater expanse of the scene which he is directing, than that finally appears on the screen; that some of the most dramatic scenes of his production flow before him in total without interruption. They are, however, photographed by several cameras, because one camera could not cover the whole scene or even its essential action; and they finally appear on the screen as a number of pictures, each showing only part of such totality of scene or action.

The director cannot help than have the drama, smoothly developing before his eyes, carry him away, and just this necessary concentration, which makes him a great director, so often prevents him from visualizing the limitations, with which our present picture size prevents a faithful screen rendition, as impressive, as the reality, which he is directing.

The cutter, however, is trained and used to seeing action in picture size only; and if a cutter has the rare faculty of *not losing his mental perspective*, he certainly should be co-operatively on the set with the director. He is fully aware of the limitations of the framed picture

(Concluded on Page 81)

"ONLY A CUTTER"

(Continued from Page 30)

as against the unbounded reality. He is also aware of the difference between the three dimensional, color and tuneful reality, and the poor imitation, finally brought before the eyes of the spectator. To have the audience forget, it is looking at a lifeless, flat, really pitifully poor imitation of reality, is certainly homage paid to the genius of all the persons, forming the unbreakable chain of motion picture "producers," in the truest sense of the word.

And although the cutter is the last, he is not only, not the least link in this chain, but rather the anchor-bolt supporting it.

If, as is usually the case, the director has no cutting experience, then the cutter must of necessity assume and assert the position as second director.

The first director, known as THE director, often produces a number of pictorial scenes, covering the same situation or action. In his search for dramatic effects or pictorial beauty of form and composition, he covers all details of a story, usually not only more than once, but also each "take" by more than one camera angle.

That second director, known as "only a cutter," has to familiarize himself with the story as thoroughly as THE director, then search in each scene for a sequence of takes, which will depict these scenes in the most impressive manner. It is almost impossible to even enumerate, within the scope of this article, the countless number of characteristics, the cutter has to observe, on each take or even each frame (from a number of viewpoints), to finally enable him to join them as a smoothly running presentation.

Composition, action, tempo, rhythm, tone, lighting conditions and film densities, required differently for smooth even action of slow tempo, or for dramatic climaxes, or phychological brain shots, or cut-backs, the control of the proper length of detail shots; to maintain or even produce climactic effects, beyond the momentary conception of THE director—these and a great number of other record characteristics, almost unconsciously used or discarded by the really great cutter—these are the tools and materials, the master cutter wields, to honor and complete the fundamental work of author and director, and of making the picture great and wonderful in the eyes of the public. But as yet "he is only a cutter" and the public never hears of him. It sometimes sees the words "edited by" or "film editor" on the screen, but usually does not know what these words mean.

The best comparison to his work, we can think of, is the problem of making a mosaic duplicate of a master painting, out of a heap of multi-colored stones of different shapes and textures, and to fit them by careful selection, trimming and polishing, into a faithful replica of such painting. Although there are usually more chips thrown away then used, very often essential characteristics, consisting of dramatic highlights or beautiful flowing blends of form and color, cannot be duplicated, because the proper chips were not in the heap.

The director can select, change and mould the material he works with, be it

human or otherwise, tangible or intangible, to fit it to his interpretation of the thoughts of the author.

The cutter has fixed material in unyielding form, and verily his problems are the harder ones; more often then not a veritable Chinese puzzle. And crowning his difficulties are the shortcomings, which naturally appear in details of every work, be it poor camerawork, poor laboratory work, lack of an important scene detail, faulty sound synchronization or sound recording—details bound to appear, but which he must recognize, eliminate and correct.

If we consider that the cutter has to do his most important work on the negative, that sound and color effects, although in their present state as yet far below the level of photographic perfection, are nevertheless for other valid reasons forcibly injected into motion picture production, adding to the difficulties confronting the cutter, we begin to really appreciate the importance of the man who is "only a cutter."

As far as color is concerned, there is very little he can do, if the color effects are bad from a dramatic or pictorial point of view of screen effects, except perhaps convince the director, that some scenes would be better without color, if such a change is at all feasible, from a technical, or the all-important continuity point of view.

Sound in pictures has increased manifold the burden upon the shoulders of the responsible cutter.

The producers want sound and plenty of it. Therefore other picture characteristics must suffer in order to favor it. As sound rendition from the screen is far from perfect, the whole picture presentation suffers, and the final deficiencies are customarily charged to the cutter.

None knows it better than the cutter, and yet his is the duty and ambition to find, force or invent ways and means, by cutting, cutting, cutting—by duping, by transposing, by ingenious trick work, to produce a final harmony between picture and sound, pleasing to all—the author, the director and both the public and producer. How often must he beg for, or insist upon retakes in sound or picture, when he reaches an impasse, to save or make a picture.

And all during this nerve racking time of concentrated effort, up to the point of physical and mental exhaustion, he hears: "Aren't you ready yet?" "It must be finished according to release schedule." Do you wonder his face looks worried?

It is motion picture history, that many good pictures have failed to be a success, because of poor cutting. It is also a well known fact, that many pictures, obviously impossible for screen presentation when first assembled in the cutting room, have been turned over to a master cutter, and rescued by him from the wastebasket and made a commercial screen success.

How many persons, even within a studio, are aware of the cutting history of some of the most successful pictures; pictures conceived, directed and photographed on a large scale at enormous expense, resulting in hundreds of thousands of feet of film delivered to the cutting room.

After weeks of work a final sequence,

satisfactory to all conerned, is worked out by the cutter—but the picture is too long.

If the commercial limit of a picture length is, say, six thousand feet, and the assembly runs ten thousand—then the hardest problem confronts the cutter.

"The story must be told" and there is apparently not a foot in the film which can be cut out without ruining the picture. And yet, it has to be done—and it is done. How? Ask the "cutter."

But when the picture is finished, his work and merit is forgotten—the drive on the next picture begins.

Study and due appreciation of his qualifications should certainly make him elective for other and better employment.

Who, better than a successful cutter, could and should make a supervisor worthy of his name.

And no wonder that some of our best and continuously successful directors graduated from the cutting room.

And when the work is done and the picture faces to receive the expected approval—who is usually the "goat" within the studio? None other than the "cutter."

And if the presentation is a success—who gets even part of the well-deserved credit?

Our friend with the face of worried tension and nervous intelligence?

Not he, because he is "only a cutter."

* "Les Gueux"—"Beggars."
† "Sans-Culottes"—"Without Breeches."

The Delegates to the Convention Fell for the International Photographer a Thousand Ways

THE DAY THE INTERNATIONAL PHOTOGRAPHER'S ART SOUVENIR NUMBER WAS DISTRIBUTED
IT STOPPED THE CONVENTION.

100 Per Cent Negro Casts

By SILVIO DEL SARTO

It will be news, even to many members of Local 659, that our good brother, Harry A. Gant, has been producing, for the past fourteen years, motion pictures using one hundred per cent negro casts.

sound feature bears the emblem of the I. A. T. S. E. with "100 per cent" under it.

The title of the picture is "Georgia Rose" and stills shot during the produc-

United States, Canada and the West Indies.

His policy is to photograph the American negro as he really is and as he really lives and not as the white man thinks he lives. He uses no studio, but goes right into the homes of his actor folk and puts them in the film true to life.

At a three-day preview staged at the Los Angeles Lincoln Theatre, an 1800 seat house equipped with the Western Electric sound system, "Georgia Rose" played to capacity houses and won the endorsement not only of the negro fans but of white people who attended.

Mr. Gant will begin production on another all negro picture as soon as "Georgia Rose" is well on its road show tour of the centers where large negro populations wait to pay tribute to it.

Mr. Gant directs and supervises production of all his pictures and in his field occupies an unique position.

"Old Man River"

He has his own releasing organization and has just recently completed his first talking picture, in seven reels. He is now enroute east with his film for its world premiere in New York.

The main title of Gant's new all-negro

tion are shown herewith.

During his long career as a producer of one hundred per cent negro pictures Mr. Gant has won the friendship and the enthusiastic support and approbation of the negro press, pulpit and public of the

Awaiting Your Decision!

The possibility of determining a universal standard dimension for film, within the accepted range of 35 - 70 millimetre, is offered by Mitchell Camera Corporation in the Mitchell Standard 35 millimetre and Mitchell Wide Film Cameras

IF a standard for wide film of less than 70 mm. is established within one year from July 1st, 1930, we will make the changes required on our 70 mm. camera to meet such standard, if desired, for purchasers of our regular 70 mm. camera, purchased within that time, free of any charges.

MITCHELL WIDE FILM CAMERA PRICE LIST

CAMERA UNIT, 70 mm., with Silenced movement	$ 3000.00
Variable magnification focus telescope with two filters for regular and panchromatic, built-in	160.00
Automatic and hand dissolve, built-in	300.00
Floating iris, built-in (special order only)	200.00
Adjustable four-way mattes, built-in	150.00
Stock matte disc, built-in	50.00
Veeder footage counter, built-in	50.00
Dial footage counter, built-in	50.00
Magazine, 1000 foot capacity each, with anti-buckler and contractible spool	150.00
Magnifying Universal view finder, erect image, with mattes	150.00
Combination matte box, filter holder, sunshade, with double arm	175.00
Tripod base	90.00
Friction tilthead, with metal telescopic handle and rubber grip, extra heavy construction	275.00
Camera case (for camera only)	30.00
Magazine case (for two magazines each)	25.00
Astro Pan-Tachar 50 mm. F:2.0 lens, mounted	150.00
Astro Pan-Tachar 75 mm. F:2.3 lens, mounted	120.00
Astro Pan-Tachar 100 mm. F:2.3 lens mounted	150.00
Astro Pan-Tachar 150 mm. F:2.3 lens, mounted	210.00
Lens mounts for 50 and 75 mm., each	55.00

Additional lenses for wide film will be supplied as desired as soon as the lens manufacturers make them available. *Subject to change without notice. Prices net cash at our factory.*

Mitchell Camera Corporation

Chicago — Six-Sixty-Six — Chicago

Motion Picture Industries Local 666,
I. A. T. S. E. and M. P. M. O., of the
United States and Canada

By *HARRY BIRCH*
President

CHARLES N. DAVID..............................Chicago
Vice-Presidents
OSCAR AHBE ..Chicago
HOWARD CRESSSt. Paul
HARRY YEAGER...................................St. Louis
W. W. REID.....................................Kansas City
RALPH BIDDY..................................Indianapolis
J. T. FLANNAGAN..............................Cleveland
TRACY MATHEWSON.............................Atlanta
GUY H. ALLBRIGHT...................................Dallas
RALPH LEMBECK.................................Cincinnati
Treasurer
MARVIN SPOOR......................................Chicago
Secretary
NORMAN ALLEY.....................................Chicago
Financial Secretary
WILLIAM AHBE.....................................Chicago
Sergeant-at-Arms
HARRY BIRCH.......................................Chicago
Board of Executives
CHARLES N. DAVID WILLIAM AHBE
OSCAR AHBE HARRY BIRCH
MARVIN SPOOR WILLIAM STRAFFORD
NORMAN ALLEY EUGENE COUR
Offices
845 South Wabash Avenue, Chicago
BULLETIN — The regular meetings of
Local 666 are held the first Monday in
each month.

666 Chicago Delegates, I. A. T. S. E.
and M. P. M. O. Thirtieth Annual Con-
vention, Los Angeles, California.

The big show is over—and what a
show it was—California sure should be
proud, and we are proud that we were
there to see those great things, displays,
smiles, movies, scenery, beaches, and so
many other things so I am going to try
and tell you what it was to ONE LOOK-
ING FROM EAST OF THE ROCKIES.

SIX-SIXTY-SIX

DELEGATES FROM LOCAL 666
Chas. David and Harry Birch.

SIX-SIXTY-SIX

DEPARTURE
Don't think for one minute that we did
not appreciate that "send off" committee
at Dearborn Station under the guidance
of Brother Max Markman. By the way
Max, we sure enjoyed that "presenta-
tion" as the train pulled out and also all
the "trimmings," etc.

SIX-SIXTY-SIX

ENROUTE
As the California Limited rolled across
Kansas, Brother or rather President Chas.
David was racing from the engine to
observation car trying to find a tele-
phone—once in awhile he would "nap"
but if we passed a cross road where a
bell would be ringing he would imme-
diately wake up with "Hello, Daily News
Screen Service."

SIX-SIXTY-SIX

ARRIVAL
And so here we are in Los Angeles
and Hollywood—as the "Pres." and my-

[*Thirty-six*]

self step off that Santa Fe train we are
met by the reception committee who were
none other than President Wyckoff,
Brothers Hurd, Klaffki, Reeves, Tuers,
Palmer, Rose, etc., all of Local 659 and
Brothers Ziesse and Strenge, of Local
644, and the "big show" was on.

After we were all acquainted some
more "ice" was ordered and then the
regular business started.

SIX-SIXTY-SIX

THINGS NEVER TO BE FORGOTTEN
Hollywood; where all you hear is pic-
tures—and how.

Movie stars greet all the I. A. T. S. E.
members.

Ice that helps to cool that throat.

The thrill of a lifetime—meeting boys
we haven't seen in twenty years.

Mickey Whalen singing his "Hey Hey"
song.

Howard Hurd wanting to know if
you're having a good time.

Jackson Rose just doing everything to
make you feel at home.

Roy Klaffki leading the way in his
speedy Ford.

Jimmy Palmer squaring himself.

Paul Perry describing Agua Caliente.

Billy Tuers helping the boys from get-
ting too dry.

J. O. Taylor giving us the keys to his
home—oh boy!

Bud Hooper telling us about his
"talkie."

Chas. Boyle trying to find Bum, the
airdale.

Art Reeves wanting to sell anything
you want to buy.

Alvin Wyckoff as the cameraman's
"reel" spokesman.

(Concluded on Page 41)

DOWN IN THE WORLD

Left to right—*President David, Local 666, Chicago; Francis Ziesse, Local 644, New
York; Harry Birch, Local 666; Walter Strenge, president Local 644. These distin-
guished delegates to the I. A. T. S. E. and M. P. M. O. Convention will be able to
tell the boys back home all about Southern California from snow-capped Baldy to
Salton Sea. Here we find them far below Lake Michigan and New York Bay.*

Awaiting the Motion Picture World's Demands

ABREAST of the progression of the motion picture industry and its introduction of the wide film the Mitchell Camera Corporation, which since its inception, has enjoyed a most consistent growth due to the meritorious features of its 35 millimetre Mitchell camera has, in the new Mitchell Wide Film camera, created a product, which, through a number of its important features, offers the cinematographer the last word in modern camera construction; with the possibilities of determining the adaptability of the wide film.

That film, wider than regulation 35 millimetre has steadily gained ground, is evidenced by the fact that a notable number of cinematographers and directors are enthusiastic over its possibilities. They state, that while it evidently will take some time to determine its practicability as to the width—whether the standardization be 60, 63, 65 or 70 millimetre, consensus of opinion is, that 63 millimetre, which offers a happy medium between the two extremes permanently will be adopted.

Anticipating the instability of the wide film, the Mitchell Camera Corporation has included in the notable features of its 70 millimetre camera, a most important one; at small cost, it may be changed to any width less than 70 millimetre dimension.

Producing the same precision of performance as always has been found notable in Mitchell Standard cameras, the Mitchell 70 millimetre camera has been employed in regulation studio and location work by a number of prominent cinematographers who have found portability to be one of its outstanding features as it weighs but thirty per cent more than the 35 millimetre camera, as well as including all of the latter's favorable features. While not a large camera, it is built with ample room for all of the mechanical parts—without, in any way, crowding and cinematographers who know the mechanism of the standard Mitchell product are, from the start, as familiar with the 70 millimetre camera, and appreciate its ease of operation.

A number of directors, voicing their approval of the wide film, point out that it offers many advantages, among which are that greater dimension means greater scope. It will require, they say, fewer shots in order to produce a required amount of action. It will bring perspective, background and atmosphere in general, more convincingly to the screen through additional size of projection. These men, too, are of the opinion that with this greater flexibility, when a wider film dimension of universal favor permanently has been adopted—one whose greater size will not detract from the action on the screen, that even though it will mean the remodeling and reconstructing of a vast number of our theatres, that it steadily will gain the approval of the entire motion picture industry and the theatre public. It is interesting to note that a great many picture houses have converted their old screens into a size meeting the requirements of wider film while most of the newer theatres have included this feature.

Many years were required in order to bring the motion picture to its present degree of perfection—but it will not take as many more years for the world to determine what the decision will be as to the size of our new wide film pictures.

The Mitchell camera Corporation, through the keen perceptibility of its able organization is awaiting that decision with the Mitchell 70 millimetre camera.

The Daily Grind

By Ralph B. Staub

TED McCORD knows a woman who happened to be bargain hunting and picked up her husband because he was fifty per cent off.

* *

FREDDIE DAWSON says it's a funny thing how every Friday night 5000 men tell their wives they're going to the fights—and the stadium holds only 5000 people.

* *

BILLY WILLIAMS was all excited the other night thinking he got Paris on the radio. Billy says it kept saying "weee weee."

* *

BARNEY McGILL tells this one about the Scotch cameraman who after celebrating his twentieth anniversary in the motion picture business bought a new belt for his camera.

* *

JOHN SEITZ says that nowadays a man who stutters can't walk into a drug store without being handed a bottle of gin.

* *

LEN POWERS heard that 10,000 families were leaving for Florida. A new law went into effect allowing a man to collect his wife's wages.

* *

Doctor (to cameraman in bed, just had an auto smashup): 'What you need is a change of scenery."
Cameraman: "I believe I have changed most of that already."

* *

"GALLOPIN' THRU HOLLYWOOD" JIM BROWN at darmour's looking AT sets for his next PICTURE.

TED McCORD shooting a COLOR short with a GROUP of gold star MOTHERS.
SOL POLITO buying some ITALIAN salami in Henry's AND asking for a slice TO chew on.
SPEED MITCHELL buying a NEW overcoat for next FALL. Preparedness is SPEED'S motto.
EDDIE COHN going past THE five and ten without BUYING anything.
WILLARD VAN ENGER talking short reelers.
I could join a conversation LIKE that and feel right AT home having just COMPLETED my 300th SHORT.
JOHN MESCAL playing GOLF and how.
JEAN SMITH trying to FOLLOW Johnnie but only IN footsteps.
VIC SCHEURICH coming HOME after putting in THE usual sixteen hours.
BENNIE KLINE filling his CAR with gas.
THE price has dropped 3 cents BOYS don't get trampled IN trying to get to THE nearest oil station.
WILLIAM SICKNER buying SPORT shoes.
YOU'LL ruin them quick ENOUGH on those desert PICTURES you are always PHOTOGRAPHING
FRED KAIFER will be out OF the hospital in a few weeks. THIS should be good news to ALL.

—Apologies to K. C. B.

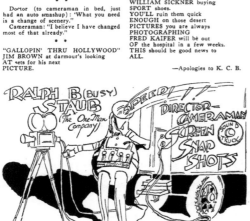

Hoke-um

By IRA

Vicarious Revenge

Dick Greene, who photographed the Kentucky Derby last May for Technicolor, tells this one which he overheard on the infield at Churchill Downs.

First Native: "Going to shoot Lem Paley for not bettin' on your mare?"

Second Native: "The infernal whelp hain't wuth shootin'. I'm goin' to send my no-'count son-in-law over to whip him."

— :: —

Prophet Isaiah Was Right

Jack Shackelford: "While in the Gobi desert I saw a lamb that could run forty miles an hour."

Ed Estabrook: "That's the only kind of lamb that could keep up with Mary nowadays."

— :: —

Financial

Cute Little Visitor: "My brother made a fortune in fruit."

Assistant Cameraman: "Florida oranges?"

Cute Little Visitor: "No, Chicago pineapples."

— :: —

A War Song

Speed Hall: "Ever hear the song about the three hoboes?"

Mickey Whalen: "Never did. How does it go?"

Speed Hall: "Tramp, tramp, tramp, the boys are marching."

Oh You Efficiency!

A certain "efficiency man" had investigated a record of wear on movie film being run in theatres of his company's circuit. He found that it was always the last 100 feet that showed the most damage. To remedy the trouble he ordered the last 100 feet of each of their productions cut off.

— :: —

Extravagance

Dev. Jennings: "Boys, put 21 Wratten filters on those Mitchell cameras."

Assistant: "What the heck does he want all those on for?"

— :: —

By Long Practice

Billy Tuers: "I can tell a chicken's age by the teeth."

Elmer Dyer: "How silly, chickens have no teeth."

Billy Tuers: "No, but I have."

— :: —

Sound Stuff

First Ebony Extra Man: "Sam, you sho' is a scream."

Second Ebony Extra Man: "Black boy, you don't 'zactly remind me of silence, yo' ownself."

Tom Galligan

Second Cameraman

St. Francis Hotel Hollywood

HO-9111 HE-1128

Dor Travis

Cameraman

Gladstone 2862

Walter J. Van Rossem

Photographic Laboratory and Camera Rental Service

HOlly 0725 6049 Hollywood Blvd.
Hollywood, California

Cash...

For professional Bell & Howell and DeBrie cameras. Send full description for cash offer. Or telegraph Bass Camera Company, 179 West Madison street, Chicago, Illinois.

The March of Progress

Abstracts of Papers, Inventions and Book Reviews From the Monthly Abstract Bulletin of Eastman Kodak Research Laboratories.

TIME EXPOSURE FROM THE POINT OF VIEW OF THE RECIPROCITY LAW AND THE SCHWARZSCHILD LAW. Photographe, 17:20, Jan. 5, 1930. The failure of the reciprocity law is discussed in its application to the calculation of exposures with small diaphragms. According to the Schwarzschild law when the f numbers progress with a ratio of 2, the exposure ratio should be 2.26.
F. B. S.

PHOTO-DRAWING AND IMITATION ETCHING. *Il prog. fot.*, 37:41, February, 1930. If a negative is projected on a sheet of paper in a darkroom and the paper is then shaded by means of a pencil until the combined effect of the projected image and the shadings are a uniform gray, the paper will on inspection be found to have on it a pencil drawing corresponding to a positive of the photograph projected. The same results can be obtained by making an enlargement and shading this with pencil until it is uniformly gray all over, and then bleaching-out the silver image by means of ferricyanide solution, thus leaving only the pencil drawing on the paper. C. E. K. M.

HIGH-KEY PHOTOGRAPHY. *Amat. Phot.*, 69:84, Jan. 29, 1930. The subject must not contain well-marked contrasts and the negative is given a very full exposure, a dilute developer being used. In the development of the print, care must be taken to avoid muddiness, and an acid fixing bath, or acid stop bath is essential. E. E. J.

PLASTIC PHOTOGRAPHY. N. Male. *Amat. Phot.*, 69:129, Feb. 12, 1930. From a negative a postive transparency is made. The two are put together slightly out of register to give a "plastic" or relief effect. Prints are made from this combination. E. E. J.

MAKING SOUND FILM. II. THE PHOTOGRAPHIC STOCK FACTOR. T. T. Baker. *Kinemat. Weekly*, 155:125, Jan. 2, 1930.

For variable width sound recording, the necessary characteristics of the emulsion are freedom from fog and from graininess, while for variable density sound recording a straight line form of the characteristic curve is the ideal. Methods of examination of the characteristics of negative or positive stock are simply explained. A. B.

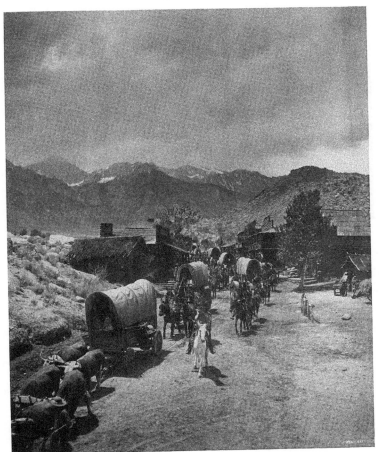

Mac Julian got a nice shot of this old set up in the country around Bishop, California. Yes, it's a motion picture set; but doesn't it look like the real thing?

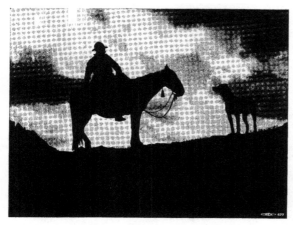

"Me and My Dog"
is the title
Jessie G. Sill
gives to this inter-
esting silhouette
photographed on
the summit of
Cloudy Pass.
It is a clever
camera-hound who
can shoot himself
without assistance.

Not so far
from the heart
of Chicago was
this characteristic
winter scene shot
by W. H. Strafford,
Local 666.
Note the
buckets on the
sugar-maple trees.

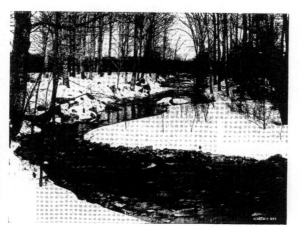

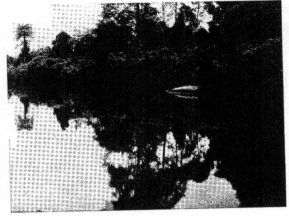

Lenwood Abbott brought this picture home from a recent trip to the Island of Borneo. It is a scene on the Bareto River of Dutch Borneo.

Al Henderson got on horseback and then concealed himself behind a wall of cactus to get this shot of wild Texas long-horn cattle. It is a rare picture for these days.

 # Cream o' th' Stills

Fred Westerberg's law of Dynamic Symmetry applied to this picture will locate the principal point of balance somewhere in the neighborhood of the fountain. The observer is given two guesses to locate it; or ask Carl Day. He photographed the picture.

CHICAGO—666

(Continued from Page 36)

Smith & Aller's dinner at the Russian Club.

That trip to the beach where the California sunshine baked a couple of Chicago boys.

That trip to Mexicali and Tia Juana, Mexico, under the careful guidance of Chas. Boyle. "Hello there, big boy"—ask Chas. he knows.

The pleasure of meeting Ziesse and Strenge, delegates from Local 644, New York City.

Also the pleasure of meeting Kelly of Local 659, from Oakland, Calif.

And O'Connor of Local 665 from Toronto, Canada.

The various trips to many of the studios where all I. A. T. S. E. delegates were welcome at all times.

California with its smiles of sunshine all the time, seemingly happy that the I. A. T. S. E. boys were here.

SIX-SIXTY-SIX
CONVENTION

Yes, we had a convention here also but I am not going into details on that as you will find that in other pages of this issue. The one outstanding feature of the convention was, our magazine, The International Photographer!

When the Convention Number, which was the June issue, was handed out at the convention—well the convention just stopped so that all could take time to "looker over."

SIX-SIXTY-SIX
GOODBYE—WE HOPE NOT FOR LONG

Like every thing else even the meeting with wonderful boys must come to a close and speaking for the entire body of Local 666, I want to say that the wonderful brotherly spirit at this time was one that will be hard to forget. Cameramen have been some time getting where they are and if all the cameramen who are in the I. A. T. S. E. look upon their brothers as Local 659 of Hollywood looked upon their visiting delegates, there will be nothing in this world that can stop their locals from reaching "top" and staying there. However, we must leave Hollywood and California and the finest crew of boys any one would want to call their friends, because friends they are indeed, each and everyone of them—so members of Local 659 we say once more goodbye, good luck and God be with you at all times. All aboard, Chicago our next stop, and we are on the way.

Saw our pal Verné Blakely the other day. His company just got through equipping a fine little sound studio for him up in the Furniture Mart building on Lake Shore Drive. Verne's getting a mighty fine little layout arranged up there. The kind anyone of the Industrial brothers would brag about. Good luck to you, Verne.

SIX-SIXTY-SIX

You guys who come up to the next meetin' will probably notice the big improvement what's been made in supplying the Local with a swell new gavel to bring about order when necessary. This is a gift to the boys from Charlie David and Red. They refuse to divulge where they got it. All they say is they had a heluva time putting it in an Akeley case the nite they found it.

SIX-SIXTY-SIX

Martin Barnett found out at a recent fire at Lyon's Ill., that burning oil tanks can take off and jump right at you. Careful Martin, or you'll miss a date one of these nights with that steady of yours we've seen you trotting around.

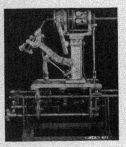

"Meet William S. Johnson"

Introduced by BEN SAVAGE

The man whose picture appears in this column, and whose duties consist chiefly of superintending the electrical department of the R. K. O. studios, really needs little introduction — especially to those who are allied with motion picture production.

William S. Johnson has long since been recognized as one of the requisite cogs in the industry's continuously moving wheel of activity. An electrical expert of prominence, long before any great amount of serious consideration had been given to the future of motion pictures—back almost a score of years ago when associated with the Newberry Electric Company, Mr. Johnson through intense appli-

WILLIAM S. JOHNSON

cation and clear foresight has kept abreast with progression of the motion picture industry and the possibilities offered by electricity, applicable to motion picture production, until today he has gained for himself an enviable name in this modern age of advancement.

R. K. O. studio's chief electrical engineer is a busy man. With blue prints and plans on the right of him, and with

activity and commotion and telephone receivers on all sides of him, one, naturally, doesn't feel privileged to take up much of his time. Brevity is a necessary requirement—one can see that—so after being ushered into Mr. Johnson's presence, who met me most cordially, I almost immediately introduced the subject of electricity. It doesn't take long for one to learn that he has a profound liking for and a broad knowledge of that branch of the industry, and to gain a man's confidence one must arouse in him an enthusiasm for the thing he most enjoys.

In retrospective mood, Mr. Johnson harked back to "the days of when." In the old days, just about the time when Micky Nielan has given up his taxi cab job to go to work at Sennett's—when George Melford was directing the classics of that age—and a studio stage fifty by one hundred feet was a big affair—it was a common occurence for three companies to occupy this small stage at the same time. And a lot of the time everybody in everybody else's way. Directors had to work alternately on account of scarcity of lights which hardly ever were allowed to cool off. Electricians then, were "grips" as well as jacks-of-all-trades.

Improvised reflectors made from tin dish pans were introduced as a pronounced step toward advancement in lighting equipment. From dish pan apparatus to the present-day employment of Laco Lites, for instance, is, indeed, some advancement and every distinct unit of the industry has, of course, shown a like improvement over antiquated methods.

Back with Famous-Players-Lasky in 1914, the arrival of our first "spot" from New York caused a great deal of excitement—"now we will do things," we thought—and it was a step forward. After this the Sperry Sun-arc was introduced, while today we have become so

Halperin and Ragin, champion soft shoe dancers of Filmland; also Blues singers, plain and fancy acrobats, radio announcers, cameralogues and what have you.

accustomed to the consistent addition of new lighting apparatus that its delivery is now regarded as an ordinary occurrence, said Mr. Johnson.

A coincidence, which prompted me to inquire whether or not William Johnson, chief engineer and superintendent of the Lakin Corporation, manufacturers of the well known Laco Lites, was related to him, caused R. K. O.'s electrical chief to say that while there was no blood relation claimed, the two men really were related in that they both had been associated with the Mary Pickford organization, back when James Johnson was Miss Pickford's studio manager and William S. Johnson was directing the electrical department. Two men, both experts in their profession and with the same name,—and worked together—employing a bromide, "It surely is a small world."

BEN-HUR *Wins!*

*Scene from the colossal
production "Ben-Hur"*

Courtesy M-G-M Studios

The following unsolicited endorsement of Ben-Hur Drip Coffee was written by PERCY HIL-
BURN, Chief Cinematographer of the above race sequence and numerous other super-produc-
tions, including "The Rogue Song," "The Unholy Three," etc.:

> "During 'time off' and in the intermissions between the shooting of pic-
> tures, many of the cameramen and technicians, as well as the actors,
> have found Ben-Hur Drip Coffee a truly refreshing drink . . . void of
> unpleasant after-effects, and at the same time easily prepared and an
> excellent 'conclusion' to any meal . . . be it sandwich or the most
> sumptuous repast. I most heartily endorse Ben-Hur Drip Coffee."

In no other field of human endeavor is there a greater tax on nervous energy · · · a greater need

for a calm sense of well-being or greater need for a stimulating drink that does not have un-

healthful or depressing reaction, than in the motion picture industry. That Ben-Hur Drip Coffee

The original and only
coffee specially adapted
for the drip method.

prepared in a Ben-Hur Healthful Coffee-Maker, fully meets

this need, is evidenced by the testimony of many represent-

ative leaders of the motion picture industry endorsing this

delicious new coffee.

The Ben-Hur Coffee
Maker Fits Any
Coffee Pot.

THE VALLEY OF THE SHADOW

Our beloved Brother, Treasurer Charles P. Boyle, is sorrowing for the passing of his mother, Mrs. James M. Boyle, who gave up this life at the home of her devoted son on June 20, 1930, in the seventy-first year of her age.

Mrs. Boyle died after two years of serious illness. She was a native of Wisconsin and had lived in California during the ten years just past. She leaves a sister and two children besides our Brother C. P.

Mrs. Boyle was of the good old Scotch-Irish stock, a woman of great force and activity and a devoted Christian. If "Blessed are they that die in the Lord" be true this good woman will have proved that "Death is swallowed up in victory."

Brother Boyle has the sympathy of the entire membership of Local 659 as well as of a host of other friends.

THE CLIQUE

What is the Clique? 'Tis a body of men
Who attend every meeting. Not just now
and then;
Who don't miss a meeting unless they
are sick
These are the men that the Grouch calls
a Clique.

Who don't make a farce of the sacred
word Brother;
Who believe in the motto "To Help One
Another,"
Who never resort to a dishonest trick;
These are the men that some call the
Clique.

The men who are seldom behind in their
dues
And who from the meeting do not carry
news,
Who attend to their duty and visit the
sick

These are the men that the Crank calls
the Clique.

We all should be proud of members like
these;
They can call them Clique or whatever
they please;
They never attempt any duty to dodge
These are the Clique that runs every
lodge.

But there are some people who always
find fault
And most of this kind are not worth
their salt;
They like to start trouble but seldom
stick
They like to put all the work on the
Clique. —G. A. L.

Clyde DeVinna has gone to New Orleans to shoot a picture for Paramount.

THAT GOLF TOURNAMENT
By Jimmie Palmer, Local 659.

Well boys, your Golf Committee functioned last evening, Tuesday, June 17th, at 8 o'clock and adjourned at 11:15 o'clock. We had quite a session and came to a lot of decisions. Those present were Virgil Miller, Norbert Brodine, Reggie Lanning, Wm. Foxall and yours truly.

We had under consideration three different golf courses and as soon as the Committee can get in touch with them and find out which one is available we will notify the membership in the August issue of our Magazine. We are, of course, for a bigger and better tournament this year.

In fairness to all concerned it will be necessary for all entrees to turn in their score cards from any course they may choose. This not only gives your Committee your average score to handicap by, but also gives you boys a chance to limber yourselves up for the tournament. You have plenty of time this year in which to play these rounds and you can hand the cards in any time now to the office of our Local.

Entry blanks will be ready by July 15th, 1930, and can be obtained at our office or from a golf representative at your studio. Don't forget, boys, this tournament is for you and you only, so jump right in and do your part to make it a huge success.

To avoid confusion and the last minute rush that we had last year, the entries will absolutely close at 9 o'clock Saturday evening, August 30th, 1930. That will give the Committee a chance to get everything in shape to handle the large attendance predicted for this year. It really looks like it is going to be one of the largest organization events ever staged.

Souvenir badges with ribbons will be issued to each entrant which will entitle him to play and to all the privileges offered. The 19th hole is for entrants only and the entrants will have badges, so that's that.

Owing to illness last year our old friend King Charney was not able to play in that famous three-some of Charney, Smith and Blackburn, but we are all looking forward to that famous trio getting together in a jovial-heated match.

Well, boys, I've given you about all there is for the present, so don't forget that "When better golf is played, the Cameramen will play it."

1111 N. VISTA ST.
HO·2953 HE·1128

The Sound Track

BORN IN JULY

Here are fifty odd reasons why the Fourth of July is called the Glorious Fourth. Here we have motion picture producers, cartoonists, engineers, pictorialists, painters, leather workers, musicians, golfists, soldiers, chess champions, etc., etc. It is some stork that knows how to concentrate a bunch of talent like this. Read em:

Paul Allen, Edgar Barber, O. H. Borradaile, Chas. P. Boyle, Milton Brown, James Casey, Fletcher Clark, George Clemens, Robert Cline, Robert Connell, Earl Crowley, Clyde DeVinna, James Doolittle, James Drought, Otto Dyer, L. T. Galezio, Merritt Gerstad, Alfred Gosden, Jack Greenhalgh, Walter Griffin, Sidney Hickox, Percy Hilburn, Russell Hoover, Roy Johnson, Ray Jones, Glenn Kershner, Benjamin Kline, Lloyd Knechtel, Robert LaPrell, Charles Lynch, Kenneth MacLean, Charles Marshall, Shirley Martin, George Meehan, Arthur Miller, Robert Mitchell, Joe Novak Lewis O'Connell, Gustav Peterson, Robert Pierce, David Ragin, Ben Reynolds, Leon Shamroy, Ernest Smith, Harold Smith, Ralph Staub, Macklyn Stengler, Hatto Tappenbeck, N. C. Travis, Edward Ullman, Dwight Warren, E. L. White, Harry Wild, Lothrop Worth, Alvin Wyckoff, Frank Young.

A NEW ERA IN COLOR?

William Worthington and his associates have sold Multicolor Films, Inc., to Howard Hughes of the famous Caddo Company, producer of "Hell's Angels."

The new organization will be known as Multicolor Ltd., and the immediate plans of the company call for a new laboratory to be built in Hollywood at a cost of more than half million dollars. Evidently the enterprising young producer has made up his mind to become a major factor in the production of color films in which he will undoubtedly be successful, possessed, as he is, of unlimited resources.

Both Mr. Worthington and Mr. Hughes are to be congratulated, the former upon his courage and stick-to-itiveness and the latter upon his zeal for doing things in pictures in a bigger, better way.

—o—

Eddie Geheller is recovering from a recent accident which threatened to destroy the sight of one eye. It was a narrow escape and the boys are congratulating him on his good fortune.

—o—

Fred Kaifer who has been in Angelus Hospital for several weeks as the victim of a fall from a parallel is recovering rapidly.

Out of Focus

INTERNATIONAL OFFICERS DEPART

This beautiful bouquet is from the developing tray of Fred Archer, of the Warner Brothers Studios.

After the close of the convention President Canavan and Vice-President' Dempsey started looking for small estates where they would .be able to rest up a few days and make a few extra dollars on the real estate, but the executing committee said they were needed in the Yeast.

A meeting of the fifteen Vice-Presidents was called, maybe it is seven, and they could not be persuaded to leave the boys out here. So after much deliberation they concurred to give the boys the following breaks.

They would be- allowed to ride on the engine so they could see all of California possible and this would permit them to be out in the sunshine and fresh air as well.

So under the supervision of W. D. "Daddy" Lang, Brother Chas. Anderson, of Local 37, was called in to make a couple of one-half hitches. As soon as the hitches were all smoothed out the boys left with eyes in their tears.

This photo was taken as the train was passing through the orange groves and as soon as the engine moves a little you can see Pike's Peak behind the smoke stack.

Do not think that our officers are Hi-Hats on account of the two quart containers they are wearing. This was suggested by Roy Klaffki and the hats can be pulled over the ears when they don't want to listen, over the eyes when they don't want to see and over the mouth when they don't want to drink, I mean talk.

All those in favor signify by the usual sign; the ayes have it.

A BLOW BY BLOW DESCRIPTION OF THE OPENING DAY

Brother Wm. (Bill) Scott welcomed all the delegates to the Greatest City in these here United States.

Secretary-Treasurer Buzzell welcomed

[*Forty-eight*]

all the said delegates to the Greatest City. in the Southwest.

Sheriff Traeger welcomed all the delegates to his hotel (County Jail) which is the finest west of the Mississippi River.

His Honor the Mayor, John C. Porter, presented the key to the city to the delegates (but failed to mention where the lock was) the Finest City on the Pacific Coast.

The Governor, the Honorable C. C. Young, said that our convention was the Largest Labor Convention that he had ever seen in his wonderful State of California and hoped to see us again in the Beautiful City.

BLOW or no BLOW they were absolutely right. That's that.

And President Canavan wants all the boys to come back next year. Yeah?

DO YOU KNOW

That President Canavan said in his report: "Local 659 has established a substantial and progressive organization. Indeed no finer example of a Labor Organization exists than this particular Local Union.

That this report was read before delegates from over 675 locals from the United States and Canada.

That every man in every one of these locals is at your service.

That every delegate got a copy of the June issue.

That this publicity for our organization is invaluable.

That the Los Angeles Chamber of Commerce co-operated with the entertainment committee.

That Fox Hills Studios and Warner Bros. put on a wonderful show for the boys.

That there were about fifteen men in a long narrow set at First National Studio doing card tricks. and telling fortunes.

That times have sure changed.

That with a progressive organization and with the help of all we should .continue to progress.

That "Bill" Koenig said to "Bill" Canavan: "Have a good time."

That everyone DID.

PARIS NOTES

Corp. Phil Tannura, or was it lieutenant, will shortly entertain the Foreign Legion of Local 659. Buddy "Alf" Williams is on his way home from the East Indies. Rex Wimpy is galloping around shooting most everything. Fleet Southcott is along to help get him on his feet and Georges Benoit calls Paris home. How I would like to be with them strolling down the Rue Raviola, or sitting in front of the Cafe de la Fay (and pay and pay) or even out to Pig Alley and Clichy. *Combien ces soir?*

INTRODUCING CLEVE BECK

CLEVE BECK
Western Tackle on the All-American I. A. T. S. E. Team

At the recent International Convention Cleve was promoted to the office of Third Vice-President. For years he has been Fourth Vice-President and if his health holds out some day he may make First. According to this the last is first. Like a pair of shoes. Out of order.

His job is a cinch. All he has to do is be in about six western states at the same time and keep everyone happy.

I met Cleve's baby boy and he has the same type body and wheel base that Cleve has.

Did you have to pay excess fare when you flew to Frisco?

TWO NORTHERN BOYS MAKE GOOD IN THE SOUTH

Had the pleasure of listening to' the reception given Joe Rucker and Willard Van Der Veer, members of Local 659, on their return from away down south, and wish to call attention that when Commander Byrd introduced the boys to the world, via radio, he forgot to mention that they were members of Local 659. So I will do all that I can to broadcast it because we are proud of them. If you want further information refer to the last October issue, page fourteen.

YES SIR! THAT'S MY BABY

Mrs. O. F. is listed in "Talking Screen" for July as one of the three best film editors. I think she *is the three* best.

CHAS. KAUFFMAN

Brother Jackson Rose and Paul R. Cramer were talking about the old days. Kauffman's name came up and they both wondered what had become of him. Some of the old timers will remember him from the Brunton Studios. If you know drop a line to this department and I will do the same for you.

Business Is Good!

The first half of 1930 has established a new all-time record for volume sales in Hollywood . . .

hat's the *True* story of

EASTMAN
Panchromatic Negative

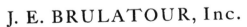

J. E. BRULATOUR, Inc.

THE CADDO COMPANY INC.
BOX TAFT BUILDING
HOLLYWOOD CALIFORNIA

May 21, 1930

Mr. H. F. Boeger,
Mitchell Camera Company,
Hollywood, California

My dear Mr. Boeger:

I want to compliment you on
the excellent performance of Mitchell
Cameras.

The fact that more than 75%
of the cameras used in filming "Hell's
Angels" were Mitchell Cameras is proof
conclusive of our high regard for them.

Sincerely yours,

THE CADDO COMPANY INC.

By Howard Hughes
President

The INTERNATIONAL PHOTOGRAPHER

Official Bulletin of the International Photographers of the Motion Picture Industries, Local No. 659, of the International Alliance of Theatrical Stage Employees and Moving Picture Machine Operators of the United States and Canada.

Affiliated with Los Angeles Amusement Federation, California State Theatrical Federation, California State Federation of Labor, American Federation of Labor, and Federated Voters of the Los Angeles Amusement Organizations.

Vol. 2 HOLLYWOOD, CALIFORNIA, AUGUST, 1930 No. 7

"Capital is the fruit of labor, and could not exist if labor had not first existed. Labor, therefore, deserves much the higher consideration."—Abraham Lincoln.

CONTENTS

The INTERNATIONAL PHOTOGRAPHER published monthly by Local No. 659, I. A. T. S. E. and M. P. M. O. of the United States and Canada

HOWARD E. HURD, *Publisher's Agent*

SILAS EDGAR SNYDER - - - - *Editor-in-Chief* GEORGE BLAISDELL - - - - *General Manager*
LEWIS W. PHYSIOC - - - - - *Technical Editor* FRED WESTERBERG - - *Asso. Technical Editor*
 JOHN CORYDON HILL - - - - - - - - *Art*

Subscription Rates— United States and Can ada, $3.00 per year. Single copies, 25 cents
Office of publication, 1605 North Cahuenga Avenue, Hollywood, California. HEmpstead 1128

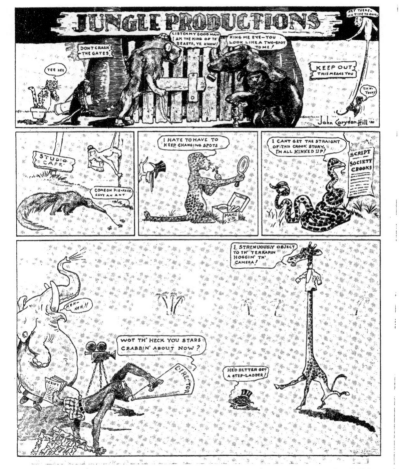

THIS TEMPERAMENTAL STUFF IS THE THING THAT IS KILLING OUR DIRECTORS

"Screen Characteristics and Natural Vision"

By Dr. L. M. DIETERICH

Cons. Eng., M. S. M. P. E., M. A. M. P. A. & S., Etc.

An Analysis From the Viewpoint of Philosophical Psychology

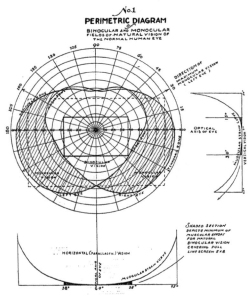

No.1

PERIMETRIC DIAGRAM

BINOCULAR AND MONOCULAR
FIELDS OF NATURAL VISION OF
THE NORMAL HUMAN EYE

INTRODUCTION

The analytical study of motion picture screen characteristics in their relations to natural vision involves a vast amount of comparative study of a number of abstract and practical sciences. The hypothetical conclusion reached by the author would, if properly presented in logical sequence, be far beyond the physical limitations of this article.

This study is therefore in the form of a synopsis, shorn as much as possible of purely scientific abstractions, graphs and formulae.

Acknowledgement is hereby made of the study of the related publications and records, and special grateful consideration has been given to the books, dissertations and articles as herein cited and which form a small part only of the necessary research material.

LIMITATION

The broad limitation imposed upon the author, for the purpose of this article, is to consider only the psychological difference between natural vision relating to the two-dimensional pictorial art on one side and the natural vision relating to three-dimensional reality on the other side.

The following analysis will show, that a really analytical study of human vision relating to motion picture screen characteristics, comprising rectangular shapes only, their proportions and sizes, must include the elements within the mentioned broader limitations, to be of any conclusive, even if only hypothetical, value.

HISTORY AND EVOLUTION OF SCREEN SHAPE AND SIZE

The shape of the screen has throughout the existance of motion picture projec-

tion, simply been an enlargement of the film picture frame or a rectangle of the proportion of 3 to 4. Its size was and has been fundamentally governed by the grain conditions of the film picture and also slightly modified by local theatre conditions, i. e., optical efficiency of projection machine, throw, screen surface characteristics, illumination, minimum screen distance, etc., etc.

The selection of the present size of a film picture frame and its proportions was simply an arbitrary selection by Edison and Lumiere for economical and practical reasons. After both Edison and Lumiere adapted the four-hole perforation, the present frame size became, through their absolute control of the early film market, a standard.

If during the years of motion picture development, artistic minds suggested a reconsideration of frame proportions and film sizes, their efforts were, on account of the commercially and universally adapted standards, fruitless.

It was only lately, when the introduction of sound on film methods robbed the picture frame of a considerable part of its width, that a change of film and frame dimensions became imperative.

Technicians began to study the problem energetically, and the selection of a new standard was sought for. The correlated screen size became an important part of this problem.

Unfortunately the searching work of the technicians was only a study of statistics of the pictorial art. The rectangular limitations or the framing of a picture were accepted without discussion. The work of the old painting masters was searched and studied. The proper artistic proportions of rectangular framing were studied, going for support and study even as far back in history, as to consider architectural proportions of the "rectangular" in the classical art. Hellenic art was accepted as "the" art of the ages and there the research work started.

The excellent and exhaustive work of Loyd A. Jones, C. L. Gregory, W. B. Rayton, A. S. Howell, J. A. Dubray, F. Westerberg, etc., brought about the so far unrefuted result, that a 5x8 proportion of a picture frame rectangular conforms most closely to the rectangulars, appearing in the outstanding records of beauty in the known history of art.

The author has however failed to see or hear of any research, endeavoring to find the psychological background for the establishment of the 5x8 proportions by the "masters."

We have no statistics, no records dwelling on this point. If we however are justified in assuming that art depends upon the creation of "significant form" (see Clive Bell), we are also justified to assume, that significant form, as con-

[Three]

ceived by the creative mind of the artist and recorded by his skill in visual form —was originated by the impressions and nerve reactions of the artist's eyes, and that his work also, becomes of importance and value only by visual inspection.

To study screen sizes and proportions from the ground up, we are therefore forced to first study the optical characteristics and psychological reactions of the natural human vision.

It may be considered unfortunate, that commercial eagerness selected lately more or less arbitrarily, a few shapes and sizes, before art, science and engineering had the opportunity, to harmoniously develop and recommend a new standard, and that certain exponents of the industry so vigorously supported this secretly developed innovation with unlimited capital and most energetic technical and commercial activities—that we are facing a similar situation as that created by Edison and Lumiere years ago.

To return to the human endowment which is the basis of all artistic conceptions, endeavors and work — natural vision.

NATURAL VISION

It is of elemental necessity to first thoroughly understand what natural vision is, its psychological characteristics and physical limitations.

It is a classical example of the evolution of the genus homo. There is a vast difference in the structure, efficiency and the nerve reactions, between the optical system of the different species of the animal kingdom. Let us consider for the purpose of this article, with due apologies to the exponents of religious philosophy, and solely from the optical point of view, man as the mentally highest type and only truly upright specimen of the ape family.

There are even between the ape's and upright man's optical systems differences, solely the results of evolutionary adaptation to the mode of man's normal physical behavior. The normal upright position of man evolved characteristics of his optical system, which are best described on hand of diagram 1. The normally upright posture of the head developed the normally horizontal position of the optical axes of his eyes.

Without going into the progressive results of evolution, determining its details, the field of vision is shown for the right and left eye. The parallax or horizontal distance between the two eyes (about 70 mm.) has been disregarded in this diagram, because it disappears, as far as its effect upon the field of natural vision is concerned, if we consider only distant, converging vision; an assumption, justified for the scope of this article.

We observe, that the field covered by the vision of both eyes, is approximately heart-shaped, with two lobes attached on each side, extending downwards and representing the vision of the single eyes only. The axes of the two eyes are both projected upon the center of the diagram.

The totality of vision, however, extends from this center more downwards than upwards, and a rectangle, closely following the outlines of vision totality, shows a dimensional proportion of very nearly 5x8 (see dotted rectangle).

[*Four*]

This totality of natural vision, for a normal human eye, is of course only correct for a fixed position of the head.

Analyzing our viewing a screen picture, we can consider this condition only, as the movement of the eyeball is very much more rapid, than that of the head.

There are however, within the range of eyeball motion also zones of comfort and discomfort, extending from consciously effortless ranging of the optical axis to its deflection by perceptible muscular effort or even painful strain. Considering the most important direction or meridian of vision, i. e., the parallactic or horizontal range of vision, we find that the extreme, covered by painful muscular exertion, covers in the average about 100 degrees on each side. This zone is, however, only relating to the respective single eye. The next zone, covered in its extreme by perceptible muscular effort, covers about 70 degrees on each side, whereas the consciously effortless range of vision of both eyes, covers theoretically about 38 degrees on each side.

In actual, every day natural vision, both eyes cover horizontally about 30 degrees on each side, or we have an effortless view of about 60 degrees in the horizontal meridian.

In the vertical meridian the effortless vision extends to about 15 degrees upwards and about 30 degrees downwards; this is a classical result of evolution of the human optical system—following the normal movements of upright man on the ground, with most attention necessary for obstacles or dangers, characteristic of the ground he walks upon.

The diagrammatic curves of muscular efforts for the deflection of the optical axis of the human eye from its normal position, looking "straight forward," shows the geometrically increasing energy, necessary to look "sideways, up or down" to the limits of vision. They also show the nearly effortless instantaneous covering power of the eyes for binocular vision, 15 degrees up, 30 degrees down, 38 degrees each side.

If we inscribe into these limits a rectangle, we find it most closely expressing a dimensional proportion of 5x8. It has been of singular interest to the author, to find that the results of his research work in natural vision, simply on a basis of analytical logic (abstract as far as screen sizes are concerned), coincides with the results of statistical research, so thoroughly conducted by others.

RECTANGULAR BORDER LINE

It may be of interest to consider here for a moment the reason, why pictures are usually contained within "rectangular" borders, when we know the actual peculiar curved border line of natural vision.

Our earliest records of primitive pictorial art show no border lines. We find borders only when architectural art was sufficiently developed to show beauty in "significant forms," characterizing the various epochs in architecture, be they Chinese, East I n d i a n, Babylonian, Egyptian, Hellenic, Mayan or others. The hard material used for the edifices constructed under these different significant forms, forced upon the early artist, the characteristic human deviation from nature—the straight line.

In the design of the earliest monuments, there naturally appeared surfaces, bordered in their simplest and most impressive contour, by straight lines, as rectangles.

If the predominant proportion of height and width in the most "beautiful" examples of classical architecture of 5x8, was the result of the innate sense of beauty of the builder—if it was his endeavor to follow the effortless range of vision of his eyes—designing and correlating his system of beautiful proportions for a definite viewing distance—we do not and never will know.

Fact is, however, that these proportions were established in the progressive architectural arts.

Fact is also that there came a time, when such surfaces were embellished by a variety of designs in order to cover their plainness, a time, when pictorial art was called upon to beautify these surfaces.

Of our earliest records of pictorial art, mural paintings fall within this class. It was not a question for the painter to design a fitting border for his composition. The question was to compose his picture for an already existing border line. The esthetic pleasure, produced by the viewing of such "beautiful" forms, associated the combination of paintings and rectangular borders for all times, as a necessary basis, for all future artistic endeavors in pictorial art.

A rectangular border of 5x8, as an absolute "necessity" for finished beauty in a picture, is successfully contradicted, however, by the fact, that we have a great many masterpieces, especially in movable paintings, which although mostly rectangularly framed by no means show the 5x8 frame proportions, but follow the concept of composition, to whatever frame proportions the sense of beauty of the painter selected.

Even today, the director and camera man have to exert more than ordinary artistic efforts, to always cover the unchangeable frame area with beautiful compositions.

The foregoing statements seem to indicate, that a 5x8 motion picture frame should best cover all artistic and esthetic demands. The actual size of the picture to be shown on the screen however, is governed by more complex conditions.

The underlying condition is always the limitation of effortless natural vision without head movement. If such condition is covered, then the picture is "easy to look at"—it can be viewed with the maximum of comfort, and the public is pleased (in this respect).

(To be concluded in September)

PATSY MILLER PLAYS M. OF C.

The first feminine master of ceremonies in the Screen Snapshots series is played by Pasty Ruth Miller in the Snapshots issue twenty-five directed by Ralph Staub for Columbia release. With the aid of a get-there-in-a-hurry machine invented by Miss Miller's husband, Tay Garnett, Patsy introduces to the audience Raquel Torres, Eddie Cantor, Ronald Colman, Samuel Goldwyn, Davey Lee, Dorothy Revier, Matt Moore, Eddie Buzzell and Evelyn Laye, noted English actress.

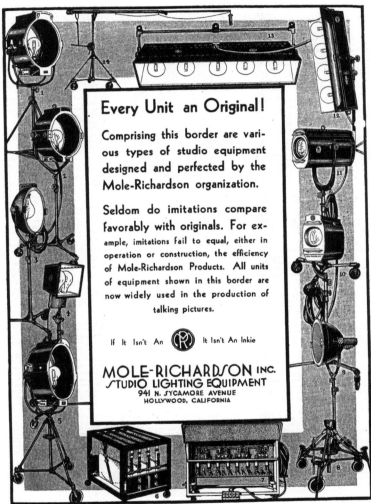

Every Unit an Original!

Comprising this border are various types of studio equipment designed and perfected by the Mole-Richardson organization.

Seldom do imitations compare favorably with originals. For example, imitations fail to equal, either in operation or construction, the efficiency of Mole-Richardson Products. All units of equipment shown in this border are now widely used in the production of talking pictures.

If It Isn't An ℗ It Isn't An Inkie

MOLE-RICHARDSON INC.
STUDIO LIGHTING EQUIPMENT
941 N. SYCAMORE AVENUE
HOLLYWOOD, CALIFORNIA

Union Labor Post, American Legion

Every one may not know, but certainly the members of the Unions comprising the Los Angeles Amusement Federations do, that there is another Union Labor Post of the American Legion in our midst, through the initial steps taken by Paul R. Cramer, of Local No. 150, I. A. T. S. E. and M. P. M. O., of United States and Canada, a former World War veteran.

Brother Cramer could not understand why, because he worked at night, that it should become necessary to give up the pleasures of the comradeship of other World War veterans, therefore: "Why not an American Legion Post that would meet where he could attend?"

After a very careful survey of the city posts, none such could be found, and after canvassing Los Angeles County and finally in desperation the State of California he gave it up. But the idea was constantly growing. The only alternative was to get in touch with all ex-service men in the same line of work and start a post for the men who work at night.

At this stage of the venture the real work began, as there had never been an occasion for records to be kept in the business offices to show who had or had not been in the service. Personal contact was then imperative and every man in the Local was approached individually, which from the start was a test for the most persevering.

There seemed to be a general desire for such a Post, but due to thoughtless acts of certain individuals, there had been created a feeling of uncertainty as to the advisability of combining the activity of Organized Labor with that of the American Legion.

It became necessary continually to refer to past similar activities of these two great organizations, so that each brother contacted would realize the great good that would come out of the cementing of the comradeship of the American Legion with that of the brotherhood of Organized Labor, the two greatest fraternal organizations in the United States, and today we have in our midst a new post of the American Legion, "The Dawn Post No. 380, of the Department of California, City of Los Angeles." The meetings are held the first and third Thursdays of each month, meetings called for midnight or shortly thereafter, giving all members a chance to reach the meeting place on time after leaving their places of employment in the theatres.

The first man to take a real helping hand with Brother Cramer was Brother Clyde Salyer, of Local No. 150, who like himself had been a member of the American Legion in Bakersfield, California, but whose work prevented him from attending meetings in Los Angeles, so with two men in the field things were looking quite a bit more hopeful.

Our next friend, from an unexpected quarter, was none other than Brother Earl Hamilton, president Local No. 150, who gave us the privilege of the floor at one of the regular Local meetings which was a means of acquainting some five hundred men of the scope of work being

PAUL R. CRAMER

done by the American Legion. After that meeting it was a regular thing for Brother Cramer to make announcements as to the progress of the newly formed Dawn Post.

At the end of the second meeting we had as helpers and friends, who became members, Brothers Fred Borch, Jack Staikey, Charles Vencil, Harry Little, James Pointner, making seven good hard working friends. From then on success was assured. In the next two weeks we had the original fifteen members—Brothers Milton Burns, Clyde Felts, James Graham, B. J. Moody, Neal Matheson, Chas. Piper, Chas. Ryder and Guy Wood, so we called our meeting at Local headquarters after midnight and we adjourned at dawn, so we decided then to call the newly formed post "Dawn," being the only one of its kind in the United States. At this time nominations for officers, the writing of constitution and by-laws, etc., occupied our attention.

Some of our newest members are: Brother Sidney Burton, president of the Hollywood Chapter of the American Projection Society; Brother Dave Levitt, of the Board of Governors of the A. P. S.; Brother Art Schroeder, of the now famous "Shooting Trouble" column of the A. P. S.; Brother R. D. Babcock, one of the projectionists at Grauman's Chinese Theatre in Hollywood.

At the third meeting thirty members were on hand and an election of officers took place. We then applied to the Los Angeles County Council of the American Legion for their indorsement for our temporary charter, which was granted with the approval of the Union Labor Post of the American Legion which was already in existence at the Central Labor Temple with Clyde Isgrig as their commander and Leo DeMoulin as adjutant. Dawn Post has at the present time thirty-seven members of Local Nos. 150, 37, 33, 683, 659 and 47 of the American Federation of Musicians and doing nicely.

On May 15th, after midnight, the installation of officers took place, preceded by the initiation of the entire membership into the American Legion. A ritual team lent dignity to the occasion when the comrades were enlightened into the purposes of the American Legion and again when inducted into the various offices. Some three hundred visiting Legionaires throughout the city attended the ceremony and were highly pleased with the success of Dawn Post and offered their support unstintingly for its future success.

Ham and eggs were served at 3 a.m. The enthusiasm was so great among the kin folk of the members of Dawn Post that an Auxiliary of the American Legion was immediately formulated so that the feminine members could also render service. The ceremonies of this organization will be held in joint session for the June meeting.

The officers of Dawn Post No. 380, of the American Legion, are as follows: Commander, Paul R. Cramer; First Vice-Commander, Clyde W. Salyer; Second Vice-Commander, B. J. Moody; Adjutant, Fred L. Borch; Chaplain, Harry Little; Historian, James Pointner; Sergeant-at-Arms, Milton Burns; Assistant Sergeant-at-Arms, Guy M. Wood; Publicity, Chas. A. Vencil; Service Commander, Neal Matheson; Americanism, Ben Rubein; Membership, Clyde Salyer; Athletics, Jack Staikey; Photographer, W. R. Hermance; Assistant Photographer, Guy Wood; Delegates to County Council, Jas. Graham, Robt. Timmons; Alternate Delegates County Council, H. E. Alford, E. J. Dahy; Executive Board, P. R. Cramer, chairman, Harry Little, J. Pointner, C. Ryder, G. Wiggins, Wm. Hermance, Clyde Salyer, Fred Borch, B. J. Moody.

And for the benefit of those who do not know, Brother Cramer of Dawn Post, of the American Legion, is the same gentleman the delegates of the I. A. T. S. E. and M. P. M. O. of United States and Canada, met in the lobby of the Alexandria Hotel in Los Angeles, the week of June 2nd to 7th and the boy who met them on the train, Brother George Wiggins, is also a member of Dawn Post as well as Brother Fred Borch, who registered them in room 353; Brother Clyde Salyer and Brother H. E. Alford, who played golf with them; Brother Dave Levitt who gave them rides in his car to see the sights with traffic signals, etc., and Brother Lew Blix, business agent of Local No. 37, Studio Mechanics, who put on the lighting that famous Monday night, June 2nd.

With the establishment of Dawn Post in Los Angeles, we should like to hear of the formation of similar posts throughout the United States and Canada.

Shirley Vance Martin says his doctor asks: "What is this pancreatic stock which you use taking photographs?"

QUIET ARC LAMPS BOON TO PRODUCER

That the employment of Brown-Ashcraft equipment by Fox West Coast Studios, in preference to all other makes of studio lighting apparatus because of its practicability and many meritorious features is manifested by the fact that more than eighty per cent of Fox electrical equipment has been furnished them by the Cinema Studio Supply Corporation.

The Fox organization has, since the advent of sound pictures and the perfecting of Brown-Ashcraft arc lamps, given the screen a number of the most consistently meritorious pictures and it is with a great degree of pride that the manufacturers of Brown-Ashcraft products accredit themselves with having been able to produce for the Fox studios, equipment that is made to the standards demanded in the production of pictures bearing the Fox name.

In this age of precision, Cinema Studios Supply Corporation has kept abreast of progression with modern light facilities, offering the picture producer the most advanced methods of construction and the results of years of experience in the motion picture industry.

Ever co-operating with prominent studio technicians, as well as having associated themselves with a staff of most efficient electrical experts, the manufacturers of Brown-Ashcraft (Quiet) Arc Lamps have gained the enviable confidence of the industry's most outstanding producers of motion pictures.

The recent development of the electrolytic condenser by W. J. Quinlan, chief engineer of Fox Film Corporation, has been resultant in creating a consistent demand for the arc type of illumination. Communtation ripple or "hum" has been entirely eliminated and in conjunction with the choke coil, is a feature which is installed as a part of every Brown-Ashcraft lamp. Fibre gears in these products have added greatly to that attainment of absolute silence of which Brown-Ashcraft Arc Lamps now boast.

That Fox West Coast Studios have purchased more than $200,000 worth of Brown-Ashcraft arc equipment during the past two years is proof enough of the apparent degree of perfection claimed for Brown-Ashcraft products by Cinema Studio Supply Corporation.

HOEFNER RETURNS

Fred Hoefner, proprietor of the Cinema Machine Shop, 5319 Santa Monica boulevard, has returned from a three weeks' visit with his mother, in Buffalo, New York. Mr. Hoefner went and returned through Canada, where he spent a few days at Lake Louise and Banff. He visited Rochester and Chicago and reports business quiet in the East and Middlewest.

VISUAL EDUCATION

San Diego claims to be the best equipped in visual equipment material of any municipality in the country, speaking, comparatively. The thriving town near the Mexican border possesses forty projection machines in its visual education department.

THE TWO YEAR CLUB

In the interest of their employees Mole-Richardson, Inc., designers and manufacturers of incandescent lighting equipment, have organized a Two Year Club among the mechanics in their shop. Those who have been employed by Mole-Richardson for two years or one hundred and four weeks are eligible for membership. Total membership now amounts to twelve.

Members of the club receive one week's vacation with salary. It is commonly understood that ordinarily mechanics are not granted vacations with salary.

Mr. Mole and Mr. Richardson believe that this intra-organizaiton fraternity has accomplished much in building earnestness, loyalty and stability among their employees. This, they maintain, is further reflected in the high type of work that is steadily turned out by the organization.

Mole-Richardson, Inc., also manufacture various mechanical units for studio set work such as microphone booms, rolling tripods and many other products that have become vitally necessary since the inception of talking pictures.

"Mack" Gibboney, discussing that baby of Creco's which he insists was born without a squawk, says the Mute lamp will be on the market by September 1. A hundred of the new-comers, 50 in the 24-inch style and 50 in the 18-inch, will be ready for rental. As soon as the factory gets into mass production the lamps will be on sale.

 # Cream o' th' Stills

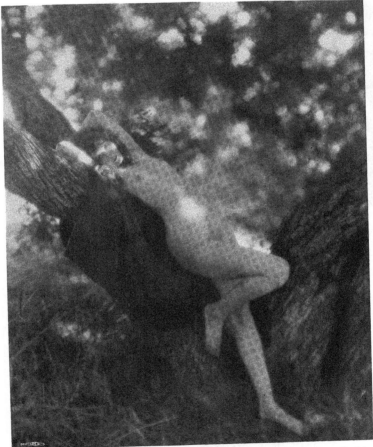

This unusually beautiful and chaste study in the nude is a product of the camera of one of Local 659's cleverest still artists.

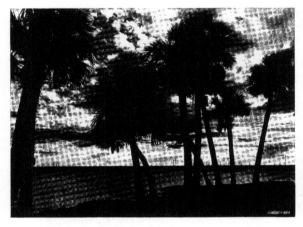

W. A. Fraker is responsible for this marine shot which he "got in the box" at a fishing village on the west coast of Mexico. The cocoanut palms are always sillouetted against the sky.

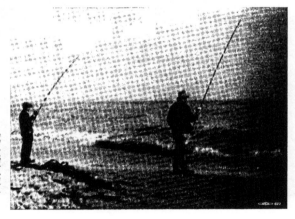

Surf fishing is one of the delights of Warner (Bill) Crosby. Here we have Mr. Baxter and his pal plying their piscatorial activities, while Warner is also shooting their pictures.

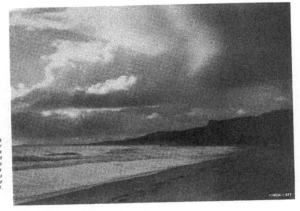

Walter Van Rossem loves to wander around Santa Monica Bay on cloudy days looking for shots like this. As a pictorialist our Van is a simon pure artist.

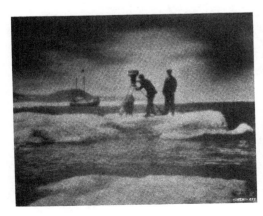

On the ice floes north of Siberia. H. M. Wycoff at the camera for the American National Museum (Smithsonian Institution) making the first complete motion picture records of native life in the Arctic regions.

Cream o' th' Stills

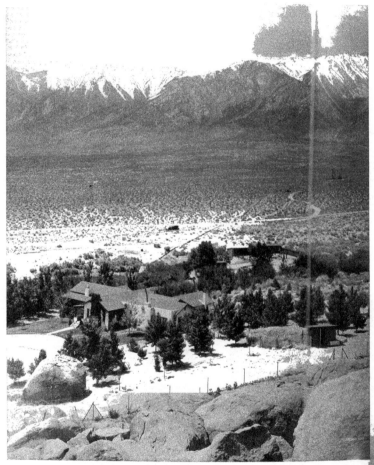

This picture of Clarence Badger's Rancho at Lone Pine, California, was taken on an exceptionally clear day by Longworth, that sterling artist who is indefatigable at searching out things to shoot at. Mr. Longworth knows his deserts.

In Your Next Picture

MORE and more camera men are finding that in Eastman Panchromatic Negative, *Type 2*, they have a remarkable emulsion. They find ample speed ... unsurpassed latitude ... unique fineness of grain ... splendid rendition of shadow detail ... a wear-resisting base ... plus true panchromatic balance.....Use *Type 2* in your next picture.

EASTMAN KODAK COMPANY
ROCHESTER, NEW YORK

J. E. Brulatour, Inc., Distributors
New York Chicago wood

 # Cream o' th' Stills

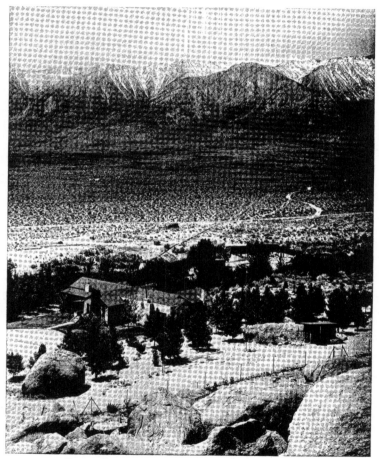

This picture of Clarence Badger's Rancho at Lone Pine, California, was taken on an exceptionally clear day by Bert Longworth, that sterling artist who is indefatigable at searching out things to shoot at. Mr. Longworth certainly knows his deserts.

On Paramount Lot

To get back to work, it might be said that Paramount is doing its share to keep the poor abused cameramen and their cohorts from the poor house . . . Eight companies going strong and making "Paramounts the best shows in town."

Our first line of defense is unbeatable with such men as Stout, Abel, Garmes, Lang, Siegler, Fischbeck, Gerrard and Wimpy . . . and when it comes to seconds, just go down the list of the membership and pick out about twenty-five of the best and you'll find 'em working on Marathon street—doing things and going places for the delectation of those who like GOOD photography . . . and for every Second there is an assistant whose versatility is best understood when you see him driving through Hollywood streets with Rolls-Royces and Cadillacs with 108 cylinders, tendering his paycheck for gasoline and laughing boisterously as the station attendant faints.

The three musketeers—Bennett, Pittack and Laszlo—are working their alarm clocks overtime in order to play eighteen holes before eight-thirty . . . figure it out for yourselves!

Rex Wimpy has returned to the fold, after a three months' sojourn in the capitals of Europe, shooting "stock" stuff and material for coming pictures. While "over there" Rex worked in Paris, Vienna, Berlin, Monte Carlo, Nice, Lucerne, Milan, London . . . with a few "pick-ups" in the beer-gardens and on the side-walk cafes . . . Guess what he picked up!

Archie Stout is 'Rollin' Down to Rio" with Rowland Lee; Dave Abel is beautifying "The General" for Gasnier-Zukor; Lee Garmes is binding Sternberg's next production in "Morocco"; Chas. Lang is making Jackie Coogan look like "Tom Sawyer" for Cromwell; Al Siegler will wear a sailor suit with Jack Oakie, for Heerman; Harry Fischbeck, of course it's Clara Bow, in "Little Miss Bluebeard" for Frank Tuttle; Henry Gerrard is hiding out in "The Little Cafe" with Dr. Berger; Rex Wimpy is studying "Social Errors" with Gardner and Knopf . . . the rest of us are just working here.

And don't forget September seventh!

Lionel "Curly" Lindon is now writing a book on his underwater experiences; it is reported he may also write a sequel to that song starting "Down Among the Corals," he evidently did some piscatorial investigations while operating an underwater blimp in the kelp jungles of the South Seas—near Catalina.

The new "Recreation Room" for the cameramen has not received the attention it deserves, because production has thinned the ranks of the PP (a game with cards), but they are all looking forward to a day or two between pictures, that they may fully enjoy the benefits (and losses) of such recreation. Such a room is greatly appreciated by the boys; cameramen are, at heart, "lounge lizards," hence its popularity.

Virgil Miller is justly proud of the new steel lockers in his camera locker room—twenty-six have just been completed, and others will be added as needed. They are made of heavy steel wire, and insure the proper storage of the expensive sound camera equipment; they also furnish an incentive to the boys in keeping their assigned cameras in the best of condition, without danger of pet equipment being "borrowed" at inopportune times, without being returned.

"The Spoilers" troupe, consisting of Fischbeck, Clemens, Fapp, Titus, Lynch, Myers, Bourne, Seawright, Norton and La Barba, spend their evenings on the beach . . . their sets are built down by the briny near Oxnard . . . which accounts for peeled noses and Hawaiian complexions. Funny how some people get paid for summer vacations!

Bennett, Pittack, and Laszlo are to be found on Chas. Lang's set, unless they are out practicing at Westwood for the golf tournament of September 7th. Virg Miller says he knows when they have been golfing, because the Laboratory generally reports finding "tees" in their "daily soup," indicating a 5:30 exposure and too much contrast . . . in golf scores.

More next time—and don't overlook the golf tournament, on September 7th.

Copies of Convention Souvenirs Available

READERS of International Photographer and especially members of Local 659 and allied organizations who may wish to send copies of the Convention Souvenir Number to friends may have them mailed on forwarding 60 cents to the office of the magazine at 1605 Cahuenga avenue.

This will include the maximum mailing charge of 25 cents.

As will be recalled the issue, which weighs nearly two pounds, is of 214 pages and four-color cover.

Packed with fact and fancy, also it contains a faithful reproduction in colors of Lew Physioc's striking and fascinating painting of the California desert.

It contains also in colors a two-page spread of an airplane photograph of Hollywood and San Fernando Valley.

It contains—and printed on India paper—thirty-two pages of "Cream o' th' Stills," selected from the finest work of the premier photographer-artists of the world.

It is in all truth a de luxe edition.

Single copies at the office 35 cents.

Local 659 acknowledges receipt of the announcement from Paris, France, that on June 14, 1930, a girl, Alma Jeanne, was born to Director Phil Tannura and wife. The entire family is doing famously. Local 659 extends heartiest congratulations.

Production in Japan

SPECIAL CORRESPONDENCE TO LONDON
(Contributed by Maurice Hall, Exeter, England)

Japan has an important though strictly local rank in the cinema art and industry. She is the largest producer of films in the world. Her annual output of full-length "feature" films, exclusive of news reels and short subjects, is between 800 and 850, as compared with Hollywood's 550 to 600, and it is said to be increasing at the rate of 30 per cent yearly. Of the total number of films shown in Japan, it is estimated that 80 per cent are Japanese and 20 per cent foreign. But though Japan is a vigorous producer, she does not count as an exporter because of the purely national appeal of her native screen drama.

The Kazudo (literally, "moving") are flashy buildings in busy thoroughfares. Chairs or benches are provided. The attendants wear short skirts and white aprons. The orchestra is often fairly good. No visitor to Japan today could expect to experience the joy of one of my first visits, about 15 years ago, to a Japanese picture theatre. The entertainment was a screen version of some Wagnerian opera. At the climax of an emotional scene a knight galloped down a long forest vista, and as he rode away the orchestra struck up "Annie Laurie." Repertoires are now much more extensive, and most of the high-class theatres play the incidental music that has been arranged by the producers.

About 350 foreign films are imported annually into Japan. Of this number Europe contributes only about 90; the rest are American. Seven American film corporations have their own distributing organizations in Japan, and, in addition, there are 17 Japanese companies handling foreign films. Paramount, which imports the largest number of films, owns and runs a large cinema theatre in Tokyo.

THE ORATOR

Every suburb of Tokyo has its picture theatre; and in Asakusa, the amusement district, picture houses are more numerous than theatres are in the Shaftesbury avenue region of London. In Japan altogether there are over 900 cinema theatres, or one to every 60,000 of population. Villages which are too small to support a regular theatre are visited from time to time by traveling film showmen.

The audiences demand long programs, and this fact, together with other items of overhead expense unknown in Europe, is said to account for a somewhat high proportion of failures. Every picture theatre requires the services of an orator who explains the picture as it is screened. The necessity for this service is obvious in the case of imported films with captions written in English. Japanese films have their captions written in Japanese, but orators (benshi) are employed to explain the action. The practical reason is that many of the audience are unable to read quickly enough the intricate Chinese characters employed, but there is another. At first Japanese films dispensed with captions altogether, and the action was explained as the film moved along by three or four speakers who impersonated the principal characters. The audience, accustomed to the story tellers, enjoyed this; but it was too expensive, and now captions are devised and a single benshi outlines the story. The success of a film depends to a considerable extent on the skill of the orator. He should be a good mimic, able to bring out the salient points of the drama in pithy language, and gifted with a sense of humor. A good benshi who can keep his audience alternately chuckling and shuddering agreeably commands his price, which in the best theatres of Tokyo may range as high as 600 pounds a year or even more. Good theatres need four or five speakers, and their salaries, added to those of the now indispensable orchestra, help to swell the running costs.

The capital invested in the industry, taking paid-up shares of the leading companies as the basis of calculation, amounts to about £1,500,00. The three chief producers are Shockiku (capital, £687,500), Nikkatsu (£337,500), and Teikine (£200,000). There are in Japan six producer-distributor companies operating 18 studios. Three of these expect to produce two films every week; the others range from one a week to one a month. A record in rapid production was established last year, when a five-reel film was turned out in 35 hours. Seventy-two hours later it had been cut, titled, and censored, and was being shown on the screen. The highest salary paid to a

Japanese film "star" is £300 a month; no woman actress earns more than half of this amount.

The production of Japanese films is said to be increasing at the rate of about 30 per cent yearly. The quality is also improving rapidly, mainly because of the aptitude which Japanese producers show in keeping pace with Hollywood. Little claim for originality is made; Hollywood's influence is supreme; but the Japanese say, apparently with reason, that they follow Hollywood intelligently. The large class of Japanese cinema theatregoers which appreciates foreign films has developed a taste for Hollywood and a curious understanding of American life as depicted on the screen. I have frequently been astonished at the quickness with which Japanese young men and women get the points of a purely American situation.

Japanese films deal chiefly with cloak and sword drama. The subjects are taken largely from those romances of chivalry of which the Japanese are inordinately fond; but under Hollywood's influence, modern themes, such as the war with Russia, are being taken up. The scenes of the cloak and sword drama are indubitably picturesque but unexportable. The grim Eastern faces, grimness heightened by the make-up, contempt of the probabilities shown, the unfamiliarity of the sentiment, the strangeness of the emotional and material background, combine to make Japanese films uninteresting and even distasteful to the European or American playgoer. The love of the Japanese for their own drama gives the industry a natural form of protection which the State supplements by a duty of three-farthings on each foot of film, a rate which works out at about £20 for the average play. Raw film comes in duty free.

The prospects of British films in Japan will depend entirely on their quality. Japanese distributors and the public have been brought up, so to speak, on Hollywood films. Hollywood has formed their taste and established itself as their criterion. "English life" is unfamiliar to Japanese audiences. The first requisite in making a bid for a share of the Japanese market is a higher technical standard.

Simplex Projectors

To supply the needs of theatre owners who have installed the regular model Simplex projector we have designed and placed on the market a new Rear Shutter Assembly similar to the one furnished with our new Super Simplex projector. This assembly is attached to the regular Simplex mechanism and by its use all the advantages are acquired which are gained through the use of the Rear Shutter Assembly on the Super Simplex.

This new assembly includes many features found only in the Super Simplex, such as the new type gate opening device, eyeshield, new type framing device, the pilot lamp assembly and the shutter adjusting mechanism. All of these are manipulated from the operating side of the mechanism.

The new assembly has been in practical operation for some time on the Super Simplex and when attached to the regular model Simplex projector will be found to give equally satisfactory results. The advent of sound pictures made it necessary to discard the old type opaque screens and substitue therefor various type of perforated screens, so that the sound might be more satisfactorily transmitted through the screen. Porous screens have reduced the light from 25 to 50 per cent and this necessitated the use of much higher amperage in order to bring screen brilliancy back to somewhere near normal. The result of this increased amperage has been a tremendously increased amount of heat at the aperture plate and over the front of the mechanism. This not only caused warpage and damage to the rear of the mechanism, but also developed a great deal of buckling of the film and a corresponding amount of distortion of the sound track on the film. The former is readily visible on the screen and most annoying to the observer. The latter has not been so obvious, but it can be readily appreciated that sound waves photographed upon the film when distorted cannot possibly reproduce with proper fidelity the excellent results obtained in present day recording.

The elimination of these two defects has naturally been of great importance, but the fire hazard which developed through the use of higher amperage was far more serious. It has been thoroughly realized that the film has never been adequately protected by cooling devices during its transit through the projector, but due to relatively lower amperages and various protective devices on the projector, the fire hazard has not been a particularly serious problem. With the introduction of sound, the greatly increased amperages increased the hazard to such an extent that fire authorities throughout the country have become very much interested in the matter. This will undoubtedly in the very near future culminate in laws being passed, which will compel users of motion picture equipment to provide adequate means for cooling the film.

The Super Simplex mechanism and the new assembly for the regular Simplex projector have anticipated this and provide a certain solution for the fire hazard problem. Exhibitors are now enabled at a very low cost and little or no trouble to properly equip their projectors and protect the film from excessive heat. The new Rear Shutter Assembly also solves the problem of buckling and sound distortion.

Attempts have been made in various ways to reduce heat and eliminate buckling, but the results have never heretofore been satisfactory. The most successful efforts to cure this serious evil have been through the use of the rear shutter, but practical difficulties were encountered which required long and careful study and much engineering skill to overcome. It is a great satisfaction to the International Projector Corporation to make this device available to users of regular Simplex equipment. The rear shutter assembly entirely meets the exacting demands of present day projection by providing more light and at the same time reducing the heat at the aperture.

Illumination is increased greatly, the percentage of increase depending on the focal length and type of lens being used, and the heat at the aperture plate is reduced between fifty and seventy-five per cent.

This remarkable improvement is due to interposing the new shutter assembly between the arc lamp and the film, thereby making it unnecessary to use heat plates or shields in proximity to the film. The blades of the shutter in their new position immediately eliminate fifty per cent of the heat from the arc and, in addition thereto, a further large decrease in heat is obtained by using this shutter to create a partial vacuum at the aperture and set up an air disturbance in the beam of light which accomplishes the desired result. The air current set up by the shutter will positively keep the film cool and therefore prevent buckling. The width of the near shutter blade no longer depends on the size of the lens so that a shutter using a ninety degree effective blade can be used with a lens of any diameter, while with the old type shutter a minimum of one hundred and two degrees was necessary. A model of this assembly may be seen at any office of the National Theatre Supply Company.

(Right) Bell & Howell master craftsman using measuring projector in which the greatly magnified contour of the teeth of a cutting tool is projected upon a large scale drawing of the tool for accurate measurement. (Below) Close-up of cutting tool in measuring projector.

BELL & HOWELL
PRECISION
CHALLENGES THE NAKED EYE

So greatly magnified on the theater screen are the faults of defective films that the naked eye cannot be trusted to measure or test the machinery through which the film runs on its way from raw stocks to projection booth. With Bell & Howell cinemachinery, hundreds of thousands of dollars are invested in optical measuring instruments which give readings down to the ten thousandth part of an inch so that the precision necessary for perfect moving pictures may be accomplished.

Just as this necessity for precision challenges the ability of the naked eye, so does the picture projected on the theater screen challenge the naked eye to detect flaws due to inaccurate preparation of the film. In perforating, photographing, printing, cutting and splicing the film is ever ready to reproduce the slightest defect transmitted by the machinery through which it runs. For more than 23 years, the major film producers and distributors of the world have been assured of perfect movies on the screen through the use of Bell & Howell Standard Cameras, Printers, Perforators and Splicers.

BELL & HOWELL

BELL & HOWELL COMPANY

Dept. T, 1849 Larchmont Avenue, Chicago, Illinois ⋅ New York, 11 West 42nd Street

Hollywood, 6324 Santa Monica Boulevard

London (B & H Co., Ltd.) 320 Regent Street

Established 1907

[*Thirteen*]

The American Made Spanish Talkies

By GUILLERMO PRIETO YEME
(Written for THE INTERNATIONAL PHOTOGRAPHER)

From the viewpoint of a loyal Spanish-American, there are two main reasons why it is *conditionally* desirable to have Hollywood as the producing center of Spanish talkies: First, in order to enjoy the benefit of the wonderful technique so highly developed in the United States, insofar as camera and sound effects are concerned; and second, because by making the films in a neutral country, so to speak, the producers are compelled to create an art that must be suitable for Spain as well as for Spanish-America, and this, most fortunately, will prevent each country from trying to produce a narrow regional art.

When I say "conditionally," above, I mean this—provided the Spanish talkies produced in the United States are not intended to Americanize the Hispanic peoples by imposing upon them the commercial and popular art of this country, the peculiar philosophy of life which so well befits the American mind, but seems so out of place in any other race of the whole world—the unmistakably American notion of things.

It would certainly be most irritating to us if we were condemned to have too much uniformity of standards all over the world; if even the best traits, the most wonderful and characteristic traits of American civilization, finally succeeded in dominating all countries. Variety, to our mind, is the most precious asset of this tiny world of ours.

Although there is much that the Spanish speaking countries gain by the fact that their talkies are produced at present in a neutral country—and therefore this art ought to unite Spain and her old dominions—results thus far have been most unsatisfactory. Heavy expenditures have been incurred, but to no avail. The effort has been almost totally fruitless. Conflicts, rivalries and petty competitions have actually divided the people whom this art should have brought together. As an amusement the plays thus far produced have turned out most imperfect, definitely condemned to some sort of a failure. Their imperfections lie both in the essence and in the form of such talkies.

They are essentially imperfect because the stories on which they are based belong to the popular commercial art of Anglo-America, which, while pleasing to the masses of the United States, will assuredly seem hard to understand, to say the least, to the Spanish speaking peoples, even though the versions or adaptations may be cleverly done, as is the case, for example, of "The Bad Man," conscientiously directed by Bill McGann, the very able director of First National pictures.

Formally, the majority of the Spanish productions are imperfect because, incredible as it may seem, hardly any professional actors take part in them and there has been no training given to the amateurs who compose the casts, some of whom are not even experienced amateurs, but merely persons who get into the studios as their only means of making a livelihood.

Aware of the failure of the Spanish talkies made in California, a great writer of Mexico, who has traveled very extensively and is well posted on theatrical art, tells me in a recent letter: "What is the matter with the Spanish talkies made in California? What is it all about, that conflict they speak so much of these days, that strife between Spaniards and Spanish-Americans? It strikes me as just one more international intrigue on the part of those who still are antagonistic to the old Spanish nation."

My answer was that the conflict on foot might be summarized as follows: "A lofty purpose unites all men, while a petty, selfish interest divides them."

This is not, forsooth, a true conflict of genuine interests between Spain and Spanish-America, but merely an economic little war waged by a few gentlemen from several countries, for personal reasons.

There has been no one sincerely interested in the defense of Spanish civilization and of genuine Hispanic culture. If, instead of fighting among themselves for the positions of translators and actors, these men from different Spanish speaking countries had had the interest of their race actually at heart, they would have got together in order to discuss and analyze, under the guidance of unselfish and well prepared men, that which is most expedient to Spain and to the republics of the New World.

Thus there never would have arisen any division among them. There is a sacred interest that is common to the whole Spanish speaking world, and that is far superior to all these niggardly ambitions, this plebeian greed and these prosaic rivalries of a few opportunists and job-seekers. And not one of them, in the present instance, thought of this sacred interest!

The first thing that should have occurred to those anxious to take advantage of this incipient industry, should have been the fact that the production of Spanish talkies based on American stories cannot readily agree with the legitimate interests of Spanish civilization, because even the conception of art is different in both races.

From a practical angle this point is not negligible by any means, because no race on earth will allow its traditions to be wiped out to no purpose, to, no advantage, and more particularly if this be done by supplanting its own creations with the mediocre commercialized popular art of any other race.

Therefore, acting in all honesty, those who were called upon to render translations, should have tried to make the producers realize that in order to deserve and to attain real success, commercial and otherwise, in Spanish speaking countries, it was indispensable to give to their productions a Spanish soul, not the language alone, not the aspect or the flavor, but the full spirit of a Spanish literary creation. Such translators as could not offer any original stories of their own, might well have suggested the names of playwrights from Spain and Spanish-America who could have taken up the task with real efficiency. Even American culture would have profited by such contact with the Spanish nation, so rich in literary tradition.

The would-be actors, far from getting disgusted and claiming to be the victims of Spanish intrigues when they were required to use the proper pronunciation, should have started at once to study the prosody of their language, badly neglected in some sections of the New World, and even in some provinces of Spain, in view of the fact that "any fool can talk a language, but it takes a studious man to do it properly."

However, it is not too late to make amends. If some one sufficiently unselfish and possessed of true intellectual worth succeeds in winning the attention of the California producers, it will be easy enough to solve the outstanding conflict —that of unifying Spaniards and Spanish-Americans again on points of higher interests common to both, far from dissensions arising out of individual competition that favors neither the old Metropolis nor the old colonies of Spain.

There are three fundamental points I should like to suggest as leading toward artistic and commercial success on the part of the producers of Spanish talkies, without impairing the integrity of the Spanish-American civilization, to-wit:

First: That due preference be given to stories written by professional Hispanic writers.

Second: That the producers combine their support in behalf of a sort of academy where the Spanish speaking elements to be used in the casts will receive a short course of the proper elocution. Thus there would be no further discrimination against the nationality of would-be actors, since all of them would be properly qualified to play any role, whether in the portrayal of regional or universal characters.

Third: That the producers assist some well known writers to propagate in Spain and Latin-America the ideas that will patch up all present differences.

But, of course, these points are never brought to the producers' attention by men who are not deeply concerned in the vital interests of their own race.

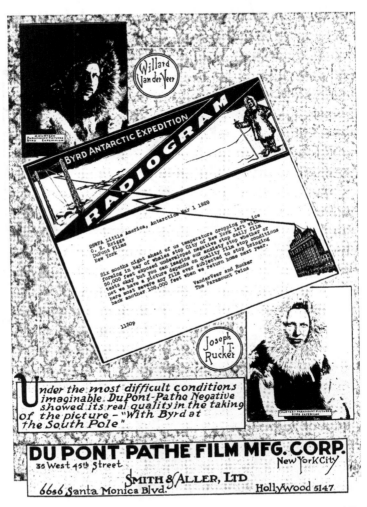

Some Illustrations of Dynamic Symmetry

By FRED WESTERBERG, Local 659

1.272

GRAPH A.

IN the June issue of THE INTERNATIONAL PHOTOGRAPHER I tried to show that the root 1.618 rectangle which is practically the 8x10 shape, seemed to offer the photographer the best possibilities for a study of dynamic symmetry due to its fundamentally dynamic characteristics.

Let us see how it works out. Graph A indicates a layout transcribed on a piece of transparent celluloid for use as a guide either in looking for a set up or in trimming the finished picture. Only the one diagonal is used as the other can be obtained by reversing the sheet of celluloid.

The four points on the diagonal indicate the points of intersection of not only the diagonal with the primary and secondary crossing lines but also of the principal lines parallel to the sides. These parallel lines are indicated by the notches along the edge.

To illustrate the use of this guide in trimming the finished picture I have taken the liberty of trimming on this basis two of the photographs that appeared in the June issue of THE INTERNATIONAL PHOTOGRAPHER.

I sincerely hope that the respective photographers will not take offense at this as I am merely doing it to illustrate some of the changes which the use of a dynamic layout would impose. The trimmed pictures are not necessarily an improvement, as something has undoubtedly been lost in many of them by con-

tracting the scope of the scenes. It does indicate though, I believe, that a certain sense of satisfaction is aroused by having the dominant points, lines and masses grouped more nearly along dynamic lines.

The contention is often made especially by painters that an analytical approach robs the artist of all feeling, that it kills that vital spark which guides him willy nilly to the heights of pure art.

There is some truth in this. Great art is impossible without feeling. It is equally impossible without law. Un-

bridled emotion can only lead to chaos, but an intimate and finely attuned feeling for the laws of life contains elements of the sublime. How little we know or feel of these things! Quite unknowingly science by probing the secrets of nature may prove to be in the end the handmaiden of art. The subject of dynamic symmetry has undoubtedly opened up new vistas along this line.

Only recently while on a visit to the library of the University of California at Berkeley, I tried to obtain Hambidges' "Dynamic Symmetry in Composition" only to find that it was in the possession of a professor in Zoology.

Thus is seems that photography occupies a strategic position at the crossroads of Science and Art. May she make the best of it. *(See also page 17.)*

(See also page 17.)

EIGHT LANGUAGES

Phil Tannura, Local 659, who has been directing short subjects for Pathe, at Paris, during the past year, writes Treasurer Chas. P. Boyle that he is producing pictures in eight different languages and doesn't know which he likes best. His letter rather suggests that a picture in Esperanto or Volapuk is what is most needed just now. Courage, Phil.

IT WAS MILDRED COSTELLO

Mildred Costello is the name of the charming young lady in Spanish costume on the front cover of THE INTERNATIONAL PHOTOGRAPHER for June. Miss Costello is a dancer and was selected by Fred Archer for her place on the cover because of her peculiar fitness for it. Local 659 thanks Miss Costello for her kindness.

ANOTHER ILLUSTRATION OF DYNAMIC SYMMETRY

World's Champion Dare Devil

Photo by Francis J. Burgess

Dick Grace, the man who cracks up real planes for reel audiences. He has cracked up more than thirty planes for the camera and is still alive, well and happy notwithstanding he has suffered many hurts, among them a broken neck.

Half and Half

"I'm kind o' worried about that assistant o' mine," said the cameraman. "He's one of those young fellows who are too smart to take advice and not quite smart enough to think it up for themselves."

No Room

Henry Prautsch, mathematical wizard, has figured out that prohibition is here to stay. With department drug stores on every corner and miniature golf links on all the vacant lots between, there is absolutely no place left for a saloon.

MR. EASTMAN RETURNS

George Eastman, head of the great Rochester plant bearing his name, was a visitor for three days in Hollywood during the past month.

Mr. Eastman, following a bear hunt in Alaska, made an inspection of the Eastman properties in San Francisco, the branch plant and the stores.

In Hollywood he looked over the Brulatour plant, the Eastman building alongside and the new 16 mm. branch structure on Las Palmas.

The manufacturer made extended drives around town before leaving for San Diego on a trip of inspection. He started east from San Diego, returning to Rochester after an absence of two months.

JOE STILL WANDERS

That a two months' vacation in his home town is not enough for an old New Yorker is the rule laid down by Joe O'Donnell, treasurer of the Cinema Studio Supply. Joe, accompanied by his family, rolled out of Hollywood on May 21, saying he could be expected home July 21. The day has been extended to August 1, with the gang wondering how much rubber there is in the last named date. Some men surely do get the breaks.

OUR FRIEND THE MAJOR

Major Ted Curtis, general sales manager for motion picture films of the Eastman Kodak Company, Rochester, New York, is in Hollywood to escape the heat and incidentally to look after the interests of Eastman Pan and Ortho. The International Photographer extends to the gallant major the heartiest of Panchromatic welcomes to Hollywood.

Phone GLadstone 4151

HOLLYWOOD STATE BANK

The only bank in the Industrial District of Hollywood under State supervision

Santa Monica Boulevard at Highland Avenue

Dependability...

BUILT in a variety of sizes conforming to the most exacting demands and precision of the motion picture producer, BROWN-ASHCRAFT (Quiet) Arc Lamps are today's expression of modern efficiency.

Due to the development of the Electrolytic Condenser and Choke Coil, the arc light is again gaining favor in most of the studios. Producers who want photographic quality, will find in the 36-inch Brown-Ashcraft (Quiet) Arc Lamp, illustrated above, as well as all Brown-Ashcraft products, a supreme achievement in studio lighting equipment.

That BROWN-ASHCRAFT products can be relied upon is perhaps one of the important reasons for their ever-increasing popularity in the motion picture industry.

CINEMA STUDIOS
SUPPLY CORPORATION
HARRY D. BROWN

"Everything Mechanical and Electrical for the Studio"

1438 Beechwood Drive

Phone HOllywood 0513

Cinematographic Lighting: Mood Stimulus

By A. LINDSLEY LANE, Local 659; S.M.P.E.

Mood stimulus is constituted of the most delicate mechanisms the makers of motion pictures employ; yet strange though true enough, in direct contrast to these many complex and elusive mood stimuli is the simple positiveness of their effect upon the motion picture audience.

The mood of a motion picture is qualified and partially controlled by the photographic lighting. The lighting of a motion picture is one of the cinematographer's most important contributions to the making of a picture.

The function of photographic lighting in motion pictures is an almost untouched literary and psychological field. It has been said that the creative workers in American motion pictures have been peculiarly inarticulate except through their own work. This may be so. It may be that the men who have actually been doing things in pictures found themselves too busy catching up with their jobs to have time for academically formulating and giving literary expression to their respective theories, techniques and crafts.

Before discussing mood in cinematographic lighting it will be orienting to consider the cinematographer himself to determine what should be his conception of his contribution as part of the finished picture? What his attitude toward his work of enhancing the picture's significance and effectiveness?

The successful cinematographer is constantly growing, continually developing his aesthetic consciousness, is increasingly cognizant of his potentialities and responsibilities, and is more and more realizing that within his immediate jurisdiction comes the duty and privilege of interpreting through pictorial mood the philosophy and the drama of the picture story.

It is interesting to note, for the reasons contained in the above paragraph among others, that the ever watchful producer is today choosing certain cameramen for certain productions, esteeming duly the potency of mood and prizing highly every contributing factor that either creates or sustains mood both in the making and exhibiting of his product.

So the cinematographer of mature artistic integrity looks upon himself as a creative interpreter of the director's picture story. The director mentally visualizes a composite entity, his completed picture; the cameraman photographically picturizes and interprets the director's vision and purpose, and when rightly done his work is self-effacing by its very concord with and superlative interpretation of the picture's dramatic and philosophic content. Hence, to the degree that the cinematographer and his efforts as such successfully elude the awareness of the audience, and to the extent the cameraman induces audience

Al Lane (A. Lindsley) with this issue submits the first of a series of papers on a subject of prime importance to cameramen; and one that has been significantly avoided by writers on cinematography. It is a difficult subject, so more credit to Al, who, we feel, has handled the discussion not only with stimulating enthusiasm, but with incisive clarity. Lane is a Columbia University man and studied the Fine Arts at Boston. His professional training has been almost entirely at the M-G-M studios. As evidenced by the current series of articles and his "The Larger Screen" which appeared in the June, 1930, number of THE INTERNATIONAL PHOTOGRAPHER he is not confining his motion picture efforts exclusively to the camera. We look for much from this energetic and studious young man in the future toward the advancement of the arts and sciences in motion pictures.—Editor's note.

awareness to feel and fully enjoy the story unfolding before it, does he concede his efforts worthy. And to the consummation of this ideal he skillfully employs every known facility of the art and craft of motion picture photography, which in the resultant, reduced to its least common denominator in black and white photography, is the apropos flowing-chiaroscuro of highlight, half-tones and shadow.

This purely aesthetic approach must necessarily be tempered by a quantity of practical production problems. That great portion of the cameraman's problems is hereby acknowledged and dismissed as irrelevant to the object of this paper. Suffice to remark that the supremely valuable cinematographer is he who combines in rich measure the dual attributes of sensitive aesthetic perception and creativeness with practical business acumen and production foresight.

The reactions of the average individual to light manifestations are based upon and the result of centuries of inbred contact and development. Light expresses definite qualities and impressions according to its manifestation type. Primitive man's close relationship with nature taught him many rudimentary facts about light, which as man developed became divided and subdivided into more refined distinctions. Thus there was realized in fact a language of light; a simple universal language understandable and meaningful to everyone. As for example, the hot noonday sunlight with its orange-white glare seems to advance and smite man, seeming to bear down upon him willfully, in this way stimulating the protagonistic mood in man. Again the cool blue-white moonlight seems to retreat within itself seeking to elude tan-

gibility, stimulating man to a mood of repose and reflection. These elementary responses have been ingrained in and become a part of man's being through the ages; they are simple absolutes and cannot be voided. There are others equally positive.

As the process of refinement in man progressed the positive singleness of reaction diminished, the individual's own personal experiences entering to qualify his reaction to a given light manifestation. However, with all this civilized personal response variation there is adequate fundamental stimuli to serve as the basis of a mood language through light in motion pictures. Whatever varied individual interpretations are made never affect the predominating mood sufficiently to permit gross misinterpretation, for the reason that in motion pictures the mood is also drawn through the many contributing dramatic stimuli of facial expression, body poise and movement, locale, the elements, set, costumes, clothes, set appointments, music and sound.

The language of light in its more complicated connotations is still an incipient medium. It is perhaps wise and far-seeing to think of it as an extraordinary living and growing thing, not yet near reached its majority, though slowly but surely evolving with strides probably at least equal to if not greater than the public's growing appreciation and understanding of the beauty, power and significance of the language of light itself, the one encouraging and developing and being encouraged and developed by the other. In this prevails a neat inter-play of competitive growth.

Recall the alleged inarticulateness of motion picture makers, specifically in this instance the cinematographers. From the foregoing paragraph it is now plain to be seen and no wonder why the cameramen have said little and done much, for they have been studying a new language, sincerely striving to comprehend, to master, to make intelligible and beautiful a most elusive and exquisite medium of expression; so that all who may pass may read and enjoy, and to those who care to go further, richly reward with keen delight in the esoteric, the advancing outpost.

Intestinal Fortitude

Ben Lyon: "American women have lost their nerve."

Tourist: "You ought to see some of the entries in our beauty contests back east."

Identification

Waiter: "Did you have soup or chili?"

Bob Tobey: "I don't know, but it tasted like dish water."

Waiter: "That was soup. Our chili tastes like hell."

Fearless Multiplex Automatic Printer

The introduction of sound into the motion picture industry has brought about many new and revolutionary developments. Constant progress has been made in production methods, and new and efficient systems have been introduced all along the line to lower production costs.

In the laboratories the use of machines has practically supplanted the hand methods of processing film. This has given the laboratories an opportunity to greatly increase their output, however they are still somewhat handicapped for equipment.

The operation of printing has been one of the greatest obstacles confronting the laboratory superintendent, for at the present time the printing capacity is the limiting factor of the laboratory output. The ordinary picture of seven reels or 7000 feet generally requires about 250 prints for the ordinary release, or an approximate total of 1,750,000 feet. Inasmuch as normal printing speed is around 60 feet per minute the minimum time required for a release print is 29,166 minutes or 453 hours. This in turn requires 54 days of 8 hours each for one man or with seven printers in operation, 7½ days are required as a minimum time.

The Fearless Camera Company in keeping with their policy of constantly developing new equipment for the motion picture industry have given the printing problem a tremendous amount of thought with the result that a new type printer is being developed, which will be ready for the market in a short time. This printer has a capacity of from 50,000 to 100,000 feet per hour, depending upon the customer's requirements. It will be known as the Fearless Multiplex Automatic Printer.

Both the sound track and picture are printed simultaneously so that the print is ready to go to the developing machine when it comes from the printer.

The Fearless Multiplex printer as the name implies is a multiple printer which can be furnished to print from five to twenty reels simultaneously. The size of course determines the output of the machine. The machine is built upon a substantial base. The positive film reels are mounted below the base and both the feed reel and take-up reel are so mounted. Both the sound track and picture negative are fed continuously through the machine.

The two negatives are arranged so that the picture is printed and then the positive passes through a loop during which it is offset so that it comes under the sound track printing aperture.

The two negatives pass through the machine in a parallel position, the outer film being the picture negative and the inner film the sound track. Each negative is spliced so that it forms a continuous strip of film. The negative films are arranged in loops above the machine, so that the negative does not require re-winding. The loop mechanism is driven synchronously with the printing mechanism so that there is never undue tension placed on the film.

The multiple lamp houses are arranged above the machine permitting the light to project down through a system of condensing lenses to the film. The film ties in a flat position making the printing operation always visible. This enables the operator to detect any damages that may arise in the negative.

One of the most interesting details of the new Fearless Multiplex printer aside from its tremendous capacity is the method and construction of the automatic light change mechanism. The control itself has been in use for other purposes for years. As a matter of interest the control is a perforated paper tape synchronized with the film. In fact the first model built has a control in it taken bodily from a player piano. Of course not all of the orifices in the controller are used, but the mechanism itself has proven ideal for the purpose.

The control roll as stated before is synchronized to the film. The edges being perforated so that as it passes over a special sprocket exact synchronization is achieved. The control tape after being perforated is spliced to form an endless belt. The length of the roll is adjustable, making it possible to vary from 6 to 12 feet in length. Thus giving ample room for a large number of light changes.

The control itself used to actuate a Selsyn motor which in turn is used to open or close a light metering exposure orifice. Each of the various exposure apertures are interconnected so that while one control roll of tape regulates all exposure apertures, the control is delayed to the point where they are exactly made at the proper time. While the description of mechanism used may sound complicated, in actual construction it is quite simple.

The standard control roll regulates twenty-two different lights for the picture negative and twenty-two lights for the sound track negative.

Inasmuch as the standard piano key board has 88 keys and the control used for player pianos has corresponding number of orifices, the printer may be arranged for forty-four light changes for both the sound and picture negatives. Of course such construction entails more expense and an addition in price.

The take-up for the film after it has been printed is an adaptation of the automatic take-up used in the Fearless Silent Camera. This take-up is used to impart a uniform tension to the film as it is wound upon the take-up reel. Briefly the tension of the belt that drives the take up reel is controlled by a lever that has a roller at one of its outer ends that rolls on the film being taken up by the reel, and another roller on the opposite end that rolls on the take-up belt. The lever itself is controlled by a spring that is adjusted to a point where proper tension is placed on the film. This automatic take-up feature precludes any chance of damage to the positive film.

Extreme care is used so that the negative will not be damaged. After leaving the machine the negatives pass through a cleaning compartment where they are sprayed with alcohol and are then wiped and dried by a clean stream of pure air. This feature keeps the negative in perfect condition and eliminates any chance of dirt being picked up by the film and consequent damage that dirt causes. Inasmuch as the film only passes through the printer once for twenty or more prints the damage to the negative is very slight compared with the present practice of passing the negative through a printer for each reel of positive desired.

The normal speed of operation for the Fearless Multiplex printer is 120 feet per minute but it is designed and constructed so that it may be operated at speeds up to 200 feet per minute. In this respect it might be well to note that the machine is driven by a synchronous motor and that an extremely heavy fly-wheel is used to absorb any irregularity of speed in driving mechanism. Uniform speed is imperative for a sound track printing and undue pains have been taken to attain this result.

Precision ball bearings are used throughout the machine to eliminate friction and insure reliability of operation with a minimum of maintenance expense. Stainless steel is used for the aperture exposure plates. The very highest grade of materials, and workmanship are insisted upon in the construction of this machine.

While this new printer is sensational because of its radical designing, tremendous output capacity, high quality of materials precision workmanship and economy of operation, it does not depart from tried and proven design in theory and construction.

It was designed throughout by Ralph G. Fear whose long association with the photographic and laboratory end of the motion picture industry, as mechanical engineer, peculiarly fits him for this work. It is a modern 1930 model printer for 1930 conditions.

Of course with such a revolutionary step forward, the Fearless Camera Company felt it necessary to protect itself and its customers by patents. It has patent applications pending on the use of light control mechanism, the continuous film tape, the multiple printing heads, the control of more than one exposure aperture by the film control reel, the continuous control perforated tape, the film cleaner and on the general construction of the machine. In short the Fearless Camera Company has gone to the limit to protect this machine against any sort of patent infringement.

Movie Folk Uncover Temple

PICTURES have been made in every corner of the world with stories pretending to be in each locale. Of these, many have been made in the studios with fake sets. "Nanook of the North," "Grass," "Chang" and others which have been big box office attractions, are a few of the best examples of the real ones.

The picture public has an idea of the customs and living conditions of most of the countries of the world with the exception of Old Mexico. Most of the pictures that have been produced concerning Mexico show the Mexican people as bandits or the unprincipled characters who frequent the border towns.

Producers have overlooked an unlimited field of material besides the facility of duplicating all kinds of scenery—for instance, the companies which have gone clear to the South Sea Islands for scenery which can be found

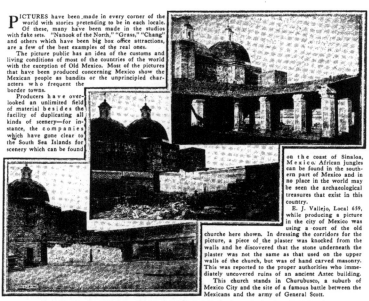

on the coast of Sinaloa, Mexico. African jungles can be found in the southern part of Mexico and in no place in the world may be seen the archaeological treasures that exist in this country.

E. J. Vallejo, Local 659, while producing a picture in the city of Mexico was using a court of the old churche here shown. In dressing the corridors for the picture, a piece of the plaster was knocked from the walls and he discovered that the stone underneath the plaster was not the same as that used on the upper walls of the church, but was of hand carved masonry. This was reported to the proper authorities who immediately uncovered ruins of an ancient Aztec building.

This church stands in Churubusco, a suburb of Mexico City and the site of a famous battle between the Mexicans and the army of General Scott.

Top—The Church as Vallejo found it. Center—The government employees clearing the walls of plaster. Below—The court practically restored.

Producers and Technicians

A Non-Partisan Critical Study of the Relationship Between Producer and Technician

By CRITICUS

(This is the third of a series of expert articles on motion picture production, to be followed by others in succeeding issues)

THE PRODUCER

Let us assume that the producer has all the physical equipment necessary for the production of a motion picture at his disposition, or in other words, a perfectly organized and equipped studio is ready to spring into action at his command.

Long before this command is given he establishes the basis for a greater or less difference between the two amounts of money previously mentioned (costs and receipts) be it on one or the other side of the ledger.

In the last analysis he is and must, like any other business man, be a gambler, with the difference, however, that the gambler as such is in his success or failure governed solely by the law of chance, if a law it can be called, whereas the business man, according to his experience, shrewdness and foresight or business intuition, more or less tempers such laws of chance in his favor. It seems to be a statistical fact, existing from the beginning of history, that the odds of each gamble or enterprise decrease with the ability of the gambler or businessman to temper, influence or change such law of chance in his favor.

That is exactly the position of the producer, determining the character of a production, before he gives his command to start. Under the present state of the motion picture art, mostly all of the productions are based on a mental conception of dramatic poetry—popularly called a story.

To determine upon the story is the momentous decision of the producer. The story is the basis upon which the production is built, and the final structure either stands up or crumbles under criticism, depending mostly upon the strength of the fundament—the story.

What governs the producer in making his momentous decision—the selection of a story—and what should be his qualifications, to enable him to predetermine the final success at the time of his selection?

He must, of course, be thoroughly familiar with the character and efficiency of the mental and physical equipment of his studio, unfailingly foreseeing its ability to solve production problems as they may arise and visualizing the degree of perfection, be it physical, artistic or dramatic, which his organization is reliably able to produce.

These are elements of consideration which he knows, is familiar with, and can use as a general places his combat units before the start of a battle. But just as the general gambles with the assumption of knowledge of the strategical or tactical intentions of his adversary, so the producer gambles with the

The three words of this title completely describe and encompass the personal elements determining the difference between the amount of money invested in a motion picture production and the amount of money ultimately received through its presentation to the public.—Editor's Note.

future state of mind of the public which may exist at the time the production is released.

To influence the law of chance in his favor, the successful producer should not only have that vaguely understood gift, called intuition, but should be an ardent and earnest student of history, politics, national economy, of religious philosophy and national characteristics, and in its most perfect characterization a student of man, a searcher of truth and reason.

It may sound nearly ludicrous, to make such demands for the mental capacity of a motion picture producer, but an analytical study of the personal attainments of successful motion picture producers will more or less definitely convince the reader of the logical truth underlying the foregoing fragmentary statements.

There are today in Hollywood two out-standing and confirming examples of these assertions of the writer.

Both eminently successful producers: one a rather young man, typifying intuition, with the halo of genius on his brow, the other a man of mature age, a profound student not only of this industry but national and international conditions, a man of recognized national importance.

If true, the motion picture producer assumes a height of mental, and, as a result, business importance, seldom realized by persons outside, and yes, even inside a studio.

But these mental attainments constitute, as far as motion picture endeavors are concerned, a great part of what we before called intuition, or in reality, more or less reliable foresight into the future state of mind of the public. To foresee or correctly foreguess the receptiveness of the best paying class of the public, impresses upon the producer the fundamental characteristics of the story he searches for.

It is a peculiar fact that present day literary endeavors do not seem to produce "stories" easily covering the demands of the producer. It would take a book in itself to elucidate the chaotic conditions existing between demand and supply of motion picture themes. It seems that a new, motion picture-wise generation of literary genius has to be established by evolution to bridge that chasm.

Supposing, however, the producer has found and acquired that story. As soon

as he gives the order to start the concerted action of the various departments of his studio assume under his driving dominance feverish activity. His constructive activity, however, usually shrinks to the duty of an intelligent, growling watch-dog.

THE TECHNICIAN

Constructive activity passes to the technician. We consider here every human link in the producing chain from the producer on as a technician, whatever his work and duty is, each one within his larger or smaller circle of responsibility and correlated authority performing with a technique familiar to him. And it is right at this point that the average producer falls short of his effective generality, although being in supreme command to the very end of the production.

This shortcoming results very naturally from conditions in this industry, which are exact replicas of conditions, that existed in other industries during their period of adolescence.

During such period there are usually only a small number of competitors. The novelty and meritorious characteristics of the products of such novel industry bring large and quick profits for comparatively small investments. Refinements and economy are then not a necessary adjunct of production. Such conditions of course invite and produce competition, and although the majority of such competitors are short lived for want of proper business instinct, lasting competition gradually develop and produces organization of effects, resulting in more economical methods of production, and in improvements and refinement of products, until a common level is reached, above which periodically different producers rise, according to the mental qualifications of their managing personnel.

It is at this period of the upbuilding of an industry where the value and importance of the technician makes itself felt in an ever-increasing rate.

This period has been reached by the motion picture industry, but only a few of the producers realize it; very few of the producers have had the opportunity of similar experience in other industries, or have made a profitable study of the development of other industries.

So far, the technician in the motion picture industry has only found appreciation by the producer when and where his services were of palpable importance.

Until very recently, the technician developed with the industry by the rule of thumb, under the hard, but slow taskmaster "Experience," and only lately has the trained technician had the opportunity to surprise the producer by the tremendous increase of financial returns,

which he made possible by his influence upon production.

The value of the theoretically trained technician is seldom understood by the practical technician and the latter sometimes even resents well meant endeavors at co-operation.

Perfect theory and perfect practice are the same thing, but neither exists.

If a technical problem must be solved, the practical technician has to attempt its solution in most cases by the trial and error method. It is usually an arduous way, time and expense piling up.

The theoretical technician can in co-operation in most cases reduce this pile to a considerable extent, especially in the initial stages of the necessary development.

When, however, this co-operation determines upon the skeleton of the necessary development in comparatively short time, then its guidance passes to the control of the practical technician.

We have here again the so highly desirable condition of due appreciation of each other's merits and useful knowledge —the foundation for the fulfillment of the ardent desire of non-political "co-operation" between the different departments.

Especially in the injection of sound into motion pictures, purely a result of technical ability, fathered by abstract, highly scientific research work, has brought about a realization by the producer of not only the value but the necessity of the enrollment of the trained technician on the staff of a producing studio. This realization is beginning to increase by reaction the valuation which the producer places upon all the technicians employed by him and which he so far mostly underestimated.

It is a fact that the majority of producers are of such business training that results are the only items forcing them to recognize technical and scientific progress, and that in only isolated cases suggested plans for improvements or perfections find their support, especially if based not only on purely theoretical but logical deduction.

The field for improvements and perfections is wide open, and a fertile ground waits only for the proper seeds and cultivation to produce a rich harvest.

The owners of the ground, however, not being practical farmers, refuse to buy the seeds suiting the soil conditions, or the tools to cultivate the ground on the basis of modern methods. The old plow-share and pair of oxen, driven to death, are still the standard. And the pity of it is, pity for the producer, that his expert adviser cannot show him the future crop in order to convince him.

The only hope to help the producer, and through him the industry, to a more rapid stride of development lies in the banding together of the technicians. This is being done in an ever-increasing rate, and the influence of societies, clubs, unions, etc., is more and more being felt by the industry.

It is to be deplored, however, that these organizations were not fathered by the producer from the beginning, and this lack of vision, which is in reality bad business, has slowed down the speed of development of the motion picture industry by unavoidable friction between the

PRODUCTION CHART
at the Start of the Industry
A one person Financier, Producer, Distributor and Showman

A one person Director, Cameraman and Laboratory

MODERN PRODUCTION CHART
What the Producer has to contend with

selfish interest of the producer and the selfish interests of the banded technicians.

Elimination of the slowing up influence of such friction in an industry, where speed of performance is of such paramount importance, calls for the candid

appreciation of the value not only of harmonious co-operation but for the active endeavor of each party to enhance the selfish interests of the other party.

What such far-sighted policy produces in the furthering of its own selfish interest cannot be better epitomized than by simply mentioning the name Henry Ford.

It is to be hoped, and signs and symptoms in the industry seem to indicate, that the producer begins to realize that the support and furthering of the endeavors of his technicians simply furthers his own selfish interests. He begins to realize, that his technicians have during routine work neither the time nor the means and facilities to bring their meritorious suggestions of improvements into such condition and form as to be presentable for the mental assimilation of the average producer. This is by no means a belittling of the mental qualifications of the producer, but simply stating the normal condition which establish the difference between a successful producer and a successful technician. Each one is of efficient value in his own field of endeavor, but of varying degrees of mental deficiency in the field of the other.

If the interests controlling the mighty motion picture industry take a leaf out of the book of experience of the other giants in industry, and actively support, father and create with adequate financial support, technical bodies, simply for the purpose of studying and solving existing problems within the studio, of problems known to be faced in the future— of problems bound to arise, but only realized by astractly searching minds of training in reason and logic—then the benefits yielded unto the producers themselves will soon make them masters not of the fourth or third largest industry known in this country, but they will be the leaders of one of the leading industries of the world.

All these abstract statements may be considered as visionary theories, were it not that they can be proven right now by facts on hand, contained in the history of the development of the motion picture industry. These facts are statistical and more or less characteristic supports of above statements.

Let us select a department whose activities are best known and understood and which might be considered as a classical example.

THE CAMERA DEPARTMENT

At the beginning of the history of this industry there were no motion picture cameramen.

Cameras were of design, efficiency and reliability, rather ridiculous to contemplate from the present point of critical inspection—the men operating them like children playing with a rusty, loaded gun—they hope it will go off, but when it does, it may mean disaster.

Motion pictures from the first single scene, of a few minutes running time, were for a long time of such poor quality, that this mighty enterprise nearly died a premature death, when the novelty effect wore off.

The diagnosticians, however keen business minds in this case, foresaw the possibilities of financial gain, and at that time eagerly sought the advise and help

of the technician—then a combination engineer-cameraman.

The evolution progressed at a very slow rate, the cameraman and the results he offered to his employer were indeed very unsatisfactory. It was at that time that the business man, like a race horse champing at the bit, felt and resented the hobble, the cameraman, and that feeling has never reached the point where it changed to due appreciation of the present day cinematographer. Instead of ever-ready harsh criticism, a feeling of admiration should prevail; the knowledge of poor support in equipment and recompense, of studied denial to grant credit for merit, should actually evoke the remorseful words: "mea culpa, mea culpa, mea maxima culpa," whenever camera results do not reach the height of perfection, expected for every picture.

It may well be mentioned at this point that many producers do not realize the box-office value of "good" photography as long as they are satisfied with the "story." Theatre statistics prove the increased attendance in favor of a story, produced by a really "artistic" cinematographer, who understands and masters composition, lighting and lens values, against a "story" of even dramatic value and direction, but photographed by a cameraman lacking above qualifications.

The cameraman usually did and does work under superiors whose previous training makes it with the best intentions hard for them to understand the problems and difficulties the cameraman has to contend with.

His just demands never did, and usually do not now, make any deep impression.

The cameraman had and has to educate himself simply by the slow process of practical experience. The tools, signally crude at the beginning, but gradually improving, and not in the least at his insistence, and following his demands and suggestions, were and are now only grudgingly supplied and maintained up to date.

The average pay was poor and it was often only by greatest economy, bordering misery, that the ambitious cameraman was able to secure equipment and produce results, satisfactorily to him, let alone his employer.

True realization, that human beings have only a limited number of hours each day when they can do efficient work, never was and seldom is now, the basis of the routine of cameraman employment. What were the consequences of this *de facto* condition?

The same, as in other industries, where the pay check and its uncertainties, combined with disregard of the humane recognition of the personal interests of the employees, brought forth the different forms of concerted measures of self-protection, known to us under so many names; boycott, strike, union, etc., etc., so often under stress ill-conceived, and under unscrupulous leadership badly organized and managed—to the detriment of both the employer and employee.

The cameramen, however, did learn from the mistakes that employees in other industries made before them.

After a long time of exchange of opinions, they organized themselves in orderly fashion, and presented their just demands to their employers.

It is a peculiar fact, that even at that stage of development, the employer at first ridiculed these attempts at self-protection, feeling too sure of the power of the pay check.

When, however, the solidarity of the whole profession of cameramen was demonstrated, including men, who by force of their outstanding achievement, had become unreplaceable, then and only then were the employers forced to grudgingly grant to the cameramen conditions of employment which, if really business men understanding the high economies, they should have themselves offered long before.

These enforced concessions are already reacting to the benefit of the producer, raising the average standard of the cameramen, owing to the fact, that a certain dignified character has been given to the profession of cameramen or cinematographers.

Their self-imposed rules and regulations are slowly being felt, resulting in an increase of efficiency, and the final, lasting benefit is enjoyed by the producer, a thousand times overshadowing the benefits so ungraciously granted to the cameramen.

It is, however, by no means a bed of roses the cameraman has conquered in place of his pallet—it still is studded with a number of hard points, which hurt.

His uphill fight with the manufacturers of the tools of his profession, especially in the optical line, is by no means finished.

The now so active, flourishing and in practical efficiency rapidly forthcoming motion picture engineer, is another development in the motion picture industry, greatly brought about by the insistence and demands of the cameramen, one of the decisive elements in motion picture production.

THE CAMERAMAN'S EMPLOYMENT

A great number of cameramen argue as follows:

That the form of employment of a

FROM ACROSS SEAS

Brother Charlie Stumar with his Mitchell in Germany. Charlie has been abroad nearly two years now. They like him over there as here.

cameraman from picture to picture is another of the hard spots in his bed. The producer thinks that such method of employment is good economy. Yes, on the penny wise and pound foolish basis. Why? For several reasons. For example, he says:

A picture is started. The director is paid for the direction of this picture, usually on the basis of a definite sum. It is certainly to his interest in every respect to finish this picture in record time.

This endeavor, if not tempered by critical consideration of final results, very often works exactly in the opposite direction, to the detriment of the interest of director and producer.

The director is not inclined to give the cameraman proper time for his necessary preparations, relating to study of scene for best camera angles, proper placing and control of illumination, study of personal characteristics and make-up of actors, let alone advisability of light tests and so forth—all really important details, which should be duly considered, studied and even tested before the actual turning of the crank begins, but the necessity of which is often not realized by the director or supervisor.

Although all this time should necessarily be spent, not for his, but the director's and producer's benefit, he often is pretty nearly forcibly prevented from doing his full duty.

Very often he yields, strongly influenced by the fact, that his income is cut off, as soon as the taking of the picture is finished. His "job" is gone and he has to "hunt" another one. Do such thoughts instill him with pride and excessive loyalty, to do his utmost for the success of "this" picture? No, it is not human nature. Who suffers under these conditions? The producer.

As cameramen are so often engaged per picture only, they work at different studios under constantly changing conditions of studio equipment and routine. The result is, that the producer, seldom realizing it, has camera crews, constantly changing, which have to adapt and conform themselves to sometimes unfamiliar studio conditions, at his expense, not so much in a financial sense but in form of final results.

That is the mental attitude of a great many cameramen.

Now let us consider the producers' angle on this question.

With him the employment of the cameraman is simply an economic question. He could not be reasonably expected to pay him a salary when he has no work for him. It is not a question of unfair treatment. He is simply executing the dogma of supply and demand.

Where the shoe pinches, however, is the unfortunate existence for seasons of production activities in the motion picture industry. Present conditions of theatre attendance do not any more justify these yearly spurts of feverish activity, alternating with periods of severe reduction in production, with the attendant curtailments of running expenditures and employment.

It seems that nowadays superior management should find a practical way of even production and employment throughout the year.

This survey of relationship between the selfish interests of producer and cameraman could be similarly shown in other departments.

STUDIO, ORGANIZATION

If the producer, for his own benefit, applies his experiences with the cameramen to his other technicians and departments, if he endeavors to make them enthusiastic followers, supporters rather than simply clock-punching, paid employees, then he will lay the solid foundation, now so often lacking, for a really efficient and economical organization.

A clear realization of such conditions, which certainly are worthy of efforts to improve them, should result in the endeavor of the producers, to earnestly study the organization of their studios.

Another observer recently remarked: "The motion picture industry is the most disorganized and the most lucrative business existing." Organization in this industry consists apparently only in the division of efforts into a number of groups or a division of labor among a number of departments.

But to prevent that ogre of wasteland, overlapping of efforts, with the resulting conflicts, inharmony, jealousy and the dreaded but paramount "studio politics," the golden rule of experience should prevail.

Make for each employee the circle of responsibility coincident with the circle of authority, neither to be violated by even the highest superior, without destroying the other and the efficiency of the man.

No efficient factory manager will give an order directly to a day laborer, disregarding his chain of organization, his superintendent or foreman or the like, without endangering the efficiency of his plant.

The study of producing agencies and their organizations, yes, and even military and church organizations, shows certain fundamental conditions of co-ordination of efforts, absent in most motion picture studios.

Where they are intelligently enforced an esprit-de-corps is fostered, which produces the concerted loyalty of all employees, and their pride in being members of such studio. Such condition is the most potent factor in ardent competition between rival studios. And such competition is ethically sound competition, and would be the greatest element in elevating, developing and furthering this interesting motion picture industry.

CONCLUSION

In conclusion the writer wants to disabuse any reader, if he thinks these articles were inspired by any partisan feelings.

They were and are intended, simply as objective analysis, to instill into all quarters of this industry the active spirit of preparedness for conditions that are bound to exist in the future.

And lest you are too prone to criticise success as unmerited, do not forget that there never was success without merit, no outstanding success without outstanding merit—personal merit, elevating its possessor above the merit level of his neighbors or competitors.

And let the technician not foster a frame of mind, antagonistic to the producer—considering, depicting and discussing him as a heartless, ruthless employer, without any humane principles.

There are many producers who have a deep affection for this industry, who devote their physical, mental and financial qualifications and resources, exclusively for its benefit on a scale, often more sacrificial, than many outsiders are capable of realizing.

There are many producers, whose phenomenal success is nothing else than a proof of their business ingenuity—but may the stress of routine and the influence of success not make them lose sight of the future and its problems and may producers and technicians candidly realize and appreciate each other's values, and harmoniously combine their efforts for the realization of a glorious future.

———o———

Report Stolen Camera

Fred I. Weddle Company, 318 West Ninth street, Los Angeles, offer a liberal reward for the recovery and return of Bell & Howell standard cinematograph camera No. 537. It was stolen July 27, along with much equipment.

MR. CHAMBERS GOES EAST

Gordon O. Chambers, a member of the Eastman Kodak research department in Hollywood, is at the home plant in Rochester for a month.

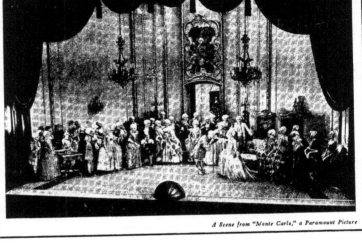

A Scene from "Monte Carlo," a Paramount Picture

Even Balance

LIGHT struck from National Photographic Carbons permits an even balance of light *and shade* between actors and the rest of the set. Light from these arcs has penetrating power unequaled by any other form of studio lighting.

For night shots, National White Flame Photographic Carbons can't be beat. Their light permits clean, sharp moonlight effects, or brilliant contrasts — often prevents expensive retakes.

National White Flame Photographic Carbons come in sizes to fit any studio arc lamp. Tests prove that they offer the most economical form of studio lighting. They give more light per watt of electrical energy than any other form of studio illumination. Actinically identical with sunlight, the choice of leading film-workers.

NATIONAL CARBON COMPANY, INC.
Carbon Sales Division: Cleveland, Ohio

Units of Union Carbide |U|C|C| *and Carbon Corporation*

Branch Sales Offices: New York, N. Y. Pittsburgh, Pa.
Chicago, Ill. Birmingham, Ala. San Francisco, Calif.

National Photographic Carbons

—

September Seventh

Virgil Miller Waxes Poetic Over the Big Golf Tournament

By VIRGIL MILLER

In the first place . . . How about wider and shorter Fairways, bigger and deeper Cups, smaller and wetter Sand-traps! Particularly for September 7th. Which leads me to say . . .

Let me rivet your attention,
To our divoting convention,
On a Fairway, in a fairway, in September;
Polish up your tees and figger
How to use your spoon and jigger,
For you'll need 'em on the Seventh—so remember!

If you're shy a good spade-mashie
Better go dig up some cash-ie,
Otherwise you may be digging divots up;
And if mental hazards worry,
Take your time—no use to hurry—
Being stingy is what counts twixt tee and cup.

If your golf-bag's a bit saggy,
And your plus-fours seem too baggy,
Just forget 'em . . . it's your form, boy! Form—that's all;
Wood and iron . . . PUTT to SINK
"Eagles" make opponents think—
Even "birdies" means your eyes are "on the ball."

So come out and do your stuff,
Try and keep out of the "rough,"
If your driver's on the blink, then fetch a gun;
Bring your "camera eye" along,
Shoot 'em straight—you can't go wrong,
Don't let "dubbed" shot stop your smile—it's all in fun.

Farewell "Spill Light".

In the development of the "Laco" new sleeve light-control, Lakin Corporation has added the proverbial feather to its cap which already carries a profuse embellishment of feathers.

That the Laco sleeve light-control will prove to be an indispensable addition to the requirements of the up-to-the-minute studio technician is borne out through the acclaim that it has received from a number of them.

Ray June, well known cameraman with United Artists, and Chief Electrician William Johnson of R. K. O. Studios, have both pronounced the new Laco light-control a great success after careful personal tests.

"Spill light" which heretofore has been the bane of the electrician and cameraman is practically done away with.

This new equipment is easily adjusted to any Laco light.

—o—

Photophobia

Bert Lynch says he has shot still pictures on so many of the M-G-M dog comedies that he is beginning to growl at his wife.

FRANCIS J. BURGESS

S. M. P. E.

Camera Department

PARAMOUNT - PUBLIX CORPORATION

Attention, Golfers!

By
JIMMY PALMER

THAT big Golf Tournament for 1930!

Well, boys, your committee has been successful in securing the beautiful Palos Verdes Golf Club course for our Second Annual Tournament to be held on September 7th. The course has been guaranteed by Mr. Jay Lawyer, president of the club, who says he will make every effort to see that the boys will have a good time.

As the play will start at 6:30 in the morning, arrangements will be made so that those who care to can get breakfast from 6 o'clock on. There is a nice plunge at the course, so bathing suits won't be amiss.

There will be a play off for the nineteenth hole and dinner after the last foursome has come in.

Be sure and get your entries in early as they are coming in fast and we have a limit of sixty foursomes for September 7th. Any more than that will have to play the following Sunday, so make haste.

The Golf Committee for 1929. Left to right—William Snyder, Reggie Lanning, Ira Morgan, Bill Foxhall, Jimmy Palmer. Virgil Miller and Norbert Brodine have been added to the Committee for 1930.

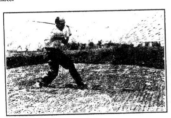

Roy Klaffki demonstrates how he and Bobby Jones get out of sand traps.

You may secure your entry blanks from our Local Office or through our golf representatives at the various studios. The fee is Three Dollars ($3.00) and by paying that fee and turning in three score cards played on any legitimate golf course you secure your entry. Entries close at 9 p.m. August 30th.

Prizes will be on display in the show windows of the Schwab Clothing store, 6358 Hollywood Boulevard, Hollywood, for one week commencing August 30th, 1930.

I get goose pimples all over when I think about this Tournament for I know now that it is going to be the greatest sport event ever staged by cameramen. Don't forget boys "whenever better golf is played, cameramen will play it."

The Palos Verdes golf course is situated in one of the scenic spots of California. It is located at White Point about two miles up the coast from Point Fermin and from bluffs two hundred feet high overlooks the Pacific as far as the eye can reach in every direction. To seaward thirty miles is Santa Catalina Island, while all shipping going into and outward bound from San Pedro Harbor is in plain sight of the golfers at all hours. It is a playground to inspire any lover of golf and the beauty of the place is worth taking the trip to see. A drive of fifty-five minutes straight out Western avenue and over the hills will bring you to Palos Verdes golf course.

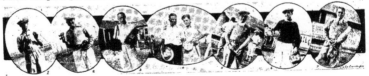

Some of the 1929 winners with their spoils.

Television Up-to-Date

By F. G. Lawrence

There have been numerous articles published in the newspapers, trade papers and periodicals, regarding the demonstration of television which the General Electric made on May 22nd, in the Proctor Theatre at Schenectady, New York.

There have been extravagant predictions relative to the use of television as an amusement device, and it is of interest to those of us engaged in the motion picture industry as to just what these developments are, and what possibilities they have in the amusement field.

would correspond very well with that given by a motion picture thrown on the screen by a projector which was underlighted. The image was quite distinct in all parts of the house, and an observer who was not too critical would probably have said that the picture quality was equal to that of the average motion picture.

It does seem that the fundamental ideas that are the basis of present television development impose great restrictions upon the production of an image equal in size to that of the motion picture.

The apparatus used in this demon-

photo-electric tubes and the other electrical devices embodied in modern television, was unable to make a practical application of his idea. He did, however, clearly invent the idea of scanning a picture line by a spot of light.

The scanning disk is a metal disk driven at a fixed speed by a synchronous motor receiving its energy from a timed circuit such as is found in all the modern alternating current power systems.

The scanning disk has near its periphery forty-eight small perforations equally spaced in the form of a scroll, the starting hole of which is approxi-

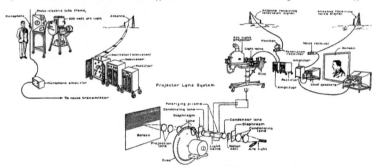

Projector Lens System

It has been the policy of the Mole-Richardson, Inc., to have a representative of their company attend each of the semi-annual conventions of the Society of Motion Picture Engineers. Elmer C. Richardson attended the Spring Convention held in Washington. In order to get a line on the general trend of activities, a considerable stay was made in New York by Mr. Richardson, with side trips to the R. C. A. Victor Engineering headquarters at Camden, N. J.; to the General Electric Company in Schenectady, New York; and to the Bausch and Lomb Optical Company in Rochester.

It was Mr. Richardson's good fortune to be in Schenectady the morning that the gentlemen from the Research Laboratories made the demonstration of their television apparatus. The television transmitter was operated from the General Electric Co.'s Broadcasting Station WGY, and the television receiver was installed in the R. K. O. Proctor Theatre in Schenectady. The distance between the transmitter and receiver was approximately one mile.

The image projected by the transmitter was approximately six feet square, and the transmission gave an image which

stration was developed by Dr. E. F. W. Alexanderson, consulting engineer of the General Electric Company, a pioneer in the field of television, and its kindred arts—radio and sound pictures.

Three years ago the engineers of the Research Laboratories of the General Electric Company privately demonstrated television showing an image about three inches square. Last year when Mr. Richardson was at the laboratories they made a demonstration showing an image about fourteen inches square; this year the image six feet square shows a perfection both in the brightness of the picture and in the quality of the detail, which is decidedly superior to that shown in their earlier development.

To those who have even a slight knowledge of the principles of television it will no doubt be of interest to explain something about the apparatus involved and what the new developments are that make it possible to transmit a television image as large as that recently shown.

The basic principle of television embraces the use of a scanning disk which is fundamentally an invention made fifty years ago by a German named Nipkow, who not having either radio amplifiers,

mately one inch farther from the center of the circle than the final or forty-eighth hole. In other words the pitch of the scroll is one inch in one revolution.

Figure 1, shows a schematic representation of the transmitter station. The transmitter consists of an arc light properly housed which is provided with an optical system for passing parallel rays of light through a scanning disk which is mounted in the drum-like enclosure. The person or subject whose image is to be transmitted stands in front of the revolving disk so that in one revolution of the scanning disk each successive hole in the scanning disk will permit a small beam of light to be passed over his head and shoulders, the device being limited at present to the scanning of an area approximately two feet square. If one were to observe the subject being scanned, and the disk were revolved very slowly, he would note a series of spots of light passing over the subject, each successive spot just slightly overlapping the path of the one which preceded it. The disk of the transmitting apparatus revolves at a speed of 1200 revolutions per minute, and when one observes the subject being scanned it appears as

though the subject were lighted from one general light source.

Adjacent to the subject in a suitable frame shown in the illustration there are installed four very sensitive photo electric cells, which set up a feeble electric current which is proportional to the stimulus which they receive from the light reflected from the subject, as each successive scanning beam passes over the scanned area. To make this clear—think of the scanning disk as revolving very slowly; when the starting hole passes its beam over the area to be scanned — assuming the subject were standing against a black background, and that the light would merely follow on the black background—there would in this case be no stimulation of the photo-electric circuit since the black background would reflect no light, but when the beams from the subsequent holes in the scanning disk began to traverse the area occupied by the subject, the varying areas of dark and light in the subject would reflect similar varying amounts of light into the photo-electric cells, which would then begin to pass an electric current proportional to the stimulus energizing the photo-electric cells.

The feeble current developed in the photo-electric circuit is then amplified in apparatus very similar to that used in radio broadcasting.

The Television receiver and projector is illustrated in Figure 2. Its operation may be described as follows:

First of all, the radio impulses sent out by the transmitting station are received on an antenna just as in the receiving of radio broadcasting and are similarly amplified to the desired degree before being introduced into the televisor or television receiver.

The televisor used by Dr. Alexanderson in making his demonstration at the Proctor Theatre is shown in a schematic layout in Figure No. 3. The light source is an high intensity arc using a current of 150 amperes. Incidentally only a small amount of the light from this arc was projected, but arcs of less power do not supply the brilliancy required.

The light from the arc is passed through a suitable optical system, then through a water cooling cell and passed through a light valve, the principle of which will be described later. From the light valve the light passes through a diaphragm and through a scanning disk, which in this apparatus contained 5-1 small lenses; and thence through a proper optical system to produce an image on a screen seventeen feet distant, the image being approximately six feet square.

The heart of this television system lies in the light valve, which is a form of the Kerr cell. (Reference to this type of light valve may be found on page 748, Vol. XII, Transactions of the Society of Motion Picture Engineers.) The Kerr Cell operates on the principle of polarization of light by Nicol prisms and a fluid such as nitrobenzol. Such a cell will valve light passing through it, in proportion as its polarization characteristics are affected by a high potential current impressed upon it. In this television receiver the current supplied to the

Kerr Cell is the television signal, properly amplified and raised in potential.

When the apparatus is in operation, the scanning disk of the receiver is driven at exactly the same speed as the scanning disk of the transmitter unit, and by an ingenious arrangement is adjusted so that when the No. 1 hole passes the scanning beam over the subject, the No. 1 hole of the transmitter passes through the rays of light from the light valve, and the image resulting from the passing of the forty-eight holes at the rate of 1200 revolutions per minute of the scanning disk, produces the television image on the screen.

While the results produced with the television equipment as demonstrated in the Proctor Theatre were very remarkable, it does seem that we are still a long way from the practical application in the amusement field. The present apparatus is limited to the scanning of a relatively small area. In the demonstration only the head and shoulders of the performer were visible.

The limitations imposed upon the system by the optical system and the light valve, greatly restrict the possibilities of an image of greater area. Television signals transmitted by radio waves are subject to the same limitations as radio, i. e., static, interference, etc.

The significance of the demonstration was the rapidity with which the developments are made in modern research laboratories. One year we have a television picture three inches square; the next year fourteen inches square, and the next year a very satisfactory picture six feet square.

The motion picture industry apparently has nothing to worry about in the field of television as it stands today, but some of the best scientists in the country are devoting their efforts to overcoming the obstacles which stand in the way of progress in this new art. These scientific men work in a friendly rivalry in this research problem. Sometimes their solutions are parallel, at other times they work on widely different lines, but ultimately just as in the field of sound motion pictures their efforts will be rewarded by achievement.

Virgil Miller has had so many applications for work in the new Paramount-Publix Studio in Paris that he is beginning to think that perhaps the night-watchman did have some information based on facts. Virg is contemplating a course in French, hoping to find a new phrase that will have more meaning than the present one in English of "I don't know; as soon as I learn something, I will let you know; in the meantime, leave your name and address with my secretary or at the front gate; I'm sure your war experience (at home) will make your services invaluable 'over there'; yes, you are the first one who has made application (starting all over again) . . . etc." In the meantime Virgil is preparing and shipping a number of sound cameras overseas, working overtime that "fifty million Frenchmen can't see wrong."

Review-ettes

ONE thing is certain, and, the fact cannot be overlooked by anyone whose business it is to review motion pictures, and that is—photography becomes a greater marvel almost daily. Pictorially practically every photoplay is above reproach in these times of consummate skill so outstanding among those behind the cameras and this constitutes a deserved tribute to our own Local 659 and affiliated cameramen.

By way of inaugurating this new department, which will be devoted to reviewing several leading pictures each month, the writer wishes to express his feeling of elation over his discovery that in the case of each and every feature viewed he found the photographic effects worthy of special mention and high commendation.

FOR instance let us consider "Lawful Larceny," one of the current successes in which Bebe Daniels and Lowell Sherman cover themselves with glory. Roy Hunt has done a thoroughly good job of finishing this picture. In fact, he has displayed that genius which is becoming more and more a fixed quantity among our boys. Many of the shots are par excellence and at all times there is in evidence the proof that a deft hand and a real camera-minded brain were co-ordinating perfectly while Mr. Hunt was on this job.

Incidentally, Lowell Sherman not only co-starred in this picture, but he directed it and thereby leaped into the foreground of prominence as a real find for Radio Pictures. A combination of rare showmanship and high artistic attainments reveal themselves in Mr. Sherman's favor and he certainly looms as one of the directorial masters of the early future.

ONCE again does the photographic mastery prevail in "Old English," Warner Brothers' latest special, starring the irresistible George Arliss. To James Van Trees goes the credit for photographing faultlessly this sure-fire hit. He has caught the spirit not only of the enthralling story of the great man of power in early-day British shipping, but he did full justice to the amazing finesse of the dramatic artistry of Mr. Arliss, who should feel grateful for the wisdom of the producer placing such a man as Mr. Van Trees in charge of the photography.

By the way, Leon Janney, the youthful screen prodigy, appears in support of the star and once more he almost steals every scene in which he participates. That Janney lad bears watching by all those who gain thrills from keeping close tab on comers.

Alfred E. Green, who directed "Old English," has held up his end of the task admirably and is entitled to a lot of applause. Undoubtedly, he is one of the great film directors of this day.

[*Thirty-two*]

A THIRD current release which brings to the foreground the constantly improving quality of photography is "The Dangerous Nan McGrew," starring Helen Kane, the popular 'Boop'-boop-a-doop girl." George Folsey, who photographed this comedy, must have had a lot of fun engineering his angles on this veritable fun-fest. A great deal of ingenuity was required to get "in the box" all the high-speed tempo Director Mal St. Clair has generated for this opus. George had to be on the job every second to get this unusual satire on film.

Victor Moore, an old stage favorite; Stuart Erwin, one of the new comedians who is coming forward with breath-taking rapidity; and James Hall all distinguish themselves.

IT is rather late in the day to write about "Hell's Angels," but so is it to write about Napoleon, Aida or the Garden of Eden, but in spite of the lateness it may be considered as never out of place to commend a thing unusually excellent whether it be breakfast food or a new kind of airplane.

After all the mental elite had sat in judgment as to the merits of this picture from drama to photography and had given sage attention to all the elements there was the usual schedule of "bad spots," sins of omission and commission of various sorts, but how any reviewsmith could sit through the running of this picture and not gather from it a tremendous admiration for the producer and his achievement is difficult to reconcile with good picture judgment.

The cameracraft is one of the grand triumphs of all time; the synchronization perfection; the projection worthy of the highest expert praise and the drama admirably handled. All this in a theatrical setting of extraordinary brilliance constitutes a film offering of an all-around excellence seldom met with and of this particular kind unequaled.

As everyone knows Harry Perry was supervising cinematographer of the aerial sequences of this picture, while Gaetano Gaudio directed the photography of the drama.

NORMA SHEARER stood 'em in line in her newest starring vehicle, "Divorcee," at Hollywood Pantages recently. This M-G-M masterwork left nothing to be desired photographically and the projection was as faultless as any ever seen in Hollywood. It was a delight to the weary spirit. The picture was most artistically staged in this gorgeous playhouse which by-the-way is the acme of comfort and, on the whole, was a noteworthy event. The camera work is to the credit of Norbert Brodine and his crew, while the directing honors go to Robert B. Leonard.

Miss Shearer acted with her usual distingue in playing roles sophisticate, and the supporting company was equal to its assignment.

THAT little Bow girl, who is said to be the discoverer and sole proprietor of "It," shows a lot of it in her latest vehicle "True to the Navy."

The writer is not just exactly clear as to what constitutes "It," but if there is such a thing as evolution, this "It" thing must be the sum total of the evolving entity at any given time.

In the little Bow girl's case this would mean that, as the result of her experience in past incarnations, she had won among other things, beauty, grace, charm, a certain ability to put over her stuff and the power to win popular favor.

In "True to the Navy" she does her best work under some intelligent direction which permits her to take advantage of her naturel spontaneity. In brief this little Bow girl is just naturally an entertainer of parts, and as she seems to be at her best when there are a lot of gobs around, it would seem to be the part of wisdom for the United States Navy to enlist her and watch itself grow.

If the "It" girl were sent to one of our naval conferences to represent the United States Navy at a ship sinking bee this ebullient brick-top would have the opposition sunk before it started.

But to return to the picture at Pantages a week or two ago—Victor Milner did his usual masterly work as chief cinematographer, while the projection was up to the high and enviable standard set by the projection staff of Hollywood Pantages.

A REPRESENTATIVE piece of motion picture craftsmanship is "The Big House," M-G-M's expose of prison life and shown recently at the Hollywood Pantages Theatre.

That matchless scenario builder, Frances Marion, wrote the script and her husband, George Hill, directed most ably—an ideal team.

As gray as the prison walls themselves is this picture, little opportunity being afforded the camera to register beautiful effects, but details were marvelously picked up and the print exhibited was a credit to editor, laboratory and cameraman alike.

The projection, as usual at this theatre, is done in a workmanlike manner. Verily projection more and more is becoming an essential factor in the sum total of motion picture exhibition.

To Harold Wenstrom is due the credit of getting all out of the photography there was in it.

McBRIDE A SECOND

In the June issue of THE INTERNATIONAL PHOTOGRAPHER James McBride Local 659, was inadvertently listed as an assistant whereas he is and for a long time has been a second cameraman. The editors regret the oversight.

"Mike"

By John Leezer

While engaged in getting a little "shut-eye" on the end of a boom the other morning, I was awakened by a couple of camera assistants spilling their troubles to each other. One by the name of George says:

"I wanta tell the cockeyed world that us assistants is gettin' the uncooked end of the deal. Me for instance. I drives down here this mornin' at eight o'clock. I'm not kiddin' ya, it was an eight o'clock call an' if somethin' ain't done about it, they'll be handin' out seven o'clock calls. Well anyhow, what do I find but some bozo parked in my space an' when I puts up a holler, the guy in the funny uniform says:

"Bring your can over here, the general manager won't be here today, an' you can use his garage.'"

I pays no attention to the Famous Last Words talk an' says: "Who's heap is that in my stall?"

"That belongs to one of the directors. What ya gonna do about it?" says the chocolate soldier.

"Get him outta there or I'll report ya," says I an' it worked. In about seventeen minutes that director had his Chevy out a there an' me an' me Lincoln was where we belonged. But I'm askin' ya. Can you beat it, the way some guys try to hand you somethin'?

But that wasn't all of it. I couldn't find a wagon to haul the junk from the camera room to the set, so I had to pack it on me back. 'Ats all right though, cause it happened once before an' to be on the safe side, I took out a card in the Piano Movers' Local. It was nine o'clock by the time I had the outfit set up an' I had a runner in one of me socks a yard long; me new pair of spring suspenders was out a sink an' me disposition ditto.

At nine thirty, I'm settin' in the director's chair, givin' me nails a man cure, when along comes Bill, the big stiff. He's got a lotta crust, tryin' to alibi himself as a head cameraman. He was tryin' to look through a blue glass an' tell the gaffer where to put three suns an' sixteen orange-peels. But the gaffer says nix, so the big bluff says, "O.K. Amos." 'Light it like you did the last one an' it'll be jake with me. An' then he sees me. What's the big idea? Ya had a eight o'clock call didn't ya? An' I says, "Quiet! We're runnin'." "Quiet me eye," says he. "Do it again an' I'll report ya.'

The director calls him before he can pass out any more bull, but when he comes back he says to me, "At's all right kid, fergit." I had to say somethin' 'cause the director's sore this mornin'. I'm askin' ya again. Can you beat it? An' they —— "O.K. Bill. It's practically there." Then the grievance committee adjourned.

Pretty soon I heard the director say, "Bill, this is the dolly shot I was tellin' you about yesterday." "O.K." says Bill and called Eddy, the champion dolly cameraman of the West Coast. "From here to there Eddie an' back again," says Bill. "O.K." says Eddie. Eddie always says O.K.; even when they asked him to work Memorial Day.

"From here to there," meant that I would be swung around in a semi-circle on the end of the boom so that I could listen in on what a fleshy colored lady was supposed to say as she tramped along ahead of the dolly. We tried it once; then Eddie squawked. "Can't keep the same distance all the time," says he. Then Bill said "O.K." "Get a board about six feet long and let it stick out in front of the dolly," says Bill.

While the dolly was following the lady dinge the board kept her at the right distance but when she tried to follow the dolly on the return trip, she bumped her shins against the board which caused the director to say a few things derogatory to cameramen in general.

"O.K." says Bill. "Get a piece of rope." This was brought and one end fastened to the dolly, leaving about six feet dragging on the floor. "Now," says Bill, "all ya have to do is walk at the end of the rope."

It looked like it was goin' to work until we were about half way across the room. Then the two hundred and fifty odd pounds stepped on the rope. Three husky ex-longshoremen were pulling the dolly and the effect was precisely the same as if the rope had been attached to a street car. I have seen some wonderful flip-flops, on the Sennett lot and elsewhere, but nothing to equal that one. It wasn't a three-point landing by any means. Just a one point; the back of the lady's neck.

"Let's forget the dolly shot," suggested the director. "Amen!" groaned the colored lady, but I'll bet she won't forget it in a month.

YOU CAN'T JUNK EXPERIENCE

Some months ago in an editorial utterance The International Photographer warned the pioneer members of this magnificent organization to pay no attention to the chatterings of those magpies who put every man in the antique shop who has reached the age of forty or more.

Not long ago Henry Ford was quoted as saying "if all the men of fifty-five years of age or over were removed from industry there would not be brains enough to carry on." The older men, Mr. Ford pointed out, are an indispensable balance to the younger and more vigorous workers.

And now Dr. J. A. Britton, Chicago physician, who appeared before the convention of the American Medical Association there, says he believes American industry "makes a serious mistake in discarding a man when he reaches the age of 45."

"When this is done," Dr. Britton says, "the ten years of a man's life in which he attains his maximum efficiency are being thrown away. The age of maximum efficiency is attained in the last ten years.

"From the ages of forty-five to fifty-five a man delivers more in judgment, stability and loyalty, and in every virtue except muscular agility and sheer muscular power. In professional baseball, for instance, a man may not be worth much at 45, but even in baseball I have much at 45, but even in baseball I have pennants."

It is noteworthy that the pioneer cameramasters of the motion picture industry are still with us, still in the spotlight, still doing the big jobs and still delivering the goods. Nay, more, they are showing the way to do things better, they are suggesting improvements and new devices and superior methods. Some of them are being made directors by observing producers and more of them will be, for the great seed-bed of producers and directors of the future is this great body of intelligent, alert and progressive men known to the public generally as "cameramen."

In reality they are technicians and artists combined and among them are to be found the smartest and most constructive critics of production in the motion picture industry, bar none.

Recent and Future Economic Changes In The Motion Picture Field

Abstract of Address by Dr. Franklin S. Irby, of New York, Associate Editor of Electronics, Before American Society of Motion Picture Engineers, Wardman Park Hotel, Washington, Monday Morning, May 5

Stimulated by the increasing drawing power of the talking picture, the motion picture industry experienced in 1929 the best year of its history. The wiring of theatres for sound pictures progressed rapidly here and abroad, and at the close of 1929, there were approximately 9,000 theatres equipped for such pictures, out of a total of 22,600 in the United States. There were about 2,000 sound installations in Europe.

It is estimated that at least 5,500 additional theatres in the United States will be equipped for sound during 1930. This will mean that 75 per cent of all picture houses in this country will have sound apparatus by the end of this year. The total installations in Europe will probably reach 5,000 by the end of 1930, bringing the total installations throughout the world to 22,000 or about 40 per cent of the theatres built. This record-breaking growth will be considerably slackened at the end of this period, though it is expected that installations will continue until all suitable theatres have been equipped. Just what will be the final percentage of sound installations will depend on language barriers and limiting size of theatres in which sound equipment will pay. Satisfactory solutions will ultimately hurdle both these present barriers, and at no distant date we may expect a sound equipped theatre or no theatre at all.

Rise in Theatre Attendance

It may be of interest to note the rise in attendance at motion picture theatres during the past eight years. The first sound equipments were installed in the latter part of 1926; however, no great public interest was aroused until the introduction of the talking picture, "The Jazz Singer," in October, 1927. The immediate success of this sound picture was the turning point from silent to audible pictures. The phenomenal rise in the attendance curve is most marked from this time up to the present and many indications point to even higher levels. It is conservatively estimated that the total average weekly attendance will reach 125,000,000 by the end of 1931. This is based on the increased number of theatres that will be equipped, and the better quality and wider scope of sound pictures. With the present attendance of 115,000,000 paid admissions per week, it means that practically the entire population of the United States attend the picture theatre once every seven days. It is

no longer be considered a luxury, but are a necessary form of recreation for the masses.

The average admission price in the key cities is given as 55 cents, while the average for all theatres is approximately 35 cents. Using an average admission price of only 30 cents and 100,000,000 as the average weekly attendance, it is estimated that the total annual paid admissions to American theatres has reached the sum of $1,560,000,000. Of this amount, $500,000,000 can be attributed to the introduction of sound pictures.

In contrast with such stupendous figures even for our present time, let us consider the early development of the railroads. The Baltimore and Ohio Railroad was organized on July 4, 1828, with a capitalization of $5,000,000. During the first fifty years of railroad development it is estimated that only $400,000,000 was expended on construction. Compare this modest sum with the estimated paid admissions of $500,000,000 to our movietheatres for the first four months of 1930!

In 1907, there were 5,000 theatres in the United States; at the beginning of 1930 there were 22,624, representing an average growth of about 740 theatres per year. This average has now decreased to about 500 new theatres annually. It should be noted, however, that the type and size of the new theatres are far superior to the earlier theatres. The total investment in the motion picture industry has increased year by year until today it is about $2,500,000,000 in the United States. In Europe, the total investment in this industry is estimated at $1,000,000,000.

Economic reasons for the growth of theatre chains are many. First, they have introduced better theatres, better management and better planned performances. Second, by representing diversified investments in various sections of a single city, as well as by states, they have provided greater stability and less risk to the investing public. By enabling the building of elaborate and beautiful theatres chains have done much to increase the public's theatre-mindedness. There are other important reason for this fast chain growth, and expectations for future growth. Huge sums have been invested by the producing companies in studios and equipment. This is particularly true with the advent of sound-recording apparatus. It is seen, therefore, that to protect the future outlet for their pic-

tures, an assured means of distribution under their personal control is necessary. The above reasons, as well as the competition for future production outlets, will be the guiding influence in chain expansion.

For the motion-picture engineer, these concentrations should create a greater demand for his service. The larger chain units will undoubtedly build up their own special research and technical staffs to handle the increased complexity of mechanical and electrical equipment. Such staffs are already in existence for several groups, as is well known.

Foreign Chain Controlled Theatres

"Of the 27,000 theatres in Europe, relatively few are under any chain control. However, there are some well organized units in a few of the principal countries. In Great Britain, Gaumont controls 300 theatres; Provincial Cinema controls 150; Associated British controls 110; and United Pictures 50. There are a great many other chains that control from six to twelve theatres; theatres so controlled represent, as a rule, the better class houses in key locations.

The principal theatre chains of France are: Pathe-Natan controlling 60 theatres; Aubert-Franco-Film controlling 40 and many smaller chains of 8 theatres or less. Of the German chains, U. F. A. controls 80 theatres throughout Germany, and Emelka controls about 50 theatres. In Italy, Pitaluga has a practical monopoly of the most outstanding theatres. In Australia, Hoyts Theatres, Ltd., and Union Theatres, Ltd., control 250 theatres.

It is worth noting that very recently we have seen American capital entering foreign theatre control with the acquisition of the Gaumont chain in England by William Fox, this control now being under the Clarke syndicate. Also, within the past two weeks we have seen a substantial interest acquired in the Kuchenmeister group in Germany by Warner Brothers. This group includes Sprekfilm of Amsterdam, Tobis of Berlin, Associated Sound Film Industries, Ltd. of London and Compagnie Francaise Tobis of Paris. The patents and license involved are those controlled by both the Kuchenmeister-Tobis and K l a n g f i l m groups. The latter companies occupy an important position in recording and reproduction of sound pictures in Germany and Switzerland as well as in other European countries. A direct interest in the patents and licenses of the companies

involved is thus obtained by Warner Brothers.

Foreign chains, up to the present, have been greatly handicapped due to the lack of capital. The European mind has not fully grasped the significance of building well-designed and attractively decorated theatres, as a means of creating a greater public desire for theatre recreations. Given an opportunity, American capital will introduce the most modern of houses and with better showmanship increase the theatre attendance and profit.

In continental Europe, there are serious problems still to be solved before such a step will be feasible. One is the sluggish attitude toward doing things differently from the way they have always been done, and secondly, the great fear of having this field taken out of their hands. This is understandable, but after all, the masses abroad would actually appreciate good entertainment as they do here. It would appear practical, that a few modern, well-managed theatres placed in key positions toward the modernization of the European theatre industry.

SOUND PICTURES AND FOREIGN MARKETS

The enormous increase in the average weekly attendance in American theatres following the introduction of sound has already been shown. The same is true, although to a lesser degree, for the theatres in Europe which have been equipped with sound apparatus. With theatres throughout the world wired for sound, there are important problems of language to be considered to produce the proper pictures for our foreign markets. American pictures are now shown in 70 countries with sub-titles translated into 37 foreign languages. Heretofore, the silent picture was universal in its appeal. The print destined for foreign countries needed only the translation of sub-titles in the native language. This, of course, is impossible with sound film, and therefore, new solutions have been advanced. A "double-shooting process" has been used to some extent, in which two separate groups of players are used with one story and the same group of settings. Another solution which has been used effectively in the case of sound on film, is to insert a section of film in the feature at certain intervals on which there has been recorded sound in the foreign language which describes the picture plot in the same way as a master of ceremonies is sometimes used. Another method has been to print the sub-titles on the picture at requisite intervals, and continuing to use the sound reproduction as recorded in English. All of these systems have certain drawbacks, and may be considered only as temporay expedients. However, where the particular foreign market warrants, the use of foreign players in the double-shooting process seems a way out for economical production to a limited extent.

Despite this apparent handicap of language, it is interesting to note that United States film exports increased 60,-000,000 linear feet in 1929 over 1928. The total American film production in 1929 was 282,000,000 feet of which about 8,-000,000 feet was negative film. This compares with approximately 1,000,000,000 feet of positive film produced in the United States in 1929. It can be seen

TOO LATE FOR JUNE

Archie Stout stands treat for his kid friend while relaxing at Santa Barbara.

that our foreign markets in the past have been important, and every effort will undoubtedly be made to continue them in the future.

It is estimated that 85 per cent of the motion pictures shown throughout the world at present are produced in the United States. Of the remaining 15 per cent Germany has 8 per cent of the showing, England and France about 2 per cent, while the remaining 3 per cent is accounted for by all other film-producing countries. It should be pointed out, however, that the popularity of sound dialogue films in other countries in which English is not the national language is already beginning to wane, while in Great Britain, Australia and New Zealand they are growing more popular. It is obvious that either these countries will have to be supplied with the proper type of silent films and a limited number of sound films, of the musical type, or else sound films in their respective national languages.

WIDE FILM DEVELOPMENTS

After two years of most hectic and revolutionary developments, the motion picture industry might well pause for breath, but this appears improbable. New technical developments that may be as far-reaching as the introduction of sound are crowding upon the scene, and producers must embrace them or be left behind in the race for supremacy. The major developments in the offing are: the growing use of color, and the introduction of wide film. My comments will be restricted to the introduction of wide film.

One of the first important economic problems should be settled at an early date—that is, a standard width for the new wide film, whether this film should be 70 mm., 65 mm. or 56 mm., will be left for the discussion of others. However, it is apparent that a standard width and other essential dimensions should be agreed on to preserve the great advantage of interchangeability of films. Our motion picture industry owes its success, in the past, to the universally-adopted 35 mm. film, which allowed pictures made in Hollywood to be shown throughout the world. It should be apparent that to require different projection heads and other equipment to handle widths of film, other than the present 35 mm. film and one standard wide film would not be practical. The introduction of the new

equipment in this country will probably be slow, and at the same time expensive. The same will be true for foreign installations, and unless a standard width is agreed upon, serious obstacles will arise in the future.

EDUCATIONAL SOUND FILMS

The evolution which has taken place from silent to sound pictures has opened new doors for the use of films as a means of education. Great opportunities lie ahead of the industry for intensive development in this field. Every high-school auditorium in this country should eventually be equipped with sound projectors.

In the past, the use of silent films for instruction purposes has had a limited application. The advent of successful sound pictures is as yet so new that producing companies have not had time to consider the development of this field. In fact, such companies have considered educational films outside the realm of their activities.

Up to the present at least, the high cost of sound recording equipment and the lack of subsidies from the states and federal educational departments have prevented a greater use of sound films for this purpose. Quantity production of educational films would lessen considerably the costs involved. Some means for equitably distributing such costs should be found. Why not seek the aid of the individual states and other responsible bodies for such a worthy cause? The universal adoption of sound films for educational purposes would make it possible to present the finest teachers of the country to many audiences. Perhaps the students of tomorrow will see and hear of the places on the geographical horizon which today are confined to the pages of a book.

The twentieth century has ushered in many outstanding scientific accomplishments, the airplane, the radio, the telephone and many others, but none have contributed more to the happiness of the human race than motion pictures. They have brought vision, romance, and laughter to make life more interesting. Today with sound pictures, even those millions throughout the world who cannot read will have the books of knowledge opened to their ears. Today the motion picture industry stands at the threshold of new adventures. The phychological aspects of the upheaval that has just transformed this great industry have not yet been fully realized. We can expect greater realism, greater stability, greater accomplishments, and greater prosperity for the future.

AN EYEMO ENTHUSIAST

Before Sergi Eisenstein, the Russian director of "Cruiser Potemkin" and "Ten Days That Shook the World," came to this country recently under contract with Paramount, he made a picture in Holland. For this work he used the Dutch cameraman Henk Alsem, who for a long time has been a keen enthusiast for the Bell & Howell Eyemo camera. It will be remembered that some time ago while in China in Fox news service, Alsem risked his life to save an American flag from desecration.

Chicago — Six-Sixty-Six — Chicago

DELEGATES REPORT

President Chas. David was the super-attraction at the last meeting of 666, of course at the usual place, the Palmer House. He gave the boys a word-trip on his experiences as a delegate to the I. A. T. S. E. convention held in Los Angeles. The boys said that his report was a good one although there was no one to check or double check on him as yours truly, delegate No. 2, had not returned to Chicago until after this meeting had been closed. It has been said that I was in no condition to return to Chicago, that I had been seen leaving a train for Excelsior Springs, etc. To tell the truth and also to let some of the boys know that even delegates must work, I must confess where I was after my departure from the convention. Some years ago someone dug a hole 200 miles long and 13 miles wide some where in Arizona and decided to call it the Grand Canyon.

There is a railroad that runs almost into this Grand Canyon called the Santa Fe. It seems that this said railroad wanted some movies made at the Grand Canyon and that is where I spent my time after the I. A. convention had adjourned. I hope this will disprove the Excelsior Springs report. Believe it or not.

SIX-SIXTY-SIX

659 AND 666

It was indeed a pleasure to spend several weeks with Brother Edward Kemp, of 659, traveling New Mexico and Arizona. Brother Kemp was hot on the job when we met and the first thing Kemp wanted to know was if my card was paid up. This was the first time that I had been asked by anyone to show my card, I wondered if I had left it at home, but I had it and after he saw 666 ALL PAID UP—everything was jake,

the usual brotherly love was expressed and we went to a nearby drug store and enjoyed something in steins. Boy, that is real brotherly love, hair tonic and everything!

SIX-SIXTY-SIX

HUNGRAY "DAWG"

After paying hotel bills, arranging baggage and then the business of waiting for a train I wondered where Brother Kemp was keeping himself. Shortly before said train started to chew-chew east, Kemp appeared at the depot very much depressed and in deep thought. I noticed a white bag in his hand and thought maybe Kemp is going to present me with "ham and" to use en route. Kemp asked me if I had seen a little hound running around and when I advised him that I had not, he then confessed the

(Continued on Page 41)

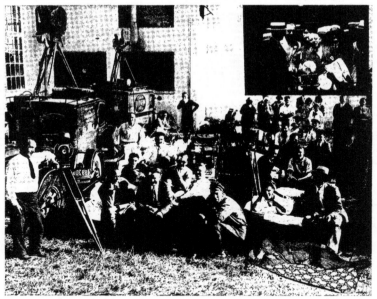

Talk about preparedness. The nations could get a few valuable tips from this group of news photographers in camp at Sky Harbor, Chicago, where they awaited the coming to earth of the Hunter Brothers at the termination of their endurance flight. It's a hard life.

The Daily Grind

By RALPH B. STAUB

MERRIT GERSTAD, visiting Lon Chaney's house tells this one:

Salesman (at the door): "Mrs. Chaney, can I sell you some tea?"

Mrs. Cheney: "Ceylon?"

Salesman: "Yes; I just passed him in the driveway."

* *

GEORGE STEVENS photographing a comedy wedding.

Preacher: "Do you take this woman for better or wurst?"

Comic: "Oh, liver alone, I never sausage nerve."

* *

BOB TOBEY after three bottles of Hollywood Special went to a talkie and after the show went around back to see the girls come out.

* *

FREDDIE DAWSON has just written a song dedicated to the osteopaths entitled: "This Is How I Kneed You."

* *

BILLY MARSHALL calls his assistant horse because he takes after his fodder.

* *

JOHN BOYLE (to assistant): "I'm sorry to say that we have lost one of our most valuable employees."

Assistant: "How come?"

John: "Because you're fired."

* *

MARCELLE GRAND (talking to best girl on phone): "Dear, would you like to have dinner with me tonight?"

Girl Friend: "I'd love to."

Marcelle: "Well, tell your ma I'll be over about seven."

* *

BOB PLANCK: "So your nickname is Gopher; where did you get a name like that?"

JEAN SMITH: "Well you see, when Ray June wants anything, I go fer it?"

* *

JACK ROSE: "Where is the wailing wall?"

HOWARD HURD: "It's a street in New York."

* *

GEORGE BARNES (leaving New York to come to Hollywood, at station): "How much for traveler's insurance to Hollywood?"

Agent: "It's a dollar twenty by way of Atlanta and New Orleans and two hundred and forty by way of Chicago."

* *

BERT LONGWORTH, ace stillman and right hand boy to Hubert Voight, director of publicity at First National, was the lucky and skilled party to win one of the silver loving cups given by Warners at their annual tournament. Believe it or not, but Bert never played a game of golf (its called flog in the pitch and putt courses) in his life and with a fifty handicap made the score of 72, winning in his class. Bert is one stillman who, I personally believe, has more ideas in that one little head than most of our so-called big idea men and if anyone doubts this remark, I challenge them, as Buddy Bert and I have worked to-

gether so long in this newsreel and publicity racket I should be one who knows. Even with his beautiful silver loving cup, I believe Bert will still drink out of a saucer.

* *

GALLOPIN' THRU HOLLYWOOD
ELMER fryer in a new car
I'M not allowed to
ADVERTISE any makes.
JOE walker getting
PACKED to leave for
LAKESIDE new york.
DITTO elmer dyer.
TONY gaudio at first
NATIONAL enjoying a
PLATE of macaroni
BETWEEN dialogue
REHEARSALS.
ART reeves talking
SHOP to RAY rannahan
RAY talking color
HE should know.
OTTO himm wearing
A new golf outfit
OTTO never plays
GOLF.
ALVIN wyckoff telling
THE boys a little
OF this and that
BUT it's always good
ADVICE when it comes
FROM alvin.
BILL fraker eating
A nice big
CHOCOLATE cream puff
BILL you're getting fat.
I THANK YOU.

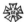

Hoke-um

By IRA

Answer That One

Friend Baker: "Junior, you're a naughty boy. You can go to bed without your supper."

Junior: "Well, pop, what about that medicine I have to take after meals?"

— :: —

Good Today Even

I remember this one from premicrophone days when dialogue and diction were just two words beginning with "D."

Edith Roberts: "Oh, sir, how can I ever repay you for your kindness to me in this hour of distress?"

Jim Farley: "Doesn't matter, sister; check, money order, or cash."

— :: —

Of Course

Willard Vander Veer, who photographed the Byrd Expedition at the south pole, says the thing that strikes him strangest upon his return to civilization is having to pay 15 cents for 25 pounds of ice.

— :: —

How About This Speed?

Speed Hall says the girl he took to the dance last week called him "mustard," because he was always on her "dogs."

— :: —

The Last Scotch Story

Maury Kains writes in to ask if we had heard about the Scotch gangster who took his victim for a walk.

— :: —

Fred Can Tell 'Em

Fred Kaifer says the *Literary Digest* published an article several weeks ago entitled "How to Fall Down." Fred wishes any *Digest* readers, who seek additional statistics on falling down, would see him at 105 Angelus Hospital. He has a lot of first hand information on the subject.

— :: —

Big Game Stuff

Joe Darrell: "Have any luck hunting lions in Africa?"

Dale Deverman: "Yes, I didn't meet one."

Building Note

First Extra Man: "I saw you groping in the land of inebriation last night."

Second Extra Man: "Buddy, you're all wrong. That was a gutter of fresh cement."

— :: —

There's a Difference

Plumber: "You say that when the studios open up again you will be working 16 hours a day? Why I wouldn't think of such a thing."

Cameraman: "I didn't. It was the movie producer who thought of it."

— :: —

Oversight

Art Reed: "A fellow wrote me a letter saying he'd shoot me if I didn't keep away from his wife. I'm terrified."

Al Gilks: "That's easy. Just keep away from her."

Art Reed: "You don't understand. The chump didn't sign his name."

— :: —

Affliction

Editor: "You have a lousy sense of humor!"

Me: "I wondered why I had the itch to write."

— :: —

Circumspice

Visitor: "I see a lot of 'Spud' cigarettes around the studio."

Property Man: "If you look close you'll also see a lot of 'Clowns'."

— :: —

Fatal Mistake

Art Reed (meeting old friend): "I thought you were directing at the 'Synk-Em' studios."

Director: "Not any more. You see, I called lunch one day promptly at noon."

— :: —

Pathological

Bob Bronner: "Where were you born?"

Bob MacLaren: "In a hospital."

Bob Bronner: "No kidding! What was the matter with you?"

— :: —

The Good Old Days

When a 400-foot roll was a full load.

[*Thirty-nine*]

The March of Progress

*Abstracts of Papers, Inventions and Book Reviews From the
Monthly Abstract Bulletin of Eastman Kodak
Research Laboratories.*

WIDE ANGLE WORK. *Brit. J. Phot.,.76:770*, Dec. 27, 1929.
Practical points in the making of wide angle photographs and
concerning the special characteristics of lenses and cameras
suitable for this type of work are discussed.

DURALUMIN FOR CAMERAS (CORRESPONDENCE). J. A. Sinclair
(Newman and Sinclair, Ltd., and J. A. Sinclair & Co., Ltd.).
Brit. J. Phot., 77:27, Jan. 10, 1930. The manufacturers of dura-
lumin, replying to the above, in connection with the discussion
on the corrosion of properties of *aluminum and duralumin, state
that the latter metal has proved very satisfactory in cameras
exposed to tropical moisture or sea air, while aluminum under
these conditions rapidly disintegrates.* A. B.

DURALUMIN FOR CAMERAS (CORRESPONDENCE). A. H. Hall.
Brit. J. Phot., 77:40 Jan. 17, 1930. Hall states that *aluminum*
of high quality manufactured-to specification as regards com-
position, *is less susceptible to corrosion than duralumin, when
exposed-to tropical conditions or to the effects of sea water.
Slight impurities, however, have a profound effect on the cor-
rosion resistance properties of aluminum.* A. B.

PROGRESS IN THE MOTION PICTURE INDUSTRY. (OCTOBER,
1929, REPORT OF THE PROGRESS COMMITTEE.) *J. Soc. Mot. Pict.
Eng.*, 14:222, February, 1930. This is a comprehensive classi-
fied compendium of advances in motion pictures and allied arts
for the preceding six months period. C. T.

HUMAN EQUATION IN SOUND PICTURE PRODUCTION. T. Ram-
saye. *J. Soc. Mot. Pict. Eng.*, 14:219 February, 1930. This is
another attack on the "hokum" of the sound technician. C. T.

ART AND SCIENCE IN SOUND FILM PRODUCTION. J. W. Coff-
man. *J. Soc. Mot. Pict. Eng.*, 14:172, February, 1930. Many
of the mysteries of technical expertness on the part of sound
men in the studios are branded by the author as superstition
and "hokum." Practical recommendations for better cooperation
among the technical studio staff are given. Authority should
center in this direction. C. T.

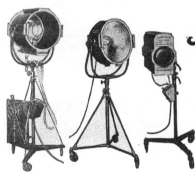

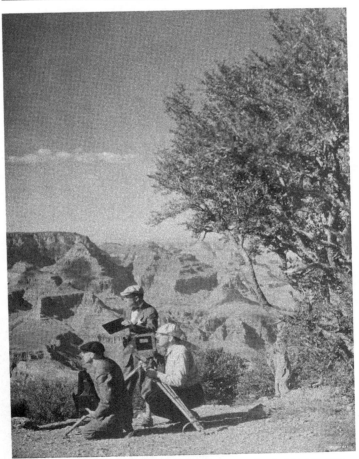

't to right, Edward A. Kemp, Local 659, Carl Birchfield, Advertising Department Santa Fe Railroad Co., Harry
Birch, Local 666, Chicago, photo by Kemp. This is not a picture of the Chicago skyline.

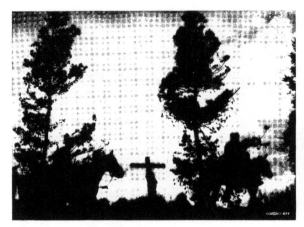

*In the Art
Section of the
June issue of the
INTERNATIONAL
PHOTOGRAPHER
this picture was
inadvertently
credited to Brother
Gaston Longet.
The artist is
Roman M. Freulich.
The editors regret
the over-sight.*

*Here we find the
parallel high on the
wind-swept rocks of
of Kern River, a
location often used
by the movies. The
prostrate gentleman
on top of the vibrating
wooden tower is no
other than Lauron
Draper, Local 659.*

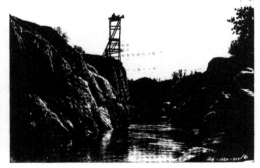

 # Cream o' th' Stills

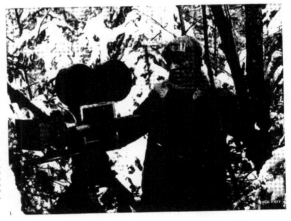

Virgil Miller brought this snow shot home from the wilds of Platsburg, New York. The original showed much more of the snow-laden forest around the cameraman, and the still suffers from the cutting.

Bert Lynch is responsible for this delightful still from "Dogway Melody." It might be labelled "Vacation Blues," or perhaps "We Won't Go Home 'Til Morning."

 # Cream o' th' Stills

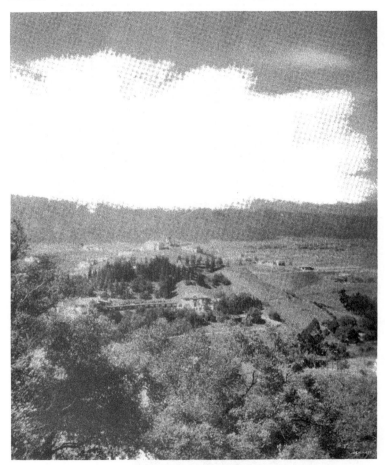

William H. Tuers snatched this charming shot from the bosom of Mother Nature one day during the last rainy season. The scene is from the Southern California landscape. Where is it?

CHICAGO—666—CHICAGO

(Continued from Page 36)

secret of the bag. Having seen a "dawg" that he said looked hungry he decided to get him something to eat. He did, bought two hamburgers on rolls and then the "dawg" was gone. I hope that Brother Kemp found use for the hamburgers "dawg" or no dawg."

SIX-SIXTY-SIX

ENDURANCE ENDURED

It seems that these endurance flyers are causing other endurance contests that we never read about. For instance, out at Sky Harbor, Illinois, a couple of young aviators decided to break the world's record for staying in the air. Well you have all read about them being in the air, but I don't think anyone has any idea of how the news cameramen have been "in the air" on the ground. The minute the 420 hours record had been passed all the news men started for Sky Harbor and were there for twenty-four hours each day "in the air" you should have heard them when they called in for clean shirts, smokes, bedding, etc. Sleeping right on the job, as they never knew when this "City of Chicago" was going to descend. Well it finally came down after breaking the world's record by 133 hours, making a total of 553 hours in the air for the aviators and 133 hours "in the air" for all news men. When that plane came down, it was a sight; cameramen with long beards, some in pajamas, some with half of their faces lathered, and all trying to get the first close-ups. Brother Norman Alley claims that had these flyers stayed up much longer he was going to buy a home near Sky Harbor and move his family out with him. He feared that being away so long, his family might mistake him for a stranger and fill him full of lead if he tried to enter their home.

SIX-SIXTY-SIX

NAMESAKES

During the covering of a story for Pathe News, Brother Tony Caputo was doing the

Motion Picture Industries Local 666, I. A. T. S. E. and M. P. M. O., of the United States and Canada

By HARRY BIRCH
President

CHARLES N. DAVID............................Chicago
Vice-Presidents

OSCAR AHBEChicago
HOWARD CRESSSt. Paul
HARRY YEAGER...............................St. Louis
W. W. REID...................................Kansas City
RALPH BIDDY..............................Indianapolis
J. T. FLANNAGAN...........................Cleveland
TRACY MATHEWSON..........................Atlanta
GUY H. ALLBRIGHT..............................Dallas
RALPH LEMBECK.............................Cincinnati

Treasurer

MARVIN SPOOR....................................Chicago
Secretary

NORMAN ALLEY...................................Chicago
Financial Secretary

WILLIAM AHBE....................................Chicago
Sergeant-at-Arms

HARRY BIRCH.......................................Chicago

Board of Executives

CHARLES N. DAVID	WILLIAM AHBE
OSCAR AHBE	HARRY BIRCH
MARVIN SPOOR	WILLIAM STRAFFORD
NORMAN ALLEY	EUGENE COUR

Offices

845 South Wabash Avenue, Chicago

BULLETIN — The regular meetings of Local 666 are held the first Monday in each month.

usual directing while looking through the ground-glass. Tony yells: "Hey, Rufus get away from that mike!" While Brother Rufus Pasquali obeyed orders, so did a distinguished looking gentleman that happened to be standing near the mike. Again Tony

was heard: "Hey, Rufus move that cable out!" This time Pasquali moved the cable, but the silk-hat gentleman wondering, happened to see the light of day, smiled and walked away. The "silk-hat" gentleman was none other than the Hon. Rufus Dawes.

SIX-SIXTY-SIX

IN FOCUS IN SPOTS

By Birch's Sassiety Reporter

Well we see that Harry Birch, who runs this page went and exposed us last month, so all your birds now know just what "eagle eye" is playing "housedick" on your monthly activities. This is just to notify all youse guys that Harry's making our identity public will absolutely have no effect on our past policy in this column. We will continue our past policy of fearless, truthful journalism. As for example if we see Norm Alley in a $11.00 suit we'll call it a $11.00 suit in our column and not: "Our secretary appeared on the scene in a gorgeous sport suit looking like he was ready to leave for the races, etc." If any of the

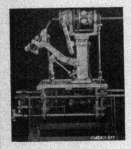

boys know of any activities around the district that are of interest to this department we will gladly accept them and guarantee immunity to the sender.

Chicago opened up the great big new Board of Trade the other day. In case you don't know it this is the joint where a flock of guys get together everyday and yell at each other so's your local baker can charge your ball and chain ten cents for a five cent loaf of bread because said ball and chain is too lazy to bake it herself. Well of course such an event has to go down in posterity so, of course, the usual celluloid historians were called in to get some of the ceremony with sound effects. Norm Alley trotted over with his three ring circus consisting of Eddie Morrison, Phil Gleason and Harry Neems. Harry Neems entertained as usual with his famous blues songs during lulls in scenes. Fred Giese got out on the floor during trading and everybody mistook him for the guy what owns the place. Giese is one of the style leaders of 666 now. It is rumored he is keeping himself broke keeping that razor edge crease in his trousers and keeping that great big panama hat looking like it just came off the boat from the tropics. Just wait Fred until you get mixed up in a hotel room somewhere where some guy decides he knows how to make ginger ale fizz when pouring it out of a bottle. Getting back to the Board of Trade incident Tony Caputo and Wallie Hotz were up on the shelf with their squawkie equipment. So was Red Felbinger and Wayman Robertson. Charlie Ford had a big crew of Daily News crankers out at different vantage points among whom was Jack Barnett wrestling a big heavy Eyemo. Urban Santone made his first public appearance hereabouts in a long time at this affair. Urban for one time was stumped, the noise in the room was so heavy it dinned his usual loud voice and nobody heard him.

Orlando Lippert, of 644, who is summering in this town was discovered on South Wabash avenue the other night all dressed up in a cute white little "Lord Fauntleroy" suit. Lippert stammered to us when we caught him in the get up that he was on his way to a dress ball and represented a Prince Charming or sumpin' of that nature. Well we figger that about all that was missing in the outfit was a hoop and a sailor hat. He looked to darling for anything and this department would give five bucks for a still to furnish the "Page" showing little "Boy Blue" all ready for the ball. Luckily we have no curfew in this village or Lippert certainly would have been sent home to his mamma, pronto.

Norm Alley threatened to take the newsreel gulf championship away from Wayman Robertson a few weeks ago. Alley fortified himself for his so-called slaughter of the champion on the links by inviting Jimmie Pergola along. Pergola spends his winters in Florida as a divot digger down there and Alley figgered this would get Robertson's idea off the game. Well Robertson is a true Scotchman (ask Red, he knows) and went through in style. It seems Alley, after the match started, got awfully interested in killing snakes on every fairway. On the sixteenth hole Pergola got interested in picking up catnip out of the creek. Caddy fees were to be paid by the one making the highest score on the last hole. Robertson who played religiously throughout the match got a little excited then, being Scotch, you know, and got rattled enough to have to open up his pocketbook and lay out for the round. Alley furnished the oil can to Rob to oil hinges on his purse so's he could open it.

Speaking of golf, the town is full of miniature courses now and the other night we met Urban Santone on one of them up north. Well the dago started to brag he's gotten so interested in his new pastime that he can make every hole in one. He tried us out with a great big earful on how good he is that we would like some hombre to get up and take him down in "baby golf."

It is rumored that Eddie Harrison and Phil Gleason have gained the lasting friendship of the manager of the Maryland Hotel by acting as masters-of-ceremony at a recent bachelor dinner given at the above mentioned boarding house.

Bob Duggan just returned to town with a heavy coat of tan (from first impressions). Said coat of tan turned out to be nothing more than a lot of old fashioned coal dust which was removed a little later with an ordinary bar of Fels-Naptha. Bob put in a week in some coal mine filming the low down on why the furnace keeps us broke in the winter time. Bob says he spent his evenings while on this job trying to polish the rings out of the bathtub after trying to clean up after the day's grind.

We saw Ralph Lembeck, the "famous sheriff from the sticks," down in Cincinnati not so long ago. Ralph kindly reminded us that we forgot to mention that he was sporting an entire brand new set of molars. Ralph finally has mastered them and can again laugh out loud without having 'em drop out. You're welcome Ralph for this publicity. You asked for it yourself, you know.

This department is pleased to give its readers first authentic account of the recent I. A. convention at Los Angeles and covering full activities of 666 delegates. Just one of our many hot scoops at no extra cost to our admirers. Here it is:

California Limited pulled into Los Angeles early Wednesday morning and Charlie David and Harry Birch immediately proceeded to hotel with a motorcycle escort clearing way so as there'd be no delay in starting first day's session. Session began immediately as soon as force of fifteen bellhops was recruited to trot ginger ale and ice up to the room. As there was much business to do, the first day session lasted well into the wee small hours.

Thursday morning recess was immediately declared after session started so young army of maids could straighten out headquarters. Maids were little slow so convention convened several hours later at Mexicali, Mexico. Much was done away down here also. Outstanding highlight day's program was colorful speech by Delegate Birch, which he emphasized by using the hotel furniture to attract attention, other delegates participating. Three broken chairs. Later, meeting adjourned on recommendation detective and reconvened next morning, Friday, at Tia Juana, Mexico. Delegate Birch called meeting to order whereas police helmet to establish order. Delegate Birch apologized for missing star which officer refused to part with. Delegate David proposed a good-will tour though leading spots in Tia Juana and delegation proceeded with Birch, unofficial ambassador, good-will to all leading strangers encountered in leading spots. Next day at Agua Caliente, delegates took up important task investigating gambling conditions. Decided lottery didn't pay to be passed up by I. A. Checked on dice, voted O.K. by delegates from Chicago who conducted this investigation with pair dice furnished them by Pete Fish, Chicago, before entraining. Delegation here entrained to catch much needed rest en route to Hollywood sessions.

Sunday night Chicago delegates reach Hollywood. Delegate Birch's missus there to greet Harry with bells on. Birch went to quarters immediately to get much needed rest. Monday the big session in the amphitheater of the Brown Derby. Delegate David put on all his efforts in conscientiously building up the reputation of the lasting stamina of the spirit of 666 and collapsed after the session. Revived early next morning with ice-packs and bismuth and pepsin. It's all over now and Delegate David is back in town resting a week before making his report to the brothers. Delegate Birch has not arrived as yet. It is rumored he was seen detraining at Excelsior Springs, Missouri, for several days to assort his notes on business transacted. David was met at train on arrival in the Windy City by large reception committee of bill collectors and Secretary Alley. Alley dropped over on telegraphed request of our worthy President and brought the bag of cloves and package of Sen-Sen as requested. The boys sure owe the worthy delegates their lasting thanks for the vigorous way in which they attacked the above hard problems which confronted them.

Starting next month on the "Page," greatest mystery story ever published, by our two co-authors, Harry Birch and Charley David, entitled: "What Happened to the Thousand Dollars."

One Man's Opinion

By Pierre Mols

During the last year colored motion pictures have come to the foreground very rapidly and seem to have made a favorable impression on the public.

The introduction of color into motion pictures has been under severe criticism, especially among the people directly connected with the industry. This is a phase of any new project.

Color as seen on the screen today has by no means attained perfection. However it took many years for black and white motion picture photography to achieve its present status, nor has it yet attained perfection.

The mechanical difficulties encountered in colored motion picture photography are so many more compared with those in black and white photography that the present result, accomplished by the "two-color processes," is quite remarkable.

A reproduction on the screen in black and white of intense dramatic action is far from being true to life. A reproduction in black and white of a beautiful painting is not true. Both are impressive and emotional, which qualifies them as works of art; but color intensifies the composition of the masses and lines and the thought-expression, because it gives to the final result the brilliant vibration of the color of nature, which is full of color. Herein lies the value of color.

In black and white we can create beautiful compositions and enhance the emotion and thought of dramatic situations by proper lighting. Through the addition of color, which gives us all the hues and shades of a beautiful setting, our emotions are stirred to a much higher pitch. Every person is emotionally affected by color. By applying the proper color harmonies to dramatic or comedy settings the spectator will be consciously or unconsciously emotionally stirred by the color vibrations, adding considerably to the thought and feeling of the action.

A great mistake, in my opinion, has been made with regard to the application of color to motion pictures, which also occurred with the introduction of sound. The art of pantomime, which is the art of motion pictures, suffered a great deal when sound was first introduced. Pantomime and action were sacrificed for dialogue, but gradually we are getting back to the point, where sound is used to intensify action and pantomime, instead of the reverse. The same occured with the introduction of color. The use of it has been badly abused by the producer. The proper application of color harmony has hardly ever been taken into consideration, except in a very few instances. May I state, for instance, parts of "The Rhapsody in Blue," in Paul Whiteman's "King of Jazz." Every spectator was impressed by the beauty of these scenes. This height of beauty could never have been reached by black and white photography, due to the lack of color vibration to each individual.

The color in most color pictures has been unnatural in contrast, mainly caused by improper application of color in the settings. For instance, brilliant shades of red have been used extensively in sets and costumes. People seem to be under
(Continued to Column 3)

"Hot Points"

Conducted by Maurice Kains

During the past few months there have been several instances of cameramen shooting scenes badly out of focus simply because the ground glass had been replaced backwards in the camera after cleaning it. While it seems almost impossible that such mistakes could occur, the fact remains that they did occur and can occur again, especially where there are so many cases of cameramen and equipment being switched around from place to place.

Calibrated lenses are somewhat of a protection against this error, but very often a cameraman using an outfit for the first time doesn't wish to take any chances on lens markings, and protects himself by focusing entirely by eye. He is wise, for he knows how much equipment is shifted around these days.

· FIG · 1 ·

To help the cameraman protect himself and to reduce future chances of a repetition of this serious mistake, I offer an original idea for consideration. I have tried it out and find it practical. Remove the ground glass and hold it so that the ground surface is uppermost and the sound track to the right. Now en-

· FIG · 2 ·

grave, etch or scratch a tiny letter "R" backwards (as in Figure No. 1) on the ground surface; fill the letter in with black grease pencil and wipe off surplus grease. Now replace ground glass in its proper position in the camera. When looking through the camera the letter "R" will now be right side up and no longer backwards (see Figure No. 2). The "R" stands for "right." If the ground glass is replaced incorrectly, the letter "R" would immediately catch the eye of the cameraman, as it would be in the lower part of the aperture and would be upside down instead of right side up in the upper part of the aperture.

In some studios the sound track is often shaded heavily with the inside matt, so it will be advisable to have the letter etched so close to the Movietone line as possible so that it can be seen through the shading.

The Vitaphone aperture can be handled in exactly the same manner.

Two Color Aids

Two distinct aids to cinematographers are available to those desiring to take up the creating of color pictures.

Every cameraman that possesses a Mitchell or Bell & Howell camera can make his own color separation negatives. Use an intermediate magazine such as is generally utilized in the making of trick pictures so that two separate rolls of film may be passed through the camera and taken up in separate spools. Any of the camera makers will supply intermediate magazines.

A Red-Ortho negative which is insensitive to red light and which carries a filter color on the emulsion surface, is placed in contact, emulsion to emulsion with a panchromatic film strip. In that condition, at the aperture gate, the light through the lens impresses on the front film all but the red portion of light that strikes it. The light then continuing through the front film has the green-blue portion of the light absorbed by the red filter, while the red portions pass on to the panchromatic negative and make a record of the red portion of the colors on the back film. It is well to have as good contact at this point as can be obtained. Two pictures are made at once exactly alike excepting for differences in color values.

The Red-Ortho negative film has a surface coloring that is not easily removed. For those who wish to get rid of the coloring it may be done by placing the film either wet or dry, into a water bath containing three per cent hydrosulphite of soda. This material is a bleaching substance sold to laundries for taking stains out of your clothes. Formerly only used by laundries, it is now being used in keg lots in most of the film laboratories on the west coast.

If prints are to be made on double sided stock, that is a base with an emulsion on each side, a positive print is made on one side from the pan negative and toned blue as with iron while on the opposite side a print from the red-ortho negative is made and toned red as with uranium. A natural color print will result.

Somewhat the same procedure may be followed with the newly announced "sandwich" film, a positive stock having two emulsions on one side separated with a layer containing a non-actinic substance. It may be printed from each side and gives two completely separated images which do not blend into one another and can be treated separately.

ONE MAN'S OPINION
(Concluded from Column 1)

the impression that the color processes emphasize the brilliancy of the colors in the setting. However this is not true. With conditions as they are at present, the colors are being actually subdued in the laboratory process, to try to attain natural color values.

Why not use the more subdued and neutralized colors to better advantage? The effect will be more pleasing to the eye and truer to nature and the public will receive colored pictures with yet more enthusiasm.

Get the Picture

Photography Is Important Among the Widely Diversified Railroad Occupations

(Contributed by LOYAL HIMES from a story in the Southern Pacific Bulletin)

The average passenger, traveling on the railroad, or the shipper or receiver of freight, would probably be greatly surprised to learn of the many branches of modern industry and science in which the railroad has to participate in order to render the satisfactory transportation which he accepts as a matter of course.

To most people, giving the matter little or no thought, the operation of trains is the only concern of railroad officials. While the operation of trains, with consequent transportation of passengers and merchandise, is the ultimate object of a railroad, to successfully accomplish this end, the services of a multitude of widely divergent professions must be called into use.

Should the population of an up-to-date city be almost entirely decimated through pestilence or other cause, it would be possible, from the ranks of a fully organized modern railroad, to supply members of practically all the trades, professions and crafts necessary to again put the city on a smoothly running basis, with all the comforts and conveniences to which it was accustomed.

One of the arts which occupies a prominent place in railroading today is photography. There is hardly a department that does not have frequent need for photographs, and, to meet this need, Southern Pacific maintains two complete photographic plants, equalling if not exceeding, in size and equipment, the largest and best commercial photographic studios.

The main laboratory occupies an entire floor of the general office annex in San Francisco, where the duplicating bureau is located. This bureau is under the management of E. W. Irwin, who also has supervision of the photographic work. There are two commodious and well arranged dark rooms, a room for printing and another for the making of enlargements, as well as a large room in which are located the photostat machines, of which there are three, copying cameras and other equipment used in finishing. There is, in addition, a complete motion picture laboratory, operated by Loyal Himes, head photographer. (Member of Local 659).

There is a dark room, a drying and assembling or cutting room, and a small auditorium, seating about a hundred persons, for the projection of the finished pictures. This room is also utilized as a studio for the taking of portraits.

A branch of the duplicating bureau is maintained in Los Angeles, under the direction of George Brown, in which a smaller but complete photographic plant is operated. There are ten employees in the San Francisco photographic department, five photographers and five photostat operators. The Los Angeles laboratory is manned by one photographer and

The photostat machines are important items of equipment in the photograph department. They are used for copying documents, maps, drawings and similar items, and are in almost constant use every day. Jessie Kurtz and Leo Poyry are two operators in the San Francisco bureau.

one photostat operator. In addition to this, at headquarters of each one of the company's twelve divisions, a large camera is kept on hand for use in emergencies where it is not possible to send a photographer from headquarters in time, or where the work is of such a character it can be handled by a member of the local office.

News Cameramen

The bureau of news, which has offices at San Francisco and Los Angeles, and which is independent of the duplicating bureau, also has photographers at both points who make pictures of news events in railroad circles and general publicity pictures.

From the foregoing, it will be seen that photography occupies a prominent place in the modern railroad.

The motion picture cameras, of which the company has two, are used to make records of important events in the railroad's history, such as the completion of a new line, etc. Travelogue films are also made of scenes of interest along the company's lines, and these are loaned, rent free, to various societies, clubs, etc., for exhibition, furnishing at one and the same time entertainment for the audience and advertising publicity for the company.

The enlarged pictures seen on the walls and displayed in the windows of city ticket offices and off-line agencies are all made by the company's photographers. The largest enlargement turned out in the laboratory so far was 7½ feet by 12 feet.

There is no branch of the photographic art that the photographers are not called upon to do from time to time. Landscapes, portraits, groups, copies of pictures, old and new, enlargements, lantern slides, motion pictures and speed photography, all come within the scope of the department's activities.

The photostat machines are large cameras equipped with prisms, which are used for making copies of all kinds of documents. Should there be question as to payment of a bill, a photostat copy of the cancelled check is made as evidence. Sometimes rare old books which cannot be purchased are borrowed and copied in their entirety. The principal difference between a photostat machine and a regular camera is that, instead of film or glass plates, sensitized paper is used in the photostat.

Most of us amateur photographers are more or less uncertain of the outcome after we have pressed the button. We take our films to the finisher and, when the prints are delivered to us, look them over dubiously and make some sage remark about having to get a "stronger lens." Of course, there is no such thing as a "weak" lens or a "strong" lens, but the amateur apparently thinks there is, and upon the faults of his equipment he is prone to lay the blame for blank films, double exposures, pictures out of focus and negatives badly under-exposed.

Sure Shots

We have a feeling, bordering on reverence, for the professional photographer who gets the picture every time.

However, the professional has only one advantage over us. He is taking pictures all the time and, out of his constant experience and study, is more apt to "bring home the bacon" than the occasional worker. But he has his troubles at that, and the pain growing worse, so called rainstorm, or any other uncertain light condition, makes as much of a problem for him as it does for us. And the railroad photographers do not work only when the sun is shining.

If an order comes in for a picture, it has to be made at the time wanted, no matter what the weather. There are many events which must be photographed when they occur, or not at all, and the conditions under which they are made are of secondary consideration. Rain, snow, darkness, wind, dust; all must be overcome when the order goes out to "get the picture."

So, in the duplicating bureau, the words "Get the picture" have come to be a slogan. It is much easier to be able to show a picture than to think up excuses for failure to get it, and, as a great deal of their work is done under most adverse conditions, and at times hundreds of miles from home, the determination to get a good picture at any cost is so grimly imbedded in each man's mind that, at times, the endeavor to "deliver the goods" has brought about some unusual experiences.

OVERCOME OBSTACLES

Recently, one of the photographers was making pictures of ski jumpers in the Sierra Nevadas. There was about four feet of light snow on the ground and, as he walked, he sank into the snow up to his waist. Heavy clouds covered the sky, and, to make matters worse, about the time the program began it began to snow again. But he had made an all-night trip just for those pictures and was not to be daunted, so, struggling through snow to his hips, he got the scene, fought the adverse light conditions, and "got the picture."

On another occasion, one of the boys was sent to make pictures of one of the limited trains at a certain point. Minimum delay to the train was essential, it being desired not to hold it over a minute. Accordingly, he selected three locations beforehand and set the camera up at the first one, on a slight rise of five or six feet. The moment the train stopped, the first picture was made. Then the photographer started down the incline to the second location, when he lost his balance and, with the camera, went rolling down the slope. He jumped to his feet, intent on not delaying the train, got the other pictures, released the train, and then noted for the first time a pain in his side. The next day the doctor found that in his fall he had broken two ribs, and for the next few weeks he went about in a cast. But the train was not delayed, and again, he "got the picture."

At one time, one of the men made a trip of several hundred miles to take some scenic views. At the end of the trip several people were secured to pose in the pictures, and the entire party started on horseback into the mountains, half a day's ride. About two hours out, the photographer's horse unexpectedly shied, tossing the rider and his camera

(Concluded on Page 46)

HYMENEAL

If all the good wishes for happiness and prosperity that the members of Local 659 are sending to Mr. and Mrs. Edward O. Blackburn should be realized their lives will be made up of nothing but golden days.

Our friend Blackburn, whom his many friends had come to look upon as a confirmed bachelor, just recently stole away like "the Arabs" and brought back home

MRS. EDWARD O. BLACKBURN

to Beverly Hills as lovely a bride as ever stood at the altar, in the person of Miss Rebecca Ackerman Hall, daughter of Mr. and Mrs. Frederic Hall of Porterville, California.

A honeymoon in the High Sierras followed the wedding at Porterville and the newlyweds are now at home in Beverly Hills, 614 North Elm Drive.

The former Miss Hall is a woman of exceeding charm, of brilliant intellect and of many graces and accomplishments, while Mr. Blackburn needs no recommendation or introduction to the social and business world in which he occupies a postion of prominence and popularity.

THE INTERNATIONAL PHOTOGRAPHER extends to Mr. and Mrs. Blackburn its congratulations and sincerest wishes for a long and happy life.

"WHAT DREAMS MAY COME!"

THE ABOVE "WHAT HAVE YOU" WAS
A DREAM HAD BY "PEG" LYONS AS
TOLD TO FRED ELDREDGE, ON
THE DOLLYING, LOOSEHEAD
PICTURE "PLAY BOY" AT W.O.

GET THE PICTURE

(Continued from Page 45)

to the ground. The only harm the rider suffered was to his dignity, but the ground glass in his camera was hopelessly shattered. Remounting his horse and starting on, his great worry was how he could possibly get any pictures without a glass to focus on. The trip was made at considerable expense, horses and models had been hired, and to return empty-handed was unthinkable. He was about to give up in despair when a halt was called for lunch. As he ate his lunch, his mind still on his problem, he observed that the sandwiches were wrapped in oiled paper, which gave him an inspiration. He smoothed out one of the papers, pinned it into the ground glass frame, and a trial showed him that he could see a faint image on it. For the rest of the day he worked with this improvised screen and, when the pictures were developed a thousand miles from where they were taken, they showed that apparent disaster had been turned into success and that again he had "got the picture."

When President-elect Hoover was en route to Palo Alto for the notification ceremony, he was guarded on all sides by secret service operatives. On instructions, one of our photographers went to get a picture of Mr. Hoover and the Sunset Limited. A struggling mob surrounded the train, but he managed to get to the front of the crowd. It was night, and he held in his hand a flash lamp. The secret service men, seeing the stir as the photographer wormed through the crowd, and observing the flash lamp and camera, immediately suspected bombs or worse, and started into action—the investigation to be made later. In the midst of the struggle, the flash lamp went off, scaring everybody half to death, including the photographer. Peace was finally restored, after credentials had been shown and explanations made. Another "shot" was made, and the result of the effort was the cover picture of the March, 1929, *Bulletin*. Again, he had "got the picture."

These are but a few instances of what the men are sometimes up against on location. They could be recounted indefinitely. Such things as jammed shutters, broken tripod legs and like accidents which would send the average man home in hopeless despair are simply regarded as annoying incidents to be overcome in whatever way the ingenuity of the operator suggests.

The personnel of the San Francisco photograph department is Loyal Himes, head photographer; Stanley Besozzi, Steve Edwards, Homer Fish, Andrew Patrician, Al Rommel, Charlie Thomas, Leo Poyry and Jessie Kurtz. At Los Angeles, Paul Talbot is the photographer, and Jack Herold the photostat operator.

CLEARING HOUSE FOR CAMERAMEN

Art Reeves and Cliff Thomas announce the opening of the Hollywood Camera Exchange at 1511 Cahuenga. There has been a long felt need of one central place where cameramen could dispose of their extra equipment. It would take unlimited capital to buy all the cameras and equipment in Hollywood and so the boys will take in on consignment any cameras or equipment for sale and display at prices agreeable to the owner. Nearly every cameraman has valuable equipment, laying around that he could turn into cash before it becomes obsolete.

The boys will carry a full line of kodak films and supplies and have made arrangements with Bell & Howell to carry their line of 16 mm. cameras and projectors. They also will have a projection room for 16 mm. and 35 mm. portable projectors.

The rentals of Mitchell cameras and Bell & Howell cameras and motors will be a distinct service to cameramen. There are many cameramen who have cameras for rent that are too busy to look after the rentals of their equipment. Cameramen who have equipment for rent can place it here and it will get the utmost attention because they are making a specialty of renting. The store in which they are located is where Roy Davidge started and has a large film vault in which to keep the camera equipment.

A dark room for loading purposes will be available and every possible accommodation will be provided for patrons. This enterprise of Brothers Reeves and Thomas will fill a long felt want. They are well known and popular and should build up a successful business. Local 659 bespeaks for them an unlimited prosperity.

JUDGE LESTER E. HARDY

Members of Local 659 and affiliated Locals are asked to consider the claims of Judge Lester E. Hardy, candidate for re-election to the office of Justice of the Peace of Venice Township, an old and tried friend of Labor and an officer of unusual talent and of excellent character.

Lester E. Hardy came to Los Angeles in 1905. He was admitted to the bar in July, 1912; elected Justice of the Peace of Venice Township, November, 1926; took office Janary, 1927. Appointed to the Los Angeles Municipal Court by order of Judicial Counsel February, 1927, and served until December, 1928, at which time he resumed the private practice of law. Judge Hardy was the first Justice of the Peace appointed to a municipal court in the State of California. He is a member of Masonic bodies, the Elks, Foresters, California State Bar Association, Los Angeles Local Bar Association and Santa Monica District Bar Association.

TRIPOD TO MEGAPHONE

The recent calling of Daniel B. Clark and George Stevens from the camera to the directorial chair by the heads of their respective studios, the Fox Corporation and the Hal Roach Studios, is evidence that official eyes are not blind to the rich material that is available back of the tripod.

DANIEL B. CLARK

Mr. Clark is a distinguished member of the camera fraternity. For two terms he was president of the American Society of Cinematographers and he has always been high in the councils of that organization.

For years he was one of the camera aces of the Fox Company and during that time he photographed sixty-four Tom Mix features. It is not too much to say that his pictures were an important factor in the great success of that corporation.

George Stevens was too full of production ideas to remain longer in the photographic department at the Hal Roach Studios. He will write his name high as a director.

Both these men are young in years, but old in experience and there is no good reason why thirty years from now they should not be turning out greater masterpieces than they ever dreamed of making in the past or now.

GEORGE STEVENS

The members of Local 659 enthusiastically acclaim and congratulate Messrs. Clark and Stevens and they also congratulate the far-seeing producers who called them to the directorate.

WHAT SAY YOU?

All members of Local 659 should rent all their camera equipment from their brother members in preference to nonmembers, according to my point of view. Why not be a 100 per cent member. I thank you. A MEMBER.

Fred Campbell, chief of the camera department of Pathe Studios, is spending his vacation in Havana with Eddie Snyder, who is down there shooting "Her Man," starring Marjorie Rambeau.

HOME FROM THE ORIENT

Billy Adams is back from the Orient after an absence of three months with the Harry Garson unit of the Universal Film Corporation. Bill was taken sick shortly after his departure from Hollywood and had to be taken by Len Galezio, who left for Singapore on the day Adams departed for home.

Up to the time he left the unit very little shooting had been done, the energies of the expedition being devoted to building a satisfactory laboratory in Singapore.

The jungle is only fifty miles from the city so that the company will suffer but little hardship in getting the wild stuff they are looking for.

Mr. Adams reports all other members of the expedition in good health when he left.

UNFINISHED BUSINESS

Gaetano Gaudio, supervisor of cinematography for Caddo, has returned from Italy where he sojourned for three months following the completion of his great work on "Hell's Angels." He was too busy to talk about his trip in time for this issue, but promises to tell an interesting story in our September issue.

Charles Rosher and wife are at home again in their beautiful chateau, on the famous Uplifters' Rancho, after a year's sojourn in England, where Mr. Rosher has just completed a contract at Elstree. In a future issue of THE INTERNATIONAL PHOTOGRAPHER Mr. Rosher will tell of production and labor conditions in the English studios.

CHARLES H. KELLY

Charles H. Kelly, chief of police of Pasadena, who is running for the office of sheriff of Los Angeles County, came up from the ranks. Starting as a patrolman on the police force of St. Joseph, Missouri, he worked his way up to the office of chief. That was over twenty years ago.

Since coming to California and particularly during the last ten years he has carried on his shoulders the great responsibility of handling tremendous crowds attending the annual Pasadena Tournament of Roses and the East vs. West Football classic. His efficiency in the direction of traffic and the protection given to the thousands of visitors and automobiles speaks volumes for his executive ability.

This is only one of many reasons why Charles H. Kelly is the logical candidate for sheriff, according to Frank Lawrence, well known film editor, who is acting as district manager for Hollywood and the film industry in association with Judge Lester E. Hardy, treasurer of Kelly's campaign.

Out of Focus

GREATEST KICK OF ALL

By PERRY EVANS, Local 659

In these modern times with airplanes common as row-boats and when every other man's grandma boasts of having experienced the thrill of an airplane ride, it seems this generation has become more or less callous or immune to sensation. But for the benefit of the dissatisfied customers who think it is all a game of ping pong and before they resort to the extreme of indoor sport in search of a kick such as, a shot in the arm, hitting the pipe, joining the ancient order of snow-birds or playing bridge might I suggest a dish that may contain the desired effect.

Climb into a plane about midnight and all by yourself take off into the darkness. If this doesn't prove spicy enough we will add a good old fashioned sleet storm mingled with plenty of snow, a seventy-five mile an hour side wind to toss your ship around causing the compass to spin thereby giving you incorrect reading. Watch that library of instruments close and keep one eye glued on that bank and turn indicator. This pet puts you wise to a couple of suicidal tendencies, such as steering straight and staying right side up. Believe me, those are two things that "every young flier should know." Then just to thicken the soup we will have a cranky old motor and a load of ice on the wings big enough to keep Red Grange busy all summer.

After several hours of this you set her down at your destination, taxi into the hangar and as you wiggle out of the cock-pit unbuckling the harness, sidearms and what-not some one comes running up shouting: "Say, boy, how did you ever make it?" And if your face isn't frozen stiff you try to smile, answering him in the terms of an old seasoned mail-pilot: "The night being damp and cheerless I retired to my library for a little quiet reading."

Let your poets rave as they please about the infinite beauties of nature. The flash of a beacon is the grandest sight in the world to a pilot lost in the night.

THANK YOU MATES

After the hand I received from the Brothers upon being nominated for treasurer at the last general meeting it is very plain to me that I will have to do some first class treasuring for the next two years.

I will try to have bigger and better stamps for the Brothers. Also stamps that will last longer. No fooling. Wait and see.

To be serious (if possible) I want to thank every one that was at the meeting and promise you I will try my best to carry on the work the way you want me to. Cut.

HOW TO WRITE A SCENARIO WITH TWO CHINS

By PROFESSOR NIL

(That Evident Author)

Professor Nil was just coming out of the Hollywood police station. He said he had just applied for his driver's license and when he was able to recognize me he said: "When do we eat?"

I realized that I was stuck for two bits, so after a porterhouse steak and a good cigar we went up to the Recreation Room for a rest. The room was full of boys looking for work so we jumped out the window as a big touring car a mile long drew up to the curb.

The chauffeur said: "Are you Pro. Nil," and the Pro. started to run. I grabbed his arm and told him to wait a minute. The driver said that he was to take the Pro. to the Biltmore to meet Mr. Guzzle.

This sobered the professor up and he called me to one side and said: "I have a chance to pick up a few dollars; will you come with me?"

Well, I was thirsty and was in a condition to appreciate it so I said I would go.

We arrived at the hotel and met Mr. Guzzle. The Pro. said: "This is my cameraman, show him your viewing glass."

Then we went over in a corner and the Professor explained his idea to Mr. Guzzle.

"We must have an original story," said the Pro., so we will go to a two handed book store and buy the oldest magazine that we can buy. That way we are sure to get an original story. It's a cinch," said the Pro. "The main thing is the plot."

So after lifting a few we went out and got a magazine dated 1857.

After we went back to the hotel the Pro. looked through the book and brightened up as he said, here's just the thing. It's all about a boy and a girl and is called: "When Jeremiah Comes."

We'll change the title to, "Jerry Makes Merry!"

In the original, the boy loves the girl and has to go to the city to look for a job of work. While the boy is gone the mortgage drives up with a mustache and a pair of boots.

We'll change that to the payment is due on the car. Let the man keep the mustache and boots and we'll add a riding crop which can be used in the big fight scene.

In the original the heavy leers at the girl. In our story we will cut to insert of girl's beautiful legs.

In the original the boy is going from saloon to saloon looking for work. We will show him in the park reading the want ads. Chance for some beautiful shots here.

Now in this story the girl's father

gets his whiskers caught in the cream separator, but in our story we will have him lose his balance at the bank and fall for his stenographer.

In the original the boy looked all over the city for two days and could find no work so figured he would go home and rest. He gets there just in time to sock the heavy on the chin and tear up the mortgage. But we will change that a little. We will have the boy come home and take his girl over to live with his father, who has married the stenographer, and she now has a steady job.

In both cases they kiss and call it a day.

Now all I need said the Pro. is a couple of hundred dollars to rent an office and I can start casting, and he pulled out his pencil and started to figure.

Mr. Guzzle motioned for me to follow him and we went outside. He said to me: "Did you hear that?"

I said: "Yes."

He said: "Are you a cameraman?"

I said "No, I'm a mortgage; tear me up."

There is no *substitute* for

EASTMAN
Panchromatic Negative

There is no *equivalent* for

EASTMAN
Panchromatic Negative

J. E. BRULATOUR, Inc.

NEW YORK　　　　　CHICAGO　　　　　HOLLYWOOD

MITCHELL WIDE FILM CAMERAS were used in shooting the following pictures:

BILLIE THE KID—*Metro Goldwyn Mayer*
THE FOX FOLLIES—*Fox*
HAPPY DAYS—*Fox*
THE OLD TRAIL—*Fox*
SONG O' MY HEART—*Fox*
Others Preparing.

The MITCHELL WIDE FILM CAMERA was selected by the producers of these pictures as it is a camera of proven quality.

Prompt delivery can be made of 70 MM Cameras.

If a standard for wide film of less than 70 MM is established within one year from July 1st, 1930, we will make the changes required on our 70 MM camera to meet such standard, if desired, for purchasers of our regular 70 MM camera, purchased within that time, free of any charges.

If any size, other than 70 MM, is desired, we can furnish cameras on short notice.

Mitchell Camera Corporation

665 North Robertson Blvd. West Hollywood, Calif.

Cable Address "MITCAMCO" Phone OXford 1051

INTERNATIONAL PHOTOGRAPHER

HOLLYWOOD

25c

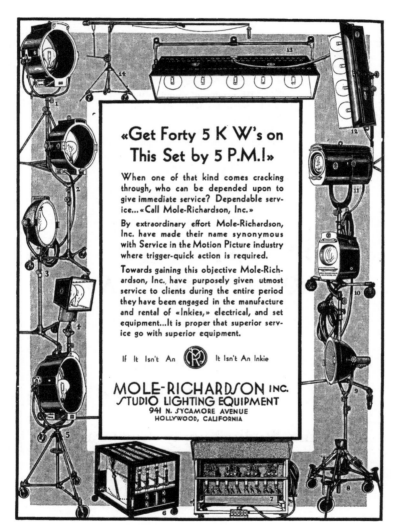

«Get Forty 5 K W's on This Set by 5 P.M.!»

When one of that kind comes cracking through, who can be depended upon to give immediate service? Dependable service...«Call Mole-Richardson, Inc.»

By extraordinary effort Mole-Richardson, Inc. have made their name synonymous with Service in the Motion Picture industry where trigger-quick action is required.

Towards gaining this objective Mole-Richardson, Inc. have purposely given utmost service to clients during the entire period they have been engaged in the manufacture and rental of «Inkies,» electrical, and set equipment...It is proper that superior service go with superior equipment.

If It Isn't An (MR) It Isn't An Inkie

MOLE-RICHARDSON INC.
STUDIO LIGHTING EQUIPMENT
941 N. SYCAMORE AVENUE
HOLLYWOOD, CALIFORNIA

The
INTERNATIONAL
PHOTOGRAPHER

Official Bulletin of the International Photographers of the Motion Picture Industries, Local No. 659, of the International Alliance of Theatrical Stage Employees and Moving Picture Machine Operators of the United States and Canada.

Affiliated with
Los Angeles Amusement Federation,
California State Theatrical Federation,
California State Federation of Labor,
American Federation of Labor, and
Federated Voters of the Los Angeles Amusement Organizations.

Vol. 2 HOLLYWOOD, CALIFORNIA, SEPTEMBER, 1930 No. 8

"Capital is the fruit of labor, and could not exist if labor had not first existed. Labor, therefore, deserves much the higher consideration."—Abraham Lincoln.

CONTENTS

The INTERNATIONAL PHOTOGRAPHER published monthly by Local 659, I. A. T. S. E. and M. P. M. O. of the United States and Canada

Copyright 1930 by Local 659, I. A. T. S. E. and M. P. M. O. of the United States and Canada

HOWARD E. HURD, *Publisher's Agent*

SILAS EDGAR SNYDER - - - - - *Editor-in-Chief* GEORGE BLAISDELL - - - - - *General Manager*
LEWIS W. PHYSIOC - - - - - *Technical Editor* FRED WESTERBERG - - - *Asso. Technical Editor*
JOHN CORYDON HILL - - - - - - - *Art*

Subscription Rates—United States and Canada, $3.00 per year. Single copies, 25 cents
Office of publication, 1605 North Cahuenga Avenue, Hollywood, California. HEmpstead 1128

The members of this Local, together with those of our sister Locals, No. 644 in New York, No. 666 in Chicago, and No. 665 in Toronto, represent the entire personnel of photographers now engaged in professional production of motion pictures in the United States and Canada. This condition renders THE INTERNATIONAL PHOTOGRAPHER a voice of an *Entire Craft*, covering a field that reaches from coast to coast across the nation.

Printed in the U. S. A. at Hollywood, California

Screen Characteristics and Natural Vision

An Analysis From the Viewpoint of Philosophical Psychology. Part 2.

By DR. L. M. DIETERICH.

Wide Screen

Let us illustrate on hand of a rather extreme screen size.

In order to maintain the necessary minimum height of the screen proper proportions unfortunately call for such width of screen and related minimum viewing distance that the latter produces uneconomical conditions, so far as a desirable theater seat capacity is concerned.

If a so-called "wide film" is fittingly projected on a screen of say 40 feet width, the minimum comfortable viewing distance is 40 feet (see Diagram 2), if effortless scanning is upheld.

Such minimum distance excludes a number of seat-rows, which must be filled, to maintain normal box office returns.

What are now the sense reactions upon patrons sitting closer than at a 40 foot distance.

To visually quickly cover the whole expanse of the picture such closer distances calls for unusual efforts of the eye or even neck muscles, with resultant strain and discomfort. Furthermore, when details towards the edge of the picture are viewed at an angle of less than 60 degrees, the distortion of these details becomes increasingly apparent, and a decidedly unnatural effect is produced, thereby destroying the inherent beauty of the composition.

Viewing, however, such a wide picture from the minimum distance of 40 feet enhances its beauty over that of a narrower picture for several reasons. Leaving aside the greater latitude of possibilities for composition, more closely approaching natural vision, a decided factor for three dimensional effect is established by the following reason: If the eyes wander from central viewing distance of 40 feet towards the edges of the picture, the viewing distance increases up to 44 feet (see diagram). To keep the eyes properly focused, the accommodation mucles come involuntarily into play to flatten the crystal lens of the eyes; the angle of convergence is also automatically changed.

Both of these automatic muscle activities and they "alone," produce our sensory impression of depth, when we look at reality. Similar sensory reactions take place, when accommodation and convergence change while looking at different parts of a picture, far enough from each other, to make

Four

DIAGRAM
of
HUMAN OPTICAL TRACTS
LEFT EYE RIGHT EYE

Diagram 3.

such reactions perceptible.

We receive, therefore, a decided three dimensional illusion or depth impression, when we look at a "wide" screen picture from a proper distance. Emphasis should be given to the fact that this three dimensional illusion as an attribute to "wide screen," pictures, has no foundation in or connection with the size or the width of the film, or the optical system producing pictures thereon, or the optical characteristics of the projection system.

In connection with this analysis of natural human vision, one of its most interesting characteristics from a photographic point of view—its depth perception—the reason for same, and the possibilities of similar screen illusions as above touched upon, had to be closely analyzed and studied.

In the art of stereoscopy, which attempts to produce depth effects in a complex photographic way and by special viewing apparatus, similar sense reactions, as those produced

by the eyes when they look at three dimensional reality take place, and thereby certain pleasing effects have been achieved in still photography. These come, however, more into a class of photographs, which we might call unusual effects rather than sound approach to natural vision.

Even Helmholtz states in his "Antagonism of Visual Fields" that the total perception of two visual fields, which is required for vision through a stereoscope, is not a normal physical phenomenon.

Lens Parallax

There are, however, possibilities in regular motion pictures and their projection which point to an increase of depth illusion, even if remote from the visual depth perception of natural vision of three-dimensional reality.

We have stated before that one of the necessary functions of the eyes to produce depth perception, is convergence. Convergence is based upon and only possible by the parallax or the distance between the eyes.

The sensory result is the assimilation of two pictures of an object from two different viewpoints. If we look at Diagram 3 we see that the nerve supply for the retina of each eye is furnished by two different strands or fibrils of the optic nerve. Each strand serving approximately one-half of the retina leads to a primary nerve center, lying on that side of the brain which is opposite to the location of the center, which supplies the other half of the retina.

This being the case for both eyes, the strands, coming from both eyes, cross each other at the optic chiasm, combine correspondingly to two main strands, and enter the relative primary nerve centers. The so far accepted hypothesis is that the two pictures coming from the two right halves of the two retinae combine into one sense picture at the right primary center, and combine with the picture, similarly formed by the left primary center, to a composite depth picture at the final nerve center.

If we destroy one eye, we still have a right and left picture at the primary nerve centers, as produced by the right and left half of the remaining eye. The characteristic difference lies in the difference of magnitude between the binocular and monocular parallax (see Diagram 3).

This nerve distribution explains the fact that persons born blind or rendered blind in one eye early in youth

become by association and experience endowed with perfect depth perception. It is furthermore not generally realized that a single photographic lens has just the same as a single human eye, a parallax, depending in its magnitude upon the lens diameter.

This parallax, although actually circular, becomes of important effect, however, predominantly in a horizontal direction, coinciding with the normal directional position of the human parallax. It is the horizontal parallactic view which produces in its ramifications the various sense reactions, resulting in our perception of depth.

This can be best proven by covering a lens and leaving only two diametrically opposed appertures or coverholes near the periphery of the lens open. The picture, taken by such a lens, shows objects in focus as single images; objects out of focus are double in appearance, directly comparable with superimposed steroscopic couples.

That is one of the psychological reasons why regular or monolens photographs show greater depth when viewed with one eye instead of two, by monocular instead of binocular vision.

The hypothetical reason for this effect, as conceived by the author and so far not expressed by other investigators, is as follows:

When we view reality by binocular vision, our sense assimilation of two pictures of a three dimensional object, each of different angular value, produces the effect of depth. When we look with both eyes at a two dimensional picture or object, both eyes receive the same picture; there are no "sides" of any object to look at.

This characteristic difference between the two pictures is absent—we see not the depth produced by reality. This negative parallactic sense reaction furthermore destroys even that lesser depth effect, which is produced by the parallax of the single eye (see Diagram 3). If we look at a picture, however, with one eye only, then its parallactic reaction recognizes the lens parallax in a sensory way, and greater depth is seen than when looking at it with both eyes.

This analysis shows that there is a "photographically" established depth factor in every monolens picture.

Increase of Depth Effect

This effect is enhanced when viewing the photograph through a small hole, at the proper distance from the pupil, or by looking through a tube. Out of various results thereby obtained, the one of interest for the purposeof this article is the one whose effect becomes effective when the borders of the photographs are beyond the field of vision. In such a case it is impossible to place the picture plane in space, especially when viewing a transparency. The depth characteristics of the monolens picture, including shadow effects and perspective, assume their full value with a resulting depth effect, otherwise not appearing in monolens photographs. This more or less complete inability to place the

picture surface (screen) in space is so effective that it even influences binocular viewing of the picture, with a depth perception which is not apparent when the position of the picture surface in space is clearly recognized.

The depth effect produced when viewing a picture or photograph, by suppressing distinct border lines, and by reducing the parallactic action of binocular vision, either by an Iconoscope or by monocular vision, which has been so thoroughly studied by Professor Ames of Dartmouth College and others ("The Illusion of Depth from Single Pictures," Optical Society of America, "Depth in Pictorial Art," College Art Association of America a.s.f.) resulted in several theories for the explanation of the psychology of these illusions. Without entering into any controversies between these theories and the author's hypothesis, such points as are brought out by them in common and of interest to the motion picture industry may be mentioned here as a basis for possible research work for the production of enhanced depth effects in motion pictures.

1. Theoretical and experimental study of lens diameters with correlated aperture control should photographically increase the depth value of monolens pictures.

2. As binocular viewing with "unaided" eyes is essential, enforced monocular vision seems for the present not a commendable research endeavor.

3. Suppression of distinct picture bordering, however, and relating treatment of screen surfaces in order to suppress visual location of screen in space, seems to be worthy of serious research.

4. If coupled with an approach to the facts of natural vision, as far as perhaps automatic lens or focus accommodation is concerned — the elaboration upon practical screen size and shape becomes of interest; again, however, if governed by the demands for the closest approximation of natural vision.

5. The shape of the illuminated part of the screen should conform to

the best advantage of the momentary composition.

For this purpose technical means under the instantaneous, effective control of the cameraman are conceivable and if the rectangular, sharply defined border is at the same time robbed of its commanding position (see Diagram 3), the depth illusion of motion pictures would of necessity be greatly increased.

The size of the projected picture should, in the opinion of the writer, be governed by the image size of the acting persons as closely as present practices permit, their angular size when viewing the screen from the minimum distance to be the same as the human eye subtends when viewing them in reality from a distance in harmony with camera distance and taking and projection lens values.

With these limitations as a basis, the width of the screen should subtend an angle of not more than 60 degrees for the minimum screen distance. A less distant position of the spectator of course decreases pleasing effects.

This seems to be unavoidable, however, when we consider the great depth of a theatre seating space and the resulting great difference of screen distances for the individual spectators.

To reach, as in so many other human endeavors, a practical solution of an ideal conception, we must compromise, and the selection of the most effective mean screen distance is the best that can be done for each individual motion picture theatre.

It is opportune at this point to mention the influence which certain deformations of the flatness of the screen have upon the "depth" of a normal picture projected thereon.

Quite a number of special screen designs, including three dimensionally curved screens, double screens, rotating auxiliary screens, v i b r a t i n g screens, perforated screens, translucent screens, screens with a radical departure from smooth surfaces, have been suggested, patented, demonstrated and so far found wanting for successful application.

Although some of these methods and devices did actually produce improved depth effects, such effects were in most cases restricted to a definite relative position of the spectator or for other reasons not practical for auditorium or theater use.

The study of this branch of depth effect producing methods is quite interesting and instructive, but cannot be presented here in detail.

In order to stay within the scope of this article, the author has been forced to make a number of statements without lucid explanations, but hopes to enlarge upon the most important items in a logical way in future articles, considering "this" article, more or less, only as a program of further disclosures.

Jackson Rose has just completed his assignment with John Stahl at Universal on "The Lady Surrenders." This picture features Genevieve Tobin and Conrad Nagel.

Units of Exposure

Technical Editor Fred Westerberg Makes Interesting Reply to Brother Thomas of Creston, Iowa

By FRED WESTERBERG, Local 659

The following letter, which explains itself, was received recently from Brother P. E. Thomas, secretary-treasurer of Local 593, I. A. T. S. E. and M. P. M. O., of Creston, Iowa.

Editor INTERNATIONAL PHOTOGRAPHER:

I AM seeking information regarding photographic lenses, of which I know very little, and I express the hope you will be kind enough to place this letter in the hands of a brother member of Local 659. The photographers in this vicinity with whom I am acquainted are unable to assist me, hence I feel at liberty to ask information from those connected with the motion picture industry.

The writer is "sorta" a ham camera (still) enthusiast, a hobby that has developed into a great deal of mystery. Recently I came into possession of a Graflex fitted with a French lens with a speed of F 3.5 and an E. F. of 6 inches. The diaphragm markings run from F 3.5—5—7—10—14—20 respectively.

These markings or stop numbers are presumably half way between the F/ values ordinarily used on lenses of American manufacture, are they not? On the inclosed sheet in red I have given my interpretation of the comparative F/ values, and this is the matter I wish to have cleared up.

Also what relation to exposure is there between a focal plane shutter and those used on an ordinary kodak? I have been advised that a focal plane shutter will do in one-fiftieth of a second that which requires one-hundredth of a second with other types of shutters.

I will greatly appreciate any information you may offer on the above mentioned subjects and thanking you, I am

Respectfully and fraternally,

P. E. THOMAS.

Dear Brother Thomas:

Mr. Snyder has asked me to do what I can to clear up the mystery for you, so here goes.

The calibrations, F/3.5, F/5, F/7, F/10, F/14, F/20, etc., chosen for your lens, are in a way quite sensible. Starting at F/3.5, the largest stop, each succeeding stop reduces the brightness of the image by one half. This prevents the stop F/3.5 from becoming a fractional stop dangling like a tail at one end of the scale.

The greatest drawback is the confusion which may arise in comparing your stops with the standard series F/4, F/5.6, F/8, F/11, F/16, etc. If your stops actually come halfway between as you suspect it

LENS APERTURES	EQUIVALENT VALUES IN EXPOSURE UNITS	SHUTTER SPEEDS	EQUIVALENT VALUES IN EXPOSURE UNITS
F/45.28	⅛	1/800 Sec.	⅛
F/32	¼	1/400 Sec.	¼
F/22.64	½	1/200 Sec.	½
F/16	1	1/100 Sec.	1
F/11.32	2	1/50 Sec.	2
F/9.24	3	3/100 Sec.	3
F/8	4	1/25 Sec.	4
F/7.16	5	1/20 Sec.	5
F/6.53	6	3/50 Sec.	6
F/6.04	7	1/15 Sec.	7
F/5.66	8	2/25 Sec.	8
F/5.06	10	1/10 Sec.	10
F/4.62	12	3/25 Sec.	12
F/4	16	4/25 Sec.	16
F/3.58	20	1/5 Sec.	20
F/3.2	25	¼ Sec.	25
F/2.83	32	1/3 Sec.	32
F/2.53	40	2/5 Sec.	40
F/2.3	50	½ Sec.	50
F/2	64	2/3 Sec.	64
F/1.84	75	¾ Sec.	75
F/1.60	100	1 Sec.	100
F/1.41	128	1¼ Sec.	128

would not be so bad, but as it happens they do not do so. Such a series would read F/3.2, F/4.6, F/6.5, F/9.2, F/13, F/18.4, etc.

In comparing different F values in a lens it must be remembered that the brightness of the image varies directly as the area of the effective aperture. This is the key to the exposure factors. The formula is Pi R^2 equals A where A equals Area; R equals Radius; Pi equals 3.1416. The radius is obtained from

$$\frac{Focal\ length}{Stop\ value} = Diameter$$

For example the stops F/4, F/5 and F/5.6 work out as follows for a six-inch lens:

	Diameter	Radius	Area	Relative Brightness of 1 image
F/value	F/stop=D	D/2=R	Pi R^2=A	
F/4	1.5	.75	1.76715	2
F/5	1.2	.60	1.130976	1.28
F/5.656	1.0606	.5303	.883575	1

It can be seen from the foregoing that the F system is mathematically quite simple. Its use is therefore justifiable from the standpoint of the lens maker. The use of this system as a guide to exposure, however, is complicated by the fact that no direct index to exposure is furnished, due to the system being based on the relation of the diameter to the focal length. The factors can of course be computed rather easily, as I have shown, but still this does not help the photographer to visualize the exposure situation at a glance.

I rather suspect that most of us would be just as well off if the various stops were merely given names such as Ferdinand, Lucas, Emma, etc. What is needed is a new language of exposure.

I can see a conversation something like the following take place in the future. One photographer is showing another one a new picture he has made.

"Rather nice," says the friend, "What did you give it?"

Steel fingers of Microscopic Precision

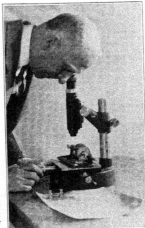

Bell & Howell craftsman using a tool-maker microscope in the inspection of an automatic screw machine circular form tool. This tool is used in making the blanks for the take-up sprockets for Filmo 70-D Cameras. This measuring instrument serves to ascertain the structure of metals and flaws in tools and is used for measurements of gauges, gear teeth, angles and contours. Measurements can be taken to .0001 of an inch.

STEEL fingers perforate miles of celluloid ribbon that will be sent to Hollywood to catch the voice and charm of a celebrated actress. In Hollywood, steel fingers move this ribbon past a sensitive camera lens, recording the movements of actors on "location." In a little town in Vermont, steel fingers move this ribbon past a projection lens, and scores of theater-goers thrill to the *life-like* action before them.

The success of this cycle of movie making rests, in great measure, upon the similarity of the steel fingers which perforated the film, those which moved it through the camera, those which moved it through the projection machine. A flaw in the first two sets of fingers would have rendered the last set of fingers clumsy and ineffectual. But there were no flaws, and the movie goes on the screen without a hitch.

Microscopic precision is the only phrase which adequately characterizes the design and manufacture of Bell & Howell cinemachinery, from Standard Perforators to Standard Studio Cameras, Printers and Splicers. For only microscopic precision could have guaranteed that the small town in Vermont would thrill to the life-like shadows which moved across the screen.

Bell & Howell cinemachinery has been the choice of the major film producers of the world for more than 23 years. Behind its precision lie the Bell & Howell Engineering Development Laboratories, which concern themselves not alone with manufacturing problems, but with every problem in the industry as well. You are invited to submit your problems to our engineers.

BELL & HOWELL

BELL & HOWELL COMPANY, Dept. U, 1849 Larchmont Avenue, Chicago, Ill. · New York, 11 West 42nd Street
Hollywood, 6324 Santa Monica Blvd. · London (B. & H. Co., Ltd.), 320 Regent Street · *Established 1907*

EXPOSURE TIME	800	400	200	100	50					1	1½	2	3	4	5	8	10 (SECONDS)
LENS APERTURE	F/45	F/32	F/22	F/16	F/8										**E.U.C CALCULATOR.** COPYRIGHT 1930 — J.F.W.		
EXPOSURE UNITS	⅛	¼	½	1	1½	2	3	4 5 6 7 8 10 12	16 20 24	32 40 50	64	100 128	200 256	400 512	800 1024 E.U.s		

"Well," replies the first, "I made a few exposures at 12 E. U.s, but the scene was pretty contrasty, so I tried one at 30 E. U.s and developed it in dish water. Glad I did. I could have given it 60 E. U.s without hurting it."

Simplification and visualization of exposure is in reality quite possible. It all hinges on the idea of conceiving of exposure as work performed in terms of a definite unit of work. I have chosen as a possible unit of this kind the work or exposure accomplished by the aperture F/16 when allowed to operate for 1/100th of a second. This unit may be called 1 E.U. or 1 exposure unit.

Other apertures and other shutter speeds automatically would receive values in proportion to the work that they do. Some of these are shown in the table on page 6.

The complete equation would be units of time (in E.U.'s) times units of aperture (in E.U's) equals units of exposure (in E.U's).

To illustrate:

1/25 sec. at F/8 equal 4x4 equals 16 E.U.s.

1/50 sec. at F/2.3 equals 2x50 equals 100 E.U.s.

1 sec. at F/16 equals 100x1 equals 100 E.U.s.

As an aid in transposing E.U.s into their equivalent values in time and aperture I have worked out a calculator that operates like a slide rule. (Fig. 1) Slide the middle bar until the stop you wish to use coincides with the E.U. value that you have selected. The arrow at F/16 will point to the shutter speed required.

Various types of filters may also be given E.U. ratings, one set for orthochromatic film, another for panchromatic film.

Even film speeds can be expressed in the same way. A slow emulsion requiring twice as much exposure as ordinary roll film may be given a rating of 2, for instance. H. & D. ratings are simple enough and a delight to the scientific mind, but the man in the street somehow is not quite comfortable in their presence.

I might suggest, Brother Thomas, that you recalibrate your lens in exposure units. Your shutter speeds could be designated in the same way, thus enabling you to think entirely in terms of E.U.s. The fact that it probably has not been done before should not deter you. Be a pioneer.

Now in regard to your question on focal plane shutters I might say that there are two angles to be considered. One has to do with exposure efficiency, the other with the character of blur obtained in photographing moving objects.

A focal plane shutter undoubtedly produces a more fully timed negative than a between the lens shutter does over a similar interval of time. With a focal plane shutter the lens operates at its full stop opening throughout the exposure, while with a between the lens shutter an appreciable interval is devoted to the opening and closing of the diaphragm of the shutter.

In reality a quick fading in and fading out of the image takes place. The percentage of time devoted to this fading in and out increases as the time of exposure is reduced. It also varies with the make of shutter used as some are more efficient than others in this respect.

It might prove interesting to photograph some object moving at a uniform rate of speed, such as a strongly illuminated white spot on a phonograph disc to compare the two types of shutters. A comparison could also be made of a between the lens shutter when used wide open with its performance when used at a small aperture. This would determine how long it takes for the diaphragm to open and close.

It is claimed that the character of the blur obtained in photographing moving objects is less objectionable when a focal plane shutter is used. If so it is due to the fact that only a portion of the picture is exposed at a time as the slit travels across the face of the plate.

While the blur may for this reason be less objectionable in shape its size should be the same. The moving object would cover the same distance in each case if the shutters were properly calibrated. The advantage, if any, would probably be in favor of the between the lens shutter due to the above mentioned fading at the beginning and end of the exposure.

As one "sorta" camera enthusiast to another, I wish you success.

J. F. WESTERBERG.
Associate Technical Editor.

A. S. C. Year Book a Credit

The A. S. C Year Book is off the press and it is altogether a credit to that fine organization and to the editor, Mr Hall. It is loaded with art and with interesting text and will prove a useful handbook to the cinematographers. Typographically it is irreproachable, and it is also an excellent specimen of the binder's art. When cinematographers set out to do a thing they do it well.

Universal Golfers Compete

Universal players, studio executives and technicians are preparing for the annual Universal studio golf tournament to be held Sept. 14 and 21 at the Girard Country Club.

Curly Robinson, in charge of registration for the competition, already has recorded a large entry list. The prizes will be in excess of those presented 1929 winners.

..CONSTANT PROGRESS

TODAY'S achievements are possible only because there was constant progress yesterday. Tomorrow's accomplishments, likewise, depend on today's consistent advances. That is why you can depend upon General Electric MAZDA lamps to continue in their position of leadership. They are the product of 50 years' steady progress . . . of the unparalleled MAZDA research service . . . of General Electric Company.

Ideals of service and the responsibilities of leadership have produced the G. E. MAZDA photographic lamp. Finer materials, better construction and improved design will constantly make them finer tools in the hands of the cinematographer.

General Electric MAZDA photographic lamps are produced in accordance with a program of constant progress.

The 10 kw. photographic lamp is a specific example of the improvements made in lamp construction in a single year. More rugged bulbs, stronger supports and higher efficiency provide for constantly improved performance.

Join us in the General Electric program, broadcast each Saturday evening over a nation-wide N. B. C. network

GENERAL ELECTRIC
MAZDA LAMPS

Local 659 Honors Rucker at General Meeting

THE General Meeting of Local 659, held in the Hollywood Chamber of Commerce Auditorium on the night of Aug. 7, 1930, was largely attended. It was a busy night and a lot of business was cleaned up, with President Alvin Wyckoff in the chair keeping his foot on the gas.

After a brief talk by the president, who called attention to the beautiful floral offerings sent the local by J. E. Brulatour, Smith & Aller and Mitchell Camera Corporation in honor of the local's completion of its second year, a number of new members took the obligation.

The installation of officers chosen at the recent election who will serve during the ensuing two years was presided over by Cleve Beck, third vice-president of the I. A. T. S. E. and M. P. M. O., who did the work in his own inimitable style.

In a happy speech Brother Hal Mohr presented to President Wyckoff a beautiful gavel, paying to our president, now entering upon his second term, a glowing tribute of appreciation and regard, to which Brother Wyckoff responded in well-chosen sentiments straight from the heart.

PALMER TALKS GOLF

Chairman James Palmer, of the golf committee, told the assembled members to be on the alert to get their entries in on time for the second annual tournament, to take place on the Palos Verdes course Sunday, Sept. 7.

The other members of the golf committee present reported that they expected a record-breaking attendance and that there would be an unusually attractive array of prizes and trophies.

Lew Blix and Ted Eckerson, business agents respectively of Locals 37 and 150, addressed the meeting briefly. President Wyckoff then introduced George Blaisdell, who was recently appointed general manager of THE INTERNATIONAL PHOTOGRAPHER.

Mr. Blaisdell needs no introduction to any group in the motion picture industry. He is a pioneer of the trade journal field, having been editor of the old Moving Picture World and the Exhibitors Trade Review and more recently associated with Variety. He enjoys a wide acquaintance among the producers and is a welcome visitor in the studios.

RING FOR JOE RUCKER

A happy event was the presentation of a ring to Brother Joseph

Miscellaneous Record

Date	Particulars	Amount	Signature of Secretary
10-9-28	Initiation Fee	100 00	S. G. H.

Cinematographer's Membership Card №. 36434

Issued to Bro. Joseph T. Rucker
INTERNATIONAL PHOTOGRAPHERS OF THE
By MOTION PICTURE INDUSTRIES, I. A. T. S. E.
CITY STATE
Local Union No. 659 of the International Alliance of Theatrical Stage Employes and Moving Picture Machine Operators of United States and Canada, affiliated with the American Federation of Labor

PRESIDENT SECRETARY
Void after July 31, 1929

SEASON 1928-1929

The card which soared over the South Pole.

Rucker, who, with Brother Willard Van der Veer, was official cinematographer of the Byrd Antarctic Expedition, guest of honor of the evening.

The ring presented to Brother Rucker was a masterpiece from the studios of J. A. Meyers & Co., 822 South Flower St., Los Angeles. A ring of identical design was at the same time presented to Brother Willard Van der Veer in New York, President William Canavan of the I. A. T. S. E. and M. P. M. O. making the presentation speech.

PERSONALLY CONDUCTED TOUR

Brother Rucker, who is now located at San Francisco, flew down to be present at the meeting and incidentally exhibited to the assembled brothers a copy of the official pictures of the Byrd Expedition as ed-

ited by Julian Johnson and released by Paramount.

Previous to the showing Brother Rucker spoke interestingly of the expedition, of life in Little America and of the trials of the cameraman in the polar temperatures. He also made explanatory remarks during the filming of the picture.

The picture, though run without music, made a tremendous impression on the cameramen present, who viewed it not only from the cameraman's standpoint, but also from that of the fan who comes to be entertained, and the picture and its photographers were applauded to the echo. It was a great occasion both for Brother Rucker and for Local 659.

On his part, Brother Rucker presented to Local 659 his membership

(Concluded on Page 42)

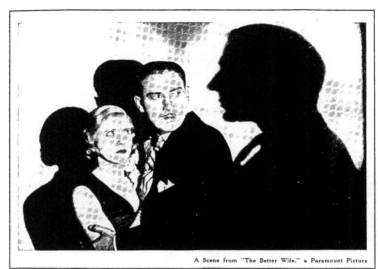

A Scene from "The Better Wife," a Paramount Picture

Shown in the right light

HERE SHE IS! You've seen her a thousand times on the screen. Her demure little smile is warm and friendly. Midst elaborate scenery and dazzling surroundings, she never loses her piquant charm. National Photographic Carbons have given "light men" and photographers the chance to present her at her best, making her success theirs as well.

For medium and long shots, National White Flame Carbons have actinic carrying power identical with that of pure sunshine. Every graceful gesture is registered, is made an exciting pattern of light and shadow. Use them for sharp moonlight effects, for brilliant, clear-cut contrasts, for scenes exacting in detail.

Stars have learned, "light men" and photographers have learned, that National Photographic Carbons are always dependable. Whether in the daily routine of studio work or for unusual scenes under the most exacting conditions, National Photographic Carbons will help you get your stars over.

NATIONAL CARBON COMPANY, INC.
Carbon Sales Division: Cleveland, Ohio

Unit of Union Carbide UCC *and Carbon Corporation*

Branch Sales Offices: New York, N. Y. Pittsburgh, Pa.
Chicago, Ill. Birmingham, Ala. San Francisco, Calif.

National Photographic Carbons

—

Who Can Solve This Problem?

This Is Addressed to Producers, Cameramen, Technicians, Engineers and All

By (BILLY) G. W. BITZER

Look at this picture and the accompanying table of figures. If you can in your wisdom figure it out send in your answer to me.

On the left (the large film) we have a photographic reproduction of a film made in 1897. Photographed for the American Biograph Company by G. W. (Billy) Bitzer. It is a picture of the New York Central Railroad's crack train of that day, the Empire State Express, going at the rate of sixty miles per hour.

The smaller film on the right is a Colorcraft film taken in color with sound track, the most modern and up to date achievement in the moving picture world today. This film was also photographed by "Billy" Bitzer, whose hands are shown holding two films, specimens of his work in 1897 and 1930.

Now here is the problem to figure out. The film of the train (the old film) taken thirty-three years ago is just twice the width of the Colorcraft film (the new film) which is the standard size film today. The speed or sensitiveness of the old film was a tremendous lot slower thirty-three years ago than today as was likewise the lens.

This wide film necessitated the using of a much larger focus lens and it was a very slow lens in comparisons with the high speed lenses which are necessary today on account of the sound which has been added to pictures, requiring the film to run at the high rate of twenty-four pictures per second or ninety feet per minute.

Today we just barely get enough exposure with a many, many times faster lens and film. Yet this train picture was taken at the rate of thirty pictures per second or three hun-

dred and twenty feet per minute and on a film over nine times the area of the present day film. Here's the table:

1897

Speed of film H. & D....25% Slower	
Speed of Lens B. & L......	F. 6-8
Focus of Lens B. & L.......	8"
Pictures per second.........	30
Feet per second............	320
Size of film................	2 23/32

1930

Speed of film H. & D.....25% Faster	
Speed of Lens..............	F. 2/3
Focus of Lens..............	2"
Pictures per second........	24
Feet per minute............	90
Size of film................	35 mm.

Our thinking technicians will say: "Well you're showing us an exterior scene. We can do the same today."

But on this same width, slow emulsion film, the same slow eight inch F. 6-8 lens at the same high rate of picture per second, a picture was taken at the Coney Island Athletic Club of the Sharkey-Jeffries world championship fight with little street arc lights which were nothing like the present day terrific looking search lights one sees in the studios and when pictures are made on the street at night.

Just a few more figures that I believe are mighty interesting. This fight lasted twenty-five rounds. Figure three minutes to each round, and one minute intermission during which the cameras were running. There are 5280 feet to a mile and we have therefore approximately seven and one-quarter miles of film. And this picture earned for its owners I understand over a million dollars thirty years ago.

So the only really new thing in pictures today is color. We've had wide film and made pictures upon it years ago. It is as old as the hills almost. At least it is as old as the hands holding the film in the picture —the hands of Billy Bitzer and who shot 'em all.

George Meehan is engaged in special process work for United Artists.

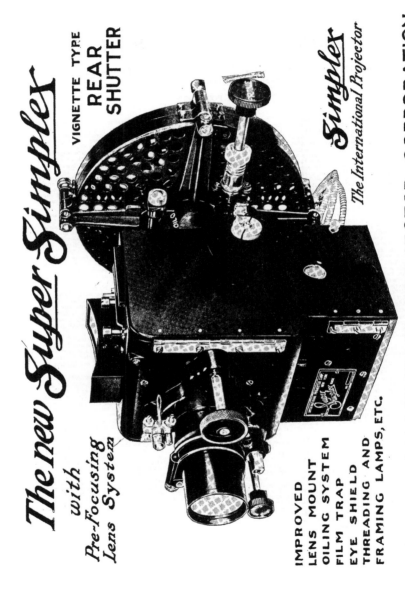

Knights of the Camera

Some Unsung Artists of the Cinema—Reprinted by Special Permission from the
Theatre Guild Magazine of New York

By HARRY POTAMKIN

I T IS taken for granted among American film-makers that "cameramen rarely break into print." Although the photography and shots of a movie may be admired, the identity of the cinematographer excites no curiosity, save in the industry of the film and in the trade of the cameraman. What devotee of the American film will recall these names: Billy Bitzer, Alvin Wyckoff, Karl Brown, Charles Rosher, Gilbert Warrenton,, George Folsey, Oliver Marsh, Bert Glennon, Karl Struss?

The enthusiast may recognize two associated with direction, Karl Brown and Bert Glennon. But he would never remember that so many of the films which he enjoyed owed much of their merit to the camera work of either. Yet many a film has been given its outstanding quality by the cinematographer. Frequently t h e work at the camera has deetrmined the film.

In a consideration of the cameraman (who is more truly the camera ængineer), one naturally begins, in America, with George William (Billy) Bitzer. About thirty-five years ago Bitzer turned to the camera from his trade of electrician, and American motion picture history wrote its first chapter. In 1896 Bitzer caught McKinley receiving the notification of the presidential nomination in Canton, Ohio.

FILMS PRIZE FIGHT

A few years later he recorded the Jeffries-Sharkey bout, inaugurating the practice of artificial lighting. This historical note is highly interesting, when we recall that Hollywood was founded in the search for natural sunlight. The movie began outdoors, but the Jeffries-Sharkey fight at the Coney Island Athletic Club on Nov. 3, 1899, brought the film indoors. Some four hundred arc-lamps were clustered over the ring and the camera speeded to a night's mileage of seven-and-a-quarter of negative, then postal card size.

The American Mutoscope and Biograph Company was born into the studio world with that film and Bitzer was its dominant figure. The director was incidental.

With the new century, however, the film moved toward its creator, and that evolution was consummated in David Wark Griffith. D. W. was an actor. Bitzer was camera lord. One day the director of a film was absent. Griffith was called in to substitute. With that incident the famous AB (American Biograph) became a leader; the great Griffith-Bitzer team commenced.

This combination was responsible for the close-up. Of course, the bold image existed in the film before the Biograph days. The very first peep-show films were large scale. That, however, was an expedient to film a moment.

The first use of the close-up in the movement of a narrative film was made in "The Mender of Nets," in which Mary Pickford acted and which Griffith directed and Bitzer photographed. It is a victory such as this that I call camera engineering.

EVOLUTION OF CLOSE-UP

The too superficially reasoning critic may condemn the close-up as a banality—its use has been banal—it is nevertheless, as a rhythmic component, intrinsic cinema. We may note here that in America the close-up has remained a device for effect. In Europe it has evolved as a structural element and has attained, in "The Passion of Joan of Arc," the eminence of a structural principle.

In this evolution we connect two great directors, Griffith and Carl Dreyer, who acknowledges the former as a pioneer; and we join as well two very great cinematographers, Billy Bitzer and Rudolph Maté.

Bitzer is responsible for certain controls of photographic quality. It was he who originated the soft focus, the elimination of the sharp corners of the film frame and the use of gauze to tone the film to a mist (as in "Broken Blossoms").

In America, again, we have not gone on with these modifications of the literal in film photography. It is in Europe we find their continuation and extension.

Cavalcanti films "The Petite Lily" through gauze to depersonalize the characters, and Man Ray sees his characters through a mica sheet which grains the picture and renders it liquid in consistency.

There is one European device we have borrowed and abused to death: the rising mist. This appeared in "The Flesh and the Devil," was used effectively in "Sunrise," and then repeated in numerous Fox films. But otherwise our cinematographers have no¹ learned the treatment that modifies the literal.

The mind of the American film, regarding both content and approach, is literal; and that is why the American film' is still rudimentary, and why no one here has extended or even equalled the compositions of Griffith or logically developed the innovations of Billy Bitzer.

For instance, let us refer to the camera angle, a major instance of camera engineering. In "Intolerance," in 1915, Bitzer used the angle and the mobile camera to descend, in the Babylonian scene, from a view looking down upon three thousand persons to a close-up of the central personage. America quite forgot this powerful method until the German film, "Variety," introduced the angle as the determining structure of a film and sent all Hollywood into a frenzy from which it has only recently recovered.

Nor has there yet been very much learned by director or cinematographer of Hollywood about the angle as a principle, rather than as an effect device. We have few camera engineers, or camera estheticians; they are mostly cameramen.

Coupled with the name of Billy Bitzer is that of Alvin Wyckoff. Wyckoff is to the reputation of De Mille what Bitzer is to the realization of Griffith's ideas. There is no knowing what Wyckoff might have accomplished had he worked with the creator instead of the barker. Nevertheless, what remains with one after an early De Mille film is, besides the sense of claptrap content, a memory of photographic, cinematographic splendor.

Wyckoff is especially noted for the invention of new lenses and for innovations in lighting. He is accredited with having first effected the reproduction in the film of the lighting of a cigar or cigarette.

BITZER AND WYCKOFF

In 1928 the famous "originals" and olden rivals, Bitzer and Wyckoff, joined together to film (at the behest of George Barnes, the Goldwyn cameraman) the movement of men through a marsh in "The Rescue." This itself attests to the fact that the "originals" have not yet been duplicated.

These two men, Bitzer and Wyckoff, belong to the category of camera engineers. The camera esthetician I term the cinematographer who is also an independent director. In America we may number among these, Schoedsack and Cooper, makers of "Chang"; Robert J. Flaherty, the great lyricist of the cinema who made "Nanook of the North" and "Moana of the South Seas"; and Karl Brown, who constructed and realized "Stark Love."

Brown is one of Billy Bitzer's boys, and his record in cinematography includes "The Covered Wagon" and "Beggar on Horseback."

Was not the cinematography of these films largely responsible for their success?

Indeed, for me "The Covered Wagon is a directorial failure and a cinematographic (cameraman's) success.

"Stark Love" is not a directorial success either, but it marks the passage of the cinematographer into control, a passage we find common in amateur film-making and in Europe. In "Stark Love," however, Brown turned the camera operation over to James Murray.

LIGHTING AND COMPOSITION

Among the American amateur camera estheticians I note Dr. John Watson, Ralph Steiner, Paul Strand and Charles Sheeler, Jo Gercon and Louis Hirshmann. Their films are personal declarations.

When we come to Europe we find the cameraman's contribution more generously credited. No one thinks of "The Passion of Joan of Arc" without remembering the work of Rudolph Maté: the intensive application upon the slow curve, the scrutiny of the physiognomy, the stark lighting, the composition in the lens, the resilient movement of the camera in the mob scene.

When one mentions "The Armored Cruiser Potemkin," immediately the name of Tisse follows for his terrific impact-filming. These are, of course, cardinal instances. But so are "Intolerance" and "The Birth of a Nation"—yet who recalls Bitzer as responsible for much of these?

The point, however, has less to do with credit for the individual cameraman; the companies know of him. I am more concerned with a record of the work of these individual cameramen in the collective art of the cinema.

The most eminent of the Europeans in the contribution of camera engineering to the cinema is Karl Freund. Freund established the mobile camera in "The Last Laugh"; the camera angle in "Variety." The numerous intermediate controls of the image, such as the multiplying and distorting prism, the haze-glass, the kaleidoscopic toy with its changing patterns in central balance, were introduced by Freund.

AGAIN THE CLOSE-UP

He is responsible for the exciting edifices of "Metropolis," all miniature models. We get here our milestones in cinematographic history: Bitzer, Freund, Maté. Bitzer uses the close-up for the first time in a film at varied arrangement; Freund first uses it revealingly in the structure in "The Last Laugh"; Maté, through Dreyer, makes it the structure, where it ceases to be a close-up and becomes a structure in relief.

Bitzer uses the angle as a detail in "Intolerance"; Freund uses it as structure in "Variety"; Maté renders it rhythmic and poignant in "Joan." At the present moment there is another comparison between Bitzer and Freund. The latter is today sponsoring in America a new color process;

the former is active in the promotion of the wide film. These are logical terminals for camera engineers.

Freund made with Walter Ruttmann the composite document of "Berlin: the Symphony of a Great City." In this he is the innovator of a new form of motion picture which stems from the simple newsreel and travelogue.

In Russia, Dzige Vertov is broadening this form of objective, non-narrative film; and numerous young men in Paris are beginning their careers with such film arrangements. Among these are a number of young men who are cameramen as well as directors. The numbers include Vertov's youngest brother, Kauffmann. A third Kauffman (this is Vertov's family name) is a co-worker with Vertov, having made with him "The Man with the Hand Camera", as yet the best example of what is called the montage-film.

The montage-film is a film assembled of separate sequences which is not *immediately* related to a single thing or event, but which, when joined out of these images or sequences, becomes a unit organized in a definite rhythm.

FOREIGN CAMERAMEN

Russian film-making is stimulated by a social idea, and hence its camerawork moves on toward new areas of greater magnitude. I have mentioned Eisenstein's cameraman, Edouard Tisse, who has worked under Eisenstein and Alexandrov (the latter must not be forgotten as a collaborator).

But one cannot overlook the great work of Anatoly D. Golovnia, who realizes the imaginings of Pudovkin, the romantic of the Russian cinema. Golovnia's work in "The End of St. Petersburg" adds his name to the lists of the heroic in camera creation. Pudovkin's "Storm Over Asia," which I saw intact in Amsterdam, will shortly be released here.

The camera work of K. Vents is eminently structural, with its general perspectives, its hyperattentive eye, its intelligence. And certainly the most beautiful detail of "The New Babylon," that film of sustained tones and stylization, is the camera as A. N. Moskvin employed it.

To these names we must add those of Evgeny Shneyder for "A Fragment of an Empire," distinguished by such camera achievements as shooting as many as four levels or planes, and getting them tonally, structurally clear and outstanding. The American technique has not often achieved this multiple-level filming. A Bitzer could achieve it; not many more.

Another name must surely be appended: O. Demutsky, cinematographer of "Arsenal." The work of K. Kuznetsov in "The Village of Sin" actually transcends the directorial achievement itself.

It is in the Soviet cinema the camera engineer is recognized. His position in the collective scheme of film-

making is equal to that of the director. He approaches his task not as one assigned to it after the plan is made and the scene set, but as one participating in the making of the plan.

Tisse, for instance, studies the scenario first, then consults the scenewright, together with whom the relation of camera, lights, and decor are determined, proceeds thence to the mapping of the "light-scenario," which serves as a blueprint for his assistant, a sort of camera stage manager.

CAMERAMAN-ENGINEER

Then, and only then, after the cameras and lights have been adjusted upon the basis of the camera chart does Tisse himself appear for the final relating of equipment to the thing filmed, to direct, that is, the camerawork just as the regisseur directs the players.

The rank of cameraman as engineer is the basis and aim of the course in the State School of the Cinema, where the students receive not only practical training, from menial tasks to the command of the camera, but also theoretical, in the study of the literature and principles of cinematograph as a medium.

Chemistry is taught in the second year, but not solely as a laboratory science; rather in relation to the art of the cinema. The course concludes with a study of optics. The camera engineer coincides, in the Soviet cinema, with the camera esthetician.

In France, as Mme. Dulac says, the successful film is found wherever the cameraman, director and cutter are one and the same. Such an identification we find among the American amateurs, but in Continental Europe the distinction between amateur and professional is not made.

Most noted among the independents the *avant-gardistes*, are Mme. Dulac, the American Man Ray, the Ukrainian Eugene Deslaw, the Parisian André Sauvage, the Hungarian Moholy-Nagy, the American Francis Bruguière and the Dutchman Joris Ivens.

Germaine Dulac, recently named a Chevalier of the Legion of Honor, was among the first to introduce the screenpanel, where only a portion of the screen is used at a time.

BRINGING BACK MELIES

The effect is achieved by masking the lens to hide the portion that is not used. This is a simple instance of the treating of the initiating instruments, camera and negative, in relation to the screen. Dulac has also, in "The Sea-Shell and the Clergyman," effected the illusion of a body dividing in half.

This simple device relates her to the father of film virtuosity, the Frenchman, Georges Meliès, the magician who used the movies in the nineties as an aid to his illusion-act. Dulac places a cord down the center of a man's face. She moves the camera leftward from the cord as the limit of the lens.

The right half of the lens is masked to prevent light from striking that part of the negative which is not to be impressed. Then the other half is masked and the camera moved rightward from the limit of the cord. The spectator sees the body as dividing away from the center.

DULAC THE ARTIST

Mme. Dulac does not end with virtuosity. These devices are contained in the fluid rhythm of the film. The camera virtuoso becomes the camera esthetician, the creative artist. Dulac was one of the first to use the prism, the distorting mirror, and similar devices as means to sensitive and descriptive detail.

Man Ray represents the entrance of the painter into the film. His entrance has come by way of photography, as is also the case with Moholy-Nagy. These men belong in the history of the absolute film, the film of organized, non-human components, which begins with the Norwegian Viking Eggeling and his disciple Hans Richter.

The independent film includes other artists who have come by way of painting or photography. Francis Bruguière, an American resident in London, has made part of a projected film, "The Way," which, by means of simultaneous images or multiple exposures, tells the story of the life of man, from birth to death.

This is the work of a camera esthetician. At present he is animating abstractions in paper, illumined and transfigured by light. The artist of the still camera and the light picture becomes the artist of the play of light.

STUDY OF SOMBRENESS

Eugene Deslaw has turned his camera upon machines and electric lights and made them dramatic and compositionally significant. André Sauvage has turned his camera upon day-by-day Paris to study the movements about its subways, quays, and markets.

Joris Ivens of Amsterdam comes to film creation as a phototechnician. His first film was a documentation of the vertical opening and closing of the Rotterdam Steel Bridge. He then made a film of the oily Dutch rains.

With his hand-and-eye camera poking under legs and between wheels, he has produced the most interesting objective study of somberness I have ever seen. This is a phototechnician's film, a film of filters and camera.

I have presented a summary of the diversified camera workers, the cinematographers. Inventors, engineers, estheticians, creators are comprised in the term cameraman. Today the newsreel has begun to give recognition to the cameraman as a creator.

The film-actor knows how important to him or to her is the cameraman, and Lillian Gish accordingly pays this tribute to one: "I have often been called a Griffith product. Well, in a way I am, of course. In a great many ways I am not. Nearly all my early pictures were directed by Tony Sullivan and Christie Cabanne, with the famous cameraman, Billy Bitzer, as valuable to the picture as the directors."

———o———

Take on Rayflex Screens

Rayflex screens, manufactured in Napanee, Ind., will be distributed nationally by Hollywood Film Enterprises. The product is based on glass beads.

The local company will distribute from three points—its home offices here and its branches in New York and Chicago.

———o———

Fall Meeting S. M. P. E.

The fall meeting of the Society of Motion Picture Engineers will be held at the Pennsylvania Hotel in New York, Oct. 20-23.

The program of papers and entertainment is already in preparation.

Back to the Camera

William Worthington, but recently retired from active service with Multicolor, which color process for film he originated and developed in company with Roland Lee and W. T. Crespinel, will again don sock and buskin before the camera, and later may resume his successful directorial career which ended when he left Sessue Hayakawa to research in three dimensional and color photography.

As stated in our July issue, the control of Multicolor was recently sold to Howard Hughes and this transfer of interests leaves Mr. Worthington free to do the things he loves best to do—act, sing and direct. Mr. Worthington was a successful featured player, musician and director before the movies became popular and he is still in demand. It was in 1925 that Mr. Worthington became interested in stereoscopic photography and began research work to develop the idea along practical lines for motion pictures.

After many disappointments and great sacrifice the project was abandoned and Mr. Worthington, his son-in-law, Director Roland Lee and W. T. Crespinel joined forces and organized Multicolor Films, Inc., with headquarters in the old Morosco laboratory building. Here they worked out the Multicolor system of color photography for motion pictures and so successful were they that the attention of Howard Hughes was attracted to the business with the result as before stated.

Mr. Worthington's success directing the great Japanese star, Hayakawa is a part of the history of the industry, and stage lovers will remember him as director of Henry Savage's great production of "Everywoman" in which he also played a part and sang.

It is a pleasure to congratulate him upon his success after long years of sacrifice and to wish him unbounded prosperity in his return to work before the camera.

Cream o'th'Stills

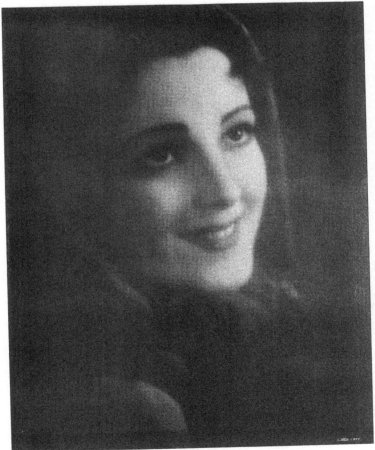

This study by Gordon Head was posed by Lea Torri, Countess de Morels. It proclaims Head in one of his tender moments and if he never photographed another picture it would be sufficient to fix his status as a master portrait artist.

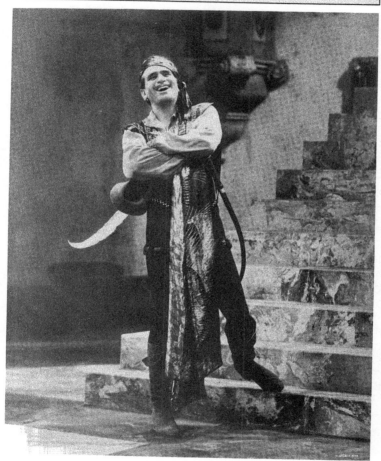

Charles E. Lynch contributes this study of Douglas Fairbanks at his best. Here Doug is seen in characteristic pose as Petruchio in "The Taming of the Shrew." Lynch loves to catch them when they are not "acting" and that's the way they must get stills of "Doug," if at all. In this case, the dynamic Fairbanks was doing a little rehearsing all by himself when Mr. Lynch surprised him.

 # Cream o' th' Stills

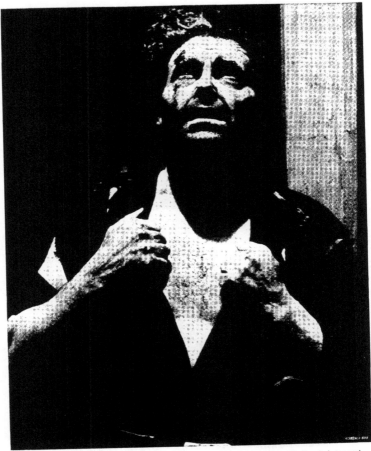

Do you recognize in this picture that master actor of stage and screen, one William Farnum? Here he is presented by Oliver Sigurdson in the leading role of the new screen version of "Ten Nights in a Bar Room." This still is the product of two great artists working in cooperation.

Cream o' th' Stills

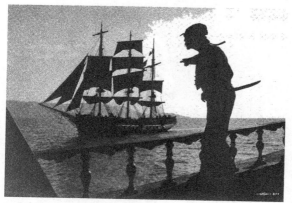

"Wooden Ships and Iron Men" is the title of the picture from which came this interesting still via the camera of David Ragin. The silhouette is reminiscent of the Jolly Roger and the Spanish Main.

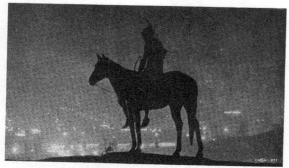

This nocturne is entitled "The Scout" by Clarence Slifer, the artist who trapped it. The fog was drifting in to partially obscure the field of diamonds and rubies that is Los Angeles at night, but the effect is still there.

How the Camera Sells Goods

A CHAIR salesman had tried for twenty years to sell chairs in the Orient.

He sold a few but not enough to encourage his firm to keep up its efforts to win the East, and the decision was made to quit.

Just then the chief executive of the firm saw one of the early industrial films and it gave him a great idea.

He would show by motion pictures how his chairs were manufactured. He did. It was a fine film, for it showed every step in the evolution of a chair from tree to market.

Triumphantly the film was shipped to the agent in the Orient.

The agent joyfully exhibited the film to his prospective customers.

They were charmingly entertained and thanked him profusely.

But they did not buy any chairs.

The agent was flabbergasted.

So was the firm.

So was the man who made the picture.

AGENT SEES LIGHT

Something was wrong.

The agent studied the film.

He ran it time and again and at last something happened.

The chair on which he sat was uncomfortable. He kicked it away and took another of different design and materials.

Suddenly a great light burst upon him.

The picture showed how a particular kind of chair was made, but it did not show how chairs were used nor the great variety to be had. The agent cabled his firm.

In time a new film arrived.

It was made by a different cinematographer and every foot of it was staged like a feature picture.

The various kinds of chairs were shown in use in the midst of appropriate surroundings—rocking chairs, folding chairs, swivel chairs, reclining chairs, hard-bottomed and over-stuffed chairs, wicker and cane chairs, chairs for rich, poor and middle class, etc.—all shown in active use in office, drawing room, boudoir, in camp, on board ship, in palace and in hovel. In short, the subject was dramatized. The chairs were made to act, they were made to live.

THE BUYERS BUY

When the agent showed this new film to his prospective customers they were not only entertained. They bought chairs.

There are two kinds of industrial films—those that do not sell goods and those that do sell goods.

The first of these classes is like the first chair film mentioned here.

The second of these classes is like the second chair film mentioned here.

What makes the difference?

The first film was shot by a photographer who knew nothing of dramatizing his subject nor how to handle people nor how to put beauty into his picture.

The second film was shot by a photographer of the I. A. T. S. E. and M. P. M. O. school—a man skilled in obtaining dramatic effects, who knew how to direct action, who knew how to light a set, how to get the full values of beauty when present or put it in when lacking—in short, an artist with a background of many years service in the studios, a master of the camera like a virtuoso is master of the violin.

KNOWS HIS BUSINESS

Such a photographer is a master of motion picture production in all its moods and tenses. He can figure costs and he can write a story or direct. He can also edit film and he knows props and materials.

In his vast experience he has shot about everything in the earth, in the sea and in the air, and nothing much can surprise him.

These cameramen have been instrumental in bringing about the truly remarkable improvements that have made motion picture photographic instruments, cameras, lenses, etc., the scientifically perfect mechanical instruments they are today.

They have fostered and given impulse to the most adequate sensitive materials which make that wonder of all wonders, the modern motion picture film.

STRONG ON RESEARCH

They have studied and fostered the laboratory procedures most adaptable to these sensitive emulsions.

They have brought about the most efficient system of artificial illumination that can be devised in connection with the films and laboratory procedures and, with all this, they have not only continuously striven for improvement in the quality of their work, which is reflected in the professional reputation of their members, but also in the economic factors of the making of pictures.

The school of the I. A. T. S. E. and M. P. M. O. is the school of perfection in motion-cameracraft and the graduate of this school is the master of every phase of photography.

Because of the peculiar organization of the motion picture industry there always are a number of these cameramen available for engagements to make industrial or educational pictures, and the services of these photographers are offered to those individuals and firms planning to have industrial motio pictures made for the purpose of exploiting, advertising and selling their products.

The camera is a sure-fire salesman when directed by a cameraman qualified to wear the insignia of the I. A. T. S. E. and M. P. M. O.

A Friend from U. of M.

James C. Lawrence, assistant to the President of the University of Minnesota, accompanied by Mrs. Lawrence and their two charming children, stopped in Hollywood early in August to call upon the motion picture industry in general and the Academy and cameramen in particular.

The U. of M. is one of the greatest, most progressive and most affluent of the great educational institutions of the world, with an endowment exceeding fifty millions of dollars and a student body of over 27,000. It is immensely interested in motion pictures, particularly from the artistic, scientific and photographic angles.

Two years ago the University of Minnesota through Mr. Lawrence invited a brother cameraman, Joseph Dubray, to address that body on motion pictures from the standpoint of the camera, and Mr. Dubray, as the representative of the A. S. C., fulfilled the engagement with eclat. This year the university repeated the invitation, and Mr. Dubray, now of the Bell & Howell Company, again covered himself 'and the cameramen with glory.

On his recent visit here Mr. Lawrence visited the Academy, where he met Secretary Frank Woods, Lester Cowan and Don Gledhill, and invited the Academy to co-operate with the University of Minnesota by sending specialists to address the student body and faculty. Mr. Lawrence and family made a survey of Paramount Studios and also visited the A.S.C. and the International Photographers.

It was evident from his comment in general on the subject that the tremendous influence of his great school has definitely been given to the support of the motion picture industry, and it is with pardonable pride we reflect that the cameramen largely may take credit to themselves for bringing about this most desirable entente cordiale.

---o---

Our Cartoonist

Glenn Kerschner, the clever cartoonist who usually has a message in art for our members in the pages of this magazine, has a field to himself, apparently. He knows the life of a cameraman from crank to rushes and he has a sense of humor and an understanding of human nature to match his intimate knowledge of the craft. That's why his cartoons go home. But Mr. Kershner's cleverness is not limited to his pencil. He is a musician of great talent, and though it may not be generally known it is nevertheless a fact that Brother Kershner also has a remarkable directorial ability. For several years he directed, photographed and produced "Ford's Weekly," and if our gift of prophecy is not entirely at fault it will not be long until he takes up the megaphone for keeps.

---o---

The articles by "Criticus" will be resumed in October.

Amateur Cinema Art

Two Samples of B & H Equipment

Shown at the right of the accompanying cut is the B & H Filmo all-metal tripod, built with tubular extension legs and simply locked when in position. The swivel head is inclosed and dust proof. One of the chief claims advanced for the tripod is its steadiness.

In the center and on the left is the B & H photometer, designed to enable the photographer to secure accurate and rapid exposure readings. Three motions will yield a direct view of the object to be photographed, instantaneous readings and accurate exposure.

THE rise and expansion of the 16 mm. business in no way has interfered with the sale of still cameras for the home trade. That is the declaration of H. S. Wetmore of the cine kodak department of the Eastman Stores in Los Angeles.

Not only has the sale of amateur motion picture cameras not militated against their older brother, the still instrument, but if anything it has stimulated the demand for them, Mr. Wetmore insists. In explanation he points out that in a great many cases buyers of 16 mm. cameras have had no previous photographic experience. As they learn more of the ways of their acquisition they aspire to progress along the film road, and their next step is to purchase a still camera.

The first one is usually a small instrument and of moderate cost. As the bug bites deeper and ambition is stirred the apprentice aims to reach out. And if he has the price to draw upon invariably he does do just that.

In the seven years marking the rise and development of the smaller film the Eastman company alone has established ninety service or processing stations for customers the world over.

In the beginning there was but one of these in the United States—Rochester. Now in this country there are eight, of which Hollywood is the latest. Here there is a fine structure adjoining the Brulatour headquarters on Santa Monica Boulevard.

STEAMERS WILL INSTALL

Illustrating the service facilities that follow the photographic traveler around the world there are three projection rooms in the local Los Angeles Eastman store in Hill street.

Asked as to the accommodations provided for amateur photographers on ocean stemships, Mr. Wetmore said already two around the world boats had provided processing stations. The last of these was the Belgenland, manned by a corps of experts provided by the Kodak company.

It was only a question of time, the Eastman man suggested, before all large liners will carry processing quarters for amateur films. Encouraging this action is the disposition of governments to remove the impediments that in the past have deterred travelers from carrying motion picture cameras. First of these is the duty on motion picture film.

Until recently duty had to be paid on 16 mm. at the same rate as that imposed on standard. Under the new United States tariff the rule is laid down that film of 16 mm. or smaller, manufactured by an American company and devoted to non-commercial purposes, shall be exempted from payment of duty.

FAMILY MAN CHIEF BUYER

While the chief purchasers of 16 mm. equipment were either men at the head of a growing family, sportsmen or travelers, it is to the first named classification that go the larger number of sales, declared Wetmore. The idea of creating a library that will contain motion pictures of the children in a family, from infancy to maturity, is one that requires no great quality of salesmanship to sell to a prospect if he be the head of a family of youngsters.

Regarding color pictures the Kodak man said the sales were increasing steadily. One of the factors contributing to their popularity was the comparatively slight margin of 20 per cent additional cost over that for black and white panchromatic.

Asked as to what particular department of professional motion picture makers contributed most largely to the buying of 16 mm. equipment Wetmore suggested it was surprising the number of directors who were becoming steady customers.

Adding to Life of Film

The Albert Teitel Company, New York film expert, for many years has been answering the question of how to prolong the life of film. The problem is recognized as a vital one by distributors of theatrical subjects, accustomed as they are to frequent replacements of prints.

Amateur photographers, desirous of handing down to a succeeding generation shots of intimate family happenings, are particularly concerned about preserving that record. They have not the advantage of being able to wire the laboratory to make another print, as the theatrical distributor can do. Again the big picture is on the market for a year and then retired, where the family film is practically always subject to call.

The Teitel company aims to do two things among others: To secure through its New Life method, impregnating the film with moisture, removal of brittleness; also in combination with this process the application of the Scratch Proof method.

The treatment is applied to new films preferably and also to old.

Critical Focuser for Amateur

To give the amateur the same precise focusing facility that the professional cameraman has had at his disposal in the Bell & Howell standard studio camera, this company's engineers have designed a critical focuser for the Filmo 70-D home movie camera.

This unit includes all the advantages of the professional camera focusing system and, further, gives an even greater magnification of the image—a magnification of 25 diameters. This magnification is of great help because the minute details of the object to be photographed are thus rendered clearly visible and can, therefore, be brought to a critical degree of sharpness with the least effort on the part of the operator.

New B. & H. Device

AMAZINGLY simple and practical, a new device for automatically cleaning 16 mm. motion picture film, as it is being projected, is announced by the Bell & Howell Company. No longer will the home-movie projectionist need to clean his film laboriously and ineffectively by hand.

The B. & H. Film cleaner, as it is called, not only prolongs the life of film by removing grease, oil spots and dirt, but the new screen brilliance resulting from film scientifically cleaned is a tremendous factor in securing perfect projection.

This new device, which weighs only 14¼ ounces, is quickly attached to a Filmo projector and is as quickly detached. The film is thoroughly cleaned on both sides as it runs through a pair of tapes moistened with Filmoleen, an especially prepared cleaning fluid. Under well-regulated pressure, the dirt and grease are automatically wiped off. Then in passing through the projector mechanism, the film becomes perfectly dry before it reaches the take-off reel.

Clean tape is brought into place at a turn of a knob whenever the old tape gets dirty. A 3-foot roll of tape is supplied for each side of the cleaner—enough to clean many feet of film.

Rounding Out First Year

The firm of Ries Brothers has completed its first year as Hollywood Eastman representative in the professional as well as the amateur field of photographic supplies. Both Park J. and Paul were cameramen before entering business for themselves ten years ago, first at 6035 Hollywood boulevard, then in Western avenue, and for six months past in commodious quarters at 1540 Cahuenga avenue.

One of the features of the new home is the darkroom, one of the best equipped in the city.

The Entire 16 mm. Industry Is Going Talker

THE entire 16 mm. industry is going talker just as the professional 35 mm. industry turned to sound practically overnight, declares Walter W. Bell, manager of Cine Art division of Hollywood Film Enterprises.

This is the report the Hollywood man sends from New York, which city he reached early in August after a six weeks' trip across country in the interest of Cinevoice, the 16 mm. talking device distributed by his company.

Bell traveled 5842 miles from Hollywood Boulevard to Times Square. He rode with or on the heat wave, where records for high temperature were being steadily broken, but in spite of the unfavorable conditions he says dealers he was meeting for the first time met him with open arms and also with smiles when they learned he brought with him a sample of talking 16 mm. films.

STRONG FOR 16 MM. SOUND

Among the cities in which the major dealers looked over Cinevoice were Salt Lake City, Denver, Kansas City, St. Louis, Detroit, Toledo, Cleveland, Buffalo, Rochester and Philadelphia. Results from the viewpoint of orders were practically 100 per cent, the Hollywood man reports in a note to International Photographer.

The manager of the Cine Art division of the Hollywood company—in fact one of the pioneers of the 16 mm. field—was putting all his eggs in that small basket when the world and his wife could see nothing in this tiny stuff. He had had much experience in the 35 mm. field before he started in a minor way in the home field, opening offices in San Francisco. That was about four years ago.

One day Bell wrote Bill Horsley regarding 16 mm. matters, unwittingly revealing to the local laboratory man that the writer knew something about 16 mm. Horsley had been looking for just such a person. He hopped into his machine and started post haste for San Francisco.

JUDGMENT VINDICATED

The result of that visit was the removal of Bell and his business to Beachwood drive in Hollywood. The volume of orders increased so rapidly that the 16 mm. product submerged the 35 in the lab. Some time since Cine Art was taken over by the Horsley company.

Ever since the coming of sound upset conditions in the professional field Bell has been working to find a satisfactory device for the amateur trade. As soon as the demonstrations on Cinevoice convinced him it was "right" he wasted no time in setting out across country, meeting for the first time hundreds of dealers with whom he has been corresponding for several years.

The Hollywood man writes that finding practically all dealers interested in the talking phase of home pictures affords him a great deal of

Hot Points

Conducted by Maurice Kains

ONCE in every blue moon the time comes when you wish you had a camera jack or two, and they invariably can't be obtained or located.

I noticed Ed Hammeras of the Fox miniature department using a clever substitute for a camera jack, and it works. Take a turnbuckle and cut it in half with a hacksaw. Now cut the hooks from each end and sharpen the remaining ends on the grindstone or with a file. Keep both of the jacks, because you'll need two jacks on a free head. Just drill a hole through the pointed end and tighten jack with a nail. Isn't that a dandy idea? Now you send a hot point in to me and get credit for it.

Clever Camera Car

A certain transportation company here in Hollywood rents the cleverest camera car I have yet seen. I wonder why the studios don't copy it.

It is a Ford chassis with a body similar to a laundry truck body. There are three doors on each side of the car. The interior is arranged in shelves. The equipment that is not likely to be needed is stored on the upper shelves, while the lower shelves are used only for the cases that have to be opened occasionally.

The front compartment, just behind the driver's seat, is generally empty when on location and is used for an emergency darkroom and loading room or for developing tests.

The car follows the cameras on practically each and every setup.

Getting Even Pressure

J. P. Van Wormer has a stunt for making the Mitchell pressure plate safer for assistants. Van finds that sometimes when loading the cameras in a dark place there is a possibility of pushing the spring which holds the pressure plate too far into the camera, thus causing an uneven pressure on the plate, which could throw the picture out of focus on one side. Van's idea is to mill out a tiny slot in the back of the pressure plate, just in the center. As the spring is pushed over the end of the spring snaps into the slot and holds the plate correctly, securing an even pressure over the entire pressure plate.

Come on, guys! Let's have more and hotter "HOT POINTS." We need 'em! Address them to me at the office.

personal gratification in that it was a vindication of his judgment.

In New York Bell has been negotiating with some of the large producers regarding 16 mm. distribution rights. Indications are that on his return he will have something of large interest to tell the 16 mm. trade. He is expected home shortly after Labor Day.

The Daily Grind

By RALPH B. STAUB

Bob La Prell—Clothes always give me a lot of confidence.

Bob De Grasse—Yeah, you can go so many places with them that you can't without them.

Ben White says the height of something or other is a colored man having an operation and getting sewed up with white thread.

Joe Morgan—I know a joke about a skirt.

Jim Fernandez—Tell it.

Joe Morgan—Naw; it's too long.

John Fulton—Give me peach pie.

Waiter—We're out of it.

John—Give me a raspberry, then.

Waiter—Sorry, sir, but we waiters are not allowed to be rude to guests.

Mike Joyce to Elmer Fryer—That swell looking gal may be dead from the shoulders up, but she can bury her head in my arms anytime she likes.

Irving Glassburg (talking to cop) —Would you help me find my car? Here's my key.

Bennie Kline (showing painting)

—It took me eight years to complete this work.

Rube Boyce—Remarkable.

Ben—Yes, one week to paint it and seven years and fifty-one weeks to sell it.

Teacher (in night school)—Can you give me a simple problem in division?

Roy Hunt—Sure; how much water does it take to make two quarts out of three pints of gin.

Hal Porter (to script girl)—You should see the new altar in our church.

Girl—Lead me to it.

Si Snyder says a bathing suit is a costume with no hooks on it, but plenty of eyes.

———o———

"GALLOPIN' THRU HOLLYWOOD"

DEWEY Wrigley at the CARTHAY premiere of HOLIDAY ditto

BILL Thomas shooting STILLS.

FRANK Blackwell shooting

NEWSREEL next to ME at same premiere. LEO Shamray making OPPOSITION reel and LIKING it; always FELT Leo was a COMPETITOR. VISITED Marilyn Miller SET met Ernie HALLER and his ABLE assistant HARRY Davis who HANDLES all of ERNIE'S closeups of MARILYN Miller. FREDDIE Kaifer up and AROUND on crutches but IT won't be long before THEY'LL be in the ashpile GLENN Kershner drawing PICTURES of our prizes FOR the annual golf TOURNAMENT I hope none of YOU boys are neglecting TO JOIN THIS TOURNAMENT TO BE HELD ON SEPT. 7TH AT PALO VERDES GOLF CLUB A GREAT TIME WILL BE HAD BY ALL (ask the boys who went last year). POLISH up your niblicks, boys; THANK YOU.

RALPH B. STAUB,

Huntington Library and Gallery

A Gold Mine of Art and Information Ready to the Hand of the Cinematographer

By SHIRLEY VANCE MARTIN, Local 659

HOW many members of the photographic fraternity are aware of the fact that they are the heirs to a gold mine—a mine inexhaustible in "pay dirt"? A mine whose wealth may be carried away in as great quantities as the desire of every individual may dictate and still leave enough for all who follow. This mine has been presented by deed of gift to us all and yet—like the Britisher who had never seen inside the Tower of London—not one in twenty of us has taken the trouble to drive a mere handful of miles to view his heritage, much less bring back from this great mine a tithe of the precious material which has been bestowed upon him.

This gift to "The People, whomsoever," is the Huntington Art collection at San Marino, a matter of two or three miles south and east of Pasadena.

And the wealth therein contained is a wealth of paintings, art objects, historic bronzes, miniatures, marbles, tapestries, porcelains, all by recognized masters; every line and thread and contour denoting Art in the highest degree and all a wealth of information, historic erudition and artistic education which cannot fail to be of value to every member of every creative craft—would he but spend the time to go take what has been so generously offered him.

This collection originated as the personal collection of Henry M. Huntington for his own joy of possession. For many years he not only gathered materials in his own travels, but for the collection of books, manuscripts, rare volumes and first editions, agents in practically every quarter of the world sought for authentic pieces which might bring the entire collection to the perfection which he sought.

Now the library collection embraces more than 175,000 volumes dating from long before books were printed, including the first book that was printed, the Gutenburg Bible (circ. 1425), to those of our own times.

This library is the greatest repository of English books printed prior to 1641. It contains one of the most remarkable and complete collections of Shakespeare. Of manuscripts and papers other than books there are more than 800,000, each of profound interest and great intrinsic value. Of our modern times it holds the largest Lincoln collection as well as of works on the Civil War.

An exquisite park of more than 200 acres the Huntington estate invites the lover of the outdoors to linger long under the huge trees and along the quiet walks; the vast gardens, courts, patios planted to all manner of exotic ferns, flowers and shrubs, beguiling one with a sense of restfulness and quiet in perfect keeping with the spirit of the place and entirely apart from the mad rush of the outside world.

A Japanese sunken garden, perhaps the largest and most perfectly planned hereabouts, fully satisfies the picture-seeking eye, while a vast cactus garden full of the rarest species of the prickly tribes begs to be not overlooked in its sandy desert setting.

On every hand views and vistas and nature's pictures while one stands before the great bronze figures of the Apollo, Diana, Hercules, Antinous the beautiful, placed before the library building, thrilled with the knowledge that these were the very pieces ordered by King Francis II, torn from their bases by the French Revolutionists and lost, to turn up fifty years later in the gardens of an English earl.

The entire estate as originally planned was purely for the pleasure of the Huntington family without concrete thought as to its passing on to the American people. And what is now the Art Gallery was the home place, and a real home it was with the vast living rooms used as living rooms, Mr. Huntington's favorite being the library lined to the ceiling with carved English oak, carved and built abroad and afterward set up at San Marino as it now stands.

All rooms have had to be somewhat modified to suit the needs of an Art Gallery though still retaining a feeling throughout of intimate personality foreign to most Art Museums.

For the interest of those of us whose trend of mind and heart are toward pictures there is a great collection of the very best examples of works of the English painters of the eighteenth century. Gainsborough, perhaps, heads the list, with George Romney, Sir Joshua Reynolds, Sir Thomas Lawrence following close in representation.

One of Turner's most gorgeous creations is there. Eight large tapestries from the French looms of Beauvais are marvels of beauty in design and workmanship, and valued by the square inch.

In the rooms dedicated to Mrs. Huntington Italian primitives hold the principal place, while in one corner of this same primitive room an original bronze by Benvenuto Cellini shows the exquisite grace of that great sculptor.

Each painting, bronze, each piece of Tom Chippendale's marvelously beautiful old furniture holds the fascinated gaze of the visitor, who realizes that it is a perfect example of the master craftsman or is of great historic interest or has, like the two Chinese vases of the Kien Lung dynasty, come down a thousand years of time to be at last bequeathed to the people of today.

A volume might be written describing the cabinets and console tables of exquisite French workmanship delicately inlaid in woods so rare even in the day of their construction as to be almost or quite unknown in the present time. Ornamented with heavy bronze ormolu gilded, and requiring years in the making each piece bears the signature of its maker. The cabinetmakers of that splendid Empire period were artists, and in every line and curve their product showed the hand of a master.

Only as one stands before such marvelous paintings as "Pinkie," Romney's "Lady Hamilton," the divine lady of Lord Nelson; "The Tragic Muse," the more famous "Blue Boy" and many more equally beautiful examples of eighteenth century masters can the fact be realized what a heritage in art and what an opportunity for self-improvement have been given to us "to have and to hold."

A single visit gives one but a scant and superficial idea of this great accumulation of pictures and art gems. The case of ivory miniatures, painted by the famous miniaturists of the later eighteenth century, framed in precious stones, alone warrant a day spent among them; but to the "seeing eye" and to that one ever anxious to improve his own art feeling, each visit and every subsequent hour spent in the gold mine of this collection gives a deeper appreciation of its meaning to us all and a greater joy in the sharing of its riches.

A few random remarks on the more material side of the estate may be not uninteresting. The library building, housing not only the immense number of volumes but manuscripts, old, old maps and globes, bindings studded with gems, besides paintings and marbles, is constructed entirely of steel and concrete, opal glass forming ceilings and floors; while all volumes on display, as the Gutenberg Bible, the first copy of the present St. James Bible, the No. 1 copy of "Milton's Paradise Lost" are all within heavy plate glass cases.

To those who might be tempted to

(Concluded on Page 26)

Above — Lower main corridor in Art Gallery. Left center, top, rear entrance to Art Gallery. Center row, left, a room in Art Gallery.

At right—One of the charming court yards of the Art Gallery, formerly the home of the Huntingtons. Bottom row, center, the famous Blue Boy. Below, a priceless chest.

Library and Art Gallery, San Marino, Calif.

Above—Left to right. Main entrance to Library; the celebrated painting, "P i n k i e." Center of lay-out, Gutenberg Bible. At left, one of tapestry exhibits.

At left—One of the rare vistas looking toward the mountains. This is a shadow-lawn, lined with cocas palms and in the background a glorious view of Mounts Wilson and Lowe.

Huntington Library and Art Gallery

(Continued from Page 23)

follow the example of that one who kidnapped "Mona Lisa" bodily from her frame in the Louvre, I might say that these vast buildings are protected by the most perfect systems of alarms yet to be devised.

Every door, window, or aperture six inches square is so guarded electrically that the insertion of so little as a knife-blade would cause some one of three separate systems to give strident voice to any untoward attempt on the part of an unwelcome visitor. Guards are everywhere.

On August 30, 1919, Mr. Huntington conveyed to "All people, whomsoever," this entire collection to be administered by a Board of Trustees for the people, so that upon his death in 1927 this organization was already smoothly functioning. Shortly thereafter the formal dedication and opening took place.

Personal contact with those who have the stewardship of the collection is a pleasure, indeed, as each is learned in pictures, books or art in other forms and always a most courteous fount of knowledge to those who would learn of the beauties of the collection.

In conclusion let me quote Leslie M. Bliss, the librarian: "And so what many thought to be only the passing whim of another wealthy collector has resulted in the founding of one of the world's greatest libraries and an institution which is to be an active force for increasing the world's knowledge."

U Spending a Million

Plans have been completed for the construction at Universal City of what it is claimed will be the most efficient film laboratory in the world.

The new building, which will cost approximately $750,000 and will be of reinforced concrete, will have a basement and two floors, but will be constructed in such a manner that it may be heightened at will.

Adjoining the laboratory will be a large camera building, while a similar structure on the other side of the laboratory will house the film vaults and cutting rooms.

Two hundred thousand dollars is being expended for the construction of two huge sound stages. Plans for these, which will be named Nos. 17 and 18, call for two adjoining buildings, each 150 feet square, with soundproof partitions which may be swung open like huge doors, converting the two buildings into one stage.

A unique feature of the stages is that all sound equipment will be of the portable variety, which may be moved from one stage to another or follow a company from the studio to location.

Review-ettes

IF you are looking for some lessons in what Lindsley Lane would call "psychologically-apropos chiaroscuro," go and see "The Storm," for that picture is wonderful in its lights and shadows, and the old master who teaches the lesson is none other than Alvin Wyckoff.

This picture had its premier in Los Angeles at the Million Dollar Theatre and immediately scored a box office hit.

The story is of the French-Canadian type and its title may most certainly be classed as onomatopoetic for the word "Storm" surely describes what happens in this picture.

It roars its way through water and air and through the hearts of William Boyd, Paul Cavanaugh and Guadaloupe Velez.

"The Storm" is a Universal picture, cleverly directed by William Wyler, and the best screen melodrama for a long time.

Good as the picture is in all its major elements, Mr. Wyckoff's photography is the finest thing about it.

Verily, he had his opportuntites and, like the cameramaster he is, took full advantage of them, particularly in the sequences in which Fachard and Manette, in their birch canoe, shot the rapids; the leap and escape of Fachard; the blizzard and the snow slide.

It will be a long time before there is recorded on film another series of water shots like those made by Wyckoff. His materials were rich and he painted his picture with bold and trenchant strokes, as is characteristic, and yet in the tender sequences his touch is as gentle as a zephyr.

"The Storm" is an additional wreath of laurel in the collection of Wyckoff, who has always been an ornament to his craft, and if you want to see a real, for sure, honest, old fashioned, movie, don't fail to see this piece.

Good projection helped to bring out the photography and the sound also was well recorded and reproduced.

———

AT Hollywood Pantages Theatre during the week of August 18th, there was shown the M-G-M picture, "Romance," starring that exotic actress from the northland, Greta Garbo.

The Garbo needs no one to sing her praises. She IS and that's enough, but it may not be superfluous to mention that in the role of the Italian diva she is at her best.

This femme from the fjords is in a class by herself and has a line of stuff decidedly her own.

As a camera subject she is difficult, but once properly lighted, Garbo is a delight to the photographic eye.

In "Romance" William Daniels accomplishes a most creditable bit of cinematographic engineering. It is interesting to study his problems from the screen and it is evident that he had a sympathetic director working with him in the person of Clarence Brown, whose masterly direction is evident in this production.

It is not difficult to tell by a study of a picture on the secreen just where the master cameraman is forced to make a shot against his better judgment for, if the cameraman knows how to light his shots his technique is obvious and when aribtrarily interfered with it is immediately reflected from the screen.

In "Romance" there must have been a sympathetic understanding between director and cameraman, for the tempo was smooth and the lighting of nearly 100 per cent of the shots correct.

The sound recording was eminently satisfactory and the projection, as usual at Pantages, first class.

The work of that fine old actor and friend of cameramen, Lewis Stone, was delightful and, all elements taken into account, "Romance" is a credit to the industry.

———

FLOYD BACON brought it home in his direction of Warner Brothers' "Moby Dick," the latest starring vehicle of Mr. John Barrymore, which opened at Warner Brothers' Downtown Theatre about the middle of August.

The picture is as vigorous as "Shore Acres" or "Hearts of Oak," of old time. The odor of whale oil is all over it and the sea-going New England spirit is never absent.

Mr. Barrymore, of course, lives up to his screen traditions, dominating the piece from main title to fade out. But he isn't just the poetic and appealing soul he was in the silent version, made a few years ago and entitled "The Sea Beast."

The production is done with a fine vigor and considerable intelligence and the photography under the direction of Robert Kurrle is one of the three outstanding elements of the entire work. He overlooks no opportunity to write his story with bold and skillful strokes in keeping with the psychology of his dramatic material.

The clear, steady direction had more to do with the excellence of the screening of this picture than any but a careful observer would note.

———

"TOP SPEED," featuring Joe Brown, at Warner Bros. Hollywood Theatre, represents a fine piece of camera work by Sidney Hickox.

That wild ride in the closing scenes is an extraordinary bit of high powered cinematography ably managed and brilliantly recorded.

This particular series of shots is called into being by a runaway speed boat which is wilder than any broncho ever busted.

Also there are many scenes of sheer beauty in the picture and the direction is capably handled by Mervyn LeRoy, who evidently cooperated with his cameraman.

———

NORBERT BRODIN is receiving an avalanche of compliments on the masterly manner in which he put "Holiday" on the film for Pathe, now running at Carthay Circle.

Mr. Brodin had something to shoot at, for the story, sound, cast and direction co-operated 100 percent to produce a picture which provoked such press comments as this by Llewellyn Miller in the "Record": "A rare union of wit . . . humor . . . good taste . . . like a breath of fresh air . . . after the over-heated sentimentality of so many pictures . . . I hope it runs until Christmas . . . so that I can send tickets to all my friends as the perfect gift."

Strange how our perfectly good critics persist in ignoring the photography and the cameraman in their reviews when the camera is the sine qua non of the picture—the fulcrum upon which the entire industry turns.

With no intent whatsoever of being impertinent one would almost conclude that the average reviewer knows nothing of the art of motion picture photography and therefore does not attempt to judge it.

In this "Holiday" opus Ann Harding again asserts her histrionic cleverness. She is decidedly worth seeing and hearing, and don't forget Norbert Brodin. He is very much in that picture even though you don't see him.

———

"THE DAWN PATROL," at the Orpheum, but recently, while not another "Hell's Angels," is a great aerial picture and those who are not fed up on pictures of this kind will find in it an entertainment decidedly worth while.

It has a real story and its featured player, Richard Barthelmess, in his performance in the role of the flight commander, measures up fully to the stature of his best previous characterizations.

The production under the direction of Howard Hawks is big and fine and his handling of the dramatic sequences was done with unusual power and imagination.

The photography under the direction of Ernest Haller was brilliant from first to last and much of it was difficult to handle.

Here is another picture where perfect co-operation between director and cinematographer produced a masterpiece.

The sound and projection leave nothing to be desired, while the cast is without exception in capable hands with Neil Hamilton doing an extraordinary piece of work.

"The Dawn Patrol" is in all its major elements a motion picture spectacle of distinction.

One of Local 659's Examples of
Success Through Application

IN the ranks of Local 659 are many striking examples of what may be achieved by a combination of ambitious perseverance and applied ability—and one of the notable of these is supplied by Lee Garmes.

From prop boy fourteen years ago to top camera in a Samuel Goldwyn troup in 1930 covers a lot of ground, but that is the story. It is not altogether a tale of steady progression from one job to another a little better and more remunerative. There have been lean days, but they never were permitted to slow down the determination to get ahead.

Garmes entered picture work in 1916 when he left school. His initiation was as prop boy. Gradually his field was extended as is customary in work of that kind. He had his days as second assistant director and as first assistant. But always there was a hankering for fussing around a camera, and no opportunities were overlooked for getting his hands on the instrument.

As a result in 1918 Garmes "hired out" as a full-fledged cameraman. Among the companies for which he worked were Universal, C. L. Chester, and Robertson-Cole.

It was toward the end of 1925 before Garmes was assigned to his first

major feature—"The Grand Duchess and the Waiter." As a result of his work on that subject he was signed

Lee Garmes, Local 659

by Paramount for a year at its New York studio.

SHOOTS PICTURE IN FRANCE

Then Rex Ingram took the young photographer with him to Europe for work on "Garden of Allah."

First National offered Garmes a contract. It was accepted, and as a result some of the major productions of the Burbank studio went out to the world under the photographic imprint of Lee Garmes.

The first picture was "Rose of the Golden West," followed by "Helen of Troy," "Love Mart," "The Barker," "Little Shepherd of Kingdom Come," "Yellow Lily" and "Captive Woman."

Among his Technicolor pictures are "Song of the Flame," "Bright Lights," "Mademoiselle Modiste," released as "Toast to the Legion," and "Whoopee."

The last named was a Goldwyn-Ziegfeld subject, the cost running into seven figures.

Garmes has just finished shooting "Morocco" for Paramount, which company secured his services from Goldwyn. The photographer now is back on his home lot, where he is preparing to shoot "Prodigal," starring Ronald Colman under the direction of Irving Cummings, loaned by Fox for the picture.

An interesting phase of the Goldwyn engagement is that the only bond between cameraman and producer that the former will remain in his employ for a year is a handshake—a "gentleman's agreement."

And that situation in Hollywood constitutes a tribute of one man to the other, a tribute to character as well as to reputation.

By HARRY BIRCH

666 Now at Home

WELL, well, the biggest news that Local 666 has to broadcast this month is about our new home. Local 666 has new headquarters with address at 1029 South Wabash Ave., Chicago. Visiting members will be welcome at all times and you will always find an easy chair to camp in, providing, your card is paid up to date.

The young lady will be waiting at all times to "collect." Next month we will publish some photographs of our new home. However, don't forget the address when in Chicago.

SIX SIXTY SIX

Vacation Time

It seems that even cameramen take vacations. I have looked around for some of the boys to find out what is going on, but no luck. Oh, well, vacation or no vacation, 666 must have the "Page" with its nice new heading an' ever'thing!

SIX SIXTY SIX

Reminiscing

With the "timely gossipers" on vacation I was just wondering how many of the boys remember:

When Gene Cour wore a derby and had three Fords stolen in one year.

When Norman Alley made "stills" and thought he was the "cats" minus the mustache, and later drove a Buick touring with no brakes.

When "Bull" Phillips and Charles David were making "black and white" comedies.

When Charles Gies was chief title "shooter" at Rothacker's.

When Rothacker's camera department claimed Wesley Smith, "Billy" Aldis, "Bing" Klingensmith, Eddie Linden, "Shorty" Ries, Tiry Miller and Harry Birch.

When Bill Strafford was putting the O. K. on expense accounts for Selig-Tribune.

When George Bertram walked to work at Rothacker's.

When Oscar Ahbe ran a post card studio and collected with a gun.

When Martin Barnett hired a red cap (25c) to carry his Eyemo on a stunt.

When Harry Birch wore a leather coat and made twelve stories a week for Fox News.

When Sam Embers was an actor.

When "Red" Felbinger was chief cameraman for Cathedral Film Company.

Motion Picture Industries Local 666, I. A. T. S. E. and M. P. M. O., of the United States and Canada

President
Charles N. David..........Chicago

Vice-Presidents
OSCAR AHBEChicago
HOWARD CRESS............St. Paul
HARRY YEAGER............St. Louis
W. W. REID..........Kansas City
RALPH BIDDYIndianapolis
J. T. FLANNAGAN.........Cleveland
TRACY MATHEWSONAtlanta
GUY H. ALLBRIGHT..........Dallas
RALPH LEMBECKCincinnati

Treasurer
MARVIN SPOORChicago

Secretary
NORMAN ALLEYChicago

Financial Secretary
WILLIAM AHBEChicago

Sergeant-at-Arms
HARRY BIRCHChicago

Board of Executives
CHARLES N. DAVID WILLIAM AHBE
OSCAR AHBE HARRY BIRCH
MARVIN SPOOR WILLIAM STRAFFORD
NORMAN ALLEY EUGENE COUR

Offices
1029 So. Wabash Ave., Chicago
BULLETIN—The regular meetings of Local 666 are held the first Monday in each month.

When Charles Ford carried the "responsibilities" of the I. A. in Indianapolis.

When Dave Hargan had hair and drove a Henderson car.

When Howard Hurd chased copy around the Chicago Journal.

When Granville Howe was chief cameraman for Otto Brinner, alias "Hyne."

When Jack Rose owned 29 hats, actual count, and rode the Broadway car to work.

When Conrad Luperti was the miniature expert.

When John Seitz was boss of the wash room and Otto Himm was his trusted assistant.

While you are with us, Brother Kelley, do not hesitate to call on Local 666 for any help that we might give driver.

When Max Markham was a race driver.

When Bert Kleerup was skinny.

When "Bull" Phillips was a prop man in Florida and advance man for a circus in Canada.

When Shorty Richardson was a "still printer" in Paris.

When Charley Boyle was in the transportation business in Chicago. "Check and double check."

When E. R. Trabold wore spurs to ride a flivver in France.

When Art Reeves bought a run-down Pathé from the great Phillips.

When Walter Lundin was a swimmer in the Chicago river marathon.

When Urban Santone signed his name Jr.

When Red Kuersten and Sam Savitt were officials in the Punch Board Film Company.

When Verne Blakely was an understudy of Jack Rose.

When Harry Zech was "head" man of Essanay and among those present were Dave Hargan, Jack Rose, Art Reeves, Bill Miller, Smitty, Major Spoor and Frank Williams.

Well, well, and so we could ramble on, but I wonder how many remember "way back"?

SIX SIXTY SIX

Visitor

Chicago was honored by a hurried visit from W. W. Kelley, of Local 659. Brother Kelley rushed in on us, and wanted to know where he could buy an "arm full" of developing tanks and other equipment. His journey here seems to lead to Peoria, Illinois.

SIX SIXTY SIX

Police Call a Cop

It seems that Brother Norman Alley will be forced to hire a policeman to watch his automobile. Brother Alley was "shooting" a story at the detective headquarters in Chicago, while his mighty Studebaker was standing outside. Finishing the job, he discovered his car was gone.

Note.—Alley, why not buy a new Austin. You could take it inside with you.

SIX SIXTY SIX

Henry Sells Another?

Business must be good or discounts lower—Brother David was seen with a new Ford roadster—maybe Charles won it in a beauty contest or somethin'.

SIX SIXTY SIX

Wires Will Be Wires

It seems that in the building of a short wave radio receiver Brother Charles Ford needed some special wire to complete the job. He sent Brother Jack Barnett out in the afternoon to find this wire for him. Barnett in searching the town for this special wire met some of his old friends, and as it was very hot Jack
(Turn Page)

and his friends entered into the spirits of the occasion and the entire party was a huge success until Barnett remembered the wire for Ford's radio.

After much thought, Barnett decided not to disappoint Brother Ford, so he immediately went to the Western Union office and sent the following telegram to Ford's home:

"Dear Ford: Here's your wire. Kindest regards."

P. S.—We understand that Brother Ford has permission from the chief of police now to carry a cannon—so if you are in Chicago don't send Ford a "wire."

Tony Wants Sound

These sound men must have sound. While Tony Caputo was "shooting" a news picture on the Bamberger-Watkins baby mix-up it seems that the babies were behaving very nicely, smiling and enjoying posing for the movies, which is very unusual for crying babies. Tony decided he wanted some noise. "Hey, nurse," he yelled, "squeeze one of those babies so it will give us a little sound"—and then Tony got a real "squawkie."

Scoop or Trouble

Our President, Charles N. David, was seen with his head buried under the hood of a Packard. A Chicago policeman was with him. At first we thought he had lost his new Ford and was looking for it under his hood! However, the truth must come out. The Packard had been standing on Wabash Avenue for about ten days and Charles and the cop decided to find out to whom it belonged. Serial numbers proved it had been stolen from Milwaukee. If there is a reward given, David claims the boys are in for a big feed. (It looks like another evening at Won Kow's.)

In Focus—In Spots

By Birch's Sassiety Reporter
Mr. Harry Birch, Editor,
The Page,
Chicago, Ill.
Dear Boss:

Har! Har! Har! Har! Excuse all the hilarity, Harry, but honest I can't help it. I'm sitting up here in the north woods 'ritin' this, and honest, Harry, I just gotta give the "rasp-berries" to youse guys what's sweltering down there in Chicago in the heat.

It must be tough for old Charlie David lugging around his great big heavy Eyemo and Norman Alley dashing out to Arlington to make the first race after telling Eddie Morrison to stand by on South Wabash in case something busts.

Well, Harry, it's cool as hell up here, so to speak, and the fishin' is great. I got a joint all by myself on a little lake up here near Eagle River without telephone, telegraph or newspapers. I got a first class cook, too.

Now don't worry about me, Harry, I'm not bustin' any rules, as my cook is union help. He's from 644, and Lippert's his name, and how that boy cooks steaks. If he could only bake a cake I'd marry him in a minute. Right now I got him busy mixin' me up first class gin bucks so's I can concentrate and get off all the hot dirt what I picked up for you in the last month.

This is the only work I'm gonna do up here, but wothel, I guess you and me gotta keep the gang informed. Please give my love to the gal in that Western Union office. The mosquitoes up here are terrible. Hoping you are the same,

Your first class
SASSIETY REPORTER.

Editor Wrong, of Course

Listen, all youse brothers of 666 in good standing, this is the time for youse hombres to come to the aid of old 666. A serious situation has arrived. The freedom of the press has been challenged and, brethren, I arise to say it ain't right. Boys, we must keep a cool head and face the situation squarely.

What I'm belchin' about, somebody out thar in Californy cut my column last month—the July issue, to be eggsact.

All you admirers of mine what's gettin' bum publicity from me should join with me in belchin' about the ruthless way my column was chopped up in the July issue. Any scribe with a weaker constitution than I got would toss up the sponge, but I ain't gonna do it yet. I repeat, it ain't right, and they're going to keep on getting these first class razberries on youse guys, but if they don't print them, well that's up to youse guys to protest. I personally feel youse is all entitled to all the hot information about 666 while it's hot by someone who's not so hot.

That Endurance Stuff

Well, I'm sure glad that endurance flight record has ended. Most all the star celluloid historians of 666 were there. The newspapers forgot to mention the endurance contest between flyers and the movie men waiting for 'em to land and, what's more, for they were still up when the flyers came down. A lot of 666 boys are still dashing about sleepy-eyed, trying to make up some of the missing winks they lost out at Sky Harbor.

As soon as the endurance ship City of Chicago approached a new record, Norm Alley moved Eddie Morrison and Phil Gleason out to the field. Charlie David dragged the body out in person and brought Jack Barnett along for company. The Pathe truck rumbled up, carrying our friend Rufus Pasquale, Wallie Hotz and Tony Caputo. Orlando Lippert, of Paramount, dashed in wearing riding breeches and boots, so Eddie Morrison set out to see where Lip left his horse.

After the first two or three nights the boys mastered the knack of getting some winks stretched out on canvas on the hard ground and on cushions from the cars. All except Charlie David; it seems that ever since Charlie mixed with them hombres out on the coast he wants to put on the Ritz, so Charlie moved his own tent out to the field, which he refused to share with anybody.

Well, one night after retiring the tent came down on Charlie, and he is still trying to find out to this day who done it. So far he ain't been successful. As we report all the news in this here column, we are sorry, but we now gotta tell the secret as to who done it. Honest, we can't tell a lie; it was Jack Barnett and Phil Gleason.

About one thousand spectators who hung around the field every night to keep the newsmen from sleeping got an awful shock to see Rufus Pasquale wear his heavies in the hot summer weather. It all came about

when Rufus, Jack Barnett and Phil Gleason trotted out wearing nothing but their underwear to do a spring dance for the crowd. They were showered with pennies to play a return engagement, but you know how modest them boys is, so they had to be coaxed out for the curtain call.

Eugene Cour and Norm Alley, who both are a couple of head men for their respective outfits, paid visits to the field regularly to give their poor suffering charges the old hokum about carrying on and so forth and then dashing off to golf games.

SIX SIXTY SIX

Casey Jones, a real old-timer in the flying racket, corralled the boys one night and put on a feed for the gang at the fashionable Petrushka Club, which is right on the field. A lot of society dandies dolled up in fancy summer white flannels probably wondered who the ditchdiggers were that Casey dragged in before them, but they wasn't ditchdiggers at all; them was newsreel men out on an informal party.

A few days before it all ended, Frank Bering, what runs Mrs. Sherman's boarding house, heard of the plight of the gang and sent beds and a bell hop out to make things worth living for the gang. Frank never forgets the gang when they need anything. I guess he and Al Fuller over at the Palmer House rate aces with the gang at all times.

SIX SIXTY SIX

Best Show in Town

Society Note: Red Felbinger, head man at the local Paramount News office, is flashing around in a new Packard car which he claims is his own.

SIX SIXTY SIX

These Blondes Unafraid

Well, I gotta go back to my fishing now, as my cook, Lippert, finished quite some time ago packing my thermos bottle with about ten gin bucks. Just heard a shotgun go off across the bay. I hope it ain't Lip. getting caught rounding up those chickens I sent him after. Lip's as good a cook as he is a cameraman. He just came up here for a couple of weeks while he's waiting for a tail wind on his proposed dash across the continent in

his DeSoto. Lip. hopes to make California in about a couple of months with his high power car. His take-off has been postponed by a series of mishaps, mostly financial. If he ever gets to Hollywood they better lock up all them blondes out there. He's the guy with the IT what gets gals to bring him chicken when he's out on a long assignment. See you next month.

LOOKING AHEAD

Faxon Dean tells this one on a fellow-countryman who was held up by a highwayman one dark night on a street of Glasgow.

"Your money or your life!" hissed the highwayman.

"Take my life, mon," said the victim; "I'm saving my money for my old age."

—::—

MOOT QUESTION SETTLED

Gordon Pollock prides himself on a set of Shakespeare, beautifully bound.

The other day his wife announced that a rat had apparently gnawed one of the volumes.

"That settles it," said Gordon, "even the rats think it is Bacon."

—::—

A SLIGHT IMPERFECTION

Cleve Beck tells a story to exemplify the pride which every union man should take in the work by which he makes a living, no matter how humble the trade.

Two street sweepers seated on a curb were discussing a comrade who had died the previous day.

"Bill certainly was a good sweeper," said one.

"Ye-e-s," conceded the other thoughtfully, "but don't you think he was a little weak around the lamp posts?"

Hoke-um

By IRA.

A WARNING

Earle Walker, beneath whose quiet demeanor hides a brilliant World War record, says that one of the humorous, yet pathetic, touches of the French front was a shattered sign posted on a tree near Belleau Wood. Translated it would read: "No shooting on these premises under penalty of the law."

—::—

FATAL WEAKNESS

Charles David, president of Local 666, Chicago, tells this unauthenticated story of two of his home town citizens:

Judge—Your son has been arrested so many times that I'm tired of seeing him in my court. If you show him the right way he won't be coming before me.

Father—I have showed him the right way, Judge, but the young fool has no brains. He always gets caught.

—::—

RETORT COURTEOUS

Cutter girl—The man I marry must be a real hero.

Her patcher—Say, kid, he would be!

CHARLIE WAS TERRIBLE

Extra actor (telling tales of the days when theatres had stages instead of screens)—Poor Charlie got the hook awfully that night. They hissed him right off the stage. Then I came on. The audience quieted as if by magic and listened to my first number with every attention. Then, just as I finished, darned if they didn't start hissing Charlie again.

—::—

EDITORIAL OVERSIGHT

Little Miss Kershner—Daddy, they left a page out of the International Photographer.

Glenn—How's that, sister?

Little Miss—Why, Daddy, your cartoon isn't here anywhere.

—::—

IF GOLF INTERFERES

Cameraman (practicing on Sunday for tournament at Palos Verdes and spies the pastor of his church also on the course)—I'm astonished to see you here. Do you consider it becoming in a clergyman to play golf on Sunday?

Pastor—No, I don't. That's why I gave up my pulpit.

—::—

CORRECTED

Sightseer in studio—I've been to every country on the globe and I've seen everything there is to be seen.

Extra actor—Did you ever drink any Hollywood bootleg?

Sightseer—No.

Extra actor—Well, then, you ain't been nowhere and you ain't seen nothing!

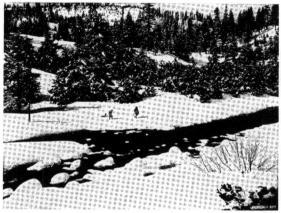

Such a picture as this beautiful winter scene is a positive delight to contemplate during these smouldering mid-summer days. It is an offering from the prolific and facile camera of Bert Anderson.

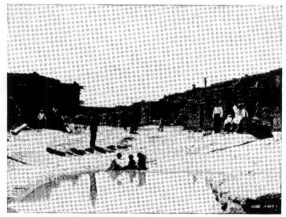

This is a shot of Acama, a Pueblo Indian village somewhere in New Mexico. Fred Mayer picked up this picture while wandering around in the Indian country contiguous to the Santa Fe Trail. No posing here; it's the real thing.

 # Cream o' th' Stills

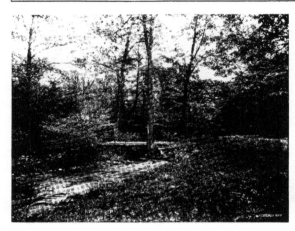

W. H. Strafford, of
Local 666, Chicago,
loves to range around
with his camera in
the hills and dales of
Northern Illinois and,
would you believe it,
this lovely place is
only twenty-three
miles from the center
of the Windy City.

Otto Dyar thought
he saw a picture in
this combination of
rocks and sand dunes
that he ran into away
up in "Monumental
Valley" while on
location for Para-
mount. Mr. Dyar
thought right.

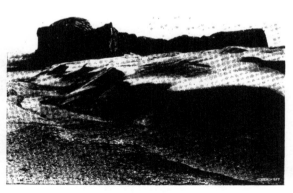

 # Cream o' th' Stills

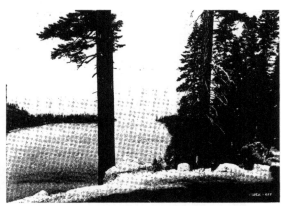

Lake Tahoe has been photographed at least once for every tree within a mile of its wooded border, but there was never a more intriguing snapshot than this from ye goode boxe of Frederick Campbell. This charming vista is as Mark Twain first saw the lake.

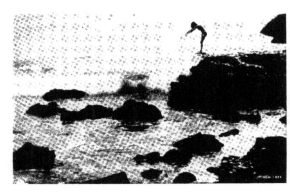

Here is a surpassing work of the pictorialist's art from the camera of H. Blanc, the locale being the neighborhood of Laguna Beach. The mermaid, in her frame of sea and rocks, makes a picture not soon to be forgotten.

 # Cream o' th' Stills

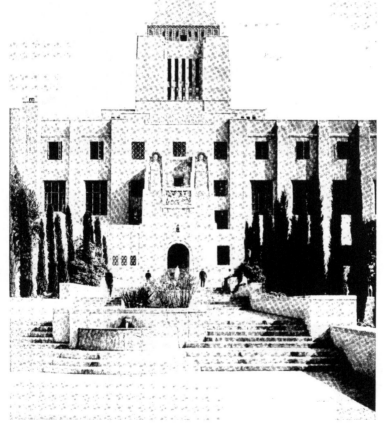

Lindsay Thomson is not to be beaten at this class of photography. He has a knack of finding real pictures where many see only objects. This is a shot of the imposing Los Angeles Public Library.

A Visitor from the Antarctic

International Photographers Honored by a Visit from Brother Joseph T. Rucker, Late with the Byrd South Pole Expedition. An Exchange of Courtesies

SLOWLY but surely the story of the motion picture cameraman in all his glory is being written by the cameraman himself.

It won't be long now before the cinematographer, so long shut out of the limelight by others less picturesque and capable, will come into his own and be given the place in production he has all along deserved.

We are reminded of all this when we contemplate the recent achievements of Brothers Joseph T. Rucker and Willard Van der Veer, lately returned with the Byrd Antarctic Expedition from the conquest of the South Pole.

These two modest men, members of Local 659, I. A. T. S. E. and M. P.M.O., like their fellows, have little to say of their own personal achievements while giving all the glory to others, and yet it is through the untiring and efficient work of these two men that the story of this glorious and amazing expedition will be told quickly to the millions.

Books take long to write and are read by the few, but the pictures that run on the screen before the eye tell their story to the mind in one brief hour and far better than cold type.

When one contemplates the difficulties met and overcome by these brave and resourceful men one begins to realize that there is vastly more to the making of a motion picture than merely the *mechanics* of it and, also, that the making of a picture is the most interesting thing about it.

In the filming of the official record of the Byrd Expedition, from the time the ships sailed into the icy seas of the Antarctic until the fadeout on the lone penguin standing there on the ice barrier with Joe Rucker's necktie around his neck, bowing a grave farewell to the departing ship, there was hardly a frame of film that was not shot in pain.

And in viewing the amazing panorama unfolded in the picture released by Paramount the reader is asked to bear in mind that what he sees is less than 10,000 feet of the more than 150,000 feet of film exposed by Rucker and Van der Veer.

This other 140,000 feet is just as wonderful as the 10,000 feet you see on the screen, and was just as painfully ground out, not with a motor, but with a crank.

The camera equipment provided for Rucker and Van der Veer consisted of two Akeley motion cameras and one Eclair and four automatics,

while a mapping camera was also carried for aerial use.

In the flight over the Pole the photographic shots were made by Harold I. June, relief pilot and radio operator, as only four men could go in the plane and the relief pilot was indispensable.

When the time for the polar flight arrived Rucker and Van der Veer carefully computed the light values for the entire trip and arranged the diaphraghm of June's camera so that he would have no trouble and, when one contemplates that he had to do this work in connection with his radio and relief pilot duties it is remarkable that the results were so excellent. Our two cameramen say that June's work was great.

The two Akeley cameras were rebuilt in New York in order to equip them to withstand the low temperatures of the Antarctic, but in spite of the careful rebuilding both cameras bound up at 30 below and had to come down in Rucker's shop at Little America. There was constant readjustment as the temperature changed. As for the automatics, they all quit at 15 degrees below zero.

The Dupont film was packd in 400 foot tins, ten tins to a case, and each tin was dipped in lacquer. The ten tin units were then sealed in zinc containers and placed in wooden boxes lined with celotex.

So perfect was the packing done and so efficient were the packing materials that only one 400 foot tin of film was lost, and this notwithstanding that in loading the ship the film was put into the bilge so that much of it was under salt water from the time it left New York until unloaded at Little America.

Mr. Rucker had a lot of fun telling about their dark room and work shop. The structure was built of scraps of everything available, but mostly of packing cases. It was heated by oil, and when the temperature at the work bench level had been run up to 65 degrees, a comfortable working temperature, it was 110 at the ceiling (6½ feet high) and 30 degrees below zero on the floor. Imagine working under such conditions!

The extreme low temperature made the film hard to handle and the most extreme care had to be taken in loading, for the ice-cold film would snap like glass.

All film was hand-cranked; long extension handles being used in order to accommodate the immense gloves worn by the cameramen and yet all loading and reloading had to be done with bare hands.

This usually meant "burned" fingers, for contact with the frozen metal of the cameras would always take off a patch of skin.

"Imagine," said Mr. Rucker, "using a changing bag in a tent at 40 below zero."

In the summer season, with twenty-four hours of daylight there was, of course, constantly changing light and this was a matter compelling constant vigilance.

Rucker and Van der Veer maintained a constant twenty-four hour watch. One or the other was always on the job and sometimes both were on duty. And our brothers were not alone cameramen. No, indeed. They were just like all the other members of the expeditionary force; individuals under the command of superior officers and they took their turns at assisting the chef, washing dishes, waiting on table or what not like all the rest of that brilliant and blessed company.

In all the 155,000 feet of film exposed only about 800 feet was lost—a record, probably, under any and all conditions and 14 months between exposure and development.

All interiors were shot with four portable arcs. To get current the gasoline electric generators from the radio were used and, therefore, interiors could be shot only when the radio was silent.

"We usually kept one camera in the house and one outdoors," said Mr. Rucker. "Even one's breath would freeze 'em up and we were constantly baking them out. Believe it or not, in the coldest weather outdoors the breath would freeze so quickly and so hard that one could hear it, like the crumpling of crisp paper.

"From spring, 1929, to February, 1930, we had only 17 days of sunshine, and you can readily imagine we were busy. The flight over the pole required eighteen hours. Of course we all longed to be one of that historic four, but as that was impossible we consoled ourselves with the thought that there was glory enough for us all in the brilliant success of our beloved leader, than whom there was never a braver, abler, juster or a more considerate. It was a great honor to be with him."

As an evidence of the esteem in which Rucker and Van der Veer are held by their fellow-members of Local 659 they were recently presented with identical rings designed by Joseph A. Meyers & Co., of Los

(Concluded on Page 36)

VII. A sick dog stops the traffic. VIII. Left to right—Gould, Van der Veer and Rucker. X:
Rucker and Van der Veer tuning their Akeleys after the long winter. IX. Rucker rigs a boom on
ica. V. Van der Veer looks over his Ake'ey. VI. Gould and his party start south.

VII. *A sick dog stops the traffic.* VIII. *Left to right—Gould, Van der Veer and Rucker.* X. *Rucker and Van der Veer tuning their Akeleys after the long winter.* IX. *Rucker rigs a boom on the New York to film the Eleanor Bolling, following.* XI. *On the edge of a crevasse.* XII. *Heavy sledding over pressure ice.*

American Talkers in Japan

Addition of the Voices Increases Fans' Devotion to Stars

By HARRY A. MIMURA, Local 659

THERE are three kinds of theatregoers in Japanese theatres to see American talkers. The first group includes foreigners and some people who thoroughly understand the English language. The second is a class which has had sufficient education to understand English to a certain extent, but not quite enough for hearing. The third class comprises those who have not had any chances to get familiar with the English language.

In number the second group constitutes the greater part of the audience so it did not have much trouble in enjoying the entire picture in those good old silent days. Then the talker invaded Japan to confront the unfamiliar with English-speaking audience.

Of course, there was what is called a "benshi" (interpreter) to translate the spoken titles to those who could not read captions. This became more important to the Japanese theatre since the lesser number of people understand the English dialogue. It seems to be a very ridiculous and bothersome thing to do, but it is the only way to show American talkers to the public.

What the "benshi" does is to stand behind the screen and watch the picture and as soon as an actor finishes a dialogue the "benshi" simply repeats the same thing in Japanese. In case two persons are in conversation he changes his voice, impersonating two characters.

It is a very awkward custom for those who do not need the help of "benshi," so naturally the talkers are not as welcome as the old silent pictures.

Some people in Japan are so Americanized they can't live without the American daily dozen, including talkers. It is said that the popularity of certain actors and actresses has greatly increased since the talkers went over there.

One girl wrote me quite a while ago saying she is more crazy over Ronald Colman's pictures since she heard him speak in "Bulldog Drummond." She says now she must powder her face before she sees and hears Mr. Colman on the screen because she feels she is standing face to face with him in the flesh, on account of his voice.

Recently one of the motion picture magazines asked the following question of twenty-five prominent persons connected with motion picture work in Japan: "What is your favorite talker?" According to the magazine, "Alibi," "Sweetie," "Broadway Melody," "Virginian," "Show Boat," "Rio Rita" and "Seven Days' Leave" were chosen by most of them.

Not so long ago Universal made a Japanese version of "The King of Jazz" with two local Japanese actors playing master of ceremony, introducing players, musical numbers, etc. The Lasky studio did the same thing, inviting one of the "benshi" from Tokyo to introduce "Paramount on Parade" to Japan. Those two pictures are eagerly awaited by the Japanese film fans and will create a big sensation when they reach Japan, I'm quite sure.

A Visitor from the Antarctic

(Continued from Page 33)

Angeles, Rucker at the general meeting of Local 659 in Hollywood, Van der Veer in New York, where President William F. Canavan, of the I. A. T. S. E. and M.P.M.O did the honors. President Alvin Wyckoff of Local 659 made the presentation speech to Mr. Rucker.

The rings, which are of green gold, bear on the setting the insignia of the I.A.T.S.E. On one side is the figure of a fur-clothed cameraman with tripod and camera, and an American flag dropping from a plane. On the reverse side is a ship fast in the ice.

Following the name of each man, underneath the setting, which is released by a spring and swinging on a hinge, is the following inscription: "In recognition of his photographic achievements with the Byrd Antarctic Expedition, 1928-1930. International Photographers, Hollywood, California."

In The International Photographer of October, 1929, Mr. Russell Owen wrote at length on the subject of cameras in the Antarctic as told him by Rucker and Van der Veer.

Don't Forget Sunday, September 7th

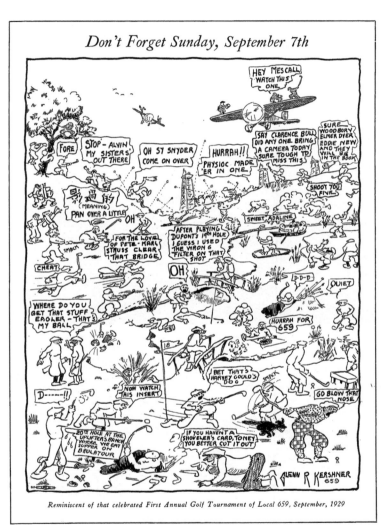

Reminiscent of that celebrated First Annual Golf Tournament of Local 659, September, 1929

There'll Be Prizes for All

The Palos Verdes Golf Course looking across the links toward the Beach Cities of Santa Monica Bay. It's a great playground.

Golf

By JIMMIE PALMER

Hurrah! or something like that, for I'm about dizzy collecting prizes for the Tournament! Boys, we surely have a lot of friends in and around the industry, for we will have a collection of useful prizes that will make the Tournament well worth while—golf clubs with bag, complete; sets of matched irons, the best that money can buy; bank accounts, cameras, clothes, camera equipment, rings, cigarette cases, and, well, I haven't space enough to name them all, but they may be seen at Schwab's Clothing Store, 6358 Hollywood boulevard, the week commencing August 30th.

Don't forget, the entries absolutely close at 9 p. m,. Aug., 30th. Get your tag at your studio or at the Local office now!

I have been confronted with a lot of excuses as to why certain members won't play in the Tournament. They are such as: "I don't like golf;" "I don't play very well;" "I have never played golf;" etc.

I want to say this to you boys, that "Have never played" or "Can't play the game"—over fifty percent of the boys that showed real sportsmanship and entered the Tournament last year had never played golf before and a lot of them received prizes just the same. Also, I have never heard any of them voice an opinion other than it was as fine a day of sport as they ever spent.

Now to you who are misguided by the word Tournament,—this word does not imply professionals or experts. If you are a beginner, don't think you will be alone on the course for a gallery to watch. There won't be any gallery and I can safely say that seventy percent of the boys playing this year have never played before and I'll guarantee that none of them will regret it.

Now as to the feed—instead of having a dinner at the end of the play which those wanting to get home to their families might miss, there will be an open buffet lunch by Agfa-Eastman-Dupont Inc., the well known FILM TRIO. You fellows served from eleven o'clock on. And such a luncheon! It will be furnished don't have to be told—that with them behind it it will be a real feed.

Your committee has decided that, with the handicapping system adopted, it will not be necessary to turn in any qualifying score cards. All that is asked is that you turn in your true average score so that we can decide your handicap. As the play is limited to our membership we can place confidence in the honor of our Brothers which will simplify matters greatly for all concerned.

Remember, boys, your Committee is working hard to make a success of this Tournament and there can be no selfish motive behind it. It will be of benefit to one and all alike, so pitch in and help your Committee out. All the world is looking to see what kind of sportsmanship reigns amongst the Cameramen, so let's show them.

Don't forget, when better golf is played—the Cameraman will play it!

See Them at 6358 Holly Blvd.

They Start Early

In this picture we have none other than Miss Barbara Ann Brodin, daughter of our well known camera brother, Norbert Brodine. This little lady is getting an early start at the

game and promises to be an expert before many seasons have passed. If it wasn't for the fact that she doesn't hold a paid up card in Local 659, Brother Brodin would enter her in the Tournament September 7th. Best of luck, little lady, and we still contend that when better golf is played, the cameramen, or Barbara Ann, will play it!

―○―

A Lot of Aluminum

One of the largest pieces of solid aluminum ever produced, weighing more than 300 pounds, recently was specially cast for Lakin Corporation by Alumbra Foundry Corporation, Ltd., for use in the development of the new 36-inch Dietz reflector.

A fair estimate of the size of this casting may be gained from the knowledge that aluminum has only one-fourth the weight of lead and three-eighths that of iron.

According to James Johnson, president of the Alumbra concern, which specializes in aluminum work, castings of this size rarely are produced for use in studio lighting equipment because of the precision involved in casting them.

The new Dietz reflector will be handled exclusively by Lakin and will be available in September.

―○―

That Big Feed

Agfa-Dupont-Eastman will be hosts to our hungry golf players at the Second Annual Tournament, Sunday, September 7. It will be the biggest, finest feast in the history of motion pictures.

When Bobby Jones Threw One Dirty Look at Zim—

By 666's Sassiety Reporter

I guess there's one prize boner pulled on every story that busts, and this time Zimmerman cops the trophy for the one he pulled up at Minneapolis on the Bobby Jones golf match. I guess we can call it the Jones match, as it seems he played all the golf in that tourney, anyhow.

Well, this man Jones is all set to putt on the eighteenth hole, the movie men are all set to record it for posterity, the gallery is all quiet, Jones is about to sink the ball when all of a sudden Zim's voice cries out, "Hit it!"

Bobby stops short and throws a dirty look over at Zim and then starts on his second attempt.

Again the gallery is startled with Zim's "Hit it!"

Finally a couple of golf officials investigate and discover Zim is just telling Saunders, his sound man, to hit the camera switch so's Pathe could get Jones' putt on its celluloid.

Oh, well, anyway, Zim got his picture.

Roy Johnson, winner of the Tournament of 1929. Brother Johnson and Brother Hap Depew tied for honors, but in the playoff Johnson won. The tie was at 81. The score in the playoff—Johnson 77, Depew 81.

How to Get There

Before you start for the Palos Verdes Estates Golf Course, Sunday morning, September 7, be sure to study this little map.

And be sure also not to confuse the

Palos Vedres Golf Course with the Royal Palms or San Pedro Course at White Point.

All of you know how to reach Redondo Beach from any part of the Metropolitan district of Los Angeles and once at Redondo Beach the rest is easy.

As you approach the Palos Verdes Estates from Redondo you will meet with numerous signs bearing the legend "To the Palos Verdes Golf Course" and if you follow them you will not get lost.

It is at Palos Verdes Estates that the famous ocean drive along the coast to the Harbor begins and if you finish your eighteen holes before dark you will find the trip back home more delightful if you take the route along the ocean toward San Pedro and up over the hills to Western Avenue and thence straight into the city through Lomita, Torrance, etc.

But the important thing to do is to get to Palos Verdes Golf Course. It's up to you whether you get back or not, but for the benefit of the timid members the Committee has arranged for a guard equipped with food, camp equipment and extra golf balls to look after those who have to spend the night trying to get out of th enough.

―○―

Sixty Foursomes

At our Second Annual Golf Tournament, Sunday, September 7, we hope to start at least sixty foursomes. Local 659 is counting on you.

Thirty-nine

Remember--the Boys Expect You

Clubhouse Palos Verdes Golf Course.

up to you whetheer you get back or n ot, but for the benefit of the timid members the Committee has arranged for a guard equipped with food, cemp equipment and extra golf balls to look after those who have to spend the night trying to get out of the rough.

To help you out:

FROM HOLLYWOOD OR BEVERELY HILLS go west on Santa Monica Boulevard, keep on left side of the car tracks to Overland Boulevard; turn left onto Overland Boulevard and continue across Venice Line car track in Culver City; c o n t i n u e straight past Fox Hills Country Club to Centinela Boulevard; turn left onto Centinela Boulevard into Inglewood; then on Hawthorne Avenue through Hawthorne to the Redondo-Torrance Road, which is the first through street beyond the Santa Fe Railroad overhead crossing; turn right on the Redondo-Torrance Road into Redondo to the car track; turn left and follow car track to end of line and continue one mile further to Palos Verdes Estates.

FROM WILSHIRE BOULEVARD go south on Crenshaw Boulevard which at Adams Street becomes Angeles Mesa Drive; continue on Angeles Mesa Drive to end of pavement at 80th Street; turn left one block to 8th Avenue; turn right to Manchester Avenue; turn right onto Manchester Avenue past the Potrero Country Club to Prairie Avenue; turn left onto Prairie Avenue to the Riverside-Redondo Boulevard; turn right onto the Riverside-Redondo Boulevard to Hawthorne Avenue; turn l eft onto Hawthorne Avenue to the Redondo-Torrance Road; turn right onto the Redondo-Torrance Road into Redondo to the car track; turn left and follow car track to end of line and continue one mile further to Palos Verdes Estates.

Getting the Dope

HANDICAP SCORE PLUS ACTUAL SCORE (FOR AVERAGE) LESS HANDICAP DETERMINES NET SCORE

SEPT. 7th 1930 COMMITTEE

PALOS VERDES

GOLF TOURNAMENT LOCAL 659

Hollywood: The Truth

By GEORGE BLAISDELL

REGARDLESS of business conditions at home Uncle Sam tilted his export figures for film during the first half of 1930 as compared with the same period for the preceding year. The advance is practically 21 per cent. In terms of dollars and cents the gain is $796,150 over 1929, when the value of exported film was $3,331,022.

The figures are suplied by N. D. Golden, assistant chief of the motion picture division, Department of Commerce, in an exceedingly interesting circular of seven pages.

In the first half of the present year 2,788,991 feet of silent negative and 3,292,805 of sound were exported. It may be observed the government estimates the value of the silent negatives at approximately 8½ cents a foot and the sound at 12 cents.

The estimate placed on the silent positive a trifle under 2½ cents a foot and on the sound positive a little over 2½ cents.

* * *

Europe is still the big customer for American films, this half year's importation of 63,878,047 feet having a declared value of over $2,000,000, a gain of over 23,000,000 feet over 1929. The gain was accounted for chiefly by the United Kingdom and France. This year the latter country more than doubled its importation of American film for 1929, the figure being 13,445,037 feet.

Germany stands third in Europe and sixth in the world as a consumer of American film. Australia is third, with importation the first half of 1930 of 11,916,627 feet; Argentina is fourth in world rank, with 8,781,479 linear feet; Canada five, 8.649.-511; Germany six, 7,875,256; Brazil seven, 7,118,661; Mexico eight, 4,-819,965; British India nine, 3,862,-589; New Zealand ten, 3,222,226.

During the same period the exportation of unexposed film increased more than 30 percent over 1929, this year's figures being 35,658,218 linear feet. Coming into the United States were 1,237,677 feet of negative, a trifle less than last year. There was a decline in the importation of positive, the amount being 2,447,391 feet, about 400,000 less than in 1929.

Good-bye, Pie! !

MACK SENNETT has quietly and most effectively executed an about face in the character of his comedies. Briefly put, the slapstick order yields to the situation, the kitchen gives way to the parlor.

The transformation is effected easily and smoothly. What is notable is that the fun remains. It ranges from chuckles to boisterous laughter, in volume equaling that of the Keystone cop days through the various changes in style down to the present.

In a series of five comedies shown at the Sennett studio on a recent evening pie filling entered into but one of them. It was a different pie from that which Sennett followers have been trained to expect. It did not possess that comprehensiveness, that widespreading and deep mushiness, that insidious eyefilling quality, we instinctively look for under the brand of Sennett.

* * *

It was an extremely polite pie, anaemic, bloodless. It was such a creation as might by George Arliss have been bestowed upon the dead pan of Buster Keaton without sacrificing one jot of that austerity of manner or one tittle of that Disraelian dignity. But the laugh did not lean on the pie so much as on the surrounding circumstances.

When an old-timer, one who had followed Sennett from the Biograph days, was moved with damp eyes to remark as a comedy faded from the screen "That was a sweet picture" it may be set down as a fact the transformation is complete.

The comedymaker has received many kind messages from inside the trade and without congratulating him on his new comedies.

Fame Follows Kiss

IN the intensely interesting article by Harry Potamkin, reprinted in this publication through the courtesy of the Theatre Guild Magazine of New York, reference is made to the close-up.

Mr. Potamkin suggests the first use of a close-up in the movement of a narrative film was made in "The Mender of Nets," a Biograph subject in which Mary Pickford played and which was directed and photographed by Griffith and Bitzer, respectively.

The writer quoted introduces the reference by saying the bold image existed before Biograph, even in the peep-show films.

Those who saw May Irwin and John C. Rice in "The Kiss" undoubtedly still will recall the thrill that followed the initial view of that first screen close-up. More especially will they recall it if they saw the brief bit of film projected on the enormous screen at Koster & Bial's in New York.

At the moment this writer has no access to the "dope" on the picture—but to the best of his recollection it was shot in the final decade of the preceding century and in the days when a length of 100 feet constituted a real feature. "The Kiss" probably ran less than 50 feet.

* * *

The picture showed the comedians as a two shot and then singly the face of Rice as he mugged the genial May, followed by the reaction on the face of the coy and generously figured comedienne. The singles filled the screen. Probably nothing projected in the more than thirty years that have followed has created the amazement and likewise the mirth that rode on those few feet.

Following that fraction of a second when she laid aside her coyness and hesitation May threw into the clinch her whole soul and incidentally both shoulders the while the house screamed and squirmed.

Recollection of that moment leaves one cold and unmoved under the comparatively pale and puerile attempts of latter day necking flappers to impart a kick to their male admirers. Talk about becoming famous overnight! May Irwin achieved lasting fame in forty seconds.

Silents Become Vocal

WESTERN Electric recently completed its six thousandth installation. The house was the Comedia, Marseilles, France. In Europe alone the company claims 1400 houses have-been equipped.

In the Orient 46 houses have been wired. Eight of these are in Japan, 17 in China, 8 in the Philippines, 9 in the Dutch East Indies and 4 in the Straits Settlements.

The company recently has completed a contract of more than ordinary interest—that of wiring the auditorium of the Naval Academy. One of the stipulations imposed on the engineers was that the job must be foolproof so far as it humanly was possible so to make it. The reason ascribed was that at a certain hour in the evening 3000 midshipmen must retire from the hall and to their quarters—regardless of the stage of completion of the show at the moment.

That's putting responsibility aplenty on one lone operator—and probably an enlisted man at that, one who faces the possibility of thirty years under the command of some of those in his big audience who may take exception to his style of projection.

Turning Clock Back

RUCKER and Van der Veer down under the world had scant facilities for seeing on the screen the results of their work. They had to do the best they could under the circumstances. It was a case of leaving the answer on the lap of the gods.

The cameramen on "Trader Horn" were not quite so badly situated, as

there was a laboratory in Nairobi, from which periodically reports could be obtained as to how their stuff was running.

It is difficult to believe that right in Hollywood a camera crew will go through a picture without having seen a foot of the dailies during that time. It's a fact nevertheless.

The instances must be few, which speaks well for the average judgment of those responsible for the production of pictures.

* * *

On the other hand the few instances where the strange practice obtains speak very loudly for the lack of judgment on the part of the director or supervisor.

The wise director seeks the full co-operation of his cameraman—and invariably gets it. It is to the advantage of the man directing the photographic department of a production to secure the best results possible, for the sake of the picture and for his own individual reputation.

The best results cannot be secured when a cameraman is forced to go to a theatre in order to learn how his picture looks on a screen.

Lakin Installing

The Lakin Corporation has been awarded the contract for installing the heating and ventilating system of the new Universal west coast laboratory, which will be modern in every detail.

Local Honors Rucker

(Continued from Page 10)

card, which he had carried with him to the Antarctic and which he was thoughtful enough to send on Admiral Byrd's flight across the South Pole, in the pocket of Harold June, the relief pilot and radio operator.

It will be cherished in the archives of Local 659 as its most precious document. A fac simile of the card is herewith presented.

Attorney R. H. Phillips, candidate for judge of the Superior Court, addressed the meeting on the subject of "Educating Capital to Unionism." He was given a cordial reception and close attention.

———o———

Fred Kaifer Recovering

Fred Kaifer, our good brother who several months ago was thrown from a parallel and painfully injured, is at last out of the hospital and rapidly on his way to complete recovery. At the last general meeting of Local 659 Fred was joyously greeted by all the members. It is fine to see him out again and with no permanent disability.

Cinematographic Lighting: Mood Stimulus

(The Philosophic Approach)

By A. LINDSLEY LANE, Local 659 and S. M. P. E. Part 2.

The introductory paper of this series observed that light is a universal language invested with the power of stimulating mood in humans. It also discussed the place of the cinematographer in the making of a motion picture. The present paper briefly considers the cameraman's initial approach in fulfilling his part of furthering through the medium of mobile and static light the picture story moods.

Two extremes cited below indicate the range of pictorial mood in motion pictures, the mood making more pronounced the dramatic or comedy content: Form congruent with content.

The director of farce comedy demands that everything in his picture be brilliantly illuminated and plainly visible to the audience at all times. He perceives his screen action to be very fast and that it is easily lost unless distinctly displayed through photographic clarity. And he knows that action lost through shadowy photography may mean sacrificing not only the humor of the immediate point but of an entire situation, consequently precluding the laugh and nullifying his sole intent.

Furthermore, the comedy director believes pictorial brilliance tends to induce gayety of spirit in the audience which in turn makes the audience receptive to the comedy content. And audience reactions over a period of years prove the comedy director correct in his showmanship.

The director of murder mysteries sees value in appealing to the unsatisfied imagination of his audience through black and gray obscurity, with a suggestion here and there of something definite to stimulate further their imagination. He feels that the heavy masses of dark tone on the screen are in keeping with the somber dramatic content of his story; and that the mysterious indistinctness splotched fitfully with thrilling, divulging half-light permits no diminishing of the exciting urge to unravel and solve the mystery.

And in this respect the murder mystery director is as correct in his showmanship as the comedy director, audience reactions and the box office having verified his technique.

Let it be understood, before continuing further, that this series of short papers has no intention of categorically tabulating the myriad moods that may be cinematographically interpreted, or of outlining the technical methods of achieving these moods.

Every professional cameraman realizes the futility of attempting so involved a treatise at the present unsettled development period of cinematographic light-language. And most cameramen will likely agree that the proper time for such detailed data will always be at the discussions with the director of story, action-continuity, the planning of sets, and during the filming of the picture.

STIMULATING IMAGINATION

However, these papers will consider the two major approaches of the cinematographer in his job of interpreting the story, in the belief that they will be stimulating to the imaginative cameraman in using his own specific technique.

The basic approach is the philosophic. Approaching a story from this logical beginning the cameraman first asks himself: What is the status in life of the vital character or characters in the story? What their philosophy of life in general as delineated or implied in the "original" novel, short story or play? These two questions primarily interest the cameraman when he first studies the story.

Then later, at an appointed time, the cameraman confers with his director on his findings and impressions, and together, the director and cameraman study the parts in life their leading characters play in the story. And from this conference evolves their conception of the one or more predominating philosophic moods of the picture, to be cinematographically expressed as an ever-present, inter-acting and ever-flowing mood background in the finished motion picture.

Subsequent conferences with the director entailing detailed study of the final continuity determine specific treatment sequence by sequence of the philosophic moods. At this same time another indispensable contributor sits in at the conference, the art director.

These three men plan settings to impress locale, type, period and status, designed to reflect the kind of people live therein, and what is more, through architectural and attributive emphasis, to "point out" the people as being that especial kind.

Thus the settings express, in concurrence with the lighting, the particular background philosophic moods, and so are an innate, constructive part of the composite entity—the finished motion picture.

The specific matters of mutual interest in sets between cameraman and art director are: Set proportions; tone distribution and balance in set; and practical shooting design of set, with reference to lights and their positioning, and the facilitating of camera set-ups at significant and effective angles and for perambulating.

In telling the picture story through the story lives of the screen characters the cameraman seeks to distill the essence of the whole of the lives of the characters upon the screen in a selected series of highly concentrated extracts; that is, he simplifies and points the thoughts, atmosphere and environment they live in; he crystallizes into an aesthetically synthesized composite their implied before-story and between-sequence lives.

And in so signifying rather than fac-similing, the cinematographer is paralleling the director's work, is, in fact, doing the same as the artists of every art—selecting, correlating and emphasizing—to make complete and beautiful the finished work. For the omnipresent "practical limitations" laws rule every art. And practical limitations have as unrelenting and restrictive holds on the motion picture as on any medium of aesthetic expression.

CLOSE TO DIRECTOR

It is quite manifest then that the cameraman must know somewhat intimately the lives of the story characters, and work in closest concord with his director (who is the man mostly concerned with the placing of the story characters in their life niches) that he may achieve the true and telling atmosphere of their story lives, bringing out unmistakably the life flavor of the characters during a comparatively very restricted portion of their inferred and postulated lives because of practical presentation-time limitations.

In other words, the cameraman stimulates within the picture observer's imagination much of the story characters' before-story and between-sequence lives through pointed inference, thus making more meaningful and complete the immediate story situations and philosophy.

The first of two comparative, contrasting examples will be used to indicate the method of the philosophic approach. The first, a sequence of scenes showing a lovely young wife, happily rushing about the cheery apartment, all ecstatic anticipation,

preparing a birthday dinner for her beloved hubby. The second example, a sequence of scenes showing a bedraggled, sickly wife crawling about the poverty-stricken flat, a crying child on the floor, the wife pitifully trying to lay out a meager yet appetizing supper for her hard-working husband.

These sketchy examples present certain similar conventional relationships and factors common to both women, such as, each has a husband whom she dearly loves, a home and the attendant responsibilities; but, because of the great disparity of their life conditions and experiences, the views on life of these two women are vastly different. The untroubled wife cannot see life through the eyes of the poor anaemic wife whose philosophy is her own mental residuum of extremely trying life experiences.

STUDY BEFORE FILMING

So it is straight to the beginnings, the life experiences of the story characters, that the sincere cameraman makes his initial approach, being always sensitive to his purpose in this searching and perceiving of ultimately translating these lives into pulsating pictorial mood stimulus.

From his beginnings, in this instance, the cameraman becomes familiar with the happy and sheltered life of the lovely young girl; her ideal marriage; her devoted love for the young and successful businessman hubby; her life with a zest for living, without hardness to dull the keenness of her vivid joys. Then, with this basis of literary data and its concomitant mass of minor detail, the cameraman comes to the specific sequence for careful study prior to filming it.

He questions in detail the relationship of the sequence to the story; the way it should affect and advance the story; and the audience reaction to this sequence desired by the director.

He learns that the sequence commences the building-up to a gay celebration of the husband's birthday, which festive occasion abruptly turns to tragedy at its high point.

TRANSMITTING A MOOD

Finally, with all of his constructive guiding data at hand, the cameraman proceeds to construct its positive complement, the abstraction of the dramatic-philosophic mood of the sequence. In this example the cameraman's construction is of the following order: Charming scenes of ecstatic anticipation and tender devotion, in harmony with a predominating faultless love delineated through the literary content of preceding sequences, exemplifying "lilting happiness."

Having thus crystallized the mood of the sequence in his mind, relative to both the suggested-life background and the immediate story dramatic-philosophic significance, the cinematographer starts visualizing the psychologically-apropos chiaroscuro to transmit the mood to the audience.

This apropos chiaroscuro he definitely designs as he studies the set and its appointments, knowing the action-continuity that takes place there; and concretely, irrevocably registers upon the film as he photographs the picture story.

It is here, at this crucial moment of fixing the keystone in the arch metaphorically speaking—the fusing of the creative effort with the receptive effort, that the true artist in the cameraman, or lack of such, proves itself.

The cameraman's aesthetic perceptions and his own character are reflected in his screen chioroscuro. His work may be sensitive and truthful to the story characters' philosophy and the story philosophy, or, still truthful though less delicate in its nuances; or, it may be untruthful and everything from pretty to harsh.

It will be well to explain the meaning of "apropos chiaroscuro" in this context. As used here it refers to the correct spacing, balance and emphasis of picture tone-arrangement to stimulate within the audience an emotional response that is conducive to the fullest enjoyment of the particular story content.

The apropos chiaroscuro for the example taken in this paper is patently one of high key, however, though generously sprinkled with area, there is a delicate but firm indication of velvet lower half-tones and shadows to tell unmistakably of the rounded balance of living of the happy woman.

It would be possible to go to some length connoting the chiaroscuro to the characters' philosophies and the story philosophy; but as this paper is not written for extended itemization of character and story premises it is obviously impossible to enumerate the connotations, and only a few based on the sketchy example must suffice.

RADIATING VITALITY

The young woman is vibrant with life of many facets—thus the wealth of small areas of high-light; her vital forces are surrounded and permeated with the joys of life—expressed by the multi high-lights projecting vitality in all directions throughout the smooth, broad areas of higher half-tones that dominate the scenes in key; her economic position of easy adequacy, and the depth and refinement of her character, are felt through the rich velvet lower half-tones and shadows of unobtrusive but firm ideas. This, in a word, constitutes the suggested-inferred-life background.

The immediate story dramatic-philosophic significance of the ecstatic anticipation, the building-up to unpressaged tragedy, is expressed through the general high key tone-scheme with the glittering high-lights and the shadow implications; but the impending tragedy is not felt since the shadow area is vigorously dominated by the vibrations of the high key.

Thus is the blow delivered by the sudden tragedy to the audience through the story participants, heightened by the subsequent abrupt and contrasting use of relatively intense shadow chiaroscuro at the moment of tragedy and throughout the ensuing story sequences; for the verisimilitude of life flow, of ups and downs, is imparted through broad mood contrasts of philosophic atmospheres.

Another province is given the flow of philosophic chiaroscuro, and that is the aforementioned story philosophy. There are times when the prevailing mind and habit conditions of the leading character or characters are not reflected through the cinematographic lighting, but are foreign to it, maybe conflicting directly with it. The purpose of this reverse technique is to direct and control the characters in the way of the story's philosophy—the author's or director's point of view—and is employed when some teaching is desired of consummation.

DRAMATIC EMPHASIS

Seldom is it sufficient to light a scene with only the philosophic aspect treated. As a rule there is another factor that influences the scene chiaroscuro as essentially as the philosophic, the 'dramatic-emphasis' aspect. Now this is to be distinctly differentiated from "immediate story dramatic-philosophic significance" chiaroscuro which functions within a sequence or more.

Dramatic-emphasis chiaroscuro concerns the content of a single scene, that is, the emphatic tone-scheme within an unbroken camera set-up between two cuts, fades or dissolves. It also may concern dramatic emphasis within a series of consecutive scenes through increasing or diminishing light intensities, as well as juxtaposed scenes through contrasting light intensities.

Moreover, immediate story dramatic-philosophic significance chiaroscuro deals with dramatic abstractions, such as, happiness, grief, ambition, apathy, and so on. Dramatic-emphasis chiaroscuro deals with definite action; localized thought reaction; and specific symbolism expressed in set appointments or natural settings.

The "dramatic emphasis" flow of mobile light in motion pictures is a secondary current within and a part of the primary "philosophic" light stream, enriching and intensifying the fundamental flow with intimacy, individuality and the quality of occurring reality.

Dramatic emphasis, as the second major approach of the cameraman in his work of interpreting through pictorial mood the story content, will be taken up in the next paper.

The Big House

LIGHT EFFECTS ATTAINED BY INKIES

Technical information in this article was furnished by Lew Kolb, mechanical superintendent, Metro-Goldwyn-Mayer Studios

By F. A. LAWRENCE

ONE of the most outstanding pictures of the year is "The Big House," produced by Metro-Goldwyn-Mayer, directed by George Hill, starring Chester Morris, Wallace Beery, Leila Hyams and Robert Montgomery. Credit for the unusual photography goes to Harold Wenstrom, M.-G.-M. cameraman.

The mechanical or technical phases of this film install a new level of perfection for the sound era of motion pictures. Camera angles, lighting effects, set construction, mass movement and various other elements seldom found in one picture are all combined in "The Big House."

Undoubtedly one of the finest, most impressionable features of "The Big House" is the extraordinary lighting accomplishments displayed. Those who have witnessed the picture will remember with what accuracy lights and shadows served to portray the grim atmosphere within prison walls.

GRIM SCENE

One scene in particular which transfers the sickening reality, the numbing shock of prison to audiences, discloses the guard conducting the new convict, Kent, played by Robert Montgomery, across the inner yard to the cell house.

This shot, appearing early in the film, by its tremendous force literally places its audience within the prison walls—brings to them with all fidelity kindred sensations of the prisoner condemned to serve his sentence. Here is an effect achieved by contrasting lights and shadows—shadows, cruel, cold, hard, overpowering in their intensity; shadows that seem to breathe the grimness of prison. This shot clearly indicates what can be accomplished in set lighting.

Of the seven hundred or more scenes taken in "The Big House," all were illuminated with Mole-Richardson incandescent equipment.

LIGHT UNITS EMPLOYED

In recalling several other impressive shots where lighting gave reality it is of interest to know just what light units were employed to achieve the effects. In the scene where Kent's finger prints are taken, one rifle and one duce, twenty-seven amps combined, were used.

This shot was closely followed by a scene showing the prisoner's arm length being recorded on a measuring

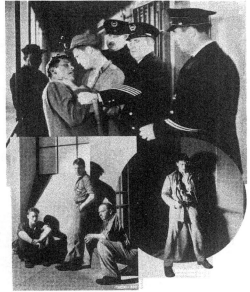

Stills showing lighting effects from "The Big House."

rack. Two 5 k.w. inkies, one flooded out and one pulled down to cover the torso, lighted the set.

The effects of these shots are highly impressive, due to the lighting treatment, which seems to bring forth more clearly and forcefully than could otherwise be obtained the relentless efficiency, the everlasting constriction of Law wrapping its coils about the criminal.

As the film progresses a scene portrays the interior of the cell occupied by the three prisoners, principal characters in the picture. Chester Morris, as Morgan, lies in his bunk smoking a cigarette. Lights have been subdued yet you discern Morgan in the semi-gloom tossing restlessly. The lighting effect here makes one almost feel the darkness, the torturing, stifling confinement. Only one rifle was used, placed overhead in the middle of the set—a straight down shot.

MOUNT RIFLES WITH CAMERA

The panoramic view of the riot in the messhall, a tense, highly dramatic semi-climax, was lighted by overheads and frontlights, sharply focused. The total amount of amps used here was approximately 3500.

Particularly interesting and effective was the close-up shot in the messhall showing Butch's knife being passed under the long table from hand to hand. Machine Gun Butch was played by Wallace Beery. Two incandescent rifles mounted with the camera on a moving perambulator about three feet high furnished the light. This unique shot with the ingenious lighting effect more than volumes tells the craftiness of prisoners, how they deftly contrive to "fox" the guards.

The cell tier sequence, where Morgan accuses Kent of planting the knife in his coat, was illuminated with general foreground light, two duces, two rifles and a 5 k.w. The killer fury that writhes in Morgan's face, the ghastly mocking play of shadows in the background, all skillfully held together in one remarkable composition, attest the competence and artistry of those responsible for the lighting effects and the wide range of adaptability of the lighting equipment used.

DRAMATIC LIGHT EFFECTS

Perhaps the most powerful sequences from the standpoint of punishment meted out to convicts are the

dungeon shots, particularly the dungeon corridor, lighted from overhead by four incandescent rifles. There is an element of hopelessness and despair in this scene that is quickly felt but presently dissipated by dialogue.

Such vividness, such feeling imparted by this shot must be attributed entirely to the lighting of the set, simple yet tremendous in its effect. One sees the vacant, steel corridor — steady, white illumination, suddenly dimmed to a weird, unnatural gloom. There stark drama is achieved, without characters, without movement, without sound—only effect, with incandescent light.

"The Big House" carries one along; there is no let-down. The observer is whirled into the mad, human chaos within the cellhouse at the height of the prison break. Four thousand amps lighted this masterful scene.

During one day four of the large panoramic shots were taken,: 1500 characters in each shot. Over 15,000 amps were used to light these sets.

Multicolor Lab to Cost Half Million

THE erection of a Class A structure for Multicolor, Ltd. is now under way between Orange, Romaine and Sycamore Streets in Hollywood. It will cost $500,000, be two stories in height, containing approximately 50,000 .square feet of floor space, and will have a completely equipped laboratory for the manufacture of Multicolor Film.

General and executive offices of the company also will be in the building. Every known feature for the production of Multicolor film will be incorporated in the structure. The laboratory is to be air conditioned.

Necessity for the erection of the plant is due to the increasing demand for Multicolor Film and the future program of the company, which calls for extensive production and expansion, according to H. B. Lewis, general manager.

Because of its simplicity and adaptability to standard camera equipment, Multicolor is to be manufactured extensively not only for major motion picture companies but also for use in industrial, educational and amateur fields.

Commenting further regarding the technical features of Multicolor film, Mr. Lewis says it obviates the use of special cameras or additional lighting. The prints may be projected in any standard projector.

The claimed feature of the process is its double negative, which serves at once as a film and filter. The feat of making slow-motion pictures in full color has been achieved with the Multicolor process. Present sound systems may be used, the sound track being colored by either one of the basic colors used in coloring film.

The Multicolor structure is scheduled to be ready for occupancy within ninety days.

GOLF by OTTO PHOCUS

How's your nance? I mean stance. Here we have Bro. Edward Cohen, no relation to Harry, showing what the well oiled student of America's greatest pastime does when backed by two oil wells. This is an unusual shot of a Bro. making a shot without any wires or double exposures to help. Note Hypo spots in sky which indicate oil well.

Spirit of the game. Here we have an Asst. cheering a First Cameraman after he has made a difficult shot. This shows how Bro. Wm. Foxall, Chief Asst. in an unusual pose where he has forgotten slates, chalk and reports as well as focus, and everything else that an asst might forget, wishing that the First Cameraman makes his objective. Note: Bro. Wyckoff (Left) reading the minutes of the last meeting. extreme right Simmie Aller cheering for Agfa Stock.

Do you assume the correct posture? Even his best friends wont tell him. Here is Bro. Roy Klaffki, often referred to as Bro. Klasski, that eminent monologist knocking radish seeds and a golf ball from a bean patch—right to left—without the aide of the Wage Scale and conditions.

The Victor. This shows what can happen at a golf fiesta providing no one is looking. Bro. Jefferson Gibbons, no relation to Floyd, at one time had the three first prizes. As soon as they were missed Bro. Hurd went through the list of unemployed Assts. and in a short time arrived at a decision.

Chopping a Golf Ball in two. Here we have Bro. Glen Kirchner that well known cartoonist for our International Photographer and other pretty good magazines. You can tell that in this case the golf ball is a tennis ball, but this is for photographic purposes only, as we can assure you that Bro. Glen can tell the difference at all times. Note. Bro. Kirchner lost some clubs at a free contest recently and is taking no chances as you can see by the position of his clubs and bag.

A reward for a toothsome. (twosome) This beautiful etching was caught in front of the Gents Rest at the end of the game. We could call this Cecil and Sally but the gent at the right is known as Len. Note. Never let your expression know how good you are.

Never let your right leg know what your left leg has been up against. Here we have the Unknown Cameraman making a drive into the Fox Westwood Studios trying to sock his favorite Director upon the esophagus or other parts in continuity. Note bulge in right hip pocket. This is a photometer, carried by all cameramen to tell whether they are east of the Rockies or not.

Prominent people often attend golf fiestas. Reading left to forward we have L. B. Mayer—Jesse lasky—J. Leonard Warner—Louella Parsons—and Gaetona Mussolini. Note. If the picture you see for 65 cents or whatever the condition may warrent is not to your liking, write to any of the above notables c/o this office and try and get a reply.

How the well dressed man will land. Here we have Bro. Joe Valentine who gets a brake every 14th of Feb. on acct of being no relation to St. Val. Can you tell by this unusual Marine view whether or not Bro. Valentine will make a three point landing?

Thus ends a perfect day. Here we have Pres. Wyckoff and Benito Gaudio in an argument as to the best way to shoot a sunrise at sunset. All studio thoughts have been forgotten and we see herein what would take years to accomplish were it not for the game of GOLF. Note. Bro. Wyckoff has his hand above the waiste, but in the next exposure he has it on Tony's hip to see if he has anything that might go off with a BANG.

Make your shot regardless of the hazard. After Bro. Len Smith made a six mile drive, by the time he got to his ball an Anhueser Bush (check spelling) had sprung up. As bro Smith said "I've had worse things than this sprung on me."

Is the Great Mystery Solved?

What does a positive electron do at 403.5 degrees centigrade below zero?

What does a negative electron do at 300 degrees centigrade below zero?

Will they continue to move in a circle of lead at these temperatures, after the current has been shut off?

What does a cat do when it listens? When can an eagle hear best—at sunrise, at midday, or at sunset?

If you know the right answers to all of the foregoing questions you will know what some governments think about the new "directional mike" now being developed by Bert Hodges for Western Engineers.

Film Enterprises Close
Big Projector Deal

Hollywood Film Enterprises has closed a contract with the Ampro Precision Projector Corporation whereby it will take over the distribution of the western hemisphere. That means North and South and Central America.

The undertaking will mean substantial expansion for the Horsley corporation, already reaching out into new fields in the amateur department of motion pictures. The Ampro is a comparatively new projector and is manufactured in Chicago.

CLASSIFIED

The Playback Machine

One of the most recent developments in sound equipment is the playback machine, conceived by Ted Soderberg, chief of the sound department of Universal.

The machine solves many problems in the cutting of sound film. Use of the machine, it is stated, will save a large amount of time and money. Directors, sound technicians or whoever wishes to hear the taken dialogue may run the film through the playback machine, eliminating the necessity of attaching a soundhead to the projection machine.

The playback may be used on the set or taken on location trips. The amount of time saved and the convenience of this unit is quite obvious.

After the playback was conceived, Mole-Richardson, Inc., was called in to produce the machine. Just recently a playback machine was sent on location to Borneo.

Right Now!

EASTMAN
PANCHROMATIC
NEGATIVE

*Is Reflecting Its Broad Superiority—
Embellished and Emphasized by
the Delightful Artistry of*

·AND MANY OTHERS

J. E. BRULATOUR, INC.

NEW YORK CHICAGO HOLLYWOOD

INTERNATIONAL
PHOTOGRAPHER
HOLLYWOOD

25¢

A Few More of Our Current Photographic Successes

Negative? Naturally!

REG. U. S. PAT. OFF

CAMERAMEN

"Monte Carlo"Paramount.............. Victor Milner
"Playboy of Paris"Paramount............. Henry Gerrard
"Her Wedding Night"Paramount........... Harry Fischbeck
"Anybody's Woman"Paramount...., Charles Lang
"Feet First"Harold Lloyd............ Walter Lundin
"Viennese Nights".........Warner Bros..............Frank Good
"Leathernecking"............R. K. O....................Roy Hunt
"Cock o' the Walk"Sono Art.............. Harry Jackson
"What A Widow"United Artists............ George Barnes
"A Lady Surrenders"Universal.............. Jackson Rose
"Spurs"Universal............ Harry Neumann
"Three French Girls".........M. G. M..............Merritt Gerstad

"The DUPONT Trade Mark Has Never Been Placed On An Inferior Product"

SMITH & ALLER, Ltd.

6656 Santa Monica Boulevard HOllywood 5147

Hollywood, California

Pacific Coast Distributors

For

DU PONT PATHE FILM MFG. CORP.

35 West 45th Street New York City

The
INTERNATIONAL
PHOTOGRAPHER

Official Bulletin of the International
Photographers of the Motion Picture
Industries, Local No. 659, of the
International Alliance of Theatrical
Stage Employees and Moving Picture
Machine Operators of the United
States and Canada.

Affiliated with
Los Angeles Amusement Federation,
California State Theatrical Federation,
California State Federation of Labor,
American Federation of Labor, and
Federated Voters of the Los Angeles
Amusement Organizations.

Vol. 2 HOLLYWOOD, CALIFORNIA, OCTOBER, 1930 No. 9

*"Capital is the fruit of labor, and could not exist if labor had not first existed.
Labor, therefore, deserves much the higher consideration."—Abraham Lincoln.*

CONTENTS

The INTERNATIONAL PHOTOGRAPHER is published monthly by Local 659, I. A. T. S. E. and M. P. M. O.
of the United States and Canada
Copyright 1930 by Local 659, I. A. T. S. E. and M. P. M. O. of the United States and Canada
Application for entry as second-class matter is pending.
HOWARD E. HURD, *Publisher's Agent*
SILAS EDGAR SNYDER - - - - *Editor-in-Chief* GEORGE BLAISDELL - - - - - *General Manager*
LEWIS W. PHYSIOC - - - - - *Technical Editor* FRED WESTERBERG - - - *Asso. Technical Editor*
JOHN CORYDON HILL - - - - - - - *Art*
Subscription Rates—United States and Canada, $3.00 per year. Single copies, 25 cents
Office of publication, 1605 North Cahuenga Avenue, Hollywood, California. HEmpstead 1128

VALEDICTORY

AFTER the best part of a decade in the service of the cameramen of Hollywood as editor of The American Cinematographer and The International Photographer, the two periodicals owned and published by the American Society of Cinematographers and The International Photographers of the Motion Picture Industries, respectively, the writer retires to engage in other business.

It is with profound regret that I must break the ties of pleasant association through the years spent in the building of these magazines, but it is with pleasure that I seize this opportunity to express my deep and enduring regard and gratitude to this magnificent body of good citizens whom I have had the honor to serve.

If there should ever come a time when a memorial is erected in a future motion picture hall-of-fame to the glory of the cameramasters of the cinema and I am still to be found anywhere on this mundane sphere I should love the happy task of writing it, for I feel that if anyone knows them and their achievements, their ideals, their problems, their joys and sorrows, and what is in their hearts, I am that man; and, in addition, I could bring to the work the inspiration of a true affection made steadfast through years of intimate association.

IN retiring as their editor I bespeak for my successor, Mr. George Blaisdell, the enthusiastic support and friendly co-operation of all our brothers, for so shall The International Photographer prosper and wax great.

I wish I might be able to shake the hand of every member and wish him peace, prosperity and happiness, but as I am not able to put sound into this valedictory I must content myself with the written word.

It is a fine thing to know a body of 800 men well enough to call them by their nick-names, to have their good-will and to work for their welfare; and, in the years to come, the writer's proud boast will be that he had a large part in the conception and building of two magazines for the cameramen of the motion picture industry, both of which are successful and internationally known and respected.

In closing the writer desires also to express his lasting gratitude to all those advertisers, contributors and artists who have in any way assisted him in his work and to all his office associates whose unfailing courtesy and friendly co-operation enabled him to carry on toward success.

And if there be any of those whom I have served in these tasks who would be concerned to know my personal attitude of heart and mind toward him let him read Leigh Hunt's "Abou ben Adhem" and commit to memory the fourteenth line.

By this sign are we all one.

Hail and farewell!

Silas Edgar Snyder.

Egypt the Magnetic Seen by Parichy

With Camera and Notebook News Man Graphically Records Reactions When Roaming Among Monuments of Sixty Centuries

By ESSELLE PARICHY

Esselle Parichy

TO me Egypt is perhaps the most magnetic land in the whole world, where you can dwell in the glorious past . . . a Past that reaches back, back to the dawn of civilization, or where you can sit on the terrace of the most luxuriant of hotels, sipping fragrant beverages, and watching the streets where pandemonium reigns.

Here in this "Arabian Nights" setting the cinema current of humanity filters past presenting customs both familiar and strange . . . Mohammedanism and Christianity, Paganism and Barbarism, Wealth and Poverty blend in a spectrum of romance and mystery.

Atop the undulating gait of an asthmatic camel you feel orientated and legend-haunted as you pilgrimage to Gizen and the Sphinx. What is the answer to this Lady of the Enigma, who has baffled the wise ones for six thousand years?

As you gaze upon the world's greatest conception of man's imagination rendered in ageless stone you vision the Pharaohs, Mary and Joseph, Alexander the Great, Caesar, Cleopatra and Napoleon, all asking this same question.

Whether you believe in a shining halo of faith, are sub-religious or merely hope, you can but appreciate the intense belief of these ancient people in a life beyond the tomb, as proved by the extreme care and splendor rendered the dead of that early age.

Historical research sets a stage teeming with life as in the days of the Pharaohs. Ever alert are the native toilers in quest of hidden treasure and secrets to be brought to light; they seem to have an uncanny sense of anticipating a find, which brings a reward of extra "baksheesh" beside the satisfaction of discovery.

Moonlit Karnak

Time and patience mean little to these native workers, s i n g i n g in rhythmic chants, as they carry one stone at a time in excavating and restoring temple and tomb. A great deal of this work is being carried on at Karnak.

Only the eerie cry of the jackal and the pariah dog in the native village near brought me back to 1930. Moonlit Karnak is the most beautiful memory in the world.·

Karnak, built under many Pharaohs, contains the largest temple in the world, now in ruins, and at the end of the avenue of its huge lotus columns, hypostyle halls and pylons stands the solid granite Obelisk of Egypt's only woman Pharaoh, Hatshepsut.

Colossal are the statues that stand guard here forever at the portals that now give entrance to a vanquished glory, but later, as I stood alone in the moonlight beside the Sacred Lake, I observed a transfiguration in the pale recesses of these temple halls, and seemingly at a glance they were again peopled with the spectres of a victorious realm.

Crossing the Nile from Karnak I visited the Royal Tombs of the Pharaohs in the Valley of the Kings, where I descended into the depths of many rock-hewn sepulchres, their walls so perfect in their carvings and colorings, as though the artist had but just finished his task.

Here a student versed in archaeology can read in hieroglyphic the life history of the Pharaoh and his faith in the next world as inscribed in the "Book of the Dead." The tomb that attracts the traveler most, although not so large or elaborate as the others, is that of Tut-Ankh-Amen. All the findings of this tomb have been transferred to the Cairo Museum, with the exception of the massive sarcophagus carved from a single piece of quartzite of a delicate pink coloring and housing the outer coffin.

Visit to Cairo Museum

You are allowed but five minutes, under guard and in silence, to gaze upon this age-old recent find. One can feel only a sense of deep awe and respect, as there can be no vulgar intimacy in the presence of this open stone shrine.

To visit the Museum at Cairo and view the tomb collections of Tut-Ankh-Amen is alone worth a trip around the world, and to me the most amazing and interesting is his solid gold innermost coffin, wrought in the shape of the God Osiris, judge of the dead, and inlaid with lapis-lazuli, carnelian, turquoise, and many other semi-precious jewels.

The childlike expression of this young Pharaoh in solid gold, fashioned by hands, long crumbled in the forgotten dust of thirty-three centuries, is indeed a true evidence of a skilled artist and master craftsman.

Another outstanding piece worthy of mention is the gold throne of Tut-Ankh-Amen, on the back of which is

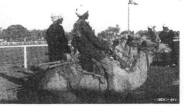

Left, silent watchers in the Temple of Rameses III, Karnak. Right, camel racers at Luxor Gymkhana Club await, in perfect alignment, the drop of the starter's flag

Five

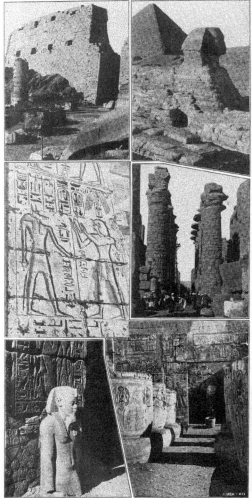

embossed a domestic tableau of the boy king and his exquisite little wife, Ankh-es-en-Amen, who is in the act of anointing him with perfume or unguent from out a jar held in a dainty hand.

Kingly Treasures

Here is clearly depicted to one's imagination a true love life of this royal pair, so abruptly ended in the untimely demise of the young king. Rare beauty of design and material; intricate cloisonné patterned in solid gold, urns and cosmetic jars in profusion of translucent carved alabaster; ivory and ebony compose the t r e a s u r e s of Tut-Ankh-Amen; so many there are to hold one's attention it would be impossible to enumerate them all here.

In all the ancient royal Egyptian burial rites the sacred scaraboeus plays an important part, and scarabs made from all sorts of materials and carvings are buried with the royal mummy, signifying, in their belief, the resurrection.

In Luxor, I was fortunate to come into possession of a genuine stone scarab through the gift of my dragoman, bearing the cartouche of King Thutmos III., Eighteenth dynasty, 1650 B. C.

A Dragoman Assistant

Mahmoud, my dragoman, knew his Egypt, and I found him quite a clever and interesting personality, radiating cheer with his smile working overtime and eager to lend every assistance in my work there, brushing natives aside to make room for camera and equipment. Egypt is hard to get photographically, owing to c l o u d l e s s skies, and little or no rain to wash the dust laden air; consequently the result is a strange impenetrable yellow glare.

Repeatedly my tests would show flat detail. Strange as it may seem, panchromatic is an almost unknown quantity in this country. While in Cairo I bought up all the Eastman supply of pan and straight stock from the agency in the Kodak building, a new and modern structure which is a pride to the city and the profession. The management took me through a

Upper, left, one of the huge entrance pylons of Karnak; right, the world's greatest conception of man's imagination rendered in ageless stone

Centre, left, the sculptures that cover the temple walls at Thebes are deep cut and expressive. Here is shown a detail of Anubis, the jackal-headed God of the Dead, holding the "key of life" in the right hand and being presented with an offering. Right, native workmen toil in restoration of the Avenue of Columns at Karnak

Lower, left, in a secluded corner of Luxor Temple one comes upon a broken granite Pharaoh of the time of Moses. Noble yet childlike is the expression of this age-old ruler. Right, feeble efforts of Today are endeavoring to restore to former grandeur Theban temples of Yesterday . . . Details of a corner, showing patched hieroglyphics and masonry

well appointed laboratory, which for the moment made me feel I was back in Hollywood.

One of my many amusing set-ups was upon the roof of the police station in the native quarters of Luxor —a coveted and privileged spot, I learned—during the festival of the "Procession of the Holy Carpet," which is celebrated annually, and a sight to warm the cockles of any photographer's heart.

Preceding the parade was a splendid spectacle of horsemanship upon Arabian mounts, the finest horseflesh in the world. These rich Egyptian landowners have so trained their horses that they will dash madly a distance of 200 to 500 yards, and with a suddenness surprising, s t o p w h e n their rider touches the ground with a long flexible staff, as if a brake had been applied.

They perform to the throb of the native derabukkeh and wail of pipe— weird music that weaves the spell of Egypt.

Between shots, the chief of police climbed to the roof to serve me with Egyptian coffee in thimble sized cups. Egyptian coffee is brewed for hours, and is thick with pulverized grounds of a molasses sweetness and served with a spot of ambergris. The aroma wafts one to delirious heights, but a thimbleful suffices as to taste. However, one drinks with gusto not to offend.

A Tense Situation

An incident I shudder to recall is when the camera jammed in the Temple of Queen Hatshepsut at Deir-el-Bahri, and I was forced to unload the magazine without a changing bag in a dark subterranean tunnel.

I had just photographed a cobra and some scorpions that came forth from just such a place, and no doubt they had many relatives right where I was sitting. To add to my mental agitation bats flopped about in confusion.

Mahmoud proved an excellent camera assistant, c a r r y i n g the load through desert sand and climbing perilous heights in temple ruins. I could also draw upon his store of knowledge in native lore. One of the

Upper, left, Memphis, the first capital of Egypt. The alabaster sphinx is one of the few remaining monuments of this ancient site of the beginning of civilization. Right, African skies pierced with minarets of many sacred mosques where the muezzin calls the passion of souls for prayer

Centre, left, in the Valley of the Kings—entrance to tomb of Rameses VI, directly above the tomb of Tutankh-Amen. Right: This is the Thinking Place of Rameses the Great, in the Ramesseum at Thebes, with its dignified halls and columns open on all sides to the sun

Lower, left: Modesty personified is the poise of the diminutive wife of Rameses the Great, as she stands at the side of her King in Luxor Temple. Right, in the Temple of Karnak a dragoman deciphers hieroglyphs to an interested listener

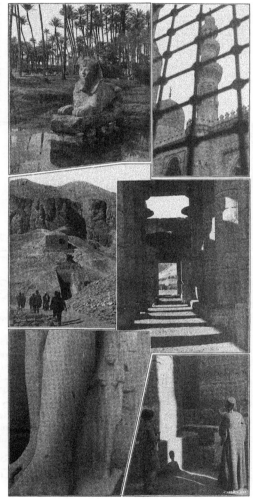

quaint customs, he told, that was handed down from the Koran, is that the rider of a camel must first greet the man on horseback; the man on horseback greets the donkey rider, and the latter the man afoot. In other words, the first greeting must come from "the man higher up." The expression is ever "Salaam Aleikum!" (peace be with you).

A Domestic Touch

I recently received a letter from Mahmoud telling of his "being in a honeymoon now," with festivities lasting many days—music, dancing girls, native drums, Arabian running horses, holy dervishes, and all the trimmings. He is very prosperous as they reckon wealth there, and as he and I attended a native wedding while in Luxor I can fully appreciate the costly and colorful vision so vividly described in his letter.

Quoting further from his letter: "Now the Nile is rising up and all of Egypt along the banks and for miles on each side is in inundation, and very beautiful when the moon shines on it, and the trains run through it to Cairo."

I hope soon again to journey to this "Sunday-school-picture" land—to see African skies pierced with minarets of many sacred mosques, where the Muezzin calls the passion of souls for prayer; to sail down the Nile, Egypt's "blood stream," with its palm-fringed shores dotted with native mud huts, the graceful lateen sails of my dahabeah silhouetted against the sunset glow; to feel again the dignity of the pyramids; to wander in the quaint Mouski Bazaars where one sees strange sights, like from the reflection of Aladdin's Lamp; to give coins to the little baksheesh beggars; to see flying dust from naked feet in the crowded labyrinthine streets; to watch the motion of sinewy fingers as the "Galli-Galli" man performs his bag of tricks, beside lazy camels drowsing in the hot sun; to walk in Africa's most brilliant of dawns, flaming sunsets and mellow moonlight nights.

This is indeed a picture focused in Yesterday's Memory.

King Charney says...

WHETHER IT BE CARBON OR INCANDESCENT LIGHTING
WHETHER IT BE TALKIES OR SILENT

Insist Upon Negative

For definite results

AGFA RAW FILM CORPORATION

DUNNING PROCESS

A few current releases containing Dunning Shots

"SEE America Thirst"—U

"What a Widow"—
Gloria Swanson

"Soup to Nuts"—Fox

"Her Man"—Pathe

"Romance"—M-G-M

"Half Shot at Sunrise"—RKO

"Just Imagine"—Fox

"Leathernecking"—RKO

"Ladies of Leisure"—Col.

"Up the River"—Fox

"Madame Du Barry"—U. A.

"Holiday"—Pathe

"Liliom"—Fox

"The Lottery Bride"—U. A.

"Born Reckless"—Fox

"Losing Game"—RKO

"Tonight and You"—Fox

DUNNING PROCESS
"You Shoot Today—Screen Tomorrow"

932 North La Brea GL 3959

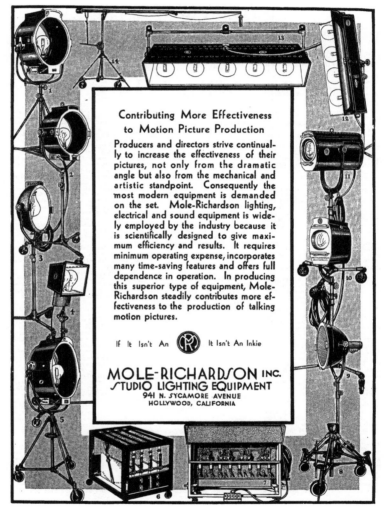

Reviewettes

WARNER BROTHERS Vita-phone production, "The Office Wife," attracted a lot of attention at Warners' Down Town Theatre the latter part of September.

William Rees held the assignment on the cinematographic work and, as usual, he and his capable associates turned out a craftsmanlike job.

Dorothy Mackaill is the featured player and Dorothy is not a difficult subject when she is in the proper mood. This is probably her best picture, and she gave it all she had, which, under the able direction of Lloyd Bacon, will be quite enough to click at the box office.

The sound recording and projection were in keeping with the excellent photography.

IN "What a Widow" that admirable trooper, Gloria Swanson, puts over another box office picture which opened recently at United Artists Theatre.

When Gloria's epitaph is written it will be said therein that she was not only a pioneer of the screen, but that her sincerity never failed. If she has faults they are for the most part thrust upon her by the limitations of her stories and the super-wisdom of some of her directors.

Miss Swanson, while not the easiest of subjects for camera recording, is radiant under the magic touch of George Barnes. But that is not all, for the entire production is brilliantly cinematographed and is a study for the interested cameraman.

The projection was a smoothly flowing stream of lights and shadows without lack of tempo, entirely creditable to the crew of this house.

GRIFFITH'S "Birth of a Nation" with its new dress of sound, had its birthday party at the President Theatre, Los Angeles, late in September and played to a packed house of appreciative fans.

The photography of the old master, Billy Bitzer, still scintillates from the screen. Volumes have been written about it, but it is a pleasure, once more, to pay tribute to this fine old pioneer.

Did the sound help this classic of the screen? It did not add to its subtle charm nor to its intense interest, but the sound was nevertheless put into the picture in a masterful manner by men who certainly know how to solve their problems, and the rabid sound fans will like the picture the better for it. Projection good.

SCREEN credit for the cinematography on "The Girl of the Golden West" is given to Sol Polito and Charles Schoenbaum, and the old saying, "Credit to whom credit is due" is exemplified in this case, for the work done by these two cameramasters on this picutre is surely a credit not only to the picture but to their craft.

Their opportunity was great, of course, for they had wonderful material to work with, but these very opportunities brought with them many problems to be solved and they had no easy time with the star.

Ann Harding, while no "raging beauty," is a joy forever in her histrionic moments. Her personality is dazzling and one destined to be outstanding so long as she cares to identify herself with the screen or stage.

She has not merely IT, but everything, howbeit she is not easy to photograph in action, and here is wherein comes the fine Italian and Germanic hands of Polito and Schoenbaum.

Masters of lighting and of camera technique, they made of Miss Harding in "The Girl of the Golden West" a living, breathing, palpitating flesh and blood woman moving in the midst of a world of reality.

The picture, running at this writing at Warner's Hollywood Theatre, is a First National Vitaphone directed by John Francis Dillon, who evidently is a close co-operator with his cinematographers.

It is a credit to the industry.

AT Pantages Hollywood, "Let Us Be Gay" occupied the screen the week beginning the ides of September, with Norma Shearer in the star role.

It is an M-G-M opus and, like all the pictures featuring this star, its production features are unexceptionable.

To Norbert Brodin was given the assignment of chief cinematographer, a rather pleasant berth on a Shearer picture, as the star is a 100 per cent co-operator with her photographer.

She is tractable, is photography-wise, and not only gives the cameraman every possible assistance, but credits him with the intelligence to do the best possible for her. Hence, she is always in good hands, and, if some of the other stars would profit by it, that's why Miss Shearer is always photographically impeccable on the screen.

Robert Z. Leonard scores again as a director of showmanship, artistic sense and restraint.

AT Loew's State, late in September "Dough Boys" stars Buster Keaton in an M-G-M production that is one of the best things the comedian of the frozen face has ever done.

Leonard Smith did the camera work, a rather difficult assignment, but as turned out by Mr. Smith it gives Keaton a negative technically and artistically 100 per cent.

Sound and projection left little to be desired.

AT THE Paramount, Sixth and Hill, "The Spoilers" is an Edwin Carewe production for Paramount release, and the lure of that

fine old Rex Beach story is attracting the cash customers to the box office in flattering numbers.

In some spots it is in no wise superior to its two predecessors of the silent screen, but an exceptionally fine cast puts it over.

The sound adds or detracts from the picture, just as you like, but there is no question that the sound engineers did a workmanlike job in putting in the sound.

Harry Fischbeck, in charge of photography, had his work cut out for him in handling the difficult sequences of "The Spoilers," but he did the job beautifully and thereby lived up to his reputation of being a painstaking and thoroughly dependable cinematographer.

Edwin Carewe directed and evidently was not much bothered by the omniscient supervisor. It is probably Carewe's best piece of work.

And this makes one wonder just how many times more "The Spoilers" will be filmed. If producers do not soon get another idea we are in danger of seeing the entire motion picture world go "Spoilers" with this sure-fire old formula in every theatre.

And this also suggests that time honored slogan: "When bigger and better pictures are made supervisors will not make them."

"Madam Satan," opening at Fox Criterion as our magazine goes to press, is, strange to say, a motion picture.

This is not merely a stage play put over with dialogue as, for instance, "Let Us Be Gay," excellent as that is, of its kind, but it is really an action picture which reminds one pleasantly of the good old days when motion pictures had motion and were many and good.

"Madam Satan" is a Cecil B. De Mille, M-G-M production with story by Jeanie MacPherson and dialogue by Elsey Janis and it is most efficiently cinematographed by Hal Rosson.

Signal Corps Attention

All members of Local 659 who served in the Photographic Section of the Signal Corps, U.S.A., during the World War, are requested to send their names, addresses and assignments to the editor to be used in an article to be written by Lieut. Colonel WalterE. Prosser, U.S.A., officer in charge of the Army Pictorial Division. Col. Prosser's article will be published in this magazine.

Padded Cell

Actress—I'm just crazy about you! Cameraman—Well, run along, sister. This is a camera booth, not an insane asylum.

We Wonder, Too

Betty the Revue Girl says: "If what they can't see won't hurt 'em, why not let 'em see it?"

A Scene from "Anybody's Woman," a Paramount Picture

Shown in the right light

HERE SHE IS! You've seen her a thousand times on the screen. Her demure little smile is warm and friendly. Midst elaborate scenery and dazzling surroundings, she never loses her piquant charm. National Photographic Carbons have given "light men" and photographers the chance to present her at her best, making her success theirs as well.

For medium and long shots, National White Flame Carbons have actinic carrying power identical with that of pure sunshine. Every graceful gesture is registered, is made an exciting pattern of light and shadow. Use them for sharp moonlight effects, for brilliant, clear-cut contrasts, for scenes exacting in detail.

Stars have learned, "light men" and photographers have learned, that National Photographic Carbons are always dependable. Whether in the daily routine of studio work or for unusual scenes under the most exacting conditions, National Photographic Carbons will help you get your stars over.

NATIONAL CARBON COMPANY, INC.
Carbon Sales Division: Cleveland, Ohio
Unit of Union Carbide UCC *and Carbon Corporation*
Branch Sales Offices: New York, N. Y. Pittsburgh, Pa.
Chicago, Ill. Birmingham, Ala. San Francisco, Calif.

National Photographic Carbons

—

Eleven

Horsemen of the Air

Presenting Local 659's latest converts to aviation. These three boys are just beginning solo training and it won't be long until they will be driving their own planes. Left to right: J. B. Alexander, agent of the Fairchild Company; Mickey Whalen, Curley Linden and Osman Borradaille, members of 659; Earl Gordon, manager of operations Metropolitan Air Port.

Wyckoff to Multicolor

President Alvin Wyckoff, of Local 659, has been added to the staff of Multicolor. Mr. Wyckoff has devoted much time to the study of Multicolor, and with his great background of experience and photographic knowledge, should become an invaluable asset to this fast coming color system.

Expansion

The Hollywood Camera Exchange, recently established by Arthur Reeves and Cliff Thomas, 1511 North Cahuenga Avenue, has already been forced to expand by taking additional space adjoining its present location.

Dyer Returns

Elmer Dyer returned from Lakehurst, New Jersey, in time to break par in Local 659's golf tournament at Palos Verdes, September 7th.

Mr. Dyer spent six weeks at Lakehurst shooting the air sequences in Columbia's big aerial picture "Dirigible." He spent two nights and many days on the naval dirigible *Los Angeles* and, in spite of heat and mosquitos had a good time. The mosquitos, he said, were a great help. They used 'em for aeroplanes when the latter were laid up for repairs. Mr. Dyer is now with Multicolor.

On Paramount Lot

Charles Lang is the photographic authority on a Richard Wallace production featuring Ruth Chatterton. Bennett, Pittack and Laszlo are on the pan-handles, while Morris, Shirpser and O'Toole keep the metal parts polished.

Lee Garmes and Henry Gerrard are up at Sonora, making "Fighting Caravans," with Otto Brower directing Gary Cooper, Lila Damita, Ernest Torrence, Tully Marshall, Gene Pallette, Fred Kohler and about 180 others. Mayer, Lynch, and Titus are the men wearing puttees and reversed caps, while Burgess, Cruze, Lane, Harlan and Roe are wrangling film and kodaks.

Vic Milner will soon start a Schertzinger production featuring Wm. Powell, Cavanaugh and Compton. Needless to say Vic will have his old stand-bys, Mellor, Rand and Knott to consult about exposures, while Ahearn, Ballard and Smalley will tell the aforementioned experts whether or not they are right or wrong.

Dave Abel will ably handle Cromwel's "Unfit to Print," featuring Bancroft, Francis and Toomey, starting soon. Clemens, Fapp and Lindon will probably show Dave the set-ups that require the least exertion, with King, Bourne and Rhea helping them.

Harry Fischbeck will probably make "North of 36," which is now being groomed for Sloman's direction. Harry's help is as yet undetermined. A production of this calibre will require sturdy men and it may be necessary to revise the wage scale that such men may be paid by "weight"— a thought for the revision committee.

Mel Stamper, Virgil Miller's assistant, has been vacationing, with the result that Virg. has been so busy that his wife thinks he is also vacationing. Virg. says he's "cut off" so many heads recently he feels like a Chinese executioner; however, everything will be all right if he can remember all those to whom he has said: "I'll keep you in mind."

A PLEDGE

To Theatre Owners, Managers and Projectionists to Maintain

SUPREMACY

It has been our responsibility to satisfy the needs of the motion picture industry and to meet many emergencies created during a period of extraordinary expansion and unparalleled activity.

With increased manufacturing facilities and closer contact with our selling organization we pledge this great industry that, we will render even greater service and maintain the high quality which has won a world-wide supremacy for

THE INTERNATIONAL PROJECTOR

INTERNATIONAL PROJECTOR CORPORATION
90 GOLD STREET NEW YORK

The Academy's Symposium

Technical Men, Cinematographers and Scientists Express Highly Divergent Views on the Subject of Wide Screen Sizes and Proportions

By FRED WESTERBERG
UnitedArtists; Associate Technical Editor International Photographer

UPWARDS of 300 invited guests attended the meeting called at Fox Hills Studio on the night of September 17, by the Academy of Motion Picture Arts and Sciences, for the purpose of discussing the wide screen.

The gathering was representative of the Hollywood motion picture industry and the exchange of views was most interesting, if not conclusive.

Nugent H. Slaughter, sound expert under his direction the meeting moved off smoothly and without delay.

Douglas Shearer, sound technician and cameraman, spoke on the physical aspects of screen phoportion, photography and sound in relation to a larger screen.

He said that the need is not so much for larger figures on the screen as it is for more scope in their movements. He illustrated this by showing a drawing masked to a 3x4 proportion. By removing the mask additional space was shown without affecting the size of the picture.

The pseudo-stereoscopic effect obtained on wide film was attributed to the wide angle of view.

Measuring Grain

Some grain measurements were given. Mr. Shearer found that the average negative of .7 density contained 25 silver clusters to each square thousandths of an inch. Positive emulsion was found to have about 4 times as many clusters per unit area as negative film. Negative grain could be reduced, he said, by making a reduced print on 35 mm. film from a wide film negative.

If reduction prints were made, he said, there would be no need to make provision for a sound track on the wide negative film. This would permit a reduction to be made in the total width of the film.

Mr. Shearer doubted the value of a wider sound track than is now used. A gain of 6 decibells in volume would be obtained by doubling the area of the sound track, he said, but the ground noise would also be raised about 4 decibells, so the resulting gain of 2 decibells would hardly be worth the trouble and expense.

He also said that the present speed of 90 feet per minute is sufficient to obtain a register of the highest audible frequencies and concluded, therefore, that any greater speed would be unnecessary.

Dr. Lee De Forrest spoke on standardization of wide film. He reviewed the activities of the sub-committee of

the S.M.P.E. on standardization, of which he was a member. He cited some of the dimensions that had been arrived at from an engineering point of view. He concluded by saying that the committee had gone as far as possible and that it was up to the producers to come to some kind of a decision in regard to production requirements before any further progress could be made.

Karl Struss, cinematographer, spoke on the significance of screen proportion. He showed that a picture that is not wide enough often appears on the screen as a square due to the angle of projection, and sometimes even as a vertical picture, especially if viewed from the side of the house. Such a picture, he said, is very unsatisfactory from the audience standpoint and is one of the reasons why a wider screen proportion is needed.

Mr. Struss referred to the Gateway Theatre in Glendale, Calif., as an example of a theatre taking the bull by the horns, as it were, and giving the public a wide screen without the use of a wide film. This theatre, he said, which is typical of 90 per cent of the theatres in this country, simply puts in a matte .500x.800-inch instead of .600x.800-inch and by changing from a 4½-inch projection lens to one of 3⅜-inch focal length, obtains a picture reasonably free from grain on a screen 16½x26¾ feet, making full use of the available stage space.

Struss Likes 3 by 5

Mr. Struss considered the 3x5 proportion of this screen as ideal. He pointed out that a 1x2 proportion as used at present on wide film, instead of giving larger full figures on the screen, in this case would present them 20 per cent smaller since the maximum width of the stage was already being utilized.

Another point brought out by Mr. Struss was that the lack of height of the 1x2 proportion was keenly felt at times in striving for dramatic effect. He cited a case from one of his latest pictures where the headlight of an onrushing locomotive passed out of the top of the' screen before the locomotive could get close enough to the camera to obtain the necessary effect.

J. O. Taylor reviewed his experiences in photographing six productions on wide film. He was heartily in favor of wide film as it now stands, 1x2 proportion and all. He cited such advantages as finer grain, greater depth of focus, larger figures on the

screen and freedom from having to pan the camera.

Max Ree, art director, in speaking of screen proportion discounted the artistic problem. Audience reaction, he said, must be kept in mind at all times. As an artist he favored the 3x4 proportion as offering the necessary element of height and permitting a greater concentration of interest. But, he said, the possibilities of a wide screen for panoramas and spectacles where concentrated interest is not necessary should not be cast aside.

Suggests Flexible Screen

Mr. Ree favored a 3x5 proportion as a maximum in a wide picture. By having a screen of constant height that could be changed in width by the use of flippers he thought a better balance could be maintained between scenes meant to be merely impressive and those which demanded concentration of interest.

Ted Reed, sound expert, eulogized wide film and the 1x2 proportion. He did not believe, as one of the previous speakers did, that action on one side of the wide screen would go unnoticed when important action was in progress on the other side. He said the theatre had mastered this difficulty and thought the screen could do so likewise. He found that a wide sound track was a help in recording sound perfectly.

Your correspondent was called on for a few remarks and managed to find voice to utter a thought or two on the need of fully investigating the possibilities of 35 mm. film as a vehicle for a wide screen picture. He said that area on the film is what we are fighting for in order to reduce the amount of magnification in the projected image. It was his contention that a 3x5 proportion conserves more area than the 1x2 proportion. In closing he expressed the hope that someone would invent a method of removing the sound track from the picture space where it is seriously impairing the ability of 35 mm. film to meet the increasing demands being made upon it.

Dr. L. M. Dieterich, scientist and consulting engineer, prefaced his remarks by saying that wide film is not yet an engineering problem. The first question to study, he said, is the esthetic reaction of the public. Service to the public demands that they be given a picture at which they will like to look.

Referring to the old masters of painting, Dr. Dieterich said he had found that the best of them found inspiration in contemplating nature,

that consciously or unconsciously they were imbued with the spirit of dynamic symmetry. As evidence of this he pointed to the preponderance of the 1 to 1.618 or the 3x5 rectangle in classic art.

Effortless vision, the doctor said, embraces a field of view in binocular vision of 38 degrees on each side of the optical axis, 15 degrees above and 30 degrees below. In terms of a rectangle this gives a proportion of 3x5.

In closing he said that the first problem of wide film is to find a satisfactory proportion. Technique can come later.

Russ Entertains

Sergi Eisenstein, colorful Sovkino director, proved to be the spice of the program. He took it upon himself to rebuild nearly every argument that had been put forth. He was in rare form and his frequent coups were roundly applauded.

A horizontal picture, he said, is only 50 per cent effective. Agricultural and other natural backgrounds require a horizontal picture, but the modern skyscraper needs a vertical picture to do it full justice. A crocodile, for instance, would also call for a horizontal picture, but a giraffe would certainly need vertical treatment as would a giant redwood tree. A square aperture that could be blocked out to any desired shape called for by the scene appealed to Mr. Eisenstein.

He characterized dynamic symmetry as a device to give life to an inanimate painting, but could see no reason for using dynamic symmetry on a screen that already has life and movement. Why use any of the laws of painting in composing a picture on the screen, he contended.

He thought it would be foolish to saddle the industry with a wide film based on the esthetics of the theatre when the screen is still groping for its own esthetics. He is evidently afraid that we are going to have a white elephant on our hands.

In response to Dr. Dieterich's effortless vision argument Mr. Eisenstein brought forth the fact that although the eyes move easier in a horizontal direction this is more than offset by the neck, which can be moved more readily in a vertical direction. Mr. Reed broke in to check and double check this statement by demonstrating how easy it is to nod the head and say "yes," especially in Hollywood.

Mr. Eisenstein concluded by saying how nice it would be to be able to play not only with the story and the cutting of the film but also with a screen that could be made to take any desired shape as the story progressed.

Dr. Metfessel, professor of psychology, was the next to speak.

He questioned the esthetic value of the so-called golden section or 3x5 proportion. An early questionnaire, he said, gave this proportion a vote of 35 per cent, which was more than any other shape received, but Valentine in 1900 found in another questionnaire that any rectangle was then considered esthetically sound, except a square.

The doctor brought out the fact that the eye can only concentrate on form near the center of vision, that on the sides it is only sensitive to movement.

He also said that we have become so accustomed to stereoscopic vision that we are capable of seeing depth even with one eye under natural conditions. One of these natural conditions is that we do not see things with a border.

A large wide picture on the screen, he concluded, approximates natural conditions in that we are not so aware of the border.

Joseph Dubray, motion picture engineer and erstwhile cameraman, paid tribute in his opening remarks to the Academy of Motion Picture Arts and Sciences for its work in bringing the industry together in a concerted effort to solve the wide film problem.

Mr. Dubray stated he had found an apparent trend in Hollywood toward the opinion that the 1x2 proportion is neither pretty nor desirable. With this opinion he was in agreement.

He told that from an engineering standpoint research had proved that film based on a 3x5 picture proportion was more easily handled than film based on a picture proportion of 1x2.

Possibilities of a flexible screen were discounted by Mr. Dubray on account of the control already exercised by the cameramen in the use of making pieces on the set and vignettes in the camera.

Mr. Dubray heartily indorsed wide film, but stressed the mechanical superiority of a film having a picture proportion of 3x5.

Mr. Shearer spoke again, saying that any wide film proposals would be subservient to the requirements of commerce.

He cited the fact that it would cost about $40,000,000 to change the projection machines in this country to take wide film and that release prints alone on wide film would entail a cost of about $20,000,000 yearly. Production costs, he said, would be relatively small. He recommended that consideration be given to the idea of printing from a wide film negative to standard positive by optical reduction. The results so far obtained were very promising, he said.

In closing the meeting the chairman, Nugent Slaughter, voiced the opinion that all those who had come with preconceived notions in regard to wide film must have had many of these notions upset.

Criticus Comments

Dear Mr. Snyder,
Editor International Photographer:
You wanted me to comment on the meeting of the Academy of Motion Picture Arts and Sciences, held at the Fox Hill Studios for the discussion of the wide screen problem on September 17th.

The large attendance by members of the Academy, the S.M.P.E., cinematographers, and scientists not actively engaged in motion picture production, emphasized to the disinterested person the tremendous importance of this problem in its momentous influence upon the future of the motion picture industry throughout the world.

This meeting was supposed to be the first of a series of similar meetings. Scheduled speeches and subsequent invited discussion disclosed a variety of divergent opinions regarding the desirable shape and size of the future screen.

Many Opinions

These opinions, expressed by outstanding representatives of the different technical branches, were, however, obviously too much tinged by technical details to permit crystallization of thought of the main issue. It is to be regretted that producers and directors and the art element of the different studios were not, at least actively, represented.

Realization of the fundamental problem was only expressed, and very enlighteningly so, in the speeches of Mr. Max Ree, Dr. Dieterich and Mr. Eisenstein.

There was, however, apparently creeping up throughout the discussion a sentiment against an extreme 1:2 screen proportion and favorable comments were heard for a 5:8 proportioned shape.

It will be interesting to observe whether the Academy will, during subsequent sessions, show the courage of its convictions and produce resolutions leading to a standard of screen proportions satisfactory to all the branches of the motion picture industry and to the final arbiter—the public.

CRITICUS.

Vitaglo Making Portable

The Vitaglo Corporation of Chicago is manufacturing a portable recording unit for studio, commercial and newsreel camera. The company states this device is a portable sound on film recording unit capable of mixing four microphones, condenser or carbon, sufficient to overcome any situation which might arise before the studio, commercial or newsreel cameraman, and which eliminates the necessity of a sound truck.

The claim also is made by the manufacturer that the Vitaglo sound gate can be installed in any camera adaptable to sound on film without in any way interfering with the use of the camera for any other purpose. A company statement declares that a frequency range uniform from forty to eight thousand cycles is covered by the Vitaglo amplifier. A Jenkins & Adair condensor microphone is furnished with the equipment.

---o---

The Deadly Parallel

Walter Lundin is in the hospital with a broken knee-cap as the result of a fall from a parallel. These parallel accidents are getting to be a habit and before a tragedy happens it is suggested that producers give some real hard thought to the matter.

A collapsible steel parallel might be the solution. Who will build the first one?

Harriscolor Will Expand Facilities

HARRISCOLOR Films Inc. of Hollywood is planning expansion east and west. In Baldwin, L. I., the company will build a plant covering ground area of 100 by 100 feet. It will be in two stories and will be finished in 1931.

In Hollywood the present plant, in McCadden place on the industrial side of Santa Monica Boulevard, will be doubled in floor space.

The three-color Harris process now has been a year on the market, following the two-color method, which went into production five years ago.

With the coming of the three-color process and also of sound a marked change was made in the sturdiness of the company's cameras desiged for production work. This was made necessary by the requirements of continually matching up colors day after day throughout a regular production, a situation that does not arise in the making of a short commercial.

Increasing attention is being paid by Harriscolor to the commercial field, a number of large national advertisers already being numbered among its clients. On the industrial films use is made of Bell and Howell and Mitchell cameras converted to company requirements. This conversion is done at the Hollywood factory for the benefit of cameramen living at a distance, it being necessary merely to send on the equipment.

In answer to a question one of the company executives replied that on the average about one hour's time is required to enable a cameraman to become sufficiently familiar with the method of operation to proceed independently with his work. The time required for setting up on color work is declared to be about the same as for black and white.

The company has just completed a four-reel South Sea subject in full color and is set to make a feature western in color.

Moon Accessory Company Producing Aluminum Reels

The Moon Motion Picture Accessory organization Company, 310 East Tenth street, Los Angeles, recetly delivered to National Theatre Supply Company 1000 "Laco" aluminum reels and negotiated for 1500 sets of 2000 foot aluminum castings, purchased from the Alumbra Foundry corporation, to be used in the manufacture of 35 mm. film reels.

Until recently the motion picture industry has been dependent upon eastern firms for this product, but now that the Laco aluminum reel has been introduced a local product with claims of unusual merit is offered.

Joseph Dubray Arrives

Joseph Dubray, manager of technical service of Bell & Howell, surprised and delighted his host of friends by dropping down from the skies the other day. He will spend some time looking after the interests of B. & H. in Hollywood and will incidentally renew old acquaintances in Tek-Nik-Towne and in the studios.

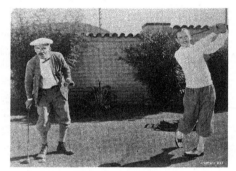

As all golfers are brothers under the skin, so Roy Johnson, one of the champ cameramen golfers, looked upon Andy Clyde, Sennett comedian, that morning the genial Andy entered the studio after a session at Lakeside. What you see was suggested by Roy—that the comedian in his natural character of golfer should be snapped in the act of slamming out a drive; and that then he should slip into his dressing room and in ten minutes return in the character of a man who in his facial resemblance might be one of his own relatives back in the bonny hills across the water, thus to watch the flight of the drive. So here we have a combination of the comedian who knows his play and his work and the photographer who knows his work and his play—only you see Andy twice, while Roy, in the background like all true photographers, finds his satisfaction in seeing others skillfully registered on his film.

Cream o' th' Stills

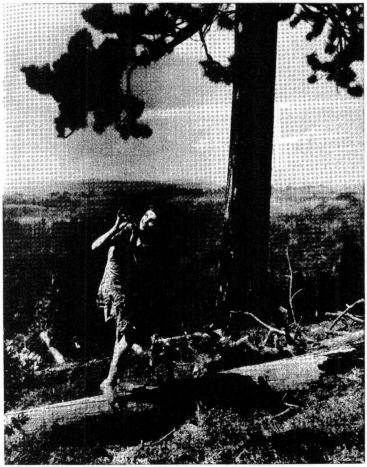

Elmer Fryer likes this elfin stuff, but according to his own account he doesn't often get subjects and locales suitable to his fancy. Here is a picture that brings back the memories of days when the fairies danced upon the lawn and gnomes were everywhere in the greenwood

 # Cream o' th' Stills

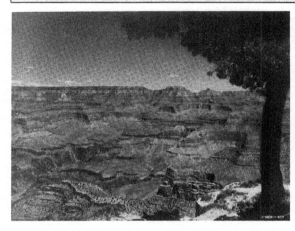

William Grimes, when on location in picturesque places, overlooks no opportunity to run down just such pictorials as this unusual view of the Grand Canyon of Arizona. The skyline is the north rim of the canyon. Note the glimpse of the Colorado river in the foreground, lower left

Just where was R. S. Crandall when he snapped this charming picture of Hollywood? It is a view not often seen of our Film Capital and gives the observer a fine idea of our surrounding hills and mountains

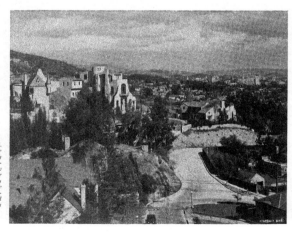

 # Cream o' th' Stills

There is no movie set in this shot. It is a simon pure picture, man, dog and all, taken by Robert Coburn in the Bret Harte country of California

This picture of domestic life on the island of Borneo—in this case a cock fight —is from the collection of Lenwood B. Abbot made on a recent visit to the Orient. Here is a happy people whose haberdasher bills are not oppressive

Cream o' th' Stills

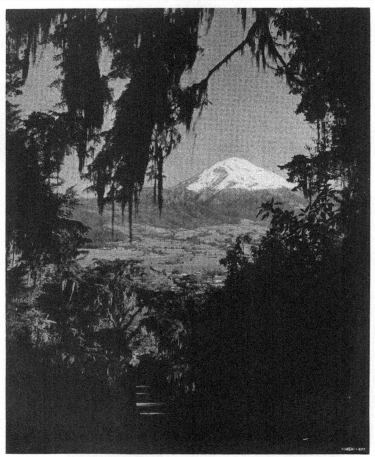

There never was a more beautiful shot of Popocatapetl, (smoking mountain, 16,500 feet) Old Mexico, than this product of the goode boxe of Jules Cronjager. The town is the picturesque village of Amecameca.

This is what counts!

EVERY quality demanded by the camera man is incorporated in Eastman Panchromatic Negative, *Type 2.* But what counts most of all is the roll-to-roll uniformity which gives such splendid results day in and day out. It is because of this factor in particular that more and more camera men daily are turning to Eastman "Pan".

EASTMAN KODAK COMPANY
ROCHESTER, NEW YORK

J. E. Brulatour, Inc., Distributors

New York Chicago Hollywood

A Laboratory on Location

Weeks and De Censo of the "Trader Horn" Expedition Did Their Big Game Hunting in the Tanks

(Contributed by CARL KOUNTZ, Local 683, from Special Correspondence to the East African Standard)

TO produce the 12,000 feet of film "par excellence" that the audiences will ultimately see and hear as "Trader Horn," the Metro-Goldwyn-Mayer Corporation is "shooting" in Africa almost twenty times that footage. Later it will be selected and "cut," and rearranged into a feature story in which wild animals and actors will appear on the screen in a drama of adventure.

One incident of the undertaking has been the establishment of a laboratory in Nairobi, which condenses the functions of delicate yet extensive equipment and 200 specialties, to a "pocket edition," manned by two picked men.

Its efficiency, under unusual conditions, is surprising. The two specialists are in step with modern film producing science. Some of its arrangements, and the qualifications of the two Americans who are doing valiant service of a technical character, are described herein.

Making the film and talkie of "Trader Horn" in Africa has not only its romantic, but its technical aspects.

* * *

One of the trials of Director W. S. Van Dyke, who is piloting the Metro-Goldwyn-Mayer Company of some forty persons through the "Dark Continent" (as it is sometimes described), was to construct a modern motion picture laboratory in Nairobi, the commercial capital of British East Africa, from whihc this band of adventurers took off for more remote places.

As the motion picture industry is constituted today, meticulous care must be taken of the film in all its stages of progress in order to insure audiences the high quality of product to which they have gradually become accustomed.

A Kenya "Lab"

To reconstruct a pocket edition of the big laboratory back home, in Culver City, Calif., was Director Van Dyke's aim. Staffed by two men, instead of two hundred, reduced in size to the smallest practicable point, and yet complete and scientifically efficient; the result is nevertheless of proportions to be an institution in itself.

Arrangements were made with the management of the Theatre Royal, convenient to the screen and projecting room, and in a wing of the building the M-G-M laboratory is established.

Some ten tons of equipment were broken from their original containers, that had come by various steamship routes from Culver City, 12,000 miles away, and arranged in the building built of stone and of the permanent type of construction which is wisely being followed in Nairobi. The first requirement was to tear down a portion of the building in order to admit the heavier portions of the equipment. Four dust proof rooms were partitioned off, and two of them made light proof as well.

Avoiding Dust

The necessity for avoiding dust, which is not unknown here, as the "winds of freedom" sweep from the broad Athi plains through the streets, is a prime consideration. One particle of dust on a negative cinema film produces little flecks on all the subsequent positive prints, and these imperfections, if in quantity, produce what the movie people call "rain," a fault which would ruin the projection value of the film. The expenditure of hundreds of thousands of dollars by the company, and the herculean efforts of the party for months in the field, would be jeopardized by "the free, wild winds."

The ordinary water supply, especially if acidity exists in the soils, is not efficient for the motion picture needs. Hundreds of gallons of absolutely pure water, in the chemical sense, must be distilled at the very beginning of the process involved. A special plant for this was installed by the mechanics of the Van Dyke party soon after their arrival in Nairobi. These versatile engineers, selected and brought over in the first instances for entirely different work, have been substituting at all sorts of unforeseen odd jobs, by the way.

Chemical Needs

The subject of chemicals for the laboratory was no slight one. Fear of the deterioration of photographic supplies, shipped throughout the tropics and then held in stock for probably a year almost on the equator, was an apprehension to begin with. Tons of developer, acids, and materials with which to mix emulsions and "fixing-baths," were packed in special heat-resisting cases and shipped via the seaport of Mombasa in advance of the sailing of the party.

The experience of American manufacturers was appealed to for assurance in preparing these items for the voyage. The director was accordingly gratified to learn that not one instance of breakage or leakage had occurred. Moreover, in Nairobi sizable stocks of chemicals are obtainable, as photography was found not to be unknown in Africa.

One of the four rooms of the laboratory was fitted with shelves and bins for the storage of the precious supplies.

Exposures

Two hundred and twenty thousand feet of negative are being exposed in Africa by the "Trader Horn" expedition. By the process that has been perfected for the M-G-M method of making sound pictures an exactly equal footage of sound "take" is required. After both of these have been carefully developed, a positive print is made for the use of the director, in checking up the results of his labors in Africa. A little mathematics will check the statement that close to a million feet of negative will pass through the important little laboratory, and it all has to be "handled with care."

The films, both positive and negative, are not allowed to remain in the laboratory longer than is absolutely necessary, and each reel as completed is deposited in a vault in Barclay's Bank. By arrangement with the insurance companies that are handling the risks of the expedition for the M-G-M Corporation, this highly valuable treasure is financially covered while in the bank and subsequently. The bonding of this film, in transit, and under the jurisdiction of a dozen different governments en route, is a story in itself. The film is triple wrapped and is handled in galvanized steel containers on account of its inflammable nature.

As the "Trader Horn" company penetrates far into the interior, in its search for the most typical and most thrilling spots in Africa, installments of the tale come trickling back to the two specialists in the laboratory. Their share in the high adventure is the responsible work of bringing the product to completed shape and its final refinement, and their reward is to check over the results of their efforts as it is projected here on the screen. Unfortunately, headquarters at Culver City have directed that the showings be strictly private, and nothing could be more so. In the hush of the lonely house, these two men are at intervals the first audience to see and hear the play of "Trader Horn."

"Movies for two," one of these strange matinees might be termed!

They see their friends, Miss Edwina Booth, as the White Goddess; Duncan Rinaldo as Little Peru, and

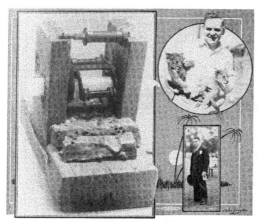

An African "Lab" with Messrs. Cause and Meeks, its operators

Harry Carey as he re-creates the redoubtable role of Trader Horn himself, uprsued by a herd of charging African elephants, and breathe a sigh of relief as Carey reaches the top of a tall tree. They see the elephants surround the tree, and breathe another sigh as at last the pachyderms turn and saunter off in the direction of a water hole. The Belgian Congo (to them) is as remote from Nairobi as China is from New York, and the only part that the laboratory men play in the high adventure is that of the heroic rearguard of the expedition.

In the Bank

By devious ways, not excluding river boats, native canoe and porterage, the product has reached them; and similarly one positive print will go back, to be projected in camp on a sheet thrown between two thorn trees for the benefit of the director and his band.

The laboratory men, heedless of hours, overtime or the passing of holidays, daily do their bit, condensing the tasks of many men into the labors of two.

The Nairobi Setting

About them is the mixed life of Nairobi. They live in a comfortable hotel. For recreation, like the postman's walk on his day off, they can go to the movies. Their thrills are natives at work hewing rocks while holding them in bare toes; high wheeled ox carts in city streets; and native waiters padding efficiently about the splendid dining room in "evening dress," that is to say, white nightgowns and bare feet. They seldom hear the roar of lion, the swish of crocodile, the snort of hippo. Compared to the situations in which the field troupe find themselves, the stay-at-homes have all the advantages of civilization.

Recently the body of the troupe returned to Nairobi with "tales to tell," and, after a pause for breath, passed on into the fastnesses of Kenya and Tanganyika, pursuing rhinos, lions and pythons, and other diverting incidents of the film. The contrast in the men was evident—sun tanned—even Harry Carey, meticulous screen star, has a peeled nose in Africa—and weather stained, the outdoor crowd presented a fine contrast to the indoor men. Paled by confinement in the darkroom, drawn by contact with chemical fumes, and weary with the effort of keeping up night after night with the batches of work that have arrived with merciless regularity, they greeted their hilarious countrymen.

The safari, the largest and the longest and the most hard working that has ever gone forth in the history of Africa, moved on. (For each day of "breathing" costs several thousands of dollars to M-G-M.) Still the labor of the laboratory men continues and the "rushes" of exciting events in the field come in.

The keeping of the records alone, with a special system of card indexes, is a job for any one man. Yet this is crowded into the interstices of time, and is only a small part of the job, according to the scale of values that exists. A barefoot native, who keeps the floors in order and runs errands and marvels at the complex equipment of the "lab," is the only help employed.

Two Specialists

An array of drying drums, reviewing reels, printing machines (photographic), are the source of constant wonder to the privileged native employee. The curiosity of the local public is not allayed by the brusque "Keep Out" and "This is our busy day" notices that the efficient American corporation had shipped over with the chemicals.

Keeping everlastingly at it is the only salvation of the two laboratory men. We have not, by the way, introduced them. Fred Meeks, a Californian of quiet manner and penetrating eye, is chief of staff. Though a young man, he has been with the darkroom side of motion pictures since their infancy, and his own. Absolutely conscious and, of course, skilled in every department of his work, if "Trader Horn" is one of the epochal successes of the picture world, much of the credit will be due to him, unsung. Stars may have their attractions for the audiences; the director, the photographers, may even be heard of by them, but the grub-like toil (or the scientific ecstacy) of nursing the film through its chrysalis stages to the final resplendent butterfly falls to the lot of efficient, ever patient and technically observant Fred Meeks.

If Fred Meeks is the chief of staff, then Domenic DeCenso also may be called "the staff." A thousand details fall to his daily lot. He was born in New York, and has been a rising technical star of Hollywood for the past eleven years. Thus the great M-G-M "coast-to-coast organization," as they are referred to by the troupe, functions. Its grist is no more remarkable than its grit.

Plenty of Work

Like all members of the "Trader Horn" exedition, DeCenso and Meeks are picked men, from among the vast organization at Culver City. As stated, their pilgrimage in the cause of art is not the thrill-filled symposium that exalts the days of the participants in "Trader Horn's" more dramatic facets—theirs but the unsung labor of service, the labor of love of their work. And it leaves but little time for the luxury of homesickness, so much enjoyed by the casual tourist in foreign lands.

When Harry Carey exhibited numerous lion skins and buffalo horns as trophies of the chase, a wistful look might have been noted in the eyes of Meeks and DeCenso. Even the two broken ribs of a member of the party as he manfully continued the safari from Nairobi, they have envied.

Perhaps when the last foot of the historic film has been filed away in its stone vaults, Meeks and DeCenso will rub the gun oil from their resting rifles and go out blinking for a spot of sport, before entraining and "enboating" on the 12,000 miles toward home.

But in the meantime for them is only the delight that inheres in a task well done. Director Van Dyke has summed up their praises in a crisp remark which is perhaps the highest encomium that M-G-M could have given to Messrs. Meeks and DeCenso. He said: "Our men know their jobs."

Golf Tournament of 1930

HE Second Annual Golf Tournament of the International Photographers, Local 659, I. A. T. S. E. and M. P. M. O., has passed into history with great éclat.

The event took place at the Palos Verdes golf course, Palos Verdes Estates, Sunday, September 7, beginning at 7:30 in the morning, the last foursome checking in about 4 p.m.

The attendance was nearly twice that of 1929, there being 33 full foursomes, with a very few exceptions, in play. The "gallery," also, was much more numerous.

The course was a tough one to many of our fledgling golfists and it wasn't duck soup for the best of them, but it was just what was needed to keep every player on edge.

The foursomes were sent out as rapidly as possible, but the procession was somewhat delayed by the intercalation of regular club members at frequent intervals.

However, the gladiators were all in full flight by two hours after noon, and it was a battle royal if there ever was one on a golf course.

Several tons of balls were lost and a truck load or two of clubs were broken or badly sprained, while tempers and expletives were scattered so thickly over the links that the sun went down in a heavy haze.

Johnny Mescall's name will go on the trophy as champion for 1930, and right on his heels was Gordon Jennings, the match being decided at the eighteenth hole.

But the pictures, cartoons and official score will tell the story better than many words, and as the radio announcer says, here they are:

We Thank You

The sincerest of thanks of local 659 are hereby extended to: The Golf Committee, comprised of James Palmer, chairman; and Brothers Lanning, Foxall, Brodin, Virgil Miller, William Snyder and John Mescall; also to the efficient sub-committee, Brothers Vallejo, Tod Declede and Fred Campbell.

Warner Crosby, Ollie Sigurdson, J. Edwin New and Lindsay Thomson for their services shooting stills on the tournament.

Schwab's men's clothiers and furnishers, 6358 Hollywood boulevard, for contributions to the prize list and for the window display.

Eastman, Ansco and Dupont for film used in still cameras.

Dupont, Eastman and Agfa for the delicious and super-abundant buffet luncheon served all during the day.

The Palos Verdes Estates Corporation for cuts and photographs.

Brother Glenn Kershner for his extraordinarily clever and appropriate cartoons which appear in this issue.

And to all others, known and unknown, who in any way contributed to the success of the tournament.

The Prize Winners

Herewith is a complete list of the prize winners in the second annual golf tournament, also the names of the firms and individuals who were donors of the prizes:

Guy Roe—$15 worth of merchandise from Schwab; donor, Cinema Studio Supply Co.

Ray Ries—Parker pen and pencil set; Tanar Corporation, Len Roos.

Jack Breamer—Pair of golf shoes from Schwab; Agfa Raw Film, King Charney.

Tom Galligan—Gold cigarette lighter set; Schwab's clothing store.

C. B. Myers—Pair golf shoes from Schwab; Agfa.

Joe Valentine—$10 savings account; Citizens National Trust and Savings Bank, Hollywood at McCadden.

Dan Fapp—Dozen Silver King golf balls; Eastman Kodak.

James Clancey—$10 order for merchandise on Schwab's; Max Factor Corporation.

Panoramic View of Survivors

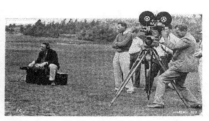

Len Roos and Bert Longnecker turn loose the Tanar portable works on President Alvin Wyckoff, shown on the opposite page talking in front of the mike

Edward Wade—$5 savings account; Citizens National T. & S. Bank.

Paul Perry—$5 savings account; Hollywood State Bank, Mr. Adams.

Dewey Wrigley—$5 merchandise order; Hollywood Flower Gardens.

Fred Eldredge—Radiator ornament; Muller Bros. service station.

Henry Kruse—Special prize; Illinois watch, for drive nearest pin at fourth hole; Bill German, J. E. Brulatour, Inc., New York.

Al Greene—Consolation prize, one of three gold cigarette cases; E. O. Blackburn, George Gibson, Bud Courcier, Eastman Kodak Company.

John Mescall—Low Gross Plaque and Statuette; Smith & Aller, Inc., Dupont.

Reggie Lanning—Leather golf bag with set of McGregor clubs and irons; J. E. Brulatour Inc., Hollywood.

Gordon Jennings—Ted Pederson, Nichols matched irons; Smith & Aller, Inc.

John Fulton—Eight MacGregor Chieftain matched irons; Eastman Kodak Co.

A. B. Nicklin—Eight Vulcan matched irons; Dupont-Pathe Film.

Hap DePew—Ellison Memo Camera; Hollywood Camera Exchange, Arthur Reeves and Cliff Thomas.

Elwood Bredell—Ring, Local 659; J. A. Meyers & Co., jewelers.

William P. McPherson—Special Vest Pocket Kodak; L. A. Eastman Kodak Store, T. O. Babb.

Bert Six—Leather golf bag; Dupont-Pathe Film.

Art Smith—Leather golf bag; Smith & Aller, Inc.

John Mescall—Baby tripod; Mitchell Camera Corporation.

William Foxall—Set of three Jack White wood clubs; Dupont-Pathe Film.

William Snyder—Camera accessory case; Melrose Trunk Company.

Karl Struss—Set of three Vulcan matched wood clubs; Smith & Aller, Inc.

Roy L. Johnson—Telechron clock; Mole-Richardson Inc.

Eddie Cronenweth—$25 savings account; First National Bank of Beverly Hills.

W. E. Thomas—Merchandise order for $25; Ries Brothers, Inc.

Henry Van Dyke—Dayton Tire, tube and tire cover; Nelson & Price Dayton Tires, Hollywood.

Samuel Manatt—Sweater and golf hose; Roy Davidge Laboratories.

Ernest Laszlo—Inland Tire; Inland Tire Company, Jay Turner.

Of the 1930 Golf Tournament

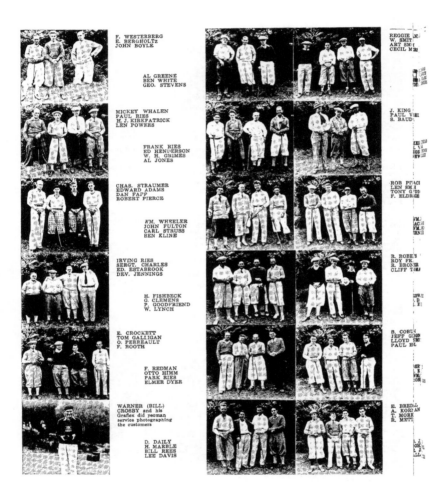

F. WESTERBERG
E. BERGHOLTZ
JOHN BOYLE

AL GREENE
BEN WHITE
GEO. STEVENS

MICKEY WHALEN
PAUL RIES
H. J. KIRKPATRICK
LEN POWERS

FRANK RIES
ED HENDERSON
W. H. GRIMES
AL JONES

CHAS. STRAUMER
EDWARD ADAMS
DAN FAPP
ROBERT PIERCE

WM. WHEELER
JOHN FULTON
CARL STRUSS
BEN KLINE

IRVING RIES
SERGT. CHARLES
ED. ESTABROOK
DEV. JENNINGS

H. FISHBECK
G. CLEMENS
P. GOODFRIEND
W. LYNCH

E. CROCKETT
TOM GALLIGAN
O. PERREAULT
F. ROOTH

F. REDMAN
OTTO HIMM
PARK RIES
ELMER DYER

WARNER (BILL)
CROSBY and his
Graflex did yeoman
service photographing
the customers

D. DAILY
H. MARBLE
BILL REES
LEE DAVIS

REGGIE
W. SMIT
ART SMI
CECIL M

J. KING
PAUL V
S. BAUD

ROB PI
LEN SMI
TONY G
F. ELDR

R. ROBE
ROY FR
R. BRON
CLIFF T

B. COBU
JEFF G
LLOYD
PAUL B

E. BRED
A. KORD
T. MORE
R. METT

WM. McPHERSON
H. KRUSE
W. THOMAS

GUY ROE
S. C. MANNAT
RAY RIES
J. CLANCY

LESTER SHORR
EDWARD WADE
BUD COURCIER
NICK MUSURACA

JOHN HICKSON
JAMES PALMER
ROBERT KURRLE
GLENN KERSHNER

HAP DEPEW
BILL FOXHALL
AL NICKLIN

H. MARZAROTI
DONALD KEYES
JACK BREAMER
K. MEADE

EDDIE COHN
IRMIN ROBERTS
JACK FUQUA
DALE DEVERMAN

MAC STENGLER
IRVING LIPPMAN
RALPH STAUB
JOE DARREL

GUY BENNETT
LOYAL GRIGGS
VIRGIL MILLER
HARRY JACKSON

CONNOR and
BLACKBURY of
Eastman's;
SHAMRAY and
SMITH, Dupont

BEN REYNOLDS
AL PRINCE
REGGIE LYONS
B. ROBINSON

OLIVER
SIGURDSON
generously gave
the day to recording
the battling hosts

The day as viewed by

Cartoonist Kershner

666 Meets

THE "Klan" met—vacations are over and it was a sight for anybody's sore eyes to see the mass of sunburned beaming faces at this meeting. Of course, the meeting was held at the Palmer House, as our regular meeting room, 1029 South Wabash avenue, has not been completed.

It seemed all the boys were trying to outdo each other, sport shirts, bloomers (beg your pardon, I mean knickers), and a few who refused to sit down due to the burning sensation caused by old man "Sol" with his summer "seatsation."

Unfortunately I arrived a little late. What a time one has if he arrives late to find a parking space when Local 666 has a meeting on. For instance, in my case, I had to drive around the block and finally decided to leave my "buggy" in Grant park. When I returned to the Palmer House I decided to check over and learned that a great deal of the wealth of the country had parked its axles and spare tires around the Palmer House so that even the guests didn't have a chance.

SIX SIXTY-SIX

Meeting

When I arrived the meeting was on. As I am sergeant-at-arms I noticed all the members had arrived ahead of me and upon entrance I found President Charles David was wielding the hammer—I mean the mallet—and calling the meeting to order. If it had not been for David and his mallet one would think that he was attending a smoker—everybody busy telling each other jokes—but it was not long until all the smiles were worn down to that look of heavy thinking when our Pres. announced all doors be locked and no one permitted to leave until all dues were paid in full. (From the tone of David's voice we wonder if he is a member of Voliva's Zionites).

Heh! Heh!

Sitting on guard and recalling the wealth in tires, tin and what have you, it was hard to believe that so many excuses could originate to leave the meeting before the dues were paid and we are afraid that some of the auto finance houses in Chicago will suffer this month as not a single member left the meeting until he was "paid in full."

Visitors at this meeting were J. L. Herrman, of Local 659, and A. T. Alexander, of Local 644. Alexander being a Chicago boy, naturally got the greatest hand, but Brother Herr-

mann soon talked Alexander off the floor.

Grief Shooters

It will interest you "out-of-towners" to know that Secretary Alley has appointed eight Chicago representatives for outlying territories. Your grief will now be passed from your local Vice-President on to your representative in Chicago and he in turn will scrap your battles on the floor at each meeting. Also for desired information you will look to your Chicago representative. All out-of-town members will be notified who their Chicago representative will be.

SIX SIXTY-SIX

Just Spoofing

Chicago was the scene of the well-known air races and 666 had approximately 30 men on the job at all times. There is always something to break the monotony on such a job, so this time Brother Fred Giese decided to start something.

Out on the field his first victim was Brother Jack Barnett.

Giese to Barnett—Say, Jack, have you made a shot of the Lindbergh baby?

Barnett to Giese (very much excited)—No, where is it?

Giese to Barnett—Right over there in the grandstand.

Enough said. Barnett was on his way. About three hours later Barnett was still looking in the grandstand as there were only 75,000 people seated there and Barnett had looked them all over searching for that little 10 pounds of Lindbergh Junior. No one said anything to Jack, and they let him look, but the Lindbergh baby was not even interested as it was cooing somewhere in New Jersey while Barnett continued to look and Giese continued to laugh.

SIX SIXTY-SIX

In Focus—In Spots

We must hear from our "sassiety reporter" so I am afraid that I will have to give him the rest of the page. You will now hear from that famous red-headed diagnostician who will entertain at this time with "In FOCUS—IN SPOTS." Mr. Felbinger now takes the air:

Hold Fast

This has been one heluva a month to get any hot dope on youse guys, seein' as how most of you have been away on vacations, with the exception of the guys on sound, of course, as they are having one swell vacation all the year around. "Yes, they are!"

While we are on vacations, Norm Alley claims he hasn't had a chance to take his this year as he has been sodabusy dashing out to Arlington race track every day and some days he even missed the first race. Charlie David is another of the boys that missed the two weeks off as he has been stuck attending conventions in Los Angeles and covering bathing beauty stories up on Oak street beach.

Real Heroes

Just read in the paper where they made another hero out of a guy who flew across the Atlantic—Coste, a Frencher, this time. Well, it just set me to thinking seein' as how they're making heroes out of everybody nowadays, why not put up some real heroes who have been heroing for a number of years without bragging about it.

So, just to get the ball rolling, I'm going to mention a couple I know of and the deeds that put them in the hall of infamy. Here are my favorite "Unsung" or maybe I better call them "Unhung" heroes.

Last month on the St. Louis Endurance flight a news reel wanted to lower a man with a mike down to the endurance ship while in flight to get the pilots to say something. They figgered they could hire some daring stunt man to do the job. Well, after shopping around they couldn't find any bird with enough guts to do it, so their own cameraman did the trick without making much fuss about it.

Blood and Sand Plus

The bird was none other than our secretary, Norm Alley, too. Norm bought himself a rope ladder, fifteen feet long, tied it to a plane, zoomed off the field and then climbed down the ladder. After climbing down eight feet Norm stopped and his refueling crew, consisting of Eddie Morrison and Phil Gleason, lowered him a gin buck.

Norm then proceeded into the endurance ship arriving just in time for tea. After a little chat with the fliers Norm started back up his rope ladder. Norm now admits the damrope certainly must have stretched on him after he got down. He claims it was a mile long on the trip back. Eddie Morrison says it took Alley fifteen minutes to get back up, but Norm insists it was hours.

Norm Gets His Orders

Anyway he got back and after landing found there was a telegram of congratulations awaiting him from his ball and chain for his heroic deed. She didn't exactly call it heroic,

Broadcasting Kind Words from
Local 273's Treasurer

New Haven, August 25, 1930.

Editor International Photographer:

Inclosed you will find my check for $3, for which please renew my subscription for another year.

Your magazine has afforded me many hours of pleasure, especially since I always have been greatly interested in the art of cinematography.

It has been very gratifying this past year to observe the gradual return to pre-sound excellency in the photography of many of our pictures, and the boys of Local 659 are to be very highly commended for the rapidity with which they have overcome the obstacles and difficulties precipitated by the introduction of sound in picturemaking.

I have been very much interested in the return of the high intensity arc, in its new silenced form, to several of the studios. The very excellent photography in the Fox pictures testifies to the desirability of this type of lighting, I believe.

May I congratulate you on your splendid publication, and with best wishes for your continued success I am

Fraternally and sincerely yours,
EDWIN W. BOPPERT.

Score Red as Hero No. 3 for this one.

Advertisement

Another thing about the air races. This department found out never to lend your pass to Charlie David for one day only. Kiss it good-by, because Charlie just don't remember where things have been loaned from. (P. S.—This is an advertisement for the other brothers. Out of town papers please copy.)

Whipped the Army

Fred Giese also had his troubles at the air races. A plane cracked up as some of them will. Also they make good pictures when they do, so Fred decided to make a shot, but the National Guard decided Fred wouldn't. One broken mike and several cut cables. Later Fred won his battle, but he had to fight half of the army to get what he wanted. It also cost Fred the razor edge crease in his rompers to get results.

SIX SIXTY-SIX

Big Reunion

Ran into a couple of the far south brothers of 666 down in Dallas, Texas, the other day while covering the flight of Coste to the Texas city of 110 degrees in the shade.

Brother Fred Bockelman and Bob Albright were dashing about with a couple of heavy DeVrys. Reminded me that all that was missing was Charlie David with his back-breaking Eyemo. Tracy Mawthewson, of Georgia, was there also.

It's funny how a guy runs across the old gang where he least expects to. I'm writing this bloney down in Dallas, and is it hot. Was wearin' my topcoat in Chicago the night I got yanked and shipped down here and I'm sorry for razzin' youse guys last month when I was cool up in the woods. Oh, well! Guess the wages of sin is a headache, so maybe it ain't all heat that makes me feel bad.

Another Headache

Well, I gotta go now, as I'm going to attend a reunion of 666 men tonite. Tracy Mawthewson, Ralph Saunders, Bob Albright, Fred Bockelman, Red Felbinger, Wayman Robertson are all attending. So tell Charlie David and Harry Birch they ain't the only ones who blow out west in the interests of 666. Another thing, youse guys ain't getting taxed for our own little-convention. The refreshment committee is pounding on the door, so so-long until next month.

though; just mentioned about whether he remembered he had a wife and a couple of kids back in Chicago who loved papa even if he pulled screwy stunts and please don't scare 'em no more.

So it looks like our daredevil secretary has been grounded by the mamma who would sooner see the provider pass his time away in an office licking stamps into the books of brothers who are paid up.

More About Heroes

Well, our next bimbo on the program pulls this one: They hold a goofy wedding down in Dayton, Ohio, where an animal trainer gets married in a cage full of lions and tigers and the boys from the movie news rumble in with a couple of hundred yards of celluloid to thrill the dear public.

Red Felbinger and Wayman Robertson blew in for Paramount and Eddie Morrison and Phil Gleason for Fox.

The sound men decides they gotta hang their mikes in the cage. They do. The wedding bells ring out for one scene and Phil Gleason decides he's gotta move his mike and no lions or tigers is going to stop him noways. So the blushing bride and bridegroom have to hold off on the "I do"

business and everybody clears out of the cage and daredevil Gleason then climbs into the cage with the animules.

Eats 'Em Alive

Well, Gleason gets nervous right away, but not about the tigers and lions. What bothers Phil is the idea of Morrison and Red giving him the razzberries in front of several thousand people about braving the tigers and to look out for same. The spectators laffed at Phil all right, but I'll bet they admired his guts just the same. Phil never took a lesson in taming lions or tigers before, but the critters behaved themselves just the same.

Real Bravery

Third and booby prize goes to Red Felbinger as a hero. Ever since the sound racket entered into things a lot of the cameramen have started to dress up like la-de-das by wearing those cute little French berets. Well, Red showed up at the national air races wearing one of those things in front of all the gang. Red knows that's a hard one to get by with, but he even went one further than most of the boys who have taken to fancy clothes. His beret was one of those bright green ones and he looked oh, so sweet.

Bell & Howell master craftsman, a 20-year veteran, measuring accuracy of lens centering in turret opening of B & H Standard Cameras. His aperture centering gauge, which checks each turret lens opening for both focusing and photographing apertures, insures accuracy within .0005 of an inch.

Turning Atoms *inside out*
looking for better movies!

TECHNICAL improvement in motion pictures is sought in many places, and in many ways. In the Bell & Howell Engineering Development Laboratories, even the atom and its electrons are scrutinized for clews. To lengthen the life of gears and punches, to reduce friction in moving parts, to make a single part do the work of two . . . these are the object of relentless search, beginning with the molecular structure of the metals themselves, and with never an end to the quest.

In more than 23 years of endeavor, Bell & Howell have brought an enduring order into the technical phases of movie-making. In Bell & Howell Standard Cameras, Printers, Perforators and Splicers are seen the fruits of this labor.

Every problem in movie-making is made a Bell & Howell problem. Highly trained and of long experience, its engineers are as eagerly searching today as they were nearly a quarter of a century ago.

You are invited to submit your particular problems to the Bell & Howell Engineering Laboratories for solution, with the assurance that skill and understanding of the highest order are turned to the task.

BELL & HOWELL

BELL & HOWELL CO., Department V, 1849 Larchmont Avenue, Chicago, Illinois
New York, 11 W. 42nd St. • Hollywood, 6324 Santa Monica Blvd. • London (B & H Co., Ltd.) 320 Regent St. *Established 1907*

The Human Element in Motion Pictures

*This is the fourth of a series of expert articles on motion picture production,
to be followed by others*

By "CRITICUS"

THE motion picture industry is at present a conglomeration of detail problems, and the outstanding problem is, to find the best compromise between such detail problems.

If such compromises can be found, which permanently so govern and determine methods and practices, that the final screen results are satisfactory to the public—then we have found the closest possible approach to the solution of the problem, paramount in every producing business, i. e., Standardization.

The production of a motion picture however is of so complex a nature and its character is continuously so changed by the addition of elementary new effects, that complete standardization will probably never be accomplished.

If the confronting problems were of a purely technical nature, then some form of a final standardization may be thought of or conceived. There are of course a number of apparently purely technical problems. In their majority however, they are not only influenced by their technical neighbors, but also by psychological conditions, which fluctuate in their scope under the influence of the human element controlling, shaping and altering them continually.

The Human Influence

The influence of the human element upon motion picture production can be segregated into two main classes.

Within the first class it assumes dominant character. This class includes the activities of the producer, the most important human element in motion picture production.

His personal decision establishes the skeleton of the production as far as the desired dramatic reaction upon the public is concerned.

The human elements represented by such of his assistants whose activities lie in the dramatic, artistic or general aesthetic branches then become of importance and are also included in this class.

All of these human elements however are of only slight influence upon the major problem: Technical Standardization.

Standardization in its broadest sense is a non-competitive problem including in its desirable influence upon the industry the element of interchangeability, and in its final analysis the all important decrease of production cost.

Always a Business

Motion picture production is a business, or the endeavor to acquire the public's money for service rendered at the least expense.

This expense is greatly influenced by the second group of human elements entering into a motion picture production: the Technicians.

They are, in close cooperation with the first group, of essential influence and responsibility as far as production methods, practices and cost are concerned.

It is their problem to mold upon the skeleton delivered to them beautiful, living forms at least expense.

Here we have again a necessary sub-division of these human elements: Those establishing the technical means, and those using such means, and developing and practicing the most efficient methods in their employment.

Of Critical Importance

In our consideration of the influence of human elements upon motion picture production we have now reached those elements, which are in their individual values and efficiency of such everchanging problematic influence upon the final business value of a screen presentation and upon the major, non-competitive problem: Standardization.

Fundamental methods are within the activity-scope of the scientists with psychologically sound engineering attainments.

For the technical means the motion picture engineers of chemical, optical and mechanical training are responsible in the creative sphere of their activities.

And finally we have those technicians who have to practically employ those methods and means delivered to them.

Cannot Be Predetermined

The always slow rate of progress during the first stages of evolution in any industry determines the universally practical character of methods and means, developed at such successive stages. It is the rather crude character of methods and means so far developed for the motion picture industry which makes the influence of the human element in their employment of such critical importance, now vividly apparent in every single picture production.

Methods, and even more, means depend for their results so much upon the human element controlling them, that the results of their employment are beyond the sphere of predeterminable characteristics.

Up to this point, but not farther, the critical analysis of the evolutionary processes within the motion picture industry shows a gradually, but steadily increasing beneficial influence of the human elements, their endeavors and accomplishments.

This statement, however, cannot be truthfully repeated, when we analyze the influence of the human elements upon the practical results of the now available methods and means.

It would, however, be manifestly unfair to saddle all unsatisfactory results upon this last group of human elements.

The Remedy

Impartial investigation shows that final satisfactory results in their majority are not assured by the average ability of the individual human element of this last group, but made uncertain by the unreliability of the optical, mechanical and chemical means now available.

In their detail use under even best judgment, derived from practical experience, the final results are rarely of absolutely predeterminable value.

The personal equation of each individual human element makes itself noticeably felt, and final results are sometimes disastrously impaired by some slight error of judgment of any one of the vast chain of workers using the prescribed methods and supplied means.

What is now the remedy for these unsatisfactory and vastly uneconomical facts?

If the business controlling financial interests once realize that it is far better for their individual financial success to freely cooperate with their competitors in efforts of unified standardization rather than to improve their own methods and means on a competitive basis, formed by the characteristics of their individual organization, if they once realize that by present methods they often bar the most important result of standardization, i.e. interchangeability—then, and only then, standards of logical and efficient methods and adequate means of inflexible performance can be developed.

Better standardization should be obtained by such concerted, non-competitive efforts for any one milestone on the road of evolution.

For Research Center

The practical organization to perform such badly needed service for the whole motion picture industry, and do not forget—for each individual production—organization seems to suggest itself as a properly organized research center, financed by all producers, and manned by a personnel not in any way affiliated with any one of such contributing corporations or business enterprises.

This seems to be the logical road to follow in order to eliminate as soon as possible from motion picture production the human element in its dangerous and far reaching attribute—the human error.

 # *Cream o' th' Stills*

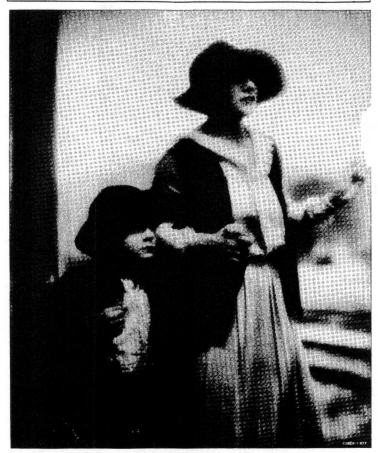

This study by Frank Tanner is a work of art. Note the lighting and the way he brings out the expressions of his subjects. Mr. Tanner is one of those who can get a picture out of a corn cob and a pumpkin vine.

 # Cream o' th' Stills

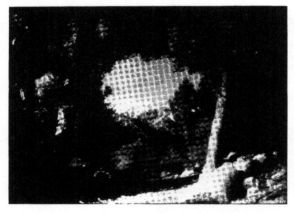

Bert Baldridge
loves to record such
vistas as this when
out stalking the wary
pictorial armed
with his still camera.
It is a picture of
the high Sierras in
late winter and,
needless to remark,
it is a masterpiece.

This photograph by
Gorman A. Charles,
Staff Sergeant,
official photographer,
Signal Corps, U.S.A.,
was pronounced
officially "one of
the best ever seen"
by headquarters.
It is, indeed, an
excellent still. The
subject is the
C.M.T.C. Field
Artillery on the
range at Gigling
Reservation, near
Del Monte, California.

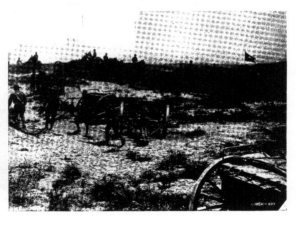

 # Cream o' th' Stills

The Mandiante Indienne." (Indian Beggar) is the title given this study by Paul Ivano. It is one of a collection photographed by Mr. Ivano during a tour of Latin America. The old Indian woman sits at the entrance to a church in Old Mexico

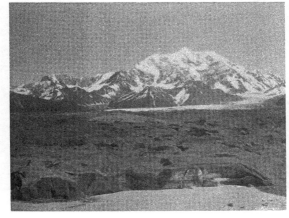

A small section of Grand Plateau Glacier in Alaska photographed by our Mr. J. M. F. Haase, chief photographer of the U. S. Navy. The walls of this river of ice are 300 feet in height and 125 miles long. Mt. Fairweather, 15,630 feet, forms the sublime background for this shot

 # Cream o' th' Stills

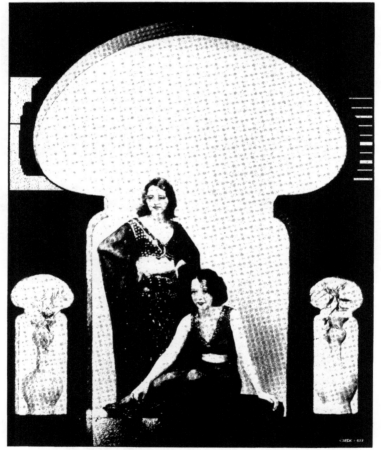

Any one at all familiar with the work of Fred Archer will see the spirit of this great artist in this exquisite etching. The composition is faultless and the conception, though ultra modern, is delightfully natural.

Amateur Department

Tracing Growth of Home Pictures

Brief History of Inception and Development of 16 mm. Cinematography as Shown by Record of One Maker.

IT'S a long way, in years and in progress, from daguerreotypes on our grand-mothers' mantlepieces to a casual hundred feet of home movies snapped at a picnic.

During the time one of Daguerre's subjects sat in rigid discomfort for a single exposure her less patient great-granddaughter can get the family motion picture camera from a table

drawer, "press the button" to snap the children in the backyard sandpile —on bright days or dull—and put the camera away for thirty or forty more feet at the country club later in the day.

Strangely enough, Daguerre and home movies have one fact in common other than the bare one that both are connected with the history of photography. Both of them produce a positive image direct from the camera without printing from negatives.

Reversal Process in 1923

Since Daguerre's tintypes the way of photographic progress has been by plates and films. They permitted duplication, which was necessary for both photographs and professional motion pictures—but another reason the negative step was continued was that there was no other consonant with the best photographic quality.

Then along came home motion pictures with their need for finished positive films at low cost yet with no photographic quality sacrificed. With home movies—or not long after them —June, 1923, to be exact—came the

perfection of the "reversal process" of finishing movie film.

A word or two about the ingenious machine which actually develops and "reverses" amateur motion picture film after it has been taken from the camera will be of interest. It is five or six feet high, about a foot wide, and perhaps fifteen feet long and is almost entirely inclosed to keep dust and light from the film.

The reel to be processed is fastened to a leader which slowly passes through an opening in the front end of the machine. If we could look inside we should find it being carried in a series of loops through a deep, narrow tank of developing solution. The speed at which it travels is so adjusted that when it emerges it has received precisely the correct development and is ready for a short rinse.

Then, without the "fixing" which would ordinarily be the next step, it is led into another tank, the "bleaching bath," where a drastic operation is performed. All the metallic silver which formed the negative image is removed, leaving transparent film except where the unexposed silver halide remains.

Process of Conversion

The black areas of the film which the camera recorded from the white of the subject are all cleared away in proportion to their brightness, and the light of the movie projector can shine through white to the screen. Any further exposure to light will simply darken the silver halide which remains on the film because it had cor-

responded to dark areas of the subject and was not exposed.

Where it becomes dark the light of the projection machine will be retarded and dark will show on the screen. When this change has been accomplished the film will be positive.

So it is rinsed again and emerges momentarily over a tray in the middle section of the machine underneath which are dim yellow lights. That is to give a glimpse of the film as it passes. The room itself is otherwise totally dark. Then the film is given a second exposure under a white light of variable brightness, depending on the density of the film after the first exposure.

Again the endless chain of film creeps into a developing tank and into a rinse. Then, this time, it is fixed. After a thorough wash, it passes into another series of loops through which warm air blows to dry it. Finally it emerges from the machine ready for spooling, inspection, and return to its maker's projector.

Two Hours in Process

But this sight of the "reversal process" shows only what can be seen without a microscope. The genesis of the process and the refinement by which it improves motion picture quality rests in the ultra-minute grains of silver halide suspended in gelatin on the surface of the film.

What happens to the film during its two hours in the processing machine is shown in terms of particles by the diagrams on this page. They were drawn from photo-micrographs of Cine-Kodak film.

Section 1 shows the grains unexposed to light. Section 2 shows the film after exposure, with the larger particles affected by the light. Section 3 shows the film after development—

the negative stage. In section 4 the black metallic silver has been bleached out and the film has been exposed to light. In mathematical proportion to the lack of brilliance of any area of the subject there is silver halide left on the film undisturbed by the bleaching.

As soon as they have been developed out (Section 5) these remaining grains will determine the density of this area of film and its consequent function in causing shading on the amateur movie screen.

Removing Grain

Altogether apart from economy, the reversal process has several marked advantages. Most notable, it compensates for improper length of exposure to a striking degree and it practically eliminates graininess. The larger grains, or clumps of grains, which cause this graininess are, because they are more sensitive to light, exposed in the camera most readily and developed and bleached out in the reversal process as shown in the diagrams.

The final image is, therefore, made up of the smaller, less sensitive grains, which do not cause graininess; except that in the areas representing the very dark parts of the subject the original exposure does not affect even the largest grains, and they are left for the second exposure. But that does not permit graininess, for it occurs only on the light parts of the screen picture. The cause of graininess is removed from the light areas where it is necessary.

Too, the second exposure of the film, controlled in accordance with the transparency of the film after it has been bleached, is responsible for the latitude which makes evenly lighted pictures on the screen even though the exposures have been uneven.

If the original exposure was too great and overmuch of the silver halide was exposed and developed and bleached away, then the film is abnormally transparent and the second exposure is increased and brings out more of the remaining silver halide grains so that the final image shall be of normal density.

Conversely, if under-exposure followed by bleaching removed too little of the original silver halide the second exposure is decreased so that too many of the remaining grains will not be developed and left to make an over-dense positive image.

Enter Panchromatic

After the second development fixing removes the silver halide which still has not been exposed. Otherwise it would make the film opaque in the wrong places.

Early in 1928 the Eastman Kodak Company announced 16mm. panchromatic safety film.

Briefly, Cine-Kodak panchromatic film, being sensitive to light of all colors, reproduces these colors in monochrome on the screen more nearly in their accurate tone relationship one to the other. Ordinarily films, on the other hand, are sensitive chiefly to blue and violet light, while to the eye green and red are brighter colors. So it naturally follows that with this material there is a greater difference between the brightness of colors as reproduced on the screen and as seen by the eye.

Panchromatic film, however, has no such handicap, and its sensitiveness to all colors assures you of results hitherto impossible. That thing called quality—hard to define but easy to discern—stands out as soon as the picture is snapped on. You don't have to study the screen to see it. It's instantly evident.

Almost before the public realized the significance and capabilities of "Pan," a second announcement, almost unbelievable at the time, was made.

On Monday, July 30, 1928, a representative gathering of scientists, photographers and motion picture engineers were introduced to Kodacolor—home movies in full natural color.

The only equipment necessary beyond that used for regular black and white movies is a lens of f.1.9 speed or better, a Kodacolor filter and sunlight.

Kodacolor Follows

The Kodacolor filter is composed of three bands of dyed gelatin, red, green and blue — cemented between disks of optical glass. Kodacolor Film is similar to regular Cine-Kodak Film, except for two necessary differences.

The first is that Kodacolor film is panchromatic—or sensitive to light of all colors.

The second is that the uncoated side of the transparent film base is embossed with minute cylindrical lenses which join one another and extend the entire length of the film. There are about 220 of these lens elements in the width of the picture area, causing the peculiar satin-like appearance characteristic of Kodacolor Film.

The film is so wound that when it is loaded into the camera and exposed in the usual way the picture is taken through the film base. Each embossed lens forms an image of the color filter on the sensitive surface of the film. By this means, when white light falls upon the filter, it is broken up into its principal components, which are red, green and blue. (See Figure 1.)

When Shooting Red

Let us suppose that we are taking a picture of a red object. Only red light is reflected by such an object and some of these rays fall upon the Kodacolor filter in the camera lens. Both the green and blue portions of the filter absorb red light, but the red portion allows the rays to pass through.

The camera lens focuses these red rays upon the proper portion of the
(Continued on Page 36)

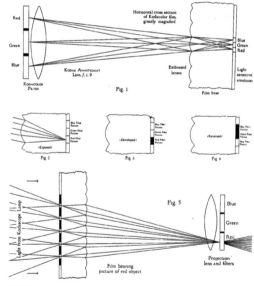

De Forrest Home Film
Will Be 20mm. Wide

ON or about January 1 of the new year the home picture industry will have available sound on film. That is the promise of Dr. Lee De Forrest, whose rank as an inventor and scientist guarantees the

Dr. Lee De Forrest

"ifs" have been accounted for and that fulfillment will follow.

While the reproducing device to be manufactured by the company with which Dr. De Forrest is associated will provide for the projection of silent 16 mm. film the sound film to be supplied by the company will be 20 mm. in width.

This dimension will allow 16 mm. for the picture and 4 for the sound track. The picture will be photographed in 35 mm., as is customary in the case of the smaller film when designed for commercial uses, and then reduced to 16 mm. The sound will be dubbed from the larger to the smaller.

Dr. De Forrest has been working on the problems of sound on 16 mm. film for upward of four years. He has experimented with all kinds of projectors, and believes now his final decision will be between two brands.

Plans are under development by the doctor and his associates to manufacture and market a sound recording camera as soon as the sound reproducing and projection apparatus is well on its way.

Already the doctor has received an offer of a contract for a million dollars worth of his apparatus by Los Angeles interests, a deal large enough to keep his company busy for its first year.

The doctor is convinced that Hollywood for many months has been and

for the immediate future surely will be the centre of things in all matters pertaining to sound, both recording and reproducing.

Will Have Own Studio

The first move of the De Forrest Company will be to bring here all of its projection and reducing apparatus and to form an alliance with a large machine shop. Then will follow the establishment of a laboratory and in turn, when the company begins the making of its recordings, the creation of its own studio.

As to its line of product in the beginning Dr. De Forrest said the company would follow generally the line of least resistance, or accept the more promising contracts. One field that looks particularly attractive at present is that of the industrial. For it have been made a great many silent films, designed for and consequently more or less restricted to 16 mm. size, for which their owners are seeking an accompanying lecture.

The educational field will receive much attention, at home and abroad as well. The doctor mentioned the possibilities of educational film in neighboring Mexico, especially in view of the recent pronouncement of the president of that republic regarding educational expansion.

Solving Wide Tangle

The cost of the De Forrest reproducing and projection system will be in the neighborhood of $600. The apparatus will weigh less than 100 pounds.

Dr. De Forrest sees a solution of the wide film controversy in the reduction of the 65 or 70 mm. negative to 35 mm. In this way the de luxe house and the common ordinary theatre will be provided for. The first house with its special projection machines and extra wide screen may rent the 65 or 70 mm. positive, while the less fortunately situated theatre can change its projector and lenses to accommodate the amended shape of the frame in the 35 mm. positive, make its screen as wide as possible, and show its suburban audiences a sure enough wide screen.

The doctor believes there would be advantages in recording on the wide film, such as elimination of ground noises, and these advantages would flow to the 35 mm. negative when reduced, although he remarked there were now very little in the way of ground noises noticeable in the 35 mm. recordings.

An Exposition in Film

A motion picture record of activities which will extend over a period of more than three years has just been inaugurated by the management of the Century of Progress Exposition, which will be held in Chicago in 1933.

Major Lennox Lohr, exposition manager, is here seen with a Bell & Howell Eyemo camera taking the first motion picture for the record. The occasion is the ceremony of breaking ground for the exposition's Travel and Transport Building.

The motion picture record will tell a progressive story of the activities connected with the exposition from now until its close.

In addition to the use of the movies for record purposes, lecturers will show high spots from these pictures all over the world to tell what is being done to prepare for the big fair.

Beginning of motion picture record of the Chicago 1933 Exposition

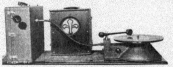
Tracing Growth of Home Pictures

(Continued from Page 34)

picture area of the film. Each minute embossed lens in this portion then sends these rays to the position occupied by the image of the red filter. (See Figure 2.)

When the film is developed, these portions that have been struck by red light will be rendered black and opaque by a deposit of silver. (See Figure 3.)

The film is now put through a reversal process which removes the silver from the opaque areas, leaving them clear, and blackens the areas that were not struck by light in the exposure of the film. (See Figure 4.)

Photographing Color

The film so processed is ready for projection. It is threaded into the Kodascope with the base side facing the projection lens and its Kodacolor projection filter. The light from the lamp passes through the clear spaces on the film—which, as you remember, is where the red light rays were focused—and is sent by the embossed lenses through the projection lens and red portion of the filter. It then falls upon its proper position on the screen, reproducing the color and form of the red object photographed. (See Figure 5.)

By following this description for a red object it is easy to see what happens when a blue or green object is photographed. Objects of all other colors reflect varying proportions of

red, green and blue light. For instance, yellow reflects red light and green light; Purple reflects red light and blue light; blue-green reflects green light and blue light; white reflects light of all colors; and black reflects very little light of any color.

It can thus be seen that the Kodacolor process is capable of reproducing all colors by separating them into their components and recombining these components on the screen by means of the Kodacolor filters and Kodacolor film.

The development of equipment has kept in step with that of film.

The first Eastman amateur movie camera—perfected and offered at the same time as 16 mm. reversal film—was the Model A, f.3.5 Cine-Kodak—a hand driven machine. Wonderful as it was at the time, it seems to us now an unnecessarily bulky and expensive bit of mechanism as compared to the present Cine-Kodaks.

This Model A was followed in October 1925 by the Model B, f.6.5—the first spring driven Cine-Kodak. A faster lens was in demand—the Model B, f.3.5, was announced in May, 1926.

Cutting Size and Weight

Kodacolor required a still faster lens, and achieved it in June, 1928, with the Model B, f.1.9. Small as these Model B cameras are a further reduction in size and weight was demanded of Eastman engineers, the Model BB, f.3.5 and f.1.9 Cine-Kodaks, were offered to the amateur in May, 1929. These newer cameras had but a 50-foot film capacity as com-

pared to the 100-foot capacity of their predecessors.

However, in August, 1930, the Eastman Company offered the new Model K, f.1.9 or f.3.5 Cine-Kodaks—both focusing cameras and both having 100-foot film capacity—and the new Model M fixed-focus f.3.5 Cine-Kodak. This latter camera tips the scales at the modest weight of 3 pounds 6⅞ ounces!

Nor have projectors lagged behind. Modern Kodascopes automatically thread the film, rewind by motor, pause when desired for the scrutiny of a particularly beautiful scene, project the film in reverse—yet fold up and disappear into a case which could fit in an ordinary hatbox.

Your home moviemaker has his editing and splicing outfits, film humidors, filters, artificial flood lights, tele-photo lenses, and all accessories.

Through Kodak Cinegraphs, first offered in June, 1927, he is able to procure short, professional movies of 100, 200 or 400 feet in length. Comedies, animated cartoons, natural history, travel, adventure, sport, the World War—all are his at a modest cost.

Ever since the advent of 16 mm. film, the amateur has been able to rent from many branches of Kodascope libraries a very fair proportion of the best known professional film successes—full length feature films reduced to 16 mm. proportion.

Wide Range in Surgery

In many other fields besides the making of strictly "amateur" movies, 16 mm. film is playing an important part. Prominent among them are medical movies. The first medical motion picture produced by the Eastman Kodak Company was prepared in conjunction with the American College of Surgeons in 1926.

The film, "The Diagnosis and Treatment of Infections of the Hand," was the forerunner of the considerable number of medical films now available on anatomy, physiology, bacteriology, embryology, surgery, experimental medicine, health examinations, obstetrics, hygiene, sanitation, public health, neurology, approved hospital practice and nursing.

And then, in May, 1928, came the establishment of Eastman teaching films. Two years of extensive experimentation with 16 mm. classroom films, including twelve weeks' use of teaching films by schools in twelve cities, convinced the Eastman Company educators alike of the value of this method of education.

As early as October, 1928, the United States Bureau of Education reported that "fifteen thousand educational institutions, ranking from the kindergarten to the university, are now estimated to be equipped for motion picture projection."

An imposing list of 16 mm. class-room films are now available on the following subjects: Applied art, general science, geography, health and nature study. And many leading schools in this country and abroad are using them.

Yes, 16 mm. movies have progressed indeed, and yet only one hundred years have elapsed since Daguerre!

Hollywood Film's Sound Studio
Will Stamp Its Own Flexo Records

HOLLYWOOD Film Enterprises at its plant at 6060 Sunset Boulevard is rushing to completion a combined sound radio and record manufacturing establishment, the first so far as is known of its kind in the world.

The major portion of the company's activities will be devoted to 16 mm., although the equipment may be applied to standard size film with equal facility. The plant will be in full operation before Nov. 1.

Hollywood Film Enterprises is the title under which are operated all of the varied interests of William Horsley and associates. The Horsley laboratory and studio at the address named have been in business many years, and were among the first in the country to recognize the potentiality of the 16 mm. field.

In the building at the corner of Sunset and Beachwood Drive there has been isolated from the main structure a space 45 by 50 feet. The floor area has been converted into an island, in accordance with the best sound studio practice, making it entirely independent of the surrounding building.

Large Camera Room

The ceiling and walls are being completely silenced, with protection not only from outside noises, but also creating a barrier between the elaborate camera room and the studio proper.

The camera room occupies one corner of the stage. It has the form of a quadrant, the arc containing ten windows of double optical glass. The room is large enough to permit three cameras to be trained on a set on any part of the stage.

The record manufacturing plant will adjoin the recording studio and will extend for 125 feet down the Beachwood drive side of the structure. The machinery being installed is designed to produce in large quantities the Flexo record, for the manufacturing of which for use in or with motion pictures the company is licensed by the present organization.

These records will be used in conjunction with Cine Voice equipment, a talking picture machine with positive drive playing all types of sound on disc films and may be attached to any 16 or 35 mm. portable projector. These machines are now in quantity production at the plant of the Cinema Studio Supply Corporation.

To Produce Industrials

The company will enter actively into the industrial or commercial phase of motion pictures in both 16 and 35 mm.

Walter W. Bell, manager of the Cine Art division of Hollywood Films, outlined the plans of the company in this department. Mr. Bell has just returned to Hollywood from a trip of 9000 miles around the country. In the course of that journey he met a number of I. A. T. S. E. cameramen engaged in industrial work, some of them possessing laboratories in which they do their own and outside work.

These men, the Hollywood man learned, in the past have made in the silent form many industrial pictures the owners of which now are seeking to have them synchronized for sound or for lectures. It is this kind of work in which, among others, the local plant will specialize, either in 35 mm. or reducing to 16 mm.

Exports of 16 mm.
Cameras Decline
First Half of 1930

UNITED STATES exports of 16 mm. cameras and projectors for the first six months of 1930 declined in volume when compared with the numbers shipped for the six months of the preceding year.

The let down was most marked in the case of cameras, the slump amounting to nearly 50 per cent. For the present year the figures supplied by N. D. Golden of the Department of Commerce at Washington show 761 cameras were shipped, the valuation being $91,519.

In the preceding year for the same period 1383 cameras were exported, with a valuation of $136,176.

The decline in the export of projectors was not so marked as in the case of cameras. The figures for the present year cover 715 projectors valued at $69,610, while those for the first half of 1929 were for 946 projectors valued at $92,589.

Japan purchased 230 16 mm. cameras the present year, against 114 for the United Kingdom. Switzerland and Argentina bought the identical number, 50, but the latter paid for these $11,156, practically double the amount surrendered by the Swiss.

Japan was the second largest projector buyer among the nations of the world, with 150 to her credit, Canada being her leader with 217. Japan, nevertheless, bought the more costly equipment, as she is credited with an expenditure of $14,757, against Canada's $16,918. In 1929, for its first half Japan paid $30,350 for 376 projectors.

Eastman's Processing Plant
Most Completely Equipped

THE Eastman Kodak Company's new processing and finishing building in Hollywood now is in full swing. It is situated at 1017 North Las Palmas street and is under the superintendency of B. J. Burns.

The latest thing in ventilation is installed throughout the structure. Supplying a storage tank is machinery able to provide 300 gallons of 40 degree water each hour.

At the rear of the second floor is a large hypersensitizing plant. With the mixing tank is a ten-ton York ice machine. The establishment also is provided with automatic heating plant, twenty horsepower compressor, shipping room, storage vault with steady temperature and machine and projection rooms.

The Eastman Kodak Building on Santa Monica boulevard has in operation two additional projection rooms, both devoted to 16 mm., one to Kodacolor and the other to black and white. In the latter room, for the accommodation of visitors, are three machines of varying Eastman models.

Riesenfeld Synchronizes
Two 16 mm. Short Classics

Hollywood Film Enterprises now has ready for delivery two subjects synchronized by Dr. Hugo Riesenfeld and his orchestra of sixty pieces. They are "Beauty the World Over" and "Bridges the World Over."

Each will be 400 feet in length of 16 mm. film, the recording on Flexo. The musician had seen the subjects projected silently and was attracted to them, so much so he expressed a wish to put them to music.

In collaboration with Life magazine the company also has ready for immediate delivery in 16 mm. a series of animated cartoons 250 feet in length.

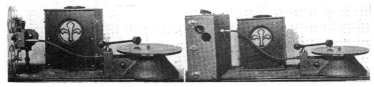

Cinevoice adapted and attached to both Bell and Howell 16 mm. Filmo Projector and to 35 mm. Portable De Vry

Colortone Film Truck Completes
Recording on "Breed of the West"

COLORTONE FILM RECORD- ING, INC., with its sound truck is well started on its business way. Already in the month it has been operating it has completed several subjects. One of these was "Breed of the West," directed by Al Neitz and photographed by William Nobles.

The picture was made by the National Players and will be distributed by the Big Four, the organization at the head of which is John Freuler, one time chief of the famous Mutual organization. It was Freuler who brought himself and his organization to world attention in the second decade of the present century when he offered in a battle among producers for the services of Charles Chaplin the sum or $10,000 a week for one year and a bonus of $150,000 to sign the contract.

It is a matter of history that the comedian accepted—and that Freuler and his associates made a wad of money.

After a period out of the business, in which he had had wide experience in turn as exhibitor, distributor and producer, Freuler again is back in the industry. He is already set to make another subject with Colortone as soon as the latter organization is free of prior engagements.

The owners of Colortone are C. S. Piper, a member of Local 659 and a former Fox News man in the northwest; Bert G. Gates and G. M. Vinton. Homer Elmaker, late of the Fox sound technical forces, is on the monitor.

Other subjects already completed by Colortone are "Bells of Capistrano," a two-reel Latin production, and the scoring and color sequences of "Doc" Cook's South Sea Island productions.

The company is prepared to record either in Multicolor or Harriscolor and general sound track work as well. The recording is done on separate film. In event of an emergency a complete camera equipment is carried with the truck, which is prepared to go wherever an automobile may penetrate.

———

Through an error in the September issue the Hollywood Film Enterprises was made to take over too much territory in its distribution agreement with the Ampro Projection Corporation. What should have been said was "the distribution of the west coast of the western hemisphere."

Pete Harrod Heads New
Lakin Rental Department

THE Lakin Corporation has named H. H. (Pete) Harrod as head of its rental department. Twenty-four-hour service will be maintained for its customers, and competent technicians and crews will handle delivery and return of equipment, without extra charge to the

H. H. (Pete) Harrod

producer, introducing a new feature in the motion picture industry.

Don Campbell, well known in the industry, will assist Mr. Harrod.

"Pete" Harrod has been associated with the electric side of studio activities for sixteen years. He began with Universal in 1914, in the days when the juicers hauled their lighting apparatus on flats. If a heavy rain descended on the open stages, then it was back to the garage for everybody and everything.

Following three years at U, Harrod was four years with the Lois Weber organization, among other duties supervising the lighting of stages. It was during this time he built the first portable motor generator set.

The equipment in its design combined all the knowledge and previous experience gained by Harrod. It was the marked ability displayed by the electrical expert in these excursions into the manufacturing field that brought him to the attention of Paramount.

In the early twenties Harrod took over the responsible job of chief of the electrical department.

One of the outstanding services he performed for the Paramount organization in the five years he served it was the building of the first radio transmitting and receiving set. The device was most successfully used first in "Old Ironsides" and in "We're In the Navy Now." It made possible dispensing with the expensive and

Encouragement

Helping others is helping ourselves.

The fellow next to us on our job *needs* our encouragement.

Let's help him with a kindly *word*.

When we see him doing some work a little better, let's remark about it if possible.

Now and then saying something *encouraging* to him will help us.

Furthermore, he will become more interested in *our* work.

We might go even farther by lending him a hand where it doesn't interfere with any rules —*it will come back* in big measure.

Helping the other fellow with words and acts of *encouragement* works both ways.

C. KING CHARNEY.

comparatively slow boats in communicating across water distances, and materially reduced production hazard.

Pete Harrod has a host of friends in the picture industry who will wish him and his employers well in the new affiliation.

Pete Mole Goes East

Peter Mole, President of Mole-Richardson, Inc., studio lighting engineers, left recently for the East to attend the annual convention of the Society of Motion Picture Engineers. Mr. Mole plans to visit the General Electric Research plants and laboratories of the Western Electric Company in New York City and the Development Laboratory of the R. C. A. Phototone at Camden, N. J. His visit to the East also gives Mole-Richardson, Inc., opportunity to contact Eastern studios.

Peter Mole

It is the policy of the Mole Richardson Company to send one of its members to the East semi-annually for the purpose of making an extensive survey and study of the studio lighting, sound and electrical developments such as are continually being evolved and improved by the Eastern manufacturers and motion picture producers.

Mole-Richardson are the original designers and manufacturers of incandescent lighting equipment, commonly called "Inkies," and are known for their development of many devices for the production of sound motion pictures.

How They Do It.

Half the people in Hollywood are living off the movies. The other fifty per cent are living off the folks back on the farm.

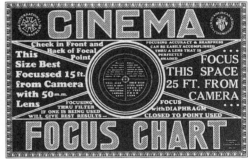

Here is a reproduction of the Cinema Focus Chart, for amateur as well as professional, the invention of Jackson Rose, a member of Local 659. It is a worthy successor of the color chart recently designed by the same cameraman. Opened the chart measures 12 by 18 inches. With a brown leather backing it folds three times, or into a compact package but 6 by 12 inches. The printing is on heavy, durable bond paper. When printing and binding are completed each member of Local 659 will be given a copy

Thirty-nine

Shooting Around the World

By HENRY FREULICH, Local 659

SIX months ago I decided to take a trip to Europe with a double intention. The first was to obtain employment in Germany whereby I might gain some training in the photographic work for which the German technicians are famed. At the same time this appeared to be a grand opportunity to see a little of the world.

After being in Germany three days I learned that work was not easily to be found, especially for one who was unacquainted with the German language. Therefore, I changed the trip into a purely pleasure venture and proceeded to enjoy myself and see the sights.

The first thing I did was to purchase a Leica camera, one that uses motion picture film and makes thirty-six pictures without reloading. Germany, Austria, Czecho-Slovakia, Italy, Switzerland and France were the countries that I toured, all of them interesting from both a photographic and a tourist viewpoint. I "did Europe" in three months. I was on the go all the time, not missing an hour from the steady purpose of viewing the wonders of these countries.

Then I caught a boat from Genoa, Italy, to Shanghai. This boat was a combination freighter and passenger boat which made stops at Colombo, Singapore, Java, Manila and Hong-kong. I arrived in Shanghai five weeks later. I had thought Europe was wonderful, but found the Orient impressed me much more.

One Day: 135 Shots

On the first day in Shanghai I made 135 pictures, but Shanghai was only the beginning. My next stop was Peking. Of all the cities I had been in this gave me the biggest thrill. Temples, palaces, narrow, winding streets—all of them remarkable and strange.

The most interesting thing was the people. In Peking one feels he is in a world of two thousand years ago. And I went crazy making pictures. After five days of Peking I took a small Japanese freighter bound for Kobe, Japan. When we were fifteen hours out we were caught in one of the worst typhoons on record.

I had read so much about typhoons that at first I was delighted with the prospect of experiencing one, not realizing how serious it was. However, after floundering for six days through this one, without having eaten a meal and wishing I were dead, I was not so pleased.

We finally arrived in Moje, Japan, three days late, but we couldn't leave this town because the wind was so bad.

The "Still" Record

Our boat was anchored about 150 yards from shore and we could see houses blown from their foundations and small fishing vessels thrown up on the shore and completely demolished. The next morning we were able to leave, a sad, woe-begone company, arriving in Kobe fifteen hours later. Then for a wild rush through Ja-

pan, truly a tourist's delight. After two weeks of that glorious country, I took passage on a homeward-bound ship with 2,500 photographs in my possession.

The reason I am writing this is that because of having experienced these wonderful things myself, I feel that other young fellows also should experience them because of their wonderful educational value and broadening influence.

So far as working away from home is concerned, this is very impractical unless one has a job lined up before leaving this country. The best thing to do is to work hard in Hollywood, save money, then take a good long vacation. It costs a little money, I admit, but the advantage gained is worth many times the amount expended.

W. E. Sound System

World wide installations of Western Electric sound system total 6,670, according to the latest report. Of this figure 4454 are in the United States and 2216 are in the foreign field.

Several interesting figures are revealed by the report. Great Britain has passed the 1,000 mark with 1,006 complete installations. Two installations have been made in Iceland, and Malta has been added to the list of countries where installations have been contracted for.

Renewed activities are shown in Poland, where installations have increased to 24; in Spain, where the total is now 23, and in Austria, where 31 Western Electric sound systems are now operating.

Kelsey As Traffic Cop

Fred Kelsey has just completed the role of Hollywood traffic cop, or in other words, master of ceremonies in the all-talking Screen Snapshots No. 1 of the new series for the coming year, directed by Ralph Staub for Columbia release.

While on duty Fred meets an old farmer friend from Sandusky, Ohio, and takes him around Hollywood visiting various stars.

Cliff Edwards sings and plays the uke for them. Joe E. Brown puts on a talking bout with First National's mechanical men. Jeannette Loff stages a spaghetti-eating contest. Other stars in the reel are James Gleason, Bob Armstrong, Lew Cody, Doug, Jr., and Joan Crawford.

Correct

Movie Producer—At last, a store of genuine antiques.

Propertyman—Better be careful, boss. They look like a lot of second-hand stuff to me!

—:!—

Never Heard of Him

Maury Kains tells about a Scotch friend of his who refused to drink out of a bottle because it had to be tipped.

Hollywood: The Truth

By GEORGE BLAISDELL

UNDER the fearless banner of Local 666 the contributing Sassiety Reporter discusses a couple of those cameramen who for years have been heroing totally unsung—complete strangers to the spectacle of mutilated telephone directories and ticker tape falling snowfashion from fifty-story structures into highways jammed with jostling and yelling humanity.

There's the tale about Secretary Norm Alley pinch hitting for stunt men seized with cold feet and an attack of discretion when a call came for a man to take a microphone from the refueling plane into the endurance ship.

And there's that quaint twist of the following "congratulations" from the "ball and chain" which to most married men, cameramen and others, will sound more like a "bawling out."

No wonder the secretary has his orders now the result of which will be his permanent grounding.

In the Lion's Cage

And there's Phil Gleason, on the sound end of a news team recording a wedding in a cage of lions, who holds up the show several thousand persons are watching when he clears out the cage in order to secure a more advantageous position for his mike.

Right away Phil is nervous, plenty—hot, if you please, because of the lions, who possibly are moved by a dim consciousness their visitor is there to shoot them and are behaving most circumspectly. The occasion for the uneasiness is the razzing that is going on outside the cage on the part of Gleason's unfeeling associates—one of the trio being the humorist who unfolds the tale.

Undoubtedly, as the latter relates, the spectators admire even as they laugh. And well they may.

Little but Oh My!

A SMALL camera, an instrument weighing but fifteen ounces, bulks large in the present issue of International Photographer. The remarkable Egyptian pictures adorning the opening pages and so vividly described by Esselle Parichy were photographed by that twofold artist with a Leica camera using motion picture film.

The original negative of these pictures is approximately 1 by 1½ inches in dimensions, two of the usual frames of the 35 mm. film being used. When the prints came to us they had been enlarged to 8 by 10 inches.

Photographically these revealed no trace of the difficulties described by Parichy—cloudless skies, with the impenetrable yellow glare due to absence of rain to wash dust-laden air.

It is hard to realize such pictures could have been made with an instru-

ment roughly 1¼ by 2¼ by 5¼ inches.

In another part of the magazine Henry Freulich, also of Local 659, describes how with a Leica he spent six months in touring the world on a vacation. So industriously did he employ his shooting time that he returned to Hollywood with 2500 photographs as a permanent record of his journey.

Arizona Still Hot

CHARLIE BOYLE gets over a message from Flagstaff that while 659 was putting over a golf tournament some of its expatriated sons were conducting a Navajo-Hopi sweepstakes. Among those participating were Ed Snyder, Joe La Shelle, Carl Webster, A. G. Schaffer, Dave Smith, J. McBurnie, William Marguilies, L. Worth and William Draper.

The truant Out of Focus reporter declared he couldn't tell us how hot it was in the shade as there wasn't any, but it was agreed the sun was hot.

Indications at time of writing were that the Pathe company on the Painted Desert would remain there until at least Oct. 15.

Johnny on the Spot

A GAIN an amateur photographer steps into a breach and supplies the world with a most important bit of film. One of the places where the news man can be with his camera only through accident as a general rule is on shipboard. He can't be everywhere, especially a participant in a marine disaster.

C. G. Mills, an engineer for General Motors, was returning from Australia on the Ventura, the vessel that went to the rescue of the passengers of the sinking Tahiti.

With his 16 mm. Bell and Howell camera Mills shot plenty of film, which upon arrival in San Francisco on a Monday night was put on a plane for New York. It arrived in the east Wednesday morning and after being enlarged was exhibited on the local screens that evening.

Uncle Sam Alert

THE United States Signal Corps is paying serious attention to this new sound thing of which so much has been heard in the preceding two years.

One of the indications of the interest it is taking in all that pertains to sound activities in the western studios is the assignment of Gorman A. Charles, staff sergeant, Signal Corps, to Hollywood during August and September for observation of and training in sound work.

The sergeant, who is a member of Local 659, through the cooperation of the organization's executives and

studio chiefs has had all doors opened to him and all courtesies extended. This has been true of large and small lots alike and allied concerns.

Following completion of his tour of duty in Hollywood the sergeant will sail on the army transport Somme for his new station as official photographer in the Hawaiian department. He will be situated at Fort Shafter, Honolulu. Incidentally the sergeant extends an invitation to all brother members of Local 659 on location in the islands to look him up. It will be his sixth tour of duty on that station.

Sergeant Charles, who joined the army in 1908, has been in the signal corps since 1916. His ordinary station is at headquarters Ninth Corps Area, Presidio, San Francisco. During his stay in Hollywood he has been a welcome visitor at the headquarters of the cameramen. Their hearty good wishes will follow him.

Technicians Multiply

HEREAFTER when the Society of Motion Picture Arts and Sciences plans to hold a discussion on a subject as interesting to the technicians as is that of wide film it will be well to take into account the increased number of men vitally concerned in the premises.

Two years ago, in the early days of sound discussions in Hollywood, hardly a corporal's guard would have appeared to sit in following a call similar to that sent out for Sept. 17. The restaurant at the Fox Hills studio on the occasion named was crowded, the attendance representing probably double the number expected. As a result when a speaker turned to charts or a blackboard there was much craning of necks to see what it was all about.

The great need for the occasion, and there is no reason to believe a similar need will not be apparent and more so in future technical gatherings, was for a platform for the speakers so that both they and their demonstrations could be in plain view of the audience.

In the earlier days of its organization the academy was looked upon by many in the industry as "not so hot," but the development of sound would seem to have provided an ample niche into which it might most beneficially fit.

It was imperative there be some medium for the collection and dissemination of technical information—without delay. Probably in course of time this function will be taken over entirely by the Society of Motion Picture Engineers. In the meantime the two organizations would seem to be working in cooperation to their mutual advantage and to the benefit of the industry.

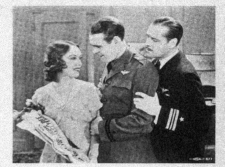

Cinematographic Lighting: Mood Stimulus

The Dramatic Emphasis Approach
Part III

By A. LINDSLEY LANE, S.M.P.E.

THE motion picture is pre-eminently an aesthetic medium of temporal attributes: continuity through significant movement. It is a continuous flow of shifting focal-points: constantly fluxing definitive focal-points within more inclusive ever-changing focal-points.

In the preceding paper of this series on "The Philosophic Approach" of the cameraman in his tone-mood interpretation of picture-story content, the fundamental flow of: leading characters' "suggested-inferred-life background" and "immediate story dramatic - philosophic significance" chiaroscuro was termed "primary light stream."

This apropos chiaroscuro flow concerns the undercurrent life background of the foremost story characters, and the flavor and atmosphere of their current lives, of which a very limited portion is recreated cinematographically as the indicative essence of the characters' life philosophies and conditions; comprising a flow of shifting focal-points generating in the moviegoer emotional responses conducive to the ready acceptance of the dramatic significance of the particular story content.

Dramatic Abstractions

In the present paper a secondary flow of focal-points within and a part of the primary stream is considered. Into the primary flow of mobile stimulative and interpretative light the equally important "dramatic emphasis" chiaroscuro stream is confluenced. This flow of definitive focal-points concerns specific action and localized thought reaction and precise symbolism; whereas "dramatic-philosophic" flow of chiaroscuro concerns the dramatic abstractions in the story trend.

To indicate the method of the dramatic emphasis approach, the second of two examples sketched in the preceding paper will be used; the philosophic chiaroscuro being first stated as the logical prerequisite to intelligent construction of the dramatic emphasis chiaroscuro.

Data Recounted

The literary data underlying the example is recounted: A bedraggled, anemic wife, still quite young, and married to the man of her choice. Adversity early cast her man into a rut; the constrictive effect of this hardness of life incrusting its dark shadow over the lives of wife, child and man.

The wife has known but little of light happiness, and that mostly while a girl in school; her life one of harshness and gnawing bitterness. This data, most sketchily, constitutes the life background of the leading character, upon which the suggested-inferred-life chiaroscuro is based.

For purposes of simplification and clarity, sequences preceding and following the present sequence example are of similar drab tone. All these sequences contain the dramatic intent of eloquently impressing the condition in life of the woman and her family, before eventually, through flowing dramatic structure (story continuity), lifting her to a comparatively exalted place in life.

Meager Yet Appetizing

In the sequence example here considered the woman is crawling about the poverty stricken flat, pitifully trying to lay out a meager yet appetizing supper for her hard-working husband. The data in this paragraph suggests the relationship of this sequence to the story trend, upon which the immediate story dramatic-philosophic chiaroscuro is based.

The cameraman now with his contributive guiding data at hand constructs its positive complement: The abstraction of the dramatic-philosophic mood of the sequence. His construction is of the following order: Depressing scenes of forlorn abjectness and unswerving devotion, in harmony with a predominating tortured love delineated through the literary content of preceding sequences, exemplifying "unmitigating grief."

The psychologically apropos photographic interpretation of the abstraction "unmitigating grief" is: An unrelieved monotony of lower-scale grays, with insidious deep-shadow areas, avoiding any intimation of delicate highlights.

Dramatic Emphasis

As was previously observed, seldom is it possible to interpret alone the philosophic aspect. The dramatic emphasis aspect, as a rule, is essential to the utmost expressiveness of the complete interpretative light stream. Dramatic emphasis chiaroscuro in this chosen example is extremely important, as further data of the sequence attest.

The poor woman is desperately working to prepare supper, when a bright-cheeked girl, a neighbor acquaintance, merrily pops in and laughingly gives her a huge bunch of wild flowers gathered in the fields that day. The sad woman responds with all the warmth and appreciation her sick heart and washed-out body allow her to summon forth, being deeply affected by the little girl's thoughtfulness. She places the flowers in a vase. The girl sees the woman is busy and soon leaves.

Here another story premise must be stated. The vase into which the woman puts the flowers is the one existing symbol of her erstwhile happy hours. It was won by her in a raffle at a church fair. She was joyous and carefree then as never since in her life.

Vase Seems to Glow

The woman pauses in her work to regard the flowers, and is slowly drawn through their smiling faces to their container—the vase. By the well understood psychological process of catenation her thoughts pass through the vase into a gradually emerging paradisaical retrospect of her brief happy span. Her face softens and its chronic pastiness with infinitesimal gradations livens to supple texture.

The vase seems to glow as she gazes in transfixed rapture into its revealing depth. While she passes further into her reminiscences the glow of the vase reflects more warmly upon the woman's face, seeming to transmit its life into her being—and it does—by virtue of the cinematographer's dramatic emphasis lighting.

Thus, by localized dramatic contrast, the dire condition and grief of the woman in her current living are emphasized. That is, the vase is the living embodiment of all the freedom and joyfulness she has ever had or may reasonably expect; and by specific action this vase is, so to speak, brought to light and strikingly contrasted with every other opposing thing in the home, thereby making infinitely significant all of the decaying hopes the woman suffers in this tomb—her home.

Steps Retraced

To retrace in a more technical way the steps just mentioned: The dramatic significance of the woman's retrospection is pure story content up to a certain measure, which literary content stimulates the moviegoer's imagination to an acceptance and nebulous reconstruction of the woman's thrilling reverie.

Then with this powerful inter-action as a basis for even greater emphasis and ultimate effectiveness, the cameraman superposes a physio-psychological stimulus in the form of apropos light.

Specifically, he causes the vase to increase in luminosity and this augmented vitality to be reflected upon the ensuing face in a like magnification of the external manifesta-

tion, harmonizing with the woman's inner flaming of spiritual intensity; and all this process executed with delicacy and in the most skillful nuances to retain a perfect illusion of occurring reality, that the physical recreative efforts may not be a self-conscious and self-evident use of medium.

Woman Is Stirred

The psychological connotation of this definitive focal-point chiaroscuro is simple enough: As the vibrations of retrospect impact in a flowing stream through the woman's mind and across her heart the dulled sensibilities of her emotions undergo a metastasis—the cold hardness that has long since become a part of her being is temporarily softened and made pliable, and she is stirred to a fluttering warmth.

This spiritual stirring is outwardly shown through her eyes and mouth and the muscles of her face. As the features soften and glow with the woman's vivid recollection of her happiness and cumulation is enhanced by the integral rendering of a subtle growth of physical illumination and spontaneous tone-play of soft highlights.

The poignancy of this technique is apparent when the depressing background of stark philosophic chiaroscuro enshrouding the woman's home and life is held in mind, as overwhelmingly opposing the definitive emphatic focal-point chiaroscuro of glowing memories.

An Illustration

In the foregoing example the dramatic emphasis chiaroscuro is used within a single scene. This same example could serve as well for the "increasing intensity chiaroscuro within a series of consecutive scenes" technique.

An illustration of the use of such technique, in very intimate confluence with the basic dramatic-philosophic chiaroscuro (interpreting another story content), follows: A naked man, strapped tightly face down upon a hard stone slab in an uncovered torture pit. It is just before sunrise; and the man has endured the awfulness of enforced inertia throughout a night of damp, cold exposure.

A faint gleam, anticipating the rising sun, starts to dispel the flat grayness of the early morning hour. Presently the first feeble rays of sunlight streak almost horizontally across the vast surrounding wasteland.

Sears Man's Back

Not long after the sun ascends far enough to shoot its direct rays into the pit, and almost at once they pierce a devilishly devised magnifying glass in bunches, emerging from the glass in a controlled and concentrated beam of intense heat and brilliance.

Quickly it begins to sear across the man's back on a painfully extended tangent line, the hot point of agony advancing along the tender flesh as fixedly as the earth revolves in its path around the sun.

After hours of hell, and the sun at its highest, the beam of light and heat most direct, the man's agony reaches its peak—the heat of the encompassing inferno winding annihilating waves around his withering body. His entire misery sharply dilates through dramatic emphasis chiaroscuro developing the permeating dramatic-philosophic b a c k g r o u n d tone-scheme from a flat grayness of morning to a dazzling black and white of midday, back again to enveloping, erasing night.

No Half Tones

A dramatic-philosophic significance of "hopelessness" is connoted by the early morning flat grays. The extremity of this hopelessness is for no long time lessened at sunrise, only the quality of it being changed from comparative passivity to vicious activity.

This activity is connoted by the violently conflicting areas of solid blacks and empty whites—of deep shadows and glaring highlights in simple monotonous spacing, with no ameliorative half-tones of any consequence between them.

As the day wears to its end, so does the fast-ebbing life of the tortured man; and with the passing of the last ray of life-giving and life-taking sunlight the man's final spark of life dies out. And the chill of night sweeps across the grayness of the lifeless body in the gray pit, encircled by the gray waste.

Nature's Part

The part nature takes in the conspiracy to torture and kill the man is connoted by inter-cutting to adjacent and permeating natural phenomena; these cuts being treated with mobile apropos dramatic-philosophic significance chiaroscuro only. The presentation-time limitation is transcended by lap-dissolves.

Now be it observed the crucifying-point of heat is an actor playing a role in the story, as it is also at the same time a light manifestation constituting the prime definitive focal-point of the dramatic emphasis chiaroscuro.

Thus there is achieved, in this instance, the most potent formation of light stream chiaroscuro possible: There is here inherent both the complete mood-stimulus light stream; and the light stream as organic literary content. And it will be discovered, as pictures progress in their aesthetic refinements and involvements, that they will increasingly synthetize light as organic story content.

The aesthetic structure of this illustration, with regard to its definitive focal-point of mobile dramatic emphasis tone-scheme within and a part of the more inclusive fluxing dramatic-philosophic chiaroscuro, developing and making more effective the organically related literary content continuity, aptly indicates the pre-eminent temporal attributes of the motion picture medium.

Third Illustration

A third illustration of the use of dramatic emphasis chiaroscuro, in this case using the "contrasting light intensities within a series of juxtaposed scenes" technique, is: Two men in a spacious, richly appointed library arguing as to whether the world is becoming a better place in which to live or whether it is going to the dogs.

The day is well along, and the optimist sits in the center of the room, the benevolent rays of the mellowed afternoon sunlight streaming in upon him from space; while the pessimist sits in a corner where the dusk is slowly gathering him into its obscurity.

The propensities of the argument are made more significant by a series of juxtaposed cuts between the two opponents contrasting pictorially, with an apropos scheme of tone balance and intensity, their individual attitudes and thoughts toward the subject.

The optimist is emphatically in the rich mellowing sunlight of the maturing day—and he glories in his beliefs and his expression of them. The pessimist is, equally emphatically, in the gradually obliterating dusk of the corner—and his beliefs and their expression trouble him. Still other cuts show both these men at once, and further emphasize the tonal disparity (philosophic, dramatic, pictorial) existing between them.

Complex Tone Scheme

So in this last technique is realized a complex tone-scheme procedure: a basic contrasting of light intensities throughout the series of juxtaposed cuts, in conjunction with a fluxing-opposing of "extinguishing" to "ever more vital" intensities flowing in divergent progression.

The symbolic intent of the light source can be fulfilled by having the pessimist at the end admit his sophistry, walking over to the optimist and shaking hands, and in making this gesture, entering the shaft of sunlight on equal terms with his friend. Thus, in this third illustration, light performs a third general function in motion pictures, that of a symbol.

Three Distinct Ways

Repeating, the three distinct ways of employing light in motion pictures are:

1. Mood stimulus; a strictly physio-psychological use (and the use this series of papers has been considering).

2. Organic; as actor playing a part in the story continuity.

3. Symbolic; expressing definite literary connotations.

The possibilities of effectual light used as mood stimulus through dramatic emphasis are unlimited; examples can be cited indefinitely; but the three given in this paper amply illustrate the cinematographer's second major approach in his work.

The art of intelligently creating mood with the seductive medium of mobile light in motion pictures is worthy of the highest efforts of the true artist, for, in any art, only the true artist may achieve mood accurately and consistently.

Almost everyone thrills to and is moved by the works of Tschaikowsky, because he speaks the universal language of mood—through music—appealing to man through man's sense of hearing.

T h e cinematographer s p e a k s through flowing light—appealing to man through man's sense of sight.

Vernon Walker Finds New York Hot

VERNON L. WALKER'S two weeks' stay in New York was highly successful, according to the cameraman, with two exceptions. One of these, and naturally to a cameraman on a metropolitan assignment the minor of the twain, was the "price of eats." The report brought back to Hollywood was that a man with a dollar and a half hunting breakfast could get a "swell cup of coffee and a doughnut."

As to the second and major handicap attending this cross-country trip to secure background shots for "Check and Double Check" for Amos 'n' Andy, Artist Willis O'Brien with his charcoal eloquently tells the lurid tale. It's hot stuff, you'll agree, as you sense the story told by the wilted camera and the all-in photographer taking a gasp between shots.

With the assistance of George Peters and Buddy Harris, former west coasters; George Brown, Harry Lavine, Browning and Mueller and a couple of New York cops, Walker most thoroughly succeeded in tying up Fifth avenue from Fifty-second to Fifty-ninth streets.

For a week the photographers cakewalked around Harlem securing negro atmosphere shots—and got 'em, with a thousand laughs a day besides.

"Ed Dupar and his shadow, Ray Foster, entertained on several occasions in truly New York style with a dash of Hollywood thrown in," Walker says. "Again I had the hearty cooperation of the New York police department—great fellows all.

Visits With Gang

"Met practically all the boys at the Paramount plant and had some marvelous assistance from George Folsey and Bagley and also Johnny Swain, who has charge o' the lab.

"I didn't have much chance to visit with Walter Strenge, as he was busy out at Warners'. He certainly still is husky in his praise for the boys of 659 and the way they entertain convention delegates.

"I ran into Joe Walker and Elmer Dyer, making dirigible stuff for Columbia. Later in the week the dirigible Los Angeles flew over us while we were in Harlem shooting. Guess they were aboard it, as I heard a lot of noise, and presume it was Dyer and his Akeley.

"I guess Buddy Harris has become a permanent New Yorker. He was married while I was there."

Artist Willis O'Brien Portrays Sufferings in New York of Vern Walker and His Camera.

S.M.P.E. Adds Members

Unusual growth has been experienced this summer by the Society of Motion Picture Engineers. Eighty-four new members have been added to the membership since May 1. The international influence of the society is shown in the fact that 28 of these new members are from foreign countries.

Residences of the new members according to countries, are as follows: United States, 56; England, 11; France, 3; New Zealand, 2; South Africa, 1; India, 2; Scotland, 1; Poland, 2; Norway, 1; Germany, 2; Japan, 2; Brazil, 1.

With the large increases in membership which the society has been making for the past few years and with the unusual gains in membership for this year the fall meeting to be held at the Pennsylvania Hotel, New York, October 20-23, is expected to break all attendance records.

When the fall meeting of the society convenes Monday morning, October 20, Major Edward Bowes, managing director of the Capitol Theatre, will deliver the address of welcome, according to announcement of the Program Comitee.

Meeting headquarters will be in the Salle Moderne on the roof garden of the hotel. Women's headquarters will be on the roof garden, with Mrs. E. I. Sponable as hostess.

Golf privileges have been arranged at several country clubs.

Election of officers will be held Wednesday afternoon and the semi-annual banquet Wednesday evening. The meeting closes Thursday, October 23.

Creco Finishes Fifty Mutes

The first fifty of the new Creco Mutes were put on the market at the end of September, all of them on outright purchases. Five of these went to New York and five to Cleveland, only a portion of the desired number.

Beginning with Oct. 1 the Creco plant will have a capacity of seventy-five Mutes each month.

Mitchell Men Frolic

The Mitchell Camera Corporation held a picnic for its employees and their families Saturday, September 6, at Brookside Park, Pasadena. The plant was closed and work forgotten for the day while all enjoyed themselves.

Two hundred and thirty attended the picnic.

Sufficiency

First Assistant—I've taken that cutter girl to three of the best talkies and bought her two chicken dinners at the "Top o' the Hill." Now, ought I to kiss her?

Second Assistant—Naw! You've done enough for that girl.

The Merry Ha! Ha!

Waitress—Well, I'd just like to see anyone run away with me.

Art Reed—Ha, ha! So would I,

Real Grief

Allan Davey came across a youngster recently sitting on a curbstone in Culver City crying as if his heart was broken.

Having two children at home, Allan naturally was sympathetic and asked: "What's the matter, sonny?"

"Mom's gone and drowned all the kittens," sobbed the boy. "Oh," he sobbed on, "and she promised to let me do it."

—::—

Polite Comeback

First extra girl—I certainly don't care for men. I've said "No" to several of them.

Second extra girl—What were they selling, dear?

"Amos 'n' Andy"

Billy Marshall has just finished the photography on R.K.O.'s much heralded production, "Amos 'n' Andy" upon which he worked eight weeks. Mel Brown directed and Billy had as his associated artists, Eddie Pyle, Eddie Henderson and Bernard Guffy, seconds: Cliff Stine, Eddie Adams, Jim Daily, assistants. Billy Marshall was formerly cinematographer with Valentino and other great stars. He bespeaks for "Amos 'n' Andy" an unqualified success.

Musta Been a Wee Scott

Charles Rosher, who has just returned from a two-year contract with the Elstree Studios in England, tells his one of a London newsie.

Seems the newsboy had collected one penny for an evening paper. As a pleasantry, Rosher remarked that if he were in Hollywood such a paper would cost three cents.

"Well, guv'nor," replied the youngster, "if ye're lonesome you can pay me the other two pennies an' maybe I'll make you feel more at 'ome."

—::—

Three's a Crowd

"Police! police!" shrieked a Hollywood extra girl from an apartment window.

"What's the matter up there?" growled the corner cop.

"There are two strange men in my apartment and I want you to put one of them out."

—::—

Hard Times Hint

Speed Hall worked till midnight at the Hollywood Camera Exchange recently. Next day he stayed in bed until lunch time. Speed says it's cheaper to stay in bed than to buy breakfast.

—::—

Gracious

Revue Girl—A penny for your thoughts, big boy.

Art Reed—I was only thinking that if a moth had nothing but your bathing suit for lunch it would starve to death.

Hoke-um
By Ira

Answer Department

Dear Mr. Hoke-um:
I want to surprise my husband on his birthday. What can I do? Sincerely, HIS WIFE.
Hide behind him and yell "Boo!"

—::—

Not Quite, Sir Thomas

Sir Thomas Lipton, telling of his boyhood, loves to say: "We were poor and Irish and that's as poor as you can get."

That's high society, Sir Thomas. The real level is when one is poor and a cameraman.

—::—

These Hot Nights

First Assistant—Last night I dreamed I died.

Second Assistant—And the heat woke you up?

—::—

That's How It Started

Jeff Gibbons (following 659's golf tournament)—I never take anything back—never.

Joe Darrell—Do you mean that?

Jeff—I certainly do.

Joe—Lend me ten bucks, Jeff.

—::—

Of Course

Assistant—What always comes in pairs?

Loader—Tripod cranks.

Assistant—Nope, pear seeds.

Idea Wanted

Cliff Thomas—Say, what became of that new camera the Synk Company was talking of putting on the market?

Art Reeves—They had to give it up. Nobody could think of a new idea for a swingover.

—::—

Them Suitcases

Electrician (struggling with a light)—The leading woman is really a lot older than she looks.

Cameraman (hoping for the best)—Yes, and what's more, she looks it.

—::—

Oh, Yeah?

Gene Hagberg—Did you take your girl home last night?

Bob Tobey—Nope, I left her at her apartment.

—::—

A New Assistant

A 659 loader had just taken his stand before the examining board to explain why he should be promoted to the exalted position of assistant cameraman.

"Now, suppose you've been ordered to set up your camera," said President Wyckoff. "What is the first thing you would do?"

"Look at the number," reported the loader without hesitation.

"Look at the number? Why, that isn't important just then."

"It sure is, Mr. Wyckoff. Supposin' I got all through with the job and looked at the number and found it was another guy's camera."

STUDIO LIGHTING

EQUIPMENT

KLIEG-SUN

SIDE FLOOD

PLUGGING BOX

CONNECTORS

ANYTHING required in the nature of lighting equipment for sound or motion picture production or photographic studios can be furnished by Kliegl—lamps of all kinds, both high-candle-power-incandescent and arc types; floodlights, spotlights, overhead lights, side lights, etc.; for close up or long range work; provide highly efficient brilliant light source, exceptionally flexible, and permit photography with clearness of detail, full color values, sharp definition, and freedom from sound interference, with ease and dispatch. Also various forms of wiring devices; portable plugging boxes; pin-plug connectors; floor pockets; wall pockets; and special apparatus made to order.

KLIEGL BROS

UNIVERSAL ELECTRIC STAGE LIGHTING CO., INC.

321 WEST 50th STREET

NEW YORK, N.Y.

*Part of the lathe section of our plant in which
our Standard and Wide Film Cameras are made.*

Our Thoroughly Equipped Plant

enables us to handle special work which
always receives the same careful atten-
tion that we give to the manufacturing
of our cameras.

*Your inquiries on special work
are solicited*

Mitchell Camera Corporation

665 North Robertson Blvd.
WEST HOLLYWOOD, CALIFORNIA

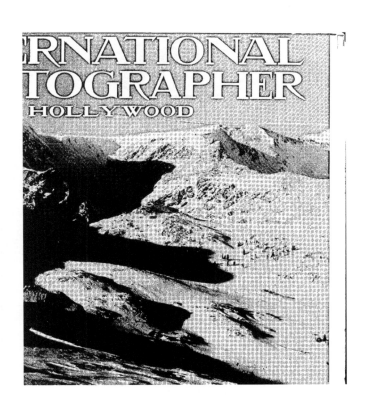

ERNATIONAL
TOGRAPHER
HOLLYWOOD

A scene from "Morocco," a Paramount Picture

. . . and now, even *more* faithful! for "*Widies*" and "*Color*"

THE talking-singing-*living* pictures have developed more exactions from light and photography in the past year than pictures developed in ten years before.

And "light men' find that National Photographic Carbons have advanced in step with every development . . . the new areas of "Wide" films . . . the finest of values for color photography.

National Photographic Carbons for every delicate nuance of color—every charming ripple of rhythmic movement—every accent of light and shadow—ability to serve the difficult close-up or long-shot.

National Photographic Carbons—as reliable as a shaft of sunlight—as sensitive as the play of moonlight on the surf—faithful friends of "light men," cinematographers, and stars.

NATIONAL CARBON COMPANY, INC.

Carbon Sales Division: Cleveland, Ohio

Unit of Union Carbide |U|C|C| *and Carbon Corporation*

Branch Sales Offices: New York, N. Y. Pittsburgh, Pa.
Chicago, Ill. Birmingham, Ala. San Francisco, Calif.

National Photographic Carbons

The
INTERNATIONAL
PHOTOGRAPHER

Official Bulletin of the International
Photographers of the Motion Picture
Industries, Local No. 659, of the
International Alliance of Theatrical
Stage Employees and Moving Picture
Machine Operators of the United
States and Canada.

Affiliated with
Los Angeles Amusement Federation,
California State Theatrical Federation,
California State Federation of Labor,
American Federation of Labor, and
Federated Voters of the Los Angeles
Amusement Organizations.

Vol. 2 HOLLYWOOD, CALIFORNIA, NOVEMBER, 1930 No. 10

*"Capital is the fruit of labor, and could not exist if labor had not first existed.
Labor, therefore, deserves much the higher consideration."—Abraham Lincoln.*

CONTENTS

The INTERNATIONAL PHOTOGRAPHER is published monthly by Local 659, I. A. T. S. E. and M. P. M. O.
of the United States and Canada
*Entered as second class matter Sept. 30, 1930, at the Post Office at Los Angeles, Calif., under the act of
March 3, 1879.*
Copyright 1930 by Local 659, I. A. T. S. E. and M. P. M. O. of the United States and Canada
HOWARD E. HURD, *Publisher's Agent*
GEORGE BLAISDELL · · · · · · · · *Editor* LEWIS W. PHYSIOC ⎱
 ⎰ *Technical Editors*
IRA HOKE · · · · · · · · *Associate Editor* FRED WESTERBERG ⎰
 JOHN CORYDON HILL · · · *Art Editor*
Subscription Rates—United States and Canada, $3.00 per year. Single copies, 25 cents
Office of publication, 1605 North Cahuenga Avenue, Hollywood, California. HEmpstead 1128

The members of this Local, together with those of our sister Locals, No. 644 in New York, No. 666 in
Chicago, and No. 665 in Toronto, represent the entire personnel of photographers now engaged in pro-
fessional production of motion pictures in the United States and Canada. This condition renders THE
INTERNATIONAL PHOTOGRAPHER a voice of an *Entire Craft,* covering a field that reaches
from coast to coast across the nation.
Printed in the U. S. A. at Hollywood, California

Considering Focus Depth Problems

Charts Designed to Help Cameramen Visualize Possibilities as Well as Limitations Under Different Conditions

By FRED WESTERBERG
Technical Editor

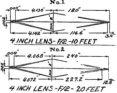

IN view of the difficulties that beset even the most talented and skillful of cameramen in keeping our famous stars in focus at all times, it may seem hazardous to suggest that there is such a thing as depth of focus.

The question, however, is one that cannot be ignored entirely. Ultrarapid lenses in the longer focal lengths that have been used in the past for close-up work demanding

very little in the way of depth of focus have now blossomed out as general purpose lenses of which a great deal will be expected, especially the ability to produce satisfactory definition of more than one plane in the picture.

That pictures made on wide film may subsequently be reduced to standard size film in the positive print in no way alleviates this condition. Once a negative is made in which the defi-

nition in some portion of the picture is deficient, all the king's horses and all the king's men will be unable to do anything about it.

Curiously enough, the first reaction

(Continued on Page 46)

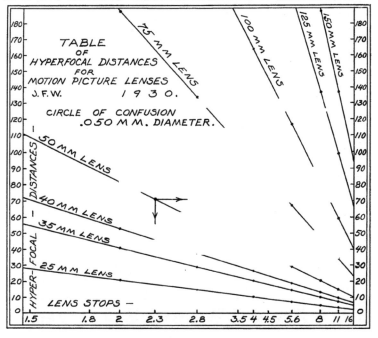

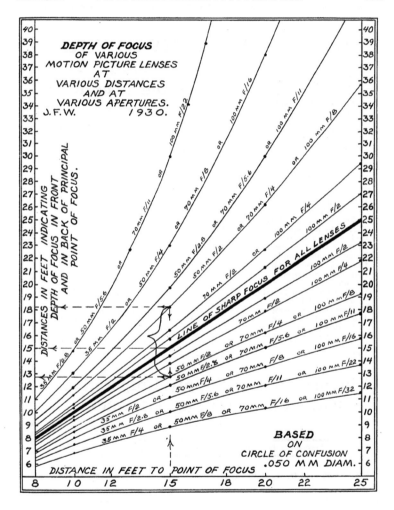

Idealizing an Industry's Future

Writer Tells of Great Sacrifice of Time, Effort and Expense Simply Through Avoidance of Banding Together

By CRÍTICUS

IN OBSERVING, enjoying and analyzing the rapid development of the motion picture industry and what we are tempted to call its philanthropic influence upon mankind, there comes an irrepressible temptation to visualize a future perfection of screen pleasures which we hope are not castles in Spain or a vanishing mirage.

On more sober thought the number of obstacles to be overcome, the to-day existing baffling problems, the woefully crude details of equipment in optical, chemical, acoustic, chromatic and mechanical sciences and practice bring about a reversal of enthusiastic hopefulness.

The short span of the existence of the motion picture gave slow-working evolution no chance to evolve a motion picture psychosis, so necessary in its full value for the logical improvements of the practically unlimited possibilities of the motion picture industry in its beneficial influence upon the psychic evolution of man.

The goal, however, is of such a value that it is worth great efforts and even sacrifices of momentary values to reach it or even come perceptibly nearer to it.

Single Human Limited

Even serious considerations of such thoughts, however, are of no value as long as they are of abstract nature.

We know that thoughts are the necessary start of every practical achievement, but call for practical efforts and application to bring practical results.

We also know by experience that the practical efficiency of any human being in developing a thought is rigidly limited.

The realization of this limitation evolved the banding together of individuals for the effective and rapid evolution of practices based upon thought.

This is true throughout the history of mankind in all of its aspects, be they based upon religious, sociological, national, commercial or any other forms of original thoughts or desires.

It is also true in regard to the building up of the vast motion picture industry, founded upon a single thought—the illusion of motion, produced by a rapid succession of fixed photographic images.

Single-handed efforts were startling in results, but progress was slow.

Logical vision of future possibilities brought about concerted action of interested individuals. Their banding together increased at a rapid rate, resulting to date in the existence of a number of vast organizations spread over the whole world.

Bands Increase Rapidly

The rapid increase of this banding together process increased the size of these organizations, in the number of their correlated individuals, their financial and other facilities and consequently in the perfection of their products at a rate unprecedented in the known history of industrial developments.

This process, however, has reached a period of more or less stagnant character.

The innumerable problems confronting the development of this industry are of course segregated into definite groups, calling for segregated efforts to bring them to a phase of solution.

These definite groups are well known and characteristic of the motion picture industry. They are so broad in their fundamental characteristics that they constitute a standard program of problems for every one of the great number of motion picture enterprises.

Each of these enterprises bent its honest, untiringly energetic efforts individually upon the solution of such problems—common to all the enterprises.

Each one of these enterprises owes its success to the banding together method, and each one realizes that the practical solution of a number of such problems is difficult of solution, many such organizations are even aware of the fact that they are individually

Expression on the face of an Egyptian as with bare hands he examines a scorpion. Photographed by Esselle Parichy

not fully able to solve some of these problems.

Not Banded Yet

Despite this knowledge, despite the beneficial experience of their own evolutionary methods, based on the banding together principle, there is an apparent lack of the knowledge of the realization, that that fundamental thought of useful banding together is still waiting for its broad application for the common best interests of the motion picture industry at large, and thereby for the best interest of each individual enterprise or organization.

Assuming that all these enterprises are working under the severest ethical code of fair competition, this principle of competition, ever useful for the common good, apparently acts as a brake on the momentum of rapid development.

There is a tendency of secrecy permeating most of these organizations, a fear of imparting information of any further approach in the solution of such problems to the industry at large, for fear of strengthening the position of a competitor.

The lesson of the application of the banding together thought for the benefit of all and individually has been forgotten.

There is apparently no realization of the tremendous amount of saving of money in vast sums for every individual enterprise—of years of time now lost in individual problem solving efforts—of an inconceivable loss of possible financial returns, ever paralleling perfection of product and service—all due to only individual efforts, limited in their results by the fact that such efforts *are* individual.

Speeding Up Urged

Is there no way to speed up progress in the motion picture industry, to speed up progress for the benefit of all? Is there no way to prove that castle in Spain, that mirage, not a dream but a reality?

There certainly is, theoretically.

We fully realize that to enter into a practical application of such theoretical possibility constitutes perhaps a greater problem than all the other motion picture problems combined, if its solution should be attempted in its entirety.

There is, however, a practical way of reaching this goal by applying the banding together principle to one detail problem after the other.

This procedure is now successfully employed by the greatest and most successful enterprises and industries we know of.

It's the banding together of the most efficient number of the most efficient individuals for the solution of one detail problem after the other, of the organization, in other words, of what is commonly called a research organization.

A study of the history of research of the banding together type in any

(Continued on Page 46)

Development and Good Negatives

Eastman Official Discusses Relations Between Incorrect Practices and More Common Complaints About Quality

By J. I. CRABTREE

WHILE there is no question that cinematographers as well as laboratory men realize the importance of correct development in the making of good negatives it may be of interest to review the relation between incorrect development and some of the more common complaints regarding negative quality in the light of recent researches.

The contrast of the negative is determined by the nature of the subject and the quality of the lighting, the nature of the emulsion and developer, and the time and temperature of development. Since most laboratories keep an accurate control of temperature, the usual cause of excessive contrast is an excessive time of development, and, vice versa, a lack of contrast is due to underdevelopment.

It is possible to vary the characteristics of the emulsion so that even with prolonged development the contrast of the negative is not excessive, but when photographing scenes in dull weather it is frequently not possible to secure enough contrast with such an emulsion even on prolonged development. An emulsion should be capable of giving a sufficient range of contrast, and the desired contrast should be secured by developing the film to the correct degree.

The ability of an emulsion to record shadow detail depends upon its light sensitivity or speed. It is well known if a fast emulsion is developed in a developer containing potassium bromide the resulting negative may only have as much shadow detail as a negative made on a slower emulsion but which was developed in a developer which did not contain bromide.

When Developer Is Exhausted

As a developer becomes exhausted it accumulates potassium bromide and potassium iodide so that a used developer is incapable of developing out as much shadow detail as a fresh developer. Lack of shadow detail in negatives is often a result of developing in an exhausted developer. It has been found by Dundon and Capstaff that by developing an emulsion for a short time in a fresh developer and then continuing development in a partially exhausted developer very little loss in speed results.

The effect is clearly shown in Figure 1. Negatives which had received identical exposures were developed in fresh and old developers and pictures printed from these so as to give (a) the best print from the negative developed in the fresh developer, and (b) the best print developed from that in the old developer. These are shown at a, b, c, and d; a and b received equal exposures during printing and likewise c and d.

How Detail Is Lost

The difference in appearance between a and b and between c and d gives one some idea of the difference in density between the two negatives. A comparison of a and d, which are the best prints obtainable from the four negatives, shows that a decided loss in shadow detail results from using an old developer.

The ability of the borax developer to produce fine-grained images is largely due to the high concentration of sodium sulfite (about 10 per cent), which has a decided solvent action on the emulsion grains. If the developer is diluted the solvent action of the sulfite is reduced and therefore its fine-grain producing properties fall off very rapidly.

It is, therefore, very important that the developer *should not be diluted*. If a slower working developer is required the quantity of the other constituents should be reduced, but the concentration of the sulfite should be maintained constant.

The process of reducing the size of the emulsion grains by solvent action requires time, so that the longer the time of development required to produce an image of given contrast the greater is the reduction of graininess.

In other words, if a negative requires, say, 10 minutes in the usual developer, the graininess may be reduced by reducing the quantity of the developer constituents but maintaining the concentration of the sulfite equal to 10 per cent, so that, say, 20 minutes would be required for the correct degree of development.

Increasing Graininess

On the other hand graininess of a negative increases with the degree of development or contrast or gamma, so that forced development causes increased graininess. A brilliantly lighted subject requires less development to produce a negative of given density contrast than a flatly lighted one, and in turn it will be less grainy. The difference between the above mentioned factors should be clearly understood, namely (a) graininess increases with the *degree* of development but (b) for a given degree of development and providing the concentration of the sulfite is maintained constant, graininess *decreases* as the *time* of development increases.

It is very important, therefore, not to attempt to speed up development of negatives in the borax developer so that development is complete in less than about 10 minutes. Such practices as adding carbonate to speed up development are to be deplored. Fine-grained negatives cannot be made in a hurry—they require time.

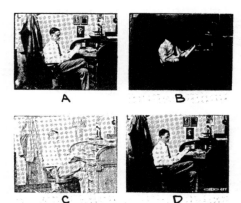

A B

C D

Engineers Hold Largest Convention

Wide Film Committee Reports in Favor of Ratio of 1.8 to 1 as the Best Compromise in a Most Difficult Situation

WITH more than 300 persons registered, the Fall 1930 meeting of the Society of Motion Picture Engineers at the Hotel Pennsylvania in New York City, Oct. 20 to 23, stands out as the greatest in the history of the body. At the preview Monday night Paramount's picture "Playboy of Paris," starring Maurice Chevalier, and the Fox picture "The Big Trail" were shown, together with a number of short subjects from Audio-Cinema, Pathe and Paramount.

Electrical Research Products Inc., furnished sound projection equipment. International Projector Corporation furnished the projectors. Bausch & Lomb furnished stereoscopes and lenses. Local 306, Motion Picture Operators, did all installation work for the sound picture equipment under the direction of Charles Eichornn, vice-president.

Raven Screen Corporation supplied the screens.

Ampro Corporation, Chicago, furnished 16 mm. equipment.

The Bell Telephone Laboratories entertained the society Thursday with a trip through the laboratories, a luncheon and a two-way television demonstration.

The majority of the members of the society took advantage of a boat trip around Manhattan Island Wednesday afternoon.

The banquet was an unusual success and was in honor of motion picture producers, with many leading figures of the industry present.

Election of officers reinstated the officers who served last year and also elected W. C. Kunzmann and F. C. Badgley to serve on the Board of Governors.

Guests of Honor

The guests of honor at the banquet were H. B. Charlesworth, vice pres. Bell Telephone Laboratories; A. N. Goldsmith, vice president of Radio Corporation of America; Will H. Hays, president Motion Picture Producers and Distributors of America; Felix Feist, general sales manager, Metro-Goldwyn-Mayer; Paul Gulick, director publicity of Universal Pictures Corporation; Jesse Lasky, vice president Paramount; L. I. Monosson, Amkino Corporation; G. O. Quigley, Vitaphone Corporation; J. E. Otterson, President Electrical Research Products, Inc.; A. E. Reoch, vice-president R.C.A. Photophone; C. J. Ross, executive vice president, R. C. A. Photophone; L. E. Thompson, vice president RKO; Sergei Eisenstein, Russian director; John Wayne, star of "The Big Trail" and H. G. Knox, vice president Electrical Research

Products Inc. All of these made short talks.

Favor 1.8 to 1 for Wide Film

The committee on wide film felt that the standardization of wide film dimensions was the problem of prime importance before it, and the subject had been considered at great length at three meetings of the entire committe and at seven meetings of a sub-committee consisting of Messrs. Batsel, chairman; Daveo, DeForest, Evans, Griffin, LaPorte, Spence and Sponable.

It was generally agreed that placing the sound track on the present 35 mm. film resulted in a picture with undesirable proportions. When these proportions were corrected by masking the height, the smaller area of picture required a greater magni-

J. I. CRABTREE,
Eastman Kodak Company, Re-elected President Society Motion Picture Engineers

fication of the film to cover the same size of screen.

As the magnification has already been pushed close to the limit set by the graininess of the film and its unsteadiness in the projector, the utilization of a portion of the film for the sound track has made the projection of pictures of even moderate screen dimensions not altogether satisfactory.

Simultaneous with the general introduction of sound has come a desire on the part of the industry for a

larger projected picture which will include more action.

Although several methods have been suggested for the realization of large screen pictures with the present 35 millimeter film, this committee feels that none of these methods offers a permanent solution to the problem. At the present time the only satisfactory method of obtaining a large screen picture seems to be through the use of a wider film.

There are many obvious advantages to wide film, the committee conceded. It not only permits a sound track of more satisfactory width than in use at present, but it makes possible large screen pictures having a greater variety of composition and more action without exceeding a practical limit of magnification.

In considering a new standard for motion picture film this committee has been guided not alone by engineering principles but by considerations of the cost to the industry of a new standard and of the necessary transition period.

It is obvious that any practical recommendation must involve the ratio of screen width to screen height that is already established within reasonably narrow limits by both the proscenium arch and the balcony cutoff in existing theatres.

An investigation of this subject shows that, whereas a few of the larger theatres can use a ratio of width to height as great as 2 to 1, the ratio for the smaller theatres is usually less.

After careful consideration of this subject the committee recommends the adoption of a 1.8 to 1 ratio of width to height as the best compromise. This ratio seems to be not out of line with prevailing sentiment among members of the academy.

During the deliberations of the sub-committee it became increasingly evident that the adoption of release prints with a width in the neighborhood of 65 to 70 millimeters would be economically impracticable for a large proportion of theatres.

It seemed desirable, therefore, to give consideration to a film size intermediate between these dimensions and the present 35 mm. standard. The committee is working on a layout that will permit the use of the 1.8 to 1 ratio that will provide for a wider sound track and more suitable margins and is attempting to assign dimensions to this film that will permit the most economic use of existing 35 mm. equipment.

While the specification of the release print dimensions is the problem of most importance this committee has under consideration a negative of such proportions that it may be printed by optical reduction on the new intermediate film size or by contact on a larger film for the deluxe houses.

An agreement on the above plan

In Notable History of Organization

has been reached so recently that there has been insu....cient time to complete the final details for presentation to the society.

These will be circulated to the members of the society with the minimum possible delay.

Color Committee Reports

The May report of the Color Committee gave a list of producers of color pictures and the systems used. At that time the Photocolor Corporation report had not been received. According to A. G. Waddingham, technical director of the corporation, "the color camera is of special design, photographing a pair of images in conjunction with special taking filters and an optical system employing the split beam method of photographing."

The negative is printed upon a specially designed optical printer which prints the two respective images in registration upon duplitized positive stock.

The print is next transferred to the green processing room and receives the application of the blue-green complementary dye on the side containing the image from the red sensation negative.

The print then receives the orange-red dye upon the image from the green sensation negative.

Mr. Waddingham says the process is entirely adaptable for the production of sound prints in color, either by the disc method or the sound-track on film method.

The company is well equipped with a thoroughly up to date laboratory, and a new sound studio is in the course of construction.

Film Pack

A specially made negative is being marketed, for use with the Film Pack system, known as red ortho front negative. This has a blue-sensitive emulsion, on the surface of which is a layer containing a red coloring matter.

In making color sensation negatives by this system, red ortho and a panchromatic negative are placed emulsion to emulsion in the camera and exposed simultaneously.

The light from the lens passed through the red ortho, recording the blue end of the spectrum. The red colored layer then filters and the blue and the red end of the spectrum passing through are recorded by the panchromatic negative.

The red coloring matter on the red ortho is removed from the developed, fixed and washed negative by bathing in a 3 per cent solution of hydrosulphite of soda.

New Color Process

A new color process is being introduced from Germany, known as the "New Color Process." It is claimed this is usable for either motion picture or stills, although in the description the method of using it for motion pictures was omitted.

Color Committee Describes in Detail Various Methods of Many Laboratories—Lighting Influenced by High Intensity

Successive exposures are made in a special camera fitted with tricolor filters. The color value negatives are printed on to positive films which have their respective dyes incorporated in the emulsions. The films are then developed, fixed, washed and subjected to a warm water treatment. No formulae were given. The silver images are then reduced, leaving pure dyed images, which it is claimed can be either transferred to an individual support, or the three films can be placed in register and bound. The printing is accomplished by printing through the celluloid side of the film.

Three-Color Additive Processes

In the Herault color process a three-color sector wheel is rotated in front of the camera and the contact print negative is dye tinted so that each successive group of frames is tinted one of the primary colors. The three-color positive is then projected with a continuous projector (Continsouza-Combes).

The method is said to suppress the

OFFICERS RE-ELECTED BY SOCIETY OF MOTION PICTURE ENGINEERS

President, J. I. Crabtree, Eastman Kodak.

Secretary, J. H. Kurlander, Westinghouse Lamp.

Treasurer, H. T. Cowling, Eastman Kodak.

Governors, elected for first time, W. C. Kunzman, National Carbon and F. C. Badgley, Canadian Government Motion Picture Bureau.

chromatic flicker when projected at 24 frames per second; only spherical lenses are used in this projector. This plan is somewhat similar to that now being suggested by Wolf-Heide.

Horst System of Color

In this system three pictures are taken simultaneously with three-color filters, using a prism system in the camera. In the positive each frame carries three images, each corresponding to one of the color separation images of the negative. This method is being sponsored in Great Britain by Universal Productions, Ltd.

Report From Dr. Walter Clark

In a report from Dr. Walter Clark, London, August, 1930, he states that "a number of color cinematography processes are being investigated in England, and a few productions are in progress utilizing some of them. Processes being studied or used in

England include Pathecolor, Talkie-Color, Zoechrome, Dufay, and Raycol."

The Chromolinoscope

In a paper entitled "The Chromolinoscope Revived," Dr. H. E. Ives has described several applications of the instrument devised by his father, F. E. Ives, in 1901.

Methods of making "ridged" images and ridged film records from three-color separation negatives are described, as well as a method of copying film containing line images.

A Review

A review of recent advances in color photography is published by G. Grote in the Photographische Korrespondenz, Vol. 66, p. 91, April, 1930.

Keller-Dorian Method

Dr. N. M. LaPorte of the Paramount Publix Corporation says "relative to our experience with the Keller-Dorian method, while our preliminary investigations show that there is considerable merit to the process, we have not made any commercial takes to date."

Camera Gate for Film Pack

A camera gate that holds two films in contact while at the aperture gate in a camera and suited for composite photograph and film pack color negatives has been issued in England. The gate seems specially suited for Bell & Howell cameras and is known to produce very excellent results.

First Color Film

"The Glorious Adventure," first of the full length, full color pictures to see the light of day, was shown some ten years after its original debut at the Filmarte Theatre, Vine Street, Hollywood, for a week beginning August 15, 1930. It received favorable comments from the press.

Multicolor

A demonstration reel was shown colored by the Multicolor system. The negatives were made by the film pack system and most of the scenes exhibited were made under artificial light.

Sennett Brevities

An exhibition of work done by the Sennett Laboratories, Studio City, Calif., was shown. All the negatives are made by the film pack system. The aim here, according to the Sennett organization, is to produce films with good photography and the color subdued.

Magnachrome Film

This system gives wide film sound and color. It is an additive method with many of the old features utilized, but designed to rid itself of

Egyptians entertain Esselle Parichy as he reciprocates by taking their picture even though two of the number take unkindly to the proceedings

color bombardment and color fringing.

This is accomplished by having the film pass through the normal projector at the standard speed of 90 feet a minute with, however, an intermittent movement, which operates with an eight-sided cam instead of the usual four-sided cam. This gives 48 pictures a second of half the usual height, instead of 24 full frame pictures a second as is customary. At this speed of 48 changes a second there is little or no color bombardment.

The negatives are preferably made by the film pack system. The only change in the camera is that it is fitted with a half size aperture gate and the normal speed of 24 pictures a second insures good exposures. Other methods of making the negatives may be used.

For the positives the negatives which have been exposed as above described are printd in sequence giving on projection a series of 48 pictures a second, with the sound at 90 feet a minute giving perfect reproduction.

No fringing is discernible as the negatives have been made in pairs. In addition to this the film is tinted with alternate spaces of red and blue-green, so that after leaving the laboratory the films cannot be joined or run out of color.

No public demonstrations have been given, although private exhibitions have brought forth ecomiums. As the process has no toning, using black and white pictures and makes use of process in which the problems are familiar and well worked out, the film can be introduced at low cost.

The above description covers much that has been done, but, as many changes are being made. no demonstration will be given until the spring meeting of the society.

Roy Hunter of Universal, who has been active in the development of Magnachrome system, has supervised the making of a two-reel picture without color using this method of projection.

Little Change in Lighting

The Studio Lighting Committee reported there has been little change in the methods of studio lighting since the report given at the Washington convention last May with but one exception, that there seems to be a tendency on the part of many of the studios, where incandescent lighting has been used to a very large extent, to increase the number of high intensity spots and sun arcs for floodlighting purposes.

This has been rendered possible by the efficient silencing devices which have been installed on the direct current generating equipment and the arc lamps in the various studios.

Manufacturers of arc lamp equipment are advertising some new equipment for high intensity arcs in which they claim to have eliminated many of the sources of noise which were present in the older lamps.

None of the information which the committee has been able to obtain in the past six months is of a character which advances the real knowledge of studio lighting to any great degree. Basic information with regard to the various sources of light which are available is given in many articles which have appeared in the transactions of the society and of which a bibliography was presented in the last committee report.

Any additional knowledge must be gained in the studios themselves, and in spite of very earnest efforts on the part of the committee up to the present time it has been impossible to obtain this information.

It is understood that in past years attempts have been made to utilize photometric measuring devices in the studios, but that none has been found satisfactory or useful for one reason or another. Of late some little work has again been done on this problem, but up to the present time little progress has been made in the practical application of these instruments.

Efforts should be continued on the part of the committee, it says, to obtain the information from the studios which will give the best possible answer so that standards could be set up for desirable levels and types of illumination for the various kinds of sets which are encountered in the practical production of motion pictures.

The methods which can be applied in this work probably lie in the determination of levels of illumination coupled with the photographic values of the light actually used and micro-density determination of films taken with the various types and mixtures of illuminants.

Light Weight in Equipment of Importance on Location

ACCORDING to James Almond, R.K.O. electrician, one of the serious problems encountered during the recent filming of "The Silver Horde" in the far north was to determine an adequate means of transporting cameras, lighting and sound equipment to the numerous locations in Alaskan waters.

Due to the fact that quick shots were required and but a small amount of apparatus could be loaded on the small, fast barges that finally were employed, necessity called for apparatus that would minimize the transportation of dead weight.

Laco lighting equipment, because of compactness and light weight due to the employment of aluminum in its manufacture, proved to be an efficient factor in aiding in the production of the picture, according to Mr. Almond.

Since his ten years experience in the picture industry Almond says never before has the necessity for minimizing dead weight been so forcibly demonstrated as during the filming of this subject, production of which met with many obstacles successfully overcome by the employment of modern apparatus.

He believes the day has arrived when necessity requires the manufacture of all equipment used in picture production be made to meet the demands for products from which weight has been cut to a minimum.

During the six weeks spent in the north Almond says the company enjoyed a number of interesting experiences among which was the filming of a salmon cannery, where the complete process was photographed from the time the fish were caught until they were prepared, canned, packed and ready for shipment and the canopener.

Sound in 240 Seat House

Believed the smallest sound theater in the world is the Crescent at Temiskaming, Quebec, seating 240. It is patronized almost entirely by employees of a pulp company, the plant of which is situated there.

Stumar Tells of German Production

AFTER an absence of eighteen months in Germany, where he has been photographing pictures for Universal, Charles Stumar returns to Hollywood with many laurels added to his chaplet as a cameramaster.

While abroad he was located at the UFA. Studios, Neubabelsberg, a suburb of Berlin, and during his sojourn there he shot sixteen pictures for Universal release and two independents.

All of the pictures ran about 7000 feet in length and were shot exclusively with Mitchell cameras while using Klangfilm sound and with De-Bries when Tobis sound was employed. It required only sixteen to eighteen days to finish each feature picture and Mr. Stumar cannot too highly praise the perfect organization of the German production machinery which overlooks nothing and functions like a Swiss watch.

In Germany, Mr. Stumar says, there is an organization known as the Association of Picture Workers, which corresponds with our I.A.T.S.E. and which is made up of locals formed of sound men, directors, assistants, writers, cameramen, still men, art directors. There is a fine spirit of co-operation between these co-ordinated elements and it all makes for speed and efficiency in production.

The popularity of sound pictures is increasing in Germany, but owing to the very few first-class sound studios in the country there is a serious shortage in the output of the sound pictures.

There are, indeed, only four efficient sound studios available and there are no more building just now.

American Films Not Popular

American pictures are not popular in Germany and the reason, according to Mr. Stumar, is that the fans do not understand our pictures. German pictures for Germans seems to be the trade slogan there.

Mr. Stumar was generous in his praise of the German cinematographers and he says that photography is recognized there as the dominating feature of a production—the "main thing," as he termed it.

He mentioned particularly Rittau, Hoffman, Grupd and Kanturek as cameramasters of the highest attainments. The electricians, also, were 100 per cent efficient.

The eminent sound engineers Drs. Leistner of Klangfilm and Grimm of Tobis came in for unstinted praise by Mr. Stumar, and his tribute to the art directors was spoken with enthusiasm. He said they were supreme masters of camouflage and that their clever artistry had almost revolutionized set construction, decoration and furnishing, and thereby had effected the saving of millions to the producers.

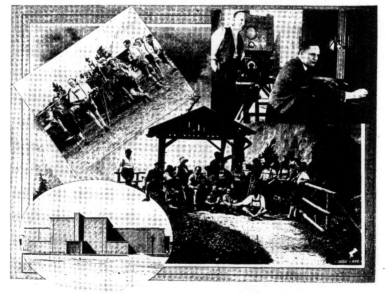

Upper left, *Innsbruck Tyrol, 10,000 feet elevation, Charlie Stumar second from left by side of camera. Upper right, Ufa monitor room, sound chief, Dr. Eric Leistner, at panel, with Stumar standing behind. Center, staff and players. Lower left, new Ufa sound stage, near Berlin, built of sound-proof brick.*

Cream o' th' Stills

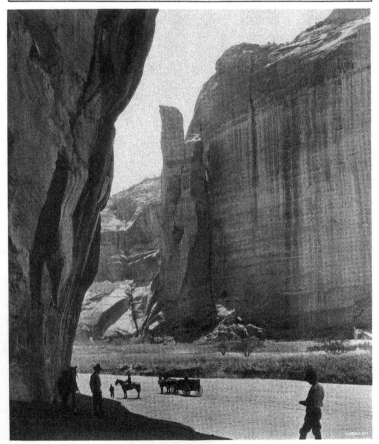

A view of the Canyon de Chelly in Arizona. What a story might be written around those perpendicular walls by a geologist—a tale of eroding ages. We are under obligation to Edward H. Kemp for the striking photograph.

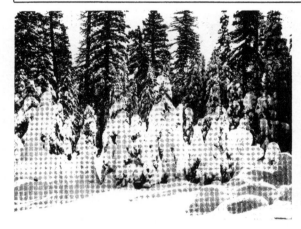

Loyal Himes brings to Northerners transplanted to the snowless lowlands a deep breath of frost from the heights above Lake Tahoe—the magic of winter and "the beautiful" convert young trees into parading penguins, with their playmates the seals reclining in the foreground.

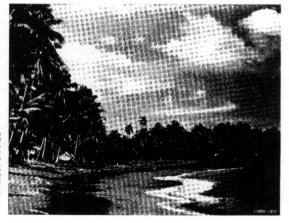

Step across many miles of the old Pacific and stand in with Guy Wilky as he sees through his finder a bit of Tahitian strand, with its receding wave in the foreground and native huts sheltered among the dense South Sea Island foliage in the background.

 # Cream o' th' Stills

From Otto Benninger
comes a memory of
Gene Stratton Porter
in his permanent
record of the flagged
and trellised arbor
with its background
of old-fashioned
garden. This was
photographed at the
Rome City (Ind.)
home of the lamented
authoress who met her
death in a Los Angeles
traffic accident.

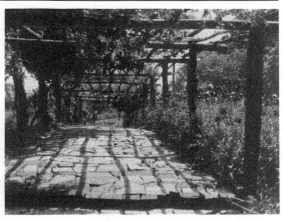

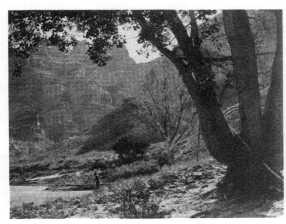

Ralph E. Yarger
"shoots" a fellow-
photographer in a
picturesque setting
doomed or rather
destined by a
progressive people
to undergo violent
change in a few short
years. The site shown
is not a great
distance above the
projected
Boulder Dam,
on the
Colorado River.

 # Cream o' th' Stills

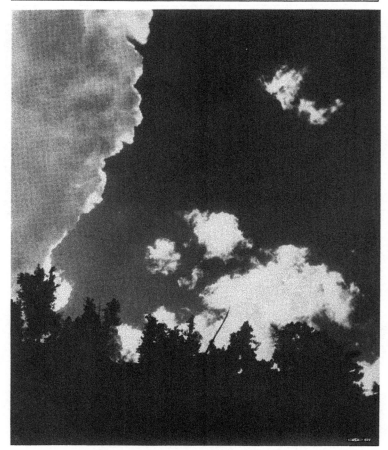

Richard Worsfold catches an odd cloud effect in Yellowstone National Park

Care of Photographic Lenses Vital

Review of Materials Going Into Construction With Suggestions for Obtaining Highest Results from Opticians' Art

By JOSEPH A. DUBRAY

THE most important requisites of a modern cinematographic lens are critical definition and flatness of field for as large an aperture as possible—in other words, luminosity combined with perfection of image formation.

It is well known that in a photographic objective a number of errors, called aberrations, which impair the quality of the image, are unavoidable because intrinsically inherent to the physical characteristic of glass and to the shape of the surfaces to which the glass is ground.

It is the aim of the lens designer to reduce these errors to a minimum and to reach a compromise which satisfactorily answers the requisites of sharpness throughout the field and luminosity.

Lens aberrations are the result of the behavior of the rays of light while passing through the glass. It is quite obvious that in order to form a perfect image of an object the light rays after passing through the lens should all converge to one point.

It is known that due to the spherical form of a lens the incident rays that strike its surface at varied distances from the lens axis converge to different points and thus produce the numerous kinds of errors which are grouped under the general name of "spherical aberrations." It is also known that the decomposition of white light into its colored composites produces errors known as "chromatic aberrations."

Glass Quality Important

Since it is quite impossible practically to depart from the spherical shape and since glass is the only material which successfully can be used in lens making, chemists produced glasses the composition of which while determining its density, would permit to control, so to speak, the path of the light rays within their mass, and opticians devised such combinations of lenses of different glasses and different shapes in which the errors produced by any one single or combination of lenses would be neutralized by the other, resulting, in a whole in which the residual aberrations were reduced to an acceptable minimum.

The composition of glass plays, therefore, an extremely important role in the quality of the image formed by the photographic lens, and it is quite obvious that any even so slight modification in its molecular structure greatly impairs the quality of the image itself.

Ordinary glass is principally made by mixing, by fusion, silicates and an alkali. For optical glasses other substances are incorporated which alter the density of the glass, which, in turn, influences the deviation impressed upon the light rays when passing from air into the glass or from one type of glass into another.

Due to the optical properties of the different types of glass used in the making of photographic lenses and to their specific functions as elements of a composite objective, lenses made of glass which contains a high percentage of "barium" are the ones usually found on the outside of the objective where their surfaces are in con-

Joseph A. Dubray

stant contact with the atmosphere and in possible contact with extraneous bodies, such as moisture, dust, or the human hand.

A glass mixture is not a true chemical compound. Its elements do not undergo a complete chemical union, but are held, so to speak, in suspension. Ordinary window glass, which is a mixture of silica and alkalies, has a so-called "fire polished" surface. The molten mass is spread in the desired thickness for cooling on large metal slabs, and after cool-

ing does not require any further mechanical polishing.

The cooling of the glass surface takes place very normally and the glass molecules settle down, so to speak, in a very comfortable position, quite unwilling to be disturbed. This gives a tough surface to the glass and a remarkable resistance to outside influences.

Optical glass for lensmaking is not so treated, for after the molten mass has cooled it is broken up, remolten in particular shapes, and finally mechanically ground and polished. This manhandling results somewhat in a breaking up of the natural molecular arrangement of its surface, leaving loose ends in the molecular structure which form points of attack for foreign interference.

Sensitive Surface

The surface of a mechanically polished glass surface can be compared to that of a fire polished surface as the surface of a ploughed field can be compared to that of a hard rock floor. The first is sensitive even to a slight pressure of the foot or hand, while the other presents an effective resistance to these interferences. Extraneous substances coming in contact with optical glass have an effect upon its surface which can be compared to the mark left upon soft soil by the pressure of a foot.

As we said previously, a commonly used type of optical glass contains a considerable percentage of barium, which, though held in extremely close contact with the silica, does not thoroughly mix with it and retains therefore its chemical characteristics, making the glass unstable.

A Tarnish That Sticks

Barium reacts especially with sodium alkalies, carbon dioxides, and the acid humors that are expelled by the human body. This reaction is very rapid, and is the cause of a blue tarnish on the glass which can be detected by microscopic examination before it becomes visible to the naked eye. A few hours' exposure may be sufficient to produce a tarnish on the surface of the glass, but it may take a month before it actually becomes visible to the eye.

The most unfortunate part of the whole matter is that once the tarnishing has started there is nothing that can remove it but a complete repolishing of the glass surface. This cannot be done by others than the most expert opticians, and preferably by the particular optician who constructed the lens.

A photographic objective is, therefore, quite a delicate instrument, and good care should be taken of it in order to prevent the extremely disagreeable effects that may result from neglecting some very simple precautions.

Here are some rules easy to fol-

low and which should never be disregarded:

Do not permit your lenses to be exposed to undue influences of the surrounding atmosphere. Make it a habit to protect them, when not in use, with the caps which are furnished with each lens, even when the camera is stored away in its case.

After your work is done always clean the lenses in the manner which will be suggested later.

Always remove immediately all moisture that may be deposited from exposure to the elements or from sudden changes of temperature. This precaution should be very carefully followed when lenses are exposed for any length of time to the moisture which is always present near and on the sea. The marine atmosphere is rich in sodium alkali, of which barium is very avid.

Don't Touch Lenses

Do not touch lenses with your fingers. It is quite interesting to note that the humors secreted by the human body vary considerably with individuals. The effects of these humors upon optical glass may vary and may be more or less pronounced with different individuals but are always deleterious.

Besides the above precautions which will eliminate damage to lenses due to chemical reactions one must also take good care not to mar the polish of the lens surface through physical contact.

A certain accumulation of dust on the lens surface is unavoidable, and any rubbing of this dust upon the lens results in scratches which impair its performance. It is quite essential, therefore, that the cleaning of a lens be done rationally and carefully.

A fine camel hair brush should first be used to remove all particles of dust or grit that may be deposited upon its surface.

Then the lens should be wiped with a lintless, soft linen cloth, from which all hardness and all fillings have been removed by repeated washings.

It is advisable, even quite essential, to slightly moisten the cloth with a lens cleaning fluid, the chemical compostion of which is such that it does not provoke the slightest impairment of the glass.

Finally the lens should be wiped with a soft, dry chamois leather, which has not been submitted to an oil tanning process.

The wiping with both linen and chamois leather should be done with a circular motion, working from the center of the lens to its edges.

The writer has always considered a photographic objective not merely as an optical instrument, but as something possessing a personality of its owner, which is finally expressed by the refined beauty of the pictures it produces. He feels that the simple precautions expressed above are not a burden but a pleasureable duty imposed upon the lens user and may be considered as a tribute paid to the scientific knowledge and indefatigable ingenuity cumulated through years and years of patient research by lens designers and lens makers.

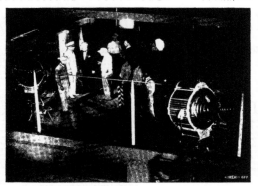

Transporting Laco Lites and other equipment during the filming of a northern picture

Dramatic Critic Turns Projectionist

THROUGH the courtesy of the Projection Advisory Council, an organization devoted to the interests of those mechanical wizards who operate the projectors in picture houses, I was recently given a brief but intensive course of instruction in the intricacies of the projection room.

To the layman there is something revealing in the complicated and highly responsible office which devolves on those who control the sound and visual machinery of reproduction. The impression is widespread that the faults and virtues of sound reproduction lie almost wholly with the actual taking of the picture, and that the operator in the theater has only to press a few buttons and thereupon smoke a cigar while the film unreels itself.

That this misconception should be so prevalent is only natural when you consider the enormous publicity which centers around the picture studios and the corresponding obscurity of those less glamorous souls whose duties are shrouded in technical mysteries. But let me assure you that the projection room, with its bewildering array of dials, indicators, gauges and electrical whatnots, to say nothing of the formidable projection machines which point through little windows down into the auditorium below like a battery of light artillery, contains within itself an abundance of marvels, even to one whose knowledge of things scientific is considerably below zero.

After being shown around by Mr. Smith, of the projection room staff at the Astor Theatre, I came away with increased respect for this whole problem of sound in pictures. For one thing, I learned that the smoothest sound effects can be ruined by carelessness or inexpertness in the projection room, and that it is only by constant vigilance and intelligent supervision that a picture is kept to its proper value. And conversely, I found that not every instance of defective sound is blamable on the projection room operators. The studios not infrequently turn out a film in which the inadequacies of sound are responsible for the flaws which the untutored layman is prone to ascribe to the operators.

The functions of the projection room are not confined to mere mechanics. The operators have to know their pictures thoroughly in order to get the cues for the changeover from one reel to another, and to signal the stage crew at the right moment for the drawing of the curtains. This necessitates a fair knowledge of music, since the cue at the end of a reel may occur in the musical score. Under ideal conditions a new picture is given a preliminary rehearsal before it goes on for the public, but oftentimes, and in the smaller houses especially, the films do not arrive until a half hour or so before the scheduled performance. In that case the operator gets the blame when things go wrong. All in all it's a ticklish profession, and one that fully justifies the pride which its practitioners take in it.—Thornton Delehanty, in the New York Evening Post.

Here are
all the qualities you want

LOOK over this list:—(1) true color balance; (2) unique fineness of grain; (3) unsurpassed latitude; (4) ample speed; (5) ability to give splendid shadow detail. Add these characteristics: (1) a tough, wear-resisting base; (2) unfailing roll-to-roll uniformity.... Then you have all the qualities you want in your negative film. You can get the full combination only in Eastman Panchromatic Negative, *Type 2.*

EASTMAN KODAK COMPANY
ROCHESTER, NEW YORK

J. E. Brulatour, Inc., Distributors

New York Chicago Hollywood

Looking In on Just a Few New Ones

Morocco

By GEORGE BLAISDELL

THERE'S a new luminary in the American film firmament. It's a woman, and a real one, if one may base his judgment on her appearance in "Morocco," in a single production. Flapper distinctly and distinctively she is not. She is as far removed from the Totty Coughdrops sample of studio rave as is Los Angeles from Berlin, her birthplace.

Marlene Dietrich most conspicuously has poise, the poise that spells surety in herself, and that surety in turn which spells a combination of education and native intelligence. Men there are, many of them, who will aver that in their opinion beauty of feature as the world of today interprets that term she has not in any marked degree.

But they will insist that what she has is ample, and that when to this lesser attribute is added the supreme charm of face and manner and voice and incidentally figure the combination is such as to stamp Dietrich as one of the great players of the screen.

Coming back to that matter of poise. We see the actress placed opposite Adolphe Menjou, who since the days of "The Woman of Paris" never has been topped by any one in the interpretation of the art of sophistication. The intervening years have taken none of that distinctive polish from Menjou; rather have they emphatically added to it. Yet Dietrich meets that master in his chosen field and emerges from the contact with equal honors.

Gary Cooper is billed as the star, or at least is given the prestige of premier position in the billing. With any other woman than the one selected he would have had a stout claim to the more or less intangible honor.

For if at any time in any part he has given a performance matching his work in the subject under review the present writer did not witness it. And he saw him in "The Virginian."

Two other players with parts and characterizations that entitle them to mention in such sterling company are Francis MacDonald as the hardboiled sergeant of Legionnaires and Ulrich Haupt, who portrays the adjutant husband of a faithless wife in love with a soldier.

The story, commendably clean to the average citizen of the world, lifts its follower out of himself from the first note. It is a tale of a woman variety artist, embittered by her experience with men, who meets in Morocco a soldier whose unpleasant experiences with women are responsible for his presence in the Foreign Legion.

Beside these two stands a man of wealth who falls deeply in love with the girl—so deeply he will go the limit in aiding the woman to attain whatever she wants. The first two are in love in spite of their mutual conviction such a situation is impossible.

There is in this "Morocco" of Paramount a dialogue that is smart because it is human and natural; there is a sweep of color and spectacle; of clash of wits and brawn; of drums and marching men; of blind romance and deep sacrifice.

Joseph Von Sternberg is the director of this remarkable picture, which easily will raise him several large notches in producer estimation—which to him and his employers is important—as well as to that small portion of the general public which has any thought for any factor other than that of players. Jules Furthman is credited with the story, one that most writers would have been content even to have had a hand in creating.

Lee Garmes will have reason to remember October, 1930, a month in which appeared his name as the photographer of "Whoopee" and "Morocco." The fact that either or both of these will command consideration in the selection of the ten best pictures of the year will not militate against his ascending reputation as a cameraman of recognized ability.

Big Boy

JOLSON fans will like their favorite in "Big Boy," produced at the Warner's Hollywood house early in October. The singing comedian does his stuff on the slightest provocation or even without it, with a result pleasing or otherwise according to individual predilections. One thing is certain, or maybe two things are. These are that the famous voice still is up to its best and that the recording is worth while.

As to the appeal of the "song hits" it is not quite so apparent. When Jolson with a chorus of darkies leads in a number of old time pieces on the lawn in front of the Southern mansion the resulting entertainment reaches its peak for the subject.

The story is fragile, but nobody seems to worry about that, and the cast is competent or would be if there were much for it to do. Alan Crosland directed the tale, adapted for Warners from a play by Harry Atteridge. The excellent camera work was in charge of Hal Mohr.

The White Hell of Pitz Palu

WHEN "Pitz Palu" left the expert hands of its cameramen and directors it was without question one of the world's great pictures.

For behind the thin veneer of fiction in "Palu" is the portrayal of the common ordinary perils of the Alpine mountaineers, ordinary to them but inconceivably beyond the ken of lowland mortals.

Even after "Palu" passes beyond the control of the director and cameraman it remains a great picture. The titles supplied to Universal for the subject by Tom Reed are dignified and in the full spirit of the absorbing story.

Not even the abysmal paucity of production judgment that condoned the injection into this classic of the claptrap bombast of a professional broadcaster could utterly destroy that greatness. It survived the contributions of that illusion-killing, intruding outlander injected with irritating regularity throughout the seven thousand feet.

The employment of McNamee as a lecturer on this marvelous subject provides partisans of silent pictures

Here is a corner of Phoenix Lake, Sonora, as recorded by the camera of Francis J. Burgess.

been undiminished in volume in spite of his public appearances. Garbed as when found by his discoverer this sweet-voiced child of the hills charms and stirs as no sophisticated artist possibly could. If he remains in the obscurity to which he now has returned it will reverse the usual rule of the successful entertainer.

It would be an interesting thing to see what Broadway would do to Elton.

Just Imagine

FOX gives us something new in "Just Imagine"—a most fitting title, by the way—the creation of three young men from the East who came west to make a motion picture. There's nothing in the way of news in the statement that men left the east to do that little or greater thing, but in the present instance they most notably succeeded. And that is news of first importance.

De Sylva, Brown and Henderson opened at the Carthay Circle October 10 a production that would have been claimed with pride by the best of the veteran producers.

If the great public really is crying for something new it will find it here. It will find what started out to be a straight musical comedy, but which owing to the supposed slump in the demand for that particular type of entertainment was converted into a phantasy with musical settings—thereby ringing a very large bell.

The picture provides a complete vindication for the much maligned miniature. Only by the use of such could the production as we see it have been possible. It is somewhat incongruous at that to characterize as a miniature a stage setting costing nearly $200,000 in real money. We are referring to the city of the period of 1980 which we see in the picture.

The view and the use made of this set, the singing of the drinking song —a masterpiece in itself—and the departure from the earth of the plane bound for Mars, all of which fall in the first half of the production, are enough in themselves to guarantee the success of "Just Imagine."

El Brendell furnishes the comedy and Marjorie White is a most efficient co-worker. Others with plenty to do are John Garrick, Hobart Bosworth, Frank Albertson, Maureen O'Sullivan, George Irving, Joyzelle and Ivan Linow. David Butler directed his own smooth continuity.

Ernest Palmer commanded the extensive camera crew with credit to his production and his craft. Joseph E. Aiken directed the sound recording.

The Dawn Patrol

REGARDLESS of the inevitable, unavoidable feeling that "The Dawn Patrol" in its underlying theme parallels one or more notable predecessors it is an appealing picture, a moving one. In all truth it is a gripping story.

Under the guidance of Director Howard Hawks the individual and interwoven interpretations of Richard Barthelmess, Douglas Fairbanks junior and Neil Hamilton are rugged, soldierly and convincing. The First National story turns on these three, and they are finely supported.

Tragedy stalks through the whole tale, but it is a tragedy that is mitigated by shining examples of comradeship and self-sacrifice.

"Smashing" is the proper word to use in describing the climax. Barthelmess as the leader of a flight squadron disobeys instructions and leaves the ground to destroy an important ammunition dump well into enemy territory. A brother of the man selected for the assignment had been killed on a mission entered upon under orders from the commander. On the night before the great morning the commander plies with liquor the surviving brother, lulls him to sleep under promise of calling him, then slips away.

The destruction of the enemy property is most convincingly shown. So, too, is the later dropping into the

(Continued on Page 42)

Francis J. Burgess picks a spot in Sonora, Cal., up in the Bret Harte country, to show a motion picture company on its way to location

Brulatour Talks to Cameramen

In Visit to Stated Meeting New Yorker Tells of Earlier Days — Color Is Not Dead, Says Howard Lewis of Multicolor

THE stated meeting of Local 659 held on the evening of October 9 was marked by the presence as guests of Jules Brulatour, Edward O. Blackburn and Howard Lewis, the latter the head of the Multicolor Laboratory.

One of the more important decisions of the membership during the evening was the declaration of its antagonism to the principle of daylight saving and its determination to do all in its power legally to defeat the measure coming before the voters at the November election.

Mr. Brulatour, who holds a gold card of membership in the sister cameramen's local in New York, No. 644, said in responding to an introduction by President Alvin Wyckoff that the privilege of being present was to him a very great pleasure and honor. He added that the invitation from the officers of 659 brought a peculiar feeling of gratification, a feeling that after all there is something more in life than the mere seeking of dollars and the rush for glory.

Grown Up Together

"We have grown up together," he declared as he looked over the Chamber of Commerce auditorium containing many veteran photographers with

Jules E. Brulatour

whom he had been continuously associated since the days when he represented Lumiere films.

Mr. Brulatour said there is nothing in the world that brings men

closer together than mutual struggles, such as they had all been through in days when the material with which they worked was much different from that put into their hands today. He said he saw in the audience many of the brothers from the old Fort Lee clan as well as from that of Long Island.

The Eastman executive referred to the cordial relations existing between the members of Local 659 and the head of his Hollywood office and expressed his thanks for the many courtesies extended.

President Wyckoff in responding assured the preceding speaker that the officers and members of Local 659 felt very close to him and appreciated his efforts in their behalf. He then introduced Mr. Blackburn.

As the west coast representative of the Brulatour forces was getting to his feet he was overheard to remark to his chief something about "a tough egg to follow."

Mum on Film

"About the only thing I care to talk about tonight is golf," declared Mr. Blackburn in opening. The speaker's withholding of his own volition of the second and more important of the two subjects which at all previous times he has expressed willingness to discuss instantly was recognized by the membership to its intense amusement. Mr. Blackburn suggested, however, that if any one cared to arrange a day to discuss any other subject he would be at his service. He added to Mr. Brulatour's his own appreciation for the privilege of being present at the meeting.

Harold Smith, business representative of Local 695, the new organization of the sound men, thanked the officers and members of Local 659 for their cooperation during the past year. The speaker referred to the early antagonism between sound and photography, declaring that feeling not only had been entirely removed but had been replaced by one of real fraternity. Mr. Smith was heartily applauded.

Greetings From East

Elmer G. Dyer, recently returned from an assignment in the New York jurisdiction, brought greetings to the west coast photographers from the officers and members of Local 644. Mr. Dyer told of the many courtesies extended to him and his associates by the New Yorkers and of the hearty appreciation for these by the westerners. The applause that greeted his statement demonstrated the appreciation extended to his fellows here.

Mr. Lewis told how shortly after

Admiral Byrd Praises His Two Cameramen

New York, Sept. 26, 1930.
International Photographers, Local 659, I.A.T.S.E.

I am delighted to hear that you have so signally honored Van Der Veer and Rucker. They were great comrades as well as artists, and I join you in honoring them.

R. E. BYRD.

Van Sends Thanks

New York, Sept. 26, 1930
International Photographers, Local 659, Hollywood.

My most sincere thanks for the beautiful gift from International Photographers, presented to me this week through Local 644, New York. It is impossible for me adequately to express my deep appreciation for the honor you have bestowed upon me in the presentation of this handsome, unique ring, which will serve as a constant reminder of my membership in Local 659 and the members I had the pleasure of meeting on the Coast before sailing with Byrd for the Antarctic.

Fraternally yours,
WILLARD VAN DER VEER.

leaving college he had five years ago joined the organization of Howard Hughes, being associated up to a few months ago with the Hughes Development Company and with activities unconnected with motion pictures.

Color Is Not Dead

He referred to his experiences in geting acquainted with the intricacies of a new field and of his appreciation for the cooperation he had continuously received from the cameramen. He spoke of the progress that was being made, saying that before the close of the evening the members would have an opportunity to see examples of some of the work their associates were doing at the laboratory.

"Color is not dead," he declared with conviction.

When the meeting was concluded the members adjourned to the Eastman Theatre, through the courtesy of Mr. Blackburn, and witnessed a program of selected pictures.

"Shoot" Bobby Jones

The Eastman Company is releasing a 400-foot 16 mm. film showing Bobby Jones in both normal and slow-motion pictures. Running through the film is a cinegraph which by means of dotted lines permits the course of the clubhead to be followed. The picture is described as having unusual interest for golfers.

How a West Indies Blow Behaves

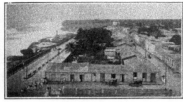

S HOWING the fury of a Caribbean hurricane, such as that which recently wrecked Santo Domingo City, H. C. Ramsey, Local 659, submits these pictures which he photographed in the city named during a "minor" hurricane in October, 1921.

In 1912 the U. S. S. Memphis was riding at anchor a mile out when it was picked up by a tidal wave and deposited on a big rock thirty feet from shore. It is still there.

In the single picture the war vessel is shown in calm weather. On the left hand a few feet of the mast may be seen over the top of a wave, during the progress of the "minor" blow. On the right may be obtained a better idea of the intensity of the storm

when it is explained the cliffs over which the waves are breaking ordinarily rise fifty feet above the water.

The tower shown in the picture rises from the cathedral under which Columbus is buried.

Meyer Selling Nagels

Hugo Meyer & Company of New York has assumed distributorship in America on Nagel cameras, which will be equipped with Hugo Meyer lenses. The company has effected certain changes which it believes will make this line outstanding among imported cameras. Describing in detail its acquisitions, the company is mailing a catalogue of 40 pages. Among the new series are the Vollenda and the Recomar.

Among the features claimed for the Vollenda is that it is the only automatic focusing type camera with automatic return to infinity when the camera is closed, regardless of what point the distance indicator was placed when last used.

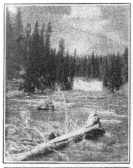

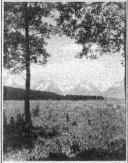

Remarkable
Polak in

O N THESE two pages are recorded a dozen of the approximately 170 nonproduction shots photographed by Henry E. Polak, Local 659, in the course of a fifteen weeks' trip on location. They provide a striking example of the opportunities afforded still cameramen and others when they are members of a company, making a big outdoor picture.

In the present instance the subject in production was "The Big Trail." Polak left Hollywood with a troop on April 19 last and did not return to the Fox studio until the end of the following July. The major part of the time was spent in Yellowstone Park and Jackson Hole, Wyoming.

While away from Hollywood this unit on this one trip experienced temperatures ranging from freezing to 100 degrees of heat.

The young photographer whose work we see on these two pages has been particularly fortunate in his out-

door assignments during the nearly five years he has been in professional photography. Even prior to that time in school he "dabbled" with a camera.

While with his present employer Polak, who was born and raised in San Francisco, was for two years with the Buck Jones company on western pictures, and with that single troupe saw much of the mountain country.

In this necessarily brief description of the various subjects a beginning will be made at the upper left and from that point descending and following around to the point of starting.

No. 1—Lewis River and Fall in Yellowstone National Park. This picture was photographed about one

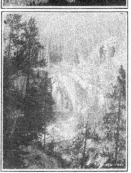

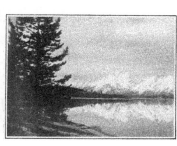

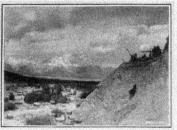

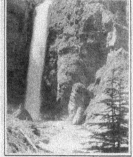

ark Shots by
lak ckson Hole

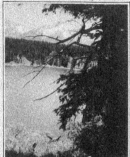

6—Here again we see Mount Moran behind Jackson Lake.

7—In the foreground through the trees we see Jenny Lake, and in the background at the foot of Mount Teton is Jackson Lake.

8—Jenny Lake again.

9—Tower Falls, Yellowstone.

10—The location is Spread Creek Flats from behind the Teton range in the Jackson Hole Country. In the upper part of the picture a storm is seen gathering. In the center is Jackson Lake. Against the cliff on the right of the picture a wagon is being lowered upon a rope to the floor of the valley, there being no road. In the left foreground are seen a number of wagons that have been let down the cliff by the same tedious and hazardous method.

11—Here is the bridge over the Yellowstone River.

12—There is little in this snow covered landscape to indicate that it was photographed in July. The cameraman is standing near the crest of Teton Pass in the Snake River and Jackson Hole Country. In the background is the Continental divide. In the foreground in the snow stands a horse wrestling with a nosebag.

2-North of Moran in Jackson Hole ..nry near Spread Creek. The pic- .. evas shot at noon.

3-Gibbons Falls, Yellowstone Na- .on Park. In spite of the indica- ..nf there being a person against .. iff in the upper right hand sec- ..of this picture this is not a fact. ..he was no human being within the ..ni of the camera's lens.

4-This remarkable reflection was ..ographed at Jackson Lake. In ..ackground are Mount Teton and ..oot Moran. The elevation of the ..rtnamed is approximately 13,700 ..d he latter over 12,000 feet. The ..ograph was taken in the early ..ir ng light.

5-Here is a shot of Jupiter Ter- ..ce Mammoth Hot Springs, Yellow- ..on

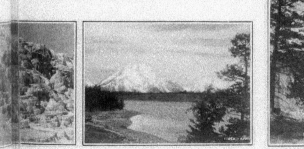

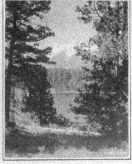

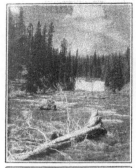

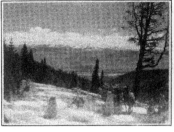

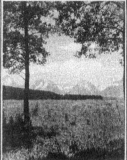

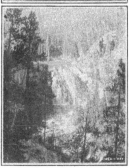

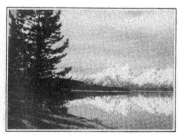

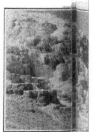

Remarkable Phot. Polak in Jackson

ON THESE two pages are recorded a dozen of the approximately 170 non-production shots photographed by Henry E. Polak, Local 659, in the course of a fifteen weeks' trip on location. They provide a striking example of the opportunities afforded still cameramen and others when they are members of a company making a big outdoor picture.

In the present instance the subject in production was "The Big Trail." Polak left Hollywood with a troop on April 19 last and did not return to the Fox studio until the end of the following July. The major part of the time was spent in Yellowstone Park and Jackson Hole, Wyoming.

While away from Hollywood this unit on this one trip experienced temperatures ranging from freezing to 100 degrees of heat.

The young photographer whose work we see on these two pages has been particularly fortunate in his outdoor assignments during the nearly five years he has been in professional photography. Even prior to the time in school he "dabbled" with a camera.

While with his present employer, Polak, who was born and raised in San Francisco, was for two years with the Buck Jones company on western pictures, and with that single trip saw much of the mountain country.

In this necessarily brief description of the various subjects a beginning will be made at the upper left and from that point descending and following around to the point of starting.

No. 1—Lewis River and Falls in Yellowstone National Park. This picture was photographed about noon

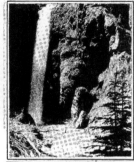

Shots by
ckson Hole

2—North of Moran in Jackson Hole
near Spread Creek. The pic-
ture was shot at noon.

3—Gibbons Falls, Yellowstone Na-
tional Park. In spite of the indica-
tion of there being a person against
the cliff in the upper right hand sec-
tion of this picture this is not a fact.
There was no human being within the
range of the camera's lens.

4—This remarkable reflection was
photographed at Jackson Lake. In
the background are Mount Teton and
Mount Moran. The elevation of the
first named is approximately 13,700
and the latter over 12,000 feet. The
photograph was taken in the early
morning light.

5—Here is a shot of Jupiter Ter-
race, Mammoth Hot Springs, Yellow-
ston

6—Here again we see Mount Moran
behind Jackson Lake.

7—In the foreground through the
trees we see Jenny Lake, and in the
background at the foot of Mount
Teton is Jackson Lake.

8—Jenny Lake again.

9—Tower Falls, Yellowstone.

10—The location is Spread Creek
Flats from behind the Teton range in
the Jackson Hole Country. In the
upper part of the picture a storm is
seen gathering. In the center is
Jackson Lake. Against the cliff on
the right of the picture a wagon is
being lowered upon a rope to the
floor of the valley, there being no
road. In the left foreground are seen
a number of wagons that have been
let down the cliff by the same tedious
and hazardous method.

11—Here is the bridge over the
Yellowstone River.

12—There is little in this snow
covered landscape to indicate that it
was photographed in July. The
cameraman is standing near the crest
of Teton Pass in the Snake River and
Jackson Hole Country. In the back-
ground is the Continental divide. In
the foreground in the snow stands a
horse wrestling with a nosebag.

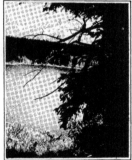

Record Made by Kane
At Joinville Studios

SIX months is a short time in which to create a motion picture studio plant—by Americans in a foreign country—representing an outlay exceeding $2,000,000; the assemblage of a permanent personnel of more than 300 employes from the four corners of the globe; the recruiting of artists in a dozen countries, and the making of feature productions in French, Spanish, Italian, German, Swedish, Polish, Dutch, Russian, Czechoslovakian and Hungarian.

This is the record of achievement credited to Robert T. Kane in Joinville, Paris, and his "original Kane organization"—Philip Tannura, Local 659; Harry Stradling, Local 644, and Vernon Ashdown, Local 52.

The studio now is the third great producing unit of Paramount Publix. It was in the latter part of 1929 that Kane conceived the idea of going to Paris to make talking pictures for general distribution throughout Europe. He was one of the earliest correctly to forecast the revolutionary effect of sound in the industry and to foresee the advisability of centralizing production of multilingual pictures in Europe.

Lease Gaumont Plant

With the three men named accompanying him Kane sailed for France prepared to institute Robert T. Kane Productions.

The first move was leasing the old Gaumont studios, situated in the Rue de la Villette, Paris. In two weeks the first short subject was produced in French. Fifty others in various languages followed, and all met success.

For the first time foreign countries heard their native tongues, instead of foreign ones, when there came to them the voice of the players shown on the screen. They clamored for longer subjects so insistently that it was decided to make the experiment. The first feature was "Hole in the Wall," which was produced in French, Spanish and Swedish. It was a success in the three countries interested. Other countries with theatres equipped for the reproduction of sound wanted pictures made featuring their own stars.

Paramount Enters

Kane lost no time in preparing to accede to requests so potential in promises for the future. He selected a site for a studio in Joinville, a few miles outside of Paris.

In three months two sound stages had been built, a record for Europe. As soon as the recording equipment had been installed four companies began work. Two operated in the daytime and two at night.

At this point Paramount entered the production picture. Adolph Zukor and Jesse L. Lasky came to Joinville and before they left had completed negotiations which transformed the original Kane organization into the Paramount Studios.

Early in September six stages had been completed and all were working to full capacity. The plant is one of the most modern in Europe, if not the most modern, its equipment matching that of any of its American competitors.

The first year's production schedule of 110 features and 50 short subjects is well on its way under Kane, now general manager of production for Paramount in Europe.

The Joinville studio, with its equipment and personnel representing so many different countries, commands a unique place in the industry. Visitors to the plant hearing among the workmen, technicians and executives so many languages, and then passing from one stage to another and observing the filming and recording of these subjects in many tongues frequently employ the term "Babel Studios."

The remarkable result of the venture demonstrates what may be achieved by one man with faith in his close organization the three members of which reciprocate that faith to the full.

Philip Tannura, representative of Local 659 in the trio, up to two months ago had directed thirty-five pictures in French, Spanish, Italian, Dutch, Russian and Portugese. In cases of emergency and "just to keep his hand in" he has photographed two features.

Incidentally the 659 man has trained over thirty men in the camera department and other branches of studio routine.

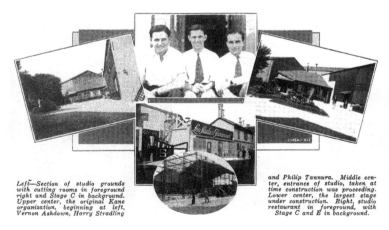

Left—Section of studio grounds with cutting rooms in foreground right and Stage C in background. Upper center, the original Kane organization, beginning at left, Vernon Ashdown, Harry Stradling and Philip Tannura. Middle center, entrance of studio, taken at time construction was proceeding. Lower center, the largest stage under construction. Right, studio restaurant in foreground, with Stage C and E in background.

Hoke-um

By Ira

Yes, Like a Sailor

John Boyle Jr., aged five years, shows a great deal of interest in a neighbor's litter of Persian kittens. The other day he came to his mother with a brand new question, something like this:

John Junior—Those kitties have only their mother to care for them. Where do you think their father is?

Mother—I don't know, Son.

John Junior—Mother, do you suppose he is away on location?

—:—

So Used to Sleighing

Maury Kains tells a story about a Scotchman who told his little son that Santa Claus had committed suicide.

—:—

Couldn't Be Nearer

Bob Bronner—How come you were born in Scotland?

Bob MacLaren—Well, you see I wanted to be near my mother.

—:—

She'll Never Tell

Gaffer—That leading woman looks rather old for the part.

Cameraman—Old? I'll say she does. I'll bet she remembers the Big Dipper when it was only a pint cup.

—:—

Labor Notice

First Extra Man—I don't believe the employment situation is as bad as it is painted.

Second Extra Man—What makes you think so?

First Extra Man—Just saw a sign at the Post Office: "Man Wanted for Mail Train Robbery."

—:—

Page the Minister

First Cameraman—Charlie asked his girl for a kiss last night.

Second Cameraman—What did she say?

First—Same old thing.

Second—What did he do?

First—Same old thing.

—:—

Not Always Then

Billy Marshall—Why are actresses like automatic pianos?

Billy Tuers—I'll bite; why?

Billy Marshall—You can't play them without a roll.

—:—

Waterhole Wiped Out

If Cahuenga and Hollywood Boulevards were to be repaired all the H yw d cowboys would be homeless oo

—:—

Giving 'Em the Air

Joe Johnston shot a news feature at a little upstate town a few weeks ago. On the gas pump of the rural filling station he observed the following sign:

"If you own Mail Order tires, kindly take them over to the Post Office for free air."

—:—

Planting an Alibi

Henry Prautsch—Dearest, could you be happy with a man like me?

Cutter Girl—Maybe—if he weren't too much like you.

—:—

Have a Little Patience

Extra Man—This is the best miniature golf course I ever played upon.

Another—This isn't a course. We're on the city dump.

—:—

No Drug Clerk

Assistant Cameraman—How much did Helen of Troy weigh?

Laboratory Assistant—Sorry, old man, I don't know much about Troy weight.

—:—

Well—

First Cameraman—L o o k h e r e, pardner, I hear you said I was no gentleman.

Second Cameraman—No, Bill. I said you preferred brunettes.

—:—

A Topper at That

Bob Tobey—Where was the Declaration of Independence signed?

Fred Kaifer—At the bottom, of course.

—:—

Never Tried It

M. Hall says 50 million dollars can't be wrong.

The March of Progress

Abstracts of Papers, Inventions and Book Reviews
from the Monthly Abstract Bulletin of
Eastman Kodak Research
Laboratories

WIDE ANGLE WORK. *Brit. J. Phot.*, 76:770, Dec. 27, 1929. Practical points in the making of wide angle photographs and concerning the special characteristics of lenses and cameras suitable for this type of work are discussed.

DURALUMIN FOR CAMERAS (CORRESPONDENCE). J. A. Sinclair (Newman and Sinclair, Ltd., and J. A. Sinclair & Co., Ltd.). *Brit. J. Phot.*, 77:27, Jan. 10, 1930. The manufacturers of duralumin, replying to the above, in connection with the discussion on the corrosion of properties of *aluminum and duralumin, state that the latter metal has proved very satisfactory in cameras exposed to tropical moisture or sea air, while aluminum under these conditions rapidly disintegrates.*

DURALUMIN FOR CAMERAS (CORRESPONDENCE). A. H. Hall. *Brit. J. Phot.*, 77:40, Jan 17, 1930. Hall states that *aluminum of high quality manufactured to specification as regards composition is less susceptible to corrosion than duralumin, when exposed to tropical conditions or to the effects of sea water. Slight impurities, however, have a profound effect on the corrosion resistance properties of aluminum.* A. B.

PROGRESS IN THE MOTION PICTURE INDUSTRY. (OCTOBER, 1929, REPORT OF THE PROGRESS COMMITTEE.) *J. Soc. Mot. Pict. Eng.*, 14:222, February, 1930. This is a comprehensive classified compendium of advances in motion pictures and allied arts for the preceding six months period. C. T.

HUMAN EQUATION IN SOUND PICTURE PRODUCTION. A. Ramsaye. *J. Soc. Mot. Pict. Eng.*, 14:219, February, 1930. This is another attack on the "hokum" of the sound technician. C. T.

ART AND SCIENCE IN SOUND FILM PRODUCTION. J. W. Coffman, *J. Soc. Mot. Pict. Eng.*, 14:172, February, 1930. Many of the mysteries of technical expertness on the part of sound men in the studios are branded by the author as superstition and "hokum." Practical recommendations for better cooperation among the technical studio staff are given. Authority should center in this direction. C. T.

UNDEREXPOSURES. *Camera (Luzern)*, 8:254, March, 1930. Underexposed negatives can sometimes be improved by one of the following means: (1) After no further shadow details develop, and while the negative is still in the developer, it is illuminated one or two seconds with a match. It is then developed until all is black. A positive is thus obtained from which a better duplicate negative can be made. (2) An underexposed fixed negative is bleached with mercuric chloride and covered with black lacquer. Viewed from the glass side, a good positive is seen which can be photographed again. M. W. S.

PHOTOGRAPHIC STANDPOINT. G. W. Bucklin. *Photo-Era*, 64:88, February, 1930. In photographing a long building—a long focal length lens was used in taking a series of photographs and the prints were joined together in order to make a new negative. The result was a final print which could not be duplicated by even a wide angle lens. C. H. G.

WIDE FILM PROBLEMS. R. H. Cricks. *Kinemat. Weekly*, 15:67, Feb 13, 1930. It is contended that the only real advantage of wide film, namely, improvement with regard to the emulsion grain size problem, does not justify the enormous expense of new projection aparatus and new screens in every cinema. A simple and less expensive method of overcoming the grain size problem would be to photograph on double width negative material, afterwards printing on standard size slow speed, fine grain positive stock. A. B.

USE OF THE FINDER ON SPRING DRIVEN MOTION PICTURE CAMERAS. H. Pander. *Camera (Luzern)*, 8:244, March, 1930. With short focus lenses, the parallax in finders is negligible, except for close-ups, where it can be compensated for by tilting the camera. With long focal lenses a magnifying finder is more accurate than an ordinary sight finder with a masked field. *Telescopic gun sights with moderate magnification can be used as finders with long focus lenses.* M. W. S.

PHOTOGRAPHY FOR REPRODUCTION BY ROTOGRAVURE. H. S. Thomas. *Printed Salesmanship*, 55:122, April, 1930. Good advice is offered about what to do and what not to do in preparing photographic illustrations for the rotary photogravure process A. J. N.

BR. 324,394. T. T. Baker; Color Photographs (British and Foreign), Ltd. A tri-pack for color photography of the kind in which the front, intermediate and rear sensitive layers record respectively the blue, green and red sensations, and in which a blue-absorbing filter is interposed between the front and intermediate layers, is characterized mainly in that the front layer comprises an ordinary emulsion of coarser grain than the Lippmann emulsion, which has been rendered highly transparent either by dilution, as with gelatin, or by coating it thinly on its support, and the intermediate layer is less transparent than the front layer, but more transparent than the emulsion layers used in ordinary photography.

"Danger Lights"

This interesting production still was shot by Robert W. Coburn on location near Lombard, Montana, at a station on the Chicago, Milwaukee & St. Paul. It is a flash of the camera crew on "Danger Lights," an R.K.O. special railroad story, directed by George Seitz.

Carl Struss was director of photography on this picture which was the first photographed with the new Geo. A. Spoor camera man draped over the railroad grade in graceful festoons may be described (with the use of the Mount Wilson telescope) such eminent artists as Carl Struss, John W. Boyle, Jeff Gibbons, Robert De Grasse, Witham Clothier, Richard Davol, Willard Barth, Fred Bentley, James Daily, Burnett Tuffey, Clifford Stine, all of Local 659 and Major Spoor and C. A. Luperti, both of 666, Chicago. Bob Coburn is somewhere out in front shooting the group.

The bass-drum like object in the lower right hand corner is the mike and it is some mike. No matter what the background noises may be, whether a rolling mill or a passing train, just point the mike in the general direction of the dialogue, if any, and it will pick up the talk to perfection.

On the six weeks' location trip the group travelled 10,000 miles, covered fourteen states and worked along the C. M. & St. P. railroad from Great Falls, Montana into Chicago.

Only one Spoor camera was used on the picture, the others were Mitchell

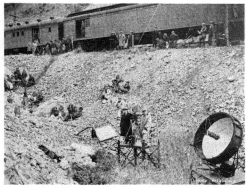

35's. Yes, it was cold. The camera gang is all huddled up waiting for a snow storm to pass.

His Preference
Robert MacLaren—What color is best for a bride?
Henry Prautsch—I'd prefer a white one, myself.

The World Do Move
Movie Producer—Rebecca, this will be a fine neighborhood in which to build our palatial new home, don't you think?
His Wife—It's too old-fashioned, Joe. Just look; there isn't a single miniature golf course in the entire block.

Imagining New York City of 1980

Fox Technicians Create a Magic Community of 200-Story Structures and Establish Illusion in Unusual Degree

THE two illustrations shown on this and the adjoining page represent what undoubtedly will be conceded as the highest form of the motion picture art director's work up to this time. They portray the conception of the artist as to what New York will be like fifty years hence.

The magic city is one of the features of "Just Imagine," a Fox production to be released generally between now and the first of the year. It opened at the Carthay Circle Theatre in Los Angeles in October for a pre-showing, and on its opening night the New York of 1980 was greeted with applause the spontaneity and enthusiasm of which was entirely unlike the perfunctory and sympathetic handclapping which customarily obtains on similar occasions.

It was a tribute to the art director, Stephen Goosson, and the director of effects, Ralph Hammeras, and to their associates in and out of the company who had lent of their skill to the remarkable result.

Cost $200,000 to Build

The city was constructed at a cost of approximately $200,000 in a dirigible hangar on the Baldwin estate outside of Pasadena. It covered a plot of 70 by 225 feet in area. The tallest buildings were 40 feet in height, and represented structures of 200 stories. The illusion of towers rising more than 2,000 feet above the ground was established without any stretch of imagination on the part of the beholder.

The structures were provided with nine levels, for subway and elevated trains and for vehicles and pedestrians, and with connecting bridges. From steamship offices passengers embarked on ships entering lanes below them, or anyway that was the idea. Ocean air liners departed from landing places on the buildings—or they might have.

Helicopters descend slowly, and on one occasion two of these strange ships "float" side by side while their passengers pass the time of day until sent on their way by traffic cops stationed in nearby "blimps." Zeppelins and twin dirigibles swing over the town at will.

Lights and Beacons

Fourteen switches control the myriad of lights which illuminate the buildings and highways and also the beacons which make the airways as day.

The imagination expended on this work has been worthy of a Jules Verne. It is a good place to mention that some of his seemingly wild dreams have come true—and even he never had the temerity to suggest a submarine would enter on a polar journey right now is under preparation, with the government contributing a sub for the purpose.

If it may be in order the suggestion is here made that it would be a gracious gesture for the producing company to deposit a print of this subject with the Smithsonian Institution in Washington with the understanding that it be preserved for showing at the end of the century. Of course, with it should go a projection machine and sound reproducing apparatus of the vintage of 1930; otherwise the film might be just film with no place to go.

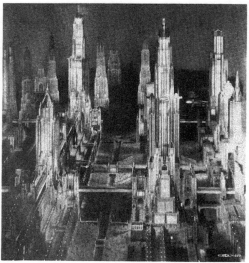

Native Sound House Ready to Show Films in Manila

Locally perfected films, depicting Filipino legends and stories, will be exhibited exclusively in the showhouse now practically completed on Rizal Avenue, according to a recent announcement, according to Assistant Trade Commissioner Clarence P. Harper, Manila, P. I. The theater is owned by the Far Eastern Theatrical Enterprises, of which E. Cu Unjieng, local Chinese merchant, and Petrolilo Tolentino, director of the Central Film Producers, are the principal stockholders.

Among the proposed native films which will be synchronized to be shown in this theater are the "Florante and Laura," a Tagalog masterpiece by Francisco Baltazar; "Alang Dios" (There is No God), a popular Pampango drama by the late Juan Crisostomo Sotto, and Rizal's two famous novels, "The Social Cancer" and the "Reign of Greed."

The theater will be in all respects as modern as any of the present showhouses in Manila. It will have a seating capacity of approximately 500 in the general admission and a like number in reserved seats.

Honolulu Takes Tour

Four Hawaiian theatres have contracted for Western Electric equipment—the Maunakea, the Kaimuki, the New Kalihu and the Fort Shafter Post Exchange in Honolulu.

Report New Color Process Acquired by British Group

It is reported a new film color process has been successfully invented by R. S. Allridge, the patent rights of which have been acquired by the Raycol British Corporation, of which Maurice Elvey, motion picture producer, is managing director, according to a report from Alfred Nutting, clerk of the American Embassy, London, made public by the Department of Commerce.

The principle is stereoptic, two lenses being used, one collecting the reds and the other the greens. The two pictures are overlaid in projection and shown through red and white, the result being that practically the entire spectrum can be presented, though blue and yellow are naturally the most difficult colors to get absolutely clear.

It is stated the picture, as shown, combines well-nigh perfect registry of color with stereoscopic clearness, both of background and foreground; and that this is accomplished at a price which is no greater than that of an ordinary black-and-white picture, apart from the purchase of the actual camera.

The projector also is reported to be extremely inexpensive, and that a picture can be taken, developed and reproduced on the screen in a single day; and, further, that the new process is peculiarly adaptable both to sound pictures and to the probable arrival of the wide film.

The process has been utilized in the Elvey talk-film "The School for Scandal," which is now being shown at the Plaza theater, London.

New Sound Firm in Holland

A new sound film company is to be organized in Holland under the name of Cinetone, with a capital of 125,000 gulden. It is the intention of the new concern to make and produce sound films and to market both this product and sets for sound film reproduction. It is stated there will be two kinds of such sets—ordinary sound reproducers and sets which can be used for radio. The company has concluded an agreement with an American company of Chicago for the distribution of sets produced by the latter.

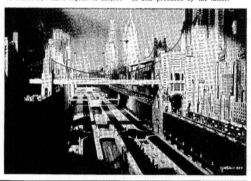

Why Sound Must Be Easy to Listen to

Public Psychology Requires It, Says Expert, Who Outlines the Many Factors Entering Search for the Ideal Equipment

By S. K. WOLF
Theatre Acoustics Engineer, Electrical Research Products, Inc.

THERE is a great deal more to this matter of sound than simply making a program understood. Public psychology demands that it be "easy to listen to."

We can discuss this subject in terms readily understood by everyone, namely, percentages. A theatre can be rated in the percentage of intelligibility of speech, which is the index of "how easy to listen to" the patrons find sound in that theatre.

Telephone engineers have found that a good measure of the efficiency of a transmission system is in the percentage of disconnected, meaningless syllables that can be understood through it. This is called an articulation test.

An articulation test of normal speech direct from speaker to listener under perfect conditions gives 96 per cent. If there is any doubt in your mind that speech cannot be transmitted 100 per cent under ideal conditions, try this simple test. Ask your listener to close his eyes, so that he may not read your lips.

Then you say the following words once again—map, nat, mack, nap, mat and nack, and ask him to write them down as you say them. Providing you do not unduly emphasize the final consonant of these words, you will find that one or more of them have not been understood. This gives you an idea of the difficulties encountered in speech transmission.

Loudness a Factor

The loudness with which sound equipment is operated is an appreciable factor in the intelligibility of the resulting sound. There is a fairly broad range of volume, about equivalent to the volume used in average conversation, for which there is no depreciation in intelligibility. However, as tests have shown, if the loudness is somewhat greater or somewhat less than the conversational loudness, we can expect a reduction of articulation of one to five per cent.

Another factor influencing the intelligibility of speech is the amount of extraneous noise present. Audience noise is of two kinds. The first includes whispering, coughing, laughing, rattling of programs, etc., and is not controllable by the exhibitor. The other, scuffling of feet on concrete floors, is controllable and eliminated with the use of a carpet. Further noise is often introduced into a theatre by and through the heating and ventilating systems, and street noises

sometimes enter through this channel. This, too, is controllable. Tests have shown that if the aggregate noise is 20 per cent as loud as the sound, the articulation will be reduced 10 per cent.

Excessive reverberation is still another factor tending toward decreasing the articulation in the theatre. If, in any given theatre, the reverberation exceeds by two seconds a certain optimum value, a reduction of 10 per cent in the articulation results. It can be readily seen that this condition is often encountered in houses not properly treated acoustically, when the audience present is small.

Estimating Articulation

There are two more factors to be considered before we can round out our estimate of the probable articulation of the theatre, and these are the percentage reduction necessary on account of the recording and on account of the reproducing system. Since the articulation rating for speech under the best conditions from the original sound source is only 96 per cent, let us assume that the best possible recording and reproducing would be 95 per cent each, or a reduction of 5 per cent each.

To sum up these reduction factors and to get an idea of how a theatre would rate under the conditions that I have outlined above, we get the following:

Articulation of original speech under perfect conditions	96%
*Reduction due to incorrect loudness	5%
*Reduction due to extraneous noise in theatre	10%
*Reduction due to reverberation	10%
Reduction due to recording	5%
Reduction due to reproducing	5%

*Controllable by exhibitor.

Interferes With Comfort

Extensive tests by Dr. Fletcher, of the Bell Laboratories, have enabled him to draw a curve showing the relation between the percentage articulation of meaningless syllables and the resultant conversational efficiency in which the listener has the aid of context of the sentences in which the syllables are found. From this curve we find that in a theatre having an articulation rating of 61 per cent the conversational efficiency would be 90 per cent. This means that the patrons would miss about 10 per cent of what was going on, which would keep them under a continuous strain to try

and make it out. This strain is perhaps not conscious but does interfere with the ease and comfort of the audience.

Loudness of operation, extraneous noise and reverberation in the theatre are controllable by the exhibitor in ways described above.

Must Be "Room Tone"

In addition to these measurable factors there is another that has an appreciable place in show psychology, illusion. The sound must appear to come from the picture and yet the listener must be made to feel that he is in the same room with the speaker. With present day recording the areas around and immediately in back of the horns should be sound reflecting, which allows the "room tone" of the recording to become associated with the "room tone" in front of the theatre, so that the listener unconsciously feels that he is in the same room with the speaker.

With so many factors bearing upon the net result, each presenting its reduction factor, however small, it behooves the exhibitor who wishes to preserve and increase his success to see that all reduction factors within his control are kept to the absolute minimum.

The best possible equipment obtainable, properly operated in a theatre that is acoustically correct and free from extraneous noise, is the only possible answer to "easy listening" and increasing receipts.

———o———

Honor Struss and Mohr

As a representative of the technicians' branch in the board of directors of the Academy of Motion Picture Arts and Sciences, Karl Struss has been elected to serve three years.

Hal Mohr, president of the American Society of Cinematographers, was among those elected to serve on the technicians' branch executive committee for one year.

———o———

Why, Clyde

Clyde DeVinna — While photographing native life in Africa I came across a tribe of women who had no tongues.

Billy Marshall—Gosh! How could they talk?

Clyde—They couldn't! That's what made them wild.

———

Did you ever hear the fellow that plugs pills and says: "If you are not sick now, you will be some day." I'm just crazy about that bird.

———

Or the guy that is plugging oil land and tells about the marvelous fresh water well they just brought in.

———

At the conclusion of a beauty talk by a boy with a tenor voice the announcer said: "The orchestra will now play Ya Pansy." (Japansy).

 # Cream o' th' Stills

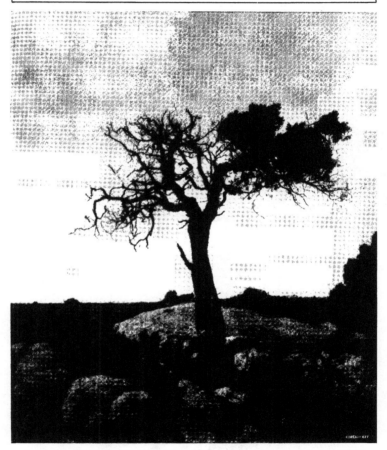

One of the old settlers of Brush Creek Ranch in Wyoming fights for his existence. It's a losing battle, as Bert Baldridge shows us in this interesting photographic study.

 # Cream o' th' Stills

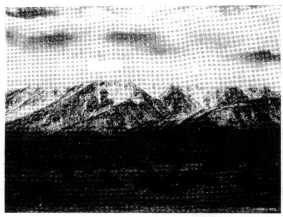

Here is the Lone Pine country in the early spring. It is one picture at least that Elmer G. Dyer photographed with his feet on Mother Earth and not high in the air. A dozen miles of desert or perhaps more have to be crossed to reach the sharp ascent to the snow-covered Mount Whitney range towering to nearly fifteen thousand feet in the background.

This is a picture going to prove that the making of western subjects is not all cakes and ale for the players—and even more so for the cameraman who records the heroic doings. Jack Holt is the rider hurrying to save a Paramount heroine, but behind the non-mobile camera is Rex Curtis calmly doing his stuff.

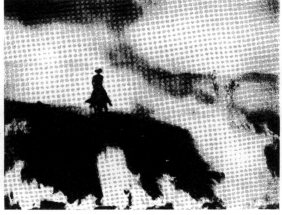

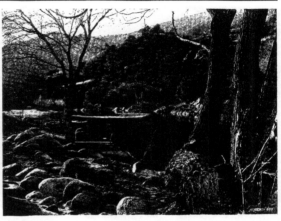

A romantic spot charmingly portrayed, as the reader will agree. Oliver Sigurdson is the artist. The site is the Kern River at Democrat Hot Springs, halfway between Bakersfield and Kernville, the latter a town that at one stage of its history packed a dozen saloons and two distilleries into a couple of blocks. It was the gold country.

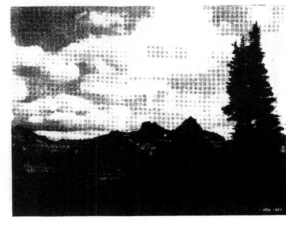

It's a matter of regret the pages of this magazine are not large enough to bring to you this striking picture in the 11 by 14 inch form in which Robert Palmer submitted it to us. The subject is an early afternoon shot of the Tatoosh range, south of Mount Rainier, Washington.

 # Cream o' th' Stills

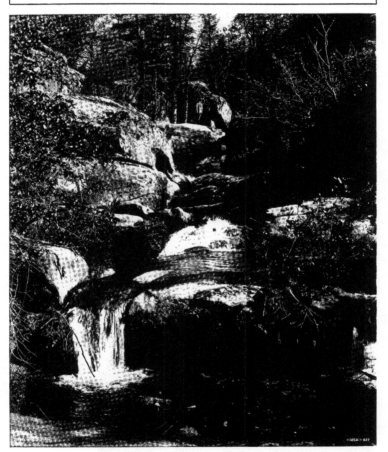

Pine Flats seems an incongruous name for a rugged and rocky spot like this. It's a section of a resort above Bakersfield, near California Hot Springs. Roy Vaughan is the artist.

Amateur Department

Toy Projectors Big Holiday Factor

Eastman the Third Maker to Enter Market with Indications Pointing to Heavy Demands From Cine and Drygoods Stores

THE prediction is made that toy 16 mm. projectors will be the leading factor or one of the leading factors in the coming Christmas holiday trade. The assertion is made by Walter W. Bell, manager of the Cineart division of the Hollywood Film Enterprises, who for four years has kept closely in touch with the development of the amateur film business throughout the world.

Illustrating his remark Mr. Bell quotes a Los Angeles man heavily interested in 16 mm. devices who has just returned from a business trip to the north.

In one small kodak store in San Francisco the proprietor has installed for his Christmas trade an advance order of 300 16 mm. projectors. The action of the Bay City man is symptomatic, Mr. Bell says, of what is being done in other stores throughout the country. He asks if this lesser dealer is moved by his inquiries to install a stock of that size what may be expected to be the course of action followed by the large department stores which conduct an enormous photographic business.

Eastman in Toy Market

Eastman Kodak is the latest company to announce a similar line of equipment, the Kodatoy, retailing at $12 and including in the sale a small screen. These are being stocked heavily all over the country.

Q R S of Chicago and Keystone Manufacturing Company of Boston, the latter formerly specializing in 35 mm. toy projectors, now are firmly intrenched in the 16 mm. toy field. In addition to these, Montgomery Ward through its mail order stores throughout the country is marketing a 16 mm. projector. For these the price ranges between $7 and $15.

These last named three companies are being supplied their toy film through Hollywood Enterprises, in lengths of 10, 25, 50 and 100 feet. The two most popular sizes are 10 and 25 feet. The Eastman company also is distributing toy film in these shorter lengths.

The toy moving picture projection machine in 35 mm. size as well as 16 always has been a popular bit of merchandise in toy stores during the holidays, but its larger success has been militated against heavily through two important business factors.

Risk of Inflammables

One of these was the very tangible expense attending the purchase of equipment of either size and the other the risk following the possession of inflammable 35 mm. film with its necessary heavily increased insurance cost if not actual prohibition in homes.

Where heretofore the cost of 10 feet of 35 mm. film for exhibiting would have ranged up to $1.50 the 16 mm. toy variety now may be purchased on non-inflammable film for 40 cents. Added to this is the advantage of increase in actual footage on the part of the smaller film of two and a half times.

Mr. Bell calls attention to the certain opening of a field for more expensive home projectors through the expanding use of the lesser priced equipment. He points out that practically from the inception of the picture business it has been the children who first were the steady family customers of motion pictures, their parents following willingly or otherwise eventually.

Horsley Saw Field

He so sees the inevitable result of the present drive in the sale of low-priced equipment—that the parents will become interested in the toy equipment and will be concerned in securing more solidly constructed machines.

Hollywood Film Enterprises was

H ERE is an example of one of those rare instances wherein a man's hobby parallels his business, like the oft-quoted instance of the mailcarrier taking a walk after dinner.

In the right foreground we see Colonel William G. Stuber, president of the Eastman Kodak Company. The very young man who so unconcernedly ignores the camera like all genuine screen artists is William James Stuber, while leaning over him is Marjorie Stuber.

In photographing his grandchildren Colonel Stuber is pursuing one of his chief recreations. Nor is he content merely with exposing the film. Instead of passing this on to some one of the thousands of Eastman employes he chooses to do his own developing and printing.

Colonel Stuber before joining the Eastman company was internationally recognized as one of the outstanding figures in American portrait photography. For several terms he served as president of the American Photographic Society.

the pioneer in the manufacture and distribution of toy lengths of 16 mm. film. The opening of the field is credited to the business acumen of William Horsley, who already had begun to convert a goodly part of his laboratory from a 35 to a 16 basis. Q R S was the first concern to agree with Horsley as to the future in the toy film field and plunged heavily.

Illustrating the compact manner in which this toy film is being shipped from Hollywood in a sum totaling many thousands of feet weekly a box 2 by 3½ inches in dimensions will carry five 25-foot rolls each in a box three-quarters of an inch thick by 2 inches square.

A Dozen in One

In a container the outside measurements of which are 1½ by 3 by 4¼ inches 12 ten-foot rolls are packed.

Let it not be understood that these ten-foot rolls, which incidentally contain 400 frames, represent simply so much footage and not much else. Each box, if you please, represents what the little folks will declare is a separate story and they will quote you the titles to prove what they say.

In a representative group of 12 subjects are cartoons, comedies, natural history subjects, such as in this instance "The Elephant"; and western and outdoor subjects. In the latter field are "The Roundup," "The Cowboy," "Branding Cattle," "Arizona Trails," "Fighting It Out" and "The Cowpunchers."

It really is going to be a film Christmas for the kiddies even if the grown-ups openly do not sit in. Likewise this branch of the holiday trade is providing a lot of employment for Hollywood film workers.

Bronze Medal Awarded to B. & H. for Aiding Airmen

THE Bell & Howell Company has been awarded a bronze commemorative medal in recognition of cooperation in connection with the record-breaking national air races held in Chicago recently. The medal was awarded by the officers and directors of the Chicago Air Race Corporation.

Prior to the races, a Filmo projector was used to stimulate interest in the coming aviation events by showing movies of last year's air races all through the Chicago metropolitan area. These pictures were shown several times daily during a 30-day period to various organizations with splendid results.

At the air races themselves 16mm. motion picture cameras were very much in evidence. All over the closely crowded seats spectators were to be seen using their movie cameras to make motion pictures of the air events. Aviation will unquestionably

Victor Issues Catalogue

The Victor Animatograph Corporation of Davenport, Iowa, has issued a new loose-leaf cine equipment and accessory catalogue. The publication is handsomely printed in colors and most attractively bound. Prominently featured is the new model 5 Victor camera with visual focusing. There is a wide variety of lenses listed, these including the works of the best manufacturers.

Other equipment described in the catalogue are the Victor Cine projector, film prepared for daylight loading, reflectors and lamps for use in photographing, projection screens and many other accessories.

New model 5 Victor camera with visual focusing, mounted on a new Stanrite tripod.

Church Paper Conducting Motion Picture Department

SUCH wide interest has been evinced in the use of motion pictures in the church field that the religious magazine The Expositor has opened a questions and answers department to take care of inquiries from clergymen who desire information as to how to employ pictures to the best advantage in their work.

The department is conducted by Ford Hicks, vocational advisor of the Bell & Howell Company, Chicago. Letters of inquiry have been received in considerable number from all parts of the country.

J. M. Ramsey, managing editor of The Expositor, is himself a motion picture enthusiast of genuine attainments. He has written a number of articles on cinematography which have appeared in photographic publications, and he has also at least one movie appliance invention to his credit.

Tolhurst to Lecture

Louis H. Tolhurst, a specialist in micro-cinematography, has been invited to visit the University of Minnesota and make a lecture during the present scholastic year. The action is the result of communications passing between J. C. Lawrence, assistant to the president of the University of Minnesota, and the Academy of Motion Picture Arts and Sciences.

Mr. Lawrence wrote to the Academy that he understood a member of that body "had developed an admirable technique for making micro-motion pictures which was utilized in the films of a fly's eye and of ant colonies." The university official stated that the Minnesota institution desired Mr. Tolhurst's assistance in instructing some of its scientists, so that motion pictures can be made the instruments of effective teaching work in different fields.

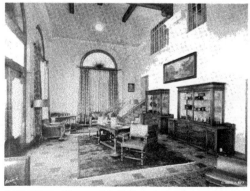

A part of the reception room of the Kodak Service Building on Santa Monica Boulevard, Hollywood, which now serves as a kodak store. Ray Claflin is manager.

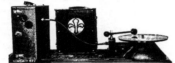
Don't Panaram If It Is Avoidable, Eastman Man Advises Camera Novices

NEVER panoram when avoidable, is the advice to amateurs given by I. H. Andrews of the Eastman stores of Los Angeles. Use one or more stationary shots instead, he says. If you must panoram, he continues, turn the camera slowly; in fact, just as slowly as you can move.

Following these two rules, Andrews declares, will result in a much higher average of good pictures.

"During the past year I have projected thousands of rolls of amateur cine film for our customers, and as a result two impressions stand out in my mind," continued the Eastman man.

"The first is, the remarkable success and high average of pictures which even the rawest beginner achieves. This is largely due to the remarkable latitude of reversible film with its automatic processing and to the great depth of field rendered by the short focus anastigmats used in 16 mm. cameras.

"The second impression is the curious fact that nearly all amateurs make the same errors, which result in spoiled film. I believe it is safe to say that 95 per cent of all spoiled film is due to one cause—too much and too fast panoraming.

It is a curious fact, but true, that a movie camera placed in a person's hands for the first time always causes the same mental reaction—to turn it in every direction and spray the landscape with imaginary movies. This technique is fine for sprinkling the lawn or operating a machine gun, but not for picture taking.

"Nine out of ten panorams made by amateurs would have been better pictures had the Kodak been held stationary. Out of the nine, at least six are panoramed too fast, resulting in a blurred, jumpy film, hard on the eyes and anything but pleasing to look at. If you watch the professional screen, you will notice that very few panorams are used and these are made at a very slow rate.

"Considering that most spoiled film is due to the one cause and that the correction of this is entirely in the hands of the amateur himself, requiring no more technical skill nor judgment, it behooves us all to watch our step in the matter of panorams and follow these rules outlined."

New Victor Directory

The Victor Directory of Film Sources, "Where to Buy, Rent and Borrow 16 mm. Films," has been completely revised and the new volume will be ready for distribution by the middle of November.

It was intended to fill a need for a complete and accurate listing of 16 m/m film sources, and to thus place at the disposal of 16 m/m. equipment users the great and constantly growing mass of film which existed but was not easily available for the simple reason that few projector owners knew of more than a very limited number of sources.

The Victor Directory is distributed free to owners and prospective owners of 16 m/m equipments.

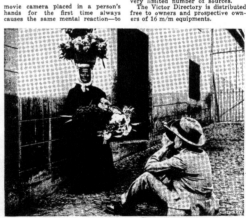

Burton Holmes abroad with his Eyemo stands an animated flower garden against a wall and shoots it. We may be sure before the lecturer completes his record he has not neglected the upper stories of his unique emporium.

Before and after taking an external application of Max Factor make-up. The subject is a young man employed in the establishment of the cosmetician named. He is not an actor; neither has he ambitions in that direction. He is merely contributing a background in order that the skillful M. F. may demonstrate how in minutes he does things on which old Father Time expends years.

Films and Ediphone Used To Analyze Football Plays

AT Chicago while Lorenzo Baker of Columbus, Ohio, with a Filmo 16 m/m movie camera made play-by-play pictures of the Northwestern-Ohio State football game from the roof of the press box at Dyche Stadium, L. W. St. John, athletic director of hio State, at the movie operator's side dictated into an Ediphone a detailed account of each play.

The joint record was immediately used by the football experts of Ohio State to analyze every angle of the game.

Two Filmo cameras were used in taking the movies. One was alternately in action while the other was being reloaded with film.

The movies were taken at a speed of 32 exposures per second, resulting in a recording which has been found to be just sufficiently slow-motion when projected to permit of satisfactory analysis and study.

Bell & Howell Releasing Short Russian Educationals

THE Bell & Howell Company has prepared one and two reel versions, on 16mm. film, of some of the Russian Amkino's best productions.

Among these is a two-reel picture of life among the primitive family tribes of a tiny, forest people, the Ussurians. Their mode of getting a living by skillful hunting and fishing, their social division of labor between the sexes, and finally the influence of western civilization in bringing commendable changes to these backward, simple people are arrestingly portrayed.

One of the most interesting moments shows the excitement of a native when he sees himself in the movies for the first time. This film, which is entitled "Taming the Taiga," ranks with the best socio-naturalist films and is of compelling interest.

Another of these is the one-reeler, "Hunting and Fishing in Siberia," which includes the killing of a giant bear by a native, single-handed and armed only with a spear.

A third is a one-reeler on Afghanistan, reported to be the only motion picture ever made with the consent of the Afghan authorities. The extremely primitive methods of life are plainly and interestingly shown.

Prague Has 24 Sound Theatres

There are at present 68 wired houses in Czechoslovakia with 24 of these in Prague. Seven different systems are now in use. An American firm is credited with 21 installations, Klangfilm and another American firm with 14 each, the others being minor sets.

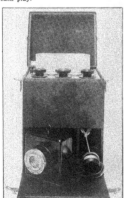

Left, Amplifier with panel showing controls and meters. Lower center, condenser microphone. Upper center, interior of microphone. Right, amplifier case showing compartment for carrying microphone and head phones.

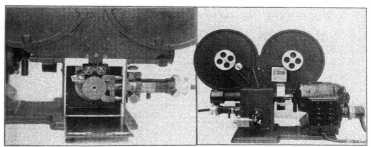

Left, detailed view of recorder showing movement of film over sprocket and placement of recorder tube. Right, rear view of recorder showing tachometer, footage indicator and switch control.

Ship Audio-Camex Outfit to Mexico

THE Hollywood Camera Exchange has just shipped to Mexico a complete Audio-Camex equipment, of which it is distributor. The apparatus will be used in making Spanish-speaking subjects.

The portable equipment is contained in five boxes and weighs when complete about 275 pounds. In the boxes are contained the amplifier and microphone, with headphones and recording tube; amplifier batteries; the recorder and its cables; motor batteries; and separate synchronous motor to drive camera. The entire outfit will fit in the rumble seat of a car.

The amplifier is of the two-stage direct coupled recording type, with gain in excess of 100 decibells. It is complete with gain control, lamp voltage regulator, plate current meter, volume indicator and cannon connectors for microphone and battery supply. All are assembled in a carrying case measuring 17 inches high, 11 inches wide and 10 inches deep and built to accommodate two recording lamps and microphones.

The tubes used are one UX 245 and three UX 227 and may be procured practically at any radio store in the world, as is also the case with the two WX 12 tubes employed in the two-stage amplification. The two-stage condensor microphone is assembled in a drawn duralumin case with cannon connectors.

The equipment is designed as an integral unit, the amplifier having input impedence suitable for this microphone.

The recorder is built to accommodate standard Mitchell magazines. It has a tachometer for speed control, footage indicator and adjustable recording lamp holder.

The recording lamp, known as the Audio-Lite, was designed by local engineers, and the Hollywood Camera Exchange is acting as their sole agent. It is operated by direct current synchronous motor matched with camera motor. This may be operated alone as a regular motor for synchronizing pictures or separate sound track or will run in synchronization with the camera motor.

The switch is so arranged that either the camera motor or the recorder motor may be run separately or both may be run together in synchronization. This is claimed to be the first time direct current synchronous motors have been placed upon the market. At this time these motors are operating on 110 volts B batteries, thereby eliminating the motor generator system hitherto used to run synchronous motors.

Deputies Have Sound Theatre

A cinema projection room has been established in the French Chamber of Deputies. It was inaugurated on July 10, by Mr. Borel, president of the Groupe Cinematographique, which comprises some fifty deputies.

It is interesting to note that the first film chosen was Eisenstein's "Cruiser Potemkin," the public exhibition of which is prohibited in France. The projection room is equipped with a Gaumont reproducing set.

Tales from an Old Lyre

As Brother George Robinson was fixing a color screen on his camera while on location in Red Rock Canyon with the Wyler Company, he noticed his assistant oiling a Winchester rifle, and strolled closer to inspect it.

"Fine gun you have there," he remarked.

Brother Gene Hagberg looked up with a smile. "Yeah, fetched it along to shoot coyotes—want to try it?"

"Is it loaded now?" asked Brother George.

"Sure—five cartridges," and Brother Gene handed his firearm to the cameraman.

Brother George looked around for a suitable target and observed an aged jackrabbit under a Joshua tree some hundred yards away, leisurely scratching at fleas. Taking careful aim, he fired.

The rabbit wagged one ear forward and back. Brother George essayed another shot, more deliberately.

Brother rabbit wagged the other ear.

Three more explosions started echoes in the canyon and a raucous laugh from Brother Gene. The rabbit evidently did not object to guns, but was amazed by Brother Gene's voice, so, giving a disdainful look, he ambled leisurely off among the mesquite towards the county line along the horizon.

"Here, take your gun, it's no damn good," said Brother George in disgust, and he started back to his camera.

That night, shortly after midnight, Brother George was awakened from a sound sleep by insistent knocking on his bedroom door.

"Who's there?" he snarled.

"It's Gene," came faintly. "Say, George, I just remembered those shells have been in the gun ever since Fourth of July. They were all blanks!"

"Crash!" A hobnailed boot splintered a section of the door. Hasty footsteps retreated down the hall, and silence again surrounded the old hotel.

As Brother George entered the dining room next morning, red-eyed from loss of sleep, he saw his assistant across the room with a smoking platter of ham and eggs between him and a scraggly-bearded stranger.

Brother Gene noted his entrance and saw with apprehension Brother George approach with evil intent in his eye, and a china sugar bowl in his hand, which he raised with a threatening gesture.

"Morning, George," said Brother Gene with a forced smile. "Do you know I saved you a lot of money?"

The cameraman paused in indecision as Brother Gene went on hastily: "You know there's twenty-five dollars fine for shooting game out of season. Meet my friend, 'Pop' Hawks, the game warden of this county."

Brother George glared at him a moment, disdaining to answer, then retreated to a far corner, where he also gloomily ordered a platter of ham and eggs to drown his resentful emotions.

Brother Gene wiped the perspiration from his brow and sat down heavily. Turning to the bearded stranger, he remarked: "Hope you don't mind my alluding to you as the game warden, but I had to lie about something to save my life."

"Naw," dryly answered the old man, casually pushing open his vest to display a star. "Ye see, I happen ter be th' game warden!"

Mexico City Opens Theatre Wired by American Concern

A new motion picture theater was recently opened to the Mexico City public, the Balmorri, in the Avenida Alvara Obregon, some distance from the present theater district, according to Assistant Trade Commissioner Arch F. Coleman.

The theater is the most modern of its kind in the Republic, and is equipped with the latest electrical devices. It is said to be the first motion picture theater built in Mexico which combines acoustic excellence with the customary film paraphernalia, and the sound machinery is the product of a well-known American concern.

Prix Cidale Is Founded

The International Committee for Artistics and Literary Propaganda by Motion Pictures, working in the spirit of the League of Nations, has just been constituted in Paris for the favoring of cinematographic production of a scientific, social, instructive, economic, historical, artistics or literary value. An international prize of 150,000 francs, to be known as the "Prix Cidale," will be instituted.

666 CHICAGO 666

By HARRY BIRCH

Meeting

YOU should have seen the chests puff out of all the 666ers when they attended the October meeting, the first one held in their own headquarters at 1029 South Wabash Avenue. The furnishings were not complete, but the true spirit of the brotherhood was there. This is just another step of advancement of Local 666.

President David conducted the meeting, and he told the boys that 666 was going to have the finest office in Chicago and that Local 659 would have nothing on us when he completes the furnishing of it.

The outstanding topic of the evening was a motion that out of appreciation to Brother Eugene Cour he be presented with a life membership gold card to Local 666. This motion was seconded by the entire assembly. The indebtedness of Local 666 to Brother Cour will never be paid for that first year's service acting as secretary.

It was also decided that all committees shall make a formal report on their activities at the next meeting.

Brother James Rotuna has consented to give the boys the "inside" on themselves at the next meeting. The "inside" is Rotuna's lecture and film on the "Unhung Heroes of Cinema Land."

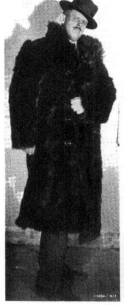

When Winter Comes

No, this is not one of the specimens brought back by the Byrd expedition, but is our President, Brother Charles N. David of Local 666, modeling for the boys as to what the well-dressed cameraman will wear this winter. Of course, this is entirely too heavy for the man who uses sound equipment, but for an Eyemo specialist it is the cat's fur. Fur what? We should know—ask David.

What's Wrong Here?

It is said that Brother Jack Barnett, with the Daily News Screen Service, covered an Irish golf tournament on Yom Kippur. "Boy, tha' suah am a mess."

Again we have that Cord car. Brother Charles Ford called in and advised that he was sitting on the shores of Lake Michigan and the said Cord refused to start. This is supposed to be a secret, but with the aid of our "Pres" David and Birch's Packard assistance was soon given a little "push and pull."

A story . . . more film was needed . . . telephone call . . . Brother David alone at the office . . . messenger boy and loaded De Brie Magazine rushing to scene . . . story lost . . . REASON . . . Brother David in his hurry loaded said magazine with emulsion wound in.

Brother Barnett yells because he claims his name is never mentioned on the page and he feels that the cockeyed world should know where he is. For the information of all the brethren Martin is now associated with Harry Birch at the new address, 5100 Ravenswood avenue. (Bill collectors, please take notice.)

Skeletons Still Alive

It seems that skeletons will continue to fall out of closed doors. This photograph came in the mail unsigned, with the title "Rothacker's Cameramen Waiting for the Sunrise in 1914." From left to right, Harry Birch, Billy Aldis, Eddie Linden, Gus

English and Irving (Shorty) Ries. Just look at that line-up of expensive equipment.

SIX-SIXTY-SIX
Visitors

Local 666 was honored by two "out-of-towners." They are Brother William B. Jacobs, from Toledo, and Brother Clarence Gutermuth, from Fort Wayne. It was indeed interesting to hear the "out-of-towners'" viewpoint on the activities of Local 666.

SIX-SIXTY-SIX
At Last!

It seems that the cameramen are getting a break at last. Brother James Rotuna has not been satisfied with the way "Unhung Heroes of Cinema Land" have been handled in the past. Brother Rotuna has therefore turned "Burton Holmes" in honor of all cameramen.

In the past few weeks over 450 business men of Chicago have heard some of the sad tales of the cameramen.

Brother Rotuna, who is the official aerial photographer for the National Air Transport Company, and a capable one for the job, has appeared before some of Chicago's largest business clubs. His lecture is on the struggles, dangers and hardships of the movie man in securing his story. In connection with his talk there

are some wonderful news-shots submitted by the Daily News Screen Service, Pathe, Fox and International.

One of the high lights of the complete picture is a news story by Pathe entitled "A Race With Death." The picture shows one of the "boys" making his final fade-out. Charles Traub was his name. Both Traub and Lee Bible were killed at Daytona Beach while Traub was photographing Bible's speed test.

Among the clubs that have been honored by Brother Rotuna are the Adventurers, Quadrangle, Humbolt, Woodlawn, Central, Marquette, Austin Lions and the North Shore Ravenswood Kiwanis clubs.

SIX-SIXTY-SIX
Just Thinks He's Sorry

I am sorry our "Sassiety Reporter," Red Felbinger, is not represented on the page this month. Unfortunately, he is in St. Louis covering the World Series, but we hope he will be with us next month.

SIX-SIXTY-SIX

In Focus — In Spots
By Birch's Sassiety Reporter

B OY! We certainly live in a age of fast ones. Nowadays even your best friend won't tell you. I guess guys lay awake nights trying to figger out ways of keeping the truth from bein' told. What I'm

gettin' at is this; youse guys all know how I pick up all the hot stuff.

Well, I just run across a sign, never mind from where, that Harry Birch, the boss of this here page, went to a lot of trouble apologizing saying that I wuz to be very conspicuous, this month, by my absence on this here page.

Now we all agree that this guy Birch is a good news man and ought to certainly know what he is talking about, but wotahel, we all make mistakes, the idear of the pencil manufacturers putting rubbers on the pencils bears me up on that. I just want to take Harry down here, though, for a little carelessness in making so rash a statement. Harry just put that down, and never even went to the trouble of looking over the local police blotters to see if yoors trooly was registered.

Well, I guess even then he would not have located me, as you see I been out on a hot story which I want to get to my admirers while it's hot. I'm sittin' here right now waiting for a call to come in and give me the big scoop and I'll bang it out right quick.

Hot from St. Louis

Well I been spendin' a good deal of last month around St. Louis on the World Series, which is a bunch of baseball games played for the benefit of the newsreel boys, so's they can get one more good workout before the winter sets in.

While waiting I ran across our old friend Mac Guire. Brother Mac has given up the old grief of grinding a box for the glass business. Mac taught me a good deal about glass one night. Never knew there were so many different brands of glasses, and Mac and I sampled an awful lot of them, including the contents.

Well, Norm Alley dropped in on the series with his big happy family of Charlie Geis, Harry Neems, Eddie Morrison and Phil Gleason. Alley also had on a new suit which didn't cost eleven simoleons. He bought this one down in St. Louis and it cost 22.50.

We see where Alley has turned announcer now. Alley spent all his time sittin' on the roof of the ball park eatin' peanuts and givin' play by play description into the mike of his crew's camera. I stood there watching Norm, and I come to the conclusion Norm has finally discovered something to take the place of the good old Eymo since we had handed them heavy sound boxes.

Big So-and-So Comma

Just got a leter from our old co-worker Orlando Lippert, who took Horace Greeley's advice, or maybe listened to Charlie David rave about sunny Hollywood. Lip finally packed up his tooth brush, put five gallons of gas in the old mill and pulled out for the coast and sent me the following when he arrived there:

Lip Verbatim—Almost

You great big so-and-so comma and you've never made the trip across·

Summer vs. Winter

While we were sweltering with a temperature around 100 in Chicago some one laid this picture on the writer's desk. It was made last winter when Chicago was around 10 below zero. It looks as if this might be part of the Byrd expedition, but it is just a couple of 666 members on a job

wrapped up trying to keep warm. Left to right, Sam Savitt of 666, Si Griever, Martin Barnett and Urban Santone, Sr., also of 666. It won't be long now until the boys will be getting out their woolens and chasing the moths away in preparation for another winter, and then we may show you how some of these "hombres" looked in the summer time.

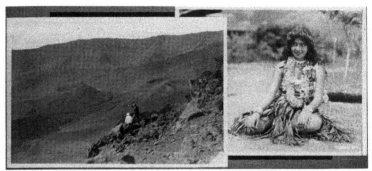

Harry Perry in the Hawaiian Islands records on the left the crater Haleakala, on the Island of Maui. To get this photograph it was necessary to pack for two days on mules. On the right is a "little Hula girl."

country in an automobile? Well I made it—and I swore I'd—well, I'll relate from my diary how I felt.

Thursday—We're off! I stuck the old mud hen into the wind and away we went. No stops! California, here I come. Nothing can stop me now.

Still Thursday—Pontiac, Ill.—Five hours in a repair shop. Limped into Springfield. $14 for repairs.

Friday—Springfield to St. Joe, Mo. plenty long ride.

Saturday, Sunday—Waiting for repairs from Kansas City. (Expurgation.)

Monday—Ottawa, Kan.—more repairs. For two cents I'd turn back. (Ex.)

Tuesday—Tulsa, Oklahoma to Maclean, Texas. Texas roads! (Ex.)

Wednesday—To Albuquerque, N. M., roads worse than Texas. Took 83-mile short cut. No farms, no houses, nobody, nohow. The car can't stand the strain of these roads. Washboards, ditches, cowpaths. Holy cats. Can't stand this. I'm going

NUPTIALS, ETCETERA

Brother Louis Neville, a 666er, of Indianapolis, officiated as best man for three weddings this year —the latest was the wedding of Miss Marie Shay and Brother Ralph Biddy, also a 666er.

Neville says "This is the best way of getting to kiss somebody's wife without getting shot" (but don't tell Ralph).

Local 666 desires to congratulate Mr. and Mrs. Biddy and wishes them many happy and prosperous years.

bughouse and the car to pieces. One puncture.

Thursday—To Flagstaff, Arizona. (Ex. plus.)

Friday—600 miles to San Bernardino, through desert at night. So cold I wore three sweaters. Roads!

Saturday—California, here I am. God's country! Marvelous country! Beautiful country! A paradise. Went

swimming in the ocean and drank orange juice from oranges off the trees. Joined chamber of commerce.

Moral: Come to California, yes, but do it by train, not by automobile. Yoors trooly, Lip.

Well, I gotta go now. See you next month.

Fire-Proof Screen

The Du Pont Laboratories following months of research announce a fire-resisting motion picture screen. The new material has been subjected to all forms of rigorous tests, both in the company laboratories and those of the National Fire Underwriters.

Aside from the fire-resistant feature the new material also has the advantages of a matté finish, which gives a uniform degree of reflection and a construction which permits of easy and clean perforation for sound projection.

The material is designed not only for use in the theatres but for schools, colleges and other institutions desiring a screen that will resist fire.

(Continued from Page 21)

camp by an enemy airman of a souvenir of the commander—a silent message telling of the latter's death.

Ernest Haller was the cameraman, with Elmer Dyer being responsible for the remarkable series of shots taken in the air.

The Spoilers

WHEN a story invites three major productions across a period of sixteen years there must be in it something distributors consider of inherent strength. Paramount so construed "The Spoilers" when it delegated Edwin Carewe to remake it, this time with dialog and sound, and it may be said with at least measurable success. The degrees of that success in this Hollywood town filled with production-satiated men will be according to the individual viewpoint—and that is of wide variance.

Men only are quoted in this instance, because seemingly this fine old tale of Rex Beach's is cut out for men especially and for women only incidentally. For frankly it is a man's story, and if a person of the male persuasion looks to the female of the species for a rating on the subject he may not get 100 per cent.

But for the youngsters, both boys and girls, if a pair of these sitting in front of this writer at Pantages' Hollywood house during an October evening may be taken as a criterion the excitement they derived from the action on the screen seemed to be about all the adolescent ought to be expected to encounter.

Comparisons are the natural thing. The writer was one of those who saw the first production in New York. If his memory serve him correctly the Selig subject was shown in the Strand, opened it in fact—the exhibition of the picture being delayed a long time in the metropolitan territory in order that it might open the big house, the most pretentious picture place in that city up to that time.

And about the fight, the main thing in the story: It must be borne in mind that picture judgment in the mass has undergone much change in the intervening sixteen years; it is vastly more critical now. It is unlikely any scrap could be staged today for the screen that would linger in screen memory for sixteen years to come.

The present edition of the bruising encounter between Glenister and MacNamara certainly mussed up things aplenty, whether it was Gary Cooper and William Boyd or whoever it may have been. The absence of light in the observer entirely in the dark as to the identity of the participants. If it really were them there was no particular reason for putting out the lights in the fiercer stage of the encounter. However, the immediate foregoing is more or less Hollywood stuff anyway.

The picture has abundant material to cause it to be commended in any town. Portraying it is a cast of unusual rank—Cooper, Kay Johnson, Betty Compson, Boyd, Harry Green, Slim Summerville, James Kirkwood—so disguised his best friend will never recognize him: Lloyd Ingraham and Oscar Apfel. The spectacular staging was on a scale to match the quality of the players.

The underlying theme, it may be recalled by those who have not recently been in contact with the tale, is the disaster threatened in a primitive mining country by the entrance into it of one or two crooked Washington officials with the idea of "getting theirs" before they can be stopped.

This phase of the story was more convincing in its working out than was the accompanying romance. Kay Johnson as Helen Chester, regardless of the sincerity and earnestness with which she worked, seemed never to the observer out front to get away from the fact that she was a society girl and the accompanying feeling that a society girl was out of place. Kay Johnson is one of the few who plays the woman of society and really and inescapably is that person.

The deep appeal of the picture lay in the three partners, Cooper, Summerville and Kirkwood. It was the battle of these three to save their valuable property from spoliation and their deep friendship for each other together with the cleverly designed antagonism of the politicians that lifted the story above the spectacular surroundings in which it was laid.

There was a goodly sprinkling of fun to leaven the more tense scenes.

Harry Fischbeck was the chief of the large camera staff, which acquitted itself with distinct credit in the difficult surroundings in which it was called upon to work.

Whoopee!

WHEN Florenz Ziegfeld joined hands with Sam Goldwyn to make a picture he contributed much to the entertainment of picture-goers the world over. Plainly the combination makes a great team, and one that in all likelihood will be heard from again. For up to this time no man ever has been a partner in so marked a screen success as these two men have scored and let it go at that.

"Whoopee" is a splendid picture. That goes for all departments of screen production, from foundation up. Primarily it has movement. From the drop of the hat the action flows rhythmically, steadily and with celerity.

There is sound most skillfully recorded and there is Technicolor beautifully photographed.

Being a show with which the name of Ziegfeld is associated of course there are girls—plenty of 'em, not merely the sort that are easy to look at but of the attention compelling variety; and praise be no cradles were rifled in picking them. They do their dance stuff, too.

Then just to prove that the crepe-hanging prophets who insisted singing in chorus and otherwise was deader than a doornail the singing in the picture shown at the United Artists Theatre in mid-October constitutes one of the charms of the production.

But now as always has been and always will be the case, one good picture will upset a fleet of limousines loaded with distribution executives.

Eddie Cantor comes into his own with the screen world. In spite of other efforts this is his real camera debut. He is on his own ground—in the general neighborhood of Forty-second and Broadway—from first to last, and never gets away from it. The stamp of sophisticated Broadway is on the whole show.

Thornton Freeland, one of the newer accessions to the directing ranks, held the megaphone most

worthily. Busby Berkeley was dance director, Al Newman musical director and Richard Day art director, the latter being the conspicuous example of inability to forget that a screen production is something different from a stage show—that a sky which looks okeh in a theatre may be blooey, much too blooey come to think of it, in a picture.

The camera department gives an excellent account of itself, the work being credited to Lee Garmes, Ray Renahan and Gregg Toland. One of the most effective bits was that of the dancers shot from overhead, with the routine designed to conform to the angle. Oscar Lagerstrom was sound engineer.

One of the interesting members of the adequate cast was Chief Caupolican, an Indian with a striking voice as reproduced and who experienced no difficulty whatever with his lines. The music was by George Olsen's orchestra, finely handled and never obtrusive.

The Virtuous Sin

PARAMOUNT scores again with Walter Huston. This time it is "The Virtuous Sin," by Lajos Zilahy, screen play by Martin Brown and scenario by Louise Long. It is an excellent scenario, directed by Louis Gasnier and for the dialog by George Cukor. Jack Bachmann supervised this tale of Russia at the opening of the Great War, and with Bachmann's deep knowledge of Russia and its people we may be sure it is authentic. The production has the stamp of authority all the way.

The theme is continental in its freedom from the bonds of convention, in its ignoring of the more or less widely vaunted screen "code," in its humanness and its common sense if you will.

A young woman student in chemistry interested in the work of a young doctor engaged in a hunt for a tubercular serum consents to marry him on the understanding marital relations will be assumed if and when she really loves him. On the verge of the great medical discovery the doctor is called to the colors.

The doctor's ineptitude for soldiering gets him into difficulties with the general, a martinet. He is sentenced to be executed for sedition. To save him, the wife in order to reach the

general joins the entertainers in a house where the staff visits. The general falls in love with her and she finds she reciprocates it.

The husband is not executed, he is restored to his rank with murder in his heart, later is returned to his research work, husband and wife separate, legally, and the picture ends with the wife in the general's arms.

The reader may guess what is not here recorded, but under the spell of Huston and Kay Francis it seems quite the right solution of the domestic tangle.

In any event it is a picture for which theatre men may begin right now their exploitation plans, for the production will back up a strong campaign.

Interest is centered on two persons, in spite of the sympathy inspired by the husband in his predicament. There is nothing to indicate until the story is approaching its end that the finale will be anything different from the usual mush, but the tag comes with a swiftness that is as satisfying as it is surely the way human nature ordains these things shall be done—that it is better for two to be happy than that three shall be miserable.

Huston unsparingly lays the lash on himself in his interpretation of the martinet, a most unsympathetic part until the general's affection for the woman changes his outlook on life. It seems each succeeding portrayal by this comparatively newcomer to the screen adds to his reputation, and this in spite of the fact each role is radically different from its predecessors. That faculty, after all, is the real mark of the actor.

Kay Francis sustains throughout with conviction the difficult task set for her, in gentle company and in rough. Kenneth MacKenna commands abundant sympathy and gamely fights a losing battle.

David Abel is the cameraman who so skillfully supervises transference to the film many following and other shots requiring the photographer's full share of judgment. The staging is elaborate.

The Big Trail

RAOUL WALSH has well done a big job in making "The Big Trail." None but an organizer with an organization just in advance

of his every step would have yielded the results found on the grandeur screen at the Chinese in Hollywood.

And for a moment paying respects to that wide film: This writer chooses to hazard a statement- it will remain with us. Unquestionably there will be hesitation on the part of owners of houses already doing business to undertake extensive alterations in order to employ it; but if any theatre man is planning a new house and neglects to provide for wide film he is more than likely to be in the same predicament as that famous trinity of tailors in London who denounced the new order. The only works that exhibitor will gum up will be his own.

The Fox picture in the sweep and scope of its settings is a most perfect example of the possibilities of the new photographic frame.

There was truth in the widely heralded stories about the magnitude of the subject. And this story of Hal G. Evarts in its screen interpretation overlooked none of the well tried avenues leading to the entertainment of the public. Not all of these roads led to entire success.

The noticeable letdown was in the comedy department. There was fun, a goodly measure, but it did not flow from the comedian. El Brendel, although he opened his bag of tricks, was not, as the billing indicated, one, two, three; neither was he one, two, six. He was overborne by the drama and by those who portrayed it.

Somewhere in printed matter there was a suggestion the picture was without a star. The allegation is wide open to dispute. The public is quite likely to say John Wayne is very much one, more than easily according to many standards, and with the benefit of experience is certain to go far—if only he keeps his head. And he seems very much built that way.

Marguerite Churchill repeats in her role the success of Lois Wilson in "The Covered Wagon." Her difficult characterization is skillfully drawn and finely and minutely followed.

Distinct hits are registered by Tully Marshall as the scout friend of the hero; by Tyrone Power, black muzzled pirate of Falstaffian mold and sepulchral voice; bv Russ Powell, who in the way of fun steals the

(Continued on Page 44)

Industry's Representatives Adopt
Uniform System for Changeovers

A FORM of standard release print, which is expected to result in more uniform projection in motion picture theatres, and in reducing mutilation and waste of film, has been announced by the Academy of Motion Picture Arts and Sciences through the Motion Picture Producers and Distributors of America, Inc. Recent indorsement by the national organizations of projectionists completed the efforts made during the past six months by the academy to bring into cooperation every technical branch of the industry on behalf of the standard which has been adopted by the major producing and distributing companies, to go into effect November 1, 1930.

The standard was worked out by a sub-committee of experts under supervision of the academy producers-technicians' committee, and involved survey, analysis, and correlation of practices and opinion of technicians in the studios, laboratories and theatres throughout the country, production of test reels, and experimentation with various methods.

Educational Program

During the next few weeks an advance educational program will be conducted. It is hoped to reach every theatre, exchange, and studio in the country, acquainting theatre and exchange managers, projectionists, film editors and laboratory executives with the features of the new standard.

In bringing about a uniform method of changeover one of the most irksome problems in projection should be solved. At the present time individual projectionists commonly put on their own changeover marks. These accumulate and give rise to a constant demand for replacement by exchanges.

The new changeover signal is a small circular opaque mark with transparent outline printed from the negative. Each signal is four frames in length and is placed in the upper right hand corner of the frame.

In addition to the changeover system, the standard specifications cover the leaders both at the beginning and end of the picture.

Listing the Credits

The committee of experts which worked out specifications for the standard consists of Messrs. Sidney Burton, representing the projectionists; N. H. Brower, representing the exchanges; A. J. Guerin, release laboratory representative; I. James Wilkinson, film editor; Gerald F. Rackett, former manager of the Technical bureau, and Sidney J. Twining, studio laboratory representative, who served as chairman.

Among projectionist leaders who have been active in furthering the standard are George Edwards, international president of the American Projection Society; Thad Barrows, J. P. McGuire, Jess Hawkins, Harry Rubin, Lester Isaac, and Charles Eichorn, executives and leaders of the Projection Advisory Council, and Sam Kaplan, president Local 306, New York.

Parichy to Make Pictures
in South During Winter

E SSELLE PARICHY Local 659, whose strikingly illustrated story on Egypt opened our October issue, is leaving Los Angeles November 1 for the winter. His first destination will be Miami, where he will make his headquarters.

Almost immediately he will depart for a tour of Cuba, Haiti, Jamaica, Porto Rico and the Bahamas. In these islands he plans to make several stories of native life.

Returning to Florida the photographer will produce a Seminole Indian story in the Everglades, "always interesting country," he declares, "as I have done it before."

It is Mr. Parichy's intention to shoot not less than 15,000 feet of film on the various subjects, and much attention will be given to still pictures.

All of the negatives exposed on his recent trip in Europe and Egypt have been disposed of to his entire satisfaction, and the photographer-writer admits his anxiety again to be on his way—he has an itching to feel "sand in his shoes." As usual on all of his journeyings he will be accompanied by Mrs. Parichy.

Earl Hayman Constructs
Microphone for Altitude

E SPECIALLY-built microphones, equipped to counteract change in altitude were used during the filming of Paramount's "Fighting Caravans" at Sonora Pass, California.

In order to record, in sound scenes at an altitude of nearly 10,000 feet, a new type of microphone was required, since earlier experiences had proved that the ordinary instruments were not entirely satisfactory at such heights.

This effect of altitude is created because the two tiny plates which record modulations of sound are encased within a tube where the air pressure is equal to that on the outside. When altitude increases, air pressure diminishes on the outside and the tube swells, permitting the plates to draw apart.

As a result of experiments made by Earl Hayman, recording engineer, the special microphone was constructed. The secret of its success lies in a tiny valve on the tube wherein the plates are located. This valve is opened while the instrument is being carried to a higher altitude so that the pressure is equalized inside and out.

The Big Trail

(Continued from Page 43)

show. And there are David Rollins, Charles Stevens and Ian Keith.

So far as noted not a single fist blow is struck in the course of the picture, and that in a western subject is something of a record in itself—and not an unwelcome one either.

The story is packed with hardship and hazard. Not the least of these are the crossings of streams, one of these in a thunderstorm. It is a novelty to see on the screen through the blinding rain streaks of lightning with accompanying flashes of light and hear the following roars and continuing reverberations.

Arthur Edeson was the chief cameraman, paying his special attention to the three grandeur cameras. Lucien Androit was first cameraman on the three standard cameras also employed steadily through the production.

The large camera crew had its full share of the dangers of the tour, but fortunately all returned safely. Indications are they brought home with them something new in sound—the photographing and simultaneously recording of a thunderstorm, with the lightning flashes clearly outlined in the sky.

It is said the company waited long to get a storm—and as is customary in such circumstances got quite a lot more of it than even an ambitious director originally contemplated. But it is in the picture, and there is little likelihood any other outfit for some time to come will bring in anything that for realism in its own department will relegate it to second place.

Two New Assemblies Are Announced For Power's Projectors

THE International Projector Corporation announces two new assemblies designed to facilitate the manipulation of lenses and apertures and to make for improvement in projection where Power's projectors are employed.

Many features have been added to the Power's front plate assembly which is believed will appeal to the projectionist. Practically an instantaneous change of lenses is now possible with the new unit. A lens device has been added, enabling the centering of the projected picture on the screen when sound on film is used.

The instantaneous change feature allows the use of the proportional type aperture plate and a shorter focal length lens so that the projected picture with sound on film may be increased in dimensions to meet the dimensions of the silent or sound on disk prints.

Another feature of construction is the elimination of the old type rack and pinion lens focusing adjustment and the substitution therefor of the micrometer type of focusing pinion which allows the accurate adjustment of the lens and eliminates the possibility of the lens jarring out of focus at any time during projection.

A new type framing lamp assembly has been incorporated in this device and may be instantly removed for lamp replacement when necessary. The pull chain for the lamp socket is readily accessible to light the framing lamp when threading the projector.

Multicolor Laboratory Set for Opening November 15

THE million-dollar laboratory of Multicolor in Hollywood is expected to be ready for occupation by November 15. The structure will cover a ground area of 45,000 feet. The initial crew is set at 200.

Multicolor reports it has obtained the services in its camera department of Alvin Wyckoff, president of the west coast International Photographers, the largest body of professional motion picture cameramen in the world; Hal Mohr, president of the American Society of Cinematographers; Tony Gaudio, Harry Perry, Billy Williams, Harry Zech and Elmer Dyer.

A number of industrial laboratories have been leased to produce educational and commercial films in Multicolor.

Devises "Rotary Shot"

Something new in camera ingenuity has been devised at the United Artists studios. Moving in three directions, two of them simultaneously, the "rotary shot" is the invention of William Cameron Menzies, supervising art director.

A giant perambulator-elevator, containing a caged camera platform, was built. The perambulator hangs from a rail attached to the ceiling of one of the giant stages. The perambulator moves in either a straight line or a semi-circle as desired, and the elevator moves up or down at will by a special system of weights and pulleys. It gives a camera range of the entire stage in any direction and from floor to ceiling and requires a crew of six men to operate it.

Fryer Goes Far to Get Still Material for Magazine Pages

UNDER the direction of Elmer W. Fryer, portrait photographer and head of the still department for Warner Brothers and First National, locations for portraits and special art are now sought by these companies in just the same manner the location departments seek out suitable backgrounds for movie scenes.

The expense of this course has been more than justified by the tremendous returns the studio has received in magazines, rotogravure sections and other art publications all over the world.

When a certain kind of art is wanted for certain players a location is sought out and then the players involved, with whatever costumes or props that may be necessary, are taken on the trip, where Fryer does his

Hunting still locations—Elmer W. Fryer and Robert Donaldson

stuff with a camera just as he would in a gallery. Distance is no object when a certain locale is needed. For instance, Fryer made a trip to Sonora, Mexico, with Ann Harding, Loretta Young, and James Rennie, to obtain special outdoor portrait art for "Girl of the Golden West" and "The Right of Way."

The accompanying photograph shows Fryer and Bob Donaldson, of the First National Publicity department and former U. P., picking locations for winter scenes in the high Sierras near Lone Pine, for a special layout of Lila Lee and Sidney Blackmer, who were taken on the 230-mile trip especially for this purpose. More than one hundred special outdoor compositions were obtained in and around this location.

Considering Focus Depth Problems
(Continued from Page 7)

on using a wide film camera is one of surprise at the amount of depth obtainable with the 75 and 100 mm. lenses. In using these lenses for close-ups we have perhaps accustomed ourselves to a lack of depth that was in large measure due to being so close to the object.

Figures 1 and 2 illustrate this point. To simplify the drawings, the depth toward the camera only is shown. In the case of the 100 mm. lens at F/2 focussed on an object 10 feet away the depth is only 3.4 inches, but doubling the distance to 20 feet increases the depth nearly fourfold to 12.8 inches. At 40 feet distance the depth forward would be 50 inches.

Still the depth is little enough, especially at the longer stops. There are times when the point of focus has to be judiciously chosen in order to get the full benefit of depth without wasting it where it is not needed. This is where depth of focus tables may indicate not only limitations but also possibilities of depth that might be overlooked in the heat of battle.

Solving a Daily Problem

For instance, let us assume that we have the problem of photographing a scene with two characters of equal importance, one at 10 feet, the other at 15 feet, from the camera, with a 50 mm. lens. The table tells us that at F/2 we could focus back to 11 feet 4 inches without serious loss of definition of the object at 10 feet. At 11 feet 4 inches the depth back would reach 12 feet 9 inches, which is 2 feet 3 inches short of our goal. Reference to the table will show that to achieve a total depth of 5 feet from 10 feet to 15 feet distance the lens would have to be stopped down to about F/3 and focussed at 12 feet.

The successful application of depth of focus in practice is no haphazard matter, and it will prove even more difficult to handle with wide film. A measure of success is possible by direct focussing on the ground glass by eye if one has time and cares to fiddle around, but consistently to place the zone of good definition where it will do the most good one should really use a tape measure in conjunction with lenses that have been accurately scaled.

It is a great feeling to know as Lindbergh did in his flight over the Atlantic that scientific instruments when carefully checked for accuracy and when scientifically applied to the work at hand do not lie.

Idealizing An Industry's Future
(Continued from Page 8)

industry, and its unbounded progressive influence for the good of such industry and all its individual members, should certainly bring out the different motion picture enterprises into a frame of mind and intention to band together in research for the best of their individual interests.

When we learn of a certain achievement of a certain organization in the line of one of the major problems, and of another in the same line, and of a third, and realize the time and effort and expense of these individual efforts and the limitations of these efforts and achievements, we actually feel it to be pitiful that a combination of all these detail achievements is not available to the whole industry.

The achievement would be so much greater, one baffling problem would have been solved and forgotten in less time at less expense, and confident courage would govern the concerted efforts to solve the next important problem.

It can be done, the industry can be speeded up in its development, the individual enterprises can enter into a new era of prosperity by—

Banding together in Research.

Portable Sound Invading Twoscore Brazilian Cities

A CCORDING to Trade Commissioner Harvey Sheahan of Rio de Janeiro, sound equipment is barnstorming Brazil. One of the leading American distributors of sound equipment has secured a specially constructed portable sound unit, and in conjunction with one of the prominent American motion picture distribution houses is planning an actual demonstration of sound pictures in forty cities of the states of Minas Geraes and Sao Paulo.

This hook-up is intended to show the box office value of such installation to theatre owners in towns where no sound equipment has been sold. It is planned to keep this unit on the road for approximately six months, and the officials of both companies concerned are very optimistic as to probable results.

This is the first attempt of its kind in Brazil to create interest in sound units and sound pictures outside of the ten or twelve principal cities. The equipment is packed in special trunks and can be handled through trucks or on the railroad.

Nearly 7000 Installations

The latest report of installations of Western Electric sound systems throughout the world shows a total of 6870, of which 4549 are in the United States and 2321 in the foreign field, reports W. E.

The installations in Brazil show an increase of 4, from 19 to 23, with the last report. The installations in Spain also have increased substantially, from 25 to 32.

Johnny Bull Uses Scissors

According to statistics published by the British Board of Censors, 71 new feature films (3,000 feet or over) were censored in Great Britain during August, 1930, according to Trade Commissioner George R. Canty, Paris, in a report to the Department of Commerce. Of these 71 films 50 were sound-synchronized and 21 were silent.

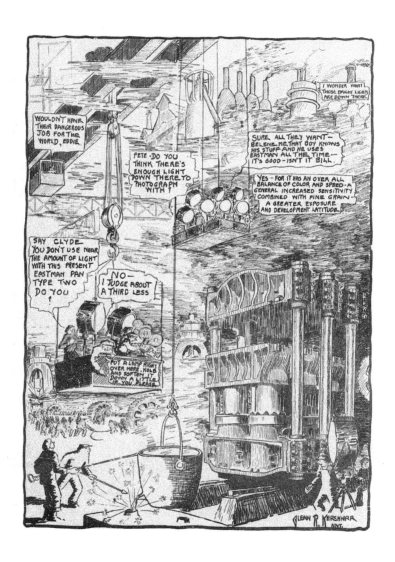

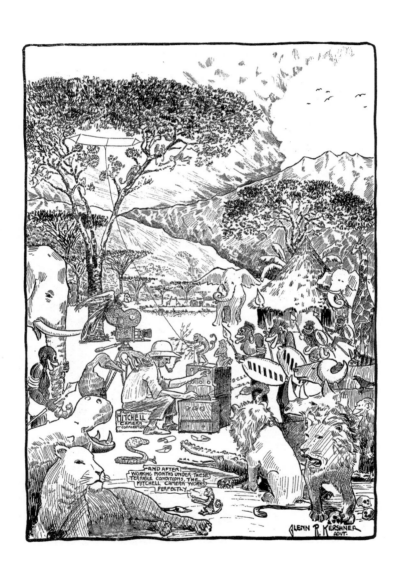

INTERNATIONAL
PHOTOGRAPHER
HOLLYWOOD

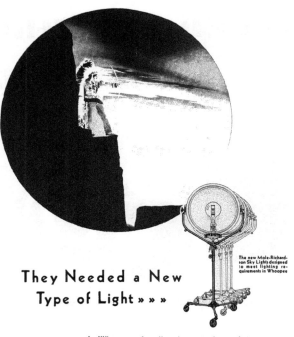

The
INTERNATIONAL
PHOTOGRAPHER

Official Bulletin of the International Photographers of the Motion Picture Industries, Local No. 659, of the International Alliance of Theatrical Stage Employees and Moving Picture Machine Operators of the United States and Canada.

Affiliated with
Los Angeles Amusement Federation, California State Theatrical Federation, California State Federation of Labor, American Federation of Labor, and Federated Voters of the Los Angeles Amusement Organizations.

Vol. 2 HOLLYWOOD, CALIFORNIA, DECEMBER, 1930 No. 11

"Capital is the fruit of labor, and could not exist if labor had not first existed. Labor, therefore, deserves much the higher consideration."—Abraham Lincoln.

CONTENTS

The INTERNATIONAL PHOTOGRAPHER is published monthly by Local 659, I. A. T. S. E. and M. P. M. O. of the United States and Canada

Entered as second class matter Sept. 30, 1930, at the Post Office at Los Angeles, Calif., under the act of March 3, 1879

Copyright 1930 by Local 659, I. A. T. S. E. and M. P. M. O. of the United States and Canada

HOWARD E. HURD, *Publisher's Agent*

GEORGE BLAISDELL - - - - - - - *Editor* LEWIS W. PHYSIOC ⎱
IRA HOKE - - - - - - *Associate Editor* FRED WESTERBERG ⎰ - *Technical Editors*
 JOHN CORYDON HILL - - - *Art Editor*

Subscription Rates—United States and Canada, $3.00 per year. Single copies, 25 cents
Office of publication, 1605 North Cahuenga Avenue, Hollywood, California. HEmpstead 1128

The members of this Local, together with those of our sister Locals, No. 644 in New York, No. 666 in Chicago, and No. 665 in Toronto, represent the entire personnel of photographers now engaged in professional production of motion pictures in the United States and Canada. Thus THE INTERNATIONAL PHOTOGRAPHER becomes the voice of the *Entire Craft,* covering a field that reaches from coast to coast across the nation.

Printed in the U. S. A. at Hollywood, California.

Physioc Returns from Asian Trip

Cameraman on U's "White Captive" Company Graphically Describes Happenings of Six Months' Location Jaunt

LEWIS W. PHYSIOC, art director and chief cinematographer of Universal's "White Captive" company, after an absence of six and a half months on the other side of the world is back home in Hollywood. With him is his second cameraman, Len Galezio.

Physioc, who also is a landscape painter as well as a technical editor of International Photographer, has recovered from any effects of illness that touched him as it did all members of the troupe. Eighteen accumulated pounds bear witness to that fact.

The company carried a complete sound and laboratory equipment, and believes with plenty of justification it is the first time sound has been recorded on so elaborate a scale and so far from home and ordinary facilities.

In charge of the sound was Fred Feichter as monitor and Clarence Cobb as amplifier man. The laboratory work was supervised by Sidney Lund, assisted by George De Mos.

The photographic equipment was topped by a new Akeley field sound camera, sponsored by Electrical Research Products. More than 150,000 feet of Eastman pan negative was exposed. Both photographic and recording results are said to have been satisfactory in spite of the handicapping severe rains, intense heat and excessive humidity.

The expedition was in charge of Harry Garson, and besides those mentioned included Julius Bernheim, business manager; Isadore Bernstein, production manager; Bertha Fenwick, secretary, and Dorothy Janis and Vivianne Cabanne, actresses.

Encounter Perils

The initial itinerary included Vancouver, from which the party sailed on the Empress of Russia; Kobe, Nagasaki, Shanghai, Hongkong, and Singapore. The production was photographed and recorded in the Malay Peninsula, Sumatra, Java and Borneo.

Perils were encountered, as were expected. A typhoon on the outward trip had not been on the list of anticipations, but due to the skill of the modern skipper and the facilities that radio bring to his hand the ship caught only the tail of it—quite enough to satisfy any curiosity entertained by any member of the outfit.

Physioc and Field Glasses

It was during the blow a woman was washed overboard, and it was in the frantic search to locate the unfortunate person that Lew Physioc and his field glasses entered the drama for a number of minutes and held a commanding part of the stage. We'll get to that later.

There were ten days' location in a jungle infested with crocodiles. There were a couple of elephants shot out

Lewis W. Physioc

of a herd and a good tiger was made out of a supposedly bad one. But Physioc seems able to discuss these matters without a visible trace of excitement, which incidentally if at any time he should be known to betray would constitute first-class news for all of his friends.

The photographer of the party admits the trip meant much to him—that in spite of its inevitably attendant difficulties it supplied a sequence in an ideal education of which he had long dreamed.

The journey for him was interesting right from the very start, the day the Russia left Vancouver. For one thing there was an immediate acquaintance with the captain.

One morning the skipper sent to the cameraman's cabin and asked him to come to the bridge. The former told him the ship was approaching the Aleutian Islands, and that contrary to the almost invariable rule the day was remarkably clear. As the ship came nearer the islands the captain called attention to a yellowish flotsam covering the water for miles, declaring he had seen nothing like it in twenty-five years.

The freak was quickly accounted for when a radio message from the Kentucky told of an eruption of an Aleutian volcano. It was not long before glasses revealed the faint traces of smoke rising from behind a mountain range.

Typhoon Rumors

The coaling of the ship at Nagasaki by women deeply impressed Physioc. The ship hardly had cast anchor when it was surrounded by twenty-four scows, each carrying about 200 tons of coal and each "manned" by a crew of thirty, mostly women. For six hours, like clockwork, the series of crews labored as so many machines.

After leaving Nagasaki for Hongkong the passengers heard rumors of

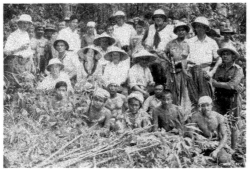

Universal company on location. The young Malay carrying the rifle is a mighty hunter and one of the few natives licensed to possess firearms. He is recognized as holding the local records for killing tigers and elephants. Also he is called upon to act as guide for visiting sultans and dignitaries

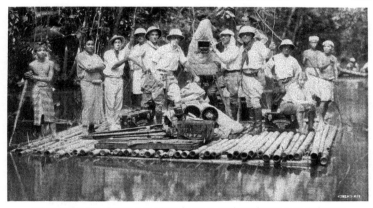

Universal's "The White Captive" troop going on location up the river to Quantan, north of Singapore

a typhoon tearing around in their general neighborhood. The captain explained to the photographer how in these days of radio often it is possible to give the slip to these terrors of the sea—to outmaneuver them, so to speak.

It was not long after when a ship wirelessed that it was in the blow, gave its position and the wind's direction, and the point on the Chinese coast where the storm was expected to hit and rebound to sea like a billiard ball against its cushion.

The captain turned sharply to port and went to sea for a hundred miles, from that point gradually circling to the north. As a result the Russia got only the tail of the blow.

It was during this latter muss, however, when the ship was startled by the cry of "Man overboard!" The wheel was thrown over so sharply the vessel heeled away over and the water poured on to the decks. Then came word it was a woman that had left the ship, but it was impossible to do anything to help her as she could not be seen. A life preserver was thrown over in order to get the drift.

Tale of Two Great Heroes

At this point Physioc, with a glass in his hand at the time the cry was sent out, was fortunate enough to spot the woman in the water. Asking the discoverer to keep the woman in the field of his glass and assigning the first officer to stay with him, the skipper hurried to the wheel to stick with the quartermaster. The ship was maneuvered in the direction of the woman.

Four boats were lowered, but were no sooner in the water than they were blown away from the direction they wanted to reach. Finally the skipper got the ship so that the victim was in

its lee and partly protected from the gale.

All this time the ship's cook had been very uneasy. Finally he announced to the first officer he was going over after the helpless woman. He was very promptly told a man with a wife and kiddies would not be permitted to do any such thing, that some one else would be found. But when no one else was found the cook mounted the rail and dived into the water.

When eventually the cook reached the woman, a Russian of powerful physique, as she must have been still to be on the top of the water, she grabbed her rescuer by the throat and was drowning him. It was at this stage of the impending double tragedy a Chinese sailor quietly slipped over the side and started his battle to reach the two. He succeeded. Between the two men the woman was brought under the lee of the Russia, and a boat was lowered to pick them up.

Over an hour was required to corral the four boats that had been first

(Continued on Page 38)

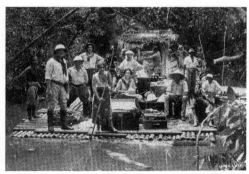

On the river in the thick of the jungle. It is near this spot where a big snake was discovered asleep in a tree. Nothing is mentioned about anybody waking him

American Film Exports Increasing

Preliminary Figures for Nine Months of 1930 Show Footage Gain of 8,900,540 Feet Over Same Period of 1929

By C. J. NORTH
Chief of Motion Picture Division, Department of Commerce

PRELIMINARY figures of American motion picture exports for the first nine month of 1930 show an increase of 8,900,540 feet and a value increase of $719,212 over exports for the corresponding period in 1929.

The United States shipped to all markets of the world during the 1930 period 210,037,969 linear feet of motion pictures with a declared value of $6,168,703, as compared with 201,137,-429 linear feet valued at $5,449,491 for the corresponding period in 1929.

This 1930 total incidentally is the largest since the Motion Picture Division began to make compilations on the subject back in 1925.

The largest increase was in exports of positive motion pictures, which amounted to 201,320,492 linear feet valued at $5,166,805 in the first nine months of 1930, as against 195,018,280 linear feet valued at $4,610,723 for the same period in 1929.

Increase in Negative

Exposed negative film also shows an increase, the figures for 1930 being 8,717,477 feet with a declared value of $1,001,898, as against 6,119,149 feet valued at $838,768 for the 1928 period.

It is interesting to note that of the motion picture films exported from the United States during the first nine months of 1930 5,208,810 feet of negatives and 132,239,581 feet of positives were sound synchronized.

As 1930 is the first calendar year in which sound films received a separate classification from silent films in our export statistics, no comparison in this regard can be made with the 1929 period.

Since the introduction of sound and

dialogue film Europe has become by far our largest quantity market at the same time maintaining its position as our best source of revenue.

For the first nine months of 1930 American exports of motion pictures to this region reached the unprecedented total of 93,537,822 feet, or not far below half of our total film exports.

This figure furthermore shows an increase of nearly 20,000,000 feet more than for the 1929 period which

	First Nine Months of 1929		First Nine Months of 1930	
	Linear Feet	Value	Linear Feet	Value
Europe	74,366,404	$2,324,219	93,537,822	$3,212,341
Latin America	57,695,969	1,438,356	56,851,729	1,362,808
Far East	47,049,888	1,080,348	38,878,767	918,281
Canada	10,609,548	462,734	12,534,397	501,469
South Africa	3,459,097	87,155	2,608,288	70,805
Other Countries	7,956,523	106,679	5,626,966	102,999
Total	201,137,429	$5,449,491	210,037,969	$6,168,703

United Kingdom Leads

The United Kingdom remains by far our leading individual film market, showing an increase of nearly 10,000,000 feet over its record 1929 figures. France, which stool ninth in the 1928 period and seventh in 1929, went to second place in 1930 both in Europe and in the world. Her total of 17,318,513 linear feet is well over double her film importations from the United States during the first nine months of 1929.

Germany, our third largest market in Europe, has declined from fifth to sixth place as a world market even though our exports of films to Germany for the 1930 period were nearly 1,000,000 feet greater than in the 1929 period.

Spain appears as our fourth largest European market and the ninth in the world. This is the first time this country has been in the first ten of our world markets.

The three countries in Latin America which almost invariably appear among our ten leading film markets

in turn topped 1928 by nearly 25,000,-000 feet.

As a matter of fact, Europe accounts for something more than our total gain in film exports, for both Latin America and the Far East showed declines from 1929. The former, which was our largest quantity market as recently as 1928, fell about 850,000 feet below its 1929 figure, while the Far East total declined just over 8,000,000 feet.

Australia Falls Off

This latter was due almost entirely to the falling off in film exports to Australia. Of other regions, Canada showed a gain of nearly 2,000,000 feet and South Africa an almost equivalent loss.

The following table gives in detail the quantity and value of American film exports to the various regional divisions of the world:

are, in that order, Argentina, Brazil and Mexico. This year is no exception to the rule, but Argentina has dropped from third to fourth, though there is only a very slight decrease in our film exports to Argentina. Brazil has dropped from fourth to seventh, while Mexico remains eighth.

Exports of films to Brazil declined over 2,000,000 feet, while similar exports to Mexico showed an increase over a little under 1,000,000 feet.

Australia, which led the world as a quantity market for American films from 1925 through 1928, continued the decline which set in for the nine months period of 1929, but nevertheless went up from fourth to third place in the markets of the world.

India Holds Tenth Place

The only other Far Eastern country which stands among the first ten markets for American films is India, which as for the same period last year holds tenth position.

The following table gives details of United States film exports to the leading individual markets of the world:

United States Exports of Films to Individual Leading Markets

Countries of Destinations	First Nine Months of 1929			First Nine Months of 1930		
	Rank	Lin. Ft.	Value	Rank	Lin. Ft.	Value
United Kingdom	1	23,111,066	$1,049,760	1	33,038,668	$1,708,843
France	7	8,022,510	199,863	2	17,318,513	429,703
Australia	2	21,133,317	485,652	3	15,538,612	393,303
Argentina	3	14,829,125	368,344	4	12,640,569	344,935
Canada	6	10,609,548	462,734	5	12,534,397	501,469
Germany	5	11,532,705	354,501	6	12,083,870	321,075
Brazil	4	12,673,107	308,807	7	9,500,083	198,842
Mexico	8	6,739,505	162,150	8	7,304,112	193,769
Spain	9	5,162,151	112,294
India	10	5,031,522	124,194	10	5,029,178	128,490

Reverse Side of Ledger

For the first nine months of 1930 American imports of negatives amounted to 1,746,114 linear feet with a declared value of $221,932, as against 1,926,749 feet valued at $243,-254 for the same period of 1929.

For these periods the imports of positives were respectively 3,407,355 feet valued at $163,563, as compared with 3,764,797 feet valued at $130,729.

In the case both of negatives and positives the total imported during the first nine months of 1930 was less than during the first nine months of 1929.

During the first nine months of 1930 American exports of films sensitized but not exposed reached a total of 60,098,922 linear feet valued at $1,341,543, as compared with 44,965,-833 feet valued at $980,202 for the first nine months of 1929.

Coincident with this gain there was a tremendous decline in the amount of non-exposed film imported. Whereas for the 1929 period the amount reached a total of 273,139,357 feet valued at $3,472,079, in the 1930 period this fell off to 103,095,089 with a value of $933,444.

Foreign Competition for American Pictures Grows Keener with Sound

FOREIGN competition for American motion picture films abroad, inconsiderable in the silent film days, is now assuming substantial form, in the view of the Department of Commerce's Motion Picture Division. The view was presented to the Society of Motion Picture Engineers, at its recent convention in New York, in a paper by C. J. North and N. D. Golden, chief and assistant chief of the department's subdivision, read by Mr. Golden.

"There is a widespread feeling that European producers are adapting themselves more readily to sound than they did to silent film production," said the paper, citing the increasing number of foreign sound-equipped theaters to show it is on that line the competition will have to be fought out.

"From less than 650 sound equipped theaters in the early autumn of 1929, wiring has gone ahead by leaps and bounds, with the result that Europe, exclusive of Russia, now presents a grand total of around 4950 theaters.

Vast Increase

"Note England, for example. Its total for this time last year is set at about 400 and this has now increased to 2600. France then had 20 sound equipped houses. Now it shows nearly 350. Germany with 30 sound houses now has nearly 950. Italy has increased from 30 to 120 and Spain from 4 to 145.

"It must be remembered that the wired theaters include without exception all the largest and best equipped theaters—the ones, in fact, which supply the bulk of the revenue to the America picture companies.

For the coming year, it was revealed, German companies announce no less than 135 sound feature pictures, French companies plan 92, and between 80 and 100 will probably be made in England. In addition, sound film projects are under way in Italy, Austria, Holland, Denmark, Sweden, Norway, and Spain; and "from far-off Athens comes news that Olympia Film, a Greek producing firm, is planning the construction of a sound film studio."

More Than Holding Own

In competition with these films in foreign languages American produc-

ers are expected to make about 150 films in German, French, and Spanish this year.

"American scenarios, technique, and directorial ingenuity will remain," the paper continued. "While it is questionable whether we again will get as large a return from non-English-speaking markets as in the silent film days, there is every prospect that we will more than hold our own even in the face of the foreign product."

American pictures are prepared for the foreign market by three methods; Mr. Golden indicated—by writing captions on the screen in the appropriate language, in pictures which have music predominant over dialogue; by "voice doubling," which means using the same picture but with the voices of foreign speakers substituted on the sound track; and by actually doing the picture in the appropriate language.

Calcutta Exhibitors Go to Sound to Hold Customers

A REPORT comes from Assistant Trade Commissioner Wilson C. Flake, Calcutta, India, that Calcutta is installing more talking picture houses. Faced with a loss of customers who now patronize the talkers, three more theatres in Calcutta have decided to follow the lead of their competitors and install American sound equipment.

Indeed, so popular have American talking pictures become that the New Empire Theatre—the only theatre in Calcutta attended by Europeans where stage shows are produced—is among the three that are changing over to sound pictures.

The New Empire Theatre started showing pictures Nov. 1. The Madan Theatre, which hesitated to change from silent to sound pictures because of its investment in a pipe organ, will be wired soon, while the Crown Theatre has just started running talking pictures.

The Crown is the first picture house in Calcutta patronized exclusively by Indians to install sound equipment, which is evidence that the Indians are pleased with American talking pictures.

Smaller Australian Houses Ask Film Duty Be Removed

Indications pointing to the gradual decrease in the importation of silent films in Australia have caused exhibitors and theatrical employees to ask the Federal Government to consider the complete abandonment of import duties on silent prints. It is hoped this move might cause distributors to continue to import silent films, otherwise unwired houses will require sound equipment or they will have to close up.

The present duty of 4d a foot plus the primage brings the total up to approximately 5d a foot, making the importation of silent films unprofitable for the distributor to handle.

There are about 900 houses as yet unwired and only a small percentage of this total can afford to wire. One reason for the difficulties of exhibitors of silent pictures is the fact that their houses, particularly in the country districts, have only a few performances weekly and returns do not justify sound equipment.

Foreign Musicians Banned

The Australian Minister for Home Affairs has stated that steps have been taken to check the importation of foreign orchestras for pit and stage performance in Australia. The talkers, in addition to the present depression, have forced many musicians out of their jobs, and it is understood these steps to prohibit the entry of foreign bands have been taken to prevent further unemployment among local musicians.

Two German Plants Install

The Jofa and Staaken studios in Germany will soon be equipped with sound recording apparatus says a Berlin message. One Tobis and three Klangfilm sets are to be installed in the Jofa studio and the installation will be completed before the end of the year. No information is available yet as to the apparatus to be installed in Staaken.

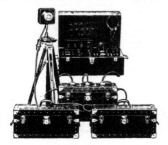
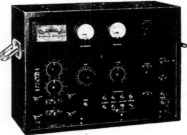

News Reel Ace Temporarily Acting

Ray Fernstrom, Hero of Bremen Interview, During Recovery from Injury Comes West for Character Work

RAY FERNSTROM, ace news cameraman, and member of Local 644, has temporarily retired from behind the camera and plans to take up character work out in front of it. The cause of this sudden change in his attitude toward the lens or his relationship to it was an accident which resulted in a serious back strain, an injury which brought from the cameraman's physician strict orders to juggle no camera until his recovery was complete.

So it is that Fernstrom for the present is on leave of absence from Paramount. He is in Hollywood aiming to employ an entirely different string on his thoroughly seasoned bow, a string that incidentally is well trained as the accompanying pictures photographed by Frank Tanner will demonstrate.

In the ten years Fernstrom was connected with the news reels he had many experiences, thrilling and otherwise. In the former category, however, none quite measured up from the standpoint of the spectacular or the dangerous as did his pushing through to Labrador unstopped by northern storms to be the first to greet the German airship Bremen and its intrepid flyers. It was a feat and a beat sizable enough to last the ordinary human a long lifetime. Furthermore, it brought prestige not only to him but to Paramount News, then established less than a year and naturally fighting hard for recognition in a field difficult to bore into.

But let's call in as a contemporaneous witness to Fernstrom's great exploit No. 7 in Paramount's "Unsung Heroes" series. After adding the news film reached New York April 20, 1928, we'll let Paramount News of that period tell the tale in its own interesting way:

Paramount News Has Floor

On the biggest news story in recent years, Ray Fernstrom, a Paramount News cameraman, flew 2400 miles through blizzards and over Canadian mountains to make the first moving pictures of the transatlantic plane Bremen and its German crew after they were forced down on the Labrador coast. And while the pictures were being shown throughout the United States every other news reel representative was still icebound nearly a thousand miles short of Greenley Island.

The scoop which stands unparalleled in news reel history was accomplished in spite of cold, scanty food, a sleepless week, and forbidding weather conditions. More than fifty newspaper and picture men with a dozen airplanes were fighting to follow the trail that Fernstrom had managed to blaze.

Planes were being recklessly cracked up in an effort to break through, the newspapers were bidding as high as $25,000 for interviews with the flyers, fist fights were frequent, the double cross and the triple cross were repeatedly charged, and even guns were drawn to protect planes and pictures. It was in the face of competition such as this that the Bremen pictures were made.

Determination Won!

Fernstrom had been in Montreal on another story when the first flash came through that the Bremen had landed safely on Greenley Island. By train, auto and sleigh he at once headed down the St. Lawrence river, arriving at Murray Bay, as the New York newspapers described it, "a slim blond young man of Swedish descent, sloshing about among the melting ice in knickers and low shoes, but frantically clutching a camera and a safety razor." Once at Murray Bay he found a place on the floor of the Canadian Trans-Continental Airways garage to sleep and set to work on the problem of getting into Labrador.

Two planes were being sent north by the Canadian Air company and places on board the one plane that was to be used by the newspapermen were being bid for furiously over the long distance telephone from New York and then being rebid by the newspapermen who were fast arriving at Murray Bay.

Fernstrom managed to secure the last of the four seats available and

Ray Fernstrom, in character, photographed by Frank Tanner

in spite of the general juggling that followed he retained it by the simple process of never letting the president of the company out of his sight.

Paramount along with the other news agencies had been rushing the other men and planes north, and by the time that Fernstrom took off for Greenley Island they had Paul Wilkerson from the Norfolk office at Quebec, Charles Snyder from the Boston office with a plane at Montreal, and Harry Cuthbertson from the New York office with a plane and a special train at Murray Bay.

Some forty other newspapermen and cameramen also had arrived there by every possible means available and half a dozen planes were lined up at Murray Bay on the slush ice to see Fernstrom off, but not daring to follow.

Perilous Journey

On the first attempt of the newspaper plane to get away the pilot, Romeo Vachon, was forced to turn back after running sixty miles through a blizzard, but on Tuesday morning they took off again, and after hours of bucking head winds, flying blind through snow and frozen fog, they won through to Seven Islands, 500 miles from Greenley.

Here they met "Duke" Schiller, the famous Canadian pilot, returning in the first of the Canadian Trans-Continental Airways planes with Major James Fitzmaurice, and Fernstrom, after making several hundred feet of pictures of him, managed to get Fitzmaurice to carry the film on down to civilization the following day.

The next morning at dawn Vachon took off again, this time with only Fernstrom and a still photographer on board, the two newspapermen who had made the trip that far deciding to remain at Seven Islands. After six hours of rough flying they reached Greenley Island and landed on the ice near the crippled Bremen.

Here Fernstrom made his sensational pictures and incidentally had the first professional interview with the two German flyers that the outside world had managed to secure.

Rushing Pictures to Lab

An hour and a half after their arrival Fernstrom and Vachon waved goodbye to the Germans and hopped off for Murray Bay and New York, 1500 miles away. They were forced down at Natashquan after 300 miles of flying, barely averting a crash as their plane skidded in among some tree stumps.

The following morning they managed to get away again, but were again forced down at Sacre Coeur, a hundred miles short of Murray Bay, and had to spend another night. The following morning they got through to Murray Bay, where the newspaper and picture men's camp was situated and where contact with the outside world was maintained.

Five minutes after Fernstrom had hopped out of the plane piloted by Vachon his pictures were started off for New York on board one Paramount News plane, while Fernstrom got away on another. Both planes came through in record time and were met at Curtiss Field by an am-

THE camaraderie that exists in the United Artists studio was splendidly demonstrated following the bereavement of Ellis W. Carter, a film loader at that plant. The young man received word of the sudden death in Seattle of his father and of the date of the funeral services.

After a speedy conference and even more definite and generous action on the part of his associates high and low Ellis was told he need have no concern as to his being able to get away to attend his father's funeral.

It was at this point he was further informed that Douglas Fairbanks, in order to make sure of Ellis' timely arrival, had arranged passage for him on the Seattle plane leaving within a few hours.

Also there came an official intimation that not only would his place be waiting his convenient return, but that during his absence he would be carried on the pay roll as continuously on duty.

phibian. This picked up the film, landed in the Hudson river near the laboratory, and from there the film was rushed ashore by a speed boat.

Before Fernstrom could reach the city from Curtiss field the film already was being screened and dispatched to theatres throughout the country.

And once in New York, Fernstrom found that he himself had become a news story, that a host of reporters were waiting to interview him on his adventures and his talk with the German flyers.

The result was that every newspaper in New York carried a story on Fernstrom's scoop. They all used Paramount News photos, some running full pages.

Silvan Harris Named Editor
By Governors of Engineers

The board of governors of the Society of Motion Picture Engineers announces the appointment of Silvan Harris as editor-manager. Harris has a background of many years of technical editorial and scientific work and left a position with the Fada Radio Corporation to accept this new place. Before joining Fada he was managing-editor of Radio News for two years and served for several years as director of radio research and design for the Stewart-Warner Speedometer Corporation.

He is a member of the Radio Institute of Engineers, American Institute of Electrical Engineers, American Physical Society, Optical Society of America and Radio Club of America, and is a graduate of Electrical Engineering, University of Pennsylvania.

Harris' chief duties will be to edit the monthly journal published by the society and carry on the routine work of the offices of the secretary and treasurer.

John Arnold (left), chief of M-G-M camera department, and Clyde De Vinna of the same staff examine the new professional 35 mm. QRS-De Vry camera. The instrument has sliding turret using 50 mm. F 3.5 and 6-inch telephoto F 4.5. There are four speeds—8, 16, 24 and 64 frames per second

Grooming Camera Battery for 1931

Technicolor Photographic Staff Under the Leadership of Ed Estabrook All Set for Company's Biggest Year

By IRA B. HOKE
Associate Editor

Ed. T. Estabrook

HERALDING the greatest of seasons in color cinematography, Technicolor's staff of artisans are grooming several score of improved cameras for the opening of the studios of Hollywood.

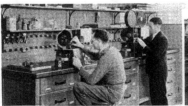

Ira Hoke

Culminating fifteen years of research, including several years of actual production, during which time some of the finest plays and operas have been successfully produced in scintillating natural color, the company's present activities presage a period which will surpass even its own efforts.

Ed T. Estabrook, chief of the camera department, assisted by his coterie of field and laboratory color-camera experts, has evolved a remarkably efficient series of working units possibly equaled by no other camera department in the world. These units are composed of men, cameras and equipment, each of which represents a complete staff capable of photographing any production from beginning to end. These individual staffs are operated on a bureau system.

The details of production day by day are reported by unit heads to Estabrook, who condenses such received information on a series of classified statistical charts before presenting it to the executive office. The chiefs thus are enabled to determine at a glance the actual working efficiency of their most essential factor, the photographic organization.

Under Estabrook's present program of expansion not only has his bureau system been enlarged but the actual working equipment has been improved to a higher degree of mechanical efficiency. Obsolete equipment and ideas have been discarded. Fresh ideas and new machinery breathe the keynote of this modern and efficient department.

Upon entering the camera section at the Seward street plant one comes first into the big assembly room where long benches and cabinets house equipment assigned to various units. Each cameraman has a work bench and locker space for the proper care and storage of equipment under his assignment. At one end of this assembly room opens the fireproof camera vault.

Following Camera Through

The main assembly room is centrally located. Directly connecting with it through fireproof doorways lie the chief cameraman's office, machine shops, camera testing laboratory, developing and drying rooms, and the prism department.

Let us trace the course of a camera through this series of departments at the end of a day's work. Upon being unloaded from the camera car it goes first to the room where a series of mechanical tests are made under actual photographing speeds and conditions. While the film thus made is being sent through the rush developing laboratory in an adjoining room the camera is turned over to the lens experts, who thoroughly test calibration and focus of each of its several lenses.

Should no variation from normal be discovered, the camera is sent to the prism room, where the alignment of its optical system undergoes a microscopic test. Finding no abnormalities there, the camera is set out for a thorough cleaning and polishing. When finished the instrument is then placed on its individual rack in the fireproof safe.

It may here be mentioned that every camera used in production must go through this series of tests each night before it is again sent to the studios. This is just one of the many precautions taken to insure the producing company against loss of time and money due to imperfect camera equipment.

Space will not permit detailing the operation of each of the various special departments, but no visit to this institution could be complete without mention of the lens laboratory and machine shop.

Lens Rigidly Tested

Under the supervision of Louis Mellor, formerly of the Bausch and Lomb Optical Company, each lens to be used in the color cameras is subjected to rigid tests for color and op-

(Continued on Page 40)

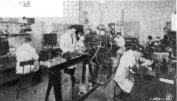

A Corner of Technicolor's Precision Departments

In Memoriam

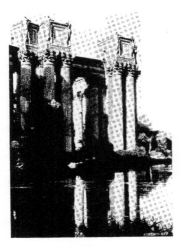

Sergeant Gorman A. Charles, official Signal Corps photographer of the Ninth Corps area, United States Army, and first lieutenant Signal Corps Reserve—a soldier and a man among men—died suddenly in Honolulu Nov. 10 two hours after arrival there on assignment. Underneath is a reproduction of one of the sergeant's shots—of the monument and the river under the shadow and by the side of which at Arlington he will sleep the long sleep.

Geoffrey D. Heriot, artist and gentleman—quiet, retiring, and affectionately known to his friends as "Pop." He went to M-G-M as one of the old time L. B. M. regime. His death came Nov. 2 after an illness of several months.

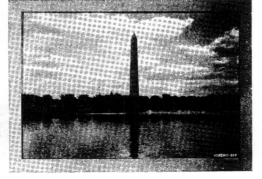

 # Cream o' th' Stills

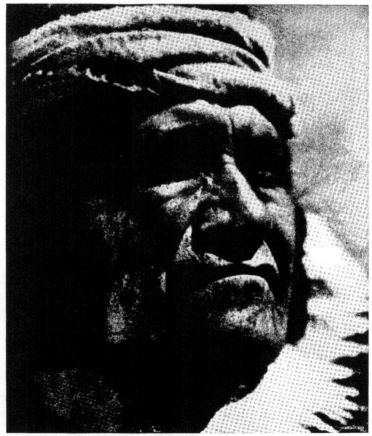

Leon Shamroy contributes this portrait of "El Cacique de Acoma," classic featured high priest of the Acomas, a tribe of agricultural Pueblo Indians of purest strain.

 # Cream o' th' Stills

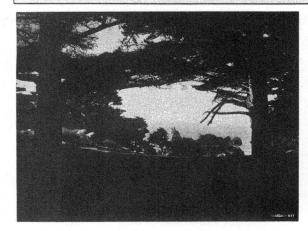

Robert Coburn picks this gem out of a collection made while shooting in silhouette a Bruce scenic near Carmel, a California coast community famed for its artist colony. The evidence is here that the Carmelites hold no monopoly on artistry.

And from thousands of miles across the Pacific and below the equator comes this bit of Tahite, reminiscent of "White Shadows of the South Seas," prepared for us by Bob Roberts.

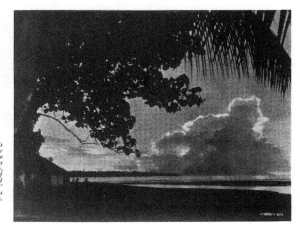

 # *Cream o' th' Stills*

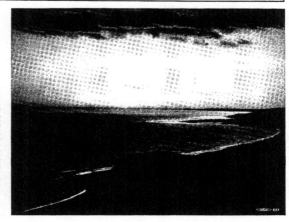

This splitting of the sun was accomplished by W. J. Van Rossem, standing on an elevation behind the beach of Malibu, in which community reside many persons who contribute to the screen entertainment of the world at large but here cut off from that world by even the absence of telephones.

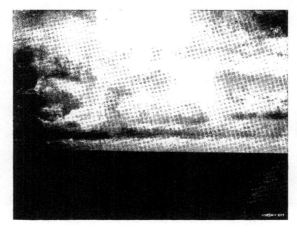

Lewis W. Physioc, one of the technical editors of International Photographer, when on location in the Orient sent regards to old friends and this picture taken "At early morning in the China Sea." After seeing it we may know better just what Kipling had in mind when he wrote those explosive concluding lines in the chorus of "Mandalay."

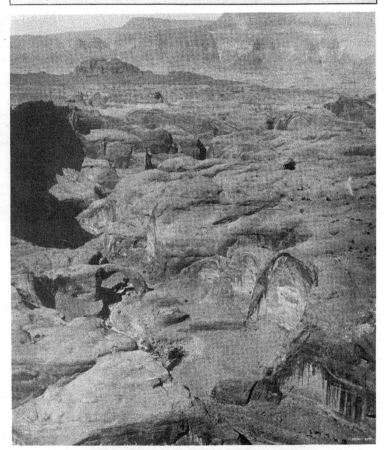

In the left center will be noted the Rainbow Natural Bridge, its huge bulk almost lost in the surrounding gigantic volcanic formations. It was photographed recently by Frank King during a 700-mile air hunt for news pictures.

Industry Must Look Truth in Face

Money Devoted to Added Exploitation with Its Unjustified Adjectives Should Be Devoted to Improving Product

By CRITICUS

THE cycle of marked reduction of exchange of financial values is again upon us and commercial activities are sluggish. All business enterprises throughout the country are suffering.

So is the motion picture industry. Managements are naturally worried and are casting about frantically for effective means speedily to improve the balance sheets.

Studio heads are called upon by the financial interests, usually some thousands of miles away, to prove their managerial efficiency under these emergency conditions, and ultimatums are floating around in the heavily charged atmosphere.

No wonder they are mentally disturbed, no wonder they try expedients in the hope of momentary results.

No wonder they have not got the courage of their conviction, if such a conviction they do have, that there are more fundamental defects in their organizations than they had to admit while money came in easy.

What is the trend of their present remedial efforts? First an increase of the already top-heavy advertising budget.

Discounting By Public

The advertising art in the motion picture industry has, however, already overreached itself as far as trusting reaction of the public is concerned.

Superlative statements are the rule and have been so long that the public by sad experience discounts the from the. beginning—because the screen presentations are in the average far below the advertised value.

Advertising is one of the most potent supports of honest business, but the goods delivered must bear out the lure of the advertising. If not, the reaction of the public is just the opposite to what it is desired to be.

Money spent that way for advertising is thrown away money, does more harm than good and injures the pocketbook, the reputation, the whole ethical standing not only of the individual distributor using such business methods but the whole industry.

The irrefutable dominance of the ever existing law of supply and demand mercilessly determines the purchase price according to the quality of the offered goods.

Instead of throwing away large sums of money for futile, harmful advertising, money and effort should be applied in properly co-ordinated balance to improve the goods.

Public Will Spend if—

Regardless of so-called hard times the public always spends the necessary dimes for real good entertainments. It is a fact of historical statistics that the harder the times the more money is spent on relaxing entertainment. But it must be really absorbing entertainment and not a disappointment.

Good entertainment has been offered to the public before. It is not now. The producers claim it is due to a dearth of good stories. Not so. The stories now average not worse than they did before. It is the screen presentation which deteriorated. Excellent silent pictures drew crowds and even a poor plot was enjoyed because the screen beauty was pleasurably appreciated.

Sound came. It was forced upon the screen at a time of its logical evolution when it injured rather than improved the screen presentation.

The actual blunt facts are that we have a combination of unsatisfactory photography with unsatisfactory sound effects, which even the best story cannot efface.

This unsatisfactory total effect is here, and there is no remedy except to make best use of what we know we can do well, i.e., excellent photography and make use of sound only where its present state of perfection is a harmonious chord and not a detrimental adjunct.

Sound Will Improve

Sound effects improve continuously under the inexorably slow progress of logical evolution, and their welcome reception by the public will automatically increase with their inevitably increasing perfection.

There is at present no heroic measure which can overnight change the total value of story, photography and sound.

Such line of thought and deduction, however, does not help the producer over the hurdles—now.

There is no immediate help in useless advertising, there are no immediate remedies for radical improvement in production.

There must be realized, however, that it is never too late to mend. Mend now. You cannot obviate the patch, but you can prevent the hole becoming bigger.

There is, however, some help in the offing, and that is the old, old but nevertheless true means, to improve the ledger balance by decreasing expense when income becomes smaller. Producers realize this axiom, but

how do they try to put it into practice?

They make strenuous efforts to instill more working energy, more co-operation, more harmonious efficiency into their organization.

Is that not an admission that such conditions, necessary for any sound business enterprise, are lacking in their organization, of which they have been the authoritative and also the responsible head and final arbiter?

Is it not a fact that while money was easy it was easily spent in the wrong place and places?

Money Spent Easily

This is not meant as an arraignment of wilful inefficiency. God forbid. The author has too much respect and admiration for the honest business ingenuity of the responsible heads of studio organizations to have any such thought lurking in his mind.

It seems, however, to be a fact that the average producer made money comparatively easy and had no reason or cause to probe the effectiveness of his organization as thoroughly as present depressed conditions now ought to force him to do.

Passing the Buck

The personal, ever existing apprehension of most employees that a discontinuance of their services may be visited upon them following any mistake, the knowledge that others in the organizations are for some mysterious reasons of often arbitrary and destructive influence and power and recompense—such nervous conditions brought about by design or necessity that carbuncle of studio organizations, the "buck passer," the "yes-man."

What are the results? The executive is surrounded with and has to rely in his decisions upon a personnel which is misleading him.

He may feel that his long years of experience in the motion picture industry have given him an inside knowledge which he can rely upon.

We may, however, compare him with a man or woman whose life partner does wrong. Everybody knows it but the suffering mate.

No wonder the executive loses his perspective under the guile surrounding him.

To cut expenses is certainly necessary now, but was or should have been good business before.

How radically it can be done without decreasing production efficiency or better still by increasing it would be a genuine surprise to the financial interest if it would be done by scaling recompense according to merit and performance only.

It would bring beneficial results in this instance just as unfailingly as a matter of lessening expense as it would increase income by offering to the public a more harmoniously prepared and therefore more satisfactory entertainment.

Highlights of Progress Committee's

Fourteen Men of Notable Rank in Industry's Scientific and Mechanical Branches Review Technical Advances

A T ITS recent convention in New York the Society of Motion Picture Engineers was presented on October 20 with the foregoing abridgement of the highlights of the progress committee's report. The December issue of the Journal of the society will carry the complete story.

The report covers the whole field of the motion picture, independent of the purely production side; rather it traverses the wide range of activities that make the motion picture possible as a form of entertainment, tells of the work of men whose names the public never reads among the screen credits.

The complete personnel of the committee is M. Abribat, J. A. Ball, J. Boolsky, W. Clark, E. R. Geib, J. B. Engl, R. E. Farnham, H. B. Franklin, K. Geyer, A. C. Hardy, R. C. Hubbard, G. F. Rackett, S. K. Wolf, G. E. Matthews, Chairman.

Status of Wide Film

Plans for ultimate adoption of wide film have continued throughout the summer as several producers were known to be engaged actively in further experimentation. According to reports from production centers, negatives for several pictures have been made on wide film as well as on the usual 35 mm. width.

Agreement has been reached among leading producers on perforation standards and sound tracks, but there is still a division of opinion on total width and size of frame. One possible solution of the projector problem is to make the negatives on wide film and make reduced prints on 35 mm. for showing on the present standard projector fitted with a shorter focal length lens.

A transparent paper support which can be coated with either a positive or negative emulsion was placed on the market and the claim advanced that it was suitable for cinematograph film. Another innovation was the introduction of a film containing a layer of aluminum foil 0.005 mm. thick.

The bulk of the leading studios of Europe had installed sound recording channels by July, 1930, one of the finest being located in a studio at Wembly, England. Services of American engineers were in demand by several Russian firms to assist in establishing an expansion program.

Eighteen Types of "Blimps"

A report was published during September giving the final results of a comprehensive survey of the methods used to silence cameras in the Hollywood studios. Eighteen types of equipment were tested. One very interesting "blimp" was constructed of a cellulosic composition, the sections of which were so tightly fitted as to render the housing both airtight and watertight.

The investigation dealing with methods of silencing arc lights for sound motion picture work mentioned in the previous report of this committee has been continued and its results published. Data on test made in 14 studios and reports from the Los Angeles Bureau of Power and Light are included.

One improved type of arc lamp contains a special built-in choke coil which takes care of commutator ripple. The intermittent feed has been eliminated, non-grinding gears installed, and a new type of positive carbon used which is said not to squeak during feeding of the arc.

Improvement has also been noted in high wattage incandescent lamps. Such lamps must necessarily be subjected to rough usage and it has been a problem to make these sufficiently strong for such service.

England Using Soft Lights

A new system of bringing the current into the bulbs of 5 k.w. and 10 k.w. lamps has greatly increased their strength, reduced their heating tendency, and permitted the introduction of any amount of current. In the method used the glass does not come in contact with current-carrying parts.

Incandescent lamps are stated to be in almost universal use in sound studios in England. For overheads and banks it is general practice to use 6 to 12 lamps (1500 watt) in a fan cooled single aluminum reflector. The average lighting of a set is 400 foot candles. The use of tungsten powder for cleaning bulbs is not generally favored.

According to reports from the Motion Picture Division of the Bureau of Foreign and Domestic Commerce, the demand is increasing in foreign countries for sound pictures in native languages. The plan of dubbing foreign lines in pictures made with English speaking actors is being discouraged.

Sound film records made in Eng-

Society of Motion Picture Engineers

Report to Convention of Engineers

Wide Film, Recording, Silencing Cameras and Arcs and Developing and Printing Just a Few of the Subjects Treated

land at the Wembly studios are identified by photographing at intervals on the film, a lantern slide carrying the scene and shot numbers. Each half minute figures up to 10, in Morse code, are printed on the side of the film opposite the sound track. Corresponding figures are recorded on the picture negative in the space reserved for the sound track.

By controlling the ratio of direct sound to reverberation Maxfield states that the true illusion of nearness or distance of the speaker can be secured. There is a critical range of 50 steps of the total 120 sensation units within which sounds may be reproduced pleasantly in theatres.

An improved type of flashing lamp has been devised by Zeta which is stated to have fifty times the life of older types and to be of much sturdier construction. Recordings of nearly 25,000 feet have been made.

Beam Microphone

A beam microphone which may be focused on one speaker has been perfected by a Hollywood sound director.

Balantine has studied the effect of cavity resonance on the frequency response characteristic of the condenser microphone. Two effects causing increases over the uniform response of condenser microphones are: (1) increase of pressure on the diaphragm, and (2) acoustic resonance in the cup-shaped recess of the ring stretched over the diaphragm.

Two large equipment manufacturers during the summer of 1930 announced lower prices on sound-on-film equipment and the option of purchasing the general installation without the disk. One producer who supplied disk records exclusively began early in the summer to supply sound-on-film features as well.

It is considered by some exhibitors that film records "wear" better than disk records and have noticeably less of a metallic note when played. There are 3500 theatres, however, equipped only for disk records, and it will undoubtedly require at least two years to effect a complete changeover.

Russia Progressing

A system of recording being developed in Russia employs an oscillograph with one thread and is stated to be suitable for either variable width or variable density recording. Another sound-on-film process utilizes a sound print having the record engraved in the edge of the film.

A saffire roller pick-up device is employed in the reproduction. A roll of clear celluloid is engraved in preparing the master record and this record is then transferred to the sound print. No stages of amplification are said to be necessary in reproduction.

A report was published the latter part of May, 1930, and a second report in September, 1930, giving the results of extensive tests made on acoustic materials for set construction. Reverberation times were measured with the new materials as against times for an empty room. The greatest absorption coefficient was found with Zonolite plaster brushed 1/16 to ¾ inch thick over burlap or chicken wire.

A committee made up of representatives from the Board of Fire Underwriters, the New York Bureau of Fire Prevention, and the Motion Picture Producers Association has drawn up a code on studio and laboratory practice, the exchange and the theatre. It gives specifications for the handling of film from its development to the delivery of finished print.

New Developing Machines

Further information has been published on the Hunter-Pierce developing machine which was mentioned briefly in a previous report. The machine consists of horizontal tanks arranged one above the other with a vacuum system drying compartment on top. It processes 12 separate strands of film simultaneously at the rate of 10 feet per minute and has a capacity of about one million feet of film per week. The film is fed into and taken off the machine from the same end.

During processing the film is twisted constantly and is so exposed that any breaks can be repaired very quickly. Lasally has also published a description of two development machines, those of A. Debrie, Paris, and of Geyer-Werke A.-G., Berlin.

The former apparatus is a twin machine each part of which works independently. The developing and fixing end is located in a dark room, the washing, dyeing and drying end in a light room. Film passes in loops through the various baths at the rate of 1600 ft. per hour. The Geyer machine is of somewhat similar design.

A slowly growing appreciation of the value of sensitometric control in motion picture film development has been apparent since the advent of the sound motion picture. It is also understood to be a general practice in the larger laboratories to make duplicates of the bulk of negatives as finally edited.

In Session in New York, October 20-23

Continuous Printer

A new continuous printer has been designed for sound film records which works at 120 feet per minute. Contact is established by a curved gate with a flattened aperture through which the films are pulled at the correct tension. The printer may also be equipped with an automatic light change attachment. A strip of thin film with perforations on its edges (corresponding to scene changes in the negative) is fed into a special gate attached to the front of the machine.

The fibre strip is moved forward at a slower rate than the film, and as each hole passes over a contact (of which there are 20) a light change is effected. Changes may be made for scenes as short as 6 inches. It is not necessary to mark the negative in any way by this system.

Specifications have been drawn up by a sub-committee of the Academy of Motion Picture Arts and Sciences on a standard release print including leader, run-out and cues. It applies to either silent or sound prints.

According to trade reports orchestras have been returned to a few theatres in this country and South America which discharged their orchestra over a year ago with the installation of sound equipment.

An inventory of several leading theatres on the Pacific coast reveals, however, that certain houses appear to have a patronage which wishes orchestras and shows, whereas others have a patronage which prefers a first class selection of pictures. It appears to depend, therefore, largely on the type of clientele a theatre enjoys.

Sound Brings Changes

Sound motion pictures have introduced certain fundamental changes in the previous order of motion picture programs. Overtures played by an orchestra have largely been eliminated, the value of the newsreel enhanced, the value of comedies lessened, but greater importance has been given to cartoons. The general length of a program remains one of approximately two hours duration.

About one-third of the motion picture theaters of the world had been equipped by September, 1930, for sound reproduction of either the synchronous or non-synchronous types. In proportion to the total number of theaters Canada leads the list of countries with 70 per cent sound installation, the United States is second with 55 per cent, Great Britain third with 47 per cent. European theatres are rapidly converting their old equipment over for use with sound pictures.

Dummy Projectors Used

The suggestion made by Edgar that projection rooms in major theatres will be equipped with extra dummy machines for handling film with sound records only has been realized in the showing of the feature production "Hell's Angels" at the Chinese Theatre, Hollywood. Volume with less distortion, elimination of troubles from heating of the film, and a lowering of projector vibration are some of the advantages cited by Edgar.

Three dummy projectors connected in parallel were used in the Chinese Theatre demonstration so that two sound tracks could be played at the same time. Six reels of Magnascope film were included in the picture which was projected on a 24 by 37 foot screen and 9 extra loudspeakers were added to the regular installation which consisted of three horns.

A special amplifier system was installed to accommodate the 12 horns, which made possible an increase in volume equal to five times the normal volume of the regular sound installation.

One of the most interesting innovations in projection equipment of foreign origin is the French Nalpas double projector. Two complete sound-on-film or disk assemblies are mounted compactly on a single rigid support.

Resynchronizing Device

A resynchronizing device of British origin consists of a footage counter and a dial graduated into 16 sections, each of which corresponds to a frame. The device is attached to the 90 foot per minute spindle by a flexible shaft. The footage counter is set to correspond with the edge number on the film and the dial hand is moved to zero. The exact foot and frame passing the aperture can be detected at once, during projection.

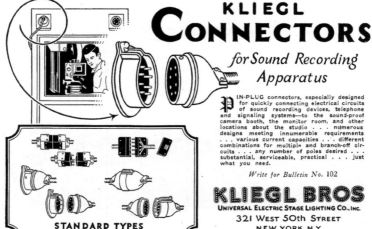

A power level indicator has been announced for reading the signal amplitude in voice transmission circuits; levels from minus ten to plus thirty-six decibels can be measured. A monitor has been developed to meet the needs for accurate indication of volume levels from power amplifiers in sound reproducing equipment.

In a new type of sound-on-film reproducer mechanical parts in the optical path have been substituted for a cylindrical lens which illuminates only 0.0005 inch of the film area, thus eliminating the usual slit. A new ultra-sensitive vacuum tube has been developed in which the grid current is reduced to a very low value for measurements as low as 10-17 amperes. Such a tube will indicate a flow of 63 electrons per second.

Harnessing the S.

A new 72 inch dynamic cone speaker and directional baffle has been announcer which is claimed to deliver clear mellow low frequency 50 cycle sounds and high frequency 7000 cycle sounds. The letters "s," "f" and "th" can be distinguished clearly. Another type described by Bostwick utilizes a moving coil piston diaphragm in conjunction with a 2000 cycle cut-off. By using this speaker as an adjunct to the ordinary type it is claimed that uniform reproduction of sounds from 50 to 11,000 cycles may be obtained.

Bull has published data on methods of measuring loud speaker efficiency. Good horn type speakers used in theatre installations are said to have an efficiency of 35 per cent; ordinary commercial speakers only 1 to 6 per cent.

At a meeting of the Societe Francaise de Physique, Dundoyer described a new type of light bulb for sound reproducing equipment. A rectilinear filament is arranged parallel to a flat plate fused in the bulb and a microscope objective used to produce a greatly reduced image of the filament on the film.

A projection lamp of novel construction is designed so that the upper part of the bulb is spherical, whereas the lower part narrows to a cylinder, near the base of which is the filament.

Limit on Wide Film

Methods of using wide-angle lenses to project a much enlarged picture on the screen have been employed in several of the large theatres for certain scenes of such pictures as "Old Ironsides," "Trail of Ninety-Eight," "The Hollywood Review," and "Hell's Angels."

In one process a movable screen was utilized which traveled downstage as the growth of the picture occurred. These methods all tend to overaccentuate the graininess of the picture.

The same defect holds if too large a picture is attempted with wide film; tests having shown that width of 50 feet is the maximum permissible before such effects begin to appear.

When space is at a premium back stage the public address system with outlets over the proscenium arch has been utilized quite successfully as a substitute for the usual horns during presentation of shorts, such as song cartoons.

A novel portable non-intermittent projector for educational use has been made available by Gaumont. It consists of a folding metal case, hinged at the top. Film moves continuously around a hollow sprocket containing a stationary prism. Light from a source on the front of the projector is directed toward the rear through a condensor system and then through the film, where it strikes the first prism. At this point it is reflected on to the second prism and thence through the rotating lens drum and is directed finally through a suitable lens system on to the screen.

Majority Held to 24 Feet

A number of theatres throughout the United States have increased the size of their screens anticipating the advent of the wide screen picture. Practically all the theatres in one circuit on the Pacific Coast have installed larger screens. A survey indicated, however, that about 60 per cent of the theatres in this country lack space for screens of more than 24 ft. width.

The large ballroom in the Atlantic City Pier Auditorium has been equipped for showing sound motion pictures and required one of the largest installations ever made.

(Continued on Page 28)

Van Der Veer and Rucker

WILLARD VAN DER VEER

THE motion picture industry's crown for the greatest cinematographic achievement for the preceding year has been awarded to Willard Van Der Veer and Joseph Rucker, who photographed "With Byrd at the South Pole."

The decision was the result of a vote open to the entire membership of the Academy of Motion Picture Arts and Sciences, 600 in number, and included all branches, from scenario writing to laboratory.

Awards made in 1928 and 1929 represented the judgment of a central board of judges, who passed upon nominations submitted by the several branches. Under the present system 298 members expressed their choice of the five nominations submitted by each branch.

The full list of remaining awards follows:

Performance by actress, Norma Shearer in "The Divorcee." Norbert Brodin photographed this subject.

Performance by actor, George Arliss

Trade's Crown for Ph[otographic] Goes to Two Men [who for N...] Years Battle[...]

for "Disraeli." Fred Archer was th[e] photographer.

Achievement by director, Lewi[s] Milestone for "All Quiet on the West[-] ern Front." Photographed by Arthu[r] Edeson.

Outstanding production, "All Quie[t] on the Western Front," Universal.

Sound recording achievement, "Th[..."]

ARTHUR EDESON

NORBERT BRODIN HERMAN ROSSE FRANCE[S ...]

Win Academy Award

JOSEPH RUCKER

...ographic Achievement
...h for Nearly Two
...Antarctic Ice

...B. House," M-G-M. Chief of unit,
R..ert W. Shirley. Harold Wenstrom
...hotographed the subject.
...rt direction achievement, "King
...f Jazz," Herman Rosse.
...Vriting achievement, "The Big
...H..se," Frances Marion.
...resentations to the winners were
...m.e following the largely attended

dinner held at the Ambassador Hotel,
at which Conrad Nagel, vice president
of the academy, presided with distinc-
tion to himself and those he repre-
sented.

Lawrence Grant spoke for the ac-
tors' branch. Miss Shearer accepted
the statuette awarded to her, while
Darryl Zanuck of Warner Brothers
accepted for George Arliss, at present
in Europe.

Charles Rosher, joint winner with
Karl Struss of the 1928 award for
cinematographic achievement, made
the presentation to Joseph Rucker,
who came down from San Francisco.
Rucker responded for himself and
Willard Van Der Veer, who is in New
York.

John Cromwell, Nugent H. Slaugh-
ter, William Cameron Menzies, Jack
Cunningham and Louis B. Mayer made
the presentations respectively for
Lewis Milestone, absent in New York;
for M-G-M sound, accepted by Doug-
las Shearer, head of that department;
for Herman Rosse, art direction; for
Frances Marion, writer, and for Carl
Laemmle senior for production.

Last year's winner of the photo-
graphic award was Clyde De Vinna.

LEWIS MILESTONE GEORGE ARLISS

ROBERT W. SHIRLEY FRED ARCHER

Looking In on Just a Few New Ones

So This is London

FOX'S "So This Is London," shown at Pantages in Hollywood the opening week in November, effectually should dissipate any feeling anywhere that among the various fields of entertainment in which the versatile Will Rogers appears before the public that of the screen has contributed the least to his international reputation.

If the reeling really existed it may have been ascribed, of course, to the great difficulty in securing stories suitable to the unique personality of this rancher-born turned citizen of the world.

The George M. Cohan play has provided excellent material as we see it adapted for Rogers. And regarding that adaptation, finely directed and photographed by John G. Blystone and Charles Clarke respectively, we see indubitable internal evidence that the chief player himself had a hand in pointing up with quip and jest an original rich foundation.

In a notable cast Lumsden Hare as the conservative English antithesis of the breezy American carries away the larger honors, due possibly in part to the double fact that the former not only was native to the "right little, tight little, island," but that on the stage he had had wide opportunity to develop and polish his characterization of Lord Worthington.

Irene Rich delightfully plays the wife of the American. Dorothy Christie shines as the English girl in love with the son of the English-hating American, a sentiment fully reciprocated by Worthington. As the elders furnish the abundant comedy and the judiciously welded drama so the romance is supplied by Frank Albertson and Maurine O'Sullivan.

Picturegoers who have not seen "So This Is London," by the time this is printed well out of the first run division, are missing a treat in entertainment wherein the robust and the tender are charmingly intermixed.

Billy the Kid

WHETHER M-G-M in its treatment of "The Saga of Billy the Kid" has enhanced picture values by sacrificing reality to romance and fact to fiction may furnish plenty of ground for controversy, but beyond that it remains true it has given a production that will thrill and interest the great mass of humans partial to stories of the early West.

"Billy the Kid" possesses in abundance that fundamental prerequisite of any screen presentation of a western tale: wide sweep of picturesque landscape, of fertile valleys and piling mountain ranges. It is right here that Gordon Avil and his staff of efficient cameramen in all truth "enter the picture"; they have most entertainingly and skillfully translated to the co-ordinating wide screen some of

By GEORGE BLAISDELL

the famed beauty spots of the locale.

The comment has been heard that the picture contains too many killings. The same criticism, conceding it is a criticism, would lie against "Macbeth," with its approximate dozen murders. The titles in either case should be sufficient warning to stay away if one be seeking a pink tea.

One of the picture's notable departures from fact is in the happy instead of the tragic ending. Billy escapes across the border, his departure unimpeded by the shots sent after him by the skilled marksman Sheriff Garrett, with Claire, his sweetheart, following him on the swift horse of Garrett, loaned for the occasion. It is a wide divergence from history, which relates how Billy was shot in his tracks as he stood dimly outlined in the doorway of a dark room and by the hand of his former friend the same Garrett, pursuing the cold dictates of an officer of the law.

Billy's earlier escape from the hangman, as related in the "saga," was one of the cleverest, most dramatic and thrilling in the records of any country. On the screen it is comparatively a farce, with the implication that the sheriff dealing with a man known to have killed at least one man for each of his twenty-one years purposely gives his prisoner an opportunity to lift a pistol from its holster.

Wallace Beery humanly and likably portrays Sheriff Garrett as the script paints him. Johnny Mack Brown rises to his great opportunity in the part of Billy. He brings restraint as well as force in depicting a sympathetic characterization. Kay Johnson as Claire stands out, fully converting one humble observer of her work in "The Spoilers" that she really and competently can do this sort of thing so far removed from society drama.

Wyndham Standing, Russell Simpson, Blanche Frederici and Warner Richmond are among other members of the cast who contribute to the realism of a strong picture.

King Vidor directs from a continuity by Wanda Tuchock, with the dialogue written by Lawrence Stallings and Charles MacArthur.

Cohens and Kellys in Africa

THE broadest of comedy marks the unfolding of Universal's "The Cohens and Kellys in Africa." To those who lean to this form of entertainment—and it would seem the majority of picturegoers do—there will be fun aplenty in watching the antics of Charles Murray and Kate Price and George Sidney and Vera Gordon.

William K. Wells wrote the scenario and dialogue which Vin Moore directed and Hal Mohr photographed. No serious pretense is made that the two partners in the piano store and their wives ever see Africa, yet we

see wild animals and hear their various roars, among these being several species of the big cat tribe. Then there is a huge python, about the appearance of which sundry serious females midwives among them also variously will roar. But that is a ground of controversy as old as the pictures.

The chief factor about the picture is that it contains many laughs for the average person, one unhandicapped by an insistent antagonism, till it hurts, "make me laugh" attitude. Scenes are provided for the everyday tired business man wherein may be measurably sated his assumed urge for the sight of girls and more girls as a really recreative diversion. The lines of the two partners at times fall in pleasant places—until the unexpected appearance of the irate wives, not exactly original in itself but always amusing.

Then in a barrelless jungle monkeys rob the helpmates of their clothing—of which ample shoulders and embarrassed screams significantly hint, but as to the manner of escape from which predicament a timely fadeout leaves us much in the dark.

Tom Sawyer

IN THE production of "Tom Sawyer" Paramount has provided something more than a screen story for boys and girls. Its appeal will traverse the range covered by a curve running from youth to doddering senility. The picture vividly brings to us the famous tale of Mark Twain, written around the childhood of the author's childhood, including the Clemens boy's supposed sweetheart.

As the author was born an even ninety-five years ago, it is fair to assume the period of the tale is a trifle earlier than 1850. The particular period, however, in the picture is not stressed, other than that Fillmore is president.

Preparation of the story for the screen was confided to Sam Mintz, William McNutt and Grover Jones. They have given John Cromwell, the director, a script that brings to life with great fidelity the atmosphere of Twain, with particular attention to the suspense.

Notable instances of the latter are the scenes of the two boys, Tom Sawyer and Huck Finn, in the graveyard at midnight as they witness a murder; the events in the courtroom wherein the murderer is exposed; and the sequence in the cave when the fugitive killer, Injun Joe, tries to catch Tom and tumbles screaming to his death in the hidden river. The following loud splash, delayed to indicate the great depth of the fall, speaks volumes for what sound has done for the screen.

The picture marks the return of Jackie Coogan after an absence of three years. His work in the title role will revive the name and justify

the fame so lavishly bestowed upon the child who through the grace and greatness of Charles Chaplin was permitted to be a co-star in "The Kid." It is Jackie's first talking picture. Certainly it will not be his last.

The portrayal of Becky Thatcher by Mitzi Green is worthy of an adult trouper—one that sticks in the memory days after seeing the picture. Little Jackie Searl as Sid the annoying kid is entitled to several bows, too. So also among the younger players may be named Junior Durkin as Huck and Dick Winslow as Joe Harper.

Clara Blandick as Aunt Polly stands out in an excellent company that includes Lucien Littlefield as the schoolmaster, Tully Marshall as Muff Potter, Charles Stevens as Injun Joe and Charles Sellon as the minister.

Charles Lang was at the head of the efficient camera crew which photographed the picture.

"Tom Sawyer" is worthy of the posting of SRO on Saturday and holiday matinees and of a full house at night. It is a picture for children and for their elders. Many of the latter will experience a choke behind the chuckle that accompanies the fading of the picture.

Feet First

HAROLD LLOYD in constructing "Feet First" sticks closely to the bridge that carried him over—with fidelity adheres to the picturemaking formula that has been the foundation of the Lloyd millions. From the beginning the public with unfailing regularity has responded to his offerings by laying down its half dollars at the box office—which after all, from the producer's viewpoint, is the best criterion of what the public wants for entertainment.

In the case of Lloyd productions the seeker for amusement knows first of all he need have no hesitation in bringing with him the whole family, a not unimportant factor. He knows, too, he is going to see a simple story, one that disregards ordinary production values, such as enormous sets filled with gorgeously if scantily gowned women, etcetera, etcetra.

The same seeker for amusement knows, too, he is going to meet up with thrills—and he does in "Feet First." To be sure, they have to do with the side of a skyscraper, a background not unfamiliar to the star's train of followers. But nature each year provides additional millions of picturegoers—to all of whom these things are new.

The present subject brings Lloyd into the picture as a shoe salesman, one whose native ability is perhaps not on a par with his great ambition —to be a big shoe man. In the effort to supply the apparent deficiency there is resort to correspondence school courses—with embarrassing results.

Singularly enough, the embarrassment frequently extends to the interested person out front. A susceptible follower completely under the spell of the aspiring salesman may feel his cheeks burn as one complication succeeds another. It is a tribute to the sincerity of the performer, to his ca-

pacity for portrayal, but it raises a question if it be entertainment of the more satisfying kind. The present reviewer recalls no similar instance, but nevertheless the feeling distinctly was present.

Many of the scenes are staged on a Hawaiian ship, on which the salesman is an unregistered passenger without funds and incidentally with a perfectly normal appetite. Efforts in some measure to abate this latter handicap to an otherwise exceedingly pleasant trip supply much comedy.

The thrills come in the last quarter of the picture. Most of these are on the outside of an office building. There is comedy in these, too, supplied by Sleep 'n' Eat, who is as true to life as it is possible for a genuine black man to be—and thereby qualifies as an actor of quality. The outboard plank sequence will be too long for many adults—but not for the youngsters, who absorb it all.

The picture was directed by Clyde Bruckman and photographed by Walter Landin. The former was responsible for the story in collaboration with John Grey and Al Cohn. Lex Neal and Felix Adler wrote the scenario. Double honors go to Paul Gerrard Smith, who built the dialogue.

In a deck scene Smith portrays with extreme fidelity a passenger who has no time or inclination for eating—and does it not only inoffensively, a rule that does not always obtain in similar circumstances, but most amusingly.

Barbara Kent shines as the girl in love with the salesman and Robert McWade and Lillianne Leighton take the parts of her father and mother—and no comment is necessary in the case of players of their rank. The same may be said of Alec Francis, the mentor of the young salesman, and Noah Young, in disguise as a boob sailor.

Playboy of Paris

LIKABLE as ever is Maurice Chevalier in "Playboy of Paris." Always does he rise above his surroundings, or the medium with which he is surrounded. The entertainment of a Chevalier picture rests in the man himself, in the artist—and the Frenchman easily "belongs" in the rather restricted group entitled to assemble under that exclusive banner, a classification generally loosely employed and likewise grossly abused.

And so the entertainment in "Playboy of Paris" rests largely in its star. If that elusive quality be not strikingly present in his theme or his story he puts it into his "business," it emerges from his personality. Assaying him from the viewpoint, not always an attitude of favorable prejudice by any means when one of the same sex is in the balance, the Frenchman impresses as a "regular guy."

Like Emil Jannings for Germany, Chevalier is an ambassador of good will for France—he, too, breaks down barriers, intangible and indefinable though they may be in his case where, in the instance of Jannings a decade ago, they were real and formidable.

After all the screen is a great leveler of international walls, as we more strongly realize when we read of George Arliss taking away to Eng-

land the palm for the best actor's screen performance for 1929-30.

Paramount has spent money lavishly in the making of "Playboy of Paris." One of the means it chose to disburse its budget was in the supporting cast; another was in its staging.

Ludwig Berger directed and Henry Gerrard photographed the picture under the supervision of J. G. Bachmann. Percy Heath adapted the story of Vincent Lawrence, with Leo Robin writing the lyrics.

O. P. Hoggie as Philbert, the kitchen mechanic who shared the fortunes of Albert the waiter, proved a foil as genuine as he was amusing. Eugene Pallette made the most of the little that fell to him, which of course was anticipated when he was included in the cast.

Frances Dee as Yvonne did well in a difficult part—that of making love constantly by assuring the object of her secret devotion that she hated him. The support was in keeping with what was to be expected from a cast containing so many successful players.

"Playboy of Paris" may not be the best in which Chevalier has been seen in the last year and a half, but for admirers of the Frenchman it is good enough not to be overlooked.

The Life of the Party

FOR two weeks early in November Warner Brothers played "The Life of the Party" In tandem in its Hollywood and Downtown houses, claimed to be the first time one production simultaneously has played in two Los Angeles first run theatres.

If the laughter that followed Winnie Lightner and Charles Judels on the twelfth day in the Hollywood be any criterion of the public appeal of the production there would seem to have been justifiable ground for the experiment regardless of the final returns.

Miss Lightner as Flo, the wisecracking New York woman bent on finding something softer than songplugging, is a fountain of mirth. No supersophistication on the part of those out front is necessary easily to follow her in this story by Melville Crosman adapted by Arthur Caesar.

Charles Judels as Le Maire, proprietor of a palatial costume shop, shares the honors as a funmaker. Irene Delroy as Dot, the partner of Flo, charmingly supplies the youthful and the love interest. Opposite Miss Delroy is Jack Whiting, of splendid speaking voice and Lindberghian mold, most natural in manner and altogether likable.

With one exception the story remains within the probabilities and clings to the comedy vein. The exception is the horse race sequence, where the action without warning plunges sharply into the field of burlesque.

Roy Del Ruth directs with skill and finesse the script that was handed him.

The entire subject is in Technicolor, and it may be said the color possesses that quality of which the observer out front becomes unconscious.

Dev Jennings was the chief of the camera staff.

Progress Committee Reports to Engineers

(Continued from Page 23)

A social center motion picture theatre has been completed in Newark, N. J. It contains a theatre auditorium seating 436 persons, a ballroom, billiard room, pingpong room, coffee and cigarette counters, card room, and indoor golf facilities, all decorated in modernistic fashion.

Eyring has shown that an auditorium to have a single optimum reverberation time should not only be free from echoes and have the proper amount of damping, but the absorbing material should be fairly uniformly distributed, resonating bodies eliminated, and a condition for diffusing sound should be assured. MacNair has suggested that the rate of decay of loudness sensation is a better criterion for the arrangement of damping material in auditoriums than decay rate of sound energy.

College Institute Courses

Several colleges are planning to institute a cultural course on photoplay appreciation during 1930-31. Arrangements have been made to release the negatives of outstanding historical pictures made several years ago for re-editing for educational purposes.

To correlate efforts being made in different countries on the production of educational films Will has advocated that the International Cinematographic Institute (League of Nations) prepare a statistical record of the demand for such films.

Motion pictures will be made from hidden viewpoints of all public events in Vienna in which the police take part; the films will be used later for police instruction.

Research in Television

Eighty per cent of the workers in a silicate factory in Russia are claimed to have been taught to read by means of sound films.

Gottheiner and Jacobsohn have reported on improvements in their technic in X-ray cinematography. In this type of work the difficulty in the past has been to get sufficient exposure to make pictures without overdosing the patient and working the X-ray tube over its capacity. A new lens of F. 1.25 was used constructed of two spherical cemented elements.

A camera equipped with a shutter admitting more light, an improved X-ray tube, a fluorescent screen, and a highly sensitive film were employed. With this equipment it was possible to take pictures for as long as 25 seconds at a time, whereas 2 to 3 seconds was the maximum exposure which could be used with older apparatus. An International Institute of Television was founded in Brussels, Belgium, which will deal with results of researches in connection with the broadcasting of pictures. Eighteen companies were reported to have twenty-two stations in operation in the United States for television experimentation. No license is granted by the Federal Radio Commission, however, unless evidence can be shown that the work represents legitimate research.

A three-day test made in September, 1930, to transmit televised signals across the Atlantic ocean failed and was abandoned. A permanent equipment installation for two-way television was set up in April between the Bell Laboratories and the American Telephone and Telegraph Company's offices, which are about two miles apart.

Transmitting Images

Television images transmitted by radio were shown as a part of one regular performance at the Proctor Theatre, Schenectady, N. Y., on May 22. A loud speaker system was used to transmit the voices of the actors who performed before a "television camera" at the General Electric plant, about one mile distant.

A 48-hole scanning disk covered the subject twenty times per second. Four photoelectric tubes responded 40,000 times per second to the impulses reflected back from the subject.

The images were transmitted on a wave length of 140 meters; the voices on 92 meters. At the theatre the light impulses were reproduced first on a

(Continued on Page 42)

Camera Crew of 61 Shoot Land Rush of "Cimarron"

THE filming of the land rush scenes for "Cimarron" on the R.K.O. location at Bakersfield called for one of the largest assignments of cameramen ever employed on one sequence. There were 28 cameramen, 6 stillmen and 27 assistants, making a grand total of 61.

The staff employed were Ed Cronjager, Nick Musuraca, Fred Bentley, Joe Novak, Edward Pyle, Pliny Goodfriend, H. Lyman Broening, Joe Biroc, Ben White, John Thompson, Ed Ullman, Fred Mayer, Rex Wimpy, Frank Redman, Jack Landrigan, Robert Pittack, Harry Jackson, Joe Walters, Ed Henderson, O. H. Borradaile, Guy Bennett, Joe LaShelle, Roy Clark, Elmer Dyer, Ed Kull, Linwood Dunn, Harry J. Wild, Bob DeGrasse, Fred Hendrickson, Otto Benninger, Rex Curtis, Mack Elliott, Newton Hopcraft, Neal Harbarger, James Daly, Rod Tolmie, E. F. Adams, Ed Kearns, Les Shorr, George Diskant, Emilio Calori, Ted Hayes, Jack Grout, Frank Burgess, Earl Metz, Louis DeAngelis, Harry Underwood, James King, Lothrop Worth, Ed Garvin, Harry Kauffman, Neal Beckner, Al Smalley, Paul Cable, Bill Heckler, Dean Dailey, Maurice Kains, Wm. J. Schuck, Harold Wellman, Willard Barth, Russell Hoover.

Fred Hendrickson photographs camera staff on land rush in R.K.O.'s "Cimarron"

A DAY IN THE JUNGLES

666 CHICAGO 666

Meeting—Deep Peace

ANOTHER month—another meeting—with the usual line of arguments and still no "pineapples" used as peacemakers. President Charles N. David swung the gavel, Brother Norman Alley handled the records, and Miss "Vi" Braun kept an eagle eye on all delinquents.

It was decided at this meeting that the "Pres" shall soon make various trips to out of town branches of 666 to meet the boys in person in behalf of the Chicago headquarters.

Two new members were initiated at this meeting, both Chicago boys—Howard F. Siemon and Duncan Taylor.

SIX-SIXTY-SIX

Expenses Pay

It seems that one expense account has paid well in the last month. Brother Eddie Morrison was seen leaving a train in Chicago and immediately going into a hat store and then beaming up and down Wabash Avenue sporting a brand new "lid."

Don't blame you, Eddie, as these wives will relieve you of your expense checks if they see them first.

SIX-SIXTY-SIX

Take Notice

Brother Charles· Ford, editor for the Chicago Daily News Screen Service, received a story from an out-of-towner (*not a member of the I. A. T. S. E.*) for use in the reel. The film report sheet was turned over to be published on the page, as Brother Ford claimed other cameramen might be glad to learn the proper way in submitting all news stories:

Film Report Sheet:
Cinematographer............
Address (City)............

By HARRY BIRCH

Local 666 wishes to express the season's greetings by wishing all of the I. A. T. S. E. & M. P. M. O. members a Merry Christmas and a very Happy New Year, and here is hoping that "Santa" fills each stocking plenty.

State............
Using............................Standard camera
 with F 3.5 lens.
Location of event............
Scene 1—Feet 7—time of day 9:30
 a.m.
Nature of light—Fair—Exposure F 4.
Taken while still was covered with
 brush.
Scene 2—Feet 5—time of day 9:40
 a.m.
Nature of light—Fair—Exposure F 4.
Bottom of vat in big ravine.
Scene 3—Feet 3—time of day 9:50
 a.m.
Nature of light — Fair — Exposure
 F 4.
Top of vat.
Scene 4—feet 5—time of day 10 a.m.
Nature of light—Fair—Exposure F 4.
Looking down into vat.
Scene 5—Feet 7—time of day 10:10
 a.m.
Nature of light—Good—Exposure F 4.
Top of shed in which whiskey was to
 be distilled.
Scene 6—Feet 6—time of day 10:20
 a.m.
Nature of light—Good—Exposure F 4.
Long shot of backside of still.
Scene 7—Feet 5—Time of day 10:30
 a.m.
Nature of light—Good—Exposure F 4.
Closeup of lookout..
Scene 8—Feet 8—time of day 10:30
 a.m.
Nature of light—Fair—exposure F 3.5.

Miss "Vi" Brown

View of inside room.
Total number of feet taken—Forty-six (46).
Editor's Note: News reel men should take notice. Boy, ain't that a dope sheet and covering a complete story in 46 feet!

SIX-SIXTY-SIX

The New Boss

It may have been easy heretofore to make excuses on back dues, but from now on it is going to be different. The boys of Local 659 know just exactly what it means when the name of Mrs. Louise Lincoln is mentioned, and now Local 666 can boast of its Miss "Vi" Braun, the boss in Chicago. For any information "Vi" will have it on hand. You will find her at all times at 1029 South Wabash Avenue, the headquarters of Local 666.

SIX-SIXTY-SIX

Won't Be Long Now!

Election over and all you readers have seen how the old country is going back to wanting good beer again. It is no more than right to let you in on a secret of how public opinion was swayed back again for the old amber fluid with which we used to get a free lunch back in the good old days. Well, this is the way it was done!

A couple of red-nosed news snoopers of 666 packs up a couple of cans of celluloid to a big brewery in Milwaukee and makes a story showing 'em putting in new machinery for turning out the amber giggle water.

Milwaukee is the logical place, as that is about all that ever came out of that town except of course "our

Here's Proof There Is a Santa Claus

FOR those who continue to say there is no Santa Claus we are going to prove to you there really is a Santa Claus, and here is the good news: Local 666 is paying for each of its members one year's subscription to the International Photographer.

This is your Christmas present, and if at any time you fail to receive this magazine please let us know immediately. It will be necessary for you to keep us advised at all times should you change your address.

Local 666 is taking this opportunity to say that we hope you will enjoy this magazine as well as we think you will, and would appreciate hearing from you at various times with any news items pertaining to the cameramen from your vicinity. Don't hesitate but send them in.

H. B.

Wm. Ahbe, Fin. Sec. Harry Birch, Sergt. Arms Chas. David, Pres. M. W. Spoor, Tr. Oscar Ahbe, V.P.

Real-Strategy

Heard this one down at the Notre Dame-Navy football game at South Bend, Ind. Tony Caputo is setting up his groan box when Wallie Hotz, his sound man, ups and asks:

"Hey, Tony, what's the idea of the Notre Dame wearing silk uniforms this year?"

"Oh, that's so's the other players get their mind off the game when they tackle an Irishman," comes back the unconcerned Tony.

high class Sassiety Reporter," who was dropped off in that burg by the stork—no reflections on Milwaukee.

President Charles David was one of the boys on this beer story—he had his heart so set on this one that he even lugged up a heavy Akeley instead of the Eyemo. Eddie Morrison and Phil Gleason even showed up on time for this one. Red Felbinger, Robinson and Santone filled up with their heavy groan equipment.

Six Weeks' Anxiety

In the picture on this page you see the boys in action as the first batch of hops go into a vat. Somebody told the gang it takes six weeks before beer is real beer, and we haven't seen Charles David since he left the brewery.

I'll bet he is sitting up there waiting to see how the first batch comes out.

You will notice Brother Santone is missing in the picture. Reason: He was trying to find out from the brewmaster the recipe for making good home brew which wouldn't blow the corks off the bottles while it was ageing.

Another remarkable thing about this picture—take a good look at Robinson (the one on the extreme right). Notice the look of disgust on him as the hops go into the vat. Just like all sound men, he is an ardent dry. Oh, well, it takes all kinds of people to make up a world.

SIX-SIXTY-SIX

In Focus—In Spots!

By BIRCH'S SASSIETY REPORTER

OUT in Kansas City I understand the Co-operative Club elected Brother Billy Andlauer as president of its shebang. Billie's gotta get up in the middle of the night now to meet the early morning trains and officially welcome all big moguls to Kansas City. So if any of youse 666

brothers step off a train out in that there burg and find a brass band serenading you, why, it's probably none other than Billie Andlauer doin' his duty an holdin' down his job.

SIX-SIXTY-SIX

Stork Tuning Up

And Brother Ralph Biddy gives up the free and easy life and gets all hooked up in holy matrimony. Well, there's only a few of us left now.

Brother Urban Santone, very much already married, dashes over to a phone every hour these here days and phones the missus to see if the stork has made his number two visit.

This is just a little pre-release information. Will let youse know later if it's a boy again or a girl, providing Santone hands the scribe a couple of high class coronas for all this publicity.

SIX-SIXTY-SIX

This Depression Is Tough

Big business has hit Film Row all right, too. Saw Fred Giese the other night and noticed the famous razoredge crease is missing from his "pants." Also the worthy secretary, Norm Alley, ain't rushing around in his big high-powered motor any more. Them nags in the fifth race at Hawthorne sure spelled hard times for Norm.

Of course, a fellow can't cut out all his expensive habits at once, though, and just to bear myself up on that one I seen Charlie David and Norm Alley giving each other one of their famous Chinese banquets out at Won Kows in Chinatown the other night.

Both are adept with the chopsticks now and Charlie insists they are a lot safer to eat with, as it does away with the danger of cutting your mouth eating with a knife.

SIX-SIXTY-SIX

What Could Be Sweeter?

Well, seein' as how I always try to hand you the dope first and seein' as how youse probably won't hear from me this year any more, I gotta close this by

WISHING ALL YOUSE BROTHERS OF MINE A MERRY CHRISTMAS AND A HAPPY NEW YEAR.

Boy, that's getting away with it this year. Last year it took me days to send youse cards, but it just goes to prove unionism makes everything easier. All I gotta do now for the holidays is ankle over to the ten-cent store and do my shopping and call up my bootlegger, and

I HOPE YOU HAVE THE SAME.

See you next year.

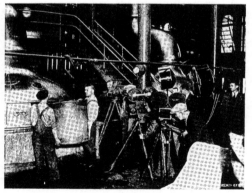

Correct

President Wyckoff (giving examination questions to applicant for rerating)—When raw film is passed through the camera and has been developed into a production negative, what is the greatest change that takes place?

Applicant—The price, sir.

—::—

Practice Wins

M. Hall says that initiates to the hobo fraternity must be able to wash their faces thoroughly without removing either their hat or coat.

—::—

These Hard Times

Harry Merland says so far there has been no decrease in the cost of everyday necessities; it still costs seven-fifty a quart.

—::—

Loyalty

Saw a "Good Humor" salesman order ice cream for dessert at Mother Mohl's restaurant.

—::—

Page Walter Pidgeon

First Assistant—Whadda you look so sad about this morning?

Second Assistant—I finally got up nerve enough to propose to my girl last night and then couldn't think of a theme song.

—::—

Here, Kitty, Kitty!

First Actress—Did you read how those horrid critics panned my part in "Love 'Em"?

Catty Friend—Don't mind critics, my dear. They are like parrots, only

Hoke-um

By Ira

repeating what everyone else is saying.

—::—

Standing Order?

Kind Old Lady (inspecting battleship on Navy Day)—Just to think, the poor boys have to stay all night on these dreadful things. Why, there isn't a bed in the place!

—::—

Plurality Vote

Willard Barth—I want to get off early tonight so I can go to the barber to get a haircut.

Billy Marshall—Here's four bits. Get them all cut!

—::—

So Soon?

First Actress—I hear Tillie married a millionaire.

Second Actress—Yeh. It was her golden wedding.

—::—

Just Noise

A certain well-known studio recently hired a great German music professor to direct its recordings. To give him a start in American ways the general manager wished off on him a contract girl whose aspirations to grand opera were a bit larger than her ability. He played her accompaniment and listened to her for a while, but she sang so far off key that he

finally jumped up from the piano and tore his hair in true stage anguish.

"Why, doctor," said the girl, "don't you like my voice?"

"Der trouble mit your voice, my dear," answered the musician, "iss dot vedder I play on der vhite keys or der black ones you sing in der gracks."

—::—

Open Sesame!

Ambitious boy, desiring to break into the Cameramen's Union—Have you an opening for a prospective member?

Business Agent—I sure have; don't slam it as you go out.

—::—

"Can Do"

"You are run down," said the doctor. "You need entertainment. Go places at night; see good plays, hear good music. Will your business permit it?"

"I guess so, doc," said his patient. "I'm head usher at the Metropolitan Opera House.

—::—

That's Different

Henry Prautsch—I would like to go to that cutter girl's wedding.

Bob MacLaren—Why, she isn't even engaged.

Henry Prautsch—I mean as the groom.

—::—

This Is the End

Maury Kains calls his girl "Postscript" because her name is Adeline Moore.

In Spite of 10,000 Dark Houses Erpi Reports Greater Box Office Receipts

CONDITIONS in the amusement field are adjusting themselves in orderly manner to the business situation. Payments on credit accounts are being maintained surprisingly well in view of financial conditions. Business promises to show a distinct improvement in the future. Theatres equipped to give quality reproduction of talking pictures are, in most cases, doing an even bigger business than they did a year ago.

These conclusions, according to C. W. Bunn, general sales manager of Electrical Research Products, are based upon an impartial nationwide statistical survey made by his sales organization.

"The most surprising part of our survey," he said, "is that while most printed reports list the number of motion picture theatres in this country at more than 25,000, the actual count by our field force shows less than 16,000 theatres in operation. Approximately 10,000 theatres have been closed, temporarily, or permanently, because they were unprepared to meet the competition of talking pictures adequately reproduced.

"At first glance this diminished total of theatres might lead to the conclusion that the popularity of

pictures has waned. This is not so. What it means is that the public, aware of the difference between good and inadequate reproduction, is patronizing the theatres where the reproduction is satisfactory.

"The patronage formerly enjoyed by the 10,000 theatres that have closed is now going to the 16,000 remaining houses. Their total weekly patronage today is larger than the weekly motion picture attendance at any previous time in the country's history.

"Of these 16,000 theatres about 10,000 have sound equipment. Of this number 4,800 have the Western Electric system and about 6,200 other kinds of apparatus.

"Our information indicates that about 2,500 of the closed theatres have a possibility of reopening.

"To date we have replaced 1,470 equipments of various makes with Western Electric. At the present time one-half of our installations are replacements of equipments that either reproduced inadequately or were not supported by the necessary acoustic advice to provide the best possible reproduction or by a nationwide service staff to assure uninterrupted operation or by an adequate supply of

replacement parts throughout the country to maintain repairs with the minimum of delay.

"We are ready now with the cooperation of engineers of the Bell Telephone Laboratories and the manufacturing resources of Western Electric to expand the cooperation we are offering exhibitors at any time that we see it is in the best interests of good sound reproduction to do so."

Selenphon Recording Sound on Strips of Sensitive Paper

According to American Trade Commissioner George R. Canty, Paris, the Selenophon system is to be used on paper stock. At the congress of German broadcasting companies in Vienna, the German representatives showed much interest in a new paper film manufactured by Selenophon.

This is a system in which the Selenophon method is used for recording sound on a sensitive paper strip. If the sound-track is 6 mm. large, it is possible to place four such tracks on the paper ribbon.

In this case 300 meters paper film would take 40 minutes to be projected. It is claimed to be possible to register whole operas according to this system, as the difficulties inherent to the use of discs fall away.

It is not impossible German broadcasters will make use of this paper stock, providing the planned negotiations with Selenophon lead to a satisfactory conclusion.

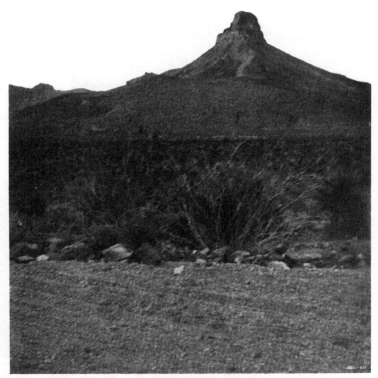

Just one of those stray shots a man will snap with just a kodak while his just a flivver is getting back to normalcy after a tough climb. Thus James Higgins identifies this striking peak near Flagstaff, Arizona.

 # *Cream o' th' Stills*

On these facing pages a quartet of veteran photographers brings scenes of snow in mountain country. This first is Ixtaccihuatl, or White Woman, in Mexico. Jules Cronjager, standing at an elevation of 8000 feet, points his camera across Amecameca in the foreground at the glacier-covered summit fifty miles distant and towering 16,705 feet above the sea.

Frank Bjerring, up in California in the Truckee River country, looks across the lengthening shadows and almost into the rays of a sinking sun so that we, too, may have a glimpse of what impresses him.

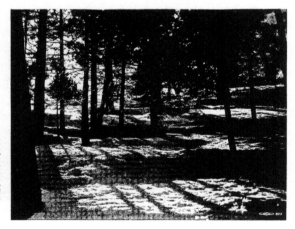

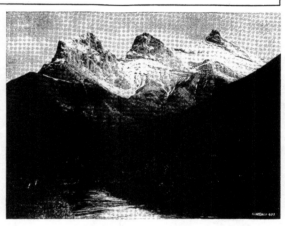

Still traveling north, this time with Alvin Wyckoff, we get a glimpse of the Canadian Rockies. The Three Sisters would seem to be members of a cold and inhospitable family—but still easy to look at if they don't sit too close.

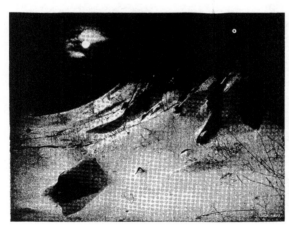

Now we are back in California, and strangely enough within a few miles, surely less than twenty, of Hollywood. The locale is Mount Lowe in winter, we are assured by George K. Hollister senior, who made this striking photograph.

 # Cream o' th' Stills

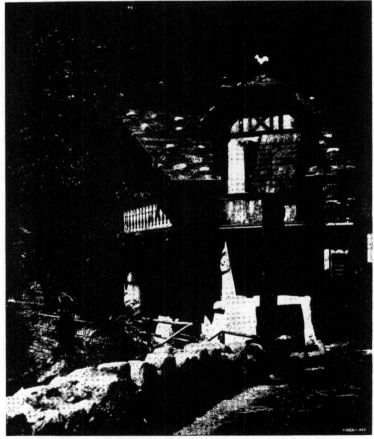

Demonstrating how it is more economical sometimes to build rather than to go afield in search of a certain structure and then transport a company, Clarence Hewitt shows us the quaint Tyrolean home created on the Fox lot by Art Director William Darling for the quartet known as the "Four Sons."

Victor Brings Out Animatophone

Device Has Vertical Record Revolving on Plane Parallel to Side of Projector and at Right Angles to the Screen

A 16 MM. talking picture projector, the first especially designed and constructed 16 mm. sound projector to enter the field, has just been announced by Alexander F. Victor, president of the Victor Animatograph Corporation, Davenport, Iowa, pioneer manufacturer of non-theatrical motion picture equipment.

The apparatus consists of the newly designed Victor model 5 projector and the No. 33 Animatophone. It is not, however, of the usual "hook-up" type which employs an auxiliary, shaft-connected turntable in connection with a regular silent projector, but assembles into a one unit, sound-on-disc synchronizer in which the turntable becomes an intimate part of the projector mechanism, being directly connected thereto.

The model 5 projector and the Animatophone were designed and perfected together as a single unit, but the present arrangement offers the advantage of its being possible to purchase the projector alone for silent operation and of later making the addition of the Animatophone, which includes all parts necessary to complete the sound equipment of the model 5 projector. The attachment of these parts is so simple that it easily may be accomplished by the owner, who will be spared the expense of returning his projector to the factory for fitting.

Vertical Record

The outstanding feature of the Animatophone is the vertical instead of the usual horizontal disposition of

the record, which achieves a new standard in compactness and light weight. The record thus revolves in a plane parallel to the side of the projector, or at right angles to the screen.

The direct connection thereby afforded, minus flexible shafts and the like, it is claimed, gives such results as have never been obtained with separate, shaft-connected outfits. Preliminary demonstrations before motion picture and sound experts have shown perfect clarity and constancy of tone.

Provision has been made in the projector for constantly maintaining an even speed, for adapting the speed to the requirements of both the 33⅓ R P M and 78 R P M records, for eliminating vibration, and preventing the transmission of extraneous sounds. Each of these features has been perfected with a deftness and ingenuity that are said to be characteristic of Alexander F. Victor's inventions.

Simple Mechanism

The normal electrical pickup and arm are used, being counterbalanced in a special way so that the needle comes in contact with the record at just the correct pressure for best reproduction. It is an interesting fact that the vertical disposition of the record and the scientific counterbalancing of the tone arm induce a normal pressure which keeps the needle in a central position in the groove, with the result that it greatly increases the life of records.

Although a perfect application of pressure sideways instead of up and down is accomplished by the counterbalance, its mechanism is not at all complicated, but, quite to the contrary, is an outstanding example of ingenious simplification. In fact, it is claimed that the system is highly superior for non-theatrical use because it combines simplicity with extreme efficiency.

The automatic air governor, the disc filter, the speed adaptor, and the pickup tension arrangement are all new ideas and are expected to contribute very largely to the future excellence of non-theatrical sound reproduction.

Automatic Air Governor

The automatic air governor is especially worthy of mention because it embodies a unique idea and performs a highly important task—the maintenance of perfect uniformity of speed. The action of the governor is induced by a forced current of air impinging against the small vane which makes and breaks the contact

in such a way that it is impossible for the motor to speed up or slow down, regardless of how much fluctuation there may be in the voltage of the line current.

Thus this one little feature has made it possible to use the regular projector motor and to eliminate the need for a large, heavy, synchronous type motor. The governor is designed to function perfectly at the two different speeds required for the 33⅓ R P M and the 78 R P M records. A small indicator is set for the desired speed and, when this is done, no other adjustments for speed need be made.

The finest quality in projection, as well as in sound reproduction, is insured by the fact that none of the desirable and widely known features of the Victor projector has been sacrificed in constructing this equipment.

Provision against damage to films —a highly regarded Victor feature— takes on added importance in connection with the use of synchronized film which, in event of damage, requires expert laboratory splicing to prevent loss of synchronization. Due to the Victor film trip, which automatically cuts off power and light if the film fails to track properly, it is claimed that a film has never been known to break or become mangled during projection in a Victor projector.

The Victor adjustable shuttle, which is said to insure permanent steadiness and quietness of operation, is another unique feature that seems to have been invented with "talkies" in mind.

Other Models Converted

It is stated that any Victor projector, Model 3 or 3B, may be returned to the Victor factory and at reasonable cost be converted into a Model 5 for use with the Animatophone.

In the standard Model 5 Victor projector maximum illumination and

universal current adaptation are provided for by a built-in transformer for 50-60 cycle A. C. operation. The current, however, may be diverted from the transformer with the result that the instrument may be operated on either alternating or direct current, with or without Victor lamp rheostat. Thus, the equipment stands entirely alone in permitting the use intermittently of all the popular projection lamps—the standard 100-110 volt 200 watt, the high intensity 30 volt-165 watt, and the 20 volt-250 watt lamps.

This new "talker" apparatus consists of only two units—the Animatophone-equipped projector and an amplifier-speaker. Two models of amplifier-speakers are offered for use with the Animatophone. Both are especially designed units in which only the highest type of well-known amplifiers

and speakers are used. Amplifiers and speakers are compactly and efficiently assembled in a cleverly designed carrying case—the No. 245 being about the size of the projector carrying case and the No. 250 about half again as large.

It is anticipated by the manufacturers that the master Model 5 projector and Animatophone will prove extremely popular with commercial, educational and religious users of motion pictures for the reason that it has no limitations, gives truly professional results, and is so compact and light in weight that it can be set up and operated in about a third of the space ordinarily required for 16 mm. talkers, and may be transported with extreme ease.

Prominent advertisers and industrial motion picture experts who have seen and heard the new Animato-

phone predict the use of industrial talkers will become even more widespread with such perfected, economical apparatus now available.

The standard model, as has already been indicated, may be used with the 33⅓ R P M records and also with the 78 R P M records. The 33⅓ records run slightly more than 14 minutes while the 78s, which are the same as phonograph records, run only about five minutes.

Films with Sound Available

In this connection it is only apropos to mention that a good selection of short talker subjects already is available for rental and purchase, and that a number of studios are specializing on short entertainment, novelty and educational talkers which are intended for home, school and church use. (S e e V i c t o r Directory of Film Sources.) The industrial user will, of course, have his films and records made to order.

It is interesting to know that the Animatophone is just one of many cine inventions by Mr. Victor. His inventive genius gave birth to the first 16 mm. camera and to such 16 mm. camera refinements as the multiple lens turret and the variable speed mechanism, full-vision prism visual focusing, a new and revolutionary color system which is not yet on the market, many outstanding projector improvements, and some two hundred other major and minor cine inventions.

In motion picture circles it is said of Mr. Victor that when he sets his inventive genius to work in any particular direction he is almost certain to surprise everyone with something radically new and different. Like the adventurer that he literally is, Mr. Victor delights in straying far from the "beaten path" and in emerging with some refinement or innovation of striking simplicity and practicability. His latest achievement is an equipment that would seem to indicate Mr. Victor is due to win just as many laurels in the talker field as he has in the silent.

Talkers Impress Executives

Reports from many sources seem to point to a noticeably increasing interest on the part of business executives in what the talking movies can do for them in stimulating sales.

Especially significant from this standpoint was the large number of sales and advertising executives who attentively observed the operation of the Bell & Howell Company's portable outfit for presenting 16 mm. pictures at the recent convention of the Direct Mail Advertisers' Association at Milwaukee.

Bringing 'Em Back

Some of the old theatre favorites announced by Kodascope as converted to 16 mm. size include "The Pawnshop," with Chaplin; "The Covered Wagon," "The King of Main Street," "Behind the Front," "Manhandled," "Miss Bluebeard," "The Night Club," "The Spanish Dancer," "The Lucky Devil," "Are Parents People?" "Dancing Mothers," "The Pony Express."

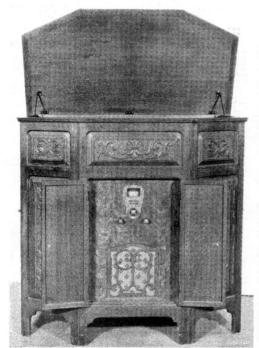

Bell and Howell's Filmophone Radio, closed

Filmophone-Radio Is Announced Ready by Bell and Howell Co.

AND now comes the last word in home entertainment. Home talkers, home movies, the radio and the phonograph are all made available in one handsome combination instrument, the F i l m o p h o n e - Radio, just announced by the Bell & Howell Company, Chicago, for December 15 delivery.

A Bell & Howell Filmo projector, utilizing regular 16 mm. size film, is used for the pictures, and a Howard chassis is the basis of the radio feature—two products famed for quality in their respective fields.

A phonograph motor is so arranged that the turntable can be operated at either the standard speed for ordinary phonograph records or thirty-three and a third revolutions per minute when the records for the sound pictures are played.

The flexibility of the new combination instrument is such that talkers and also pictures without sound can be projected. Again, the pictures may be shown with radio or phonograph m u s i c a l accompaniments not synchronized with the film. Also, of course, the radio or phonograph is available each by itself if desired.

Material Abundant

A large number of home talker subjects can now be secured from photographic dealers. Among these are the always amusing "Felix the Cat" cartoons as well as numerous other entertaining and instructional features, including many of the famous UFA educational sound pictures. It was the growing size of this list of available sound pictures that led logically to the development and announcement of the Filmophone-Radio.

Radio and phonograph combinations have already been worked out satisfactorily, but the additional problems involved in balancing the other units with the movie projector were not successfully solved until this instrument was evolved by Bell & Howell engineers.

Such a combination will unquestionably present the opportunity of entertaining the most critical home audiences. It is a combination of quality, variety, and novelty, to say nothing of unlimited material from which to draw.

Westinghouse Men Describe Recording on 16 MM. Film

A portable sound on film projection equipment using 16·mm. film was described by C. R. Hanna, P. L. Irwin and E. W. Reynolds of the Westinghouse Company, in a paper before the Engineers' Convention.

The film is standard with the exception that one row of sprocket holes is omitted to provide space for the sound track.

The projector is only slightly larger than the average silent picture projector. Detailed description of its

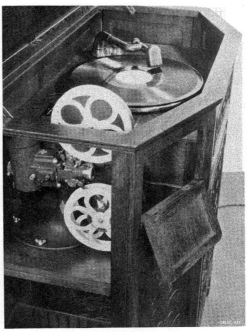

Bell and Howell's Filmophone-Radio, open

mechanical, electrical, and optical features were given.

The complete equipment is mounted in three carrying cases, one for the projector, one for the amplifier, and one for the loud speaker and screen. The projector case serves also as a sound-proof housing when the equipment is in operation.

The rewind, splicer, cables, spare tubes and lamps and the films are situated in the case for the loud speaker and screen. Each of the carrying cases weighs approximately 40 pounds, making the total weight of the equipment 120 pounds.

Now Shooting Vocal Cords with 16 MM. Home Camera

A new technique for making motion pictures of the vocal cords has been developed by the use of a quartz rod as the means of projecting a high intensity illumination within the

larynx, according to a paper read before the Society of Engineers by C. A. Morrison of the Eastman Teaching Films.

The source of light consists of the two filaments of an over-volted automobile bulb. A laryngoscope, illuminating system and viewing finder are attached to a 16 mm. motion picture camera.

This combination forms a self-contained, one-man-controlled diagnostic unit, which permits motion pictures of the cords to be made at the standard rate of 16 frames per second.

The field photographed is viewed constantly through the finder by the operator, who controls the spring motor of the camera by the usual release button. The pictures as projected fill the entire screen area. This is a magnification previously unattained under these conditions.

Adapting 16 mm. Camera to Study of Motion in Campaign Against Waste

MANY industries are looking to motion study to help eliminate as much as possible of the waste of useless motions, Allan H. Mogensen, assistant editor Factory and Industrial Management, told delegates to the Engineers' Convention.

Motion study is not a speeding-up process, he said. Instead it seeks to find the one best way of doing work, which is usually the easiest method. Extremely valuable in this work is the motion-picture camera, and the simplicity and low cost of 16 mm. film and equipment have greatly accelerated its adoption by industry.

In the past micro-motion was a complicated laboratory study, but now even the simplest of amateur cameras may be used to advantage. A brief description of the method followed in making an analysis of an operation will aid in visualizing the technique.

The operation to be studied is photographed, including in the field a fast-moving clock. This clock, known as a micro-chronometer, records simultaneously with the various motions on the film time to the 1/120,000 hour. Use of the fast lenses now available with 16 mm. equipment permits photographing an operation by natural daylight or requires only a few simple incandescent lamps.

Real Screen Analysis

After the film has been developed it is analyzed by projection on a small screen, one frame at a time.

Study of the film—a slow and laborious process—enables the analyst to draw up a "simo-chart" (simultaneous motion cycle chart).

This is a long sheet of cross section paper, on which the motion of each part of the hands, wrists, and arms is plotted against time. The micro-motion analyst breaks all motions down into seventeen fundamental motions—called therbligs (Gilbreth spelled backward). These are represented on the simo-chart by colors and symbols.

Study of this chart reveals violation of the laws of motion, and a new and better method of doing the job can be synthetically constructed. When taught to the operator this method—the one best way—makes possible greatly increased production with the same or less effort.

Film Its Own Time Clock

Lately an attempt has been made to simplify the method of eliminating the micro-chronometer. Running the camera at a constant speed results in a definite time record being impressed on the film.

That is, if the camera speed is 1000 frames a minute, then each picture will be one-thousandth of a minute later than the preceding one—and a ruler becomes the time-measuring device.

Micro-motion studies have been made in some industrial plants for many years, but with the impetus given this technique lately, it is rapidly being adopted by even the mass production industries. One large department store has been making motion studies for some time.

For training new workers the film method is of inestimable value. The effects of motion study are going to be tremendously far-reaching, and within the next years few industrial plants will exist that do not use it in one form or another.

Surgeons in Convention
See Clinical Pictures in Sound as Well as Color

THAT the surgical motion picture has arrived at a point not only of widespread use but also of official recognition is the statement of William F. Kruse, head of the educational department of Bell & Howell, following the twentieth annual Clinical Congress of the American College of Surgeons, held at Philadelphia recently.

During the five days of this meeting seven official motion picture programs were presented under the auspices of the college's committee on motion pictures. Twenty-five different films were included on these programs, six of them being talkers. An audience of over 300 was always to be counted on.

One of the official Congress lectures over the radio was delivered by Dr. P. E. Truesdale, of Fall River, Mass., who spoke enthusiastically of the part played by the motion picture in the education of medical students. Dr. William Ernest Miles, noted British surgeon, gave the movies splendid recognition in showing his excellent three reel (16 mm.) film depicting the technique employed in the cancer operation bearing his name.

Much interest was aroused by operation pictures shown in full color, and made under artificial light by surgeons themselves with amateur equipment. One booth conducted a continuous showing of approximately fifty operation films made by surgeons, and conducted a new type of "clinic" that is becoming increasingly popular at surgical, medical and dental conventions—the motion picture clinic.

Numa Roars His Last

Numa, African lion, which has appeared on the screen continuously for the past eight years, in more than 200 screen plays, is dead from cancer. He is to be stuffed and placed in the office of the Gay Lion Farm, where his intelligence and gentle manners made him a favorite.

Numa's last screen appearance was in "The Cohens and Kellys in Africa," in which he roared mightily. Also he engaged in a thrilling tussle with a man, presumably Charlie Murray, but really probably was his master.

Swiss Watching Soviet

The showing of the Russian film "New Babylon," has been forbidden in the Canton de Vaud, Switzerland, by order of the Police Commissary. It has been further announced by this official that all Soviet productions must be approved by the Department of Police before being screened.

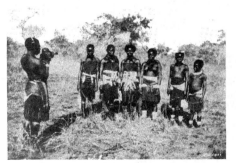

T. J. Connolly of the Palace of Justice, Pretoria, South Africa, sends to Bell and Howell this study in black showing how he is creating amateur photographers by teaching them to shoot a Filmo. In the picture possibly is a whole family, including father. The photographer looks commanding, even forbidding enough to be a stage mother-in-law, but the absence of concern on the faces of those out front seems to dispel the possibility

What a Catholic Priest Accomplished
in His Parish with 16 mm. Equipment

FIVE years ago, the Rev. S. O. Yunker, pastor of St. Vincent de Paul Church at Springfield, Ill., began work as an amateur movie-maker. He had been a still photography enthusiast, and when the Bell & Howell Company began to manufacture its 16 mm. motion picture cameras he was one of the first purchasers of a Filmo outfit.

He began his motion work as a hobby. Soon he was making "shots" of parish groups, and of course the next step was to call in his parishioners to see the results. He found that if he announced that he was to make movies of any parish event, the attendance on that occasion would be stepped up at least 200 per cent. He says that people like the experience of being "shot" by a movie camera, and the wise clergyman can turn this feeling to fine advantage.

"I have made movies of many important diocesan events," he says, "such as dedications of schools and other ceremonies, and these are shown all over the diocese. As a matter of fact, I have been making, in effect, a historical movie record of diocesan happenings. The Bishop is very much interested in the whole idea."

The Rev. Mr. Yunker has just organized a club called The St. Vincent de Paul Dramatists, part of whose activities will center around the making of amateur movie productions. The parish is largely composed of persons of Lithuanian extraction and descent, and as its first movie production the club is making a film touching upon Lithuanian history. Later several movie plays will be produced. The pastor acts as both director and cameraman.

From his particularly successful experience Mr. Yunker states that the movie camera and projector present a splendid opportunity to offer parish members a fine and enjoyable medium of self-expression.

He has presented a number of religious, educational and entertainment films secured from film distributors, but he finds it particularly advantageous to show at the same time movies of local parish events which he has of self-expression.

The pastor firmly believes the 16 mm. equipment, because of its comparatively low cost of operation, gives the up-to-date minister a very practical means of stimulating constructive parish interest.

Trend Toward More Light in 16 MM. Film Projectors

MORE exacting use of the motion picture projectors employing 16 mm. film has led to demands for higher illumination, declared V. J. Roper and H. I. Wood of General Electric in a paper read to the Engineers Society. While fundamentals of optical system design limit the light source and wattage, higher illumination than that given by present projectors is possible with tungsten filament Mazda lamps of relatively lower voltage, higher current rating, and also with more efficient optical systems.

Highest illumination in present equipments is produced by a 250-watt 20-volt lamp. The optimum lamp, a higher wattage, low voltage type, necessitates a bulb of larger size and hence some change in optical design. Optical efficiency of present equipments has been sacrificed to gain compactness and portability.

Some systems use less than one per cent of the light emitted by the source whereas it is possible to use over two and five-tenths per cent of the total. Therefore the combination of an optimum lamp and an optimum optical system offers much higher screen illumination.

Low voltage lamps practically necessitate transformer operation. It is suggested that transformer equipped projectors be provided with a changeover switch to permit the use of 115-volt lamps on direct current. A voltmeter should be provided across the secondary of the transformer and a variable rheostat in series with the primary to insure that the lamp receives its proper voltage.

Motor Executive Sends Home Pictures of Family to Mother in Denmark

WILLIAM S. KNUDSEN, president of the Chevrolet Company, who came to America as a Danish immigrant, takes home-made motion pictures of his children and those of his sisters at play, and rushes them to his mother in Copenhagen regularly, he discloses in the American Magazine for November in the first intimate interview he has ever given.

Knudsen's mother came to America first in 1917, but became homesick for her grandchildren in Denmark and went back. There she became homesick for her American grandchildren. The engineer sent experts to equip her home with a projector and now sends her films of all occasions in which the children appear. His mother is eminently satisfied with this arrangement, the motor production wizard declares.

"Grandmother," he says, "loves those who most need her. Her sons and daughters have grown up and can protect themselves. But the grandchildren are little and need the same love and care that she loved to give her own children.

"Women love children because they are helpless and because they crave infinite things. And don't forget that my mother sees the little ones as they are today and not as they were when she last saw them.

"It is strictly up-to-date love. I send the reels over and my mother is able to see her children and her grandchildren alive, laughing and waving their love at her. I still send these several times a year and have an experienced operator to project the pictures in her home."

Physioc Returns

(Continued from Page 7)

lowered. The cameraman brought back some still negatives of the rescues.

Pirates Outmaneuvered

On one of the company's trips in the eastern waters Physioc noticed the decks were being patrolled by soldiers. Inquiry developed they were guarding against possible attack by pirates, which still are active and adopt every expedient to circumvent the precautions of skippers.

In the jungle excursions the equipment was transported in praus, or dugouts. One of these carried a load of 2,000 pounds. They continually were catching on snags in the streams and as regularly the coolies would jump over the side and shove the craft across.

No equipment of any kind was lost. Four of the Chinese coolies, Physioc declares, knew every screw in the many pieces making up the mechanical outfit and took the best of care to see every single item in the inventory was brought in to its destination. At times as many as thirty coolies were employed in transportation work in the jungle.

Lose "Cat's Whiskers"

When bamboo cutters reported a tiger in their vicinity two official huntsmen were ordered out to get the cat. Natives as a rule are not permitted to carry weapons.

The tiger was brought in and Gar-

son planned to bring the skin home. He got it as far as Sumatra, where it was left to stretch and dry on the deck of a docked ship. In the morning he knew more about the meaning of the "cat's whiskers," for the tiger's were gone as well as its claws.

The whiskers are stewed in a syruppy fluid and the claws are ground into powder for the medicine men.

Five things stick in the memory of the traveler. They are:

A bicycle.

A jinriksha.

A five-gallon Standard Oil can, serving purposes conceivable and inconceivable.

A picolan—a shoulder stick or yoke on which the natives do most of their transporting. The traveler brought one home.

A Dutch wife. In spite of its strange sound it is only a pillow about 9 inches in diameter by 2½ feet long. Without one no native would think of going to his rest. The English applied the name—in ridicule. But they adopted the device, nevertheless.

Husky Ourang

During his stay Physioc made quite a study of many of the religions to be found in the Far East, especially the Mohammedan. As to the latter he discovered its followers to be very devout and the religion itself to be dignified and satisfactory. For his benefit the priests read many passages from the Koran and explained

the differences between the Mohammedan and the Christian belief.

"Very little difference at that," remarked the unexcitable photographer.

He also visited many temples and mosques and was treated with every courtesy.

Primarily the expedition went after ourang—and got them. One of these among others captured was placed in a corral that was inclosed not only on the sides but on the top as well—and most securely.

The reason for the precaution may be understood when it is explained the creature weighed 380 pounds with an armstretch of 11 feet 2 inches, and was possessed of a physical strength in full proportion to his bulk.

Canada Increases Cost of Censoring to Film Makers

According to Assistant Trade Commissioner Avery F. Peterson, Toronto, Ontario, motion picture censorship fee has advanced more than 300 per cent. An order-in-council of the Ontario Provincial Government, effective October 1, increased the censorship fee for motion picture films.

Films of foreign origin will be assessed at $10 a reel of 1000 feet as compared to the previous fee of $3. British films, for which the rate previously was $3, are now to be assessed at $7 per 1000 feet.

An additional $90,000 annually is expected to be added to provincial revenue if the new order stands.

Vitaglo Chicago Sound Studio Open for Feature or Commercial Work

THE Vitaglo Corporation is now settled in its new sound studio, 4942 Sheridan Road, Chicago, which it believes to be the best equipped between Hollywood and New York. The studio has a floor space of 50 by 75 feet, all of which has been completely sound-proofed for recording purposes. With a capacity of 300,000 watts of incandescent lighting the company is in a position to take care of anything in either the field of feature or commercial production.

While primarily the plant was constructed for demonstration purposes,

Front view of Model AB202 Vitaglo amplifier

Vitaglo has decided to accept contracts for production that have been offered it. Beside the space devoted to photographing there are recording and monitoring rooms as well as ample cutting and projection rooms, providing complete facilities for outside work.

The plant is equipped for single or double film or wax recording.

Included in the company's output is a complete line of miscellaneous broadcast, public address and repro-

ducing amplifiers. The company recently has developed a photo-electric cell amplifier entirely AC operated, requiring no B or A batteries or head amplifier. It is declared this may be placed within ten feet of a projector and produce a volume of sound sufficient to cover an audience of 5000 persons. The weight of the unit is twenty-seven pounds and has a channel for two projectors.

Compactness and Simplicity

Compactness and simplicity of operation are two of the foremost factors being featured by the makers of

Dinosaur Canyon Shot by Pathe Cameras with Sound

DINOSAUR Canyon, situated in the almost inaccessible region of the Hopi Indian reservation in Arizona and revealed for the first time to the white man in 1929, has been photographed for the first time by Pathe and will form the background for important parts of the action in "The Painted Desert," photographed by Edward Snyder.

This canyon, which has been a secret rendezvous for Hopi Indians, was unknown to Indian agents or the white pioneers of the territory until Hubert Richardson, keeper of the Cameron Trading Post, was told of it by an Indian whose confidence he had gained.

The result was that the National Geographic Society sent a research party into the section which uncovered dozens of dinosaur tracks, cut deep into the rocks and said to have been imprinted there by prehistoric monsters about thirty thousand years ago.

the Vitaglo recording camera. The single film system may be adapted to any standard Bell and Howell camera equipped with a high speed shuttle, the company states.

Mounted on the camera are a small twelve-volt motor, tachometer, flywheel and a special sprocket, including the Vitaglo sound gate. The total increase in the weight of the apparatus is set at fourteen pounds.

The new type AB202 amplifier of the company is contained in a welded steel case with a removable cover. There are channels for four microphones, a mixing system, visible and audible monitoring, with calibrated checking controls for all tubes as well as for the recording lamp. The amplifier weighs 45 pounds.

The power supply necessary for camera, motor, amplifier and the recording lamp is obtained from one

Rear view Vitaglo amplifier showing welded construction of case and outlets for microphone and power connections

case weighing under eighty pounds. All circuits and voltages are checked from the amplifier panel. The complete unit consists of amplifier, battery case, camera and microphone. The Chicago Daily News is quoted as authority for the statement that in recording football games for that journal one man has handled both amplifier and camera.

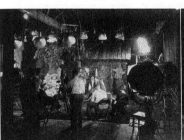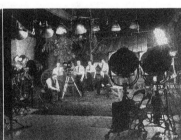

Left—Working on "Springtime in the Rockies" set in Vitaglo studio, with naked camera containing entire recording apparatus being operated within ten feet of the microphone. Right—Studio staff beginning at left: R. F. Devlin, electrician; A. B. Chereton, cameraman; Russel Stolts, assistant; M. E. Snelling, scenic artist; J. Stanley, electrician; seated, Frank Freimann, recording engineer.

STATEMENT OF THE OWNERSHIP, MANAGEMENT, CIRCULATION, ETC., REQUIRED BY THE ACT OF CONGRESS OF AUGUST 24, 1912.

Of The International Photographer, published monthly at Los Angeles, California, for October 1, 1930.

State of California, County of Los Angeles—ss. Before me, a Notary Public in and for the State and county aforesaid, personally appeared George Blaisdell, who, having been duly sworn according to law, deposes and says that he is the Editor of The International Photographer and that the following is, to the best of his knowledge and belief, a true statement of the ownership, management (and if a daily paper, the circulation), etc., of the aforesaid publication for the date shown in the above caption, required by the Act of August 24, 1912, embodied in section 411, Postal Laws and Regulations, printed on the reverse of this form, to wit:

1. That the names and addresses of the publisher, editor, managing editor and business managers are: Publisher, International Photographers, Los Angeles, California; Editor, George Blaisdell, Los Angeles, California; Managing Editor, none; Business Manager, George Blaisdell, Los Angeles, California.

2. That the owner is: (If owned by a corporation, its name and address must be stated and also immediately thereunder the names and addresses of stockholders owning or holding one per cent or more of the total amount of stock. If not owned by a corporation, the names and addresses of the individual owners must be given. If owned by a firm, company, or other unincorporated concern, its name and address, as well as those of each individual member, must be given.) International Photographers, Local 659, International Alliance of Theatrical Stage Employees and Moving Picture Operators of the United States and Canada, 1605 North Cahuenga Ave., Hollywood, California; President, Alvin Wyckoff; First Vice-President, Roy H. Klaffki; Second Vice-President, Ira Morgan; Third Vice-President, Archie Stout; Recording Secretary, Arthur Reeves; Financial Secretary, Ira B. Hoke; Treasurer, Charles P. Boyle; Sergeant-at-Arms, Len Powers. The address of all the foregoing is at 1605 North Cahuenga Avenue, Hollywood, California.

3. That the known bondholders, mortgagees, and other security holders owning or holding 1 per cent or more of total amount of bonds, mortgages, or other securities are: None.

4. That the two paragraphs next above, giving the names of the owners, stockholders, and security holders, if any, contain not only the list of stockholders and security holders as they appear upon the books of the company but also, in cases where the stockholder or security holder appears upon the books of the company as trustee or in any other fiduciary relation, the name of the person or corporation for whom such trustee is acting, is given; also that the said two paragraphs contain statements embracing affiant's full knowledge and belief as to the circumstances and conditions under which stockholders and security holders who do not appear upon the books of the company as trustees, hold stock and securities in a capacity other than that of a bona fide owner; and this affiant has no reason to believe that any other person, association, or corporation has any interest direct or indirect in the said stock, bonds, or other securities than as so stated by him.

GEORGE BLAISDELL, Editor.

Sworn to and subscribed before me this 7th day of November, 1930.

(Seal) SAMUEL T. KAUFMAN.
(My commission expires January 28, 1931.)

Grooming Cameras
(Continued from Page 15)

tical aberrations. These variations from normal often are so slight as to offer no objection to their use in the transmission of light for black and white photography.

However, the extreme accuracy necessitated in color production would be handicapped seriously by the use of lenses showing the slightest aberrancy. Not only must the glass itself pass critical examination, but the barrel and focusing mounts come in for a large share of painstaking scrutiny.

After leaving the optical bench the mounted lens is taken to an open air testing laboratory for final photographic tests as well as photographic calibration before being pronounced ready for studio production.

Machine Shop Foreman J. Henry Prautsch, known internationally for his past experience with Carl Zeiss, Jena, Germany; Voigtlander & Son, Brunswick, Germany; Kuffel & Esser, and C. P. Goerz in America, and as foreman of the Akeley Camera machine shops in New York, is responsible for the precision movements of Technicolor cameras.

No other moving picture camera and a few pieces of fine machinery necessarily are constructed with the extreme accuracy essential to the successful operation of these instruments. Nor is it just precision of movement required in their makeup.

Department Personnel

They must be light in weight and yet strong enough to stand the grueling of moving and registering three feet of film every second the camera is in operation. These are only a few of the many knotty problems successfully solved by Prautsch. Under normal production conditions his finely equipped department employs upward of forty precision machinists.

Possibly nowhere else in the cinema world are cameras given the expert care and constant attention found in the department of Estabrook. When not busy with routine work in his office the chief may be found on the set of one of the many operating units lending a helping hand from his wealth of experience gained in the field of colored motion photography.

From the early days of the company Estabrook's experience embraces work on "Ben Hur," "Irene," and many short subjects as well. These early successes were followed by Richard Dix in "Redskin." Then came the talkers and with them wide expansion.

Estabrook carefully piloted his cameramen and technicians through the whirlwind of production last year and through the depression. Today the department stands ready for the new production era, prepared to deliver the finest colored subjects it has ever screened.

Welcome Competition

The personnel of the various maintenance unit heads of the camera department is as follows:

Ed T. Estabrook, superintendent.

Gifford S. Chamberlain, assistant superintendent.

J. Henry Prautsch, machine shop foreman.

Friend Baker and Curtis Cady, final inspection.

Gerald MacKenzie and Joseph Lane, prism department.

Glen Twombly, camera materials department.

Floyd Lee, mechanical tests.

Earl Wilson, photographic test laboratory.

Estabrook is justly proud of his share in the success of the big organization. A visit to his staff becomes one of the most interesting sidelights on the manufacture of Hollywood's most famous product, the motion picture. It epitomizes the newer trend of cinema production—the propensity to make moving pictures artistically, educationally and beautifully under better working conditions than has been the lot of artisans during the years that are past.

"Competition?" queried Estabrook, in response to my question. "We welcome it. There is room for many color companies, because eventually color will largely replace the present uncolored picture. It is only by competition under production conditions that either we or our competitors can expand. It is the only means by which we may hope to accomplish the super cinema of the future."

Gaumont Studio Building
Large Addition to Plant

The Gaumont Studio has started work on a substantial addition to its plant in Shepherd's Bush in England. According to the London Bioscope, five houses adjoining the property are being demolished. They will be replaced by a basement and three story structure designed to be the principal studio.

There will be forty dressing rooms. All of these will contain the latest conveniences for the comfort of players. The flat roof will be asphalted and arranged for exterior work.

A concrete runway will connect all floors with the street level, while three elevators, one of three ton capacity, also will connect basement to roof. The present electrical installation will be quadrupled in capacity.

The building with its six stages will have a useful floor area of 47,000 square feet. Work is to be completed before the middle of 1931.

German Talker Goes Big in
Territory Retaken by France

THE French trade press reports that "Zwei Herzen im ¾ Takt," a German "talkie," broke all records in Mulhouse, Alsace. Its 28 days run at the Casino drew 50,000 spectators (Mulhouse has only 120,000 inhabitants), while pictures of international renown had a maximum run of 15 or 18 days.

The German film in question proved a good box-office success in Germany and German Switzerland, but while it is merely a good average film the chief factor of its extraordinary success in Mulhouse was the German dialogue it contains.

Sound Hits French Musicians

Cinema and theatre musicians in France have been very hard hit by the introduction of sound-films, according to Trade Commissioner Canty of Paris. Following a steady diminution in the number employed during the past year, a company controlling several cinemas in Paris is reported to have recently dismissed 500 more in one day.

Although the secretary of the Musicians' Union has issued a warning to young people not to seek orchestral employment, it is believed that orchestras will later come into their own. This belief is based on observation of what has happened in America, where unemployment in the musical profession is on the wane owing to renewed demand for "real music."

Vienna Has 33 Sound Houses

In addition to the 30 cinemas already wired in Vienna three further theatres, the Arkaden, the Astoria and the Luna, have just been installed with sound-film reproduction equipment.

Rebuilding Gaumont Palace

The Gaumont Palace, in the Montmartre district of Paris, is being entirely rebuilt, and when completed, will, it is claimed, be the largest cinema in the world with a seating capacity of over 6,000.

Included in the scheme of modernization is the installation of a four-manual organ.

North China Now Producing

According to Trade Commissioner Harold D. Robison, Tientsin, China, the North China Amusement Company recently previewed the film "Ku Tu Chun Meng" or "A Spring Dream" in the ancient capital.

This film is the first that has been produced by this company and also the first commercial film produced in North China by Chinese Studios.

Klangfilm to Produce

Klangfilm has entered the production field, states a message from Berlin. The Staaken studios, which stood empty for several months, have now been wired with Klangfilm recording apparatus.

The first film to be produced is entitled "Two Kinds of Morals," and is based on a popular play by Bruno Frank.

Sound for Greece

For next season Athens is to have 10 wired houses. There will also be 2 sound-film theatres in Piraeus, 2 in Cavalla, 1 in Patras and 3 in Salonica.

Committee Reports

(Continued from Page 28)

small monitor "teloptikon," then transferred to a light valve where the light was broken up by a 48-hole scanning disk to reproduce the images which were projected on a screen six feet square set under the proscenium arch.

Head and shoulders of the subjects were reproduced in a black and white picture showing gradation of tones. The system was developed under the direction of Alexanderson.

England Making Progress

Marked progress has also been made in England in the development of television in the hands of Baird Television, Ltd. On July 1, 1930, a demonstration of television was made before press representatives on a 3 by 6 foot screen. Screen brightness was insured by using 2100 ordinary metal filament lamps instead of neon tubes and Kerr cells as in earlier experiments.

Commutator contact switches, turning on one lamp at a time, swept the entire bank of 2100 lamps in one-twelfth of a second. The receiving outfit, on a portable truck, was installed in the London Coliseum and demonstrated as a part of the regular variety program three times daily from July 28 to August 9, 1930.

A talking film made on Friday, August 8, was televised as a special feature of the program on the closing date of August 9.

In another television system, patented by Lieut. Wold of the Quartermaster Corps, U. S. A., mechanical scanning is said to be rendered unnecessary by the use of a lamphouse having a lattice work of filaments, different junctions of which become luminous successively.

Photographing Eclipse

An attempt to make a motion picture record of the moon's shadow from an airplane during the total eclipse of the sun on April 28, 1930, was partially successful. Clouds obscured the earth below the plane which flew at an altitude of over 18,000 feet, but the shadow bands were photographed on the cloud layer. A special sound recording camera

fitted with an F. 1.4 lens and hypersensitized panchromatic film was used. Radio time signals received by the plane were recorded. Accurate timing records made on a reel of sound film by Dr. Pettit during the eclipse showed it to be 1.7 seconds earlier than calculated.

According to plans announced during the summer of 1930 positive prints made by the additive Herault Trichrome process have the three successive frames dye-tinted. Projection is made with a Continsouza-Combes nonintermittent projection which at 24 frames per second is said to suppress flicker. This projector does not use mirrors or prisms, only spherical lenses. The Wolf-Heide process is said to use a similar projection method.

Progress in Color

A new two-color additive process is reported to have been used in making "The School for Scandal" shown during the early part of October, 1930, at the Plaza Theatre, London.

Sound prints by the Technicolor process are now made with a silver image sound track having a contrast or "gamma" of unity which is claimed to represent a material advance in the art of reproduction. The feature picture "Whoopee" was made with a sound track which was developed in this way. It is stated to be impractical to control the gamma of the sound track as closely as this on black and white prints.

A new plant for the Multicolor process being constructed in Hollywood during the summer and fall of 1930 will require 200 men and will have a capacity of 3,000,000 feet of film per week.

200,000 Home Sets

Irby estimates there are over 200,-000 home motion picture sets in use. Interest during 1930 appeared to be centering in the development of sound motion picture devices for use in the home. To date these have all been of the type requiring disk turn tables, and range from simple models to very elaborate ones.

Putting sound records on 16 mm. film beside the picture is a difficult problem because of the narrow space available and the delicate equipment required for recording the sound.

Visionola is a radio-phonograph and motion picture instrument in which any combination of the three units is attainable. The image from the projector may be reflected on to a 2 by 3 foot screen mounted at the top and back of the cabinet or it may be focused directly on a larger screen. Two loudspeakers are included, one static and one moving coil, the former being mounted behind the smaller screen.

A compact mercury vapor lighting unit has been made available for amateur use, designed as a portable studio unit with a power rating of 450 watts. Dallmeyer has issued a new telephoto lens of F. 2.9 aperture which is stated to give a linear magnification of three diameters. It is supplied only in 3 inch focal lengths. The F. 0.99 lens made by this firm has been withdrawn from the market.

Industrial Field Widening

About 80 per cent of the amateur scenarists have been eliminated because of their inability to write dialogue for sound motion pictures.

According to an estimate made by Menefee a million and a half dollars were expended in the production of industrial films during 1929 which indicated a great gain in the popularity of such films. One-third of the amount was devoted to the production of sound films.

Theatres in the province of Szechwan, China, on the border of Thibet, exhibit American as well as Chinese pictures. There are 27 theatres with a seating capacity of 115,000. As this is an average of more than 4000 seats per theatre, some of the theatres compare favorably in size with several of New York's big cinema houses.

The population of the province is 60,000,000, however, so that only a few can attend at one time. Only silent pictures are shown to date.

Average daily attendance at 18 of Broadway's leading theatres with a seating capacity of 37,000 has been estimated as 100,000.

Walter F. Eberhardt, head of the public relations department of Western Electric, sailed from New York for Europe Nov. 14. He will be away until the new year.

Mole-Richardson Construct Perambulator to Eliminate Shifting on Travel Shots

A RECENT contribution in mechanical efficiency to the motion picture industry in the perambulator designed for use with blimp cameras by Mole-Richardson, Inc., lighting engineers and manufacturers.

The perambulator was designed primarily for use in conjunction with the company's tilt-head.

When the Metropolitan Studios started its talking version of "Tillie's Punctured Romance," of which Gus Peterson was photographer, it found the production required numerous travel shots.

The new design was the result. It involved certain fundamentals which serve to eliminate the difficulties encountered in the ceaseless changing from stationary to travel shots or vice versa.

As a result of the success and possibilities of the new type perambulator an improved design was perfected and is now available as stock product. Several also have been in use at Columbia and Universal.

The feature of the device is the convenience it affords the camera in changing from stationary to travel shots. The entire unit is mounted on three ballbearing, pneumatic-tired, aluminum wheels. The frame is of truss design and constructed from tubular steel substantially joined with bronze fittings. The camera may be elevated from a lens height of four feet to a height of six feet, which covers the height range necessary for this type of work.

To make the perambulator rigid for

International in Fact

Executives of Du Chrome Film System of 6723 Santa Monica Boulevard are firm believers in the significance of the first half of the title of this magazine—international.

The company during November received an inquiry from R. C. Rigordy of Calcutta, India, who conducts a laboratory at that location. Mr. Rigordy quoted the company's announcement in the September issue of this magazine.

stationary shots three jacks are provided which, when manipulated, elevate the unit, thus taking wheels from the floor, providing extra rigidity and permitting leveling of the camera. For the convenience of the cameraman an adjustable leather-cushioned seat is provided. In order to lock the front swivel wheel to any desired angle a screw clamp may be adjusted.

Cornica Wins Tenth Cup

Martin Cornica, cameraman in the special effects department at the Fox studio, is bringing new tennis laurels to the local motion picture industry.

In 1927 he walked away with the motion picture championship honors of the west coast by winning the doubles with Theodore Von Eltz and taking the victory in singles for himself.

Cornica entered the first annual Beverly Hills tennis tournament, held November 22 on the new courts, intending to take a flyer to get in training for the 1931 motion picture championship. With first honors in both men's singles and doubles, he again scored as a double winner.

With eight cups to testify to past triumphs, Cornica has now raised the total to ten.

Lyons Returns from East

Reginald E. Lyons, member of Local 659, has returned from a two months' trip to New York. While in the eastern city he paid a visit to the headquarters of Local 644 and met up with old friends among officers and members.

The cameraman also took in the American Legion convention—incidentally among the throng of New Yorkers old and new who looked upon the Hub for the first time in their lives. Lyons paid a visit to Indianapolis on his return west .

Engineers Open Eastern Home

The Society of Motion Picture Engineers has leased Room 701 in the building at 33 West Forty-second street for its New York headquarters.

The Chicago section has completed plans for regular meetings to be held on the first Thursday of each month.

Mole-Richardson Perambulator

For the December 4 meeting it is planned to visit the Enterprise Optical Company and hear a paper by O. F. Spahr on projection.

On January 8, 1931, a paper on color will be read before the society by R. Fawn Mitchell of Bell & Howell Company.

Wunder Finishes Tour

The itinerary of the Academy of Motion Picture Arts and Sciences "good will" tour as conducted by Clinton Wunder, executive manager, has been completed. Wunder addressed groups in Minneapolis, Memphis, Milwaukee, Kansas City, Omaha, St. Louis, Chicago and New York. He left Hollywood Nov. 6.

The topic "A Voice Heard Round the World" told the story of the Academy's origin, purposes and achievements. Service clubs, colleges, conventions of women's clubs, educators, film boards of trade and exhibitors were addressed.

Auerbach Representing 659

Brother Irving J. Auerbach has been appointed steward of the Northern California members of Local 659.

Brother Auerbach's Studio, under the name of Auerbach Motion Picture Productions, has made some of California's outstanding industrial and educational subjects.

The motion picture which this firm produced for the City of Monterey played a most important part in showing actual conditions to the Board of Army Engineers in Washington, and in the Government spending nearly a million dollars in Monterey Bay.

English Trade Paper
Flays Native Films
As "Potted" Plays

From the Bioscope, London

IS British production due for another big dip? It is unpleasant to strike a note of dull pessimism when all around seems brighter and brighter. It is a jarring experience to listen to a cracked bell, but no one can heal the crack by taking the clapper away. They can only stop the bell from ringing. And it might be intended for a danger signal.

Without sacrificing any of the thrills one can get out of the recent success of British pictures, let us survey the prospects. Are we moving? Leading critics, including among others Walter A. Mutch, Geo. A. Atkinson and Clive McManus, seem persuaded that we are not. I am afraid they are right.

For over a year now we have had film after film from various British companies—many good, some indifferent, others more or less indescribable—all merely potted stage plays. Nothing cinematic; little or no movement, just "potted" plays, such as could have been made—as far as story and treatment go—from the front row of the stalls of any London theatre.

And it still goes on. Players are being taken *en bloc* from the stage, stuck on to sets in familiar scenes and postures and photographed—just talking, talking—talking! During the past year or two not more than three big original stories have been attempted by the whole British production industry.

Meanwhile America, with the passing of its "talkie" infancy, has put away childish things and has returned with redoubled vigor to the task of *creating* screen entertainment. The world has been scoured for the best writers; every scrap of first-rate screen material is being snapped up. Dialogue is being made to improve upon objects achieved in the old days by sub-titles. Talk is made subservient to action; to movement; the quality which first made the film a great public entertainer.

While Hollywood blazes its "big trails," getting ready for the next screen revolution — the "widies" — Britain clings to the old tale—the "potted" play. It may be easier for British producers to buy up ready-made stage plays with popular titles than to unearth and develop their story writing departments, but it is going to prove more expensive some day very soon.

Erpi Reorganizes Activities

Electrical Research Products announces the reorganization of the company's engineering activities into three departments: Commercial, general and reproducing, the last named being taken over as part of the scope of the present operating department. This reorganization involves primarily the effective consolidation into one department of services rendered one class of customers, exclusively.

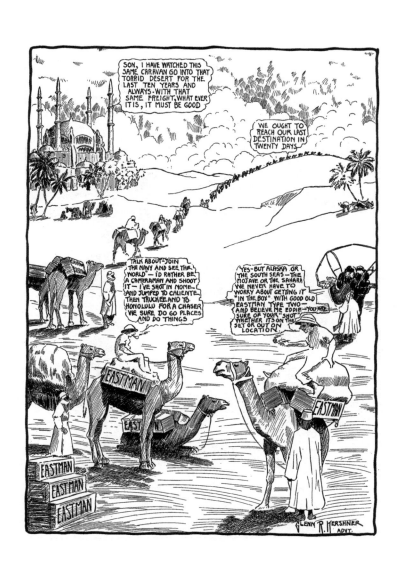

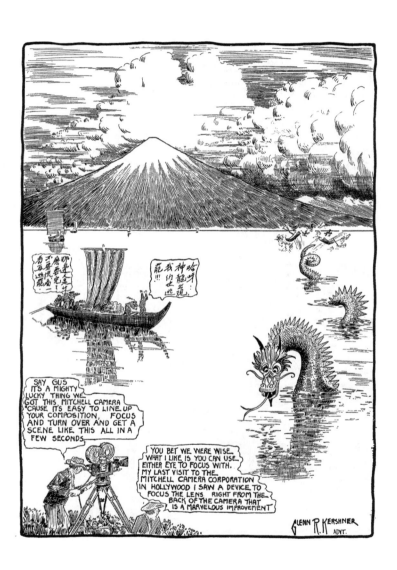

CONTACT SHEET: DO NOT SCAN

After scanning, these volumes & boxes should be held to be picked-up by:

Eric Hoyt
676 Kingswood Way
Los Altos, CA 94022
(310) 488-7043
erhoyt@gmail.com

RE: Media History Digital Library

Lightning Source UK Ltd.
Milton Keynes UK
UKHW010703271118
333020UK00004B/114/P